Oxford University Press Digital Learning Resources

Directions for accessing your

Oxford University Press Digital Learning Resources

Modern Art

A Global Survey from the Mid-Nineteenth Century to the Present

David Cateforis

Modern Art comes with a wealth of powerful tools to help you succeed in your course.
Follow these steps to access your resources:

> Visit **oup.com/he/cateforis1e**

> Select the edition you are using, then select student resources for that edition

> Follow the on-screen instructions, entering your personal redemption code when prompted

Carefully scratch off the silver coating to see your personal redemption code.

TI-0976-GHG4C7LM

For assistance with code redemption or registration, please contact customer support at **http://learninglink.oup.com/support** or 855-281-8749.

© 2024 Oxford University Press

OXFORD
UNIVERSITY PRESS

Modern Art

Modern Art

A Global Survey from the Mid-Nineteenth Century to the Present

David Cateforis

University of Kansas

OXFORD
UNIVERSITY PRESS

OXFORD
UNIVERSITY PRESS

Oxford University Press is a department of the University of Oxford.
It furthers the University's objective of excellence in research, scholarship,
and education by publishing worldwide. Oxford is a registered trade mark
of Oxford University Press in the UK and in certain other countries.

Published in the United States of America by Oxford University Press
198 Madison Avenue, New York, NY 10016, United States of America.

© 2024 by Oxford University Press

Library of Congress Control Number: 2022944537

CIP data is on file at the Library of Congress
978-0-19-084097-6

9 8 7 6 5 4 3 2 1
Printed by Lakeside Book Company, United States of America

Contents

Chapter 2 Post-Impressionism and Symbolism: Painting and Sculpture in Europe, c. 1886–1910 45

Chapter 3 Expressionism in France, Germany, and Austria 67

Chapter 4 The Cubist Revolution 91

Chapter 9 Art in France and England between the World Wars 193

Chapter 10 Modern Art in the United States, Canada, and Latin America, c. 1900–1945 213

| Chapter 11 | Modern Art in Asia: India, Japan, Korea, and China, c. 1900–1945 243 |

Chapter 14

Between Art and Life: International Trends of the 1950s and 1960s 301

Chapter 15 Pop Art 325

Chapter 18 Modern Art in India, Africa, and the Middle East, Mid-Twentieth Century 387

Chapter 19 Pluralism: Trends of the Late 1960s to Mid-1970s 413

Chapter 20 Postmodernism: Art in Europe and the United States,
Late 1970s to Late 1980s 445

Chapter 22 The Global Contemporary: Themes in Art Since c. 1989 495

Preface

Written in the context of ever-increasing globalization and in recognition of the importance of incorporating artists and cultural traditions from many parts of the world into mainstream modern art history, *Modern Art: A Global Survey from the Mid-Nineteenth Century to the Present* is the first introductory survey to include substantial coverage of modern art made outside Europe and the United States prior to the late twentieth century. While the book retains the well-established Euro–US-centric narrative of modern art, which remains fundamental to understanding the subject, it also provides a broader perspective by attending to early- and mid-twentieth-century developments in Canada, Latin America, Africa, the Middle East, and Asia, and its final chapter on art since c. 1989 is global in scope. The treatment of modern art made outside Europe and the United States prior to the late twentieth century is admittedly not as comprehensive as that given to art made inside those regions. However, the inclusion of artists and movements less familiar outside their regional contexts than are the internationally famous names of the Euro-US-centric canon will hopefully lead to further expansion of the study and appreciation of modern art history in truly global terms.

This book is intended to serve both as a textbook for introductory modern art courses and as a source of information for the general reader. It is structured chronologically. Some chapters are devoted to one modern art movement (e.g., Surrealism [Chapter 8], Pop art [Chapter 15]) or a few closely related ones (e.g., Dada and the New Objectivity [Chapter 7]) spanning a decade or two as manifested in one or several countries. Other chapters, such as those on modern art in the United States, Canada, and Latin America, c. 1900–1945 (Chapter 10); modern art in Asia, c. 1900–1945 (Chapter 11); mid-twentieth-century modern art in India, Africa, and the Middle East (Chapter 18); the three chapters treating architecture (Chapters 5, 17, and 21); and the final chapter on themes in global contemporary art since c. 1989 (Chapter 22), are broader in chronological and/or geographical scope and address multiple tendencies.

Each chapter highlights prominent artists through discussion of one or more of their key works; these works are typically both described and analyzed formally as well as interpreted contextually. These interpretations are grounded in the art-historical literature and sometimes enriched by quotations from the artists or from influential period critics. Most chapters also feature "Theories and Concepts" boxes summarizing important art-historical, philosophical, or theoretical concepts relevant to the analysis of art within that chapter and, often, elsewhere in the book.

A few notes to the reader on abbreviations and editorial choices: The Museum of Modern Art, New York, is often referred to in the text through its acronym, MoMA. The physical dimensions of artworks (including buildings) are variously given within the text in US imperial or metric units, depending on the context, with the former often used in descriptions of works made by US artists. Life dates are given only for artists who are substantively discussed in the text. In Chapter 11, Japanese, Korean, and Chinese artists and other individuals are identified using Eastern name order, with the family name preceding the given name. In later chapters, however, they are named using either Eastern or Western order, depending on how they are generally known in the West (for example, Yayoi Kusama's name is given in Western order whereas Ai Weiwei's name is given in Eastern order). The reader may determine the family name in every instance by consulting the index (where the former is listed as Kusama, Yayoi; the latter as Ai Weiwei).

Acknowledgments

It took me six years to write this book and I have accumulated many debts in the process. At Oxford University Press, I am grateful first and foremost to Richard Carlin, former executive editor, music and art, higher education, who recruited me for this project and believed so strongly in it—a belief shared by his successors, Justin Hoffman, former senior acquisitions editor, music and art, higher education group, and Justin Bailey, portfolio manager, art and education, higher education, who have my deep thanks. I received invaluable editorial support from Janna Green, former development editor, Oxford University Press Canada, and subsequently from Olivia Clark, content development editor, higher education/ academic. Olivia was my essential partner in every aspect of the extensive, multifaceted process of review, editing, revision, and decision-making that went into finalizing the manuscript and illustration program and developing the book's digital pedagogical features. I cannot thank her enough. Also essential were the tireless efforts of Meredith Taylor, permissions coordinator, to secure images and reproduction rights for the book's illustrations. I extend appreciation to Jeanne Zalesky, head of content acquisitions and development, and Meg Botteon, manager, content development, for their assistance in the final stages of the editorial process. Mary Frances Ivey has my thanks for her help in finalizing the index. I am likewise grateful to Patricia Berube, project manager; Anne Sanow, copyeditor; Michele Laseau, senior art director; and Micheline Frederick, senior manufacturing controller, for all that they did to see the book through to publication.

Many friends and colleagues have supported my work on the book by answering questions, providing information, facilitating access to research resources, providing feedback on my writing, or simply listening to and encouraging me. They include Andi Back, Rosemarie Bletter, John Bowlt, Michael Brenson, Maria Carlson, Vitaly Chernetsky, Lisa Cloar, Charles Eldredge, Leesa Fanning, Jared Flaming, Jessica Gerschultz, Kevin Greenwood, Randall Griffey, Atreyee Gupta, Tanya Hartman, Edgar Heap of Birds, Tera Lee Hedrick, Hiroko Ikegami, Maki Kaneko, Marni Kessler, Kaori Kitao, Seongim Lee, Christina Lodder, Ling-en Lu, Ugochukwu-Smooth C. Nzewi, Mark Olson, Christin Mamiya, Cara Manes, Areli Marina, Amy McNair, Robert Mowry, Eunyoung Park, Savita, Vidhita, and Vinod Raina, Rebecca Schroeder, Raechell Smith, Emily Stamey, Maya Stiller, Linda Stone-Ferrier, Mouhamadou Moustapha Tall, Marvin Trachtenberg, May Tveit, April Watson, and Todd Wyant.

I appreciate the feedback of the following reviewers, who read numerous chapters in various stages of draft and whose comments helped me to improve the manuscript:

Samuel D. Albert, *Fashion Institute of Technology*

Gwen Allen, *San Francisco State University*

Gabriela Boschi Scott, *University of the Incarnate Word*

Jill R. Chancey, *Nicholls State University*

Frances Colpitt, *Texas Christian University*

David Connolly, *Alma College*

Cheyanne Cortez, *Cabrillo College*

Erin C. Devine, *Northern Virginia Community College*

Travis English, *Frostburg State University*

Lisa Festa, *Georgian Court University*

Gregory Gilbert, *Knox College*

Craig Hanson, *Calvin State University*

Gene Hood, *University of Wisconsin—Eau Claire*

Elizabeth Howie, *Coastal Carolina University*

Karla Huebner, *Wright State University*

Joanna Inglot, *Macalester College*

Denise Johnson, *Chapman University*

Tiffany Johnson Bidler, *Saint Mary's College*

Christa Kagin, *Benedictine College*

Ashley Lindeman, *Johnson County Community College*

David McCarthy, *Rhodes College*

Meghan McClellan, *State Fair Community College*

Mary McInnes, *Alfred University*

Cerise Myers, *Imperial Valley College*

Bibiana Obler, *George Washington University*

Zhijan Qian, *New York City College of Technology, CUNY*

Kurt Rahmlow, *University of North Texas—Denton*
Denise Rompilla, *Middlesex County College*
Andrea Rusnock, *Indiana University—South Bend*
Susan Elizabeth Ryan, *Louisiana State University and Agricultural & Mechanical College*
Michael Schwartz, *Augusta University*
Mary Shepard, *University of Arkansas—Fort Smith*
Stephanie Shestakow, *Ocean County College*
Jonathan Shirland, *Bridgewater State University*

George Speer, *Northern Arizona University*
Gina Tarver, *Texas State University*
Elizabeth Turner, *University of Virginia*
Aaron Van Dyke, *Saint Cloud State University*
Samuel Watson, *University of Wisconsin–Green Bay*
Matthew Wilson, *Ball State University*
Paula Wisotzki, *Loyola University Chicago*
Chelsea Wright, *Palomar College*
and seven anonymous reviewers

Finally and above all, I am grateful to everyone in my loving family, especially my parents Mary-Ann and Vasily Cateforis, my wife Beth, and our son Alex, for their steadfast support and understanding at every step of my endeavor in writing this book; it would not exist without them.

David Cateforis
Lawrence, Kansas
November 2022

Introduction

This book offers a global introductory survey of modern art from the mid-nineteenth century to the present. It encompasses painting, sculpture, architecture, photography, and new media such as performance, installation, and video art that have proliferated in recent decades—art forms often labeled "contemporary" rather than modern, though they still qualify as modern under that word's dictionary definition: "relating to the present." This book defines modern art as art that responds to modernity's historical forces and that expresses the cultural experience of modernity (see "Modernity, Modernism, and the Avant-Garde" box). Modern artists' reactions to modernity have ranged from the celebratory to the critical: some attempt to directly represent modernity's impact on daily life, while others intensely question the nature of art itself. This latter questioning mode produced such developments as completely **abstract** art, the presentation of found or manufactured objects as art, and the dematerialization of the artwork (as in Conceptual, performance, and digital art). Modern art is, above all, innovative, breaking from tradition and striving for new modes of expression and inquiry.

Because European countries were the first to undergo modernization as well as generate modern art in response to modernization's effects, this book's opening chapters emphasize European artistic developments. Later chapters expand beyond Europe by attending to histories of modern art in the United States, Canada, Latin America, Africa, the Middle East, and Asia. This inclusive approach reflects the art-historical discipline's recent global turn under the influence of postcolonialism and globalization (see boxes in Chapters 18, 22).

The book seeks to balance broad coverage with more in-depth treatment of selected artists and artworks important to building an understanding of modern art on a global scale. This approach necessarily excludes many worthy artists, regions, and **mediums**, and not all art discussed in the text is illustrated, but in many cases links to images are provided in the ebook. Employing fundamental tools of art history, the treatment of individual artworks typically identifies the work's **subject matter** or **iconography** (in the case of art with recognizable imagery); features brief description and **formal analysis** (an analysis of the work's visual qualities); and offers interpretation of the work's expressive content or meaning within relevant frameworks ranging from the artist's biography to larger historical, social, cultural, economic, political, philosophical, and theoretical contexts. The presented interpretations of artworks, based in the art-historical literature, and sometimes informed by the artist's own words, those of a critic, or the application of a relevant theory, are not intended to be definitive. Alternative readings are always possible, and readers are encouraged to discover them in the robust critical and scholarly literature devoted to nearly every artist in this book—as well as to construct their own interpretations.

Modernist Innovation versus Academic Convention: Some Late Nineteenth- and Early Twentieth-Century Examples

Modern art's innovations have often unsettled and even outraged audiences accustomed to more conventional artistic values, only later to gain widespread acceptance. A case in point is **Impressionist** painting, which emerged in France around 1870. Many viewers and critics initially ridiculed Impressionist paintings because of their loose **brushwork** and bright colors, which diverged from accepted aesthetic standards. By the early twentieth century, Impressionism had achieved mainstream popularity in Europe and elsewhere that endures to this day.

We may gain an understanding of how Impressionism challenged conservative artistic norms in the 1870s—and identify some key features of **modernism** (see "Modernity, Modernism, and the Avant-Garde" box)—by comparing a painting by the Austrian Karl Karger (1848–1913), *Arrival of a Train at Vienna Northwest Station* (1875, Figure I.1) with

one by his contemporary, the French Impressionist Claude Monet (1840–1926), *The Gare Saint-Lazare: Arrival of a Train* (1877, Figure I.2). This also gives us the opportunity to introduce some important terms used in the study of art history, bolded throughout and included in the book's glossary. Both paintings are executed in the same medium on the same **support**—**oil paint** on canvas—and are about the same size. They feature the same basic subject matter, a train station interior with a view toward the train shed's open end and a steam locomotive on a track facing the viewer (on the left in Karger's painting and on the right in Monet's). This subject matter exemplified modernity (see "Modernity, Modernism, and the Avant-Garde" box): train travel was a nineteenth-century innovation, as were the iron-and-glass train sheds that span the platforms next to the train tracks. A significant difference between the paintings is that Karger's depicts a throng of passengers extending across the right two-thirds of the **composition**, whereas a smaller number of figures are scattered across the space of Monet's picture. Even more striking, however, is the difference in **style**—the distinctive manner in which each artist has rendered his subject.

Karger paints in an **illusionistic** style, expertly employing artistic conventions and refined painting techniques to create the illusion of an actual scene of almost tangible physical reality. Karger treats the **picture plane**—the imaginary plane dividing the picture's internal, fictive space from the viewer's

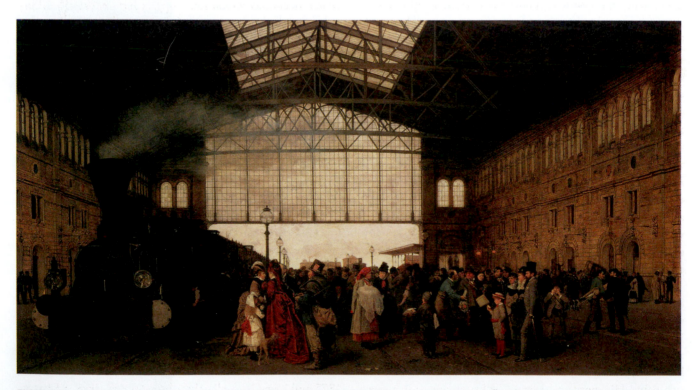

FIGURE I.1 Karl Karger, *Arrival of a Train at Vienna Northwest Station*, 1875. Oil on canvas, 91 x 171 cm. Österreichische Galerie Belvedere, Vienna.

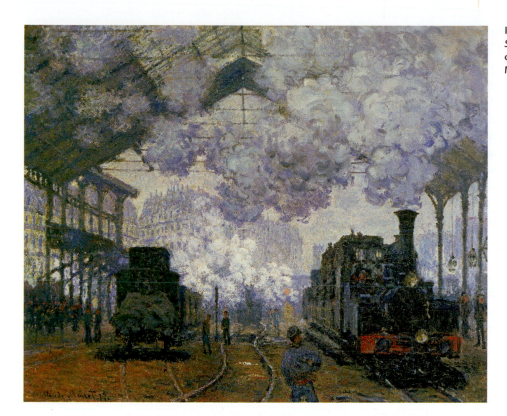

FIGURE I.2 Claude Monet, *The Gare Saint-Lazare: Arrival of a Train*, 1877. Oil on canvas, 83 x 101.3 cm. Harvard Art Museums, Cambridge, Massachusetts.

real space—like a transparent window. He uses various forms of **perspective** to establish the sense of spatial recession behind the picture plane. Entities closer to the picture plane, such as the human figures in the **foreground**, both overlap and appear larger than those in the **background** and are also placed lower in the composition. Through **linear perspective**, Karger creates the illusion of a measurable, boxlike receding space: elements in the train station's side walls such as **arcades**, repeated windows, and **stringcourses** form **orthogonal lines** perpendicular to the picture plane that converge on a **vanishing point** located in the sky below the central vertical iron bar of the train shed's **gable** end. The locomotive and train are likewise represented in linear perspective through **foreshortening**. Karger **models** the painting's **forms** through light and shade to produce a visual quality of substantial **mass** and **volume**. With careful and smooth brushwork, he delineates **shapes** and textures precisely and he uses **naturalistic** colors that match those seen in the real world.

Karger achieves his high degree of illusionism by effacing evidence of his painting process and of the painting medium's materiality. Monet, by contrast, emphasizes these very things in *The Gare Saint-Lazare: Arrival of a Train* (one of several pictures he made of this subject in 1877). Rather than rendering his forms precisely and smoothly, he does so loosely with thick, rich paint. His short, rapid brushstrokes remain visible even as they also create imagery. This is especially noticeable in the

clouds of blue and gray smoke that fill much of the composition's upper half and in the puffs of white smoke at the lower center. In contrast to Karger's wispy, transparent smoke, Monet's has a palpable presence. And while Monet, like Karger, uses linear perspective, the smoke in his composition's upper register obscures spatial recession. This, combined with the thick paint and assertive brushwork, makes the viewer aware of the picture plane's two-dimensional reality—not as an imaginary transparent window but a surface covered with paint—a defining quality of much modernist painting. Because it declares the artist's active role in creating it, Monet's painting seems to be a more subjective interpretation of reality than Karger's—more a product of Monet's individual sensibility than an impersonal application of artistic conventions.

Karger renders every element of his composition in detail and devotes considerable attention to the social status of the people on the platform—white men, women, and children in expensive clothing as well as middle- and lower-class individuals. Karger includes his own self-portrait at the right; he wears a black suit and hat and is accompanied by an aproned porter carrying a trunk and a lay figure—an artist's wooden mannequin.[1] Such anecdotal details, combined with Karger's skillful illusionism, made his picture enormously appealing to its original audience. He showed it an exhibition in Vienna in 1875 and it was immediately acquired for the Imperial Paintings Gallery.[2] To most twenty-first-century viewers, however,

Karger's picture appears like a quaint artifact from a bygone time, whereas Monet's still conveys a vivid and relatable sense of the experience of modernity.[3] Why is this? For one thing, Monet is far less concerned than Karger with providing detailed, historically dated information about his subject—he doesn't precisely render 1870s fashions, for example—and is more concerned with evoking a subjective impression of it that feels authentic and fresh. Much of that freshness comes from the fact that Monet, committed to the Impressionist practice of **plein air** painting (painting in the open air), set his easel up in the train station and painted from observation rather than executing his picture in the studio on the basis of sketches and possibly photographs, as Karger did.

Furthermore, Monet painted in a technically innovative way that invests his picture with the quality of discovery rather seeming to be a product of conventional formulas. His painting, both through its active brushwork and its imagery of drifting smoke, figures in motion, and locomotives soon to depart the station, conveys an understanding of modernity as involving instability and constant change.

By contrast, Karger's imagery appears stiff and frozen, as if recorded in a sharply focused photograph. Karger learned to paint in this crisp, illusionistic style as a pupil at the Vienna Academy of Fine Arts in the 1860s. First established in **Renaissance** Italy and widespread in Europe by the eighteenth century, academies were artist-run organizations that trained artists and held public exhibitions that provided artists with opportunities to gain critical recognition, prizes, sales, and commissions. The most influential European academy in the nineteenth century was the French Académie des Beaux-Arts. It administered an art school, the École des Beaux-Arts, and sponsored a large annual exhibition, the Paris **Salon**. A jury of artists selected the works to be shown in the Salon. By the mid-nineteenth century, the French and other European academies and their exhibition juries had become increasingly conservative, generally favoring polished illusionism of the sort Karger produced and resisting innovations such as Impressionism.

In response, Monet and his Impressionist colleagues, whose works had often been rejected by the Salon in the 1860s and early 1870s, organized a series of independent exhibitions between 1874 and 1886 (see Chapter 1) that brought their art directly before the public without the intervention of a jury. Many conservative critics were hostile to Impressionism. One, for example, criticized Monet's paintings of the Gare Saint-Lazare, exhibited at the 1877 Impressionist exhibition, as "filled with black, pink, gray, and purple smoke, which makes them look like an illegible scrawl."[4] However, others praised them; Georges Rivière recognized Monet's subjective response to his subject as compellingly modern, writing of *The Gare Saint-Lazare: Arrival of a Train*: "Looking at this magnificent painting, we are gripped by the same emotion as before nature, and it is perhaps even more intense, because the painting gives us the emotion of the artist as well."[5]

Modernity, Modernism, and the Avant-Garde

Originating in Europe in the sixteenth century and accelerated in the nineteenth century by the Industrial Revolution, modernity connotes continuous innovation, change, and progress. Modernity is characterized by advances in industry, science, technology, transportation, and communication; urbanization; secularization; the capitalist-driven expansion of markets, commodification, consumerism, and commercialized popular culture and entertainment; increasing governmental surveillance and bureaucracy, often resisted by organized and revolutionary political movements; changing beliefs about gender roles; and increased social mobility.

The Industrial Revolution engendered a shift from farming to factory work as the main source of employment. It also fostered the exponential growth of cities. New forms of transportation such as the locomotive and steamship facilitated the shipment of raw materials and merchandise and easier passenger travel. While the Industrial Revolution improved the standard of living for the growing bourgeoisie (middle class), it also created an urban proletariat (working class) living in miserable poverty. Agricultural capitalism (agricultural land owned by investors and farmed by hired labor) likewise created an impoverished rural underclass. Even more exploitative was slavery, which was gradually abolished during the nineteenth century, but which persisted into the twentieth century in some countries and had major social, cultural, economic, and political repercussions for formerly enslaved peoples and their descendants thereafter. European countries' appetite for new sources of natural resources, agricultural products, and cheap labor led them to colonize large parts of Africa and South Asia, spreading their model of modernity across the globe, but creating social, economic, and political problems for colonized societies (see "Colonialism and Post-colonialism" box, Chapter 18). New means of communication, including the telegraph, photography, mass circulation newspapers and magazines, telephone, radio, and cinema, created networks of information sharing, catalyzing social, political, and cultural change. Modern scientific discoveries both improved human life and gave impetus to secularization—the loss of belief in traditional religions. For example, Charles Darwin contradicted the biblical account of creation by proposing that all life evolved from a common ancestor and changed through genetic mutation and natural selection.

Expanding capitalism also disrupted humans' understanding of their place in the world. This economic reality became central to the bourgeois experience of modernity, as Karl Marx and Friedrich Engels famously defined it in the *Communist Manifesto* (1848):

> **Constant revolutionizing of production, uninterrupted disturbance of social conditions, everlasting uncertainty and agitation distinguish the bourgeois epoch from all earlier ones. All fixed, fast-frozen relations, with their train of ancient and venerable prejudices and opinions are swept away, all new-formed ones become antiquated before they can ossify. All that is solid melts into air, all that is holy is profaned and man is at last compelled to face with sober senses his real conditions of life, and his relations with his kind.**

Marx and Engels predicted that the proletariat would violently overthrow the bourgeoisie to create a classless society. Simultaneously, nineteenth-century feminists advocated for women's equal rights as women took on new roles not solely confined to the domestic sphere—exemplary of the social and political change associated with modernity.

Modernism refers to the ways in which artists have articulated their experiences of modernity and have given it cultural definition. Like modernity, modernism is characterized by innovation—the imperative to "make it new," in the words of poet Ezra Pound. Modernist artists reject convention in the quest for more vital and original forms of expression, creating new possibilities for other artists to develop—or to reject in favor of further innovation. Some modernist artists seek to advance social and political change or express utopian values through their art, while others emphasize art's aesthetic autonomy. The twentieth-century American critic Clement Greenberg offered a narrow but influential definition of modernism as involving each medium's self-critical preoccupation with its own properties, such as flatness in the case of painting, most fully manifested in completely abstract art. More generally, modernist art, whether or not it contains recognizable imagery, tends to emphasize formal innovation and experimentation with new materials and techniques.

Closely related to modernism is "avant-garde." A French term denoting the vanguard of an army, it was first used in an artistic context in the early nineteenth century by the French social reformer Henri de Saint-Simon, who saw artists alongside scientists and industrialists as leaders in shaping a prosperous and equitable modern society. The term evolved to describe innovative artworks as well as artists, artists' groups, and movements opposed to aesthetic orthodoxies, sometimes alienated from the tastes and values of mainstream society, and committed to exploring radically new creative possibilities.

The Impressionists' challenge to the Salon's authority became a model for rebellious younger artists in other countries and led to the **academic** system's decline. In France, progressive artists established new alternative Salons, including the Salon des Indépendants (1884) and the Salon d'Automne (1903). Private art dealers and critics writing for newspapers and magazines played increasingly important roles in advancing artists' careers and in fostering avant-garde innovation.

Monet's and Karger's railroad subject matter is representative of the process of modernization that expanded beyond Europe in the nineteenth century and continues to the present in the developing world. A highly selective survey of train and railroad imagery by other artists working in different parts of the world between the 1870s and the 1930s reveals something of the diversity of modernist expression, more fully represented in this book's succeeding chapters.

Kobayashi Kiyochika's (1847–1915) *Hazy Moon at Ushimachi, Takanawa, between Tokyo and Yokohama* (1879, Figure I.3) depicts a train traveling by night on Japan's first railway, opened in 1872, connecting Tokyo and Yokohama. This work is exemplary of the popular Japanese artistic genre of color **woodblock** prints known as *ukiyo-e* (pictures of the floating world), which had been mass produced, sold cheaply, and widely collected in Japan since the late eighteenth century. Kiyochika's print shows the train at a site called Ushimachi, crossing a three-kilometer long embankment built sixty meters offshore from an area called Takanawa.[6] His composition pairs the artificial illumination of the train cars' interiors and its red headlight beam with the moonlight and its reflection on the water, poetically juxtaposing natural and modern technological light.

Kiyochika's subject reflects Japan's modernization following Western models of industrial and technological development during the Meiji Period (1868–1912), which began with the emperor's restoration to power after a period of rule by shoguns (military rulers). *Hazy Moon at Ushimachi* also reveals the influence of Western art in its use of linear perspective, which some *ukiyo-e* artists had already assimilated in the eighteenth century in a departure from the flattened space of traditional Japanese pictorial arts: in Kiyochika's image, the telegraph lines and railroad tracks form orthogonal lines converging toward a vanishing point beyond the composition's left side. (By contrast, many progressive European and American artists were influenced by *ukiyo-e*'s distinctly Japanese pictorial conventions in the late nineteenth century [see "Japonisme" box, Chapter 1].)

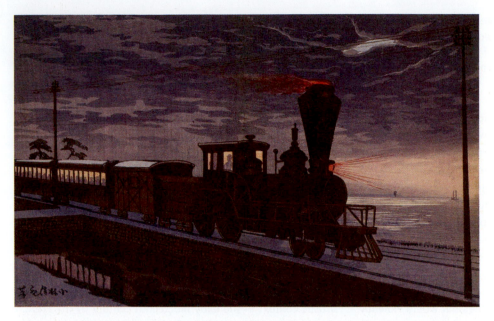

FIGURE I.3 Kobayashi Kiyochika, *Hazy Moon at Ushimachi, Takanawa, between Tokyo and Yoko-hama*, 1879. Color woodcut, 20.3 x 32 cm. Fine Arts Museums of San Francisco.

new technologies for the creation of art. A case in point is photography, which evolved alongside the steam engine and railroads, and whose early technical development is described in Chapter 1. Due to photography's mechanical nature, many nineteenth- and early-twentieth-century art professionals considered it a useful tool for accurately recording appearances rather than a creative art like painting, drawing, or printmaking. The American photographer Alfred Stieglitz (1864–1942) was an important leader in the fight to gain recognition for photography as a **fine art**. Seeking to distinguish his and his like-minded colleagues' photographs from the uncreative efforts of amateurs, Stieglitz formed the Photo-Secession in New York in 1902 (its name inspired by European anti-academic movements such as the Munich and Vienna Secessions). The next year, he began publishing a magazine, *Camera Work*, in which he reproduced the members' photographs as **photogravures**.

Stieglitz published his photograph, *The Hand of Man* (1902, Figure I.4), in the inaugural January 1903 issue of *Camera Work*. The photograph, taken from the back of a moving train in the Long Island City train yards, shows a lone locomotive chugging forward in the right center. A spume of black smoke billows from its smokestack, balanced at the left by a tall telephone pole. Silvery snaking tracks lead the eye from the dark lower foreground to the mist-shrouded background buildings beneath a cloudy sky. *The Hand of Man*'s soft focus, hazy atmosphere, and subtle range of tones exemplify the photographic aesthetic of **Pictorialism**. Pictorialist photographers emulated the poetic visual qualities of paintings such as James Abbott McNeill Whistler's nocturnes (see Figure 1.6) in order to demonstrate their medium's expressive capacity. Stieglitz called his aesthetically refined photograph of a gritty urban reality "an attempt to treat pictorially a subject which enters so much into our daily lives that we are apt to lose sight of the pictorial possibilities of the commonplace."[8] The photograph's title evokes the power of the human hand to invent transformative new technologies such as the train, the telephone, and the camera—a machine capable of creating great art when guided by the sensitive hand—and eye—of an artist.

Kiyochika depicts an American Standard-type locomotive not used on the Tokyo-Yokohama line, on which imported British locomotives ran.[7] He likely adapted the locomotive's image from a **lithograph** by Currier and Ives, an American firm whose inexpensive prints circulated through nineteenth-century popular visual culture in the United States in a fashion similar to *ukiyo-e* in Japan. Thus, unlike Monet, who painted from direct observation, Kiyochika imagined his scene and probably based it in part on preexisting visual sources. He also created a very different aesthetic effect, emphasizing sharp outlines, clear patterns, and flat surfaces that contrast with Monet's indistinct forms and lush paint handling. Kiyochika's print's formal qualities arise from the woodblock printing technique. The artist created a master drawing for the print, which then served as a template for a wood carver who cut the blocks used to make the print, with separate blocks employed for each color. A professional printer carried out the printing.

While differing from the individualistic expression of a painter like Monet, collaborative processes like that of *ukiyo-e*, in which others' hands ultimately realize the artist's vision, are very common in the history of modern art, especially since the 1960s. For example, starting in that decade, Andy Warhol and Bridget Riley employed assistants to make their paintings, while sculptors such as Donald Judd had their works professionally fabricated (see Chapters 15, 16). The execution of the work by others is fundamental to the practice of architecture, since architects normally do not themselves build the structures they design (see Chapters 5, 17, 21).

In addition to representing technological innovations such as the train, modern artists have continuously adopted

An impulse toward **abstraction** characterizes the development of European modern art in the late nineteenth and early twentieth centuries. In art history, the term "abstract" is used

in two ways. It describes representational art (art depicting things that exist or can be imagined to exist in the real world) that departs from the realistic imitation of nature to create **stylized** forms, which may be simplified, distorted, or exaggerated. It also describes art without any recognizable subject matter—also called nonrepresentational or nonobjective art—in which the art's meaning or expressive content is conveyed purely through its formal and material qualities. Nonrepresentational painting first emerged in Europe in the early 1910s, developing out of the innovations of **Post-Impressionism**, **Fauvism**, **Expressionism**, **Cubism**, and **Futurism** (see Chapters 2, 3, 4).

Cubism, the most revolutionary pre–World War I modernist painting style, involved the fragmentation of recognizable subject

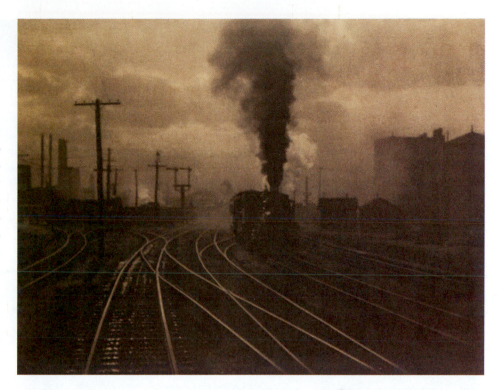

FIGURE I.4 Alfred Stieglitz, *The Hand of Main*, 1902. Photogravure, 24.1 x 31.8 cm.

matter into a multitude of geometric shapes and forms suggesting a world in flux. Cubism's radical reshaping of pictorial art evoked the reshaping of early twentieth-century modern life by such inventions as the automobile, airplane, radio, and motion pictures, as well as new relativistic understandings of space, time, and matter advanced by such thinkers as physicist Albert Einstein. Futurist artists employed Cubism's fragmented forms in rhythmic repetition to evoke rushing motion and celebrate the dynamism of modern technology and urban life.

Russian artist Natalia Goncharova's (1881–1962) *Aeroplane over a Train* (1913, Figure I.5) synthesizes elements of Cubism and Futurism to represent a train rumbling through the landscape surmounted by a biplane in the composition's upper half. Abstracting her subject matter with remarkable inventiveness and sophistication, Goncharova simplifies and fractures the structures of the airplane and train and paints numerous diagonal lines that slice through and energize them. She integrates the vehicles visually by painting the second train car from the right in a gold **hue** corresponding to that of the airplane, and by overlapping the airplane's lower wing by some of the train's upper elements. She also links the train visually with the sky by rhyming the round shapes of the train's wheels and puffs of dark smoke with those of the clouds. Portions of the plane's upper wing seem to dissolve and mingle with the clouds and the sky, suggesting the plane's fusion with the atmosphere through which it hurtles. Goncharova's painting

exalts her country's drive to modernize in a thrilling, innovative fashion that also declares her individualism and creative freedom—hallmarks of modernist expression.

In *E.F.C.B. (Estrada de Ferro Central do Brasil [Central Railroad of Brazil]*, 1924, Figure I.6), Brazilian artist Tarsila do Amaral (1886–1973, known by her first name, Tarsila) depicts a railroad subject in a very different abstracted style from that seen in Goncharova's picture. Titled for the name of a new rail line linking Rio de Janeiro with São Paolo, emblematic of Brazil's modernization, Tarsila's painting, unlike Goncharova's, does not convey rushing motion through fragmented forms. It instead presents static, geometrically simplified elements of São Paolo's industrialized landscape: roads, railcars, a railroad bridge, utility poles and towers, signs and semaphore signals, buildings, and trees. Other than the trees, which Tarsila models to give them a sense of volume, all of the motifs appear flat. So does the golden landscape, which rises steeply up the picture rather than receding into depth. Tarsila does create a sense of space within the painting through the use of overlapping and by placing objects meant to be perceived as farther away higher in the picture and generally rendering them smaller. However, the palm tree at the upper center-right seems out of scale with the elements surrounding it, creating a jarring sense of spatial discontinuity and further emphasizing the scene's artificiality.

Tarsila was a well-trained artist who had studied art for several years in São Paolo in the late 1910s and in Paris in the

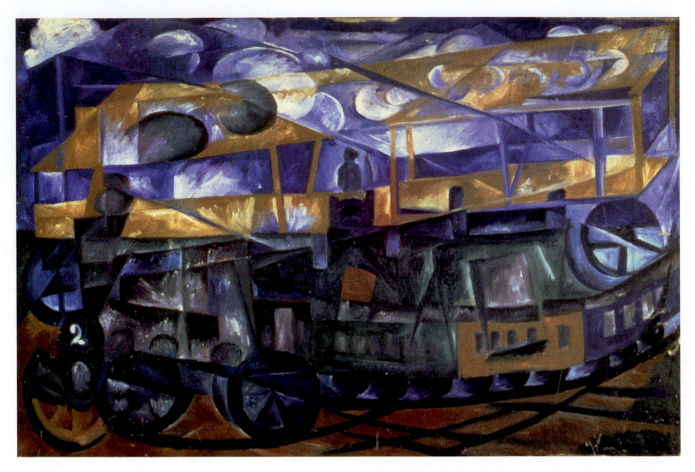

FIGURE I.5 Natalia Goncharova, *Aeroplane Over a Train*, 1913. Oil on canvas, 55.7 x 83.8 cm. State Tartar Museum, Kazan, Russia.

early 1920s, where her teachers included the Cubist Fernand Léger (see Figure 9.11). She painted *E.F.C.B.* in a deliberately naïve style to express a modern Brazilian identity—one resonating with ideas that her companion Oswald de Andrade articulated in his "Pau-Brasil" (brazilwood) manifesto. Named for the brazilwood exported to Europe by the county when it was a Portuguese colony, Andrade's manifesto likewise advocated for the exportation of Brazilian poetry, reversing the common notion that Brazil imported its culture from Europe. Andrade claimed that Brazilians possessed a dual heritage, the "forest and the school."[9] He called on his country's artists to pursue "the counter-weight of native originality to neutralize academic conformity," reacting against "the indigestions of erudition."[10] Tarsila's painting answers this call through its disarmingly simple, childlike quality.

Latvian-born Soviet artist Gustav Klutsis's (1895–1938) poster, *The Development of Transportation, The Five-Year Plan* (1929, Figure I.7), exemplifies the application of modernist formal innovation to promote a political agenda. The poster served as propaganda for the Soviet Union's first Five-Year Plan (1928–32) implemented by Soviet leader Joseph Stalin to increase the development of heavy industry and collectivize agriculture. The plan provided significant investments in railways, necessary to transport raw materials for industrial use as well

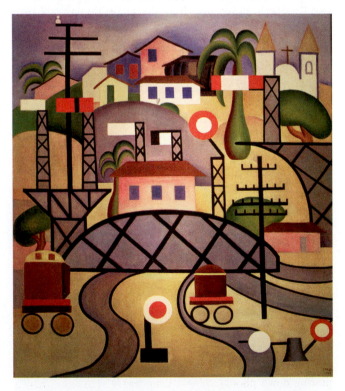

FIGURE I.6 Tarsila do Amaral, *E.F.C.B. (Estrada de Ferro Central do Brasil [Central Railroad of Brazil])*, 1924. Oil on canvas, 142 x 127 cm. Museo de Arte Contemporaneo, São Paolo.

strong diagonals evoke dynamism while the jumps in scale between the various motifs create a disjunctive effect suggesting the Soviet Union's rapid and exciting transformation under communism.

In his well-known painting *Time Transfixed* (1938, Figure I.8), Belgian artist René Magritte (1898–1967) also created a disjunctive quality, not only through a discrepancy in scale between motifs but also through their unexpected combination: he depicts a miniature locomotive steaming forward from a fireplace as if from the mouth of a tunnel. This surprising juxtaposition creates a dreamlike effect common in **Surrealist** art, of which Magritte was an important exponent (see Chapter 8). Also strangely dreamlike are the train's suspension in midair and the empty candlesticks and clock on the mantelpiece before a mirror reflecting the still, empty room, but not reflecting the candlestick on the right. Magritte intensifies his painting's dreamlike quality by executing it in a crisp, illusionistic style rather than an abstract one

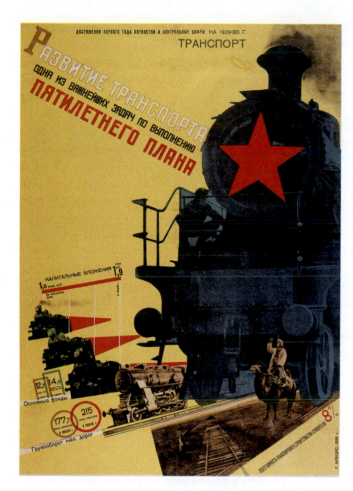

FIGURE I.7 Gustav Klutsis, *The Development of Transportation, The Five-Year Plan*, 1929. Gravure, 73.3 x 50.5 cm. The Museum of Modern Art, New York.

as finished goods. Set against a glowing yellow background, an enormous black Russian *Su*-class locomotive (built in various versions since 1910), emblazoned with a five-pointed red star (a Russian Communist Party symbol), dominates the right half of Klutsis's poster.[11] Below it, a camel-mounted man and a single-track railway refer to Russian transcontinental routes extending into Central Asia and to the Far East, indicating the Soviet rail system's nationwide reach. At the left are the diminutive, stacked, overlapping images of four more locomotives: a more brightly lit and up-to-date engine and three black ones, probably also from the *Su* class.

The text along the top of the poster declares, "The development of transportation is one of the most important tasks in fulfilling the Five-Year Plan." Additional texts at the lower left specify the increases in capital investments, fixed assets, and railway freight turnover during the plan's first two years. In combination with the design and layout of the texts, Klutsis composed the poster using **photomontage** (cutting and pasting down photographs)—a modernist technique that he helped to pioneer. The overtly propagandistic composition's

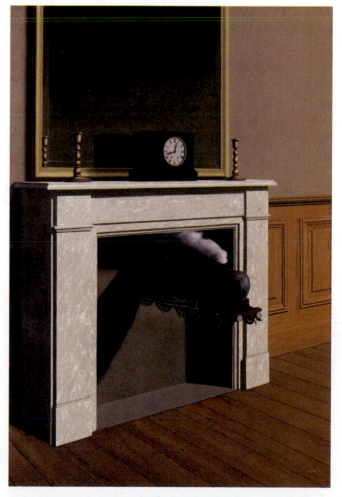

FIGURE I.8 René Magritte, *Time Transfixed*, 1938. Oil on canvas, 147 x 98.7 cm. The Art Institute of Chicago.

like Goncharova's or Tarsila's. *Time Transfixed* is modern not in its style but in the sense of dislocation it creates, resonating with the continual transformations and disruptions of modern life itself.

Neoclassicism and Romanticism: Precursors to Modern Art

Magritte was trained at the Académie des Beaux-Arts in Brussels; his illusionistic style was rooted in the same academic tradition that produced Karl Karger, and a century before Karger, Jacques-Louis David (1747–1825). By the mid-nineteenth century, the work of David and his many followers had come to represent a stultifying academic tradition that modernists like the Impressionists completely rejected. David, however, was an innovator within his own historical context as the most original and influential French Neoclassical painter. Emerging in Europe in the second half of the eighteenth century and pervading all forms of visual art, **Neoclassicism** was a style inspired by the Classical art and architecture of ancient Greece and Rome. Neoclassical artworks possess aesthetic values of clarity, order, and restraint that contemporary thinkers associated with reason and morality. Neoclassicism was thus intellectually intertwined with the Enlightenment, the dominant eighteenth-century Western European and American philosophical movement, which emphasized rational thought. Neoclassicism's sober aesthetic represented a reaction against the **Rococo**, a light, sensuous, and highly ornamental style whose principal exponent in later eighteenth-century French painting was Jean-Honoré Fragonard. Besides David, other prominent European Neoclassical figurative artists were Angelica Kauffman, the French sculptor Jean-Antoine Houdon, and the Italian sculptor Antonio Canova.

David's famous Neoclassical painting *The Oath of the Horatii* (1784–85, Figure I.9) represents an episode from the long-running war between Rome and the neighboring city of Alba Longa in the seventh century BCE that was settled by a legendary fight to the death between two sets of triplet brothers, the Roman Horatii and the Alban Curatii. David shows the red-cloaked father of the Horatii holding aloft their swords, on which the brothers swear to conquer or die. This dramatic event is not mentioned in any of the sources David would have consulted for the story and seems to have been his own invention. Behind the father, the Horatii's mother comforts two frightened children. To the right, two seated young women lean toward each other with heads bowed in sorrow.

They are Sabina, a sister of the Curatii, married to one of the Horatii, and Camilla, engaged to one of the Curatii.

The Oath of the Horatii manifests both Neoclassical aesthetic principles and David's impressive academic artistic skills. Using clean-edged forms, limpid lighting, and restrained colors, he sets the clearly defined action in an austere architectural space suggestive of a theatrical stage, its background divided by a triple arcade. He spreads the figural groups across the foreground in an arrangement suggestive of a Classical sculptural **frieze**. He renders the figures with great anatomical accuracy—employing knowledge gained through academic study of nude and clothed bodies—and models them with firm, sculptural solidity. The composition's orthogonal lines converge on the father's hand grasping the swords, making it the focal point. The taut, angular forms of the men's muscular bodies and weapons contrast starkly with the women's limp, drooping forms. Through this juxtaposition, David creates an opposition between the men's stoic resolve to sacrifice themselves for the state and the women's distress over the foreseeable deaths of their loved ones. The period's stereotypical understanding of men as rational and women as emotional by nature underpinned this opposition.

Exhibited at the Paris Salon of 1785, *The Oath of the Horatii* created a sensation through its novel subject and its stark, disjunctive formal qualities, which disturbed conservative critics. Commissioned by the government of Louis XVI, the painting's glorification of ancient Roman patriotism was likely intended to stir loyalty to the state during a period of economic difficulties and growing opposition by the bourgeoisie and peasants to the French aristocracy, which culminated in the French Revolution in 1789. After 1789, *The Oath the Horatii* was reinterpreted as a call to revolution, and David became an ardent supporter of the new French Republic.

The Oath of the Horatii is a **history painting**—the highest form of painting in the **hierarchy of genres** established in the seventeenth century by the French Royal Academy. History painting encompassed scenes from history as well from the Bible, mythology, and literature. The successful history painter demonstrated knowledge of textual sources as well as the ability to render and arrange multiple human figures into an effective composition that communicated a clear narrative and moral message serving as an *exemplum virtutis* (example of virtue). The academic instruction David received at the French Royal Academy was geared to training history painters. Such training was denied to women, who were not admitted to study in European and American art academies until the later nineteenth century (though they could be elected as members of academies based on their professional accomplishments). They were barred

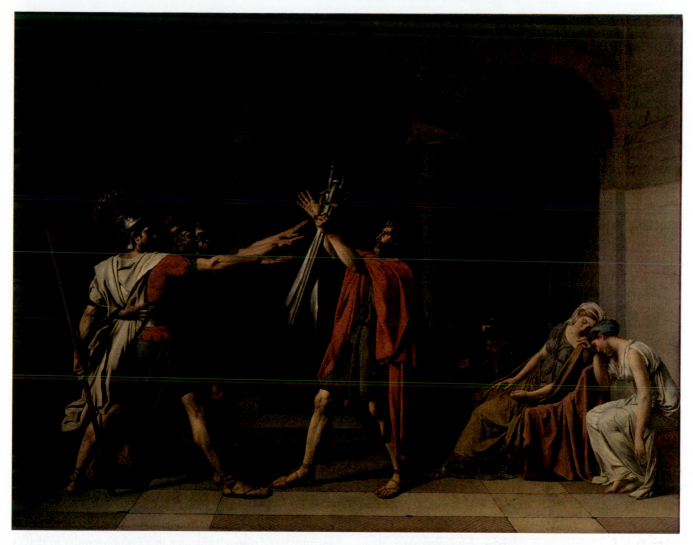

FIGURE I.9 Jacques Louis David, *The Oath of the Horatii*, ca. 1784–85. Oil on canvas, 330 x 425 cm. Musée du Louvre, Paris.

from academic study because it involved drawing and painting from the nude male model, which was considered morally inappropriate for women. As a result, women artists of the late eighteenth and early nineteenth centuries rarely made history paintings and instead mostly worked in the less esteemed genres of portraiture or **still life**. (A notable exception was the Swiss-born Angelica Kauffman, who gained renown as a history painter in England and Italy in the late eighteenth century.)

The most successful woman portrait artist in late eighteenth-century France was Elisabeth Louise Vigée Lebrun (1755–1842). She specialized in portraying aristocrats and made some thirty portraits of Marie Antoinette, the queen of France.

The most ambitious, *Marie Antoinette and her Children* (1787, Figure I.10), employs the traditional pomp of **Baroque**

regal portraiture tinged with Rococo delicacy in the rendition of the figures, rather than Neoclassicism's austere aesthetic. Its setting is the Salon de la Paix at the Palace of Versailles, with the famous Hall of Mirrors visible at the left. The seated queen wears an enormous plumed hat and a sumptuous sable-lined red velvet gown and holds her youngest son on her lap. At the left, her daughter leans affectionately toward her. At the right, the dauphin (her eldest son, heir apparent to the French crown), points to an empty cradle—a memorial to the queen's infant daughter who died while the painting was in progress.

Vigée Lebrun's portrait may have been calculated to counter popular resentment of Marie Antoinette, who was accused of being extravagant, unfaithful to Louis XVI, and a bad mother. The painting shows her instead to embody the virtuous Enlightenment concept of maternal love. The triangular figural

FIGURE I.10 Elisabeth Louise Vigée Lebrun, *Marie Antoinette and her children*, 1787. Oil on canvas, 271 x 195 cm. Musée du Louvre, Paris.

composition recalls Renaissance depictions of the Madonna and Child, giving Marie Antoinette an almost sacred presence. Behind the dauphin is a jewelry cabinet that evokes a story about Cornelia, an honorable mother from ancient Roman history. The mother of the future politicians Tiberius and Gaius Gracchus, Cornelia was visited one day by a materialistic woman who wore many jewels and asked Cornelia to show some of her own. Cornelia pointed to her sons and said, "These are my jewels." Vigée Lebrun's picture suggests that Marie Antoinette proudly displays her children in the same fashion.

A lifelong royalist, Vigée Lebrun fled France at the start of the Revolution, which claimed the lives of many of her patrons, including the royal family. David stayed and used his art to serve the new French Republic and subsequently Napoleon, who ruled France as First Consul (1799–1804) and then Emperor (1804–14, 1815). David and several of his former students produced enormous narrative paintings commemorating key events of Napoleon's military campaigns and imperial rule, applying the conventions of history painting to contemporary subjects. They also made portraits glorifying Napoleon, such as Jean-Auguste-Dominique Ingres (1780–1867)'s *Napoleon I on His Imperial Throne* (1806). This monumental painting depicts the emperor as a godlike, golden-crowned figure of supreme authority in ermine-trimmed coronation robes holding scepters associating him with great French kings and the Holy Roman Emperor Charlemagne.

David's most talented student, Ingres absorbed his teacher's Neoclassical aesthetic values complemented by reverence for the Italian Renaissance master Raphael. Ingres emulated Raphael's precise drawing, smooth surfaces, subtle modeling, graceful compositions, and **idealization** of human figures in numerous portraits as well as erotically charged paintings of female nudes. One such nude, Ingres's *Grande Odalisque* (1814, Figure I.11), represents an enslaved woman or concubine in a harem (the space in a Muslim house reserved for women). To many Europeans, the idea of the harem harboring trapped, sexually available women both demonstrated the supposed primitive savagery of the Orient (the term then used for the Middle East) and offered a titillating artistic subject. **Odalisques** were commonly represented in **Orientalist** art (depictions of Middle Eastern subjects by European and American artists).

Ingres's odalisque, seen from the back, reclines elegantly and looks over her shoulder at the viewer with a cool gaze. The painter establishes her exotic identity and location through her turban, peacock-feather fan, and the hookah at her feet, but he gives her white European skin and features to make her relatable to French viewers. The cool blues of the pillow, couch, and curtain complement her warm skin tones, while the sheet's tight linear folds accentuate her body's curvaceous smoothness. Ingres, who was capable of rendering the human body with clinical accuracy, demonstrates his virtuosity by distorting the odalisque's anatomy in a fashion similar to that of sixteenth-century Italian Mannerist painters: he elongates her back (as if she has several extra vertebrae), widens her hips, and gives her an impossibly long, seemingly boneless right arm. These manipulations heighten her body's erotic sensuousness, set in tension with her aloof expression and Ingres's disciplined technique.

While Ingres began his career within the context of Neoclassicism, his highly personal form of expression in the *Grande Odalisque* as well as its exotic subject matter are characteristic of **Romanticism**. Originating in Europe at the end of the eighteenth century and flourishing until the 1840s, Romanticism emphasized emotion and imagination over rationality. It emerged partly in reaction to the perceived failure of the Enlightenment values of reason and order in the aftermath of the bloody French Revolution and the devastating Europe-wide Napoleonic Wars (1799–1815). In general, Romanticism exalted the senses over the intellect, intuition over calculation, subjectivity over objectivity, and passion over restraint. Romanticism promoted a new conception of the artist as an

FIGURE I.11 Jean-Auguste-Dominque Ingres, *La Grande Odalisque* (*Large Odalisque*), 1814. Oil on canvas, 91 x 162 cm. Musée du Louvre, Paris.

individual creative genius striving for originality rather than following academic rules. In this sense, Romanticism set the stage for the modernist view of the artist as a radical innovator.

Initially a literary movement, Romanticism soon encompassed all the visual arts and found especially vivid expression in painting. The most notable Romantic painters were William Blake, John Constable, and J.M.W. (Joseph Mallord William) Turner in England; Francisco de Goya in Spain; Caspar David Friedrich and Philipp Otto Runge in Germany; and Théodore Géricault and Eugène Delacroix in France. Romantic painters treated all manner of subjects. Departing from Neoclassicism's emphasis on themes from antiquity, Romantic artists depicted dramatic stories from religion, literature, history—especially the European medieval period—and the recent past. They also included subjects with exotic, mysterious, monstrous, or occult qualities that appealed to the imagination—aspects of Romanticism that recurred in later modern movements such as **Symbolism** (see Chapter 2) and Surrealism. Romantic artists made portraits that sought to reveal complex psychological and emotional states. They also used landscape art as a vehicle for personal expression. The French poet and critic Charles Baudelaire recognized that Romanticism was primarily an attitude, writing in 1846, "Romanticism is precisely situated neither in choice of subject nor in exact truth, but in a way of feeling."[12]

Among the most celebrated European Romantic paintings are large canvases commemorating momentous recent events in an emotionally charged fashion. One such painting, *The 3rd of May 1808 in Madrid, or "The Executions"* (1814, Figure I.12), by the Spanish artist Francisco de Goya (1746–1828), shows a dreadful episode that occurred during Spain's occupation by

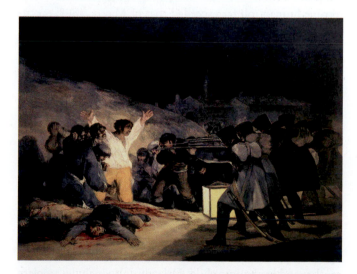

FIGURE I.12 Francisco de Goya, *The 3rd of May 1808 in Madrid, or "The Executions,"* 1814. Oil on canvas, 268 x 347 cm. Museo del Prado, Madrid.

Napoleon's army: the massacre of hundreds of Spanish civilians by French troops in the predawn hours of May 3, 1808. They were executed for their involvement in an uprising against the French the previous day, which Goya commemorated in a companion painting, *The 2nd of May 1808 in Madrid, or "The Fight against the Mamelukes"* (1814). Goya received the commission for both paintings from the restored Spanish monarchy after the country regained its independence.

In *The 3rd of May 1808*, Goya shows a group of captured rebels facing a French firing squad. He heightens the scene's emotional impact by using loose brushstrokes and strong light and dark contrasts and giving his figures thick limbs and coarse features. The principal, kneeling victim, his white shirt and yellow ochre pants harshly lit by a paper lantern, raises his arms in a pose recalling that of the crucified Christ, identifying him as a martyr. He and his companions will soon join the gruesome pile of bloody corpses below them—one fallen with outstretched arms echoing those of the kneeling man. Goya emphasizes the Spaniards' humanity through their expressive poses and facial expressions—fearful, pleading, or defiant. They are set in opposition to the faceless French soldiers, whose identical poses and raised weapons echo those of the triplet brothers in David's *Oath of the Horatii*, as if in a bitter parody of the Horatii's heroism. There are no heroes in Goya's painting, only brutal oppressors and miserable victims. Transcending its specific subject of Spanish-French conflict, *The 3rd of May 1808* endures as the first great modern anti-war artwork—an ancestor to Pablo Picasso's *Guernica* (see Figure 9.8).

A major painting by the most prominent French Romantic painter, Eugène Delacroix (1798–1863), *Scenes from the Massacres at Chios* (1824, Figure I.13), represents an event whose terrible human toll far exceeded that of May 3, 1808, executions in Madrid. In 1822, during the Greek War of Independence, the Ottoman Turks suppressed a Greek rebellion on the Aegean island of Chios by invading it and killing or selling into slavery tens of thousands of its residents. Newspaper reports of this atrocity outraged Delacroix who, like many French liberals, supported the Greeks' fight for independence, which resonated with France's own recent Revolution. He also found in it a compelling artistic subject. He fills his painting's foreground with the bodies of defeated and exhausted Greeks, watched over by rifle-wielding Turks in the shadowy **middle ground**. At the right, a Turkish cavalryman prepares to abduct a nearly naked woman while fending off a man desperately lunging at his horse. Below them, a middle-aged woman looks upward apprehensively. Beside her lies a dead bare-breasted mother and her hungry child. Delacroix also includes a violent massacre scene in the painting's central background, blurrily indicated rather than precisely described.

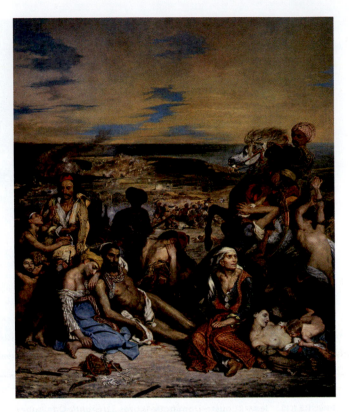

FIGURE I.13 Eugène Delacroix, *Scenes from the Massacres at Chios*, 1822–24. Oil on canvas, 419 x 354 cm. Musée du Louvre, Paris.

Intended to elicit sympathy for the Greeks, Delacroix's painting was the first that French critics described as *romantique*.[13] They used this term to highlight its vigorous and loose brushwork, its brilliant colors (now darkened due to Delacroix's use of poor-quality commercial paints), its free-flowing composition, and its intensely realized imagery of suffering. All of these qualities—many seen also in Goya's painting—are at odds with the polished illusionism, structural harmony, and emotional restraint of the classical tradition represented by David and his followers.[14] They also look forward to many subsequent developments in modern painting.

Romantic landscape painting, characterized by a new, emotional response to nature, generally took one of two forms: the visionary and the naturalistic. Artists of the first tendency, epitomized by Caspar David Friedrich, painted from memory and imagination. Those of the second, epitomized by John Constable, rooted their art in close observation of the natural world. J. M. W. Turner moved from the naturalistic approach to the visionary over his long career. Romantic landscape painting contributed significantly to the development of twentieth-century abstract art because, paradoxically, artists' constant study of natural effects of light and atmosphere gradually led them away from descriptive realism toward the communication of purely visual experiences and expression through paint itself.[15]

Friedrich (1774–1840) made landscape paintings infused with a sense of spirituality, such as *The Monk by the Sea* (1808–10, Figure I.14). He conveyed its theme—human insignificance before the immensity of God's creation—through the diminutive image of a lone black-robed monk on a barren Baltic shore. Friedrich emphasized the monk's isolation through a radically simple composition, dividing the landscape into distinct zones of land, sea, and sky. Without framing devices such as trees or cliffs, conventional in landscape paintings, these zones seem boundless. They evoke the **sublime**—an experience of elation or terror produced by the vast, the infinite, or the mysterious—as described by the Anglo-Irish philosopher Edmund Burke in his *Philosophical Inquiry into the Origins of our Ideas of the Sublime and Beautiful* (1756). Numerous Romantic painters besides Friedrich sought to evoke the sublime through more dramatic imagery such as towering mountains, erupting volcanoes, raging storms, and shipwrecks. Friedrich's quieter *Monk by the Sea* opened a path for mid-twentieth-century American Abstract Expressionist painters like Mark Rothko, who created the effect of the sublime through non-representational means—expanses of pure color spread across large canvases (see Figure 12.11). Standing before a Rothko painting, the viewer becomes the monk and the painted canvas becomes the sea. To modern eyes, Friedrich's *Monk by the Sea* might convey existential loneliness, but he intended it to be seen next to its **pendant**, *The Abbey in the Oakwood* (1809–10), which shows the monk's burial and suggests the promise of resurrection.

John Constable (1776–1837) dedicated his career to representing the rural southern English Stour Valley landscape of his youth, executing large paintings in his London studio based on pencil sketches and oil studies made directly from nature. Romantic in his emotional attachment to this subject, Constable declared, "Painting is for me but another word for feeling."[16] At the same time, he held that "Painting is a science, and should be pursued as an inquiry into the laws of nature."[17] Constable saw no contradiction between these statements; like Samuel Taylor Coleridge, whose poetry he admired, he found spiritual uplift in the attentive perception of nature.[18] In paintings such as *The Hay Wain* (1824)—showing farmers guiding an empty horse-drawn wagon across the Stour River toward a meadow in which hay is being harvested—Constable represented humans gaining their living from the land in a traditional fashion. His pictures of green, bountiful nature made no reference to British agriculture's mechanization following the Industrial Revolution, nor to the Stour Valley's ongoing economic depression. He nevertheless gave his **pastoral** subjects a modern sense of immediacy, using broken color and loose paint strokes to convey effects of movement, flickering light, and atmosphere—anticipating qualities of French Impressionism.

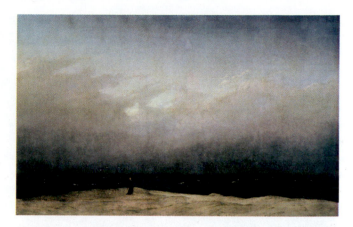

FIGURE I.14 Caspar David Friedrich, *The Monk by the Sea*, 1808–10. Oil on canvas, 110 x 171.5 cm. Alte Nationalgalerie, Berlin.

Constable's contemporary J. M. W. Turner (1775–1851) has also been considered a precursor of Impressionism because he explored purely visual effects of light, color, and atmosphere and radically dissolved form in his later paintings. Unlike the Impressionists, however, Turner employed these formal means to generate effects of sublimity and grandeur. He used landscape, like history painting, as a vehicle for profound reflections on society, politics, and the human condition.

In *Slave Ship (Slavers Throwing Overboard the Dead and Dying—Typhoon Coming On)* (1840, Figure I.15), Turner confronted the atrocities of the slave trade. It shows, in the painting's left background, a wave-tossed slave ship silhouetted against a sunset sky blazing with white, yellow, orange, and red, roughly brushed or laid down with a **palette knife**. Evoking nature's sublime and violent power, Turner's audaciously abstract painting style emphasizes the materiality of his medium over its capacity to imitate nature—a hallmark of much later modernist art. In the churning foreground waters, we glimpse African hands groping for air, bobbing manacles, and a shackled leg projecting upward amidst a swarm of voracious fish and gulls feeding on human flesh. This dreadful imagery was inspired by the story of the *Zong*, a British slave ship that ran short of drinking water during its crossing to Jamaica in 1781, leading the captain to order at least 132 Africans to be thrown overboard so that the shipping company could claim insurance compensation for the loss of its human cargo. (Slavers routinely threw diseased and dying enslaved Africans overboard—a practiced referred to in Turner's title—but those jettisoned by the *Zong* were healthy.)

Although the British Parliament had abolished the slave trade in 1807, numerous other nations persisted in the abominable practice in 1840. British warships patrolled the West African coast attempting to prevent this activity, but since the captains only received prize money for enslaved Africans captured

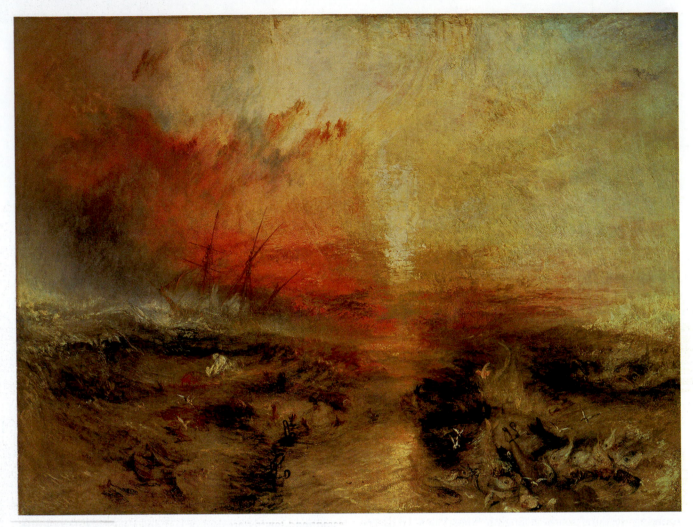

FIGURE I.15 J.M.W. Turner, *Slave Ship (Slavers Throwing Overboard the Dead and Dying, Typhoon Coming On)*, 1840. Oil on canvas, 90.8 x 122.6 cm. Museum of Fine Arts, Boston.

on the open sea, they often permitted slave ships to leave port before pursuing them. Slavers jettisoned enslaved Africans to lighten their load as they tried to outrun the British, who thus remained implicated in the slave trade's moral horror. Turner's *Slave Ship* draws attention both to the past and present British involvement in slavery, whose terrors the painting amplifies through its sublime aesthetic effects. Younger British and other mid-nineteenth-century European artists would reject such visionary, Romantic rhetoric to represent everyday subjects in a seemingly empirical manner, establishing realism as the language of their modern art (Chapter 1). However, Turner's audaciously abstract painting style looks ahead to later modernist art. Much like that of the Impressionists, Turner's painting still appears fresh and vital today—that is, it feels modern.

Realism, Early Photography, and Impressionism in France, Britain, and the United States, c. 1850–1880

CHAPTER

1

Realism was an artistic tendency that emerged in mid-nineteenth-century France and gained currency in other European countries as well as the United States. Realism emphasized the empirical observation and representation of subjects in the everyday world, rendered in a seemingly truthful manner. In this, Realism reacted against the dominant preceding European artistic movements, Neoclassicism and Romanticism (see Introduction), which the Realists considered escapist in their retreat into the past, the exotic, or the imaginative.

European intellectual, technological, and political developments of the 1830s and 1840s stimulated Realism's rise. One important influence was the positivist philosophy of Auguste Comte, who insisted that "positive" knowledge is gained only from observing the natural world and proposed applying scientific methods to the study and improvement of society in the modern age of urbanization and industrialization. The introduction of photographic technologies marked a significant innovation for Realism because photography was believed to produce a truthful image of the world. An empirical attitude also characterized Karl Marx and Friedrich Engels's theory of scientific socialism. Their *Communist Manifesto* (1848) identified class struggle as the driving force of human history; they predicted that the proletariat (working class) would overthrow the bourgeoisie (middle class), thus creating a classless society. Realist art arose in the wake of the political revolutions of 1848 in Europe that sought to overturn monarchical systems and institute greater democracy, and it often depicted peasant and lower-class subject matter. For this reason, Realism was sometimes associated with political liberalism and, in the case of the French Realist Gustave Courbet, socialism, though Realist images could also assert conservative values.

While pioneering French Realists such as Courbet and Jean-François Millet depicted working-class and rural life, their successor Édouard Manet focused on modern urban and suburban life. Manet's younger friends, the Impressionists, concentrated on aspects of modern leisure in and around Paris. These artists also pioneered new painting methods that emphasized the medium's material reality. Courbet applied paint thickly; Manet painted in a loose, sketchy manner; and many Impressionists painted in the open air using rapidly applied strokes and touches of pure color. Their aim was empirical, as well as expressive of modernity's ever-changing quality. These techniques drew attention to the materiality of paint and to formal qualities of line, shape, form, space, color, and texture. They also opened the path to modernist abstraction explored by the Post-Impressionists (see Chapter 2).

These innovations challenged the norms of academic art, which promoted the aesthetics of antiquity and the Renaissance combined with the study of nature and the live model. In France, academic art was the focus at the Académie des Beaux-Arts and the École des Beaux-Arts, the official art school. This training prepared painters for the annual Salon, a huge juried exhibition and the main showcase for contemporary art in Paris. The most successful Salon painters—among them Jean-Léon Gérôme, Alexandre Cabanel, and William Adolphe Bouguereau—pleased their audiences with engaging subject matter (often drawn from history or mythology), a

compelling plot, and smooth execution that encouraged viewing the painting's imagery as if through a window. To Salon jury members, Realist and Impressionist works looked poorly or incompletely executed with uninteresting, ugly, or offensive subject matter. Consequently, they rejected many of these submissions. The artists were often mocked or misunderstood, but they have come to exemplify the avant-garde and were later recognized as pioneers of significant new modes of expression.

While this chapter emphasizes developments in French painting, it also attends to Realist tendencies in British and American painting, as well as anti-Realist British Aestheticism, and surveys the early history of photography in these countries. Realist painting in Germany and Russia are briefly discussed in Chapters 4 and 6.

Realism in France

Realism emerged following the Revolution of 1848, which was driven by the public's demands for a greater voice in government. It ended the rule of King Louis-Philippe I and established the Second Republic, led by Louis-Napoleon Bonaparte (nephew of the emperor). He staged a coup d'état in December 1851 and a year later became Napoleon III, Emperor of the French. This period of authoritarian rule was known as the Second Empire and lasted until 1870, when France was defeated in the Franco-Prussian War.

One of Napoleon III's priorities was to modernize Paris—a project directed by his Prefect of the Seine, Georges Eugène Haussmann. Haussmann replaced much of the city's medieval fabric—characterized by narrow, winding streets and overcrowded, unsanitary living conditions—with broad avenues lined with apartment blocks of uniform height. The new streets provided light and air, spectacular vistas and opportunities for strolling, discouraged the erection of rebel barricades, and facilitated the movement of troops. The emperor also ordained the creation or repair of numerous parks and gardens and the construction of new buildings, including railway stations and the Paris Opéra (see Figure 5.1). His economic policies created new wealth centered in Paris, where the bourgeois enjoyed its department stores, restaurants, clubs, theaters, parks, and racetracks.

Gustave Courbet (1819–1877)

Realism in French painting is practically synonymous with the name Gustave Courbet. The son of a prosperous farmer in Ornans, Courbet moved to Paris in 1839. Disdainful of the **academic** training offered at the École des Beaux-Arts, he largely learned to paint by copying the works of the **Old Masters**. He was greatly influenced by the 1848 Revolution and his association with radical thinkers, such as the libertarian socialist

Pierre-Joseph Proudhon and the socialist writer and art critic Champfleury, which led him to sympathize politically with the peasant and working classes. During a fall 1849 stay in Ornans, he painted three large canvases that showed these interests. Their exhibition at the 1850–51 Paris **Salon** established his reputation as a radical Realist painter.

The first painting, *The Stonebreakers* (1849), depicts an adolescent boy and aged man in ragged clothes on a roadside near Ornans, breaking stones with hammers to make gravel. Courbet witnessed this scene and hired the workers to pose for him in his studio. To accentuate their labor's brute physicality he emphasized the material reality of the **medium** by rendering the figures, stones, and landscape with thick paint, roughly applied in some areas by a **palette knife**. Rising monumentally in the foreground, the stonebreakers have the presence of heroes in a history painting such as David's *Oath of the Horatii* (see Figure I.9) but appear awkward and degraded rather than noble. Proudhon interpreted the picture as a socialist indictment of the proletariat's exploitation.

More ambitious than *The Stonebreakers* was *A Burial at Ornans* (1849–50, Figure 1.1). Nearly seven meters wide, it depicts over forty figures—and a dog—gathered for an unnamed villager's funeral.[1] In keeping with his commitment to Realism, Courbet filled the painting with identifiable portraits of Ornans residents who posed in his studio. The only exception was his recently deceased grandfather, Jean-Antoine Oudot, portrayed at the extreme left. Oudot was a Republican during the French Revolution, as were presumably the two other men of his generation standing by the graveside and wearing late eighteenth-century clothing; their prominence doubtless communicates Courbet's own Republican sympathies. To the grave's left are the kneeling gravedigger, two red-robed church officials, the priest, assistants, and pallbearers carrying the coffin. The black-clad villagers, including several members of Courbet's family, fill the rest of the **middle ground**.

Like *The Stonebreakers*, *A Burial at Ornans* depicts a common subject on the monumental scale of a history painting but without drama, **idealization**, or any clear moral message. Despite the presence of clergy and a crucifix, no religious meaning is suggested. Courbet focuses on Ornans's living community; he represents its bourgeois citizens in a democratic fashion, packed together in procession and unified visually through the unmodulated black and white of their clothing—and with women given equal prominence to men, despite their inferior legal and social status in France at the time. In its spatial compression, stark color contrasts, tight overlap of figures, and lack of emotion, *Burial* recalls the **style** of popular **woodcuts**, **engravings**, and **lithographs** made by untrained French artists, which Courbet admired. His embrace of popular culture was consistent with the anti-hierarchal attitude his Realist paintings expressed.

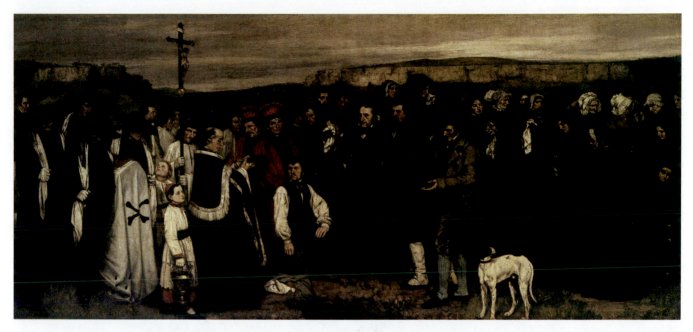

FIGURE 1.1 Gustave Courbet, *A Burial at Ornans*, 1849–50. Oil on canvas, 315 x 668 cm. Musée d'Orsay, Paris.

Conservative critics viciously attacked *Burial*. They faulted Courbet for presenting provincial bourgeois characters on a grand scale. One labeled the figures "vulgar" and another called them "grotesque caricatures."[2] But Champfleury rose to the artist's defense: "He has not exaggerated anything; it is the ugliness of the province as opposed to the ugliness of Paris."[3] For him, Courbet's work was truthful and hence successful according to the terms of Realism.

Because of their large size, coarse style, and focus on provincial and working-class **subject matter**, Courbet's paintings were seen as threatening to the urban bourgeoisie. By 1851, Courbet was openly challenging the conservative trend in France's politics, calling himself "not only a Socialist but a democrat and a Republican: in a word, a supporter of the whole Revolution."[4] He continued to exhibit in the Salon but increasingly positioned himself against the academic establishment and adopted an **avant-garde** position.

Courbet submitted fourteen paintings to the 1855 Paris Universal Exposition, an international fair that showcased innovations in industry and **fine arts** to enhance the empire's prestige. When the exhibition jury rejected three of them, he allowed the remaining eleven to be shown but set up a rival show near the official venue. Identified by a sign that read "Du Réalisme" ("About Realism"), the exhibition was accompanied by a pamphlet in which the artist declared his Realist objective: "To be in a position to translate the mores, ideas, the look of my era, according to my own estimation; not to be a painter only, but a man; in a word, to make a living art, that is my goal."[5] This declaration of artistic independence inspired many

subsequent artists, including Manet and the Impressionists, to mount their own exhibitions.

Jean-François Millet (1814–1875)

Although neither politically outspoken nor an avant-gardist, Jean-François Millet was also identified as a Realist due to his commitment to depicting peasants—a subject familiar to him from his upbringing on a Normandy farm. Academically trained at the École des Beaux-Arts, Millet established his professional reputation around the time of the 1848 Revolution. The following year he left Paris to settle in the village of Barbizon, where he was associated with the landscape painters of the **Barbizon School**, including Théodore Rousseau.

While many of Millet's paintings depict productive farm work, one of his best-known images draws attention to rural poverty. *The Gleaners* (1857, Figure 1.2) centers on three stooped, haggard women gathering the leftovers of the wheat harvest on a hot summer day, a form of charity traditionally granted to landless paupers. The massive grain stacks and overflowing hay wagon in the left background contrast with the women's scant gleanings, representing the unequal distribution of resources.

Exhibited at the 1857 Salon, Millet's painting was deemed provocative by conservative critics, who found its imagery ugly and potentially menacing. Perhaps the women working together evoked frightful memories of the armed peasants who opposed Louis-Napoleon's coup d'état.[6] Yet the picture's elevation of severe poverty into a dignified, almost classical, image can also be seen as conservative. The monumental trio of

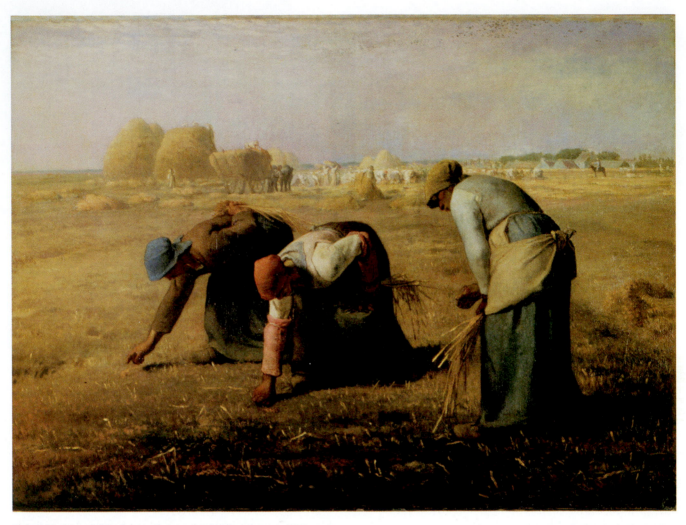

FIGURE 1.2 Jean-François Millet, *The Gleaners*, 1857. Oil on canvas, 83.5 x 110 cm. Musée d'Orsay, Paris.

powerfully modeled figures with their carefully choreographed gestures and poses dominate the landscape while the distant haystacks and hay wagon echo their AAB rhythm, visually integrating foreground and background.[7] The clear but muted colors also harmonize to mitigate the subject's harshness and create a serene mood.[8]

Rosa Bonheur (1822–1899)

A conservative alternative to Courbet's politically provocative Realism is found in the art of Rosa Bonheur, who specialized in detailed, naturalistic depictions of animals. The most famous woman painter of the nineteenth century, Bonheur received initial artistic training from her father, a painter who taught her the values of Saint-Simonism (a utopian-socialist movement that advocated the emancipation of women and the elimination of traditional gender divisions).

Bonheur gained recognition at the 1849 Paris Salon, where she showed *Plowing in the Nivernais* (1849, Figure 1.3). This large painting depicts two teams of oxen and their human drivers tilling a field under a clear, blue sky. It was probably inspired by a scene in *La mare au diable*, a pastoral novel of country life by George Sand (the pseudonym of Amantine-Lucile-Aurore Dudevant); her professional success in the male-dominated literary world would have been heartening to the young Bonheur as she forged an artistic career.

In contrast to Courbet's *Stonebreakers*, *Plowing in the Nivernais* presents a positive, even heroic image of rural labor. Painted in a smooth, **illusionistic** style adhering to academic standards, it was far more acceptable to conservative viewers than was Courbet's radical work. Bonheur's continuing efforts in this vein, exemplified by *The Horse Fair* (1853), earned the approval of the Second Empire government. The regime also awarded Bonheur the *Légion d'honneur* (France's highest-ranking official honor) in 1865, making her the first female recipient.

Bonheur's conservative aesthetic and political leanings were offset by her unconventional lifestyle. From the early 1850s onward Bonheur habitually wore men's clothing

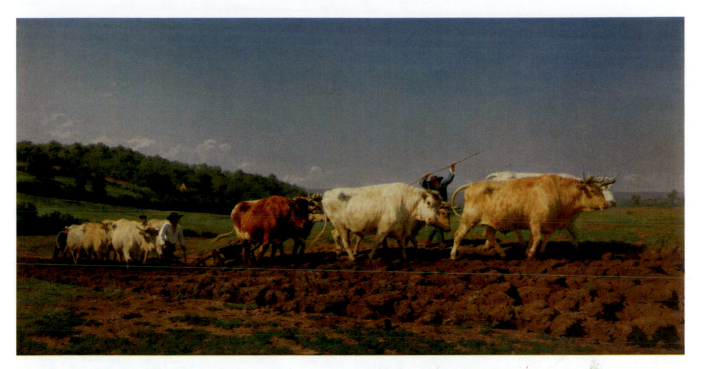

FIGURE 1.3 Rosa Bonheur, *Plowing in the Nivernais*, 1849. Oil on canvas, 133 x 260 cm. Musée d'Orsay, Paris.

(suggesting the influence of Saint-Simonism), which she could don in public only because she had a cross-dressing permit from the police. For forty years she had what today would be defined as a lesbian relationship with her companion, Nathalie Micas. Her other companions were scores of animals—including sheep, goats, horses, oxen, and lions—she kept at her country estate. Bonheur may have been so deeply attached to animals because she saw them as being free from the social restrictions she strained against and sought to subvert.[9]

Realism in Britain: The Pre-Raphaelite Brotherhood

Realism in mid-nineteenth-century British painting featured a meticulously detailed, intensely colored **linear** style based on the close observation of nature. It was practiced most notably by the **Pre-Raphaelite Brotherhood (PRB)**, a secret society formed in London in 1848 by William Holman Hunt, John Everett Millais, and Dante Gabriel Rossetti. Dissatisfied with their lessons at the Royal Academy of Arts (RA), these young men aimed to renew British art by rejecting the academic conventions they traced back to Raphael's late work. They considered its strong **chiaroscuro**, idealized figures, and harmonious **compositions** artificial and decadent.

The PRB took inspiration from the fourteenth- and fifteenth-century Italian and Northern European painters who preceded Raphael, such as Jan van Eyck and Fra Angelico. They did not imitate these artists' styles but sought to observe and render nature as freshly as they believed these artists had done. They also took to heart the words of the influential English critic and PRB champion John Ruskin: "Go to Nature . . . having no other thought but how best to penetrate her meaning, rejecting nothing, selecting nothing, and scorning nothing."[10]

Like Ruskin, the Pre-Raphaelites viewed fidelity to nature as a means of attaining moral and spiritual truth. This inclined them to paint subjects that conveyed strong moral messages drawn from the Bible, Shakespeare, and Arthurian legend more often than from contemporary British life. In its sharp-focus style, sermonizing quality, and depiction of sacred or literary subject matter, the PRB's work differs markedly from that of their French Realist contemporaries.

John Everett Millais (1829–1896)

The most technically accomplished of the Pre-Raphaelites, John Everett Millais was a child prodigy who entered the RA at the unprecedented age of eleven. He exhibited his first major religious painting, *Christ in the House of His Parents (The Carpenter's Shop)* (1849–50, Figure 1.4), there in 1850. The picture is filled with Christian symbolism that invests its secular imagery with mystical significance. The young Christ, at the lower center, has pierced his hand on a nail, foreshadowing his crucifixion. While Joseph reaches down to examine the wound, Mary kneels next to her son with a sorrowful expression, just

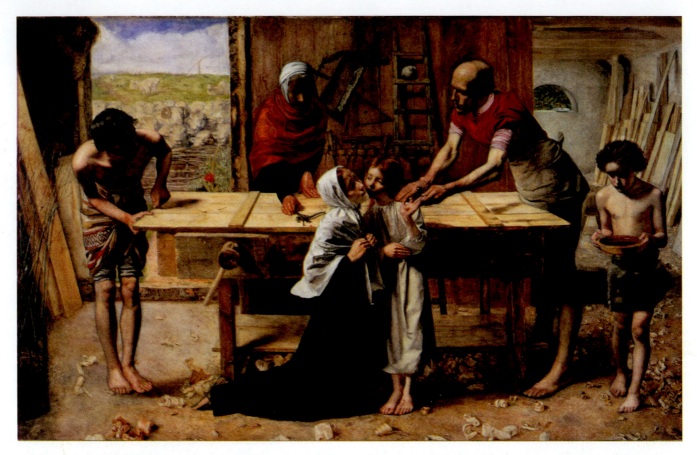

FIGURE 1.4 John Everett Millais, *Christ in the House of His Parents (The Carpenter's Shop)*, 1849–50. Oil on canvas, 86.4 x 139.7 cm. Tate, London.

as she will at the foot of the cross. At the right, the young John the Baptist brings a bowl of water, an allusion to his future role as Christ's baptizer. Other symbols are the carpenter's triangle (the Trinity); the dove perched on the ladder (the Holy Spirit); and the sheep outside the door (Christ's flock).

Millais took great pains to create a realistic painting with a sense of immediacy that feels modern. He set the scene in an Oxford Street carpenter's shop, had family members and acquaintances pose for the figures, and used sheep's heads from a butcher as models for the background flock. While his quest for visual accuracy was true to Pre-Raphaelite principles, the commonplace literalism of his imagery—right down to the wood shavings and Joseph's dirty fingernails—offended contemporary viewers who expected biblical subject matter to be rendered in an idealized style. The painting provoked harsh reviews, including from Charles Dickens, who called Millais's Christ "a hideous, wry-necked, blubbering, red-headed boy, in a bed-gown," and said his Mary would "stand out from the rest of the company as a Monster, in the vilest cabaret in France, or the lowest gin shop in England."[11]

Ford Madox Brown (1821–1893)

Although he was never a member of the PRB, Ford Madox Brown, Rossetti's one-time teacher, embraced its artistic principles and began painting pictures in the Pre-Raphaelite manner in the early 1850s.

Brown's magnum opus, *Work* (1852–65, Figure 1.5), is a tribute to the virtues of labor. The product of twelve years of effort, it was inspired by the writings of Thomas Carlyle, a historian and social philosopher who argued that work is noble, even sacred, but idleness leads to despair.[12] Like Millais's painting, this work is both intensely realistic and richly symbolic. Unlike Millais, however, Brown sought to depict modern life and its various social classes and to comment on the contrasts between industry and idleness.

Brown's crowded picture, set in the London suburb of Hampstead, features excavation workers (known as navvies) as its heroes.[13] In the brightly lit central area, they dig a ditch for a water main that will bring fresh water to the neighborhood, reflecting efforts to improve working-class living conditions. In contrast to productive navvies, the poor, unruly, and neglected children at the lower center represent idleness's harmful effects. Less admirable to Brown than the navvies but still deserving of sympathy is the chickweed seller, the raggedly dressed barefoot man at the left carrying a basket of wild plants he peddles on the street.

Behind the chickweed seller are members of the wealthy class: two well-dressed ladies strolling on the sidewalk and, in the shaded distance, a top-hatted rich man and his daughter,

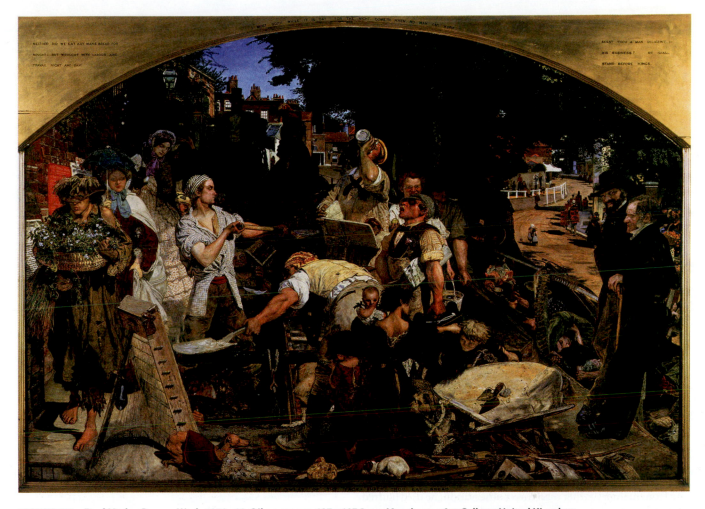

FIGURE 1.5 Ford Madox Brown, *Work*, 1852–65. Oil on canvas, 137 x 197.3 cm. Manchester Art Gallery, United Kingdom.

both on horseback. The older lady distributes leaflets advocating temperance (abstinence from alcohol)—a message clearly lost on the central beer-drinking navvy. The younger lady looks down toward her scarlet-clad whippet hound, which locks eyes with the ragged children's mongrel while the navvies' small bull terrier looks on. Even the painting's dogs are distinguished by class and regard each other warily.

At the right side of *Work*, Brown portrayed two "brainworkers." The taller gentleman is Thomas Carlyle; the other figure is Rev. Frederick Denison Maurice, the leader of the Christian Socialist party who helped found the Working Men's College, where Brown taught drawing for two years. Not simply types but recognizable individuals, Carlyle and Maurice are held up as admirable reformers aiming to improve modern life through writing, education, politics, and religion. Emphasizing this last element are the four biblical quotations inscribed on the painting's frame, which identify labor as both a necessity and a virtue; these include "Seest thou a man diligent in his business? He shall stand before Kings" (Proverbs 22:29).

The Later Pre-Raphaelite Movement

The original PRB dissolved in 1853. By 1860, the movement had entered a second phase led by Dante Gabriel Rossetti (1828–82) and his younger follower Edward Burne-Jones (1833–98). Both turned away from the depiction of contemporary reality exemplified by Brown's *Work* to create romantic images of ideal beauty set in the historical or imagined past.

During the next two decades, Rossetti worked in a sensuous, dreamy style very different from the highly detailed manner of early Pre-Raphaelite painting. He obsessively painted women wearing medieval or Renaissance clothes and playing the roles of literary or mythical characters, set in dark and claustrophobic settings (e.g., *Proserpine*, 1874). An accomplished poet, Rossetti was drawn to literary themes. Burne-Jones, a more naturally gifted painter, painted similar subjects in more elegant compositions featuring gracefully languorous figures reminiscent of those of Sandro Botticelli (e.g., *King Cophetua and the Beggar Maid*, 1884).

The Aesthetic Movement: James Abbott McNeill Whistler (1834–1903)

The later Pre-Raphaelites' cultivation of refined beauty detached from everyday reality helped to inspire the **Aesthetic Movement**, prominent in Britain from 1870 to 1900. Its principal goal was to create pure beauty, or "*l'art pour l'art*" ("art for art's sake")—a phrase popularized earlier in the century by the poet Théophile Gautier.

Along with the critic Walter Pater, the poet Algernon Swinburne, and the playwright Oscar Wilde, the expatriate American artist James Abbott McNeill Whistler was a leading exponent of aestheticism in England. After failing to graduate from the United States Military Academy, Whistler sailed to Paris in 1855 to pursue an artistic career. He established himself as a Realist under Courbet's influence before moving to London in 1859, where he took the modern city as his subject and made detailed **etchings** and paintings of life along the Thames.

Whistler's turn to aestheticism in the 1860s was sparked by his enthusiasm for classical Greek and Asian art. Assimilating the Japanese aesthetic principles of simple design and economical expression, Whistler achieved a highly personal style of distilled, tranquil beauty. This style is exemplified in his nocturnes (night scenes) of the Thames waterside, such as *Nocturne in Blue and Gold—Old Battersea Bridge* (c. 1872–75, Figure 1.6). Painting from memory rather than direct observation, he used blurred shapes and a reduced palette—subtle blues and grays, accented by touches of gold representing lights in the distance and cascading fireworks at the upper right—to transform the Thames's industrialized reality into a mysterious and poetic vision.

Through the title, Whistler associated the painting with music—a nocturne is also a musical composition meant to evoke nighttime. He also included musical terms in other paintings' titles, designating them "symphonies," "harmonies," and "arrangements." In this way, he compared his visual creations with the most immaterial and **abstract** of art forms, which does not describe nature or tell stories. Whistler said he used the term "nocturne" to "indicate an artistic interest alone, divesting the picture of any outside anecdotal interest. . . . A nocturne is an arrangement of line, form, and color first."[14]

In composing *Nocturne in Blue and Gold*, Whistler willfully departed from visual reality. He exaggerated the height and curve of the Old Battersea Bridge—in reality, squat and narrow—and greatly increased the spacing between its pilings. In doing so, he made the structure resemble the Kyobashi Bridge as depicted in a **woodblock print** by Utagawa Hiroshige (see "Japonisme" box). Whistler probably included fireworks in the painting in response to another Japanese print, Shuntosai's *Fireworks Over Bridge* (1857).

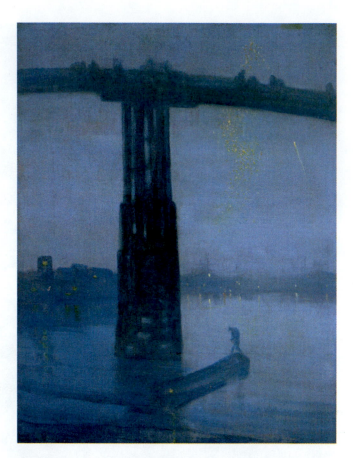

FIGURE 1.6 James Abbott McNeill Whistler, *Nocturne in Blue and Gold – Old Battersea Bridge*, c. 1872–75. Oil on canvas, 68.3 x 51.2 cm. Tate, London

In *Nocturne in Black and Gold (The Falling Rocket)* (1875), Whistler's aestheticism borders on complete **abstraction**. The picture shows fireworks exploding over London's Cremorne Gardens, depicted as scattered flecks of gold against indistinct washes of black and gray. It infuriated Ruskin, who accused the artist of impudently asking "two hundred guineas for flinging a pot of paint in the public's face."[15] Whistler sued the critic for libel and used his courtroom testimony to defend his art-for-art's sake credo. He won the case but was awarded less than a penny in damages, forcing him to declare bankruptcy. Nevertheless, he had successfully argued for the modernist focus on the independent value of art's formal qualities, anticipating twentieth-century abstractionists' complete elimination of recognizable subject matter.

Early Photography

In their abstraction, Whistler's nocturnes rejected the detailed description of nature attained through photography, the most consequential nineteenth-century scientific advance for the development of modern art. Two different means of

Japonisme

Whistler was one of many modern Western European and American artists enthralled by Japanese art. This fascination, named **Japonisme** by the French critic Philippe Burty in 1872, was stimulated by the art's wide availability in the West after the US navy forcibly opened Japan to foreign trade in 1853. Known as *ukiyo-e* ("pictures of the floating world," the world of passing entertainments and physical pleasures), Japanese woodblock prints such as Hiroshige's *Bamboo Yards, Kyobashi Bridge, No. 76 from One Hundred Famous Views of Edo* (1857, Figure 1.7) were a popular art form of the Edo Period (1615–1868). Mass printed and inexpensive, they depicted famous beauties, actors, landscapes, and other subjects from modern Japanese life. They had a strong impact not only on Whistler but also on Manet, Edgar Degas, Mary Cassatt, Henri de Toulouse-Lautrec, Paul Gauguin, Vincent van Gogh, and many other Western artists.

In such prints, these artists discovered formal devices that differed greatly from European academic conventions: elevated and slanted **perspectives**, asymmetrical compositions, flat shapes, and abruptly cropped forms. This Japanese way of representing the world helped Western artists break from Renaissance-based illusionism and develop the new forms of modernist visual expression.

FIGURE 1.7 Utagawa Hiroshige, *Bamboo Yards, Kyobashi Bridge, No. 76 from One Hundred Famous Views of Edo*, 1857. Woodblock print, 36 x 24 cm. Brooklyn Museum, New York.

creating a photograph, the **daguerreotype** and the **calotype**, were publicly announced in 1839. The former, invented by Louis-Jacques-Mandé Daguerre (1787–1851) in France, produced unique, finely detailed images recorded on mirror-like surfaces. The latter, invented by William Henry Fox Talbot (1800–77) in England, yielded less refined images than Daguerre's but introduced a printing system fundamental to later photography.

Both methods were understood as "natural" means of creating an image through light rays striking and altering the structure of light-sensitive chemicals. Talbot described photography as "the pencil of nature."[16] It offered a new way of producing images that required mastering only the use of a camera rather than drawing or painting skills. Furthermore, photographs were understood and valued in positivist terms as faithful records of the visual world, despite being almost exclusively black and white until the early twentieth century. Of course, no photograph is completely objective—making one always involves subjective decisions regarding composition, lighting, focus, and other factors.

No artist could ignore this new standard of visual realism. Some painters found it threatening; upon first seeing a daguerreotype, the French academic history painter Paul Delaroche supposedly declared, "From today, painting is dead!"[17] Certainly the profession of portrait painting declined with the rise of photography. That said, the highly detailed, full-colored paintings of some academic and Realist painters—especially Millais and Holman Hunt—might be understood as efforts to outdo photography. Many painters took advantage of photography as a useful tool. Courbet, Edgar Degas, Thomas Eakins, Henry Ossawa Tanner, and many others sometimes referred to photographs of models rather than life drawings when painting. Degas and Eakins were prolific photographers.

Whether photographs could be considered not just mechanically produced records of visual appearances but also significant works of creative expression was a contested question

in the mid-nineteenth century. Initially exhibited with lithographs, photographs were excluded from the Salon after 1850. In the 1855 Paris Universal Exposition they were shown in the industrial hall, highlighting their technical nature rather than their aesthetic interest. Four years later, Baudelaire called photography one of the "purely material developments of progress" and insisted that it should be "the servant of the sciences and arts" but never be "allowed to encroach upon the domain of the impalpable and the imaginary."[18] Yet an 1862 French Supreme Court decision determined that certain photographs could be considered works of art entitled to copyright protection.

The Early Technical Development of Photography

The principle of photography descends from the **camera obscura**, a device used by artists from the Renaissance onward. It consists of a room or box with a small aperture in one wall, sometimes fitted with a lens. Light entering this aperture forms an inverted image of the objects outside the camera on the opposite wall, which the artist can copy.

Joseph-Nicéphore Niépce (1765–1833) made the first known photograph around 1827. He used a camera obscura and a plate coated with light-sensitive bitumen that permanently fixed the indistinct image of the view outside his window over the course of an exposure perhaps lasting several days. He subsequently formed a partnership with Daguerre, who used a camera to record a latent (hidden) image on a mirror-smooth, silver-plated copper sheet coated with light-sensitive silver iodide. It was then developed through exposure to mercury vapors and fixed by a salt solution.

Daguerreotypes required a much shorter exposure time than Niépce's initial method and registered remarkably crisp and detailed images. However, they were fragile, unique objects, not easily replicated. Talbot's calotype, which fixed a negative image on paper coated with light-sensitive chemicals, solved the problem. By putting sensitized paper in contact with the negative and exposing it again to light, a positive print could be created. This **negative-positive printing method**, fundamental to later film photography, could produce an unlimited number of prints.

Because daguerreotypes offered a clearer image than calotypes (and because Daguerre, unlike Talbot, did not patent his process, except in England), they were soon being made all over the world. By 1841, technical improvements had reduced exposure times to less than a minute, spurring the daguerreotype's adoption as the dominant medium for portraiture. Commissioned portraits, previously made by painters for well-to-do clients, could now be afforded by members of the middle class, who flocked to the studios of daguerreotypists—as did the rich and famous. The daguerreotype was especially popular in the United States, with every sizable American city boasting at least one studio by the late 1840s.

Both the daguerreotype and calotype were displaced in the early 1850s by the **wet collodion process**, invented by the Englishman Frederick Scott Archer. This type of photography used a glass plate coated with a collodion and silver nitrate solution. Negatives could require only a few seconds of exposure time, yielded precisely detailed images, and could be used to make an unlimited number of prints. However, the process was cumbersome. The coated plate had to be kept wet and developed immediately after exposure; thus, working outdoors required a portable darkroom. Wet collodion negatives would be replaced in the late 1870s by dry plates coated with a gelatin emulsion containing silver salts.

Complementing the wet collodion process was the **albumen print**, perfected in 1850 by French inventor Louis Désiré Blanquart-Evrard. This type of print was made on a sheet of paper given a smooth glossy surface through a coating of albumen (egg white). A silver nitrate solution added to the albumen formed light-sensitive silver salts that yielded an image when a glass negative was placed on the paper and exposed to light. Because the image was borne in the paper's surface layer rather than its deeper fibers, albumen prints featured unprecedented richness of detail and tonal contrast. Albumen paper remained the standard until the 1890s, when it was supplanted by papers coated with gelatin or collodion emulsions.

Photography as Art

Photography's inventors did not think of it as a new medium with its own pictorial conventions but emulated the conventions of drawing and painting, suggesting that their images could be appreciated as art. One of Daguerre's first photos was a **still life** including plaster casts from antique sculptures, a common painting subject. Most of Talbot's photographs in *The Pencil of Nature* (1844–46) depicted artfully arranged still lifes and idyllic views of rural scenery.

Oscar Rejlander (1813–1875)

Many photographers who came of age in the mid-nineteenth century intentionally sought to create pictures that could be considered works of art. Some did so through **combination printing**, whereby multiple negatives were used to produce a single print. The finished composition was assembled in the darkroom much in the way a painter organizes motifs on a canvas. A well-known example is *The Two Ways of Life* (1857, Figure 1.8) by the Swedish-born English photographer Oscar Rejlander. Painstakingly put together from thirty separate negatives, this composition centers on two young men standing on either side of their bearded father in a stage-like space. One youth leans toward a group of **allegorical** figures representing vice, while the other contemplates figures representing virtue. Each faces the moral decision of which path to follow. Inspired by Raphael's *School of Athens* (1509–11),

FIGURE 1.8 Oscar Rejlander, *The Two Ways of Life*, 1857. Victoria and Albert Museum, London.

Rejlander's photograph emulated mid-nineteenth-century academic painting in its staginess, use of allegorical figures, and moralizing theme.

Gustave Le Gray (1820–1884)

Like Rejlander, the Frenchman Gustave Le Gray believed photography was a form of art. He declared: "It is my deepest wish that photography, instead of falling within the domain of industry, of commerce, will be included among the arts. That is its sole, true place."[19] Trained as a painter, he achieved exquisite **painterly** effects in his landscape photographs of the Forest of Fontainebleau—the Barbizon School's favorite painting locale—and his seascapes of the French coast. Most of the latter were combination prints made from separate negatives for the sky and the water, which typically required different exposure times to be properly rendered. But in his most famous work, *Brig upon the Water* (1856, Figure 1.9), the equal luminosity of the cloud-filled sky and water below allowed him to print the image from a single glass negative.

Although Le Gray photographed in daylight, the monochrome palette and darkness surrounding the compositions' borders led early viewers to mistake the reflected gleam on the water for moonlight. The interpretation of these seascapes as nocturnes heightened their romantic appeal.

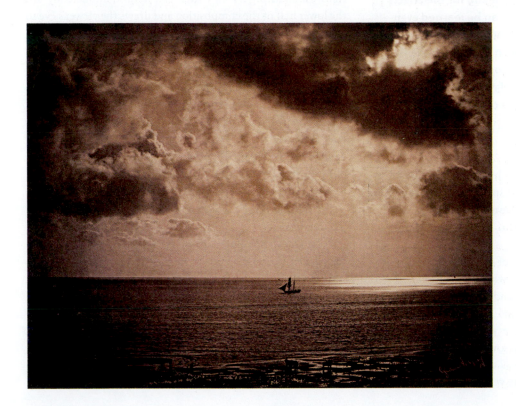

FIGURE 1.9 Gustave Le Gray, *Brig upon the Water*, 1856. Albumen print, 32.07 x 40.64 cm. Nelson-Atkins Museum of Art, Kansas City, Missouri.

Masters of Mid-Nineteenth-Century Portrait Photography: Nadar and Julia Margaret Cameron

Portraiture, the dominant photographic genre of the nineteenth century, rose to the level of art in the work of its greatest practitioners, Nadar and Julia Margaret Cameron. Both produced indelible images of their celebrated contemporaries in France and Britain, respectively.

Nadar (1820–1910)

Nadar (the pseudonym of Gaspard-Félix Tournachon) ran a successful Paris portrait studio from 1855 to 1873. He came to photography through his work as a caricaturist, having recognized its value in helping him to realize his ambitious *Panthéon-Nadar*. Intended as four enormous hand-drawn lithographs, each sheet was to feature 250 caricatured portraits of contemporary celebrities in the theater, visual arts, music, and literature. Nadar completed only the *Panthéon* of literary greats (1854) before abandoning the project and concentrating on photography.

In 1856, Nadar stated:

> **The theory of photography can be learned in an hour and the elements of practicing it in a day. . . . What cannot be learned is . . . an artistic feeling for the effects of varying luminosity. . . . What can be learned even less is the moral grasp of the subject—that instant understanding which puts you in touch with the model . . . and enables you to produce, not an indifferent reproduction, a matter of routine or accident such as any laboratory assistant could achieve, but a really convincing and sympathetic likeness, an intimate portrait.[20]**

To achieve this intimacy, he engaged his sitters in lively conversation to put them at ease. He also dispensed with studio props such as drapery and classical columns and shot his subjects against a plain background in clear, even light, focusing on their features and clothing.

Nadar's sitters included many of the period's most illustrious artists and writers, some of whom he had caricatured in *Panthéon*. One was George Sand, whom Nadar photographed several times around 1864 (Figure 1.10). France's most famous woman of letters, she was notorious for wearing men's clothing, smoking cigars, and having numerous love affairs. The portrait shown here was taken when the novelist was around sixty. She looks demure yet imposing, as befits her

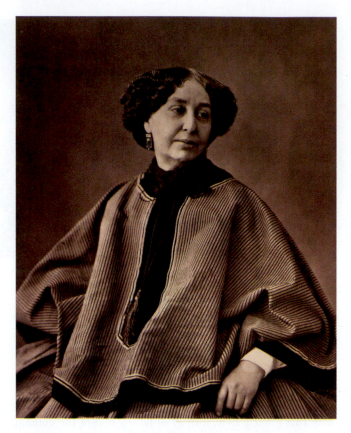

FIGURE 1.10 Nadar (Gaspard-Félix Tournachon), *George Sand*, c. 1864. Woodburytype, 24.1 x 19.0 cm. The Museum of Modern Art, New York.

stature as a distinguished writer. Her mountain-like body fills the lower half of the composition and draws the viewer's eye to her handsome face and pensive expression.

Julia Margaret Cameron (1815–1879)

Julia Margaret Cameron produced the most enduring photographs made in Victorian Britain. She took up photography at forty-eight, after receiving a camera as a gift from her daughter and son-in-law. Although her upper-class status meant that she was not expected to work for money, she zealously pursued photography professionally. She copyrighted her images, participated in photographic society exhibitions in Britain and on the Continent, and sold her prints through a London dealer.

Cameron shot portraits of family and friends, but she also made imaginative compositions in which she posed her sitters in roles from the Bible, classical myth, and literature. She drew inspiration for these latter images from fifteenth-century Italian paintings and those of her Pre-Raphaelite contemporary Rossetti. She saw the camera not just as a useful tool for recording the appearance of the world but also as an instrument for creatively interpreting it. Her aim was to "ennoble photography and to secure for it the character and

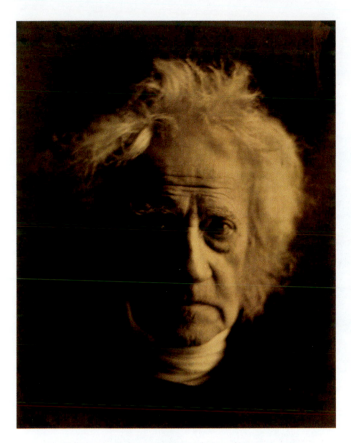

FIGURE 1.11 Julia Margaret Cameron, *Sir John Herschel*, 1867. Albumen silver print from glass negative, 35.9 x 27.9 cm. The Metropolitan Museum of Art, New York.

uses of High Art by combining the real and ideal and sacrificing nothing of Truth by all possible devotion to Poetry and beauty."[21]

Cameron's portrait of her friend Sir John Herschel (1867, Figure 1.11), the great English scientist and astronomer, shows her distinctive aesthetic. As she did with all her subjects, Cameron deliberately photographed him with a slightly blurred focus to give his image a poetic quality. She had him wash his hair and leave it tousled to suggest his intellectual energy. Draped in black, with strong light striking his fiery locks and gleaming eyes, he emerges from the darkness with the mystical intensity of an Old Testament prophet.

Documentary Photography

In contrast to the self-consciously artistic efforts of photographers like Rejlander, Le Gray, Nadar, and Cameron, many nineteenth-century photographers saw their work as essentially documentary. While they made the same subjective choices that all photographers do in choosing viewpoints, controlling lighting, and adjusting focus, their photographs were generally accepted as

useful and largely factual records of people, places, and things. These photographs served various purposes: to advance science; to survey territories, including colonial possessions (see "Colonialism and Postcolonialism" box, Chapter 18) for prospective development; and to record momentous events such as wars.

While thousands of photographs documented the American Civil War, the best known came from the studio of Mathew Brady (c. 1823–96), a daguerreotype portraitist who sent twenty hired camera operators to the Union front. Due to the cumbersome process of wet-plate photography, they could not take action photographs of battles. Instead, they photographed in the military camps and on the battlegrounds in the aftermath of fighting.

The most famous such photograph is *A Harvest of Death, Gettysburg, July 1863* (Figure 1.12) shot by Timothy O'Sullivan (c. 1840-82) and published in *Gardner's Photographic Sketch Book of the War* (1866) by Alexander Gardner (1821-82), Brady's former employee. Some Civil War photographers occasionally repositioned dead bodies and added weapons and other items to create a better composition or convey a more effective narrative. However, nothing in O'Sullivan's image suggests any manipulation: his camera confronts the grim reality of death. Unlike traditional history paintings of war subjects showing combatants as heroic, these soldiers are pathetic corpses, their shoes removed and pockets turned out by survivors who appropriated their possessions out of need. "Such a picture conveys a useful moral," wrote Gardner. "It shows the blank horror and reality of war, in opposition to its pageantry. Here are the dreadful details! Let them aid in preventing such another calamity falling upon the nation."[22]

The Painting of Modern Life: Édouard Manet (1832–1883)

The most innovative French painter to emerge in the 1860s, Édouard Manet was a committed Realist who depicted subjects from modern life in and around Paris, his native city, and painted figures from both the lower and bourgeois classes. Born wealthy, Manet twice failed to gain entrance to the French naval college before undertaking study with the progressive painter Thomas Couture in 1850. Couture encouraged him to make copies of the Old Masters in the Louvre, including Giorgione, Titian, and Diego Velázquez. Velázquez's dark palette and loose, liquid brushwork informed Manet's style of the late 1850s and early 1860s. His modern life paintings of those years referenced figures and compositions by the Old Masters he admired.

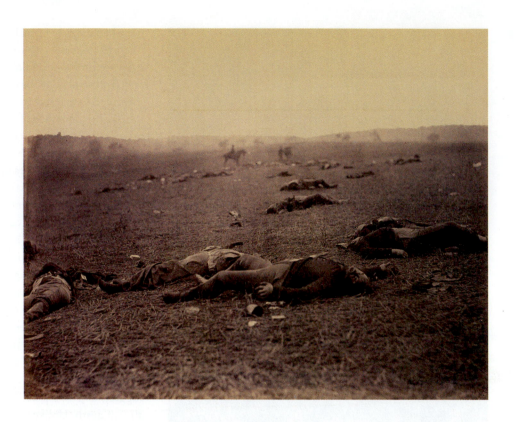

FIGURE 1.12 Timothy O'Sullivan, *A Harvest of Death, Gettysburg, July 1863*, published by Alexander Gardner in *Photographic Sketch Book of the War* (1866). Albumen silver print, 45.2 x 57.2 cm.

In the late 1850s, Manet befriended the poet and critic Charles Baudelaire and likely influenced his "The Painter of Modern Life" (1859).[23] In this essay, Baudelaire described modernity as "the ephemeral, the fugitive, the contingent, the half of art whose other half is the eternal and the immutable." As such, a painter of modern life must "distil the eternal from the transitory."[24] Baudelaire considered Paris modernity's epicenter and identified its ideal observer as the *flâneur* ("stroller")—an urbane, fashionably dressed gentleman who acutely observes the city's social life while remaining detached from it. The artist-*flâneur* should use these observations to gather qualities that will withstand the test of time, exactly what the Old Masters had achieved.

Significantly, the position of the *flâneur* was not available to French bourgeois women, who according to nineteenth-century societal norms could only venture out in public accompanied by a husband, family member, or female friend without compromising their virtue. The ideology of the time held that the bourgeois woman's proper place was in the home, where she fulfilled her "natural" roles as wife, mother, and manager of the household. Working-class women did go out in public but always risked being taken for prostitutes, who were ubiquitous in nineteenth-century Paris—prostitution being a legal but highly regulated profession in France from the time of Napoleon I onward.

The quintessential artist-*flâneur* of the 1860s, Manet focused on prostitution in two large paintings: *Le Déjeuner sur l'herbe* (*Luncheon on the Grass*) and *Olympia*. Long recognized as landmarks in the history of modern art, these pictures

arguably succeeded in meeting Baudelaire's call for painting that would "distil the eternal from the transitory." Both also aroused great controversy when first exhibited, not only because they provocatively drew attention to the morally dubious sex trade but also due to Manet's formal innovations that subverted academic norms of illusionism and emphasized the medium's material and aesthetic qualities.

Le Déjeuner sur l'herbe (1863)

Le Déjeuner sur l'herbe (Figure 1.13) was among three Manet pictures refused by the 1863 Salon jury. However, it became the chief attraction of the Salon des Refusés ("Salon of the Refused"), a government-created exhibition that displayed many of the year's excluded works. The painting was mocked and jeered by the public and critics alike.

Originally entitled *Le Bain (The Bath)*, Manet's composition is set in the countryside on the outskirts of Paris. It depicts a woman in a chemise wading in the middle ground; in the foreground, a naked woman sits next to two men wearing the fashionable garb of university students. She stares boldly at the viewer, her nakedness accentuated by her discarded clothing beside the picnic basket. (Victorine Meurent, Manet's favorite model, posed for the seated woman; his future brother-in-law Ferdinand Leenhoff was the model for the gentleman next to her, while both of Manet's brothers, Eugène and Gustave, are said to have modeled for the man at the right.) The representation of these woman in the company of two

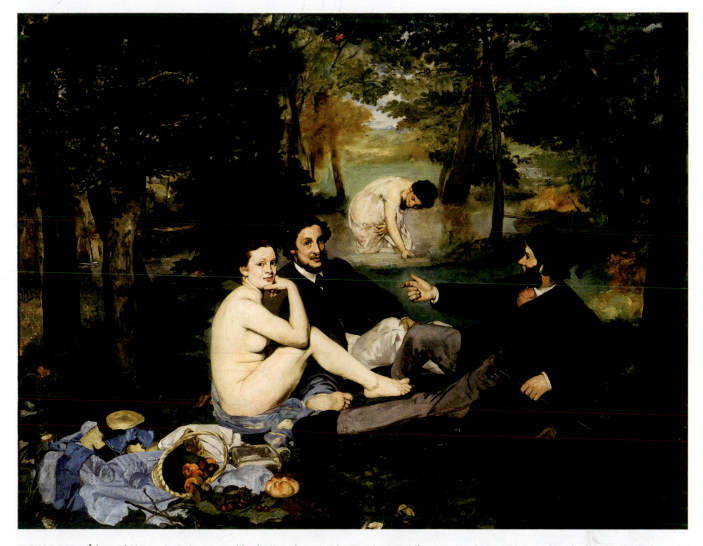

FIGURE 1.13 Édouard Manet, *Le Dejeuner sur l'herbe* (*Luncheon on the Grass*), 1863. Oil on canvas, 208 x 264.5 cm. Musée d'Orsay, Paris.

young dandies scandalized contemporary viewers, who interpreted the former as lower-class prostitutes and the latter as their clients. While it was an open secret that prostitutes plied their trade in the parks of Paris and its suburbs, Manet's exposure of this fact in a large-scale Salon painting was unacceptable to many. Emperor Napoleon III declared the painting "an offense against decency."[25]

Manet could have defended his composition as an updated version of Titian's revered *Pastoral Concert* (1509), which depicts two nude female nymphs or muses accompanying two fully clad young men seated in an idyllic landscape. Furthermore, he copied the poses of the *Déjeuner*'s three foreground figures from those of a water nymph and pair of river gods in an early sixteenth-century engraving by Marcantonio Raimondi, after Raphael's *Judgment of Paris*. These self-conscious references to Italian Renaissance models might be understood as Manet's bid to situate his work within the great tradition of Western art. They are probably better interpreted, however,

as a parody of academic tradition—a move comparable to Jacques Offenbach's satire of the Olympian gods in his comic opera, *Orphée aux Enfers* (Orpheus in Hades, 1858).[26]

Through parody, Manet revealed the unbridgeable gap between the conventions of museum art and the realities of modern Parisian life. He also exposed the hypocrisy of contemporary academic paintings that presented eroticized images of the female nude in the guise of classical goddesses to make them socially acceptable. A prime example was Alexandre Cabanel's *The Birth of Venus* (1863), a smoothly painted, highly idealized image of the love goddess borne on a wave and attended by a quintet of cupids. This painting was shown in the official Salon and purchased by Napoleon III for his personal collection.

Déjeuner also features several unconventional formal qualities. Rather than modeling his figures fully through subtly modulated lights and darks, Manet largely eliminated the middle tones, making the brightly lit bodies appear like

flat silhouettes. He disrupted the expected illusion of consistent spatial recession by picturing the wading woman larger than dictated by the rules of **perspective**, so that she appears to occupy the same plane as the foreground figures. Manet's loose, sketch-like paint handling, especially in the background landscape, also violated academic norms by asserting his medium's materiality rather than disguising it to create a detailed illusion.

Overall, the painting fails to cohere visually into a seamless composition and instead declares its status as a flat surface covered with paint—an artificial construct rather than a mirror of nature. Manet thus complicated the Realist goal of painting a truthful image of modern reality by also acknowledging material reality, following in Courbet's path. Manet's work heightens this self-consciousness through its possibly ironic references to the art of the Old Masters and the bemused expression of the seated woman, who seems to say, "I know I am posing for a painting, and you know you are looking at one." This type of awareness would increasingly characterize modernism in the late nineteenth and early twentieth centuries as art became less concerned with the outside world and more with the nature of art itself.

Olympia (1863)

Manet's follow-up to *Le Déjeuner sur l'herbe* created such a scandal at the 1865 Salon that guards had to protect it from angry viewers. The audience was incensed by *Olympia*'s (Figure 1.14) frank portrayal of a courtesan, a prostitute with wealthy and upper-middle-class clients. The subject may be named after a socially ambitious courtesan in *La Dame aux Camélias*, a well-known novel and play by Alexandre Dumas *fils*. Again using Meurent as his model, Manet presents Olympia reclining horizontally on a white-sheeted couch and staring directly at the viewer. She is naked save for a bracelet, choker, silk slipper, and the pink camellia in her hair. Olympia is accompanied by a hissing black cat at the foot of the bed, and a Black maid presenting her with a colorful bouquet. Nothing is known about the model for the maid other than her name, Laure, recorded by Manet in a notebook.[27] His depiction of Laure frankly acknowledges women workers of African origin in mid-nineteenth-century Paris. He does not render her as exotic or sexualized—both common ways of representing Black women during this period. He does, however, place her in a subordinate position to the white courtesan she serves,

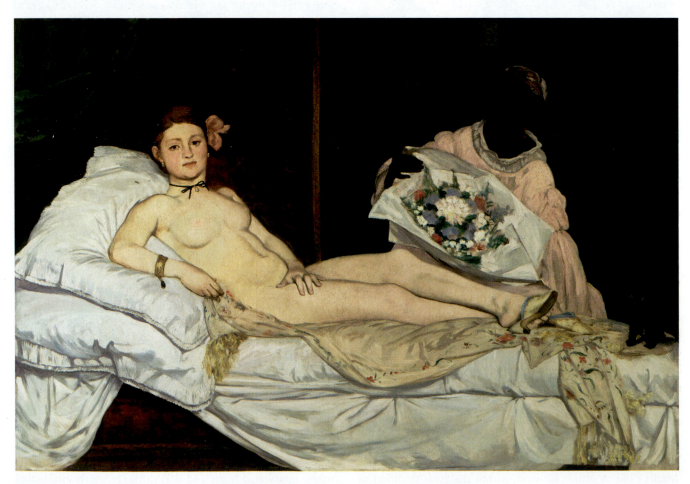

FIGURE 1.14 Edouard Manet, *Olympia*, 1863. Oil on canvas, 130.5 x 190 cm. Musée d'Orsay, Paris.

reinforcing the class and racial hierarchies that governed French society.

As with *Déjeuner*, *Olympia* is based on an Italian Renaissance composition, Titian's *Venus of Urbino* (1538), believed in Manet's day to represent a Venetian courtesan as the goddess of love. But Manet's *Olympia* is in many ways the antithesis of Titian's *Venus*: angular, tense, and confrontational rather than voluptuous, relaxed, and inviting. Not a mythical goddess but a flesh-and-blood sex worker, she acknowledges the spectator, who occupies the position of the client who has brought the flowers that the maid presents to her. One can imagine the embarrassment felt in front of this painting by bourgeois men who did business with courtesans and by their wives, who were supposed to be ignorant of such arrangements.

Many in Manet's audience also objected to the painting's formal qualities, especially its strong contrasts of light and dark and the lack of modeling in Olympia's body. Courbet described the figure as a flat, playing-card image: "the Queen of Spades stepping out of her bath."[28] However, the realist novelist (and Manet's friend) Émile Zola praised the painting in **formalist** terms: "The painter has proceeded in exactly the same way as nature herself, by means of connected surface shapes and large zones of light, and his work has something of the roughness and severity of nature."[29] Zola's opinion appeared in a pamphlet that accompanied Manet's personal exhibition, which the artist set up after not being invited to participate in the 1867 Paris Universal Exposition.

Manet's Last Major Painting: *A Bar at the Folies-Bergère* (1882)

In the 1870s and until his death, Manet continued to paint subjects from modern Parisian life, but used a brighter palette and sketchier brushwork under the influence of his younger colleagues, the Impressionists. His richly colorful *A Bar at the Folies-Bergère* (1882, Figure 1.15), his last major painting, is set in a popular Parisian nightclub with bars surrounding a theater that produced musical, vaudeville, and circus acts. A female trapeze artist's legs dangle from the upper left corner of the composition, reflected in the mirror behind the striking central figure, an attractive, young white barmaid. She stands behind a marble counter across which Manet has spread a luscious still life of liquor bottles, cut flowers, and a stemmed bowl of tangerines. These commodities signify the sensual pleasures offered by the Folies-Bergère and are associated with the barmaid, whose wide hips, firm neck, and golden hair are echoed in the champagne bottles' shapes and colors.

Manet's barmaid, modeled by a Folies-Bergère employee named Suzon, stares out at the viewer with a remote and slightly sad expression. Her joyless countenance contradicts the nightclub's glittering atmosphere. It also creates a sense of ambiguity regarding her relationship to her customer, whose position is occupied imaginatively by the viewer. Manet creates further uncertainty by shifting the reflection of both the barmaid and her patron—a top-hatted gentleman—to the right, as though the mirror were set on an angle. This modernist disruption of the rules of perspective creates an interpretive puzzle. Perhaps Manet aimed to suggest the ambiguity that characterized the interactions between the Folies-Bergère barmaids and male patrons possibly interested in purchasing not only drinks but also sex. (The barmaids were assumed by many male patrons to be sexually available as prostitutes.)

Impressionism

The term "**Impressionism**" describes an artistic movement established in the 1870s by a group of French painters who exclusively depicted subjects from modern life, disregarded academic conventions, and attempted to convey a sense of freshly observed truth. In these aims they followed the example of Manet, who was friendly with many of the Impressionists but declined to exhibit with them. The major Impressionists included Gustave Caillebotte, Mary Cassatt, Edgar Degas, Claude Monet, Berthe Morisot, Camille Pissarro, Pierre-Auguste Renoir, and Alfred Sisley.

With the exception of Caillebotte and Cassatt, these artists joined many others to form the Société Anonyme des Artistes Peintres, Sculpteurs, Graveurs, etc. (Corporation of Artist-Painters, Sculptors, Engravers, etc.), which launched the movement in an April 1874 exhibition in Paris. Every participant pledged to boycott that year's Salon, which had often rejected their submissions. Their goal was to present their work without the jury's intervention and to attract press attention that might stimulate sales. Seven more group exhibitions followed between 1876 and 1886, each with a different roster; only Pissarro showed in all eight. These events marked the group's independence from the Salon and hastened its decline as a significant venue for showing new art.

The Impressionists gained their name from the critic Louis Leroy's hostile review of the 1874 exhibition. Taking his cue from Monet's *Impression, Sunrise* (1872)—a depiction of the port of Le Havre loosely rendered through broken brushstrokes—Leroy dubbed the entire show "impressionist." He meant to indict Monet and his colleagues for merely recording their impressions and producing sketches, not finished works. He failed: Monet's chief innovation was to establish what might be called the sketch aesthetic as a valid and compelling artistic expression of modernity.

During its peak (1870s–1880s), Impressionist art had two principal tendencies. One was the quest to translate faithfully the artist's direct visual experience of nature

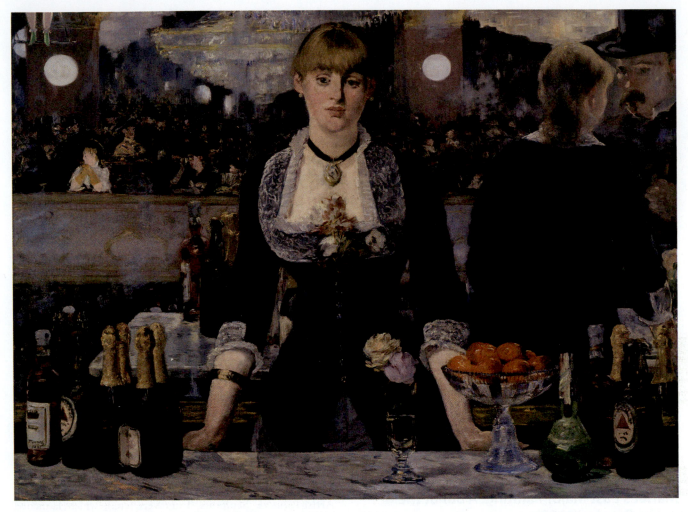

FIGURE 1.15 Edouard Manet, *A Bar at the Folies-Bergère*, 1882. Oil on canvas, 96 x 130 cm. The Courtauld Gallery, London.

through rapidly applied strokes and touches of pure color (as in the landscape paintings of Monet, Pissarro, and Sisley). The second was the careful selection and arrangement of motifs to render a seemingly spontaneously observed slice of life that is actually the product of considerable calculation (as in the figure and **genre paintings** of Degas, Cassatt, and Caillebotte). Many Impressionist paintings combine elements of both tendencies.

Impressionist art's central, though not exclusive, theme is the experience of modern leisure in Paris and the French countryside. While the wealthy had long enjoyed lives of leisure, it was a new phenomenon for the period's less-privileged classes. Industrial capitalism had created a new middle class whose members did not need to work every day and could enjoy time off; even the working classes had Sunday afternoons free.[30] New train lines facilitated weekend escapes to the countryside by the urban bourgeoisie, evoked by Monet's paintings of the Gare Saint-Lazare (see Figure I.2). Napoleon III's renovation

projects transformed Paris into a city that invited strolls along its tree-lined boulevards and enjoyment of concerts, picnics, boating, and other activities in its new parks. The city's nightclubs, operas, theaters, cabarets, and cafés offered stimulating entertainment and nightlife.

Images of such activities were meant to appeal to collectors as attractive reminders of these pursuits. It is no coincidence that the Société Anonyme held its first exhibition in the photographer Nadar's former studio: located in a fashionable quarter and close to the Opera, it was frequented by potential buyers. By the 1880s, several in the movement had achieved professional success. This was due largely to the efforts of Paul Durand-Ruel, the art dealer who represented many leading Impressionists and cultivated a market for their works. From the late nineteenth century onward, private galleries like Durand-Ruel's became increasingly important venues for the display and sale of modern art, replacing the exhibitions of the Salon, Royal Academy, and their counterparts.

Claude Monet (1840–1926)

A leader of the Impressionist movement, Claude Monet is best known for his modestly scaled, brightly colored, light-filled landscapes and waterscapes painted *en plein air* (in the open air), which evoke the pleasures of a countryside holiday. Although he worked under constantly changing conditions of light and atmosphere and required hours if not days to complete a picture, his views of nature appear as if instantly recorded. He created this effect by painting rapidly, using flecks, dabs, and short strokes of pure unblended color. His advice to the American artist Lilla Cabot Perry describes his method:

> Try to forget what objects you have before you . . . Merely think here is a little square of blue, here an oblong of pink, here a streak of yellow, and paint it just as it looks to you, the exact color and shape, until it gives your own naïve impression of the scene before you.[31]

Viewed up close, Monet's unblended strokes sit side by side on the canvas and allow us to imagine the movement of his brush. When viewed from a few feet away, the colors blend to produce a convincing representation of nature that still seems to vibrate due to the active brushwork.

Born in Paris but raised in the port city of Le Havre, the young Monet was encouraged to work *en plein air* by the older landscape painters Eugène Boudin and Johan Barthold Jongkind. Arriving in Paris in 1862, he studied briefly in the studio of the academic painter Charles Gleyre. Here, he met Renoir and Sisley, as well as Frédéric Bazille, whose work also developed in the direction of Impressionism.

Galvanized by the exhibition of Manet's *Déjeuner sur l'herbe*, Monet sought to surpass it by painting a much larger picture of the same title. His version would feature life-size figures in contemporary dress in a landscape setting painted in the open air. Smaller than his planned canvas and closer in size to the Manet work, *Women in the Garden* (1866–67) shows four women in fashionable summer dresses grouped around a tree and is painted with strong colors in full sunlight. This audaciously innovative picture was rejected by the 1867 Salon, as were most of Monet's submissions in succeeding years.

By the early 1870s, Monet was working on smaller canvases that permitted him to paint anywhere he could set up his portable easel. From late 1871 to early 1878 he lived with his family in Argenteuil. This village on the Seine was a typical Impressionist site of modern leisure: the wide stretch of the river there was the center of yacht racing in the Paris region, thus attracting large crowds on summer weekends, and became a frequent subject for Monet. Although he sometimes depicted the bustling regattas, he more often painted the river in its tranquil weekday state and focused on the water, sky, foliage, and built environment rather than human activity.

In *The Bridge at Argenteuil* (1874, Figure 1.16), a single yachtsman sails in the left background, two figures occupy a small red boat near the yacht, and a few people walk along the bridge at the right. Monet renders them all as mere smudges and more carefully delineates the empty dark-hulled yacht with its bare mast and the second mast jutting up from the painting's lower edge. He uses varied techniques to show each element's distinctive nature. For example, he depicts the water through choppy strokes of blue, green, yellow, and white, which mimic its rippling surface and denote broken reflections. He uses thicker paint and blunter strokes for the background trees and thinner paint and broader strokes for the blue sky and white clouds. The scene appears spontaneously observed and casually rendered but is really the product of astonishing discipline and technical ability.

In the later decades of his career, Monet pursued a more systematic approach. He experimented with producing multiple images of the same motif under varying effects of light and atmosphere. His most extensive series in the early 1890s depicted stacks of harvested wheat near his property at Giverny and the façade of Rouen Cathedral (e.g., *The Portal of Rouen Cathedral in Morning Light*, 1894. Using a building as a subject was an unexpected choice for an artist otherwise committed to landscape painting. However, the cathedral façade's sculptural complexity, which constantly changed visually, attracted Monet.

During two extended periods in 1892 and 1893, Monet set up his easel in rented rooms across from Rouen Cathedral. He worked on as many as fourteen canvases a day in his quest to capture the façade's appearance under different lighting conditions. While the impetus for each painting was a fleeting visual effect, his protracted painting process involved laying down multiple layers of thick paint and completing the work from memory in his studio. The finished paintings' richly textured surfaces have been likened to the stone walls of the actual building. Monet also used color to create a different mood in each painting. Moving beyond the ostensibly objective Impressionist goal of recording the appearance of nature, these paintings seem to be as much about feeling as they are about looking.

Pierre-Auguste Renoir (1841–1919)

Like his close friend Monet, Pierre-Auguste Renoir sought to translate his impressions of nature into loose, rapidly applied strokes of vivid, unblended color. However, he was primarily committed to figure rather than landscape painting. Born into a working-class family from Limoges, Renoir worked as a porcelain painter in Paris before entering Gleyre's studio. Several of his paintings were accepted by the Salon between 1864 and 1870, but his 1872 and 1873 submissions were refused.

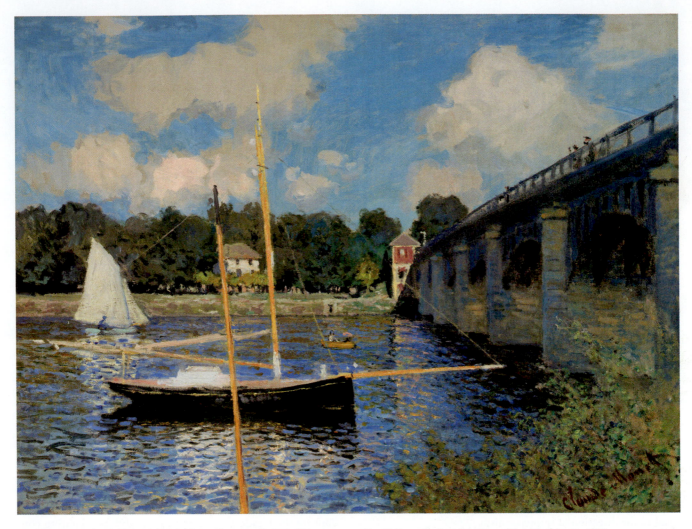

FIGURE 1.16 Claude Monet, *The Bridge at Argenteuil*, 1874. Oil on canvas, 60 x 79.7 cm. National Gallery of Art, Washington, DC.

Renoir displayed his *Ball at the Moulin de la Galette* (1876, Figure 1.17) at the Impressionists' 1877 exhibition. A celebrated masterpiece of the movement, the painting represents the outdoor courtyard of a popular dance hall in Montmartre, a working-class suburb of Paris and Renoir's home. On warm Sunday afternoons, the district's residents converged at the venue to eat, drink, and dance.

Renoir's painting offers an idyllic vision of carefree pleasure and harmonious relations between the sexes. A convivial gathering of nicely dressed, fresh-faced young people occupies the sunlight-dappled foreground of the crowded composition. Smiling couples dancing beneath gas lamps fill the middle and background spaces. Renoir engaged his middle-class male writer and painter friends and his working-class female models to pose for the figures and made studies in the open air, but he likely executed the large painting in the studio. Using swift, feathery brush strokes, he weaves together dark blues, purple-blues, and violets with warmer, lighter colors, unifying

the painting visually and creating an effect of restless motion. The dancing couple in the left middle distance, bathed in soft, broken sunlight, looks directly at us and invites us to participate in this appealing world.

Berthe Morisot (1841–1895)

Berthe Morisot was a central member of the Impressionist group, exhibiting in all but one of its eight exhibitions. As an upper-middle-class woman, she mostly depicted subjects considered appropriate to her gender and class: intimate views of her family members in domestic interiors or lush gardens. They reflect the leisured lifestyle she shared with other white French women of her class, who were supported financially by their husbands. What separated Morisot from most of these women was her serious commitment to art.

Growing up in the Paris suburb of Passy, Morisot and her sister Edma studied painting privately in the late 1850s. (The École des Beaux-Arts was closed to women until 1897.) In

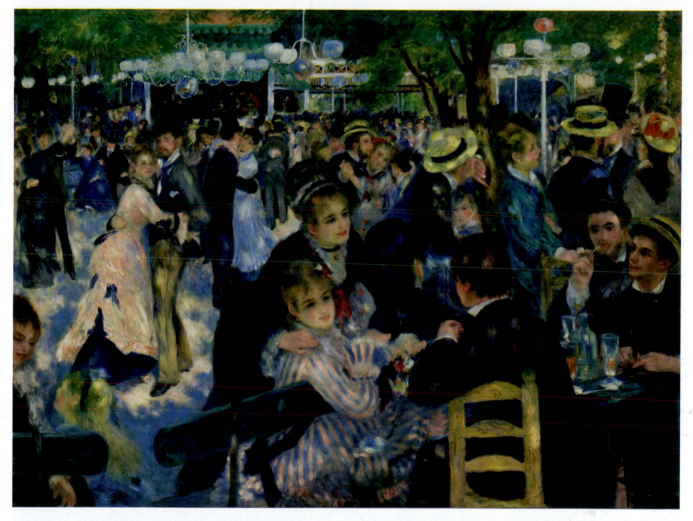

FIGURE 1.17 Pierre-Auguste Renoir, *Ball at the Moulin de la Galette*, 1876. Oil on canvas, 131 x 175 cm. Musée d'Orsay, Paris.

1860, they met the progressive landscape painter Jean-Baptiste Corot, who encouraged their interest in plein-air painting. Both sisters emulated his poetic style, with its feathery brushwork and silvery tones. Edma gave up painting after her 1869 marriage, but Morisot persisted; she was strongly encouraged by Manet, who became her brother-in-law in 1874.

Edma and her small daughters Jeanne and Blanche appear frequently in Morisot's paintings from around the time of the first Impressionist exhibition. *The Butterfly Hunt* (1874, Figure 1.18) was painted *en plein air* in Edma's garden at Maurecourt—the kind of secluded outdoor space in which bourgeois women were free to enjoy the open air without exposing themselves to potentially problematic public visibility. The painting shows the artist's sister in a dark straw hat and loose white tea gown, standing next to a slender tree and holding a green butterfly net. At the left, Jeanne, in a white hat and dark dress, looks toward her mother while Blanche, in a white dress, kneels nearby. Morisot's swift, loose brushstrokes animate the painting and, seeking to approximate her fleeting

sensations of nature, suggest rather than carefully describe the figures, grass, trees, and foliage.

Edgar Degas (1834–1917)

Edgar Degas was another core member of the Impressionist group; however, he preferred to call himself a Realist or an Independent. He shared his colleagues' independence from the Salon and commitment to depicting modern life, but he had little interest in plein-air painting. Instead, he carefully composed his pictures in the studio from memory, drawings, and photographs. This academic procedure was rooted in his brief training at the École des Beaux-Arts and three years of study in Italy in the later 1850s, where he made many drawings after the Old Masters. Firm drawing remained central to his art, though he often employed sensuous color as well.

From a Parisian banking family, Degas was close in age and social class to Manet, whom he met in 1862. Manet encouraged him to turn from history painting to the depiction of modern life. Degas first concentrated on psychologically probing

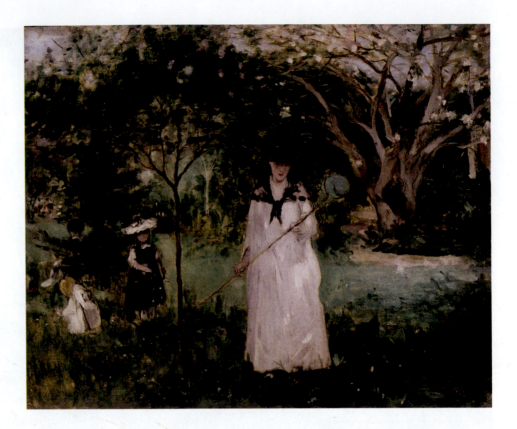

portraits of friends and relatives, but in the 1870s he turned his attention to scenes of Parisian entertainment, including horse races, musical performances, and the ballet. He observed and rendered these with the detached attitude of the *flâneur*.

Degas produced over six hundred images of ballerinas—nearly half his total output—showing them both in performance and in rehearsal. He seems to have found teenage ballerinas—who generally came from the lower classes—both sexually appealing and admirably hard-working. Drawing and painting them gave him the opportunity to represent human bodies in complex poses and to orchestrate multiple figures into elaborate and innovative compositions.

One such composition, *The Rehearsal* (c. 1874, Figure 1.19), is set in an interior lit by windows on the back wall and features a highly unconventional arrangement of bodies in space.[32] A spiral staircase in the left foreground partially blocks the view of several dancers in the background and includes the lower legs of a ballerina descending the stairs, cut off by the picture's top edge. Two russet-haired ballerinas perform pirouettes at the upper center, casting smudgy shadows on the floor. Their graceful, elevated forms are opposed by the seated, splay-footed ballerina at the lower right, who turns her back to them and crosses her arms over her blue-green shawl-covered torso.

To the right stands another dancer, much of her face and body cut off by the edge of the canvas. Behind her, her mother or grandmother (modeled by Degas's housekeeper) adjusts the standing dancer's billowing tutu, its diaphanous tulle gauzily rendered in contrast with the buttery strokes of the orange-yellow ribbon at her waist. Behind this pair near the back wall stands a red-shirted male dance instructor. Based on a photograph, it is a portrait of Jules Perrot, a famous male dancer.

With its angled perspective, unevenly distributed figures, and surprisingly fragmented forms, *The Rehearsal* seems to capture a fleeting, spontaneously observed moment; it embraces the qualities of contingency and ephemerality that for Baudelaire, defined modernity. We might also think it resembles a snapshot, but this concept did not yet exist: professional photographers of the time produced balanced, centralized compositions and avoided cropping their subjects. Japanese woodblock prints were a more likely inspiration for Degas's use of unusual perspectives and radically cropped forms (see "Japonisme" box). However, these innovations were primarily a response to modern life, which Degas and other Impressionists invented a new way to express visually.[33]

Degas continued to employ eccentric perspectives, asymmetrical compositions, and cropped figures in his works of the

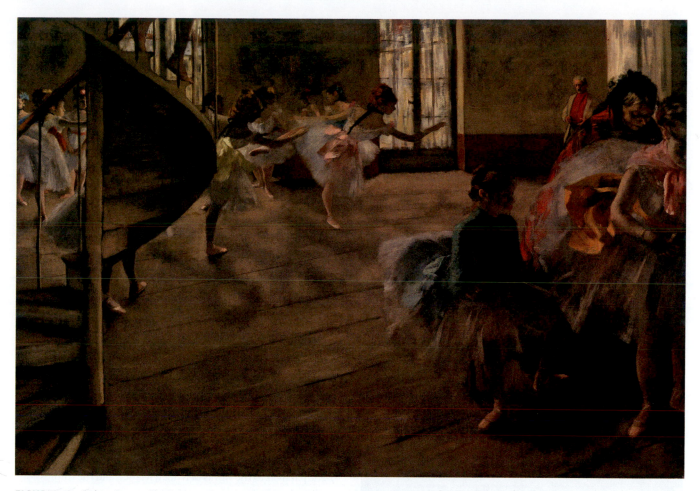

FIGURE 1.19 Edgar Degas, *The Rehearsal*, c. 1874. Oil on canvas, 58.4 x 83.8 cm. Burrell Collection, Glasgow.

1880s. In addition to dancers, his subjects included working women such as laundresses and milliners, whom he sought to render objectively by showing them engrossed in their labor rather than as flirtatious and sexually available—the way they were typically depicted in popular imagery. During this decade Degas also produced numerous **pastels** of unidealized nude female bathers in domestic interiors, several of which he showed in the final Impressionist exhibition (e.g., *Le Tub* [*The tub*], 1886). He described these nudes as "the human animal busy with herself, a cat licking itself" and noted that his models performed their toilette without awareness of the spectator, as if viewed "through a keyhole."[34] While some critics found these images cruel and misogynistic, one called them a "sincere expression of reality."[35] The reality is that Degas's subjects were prostitutes who were legally required to bathe frequently;[36] as with his images of laundresses and milliners, he showed the bathers absorbed in their daily routine rather than self-consciously displaying themselves for a male viewer. In this sense the images can be seen to respect the subjects'

privacy; on the other hand, Degas's "keyhole" views also produce a voyeuristic effect. Thus, the pictures remain ambivalent.

Mary Cassatt (1844–1926)

At the invitation of her close friend Degas, the American expatriate Mary Cassatt participated in the 1879 Impressionist exhibition and showed with the group three more times in the 1880s. Like Morisot, Cassatt represented subjects to which she had access as an upper-middle-class white woman who could not roam freely through the city like a male *flâneur*. Her art of this period focused on women of her race and class in domestic interiors, in gardens, or at the theater. The daughter of a Pittsburgh banker, Cassatt studied art at the Pennsylvania Academy of the Fine Arts in Philadelphia in the early 1860s and subsequently received academic training in Paris. During visits to Italy, Spain, Belgium, and the Netherlands in the early 1870s, she copied the works of the Old Masters and developed a robust **painterly** style in which she represented genre subjects such as Spanish bullfighters. After meeting Degas in the

mid-1870s, she adopted a lighter palette, loosened her brushwork (although firm figure drawing remained essential to her art), and began depicting aspects of modern Parisian life as experienced by women of her class.

Several of Cassatt's paintings of the late 1870s and early 1880s show women sitting in loges (private theater boxes). This subject, also depicted by Renoir and Degas, testifies to the contemporary popularity of seeing a play, opera, or ballet. Parisian theater-goers not only watched the on-stage entertainment but also observed each other. Fashionably dressed women expected to be seen, especially by men. They were typically depicted as beautiful objects to be looked at. For example, Cassatt's *Woman with a Pearl Necklace in a Loge* (1879) shows an attractive, smiling young woman displayed for the viewer's enjoyment.

However, her slightly earlier painting, *In the Loge* (1878, Figure 1.20), is strikingly different. In this picture, the foreground woman—shown in profile wearing a black matinee dress for an afternoon performance at the Comédie Française—is not a passive object of voyeuristic pleasure but actively wields her opera glasses to observe others. Absorbed in her own looking, she is oblivious to the painting's viewer and to the man in the sketchily brushed background who leans over the loge rail to train his opera glasses on her. Art historians have interpreted *In the Loge* as a feminist image of women's empowerment and an expression of Cassatt's own independent attitude.

Realism in Later Nineteenth-Century American Painting

The Realist goal of representing nature accurately was central to the American art tradition from the colonial-era portraits of John Singleton Copley to the genre paintings of William Sidney Mount and George Caleb Bingham and the landscape paintings of Thomas Cole, Asher B. Durand, and Frederic Edwin Church. These artists were committed not only to realism but also to depicting native subject matter—American people, everyday life, and natural scenery—in an effort to forge a uniquely American art. This agenda is a distinguishing feature of nineteenth-century American culture as the young country sought to define a national identity independent from Europe.

Following the Civil War (1860–65), this American strain of realism developed into a modern form of expression with aesthetic parallels to the works of Millet, Manet, and the Impressionists but that depicts recognizably American subject matter. Like their French counterparts, American realist painters of these decades—including Winslow Homer, Thomas Eakins, and Henry Ossawa Tanner—found their subject matter in contemporary life, which they observed keenly and sought to portray in a forceful and convincing manner.

Winslow Homer (1836–1910)

Winslow Homer started his artistic career as an apprentice to a lithography firm in his native Boston before moving to New York City in 1859 to work as a freelance illustrator. During the Civil War he served as an artist-correspondent for *Harper's Weekly*. He also made his first paintings, mostly depicting daily life in Union Army camps, working from models in the open air. A ten-month stay in Paris in 1866–67 likely introduced him to the work of Millet and the Barbizon School. On his return to the United States, he painted sun-filled images of modern outdoor leisure activities such as playing croquet, horseback riding, and swimming.

In the early 1870s, Homer made a series of paintings on the theme of the American country school—a national icon. This series includes *Snap the Whip* (1872, Figure 1.21), showing nine boys playing this popular game on a fall day against

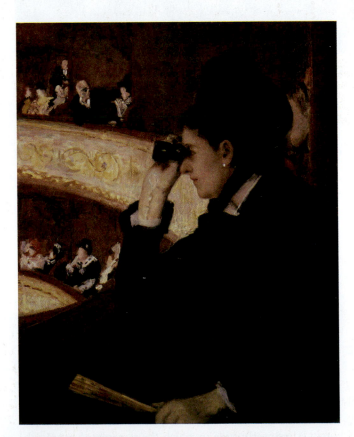

FIGURE 1.20 Mary Cassatt, *In the Loge*, 1878. Oil on canvas, 81.28 x 66.04 cm. Museum of Fine Arts, Boston.

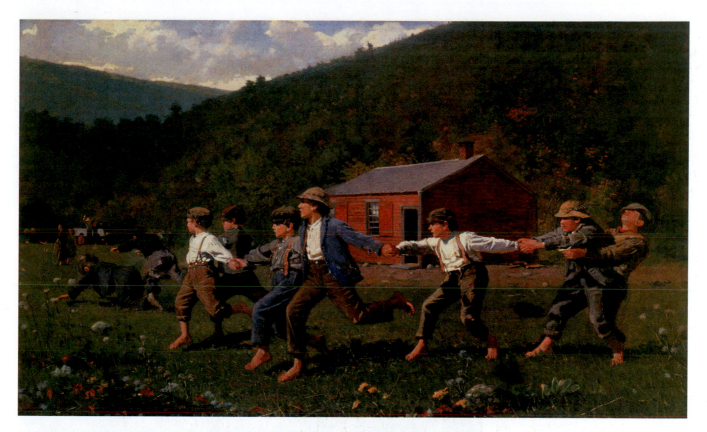

FIGURE 1.21 Winslow Homer, *Snap the Whip*, 1872. Oil on canvas, 56 x 91 cm. Butler Institute of American Art, Youngstown, Ohio.

a mountain backdrop. Two girls stand in the left background, passively observing the vigorous activity. The red, one-room schoolhouse in the middle distance adds a note of nostalgia, as such buildings were rapidly disappearing in the urbanizing country. On the other hand, the energetic, fresh-faced boys convey optimism for the nation's future. Their game—involving teamwork, strength, speed, and momentum—could be seen to symbolize the qualities that would guarantee continuing national growth and success. Homer's bold, blunt style, which features brightly lit, simply drawn, and solidly modeled figures, was praised by critics as distinctively American and refreshingly free of foreign influences.

Thomas Eakins (1844–1916)

Unlike the largely self-taught Homer, Thomas Eakins received thorough academic training. He first studied at the Pennsylvania Academy of the Fine Arts (1862–66) and then at the École des Beaux-Arts under Gérôme. On a trip to Spain, Eakins became captivated by Velázquez's intensely realistic paintings and adopted his indirect painting method, also used by Rubens and Rembrandt. This process involved laying down a thin layer of underpainting followed by layers of transparent paint (known as **glazing**). These layers mix optically to create a translucent effect very different from that produced by the French manner of direct painting with opaque pigment, which was Homer's method.

After returning to his native Philadelphia, Eakins produced a series of paintings of scull races on the Schuylkill River (e.g., *The Champion Single Sculls [Max Schmitt in a Single Scull]*, 1871). This thoroughly modern sport was a subject that he, as an avid rower, knew well. He composed these paintings in the studio, basing them on numerous preparatory drawings and precise perspectival studies. He sought to render every compositional element—boats and figures, sky and water, foliage and built structures—with almost scientific precision, an approach that resonates with the positivist attitude of the mid-nineteenth century.

Eakins chose another modern subject for his most ambitious early painting—*Portrait of Dr. Samuel D. Gross (The Gross Clinic)* (1875, Figure 1.22)—a life-size depiction of the prominent Philadelphia surgeon operating before medical students in the amphitheater of the Jefferson Medical College. Gross is shown removing a piece of dead bone from a patient's thigh, a conservative procedure meant to save the limb from

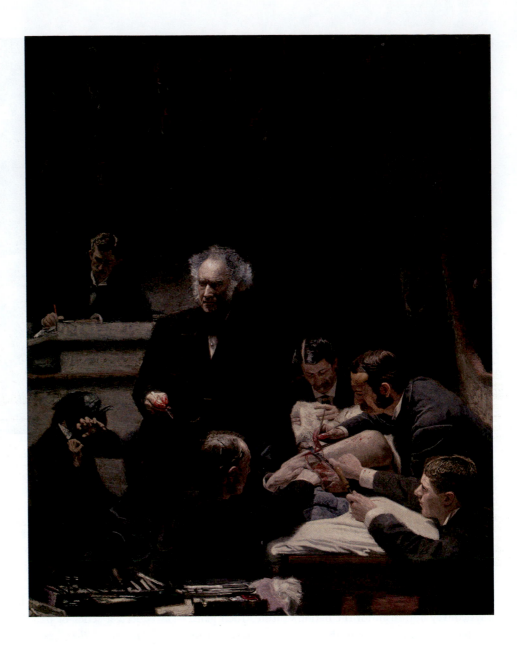

amputation. The solemn surgeon embodies scientific reason as he pauses calmly in the midst of his work. The woman at the lower left, probably the patient's relative, recoils and shields her eyes from the sight of Gross's bloody fingers and scalpel. Their contrasting reactions embody the stereotypical nineteenth-century understanding of men as rational and women as emotional. Eakins, who had studied anatomy at Jefferson, includes his shadowy self-portrait at the center right edge. The dark background and bright light dramatically illuminating Gross, the operating table, and attendants suggest the influence of Rembrandt's *The Anatomy Lesson of Dr. Nicolaes Tulp* (1632), which was also a precedent for depicting a surgeon's working lecture.

Eakins painted the *Gross Clinic* for Philadelphia's 1876 Centennial Exhibition to not only celebrate the city's scientific accomplishments, and by extension, American scientific progress, but also demonstrate his artistic prowess. However, the jury rejected the painting due to its frank and bloody realism. It was displayed instead among the medical exhibits of the US Army Post Hospital. This would not be the last time Eakins's uncompromising commitment to realism would upset his fellow Philadelphians. In 1886, he was forced to resign his teaching position at the Pennsylvania Academy after he removed a male model's loin cloth in front of a life-drawing class that included female students, violating then-current norms of propriety in his zeal to teach the fundamentals of anatomy.

Henry Ossawa Tanner (1859–1937)

Henry Ossawa Tanner became the most successful African American artist of his generation, living as an expatriate in Paris and enjoying success at the Salon. The Pittsburgh-born son of an African Methodist Episcopal bishop, he studied under Eakins at the Pennsylvania Academy between 1880 and 1882. Six years later, he set up a photographic studio in Atlanta while continuing to paint. With the support of local patrons, he traveled to Paris in 1891 for further academic training. After settling permanently in France, he specialized in painting Christian subjects.

On a trip home in 1893, Tanner painted his best-known work, *The Banjo Lesson* (1893, Figure 1.23). Set in the humble interior of a rural southern African American home, the painting shows an aged man teaching a boy, perhaps his grandson, to play the banjo. Using loose brushstrokes and rich colors likely inspired by Impressionism, Tanner shows the pair completely absorbed in the lesson. Bathing them in the warm glow of a fire radiating from the right and soft sunlight filtering in from the left, the artist invests the space with a reverential aura.

This tender yet sober portrayal countered the stereotypical images of grinning Black musicians long produced by white American artists and illustrators for the amusement of other whites. The image also rejected the racist conception of Black people as "natural" musicians by emphasizing the theme of education: the purposeful transmission of cultural knowledge from generation to generation.

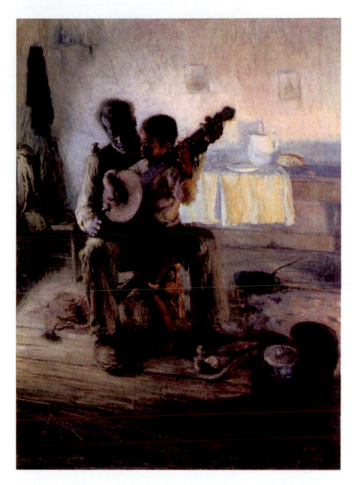

FIGURE 1.23 Henry Ossawa Tanner, *The Banjo Lesson*, 1893. Oil on canvas, 122 x 89 cm. Hampton University Museum, Virginia.

Post-Impressionism and Symbolism: Painting and Sculpture in Europe, c. 1886–1910

This chapter surveys Post-Impressionism and Symbolism, two overlapping currents in late nineteenth-century European art that reacted to or departed from Impressionism in various ways. In contrast to the Impressionists' attempts to record appearances objectively, the artists considered here, while sometimes sharing Impressionism's goal of representing contemporary reality, developed more abstract styles to convey personal and subjective content. Post-Impressionism, a term coined in 1910 by the English critic Roger Fry, is sometimes used broadly to characterize all modern late nineteenth-century art that reacted against Impressionism or narrowly in relation to the painting styles of Georges Seurat, Paul Cézanne, Paul Gauguin, and Vincent Van Gogh, as well to artists working in idioms related to theirs. Seurat and Cézanne rejected Impressionism's rapid paint handling and loose formal structure to instead develop more deliberate painting methods and rigorous compositions. Gauguin and Van Gogh expressed personal emotions and symbolic meanings in their art through the use of arbitrary colors and stylized forms.

Gauguin and Van Gogh, along with Edvard Munch, James Ensor, and Auguste Rodin (the leading modern sculptor of the period), were associated with Symbolism, an international movement arising in the mid-1880s that abandoned the objective description of reality to explore subjective and imaginative realms. One group of younger painters who were inspired by Gauguin—known as the Nabis—believed abstract art could express mystical truths. The two most prominent Nabis, Édouard Vuillard and Pierre Bonnard, suggested unstated meanings through their quiet paintings of intimate domestic interiors employing richly colorful decorative patterns.

Post-Impressionism and Symbolism arose during a period of rapid innovation in Western Europe and North America. Inventions such as the telephone, electric light bulb, gasoline-powered automobile, and cinema radically transformed society. The growth of capitalism, which promoted increasing industrialization and urbanization, was fed by imperialism: the major Western European powers colonized parts of Asia and almost all of Africa, seeking sources of raw materials and new markets for their industrial products, while the United States claimed territories in the Pacific and the Caribbean (see "Colonialism and Postcolonialism" box, Chapter 18). Inequalities of power and income marked relations between the colonizers and native peoples as well as between business owners and their employees. Strikes by laborers seeking better pay and working conditions were common during this period. Socialist, anarchist, and feminist movements—particularly regarding women's right to vote—also arose.

Little of this history is directly evident in Post-Impressionist and Symbolist art, which, even when it depicts subjects from modern life, addresses contemporary topical issues ambiguously or metaphorically, or suggests an attempt to escape the pressures of modern society. Strongly individualistic, these artists were largely concerned with pursuing their personal creative visions. Their commitment to individualism resonates with the ideas of an influential philosopher of the period, Friedrich Nietzsche. He championed the realization of individuality as the basis of modern heroism and believed that art is an affirmation of life, writing, "There is no such thing

as pessimistic art. . . . Art affirms."[1] It is hard to imagine any artist in this period—indeed, throughout the modern era—disagreeing with that sentiment.

Post-Impressionist Painters of Modern Life: Georges Seurat and Henri de Toulouse-Lautrec

Like their older Impressionist colleagues, the Paris-based painters Georges Seurat and Henri de Toulouse-Lautrec depicted scenes of modern life in the French capital. Seurat also painted landscapes. Both are considered Post-Impressionists, however, due to their pursuit of formal innovations that created highly artificial effects.

Georges Seurat (1859–1891)

Seurat pioneered **Neo-Impressionism** (named by the critic Félix Fénéon), a subcategory of **Post-Impressionism**, which renounced the intuitive, improvised quality of Impressionist plein-air painting for a more disciplined and rigorous method informed by scientific studies of light and color. After Seurat introduced Neo-Impressionism, other **avant-garde** French painters, including Paul Signac and Camille Pissarro, quickly adopted it and it spread internationally. Neo-Impressionism is most famously exemplified in Seurat's monumental painting *A Sunday on La Grande Jatte—1884* (1884–86, Figure 2.1), displayed at the eighth and final Impressionist exhibition of 1886, where it caused a sensation. Seurat executed this painting using a novel technique inspired by the writings of nineteenth-century scientists—principally Michel-Eugène Chevreul, Charles Blanc, and Ogden Rood. This technique involved laying down separate strokes of pure color (a method known as **Divisionism**), some applied as small dots (known as **Pointillism**). When seen at a distance, these discrete touches of individual **hues** would, in theory, blend in the eye to produce a more vibrant and luminous effect of color than that achieved by mixing them on the **palette**.

Of particular interest to Seurat was Chevreul's law of simultaneous contrasts of color. Chevreul believed that colors are perceived differently when placed side by side than when

FIGURE 2.1 Georges Seurat, *A Sunday on La Grande Jatte—1884*, 1884–86. Oil on canvas, 207.5 x 308.1 cm. The Art Institute of Chicago.

seen in isolation: the brain adds some of the **complementary** of each color to its neighbor. For example, when red is placed next to blue, the brain contributes a bit of green (the complementary of red) to the blue and a bit of orange (the complementary of blue) to the red. Chevreul equated maximal contrasts of the complementaries with aesthetic harmony. This idea greatly appealed to Seurat, who declared, "Art is harmony. Harmony is the analogy of opposites, the analogy of similarities."[2]

In *La Grande Jatte*, Seurat depicted a typical Impressionist subject: modern Parisians taking their leisure on the small narrow island in the Seine. However, his painting differs markedly in **formal** terms from similar Impressionist works, such as Renoir's *Ball at the Moulin de la Galette* (see Figure 1.17). Whereas Renoir uses fluent and free **brushwork** to represent the young revelers in a variety of relaxed poses, Seurat's figures—rendered through thousands of small discrete strokes of color—are rigid, highly **stylized**, and eternally frozen in place. Rather than transitory modern life, Seurat aimed to portray a quality of timeless stasis like that in the figural **reliefs** of the ancient Egyptians and Greeks.[3]

Seurat made at least fifty-four drawings and small oil sketches on panel for this work; he also painted three larger studies. He created these drawings (e.g., *The Couple: Study for "La Grande Jatte,"* 1884) by rubbing **conté crayon** over rough paper to render forms through a subtle continuum of light and dark. He thus eliminated contour lines that were the basis of **academic** drawing. In his oil studies he analyzed color relationships, pictorial space, and the placement of figures.

Seurat's final **composition** includes over fifty people, animals, and boats across a stage-like space. Its brightly lit central zone is framed at the bottom by the **foreground** shadow and at the top by a canopy of foliage. The figures are mostly shown in profile or from the front or the back, making them seem flat. Their diminishing size creates spatial recession that is countered by points of visual contact that lead the eye across the picture's surface. The tips of the black parasol held by the promenading woman at the right nearly touch her companion's walking stick and top hat. The top hat of the seated gentleman at the lower left aligns with the base of the tree trunk that seems to grow from it. This hat's front edge makes contact with the parasol held by the seated woman to the left, which touches the skirt of the standing woman whose fishing pole reaches to the painting's border. Similar connections exist throughout, knitting all the elements together. By the same token, the brushwork creates a grand sense of decorative unity from a distance, although it is seen to be quite varied when viewed up close.

Besides its revolutionary Neo-Impressionist technique, the painting's most original and provocative feature may be its representation of modern leisure as a regimented performance. The de-individualized figures come together to display themselves to one another. Seurat acknowledges the elegance of contemporary French fashion while also mocking its pretensions. This is especially true of the young woman at the right with her corseted waist, enormous bustle, and exotic pet monkey.

Some historians see *La Grande Jatte* as an image of isolated, anonymous individuals alienated and dehumanized by modern urban capitalism. Others argue that it offers an optimistic vision of social unity: a procession of contemporary Parisians whose calm grandeur mirrors the ancient Greek **friezes** that inspired Seurat.[4] These conflicting readings seem appropriate for an artist who sought to create harmony through "the analogy of opposites."

Henri de Toulouse-Lautrec (1864–1901)

Like Seurat, Henri de Toulouse-Lautrec painted subjects of modern Parisian life similar to those of the Impressionists but in a more **abstract**, Post-Impressionist **style**. He specialized in depicting the personalities and nightlife of Montmartre, a hilltop northern Paris district filled with cafés, theaters, nightclubs, and brothels. Its entertainment venues attracted tourists and its bohemian atmosphere lured young artists, including Lautrec, who settled there in 1884 after a few years of academic study.

Born into a wealthy aristocratic family, Lautrec lived with a form of dwarfism. Just under five feet tall, he had a normally developed head and torso but stunted legs; he walked with difficulty using a cane. He compensated for these challenges by wielding a caustic, self-deprecating wit, and by befriending Montmartre's socially marginal but nonjudgmental denizens, including its prostitutes. He even rented rooms in brothels, where he likely contracted the syphilis that led to his early death.

Influenced by the art of Degas and Japanese prints, Lautrec's mature painting style features flattened space and diagonal compositions. He often employed a somber palette enlivened by passages of acerbic color. He typically drew firmly outlined figures while rendering their bodies, clothing, and surroundings in a loose, sketchy fashion. His most impressive paintings are large, bustling, multifigural compositions of energetic dancers on stage (e.g., *Marcelle Lender in "Chilpéric,"* 1895) or patrons gathered in the dark spaces of Montmartre's nightspots, as in *At the Moulin Rouge* (1892/95, Figure 2.2). This picture shows a group of the artist's friends gathered around a table in the upper center and the diminutive Lautrec himself in profile in the **background**, walking alongside his cousin Gabriel Tapié de Céleyran. To the right, the famous nightclub dancer La Goulue, "the greedy one," adjusts her hair in the mirror. In the lower right foreground appears the cropped figure of a young woman (possibly the dancer May Milton), her face a whitish-green mask sharply lit from below—a startling apparition highlighting the Post-Impressionist artificiality of Lautrec's style.

FIGURE 2.2 Henri de Toulouse-Lautrec, *At the Moulin Rouge*, 1892/95. Oil on canvas, 123 x 141 cm. The Art Institute of Chicago.

Lautrec also made innovative posters advertising Montmartre's entertainment venues and prominent performers. Strongly influenced by Japanese prints, he rendered his figures through flat areas of bold color bounded by clear outlines, as seen in *Divan Japonais* (1892–93, Figure 2.3). Dominating its composition is the singer Jane Avril, seated in profile in the foreground; a lithe and modish figure in a black dress and extravagant black hat, she is accompanied by the writer Édouard Dujardin. At the upper left—her head audaciously cut off by the top edge of the composition—is the black-gloved cabaret performer, Yvette Guilbert. The sophisticated, sinuous style of Lautrec's posters helped to define Parisian visual modernity in the 1890s as well as the larger current of **Art Nouveau** (French for "new art"). Characterized by free-flowing arabesques, this style spread internationally through every sphere of the visual arts in Europe in the 1890s and early 1900s and found its most ambitious expression in architecture (see Chapter 5).

Paul Cézanne (1839–1906)

The Post-Impressionist Paul Cézanne belonged to the same generation as the Impressionists and generally shared their commitment to painting from direct observation. However, he found their attempts to capture transitory effects unsatisfying.

He sought instead to "make of Impressionism something solid and durable, like the art of the museums."[5] He realized this goal with increasing confidence in the 1880s, bringing form, color, and feeling into a grand synthesis in paintings such as *The Montagne Saint-Victoire with Large Pine* (c. 1887, Figure 2.4).

The son of a prosperous banker, Cézanne abandoned his law studies to pursue his passion for art, training at Paris's free Académie Suisse in the 1860s. Highly respectful of tradition, as a student he copied works by Titian, Rubens, and Delacroix in the Louvre and sought but failed to gain entrance to the École des Beaux-Arts. His submissions to the **Salon** were likewise routinely rejected. Throughout the 1860s, he worked in a rough, awkward style of thickly applied, generally dark colors. His portraits, **still lifes**, and fantasy subjects often featured disturbing images of sexual violence.

In 1872, Cézanne moved with his mistress (later wife) Hortense Fiquet and their newborn son to Pontoise (the home of Camille Pissarro) and then to nearby Auvers the next year. In these rural locales he began painting landscapes *en plein air*, often in Pissarro's company. Responding to the natural world's luminosity and richness of color, he lightened his palette and began to paint in small strokes and touches. He exhibited in the 1874 and 1877 Impressionist exhibitions, but unlike the Impressionists, he affirmed the physical world's solidity through deliberate and dense paint application in works such

FIGURE 2.3 Henri de Toulouse-Lautrec, *Divan Japonais*, 1892–93. Lithograph printed in four colors, wove paper, 80.8 x 60.8 cm. The Metropolitan Museum of Art, New York.

nature and the feelings they induce—into a formally rigorous structure. This is the principal difference between his mature work and that of the plein-air Impressionists, who were primarily concerned with translating their optical sensations through rapid, sketch-like brushwork and informal compositions.

In *The Montagne Saint-Victoire*, Cézanne uses short, parallel strokes, patches, and lines of pure color to suggest deep space while acknowledging the two-dimensional reality of the **picture plane**. This tension was at the heart of his aesthetic. In several areas of the composition, he creates unbounded planes of color that flow into adjacent planes of different colors—a technique called ***passage*** (employing the French pronunciation, *pä-säzh*)—so that surfaces appear to bleed together, affirming the flatness of the picture surface. In the early twentieth century, Pablo Picasso and Georges Braque would adapt this technique in their **Analytic Cubist** paintings (see Chapter 4).

Cézanne knew that **cool colors** (green, blue, and violet) seem to recede visually and **warm colors** (red, orange, and yellow) are perceived as advancing. He used this knowledge to create spatial recession through alternating zones of cooler and warmer hues in the landscape that lead the eye back into space and up the mountain. The contour lines in the valley—suggesting walls, fences, and the edges of fields—also move the eye into depth along diagonals. Cézanne counters this sense of recession by filling the sky with pine branches whose configuration visually echoes the contour of the mountain range, binding background to foreground. He further links

as *The House of the Hanged Man at Auvers* (1872–73).

Cézanne's mature style emerged in the 1880s, when he painted mostly in the environs of his native Aix-en-Provence and nearby L'Estaque. He particularly focused on a limestone mountain, Mont Sainte-Victoire, which he portrayed more than sixty times in oil and **watercolor** during the last three decades of his life. *The Montagne Saint-Victoire with Large Pine* presents a distanced, sweeping view of the valley east of the peak. Conceiving of art as a "harmony which runs parallel with nature,"[6] Cézanne did not reproduce the scene exactly but attempted to translate what he called his "sensations"—perceptions of

FIGURE 2.4 Paul Cézanne, *The Montagne Sainte-Victoire with Large Pine*, c. 1887. Oil on canvas, 66.8 x 92.3 cm. The Courtauld Gallery, London.

foliage and mountain through color by adding notes of pink to both. Finally, the prominent tree trunk serves as a *repoussoir*: a foreground object on the composition's border that frames the principal scene and enhances the illusion of depth. At the same time, the trunk's cropped extension from the bottom to the top edge of the canvas enforces the viewer's awareness of the painting's flat, rectangular surface.

Transcending these formal tensions, Cézanne's picture conveys a mood of timeless serenity, undisturbed by humans, animals, or changing weather or seasons (the pine tree remains evergreen year-round). Even the modern railway bridge in the right background seems timeless in its resemblance to the ancient Roman aqueducts built in Provence. The unchanging, monumental quality Cézanne achieves in *The Montagne Saint-Victoire with the Large Pine* fundamentally distinguishes it from Impressionist efforts to record fleeting effects of light and atmosphere.

In addition to landscapes, Cézanne painted numerous portraits and still lifes in the 1880s and 1890s. Apples and other still objects attracted him as subjects because he could arrange them into compositions with complex internal relationships that, unlike those found in nature, were entirely under his control. These paintings typically depict objects solidly rendered through varied strokes of unrestrained color, reflecting Cézanne's belief that "When color is at its richest, form is at its fullest."[7] At the same time, they often feature asymmetrical arrangements that suggest instability and dynamism.

In *The Basket of Apples* (c. 1893, Figure 2.5), the fruit seems about to tumble from the tilted basket but is blocked by the crumpled tablecloth. The cloth's downward movement is countered by the upward thrust of the wine bottle next to the basket. The larger size of the basket and the placement of the bottle slightly to the left of the central axis give more visual weight to the left side of the picture, creating an unbalanced composition. Further, the leaning bottle has two different silhouettes, the ladyfinger biscuits at the right tilt upward, and the front edge of the table occupies different levels on either side of the foreground cloth. These departures from representational convention arose from Cézanne's rejection of the **Renaissance**-based system of **linear perspective**, which is organized around a fixed viewpoint, and his acknowledgment that we

look at the world in constant motion. He therefore combined multiple viewpoints in the same painting, creating an image that seems true to our experience of the world while also generating an expressive quality of doubt or uncertainty—both hallmarks of Cézanne's **modernism**. The use of multiple perspectives was adopted and elaborated on by the Cubists in the years before World War I (see Chapter 4).

During Cézanne's final years, his painting became increasingly abstract as he simplified his forms and palette and used larger brushstrokes. He emphasized sensuously rich blues, greens, and earth colors in his many late paintings of Mont Saint-Victoire. These hues plus flesh tones saturate the three large canvases of bathers in landscapes he executed after 1900. The last of these, *The Large Bathers* (1900–6, Figure 2.6), was left unfinished at his death. Painted from the artist's imagination, it conveys both the freshness of outdoor light and color and a geometric quality of architectural order. The latter is underscored by the leaning trees that converge toward the upper center to form a triangle framing an expanse of sky and the distant landscape and river. In the left and right foreground, pyramidal groups of stiffly rendered, expressionless nude female bathers reinforce the trees' alignment. This is especially noticeable in the striding figure at the left whose rear leg, torso, and head incline at the same angle as the trunk behind her.

FIGURE 2.5 Paul Cézanne, *The Basket of Apples*, c. 1893. Oil on canvas, 65 x 80 cm. The Art Institute of Chicago.

FIGURE 2.6 Paul Cézanne, *The Large Bathers*, 1900–06. Oil on canvas, 210.5 x 250.8 cm. Philadelphia Museum of Art.

The formal union of bathers and trees suggests an ideal harmony between humans and nature rooted in the **classical** tradition that had inspired Cézanne from his student days. Even as it draws on the past, however, the *Large Bathers* points to the future. Cézanne employed revolutionary new techniques, including a radically abstract style in its highly simplified figures and landscape elements and free brushwork. He also used color to integrate foreground and background through scattered touches of rose and ochre within the blue-green tapestry of sky and foliage. The display of Cézanne's late works at the 1907 Paris Salon d'Automne galvanized young avant-garde artists. They were profoundly moved by the artist's quest to synthesize form, color, and expression in an artistic "harmony which runs parallel with nature." Among them were Picasso and Matisse, both of whom reportedly called Cézanne "the father of us all."

Symbolism

While Seurat and Cézanne based their painting on observations of the physical world, other late nineteenth-century European artists, known as Symbolists, drew their imagery from imagination, dreams, visions, myth, or literature, or represented everyday subjects in ways that suggested unstated

meanings. Uncomfortable with the effects of technological progress, capitalist expansion, urbanization, and secularization then transforming European societies, and rejecting materialism and the positivist attitude they saw in **Realism** and Impressionism, these artists sought to express a deeper, more mysterious reality whose essence could only be intuitively sensed. They called themselves Symbolists not because they used conventional symbols (though they sometimes did) but because they sought to evoke ideas—a basic function of symbols—suggesting the transcendence of material reality.

Symbolism began as a literary movement. The poet Stéphane Mallarmé expressed its basic attitude when he wrote, "To *name* an object is to suppress three-quarters of the pleasure . . . which stems from the joy of divining little by little; *to suggest*, there is the dream."[8] The movement can be seen as a revival of **Romanticism** (see Introduction), which Charles Baudelaire defined as a feeling characterized by "intimacy, spirituality, color, aspiration toward the infinite."[9]

Like the Romantics, the Symbolists believed that an artwork should arise from the artist's emotional experience. While a work might refer to the external world, its ultimate aim is to express subjective feelings, ideas, or mystical insights. It could do this through both its imagery and formal qualities. Some Symbolist painters, such as the Belgian Fernand Khnopff, rendered dreamlike visions in an **illusionistic** style, but many used line, shape, color, space, and other formal elements in nondescriptive ways to suggest realities beyond appearances.

The Symbolist movement was announced in an 1886 manifesto by poet Jean Moréas. Later that year, Gustave Kahn memorably expressed its aims: "We wish to be able to place the development of the symbol in any period whatsoever, and even in outright dreams (*the dream being indistinguishable from life*). . . . [The] essential aim of our art is to objectify the subjective (the externalization of the Idea) instead of subjectifying the objective (nature seen through the eyes of a temperament)."[10] This fascination with dreams parallels the early work of Sigmund Freud, who in *The Interpretation of Dreams* (1900) argued that dreams symbolically express unconscious anxieties and desires (see "Psychoanalysis" box, Chapter 8).

Precursors of Symbolism: Gustave Moreau, Pierre Puvis de Chavannes, and Odilon Redon

The Symbolists were inspired by Gustave Moreau, Pierre Puvis de Chavannes, and Odilon Redon—all of whom created dreamlike images prior to the 1880s. Moreau's and Redon's art played a key role in Joris-Karl Huysman's *À Rebours* (*Against the Grain*, 1884), a landmark novel not only of Symbolism but also of Decadence—a literary tendency that valued the artificial, the sensual, and even the perverse over the natural. The story's protagonist, Des Esseintes, is a decadent aristocrat who immerses himself in aesthetic pleasures, which includes decorating his country estate with works by Moreau and Redon.

Gustave Moreau (1826–1898)

Among Des Esseintes's paintings are two images of the dancing Salome by Gustave Moreau. According to the New Testament, Salome performed an erotic dance before her stepfather and uncle, King Herod. In return, at her mother Herodias's behest, Salome demanded the head of John the Baptist—who had condemned Herod's marriage to his half-brother's divorced wife as unlawful. The subject obsessed Moreau; he depicted it many times, including in *The Apparition* (1876, Figure 2.7), exhibited to critical acclaim at the 1876 Salon.

In this large watercolor, the seductive princess wears a scanty, bejeweled costume. She appears startled by John's levitating head, ringed by a radiant halo and dripping blood. John looks down accusingly at Salome, whose anxious expression suggests guilt for his death. Staged in an opulent setting inspired by Spain's Alhambra, every element of the macabre scene is rendered in fine linear detail with touches of jewel-like color, heightening the hallucinatory intensity of the supernatural confrontation.

Moreau's Salome embodies the *femme fatale* (deadly woman)—the woman who attracts and then destroys men. Introduced as a literary symbol by Baudelaire in *Les Fleurs du Mal* (*The Flowers of Evil*, 1857), the figure haunted the imaginations of countless male artists in this period, including Munch and Gustav Klimt, and remained a prevalent motif in twentieth-century literature, art, and cinema. Historians have argued that it symbolically expressed male fears of the threat gender equality posed to patriarchal power.

Pierre Puvis de Chavannes (1824–1898)

Pierre Puvis de Chavannes was the most successful French mural painter of the last four decades of the nineteenth century. Independent of contemporary artistic movements—including Symbolism—he sought to express simple ideas through formal means in his murals for public buildings. Influenced by Italian Renaissance **frescoes**, he used a pale palette to render static, classically inspired figures within

FIGURE 2.7 Gustave Moreau, *The Apparition*, 1876. Watercolor, 106 x 72.2 cm. Musée d'Orsay, Paris.

landscapes depicted in broad planes of flat color. A characteristic example of his work, *The Sacred Grove, Beloved of the Arts and Muses* (1884, Figure 2.8), portrays the nine muses (ancient Greek goddesses of the arts and sciences) and attendant figures, carefully placed in an arcadian setting to create a sense of harmony and equilibrium.

This canvas is a reduced version of the mural Puvis painted for the grand staircase of the Musée des Beaux-arts in his native city, Lyon. Despite its classical **allegorical** subject, it is stylistically modern in its flatness and lack of naturalistic detail. This quality of abstraction, along with his imagery's detachment from contemporary reality and its dreamy ambiguous mood, appealed to Gauguin and other Symbolists. And Seurat's frieze-like arrangement of motionless figures in *La Grande Jatte* was likely influenced by *The Sacred Grove*.

Odilon Redon (1840–1916)

Odilon Redon's art embodied the Symbolist concepts of suggestion, mystery, and dream. Working almost exclusively in black and white for the first twenty years of his career, he conjured fantastic, macabre, and melancholy imagery in shadowy

FIGURE 2.8 Pierre Puvis de Chavannes, *The Sacred Grove, Beloved of the Arts and Muses*, 1884. Oil on canvas, 93 x 231 cm. The Art Institute of Chicago.

charcoal drawings, **lithographs**, and **etchings**. Redon said that he achieved the "suggestive" quality of his art through "a combination of diverse elements brought together, of transposed or transformed forms, bearing no relation to contingencies, but nevertheless following a logic."[11]

We see this combination in *Eye-Balloon* (1878, Figure 2.9), likely inspired by Henri Giffard's hot-air balloon, a main attraction of the 1878 Paris Universal Exposition.[12] This hallucinatory drawing features an enormous, upward-looking human eyeball that doubles as a hot-air balloon hovering above a dark body of water. Suspended beneath it is a platter carrying a disembodied human head, also with open eyes—an image of human perception and intelligence. The balloon floats freely upward, seeking escape from the material world and union with the infinite. The severed head suggests martyrdom; it may refer to the lives lost in the Franco-Prussian war of 1870, when the French used balloons to fly mail and military personnel out of a besieged Paris.

Paul Gauguin (1848–1903)

Many works by the major Post-Impressionist Paul Gauguin possess Symbolist qualities. He rejected the objective description of nature for a stylized art intended to convey subjective feelings and abstract ideas through formal means. He called his approach **Synthetism** because it synthesized the representation of nature—based on memory, convention, and existing imagery more than direct observation—with his feelings about his **subject matter** and creative considerations of line, color, and form. He wrote: "Art is an abstraction; extract it from nature . . . and pay more attention to the act of creation than to the result. That's the only way of advancing towards God, by imitating our divine master and creating."[13]

Gauguin's innovations in painting—including distorted and flattened forms, anti-naturalistic colors, and simple shapes arranged in decorative patterns—drew inspiration

from popular art forms as well as archaic, medieval, and non-Western styles that he and his European contemporaries considered "primitive." His embrace of this art marked an early instance of modernist **primitivism** (see box) and reflected his desire to escape from modern Western urban civilization (which he considered corrupt) into a more basic existence supposedly characterized by harmony between humans and nature. He pursued this lifestyle in various locations, first in Brittany, then Panama and Martinique, and ultimately in Tahiti and the Marquesas Islands. Gauguin repeatedly failed to find the paradise he was seeking in these places so distant from Paris. Instead, he created visions of that paradise in his art.

Born in Paris, Gauguin spent his early childhood in Peru. (His mother was of noble Peruvian descent; he would later highlight this ancestry as a foundation of his primitivist attitude.)

FIGURE 2.9 Odilon Redon, *Eye-Balloon (Oeil-ballon)*, 1878. Charcoal and chalk on colored paper, 42.2 x 33.3 cm. The Museum of Modern Art, New York.

Primitivism

A significant current in modern Western art from the late nineteenth through the mid-twentieth century, primitivism refers to the use by artists in industrialized and urbanized societies of artefacts from preindustrial societies as sources of innovation. In a larger context, the term also refers to the romanticized Western view of preindustrial societies as supposedly pure, simple, and untouched by modernity. Paul Gauguin was the first major artistic exponent of modernist primitivism, which successively shaped aspects of **Fauvism**, German **Expressionism**, **Cubism**, and **Abstract Expressionism**, among other movements (see Chapters 3, 4, and 12). Western primitivists understood the masks, sculptures, textiles, and other objects made by preindustrial ethnic groups in Africa, the Americas, and Oceania as more instinctual and authentic forms of creation than art governed by the academic conventions of Western illusionism. The primitivists typically ignored the complex ritual and other functions these objects had in their native societies and wrongly considered their makers "savages" rather than skilled artists. Some Europeans also viewed the creations of marginalized people within Western society—children, peasants, **naïve** and **folk artists**, and the mentally ill—as primitive. Primitivists emulated the simple and bold designs produced by these cultural Others in an effort to revitalize their own art and culture.

Primitivism is inextricable from colonialism—the exploration, conquest, and political and economic exploitation of large regions of the world by European countries—which peaked in the late nineteenth and early twentieth centuries (see "Colonialism and Postcolonialism" box, Chapter 18). This system brought artefacts from colonized societies to Europe, making them accessible to European audiences, including artists. The distorted view of colonized people as fundamentally less human and less evolved than the Europeans who dominated them served to justify colonialism and its "civilizing" mission. (This is equally true of the relations between the settler colonialist governments of the United States, Canada, Australia, and New Zealand and the Indigenous peoples they subjugated.) Western primitivist artists' romanticized view of these peoples' art as the instinctive expression of precivilized humans living in a natural state supported the oppressive ideology of colonialism. This is the central contention of the postcolonial critique of primitivism that emerged in the later twentieth century.

At age seventeen, he joined the French merchant marine and sailed around the world for six years. By the mid-1870s, he was married (to the Danish Mette Sophie Gad) and living in Paris, where he worked as a stockbroker. He started painting under Pissarro's mentorship and entered the Impressionists' circle, participating in their last four exhibitions. In 1885, three years after losing his job following a stock market crash, he abandoned his wife and five children to pursue an artistic career.

Gauguin initially went to Brittany to escape the high cost of living in Paris. On his second visit to the region, in August 1888 he painted *Vision after the Sermon: Jacob Wrestling the Angel* (Figure 2.10), which manifests his mature Synthetist style. The painting shows a group of pious Breton women and a tonsured monk (possibly Gauguin's self-portrait) experiencing a vision of the combat between the Hebrew patriarch Jacob and an angel (Genesis 32: 22–32). Gauguin's portrayal of the vision audaciously departs from **naturalism**. He places the figures in a field of unmodulated red and gives them strong contours and mask-like faces, and he denies consistent spatial recession along the picture's left edge by placing an unnaturally small cow beside a much larger kneeling woman. The flat planes of color bounded by heavy outlines recall the lead bars of stained-glass windows and the partitions of **cloisonné enamel** metalwork. These visual features were inspired by Cloisonnism, a novel painting style developed by Gauguin's friend Émile Bernard. Elements of **Japonisme** (see box, Chapter 1) are also evident: Gauguin borrowed the diagonal apple tree from a print by Hokusai (*Plum Estate, Kameido*, 1857) and adapted the figures of Jacob and the angel from Hokusai's images of Japanese wrestlers.

Vision after the Sermon's abstracted style would have seemed outlandish to contemporary viewers accustomed to academic naturalism. Not surprisingly, when Gauguin offered the canvas to two local churches, both declined. Avant-garde critics in Paris, however, quickly recognized the painting as a masterpiece of Symbolism in its use of abstract formal means to express immaterial ideas.[14]

Seeking the ultimate escape from European civilization and the unrelenting financial pressures he experienced, Gauguin sailed to Tahiti in April 1891. As he wrote his wife, he sought to live

> in ecstasy, in peace and for art. With a new family, far from this European struggle for money. . . . in the silence of the lovely tropical night, I can listen to the sweet murmuring music of my heart. . . . Free at last, with no money troubles, and able to love, to sing and to die.[15]

Gauguin, who sailed to Tahiti as a colonist—his passage was paid by the French Colonial Ministry and he carried official letters of authorization and introduction—should not have been surprised to find that its native culture had been transformed by colonial rule and the influence of Christian missionaries. He consciously made paintings to send back to France

FIGURE 2.10 Paul Gauguin, *Vision after the Sermon: Jacob Wrestling the Angel*, 1888. Oil on canvas, 72.2 x 91 cm. National Galleries of Scotland, Edinburgh.

that would appeal to Parisian viewers who wished to imagine Tahiti as an unspoiled paradise. He tried to recapture the island's original spirit by depicting lush and idyllic tropical landscapes. He also created images of languorously beautiful young Tahitian women, including the teenagers he took as wives—a common practice among European men on the island that many twenty-first-century observers view as exploitative. One such painting, *Manao tupapau* (*The Spirit of the Dead Watches*, 1892), represents Gauguin's young wife Tehamana lying naked on her stomach on a bed, her face directed toward the viewer with a frightened expression. At the upper left appears an older, black-cloaked woman in profile, representing the spirit of the dead (a *tupapau*). While this figure might be assumed to cause Tehamana's apprehension, she may express fear of Gauguin himself. In his fictionalized autobiography, *Noa Noa*, he wrote that he entered their house late at night and struck a match and that Tehamana looked at him with fright, perhaps taking him for a *tupapau*. Or maybe she feared Gauguin for what he was—a white, middle-aged male colonialist on whom she was dependent and had little power to resist. Continuing his Synthetist approach, Gauguin adapted *Manao tupapau*'s composition from Manet's *Olympia*. He often based his figures on other artworks, including ancient Egyptian wall reliefs and sculptures from the Indonesian Buddhist Borobudur Temple, both of which he considered primitive.

After an 1893 return to France, where his Tahitian paintings failed to bring him financial success, Gauguin went back to Tahiti in 1895. Two years later—depressed, impoverished, and in declining health from syphilis—he resolved to make a painting summing up his life's work and then to kill himself. The ambitious *Where Do We Come From? What Are We? Where Are We Going?* (1897–98, Figure 2.11) depicts the journey of life in a series of figures, beginning at the right with a sleeping infant and ending at the left with a crouching old woman. The horizontal format and representation of allegorical figures in an arcadian landscape invite comparisons with the work of Puvis, whom Gauguin admired. Numerous figures are reprised from Gauguin's earlier paintings or adopted from other sources. For example, the standing figure of ambiguous gender picking a piece of fruit is derived from a drawing of a male nude then believed to be by Rembrandt, and the pose of the old woman at the left comes from an ancient Peruvian mummy in the Musée de l'Homme in Paris. The abstracted background is animated by the curved rhythms of tree branches. Its cold blues and greens set off the warm hues of the Tahitian bodies in the foreground and are complemented by the areas of chrome yellow at the painting's upper corners.

After recovering from a self-reported failed suicide attempt in February 1898, Gauguin sent *Where Do We Come From?* to Paris for exhibition and explained aspects of its symbolism in letters to friends. Gauguin identified the newborn child as symbolizing the beginning of life[16] and described the old woman on the opposite side as "near death."[17] The white bird at her foot clutching a lizard "represents the uselessness of idle words"; the blue idol in the left background "its arms raised mysteriously and rhythmically, seems to point to the hereafter."[18] Gauguin

FIGURE 2.11 Paul Gauguin, *Where Do We Come From? What Are We? Where Are We Going?* 1897–98. Oil on burlap, 139.1 x 374.6 cm. Museum of Fine Arts, Boston.

described the pair of standing, fully clothed women in the center right background as "two personages who dare to think about their destiny."[19] He also called them "sinister figures . . . [who] converse near the tree of science, their dolorous aspect caused by science itself, in comparison to simple beings in a virgin nature that could be a human concept of paradise [if] they abandoned themselves to the happiness of living."[20]

Calling *Where Do We Come From?* "a philosophical work" on a "theme comparable to the Gospel,"[21] Gauguin suggested that it contained religious significance. The standing fruit-picker alludes to the biblical original sin—Adam and Eve's eating the forbidden fruit in the Garden of Eden. The blue idol is associated with Hina, the Tahitian moon goddess and wife of the creator god Ta'aroa. The idol's form, however, derives from Buddhist prototypes, perhaps inspired by photographs of Borobodur Temple sculptures. The artist's mixture of these references indicates his belief that all religions shared a common truth. This is the basic precept of Theosophy, a system of esoteric thought familiar to Gauguin, which would influence the development of nonrepresentational painting in the early twentieth century (see "Theosophy" box, Chapter 3).

Precursors of Expressionism: Vincent Van Gogh, Edvard Munch, and James Ensor

Elements of Symbolism are evident in many works of the northern European painters Vincent Van Gogh, Edvard Munch, and James Ensor, but these artists are most significant as contributors to the development of **Expressionism**, an important current in early twentieth-century modernism. Expressionist art seeks to communicate and arouse in the viewer strong subjective feelings through distorted, exaggerated, and aggressive or jarring formal elements (see Chapter 3).

Vincent Van Gogh (1853–1890)

Vincent Van Gogh is the archetype of the brilliant, tortured, and misunderstood modern artist: ill at ease in society, passionately devoted to his personal creative vision, and a professional failure during his lifetime but posthumously celebrated as a genius. His short and turbulent life was made more tragic by an undiagnosed psychiatric illness likely exacerbated by alcohol and malnutrition.[22] He suffered mental crises, one of which likely led him to slice off either all or part of his left ear with a razor after a dispute with his friend Gauguin in late December 1888 (though a recently published theory holds that Gauguin may have mutilated Van Gogh's ear with a fencing sword in self-defense during an argument).[23] A few months later, Van Gogh committed himself to a mental asylum; in July 1890, two months after his release, he shot and killed himself.[24]

Relentlessly driven to create, Van Gogh made around 900 paintings and 1,100 drawings during a career lasting only a decade. His mature painting style—featuring bold colors, vigorous brushstrokes, and strongly outlined forms—achieved an unprecedented expressive intensity. His distinctive style strongly influenced many early twentieth-century modernists, including the Fauves and German Expressionists (see Chapter 3).

The eldest son of a protestant minister, Van Gogh grew up in the southern Netherlands. He was apprenticed at sixteen to an international art dealer but was fired. He likewise failed in his work as a Christian lay preacher in an impoverished

coal-mining region in Belgium. Through this experience, however, he discovered his artistic vocation as a painter of peasants, inspired by the example of Jean-François Millet (see Figure 1.2).

Largely self-taught, Van Gogh initially depicted still lifes, landscapes, and rustic figures in the dark, **tonal** style seen in his first major painting, *The Potato Eaters* (1885). The composition, set in a gloomy domestic interior in the artist's native region of Brabant, shows a peasant family gathered around an oil-lamp-lit table, sharing a humble meal of potatoes and coffee. The crudely rendered figures are almost caricatures but retain a sense of dignity, registering Van Gogh's respect for their difficult yet honorable lives.

Hoping to develop as an artist, Van Gogh studied briefly at the Antwerp academy in early 1886 and then moved to Paris to join his brother Theo, an art dealer who would support him financially for the rest of his life. In Paris, Van Gogh met Gauguin, Bernard, Toulouse-Lautrec, Pissarro, Seurat, and other progressive artists. Through them he absorbed the lessons of Impressionism and Neo-Impressionism, lightening his palette and painting with discrete strokes of pure color. But he soon tired of city life and, longing to look at "nature under a brighter sky," moved to Arles in southern France in February 1888.[25]

During his first year there, Van Gogh worked with great speed and intensity, painting orchards, the town and surrounding countryside, self-portraits, portraits of friends, and sunflowers in a vase. While he almost always painted from direct observation, he also sought to convey the emotions his subject aroused in him—an approach characteristic of both Symbolism and Expressionism. "Instead of trying to render exactly what I have before my eyes," he explained in a letter to Theo, "I use color more arbitrarily in order to express myself forcefully."[26]

Nowhere is Van Gogh's expressionistic use of color better seen than in *The Night Café* (1888, Figure 2.12), in which, as the artist wrote, he "tried to express the terrible human passions with the red and the green."[27] The painting depicts the

FIGURE 2.12 Vincent Van Gogh, *The Night Café*, 1888. Oil on canvas, 72.4 x 92.1 cm. Yale University Art Gallery, New Haven, Connecticut.

interior of the Café de la Gare in Arles, above which Van Gogh rented a room. Open all night long, the café was frequented by derelicts and prostitutes. He depicts them slumped over tables against the walls, while the café's owner rises like an apparition behind a billiard table. The rushing perspective lines of the upward-tilting yellow floor create a sense of vertigo exacerbated by the room's acidic colors. Van Gogh wrote:

> I've tried to express the idea that the café is a place where you can ruin yourself, go mad, commit crimes. . . . I tried with contrasts of delicate pink and blood-red and wine-red. Soft Louis XV and Veronese green contrasting with yellow greens and hard blue greens. All of that in an ambience of a hellish furnace, in pale sulphur.[28]

The use of expressive color departs from the Impressionists' attempts to record their optical sensations faithfully, while the nightmarish atmosphere conjured here also contrasts the agreeable images of café life produced by artists such as Renoir (see Figure 1.17).

It was in the asylum in Saint-Rémy that Van Gogh painted his famous *Starry Night* (1889, Figure 2.13), a visionary nocturne based on his view of the predawn sky from his window on June 19, 1889.[29] Foremost in the composition is a cluster of cypress trees rising like flames in the left foreground. Energetically delineated in dark greens, brown, and violet, they are balanced at the upper right by a bright orange crescent moon surrounded by an aura of pale yellow-green. To the left of the moon, ten magnified stars and the planet Venus (just to the right of the cypress trees) blaze in the sky, rendered as an animated field of thick strokes of varying hues of blue. Swirling through the sky is a pair of huge serpentine swaths possibly inspired by scientific illustrations of spiral nebulae. Silvery streaks, perhaps clouds or early dawn light, hug the mountains on the horizon, beneath which nestles a peaceful village dominated by a church.

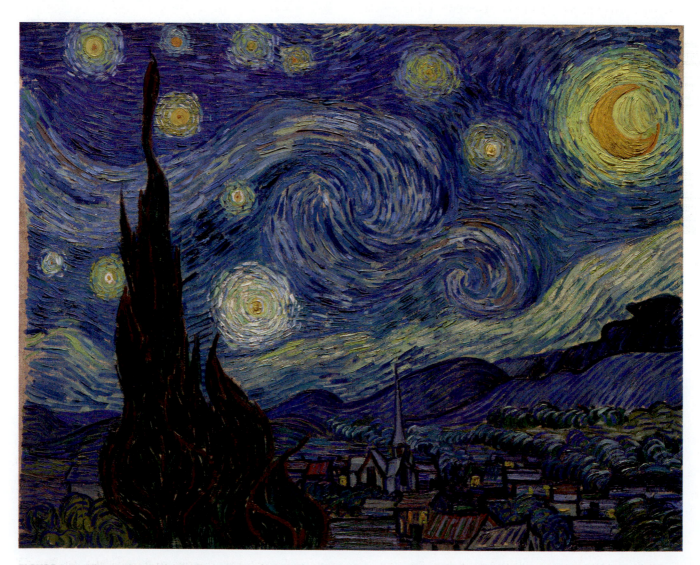

FIGURE 2.13 Vincent Van Gogh, *The Starry Night*, 1889. Oil on canvas, 73.7 x 92.1 cm. The Museum of Modern Art, New York.

Many scholars have interpreted *The Starry Night* as Van Gogh's ecstatic expression of pantheism: the equation of God with the dynamic forces of nature and the universe, with which the artist sought a mystical union. The visual correspondence, yet contrast in size, between the diminutive church spire and the towering cypresses suggests that Van Gogh found greater spiritual comfort in nature than in religion. The cypress tree carries conventional spiritual meaning: an evergreen, it symbolizes eternal life. Van Gogh attributed this same spiritual quality to blue, the painting's dominant color, which evoked for him "the infinite."[30] These interpretations can only be speculative; what is certain is that the painting's exaggerated, stylized forms, bold colors, and thick, emphatic brushstrokes seem charged with vital energy and feeling. Van Gogh masterfully channeled these impulses into a work of art that is at once formally cohesive and rapturously expressive.

Edvard Munch (1863–1944)

The Norwegian painter and printmaker Edvard Munch created highly stylized images evoking acute psychological states, often based on his personal experiences. Tragedy marked his early life: his mother, eldest sister, and brother died from tuberculosis and another sister was declared insane. Munch also suffered from poor health as a child.

Munch's first major painting, *The Sick Child* (1885–86), was inspired by memories of his sister Sophie's death. It shows a pallid blond girl sitting in a large chair and looking at an older woman who kneels next to her with her head bowed in despair. Munch worked on the picture for a year, continually laying on and scratching off thick layers of paint to produce a suggestive, unfinished effect. Because of its departure from the firmly modeled naturalism then characteristic of Norwegian painting, critics condemned *The Sick Child* when he exhibited it in Christiania (now Oslo) in 1886.

Between 1889 and 1892 Munch lived in Paris, where he absorbed aspects of Gauguin's Synthetism. He came to understand painting as a creative **medium** based more on memory and imagination than on direct observation. Moving to Berlin in 1892, where he lived for the next three years, Munch conceived of a series of paintings he called the *Frieze of Life*. In these twenty-two canvases he explored universal human emotions including love, melancholy, jealousy, and anxiety—common themes in Symbolist art.

Anxiety is the subject of Munch's most famous composition, *The Scream* (1893, Figure 2.14), which he painted in several versions and also rendered in a lithograph. Munch based the picture on an experience he had earlier in Norway:

I was walking along the road with two of my friends. The sun set. The sky became a bloody red. And I felt a touch of melancholy. I stood still, dead tired. Over the

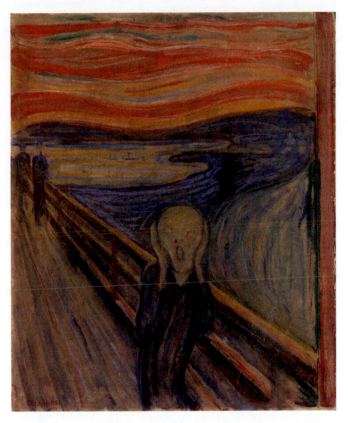

FIGURE 2.14 Edvard Munch, *The Scream*, 1893. Oil, pastel, and casein on cardboard, 91 x 73.5 cm. Nasjonalgalleriet, Oslo.

blue-black fjord and city hung blood and tongues of fire. My friends walked on. I stayed behind, trembling with fright. I felt the great scream in nature.[31]

In this unforgettable image, an audaciously abstracted writhing figure of ambiguous gender with a skull-like head and panicked, open-mouthed expression stands on a bridge. The figure covers its ears against the "scream in nature" rendered as flowing waves of color: cold blue in the water and lurid reds and yellows in the sky. With its back turned on the other pedestrians and the distant church on the right horizon, the terrified protagonist embodies the modern condition as defined by existentialist philosophers: the human being alone in the world, bereft of the certainties previously offered by religion, and wracked by anguish and dread.

James Ensor (1860–1949)

James Ensor studied for two years at Brussels's Royal Academy of Fine Arts before returning to his coastal hometown of Ostend. He continued his artistic education by studying Netherlandish **Old Masters** such as Hieronymus Bosch and Pieter Bruegel and by copying the etchings of Rembrandt and Goya. In 1883, he cofounded Les XX (*Les Vingt*, "the twenty"), an avant-garde artists' association that held annual exhibitions in Brussels in opposition to the official Salon. Les XX

invited progressive foreign artists to exhibit with the group, including Monet, Pissarro, Seurat, Gauguin, Van Gogh, and Toulouse-Lautrec.

After spending the early 1880s painting intimate scenes of domestic interiors in a muted Impressionist manner, Ensor developed a harsher, more expressive style with brash colors and coarse brushwork. Like Bosch, he often conveyed a bitterly critical view of human vice, folly, and stupidity. He emphasized these qualities by depicting figures wearing grotesque masks inspired by those worn during Mardi Gras.

Ensor expressed his negative opinion of contemporary Belgian society's dominant institutions—business, the government, the military, and the Catholic Church—in *Christ's Entry into Brussels in 1889* (1888, Figure 2.15). The enormous picture reimagines Christ's triumphant entry into Jerusalem as a tumultuous Mardi Gras procession in the Belgian capital. The small figure of the haloed Christ, riding on a donkey in the central **middle ground**, is largely ignored by the crowd that surges into the foreground. Led by a buffoonish bishop, these monstrously masked and caricatured figures represent capitalist elites and the nation's military, political, and religious authorities.[32] Stretching over the scene is a banner reading "Vive la Sociale" ("Long Live the Social," i.e., socialism). Provocatively, Ensor gives Christ his own features, identifying with him as a persecuted redeemer.

Likely painted as an angry reaction to *La Grande Jatte*, shown at the 1887 exhibition of Les XX, Ensor's picture rejects Seurat's vision of harmonious social order. The Belgian artist instead envisions his contemporaries as a rowdy, masked mob, crudely delineated through discordant colors of thick, roughly applied paint. Like much Post-Impressionist and Symbolist art, the painting makes no clear political statement, but it may be plausibly read as endorsing the Belgian socialists' equation of their cause with that of Christ—the savior of the poor and downtrodden—in opposition to the right-wing Catholic government that had suppressed recent workers' strikes.

Late Nineteenth-Century Modern Sculpture in France

For much of the nineteenth century, sculpture in Europe and North America lagged behind painting in achieving a truly modern language of expression. In France, academically trained sculptors generally worked in a style influenced by **Neoclassicism**. They sculpted commissioned portrait busts or statues based on mythology, the Bible, history, or literature for submission to the annual Salon. These sculptures were judged less for their aesthetic originality than for their ability to tell a good

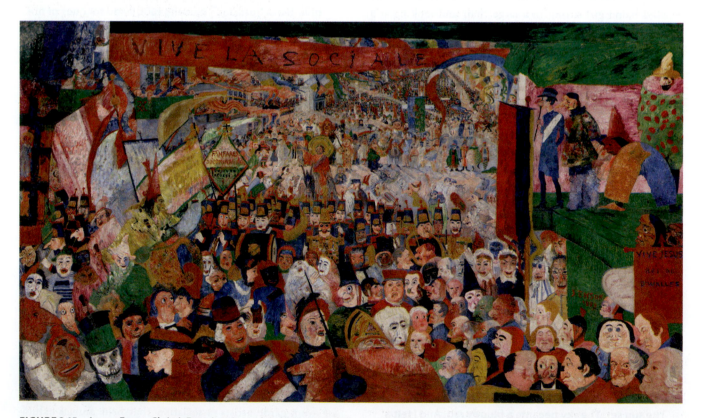

FIGURE 2.15 James Ensor, *Christ's Entry into Brussels in 1889*, 1888. Oil on canvas, 252.7 × 430.5 cm. The J. Paul Getty Museum, Los Angeles.

story or deliver an edifying moral or patriotic message. The most successful sculptors obtained government commissions for statues or monuments that celebrated heroes or historical events and were placed in public squares or parks. Men dominated the profession, largely because conventional thinking about proper gender roles held that the physically demanding and dirty work of making sculpture was less suitable to women than were the more refined arts of drawing and painting.

Auguste Rodin (1840–1917)

Auguste Rodin was the pioneer of sculpture as a vital medium of modern expression. Like his contemporaries, the Impressionists, he was committed to working from nature, which for him meant direct observation of the human model. He was capable of rendering extremely lifelike figures, but he pushed beyond anatomical accuracy to heighten his figures' expressiveness, introducing innovations that profoundly affected modernist sculpture in the twentieth century.

Rodin revealed his creative process through his active handling of clay (subsequently cast in plaster and then bronze) without regard for strict anatomical fidelity. He also gave his figures exceptionally dramatic or contorted poses and exaggerated or simplified anatomical features, all for expressive purposes. Even more revolutionary were his reuse and recombination of sculpted figures and body parts in different compositions and his acceptance of the aesthetic value of accidents and fragmentation. These innovations underscored the independence of Rodin's artistic creation from the imitation of nature—a key feature of modernism.

Born in Paris to a working-class family, Rodin was educated at a design school, where he learned drawing and **modeling**. He failed to gain admittance to the École des Beaux-Arts three times and instead worked as an artisan for jewelers, architectural decorators, and other sculptors until the early 1880s. After moving to Belgium in 1871, he began exhibiting small-scale works, including portrait busts.

While visiting Italy in 1875, Rodin saw Michelangelo's and Donatello's works. This inspired him to complete his first major sculpture the next year: a life-size standing male nude for which a Belgian soldier served as the model (1875–77, Figure 2.16). The lifelike figure stands with his head tilted back, eyes closed, and right arm raised with the hand resting on the head—a pose adapted from Michelangelo's famous *Dying Slave*. The figure's left hand originally held a spear, which Rodin removed before completing the sculpture.

The tradition of the male nude sculpture representing a god, ruler, or symbolic meaning (as an allegory) dates to ancient Greece and remained prominent in nineteenth-century French academic art. Rodin seems initially to have meant his figure—which would have been identified as a soldier through the spear—to symbolize France's recent defeat by the

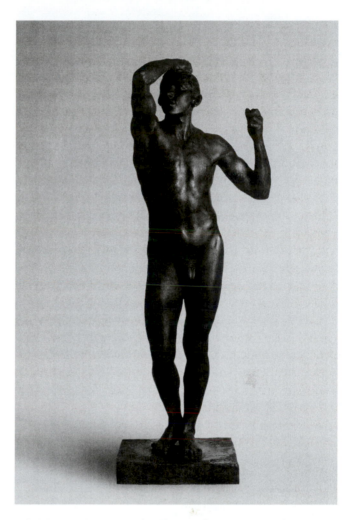

FIGURE 2.16 Auguste Rodin, *The Age of Bronze*, 1875–77. Bronze, 181.6 x 54 x 64.8 cm. Musée des Beaux-Arts, Lyon, France.

Prussians; he exhibited it in Brussels in January 1877 under the title *The Vanquished*. However, when he showed it at the Paris Salon later that year, he called it *The Age of Bronze*. This new title came from the ancient Greek poet Hesiod's conception of five periods of human history. The Bronze Age, marked by war and destruction, represented a decline from the peaceful and harmonious Gold and Silver ages that preceded it.

Because Rodin's figure held no attributes, or objects that would fix its identity or symbolic meaning, the artist could freely change its title and viewers could interpret it in different ways. This ambiguity—a feature central to Symbolist art and characteristic of modernist art in general—puzzled critics. Some of them also suggested that Rodin had cast parts of the sculpture directly from the model's body to achieve its realistic quality. Infuriated, Rodin made his next major figure, the striding nude *Saint John the Baptist* (1878–80), slightly larger than life-size to defeat any suggestion that it could have been cast from life.

In 1880, the French government commissioned Rodin to create a set of bronze doors for a new museum of **decorative arts** (*The Gates of Hell*, 1880–1917, Figure 2.17). He covered

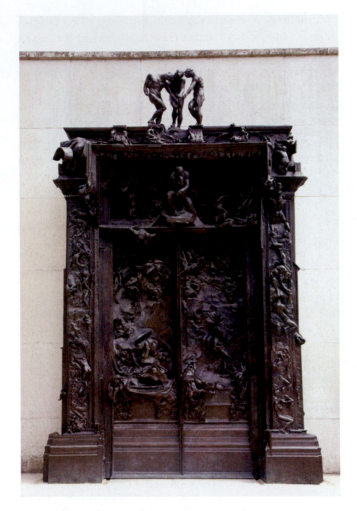

FIGURE 2.17 Auguste Rodin, *The Gates of Hell*, 1880–1917. Bronze, 635 x 400 x 85 cm. Musée Rodin, Paris.

structures of church or state, they have no goals, only restless passions. Unlike the damned souls Dante encounters in the *Inferno*, who serve as moral warnings within a religious allegory, Rodin's figures endure a modern despair drained of spiritual meaning.[33]

Although Rodin devoted intense effort to the *Gates* during the 1880s, the museum for which it was commissioned was not built and he left the *Gates* unfinished; they were cast in bronze only after his death. However, he developed many of the figures conceived for the *Gates* into independent sculptures, including his famous *Thinker*. Seated on the **lintel** in the *Gates of Hell*, this figure alludes to Dante brooding over the tormented souls surrounding him. Extracted from the *Gates*, the powerfully athletic *Thinker*—with his straining muscles and twisted pose (right elbow planted on his left knee)—becomes the anonymous embodiment of thought expressed as physical effort.

Standing atop *The Gates of Hell* are *The Three Shades*, figures of dead souls. These exemplify how Rodin reused sculpted figures in different compositions and his acceptance of anatomical fragmentation in a finished sculpture. *The Three Shades* comprise three identical casts of the same figure—adapted from the artist's Michelangelesque *Adam* (1880–81)—placed at different angles to form a triad. The shades lack right hands and their left hands are lumpy masses without fingers. Rodin omitted these features because he felt that the shades' descending arms, combined with their bent torsos and downward-craned heads, fully expressed their dejected state. In other instances, he presented as complete sculptures bodies that lacked heads and some or all of their limbs (e.g., *The Walking Man* and *Iris, Messenger of the Gods*). This inspired the modernist tradition of the partial figure as a self-sufficient and aesthetically complete expressive form.

Alongside his work on *The Gates of Hell*, Rodin received a commission in 1884 from the city of Calais for a monument to its six heroic citizens, or burghers. In 1347, they had surrendered themselves as hostages to England's King Edward III in return for his ending the siege of their city. These men expected to be executed by the English, but their lives were spared by Edward's wife, Queen Philippa. Though he initially placed the burghers atop a triumphal arch in the monument's first **maquette**, Rodin subsequently proposed to render them as a procession of separate life-size figures placed directly at street level. They would thus function, he said, "like a living chaplet [rosary] of suffering and sacrifice" with whom Calais citizens could interact and identify, feeling more deeply "the tradition of solidarity which unites them to these heroes."[34] His desire to situate his works in the same "real" space, both physical and psychological, as the viewer foreshadowed modernist innovations of the twentieth century (see Figures 16.10, 16.13, and 16.14). The Calais municipal council rejected this proposal; they could not accept its radical denial of the

the doors with numerous small figures representing subjects from Dante's *Inferno* (the first part of the medieval Italian poet's epic, *The Divine Comedy*). In the poem, the ancient Roman poet Virgil leads Dante through the nine circles of hell, eight of which are dedicated to the eternal punishment of those guilty of a particular sin. Rodin's conception of this subject was likely influenced by his reading of Baudelaire's *Les Fleurs du mal*, which emphasizes suffering, isolation, and unfulfilled desire as central to the modern human condition.

Rodin initially modeled his portal on the famous Italian Renaissance example of Lorenzo Ghiberti's *Gates of Paradise* (1425–52), a pair of gilt bronze doors featuring narrative episodes from the Bible contained within large rectangular panels. Rodin ultimately decided against confining his figures within panels; instead, he spread them all over the vast portal, liberating their bodies from the effects of gravity. Approximately 180 figures emerge from and recede into the molten matrix of the two main vertical segments, crowd into the rectangular **tympanum** above, and rise and tumble along the architectural frame. Separated from family and society, bereft of the stabilizing

convention that a sculpted figure should be separated from the viewer on a pedestal.

In the final version of *The Burghers of Calais* (1884–89, Figure 2.18), Rodin presented the six life-size figures together on a low slab-like base. Barefoot and clad in sackcloth, some with rope halters around their necks, each burgher adopts a different dramatic pose conveying a range of psychological states, from stoic determination to doubt to anguish. Rodin heightens the figures' emotional power through their vigorously modeled faces with deeply hollowed eyes and their enlarged hands and feet—expressive anatomical exaggerations similar to those employed by painters like Munch. He also recycles body parts within the group, using the same head for two burghers (with a beard added in one case) and the same cast hand attached to several different arms.

Despite these repetitions, Rodin's unconventional composition emphasizes each burgher's individuality. They cannot all be viewed from a single Vantage point but are seen individually or in pairs or triads as the viewer walks around the sculpture. Rather than moving bravely and resolutely in unison toward their fate, Rodin's burghers turn and gesture in different directions, all too human in their responses to their anticipated deaths. The monument's lack of conventional heroism disappointed the Calais municipal council. The council retaliated by installing the work in the public garden on a high pedestal surrounded by a fence, rather than, as Rodin had envisioned, in front of the Town Hall on a low base, directly accessible to the citizenry. Only seven years after his death was it moved to the location he intended for it.

Even more controversial than *The Burghers of Calais* was Rodin's *Monument to Balzac* (1897–98), a portrait of the great French novelist commissioned in 1891 by the Société des Gens de Lettres (Society of Writers). Rodin portrayed Balzac as a massive backward-leaning standing figure. His great leonine head, roughly modeled with disheveled hair and simplified features, emerges from his loose-fitting robe. The monument's 2.7-meter-tall plaster version caused an uproar at the 1898 Salon, with hostile critics comparing it to a penguin, a snowman, a sack of coal, and a side of beef. Rodin defended his portrait as an attempt to "render in sculpture what was not photographic. . . . to imitate not only form but also life" by "exaggerating the holes and lumps."[35] Through these exaggerations and by emphasizing the figure's bulk, erect pose, and proud head, he created an abstracted icon of the author as a virile and visionary genius, aloof and towering above the crowd. The originality of Rodin's vision, however, conflicted with the public's conservative expectations of monumental sculpture, and the *Balzac* was never cast in bronze during his lifetime.

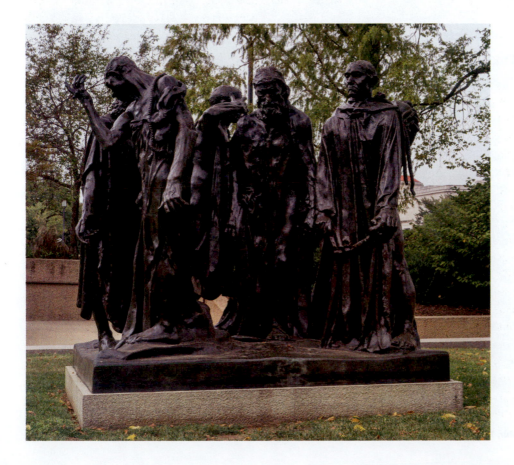

FIGURE 2.18 Auguste Rodin, *The Burghers of Calais*, 1884–89. Bronze, 201.6 x 205.4 x 195.9 cm. Hirshhorn Museum and Sculpture Garden, Washington, DC.

Camille Claudel (1864–1943)

Camille Claudel was among the few women to achieve success in the male-dominated profession of sculpture in late nineteenth-century France. She studied at the Académie Colarossi in Paris and by 1884 had become a studio assistant to Rodin. In addition to modeling for and collaborating with him, she became his mistress. After their break in 1893, Claudel became increasingly alienated from society and was finally overwhelmed by mental illness; she spent the last thirty years of her life in an asylum.

Claudel's most ambitious work, *L'Âge Mûr* (*Maturity*, 1895–99, Figure 2.19), modeled in a Rodinesque style, illustrates the theme of destiny through three allegorical figures. At the right, a woman on her knees, representing Youth, reaches toward an aging man with sagging flesh, symbolizing Maturity. While Youth implores him to stay with her, Maturity is led away by a haggard old woman personifying Old Age. Claudel masterfully integrates the three figures into a unified narrative by arranging them in a composition that ascends diagonally from right to left. The sense of leftward movement—symbolizing the inexorable pull of destiny—is reinforced by the cresting wave at the left edge of the base and by the wavelike mass of drapery that billows up behind Old Age.

Originally commissioned by the state, *L'Âge Mûr* was exhibited in plaster at the 1899 Salon of the Société Nationale des Beaux-Arts. For unknown reasons, the state's order for a bronze was subsequently cancelled, and the sculpture was instead cast for a private client in 1902. Eighty years later, the French government acquired it for the Musée d'Orsay in Paris.

Medardo Rosso (1858–1928)

Less famous than Rodin but an equally radical sculptural innovator, Turin-born Medardo Rosso reached artistic maturity in Milan in the early 1880s and moved to Paris in 1889. He reacted against the classical conception of sculpture as a discrete object separate from the surrounding environment. In figurative works such as *Aetas Aurea: L'Age d'Or* (*The Golden Age*, 1884–85)—a small bust-length relief of a mother kissing a child—he created loosely modeled and blurred sculptural

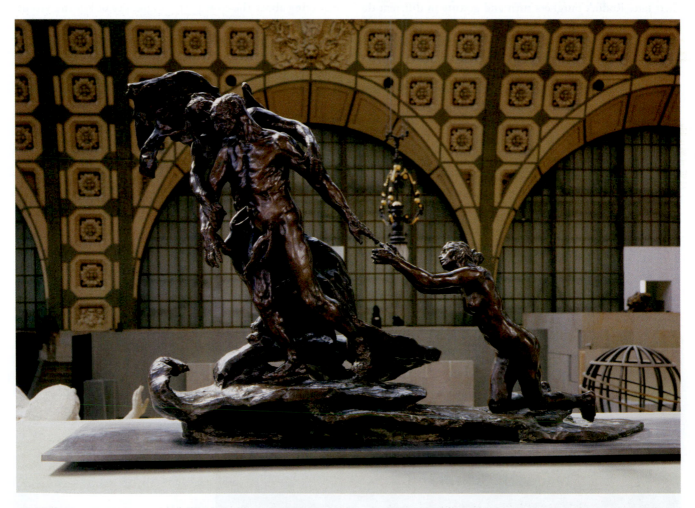

FIGURE 2.19 Camille Claudel, *L'Âge Mûr*, 1895–99 (cast c. 1902). Bronze group in three parts, 114 x 163 x 72 cm. Musée d'Orsay, Paris.

forms that suggest bodies dissolving in light and atmosphere. He favored working in wax (over a plaster core). This soft, translucent medium allowed him to create subtle transitions between forms and to suggest fleeting movement and changes in light and color, leading critics to label him an Impressionist sculptor.

Unlike Rodin, who knew and admired Rosso's work, the Italian did not create monumental sculptures with tragic or heroic subject matter. Instead he represented small-scale, everyday motifs, such as the heads of laughing children. His sculptures often possess a quality of domestic intimacy similar to that seen in the paintings of Édouard Vuillard and Pierre Bonnard.

The Nabis

Édouard Vuillard and Pierre Bonnard were the two most successful members of the **Nabis** (Hebrew for "prophets"). They came together in Paris in 1889 as a secret brotherhood of young art students who rebelled against the academic style of illusionism. The group's esoteric name was based on the spiritual interests of its founder, Paul Sérusier (1864–1927), who believed they were the prophets of a renewed art. Sérusier met Gauguin in the summer of 1888 at Pont-Aven in Brittany. Under Gauguin's direction, he painted a highly abstracted landscape on a cigar-box lid, translating the forms of nature into rough patches of flat, anti-naturalistic color squeezed straight from the tube. This small picture acquired the name *The Talisman* (1888), suggesting the almost mystical powers that Sérusier and his colleagues found in it.

While the Nabis did not develop a group style, they shared an interest in decoration—a word that in French (*décoration*) has complex and positive meanings beyond its usual definition as "superficial ornament." They rejected the Renaissance conventions of linear perspective and modeling that create the illusion of depth behind the picture plane. Instead, in the famous words of member Maurice Denis, the Nabis understood that "a picture—before being a warhorse, a female nude, or some anecdote—is essentially a flat surface covered with colors assembled in a particular order."[36]

Like the members of the earlier English **Arts and Crafts Movement** and the contemporaneous Art Nouveau (see Chapter 5), the Nabis emphasized continuity between the realms of art and design. They engaged in collaborative decorative projects ranging from architectural painting to the production of illustrations, posters, wallpaper, textiles, ceramics, and stained glass, as well as set designs for Symbolist theatrical productions.

Édouard Vuillard (1868–1940) and Pierre Bonnard (1867–1947)

Less mystically inclined than Sérusier and Denis, close friends Édouard Vuillard and Pierre Bonnard made small-scale paintings of tranquil everyday life in domestic interiors during the 1890s. While Impressionists such as Degas, Caillebotte, Morisot, and Cassatt painted similar subjects, Vuillard's and Bonnard's *intimiste* interiors (as they came to be known) seem to harbor private emotional and psychological complexities lying beneath surface appearances, giving them a Symbolist quality.

Characteristic of *intimisme* is Vuillard's *Woman in Blue with Child* (c. 1899, Figure 2.20), depicting a room in the Paris apartment of his friends and patrons Thadée and Misia Natanson. The

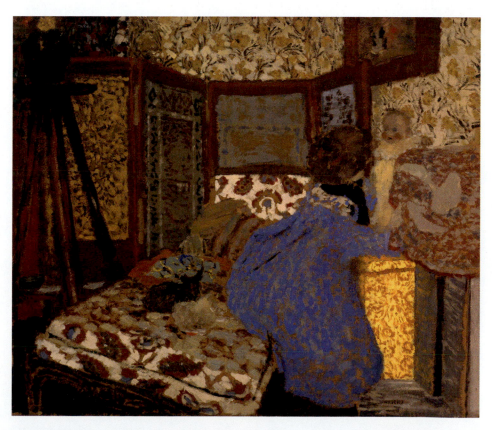

FIGURE 2.20 Édouard Vuillard, *Woman in Blue with Child*, c. 1899. Oil on compressed card, 48.6 x 56.5 cm. Kelvingrove Art Gallery and Museum, Glasgow.

painting shows Misia holding her niece, but the figures are difficult to see amidst the patterns that cover nearly every surface in the room (e.g., the chaise longue, wallpaper, folding screen, and golden yellow chest). The artist creates a flat, decorative effect through these dense and competing patterns as well as through textured brushwork and the denial of consistent perspective. The chaise longue, for example, fails to recede convincingly into depth because its front edge leans diagonally toward the viewer whereas its back appears parallel to the back wall. Intended to hang in a room of the Natansons' apartment, which was covered floor-to-ceiling with floral-patterned wallpaper, the painting served as one element in a total decorative environment designed to beautify the family's daily lives. Vuillard also painted larger decorative panels for the Natansons and other patrons.

Pierre Bonnard painted *intimiste* pictures similar to Vuillard's in the 1890s and also made posters, prints, and book illustrations. After the Nabis disbanded at the turn of the century, his paintings grew larger and more spatially complex and his colors more lush and luminous. His later works show his awareness of the Fauves' use of arbitrary, expressive color (see Chapter 3) and of the Cubists' dismantling of Renaissance perspective (see Chapter 4), but retain his own distinctive sensibility. His dining-room scenes (of which he painted over sixty between 1927 and 1947) often feature a view across a table and through a window to an exterior garden or landscape, such as *Dining Room on the Garden* (1934–35). They are masterpieces of loosely brushed, sensuous color vibrating within complex compositional patterns, as well as grand celebrations of the simple joys of domesticity.

Expressionism in France, Germany, and Austria

This chapter surveys the work of Expressionist painters and sculptors in France, Germany, and Austria from c. 1900 to the time of World War I. All art is expressive to the degree that it seeks to communicate ideas and feelings through both subject matter (in the case of representational art) and visual form. Expressionism, however, emphasizes the artist's subjective thoughts and emotions. It marks a departure from realism, involving exaggerations and distortions of line, shape, form, space, color, and texture.

Historically, Expressionism, which came into use as a term in Germany around 1910, arose as a reaction against both academic illusionism and Impressionism. Rather than seeking merely to render external appearances of people, places, or things, Expressionists used abstracted imagery to communicate subjective feelings, psychological states, and spiritual concerns. Such aims had already been pursued by late nineteenth-century Northern European painters like Van Gogh, Munch, and Ensor, who are the immediate forerunners of early twentieth-century Expressionism (see Chapter 2). The expressionist impulse eventually led to purely nonrepresentational art that sought to convey meaning through formal elements considered expressive in and of themselves. Critics used the term "expressionism" to refer not only to progressive German and Central European art (as the term has more narrowly come to be defined), but also to the contemporaneous modern French art, like that of Henri Matisse or Pablo Picasso, which Roger Fry called Post-Impressionist.

Expressionist painters in early twentieth-century France depicted conventional subjects such as landscapes, portraits, nudes, and still lifes and aimed to convey feeling not primarily through subject matter but through pictorial form. Henri Matisse, the leading artist of French Expressionism, explained this approach when he wrote in 1908, "Expression, for me, does not reside in passion bursting from a human face or manifested by violent movement. The entire arrangement of my picture is expressive, the place occupied by the figures, the empty spaces around them, the proportions. . . . Composition is the art of arranging in a decorative manner the diverse elements at the painter's command to express his feelings."[1]

By contrast, many German Expressionists tried to reveal powerful emotions not only through formal means but also through dramatic or psychologically charged subject matter. In a spirit of German nationalism, these artists drew on the late medieval Northern European Gothic tradition that eschews rationality and emphasizes intense spirituality, epitomized visually in German artist Matthias Grünewald's *Isenheim Altarpiece* (1512–16) , which gruesomely centers on the dead Christ. This northern tradition's grisly imagery was intended to evoke an emotional response from the viewer, also German Expressionism's central goal.

The history of French Expressionism centers on Matisse and other artists in his circle known as the Fauves, meaning "wild beasts" (c. 1904–07) because of their use of bright, anti-naturalistic colors and bold, gestural brushwork that conservative viewers saw as visually aggressive or even violent. Chronologically paralleling Fauvism was the German artists' group Die Brücke (The Bridge), formed in Dresden in 1905 and counting Ernst Ludwig Kirchner as a prominent

member. The Brücke artists used strong, arbitrary colors like the Fauves, but also employed sharp, angular forms that gave their pictures a harsh and anxious expressive quality. A third Expressionist group known as Der Blaue Reiter (The Blue Rider) formed in Munich in 1911 around the painters Vasily Kandinsky and Franz Marc. Opposed to what they saw as their age's excessive materialism, these artists used prismatic colors and abstracted forms to express spiritual values. This chapter considers the major artists associated with these three groups as well as their independent contemporaries, including in Austria. Expressionist architecture is discussed in Chapter 17.

Fauvism

Fauvism denotes a **style** of representational painting made in France from 1904 to 1907, characterized by effusive, anti-**naturalistic** colors, often applied unmixed straight from the tube in thick, discrete strokes or as broader planes. The pioneers of this style, Matisse, André Derain, and Maurice de Vlaminck extended the technical and **formal** innovations of the **Neo-Impressionists**, Van Gogh, and Gauguin. They did so to heighten the sense of their paintings as flat surfaces covered with colors intended to communicate the artist's emotions as much as to render an observed subject. Other artists associated with Fauvism include Georges Braque (better known as an innovator of **Cubism**, see Chapter 4), Charles Camoin, Émilie Charmy, Kees Van Dongen, Raoul Dufy, Othon Friesz, Henri-Charles Manguin, Albert Marquet, Jean Puy, Georges Rouault, and Louis Valtat.

The critic Louis Vauxcelles gave Fauvism its name in a review of the 1905 Salon d'Automne (Autumn Salon). This Salon featured the violently colored and roughly executed paintings of Matisse, Derain, Vlaminck, and others in a gallery at the center of which was displayed an Italian **Renaissance**-style sculpture by Albert Marque, which Vauxcelles wittily described as "Donatello chez les fauves" (Donatello in the home of the wild beasts).[2] The painters soon accepted the name as appropriate to their spontaneous and instinctive expression and use of pure color. Years later, Derain suggested that Fauvism might have been a reaction against the imitation of nature made possible by photography: "Colors became charges of dynamite. They were expected to discharge light. It was a fine idea, in its freshness, that everything could be raised above the real."[3]

The Fauvism of Henri Matisse (1869–1954)

Several years older than the other Fauves, Henri Matisse was the group's acknowledged leader, who, after his brief Fauve period, went on to become one of the twentieth century's most famous and influential modern artists. During the 1890s, he studied in Paris under several teachers including Gustave Moreau (see Figure 2.7), who encouraged his students to develop independent forms of expression. Matisse experimented with diverse styles before adopting the vivid **palette** and divided stroke of Neo-Impressionism after a 1904 summer on the southeast coast of France, inspired by the bright Mediterranean light and the encouragement of his neighbor Paul Signac, Neo-Impressionism's leader.

Back in Paris, Matisse exhibited *Luxe, calme, et volupté* (*Luxury, Calm, and Voluptuousness*, 1904–05) at the 1905 Salon des Indépendants—an unjuried spring exhibition established in 1884 as an alternative to the official **Salon**. His picture, painted in a simplified Neo-Impressionist style, using short brick-like brushstrokes of brilliant color set off by areas of white primed canvas, was praised by critics and purchased by Signac. The painting's five nude female bathers, who accompany the foreground figures of Matisse's wife and son, were perhaps inspired by Cézanne's paintings of bathers (see Figure 2.6), an example of which Matisse owned. Matisse quickly moved beyond Neo-Impressionism, however, to develop his Fauve style in summer 1905, working alongside Derain in the Mediterranean fishing village of Collioure in southern France. There, Matisse painted *Open Window, Collioure* (Figure 3.1), a small picture now recognized as an icon of early twentieth-century **modernist** painting.

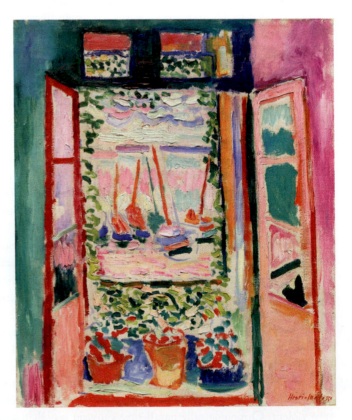

FIGURE 3.1 Henri Matisse, *Open Window, Collioure*, 1905. Oil on canvas, 55.3 x 46 cm. National Gallery of Art, Washington, DC.

In *Open Window*, Matisse renders a scene in nature—a view through a window—and experiments formally with pure color, color relationships, and diverse methods of paint application. Rejecting conventional **chiaroscuro**—**modeling** through light and dark—he gives the room's interior the same intensity of color and light as that filling the outdoors but distinguishes these two spaces through varied **brushwork**. For the interior walls and window casements, he uses flat planes of roughly applied color. He paints the elements beyond the window—flowers, balcony railing, an ivy garland, water, boats, and sky—through short, thick dabs and broader bands of color with bare patches of white primed canvas in between. Matisse also repeats identical colors in different areas to unify the **composition**, and he juxtaposes **complementary colors** to heighten their contrast and visual impact. This is seen, for example, in the complementary colors of blue-greens in the walls set next to reds and pink-oranges in the window casements.

By choosing an open window as his subject, Matisse invited comparison to the Renaissance conception of a painting as an imaginary window onto an **illusionistic** world of solid bodies and objects set in receding space (see Figure I.1). Contrary to this tradition, Matisse's style makes us aware that *Open Window* is primarily an artistic construct—a flat surface covered with beautifully orchestrated colors rather than a transparent window. In this sense, the small but revolutionary canvas marks an important step toward **abstract** painting, in which formal elements become meaningful in themselves, independent of any visual relationship to the world outside the work.

After his summer in Collioure, Matisse began work on his most ambitious painting to date, *Le Bonheur de vivre ("The Joy of Life,"* 1905–06, Figure 3.2).[4] The nearly three-meter-wide canvas depicts a utopian world in which multiple nude figures unselfconsciously enjoy sensual pleasures, including dancing, music, and lovemaking, within the embrace of nature. Serenely detached from the realities of ever-increasing industrialization, urbanization, and technological development then transforming French life, this subject is rooted in the **pastoral** tradition of

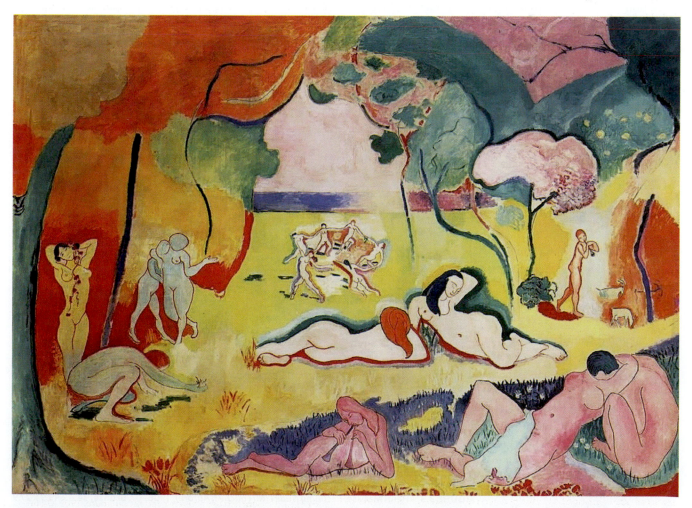

FIGURE 3.2 Henri Matisse, *Le Bonheur de vivre ("The Joy of Life"),* 1905–06. Oil on canvas, 176.5 x 240.7 cm. Barnes Foundation, Philadelphia.

European painting inaugurated by the early sixteenth-century Venetian masters Giovanni Bellini, Giorgione, and Titian. That tradition was carried on in the seventeenth century by the French painters Nicolas Poussin and Claude Lorrain and given an exotic, **primitivist** cast by Gauguin in the late nineteenth century (see Figure 2.11). Matisse radically revises this time-honored theme, however, by means of bold, anti-naturalistic colors, flattened space, simplified drawing, distorted anatomies, and rapid shifts in scale.

In this painting, Matisse renders the foliage in the picture's upper half through freely brushed patches and bands of bright, arbitrary colors, including red, green, pink, and purple. The canopy of trees opens to frame a pink sky above an azure strip of sea and a lemon-yellow field that extends into the picture's lower half. Snaking through the foliage are thin, curving tree trunks reminiscent of the undulating lines of **Art Nouveau** (see Figure 5.5). Sinuous outlines also define the sixteen nudes in the picture's lower zone. Matisse simplifies, flattens, and distorts their anatomies and creates surprising discrepancies of scale between some of them: the pair of reclining women in the center **middle ground** seems too large in relation to the **background** ring of female dancers directly above. Such shifts disrupt any sense of consistent **perspective**, while the sumptuous, flat colors also deny spatial recession. The composition reads essentially as a patterned surface, with the decorative quality that Matisse would refine in *Dance (II)* (discussed below).

Exhibited in the 1906 Salon des Indépendants, *Le Bonheur de vivre*'s audacious formal innovations upset many viewers, including Signac, who complained that Matisse had "gone to the dogs."[5] After some hesitation, the expatriate American collector Leo Stein bought the work and hung it in the apartment he shared with his sister Gertrude, an innovative modernist writer. There, the young Picasso, the Steins' frequent guest, saw the newly acquired painting. The next year he undertook his own, even more shockingly original, large multifigure composition, *Les Demoiselles d'Avignon* (see Figure 4.3)—discordant rather than idyllic—in evident competition with Matisse for leadership of the Parisian **avant-garde**.

By 1906, Matisse, Derain, and Vlaminck had begun to collect African art, which they encountered in curio shops and the Trocadéro Ethnographic Museum in Paris, after this art had entered France largely through that nation's colonial conquest of African countries. As modernist primitivists (see "Primitivism" box, Chapter 2), the Fauves ignored the complex roles that such artworks played in the social, political, and religious life of the societies that produced them. The Europeans admired these objects primarily for their abstract formal qualities, which offered a powerful alternative to **academic** realism. They were particularly drawn to African figurative sculptures, which, according to Matisse, were "made in terms of their material, according to invented planes and proportions," in contrast to European figurative sculpture that "took its point of departure from musculature."[6]

Matisse responded to African art by following its example of simplified anatomy and expressive distortions, features seen in two works of 1906–07, a small sculpture, *Reclining Nude I (Nu couché I, Aurore*, Figure 3.3), and a related large painting, *Blue Nude: Souvenir of Biskra* (1907). Matisse often made sculptures to help him clarify his ideas for paintings. The pose of *Reclining Nude I*, with the torso supported by the right arm bent at the elbow and the left arm lifted over the head, derives from the figure at the right center of *Le Bonheur de vivre*. The sculpted figure, its swelling **volumes** realized through roughly modeled clay, has bulbous breasts and exaggerated buttocks recalling similar features in African sculptures of female figures. Its pose is more dynamic than that of its counterpart in *Le Bonheur de*

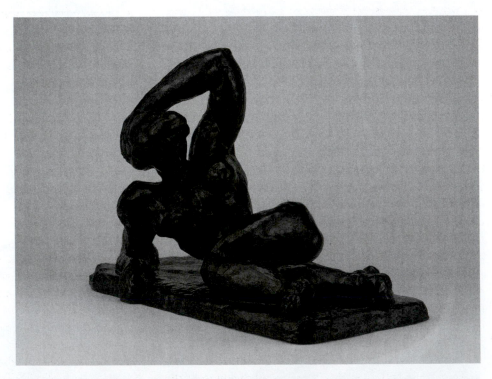

FIGURE 3.3 Henri Matisse, *Reclining Nude I (Nu couché I, Aurore)*, 1906–07. Bronze, 34.4 x 49.9 x 27.9 cm. Baltimore Museum of Art.

vivre, with the torso twisted and the left hip and left elbow thrust upward to create vertical accents in tension with the body's overall horizontal orientation.

Matisse gave the same pose and proportions to his *Blue Nude*, a late Fauve painting whose title calls attention to the assertive use of blue to outline and create shadows around the figure and to model parts of her body and mask-like face. The painting's subtitle, *Souvenir of Biskra*, refers to a desert oasis that Matisse visited on a 1906 trip to Algeria, then a French colony. He places his nude in an outdoor setting defined by green grasses, flowers, and background palm trees. The curving branches of one palm tree correspond to the curves of the nude's hip and right thigh, identifying her with fertile nature. Matisse's image of a reclining nude in a North African setting relates to the artistic tradition of the **odalisque**, a female slave or concubine in a Muslim harem, famously rendered a century earlier by Ingres (see Figure I.11) and by many subsequent European artists. The odalisque appealed to European viewers' fantasies of sexually available "oriental" women. *Blue Nude* does not fit easily into this tradition, however, due to the figure's aggressive pose and expressionless face. Hardly erotic in any conventional sense, it was considered ugly by many who saw it at the 1907 Salon des Indépendants and again at the New York Armory Show of 1913 (see Chapter 10).

Matisse after Fauvism

By 1908, Matisse had abandoned his Fauve style's violent formal qualities while retaining its intense colors. In "Notes of a Painter," an important statement he published that year, Matisse proposed an essentially therapeutic aim for his art, declaring: "What I dream of is an art of balance, of purity and serenity, devoid of troubling or depressing subject matter, an art that could be for every mental worker . . . a soothing, calming influence on the mind, something like a good armchair that provides relaxation from fatigue."[7]

Matisse pursued his aspiration to produce soothing, decorative art in his submission to the 1908 Salon d'Automne, *Harmony in Red*. The painting's subject is a dining room, described through simple lines and broad areas of flat, unmodulated color, with repeating crimson and blue-black patterns, and includes a framed landscape in the upper left side of the composition. This seamless continuation of pattern and color, as well as the rectangular green landscape that may be a view through a window or a painting itself, serve to deny measurable spatial recession and to assert the picture surface. *Harmony in Red* was not meant to record the visible world's appearance—the goal of both academic, **Realist**, and **Impressionist** painters—but to create a unified, decorative arrangement of lines, shapes, and colors that would, as Matisse said, "express his feelings."

Harmony in Red was purchased by Sergei Shchukin, a wealthy Russian collector of modern French art, who then commissioned two huge decorative paintings from Matisse, *Dance (II)* (1909–10, Figure 3.4) and *Music* (1909–10) for the stairwell of his palatial Moscow home. In *Dance (II)*, Matisse reprises the ring of ecstatic naked female dancers from the upper center of *Le Bonheur de vivre*, now reduced from six to five. He gives them firmly outlined, bluntly defined, solid brick-red bodies, silhouetted against a midnight blue sky and a downward-curving emerald green hill top. *Music* features the same basic red, blue, and green palette and complements *Dance (II)*'s kinetic energy in its static arrangement of five male musicians. Both paintings achieve a grand decorative unity that, said Matisse, "comes from the colored surface that the spectator perceives as a whole."[8] In this sense, they predict the **Color Field** paintings of mid-twentieth-century abstractionists such as Mark Rothko (see Figure 12.11).

André Derain (1880–1954) and Maurice de Vlaminck (1876–1958)

André Derain and Maurice de Vlaminck exhibited alongside Matisse at the 1905 Salon d'Automne. Derain first met Matisse in 1899, when both were students of the Symbolist painter Eugène Carrière. Vlaminck, who had no formal art training, supported himself in the 1890s as a bicycle racer, violin teacher, and journalist for anarchist papers. He reportedly met Derain in 1900 on a train between Paris and Chatou, where Vlaminck and Derain had both grown up and shared a studio from 1900 to 1901. Derain introduced Vlaminck to Matisse at the Galerie Bernheim-Jeune's Van Gogh retrospective in Paris in March 1901. Van Gogh's bold colors and expressive brushwork would inspire all three artists, especially Vlaminck. His Fauve style, typified by landscape paintings such as *Houses at Chatou* (1905), reveals this influence in its explosive colors, simplified forms, and thick, vigorous brushstrokes.

Derain's Fauve style crystalized in the summer of 1905, which he spent with Matisse in Collioure, and then blossomed in the cityscapes he painted during three short stays in London in 1906 and 1907. Derain's *Charing Cross Bridge, London* (1906–07, Figure 3.5) presents a view across the Thames from the Waterloo Bridge to the Hungerford Railway Bridge (also known as the Charing Cross Bridge) and distant Houses of Parliament and Whitehall Court. He invests this ordinary scene with extraordinary visual intensity through a ravishing combination of vivid **primary** and **secondary colors**. Much like Matisse did in *Open Window, Collioure*, Derain uses different painting techniques in different parts of the picture. This is especially noticeable in the two zones of the composition's lower half. The right side features separate strokes of pure yellow, orange, pink, and various blues, with generous areas of the white primed canvas left bare to enhance the sense of sunlight reflecting off the river surface. The left side features both sketchy and flat areas of unmodulated

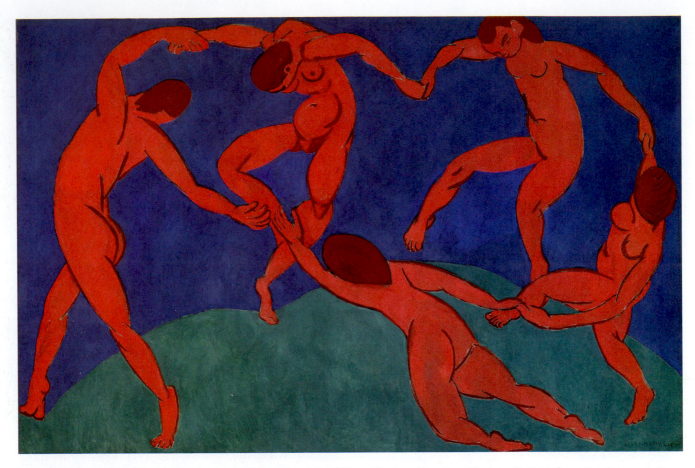

FIGURE 3.4 Henri Matisse, *Dance (II)*, 1909–10. Oil on canvas, 260 x 391 cm. The State Hermitage Museum, St. Petersburg, Russia.

FIGURE 3.5 André Derain, *Charing Cross Bridge, London*, 1906. Oil on canvas, 80.3 x 100.3 cm. National Gallery of Art, Washington, DC.

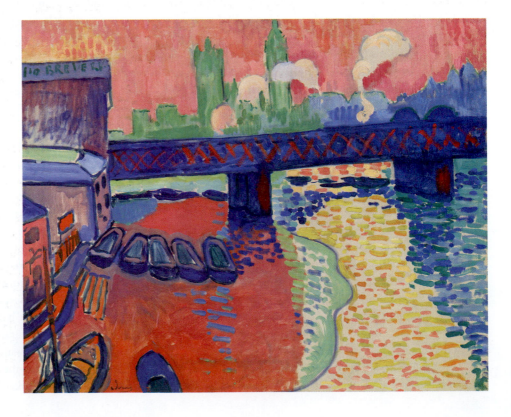

colors and simple motifs, such as the string of boats at center left, bound by thick contour lines. Together with the expressive, non-naturalistic use of color, these techniques draw attention to the picture's modernist status as a flat surface covered with paint rather than a transparent window onto an illusionistic world.

Émilie Charmy (1878–1974)

The French painter Émilie Charmy exhibited regularly in the decade before World War I at the Salon des Indépendants, Salon d'Automne, and the Paris gallery of Berthe Weill, the first woman modern art dealer. Although Charmy neither sought nor gained recognition as a Fauve, she worked in a style similar to that of Matisse and his colleagues. She used strong, sometimes anti-naturalistic colors and loosely applied paint to render **still lifes**, landscapes, and figurative subjects. Charmy was also part of the Fauve circle, painting alongside Charles Camoin, her romantic partner between 1906 and 1912. Charmy and Camoin spent the summer of 1906 in Corsica, where she created a remarkable series of landscapes (e.g., *Piana, Corsica*, 1906) featuring an invigorating tension between flat, boldly outlined dark shapes and areas of brighter, rapidly applied colors. Although her paintings resemble those of the Fauves, critics did not give her that label because the metaphor of the "wild beast" carried connotations of a violent masculine force that was not considered appropriate to her gender—and that was ideologically reserved for the male avant-garde.[9] Charmy preferred to see herself as an "independent"—a category to which women modern artists were often relegated, resulting in their marginalization in histories of modern art centered on male-dominated "isms."

Contemporaries of the Fauves: Georges Rouault and Aristide Maillol

Two friends of Matisse, painter Georges Rouault and sculptor Aristide Maillol, gained public attention alongside the Fauves but pursued different forms of expression.

Georges Rouault (1871–1958)

A Paris-born painter who, like Matisse, studied under Gustave Moreau, Georges Rouault showed several works in the 1905 Salon d'Automne in a separate gallery from the Fauves. Some critics associated Rouault with Fauvism due to the rough, vigorous quality of his line. Unlike the Fauves, however, he worked primarily in **watercolor**, using murky blue washes that generate a gloomy mood. Rouault's characteristic **subject matter**—clowns, circus and cabaret performers, and naked female prostitutes—also differed from that of the Fauves. Rouault's **iconography** was reminiscent of Henri de Toulouse-Lautrec's, but his style was infused with a sense of pathos rather than Lautrec's detachment. Rouault ultimately developed a powerfully expressive Christian art, inspired by his deep Catholic faith. His mature style of oil painting, exemplified by *Christ Mocked by Soldiers* (1932), features monumental, crudely drawn figures pressed close to the **picture plane** with bodies made of thick masses of luminous color bound by heavy black outlines. This was a rare combination in a century when modern art largely separated itself from formal religion, even as many modern artists were inspired by alternative spiritual traditions.

Aristide Maillol (1861–1944)

The 1905 Salon d'Automne not only launched the Fauve movement but was also the debut of Aristide Maillol's *The Mediterranean* (1902–05, Figure 3.6), a key work of early twentieth-century modernist sculpture. Trained as a painter, Maillol was associated with the **Nabis** in the 1890s. He made Gauguin-influenced paintings and designed tapestries before turning to sculpture near the decade's end. Using his wife as a model, he developed the pose of *The Mediterranean* in a series of studies between 1902 and 1905. Originally displayed under the title *Woman*, the slightly larger than life-size sculpture represents a youthful nude seated on the ground. Supporting herself with a straight right arm, she rests her left elbow on her bent left leg and raises her left hand to her downward-cast head. Her lower right leg crosses under the arch formed by her raised left knee. The smooth-limbed body with its simple compact pose and contemplative mood offered a striking contrast to the visual excitement of Fauve paintings in the Salon. It also rejected the energetic surfaces and emotionalism of Auguste Rodin's sculptures at the same exhibition.

The writer and critic André Gide praised Maillol's sculpted woman: "She is beautiful; she means nothing; it is a silent work. I believe one must go far back in time to find such complete neglect of any preoccupation beyond the simple manifestation of beauty."[10] The title *The Mediterranean*, which Maillol gave to the sculpture in the 1920s, connects its calm, **idealized** aesthetic to the **classical** art of ancient Greece. To observers like Gide, the sculpture's modernity lay in its self-sufficiency, its lack of a meaning beyond the masterfully modeled and harmoniously composed volumes of the sturdy young body. The female nude—serene, robust, and timeless—became Maillol's central subject for the rest of his career.

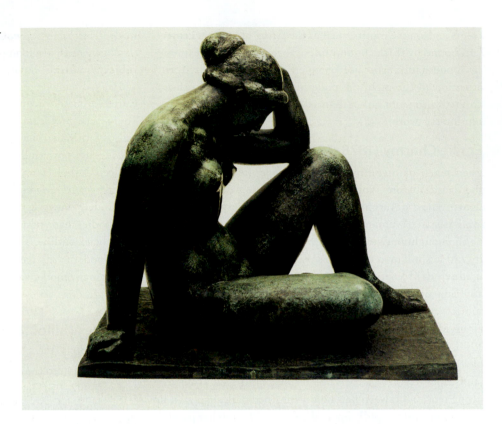

FIGURE 3.6 Aristide Maillol, *The Mediterranean*, 1902–05 (cast c. 1951–53). Bronze, 104.1 x 114.3 x 75.6 cm. The Museum of Modern Art, New York.

German Art at the Turn of the Century

Unlike France, which the Bourbon monarchs unified in the seventeenth century, Germany remained fragmented politically until its integration into a modern nation-state in 1871 under Emperor Wilhelm I. Whereas French artistic life was centered in Paris, no single German city could claim to be the nation's cultural capital: Berlin, Dresden, Munich, and other cities all attracted ambitious artists in the late nineteenth and early twentieth centuries. Multiple aesthetic currents flourished within the decentralized turn-of-the-century German art world. Most popular with the public were pictures with romantic and fantastic subject matter, inspired by myth and literature, rendered in an academic manner by such artists as Anselm Feuerbach, Arnold Böcklin, Hans von Marées, and Max Klinger. In contrast to these artists, Wilhelm Leibl painted everyday rural life with scrupulous accuracy, much like Courbet (see Figure 1.1). Leibl's successors were the painters Max Liebermann, Lovis Corinth, and Max Slevogt, who painted landscapes, figures, and scenes of modern life from direct observation using loose, rapid brushstrokes of rich color, earning them the label of Impressionists.

Standing apart from these currents were two of the most original German artists to emerge at the turn of the twentieth century, Paula Modersohn-Becker and Käthe Kollwitz. While independent of any movement, both have been considered precursors of German **Expressionism**.

Paula Modersohn-Becker (1876–1907)

Paula Modersohn-Becker developed a personal **Post-Impressionist** style in which she painted boldly simplified images, most often of the human figure. She frequently depicted children, women, and mothers with children, as well as herself, including several nude self-portraits (e.g., *Self-Portrait on the Sixth Wedding Anniversary*, 1906). Born Paula Becker in Dresden, she studied between 1896 and 1898 at the Berlin School for Women Artists, an alternative to the state-sponsored art academies, which did not admit women until 1919. From 1897 until her death, she lived for extended periods in Worpswede, a farming village in Northern Germany. It was home to a colony of artists who turned their backs on modern, urban, and industrialized Germany to depict the local peasants and landscape of moors, streams, and birch trees in a subdued naturalistic style. Becker, who married the Worpswede painter Otto Modersohn in 1901, initially worked in a naturalistic manner but soon developed a more abstract style in response to the

Post-Impressionist art she admired on four separate trips to Paris between 1900 and 1907.

Modersohn-Becker's *Kneeling Mother with Child at Her Breast* (1906, Figure 3.7) evinces the primitive force of her late work, revealing Gauguin's marked impact. The picture shows a sturdy, somber naked woman on her knees suckling a chubby blond, blue-eyed baby. Modersohn-Becker simplifies the figures' strongly modeled anatomies and presses them close to the picture plane, blocking spatial recession through a screen of dark green foliage and potted plants behind them. Shadow darkens the mother's face, deemphasizing her individuality, while bright light falls on her breasts and the nursing baby, highlighting her nurturing capacity. The scattered fruits on the ground around her read as symbols of the woman's fecundity. Scholars have suggested that Modersohn-Becker was familiar with the feminist discourse of maternalism in early twentieth-century Germany, which saw motherhood as a positive force for advancing women's rights.[11] Her many powerful images of

pregnant and nursing mothers certainly seem to support that view. Tragically, she died in maternity, of an embolism, three weeks after the birth of her daughter, at age thirty-one.

Käthe Kollwitz (1867–1945)

One of the most significant European printmakers of her generation, Käthe Kollwitz is renowned for her sympathetic depictions of the destitute and the downtrodden. Born Käthe Schmidt in the Baltic seaport of Königsberg, she absorbed strong socialist beliefs from her father, an activist in the Social Democratic Worker's Party. During the 1880s, she studied at the Women's Art Schools of Berlin and Munich and decided to concentrate on printmaking. In 1891 she settled in a working-class district of northern Berlin with her new husband, Karl Kollwitz, a physician who treated poor patients. Familiarity with the underprivileged women who sought help from the couple reinforced Kollwitz's compassion for the working class. "I was powerfully moved by the fate of the proletariat and everything connected with its way of life," she later wrote; she represented proletarian life because "I found it beautiful."[12]

Kollwitz completed her first major print series, *The Revolt of the Weavers*, in 1897, inspired by a play recounting the true story of a failed 1844 uprising by destitute weavers against their employer in the German province of Silesia. Shown at the Great Berlin Art Exhibition in 1898, *The Revolt of the Weavers* brought Kollwitz critical acclaim but disapproval from the German Kaiser (Emperor) Wilhelm II. He refused to award her the gold medal for which she had been nominated because of her art's subversive content and its potential threat to an autocratic government.

Kollwitz's next major series, *The Peasant War* (1902–08), treated a similar theme: an historic but futile uprising of desperately poor German serfs against wealthy landowners in the 1520s. The most dramatic print in the series, *The Outbreak* (Figure 3.8), depicts Black Anna—the woman who incited the revolt—urging forward a rushing mass of men wielding primitive weapons, including agricultural tools. Black Anna, a woman Kollwitz identified with personally as a powerful agent of social change, dominates the composition. Shown from the back, her leaning posture and raised hands rather than her unseen facial expression communicate her exhortation's energy. Kollwitz used a mixture of different **intaglio** techniques in this print including an unconventional one: to create the texture in the sky she applied **soft ground** to the plate, laid canvas over the ground, ran the plate through the press, and then etched the impression.

Kollwitz took up sculpture in the 1910s while continuing to make prints, including **etchings**, **lithographs**, and **woodcuts**. Poverty and misery, as well as war, death, and mothers protecting their children, were her persistent themes. These latter subjects became highly personal to her following her

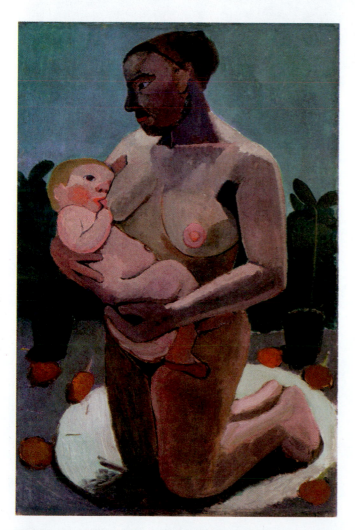

FIGURE 3.7 Paula Modersohn-Becker, *Kneeling Mother with Child at Her Breast*, 1906. Oil on canvas, 113 x 74 cm. Staatliche Museen zu Berlin – Preussischer Kulturbesitz Nationalgalerie, Berlin.

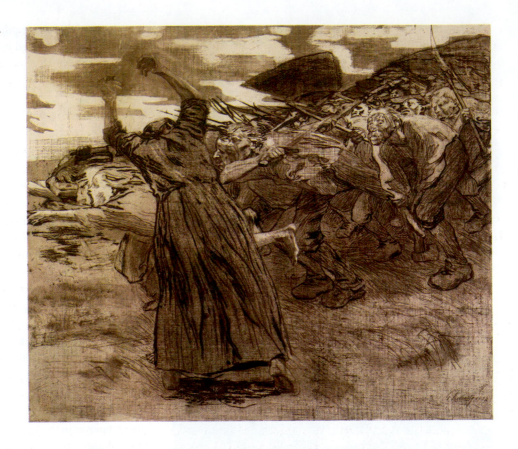

FIGURE 3.8 Käthe Kollwitz, *The Outbreak*, 1903. Aquatint, 49.2 x 57.5 cm. The British Museum, London.

son's death in World War I. A committed feminist, Kollwitz was elected president in 1914 of the Women's Art Union, an organization that sought to gain women the right to teach and study in all public art schools. When they finally achieved that goal in 1919, she was the first woman elected to the Prussian Academy of Fine Arts. She went on to teach there before the Nazis forced her to resign in 1933 due to her outspoken opposition to their politics.

Die Brücke

Four architecture students—Fritz Bleyl, Erich Heckel, Ernst Ludwig Kirchner, and Karl Schmidt-Rottluff—formed the Künstlergruppe "Brücke" (Artists' group "Bridge") in Dresden in 1905, the same year that the Fauves made their debut at the Paris Salon d'Automne.[13] Largely self-taught, the Brücke members aspired to draw, paint, and make prints together and to exhibit jointly. Over the next several years, they invited other artists to join them, including Emil Nolde, Max Pechstein, and Otto Mueller. Persisting until 1913, the group organized some seventy exhibitions of their work and participated in another thirty with other artists' associations. Thanks to their sympathetic patrons' support, the Brücke artists were able to live largely from the sales of their work. This allowed them to pursue radical innovations in opposition to established German art and artistic institutions that they considered sterile and retrograde.

The name "Brücke" signified the artists' efforts to build a metaphorical bridge between the past and the future. They probably drew the symbol from the writings of German philosopher Friedrich Nietzsche. In his influential text *Thus Spoke Zarathustra* (1883–85), Nietzsche's prophetic alter ego declares, "What is great in man is this: that he is a bridge and not an end."[14] Both Nietzsche/Zarathustra and the Brücke artists saw themselves as agents of dramatic change boldly forging a path toward a better future. The *Brücke Program* (1906), published to accompany the group's early exhibitions, clearly expresses this aim:

> With a belief in evolution, in a new generation of creators as well as appreciators, we call together all youth.
> And as youth that is carrying the future, we intend to obtain freedom of movement and of life for ourselves in opposition to the older, well-established powers.
> Whoever renders directly and authentically that which impels him to create is one of us.[15]

In Dresden, the heart of the German Empire's industrial region, the Brücke artists formed a small, cohesive community

to counteract the constant flux and fragmentation that characterized the modern urban experience. Inspired by the ideal of medieval workshops and guilds, they sought to create a sense of unity by working communally in studios, the centers of their bohemian social lives, for which they fashioned their own furniture and decorations and in which they and their friends posed for one another, often in the nude. Against what they saw as modern urban life's purposelessness and corruption, the Brücke artists proposed a utopian alternative that revolved around art as a force of renewal and a model of a liberated, harmonious existence.

The Brücke's early work reveals the influence of **Jugendstil** (Art Nouveau) **graphic art** and the Post-Impressionist paintings of Gauguin, Van Gogh, Seurat, and Signac, as well as Munch and Matisse. African and Oceanic art similarly inspired them, and they adapted its abstracted forms, particularly the **stylized** and angular treatment of anatomy characteristic of much African sculpture. The Brücke artists saw African and Oceanic art in Dresden's ethnographic museum, whose collection was formed through the German Empire's colonization of Southwest Africa and New Guinea (see "Colonialism and Postcolonialism" box, Chapter 18). The artists of the Brücke emulated African and Oceanic art's abstracted forms, which they considered expressive of an authentic and instinctual mode of creativity, not simply to rebel against outworn European academic conventions of illusionism but also to revitalize their own culture by channeling the elemental energies they considered inherent in "primitive" art (see "Primitivism" box, Chapter 2). Closely aligned with the Brücke artists' admiration for "primitive" art was their penchant for the artistic motif of women and men bathing naked in the open air. To the idealistic Brücke artists, this subject connoted the innocent and happy existence that they imagined Indigenous African and Oceanic peoples enjoyed—free of the conflicts and difficulties of modern urban capitalist and industrialized life.

By 1911 the Brücke artists had all relocated to Berlin, where they staged an exhibition at the Galerie Fritz Gurlitt in 1912 that showed the group at its most unified. They had painted similar subjects—principally nudes in the landscape and studio, and pure landscapes—in a similar style employing flat planes of bright, anti-naturalistic colors and simplified, angular forms. This unity dissolved, however, after Kirchner angered his colleagues with his 1913 history of the Brücke, in which he portrayed himself as its leader and principal innovator. The group formally disbanded that same year.

Ernst Ludwig Kirchner (1880–1938)

The Brücke's most historically significant member, Ernst Ludwig Kirchner grew up near Dresden. Lacking support from his middle-class parents, he studied architecture at Dresden's Königliche Technische Hochschule instead of pursuing his interest in art. The month before he received his diploma, he helped cofound the Brücke. The next year, Kirchner established a studio in a former Dresden butcher's shop: he made his own furniture and covered the walls with sheets bearing simplified images of nude men and women cavorting in nature and making love. His Brücke colleagues, their girlfriends, and models often gathered in Kirchner's studio, where the artists drew and painted the human figure.

Between 1909 and 1911 Kirchner, Heckel, and Max Pechstein, who joined the Brücke in 1906, also took summer trips to the small lakes at Moritzburg castle outside Dresden to draw and paint nudes, as well as sunbathe in the nude. Kirchner's *Four Bathers* (1910, Figure 3.9), a characteristic picture from these outings, shows a young girl seated at the edge of a lake in which two mature women and a male figure with a towel bathe. The sketchily defined bodies and landscape elements,

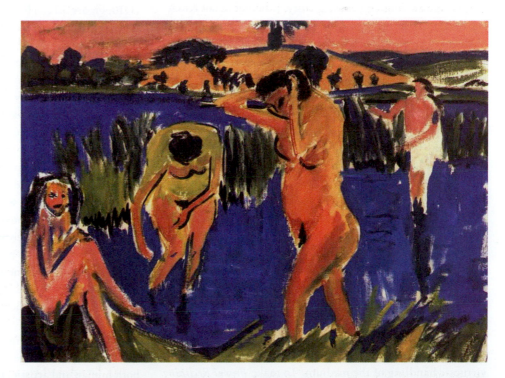

FIGURE 3.9 Ernst Ludwig Kirchner, *Four Bathers*, 1910. Oil on canvas, 75 x 100.5 cm. Von der Heydt-Museum, Wuppertal, Germany.

free brushwork, and strong colors, including the anti-naturalistic pink defining the sky, reveal the likely influence of Matisse's Fauvism. In the early twentieth-century German context, the subject of naked bathers in the open air resonated with the values and practices of *Nachtkultur*—the culture of nakedness—promoted by social reformers as a healthy antidote to urban civilization's materialism and artificiality.

In fall 1913, just months after the Brücke's breakup, Kirchner began his celebrated series of large paintings of pedestrians on crowded Berlin streets—paintings that convey urban life's alienating effects from which pictures like *Four Bathers* proposed an escape. Using spiky forms, rough brushwork, tilted perspectives, and dissonant colors, Kirchner populated these compositions with female prostitutes sometimes surrounded by potential male clients. These paintings reflected the realities of a city with a reputation for sexual licentiousness, where, since open solicitation was illegal, prostitutes often dressed like well-to-do women, attracting customers through furtive glances and gestures.

In *Street, Berlin* (1913, Figure 3.10), two prostitutes wearing fur-trimmed dresses and elaborate feathered hats stroll down the sidewalk, filling the painting's foreground. The woman on the left turns toward the dapper bourgeois man at the right. The tilt of his cane toward the women suggests he might be a potential client, or he could be the procurer, keeping tabs on his employees.[16] The strident tones of pink, turquoise, and violet combined with the figures' jagged forms, mask-like faces and the compressed, upward tilted space create a harsh and anxious expressive quality. Whether or not Kirchner meant the painting to convey a negative judgment on the morality of prostitution is a subject of scholarly debate.

Erich Heckel (1883–1970)

Like Kirchner, Erich Heckel studied architecture at the Technische Hochschule in Dresden, before dropping out to help found the Brücke in 1905. Heckel functioned as the group's business manager and kept it together when disagreements flared. In addition to painting, he devoted substantial energy to printmaking, an important **medium** for the Brücke artists. They were renowned for their efforts in woodcut, which was considered a distinctly Germanic means of artistic expression due to the mythic status of forests and trees in German culture and the mastering of the medium by late medieval and early Renaissance German printmakers such as Albrecht Dürer.

In characteristic modernist fashion, the Brücke artists made woodcuts that visually declared the nature of the materials and processes used to create the imagery—and did so in a coarse, "primitive" manner very different from Dürer's virtuosic handling of the medium. To make *Fränzi Reclining*

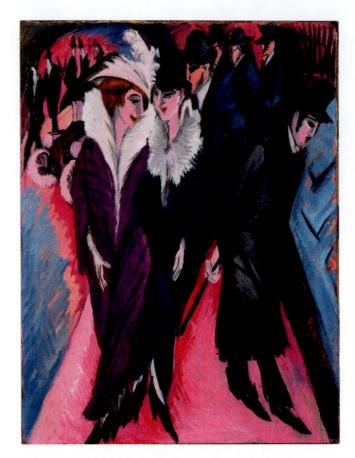

FIGURE 3.10 Ernst Ludwig Kirchner, *Street, Berlin*, 1913. Oil on canvas, 120.6 x 91.1 cm. The Museum of Modern Art, New York.

(1910, Figure 3.11), Heckel roughly gouged the block of wood to depict the simplified figure. Its outlines and features were printed from the raised sections of wood that Heckel did not cut away. He then sawed the block into pieces that he inked separately in red and in black and reassembled before printing. The model for this woodcut, Fränzi Fehrmann, was about ten years old when it was made. She and another girl named Marzella posed frequently for Heckel, Kirchner, and Pechstein in 1910 and 1911. The Brücke artists' renderings of these prepubescent girls, simultaneously innocent and erotically tempting, reflected the artists' uninhibited, anti-bourgeois approach to sexuality, which they recognized even in children—an attitude resonating with Sigmund Freud's emerging psychoanalytic theories. The artists also likely saw the girls as embodying the promise of future fruitfulness and as symbols of the "new generation of creators" announced in the Brücke program.[17] This reading is reinforced by Fehrmann's mask-like features, which recall the style of certain African sculptures. The visual connection to a "primitive" culture combined with the "primitive" quality of Heckel's technique renders the girl's image emblematic of the new beginnings, both human and artistic, that the Brücke sought to generate.

Emil Nolde (1867–1956)

Briefly a member of the Brücke but essentially an independent German Expressionist, Emil Nolde was renowned for his free brushwork and forceful use of color in oil paintings and watercolors of the natural world, as well as depictions of religious and imaginary subjects. Born Emil Hansen to a farming family in the northern German village of Nolde, the artist took the name of his birthplace in 1902. He studied painting in the late 1890s in Munich and Dachau and in 1900 in Paris, where he discovered Impressionism. By 1904, he was creating landscapes and figures in a robust style featuring loose, thick brushstrokes of rich color. This work attracted the attention of the Brücke artists who recognized Nolde as a kindred spirit and invited him in 1906 to join their group. He was only an active member for eighteen months.

Deeply religious—he claimed, perhaps in jest, that the Bible was the only book he had fully read—Nolde painted over fifty pictures of subjects drawn from the New and Old Testaments. His first religious painting, *The Last Supper* (1909, Figure 3.12), is characteristic of his mature style in its juicy **impastos** and strong colors. Nolde's composition centers on the figure of Jesus, holding the blue cup of wine he will give his disciples to drink at their last meal together before his arrest and subsequent crucifixion. In the Bible, Jesus calls the wine "my blood of the covenant, which is poured out for many for the forgiveness of sins" (Matthew 26: 28)—an allusion to his impending death, which Christians believe he suffered to redeem humanity's sins. Nolde crowds the twelve disciples around Jesus, placing three on the viewer's side of the table and squeezing the glowing faces of the other nine into the composition's upper register.

Avoiding the idealization typical of traditional images of

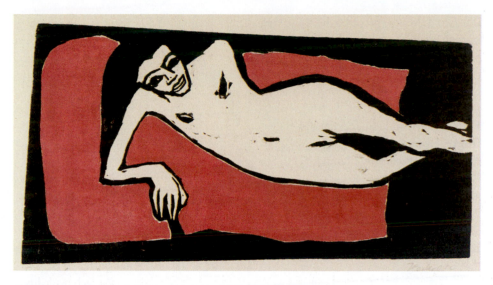

FIGURE 3.11 Erich Heckel, *Fränzi Reclining*, 1910. Woodcut, 22.7 x 41.9 cm. The Museum of Modern Art, New York.

Jesus and his followers, Nolde gives his figures the coarse facial features of simple peasants. He considered this appearance truthful to biblical reality, but it offended many of his contemporaries. These included the jury of the Berlin Secession, an exhibiting group to which he belonged, who in 1910 rejected his painting *Pentecost* (1909), a **pendant** to

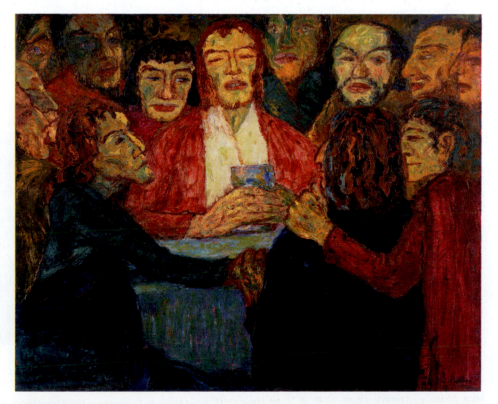

FIGURE 3.12 Emil Nolde, *The Last Supper*, 1909. Oil on canvas, 86 x 107 cm. National Gallery of Denmark, Copenhagen.

the *Last Supper* painted in the same style. This rejection led to Nolde launching a public verbal attack on the Secession's president, Max Liebermann, which took on an anti-Semitic cast. Nolde's commitment to German racial purity led him to join the Nazi party in 1933 and seek a position as official painter to the Third Reich. The Nazis, however, found his Expressionist style unacceptable. They confiscated his work from German museums, along with that by other German modernists, including members of the Brücke and the Blaue Reiter, and exposed it to public ridicule as "degenerate art" in a 1937 exhibition in Munich. The Nazis prohibited Nolde from making art in 1941, but he continued to do so in secret, producing over a thousand watercolors, often depicting flowers in his garden in lush, liquid **hues**.

German Expressionist Sculpture

German Expressionist sculpture focuses on the human figure, treated in an emotionally charged manner comparable to that seen in the paintings and graphic works of the Brücke and Blaue Reiter artists. Its creators typically exaggerate, elongate, or simplify anatomy and use dramatic or contorted gestures and facial expressions to convey powerful feelings. Their work seeks to draw an empathetic response from the viewer.

In the years before World War I, Heckel and Kirchner made roughly carved and simply painted wood sculptures of female nudes inspired by African art (e.g., Kirchner, *Dancing Woman*, 1911). Kirchner's early carvings were also influenced by the ancient figural frescoes of the Buddhist caves of Ajanta, India, which he knew from photographs. The Brücke artists drew on these "primitive" sources in their search for a fresh formal language with the potential to renew European culture, in keeping with their aim to build a symbolic bridge to the future.

Ernst Barlach (1870–1938)

Direct experience of a society more primitive than that of modern industrialized Germany inspired the mature work of the independent German Expressionist sculptor Ernst Barlach, who initially worked in the curvilinear manner of Jugendstil. On a 1906 trip to Russia, Barlach was captivated by the unrefined peasants and beggars he encountered on the steppes. He saw them as living metaphors of the human condition: "This is what we human beings are, at bottom all beggars and problem characters."[18] Back in Berlin, Barlach began sculpting small-scale figures of beggars and peasants in simple, compact poses, their bodies concealed under heavy garments, with their exposed faces and hands serving as the principal expressive elements. He first made these figures in ceramic but in 1907 began carving them in wood, inspired by German Gothic wood sculptures. Wood remained his favorite material, though he also worked in bronze.

Barlach made his most famous and dramatic sculpture, *The Avenger* (1914, Figure 3.13), at the outset of World War I, which, like most Germans, he initially supported patriotically. The sculpture depicts a sword-wielding German warrior rushing forward heroically to attack the Allies. The sharp-edged planes of the figure's fanlike robe enhance the impression of kinetic thrust. The artist described the sculpture as "the crystallized essence of War, the assault of each and every obstacle, rendered credible."[19]

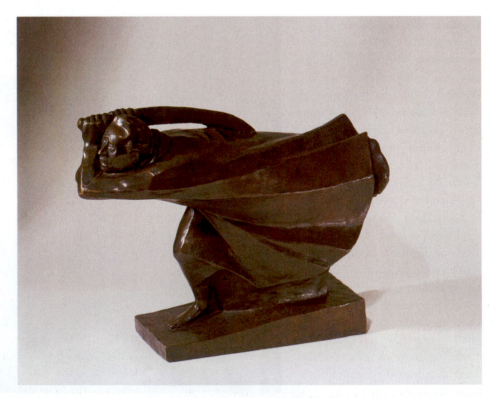

**FIGURE 3.13 Ernst Barlach. *The Avenger,* 1914 (cast later). Bronze, 43.8 x 57.8 x 20.3 cm. Tate, London.

After the war, Barlach earned several commissions for war memorials. The best known, at Güstrow Cathedral (1927), featured a life-size robed human figure suspended from chains like a wingless hovering angel. In the 1930s Barlach spoke out against the Nazis who suppressed his work, destroyed many of his public memorials, and displayed his sculptures in the 1937 *Degenerate Art* exhibition.

Wilhelm Lehmbruck (1881–1919)

Whereas Barlach's *Avenger* represents the nationalistic fervor with which many Germans greeted World War I, Wilhelm Lehmbruck's *Seated Youth* (1916–17, Figure 3.14) conveys the aching loss and despair caused by the war's overwhelming death toll. The generalized figure of a life-size nude man sits on an undefined outcropping with his legs spread, elbows resting on his thighs, and head bowed. His posture conveys a sense of grief and withdrawal made more poignant by the elongation of his limbs, which makes him appear gaunt and vulnerable. Intensifying the sense of vulnerability is the opening up of the man's body to the surrounding space, which threatens to engulf him.

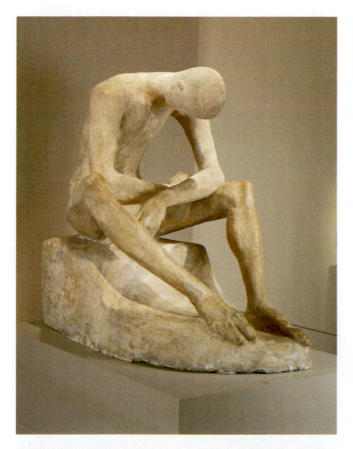

FIGURE 3.14 Wilhelm Lehmbruck, *Seated Youth*, 1917. Composite tinted plaster, 103.2 x 76.2 x 115.5 cm. National Gallery of Art, Washington, DC.

Lehmbruck received his initial training in sculpture at the Düsseldorf Academy of Art and arrived at his psychologically charged Expressionist style in Paris, where he lived between 1910 and 1914. His friends in Paris included the sculptors Alexander Archipenko and Constantin Brancusi (see Figure 9.10). Although they developed more abstract styles than Lehmbruck, he shared with Brancusi an interest in simplifying anatomy and with Archipenko an interest in integrating voids into his figures, reversing the traditional conception of sculpture as an art of **mass** and volume surrounded by space. Forced to return to Germany at the outbreak of World War I, Lehmbruck was devastated by the deaths of many of his friends on both sides of the conflict. He channeled his bereavement into *Seated Youth*, his last major work before he committed suicide at age thirty-eight.

Der Blaue Reiter

The second major Expressionist group to emerge in Germany was Der Blaue Reiter (the Blue Rider), formed in Munich in 1911. Unlike those of the Brücke, the highly individualistic artists associated with the Blaue Reiter did not develop a group style. What united them was their rejection of art based on the imitation of external appearances; instead, they sought to express subjective feelings and spiritual strivings through experimental formal means.

The Blaue Reiter grew out of the Neue Künstlervereinigung München (NKVM, New Artists' Association of Munich), an exhibiting organization founded in 1909 by Vasily Kandinsky and others. Disputes within the NKVM led Kandinsky, Gabriele Münter, and Franz Marc to resign from it in 1911 and to organize the *First Exhibition of the Editorial Board of the Blaue Reiter* that December at Munich's Galerie Thannhauser. The exhibition's title referred to an almanac that Kandinsky and Marc published in May 1912. Kandinsky's cover illustration was a highly stylized black and blue woodcut image of the mounted Saint George, the patron saint of Kandinsky's hometown of Moscow—the legendary medieval Christian knight who rescued a princess by slaying a dragon. This emblem combined Marc's love of horses, Kandinsky's frequent use of the rider motif, and both artists' affinity for blue, which they associated with spirituality. In addition to Kandinsky, Marc, and Münter, the fourteen exhibiting artists included the Germans August Macke and Heinrich Campendonk, the Austrian Arnold Schönberg (better known as a modernist composer), the Frenchmen Robert Delaunay and the late Henri Rousseau, and the American Albert Bloch, emphasizing the group's internationalism.

The Blaue Reiter almanac included essays by Marc, Kandinsky, and others and illustrations of artworks in a wide variety of styles from different cultures and historical eras. In addition to paintings by the group's artists, it reproduced Gothic sculptures, medieval woodcuts, paintings by El Greco, Cézanne, Van Gogh, Matisse, Picasso, Robert Delaunay, and the Brücke artists. Numerous paintings by the "naïve" painter Henri Rousseau (see Figure 8.1) were also illustrated, as were children's drawings, Russian and Bavarian **folk art**, and non-Western artworks including Egyptian shadow-puppets, Chinese and Japanese paintings, and sculptures from African and Oceanic cultures. This assortment of images, as well as the inclusion of a musical score by Schönberg and a stage composition by Kandinsky, signaled the editors' ideal of a synthesis of the arts, based on the German **Romantic** concept of the **Gesamtkunstwerk** (total work of art). The common feature of the chosen art was its freedom from or rejection of the conventions of European illusionism, which made it relevant to Blue Rider artists' efforts.

Works from the group's first exhibition subsequently toured several other German cities in 1912, including Berlin, where the work was shown at Herwarth Walden's Galerie Der Sturm (Storm Gallery), which became Germany's premier commercial venue for Expressionist art. In February 1912 at Han Goltz's Munich gallery, the Blaue Reiter leaders organized a second exhibition of 315 works of graphic art by thirty-one artists, including Brücke members (Heckel, Kirchner, Nolde, and Pechstein), the Cubists Braque and Picasso, and the Swiss German artist Paul Klee. Critical reactions to the two exhibitions were largely negative due to the artists' abstract styles, which challenged the taste of viewers accustomed to conventional realism. However, the group's emphasis on the spiritual purpose of art had a lasting impact on subsequent modernist developments.

Vasily Kandinsky (1866–1944)

The Blaue Reiter's most innovative artist and its leading theoretician, Vasily (also Wassily or Vassily) Kandinsky was a pioneer of nonrepresentational art in Europe before World War I. He grew up in Odessa but returned to his native Moscow in 1886 to study law, economics, and ethnology. In 1896, he turned down a teaching post at an Estonian university and instead moved with his wife Anya to Munich to study painting. Several experiences influenced his decision to become an artist. One was his encounter with one of Monet's 1890s grain stack paintings at a Moscow exhibition; at first not recognizing the painting's subject, Kandinsky realized that its colors and composition were more meaningful to him than what it depicted. Another was attending a performance of Richard Wagner's opera *Lohengrin*, where Kandinsky claimed to have experienced **synaesthesia**,

perceiving colors and lines as he heard the music. This led him to make connections between music and visual art: just as music lacks subject matter and affects the listener's emotions directly through sound, Kandinsky believed that painting could do the same through forms and colors, without recognizable imagery.

In Munich, Kandinsky cofounded the Phalanx artists' group in 1901. Gabriele Münter entered his painting class as a student in 1902 and soon became his companion. In 1904, Kandinsky separated from his wife to live and travel with Münter. Engaged, but never married, their relationship endured until 1916. In the early 1900s, Kandinsky made small oil sketches *en plein air* as well as paintings with fairy-tale subject matter drawn from medieval German legends, Jugendstil, and Russian **Symbolism**. He executed these latter pictures in a mosaic-like style of spots and strokes of rich colors on a dark background (e.g., *Riding Couple*, 1906/07). From 1906 to 1907 Kandinsky and Münter lived in Sèvres outside Paris, and saw exhibitions of paintings by Gauguin, the Nabis, Matisse, and other Fauves. After their return to Germany, they divided their time between Munich and the picturesque village of Murnau nearby. Many of Kandinsky's paintings of 1908–10 depict the Murnau landscape (e.g., *Murnau—Landscape with Tower*, 1908) with simplified forms defined through strong pure colors freely applied in short strokes and flat patches. Influenced both by Fauvism and by Bavarian *Hinterglasmalerei*—a local form of devotional folk art featuring simply rendered religious imagery painted on the reverse side of a sheet of glass—Kandinsky's style became increasingly abstract. From 1909 to 1913, he painted pictures characterized by patches of brilliant color and strong light and dark contrasts established through broad areas of white and emphatic black lines. These paintings retained subject matter based on Kandinsky's observation of nature or drawn from his imagination or textual sources, principally the Bible. However, Kandinsky obscured his imagery in an attempt to affect the viewer's psyche fundamentally through arrangements of color and form.

In late 1911 Kandinsky published a short but important book, *Concerning the Spiritual in Art*, in which he announced the theory animating his drive toward completely nonobjective painting. He argued for a form of painting that like music, would strive toward the immaterial, not seeking to imitate the external world's appearance but instead responding to the artist's "inner necessity." Fundamental to his thinking were anti-materialist philosophies and occult belief systems, including Theosophy (see box). Theosophy's influence on Kandinsky is sensed in his statement "Our epoch is a time of tragic collision between matter and spirit and of the downfall of the purely material world view."[20] Kandinsky ultimately believed that art's mission was to improve the world

Theosophy

Theosophy, derived from the Greek term for "divine wisdom," has a history dating to antiquity but gained its modern form through the Theosophical Society, established in New York in 1875 by the Russian émigré Helena Petrovna Blavatsky and others. The society's founders promoted principles synthesized from European occult traditions, nineteenth-century American spiritualism, and Indian Hinduism and Buddhism. Blavatsky taught that Theosophy conveys the fundamental truths underlying all world religions; that spirit and matter are complementary aspects of a limitless reality; and that the individual soul is a spark of the Universal Spirit. Through an evolutionary progress of reincarnations, humans can achieve enlightenment and mystical union with the divine. Theosophy's conception of an inner spiritual reality behind the one evident to our senses was important to the development of nonrepresentational art by several spiritually inclined artists in the early twentieth century. Hilma af Klint (1862–1944), apparently the first professional European artist to create fully abstract paintings, did so under the combined influences of Theosophy and spiritualism. A graduate of the Swedish Royal Academy of Fine Arts and a member of the Theosophical Society, af Klint between 1896 and 1906 participated in séances with four other women artists in which they executed mediumistic drawings based on messages from spirits. Between 1906 and 1915, af Klint created her *Paintings for the Temple*, which featured both abstract organic and geometric shapes, and whose execution she claimed was guided by spirits. Seeking to understand the art she had created as a medium, af Klint read Blavatsky's works and heard lecturers by her followers Rudolf Steiner and Annie Besant. Af Klint was likely familiar with Besant and Charles Leadbetter's *Thought-Forms: A Record of Clairvoyant Investigation* (1901), featuring illustrations of the colorful abstract patterns supposedly formed in the human aura by thoughts and emotions. Vasily Kandinsky did not join the Theosophical Society, but he read the theosophical writings of Blavatsky, Besant and Leadbetter, Steiner, and Edouard Schuré and he incorporated theosophical ideas into his book, *Concerning the Spiritual in Art* (1911). Dutch artist Piet Mondrian was a member of the Theosophical Society from 1909 until his death and theosophical beliefs informed his theoretical writings and nonrepresentational paintings (see Chapter 6). Other modern artists interested in Theosophy include Paul Gauguin, Paul Sérusier, František Kupka, Arthur Dove, Theo Van Doesburg, Paul Klee, Xul Solar, Jean Arp, Lawren Harris, Agnes Pelton, and Jackson Pollock.

by helping to usher in what he and Marc called "the epoch of great spirituality."[21] Kandinsky's abstraction thus had a deeply spiritual purpose.

In *Concerning the Spiritual in Art*, Kandinsky divides his paintings into three different categories according to their sources of inspiration. He defines an "Impression" as a "direct impression of 'external nature'"; an "Improvisation" as a "chiefly unconscious," largely spontaneous expression "of events of an inner character"; and a "Composition" as an expression "of feelings that have been forming within me . . . over a very long period of time . . . which . . . I have slowly and almost pedantically worked out. . . . Here, reason, the conscious, the deliberate and the purposeful play a preponderant role."[22] Over the course of his career, Kandinsky painted ten *Compositions*—large paintings that he considered his most ambitious and complete works. He completed the first seven in rapid succession between 1910 and 1913: the last of these, *Composition VII* (1913, Figure 3.15), is perhaps his most impressive pre–World War I painting.

Measuring two by three meters, the monumental *Composition VII* presents a crowded and dynamic array of bright colors, ambiguous shapes, and jumbles of sharp black lines that whirl and collide within an amorphous, dreamlike space. While the picture appears to have been spontaneously executed it was in fact preceded by over thirty ink, watercolor, and oil studies in which Kandinsky worked out its various visual elements, as was his practice in realizing the *Compositions*. Furthermore, while *Composition VII* may appear entirely nonrepresentational, it actually contains highly abstracted remnants of motifs recognizable from the artist's earlier pictures. These include several boats with oars (at lower left and scattered through the center), the yellow and blue trumpets of angels (long tapering shapes at the upper center and upper right), and a pair of reclining lovers (indicated through intersecting black outlined shapes at center right). These motifs refer to biblical episodes of conflict and renewal that Kandinsky frequently evoked in his paintings of 1910–13: the Garden of Eden (symbolized by the reclining lovers), the Deluge (symbolized by the boats), and the Resurrection and Last Judgment (symbolized by the trumpeting angels). Kandinsky used this iconography to convey his vision of an impending upheaval that would lead to a new age of spirituality. Less than a year after Kandinsky painted *Composition VII*, a tremendous upheaval did shake Europe, but few would argue that this cataclysm—World War I—ushered in a new spiritual age. The war forced Kandinsky to return to Russia and marked the end of the short-lived Blaue Reiter movement. Kandinsky came back to Germany in 1922 as a teacher at the Bauhaus (see Chapter 6).

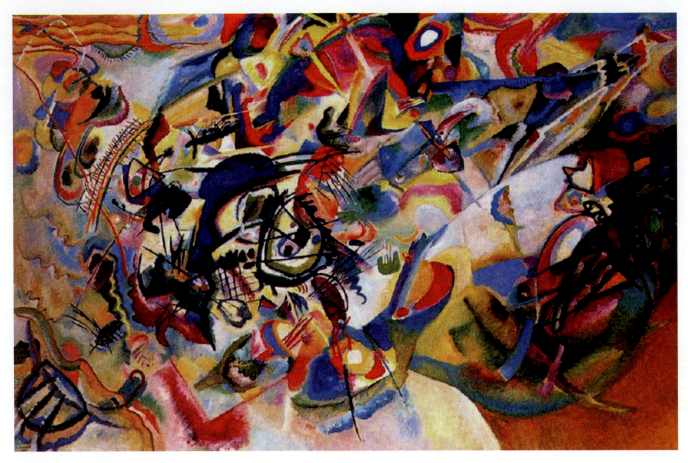

FIGURE 3.15 Vasily Kandinsky, *Composition VII*, 1913. Oil on canvas, 200 x 300 cm. Tretyakov Gallery, Moscow.

Gabriele Münter (1877–1962)

Before enrolling in Kandinsky's class at the Phalanx School in 1902, the Berlin-born Gabriele Münter studied at the school of Munich's Künstlerinnen-Verein (Association of Women Artists). Kandinsky recognized her talent and encouraged her artistic development while also becoming attached to her personally in 1904. During the couple's sojourn in Sèvres near Paris (1906–07), Münter painted in an Impressionist manner and experimented with color linocuts. A cofounder of the NKVM, she participated in its 1909 and 1910 exhibitions, leaving the group to help found the Blaue Reiter the next year.

Münter's mature artistic style is exemplified by a small picture she completed in Murnau in 1909, *Jawlensky and Werefkin* (Figure 3.16). It shows the Russian artistic couple and fellow NKVM cofounders, Alexei Jawlensky and Marianne Werefkin, reclining on a grassy hillside.[23] The high-keyed palette, simple landscape and faceless figures suggest the influence of Jawlensky, who had spent several years in France, developing a Fauve-inspired style and reducing forms to their essential characteristics. Jawlensky likely also encouraged Münter's

use of a **cloisonné** style in which areas of color are enclosed within thick black contours. This technique emulates the traditional Bavarian *Hinterglasmalerei* that Münter collected, which depict Christian devotional subjects in an elemental style characterized by strong black outlines and bold colors. Münter may have used a *Hinterglasmalerei*-inspired style in order to give this painting the qualities of honesty and spiritual authenticity that she valued in Bavarian folk traditions and also saw in children's art. At the same time, Jawlensky's and Werefkin's fashionable clothing, especially the latter's elaborate, multicolored hat, mark them as bourgeois visitors from the city—embodiments of modernity's encroachment into this idyllic rural locale.

Franz Marc (1880–1916)

Coeditor of the Blaue Reiter almanac, Franz Marc shared Kandinsky's belief in abstract art's capacity to transcend materialism and help usher in a new age of spirituality. Unlike Kandinsky, however, he retained recognizable subject matter in his paintings until 1914, shortly before he volunteered for the German army and perished on the battlefield in France.

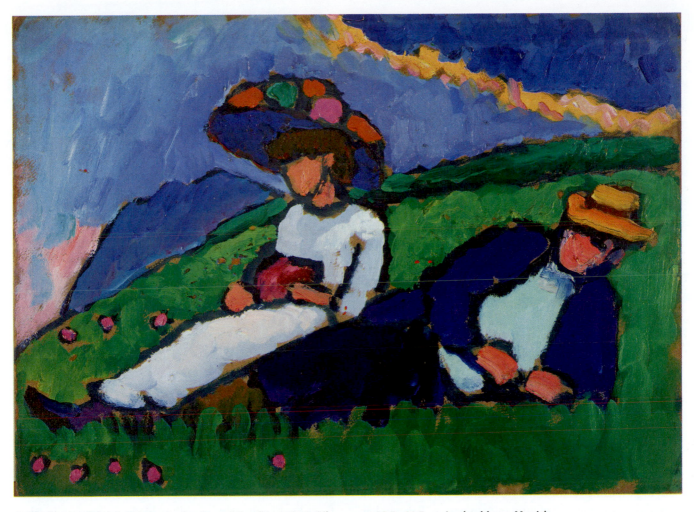

FIGURE 3.16 Gabriele Münter, *Jawlensky and Werefkin*, 1908/9. Oil on paper, 32.7 x 44.5 cm. Lenbachhaus, Munich.

Marc was especially devoted to depicting animals, believing that they led a purer, more spiritual existence than did humans whose innocence was corrupted by civilization.

Academically trained in his native Munich, Marc fell under Van Gogh's spell on a 1907 trip to Paris and emulated the Dutch artist's thick and emphatic brushstrokes in his paintings of the next few years. In 1910, he developed a friendship with the younger painter August Macke and gained the patronage of Macke's wealthy uncle Bernhard Koehler, which provided Marc with a welcome measure of financial security. Macke, who greatly admired Matisse, also encouraged Marc to abandon his naturalistic palette and heighten the intensity of his colors. The result of this development is seen in one of Marc's major paintings of the next year, *The Large Blue Horses* (1911, Figure 3.17).

This painting depicts three horses in a closely packed semicircle, with their heads all turned toward the left. The animals appear nearly identical, suggesting they share a

harmonious existence. The curvilinear outlines of their backs are echoed in the shapes of the background hills, creating a sense of unity between the animals and their environment. Further integrating the horses and landscape are the blade-like leaves jutting up from the picture's base that overlap the foreground horses' bodies, and the stylized curving white tree trunk snaking behind the head and crossing the body of the rightmost horse.

The painting's most striking formal feature is its anti-naturalistic palette. Marc models the horses' bodies through varying shades of blue with white highlights; renders the earth beneath them mostly yellow; places red, green, and purple hills behind them; and fills the sky with loose patches of primary and secondary colors recalling Kandinsky's style at the time. Marc ascribed symbolic meaning to his colors, as he explained in a 1910 letter to Macke: "*Blue* is the *male* principle, austere and spiritual. *Yellow* is the female principle, gentle, bright, and sensual. *Red* is *matter*, brutal and heavy, the color which the

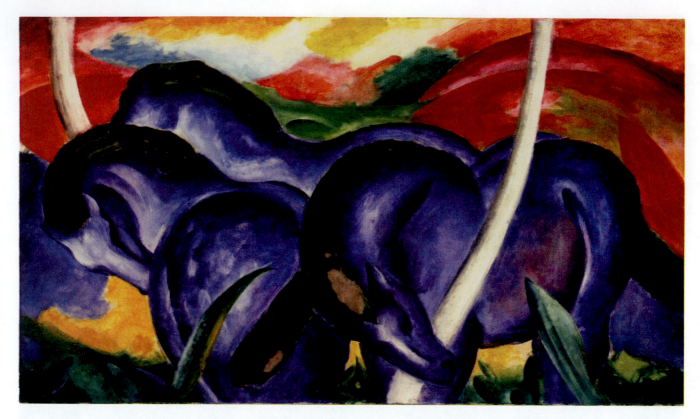

FIGURE 3.17 Franz Marc, *The Large Blue Horses*, 1911. Oil on canvas, 105.7 x 181.1 cm Walker Art Center, Minneapolis.

other two have to fight against and overcome!"[24] Thus, he conceived of his animal protagonists as spiritual creatures, embodying the same values as the rider on the cover of the Blaue Reiter almanac, but free of human domination, living in harmony with nature.

In 1912, Marc and Macke went to Paris to visit Robert Delaunay (see Figure 4.16), a fellow participant in the Blaue Reiter exhibitions. Both German artists were affected by Delaunay's personal style of abstract painting known as **Orphism** or **Simultanism** that combined Cubism's geometric fragmentation of form and space with radiant effects of light and bright, nondescriptive color. In paintings such as *Stables* (1913), Marc adapted Delaunay's style to his signature iconography of animals in nature. Fragmenting the creatures' bodies into flat colored shapes integrated into the composition's overall crystalline structure, Marc conveyed through abstract formal means his mystical view of the indivisible spirituality of all creation.

Paul Klee (1879–1940)

Active in the Blaue Reiter circle between 1911 and 1914, the Swiss German artist Paul Klee was a highly versatile, inventive, and prolific artists as well as an influential teacher and theorist. He produced some nine thousand paintings, drawings, watercolors, and prints, typically small in scale and delicately nuanced in line, color, and tone. He aspired to

create art that appeared naïve and childlike, yet he did so in a sophisticated way. His work is often witty, fantastical, and filled with abstracted images, signs, and symbols derived from his imagination as well as his keen interests in plant and animal life, poetry, and music. Music was particularly important to Klee, a talented violinist whose wife Lily was an accomplished pianist. He compared the colors on his palette to a "chromatic keyboard"[25] and sought to infuse his art with musical rhythms.

Raised in Bern, Switzerland, Klee received academic art training in Munich between 1898 and 1901 before returning to his hometown. His most significant early works were a series of etchings, *The Inventions* (1903–05). Executed in a tightly linear, mannered style, their grotesque figures (e.g., *Comedian [Komiker]*, 1904) express a satirical view of the tragicomic nature of the human condition. In 1907, Klee and his wife settled in Munich where he worked in relative isolation for the next few years. Klee met Macke, Marc, and Kandinsky in 1911 and participated in the second Blaue Reiter exhibition the following year. His association with the group stimulated his interest in the international avant-garde and prompted him to travel to Paris that April. There he met Robert Delaunay, whose Orphist shapes and colors deeply impressed him.

Klee's own breakthrough from an emphasis on draftsmanship to the free use of color came in 1914 when he spent

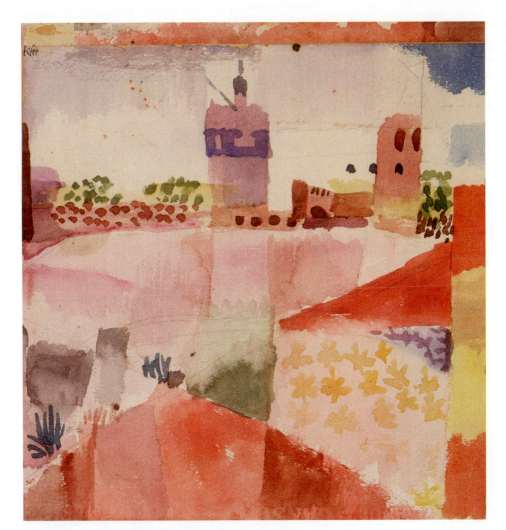

FIGURE 3.18 Paul Klee, *Hammamet with its Mosque*, 1914. Watercolor and graphite on paper mounted on card- board, 23.8 x 22.2 cm. The Metropoli- tan Museum of Art, New York.

two weeks in Tunisia with fellow painters Macke and Louis Moilliet. Klee responded to the country's brilliant light and beautiful scenery in a series of semiabstract watercolors built of soft-edged wedges and rectangles of liquid color arranged in a Cubist grid (Figure 3.18)—a linear scaffolding he would often employ in later compositions. In 1920, following service in the German army, Klee joined the faculty of the newly established Bauhaus in Weimar, where he entered the central phase of his career (see Chapter 6).

Expressionism in Austria

Oskar Kokoschka and Egon Schiele are the principal represen- tatives of Austrian Expressionism. Both painters were active in Vienna, the Austro-Hungarian Empire's capital and a lively cultural and intellectual center at the turn of the twentieth

century. The city was home to innovative architects including Otto Wagner and Adolf Loos (see Chapter 5); major composers such as Gustav Mahler and Arnold Schönberg; and influential writers such as Karl Kraus and Robert Musil. Also working in Vienna was Sigmund Freud, the founder of modern psycho- analysis, who argued in his 1900 book *Interpretation of Dreams* that dream analysis could provide access to the unconscious, primarily sexual, wishes that overcivilized society compels humans to repress (see "Psychoanalysis" box, Chapter 8). Such repression, in Freud's view, caused the anxieties and neuroses of modern life. Freud's analytic quest parallels the Expressionist art of Kokoschka and Schiele, who in their psy- chologically charged figurative images sought to make visible their subjects' desires, doubts, and anguish. Their artistic at- tempts to penetrate beneath the sitter's exterior represent a re- action against the decorative effects of Sezessionstil (Secession Style), an Austrian version of Art Nouveau (see Chapter 5),

whose leading exponent in painting was Gustav Klimt. Klimt's work emphasized ornamented surfaces, as seen in his famous painting *The Kiss* (1907–08) and his mosaic murals for the Palais Stoclet (see Figure 5.11).

Oskar Kokoschka (1886–1980)

Trained at the Kunstgewerbeschule (School of Arts and Crafts) in Vienna between 1904 and 1909, Oskar Kokoschka's earliest works were prints and postcard designs. He used flat shapes reflecting the influence of Sezessionstil but gave his figures angular contours pointing in the direction of Expressionism. In 1908, Kokoschka exhibited for the first time at the Kunstschau exhibition organized by Klimt, who had broken from the Secession. Kokoschka's work shocked conservative critics and the painter took on the self-conscious role of a young rebel.

Between 1909 and 1914, Kokoschka concentrated on portraiture, painting many well-known Viennese cultural figures such as his friend and supporter, architect Adolf Loos. He did not flatter his sitters but instead often made them look older and less attractive than they appeared in life. He did so to reveal the "truth about a particular person, and to recreate in my own pictorial language the distillation of a living person that would survive in my memory."[26] One of Kokoschka's sitters wrote that "he cuts open souls: as he paints hands and heads he exposes in an eerie way the spiritual skeleton of the person he is portraying."[27]

In April 1912, Kokoschka embarked on a tempestuous love affair with Alma Mahler, composer Gustav Mahler's widow. The relationship inspired *The Bride of the Wind* (1913, Figure 3.19), in which Kokoschka depicted himself and his lover reclining on a cloudlike form amidst a

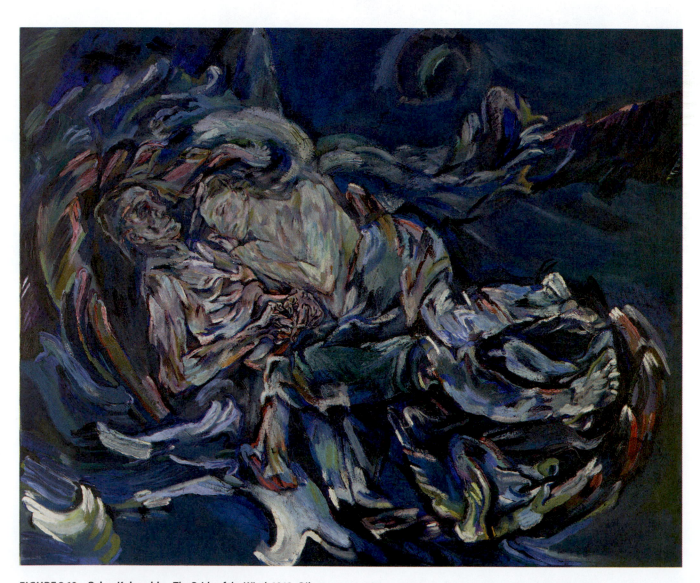

FIGURE 3.19 Oskar Kokoschka, *The Bride of the Wind*, 1913. Oil on canvas, 180.4 x 220.2 cm. Kunstmuseum Basel, Switzerland.

turbulent moonlit landscape. In Expressionist fashion, he renders the figures and their surroundings through thick, sweeping brushstrokes of cold blues and grays accented with white, red, and green. While Mahler sleeps peacefully beside him, he stares wide-eyed into space, as if contemplating an uncertain future. The painter was devastated when Mahler broke off their relationship in early 1915. He went on to serve in the army and was severely wounded. After his recovery, Kokoschka moved to Dresden, where he taught for five years at the Academy, and subsequently lived in Prague, London, and Switzerland. His later work consists of landscapes, portraits, and genre scenes painted with loose, lively brushwork in a brightly colorful palette.

Egon Schiele (1890–1918)

While Oskar Kokoschka had a long life and career, Egon Schiele died tragically young at age twenty-eight in the 1918 influenza pandemic. As a student at the Akademie der Bildenden Künste (Academy of Fine Arts) in Vienna between 1906 and 1909, he fell under the influence of Klimt, who invited him to participate in the 1909 Kunstschau exhibition. After dropping out of the Academy, Schiele achieved artistic independence in 1910 with a personal style of Expressionist figuration. A brilliant draftsman, he made drawings, watercolors, and paintings featuring gaunt figures in contorted positions defined through angular linear contours and dramatically silhouetted against empty backgrounds. Schiele obsessively drew nude female models in sexually explicit poses. He also drew and painted numerous self-portraits, many of them nude, in which he often represented himself theatrically as haunted or tortured. In *Self-Portrait* 1911 (Figure 3.20), the artist stares out with an anguished, open-mouthed expression. His bony, emaciated body, with the right arm thrust out and bent sharply downward at the elbow, is outlined with white as if haloed. The absent right hand and unarticulated genital region suggest amputation and castration, respectively. These features have been interpreted in Freudian terms as the artist's symbolic self-punishment for indulging in masturbation, then popularly (though wrongly) believed to cause insanity.

The expressive intensity of Schiele's late work is evident in the portrait of his friend Paris von Gütersloh (1918), an artist, actor, and writer. In contrast to his earlier portraits that

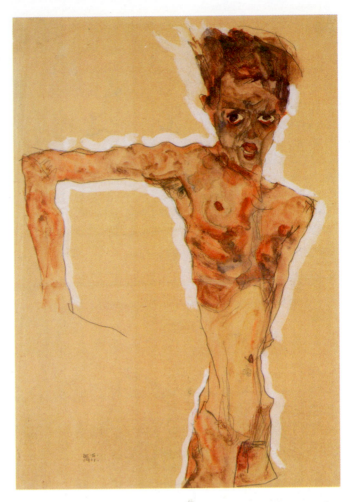

FIGURE 3.20 Egon Schiele, *Self-Portrait*, 1911. Watercolor, gouache, and graphite on paper, 51.4 x 34.9 cm. The Metropolitan Museum of Art, New York.

isolated their subjects against blank backgrounds, Schiele shows Gütersloh in the midst of a multicolored field of animated paint strokes. Seated in a chair in rumpled clothing and a blue tie, Gütersloh raises his hands in strange gestures that seem to signal an inner emotional or spiritual experience whose fervor is also communicated through his wide staring eyes. Schiele's nervous line, agitated paint handling, and harsh colors amplify the image's expressive power. In thoroughly modern fashion, the painting characterizes the sitter's psychology as much through the artist's assertive handling of his medium as through his achievement of a physical likeness.

The Cubist Revolution

Developed by Georges Braque and Pablo Picasso beginning in 1907–08, Cubism is the most influential modernist innovation of early twentieth-century art. It proposed a radically new language of representation that rejected the Renaissance conventions of illusionism already challenged by the Post-Impressionists, Fauves, and Expressionists. As its name implies, Cubism is based on a geometric formal vocabulary of lines, angles, and planes that carry aesthetic value independent of the appearance of nature. In Analytic Cubism, the subject matter appears to have been "analyzed"; it is broken down into geometric fragments as if viewed simultaneously from multiple perspectives and opened up to its shallow, equally fragmented environment. In Synthetic Cubism, which followed Analytic Cubism, images are built out of flat planar shapes rather than dissected into fragments. The latter style derives from the techniques of collage and *papier collé*, which introduced elements of physical reality into Cubist compositions. Picasso extended the principle of collage into three dimensions, making Cubist sculptures out of flat pieces of various materials—a technique known as assemblage.

Cubism offered new ways of creatively expressing the experience of rapidly changing modern life. The late nineteenth century saw the invention of such devices as the phonograph, the steam turbine, and the automobile, along with the discovery of X-rays. At the beginning of the twentieth century Guglielmo Marconi transmitted a radio signal across the Atlantic, and the Wright Brothers achieved the first powered airplane flight. These and other innovations made the world seem smaller and introduced new understandings of space and time.

Accompanying these advances was the influential theory of a fourth dimension—an extension of three-dimensional space requiring a different mathematics, popularized by the British mathematician C. H. Hinton. Albert Einstein's theory of relativity contended that space and time are not absolute but defined in relation to an observer's speed and position. Einstein also developed the conception of space-time, in which space has three dimensions and time is the fourth. The Cubists' attempts to represent different aspects of their subjects through multiple perspectives in a single image can be related to these ideas.

Another concept that attracted some Cubists' attention was "duration," advanced by the French philosopher Henri Bergson. He argued that an *élan vital* (vital life force) propels life; past, present, and future merge in a continuous state of becoming. Arising from Bergson's ideas was the concept of simultaneity, which some Cubists sought to convey by depicting elements and events in different times and places within a single composition.

Cubism's startling pictorial innovations resonated not only with these technological, scientific, and philosophical developments, but also with the era's social and political ferment. Although Cubism rarely referenced contemporary politics—the best known example being Picasso's use of newspaper clippings with stories about the Balkan Wars in many of his 1912 collages—French critics associated its departures from traditional illusionistic artistic conventions with anarchist attacks on bourgeois society.[1] Anarchism was an international political movement in the late nineteenth and early twentieth centuries in Europe and the Americas

whose adherents generally promoted individual independence and rejected the authority of the state, capitalism, militarism, nationalism, religion, and in some cases, industrialization. Anarchist writers such as Petr Kropotkin exhorted artists to contribute to society's transformation, and numerous avant-garde artists and writers, especially in France, embraced anarchism in the pre–World War I decades, attracted by its emphasis on the revolutionary power of the individualist artistic act. Artists associated with Fauvism (Maurice de Vlaminck, Kees van Dongen) and Cubism (Juan Gris, František Kupka) contributed articles and satirical drawings to French anarchist journals, and Picasso, a lifelong pacifist, was likely sympathetic to anarchist ideas.

Cubism provided impetus to Futurism, an Italian movement that applied the former's fragmented forms and multiple views to an artistic celebration of the modern world's speed and dynamism. A related British movement, Vorticism, also drew inspiration from machine forms and used a Cubist-derived geometric vocabulary. This chapter examines all three movements, while Cubism's and Futurism's impact on Russian art is discussed in Chapter 6.

Pablo Picasso (1881–1973): His Early Career

Born in Málaga, Spain, Pablo Ruiz Picasso was the son of the painter and art teacher Don José Ruiz Blasco, who encouraged his son's extraordinary artistic talent. At age fourteen, he gained entrance to Barcelona's School of Fine Arts and two years later studied briefly at Madrid's Royal Academy of San Fernando. He primarily absorbed lessons from works in the Prado Museum, however, including those by El Greco, Velázquez, and Goya. In 1899, he returned to Barcelona, joining the Catalan **modernist** artists and writers who gathered at the café Els Quatre Gats (The Four Cats). His work of this time shows **Art Nouveau**'s influence and the pessimistic aspects of *fin-de-siècle* **Symbolism** as seen, for example, in the art of Edvard Munch (see Figure 2.14).

In October 1900, Picasso traveled to Paris with his friend and fellow painter Carles Casegemas. He painted street and café scenes, some in bright colors, others in a somber **palette**, evoking the work of Toulouse-Lautrec (see Figure 2.2) and the French Swiss painter and printmaker Théophile-Alexandre Steinlen. Back in Spain in early 1901, Picasso learned that Casegemas had committed suicide. He later claimed that his grief led him to adopt blue, a **hue** associated with melancholy, as his dominant color for the next three years. His work of this so-called Blue Period depicts social outcasts—beggars, blind musicians, imprisoned prostitutes—rendered as gaunt,

diminished figures recalling the **style** of El Greco. Their miserable condition reflected Picasso's own struggle with loneliness and poverty.

Picasso's most ambitious Blue Period work, *La Vie* (*Life*, 1903, Figure 4.1), is an enigmatic Symbolist picture that seems filled with profound yet inscrutable meaning. Art historians have offered numerous (yet inconclusive) readings of its **iconography**. The painting shows a stiff nude woman and loincloth-clad man at the left, confronted by a heavily draped, barefoot woman holding a sleeping infant. Stacked canvases on the back wall suggest that the setting is an artist's studio. X-rays of the painting show that Picasso initially gave the man his own features and then changed them to those of Casegemas. Thus, the painting could be a mournful meditation on the tragic fate of the suffering artist, with whom Picasso identified. The naked woman may be Germaine Gargallo, whose spurning of Casegemas led to his suicide and with whom Picasso subsequently had an affair.

FIGURE 4.1 Pablo Picasso, *La Vie* (*Life*), 1903. Oil on canvas, 196.5 x 129.2 cm. The Cleveland Museum of Art, Ohio.

Casegemas's hand gesture is likely derived from that of the resurrected Christ in Correggio's *Noli me Tangere* (c. 1518). This would identify Casegemas with Christ, who also suffered rejection and an early death. At the same time, the morose-looking figure, unable to consummate the relationship with the naked woman—his loincloth has been interpreted as signaling impotence—might point toward the mother and child to indicate his failure to generate new life. Many other interpretations are possible; Picasso likely intended the painting's ultimate meaning to remain unknowable, like that of life itself.

Picasso moved to Paris in 1904 and took up residence in the Montmartre tenement Bateau-Lavoir (laundry boat), where his friends included the poets Max Jacob, André Salmon, and Guillaume Apollinaire; the latter two became important champions of **Cubism**. The next year Picasso entered his Rose Period, trading his cold blue palette for warm pink and **terracotta** and turning to new **subject matter**: harlequins, clowns, and circus performers. His attraction to these characters was nourished by his frequent visits to the Cirque Médrano (Medrano Circus) on the edge of Montmartre and by the association he made between itinerant circus performers and his own position as a bohemian artist on society's margins. In *Family of Saltimbanques* (1905, Figure 4.2), his masterpiece of this period, he depicts a vagabond troupe of acrobats in a

desolate landscape sketchily rendered in dusky earth tones over a layer of blue. The figure at the far left has Picasso's features; the others may be disguised portraits of his friends, though scholars disagree on their exact identities. The saltimbanques do not perform but quietly stand or sit, psychologically remote from one another despite their physical closeness. The picture retains a Symbolist quality in its refusal of narrative and its wistful mood of withdrawal.

In the summer of 1906, Picasso transformed his style in response to the **formal** simplification of Catalan Romanesque art as well as the archaic Iberian sculpture (made in Spain in the sixth and fifth centuries BCE) he had seen displayed at the Louvre. To Picasso and his contemporaries these "primitive" traditions (see "Primitivism" box, Chapter 2) offered stimulating visual alternatives to the tired conventions of European **academic art**. He channeled these influences into his unfinished portrait of Gertrude Stein, the expatriate American modernist writer who was an important collector of Parisian **avant-garde** art. Stein reported that she sat ninety times for Picasso, who depicted her as a massive seated figure draped in a voluminous brown gown. Unable to render her face to his satisfaction, he wiped out this part of the painting; he later painted it again from memory (*Gertrude Stein*, 1905–06), giving her a hard, mask-like physiognomy with asymmetrical eyes.

FIGURE 4.2 Pablo Picasso, *Family of Saltimbanques*, 1905. Oil on canvas, 212.8 x 229.6 cm. National Gallery of Art, Washington, DC.

This stylization of Stein's features was a prelude to the more daring **abstraction** that Picasso undertook in *Les Demoiselles d'Avignon* (1907, Figure 4.3). The painting's title, conferred by André Salmon, indicates the subjects' occupation and location: *demoiselle* (young lady) is a euphemism for prostitute; Avignon refers to Avignon Street in Barcelona's red-light district, where the young artist had frequented brothels. Picasso crowds his five nude prostitutes into a compressed, fractured space and gives them misshapen, flattened, angular bodies. Rather than alluring, they are aggressively confrontational, even monstrous, suggesting that fear as much as desire drove Picasso to paint them. The painting shocked many of his friends who saw it in his studio. It was not exhibited publicly until 1916 at a small venue in Paris and then disappeared again until 1937, when it entered the Museum of Modern Art's collection. In following decades, the *Demoiselles* gained legendary status as the twentieth century's most revolutionary modernist painting—one that opened the door to Cubism.

Picasso's hundreds of preparatory studies for the *Demoiselles* show that he initially intended to depict a narrative scene. The most complete drawing (1907) shows a sailor—a stereotypical brothel client—seated amidst the women. They all turn their heads toward a dark-suited male figure entering from the left, drawing back a curtain. Identified by Picasso as a medical student, he holds a book under his right arm; in earlier studies, he had the artist's features and carried a skull. This motif suggests Picasso's awareness of the threat of venereal disease, endemic to prostitution and potentially fatal if left untreated. Some scholars contend that Picasso had contracted a venereal disease on a visit to a brothel, which led him imaginatively—and misogynistically—to conflate sex and women's bodies with a fear of death. In the final painting, he eliminated the male figures and the suggestion of narrative. Now, the women confront the spectator, who assumes the position of their client.

Picasso likely undertook this **composition** to compete with Matisse's *Bonheur de Vivre* (see Figure 3.2), which he had seen at the 1906 Salon des Indépendants and thereafter in the apartment of its owners, Gertrude and Leo Stein. He drew inspiration from Cézanne's late *Bathers* (see Figure 2.6), adapting from them the poses of the squatting woman at the right

FIGURE 4.3 Pablo Picasso, *Les Demoiselles d'Avignon*, 1907. Oil on canvas, 243.9 x 233.7 cm. The Museum of Modern Art, New York.

and her companions with upraised elbows. Rather than showing relaxed nudes in a landscape as these artists had, Picasso represented them in an interior, pressed close to the **picture plane**. Furthermore, he painted them in different styles, all drawing on "primitive" sources, to produce a dissonant effect of aesthetic disunity.

The woman entering from the left, replacing the medical student in the preparatory studies, is shown in profile with a frontal eye, in the manner of ancient Egyptian wall painting. The two figures next to her, with schematic facial features and heavily outlined staring eyes, reveal archaic Iberian sculpture's continuing impact. The two women at the right have harshly rendered faces with concave noses, almost certainly inspired by African masks that Picasso saw in the Trocadéro ethnographic museum. Decades later, he called these masks "magic things" and "mediators": "They [the African artists] were against everything—against unknown, threatening spirits. . . . I understood; I too am against everything. I too believe that everything is unknown, that everything is an enemy!"[2] In giving these two women faces derived from African masks, Picasso associated them with the terrifying unknown and imagined their sexuality as a disruptive, primitive force. Adopting the racist white European view of Black African female sexuality as overt and aggressive, Picasso also engaged in a stereotypical European understanding of Africans as degenerate and savage—a rationale for colonizing them (see "Colonialism and Postcolonialism" box, Chapter 18).

Picasso called *Les Demoiselles d'Avignon* "my first exorcism painting." Whatever threatening spirits he expelled by creating the picture, he also exorcised many of **Renaissance illusionism**'s fundamental conventions. He rejected **modeling** and anatomical accuracy, giving the women flattened geometricized bodies. He rejected consistent **perspective**, presenting a bird's-eye view of the tabletop at the lower center and of the reclining figure second from the left, while showing the others straight on. He combined frontal eyes with profile noses in the two Iberian-style women but effected the most drastic anatomical distortions on the Africanized demoiselles' bodies. The squatting figure presents her backside but twists her head 180 degrees to stare out at us. The breasts of the woman above are rendered as rectangles that seem detached from her torso and appear flat despite the parallel lines along their sides that suggest modeling.

Daniel-Henry Kahnweiler, Picasso's Parisian dealer during his Cubist period, saw the *Demoiselles* as the birthplace of Cubism.[3] Many mid-twentieth-century art historians agreed; one pointed to the fracturing of natural **forms** into semiabstract tilting and shifting planes squeezed into a shallow space as a rudimentary form of Cubism.[4] Recent scholarship tends to understand Picasso's painting as clearing the way for the style rather than initiating it, partly because the violent expressive quality of the *Demoiselles* is alien to the cerebral and controlled nature of Cubism as Picasso and Braque would soon develop it.

Georges Braque (1882–1963): His Early Career

Among the young French artists shocked by the *Demoiselles* was Picasso's new acquaintance Georges Braque, who reportedly commented: "It is as if someone had drunk kerosene to spit fire."[5] Recognizing the power of Picasso's innovations, Braque quickly applied lessons from the painting to his own work.

Braque grew up in Le Havre on the coast of Normandy, where his father ran a house-painting and decorating business. He took evening classes at Le Havre's École des Beaux-Arts (1897–99) but left before graduating to apprentice in his father's trade, first in his hometown and then in Paris. This experience gave Braque knowledge of artisanal techniques, such as how to paint imitation wood grain, which he would later apply in his Cubist pictures. Settling in Paris, he studied at two private academies and, briefly, at the École des Beaux-Arts between 1902 and 1904. More consequential than this academic training was his discovery of the **Impressionists** and **Post-Impressionists**, especially Cézanne, whose example was crucial to his development of Cubism.

In 1905, Braque saw the intensely colored **Fauve** paintings that Matisse, Derain, and Vlaminck, as well as Braque's friends Raoul Dufy and Othon Friesz, displayed at the Salon d'Automne (see Chapter 3). By the next summer, he was painting in a Fauve style. He depicted landscapes by applying rough patches or small, discrete strokes of pure color, leaving ample areas of the canvas ground untouched so that the colors declare themselves independently (e.g., *Landscape Near Antwerp*, 1906). Braque spent the fall and winter of 1906–07 at L'Estaque, where Cézanne had painted. He displayed his new Fauve-style works at the 1907 Salon des Indépendants, selling all six of them. But the memorial exhibition of Cézanne's paintings at that year's Salon d'Automne led him to change his style again.

In paintings such as *Viaduct at L'Estaque* (1907), Braque followed Cézanne by giving the landscape a geometric structural quality and creating a sense of **volume** through patches and parallel strokes of color rather than **chiaroscuro**. By early 1908, he was also responding to Picasso's influence. On what was likely his first visit to the Spaniard's studio in late 1907, Braque saw *Les Demoiselles d'Avignon* and other angular abstracted female nudes. He then undertook his own picture of a female figure, *Large Nude* (1908, Figure 4.4), which blends

FIGURE 4.4 Georges Braque, *Large Nude*, 1908. Oil on canvas, 140 x 100 cm. Musée National d'Art Moderne, Centre Georges Pompidou, Paris.

Louis Vauxcelles (who had previously given Fauvism its name) wrote that Braque "reduces everything—places and figures and houses—to geometrical patterns, to cubes."[6] Even though Braque did not actually paint cubes, Vauxcelles's comment captured the geometric character of his formal language and engendered the name Cubism—a name eventually accepted by Braque, Picasso, and the many other artists who adopted the style.

Braque's best-known early Cubist painting, *Houses at L'Estaque* (1908, Figure 4.5), extends the formal features of Cézanne's late style. Like Cézanne, Braque restricts his palette to grays, greens, and ochres and simplifies his motifs into geometric forms, suppressing details: the houses have no windows and the trees have no leaves. He also follows Cézanne by rejecting consistent **linear perspective**: elements of the jumbled houses with their oddly tilting planes disobey the rules of linear perspective and seem viewed from contrasting vantage points. Illumination, indicated through highlights and shading, is inconsistent; for example, the **façade** of the house at the left-center appears to receive light from both left and right. Despite these willful departures from Renaissance-based illusionism, Braque creates a sense of physical **mass** and tangible space through his heavily—if idiosyncratically—modeled

elements of Cézanne's and Picasso's styles. Braque depicts a vertical nude woman who is either standing or seen from above in a reclining pose; this spatial ambiguity would become characteristic of Cubism. With schematic facial features and a solid blocky body heavily outlined in black, she is a sturdier sister of Picasso's demoiselles. Surrounding her are rotated gray-blue planes representing a towel or sheet. Reducing the rest of his palette largely to ochres and browns, Braque employs emphatic parallel brushstrokes of the same hue in several areas of the composition, in the manner of Cézanne (see Figure 2.6). In some places, such as the nude's body, these hatched brushstrokes create an impression of solid form and volume. Elsewhere, they exist as independent formal elements without representational value. In every case, they declare the reality of Braque's physical act of painting.

Under Cézanne's continuing influence, Braque created the paintings that gave Cubism its name: a series of landscapes filled with trees and houses simplified to geometric essentials. Rejected by the 1908 Salon d'Automne jury, they were shown at Kahnweiler's gallery. Reviewing that show, critic

FIGURE 4.5 Georges Braque, *Houses at L'Estaque*, 1908. Oil on canvas, 73 x 59.5 cm. Kunstmuseum, Bern, Swizterland.

trees and houses. Speaking of pictures like *Houses at L'Estaque*, he recalled, "I inverted the perspective, the pyramid of forms, so that it would come toward me, so that it would come at the spectator."[7] This visual effect is similar to that of a low-**relief** sculpture, or bas-relief.

Picasso's and Braque's Development of Cubism

Picasso's and Braque's different abilities and complementary sensibilities—Picasso was restless and mercurial; Braque was methodical and meditative—nourished a fruitful collaboration. Braque later recalled, "We saw each other every day, we talked a lot. . . . We were like two mountain climbers roped together."[8] By late 1908 they were regularly visiting each other's studios, beginning their remarkable joint development of Cubism that lasted until 1914, when Braque left to serve in World War I.

Picasso responded to Braque's new Cubist mode by repainting his *Three Women* (1907–08) in a Cézannist style. Rendered in a reduced palette dominated by dark ochres, reds, and browns, this composition features three nude women with simplified, faceted bodies and schematic facial features, with elbows upraised in poses that echo the central figures of *Les Demoiselles d'Avignon*. In several areas of the women's bodies, Picasso employs ***passage***, a technique derived from Cézanne in which the edges of color planes appear to flow together. For example, in the figure on the right, the patches of color that define her hand bleed into the surrounding patches that perhaps indicate a rock slab. The breaking open of contours and blurring of the distinction between figure and ground, achieved here through *passage*, is a hallmark of **Analytic Cubism**.

Picasso and Braque investigated the implications of the latter's early Cubist landscapes in their paintings of summer 1909. Braque worked at La Roche-Guyon, west of Paris, and Picasso in the Spanish village of Horta de Ebro (now Horta de San Joan). In paintings such as *The Castle at La Roche-Guyon* (1909), Braque rendered geometricized but insubstantial ochre-colored houses climbing up the picture space, surrounded and in some areas overlapped by loosely brushed patches of dark green foliage. Picasso painted more sculpturally solid houses, with white and ochre highlights and gray shadows, in a dense configuration that seems to step downward and outward toward the spectator rather than receding into space (e.g., *The Reservoir, Horta de Ebro*, 1909). In these paintings, both artists continued the early Cubist practice of employing inconsistent light sources and perspective, so that the buildings seem illuminated from different directions and viewed from multiple perspectives.

Analytic Cubism: 1909–1911

By late 1909, Picasso and Braque's Cubism had entered what is known as its Analytic phase, in which depicted objects appear not only to have been viewed from different perspectives but also broken up—the root meaning of analysis.[9] A key example is Braque's *Violin and Palette* (1909–10, Figure 4.6). A tall

FIGURE 4.6 Georges Braque, *Violin and Palette*, 1909–10. Oil on canvas, 91.7 x 42.8 cm. Solomon R. Guggenheim Museum, New York.

still-life composition rendered in a restricted palette of earth colors, black, white, and gray, it represents (in ascending order) a violin, sheet music on a stand, and a painter's palette hanging from a nail, with a curtain at the right. Both the violin and sheet music appear fragmented into unstable assemblages of shifting planes. As if untethered from gravity, their details drift this way and that; the violin strings follow different trajectories on either side of the instrument's bridge and a musical staff floats off the sheet music page at the upper left. The convincingly rendered nail that appears to cast a shadow signals the tradition of illusionistic representation that Braque overturns everywhere else in the picture. He replaces a perceptual form of painting with a conceptual one—declaring the artificiality of art instead of imitating the appearance of nature.

Braque later explained that the fragmentation of objects in paintings like *Violin and Palette* "was a means of getting closer to objects within the limits that painting would allow. Through fragmentation I was able to establish space and movement in space, and I was unable to introduce the object until I had created space."[10] The space surrounding the violin, sheet music, and palette, broken into modeled planes, seems as tangible as the objects. Indeed, Braque described this space as "tactile or *manual*,"[11] and noted that musical instruments were apt objects to depict in it since they are animated by touch.

The motifs in Braque's and Picasso's Analytic Cubist paintings of 1910 became increasingly fragmented. Picasso's *Daniel-Henry Kahnweiler* (1910, Figure 4.7)—for which the art dealer sat as many as thirty times—represents its subject through schematic, almost caricatured representational elements. Wavy lines of hair surmount eyes, nose, and a thin mustache, its curves echoed by those of a watch chain crossing the sitter's dark gray waistcoat. Demurely clasped hands are visible at the bottom center. The dark gray forms at the lower left indicate a small table holding a bottle. To either side of Kahnweiler's head are a New Caledonian figure and an unidentified African mask, signaling Picasso's enthusiasm for non-Western, "primitive" art, crucial to his break from Western representational conventions in *Les Demoiselles d'Avignon* and his subsequent works.

Picasso presents Kahnweiler's body and the surrounding objects not as solid volumes, but as disembodied, hovering planes. The body and objects open up to and merge with their environment, organized into an unstable scaffold that loosely echoes the canvas's horizontal and vertical sides. Picasso invests the picture with an ambiguous quality of shallow three-dimensionality by modeling these planes through subtle gradations of beige, ochre, gray, and white, applied in short daubs to generate shadowy atmosphere and glimmering light. These visual qualities evoke the flickering light and flashing images of early black-and-white movies—a new form of popular entertainment then exploding in Paris that Picasso and Braque

FIGURE 4.7 Pablo Picasso, *Daniel-Henry Kahnweiler*, 1910. Oil on canvas, 100.4 x 72.4 cm. The Art Institute of Chicago.

likely enjoyed and whose effects they may have sought to rival in their Analytic Cubist paintings.[12]

In their paintings of 1911 and early 1912, Picasso and Braque abstracted their subjects to the point of near indecipherability. This phase of Analytic Cubism is often called hermetic, in the sense of being difficult to understand. Braque's *The Portuguese (The Emigrant)* (1911, Figure 4.8) exemplifies this style. Rendered in the characteristic Analytic Cubist palette, Braque's subject—a Portuguese emigrant playing a guitar on a boat bridge with a harbor in the **background**—is evident in the pyramidal massing of dense planes along the composition's vertical axis. The artist also offers representational clues such as the simply rendered docking post and section of rope at the upper right, indicating the harbor setting; the two arcs standing for buttons on the emigrant's coat; and the lines defining the strings, sound hole, and neck of his guitar. However, Braque largely dissolves the figure into the overall web of shifting and interpenetrating planes that constitutes the fabric of the picture.

To counter this extreme abstraction, Braque introduced legible elements into *The Portuguese*: stenciled letters, numerals, a

FIGURE 4.8 Georges Braque, *The Portuguese (The Emigrant)*, 1911. Oil on canvas, 116.7 x 81.5 cm. Öffentliche Kunstsammlung, Kunstmuseum Basel, Switzerland.

Semiotics

Semiotics, or semiology, refers to the analysis of signs and their use. Its principles were independently established in the late nineteenth and early twentieth centuries by the Swiss linguist Ferdinand de Saussure and the American philosopher Charles Sanders Peirce.

Saussure defined the sign as a combination of a signifier (speech sounds or marks on a page) and a signified (the concept to which the signifier refers). He demonstrated that the relationship between them is arbitrary—based on social convention. This is proved by the use of different words (signifiers) for the same signified in different languages. For example, the animal called "dog" in English is "chien" in French and "Hund" in German. Saussure conceived of language as a system in which each sign's meaning depends on its difference from other signs. Such difference might consist of a simple phonetic variation, such as between "dog," "dig," and "dug." He also distinguished

between language (*langue*), the overall structure of signs, and speech (*parole*), an individual utterance made within that structure. His principles gave rise to the mid-twentieth-century theories of structuralism in such fields as linguistics, anthropology, psychoanalysis, and literary studies.

Peirce divided signs into three categories: icon, index, and symbol. The icon is related to its referent through likeness (e.g., a realistic portrait painting). The index points or is physically connected to its referent (e.g., footprints or smoke from a fire). The symbol is linked to its referent through convention (e.g., the word "dog"). This division is well suited to the analysis of visual art, in which features of these categories can overlap. For example, Dorothea Lange's *Migrant Mother* (see Figure 10.19) qualifies as an icon: a realistic image of a woman and her children. As a photograph, it is also an indexical sign, produced by the imprint of light on the film in Lange's camera. It functions as a symbol by evoking the rural poor's plight during the Great Depression. The concept of the index

is also useful in analyzing nonrepresentational painting like Jackson Pollock's (see Figure 12.4), in which the lines of paint on the canvas are traces of the painter's physical gestures that produced them.

Starting in the 1980s, the art historians Rosalind Krauss and Yve-Alain Bois used Saussure's semiotic theories to analyze Picasso's Cubist collages. They argued that these works were revolutionary in dispensing with the illusionistic conventions that still lingered, though abstracted, in Analytic Cubism. Instead, Picasso used arbitrary pictorial signs that function like words in verbal language and assume meaning through their relation to other units within the same system. In this argument, the four cut pieces of paper in *Guitar, Sheet Music, and Wine Glass* (1912, Figure 4.10) are recognized to refer to a guitar's parts only because of how they are combined. They are arbitrary signs: Picasso could use similar **shapes** in other collages to refer to other objects. For example, he also used the black section signifying the guitar's base to signify the drop-leaf of a table.[14]

logogram, and a punctuation mark (D CO, D BAL, &, 10,40). (Picasso also incorporated letters and other symbols into his Cubist paintings after seeing Braque's innovation.) Hovering near the top of the composition, the words, like the painting's imagery, are fragmentary: D BAL, for example, is probably the latter half of GRAND BAL (big dance), derived from an advertising poster. The inherently flat letters and other symbols press against the picture plane and assert the canvas's material surface, throwing into relief the shallow, ambiguous pictorial space in the rest of the painting. They also indicate that just as letters and numerals signify concepts rather than imitate visual appearances, the arcs, lines, planes, stippled brushstrokes, and other Analytic Cubist formal elements function as conventional signifiers of—rather than visual facsimiles of—reality.[13] In the late twentieth century, art historians developed a semiotic interpretation of Cubism as an art of signs, not based in mimesis (see "Semiotics" box).

Collage, *Papier Collé*, Assemblage, and Synthetic Cubism: 1912–1914

During 1912, while continuing to paint in their hermetic Analytic Cubist style, Picasso and Braque adopted new techniques that would revolutionize modern art. In May, Picasso created *Still Life with Chair Caning* (Figure 4.9), thus introducing **collage** (from the French *coller*, "to glue") to Cubism by gluing a piece of oilcloth printed with an illusionistic image

of chair caning onto a painting. (Amateurs and hobbyists had employed collage in the nineteenth century to create memorabilia but Picasso is credited with the technique's first use in fine art.) Above and to the right of the illusionistic section of chair caning, Picasso painted a fragmented, Analytic Cubist-style still life comprising a pipe, folded newspaper, stemmed glass, knife, cut lemon, and scallop shell. These ambiguously positioned objects rest either on the caned chair seat or on a table coinciding with the canvas's oval shape.

Hovering in the upper left are the painted letters JOU (from *journal*, French for newspaper). They can be read as a fragment of the French verb *jouer*, "to play," and a pun on the French noun *jeu*, "game." This wordplay suggests Picasso's view of art making as a game—a complex juggling between the "true" and the "false."[15] On the one hand, the oilcloth is more "real" than the painted still-life objects surrounding it; on the other, it is just as false since its chair-caning appearance is a machine-printed illusion. The oscillation between fact and fiction continues in the painting's "frame," a length of rope wrapped around the canvas's perimeter. The rope is recognizably real and at the same time humorously imitates a traditional gilt picture frame, the ornamental trim of a tablecloth, or the decorative carving on the edge of a tabletop.

The most radical innovation of Picasso's collage is its introduction of materials and objects from the mundane "real world"—a printed piece of oilcloth, a length of rope—into the realm of "high art," where they are given a representational function. He furthermore mocks a skillfully hand-painted imitation of reality by replacing it with the convincing illusion of chair caning stamped out on oilcloth by a machine. While Picasso never relinquished representation in his art, other

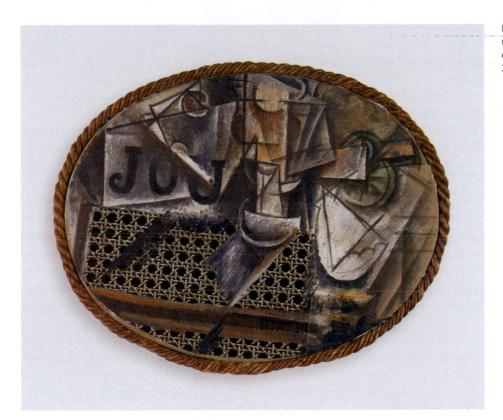

modern artists, such as Vladimir Tatlin (see Chapter 6) would soon adopt collage and its extension into three dimensions for nonrepresentational ends.

Braque followed up on Picasso's innovation by initiating **papier collé** (French for "pasted paper")—a form of collage that uses only pieces of paper. He created the first example, *Fruit Dish and Glass*, in September 1912 by affixing three cut out segments of *faux bois* (imitation wood grain) wallpaper to a sheet of paper. This material likely attracted Braque due to his training as a house painter and his earlier practice of incorporating passages of imitation wood grain, made using a house painter's comb, into his Cubist paintings, a technique he taught Picasso. Braque complemented the strips of wallpaper with Analytic Cubist-style charcoal-drawn imagery of a fruit bowl and goblet as well as the words "ALE" and "BAR" to evoke a café setting. In this *papier collé*, he continues the same complex play between fact and illusion seen in Picasso's *Still Life with Chair Caning*. As a manufactured product, the pieces of wallpaper are more real than the Cubist still-life motifs drawn around them, but also more false, since they are printed to simulate wood grain.

After seeing Braque's first *papier collé*, Picasso immediately adopted the **medium**. In *Guitar, Sheet Music, and Wine Glass* (1912, Figure 4.10), a section of patterned wallpaper serves as the background. Over it, Picasso pasted four pieces of paper along the central axis to evoke a guitar. The black curved shape at the bottom signifies the base of the guitar's lower bout; the double-curved, imitation wood-grain painted segment at

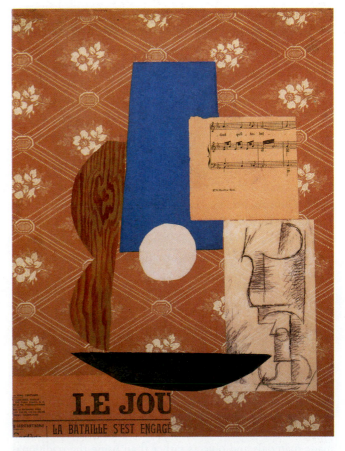

FIGURE 4.10 Pablo Picasso, *Guitar, Sheet Music, and Wine Glass*, 1912. Collage and charcoal on board, 47.9 x 37.5 cm. McNay Art Museum, San Antonio, Texas.

the left, the profile of its body; the elongated blue trapezoid, its neck; and the white disc, its sound hole. Picasso does not describe the guitar, but provides these simple signifiers that allow the viewer to imagine the instrument's presence.

To the right of the guitar body, Picasso inserts a small sheet of paper bearing an Analytic Cubist-style charcoal drawing of a stemmed wine glass. Above it and at the lower left he adds pieces of printed paper culled from the "real" world: a segment of sheet music—evoking contemporary popular entertainment—and part of an edition of *Le Journal*, a Paris newspaper. The headline, "LA BATAILLE S'EST ENGAGÉE" (the battle is joined), is from an account of the First Balkan War, a precursor to World War I. We can read Picasso's inclusion of this phrase as signaling his concern with current events and as a joking reference to the challenge Cubist collage and *papier collé* posed to traditional representational art. His probably playful intent is indicated by his truncation of the newspaper's title to LE JOU, a pun on *le jeu*.

As with his pioneering collage, Picasso's insertion of manufactured elements questions the distinction between art and life and invites the possibility of making artistic use of anything already existing—a move leading to the designation of **readymade** objects as works of art, initiated by Marcel Duchamp (see Figure 7.3). At the same time, *Guitar, Sheet Music, and Wine Glass* uses two different abstracted styles to emphasize that artistic representation is always based on conventions, or codes—it is never an unmediated transcription of the artist's observation of nature (see "Semiotics" box). One style, seen in the charcoal drawing, is that of Analytic Cubism: Picasso has dissected the goblet into an unstable, transparent assembly of straight and curved lines and shaded planes. By contrast, he has not dissected the guitar so much as constructed or synthesized it from a few elementary shapes. This mode of inventing abstracted imagery out of flat shapes that assume representational value only in combination, known as **Synthetic Cubism**, became the principal Cubist style after 1912. It is exemplified in Picasso's *Card Player* (1913–14), in which the titular figure and his café environment are conjured out of disparate, flat painted shapes of different colors, to which the artist has added linear details.

Cubist Sculpture

Picasso and Braque extended the principle of collage into three dimensions by producing sculptural reliefs out of simple shapes of paper, cardboard, wood, and other materials. These reliefs inaugurated the modernist mode of **assemblage**, in which the artist creates a sculpture by assembling scavenged or readymade materials and objects rather than using the traditional methods of carving or modeling and casting. Braque made

the first Cubist assemblages in 1912, but none survive. Picasso quickly adopted the technique, and in late 1912 assembled paperboard, paper, thread, string, twine, and coated wire into the form of a guitar (Figure 4.11). This construction evidently served as a **maquette** for a more durable version (*Guitar*, 1914) he later executed.

Picasso's *Guitar* departs radically from tradition not only through its means of creation but also in its subject matter—a still-life object rather than the human figure, sculpture's principal subject from its prehistoric origins. Equally revolutionary is *Guitar*'s inversion of the time-honored conception of sculpture as an art of solid mass and closed volumes surrounded by space. Consisting of thin planes that do not meet to enclose the instrument's body, *Guitar* is virtually free of mass and possesses no closed volumes. It is open to space, which enters the heart of sculpture.

Picasso effects a further inversion by representing the sound hole—which in a real guitar opens onto a void—as a tube protruding from the sculpture's back plane. This element was likely inspired by an African mask he owned, made by the Grebo people of Ivory Coast, in which the eyes project forward as cylinders from a flat board representing the head. *Guitar*'s

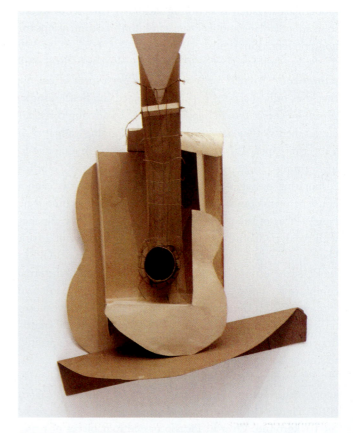

FIGURE 4.11 Pablo Picasso, *Guitar*, 1912. Paperboard, paper, thread, string, twine, and coated wire, 65.4 x 33 x 19 cm. The Museum of Modern Art, New York.

innovative qualities relate both to Analytic Cubism, in the breaking open of the object's volumes to the surrounding space, and to Synthetic Cubism, in the building up of the object from simple, flat planes. Its enduring legacy is the modernist tradition of assembled, open-form sculpture, which would soon be advanced by the Russian **Constructivists** (see Chapter 6).

Alexander Archipenko (1887–1964)

Braque's and Picasso's innovations stimulated the rise of a Cubist movement in early 1910s Paris, which included several sculptors. Among them was Alexander Archipenko, who studied art in Kyiv and in Moscow before moving to Paris in 1908. He adopted Cubist assemblage in 1913 and began constructing abstracted **polychrome** figures out of a variety of materials. A well-known example, *Médrano II* (1913–14), was inspired by his visits to the Cirque Médrano. It depicts a puppet-like female dancer made of planar, conical, wedge-shaped and spherical elements of painted tin, wood, and glass, set against a rectangular, red-painted oilcloth backdrop. In 1914, Archipenko introduced a hybrid medium he called "sculpto-painting," which merged geometric polychrome relief elements in wood and sheet metal with a painted surface to represent fragmented figures.

Archipenko also made Cubist sculptures in the round, in which he extended *Guitar*'s innovatory aspects to figurative sculpture. In *Woman Combing Her Hair* (1915), he presents a highly stylized female nude whose head and neck are defined by a void between her flowing locks and her upraised right arm. In this and other works, Archipenko uses concavities to represent what in actual human anatomy are convex masses. For example, he renders the woman's left thigh as a scooped-out hollow that under certain lighting is perceived as advancing rather than receding.

Raymond Duchamp-Villon (1876–1918)

Raymond Duchamp-Villon belonged to an artistic French family that included his siblings, the painters Jacques Villon, Marcel Duchamp, and Suzanne Duchamp. Essentially self-taught, he worked in an expressive realist style informed by Rodin's example until 1910, when he began to simplify and geometricize his figures under the influence of Cubism.

Duchamp-Villon's most original work, *The Horse* (1914), daringly abstracts its subject into a fusion of animal and machine imagery. Starting from **naturalistic** studies of a rearing horse and rider, the sculptor eliminated the rider and transformed the animal's anatomy into a dynamic configuration of organic and geometric forms, the latter suggesting machine parts such as pistons, gears, and turbines. Like his **Futurist** contemporaries, Duchamp-Villon embraced mechanization as a progressive force: "The power of the machine imposes itself upon us and we can scarcely conceive living bodies without

it."[16] He realized the final version of *The Horse* only as a forty-four-centimeter-high plaster before his death of typhoid in World War I. His artist brothers later authorized enlargements cast in bronze.

Jacques Lipchitz (1891–1973)

The Lithuanian-born Jacques Lipchitz moved to Paris in 1909, where he received academic training in sculpture. He worked in a naturalistic mode tinged with Art Nouveau stylization until 1913, when he met Picasso. Lipchitz then began to sculpt geometrically abstracted figures (e.g., *Sailor with Guitar*, 1914), their bold simplification reflecting not only the influence of Cubism but also of Egyptian and African sculpture and the work of his friends Constantin Brancusi (see Figure 9.10) and Amedeo Modigliani. By 1915, he had developed the highly **abstract** mode seen in *Man with a Guitar* (1915, Figure 4.12), first modeled in clay and then carved in stone under the artist's supervision. The figure's stark, blocky volumes are

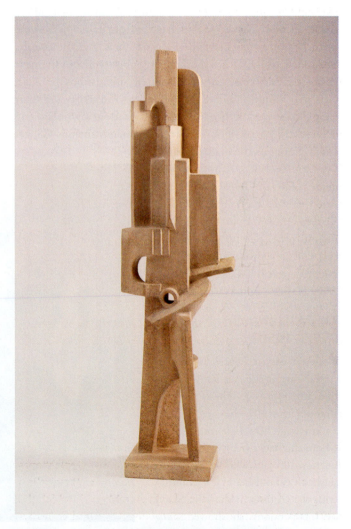

FIGURE 4.12 Jacques Lipchitz, *Man with a Guitar*, 1915. Limestone, 97.2 x 26.7 x 19.5 cm. The Museum of Modern Art, New York.

three-dimensional counterparts of the flat planes of Synthetic Cubist *papier collé* and painting. In the manner of Picasso, Lipchitz also introduces a witty visual pun into the heart of the sculpture: the cylindrical hole drilled through its center signifies both the guitar's sound hole and the man's navel. Lipchitz's later work is discussed in Chapter 9.

Salon Cubism

By 1910, awareness of Braque's and Picasso's innovations was spreading through the Parisian art world and numerous young painters were adopting the Cubist idiom. They included Alice Bailly, Robert Delaunay, Marcel Duchamp, Albert Gleizes, Marie Laurencin, Henri Le Fauconnier, Fernand Léger, Jean Metzinger, and Francis Picabia. They became known as the "Salon Cubists" after several of them exhibited together in Salle 41 of the 1911 Salon des Indépendants. (Picasso and Braque, who showed exclusively with Kahnweiler, did not participate.) This exhibition brought Cubism its first public attention and sparked verbal attacks from critics who were disturbed by its geometric treatment of anatomy. The assaults continued after a larger showing of Cubist works in the next year's Indépendants, which included submissions by Juan Gris, Piet Mondrian, and Diego Rivera. The artists and their champions met the negative critical reactions by publishing defenses and explanations of the movement, such as Gleizes and Metzinger's theoretical treatise *On Cubism* (1912), Salmon's *Anecdotal History of Cubism* (1912), and Apollinaire's *The Cubist Painters: Aesthetic Meditations* (1913). Numerous other painters soon joined the Cubist ranks, including the talented women María Blanchard, Alice Halicka, and Marevna.

Marie Laurencin (1883–1956)

Native Parisian Marie Laurencin studied art at the Académie Humbert in 1903–04, where she met Braque. In 1907 she met Picasso and through him, Apollinaire, with whom she had a five-year romantic relationship and who wrote enthusiastically about her art. Exhibiting with the Cubists in the 1911 Salon des Indépendants, she showed *Young Women* (1910–11, Figure 4.13), a painting that responds to Braque's

and Picasso's innovations but makes a distinctive statement by evoking a world of female creativity and intimacy.[17] Four lithe ivory-limbed women in an outdoor setting fill the painting's **foreground**. A violinist at the left provides music for two dancers while a seated woman at the lower center looks over her shoulder at the viewer. The rightmost dancer strokes the head of a doe, an animal Laurencin frequently depicted as a natural emblem of femininity. The compressed space and heavily outlined, exclusively female figures with their mask-like faces suggest the influence of Picasso's *Demoiselles d'Avignon* and the geometric houses in the background seem quoted from Braque's *Houses at L'Estaque*.

If those paintings served as models for *Young Women*'s composition and background, however, its central motif—female dancers in flowing robes in a garden-like setting—recalls the pagan-style, women-only outdoor dances that Laurencin's friend, the expatriate American heiress and modernist writer Natalie Barney, hosted in the first decade of the twentieth century. In 1909, Barney, who lived openly as a lesbian, moved to Paris and established a weekly literary Salon of the Amazon. Although men as well as women, including Laurencin, attended, the salon was inspired by Barney's interest in bringing together women poets in imitation of the group that gathered around the ancient Greek poetess Sappho on the island of Lesbos. In *Young Women*, Laurencin, who had romantic relationships with both men and women, imagines an exclusively female utopia of a similar kind.

FIGURE 4.13 Marie Laurencin, *Young Women*, 1910–11. Oil on canvas, 115 x 146 cm. Moderna Museet, Stockholm.

In her later years, Laurencin painted graceful society portraits and lyrical images of young women in a muted palette of pastel hues. She also produced sets and costumes for the theater and ballet.

Juan Gris (1887–1927)

Among the Cubists, Juan Gris was the closest stylistically to Braque and Picasso. Born in Madrid, Gris studied mathematics and physics there before turning to art and producing Art Nouveau-style illustrations. He moved to Paris in 1906 and two years later took up residence in the Bateau-Lavoir, where he met Picasso and members of his circle. Exploring Analytic Cubism in his early 1910s paintings, Gris, like the style's inventors, dissected his subject matter—principally still-life objects and human figures—combining multiple views of his motifs and using arbitrary effects of light and shadow. However, he

organized his compositions around diagonal grids with a more orderly character than the unstable scaffolds employed by Braque and Picasso. He also used a wider range of colors, as in his *Portrait of Picasso* (1912).

In late 1912, Gris adopted *papier collé* to create spatially complex Cubist still-life compositions that interweave pieces of cut paper culled from the everyday world—printed newspaper, patterned wallpaper, product packaging—with refined chiaroscuro charcoal drawing and flat planes of bold color. These works often include wordplay, such as the artist's witty signing of *Breakfast* (1914) through letters from a newspaper page: OURN (a fragment of *Journal*) to suggest "Juan" serendipitously appears above a headline cropped to its first word, "GRIS" (gray).

After 1914, Gris translated effects of *papier collé* into oil painting. *Fantômas* (1915, Figure 4.14) is set in a dark interior

FIGURE 4.14 Juan Gris, *Fantômas*, 1915. Oil on canvas, 59.8 x 73.3 cm. National Gallery of Art, Washington, DC.

defined through tilted black and brown planes, the latter painted to imitate wood grain. White lines define the contours of spectral objects: a table, a bowl of fruit (upper center), and a glass resting on a newspaper at the right. Gris divides the newspaper diagonally, rendering the right side opaque and the left transparent against the brown tabletop. At the left, he depicts a book in the popular crime fiction series *Fantômas*, about an elusive masked criminal genius. This might suggest a comparison between the artist's Cubist visual tricks and the fictional character's more sinister ones.[18]

María Blanchard (1881–1932)

Another Spanish-born, Paris-based artist, María Blanchard painted Synthetic Cubist still lifes and figures in a style similar to that of her friend Gris. Blanchard was academically trained in Madrid (1903–09), then spent four years in Paris where she was exposed to Cubism. She embraced this style after a sojourn in Spain (1913–16) and her definitive return to Paris, where she became friendly with Gris, Lipchitz, and other Cubists. Blanchard's *Child with a Hoop* (1917, Figure 4.15) is a sophisticated composition in which the human subject—a young girl holding a stick and hoop (used for the traditional game of hoop rolling)—and her surrounding domestic environment are built out of abutting and overlapping flat color planes, most of them tilting and angular. Some of the planes are enlivened through patterns such as the polka dots on the girl's blouse and repeated clusters of thin wavy lines evoking the grain of a wood floor. Blanchard also suggests wallpaper in the composition's upper third through spreading, unruly decorative shapes and smudges alternating between gray against red, and red against white. Like other Cubists, she also playfully includes words appropriate to the subject: "BEBE" (baby) below the child's neck and "SAGE SOIS" in front of her pelvis—reversing the expected *sois sage!* (behave yourself!). In the early 1920s, Blanchard returned to a more legible idiom in paintings like *Maternité* (1921), combining Cubist-inspired spatial distortions in the background with stylized but solidly modeled foreground figures.

Fernand Léger (1881–1955)

In contrast to the refined and cerebral still lifes of Picasso, Braque, Gris, Blanchard, and other Cubists, Fernand Léger's more monumental, extroverted art embraces the physical activities of the human body and the machine in their public manifestations.[19] While some lamented the impact of mechanization and industry on twentieth-century life, Léger viewed these forces optimistically. He understood Cubism's geometric language, with its visual suggestions of machine forms, as a means of imaginatively merging the human and machine to create a new modern beauty.

FIGURE 4.15 María Blanchard, *Child with a Hoop*, 1917. Oil on canvas, 140 x 85 cm. Musée National d'Art Moderne, Centre Georges Pompidou, Paris.

Born in rural Normandy to a farming family, Léger identified with the working classes and believed that art should be accessible to everyone, which ultimately led him to join the Communist Party in 1945. After settling in Paris in 1900, he worked as an architectural draftsman while receiving academic instruction in painting between 1903 and 1904. His encounter with Cézanne's work, which he likely saw at the Salon d'Automne's memorial retrospective, shaped the development of his personal style of Cubism, announced in his first major painting, *Nudes in a Forest* (1909–10). This crowded composition, executed in a limited palette of beige, grays, and greens, depicts multiple robotic human figures vigorously felling mechanical-looking trees. Léger seems almost literally to have followed Cézanne's famous advice to "treat nature in terms

of the cylinder, sphere and cone."[20] His transformation of nature's organic forms—both plant and human—into gleaming cylinders led Vauxcelles to call his style "tubism."

Between 1911 and 1914, Léger's work became increasingly abstract, culminating in *Contrast of Forms* (1913–14), a series of paintings and drawings employing a simple palette of black and white plus the basic **primary** and **secondary colors**. These pictures (e.g., *Contrast of Forms*, 1913, MoMA) convey a sense of physical substance through their roughly modeled, geometric forms—cylinders, cones, and rectangular solids—shifting and jostling within densely packed spaces. In a 1913 lecture, Léger declared, "pictorial contrasts used in their purest sense (complementary colors, lines and forms) are henceforth the structural basis of modern pictures."[21] A year later, he explained that contrast and rupture also defined the new, dynamic modern visual experience, exemplified by the fragmented view through an automobile windshield and "the advertising billboard . . . that brutally cuts across a landscape."[22] He argued that artists must abandon traditional forms of representation and adopt new technical means to express these new ways of seeing—the goal of his *Contrast of Forms* series.

Robert Delaunay (1885–1941)

Like Léger, Robert Delaunay used Cubist aesthetics to celebrate the dynamism of modern life. Born in Paris, he worked as an apprentice painter of theatrical sets from 1902 to 1904 but was largely self-taught as a **fine artist**. After assimilating influences from **Neo-Impressionism** and Cézanne between 1907 and 1909, he created a series of Cubist paintings of the Eiffel Tower (1910–11), an engineering marvel and icon of Parisian modernity erected for the 1889 Exposition Universelle (see Figure 5.2). In *Eiffel Tower* (1911, Figure 4.16), a characteristic work in the series, he fragments the structure and its surroundings in a manner similar to that seen in Braque's and Picasso's Analytic Cubist paintings of 1909–10. Unlike those artists' quiet studio motifs of still lifes and figures, however, Delaunay's heroic modern subject connotes city life's kinetic energy. His splintered forms not only incorporate Cubism's shifting viewpoints but also communicate excitement and agitated motion, resonating with the values of the Futurists, whose founding manifesto was published in Paris in 1909.

The Eiffel Tower paintings constituted what Delaunay called his art's "destructive" phase. He followed them up in 1912 with a "constructive" series of paintings, based on views through a Paris window, in which the tower's shape is often the only recognizable motif. He composed these pictures (e.g., *Windows Open Simultaneously [First Part, Third Motif]*, 1912) out of blocks, wedges, and patches of translucent prismatic color broken by light to suggest shifting movement. These pictures overturned the Renaissance-based mimetic conception

FIGURE 4.16 Robert Delaunay, *Eiffel Tower*, 1911 (dated 1910 by the artist). Oil on canvas, 202 x 138.4 cm. Solomon R. Guggenheim Museum, New York.

of the picture plane as a window onto the natural world and replaced it with the window as the literal subject of the painting, perceived as a two-dimensional surface covered with planes of color.

In 1913, Delaunay achieved complete abstraction in a series of *Circular Forms*, some painted on circular canvases. Many of these pictures (e.g., *Simultaneous Contrasts: Sun and Moon*, 1913) were based on the artist's observations of the sun's and moon's lights. He evoked these celestial bodies through curving bands and patches of **saturated** colors, creating the optical sensation of movement corresponding to the solar system's rhythms.

Apollinaire called Delaunay's new style **Orphism**, in reference to the mythical Greek musician and poet Orpheus. The term highlighted the "musical" quality of this art of pure color, maintaining the contemporary tendency to make analogies between sounds and colors—also pursued by Kandinsky (see Chapter 3). Delaunay called his style **Simultanism** (from

the word "simultaneity"), inspired by Chevreul's color theories (see Chapter 2), which investigated how colors placed next to each other mutually influence the viewer's perception of their hue, intensity, and **value**. Delaunay understood his Simultanism to generate a visual sensation of brilliance and movement through the precise juxtaposition of contrasting colors.

Sonia Delaunay-Terk (1885–1979)

Simultanism was jointly developed by Delaunay and Sonia Delaunay-Terk. Born in Ukraine and raised in privilege in Saint Petersburg, Russia, she studied art in Karlsruhe, Germany (1904–06), and subsequently in Paris, where she met Delaunay (they married three years later). After painting in a Fauve-influenced style in the late 1900s, she made an abstract textile work in 1911—a baby blanket for her son. Piecing together geometric scraps of colored fabric, she was inspired by Russian peasant designs, in which she recognized a visual connection to Cubism.

The next year, Delaunay-Terk began painting Simultanist compositions and in 1914 produced one of the style's grandest expressions: the huge *Electric Prisms* (Figure 4.17), exhibited at that year's Salon des Indépendants. Dominating the composition are two intersecting concentric circles divided into quadrants with alternating and repeating bands of color. They evoke pulsating illumination from the modern electric streetlights that had recently replaced gas lamps on Paris's streets. Fragmented, barely discernible figures of pedestrians occupy the lower center. At the left, Delaunay-Terk has inscribed the name of her friend Blaise Cendrars, with whom she had created the first Simultaneous book, *The Prose of the Trans-Siberian and of the Little Jehanne of France* (1913), combining his verse with her Simultanist arcs of color.

Disregarding the conventional hierarchical distinction between "fine" and "applied" art, Delaunay-Terk also created Simultaneous dresses and other articles of clothing out of geometric scraps of colorful fabric. After World War I, she became a successful fashion designer renowned for her innovative *simultané* patterns.

František Kupka (1871–1957)

A Czech artist active in Paris, František Kupka was a pioneer of nonrepresentational painting in Europe. Apollinaire called him an Orphist but Kupka rejected the designation and kept his distance from Cubism, despite being friendly with many of its artists. Trained at the art academies of Prague and Vienna, Kupka settled in Paris in 1896 and supported himself as an

FIGURE 4.17 Sonia Delaunay-Terk, *Electric Prisms*, 1914. Oil on canvas, 250 x 250 cm. Musée National d'Art Moderne, Centre Georges Pompidou, Paris.

illustrator. Engaged with spiritualism and Theosophy (see box, Chapter 3) from an early age, in the first decade of the twentieth century he combined these metaphysical interests with color theory and the scientific depiction of movement through the new technologies of Étienne-Jules Marey's **chronophotography** and cinema.

This paradoxical commitment to both methodical, scientific investigation and subjective, mystical expression led to a breakthrough into complete abstraction. After 1910, Kupka composed drawings and paintings intended to communicate meaning directly to the viewer through line and color without figuration or narrative. At the 1912 Salon d'Automne, he exhibited *Amorpha, fugue à deux couleurs* (1912), the first completely nonrepresentational painting publicly shown in Paris. Developed through studies originating in an earlier figurative drawing of a nude girl holding a ball, Kupka's composition of curved, crisscrossing red and blue shapes against a black-and-white background suggests circular motion through space, recalling the lines of movement recorded in Marey's chronophotographs.

Marcel Duchamp (1887–1968)

Duchamp studied painting sporadically at the Académie Julian in Paris between 1904 and 1905 and, by 1910, had developed a figurative style that married the solid forms of Cézanne with the intense color of the Fauves. The next year he adopted Analytic Cubism, as seen in paintings such as *Portrait of Chess Players* (1911). In *Nude Descending a Staircase (No. 2)* (1912, Figure 4.18), Duchamp presented the highly abstracted, mechanical looking titular figure as a sequence of repeated straight and curved tan and brown planes cascading down from the upper left. Although he employs the pictorial vocabulary of Analytic Cubism, his decomposed figure is not meant to be understood as a static body viewed from multiple perspectives, like Picasso's *Daniel-Henry Kahnweiler*, but as a body in motion. Duchamp's ambition to represent successive stages of locomotion through time and space in a static image was one shared by the Italian Futurists, but he executed this painting independent of their influence.

Duchamp and the Futurists drew inspiration from the same sources: cinema and Marey's chronophotography. Marey shot some of his chronophotographs against a black background with his models wearing tight-fitting black suits with white lines and dots attached to their limbs. This method produced images that rendered their motion through time and space as a series of lines and dots. Duchamp's use of these elements at the level of the figure's elbow indicates his debt to this kind of chronophotograph.

Nude Descending a Staircase (No. 2) gained notoriety when it was rejected by the hanging committee of the 1912 Salon des Indépendants, dominated by the Cubists. Gleizes and Metzinger objected to the painting's style (which they found too

FIGURE 4.18 Marcel Duchamp, *Nude Descending a Staircase (No. 2)*, 1912. Oil on canvas, 147 x 89.2 cm. Philadelphia Museum of Art.

close to Futurism, a rival movement); its title (provocatively inscribed on the painting's lower left); and its subject (which they found bizarre). The next year, it caused a sensation at the New York Armory Show, and established Duchamp's avant-garde reputation in the United States. By then, he had abandoned Cubism for more conceptual artistic investigations that secured his status as one of the twentieth century's most influential artists, primarily associated with **Dada** (see Chapter 7) and subsequent **Neo-Dada** tendencies (see Chapter 14).

Futurism

Futurism, an Italian avant-garde movement that celebrated the energy of modern technology, was founded by the poet Filippo Tommaso Marinetti. Based in Milan, Italy's most

industrialized city, Marinetti called for the obliteration of Italy's cultural past. Seeing the artistic legacy of ancient Rome, the Renaissance, and the **Baroque** as an oppressive impediment to national development, he urged artists to embrace the dynamic modern forces that technological progress had unleashed. The Futurists disseminated their ideas through manifestos vehemently proclaiming their opposition to outworn values and their commitment to innovation. In the founding statement, published on the front page of *Le Figaro* on February 20, 1909, Marinetti declared that "the world's splendor has been enriched by a new beauty: the beauty of speed. . . . a roaring car that seems to ride on grapeshot is more beautiful than the *Winged Victory of Samothrace* [the famous Hellenistic sculpture in the Louvre]."[23] He continued: "We want to glorify war—the world's only hygiene—militarism, patriotism, the destructive gesture of the anarchists, the beautiful ideas that kill, and contempt for woman. We want to demolish museums and libraries, fight morality, feminism and all opportunist and utilitarian cowardice."[24] Marinetti's celebration of aggressive values associated with masculinity, and his provocative denigration of women and feminism—often characterized as misogynistic—posits woman as Futurist man's negative Other that he must resist in order to realize his revolutionary potential.[25] Nevertheless, several women participated in the Futurist movement after World War I, including the dancer and choreographer Giannina Censi, photographer Wanda Wulz, and painter Benedetta (Benedetta Cappa Marinetti), wife of the movement's founder.

Conceiving of Futurism as a movement encompassing all arts, Marinetti enlisted the painters Giacomo Balla, Umberto Boccioni, Carlo Carrà, Luigi Russolo, and Gino Severini to the cause. In April 1910, they issued "Futurist Painting: Technical Manifesto," which described the "dynamic sensation" they would seek to represent on canvas:

> All things move, all things run, all things are rapidly changing. A profile is never motionless before our eyes, but it constantly appears and disappears. On account of the persistency of an image upon the retina moving objects constantly multiply themselves. . . . Thus a running horse has not four legs, but twenty, and their movements are triangular.[26]

The group also perceived a dynamic relationship between human beings and their environment:

> To paint a human figure you must not paint it; you must render the whole of its surrounding atmosphere. . . .
> Our bodies penetrate the sofas upon which we sit, and the sofas penetrate our bodies. The motor bus rushes into the houses which it passes, and in their turn the houses throw themselves upon the motor bus and are blended with it. . . .
> We shall henceforward put the spectator in the center of the picture.[27]

Seeking an appropriate style for their modern subject matter, the Futurists initially adopted **Divisionism**—an Italian version of Neo-Impressionism—infused with heightened color to convey urban life's vibrating energy. However, it was their merger of bright Divisionist color with Analytic Cubist techniques that most effectively articulated their dynamic vision. The first Futurist to discover Cubism was Severini, who had settled in Paris in 1906, and introduced Boccioni, Carrà, and Russolo to it when they visited Paris in October 1911. After assimilating Cubism, they went on to criticize its artists for still painting "objects motionless, frozen, and all the static aspects of Nature" and for maintaining "an obstinate attachment to the past."[28] The Futurists, by contrast, announced their orientation to the future and their search for "a style of motion."[29]

The group first showed together in Milan in April 1911. The next February, they opened an exhibition at Paris's Galerie Bernheim-Jeune. It subsequently traveled to London and Berlin and a smaller version toured other northern European cities between 1912 and 1914. By the beginning of World War I, Futurism had gained international attention as far away as the United States and Russia. The war, which the Futurists welcomed and in which many of them served, claimed the lives of Boccioni and the promising Futurist architect Antonio Sant'Elia, ending the movement's most innovative phase. However, it attracted new adherents under Marinetti's continued leadership in the postwar decades. He supported Benito Mussolini's Fascist government and oriented the movement toward furthering the regime's political goals.

Giacomo Balla (1871–1958)

The oldest of the Futurist painters, the self-taught, Rome-based Giacomo Balla discovered Impressionism and Neo-Impressionism on a 1900 trip to Paris. He proceeded to make paintings that investigated the effects of light and atmosphere, with subject matter ranging from urban streets and workplaces to landscapes and portraits. His growing interest in scientists' and photographers' optical investigations led him to embrace Futurism. In *Street Light* (c. 1910–11), one of his first Futurist paintings, Balla uses a Divisionist technique to render an electric streetlight's radiating illumination through hundreds of chevrons in varying colors. The artificial light visually overwhelms the crescent moon at the upper right, in accordance with Marinetti's privileging of technology over nature.

Familiarity with the work of the Futurist photographer Antonio Giulio Bragaglia and the earlier photographic motion studies of Eadweard Muybridge and Marey encouraged Balla to paint the successive positions of bodies moving through time and space, as had Duchamp in his *Nude Descending a Staircase (No. 2)*. Balla's most famous work in this vein, *Dynamism of a Dog on a Leash* (1912), is an amusing image of a dachshund walking alongside a woman, her body cropped at shin level. The swinging leash, the woman's and the dog's feet, and the dog's wagging tail are multiplied and blurred to create the impression of motion.

The next year, Balla adopted Cubist fragmentation to create more abstract images of speed. In *Velocità di automobile (Automobile Speed)* (1913, Figure 4.19) Balla glorifies a rushing motor car by repeating the automobile's indistinct image to express its hurtling velocity. He accentuates this effect through cascading curves suggesting rotating wheels and swirling exhaust smoke. Diagonal lines slicing through the composition also impart the sensation of dynamism. Referred to by the Futurists as "force-lines," these were intended to show the object's interaction with its environment and to involve the spectator.

Anton Giulio Bragaglia (1890–1960)

Stimulated by the 1909 and 1910 Futurist manifestos as well as by Bergson's concept of duration, the Roman photographer Anton Giulio Bragaglia formulated the theory of *Fotodinamismo futurista* (Futurist Photodynamism). In collaboration with his brother Arturo, he began experimenting with this concept in 1911 and explained it in a 1913 book. He called

it an attempt to study "the trajectory, the synthesis of action . . . the magnificent dynamic feeling with which the universe incessantly vibrates" while also revealing "the inner . . . emotions that we feel when an action leaves its superb, unbroken trace."[30] Unlike Muybridge and Marey, who recorded discrete stages of motion, Bragaglia used long exposure times to produce blurred images of figures in continuous motion. The Futurist painter and musician Russolo posed for one such photograph, *The Smoker—The Match—The Cigarette* (1911, Figure 4.20).

Gino Severini (1883–1966)

The Cortona-born Gino Severini moved to Rome in 1899, where he befriended Boccioni. Both studied painting under Balla, who introduced them to the principles of Divisionism. Severini relocated to Paris in 1906, where he met Picasso, Braque, Gris, and other avant-garde artists. Invited in 1910 by Marinetti to join the Futurists, he embraced the artistic challenge of representing speed and simultaneity. Analytic Cubist techniques enabled him to accomplish this objective in his 1912 masterpiece, *Dynamic Hieroglyphic of the Bal Tabarin* (Figure 4.21).

Set in a Parisian nightclub, Severini's picture presents the splintered forms of two female dancers in petticoats entertaining a monocle-wearing top-hatted gentleman seated at the lower right. Using Analytic Cubist fragmentation and faceting combined with bright Divisionist color, the artist creates a kaleidoscopic continuum of swinging, fractured movement. Prompted by Braque's and Picasso's insertion of lettering into

FIGURE 4.19 Giacomo Balla, *Velocità di automobile (Automobile Speed)*, 1913. Oil on card, 60 x 98 cm. Galleria Civica d'Arte Moderna, Milan.

FIGURE 4.20 Antonio Giulio Bragaglia, *The Smoker – The Match – The Cigarette,* 1911. Gelatin silver print, 11.8 x 14.5 cm. The Museum of Modern Art, New York.

their Cubist paintings, Severini includes words relating to his subject—"Bowling," "POLKA," "VALSE"—as well as nonsense words (e.g., "MICHETON") meant to evoke indecipherable sounds experienced in a noisy nightclub.[31] He also attaches real sequins to the dancers' dresses—a technique derived from Cubist collage. Suspended at the upper left is the provocative miniature image of a nude Caucasian woman riding a pair of scissors. Nearby, an equally small dark-skinned Arab man riding a camel alludes to the Turco-Italian War of 1911. National flags presented as small pennants evoke the nationalist forces that would erupt in World War I two years later.

Umberto Boccioni (1882–1916)

Perhaps the most gifted Futurist artist, Umberto Boccioni grew up in northern Italy and moved to Rome in 1899. There, he and Severini studied under Balla, who taught them the Divisionist method of laying down **complementary colors** in small discrete brushstrokes. Boccioni experimented with this technique over the next several years in Milan. His first major Futurist canvas, *The City Rises* (1910), employs Divisionism's brilliant palette and stitch-like brushstrokes to depict powerful horses and straining workmen laboring to build modern Milan. The partial dissolution of the equine and human figures into a whirling atmosphere of light and color achieves the Futurist painters' aim of denying the opacity of bodies and merging them with their surroundings.

After his October 1911 trip to Paris, Boccioni combined Cubist techniques with Divisionist color to achieve a more sophisticated visual articulation of simultaneity that, for the Futurists, characterized modern urban experience. An exhilarating example is his violently colored and visually fragmented *The Street Enters the House* (1911). In it, a mature bourgeois woman leaning over a balcony railing observes a bustle of construction workers, horses, and tottering buildings that seem to invade the space of her apartment and body.

The versatile Boccioni turned his attention to sculpture in 1912, issuing the "Technical Manifesto of Futurist Sculpture." In it, he adapted principles from Futurist painting, calling for the rejection of traditional subject matter, "a style of movement,"[32] and the fusion of the sculpture with its environment. He also argued for the "absolute and complete abolition of finite lines and the contained statue. Let's split open our figures and place the environment inside them."[33] He rejected the "traditional 'dignity'" of marble and bronze statues and advocated the use of multiple materials in a single sculpture, "glass, wood, cardboard, iron, cement, hair, leather, cloth, mirrors, electric lights, etc."[34]

Boccioni made a few sculptural experiments using various materials, but his most successful works in this medium, *Development of a Bottle in Space* (1913) and *Unique Forms of Continuity in Space* (1913, Figure 4.22), were modeled in plaster and posthumously cast in bronze. In the first of these sculptures, a bottle rising from a tilted, fractured tabletop breaks open and

FIGURE 4.21 Gino Severini, *Dynamic Hieroglyphic of the Bal Tabarin*, 1912. Oil on canvas with sequins, 161.6 x 156.2 cm. The Museum of Modern Art, New York.

appears to unfold and spiral into the space around it. In the second, a highly stylized, muscular figure, devoid of arms and facial features, marches powerfully forward like a superhuman machine. Flame-like masses ripple from the figure's calves and right buttock, suggesting its rushing motion and the fusion of the body with its environment. The striding armless figure with its bodily extensions, reminiscent of fluttering drapery, prompts comparisons with the Hellenistic *Victory of Samothrace* despised by Marinetti. Yet Boccioni's figure equally possesses qualities of a rushing automobile—the Futurists' prime symbol of modernity.

Antonio Sant'Elia (1888–1916)

The principal exponent of Futurist architecture was the Milan-based Antonio Sant'Elia. Influenced initially by Viennese modernists such as Josef Hoffmann, Otto Wagner, and Adolf Loos (see Chapter 5), he sought to conceive architecture that would express the energy of Milan's industrial growth. He turned to the example of New York City, with its soaring skyscrapers and new Grand Central Station, for inspiration. A railway station design competition spurred him to make a series of drawings for a *Città Nouva*

FIGURE 4.22 Umberto Boccioni, *Unique Forms of Continuity in Space*, 1913. Bronze, 111.2 x 88.5 x 40 cm. The Museum of Modern Art, New York.

(New City, e.g., *Station for Trains and Airplanes*, 1914). It would be a modern steel-and-concrete metropolis of unadorned factories, power stations, and tall stepped-back apartment buildings served by external elevators, rising over submerged railways and highways.

In 1914, Sant'Elia pledged allegiance to Futurism in his "Manifesto of Futurist Architecture." Rejecting all **historicism**, he called for a radically new architecture suited to the conditions of modern life: "We must invent and rebuild the Futurist city like an immense and tumultuous shipyard, agile, mobile, and dynamic in every detail."[35] Using language that predicts Le Corbusier's concept of the house as a "machine for living in," he continued, "the Futurist house must be like a gigantic machine."[36] Although inspired by New York, Sant'Elia's Futurist city denies the American value of individualism, seeking to control and organize human life in a totalized structure that anticipates the authoritarian values of Mussolini's Fascist mass society.[37] Significantly, his finished drawings for the *Città Nuova* include no people.

Vorticism

Cubism and Futurism helped to shape **Vorticism**, the only major modernist movement launched in Britain before World War I. The American-born, London-based poet Ezra Pound invented the term, from "vortex," denoting swirling circular motion around a still central point. The group's leading artist and polemicist was the painter and writer Wyndham Lewis (1882–1957), who edited the two issues of its journal *Blast*, published in 1914 and 1915. Several other painters were associated with the group, as were the sculptors Henri Gaudier-Brzeska and Jacob Epstein. Alvin Langdon Coburn introduced Vorticism to photography through his *Vortographs*, using a triangle of mirrors attached to the camera lens to represent people and objects that appear fractured and reassembled in the manner of Analytic Cubism (e.g., *Vortograph*, 1916–17).

In the first issue of *Blast*, Lewis and his colleagues declared their devotion to the modern present. They argued in strongly nationalistic terms that "Anglo-Saxon genius" was almost entirely responsible for modernity: "Machinery, trains, steam-ships, all that distinguishes externally our time, came far more from here than anywhere else."[38] Vorticist art would draw inspiration from "the forms of machinery, Factories, new and vaster buildings, bridges and works."[39] While this language recalls Futurism's rhetoric, Lewis criticized Futurist art as "too mechanically reactive and impressionistic"[40] in its attempts to represent successive stages of motion. He called for an art cleansed of sentiment—"hard, clean, and plastic."[41]

These terms aptly describe the aesthetic of Lewis's Vorticist painting *Workshop* (c. 1914–15, Figure 4.23). Its angular planes of flat color, derived from Synthetic Cubism, are bounded and traversed by crisp black diagonal lines to evoke the architecture of a modern city. The composition's rigid and impersonal quality suggests the dehumanizing potential of technology, which would prove tremendously destructive in World War I. By the time of the Vorticists' only exhibition, in June 1915, the war had scattered the group. After serving in the trenches in 1917, Lewis attempted to revive Vorticism. Unsuccessful, he then turned to a more legible representational style in which he executed portraits (e.g., *Edith Sitwell*, 1923–35).

FIGURE 4.23 Wyndham Lewis, *Workshop*, c. 1914–15. Oil on canvas, 76.5 × 61 cm. Tate, London.

Modern Architecture in Western Europe and the United States, Late Nineteenth Century to World War I

As in the realms of painting and sculpture, a tension between tradition and innovation characterized the practice of architecture on both sides of the Atlantic during the late nineteenth and early twentieth centuries. The architects we now recognize as modern took the path of innovation in response to the evolving nature of modern life, which generated the need for new building types—such as the skyscraper and large factory—and the rethinking of existing ones, such as the house.

Broadly speaking, two features define modern architecture as it emerged during this period. One is the rejection of historicism—the emulation of past architectural styles, which conservative architects continued to employ well into the twentieth century. In abandoning revival styles such as the Neoclassical and Gothic, modern architects pioneered new visual forms. These ranged from the curvilinear language of Art Nouveau to the starkly geometric buildings of Frank Lloyd Wright, Adolf Loos, and Walter Gropius and Adolf Meyer. The rejection of applied ornament, most forcefully championed by Loos, became a key principle of fully developed modernist architecture after World War I. The philosophy of functionalism justified this refusal of ornament: functionalism held that a building's purpose should determine its design—an attitude that renders decoration unnecessary, since the building's beauty is in its practicality.

The second defining quality is modern architecture's embrace of new structural technologies and building materials. Art Nouveau architects, for example, took advantage of iron's ductility and tensile strength (resistance to breaking under tension) to create skeletally thin supports shaped into sinuous organic forms. The development of steel frame construction led to the invention of the skyscraper, perfected in the United States in the 1880s and 1890s by architects such as Louis Sullivan. By the early twentieth century, architects such as Otto Wagner and Gropius and Meyer were frankly expressing the qualities of these new technologies and materials in their designs, creating an aesthetic based on industrial and machine forms understood as definitively modern. This tendency culminated in the International Style of the mid-twentieth century (see Chapter 17).

Beaux-Arts Architecture: Charles Garnier's Paris Opéra

Historicism dominated the design of major urban edifices such as churches, government buildings, and libraries in Europe and the United States for much of the nineteenth century. In France, the commissions for such buildings routinely went to architects trained at the École des Beaux-Arts. This training emphasized the study of the five **Classical** orders (different styles of **columns** and **entablatures** used by the ancient Greeks and Romans) and their employment in Italian **Renaissance** and seventeenth-century French classical buildings. Beaux-Arts architects

also learned to design orderly **plans**, often based on geometric modules, which provided for efficient circulation—the movement of people into, through and out of the building.

The grandest example of nineteenth-century French Beaux-Arts architecture is the Paris Opéra (1861–75, Figure 5.1), commissioned by Emperor Napoleon III. Its designer was the Paris-born Charles Garnier (1825–98), whose training in Classical architecture included five years in Rome as the winner of the Prix de Rome (Rome Prize), a prestigious state-sponsored scholarship. The principal **façade** of Garnier's large, impressive, and opulent Opéra features a ground-level **arcade** and upper story defined by a **colonnade** of paired Corinthian columns flanked by projecting pavilions. The colonnade and pavilions echo in a more robust **style** similar features in Claude Perrault's east façade of the Louvre Palace (1667–70; now part of the Musée du Louvre). This visual connection implicitly links Napoleon III's Second Empire to the glorious reign of Louis XIV, Perrault's patron.

Highly conscious that well-to-do Parisians attended the opera not only to be entertained but also to display their wealth through fashionable attire and expensive jewelry, Garnier provided a traditional horseshoe-shaped auditorium with tiered balconies that allowed audience members to see each other easily. The most impressive interior space, however, is the dramatic Grand Stair, ringed by four tiers of balconies affording views of opera-goers ascending, descending, and socializing in all of their finery.

Garnier's Opéra was a focal point of the new plan of Paris implemented by Georges-Eugène Haussmann as part of Napoleon III's program to modernize the French capital and promote greater prosperity for its middle and upper classes (see Chapter 1). The Opéra was located at the intersection of several major boulevards in a chic district full of banks, businesses, and the new department stores for which Paris became famous.

Iron Architecture for the International Expositions

This new, modern Paris gained renown for its large international expositions (also known as world's fairs). Similar expositions were held in other European capitals and the United States during the same period. Intended to showcase innovations in

FIGURE 5.1 Charles Garnier, Opéra, 1861–75. Paris.

manufacturing, science, and technology, as well as assert the host country's nationalistic pride, these world's fairs also included exhibitions of fine and **applied arts**. Some also featured ethnographic displays devoted to cultures considered "primitive" or "exotic" from the white Western European or North American perspective (see "Primitivism" box, Chapter 2).

For practical reasons, the structures that housed the international exposition displays needed to be very large as well as easy and inexpensive to build. Beginning with the Crystal Palace, erected for the 1851 London Exposition, many of these buildings were constructed from prefabricated modules of iron and glass; these pieces could be rapidly assembled and disassembled, an important factor since most of the structures were intended to be temporary. The use of these modern industrial materials—also the basis of iron bridges and iron-and-glass train sheds—was deemed appropriate for exhibition halls largely intended to display technological advances. However, most nineteenth-century observers considered these unadorned, functional structures to be works of engineering rather than architecture. They reserved the latter term for buildings such as Garnier's Paris Opéra.

Engineering's lack of perceived cultural value was dramatized by Garnier's and many other conservative French artists' negative reaction to the Eiffel Tower (1887–89, Figure 5.2), the most famous iron structure built for an international exposition. Erected on the Left Bank of the Seine at the entrance to the 1889 Paris Exposition Universelle to commemorate the centennial of the French Revolution and to celebrate France's industrial strength, the tower was named for Gustave Eiffel (1832–1923), a renowned engineer of wrought iron railroad bridges whose firm designed the tower. Early in the Eiffel Tower's construction, Garnier led a group of three hundred writers, painters, sculptors, and architects who published a petition protesting the tower as a "monstrous" and "odious column of bolted metal" that would blight Paris's untouched beauty.[1]

Later **modernist** critics would most admire about the Eiffel Tower what Garnier and his colleagues saw as ugly: its bracingly simple composition that frankly declares its structural logic. The tower consists of four tapering, curved, latticework piers that rise from a broad 125-meter-square base and converge, knit together at two levels by horizontal viewing platforms. Its unprecedented 300-meter height—nearly double that of the world's next tallest structure at the time—and seeming fragility—its skeletal thinness made possible by wrought iron's superior tensile strength and flexibility—astonished the public. To reassure their audience of the tower's stability, its designers added four structurally unnecessary arches to its legs. These arches also invested the tower with familiar architectural iconography, permitting it to be seen as a giant **triumphal arch** symbolizing the colossal power of modern French science and technology.

FIGURE 5.2 Gustave Eiffel, Eiffel Tower, 1887–89. Paris.

William Morris (1834–1896) and the Arts and Crafts Movement

While the international expositions celebrated new machines and manufactured products, they also displayed finely handcrafted goods that represented values antithetical to those of factory production. At the 1862 London International Exhibition, the English firm of Morris, Marshall, Faulkner & Co. (later Morris & Co.) showed prizewinning handcrafted furniture exemplary of the **Arts and Crafts Movement**, which flourished in the late Victorian period, spread to other parts of Europe and the United States, and strongly affected architecture as well as design. William Morris, the firm's founder, was an associate of the Pre-Raphaelites (see Chapter 1) and an outspoken opponent of industrial capitalist manufacturing, which he believed resulted in vulgar, shoddy products and alienated workers. His company produced well-designed handcrafted textiles, wallpaper, and furniture meant to beautify the homes and improve the lives of their owners.

The Oxford-educated Morris's views were shaped by the writings of his friend and mentor John Ruskin, an English art critic and educator. Ruskin deplored the Industrial Revolution and advocated reviving the values of the Christian Middle Ages, which he idealized as a time when artists worked in harmony with nature and a sense of spiritual purpose to create honest and beautiful buildings and objects of daily use. A similar admiration for the Middle Ages is reflected in the house that Morris commissioned from his architect friend Philip Webb (1831–1915) in 1859. Built at Bexley Heath in Kent, near London, the house had steeply pitched roofs, conspicuous chimneys, and cross **gables**, all characteristics of the Tudor Gothic medieval **vernacular** style. It gained the name Red House because of the exposed red brick of its exterior walls, which lacked a coat of stucco, then fashionable for country homes.

Morris, his wife Jane, and their Pre-Raphaelite painter friend Edward Burne-Jones created Red House's interior furnishings, gaining experience that led Morris to establish his company in 1861. In the early 1880s, he embraced socialism, and called for *"Art made by the people for the people, a joy for the maker and the user."*[2] However, his rejection of machine manufacturing limited his firm's output and necessitated high prices that ironically, made its products unaffordable to the laboring classes with whom Morris sympathized politically.

C. F. A. Voysey (1857–1941)

The simplicity of Webb's Red House was carried further in the domestic designs of C. F. A. (Charles Francis Annesley) Voysey, an English Arts and Crafts architect of the next generation. Voysey worked as an assistant to the country-house designer George Devey before setting up his own London practice in the early 1880s. He drew inspiration from sixteenth- and seventeenth-century "Old English" vernacular building styles but stripped his structures of the picturesque details retained by conventional Victorian revivalists. Broadleys (Figure 5.3), the Lake District country house he designed in 1898 for a Yorkshire couple, has the informal spread of Old English **massing** but no **half-timbering** (the rough plaster-coated walls are painted off-white); steep, prominent gables but no decorative tile hanging; and large chimney stacks that lack paneling.[3] The small-paned **sash windows** are arranged in near-continuous horizontal bands, presaging a key design feature of twentieth-century modernist buildings such as Frank Lloyd Wright's Robie House.

The **abstract** clarity of houses like Broadleys led early historians of the modernist movement to claim Voysey as one of its pioneers. But he refused such recognition, insisting that he worked in the tradition of southern English country-house building.[4]

Charles Rennie Mackintosh (1868–1928)

Associated with both the Arts and Crafts Movement and **Art Nouveau**, the Glasgow Four was a Scottish group of designers comprised of Charles Rennie Mackintosh, his wife Margaret Macdonald, her sister Frances, and Frances's husband Herbert MacNair. They worked both individually and collaboratively to create innovative designs in different **media** and sought a creative synthesis of architecture with furniture, textiles, and stained glass.

Mackintosh, the group's most celebrated member, drew inspiration from a variety of sources. The central entry of the Glasgow School of Art (1897–1909)—an institution he had attended—has bay windows modeled on prototypes from both the **Baroque** and Queen Anne (an early eighteenth-century English domestic architectural style), and an asymmetrically placed tower evoking a medieval Scottish castle. On either side of the massive entrance, the walls open into two stories

FIGURE 5.3 C. F. A. Voysey, Perspective of Broadleys, Lake Windermere, Cumbria, "England," 1898. Pencil and colored washes on paper, 26.9 x 44.9 cm. RIBA Drawings Collection, London.

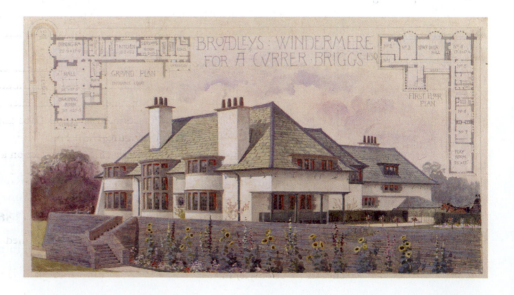

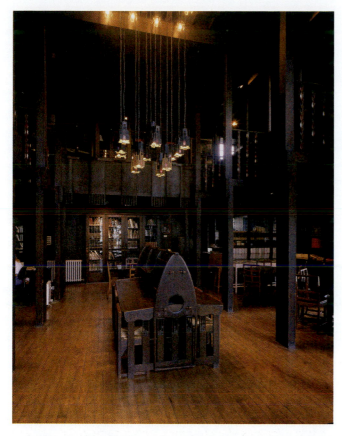

FIGURE 5.4 Charles Rennie Mackintosh, Library, Glasgow School of Art, 1907–09. Glasgow.

of enormous rectangular studio windows subdivided into abstract grids by plain **transoms** and **mullions**. Contrasting with this severe geometry are the delicate curving Art Nouveau-style ironwork brackets at the base of the upper windows (intended to support window cleaners' scaffolding), which terminate in plantlike **finials** and resemble Margaret Macdonald's paintings of elongated roses.

While a few Art Nouveau curves linger in the details, Mackintosh's complexly geometric library interior (Figure 5.4), outfitted with furniture and electric light fixtures of his own design, largely manifests an Arts and Crafts aesthetic by emphasizing simple lines and massive dark-painted wood. These qualities are most notable in the heavy timber columns and horizontal joists supporting the galleries. Largely destroyed by fire in 2014 and extensively damaged by another fire in 2018 as it was being restored, the library awaits possible future rebuilding.

Art Nouveau

Flourishing in Europe from the early 1890s to around 1910 was a highly decorative architectural style known as Stile Liberty (Liberty Style) in Italy, **Jugendstil** (Youth Style) in Germany,

and Art Nouveau (French for "new art") in Belgium, France, and England. It was "new" and modern in its total abandonment of historicism and its innovation of fresh designs emphasizing free-flowing serpentine lines inspired by plant and animal forms—a counterpoint to or escape from the regularized geometry of the urban environment and industrial forms.

In many instances, Art Nouveau architecture also announced its modernity by replacing traditional, heavy **masonry** construction with slender iron supports. In this aspect, it answered the call of the influential French architectural theorist Eugène-Emmanuel Viollet-le-Duc for a skeletal architecture using iron to achieve structural lightness and transparency similar to the kind he admired in French Gothic buildings. Although this chapter emphasizes Art Nouveau architecture, it was manifested also in painting and graphic arts (exemplified by the work of Gustav Klimt and the Czech poster designer Alphonse Mucha, respectively), as well as in sculpture, ceramics, and all areas of design, including furniture, glass, metalwork, jewelry, and textiles.

Victor Horta (1861–1947)

Like the Arts and Crafts architects and designers who inspired them, the creators of Art Nouveau emphasized fine craftsmanship rather than machine production and sought to create harmonious and aesthetically integrated environments that would surround their occupants with beauty. While early manifestations of the style are seen in European decorative and **graphic arts** of the 1880s, its pioneer in architecture was the Belgian Victor Horta, who was academically trained in Ghent and Brussels. He designed his first Art Nouveau house for Emile Tassel, a scientist and geometry professor at the Free University of Brussels, where Horta also taught.

Horta covered every surface of the sumptuous Tassel House (1892–93, Figure 5.5) interior with flowing linear decorations suggestive of snaky tendrils, as if the building were filled with organic life. These decorations spread through floor mosaics, painted walls and ceilings, and within the iron staircase and balcony railings and the budlike **capitals** sprouting from the iron columns. The columns' support of the floors enabled Horta to distribute the rooms in an unconventional manner predicting later spatial experiments by modernists such as Adolf Loos and Ludwig Mies van der Rohe (see Figure 17.3). Four floors of the Tassel House face the street while three others, set on a different level, face the back, with the main rooms oriented to the central staircase illuminated by a large skylight.

Hector Guimard (1867–1942)

Hector Guimard studied **decorative arts** and architecture in Paris before an 1895 visit to Horta's Tassel House converted him to the new language of Art Nouveau. Guimard

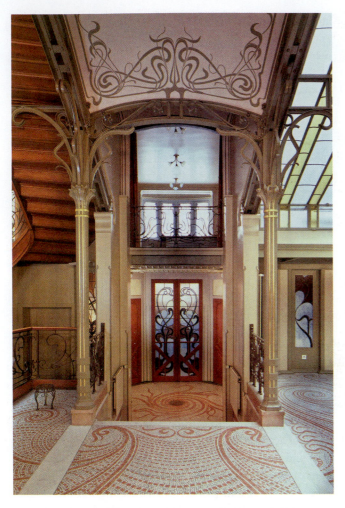

FIGURE 5.5 Victor Horta, Tassel House, 1892–93. Brussels.

became its most prominent French exponent, best known for the highly original station entrances he designed, beginning in 1899, for the Paris Métropolitain, the city's new subway system. These used prefabricated cast-iron and glass elements, with the iron painted green to imitate a weathered bronze **patina**. Guimard designed both open-air entrances with decorative **balustrades** surrounding the street-level staircase access, and sheltered entrances covered by roofs. One of three surviving canopy-style entrances, at the Porte Dauphine Station (1899–1904, Figure 5.6), features a fan-like glass-and-iron roof suggesting dragonfly wings. The roof rests on a curving iron frame supported by sculptural iron columns resembling veined plant stems.

Boldly rejecting the Beaux-Arts Classicism that still characterized most official French public architecture, Guimard's wonderfully strange and novel station entrances accentuated the modernity of the new form of public transportation to which they gave access. Sadly, many of them were dismantled in the mid-twentieth century when Art Nouveau was out of fashion.

Antoni Gaudí (1852–1926)

In Spain, the curvilinear Art Nouveau aesthetic was known simply as Modernismo (Modernism). Its most original representative was the architect Antoni Gaudí i Cornet, who worked in Barcelona, the major city of the Spanish region of Catalonia. Gaudí's audacious and distinctive style is exemplified by the Casa Milà (1905–07, Figure 5.7), a large apartment building commissioned by the industrialist Pere Milà i Camps and his

FIGURE 5.6 Hector Guimard, Porte Dauphine Métro entrance, 1899–1904. Paris.

FIGURE 5.7 Antoni Gaudí, Casa Milà, 1905–07. Barcelona.

wife, Rosario Segimon i Artells, who resided on the main floor and rented out the other units. Gaudí used steel beams to support the building and gave it an undulating façade of cut stone that resembles both an eroded cliff face—hence the building's nickname, "La Pedrera" (the quarry)—and rolling waves. Accentuating the marine reference are the extravagant wrought-iron balcony railings resembling clumps of swirling seaweed. Along the skyline, the building offers notes of fantasy in its twisting chimneys evoking helmeted guardian figures.

On the interior, Gaudí created a free-flowing plan of eccentrically shaped apartment rooms whose walls never meet at right angles. He wrapped them around two bean-shaped courtyards. Suffused both inside and out with expressive qualities of dynamic change and growth, the entire building suggests a gigantic living organism.

A devout Catholic, Gaudí spent the final decades of his life working on the Expiatory Temple of the Holy Family (the Sagrada Familia). He transformed the original architect's conventional Gothic design into something extraordinary, seeking to inspire his native Catalonia's spiritual renewal through powerfully imaginative architectural forms rooted in nature.

The Façade of the Nativity features grotto-like portals teeming with vegetal ornament and harboring figurative sculpture under gables dripping with abstract stalactites. Soaring above the portals are four astonishing needle-shaped openwork towers terminating in finials covered in colorful tile and capped by globule-rimmed cross motifs. Unfinished at Gaudí's death, the Sagrada Familia remains under construction to this day.

Turn-of-the-Century Modern Architecture in Vienna

As in other major European cities, historical styles prevailed in official architecture until the end of the nineteenth century in Vienna, the highly cultivated western capital of Austria-Hungary. In the early twentieth century, Viennese architects including Otto Wagner, Joseph Maria Olbrich, Josef

Hoffmann, and Adolf Loos turned against historicism and introduced modern innovations.

Otto Wagner (1841–1918)

Austrian modern architecture was pioneered by Otto Wagner, who worked in a Neo-Renaissance manner early in his career but called for a break from historicism after his 1894 appointment as professor of architecture at Vienna's Academy of Fine Arts, his alma mater. Wagner insisted that modern architectural forms be "in harmony with . . . the new requirements of our time,"[5] and advocated a **functionalist** position that emphasized utility as the basis of design, declaring, "nothing that is not practical can be beautiful."[6]

Notwithstanding this theoretical commitment to functionalism, Wagner employed curvilinear Art Nouveau-style decoration in the ironwork and mosaics of the most ornate of the thirty-six stations he designed for the Vienna Stadtbahn (1894–1901), a public transportation system. More consequential for architectural modernism's future course was Wagner's use of white marble panels hung from a frame of wrought-iron mullions in the Karlsplatz Station façades. These façades demonstrated his commitment to a modern architecture defined by "the lines of load and support, panel-like treatment of surfaces, the greatest simplicity, and an energetic emphasis on construction and material."[7]

These principles found masterful expression in Wagner's Postal Savings Bank, an imperial commission built in two phases (1904–06 and 1910–12). It was among the first major buildings to make extensive use of aluminum—a modern material lacking historical associations. Above an aluminum entry canopy supported by aluminum columns and **cantilevered** arms, the façade's four upper stories are clad with sheets of marble attached to the building by aluminum-capped iron bolts creating a geometric grid pattern. Wagner could have removed these bolts, which secured the panels while the mortar holding them hardened, but he left them in place to accentuate his use of the metal and to signal the technical and economic advantages of the construction method he advocated.

An iron-and-glass vault springing from slender, downward tapering aluminum-clad piers studded with rivets in decorative patterns covers the central banking room interior (Figure 5.8). Glass-brick floor panels provide illumination to the rooms below. Conceiving of the building as an elegant and well-functioning **Gesamtkunstwerk** (total work of art), Wagner designed all of the bank's furnishings and fixtures—from safes, lamps, desks, and chairs to the futuristic cylindrical aluminum heating units lining the walls—in a streamlined style emphasizing efficiency. In its functionalism and frank expression of advanced engineering and modern materials, Wagner's Postal Savings Bank announced the ideal of the building-as-machine that would define the work of modernist architects of the next generation such as Le Corbusier (see Figure 17.1).

The Vienna Secession

In 1899 Wagner surprised his academic colleagues by joining the Vienna Secession, an organization established two years earlier by young artists and architects gathered around the painter Gustav Klimt (see Chapter 3). Rebelling against academic historicism and promoting innovation, the Secession proclaimed the mystical belief that its art sprang from the "Ver Sacrum" (Latin for "sacred spring"), the title of the group's journal. Among the founding members were two former students

FIGURE 5.8 Otto Wagner, Central Banking Room, Postal Savings Bank, 1904–06. Vienna.

of Wagner, Joseph Maria Olbrich and Josef Hoffmann, who achieved the major architectural expressions of what came to be called Sezessionstil (Secession Style). Sometimes described as an Austrian variety of Art Nouveau, Sezessionstil design differs from the work of architects such as Horta, Guimard, and Gaudí in emphasizing rectilinear shapes and planar surfaces.

Joseph Maria Olbrich (1867–1908)

The commission for the Secession House (1898, Figure 5.9), the group's exhibition hall and meeting space, went to Joseph Maria Olbrich, then working as Wagner's assistant. Aspiring to create an effect of "solemn dignity,"[8] Olbrich composed the building out of simple geometric masses of whitewashed stucco-covered brick. Its principal façade recalls an Egyptian **pylon**. Crowning it is a remarkable openwork dome composed of 3,000 gilt-iron laurel leaves and 700 berries, evoking a giant laurel tree, a traditional symbol of victory and renewal. **Stylized** laurel trees and gilt foliage also appear as stucco decoration on either side of the portal, beneath the Secession's inscribed motto: "Der Zeit ihre Kunst. Der Kunst ihre Freiheit."

(To the age its art. To art its freedom.). Three sculpted Gorgon heads above the door represent Painting, Sculpture, and Architecture, while groups of stucco owls, ancient symbols of the goddess Minerva and wisdom, perch along the side walls. Within a few years, modernist architects such as Loos would denounce—and strip their buildings of—such applied ornament and conventional symbolism. However, this use of decoration and traditional iconography remained valid to Olbrich and his Secessionist colleagues, even as detractors dubbed his gilt-domed building "the golden cabbage."

Josef Hoffmann (1870–1956)

Josef Hoffmann, who worked with Olbrich in Wagner's office, designed several early exhibitions for the Secession House, whose skylit interior had moveable partition walls affording maximum flexibility in exhibition layout. In 1903, Hoffmann, his fellow Secessionist artist Koloman Moser, and the financier Fritz Wärndorfer founded the Wiener Werkstätte (Viennese Workshops). A counterpart to the English Arts and Crafts Movement, this group designed elegant, well-crafted

FIGURE 5.9 Joseph Maria Olbrich, Secession House, 1898. Vienna.

furniture, utensils, glassware, and other useful objects intended to represent "the spirit of our age in a purer, simpler, and more beautiful way."[9]

Hoffmann shared with Wagner and Olbrich the ideal of creating a total work of art, integrating custom-made furnishings, fixtures, and decoration into architecture to achieve a unified aesthetic ensemble. A 1905 commission from the wealthy Adolphe and Suzanne Stoclet for a lavish villa in suburban Brussels enabled Hoffmann to realize this utopian aim. He gave the Palais Stoclet (1905–11, Figure 5.10) a reserved exterior outlined in gilt-bronze frames and surfaced with smooth rectangular Norwegian marble panels. An asymmetrically placed stair tower culminates in four herculean bronze statues of male nudes by Fritz Metzner and a dome of vegetation recalling that of the Secession House. The geometrically orderly garden complements the house.

The opulent interiors include a main hall whose yellow-gold Italian marble-clad walls and gray Belgian marble columns provided a luxurious setting for the Stoclets' eclectic collection of ancient and medieval European, Byzantine, Pre-Columbian, and Asian art. Two fourteen-foot-wide mosaics by Klimt filled with spiraling gold tree branches grace the main dining room walls (Figure 5.11). The Wiener Werkstätte, under Hoffmann's direction, made every piece of furniture, china, glass, and cutlery for the Palais Stoclet, which took nearly ten years to complete.

Adolf Loos (1870–1933)

The German-educated Austrian architect Adolf Loos, Hoffmann's exact contemporary, rejected as degenerate the precious aestheticism exemplified by the Palais Stoclet. In his famous polemical essay "Ornament and Crime" (1908), Loos disapprovingly compared architectural ornament to the tattoos on the body of a New Guinea native or scatological graffiti on the walls of a public restroom. He argued that the more evolved a culture became, the less it needed decoration. Loos instead advocated severe geometric purity, which he realized in the exterior of the Steiner House (1910, Figure 5.12), a radically modern dwelling in Vienna designed for the painter Lilly Steiner and her husband Hugo, a wealthy manufacturer.

To comply with a regulation that the house's street-facing side could not exceed one story (excepting an attic room), Loos hid the first of that side's three floors by lowering its windows to ground level. He disguised the third story as an attic by covering it with a sheet-metal barrel vault interrupted by a dormer window. The roof flattens toward the three-story garden façade, an abstract composition of smooth whitewashed stucco-covered walls punctuated by fifteen rectangular windows. This façade, with its stark geometric simplicity, soon became an iconic example of the radical modernist rejection of historicism. Nevertheless, its symmetry, three-part **elevation**, and reductive purity are rooted in classicism.[10]

FIGURE 5.10 Josef Hoffmann, Palais Stoclet, 1905–11. Brussels.

FIGURE 5.12 Adolf Loos, Steiner House, 1910. Vienna.

The New American Architecture

Like their European counterparts, American architects worked in classical and Gothic revival styles throughout the nineteenth century. Since these styles were imported from Europe, however, the relatively young country lacked its own distinctive architectural tradition. After the Civil War, some progressive American architects sought to develop new modes of building that would express the dynamic power of the nation's rapid economic and urban development. This architecture emerged primarily in Chicago, a major Midwestern transportation and commercial center that grew exponentially in the second half of the nineteenth century, its population exceeding one million by 1890. The Great Fire of 1871, which destroyed much of downtown Chicago, created a rich opportunity for architects to design new buildings that would meet the needs of the modernizing metropolis.

H. H. Richardson (1838–1886)

The most celebrated and influential building to rise in 1880s Chicago was H. H. (Henry Hobson) Richardson's Marshall Field Wholesale Store (1885, Figure 5.13), a commission from the department-store owner Marshall Field. Louisiana-born

FIGURE 5.13 H. H. Richardson, Marshall Field Wholesale Store, 1885 (demolished 1930). Chicago.

and Harvard-educated, Richardson was only the second American to study architecture at the École des Beaux-Arts. (The first, Richard Morris Hunt, became a tremendously successful Beaux-Arts architect in the United States, working in classical, French Renaissance, and French Second Empire styles.)

After his return to the United States, Richardson gained acclaim for his design of Boston's Trinity Church (1872–77), which was inspired by French and Spanish **Romanesque** churches with their heavy masonry walls and round arches and vaults. For the rest of his short life, the architect worked in a personal style that came to be known as the Richardsonian Romanesque. Although still based on European models, it represented an alternative to the classical and Gothic revival styles and was adopted by many younger American architects. The Marshall Field Wholesale Store's Romanesque-derived features are its thick external walls of rough-cut masonry—red granite at the first floor and red sandstone above—and the round arches crowning the windows at the fourth and sixth stories.

Occupying an entire half-block and encompassing 500,000 square feet, the store had a U-shaped plan with a central loading dock (on the rear of the building, not visible in the photograph). Firewalls divided the floors into three sections, but they were otherwise open to facilitate the display and movement of wholesale goods. Richardson relieved the visual weight of the massive seven-story exterior by opening its

walls into smaller and more numerous windows as the elevation rises. Single round arches span the second through fourth stories; their rhythm doubles in the pairs of narrower arches binding the fifth and sixth stories; this rhythm doubles again in the quartets of small vertical rectangular windows perforating the top **cornice**-capped story.

Richardson's building was remarkable for its emphasis on large, clear forms and unadorned surfaces that conveyed dignity and strength. The architect told a reporter that he aimed to create beauty through "material and symmetry rather than . . . mere superficial ornamentation" and through a building "as plain as can be made, the effects depending on the relations of the 'voids and solids.'"[11] Years later, the Chicago architect Louis Sullivan praised the Marshall Field Wholesale store as "a monument to trade, to the organized commercial spirit, to the power and progress of the age."[12]

The Chicago School and the Rise of the Skyscraper

Richardson's store was aesthetically advanced but structurally conservative. Its massive external walls bore the building's weight and its floors were supported by columns. Other architects working in Chicago from the 1880s onward, known collectively as the Chicago School, adopted advanced construction techniques that enabled them to erect increasingly taller structures. The resulting new building type, the skyscraper, maximized the use of downtown real estate that had risen

dramatically in price due to speculation accompanying the city's rapid development and population growth.

The new structural system that made the skyscraper possible was the steel-frame skeleton, which evolved from the cast-iron framing first used in buildings in New York City before the Civil War. The steel skeleton composed of vertical columns and horizontal girders carried the building's weight. This allowed its internal walls to function simply as partitions and its external walls to hang from the frame like curtains (hence the term "**curtain wall**"). Also important to the skyscraper's practical development was the safety elevator, introduced by the American Elisha Otis in the late 1850s.

William Le Baron Jenney's ten-story Home Insurance Building (1883–85) was the first tall building to use a steel-frame skeleton, but it did so only above the sixth-floor level (cast-iron framing supported the lower floors). The first building entirely framed in steel was the ten-story Rand McNally Building (1889–90) by Daniel H. Burnham and John Welborn Root. Neither of these Chicago buildings, however, frankly revealed its steel frame construction on its exterior. Both were clad in masonry and had façades of horizontal layers formed by single or grouped floors separated by masonry bands or **stringcourses**. Derived from Renaissance prototypes, these horizontal, stacked designs downplayed the buildings' unprecedented verticality, which lacked an established architectural language for its expression.

Louis Sullivan (1856–1924) and the "Tall Building Artistically Considered"

Louis Sullivan offered a successful solution to the design challenge posed by this new vertical building type in his 1896 essay "The Tall Building Artistically Considered." Declaring that "form ever follows function," he argued that the tall office building's external appearance should express the uses of its interior spaces. Such a building required a basement housing power and air-circulation equipment; an amply lit ground and second floor for commercial activities; above this, "an indefinite number of stories of offices,"[13] all identical; and at the top, an attic containing machinery and conduits completing the "circulatory system"[14] powered by the basement engines. In elevation, the two skyscrapers Sullivan designed, the Wainwright Building in Saint Louis (1894, Figure 5.14) and the Guaranty Building in Buffalo (1896), clearly show the division described in his essay. This arrangement has been compared to the three parts of a classical column: base, shaft, and capital.

Born in Boston and educated in architecture at the Massachusetts Institute of Technology (the first American university to offer such instruction), Sullivan worked briefly for Jenney in Chicago (1873–74) and then studied at the École des Beaux-Arts (1874–75) before returning to Chicago and forming a partnership with the German-born engineer Dankmar Adler

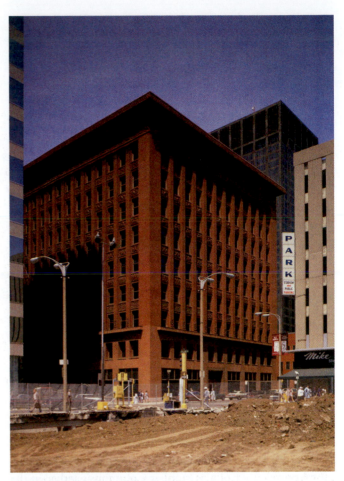

FIGURE 5.14 Dankmar Adler and Louis Sullivan, Wainwright Building, 1890. Saint Louis, Missouri.

(1844–1900). Their most important Chicago commission was for the Auditorium Building (1886–90). A 4,200-seat concert hall (with excellent acoustics engineered by Adler) occupies the center of this multipurpose building, which also contained a ten-story luxury hotel and seventeen-story office tower. (Today the building is part of the downtown campus of Roosevelt University.) The façades' arcaded **fenestration** is adapted from Richardson's Marshall Field Wholesale Store.

While heavy masonry walls supported the Auditorium Building, Adler and Sullivan used a steel-frame skeleton for the Wainwright Building. They clad its exterior in brown sandstone on the first two stories and brick above. Rather than forthrightly revealing the grid of the steel frame skeleton on the exterior, Sullivan inserted extra nonstructural piers between the windows from the third floor to the attic to double the number of bays and emphasize the building's verticality. This was in keeping with his exhortation that the skyscraper must be "every inch a proud and soaring thing, rising in sheer exultation that from bottom to top it is a unit without a single dissenting line."[15]

Sullivan also heightened the Wainwright Building's aesthetic appeal through the rich foliate ornament in red **terracotta** that frames the street-level entrances. It also embellishes **spandrel** panels beneath the windows, the bases and capitals of the piers between them, and the cornice. Free of historical references and based on curving plant forms, Sullivan's ornament has affinities with Art Nouveau but he created it independently of this parallel European development. His nature-based ornament had not just a decorative but also a communicative purpose: he used it to express organic growth and a sense of the building's internal spatial energy releasing itself.[16] He applied ornament even more lavishly to the exteriors of the Guaranty Building and in the street-level façade of his last great building (designed after dissolving his partnership with Adler), Chicago's Schlesinger and Mayer Department Store (1899–1904, later the Carson Pirie Scott Store). This building's upper stories, clad in white ceramic, express the grid of the steel-frame skeleton with unprecedented frankness.

The White City

Despite the innovations of Sullivan and other Chicago School architects, Beaux-Arts classicism reigned in official civic architecture in the United States until the 1940s. This mode's prestige was consolidated at the 1893 World's Columbian Exposition in Chicago, mounted to celebrate the 400th anniversary of Christopher Columbus's arrival in the Americas and to show off US achievements in industry, agriculture, and the **fine arts**. The exhibition grounds, laid out by the landscape architect Frederick Law Olmstead along the shores of Lake Michigan, centered around the Court of Honor. This was a lagoon rimmed by an ensemble of large, temporary buildings designed by leading American Beaux-Arts architects including Richard Morris Hunt and the firm of Charles McKim, William Mead, and Stanford White. The buildings had Neoclassical façades based on Classical and Renaissance models, intended to represent the United States as the glorious successor to the ancient civilizations of Greece and Rome as well as the Italian Renaissance. Iron supported the buildings, but their plastered façades were painted white to imitate marble, giving rise to the nickname "the White City."

The exposition's only major building designed in a style other than Beaux-Arts classicism was Adler and Sullivan's Transportation Building. Its polychrome façade and heavily ornamented arched portal set it apart from the White City, whose revivalist aesthetic Sullivan deplored as "fictitious and false."[17] Late in life he wrote that the World's Columbian Exposition set the course of American architecture back "for half a century from its date, if not longer."[18]

Frank Lloyd Wright (1867–1959)

Equally contemptuous of the White City's Neoclassical architecture was Frank Lloyd Wright, who attained great originality in his work and became the twentieth century's most famous American architect. Wright spent much of his boyhood in his native rural Wisconsin and drew lifelong inspiration from nature. While growing up he read avidly, absorbing ideas from Ruskin and Ralph Waldo Emerson, the American philosopher who advocated self-reliance and individualism.

Ambitious to become an architect—a career for which his mother believed he was destined—Wright briefly studied civil engineering at the University of Wisconsin before moving to Chicago in 1887 and joining Adler and Sullivan's firm a year later. As Sullivan's chief assistant he designed many of the firm's residential commissions. However, Sullivan fired him in 1893 after discovering that Wright had violated his contract by working independently for clients. Wright then established his own office in the Chicago suburb of Oak Park.

Throughout his long career, Wright devoted much of his energy to designing single-family houses, because he saw the family as the cornerstone of an ideal democratic society.[19] In the first decade of the twentieth century, he developed a new idiom for domestic architecture known as the Prairie Style due to its emphasis on horizontal lines and volumes that make the house appear to hug the flat Midwestern landscape. This style manifested Wright's philosophy of organic architecture, which held that "a building should appear to grow easily from its site and be shaped to harmonize with its surroundings."[20]

Wright built his most famous Prairie Style house in south Chicago for the family of Frederick C. Robie, a manufacturer of automobile and bicycle parts. To provide privacy from the nearby street, Wright shielded the ground floor of the three-story Robie House (1906–09, Figure 5.15) behind a low wall and its second story behind a balcony. The low roof covering the second floor reinforces these elements' horizontality as it extends dramatically out into space, cantilevered on steel beams.

The floating planes and jutting masses of the Robie house exterior manifest Wright's determination to break open the "box"—to liberate the building's external forms and internal spaces from containment in rectangular units.[21] This impulse is seen also in the asymmetrical plan, which rotates around the massive fireplace. Rather than closed boxes, the second-floor living and dining rooms are open spaces that flow together in front of the hearth. These rooms also open visually to the exterior through banks of windows decorated with Wright's abstract geometric designs in leaded glass. Wright extended this ideal of integration to all physical aspects of the home. He incorporated the utilities and fixtures—heating, lighting, and plumbing—into the fabric of the building. He likewise designed all of its furniture, carpets, and even dresses for Mrs. Robie to wear when entertaining.[22]

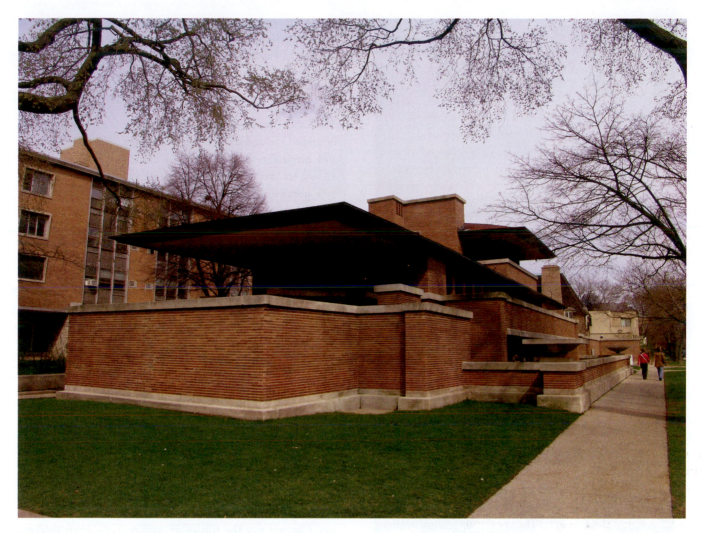

FIGURE 5.15 Frank Lloyd Wright, Robie House, 1906–09. Chicago.

Highly successful as a residential architect, Wright coveted more professionally prestigious opportunities to design large commercial and public buildings. His first such commission was for the Larkin Soap Manufacturing Company's administration building in Buffalo, New York. Unlike Wright's Prairie Style houses, which opened out into the landscape, the five-story Larkin Building (1902–06) was sealed off from the noise and fumes of the surrounding industrial environment. Wright organized the building around a central, sky-lit atrium (Figure 5.16) with circumferential balconies open to the working floor. Applying to the workplace his view of the family as democratic society's cornerstone, Wright hoped this arrangement would create "the effect of a great official family at work in day-lit, clean airy quarters."[23] Into these quarters, Wright introduced features that would later become standard in office buildings: open-plan offices, built-in file cabinets, wall-hung toilets, and air conditioning.[24] To promote free movement through the interior, he placed the stairways in hollow towers on the building's four corners and the air-circulation ducts in adjacent shafts.

He designed the entire structure to function with modern efficiency as "a genuine and constructive affirmation of the new Order of this Machine Age."[25] The Larkin Building became one of Wright's most widely published designs and had a strong impact on many European modernist architects.

Early Twentieth-Century Modern Architecture in Germany: The Deutscher Werkbund

Frank Lloyd Wright's work became well known in Europe through the 1910 German publication of a deluxe portfolio of his designs, supervised by Wright himself, who traveled to Berlin to oversee the production. At this time, the cause of modern architecture and design in Germany was promoted

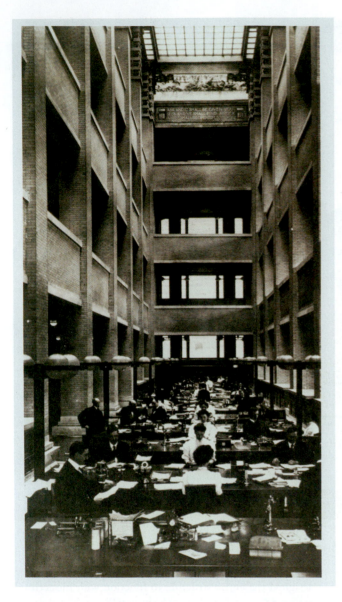

FIGURE 5.16 Frank Lloyd Wright, Interior Atrium, Larkin Building, 1902–06 (demolished 1949). Buffalo, New York.

its graphics to its products and production facilities. Behrens, who was trained as a painter, had previously worked in a curvilinear Jugendstil manner, but he developed for AEG a clean, bold geometric style expressive of industry's efficiency and power.

The AEG Turbine Factory in Berlin (1909, Figure 5.17), which Behrens designed in collaboration with engineer Karl Bernhard, manufactured turbines to propel German navy and merchant ships. The main block encompasses a vast, 123-meter-long open interior beneath a **glazed** roof supported by a steel frame. Gantry cranes used for moving the turbines during assembly ran on parallel rails in the upper walls. Behrens directly revealed the building's structural materials on its exterior by exposing the steel frame along the side wall, which opens into expansive window screens between the vertical columns. The end elevation also features a curtain wall of windows pushed forward from the flanking concrete corner panels. The gable above bears an inscription announcing the building's function, "TURBINENFABRIK" (turbine factory). Above this, the hexagonal Behrens-designed AEG logo proudly announces the corporation's identity on a building often described as a temple of industry.

Walter Gropius (1883–1969) and Adolf Meyer (1881–1929)

Behrens's commitment to creating aesthetic forms appropriate to the modern industrial world attracted numerous young architects to his Berlin office. Among them was Walter Gropius, later famous as the founder of the Bauhaus (see Chapter 6). The son of an architect, Gropius received academic training in Munich and Berlin before joining Behrens's firm in 1907. Two years later he left to found his own practice with Adolf Meyer. Their first major commission was for the Fagus Factory in Alfeld-an-der-Leine, which manufactured shoe lasts (foot-shaped wooden forms over which shoes are fabricated).

Inspired by Behrens's AEG Turbine Factory but even more radically simplified, the Fagus Factory's administrative wing (1911–12, Figure 5.18) is a flat-roofed rectangular box rimmed in yellow brick. It is supported by a steel frame from which hang curtain walls of glass with black metal panels at the floor levels. The building's corners daringly express the non–load-bearing nature of the curtain walls, dissolving into the meeting of visually weightless planes. The first major building to take the abstract form of a steel-and-glass box, entirely free of historical references and frankly declaring the nature of its advanced structural technology and materials, the wing stands as a landmark in the history of modern architecture. It presages the International Style (see Chapter 17) that would arise in the next decade.

by the **Deutscher Werkbund** (German Labor League), an association of architects, manufacturers, designers, and writers founded in Munich in 1907 by Herman Muthesius. The Werkbund drew inspiration from the English Arts and Crafts Movement and shared its goal of producing fine designs free of historicism. Unlike the Arts and Crafts Movement, however, the Werkbund embraced mechanization and industrial production, vital to the modern German economy.

Peter Behrens (1868–1940)

Emblematic of the Werkbund's values were the creative efforts of its member Peter Behrens for AEG, the Allgemeine Elektricitäts-Gesellschaft (General Electric Company). In 1907 AEG hired Behrens to coordinate all aspects of design for the firm, from

FIGURE 5.17 Peter Behrens, AEG Turbine Factory, 1909. Berlin.

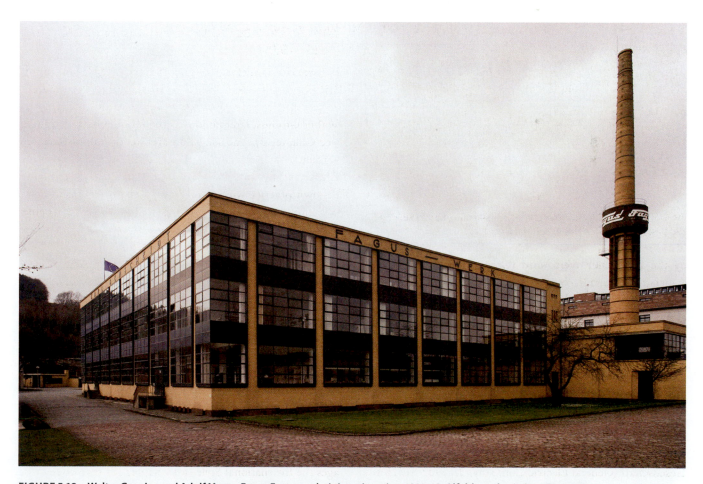

FIGURE 5.18 Walter Gropius and Adolf Meyer, Fagus Factory administrative wing, 1911–12. Alfeld-an-der-Leine, Germany.

The Russian Avant-Garde, De Stijl, and the Bauhaus

This chapter surveys several avant-garde movements of the 1910s and early 1920s that emerged with and responded to the radical changes in European society, politics, and technology during and after World War I: Rayism, Cubo-Futurism, Suprematism, and Constructivism in Russia; De Stijl in the Netherlands; and the Bauhaus in Germany.

The painters, sculptors, and designers associated with these movements generally worked in geometric styles derived from Cubism. Carrying Cubism's dismantling of illusionistic representational conventions to its logical conclusion, they made completely abstract works that asserted the independent reality of their formal and material elements, including line, shape, form, color, space, and texture. Although these works lacked recognizable subject matter, their makers did not consider them meaningless but sought through abstraction to express a wide variety of ideas, including political, spiritual, and utopian beliefs. Rayism, Cubo-Futurism, and Suprematism were painting styles, though Suprematism also influenced design. Similarly, De Stijl defined itself through painting, but encompassed design and architecture with the goal of creating aesthetically unified environments. Conversely, Constructivism and the Bauhaus were more oriented to the design of utilitarian objects and architecture, as well as photography and graphic design.

The Constructivist, De Stijl, and Bauhaus artists associated geometry with science, machinery, and technology, which they hailed as progressive forces shaping the new modern world. Constructivism, which emerged following the Russian Revolution in 1917, affirmed the new Communist government's emphasis on industry as the foundation of the future utopian society, applying abstract geometric aesthetics to the design of pro-Communist visual propaganda and utilitarian objects that could be mass-produced. Less politically engaged than the Constructivists, the De Stijl artists viewed the machine positively as a model of orderly geometric beauty. They sought to create the same kind of beauty through their rigorously geometric abstract art, design, and architecture, which they believed could help to improve society. The Bauhaus, founded immediately after World War I with the aim of rebuilding German society, sought to unify art and technology and emphasized design for industrial production.

The attitudes of the Constructivist, De Stijl, and Bauhaus artists toward the machine differed markedly from those of the Futurists and Vorticists. The artists of those earlier movements, which emerged before World War I, were romantic individualists who embraced the machine as a novel agent of change and excitement. De Stjil, Constructivism, and the Bauhaus, established during or after the war, generally viewed individualism negatively, associating it with the war's destructive chaos, competitive capitalism, or both. They placed a higher value on collective discipline and order, which they found manifested in machinery, a view shared by the Purists in France (see Chapter 9).

The Avant-Garde in Russia

Avant-garde culture flourished in Russia in the 1910s and early 1920s, including innovations in painting, sculpture, architecture, and design. This cultural ferment accompanied the great social, economic, and political upheaval of the Russian Revolution. In 1917, the radical socialist Bolsheviks led by Vladimir Lenin overthrew the czar and withdrew Russia from World War I, eventually establishing the Union of Soviet Socialist Republics in 1922 under the Communist Party's leadership.

During the early years of Communist rule the government supported the avant-garde, recognizing that its innovations might energize the masses and advance political change. By 1922, however, the government began to favor an accessible realist **style** that would communicate clearly to the proletariat (working class). In 1934, Soviet leader Joseph Stalin's government decreed **Socialist Realism** the country's only officially acceptable form of art and tasked Soviet artists with producing realistic, optimistic, and heroic imagery glorifying the struggle to achieve a classless society. The Soviet Union largely suppressed avant-garde and experimental art for the next several decades.

Socialist Realism revived the aesthetic of the nineteenth-century Wanderers, a group of painters who rejected the Western-based **Neoclassicism** promulgated by Saint Petersburg's Imperial Academy of Fine Arts to create **illusionistic** images of Russian middle-class and peasant life (e.g., Ilya Repin, *Barge Haulers on the Volga*, 1870–73). They displayed their art in traveling exhibitions across the countryside. The Wanderers' realist commitments were challenged at the turn of the century by the World of Art group, comprised of younger Russian artists devoted to **Symbolism** and **Aestheticism**, or "art for art's sake." The first World of Art exhibition, mounted in Saint Petersburg in 1899, included works by both Russian and Western European artists such as Monet, Degas, Whistler, Moreau, and Puvis de Chavannes.

By the time of World of Art's dissolution in 1906, Moscow rivaled Saint Petersburg as a Russian center of progressive art with two great collections of French modern art assembled by Sergei Shchukin and Ivan Morozov, rich in the work of the **Impressionists, Post-Impressionists,** Matisse, and Picasso. Both collectors opened their homes to young Russian artists, giving them firsthand knowledge of modern Western European art. Recent French art also reached Russian audiences through the journal *Golden Fleece* (1906–09) and the exhibitions it sponsored in Moscow (1908 and 1909).

Mikhail Larionov (1881–1964) and Natalia Goncharova (1881–1962)

Pioneers of Russian avant-garde painting, Mikhail Larionov and Natalia Goncharova met in Moscow in 1900 and became lifelong companions. They participated in the *Golden Fleece's* exhibitions and cofounded the Jack of Diamonds, a Moscow artist's group whose first exhibition in 1910 featured both Russian and modern Western European art by the likes of the French **Cubists** Gleizes, Le Fauconnier, and Metzinger, and the Munich Neue Künstlervereinigung members Kandinsky, Münter, and Jawlensky. Displeased by the Western aesthetic orientation of some of their Jack of Diamonds colleagues, Larionov and Goncharova split in 1911 to form a rival group, the Donkey's Tail. They believed that Russia's new art should draw stylistic inspiration from the country's traditional popular art forms, such as icons and *lubki* (singular: *lubok*), cheap, brightly colored prints with narrative imagery drawn from the Bible, literature, and folk culture. The style that Larionov and Goncharova developed from *lubki* and other folk sources was called **Neo-primitivism**, which signaled their aim to revitalize Russian art by returning to a primal form of Indigenous visual expression. Exemplary of Neo-primitivism, Larionov's *Dancing Soldiers* (1909–10) features a scattered **composition** of crudely drawn figures, bright colors, flattened space, and graffiti-like lines of text, all inspired by *lubki*.

In late 1912, Larionov introduced a new **abstract** style, **Rayism** (also called **Rayonism**), which he described as "concerned with the spatial forms that can arise from the intersection of the reflected rays of different objects, forms chosen by the artist's will."[1] Both he and Goncharova worked in the style, exemplified by Goncharova's *Cats* (1913, Figure 6.1). In this highly abstracted composition, the feline forms and their environment are fragmented in a Cubist manner and energized by spiky "ray-lines" recalling **Futurism**'s "force lines." Some of Larionov's Rayist paintings, such as *Rayonist Composition: Domination of Red* (1912–13), had no **subject matter**, but were composed exclusively of dynamic lines, brilliant colors, and **painterly** textures. He justified these nonobjective works theoretically by comparing painting to music, as Kandinsky and other writers did. "Painting must be constructed according to its own laws—just as music is constructed according to its own musical laws," Larionov insisted. "Any picture consists of a colored surface and texture . . . and of the sensation that arises from these two things."[2]

In addition to Neo-primitivist and Rayist pictures, the versatile Goncharova painted Cubist works reflecting the influence of Gleizes and Metzinger (e.g., *Linen*, 1913). She also worked in the style known as **Cubo-Futurism**, a Russian synthesis of the fragmented **forms** and faceted planes of Cubism with the Futurist representation of dynamic motion through rhythmic repetition of lines and **shapes,** exemplified by her *Aeroplane over a Train* (see Figure I.5). Goncharova's 1913 Moscow retrospective—the first given to a Russian avant-garde artist—contained some 761 works. It earned her the nickname of "the suffragist of Russian painting"[3]—an allusion to her success

FIGURE 6.1 Natalia Goncharova, *Cats (rayist perception [in] rose, black and yellow)*, 1913. Oil on canvas, 85.1 x 85.7 cm. Solomon R. Guggenheim Museum, New York.

as a woman in a male-dominated profession. In April 1914, Larionov and Goncharova traveled to Paris for the premiere of the Ballets Russes' *Le Coq d'or*, for which Goncharova had designed the sets and costumes. Settling in Paris permanently in 1919, they worked in ballet and theater through the 1930s.

Liubov Popova (1889–1924)

Among the most talented Russian **modernist** painters of the 1910s was Liubov Popova, who studied under the Cubists Le Fauconnier and Metzinger in Paris in 1912–13. Upon her return to Moscow, her hometown, she exhibited with the Jack of Diamonds group and made Cubo-Futurist paintings. Among these is *The Traveler* (1915, Figure 6.2), a highly abstracted, richly colored depiction of a seated woman in a train. She wears a necklace, feathered hat, high-collared black cape, and dark blue dress and reads a newspaper or magazine while clutching a green umbrella in her gloved right hand. Fragments of Russian words signifying "journals," "2nd class," "gas" and "of hats" float through the composition, evoking signage and printed matter glimpsed by the woman during her travel.[4]

In 1916, Popova joined the circle of artists around Kazimir Malevich and, under the influence of his **Suprematist** style, began making nonobjective paintings she called *Painterly Architectonics* (e.g., *Painterly Architectonic*, 1917, MoMA) composed out of large overlapping diagonally oriented geometric planes, some flat, some **modeled** like those seen in *The Traveler*. After the Russian Revolution, Popova participated in the theoretical discussions that led to the 1921 formation of the First Working Group of **Constructivists,** who rejected easel painting and emphasized the artist's utilitarian role in helping to build the new Communist society. In the final years of her life, Popova taught in Moscow at Vkhutemas (Higher Artistic and Technical Workshops) and contributed to Constructivism by designing textiles, clothing, and theatrical sets and costumes.

Kazimir Malevich (1879–1935) and Suprematism

Cubist geometry and Futurist dynamism provided the foundation for Kazimir Malevich's innovative form of nonobjective painting, which he called Suprematism. It employed a formal vocabulary of flat geometric shapes of pure color set against

FIGURE 6.2 Liubov Popova,
The Traveler, 1915. Oil on canvas,
142.2 x 105.4 cm. Norton Simon
Art Foundation, Pasadena,
California.

a white ground, with the shapes usually oriented diagonally to suggest motion. Widely influential in Russia after its 1915 introduction, Suprematism also had a powerful impact on the development of geometric abstraction worldwide from the 1920s onward.

Born in Ukraine, Malevich studied painting in Kyiv and then in Moscow starting in 1904. Visits to the collections of Shchukin and Morozov gave him knowledge of French Post-Impressionism and **Fauvism**, which influenced his artistic development. Malevich exhibited with the Jack of Diamonds in 1910 and with the Donkey's Tail in 1912, showing scenes of Russian peasant life, typically with one or more large figures

filling the **foreground** of the picture. His style evolved from a deliberately crude Neo-primitivism, akin to that of Larionov and Goncharova, to a more geometrical Cubist-inspired manner recalling Fernand Léger's "tubism" (see Chapter 4). In this mode, Malevich constructed his figures out of cylindrical or conical forms sharply lit along one edge. Malevich's *Knife Grinder or Principle of Glittering* (1912–13) is a key example of Cubo-Futurism. It presents a preindustrial subject—a peasant sharpening a knife on a pedal-powered grinding wheel—in an intensely modern style suited to the age of electric lights, motorcars, and airplanes. The knife grinder's body and environment are fractured into brightly colored geometric shapes

and forms. Repeated images of his hands and feet convey the machine-like kinetic energy of his activity.

In several paintings of 1914, Malevich combined the flat color planes of Synthetic Cubism with glimpses of figurative imagery, **collage** elements, and fragments of words, creating surprising juxtapositions (e.g., *An Englishman in Moscow*, 1914). These works' irrationality, which Malevich called "alogic," was inspired by *Zaum* (literally, "beyond mind," or "transrational"), a movement led by the Russian Futurist poets Aleksei Kruchenykh and Velimir Khlebnikov, who discarded standard grammar and syntax and combined letters and syllables to make new words. Kruchenykh declared *Zaum*'s intention to foster "a new understanding of the world"[5] and awareness of a higher reality—aims that Malevich would subsequently pursue through Suprematism. Kruchenykh wrote *zaum* dialogue for the iconoclastic Futurist opera *Victory Over the Sun* (1913), for which Malevich designed sets and costumes. Malevich subsequently identified an element of his set design, a square divided diagonally into black and white triangles set within a white border, as the origin of Suprematism.

Malevich introduced Suprematism through about forty paintings shown in 1915 at *The Last Exhibition of Futurist Paintings: 0.10* (Figure 6.3) in Petrograd (as Saint Petersburg was then known). The key painting was *Black Square*, consisting of a solid black square framed by a white border. Called the "zero of form"[6] by Malevich, the *Black Square* represented a negation of all previous conventions of Western painting, such as representation, narrative, and composition. Malevich understood it as a new beginning, "a living, regal infant, the first

step of pure creation in art."[7] He gave the *Black Square* spiritual implications by hanging it high across the corner of the room, in the place normally reserved for Christian icons in a Russian Orthodox home, surrounded by other Suprematist paintings.

Malevich defined Suprematism as "the supremacy of pure feeling in creative art."[8] He insisted that only nonobjective art could convey this "pure feeling." "The black square on the white field," wrote Malevich, "was the first form in which nonobjective feeling came to be expressed."[9] He identified the white field surrounding the black quadrilateral with "nothingness,"[10] by which he meant infinity—the generative source of all forms and sensations.

From the starting point of the *Black Square*, Malevich developed a wide variety of Suprematist compositions using planar elements in different colors, sizes, and configurations, including trapezoids, crosses, triangles, circles, and other curved shapes. Some Suprematist paintings, such as those immediately below the *Black Square* in Figure 6.3 (e.g., *Suprematist Painting [with Black Trapezium and Red Square]*, 1915) have complex, energetic compositions. Suprematist paintings' geometric elements seem to float freely in the white "nothingness" that surrounds them, suggesting their liberation from gravity. Malevich, fascinated by airplane flight, wrote, "My new painting does not belong solely to the earth." He related it to "the aspiration to space."[11]

Malevich's urge to express transcendence of earthly limitations led to his monochrome white Suprematist paintings of 1917–18 (e.g., *Suprematist Composition: White on White*, 1918), featuring white geometric shapes suspended against grounds

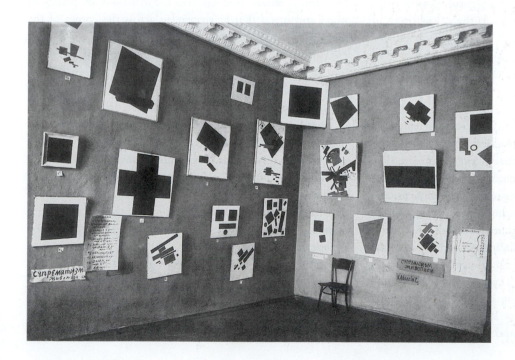

FIGURE 6.3 Paintings by Kazimir Malevich in *The Last Exhibition of Futurist Paintings: 0.10*, Petrograd, 1915.

of a subtly different white **hue**. He exhibited them in Moscow in 1919, hanging them high on the wall—perhaps to make them seem to merge with the white ceiling, conveying the concept of boundlessness central to his art.[12]

In 1919, Malevich joined the faculty of the People's Art Institute in Vitebsk, Belarus, where he organized a collective of teachers and students named UNOVIS, an acronym for Affirmation of the New Art in Russian. Answering government calls for artists to produce pro-Communist propaganda and utilitarian objects, Malevich's students applied Suprematist principles to the design of posters, typography, street decorations, clothing, textiles, and porcelain. Malevich himself contributed to the last two categories but remained uneasy with demands for art to serve society or politics. In the 1920s, this put him at odds with both the Constructivists and the Soviet regime's increasing advocacy of Socialist Realism. Dismissed in 1926 from his position as director of Ginkhuk (the State Institute of Artistic Culture in Leningrad, formerly Petrograd), Malevich returned to figurative painting in his final years. His **stylized** images of peasants with geometricized bodies and blank faces (e.g., *Girls in the Field*, 1928–30) resonate with the dehumanizing effects of Stalin's forced collectivization of agriculture during his first Five-Year Plan of 1928–32.

El Lissitzky (1890–1941)

El Lissitzky was among the many Russian avant-garde artists influenced by Suprematism. His early training in architecture and engineering in Germany inclined him toward the geometric order of Malevich's style, which he adopted after moving to Vitebsk in 1919 to teach at the People's Art Institute, first under the direction of Marc Chagall, and then under Malevich himself. Active in Malevich's UNOVIS group, Lissitzky applied Suprematism's visual vocabulary to the advancement of Communism in a lithographic poster, *Beat the Whites with the Red Wedge* (1919–20). In it, a red triangle symbolizing the Red Army penetrates a white circle signifying the anti-Communist forces in the Russian Civil War.

In 1919, Lissitzky introduced his own Suprematist-derived form of abstraction that he called Proun (pronounced "pro-oon"), a neologism whose origin he never revealed.[13] In his Proun paintings and graphic works (e.g., *Proun 19D*, 1920 or 1921), Lissitzky used both Malevich-style flat geometric shapes and images of floating three-dimensional forms, sometimes depicted in **axonometric projection** to imply their potential realization in architecture. "A Proun," said Lissitzky, "is a station for changing trains from architecture to painting."[14] In 1921 Lissitzky was appointed professor of architecture at Vkhutemas in Moscow, where he worked alongside Vladimir Tatlin and the artists of the emerging Constructivist movement. Between 1922 and 1925, Lissitzky traveled in Germany, Switzerland, and the Netherlands, where

he conveyed Suprematist and Constructivist principles to his Western European colleagues.

Lissitzky built a *Room for Constructive Art* at the International Art Exhibition in Dresden in 1926. The artist painted the walls of the room gray and lined them with strips of wood painted white on one side and black on the other. The walls seemed to oscillate between white, gray, and black as the viewer moved through the space. Lissitzky also installed sliding panels of perforated metal that visitors could move to reveal or conceal the paintings behind them. He designed this room to transform the visitor's experience from one of contemplation to participation—an essential value in an egalitarian communist society according to Marxist theory.[15] After settling permanently in Moscow in 1928, Lissitzky created Soviet propaganda in architectural, exhibition, and graphic design.

Vladimir Tatlin (1885–1953)

Vladimir Tatlin was Malevich's principal rival in the development of abstract art in Russia in the mid-1910s. Born in Moscow and raised in Ukraine, Tatlin started out as a painter and exhibited Cubist-influenced pictures in avant-garde exhibitions in the early 1910s but turned to three-dimensional work in late 1913. In early 1914, he traveled to Paris where he visited Picasso's studio and probably saw Cubist **assemblages** such as *Guitar* (see Figure 4.11), which encouraged Tatlin to assemble various materials—tin, wood, iron, glass, plaster, and tar—to create **relief** sculptures. His differed from Picasso's in lacking subject matter; they are likely the first nonobjective sculptures in the history of modern art.

In 1915, at the *0.10* exhibition in Petrograd, Tatlin showed his counter-reliefs: nonobjective constructions of planes of wood and metal that he suspended across the corner of the room from cables or ropes (e.g., *Corner Counter-Relief*, 1914). He called them counter-reliefs to emphasize their extension into the viewer's space, in opposition to traditional relief sculpture in which forms seem to recede from the front plane into the **background**. The counter-reliefs thus declared the reality of their materials and of the space they occupied. Tatlin's materialism put him at odds with the idealism of Malevich, who showed his Supermatist compositions in another room of the same exhibition. While both artists embraced nonobjectivity and geometric form, Tatlin rejected Malevich's belief in art's spiritual purpose and his continuing commitment to painting—rejections that Tatlin's followers the Constructivists would also make in the early 1920s.

In the wake of the 1917 Revolution, Tatlin became director of the art section of Narkompros (The Peoples' Commissariat for Education) in Moscow. He was commissioned to design a *Monument to the Third International*, a Communist organization (known as the Comintern) dedicated to world revolution.

Tatlin envisioned a futuristic tower rising 400 meters—a third higher than the Eiffel Tower—that would straddle the Neva River in Petrograd. The new government emphasized industrial development as vital to political and social progress, so Tatlin gave his monument the appearance of a colossal machine. Leaning on a 60-degree diagonal and supported by a spiraling skeletal iron framework, the monument would have enclosed four geometric glass volumes of decreasing sizes, housing the Comintern's legislative, executive, and propaganda offices.[16] Each of these chambers would have rotated on its axis at a different rate, from yearly at the bottom to monthly, daily, and hourly. This movement would have conveyed the dynamism of the international revolution promoted by Communism. The monument's axis was to have been oriented to Polaris, so that the heavens would seem to rotate around this center of the future world government. Although the new Communist government lacked the resources to actually build the tower, Tatlin and his collaborators constructed an approximately 6-meter-tall model that was shown in Petrograd and Moscow in late 1920 (Figure 6.4). It served as a potent symbol of the new Communist state's utopian aspirations.

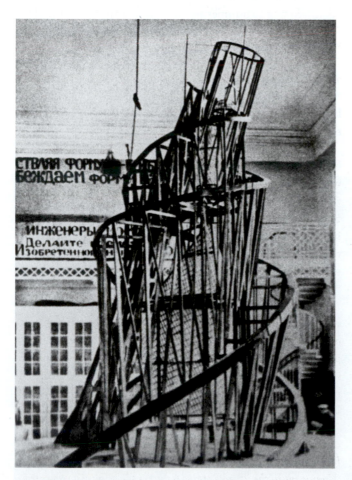

FIGURE 6.4 Vladimir Tatlin, *Model for the Monument to the Third International*, 1919–20.

Constructivism

In its application of machine-inspired aesthetics to a utilitarian purpose serving Communism, Tatlin's proposed *Monument to the Third International* embodied the emerging ideology of Constructivism. This term was coined in early 1921 by the First Working Group of Constructivists at Inkhuk (Institute of Artistic Culture) in Moscow, whose members were Aleksey Gan, Aleksandr Rodchenko, Varvara Stepanova, Konstantin Medunetsky, Karl Ioganson, and the brothers Georgy Stenberg and Vladimir Stenberg. Their theoretical discussions led these artists to reject "composition" in favor of "construction" based on a "scientific" mode involving no superfluous elements or materials.

The Inkhuk Constructivists saw themselves not as creators of aesthetically pleasing **fine art** for rich capitalists but as the engineers of new forms that could help remake the world as a Communist utopia. Their program of April 1, 1921 declared, "Taking a scientific and hypothetical approach to its task, the group asserts the necessity to fuse the ideological component with the formal component in order to achieve a real transition from laboratory experiments to practical activity."[17] This commitment to practical activity led to the concept of **Productivism**, which argued that under Communism, artistic skills should be channeled into industrial production. Many Russian Constructivists designed furniture, clothing, and other useful items, though only the textile designs of Varvara Stepanova and Liubov Popova actually went into mass production. The Russian Constructivists also worked in photography, film, theater design, graphic design (exemplified by Gustav Klutsis's poster *The Development of Transportation, The Five-Year Plan* [1929], see Figure I.7), and architecture.

Constructivism's ideas spread from Russia to Central Europe in the 1920s. Constructivism strongly influenced the curriculum at the Bauhaus in Germany and there were active Constructivist groups in Hungary, Czechoslovakia, and Poland. Some Central European Constructivists were committed, like their Russian Communist colleagues, to advancing social and political revolution through the merger of art and industry, while others continued to believe in the autonomy of the work of art.

Aleksandr Rodchenko (1891–1956)

The central member of the First Working Group of Constructivists, Aleksandr Rodchenko was born in Saint Petersburg and studied at the Kazan Art School between 1910 and 1914. In 1915 he moved to Moscow, where he met Malevich and Tatlin. He responded to the work of both in geometric nonobjective paintings and drawings (e.g., *Non-Objective Painting*, 1919, MoMA) before he renounced easel painting in 1921. That spring, at the Obmokhu (Society of Young Artists) exhibition

in Moscow featuring the work of the Constructivists, Rodchenko presented suspended objects that he called *Spatial Constructions* (visible in Figure 6.5; near the upper center is *Spatial Construction no. 12*, c. 1920).

Following Constructivist theory, these objects demonstrated their basis in a "scientific" method appropriate to Communism, with their form determined by the rules of geometry and material conditions rather than by the artist's subjective taste.[18] Each was fashioned from a single sheet of thin plywood coated with aluminum paint and cut precisely into concentric bands of equal width in the same shape—an oval, circle, triangle, square, hexagon, or octagon. When hung from the ceiling, the bands rotated into space to create an open, three-dimensional structure that implied a **volume** without enclosing it.

Rodchenko worked primarily in graphic design and photography in the 1920s and 1930s. He designed numerous advertising posters for state enterprises, including one for Lengiz, the Leningrad section of the state publishing house Gosizdat (1924, Figure 6.6). In it, the name Lengiz appears in Cyrillic letters above and below the head of a young woman in a black-and-white photograph inside a circular frame against a blue background. From her open mouth issues the Russian word for books, in red capital letters inside an expanding black wedge. Pointed green shapes framing the wedge lead the eye to a white text against a blue ground reading, "Books in all disciplines." Expressing vigor and optimism through its imagery, design, and texts, Rodchenko's poster demonstrates the application of Constructivist aesthetics not only to political propaganda

(as in the case of Tatlin's *Monument to the Third International*) but also to effective advertising.

Rodchenko took up photography in 1924, drawn to the **medium** because it was mechanical and lacked strong associations with bourgeois fine art traditions. He sought to convey through photography how urban dwellers experienced modern life, looking up at tall buildings from the street or looking down at the street from tall buildings. He shot *Assembling for a Demonstration* (1928–30, Figure 6.7) from the balcony of his Moscow apartment. The left side of the composition shows women on the two balconies below Rodchenko's. At the top, children in light colored uniforms line up in the courtyard below. The oblique view collapses pictorial space, rendering the imagery as an abstract arrangement of light and dark forms and planes. In this way, Rodchenko extends into photography the **formalist** investigations of his earlier abstract paintings and drawings but now with a social purpose.

Varvara Stepanova (1894–1958)

Varvara Stepanova was strongly committed to the concept of production art, designing textiles featuring simple geometric patterns. Stepanova also designed clothing, advocating for standardized sports costumes and work uniforms. A member of the First Working Group of Constructivists and Rodchenko's wife, she served as a professor of textiles at Vkhutemas in 1924–25. Her design for sportswear (1923, Figure 6.8), which never went into production due to the limitations of Soviet industry, was severely functional, conforming to the "fundamental principle" of "maximum practicality, simplicity, and ease of wear."[19]

FIGURE 6.5 Second spring exhibition of the Obmokhu (Society of Young Artists), Moscow, 1921.

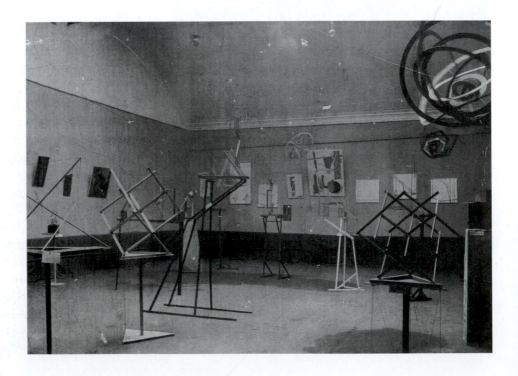

FIGURE 6.6 Aleksandr Rodchenko, Untitled advertising poster, 1924. Gouache and cut-and-pasted gelatin-silver photograph on paper, remade by Varvara Rodchenko in 1965 after a lost original, 69.85 x 86.1 cm. Rodchenko-Stepanova Archive, Moscow.

The uniforms' bold but orderly geometric ornamentation, displaying an aesthetic sensibility comparable to that of Rodchenko's poster, identifies different teams. In keeping with the Soviet ideology of sexual equality under Communism, the only concession to gender difference is the substitution of a skirt for shorts. In the later 1920s, Stepanova concentrated on posters and in the 1930s did graphic and typographic design for Soviet magazines.

Naum Gabo (1890–1977) and Antoine (Anton) Pevsner (1886–1962)

Russian Constructivism was expansive enough to include both artists who applied their creative efforts to advancing Communism, like Rodchenko and Stepanova, and those who believed in art's value independent of politics, like the brothers Naum Gabo and Antoine (Anton) Pevsner. Their "Realistic Manifesto," issued in Moscow in 1920 in conjunction with an open-air exhibition of Gabo's constructed sculptures, declared the principles of their "constructive technique" in language very different from that used the next year by the First Working Group of Constructivists.[20] The brothers used the term "realistic" not to refer to the imitation of nature, but to express their concern with essential reality, or "the laws of life." "Space and time are the only forms on which life is built and hence art must be constructed," declared Gabo and Pevsner.[21] They noted that in contrast to life's continuity, "states, political and economic systems perish"—an implicit criticism of the Communist argument that art must serve a political purpose.[22] Insisting on an aesthetic of geometric precision, Gabo and Pevsner continued, "We construct our work as the universe constructs its own, as the engineer constructs his bridges, as the mathematician his formula of the orbits."[23]

Gabo, born Naum Pevzner in Belarus, changed his surname when he became an artist to avoid being confused with his older brother. After studying engineering in Munich, Gabo took refuge in Norway with his brother during World War I, where he made his first constructed sculptures. They were inspired by mathematical models he had seen in Munich, using intersecting planes set at right angles to create

FIGURE 6.7 Aleksandr Rodchenko, *Assembling for a Demonstration*, 1928–30. Gelatin silver print, 49.5 x 35.3 cm. The Museum of Modern Art, New York.

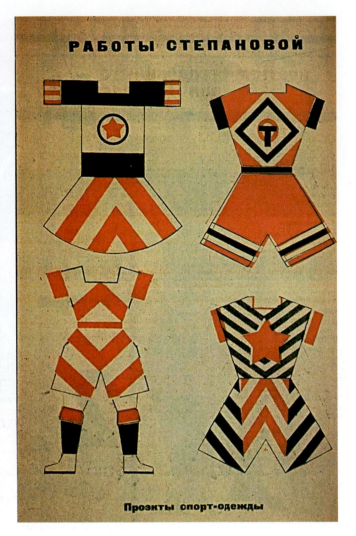

FIGURE 6.8 Varvara Fedorvna Stepanova, Design for Sportswear, 1923. Reproduced in *Lef 2*.

an open cellular structure that implies a volume without enclosing it. Employing first cardboard, then wood, and finally metal, Gabo constructed torsos and heads (e.g., *Constructed Head No. 2*, 1916). They reveal the influence of Cubism in their geometric treatment of the figure while offering a new conception of sculpture as an art of spatial depth rather than **mass** and volume.

Gabo and Pevsner returned to Russia in 1917 where they met Kandinsky, Malevich, Tatlin, and other avant-garde artists. Gabo abandoned figuration and began to make nonobjective constructions. The most important, *Column*, he first executed in celluloid and plastic and later in more permanent materials (1923, Figure 6.9). Rising from a base formed by three black discs of decreasing size, the resolutely abstract *Column* extends the flat planes of Malevich's Suprematism and Lissitzky's Prouns into three dimensions. Despite his professed commitment to autonomous art in the "Realistic

Manifesto," Gabo initially conceived of the *Column* as a large-scale public work serving a political purpose, like Tatlin's proposed *Monument to the Third International*. Gabo intended to engrave the text of the first Soviet Constitution onto the column's four transparent planes. After dark, lights from below directed at the text would have made it appear to float against the night sky.[24]

Gabo quickly grew disenchanted, however, with his Constructivist colleagues' emphasis on utilitarianism as well as increasing government hostility to experimental art. In 1922 he left Russia for Berlin, seeking greater artistic freedom. Pevsner settled the next year in Paris, where, under Gabo's influence, he began making constructions in plastic and wood, and later, sheet metal and glass. Gabo moved from Berlin to Paris in 1933 and then to London in 1936. Both brothers were influential in the international development of a politically neutral form of Constructivism reflecting Gabo's view

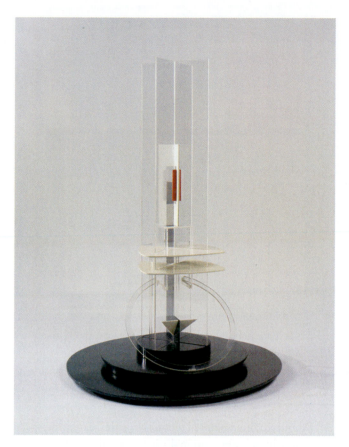

FIGURE 6.9 Gabo, *Column*, ca. 1923 (reconstructed 1937). Perspex, wood, metal, and glass, 104.5 x 75 cm. Solomon R. Guggenheim Museum, New York.

that "art has its absolute, independent value and a function to perform in society whether capitalistic, socialistic, or communistic—art will always be alive as one of the indispensable expressions of human experience and as an important means of communication."[25]

De Stijl

During the years of Constructivism's emergence in Russia, the artists and architects of De Stijl (Dutch for "The Style") undertook a similar collective quest to integrate and life through an abstract geometric aesthetic. Formed in the Netherlands in 1917, this international group took its name from the journal edited by the painter and architect Theo van Doesburg. Other prominent members included painters Piet Mondrian and Bart van der Leck, sculptor Georges Vantongerloo, and architects J. J. P. Oud, Robert van 't Hoff, and Gerrit Rietveld.

Responding to World War I's destructive chaos, De Stijl sought to realize visual harmony and order in every aspect of art and design, from typography to furniture, interior decoration, painting, sculpture, architecture, and urban planning.

Their works generally employed a formal vocabulary of basic geometric elements: horizontal and vertical lines and rectangular planes of either **primary colors** or the neutral colors (black, white, and gray). They brought these elements together into asymmetrical compositions perceived as built from individual, independent parts. Such compositions symbolized De Stijl's ethical vision of society as a healthy balancing of the individual and the collective, or the universal.[26] De Stijl's aspiration to create harmonious total environments drew on the examples of the Arts and Crafts Movement, Frank Lloyd Wright (see Chapter 5), and the Dutch architect Hendrik Petrus Berlage.

Piet Mondrian (1872–1944)

The preeminent member of De Stijl, Piet Mondrian named his mature painting style **Neo-plasticism**, using "plastic" (from the Greek *plastikos*, "capable of being shaped or formed") to refer to visual form and "neo" to signal its innovative nature. Mondrian based this style on horizontal and vertical lines, the primary colors, and the neutrals. He believed these basic elements embodied a higher or absolute reality beyond the visible, natural world. Mondrian arranged them into harmonious relationships to create models for a future utopian society that would have no need of art "as a thing separated from our surrounding environment."[27] Instead, Mondrian envisioned the "unification of architecture, sculpture and painting"[28] to create a "new plastic reality" that would be "pure and complete in its beauty."[29]

Academically trained in Amsterdam in the 1890s, Mondrian initially painted loosely brushed landscapes in a relatively dark **palette** and went on to absorb influences from the Dutch Symbolist painter Jan Toorop and the vividly colorful style of Van Gogh. Mondrian's spiritual interests led him to join the Theosophical Society in 1909 (see "Theosophy" box, Chapter 3). Like Kandinsky and Kupka, who were also engaged with Theosophy, Mondrian came to believe that only pure abstraction could express its teachings that an essential harmony unites all living beings.

After seeing Cubist works by Picasso and Braque in Amsterdam in 1911, Mondrian moved to Paris in early 1912 and began his own exploration of Cubism. He created several abstracted paintings of trees (e.g., *Flowering Apple Tree*, 1912) and, later, more highly structured paintings based on building **façades** (e.g., *Composition in Oval with Color Planes 1*, 1914). Mondrian spent World War I in the Netherlands, where he made a series of drawings and paintings based on the subject of a pier reaching out into the ocean (e.g., *Composition 10 in Black and White*, 1915), which he radically reduced to black horizontal and vertical lines against an empty ground. This "plus-and-minus" style marked the endpoint of his abstraction from nature. Henceforth, Mondrian would seek to

express "pure reality" through the "purely plastic"—allowing shapes and colors to assert their own reality, independent of nature.[30]

In 1915, Mondrian met the religious philosopher and mathematician Dr. M. H. J. Schoenmaekers, whose writings asserted the cosmic significance of horizontal and vertical lines and the primary colors. Mondrian also discovered Georg Friedrich Hegel's philosophy, which argued that civilization and art progress through a dialectical process, in which a proposition (thesis) and its opposite (antithesis) are resolved to achieve a higher truth (synthesis). Mondrian combined influences from Theosophy, Schoenmaekers, and Hegel to develop his philosophy of art. His paintings' horizontals and verticals symbolized oppositions such as universal versus individual, spirit versus matter, and masculine versus feminine. Mondrian sought to create an "aesthetic equilibrium" corresponding to the balance of opposing forces that he saw as the essential harmony of the universe.[31]

Mondrian joined De Stijl in 1917 and contributed articles to its journal until 1924. From 1917 to 1919 (when he returned to Paris), he experimented with various abstract geometric painting styles using rectangular planes of color, either floating against a white ground or contained within a grid. In 1920, he arrived at the first phase of his signature Neo-plastic style. In these paintings (e.g., *No. VI/Composition No. II*, 1920), Mondrian placed rectangular planes of red, yellow, blue, black, and varying shades of gray within black horizontal and vertical lines of uniform thickness. These asymmetrical compositions typically featured twenty or more rectangular divisions of varying sizes and orientations (horizontal or vertical). The black lines sometimes stopped short of the canvas edge, which created a **figure-ground relationship** between the terminus of a black line and the color behind it.

By the late 1920s Mondrian had eliminated dark gray from his palette, reduced the number of rectangular divisions in his compositions, and consistently took the black lines to the canvas border, locking the rectangles into place. Exemplary of this austere phase of Neo-plasticism, *Composition* (1920, Figure 6.10) is an almost perfect square featuring three small areas of color along its perimeter: a nearly square plane of red at the upper left, a tall narrow plane of blue along the right edge, and a horizontal strip of yellow at the lower center, neighbored by a block of black. The blue, yellow, and black planes border a light gray square that is the largest compositional element. The black lines forming the gray square's upper left corner also form the lower right corner of the red near-square. This links these two shapes to reinforce the nearly square format of the canvas. Avoiding conventional symmetry, Mondrian arranges his simple formal elements into a subtly complex relationship of harmoniously balanced tension.

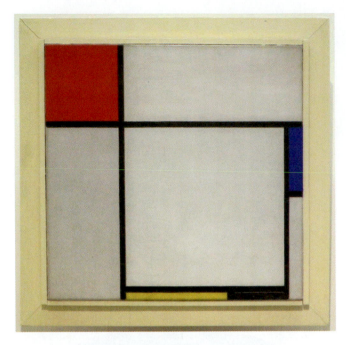

FIGURE 6.10 Piet Mondrian, *Composition*, 1929. Oil on canvas in artist's frame, 45.1 x 45.3 cm. Solomon R. Guggenheim Museum, New York.

Mondrian often painted pictures in series, exploring variations of a basic compositional idea. Periodically from 1918 onward he made paintings in a lozenge or diamond format, rotating the square canvas forty-five degrees but maintaining the horizontal and vertical orientation of the lines on its surface. Mondrian made several such paintings in 1925 and 1926, likely triggered by a disagreement with Van Doesburg, who had introduced diagonals into his paintings—a disagreement that led Mondrian to break from De Stijl. In his diamond paintings, Mondrian demonstrated that a diagonal could form the perimeter of a composition that would still feature horizontal and vertical lines that the viewer can imagine continuing to form a square outside the canvas's boundaries (e.g., *Lozenge Composition with Yellow Lines*, 1933).

By 1932, Mondrian had come to feel that the black-framed planes of paintings like *Composition* produced an overly stable effect of balance. He sought to introduce "dynamic equilibrium"[32] into his paintings by doubling the black lines (e.g., *Composition with Blue and Yellow*, 1935) to activate the compositions and prevent the colored planes from being perceived as static. In his final years, spent in London (1938–39) and New York (1940–44), Mondrian pushed Neo-plasticism into new territory. In paintings such as *Place de la Concorde* (1939–43) he increased the number of black lines and added bars of color that were not completely bound by lines. In one of his last paintings, *Broadway Boogie Woogie* (Figure 6.11), Mondrian replaced the black lines with bands of yellow interrupted by squares of red, blue, and gray. Larger rectangles of the same

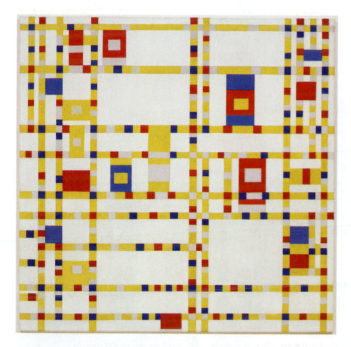

FIGURE 6.11 Piet Mondrian, *Broadway Boogie Woogie*, 1942–43. Oil on canvas, 127 x 127 cm. The Museum of Modern Art, New York.

four colors punctuate the composition at various points. The pulsating configuration suggests the New York City street grid, colorful blinking electric lights, and the fast beat and melodic improvisation of boogie-woogie, a form of American jazz that fascinated Mondrian.

Theo van Doesburg (1883–1931)

The energetic Theo van Doesburg edited and wrote for *De Stijl* from 1917 until his death. His paintings of the late 1910s are similar to Mondrian's, featuring multiple rectangular planes of red, yellow, and blue oriented to the canvas's horizontal and vertical edges. They either float against an off-white background (e.g., *Composition XI*, 1918) or are enclosed within black lines. Van Doesburg worked across media, producing stained-glass window, interior, and architectural designs. He sought to create aesthetically harmonious environments that would, in De Stijl's utopian view, improve their inhabitants' lives and help usher in a better future.

In the early 1920s, Van Doesburg disseminated De Stijl ideas to Germany. He lectured in Berlin and taught a course in Weimar in 1922 to Bauhaus students, despite not being a member of the faculty. Through Van Doesburg, the Bauhaus architects Walter Gropius and Mies van der Rohe absorbed influences from De Stijl. Van Doesburg then moved to Paris, where he organized a 1923 exhibition of De Stijl architectural projects at Léonce Rosenberg's Galerie de l'Effort Moderne.

Returning to painting in 1924, Van Doesburg developed a revised version of Neo-plasticism that he called Elementarism,

retaining structures based on right angles but shifting their axes 45 degrees to introduce a quality of dynamism. Van Doesburg applied Elementarism to his designs for the interior of the restaurant-café L'Aubette in Strasbourg (1926–28), a collaboration with Jean Arp and Sophie Taeuber-Arp (e.g., *Preliminary Color Scheme for Ceiling and Short Walls of Dance Hall in Café Aubette, Strasbourg, France*, 1926–28). He decorated the walls and ceilings of L'Aubette's largest room with rectangles of color tilted forty-five degrees to realize his aim for monumental art: "To place man within (instead of opposite) the plastic arts and thereby enable him to participate in them."[33]

Gerrit Rietveld (1888–1964)

The fullest realization of De Stijl principles in architecture was the Schröder House in Utrecht (1924, Figure 6.12), which Gerrit Rietveld designed in collaboration with Truus Schröder, a lawyer's widow who wanted a modestly scaled house for herself and her three children. Schröder requested a transformable living space on the second floor that could be either open or partitioned to create private areas. Rietveld provided this flexibility through sliding panels that can form different configurations. Schröder also wanted a house filled with natural light and open to views of the countryside. To achieve this, Rietveld provided a skylight and wrap-around windows on the upper story's southeast corner.

Rietveld planned to build the house out of concrete slabs—a machine-age building material—but this proved to be uneconomical. He instead used load-bearing brick faced with plaster, and steel I-beams to support the flat roof and balconies. Applying the standard De Stijl palette, Rietveld painted the exterior walls white and gray, the wood window frames black, and some of the girders in primary colors. The house's external appearance suggests a projection into three dimensions of the balanced asymmetry of Mondrian's 1920s paintings. Inside, Rietveld painted the second-floor partitions gray, white, or black and used planes of red, yellow, and blue elsewhere. He divided the floor into rectangular sections of gray, black, red and white. Occupying the house has been compared to living inside a Mondrian painting.

The Schröder House was the first building completed by Rietveld, who started his career as a furniture maker and joined De Stijl in 1919. His most celebrated furniture design is the "Red Blue" chair (visible in Figure 6.12), initially realized in unpainted wood in 1918 and in the painted version in 1923. Rietveld designed the chair for simple construction out of standard-sized pieces of lumber because he hoped it would eventually be mass-produced. Its frame's black horizontal and vertical bars, accented by yellow ends, resemble the grids of Mondrian's Neo-plastic paintings. The blue and red planes that form its seat and back likewise echo elements in Mondrian's paintings, tilted to accommodate the human body.

The Bauhaus

The **Bauhaus** was an innovative school of art, design, and architecture established in Weimar, Germany, in 1919 by the architect Walter Gropius. It is renowned for training students to integrate art and technology in designs embodying a modern form of beauty appropriate to the machine age. In announcing the Bauhaus, Gropius called for the creation of "a new guild of craftsmen, without the class distinctions which raise an arrogant barrier between craftsman and artist." The Bauhaus would strive to realize "the new building of the future, which will embrace architecture and sculpture and painting in one unity."[34] Gropius's ideals drew on the model of the medieval cathedral as a unified work of art. The name Bauhaus, meaning "house of building," recalls *Bauhütte*, a cathedral-mason's lodge. Aiming to restore the bond between artistic creativity and manufacturing severed by the Industrial Revolution, Gropius drew inspiration from William Morris, the Arts and Crafts Movement, and the Deutscher Werkbund (see Chapter 5), of which he had been a member.

The Bauhaus curriculum began with a six-month preliminary course (the *Vorkurs*) followed by three years of instruction in a workshop. The preliminary course stimulated the students' creativity and introduced them to materials, color theory, and design principles in preparation for more specialized study. Students then entered a workshop dedicated to sculpture, cabinetry, metals, stained glass, pottery, graphics, stagecraft, wall painting, or weaving. Jointly running each workshop were a Form Master, who emphasized theory, and a Work Master, who gave technical instruction.

The charismatic Swiss painter Johannes Itten initially oversaw the preliminary course. Other teachers Gropius hired between 1919 and 1922 as workshop Form Masters included the sculptor Gerhard Marcks (who taught pottery) and the painters Lyonel Feininger (graphics), Vasily Kandinsky (wall painting), Paul Klee (stained glass and weaving), Georg Muche (weaving), and Oskar Schlemmer (stagecraft and sculpture). Gropius served as the Form Master in the cabinetry workshop.

Like the society surrounding it, the Bauhaus was a male-dominated institution. Although women made up approximately one third of the Bauhaus student body over its history, the faculty was almost exclusively male. So many women applied to the Bauhaus in its first year that an alarmed Gropius segregated them into a "women's class" connected to the

weaving workshop. He steered them away from metals and cabinetry, which he considered more physically demanding crafts unsuited to women. Some women students did enter and succeed in these workshops—notably, Marianne Brandt in metals and Alma Buscher in cabinetry.

Itten's mysticism and belief in art as autonomous self-expression ran counter to Gropius's view that the artist should shape society through design. This conflict was heightened by Theo van Doesburg's private courses in Weimar (1921–22), attended by many Bauhaus students, in which he criticized **expressionist** individualism and promoted the aesthetic values of impersonality, objectivity, and machine production. Responsive to Van Doesburg's ideas, Gropius in 1923 reoriented the Bauhaus toward industrial design with the new slogan, "Art and technology, a new unity." Itten resigned and Gropius replaced him with László Moholy-Nagy, who encouraged the integration of art, technology, and industry.

Facing local political opposition in Weimar, Gropius moved the Bauhaus to Dessau in 1925. There, he designed a new building to house the school and reformed the curriculum, eliminating the pottery, stained glass, and graphics workshops—the latter replaced by advertising and printing. Each workshop was now partly led by a Junior Master, a Bauhaus alumnus skilled in both art and craft. The Dessau Bauhaus emphasized **functionalism**: its workshops generated designs for industrial production, typically employing clean lines and geometric forms embodying a machine aesthetic. Several product designs were licensed to German manufacturers and many are still in production, such as Marcel Breuer's lightweight tables and chairs employing tubular metal (e.g., Club chair [model B3], 1927–28), and Marianne Brandt's lighting fixtures and table lamps. Another lasting Bauhaus contribution to modern visual culture is Herbert Bayer's simple sans-serif typeface, known as "universal," which uses exclusively lowercase letters.

Gropius introduced architecture into the Bauhaus curriculum in 1927 and hired the Swiss architect Hannes Meyer, who succeeded Gropius as director the next year, to teach it. An avowed Marxist, Meyer viewed art and architecture exclusively in terms of their ability to satisfy social needs. Local opposition to communist trends in the Bauhaus led Dessau's mayor to dismiss Meyer in 1930. His successor, the German architect Ludwig Mies van der Rohe, sought to insulate the Bauhaus from politics, but the National Socialists (Nazis) took power in Dessau in 1932 and shut down the school, which they perceived as a bastion of communism. Mies briefly reestablished the Bauhaus in Berlin as a private institution before he closed it in 1933 after the state police raided its offices.

Under the rising threat of the Nazis, most of the key figures of the Bauhaus left Germany in the 1930s. Many came to the United States where their work and teaching influenced young American designers and architects. Gropius and Breuer joined the Harvard architecture faculty. Moholy-Nagy established the New Bauhaus in Chicago. Mies van der Rohe also settled in Chicago where he taught at the Illinois Institute of Technology and designed its campus (see Chapter 17). The former Bauhaus instructors Josef and Anni Albers taught at the newly established Black Mountain College, in Asheville, North Carolina, and Josef later chaired Yale's design department.

Walter Gropius (1883–1969)'s Bauhaus Building

The building that Gropius designed to house the Bauhaus in Dessau (1926, Figure 6.13) is one of the defining monuments of the **International Style** of modern architecture (see "International Style" box, Chapter 17). Commissioned by the city of Dessau, it comprises four connected elements constructed of reinforced concrete. The brick-faced exterior walls are plastered with cement and painted white or gray. A wing housing the city's vocational school—a separate institution from the Bauhaus—was linked by a bridge at the second- and third-floor levels to the Bauhaus's workshop wing, containing classrooms, studios, and an exhibition space. Vast glass **curtain walls**—a more dramatic recapitulation of the ones Gropius first used in the Fagus Factory (see Figure 5.18)—enclose the workshop wing's east and west sides creating a transparent membrane between exterior and interior. A low central section containing a stage, auditorium, and cafeteria connected the workshop wing to a five-story studio building that housed Junior Masters and some students (though most had to find lodging in Dessau).

The Bauhaus building's modern construction materials—reinforced concrete and glass—are employed without reference to historical architectural styles. Its flat-roofed, unornamented rectangular volumes and its pinwheel composition give it an abstract geometric character like that of De Stijl paintings and sculptures. Its departure from **classical** European architectural symmetry compels the visitor to walk around the building to experience it as an organic whole. Gropius gave each part of the building a unique design suited to its function and then integrated those parts into a harmonious ensemble. The Bauhaus workshops designed and produced all the interior fittings, such as furniture and lighting, as well as the typography of the school name affixed to the workshop wing's end wall. Thus, the building realized Gropius's vision of the total work of art unifying architecture and the related crafts.

Paul Klee (1879–1940)

Paul Klee, associated with the Blaue Reiter before World War I (see Chapter 3), taught at the Bauhaus from 1920 to 1931. As a Form Master, he participated in the stained glass, painting, and weaving workshops, but he did his most significant teaching in the preliminary course. His Bauhaus-published book, *Pedagogical Sketchbook* (1925), summarized his art theory centered

FIGURE 6.13 Walter Gropius, Bauhaus, 1926. Dessau, Germany.

on nature's underlying elemental forms. He instructed his students not to imitate nature's appearance but instead to "follow the ways of natural creation, the becoming, the functioning of forms," with the goal of creating like nature itself.[35] Klee also gave substantial attention to color theory and made analogies between art and music, suggesting ways of structuring pictures like a musical composition with qualities of rhythm and movement.

The roughly three thousand paintings, drawings and prints of Klee's Bauhaus period feature diverse materials, techniques, and imagery and often reflect aspects of his teaching. An example is his 1926 painting *Around the Fish* (Figure 6.14), a **still-life** composition centered on a platter of fish orbited by numerous disparate motifs against a black background. Klee invoked the fish in his teaching to demonstrate the principle of "individual" (indivisible) and "dividual" (divisible) structures. According to Klee, the fish's body could not be divided without losing its identity whereas some of its scales could be removed without compromising its individuality.[36] Klee also kept tropical fish in an aquarium and

drew his students' attention to their swimming as exemplifying movement in nature.

In *Around the Fish*, a red arrow—used in Klee's teaching to indicate motion, direction, or energy—points to a cartoonlike human face. At the composition's left and right sides are transparent cylinders adjacent to geometric shapes developed from a triangle, rectangle, and pentagon. Similar shapes appear in Klee's teaching notes. A full and crescent moon hover above the fish and a cross floats nearby. Most interpretations of the painting's cryptic **iconography** focus on the cross and fish as conventional symbols of Christ's death and resurrection. Klee probably did not intend *Around the Fish* to convey any fixed meaning, however; he saw creation as an intuitive process that produced unexpected, even magical results. His art's often fantastical and dreamlike quality inspired the **Surrealists,** who claimed him as a precursor.

Klee left the Bauhaus in 1931 to teach at the art academy in Düsseldorf and there created one of his most impressive works, *Ad Parnassum* (1932). Named for the mythical mountain home of Apollo and the Muses, it is executed in a **pointillist**

FIGURE 6.14 Paul Klee, *Around the Fish*, 1926. Oil and tempera on canvas mounted on cardboard, 46.7 x 63.8 cm. The Museum of Modern Art, New York.

technique with layers of color organized into geometric patches over which Klee drew the black linear shapes of a gateway and triangular mountain beneath a glowing red sun. In 1933 the Nazis came to power, labeled Klee a "degenerate" artist, and dismissed him from his teaching post. He fled to Bern, Switzerland, where he spent the final years of his life in declining health. His late painting, *Death and Fire* (1940), centers on a schematic image of a black-outlined white death's head within a fiery red field, approached by a stick figure at the right. It is among several images of death that Klee created as he faced his own mortality while Europe descended into the tragedy of World War II.

Vasily Kandinsky (1866–1944)

Another Blaue Reiter artist (see Chapter 3), Vasily Kandinsky joined the Bauhaus faculty in 1922 when he returned to Germany after spending 1914–21 in his native Russia. Following the 1917 Russian Revolution, he was active as a teacher and administrator in several government-sponsored artistic institutions in Moscow. He continued to make nonobjective paintings in which hard-edged geometric elements increasingly supplanted the amorphous shapes and loose **brushwork** of his pre–World War I work (see Figure 3.15). This stylistic shift reflected the influence of his Russian avant-garde colleagues such as Malevich and Rodchenko.

At the Bauhaus, Kandinsky served as the wall-painting workshop Form Master and, like Klee, taught a section of the preliminary course. His teaching, represented in his book *Point and Line to Plane* (1926), posited a "science of art" involving rigorous analysis of the formal elements and their supposed psychological effects. Exemplary of Kandinsky's quasi-scientific approach was his assignment of red, yellow, and blue to the square, triangle, and circle, respectively, based on the results of a survey he conducted at the Weimar Bauhaus. Kandinsky considered the circle a perfectly balanced shape with cosmic significance. He used this motif often in his Bauhaus period paintings, as in *Composition VIII* (1923), which features nineteen circles and a dynamic

array of other geometric elements that surround, intersect with, or overlap the circles. Carefully planned and precisely executed, this picture exemplifies Kandinsky's definition of a composition as "an exact law-abiding organization of the vital forces which, in the form of tensions, are shut up within the elements."[37]

Settling near Paris after the Bauhaus closed in 1933, Kandinsky continued to paint hard-edged geometric shapes and lines, now juxtaposed with **biomorphic** motifs inspired by biological imagery (e.g., *Various Actions*, 1941). These late works represent his personal response to prevailing modernist trends: abstract, biomorphic Surrealism and the austere geometries of Abstraction-Création, a Parisian group founded in 1931 to promote nonobjective art, which eventually counted Mondrian, Gabo, and Kandinsky among its members.

László Moholy-Nagy (1895–1946)

An influential teacher at the Bauhaus between 1923 and 1928, László Moholy-Nagy moved from his native Hungary to Berlin in 1920 where he absorbed influences from both **Dada** and Constructivism. He made nonobjective paintings in a geometric style reminiscent of El Lissitzky's Prouns (e.g., *A IX*, 1923), and in collaboration with his wife Lucia Moholy, experimented with **photograms**—cameraless photographs made by placing objects or casting shadows against light sensitive photographic paper subsequently exposed to light (e.g. *Fotogramm*, 1926, The Metropolitan Museum of Art). He also produced Dada-inspired photomontages and took straight photographs. Like Rodchenko, whom he influenced, Moholy-Nagy often shot his photographs from high or low angles to create dynamic Constructivist-style compositions (e.g., *Berlin Radio Tower*, 1928).

At the Bauhaus, Moholy-Nagy succeeded Itten as the preliminary course teacher and the metals workshop Form Master. In line with Gropius's declaration of a new unity between art and technology, Moholy-Nagy oriented the metals workshop to the practical design of simply shaped, useful objects that could be machine manufactured. Moholy-Nagy's students, including Marianne Brandt, Gyula Pap, and Wilhelm Wagenfeld, designed lighting fixtures considered classic examples of modernist design and still in production a century later.

Moholy-Nagy's most innovative creation is the *Light Prop for an Electric Stage,* also known as the *Light-Space Modulator.* Conceived as early as 1922 and realized in 1930, this motorized rotating construction is shown here in one of Moholy-Nagy's photographs of it (Figure 6.15). When activated and illuminated in a darkened room, the *Light Prop*'s perforated metal discs, mesh screens, glass corkscrew, and other elements cast constantly changing shadows and reflections on the surrounding walls. This prophetic work looks ahead to the **kinetic art** of the 1960s (see Chapter 16) and new media installations

FIGURE 6.15 László Moholy-Nagy, *Light-Space Modulator* (*Das Lichtrequisit*), 1930. Gelatin silver print, 24 x 18.1 cm. The J. Paul Getty Museum, Los Angeles.

of later decades, which also often use moving light to activate indoor and outdoor environments.

Marianne Brandt (1893–1983)

Marianne Brandt studied painting in Weimar before World War I and enrolled at the Bauhaus in 1923. Her preliminary course teacher, Moholy-Nagy, recognized her talent and welcomed her into his metals workshop. Brandt went on to excel in the school's most male-dominated unit: she was the only one of the eleven women who studied in the metals workshop to earn her degree in that medium. Among Brandt's best-known early designs is a teapot (1924) whose body, lid, and handle are composed of pure geometric forms—a hemisphere, circle, and semicircle—conforming to Moholy-Nagy's Constructivist aesthetic. Although handcrafted of nickel-silver and ebony, it was a prototype for industrial manufacturing that never occurred. After the Bauhaus's move to Dessau, Brandt designed several lighting fixtures that did go into mass production. These included a desk lamp and bedside table lamp (both 1928) designed in collaboration with Hin Bredendieck and manufactured by Kandem in Leipzig. The bedside lamp (1928, Figure 6.16) is compact, streamlined, and functional: its

FIGURE 6.16 Marianne Brandt and Hin Bredendieck, Kandem Bedside Table Lamp no. 702, 1928. Lacquered steel, 25 x 12 x 19 cm. Musée National d'Art Moderne, Centre Georges Pompidou, Paris.

adjustable bell-shaped shade directs and focuses the light, and its stable, wedge-shaped foot accommodates a groping hand sliding up to find the push-button switch in the dark.[38] Brandt succeeded Moholy-Nagy as director of the metals workshop (1928–29) and then left the Bauhaus herself. She was head designer at the Ruppel Metal Products factory (1930–32) in Gotha before losing her job during the Great Depression. She returned to painting in her later career and taught art and design in Dresden and Berlin (1949–54).

Josef Albers (1888–1976)

Josef Albers shared responsibility for teaching the Bauhaus preliminary course with Moholy-Nagy and succeeded him as its sole director. After art study in Berlin, Essen, and Munich, Albers enrolled in the Bauhaus in 1920 and became a Master in 1925. A versatile artist, he designed stained glass, furniture, metalwork, and typography. His most celebrated Bauhaus works are his sandblasted, flashed, and painted glass panels featuring complex, rigorously organized compositions of horizontal and vertical bars and rectangles of solid color (e.g., *Fugue*, c. 1926).

After leaving Germany with the closure of the Bauhaus in 1933, Josef and his wife Anni, a fellow Bauhaus graduate, taught at Black Mountain College in North Carolina until 1949. In 1950, Josef became director of Yale University's design department and began his signature series, *Homage to the Square* (e.g., *Homage to the Square: Red Brass*, 1961), which absorbed him until his death. Each of these paintings has a composition of three or four nested squares surrounded by a thin white border, with the interior square positioned near the base of the canvas. Albers gave each square a different color, applied directly from the tube with a **palette knife** onto the primed, rough side of a Masonite panel. He devoted the series to investigating the interaction of colors and the visual sensations their juxtaposition induces, including the illusion that flat planes of color advance or recede in space. Through their rigidly defined expanses of pure color and generation of optical illusions, Albers's *Homage to the Square* series predicted both **Hard Edge painting** and **Op art** (see Chapter 16).

Gunta Stölzl (1897–1983)

Gunta Stölzl played a leading role in the Bauhaus weaving program. She enrolled at the Bauhaus in 1919 after previous study at the Kunstgewerbeschule (School of Arts and Crafts) in her native Munich and wartime service as a nurse. After studying in the weaving workshop, she became its technical director in 1925 and led it as Junior Master from 1927 to 1931. During the Weimar period, Stölzl wove one-of-a-kind wall hangings with abstract geometric compositions informed by the modernist aesthetics of her teachers Itten and Klee. After the move to Dessau, she explored the use of new weaving materials such as rayon and cellophane and developed fabric designs for industrial production.

A dazzling example of Stölzl's Dessau-period work, *5 Chöre* (1928, Figure 6.17), features a complex composition of small colorful geometric elements arranged into patterns mirroring each other across its central vertical axis.[39] Stölzl made it using a Jacquard loom, which produces a weaving based upon a pattern read from a chain of punch cards—an ancestor of the computer. Excited by the Jacquard technique's potential to generate multiple copies of the same textile, Stölzl designed *5 Chöre* for mass production, which ultimately did not occur. Its German title is translatable as both "5 choirs" and "5 chords." These words' musical connotations resonate with the weaving's patterns of color-shapes that through an analogy with music suggest notes arranged into chords. The title also identifies the Jacquard loom's five-part heddle mechanism that controls the movement of the **warp** threads since heddles are loops of wire or cord attached to the loom's harness and the German word *chöre* denotes divisions of the harness.

Anni Albers (1889–1994)

Anni Albers was another accomplished Bauhaus weaver who went on to make major contributions to textile art. Born Annelise Fleischmann, she studied painting privately in Berlin before entering the Bauhaus in 1922 and married her fellow student Josef Albers in 1925. She aspired to continue her training in painting at the Bauhaus but was assigned to the weaving workshop because of her gender. She quickly grasped the loom's capacity to create geometric abstractions through colored threads laid out in the grid produced by the warp and **weft** yarns. She did not produce regular patterns, however, but infused the grid with variety, inspired by her reading of Johan Wolfgang von Goethe's *The Metamorphosis of Plants*, which points out how simple patterns in nature produce infinite variations. Albers's wall hanging, *Black-White-Red* (1926/27, Figure 6.18), for example, features six horizontal rows of twelve rectangles of identical dimensions. In each row, eight of the rectangles are composed of twelve stacked horizontal bars while the other four are divided into quadrants by thin crossing lines. No two rows are the same, which in Albers's view

FIGURE 6.17 Gunta Stölzl, *5 Chöre (5 Choirs)*, 1928. Jacquard weave in cotton, wool, rayon, and silk, 229 x 143 cm. Die Museen für Kunst und Kulturgeschichte der Hansestdadt Lübeck, Germany.

FIGURE 6.18 Anni Albers, *Black-White-Red*, designed 1926–27, made 1965. Silk and cotton, plain weave double cloth of paired warps and wefts, 179.4 x 122.2 cm. The Art Institute of Chicago.

gave the composition a sense of lively unpredictability similar to that seen in nature.

Like her teacher Gunta Stölzl, whom she succeeded as weaving workshop director, Albers experimented with unorthodox materials. For her 1930 diploma project, she used cotton chenille and cellophane to weave a light-reflecting and sound-absorbing wall covering for an auditorium designed by Hannes Meyer. After the closure of the Bauhaus, the Albers moved to North Carolina, where Anni taught at Black Mountain College (1939–49) and continued to develop her textile work, including designs for industrial production. On trips to Mexico, Cuba, Chile, and Peru, she collected examples of traditional weaving patterns and techniques, which informed her own theory and practice. The first weaver given a solo show at MoMA (1949), Albers channeled her lifetime of knowledge into a classic book, *On Weaving* (1965), on her art's history, materials, tools, techniques, and implications for modern design.

Dada and the New Objectivity

This chapter surveys Dada, an international movement of the later 1910s and early 1920s, and New Objectivity (*Neue Sachlichkeit* in German), a German artistic tendency of the 1920s and early 1930s. Dada was born in Zurich, Switzerland in 1916 and spread over the next few years to New York, Berlin, Cologne, Hanover, and Paris, and its influence reached as far as Japan (see Chapter 11). It was radically subversive, attacking all previously accepted aesthetic standards to reimagine creativity as a spontaneous and unfettered activity. Embracing absurdity and non-sense, the Dadaists saw irreverence and irrationality as potent weapons against conformity and as liberating forces, paving the way for Surrealism's more programmatic celebration of the irra-tional (see Chapter 8). Dada visual artists rejected conventional representational art, employing abstraction, collage, and photomontage, and they used readymades and chance procedures, de-bunking the idea that art should require technical skill or express individual subjectivity.[1] Their use of readymades and photomontage (typically involving photographic reproductions clipped from mass-circulation periodicals), responded to the exponential expansion of the modern com-modity culture and mass media, respectively, during this period. Seeking to break down bar-riers between the artist and the public, the Dadaists also engaged in raucous performances, perpetrated media pranks, and made installations and artworks that invited viewer interaction.[2] By contrast, the artists associated with New Objectivity—some of them former Dadaists—re-turned to conventional forms of figurative art to confront contemporary social realities.

The Dadaists espoused absurdity in reaction to the senseless destruction of World War I (1914–18), a bloody cataclysm described by one historian as "a tragic and unnecessary conflict."[3] Sparked by the June 28, 1914, assassination of the Austrian Archduke Franz Ferdinand by a Ser-bian nationalist, the war pitted a coalition of Allies led by France, Britain, Russia, Italy, Japan, and the United States against the Central Powers of Germany, Austria-Hungary, the Ottoman Empire, Bulgaria, and their colonies, and ended in an Allied victory. The first global war of the industrial age, World War I introduced new military technologies such as the army tank and poison gas as well as more efficient machine guns, artillery, and the horrors of trench warfare. It claimed the lives of as many as 9 million soldiers and 13 million civilians. Europe lost almost an entire generation of young men; many who survived the conflict suffered from traumatic physi-cal and psychic wounds.

To many intellectuals, World War I's madness revealed the failure of the rationality that had dominated European thought since the Enlightenment. The French poet Paul Valéry expressed this view in "The Crisis of the Mind" (1919):

> **The illusion of a European culture has been lost, and knowledge has been proved impo-tent to save anything whatsoever; science is mortally wounded in its moral ambitions and . . . put to shame by the cruelty of its applications; idealism is barely surviving . . . real-ism is hopeless . . . faiths are confused in their aim . . . and even the skeptics . . . lose their doubts, recover, and lose them again.[4]**

The Dadaists were among those skeptics, vehemently opposed to the war, scornful of the social and cultural institutions that had made it possible, and disdainful of art—whether traditional or avant-garde—that failed to confront the difficult realities of existence. They used nonsense to attack the mentality that could rationalize the war's carnage, as well as the bourgeois European values they saw as bankrupt. "How can one get rid of everything that smacks of journalism, worms, everything nice and right, blinkered, moralistic, europeanized, enervated?" demanded Dadaist Hugo Ball in a 1916 manifesto. "By saying Dada."[5]

Zurich Dada

During World War I, many disaffected young men flocked to Switzerland, a neutral country, to avoid serving in their country's armies. The writers and artists among them gathered at the Cabaret Voltaire in Zurich, **Dada**'s birthplace, founded in early 1916 by the German poet Hugo Ball and his girlfriend Emmy Hennings, a singer and dancer. They were joined by the poets Richard Huelsenbeck and Tristan Tzara, from Germany and Romania, respectively; the Romanian painter and sculptor Marcel Janco; the Alsatian artist and poet Jean (Hans) Arp; and Arp's partner and future wife, Sophie Taeuber, a textile designer and dancer. Later arrivals included the experimental filmmakers Hans Richter and Viking Eggeling, from Germany and Sweden, respectively.

There are several different stories of how Dada got its name. Huelsenbeck reported that he and Ball discovered the word while leafing through a German-French dictionary.[6] Ball approvingly noted that Dada means "'yes, yes,' in Rumanian, 'rocking horse' and 'hobby horse' in French. For Germans it is a sign of foolish naiveté, joy in procreation, and preoccupation with the baby carriage."[7] The various meanings of "dada" in different languages fit the internationalism of the artists, who rejected nationalism as a destructive cause of the war. Furthermore, the word's flexibility suggested it was ultimately meaningless. Tzara, who became Dada's principal promoter in Zurich after Ball departed, declared "Dada Means Nothing."[8]

The nonsensical artistic activities at the Cabaret Voltaire, which were early manifestations of **performance art**, seemed to prove Tzara's point. Borrowing the concepts of *bruitism* (noise-ism) and simultaneity from the **Futurists,** the Dadaists made cacophonous "noise music" and performed "simultaneous poems," with several voices reading verses in different languages at the same time. They also improvised dances in painted cardboard masks made by Janco. Ball wrote unintelligible "sound poems" composed of made-up words. In the final performance at the Cabaret Voltaire, which operated for only five months, Ball read his poems aloud while dressed in a "cubist" costume comprising a shiny blue cardboard tube with a huge gold collar and a tall blue-and-white-striped "witch doctor's hat."[9]

In rejecting artistic traditions that they considered decadent and associated with the war, the Zurich Dadaists also aimed to renew society and culture through "primitiveness" and "beginning at zero," in Huelsenbeck's words.[10] Ball explained that he wrote sound poetry to "totally renounce the language that journalism has abused and corrupted" and "return to the innermost alchemy of the word."[11] Arp recalled that the Dadaists "were seeking an elementary art to cure man of the frenzy of the times and a new order to restore the balance between heaven and hell."[12] Among the Dadaists, Arp was the most committed to art's curative potential, a concept the **Surrealists** also embraced.

Jean (Hans) Arp (1886–1966)

The major visual artist to emerge from Zurich Dada was Jean (Hans) Arp.[13] He was active in international **avant-garde** circles before the war, exhibiting with the Blaue Reiter in Munich in 1912 and at the 1913 Erster Deutscher Herbstsalon (First German Autumn Salon) in Berlin. He escaped conscription into the German army by going to Paris in 1914 and to Zurich the next year, where he met his future wife Sophie Taeuber and formed a creative partnership with her.

Arp's major contributions to Dada were his artistic experiments with chance and accident. He reportedly tore up pieces of paper, let them fall randomly, and then glued them down in the pattern they formed. Arp's best known work in this vein, *Untitled (Collage with Squares Arranged According to the Laws of Chance)* (1916–17), is too orderly in appearance to have resulted purely from chance operations, but what mattered to Arp was the meaning of chance itself. He embraced chance to protest what he saw as European civilization's overreliance on reason and conscious control. "'The 'law of chance,'" Arp later wrote, "which comprises all other laws and surpasses our understanding (like the primal cause from which all life arises), can be experienced only in a total surrender to the unconscious. I claimed that whoever follows this law will create pure life."[14] Written after he had joined the Surrealists, Arp's words reflect that movement's belief that chance provides access to the unconscious, understood as the wellspring of artistic creation.

Arp also exploited chance in the "automatic" ink drawings he made in 1917 by letting his brush flow freely over the paper without conscious control (e.g., *Untitled [Automatic Drawing]*, 1917–18). This produced **biomorphic** shapes suggestive of living organisms like amoebas, parts of plants, or animal bodies. Extending this process into three dimensions, Arp gave his automatic drawings to a carpenter who cut those shapes out in pieces of wood. Arp assembled and painted these wooden elements to create relief sculptures, three or four layers deep. *Entombment of the Birds and Butterflies (Portrait of Tristan Tzara)* (c. 1917, Figure 7.1) is one such sculpture composed of **abstract**

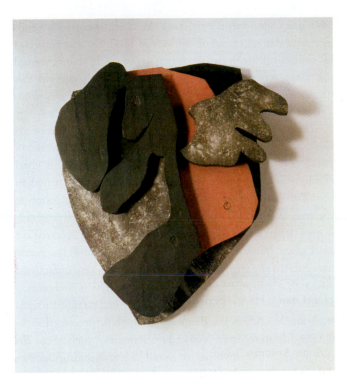

FIGURE 7.1 Jean Arp, *Entombment of the Birds and Butterflies (Portrait of Tristan Tzara)*, c. 1917. Wood, painted, 40 x 32.5 x 9.5 cm. Kunsthaus Zurich, Switzerland.

biomorphic shapes. Despite the work's title, it resembles neither birds, butterflies, nor Arp's Dada colleague Tzara. The lack of logical relationship between the work's title and its appearance exemplifies Dada's rejection of reason. The sculpture celebrates what Arp called "the senseless," which he likened to nature's "unreasonable" but vital forces, declaring, "Dada is for nature and against art."[15] Arp's biomorphism, carried on in his later sculpture (see Figure 8.11), exerted a strong influence on Surrealist art.

Sophie Taeuber-Arp (1889–1943)

The only Swiss citizen in the Zurich Dada group, Sophie Taeuber was both a talented dancer who performed at the Cabaret Voltaire and an accomplished textile artist who taught at Zurich's Kunstgewerbeschule (School of Applied Arts). After she met Arp in 1915, they became a couple and collaborated on **collages** and embroideries. They intended their use of these **mediums** as a critique of **oil painting**, which in Arp's words they regarded as "characteristic of a pretentious and conceited world."[16] Exhibiting their embroideries framed and hung on the wall like paintings, Arp and Taeuber also challenged the traditional hierarchy between "fine" and "applied" art. Some of their collages featured nonobjective **compositions** of rectangular planes arranged in a horizontal-vertical grid (e.g., *Untitled (Duo-Collage)*, 1918). Among the first purely geometric **abstractions** created by the European avant-garde, these

works likely derived from Taeuber's experience as a weaver, as the loom uses the **warp**, or threads stretched the fabric's vertical length, and the **weft**, or threads running the fabric's horizontal width.

Between 1918 and 1920, Taeuber made a series of *Dada Heads* rising from round pedestals. She fashioned them out of wood turned on a lathe and painted them with abstract facial designs recalling the **style** of Oceanic or Native American art of the Pacific Northwest. In characteristic Dada fashion, these works mock artistic conventions—in this case, of portrait sculpture. Although Taeuber later playfully designated several of them as portraits of Arp, they do not imitate human appearance beyond their basic format. Perfectly smooth and symmetrical save for its attached "nose," Taeuber's *Dada Head* (1920, Figure 7.2) looks less like a sculpture than a manufactured object with a useful function, linking it to Duchamp's **readymades**. Arp jokingly noted that Taeuber's heads could serve as hat stands, which indeed they resemble.[17]

Arp and Taeuber married in 1922 and she took the surname Taeuber-Arp. They gained French citizenship in 1926 and collaborated with the De Stijl artist Theo van Doesburg on the interior decoration of the Café L'Aubette in Strasbourg.

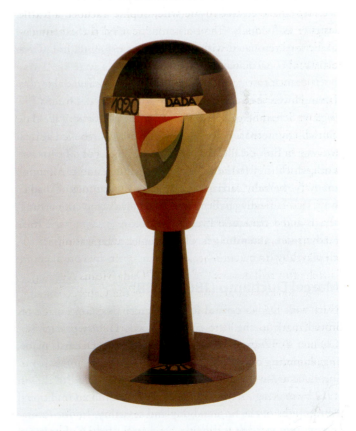

FIGURE 7.2 Sophie Taeuber-Arp, *Dada Head*, 1920. Turned and painted wood, 29.43 x 14 cm. Musée National d'Art Moderne, Centre Georges Pompidou, Paris.

Employing a geometric abstract vocabulary, Taeuber-Arp covered the walls of the café's tearoom with painted wood rectangles and squares and designed stained-glass windows composed of similar elements. In 1928, she and Arp settled in Meudon outside Paris in a house she designed. In the 1930s, Taeuber-Arp made nonobjective paintings and reliefs employing both geometric and organic elements (e.g., *Composition of Circles and Semicircles*, 1935) and participated, with Arp, in the groups Cercle et Carré (Circle and Square) and Abstraction-Création (Abstraction-Creation), both devoted to nonfigurative art.

New York Dada

The first news of Zurich Dada likely reached New York around the beginning of 1917 when Marcel Duchamp received a publication sent to him by Tzara. By this time, Duchamp and his friend Francis Picabia, French artists who had come to New York in 1915 to escape World War I, had already produced artworks manifesting Dada's iconoclastic spirit. Picabia and Duchamp joined the literary and artistic circle around the art collectors Walter and Louise Arensberg, who became Duchamp's principal patrons. The Arensbergs hosted alcohol-soaked soirées that attracted artists, poets, composers, dancers, and other creative individuals. The boisterous revelry at these evening gatherings resonated with Dada's freewheeling nature. Other artists who participated in New York Dada were the Swiss-born Jean Crotti, the German Baroness Elsa von Freytag-Loringhoven, and the Americans John Covert, Morton Livingston Schamberg, Man Ray, and Beatrice Wood. Like their Zurich counterparts, the New York Dadaists rebelled against the war in Europe and the hallowed traditions of oil painting, both which they found to be absurd and detestable. Although many New York Dadaists continued to paint, they did so in ways that radically challenged the medium's conventional materials and techniques. Even more unconventional were their readymades, **assemblages**, photographs, and performances—all playfully irreverent.

Marcel Duchamp (1887–1968)

New York Dada's central figure, Marcel Duchamp made his initial mark in the Paris art world as a **Cubist** painter (see Chapter 4). Disenchanted with what he called "retinal" painting, appealing only to the eye, Duchamp aspired "to put painting once again at the service of the mind."[18] He did this in 1912 by making a series of paintings that disrupted traditional conceptions of the human body and sexuality. In *The Passage from Virgin to Bride* and *Bride*, Duchamp used a Cubist-based **mechanomorphic** style to give his figures machinelike bodies comprising flesh-colored elements suggestive of engine parts or laboratory equipment. Duchamp thus dehumanized his subjects and denied romantic notions of virginity and marriage by sardonically comparing sexual relations to a mechanical operation. After moving to New York, he would elaborate this mechanized concept of eroticism in his most ambitious work, *The Bride Stripped Bare by Her Bachelors, Even.*

In 1913, Duchamp began to question the nature of art itself, asking, "Can one make works which are not works of 'art'?"[19] He proposed an answer by inserting the fork and wheel of a bicycle into the seat of an ordinary stool. This created an eccentric object with which he amused himself by spinning the wheel. In 1914, Duchamp purchased a bottle drying rack from a department store and, without altering it, declared it a work of art. With the *Bicycle Wheel* and *Bottle Rack*, Duchamp inaugurated the tradition of the readymade—a manufactured object that assumes the status of art through its designation as such by the artist. Duchamp distinguished straightforward readymades, such as the *Bottle Rack*, which he presented without modification, from "assisted readymades," such as the *Bicycle Wheel*, which involved his modifying or bringing together different preexisting elements.

With his revolutionary readymades, Duchamp rejected the notion that an artwork had to be created personally by the artist or by specialists working under the artist's direction. He likewise denied any physical distinction between the artwork and the useful things that surround us in everyday life. To Duchamp and his followers, what made the readymades interesting as art was the artist's situation of these mundane objects in new contexts that gave the objects the potential to take on new meanings. Duchamp's imaginative titles often suggested such meanings: in 1915, he purchased a snow shovel and hung it from the ceiling of his New York apartment under the ominous title *In Advance of the Broken Arm.*

Like most of his readymades of the 1910s, the first snow shovel Duchamp selected was later lost. This mattered little to him since the *idea* of using a snow shovel as a readymade endured. He could manifest that idea again by purchasing a new snow shovel and calling it *In Advance of the Broken Arm*, which he did in 1945 for his friend and patron Katherine Dreier's collection. Because the readymades are fundamentally concerned with ideas, they are considered the first examples of **Conceptual art**. Near the end of his life in 1964, Duchamp commissioned a limited edition of his fourteen most notable readymades, fabricated to match closely the lost originals. This was richly ironic since he had been drawn to those originals precisely because they had *not* been fabricated for him.

Duchamp's most notorious readymade was a urinal that he purchased in 1917 from a plumbing supply store, rotated ninety degrees so that it faced up, titled *Fountain*, and signed with the pseudonym R. L. Mutt (seen in Figure 7.3). Duchamp, who loved wordplay, took this fake name from a

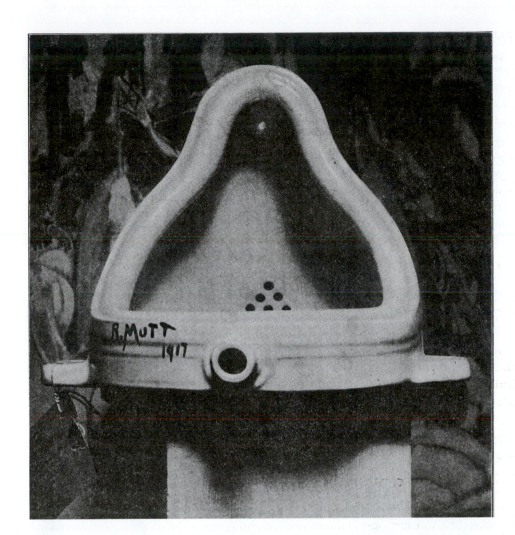

FIGURE 7.3 Alfred Stieglitz, *Fountain by R. Mutt*, 1917. Photograph of readymade by Marcel Duchamp, published in *The Blind Man*, no. 2 (May 1917): 4.

popular comic strip, *Mutt and Jeff*, as a pun on the urinal manufacturer' name, J. L. Mott Iron Works. Under the alias of Mutt, Duchamp submitted the readymade to the New York Society of Independent Artists exhibition in April 1917. Duchamp and Walter Arensberg were on the Board of Directors of this society, whose exhibition was supposed to be open to anyone who paid the modest initiation fee and annual dues. Duchamp sought to test the exhibition organizers' open-mindedness by hiding behind Mutt's name so that his board membership would not influence their response to *Fountain*. This object sparked a heated debate among the other directors, a majority of whom voted to exclude it from the exhibition because they viewed it as indecent and not a work of art. Duchamp and Arensberg immediately resigned from the society.

Maintaining the charade of Mutt as responsible for *Fountain*, Duchamp and his allies published a defense of it in a magazine, *The Blind Man*. In an unsigned editorial they argued that *Fountain* was no more "immoral" than a bathtub: "It is a fixture that you see every day in plumber's show windows." The

text also confirmed *Fountain*'s status as a work of art according to Duchamp's philosophy of the readymade: "Whether Mr. Mutt with his own hands made the fountain or not has no importance. He CHOSE it. He took an ordinary article of life, placed it so that its useful significance disappeared under the new title and point of view—created a new thought for that object."[20]

The editorial was accompanied by a black-and-white photograph of *Fountain* taken by Alfred Stieglitz (Figure 7.3) before the readymade mysteriously disappeared. Stieglitz used as a backdrop a painting by Marsden Hartley, *The Warriors* (1913), which the American artist had painted in Berlin on the eve of World War I. This juxtaposition reminds us that Duchamp submitted *Fountain* to the Society of Independent Artists just a few days after the United States declared war on Germany—a move both Stieglitz and Duchamp opposed. Duchamp may have, in Dada fashion, understood *Fountain* as a metaphorical gesture of protest against—of pissing on—the US entry into the war. This critique would have complemented *Fountain*'s role in exposing the hypocrisy of the supposedly

liberal Society of Independent Artists that did not in fact fully support freedom of expression.[21]

Distinct from the readymades, which Duchamp simply selected, *The Bride Stripped Bare by Her Bachelors, Even*, also known as *The Large Glass* (Figure 7.4), consumed eight years of creative effort. Beginning his plans in 1912, Duchamp made meticulous studies for the work and executed it in New York between 1915 and 1923. It is a highly unconventional artwork, a window-like structure painted on two large glass panels in mediums ranging from oil and varnish to lead foil, lead wire, and dust. Like Arp and other Dadaists, Duchamp employed chance in realizing the work. For example, he allowed dust to

gather on the *Large Glass* and used dust as a medium in rendering the *Seven Sieves*, one of the contraptions in the lower panel. He executed the work on glass so that its surrounding environment, outside of his control, would provide its **background**.

The *Large Glass* features a complex narrative revolving around unconsummated attempts at lovemaking, mockingly couched in the language of science and engineering. Duchamp's extensive handwritten notes, which he published as facsimiles in *The Green Box* (1934), provide an ambiguous and convoluted guide to the work's imagery. The perpetually disrobing *Bride* occupies the left side of the upper panel, her wasp-like mechanical body adapted from Duchamp's

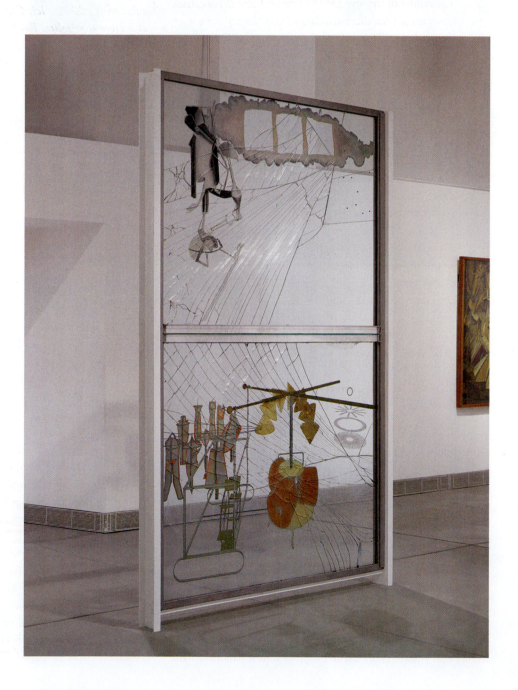

FIGURE 7.4 Marcel Duchamp, *The Bride Stripped Bare by Her Bachelors, Even (The Large Glass)*, 1915–23. Oil, varnish, lead foil, lead wire, and dust on two glass panels, 277.5 x 177.8 x 8.6 cm. Philadelphia Museum of Art.

1912 painting. Spreading out from the *Bride* is the cloudlike *Milky Way*, which opens into three holes, the *Draft Pistons*. Duchamp based their shapes on the changing appearance of a square piece of cloth suspended in a draft—another instance of incorporating chance into the work's creation. Through the *Draft Pistons*, the *Bride* transmits sexual invitations to the *Bachelors*, represented by nine *Malic Moulds* at the left side of the lower panel. They emit a "love gas" that undergoes various transformations as it passes through the machines represented below and to the right. These include the *Sleigh* with its *Watermill Wheel*; the cone-shaped *Seven Sieves* arcing across the intersecting bars of the *Scissors*; and the *Oculist Witnesses*, the circular and radiating forms at the right, derived from opticians' charts. The failure of the love gas to unite with the *Bride* causes sexual frustration that the *Bachelors* release through masturbation. Symbolizing this activity is the *Chocolate Grinder*, an old-fashioned machine with three rollers that Duchamp saw in a confectionery shop window and painted twice (in 1913 and 1914) before including it in the *Large Glass*. "The bachelor," wrote Duchamp, "grinds his chocolate himself."[22]

Notably, none of the absurd machines depicted in the *Large Glass* actually function. This contributes to its overall theme of lack of fulfillment, as does the fact that Duchamp left the *Large Glass* unfinished in 1923. After its exhibition at the Brooklyn Museum in 1926–27, the work was shattered in transit. Duchamp spent months repairing it in 1936, accepting the network of cracks as part of its content and declaring the *Large Glass* completed through the intervention of chance.

After posing in drag in 1921 for photographs by Man Ray as his feminine alter ego Rrose Sélavy (which sounds in French like *eros, c'est la vie* [eros, that's life]), Duchamp returned to France in 1923. There, he devoted himself seriously to chess, experimented with mechanical optical devices, and collaborated with the Surrealists. Rather than creating new art, between 1935 and 1941 he oversaw the fabrication of miniature reproductions of sixty-eight of his previous works. He gathered these into a portable museum called *Box in a Valise*, which he issued in several editions. After returning to New York in 1942 to escape World War II, Duchamp worked in secret for two decades on a final artwork that was revealed only after his death: *Étant donnés: 1. La chute d'eau, 2. Le gaz d'éclairage (Given: 1. The Waterfall, 2. The Illuminating Gas)* (1946–66). This enigmatic **installation** consists of an old wooden door with two peepholes through which the viewer sees a realistic sculpture of a nude white woman's spread-legged body lying in a bed of twigs. Her left hand holds a glowing gas lamp juxtaposed with a flowing waterfall in the background. *Étant donnés* complements the *Large Glass* through its literal manifestation of elements—a bride stripped bare, illuminating gas, and a waterfall—represented only abstractly in the earlier work.

Francis Picabia (1879–1953)

Francis Picabia shared Duchamp's interest in using machine imagery to represent human beings and sexual activities. Picabia adopted a Cubist painting style in 1912 and traveled to New York the next year to see his works included in the Armory Show. His second, 1915 visit to New York sparked what he called "a complete revolution" in his work: "Almost immediately upon coming to America it flashed on me that the genius of the modern world is in machinery, and that through machinery art ought to find a most vivid expression."[23] In collaboration with Stieglitz, Picabia published *291*, a magazine named for Stieglitz's gallery. In it, Picabia reproduced ink-drawn, diagram-like portraits of his New York art world friends in the guise of machines. *Ici, C'est ici Stieglitz, Foi et Amour (Here, This Here is Stieglitz, Faith and Love)* (1915, Figure 7.5) wittily represents the gallerist and photographer as a camera merged with an automobile's gearshift and break levers. The latter are

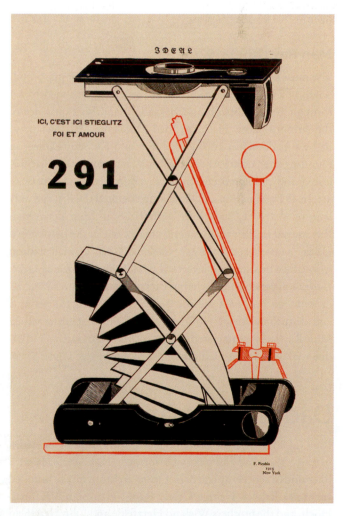

FIGURE 7.5 Francis Picabia, *Ici, C'est Ici Stieglitz, Foi et Amour* (*Here, This Here is Stieglitz, Faith and Love*), 1915. Relief print on paper, 44 x 28.9 cm. National Portrait Gallery, Washington, DC.

set in park and neutral, so the automobile cannot move. The camera is broken and its bellows sag, implying a loss of virility. These elements suggest Stieglitz's failure to realize his aims. However, the camera's lens rises toward the word "IDEAL," perhaps acknowledging Stieglitz's continuing quest to advance high culture through his support of modern art.

Between 1916 and 1919 Picabia spent time in Barcelona, New York, Paris, and Zurich, where he met Tzara, Arp, and Janco. Settling in Paris in 1919, Picabia participated in that city's Dada movement for a few years before moving to the south of France and returning to representational painting. His most remarkable later works are his *Transparencies* (c. 1928–c. 1931, e.g. *Otaïti*, 1930). These bizarre paintings feature myriad linear and opaque images—figurative, floral, animal, and architectural—copied from ancient, **Renaissance**, and contemporary visual sources and layered like superimposed photographic transparencies. Dismissed as decadent by mid-century critics, Picabia's *Transparencies* gained new respect in the 1980s as a precedent for the similar use of layered, appropriated images by **postmodern** painters such as Sigmar Polke, David Salle, and Francesco Clemente (see Chapter 20).

Man Ray (1890–1976)

The most prominent American Dadaist, Man Ray (the pseudonym of Emmanuel Radnitzky) became aware of modern art through visits to Stieglitz's 291 Gallery and his experience of the Armory Show. He befriended Duchamp after his arrival in New York and in 1920 joined him and Katherine Dreier in founding the Société Anonyme, Inc., an organization that collected and promoted contemporary European and American art. In 1921, Man Ray and Duchamp coedited the first and only issue of *New York Dada*, with "authorization" from Tzara. Man Ray moved to Paris that year and created one of the best-known Dada "assisted readymades": *Cadeau (Gift)*, a small flatiron whose face bristles with a vertical row of outward-facing tacks. *Cadeau* differs from Duchamp's relatively benign readymades in its menacing, even sadistic quality. It predicts the perverse and disturbing imagery of Surrealism, a movement in which Man Ray later participated, doing his most innovative and influential work in the medium of photography (see Figure 8.13).

Dada in Germany

Richard Huelsenbeck brought Dada from Zurich to Berlin in early 1917 and the next year formed the Club Dada with likeminded writers and artists. Other artist-members included Johannes Baader, George Grosz, Raoul Hausmann, Hannah Höch, and the brothers Wieland Herzfelde and John Heartfield (who had anglicized his name to protest German nationalism and anti-British sentiment during the war). In April 1918, with the war still raging, the Berlin Dadaists presented an evening of lectures, poetry readings, and performances in the galleries of the Berlin Secession. Huelsenbeck read his Dadaist Manifesto, in which he attacked **Expressionism** and abstraction for their detachment from contemporary events. He identified as "the highest art," that "which in its conscious content presents the thousandfold problems of the day, the art which has been visibly shattered by the explosions of the last week, the art which is forever trying to collect its limbs after yesterday's crash."[24]

As Huelsenbeck's words suggest, the Berlin Dadaists were deeply engaged with their country's political situation. Following Germany's defeat in World War I and Kaiser (Emperor) Wilhelm II's abdication in November 1918, the Weimar Republic (1918–33) was established under the moderate socialist president Friedrich Ebert. The politically left-wing Berlin Dadaists strongly opposed Ebert's government, which they saw as colluding with big business and the military. The Dadaists supported the Spartacist League, which sought to establish a communist state in Germany. After the army harshly suppressed a Spartacist uprising in January 1919, Herzfelde and Heartfield published a Dada newspaper criticizing the military and the government, *Jedermann sein eigner Fussball* (Every man his own soccer ball), which the police immediately confiscated.

The newspaper's cover featured satirical **photomontages** by Heartfield and Grosz. Descended from Cubist collage, photomontages were composed out of images and texts in various typefaces cut from newspapers, magazines, and other printed materials. Photomontage became the Berlin Dadaists' principal visual medium, used to convey social and political critique and to promote their irreverent values. They did the same through their journal *Der Dada* (1919–20), edited by Hausmann, and the *Dada Almanach* (1920), edited by Huelsenbeck and published to coincide with the First International Dada Fair. The climax of Berlin Dada, this visually riotous exhibition featured posters, photomontages, paintings, assemblages, and installations. Many of these works were critical of the military, including a sculpture by Heartfield and Rudolf Schlichter, *The Prussian Archangel*. Hanging from the ceiling, it was a life-size dummy of an army officer with a papier mâché pig's head and a waistband printed with the refrain from a German Christmas carol, "I come from Heaven, from Heaven on high." It brought charges of defamation against the artists, who defended themselves by claiming it was a joke.

Raoul Hausmann (1886–1971)

Raoul Hausmann proclaimed himself the "Dadasoph"—the philosopher of Berlin Dada. He painted in an expressionist style before joining Club Dada in 1918. He then renounced oil painting and took up photomontage, a medium he jointly explored with Hannah Höch, his companion between 1915 and 1922. Hausmann also created "poster-poems" that presented strings of

random letters, a Dada assault on literary conventions comparable to Hugo Ball's in Zurich. Hausmann's most famous work, *The Spirit of Our Time (Mechanical Head)* (1919), extends photomontage's unexpected juxtapositions into three dimensions. It is an assemblage of **found objects**—a wooden dummy head adorned with items including a tape measure, a wooden ruler, a collapsible tin cup, and parts of a pocket watch and camera. Explaining the work's critical commentary on contemporary society, Hausmann wrote, "The everyday man had only those capacities that chance had glued to his skull, on the exterior[;] the brain was vacant."[25]

Hannah Höch (1889–1978)

The only woman to participate in Berlin Dada, Hannah Höch's principal medium was photomontage, which she used to express her social and political views. Höch exhibited her large photomontage, *Cut with the Kitchen Knife: Dada through the Last Epoch of Weimar Beer-belly Culture in Germany* (1919–20, Figure 7.6), at the First International Dada Fair. The crowded and disjointed composition of photographic images and texts suggests the unsettled nature of the early Weimar Republic. Despite the initial impression of visual chaos, the work is carefully organized. The upper right quadrant is the precinct of the "anti-Dada movement," as indicated by those words hovering near the face of the deposed Kaiser Wilhelm II. To the upper right and lower left of the Kaiser's face are images of military officers. In the lower right quadrant, just below the heads of Lenin and Marx, we see "the great Dada world/Dadaists," represented by the heads of

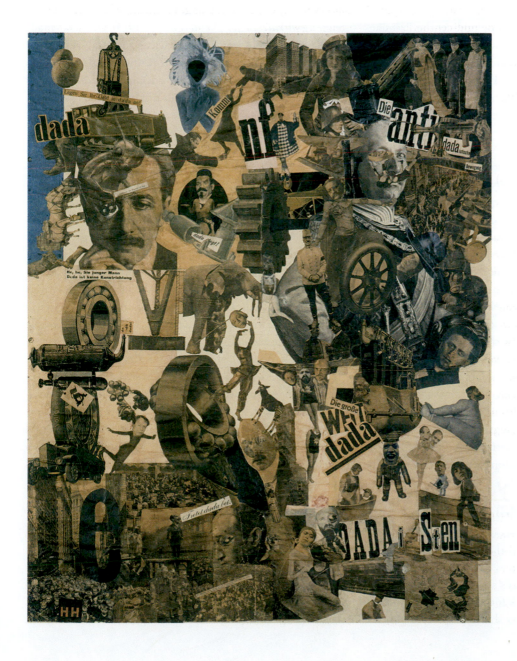

FIGURE 7.6 Hannah Höch, *Cut with the Kitchen Knife: Dada through the Last Epoch of Weimar Beer-belly Culture in Germany,* 1919–20. Photomontage, 114 x 90 cm. Staatliche Museen zu Berlin, Nationalgalerie.

the Berlin Dadaists grafted onto other bodies. The lower left quadrant shows the leader of the revolutionary sailors, Raimond Trost, exhorting a crowd to "Join Dada!" Dominating the work's upper left corner is the face of Albert Einstein, beneath the word "dada." Höch likely identified Einstein with Dada due to his revolutionary scientific theories, which resonated with her movement's commitment to artistic, social, and political revolution.

The photomontage is filled with images of movement that suggest Dada's power to induce change. Five outsized wheels or roller bearings orbiting the composition's center evoke modern machinery and create a quality of centrifugal motion. Significantly, most of the active human figures in the photomontage are women, including an ice skater and several dancers. At the work's center, the headless body of the popular dancer Niddy Impekoven appears to juggle the head of artist Käthe Kollwitz, recently appointed as the Prussian Academy's first woman professor. These images can be read as signifiers of female liberation and empowerment. One concrete instance of such empowerment was woman's suffrage, instituted in Germany in 1919. Höch draws attention to this issue through a map of Europe in the lower right corner that indicates through lighter shading the countries where women had the right to vote.

John Heartfield (1891–1968)

John Heartfield did his most consequential work in photomontage after the Dada movement dissolved. A member of the German Communist Party, Heartfield worked between 1927 and 1938 for *Arbeiter-Illustrierte Zeitung* (*AIZ*, Workers' Illustrated Newspaper), a popular leftwing weekly, for which he produced numerous photomontages opposing the Nazi (National Socialist German Worker's) Party and its leader, Adolf Hitler. One of the best known, *Adolf, the Superman, Swallows Gold and Spouts Junk* (1932), superimposes on a photograph of the speechifying Hitler an X-ray of his torso showing his gullet and belly filled with coins. This image lets the viewer "see through" Hitler's pro–working-class rhetoric to reveal that he actually serves capitalism's interests. After Hitler assumed power in Germany in 1933, *AIZ* shifted its base of operations to Prague. Heartfield worked there until 1938 and then escaped to London when Hitler invaded Czechoslovakia.

Kurt Schwitters (1887–1948)

The Hanover-based Kurt Schwitters was friendly with several of the Berlin Dadaists and shared their aim to fuse art with life. He did this by making collages and assemblages out of refuse he picked up from Hanover's streets and parks—"new art forms out of the remains of a former culture."[26] Schwitters also wrote collage-style poetry that incorporated phrases culled from advertisements, periodicals, and bits of overheard conversation. Huelsenbeck denied Schwitters admission to Club Dada, however, because of his lack of political commitment and his association with Herwarth Walden's Galerie Der Sturm, a bastion of Expressionism, which the Berlin Dadaists reviled.

Schwitters responded to Huelsenbeck's snub by devising a personal form of Dada that he called Merz. He derived the name from a fragment of the word *Kommerz* (commerce) in an advertisement for a bank that he used in an assemblage. Schwitters wrote that Merz "denotes essentially the combination of all conceivable materials for artistic purposes, and technically the principle of equal evaluation of the individual materials. . . . A perambulator wheel, wire-netting, string and cotton wool are factors having equal rights with paint."[27] Schwitters used such materials in his assemblages (e.g., *Construction for Noble Ladies*, 1919) and also made small collages out of scraps of wastepaper salvaged from the gutter. While the presence of legible texts and images in many of Schwitters's works creates the possibility of "reading" them in relation to current events, they lack the programmatic nature of Berlin Dada photomontages like Höch's *Cut with the Kitchen Knife*. They also demonstrate Schwitters's greater concern for creating firmly structured compositions, which drew him into contact with the **Constructivists** in the 1920s.

Starting in 1923, Schwitters extended Merz into an architectural scale in his *Merzbau* (Merz building), which eventually filled several rooms of the apartment he shared with his wife and son (Figure 7.7). The rooms contained **columns** and niches that Schwitters called "grottos." These harbored objects relating to the person, place, or symbolic concept to which the grotto was dedicated. Many were named for Schwitters's friends, such as the Mona Hausmann, which displayed a reproduction of the Mona Lisa adorned with pasted-on photograph of Raoul Hausmann's face. As the *Merzbau* grew, Schwitters surrounded and sometimes covered over the grottos with an unruly structure of wood and plaster, creating a total **environment**, sadly destroyed by Allied bombs in 1943. After the Nazis declared Schwitters "degenerate" in 1937 and suppressed his work, he fled to Norway, where he began a second *Merzbau* (later destroyed by fire). He built a third *Merzbau* in England in the 1940s, and died there.

Max Ernst (1891–1976)

A self-taught painter, Max Ernst exhibited expressionist works in the First German Autumn Salon organized by Herwarth Walden in Berlin in 1913. Disillusioned and traumatized by his experience serving in the German army between 1914 and 1918, Ernst abandoned Expressionism and embraced Dada's rebellious spirit. With Johannes Baargeld and others, Ernst,

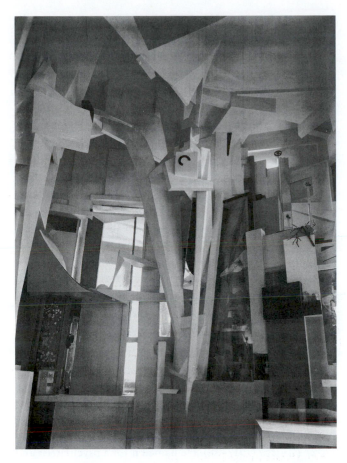

FIGURE 7.7 Kurt Schwitters, *Merzbau*, Hanover, Germany. Photographed by Wilhelm Redemann, c. 1930.

who dubbed himself Dadamax, orchestrated Dada activities in Cologne in 1919–20, publishing provocative journals that the British occupying forces confiscated. Ernst and Baargeld also staged an exhibition in the courtyard of a pub that visitors accessed via the men's restroom. Inside the courtyard, viewers encountered a girl in a communion dress reciting lewd poetry and were encouraged to destroy a sculpture by Ernst with a hatchet. The exhibition thus assaulted the sanctity of both art and religion and offended many, including Ernst's devout Roman Catholic father.

Between 1919 and 1921, Ernst made collages and photomontages using photographs and illustrations from various printed sources, including advertising catalogs. He brought these images together into unexpected combinations to create dreamlike effects similar to those achieved in Giorgio de Chirico's paintings (see Figure 8.3), which Ernst knew and admired. In some cases, Ernst simply painted over portions of catalog pages. His modifications served to "record a faithful and fixed image of my hallucination," and "transform the banal pages of advertisement into dramas which reveal my most secret desires."[28] An example of Ernst's "overpaintings" is *Stratified Rocks, Nature's Gift of Gneiss Lava Iceland Moss 2 kinds of lungwort 2 kinds of ruptures of the perinaeum growths of the heart b) the same thing in a well-polished little box somewhat more expensive* (1920, Figure 7.8). Ernst made it by inverting a cross section anatomical diagram of a horse from a teaching-supply catalog. He then selectively painted over the diagram to

FIGURE 7.8 Max Ernst, *Stratified Rocks, Nature's Gift of Gneiss Lava Iceland Moss 2 kinds of lungwort 2 kinds of ruptures of the perinaeum growths of the heart b) the same thing in a well-polished little box somewhat more expensive*, 1920. Gouache and pencil on printed paper on cardstock, 19.1 x 24.1 cm. The Museum of Modern Art, New York.

embed it in a desert landscape and added a lengthy and satirical pseudo-scientific title.

Ernst sent his works on paper to his Dada colleagues in Paris where they attracted the admiration of André Breton, the future leader of the Surrealists. In his catalogue essay for these works' 1921 Paris exhibition, Breton described their "marvelous faculty of attaining two widely separate realities without departing from the realm of our experience, of bringing them together and drawing a spark from their contact . . . of disorienting us in our own memory."[29] Ernst in the same year extended into oil painting the disorienting effects he had achieved in his overpainted catalog pages, collages, and photomontages. *The Elephant Celebes* (1921), for example, is a disturbing and enigmatic composition dominated by a boiler-bodied monster with a swinging, hose-like appendage that ends in a horned head with sightless eyes. At the lower right, a headless, female nude beckons with a gloved hand. Behind her is a tower of tottering coffee pots. Fish float in the gray sky above. Ernst's motifs came from his own imagination or from printed sources: for instance, he adapted the elephantine monster from a photograph of a communal corn bin used by a tribe in southern Sudan. The painting's bizarre imagery and inexplicable juxtapositions suggest a dream. Sigmund Freud, whose writings Ernst had read as a university student, considered dreaming a means of expressing and fulfilling repressed, unconscious desires (see "Psychoanalysis" box, Chapter 8). Freud's views provided the theoretical basis of Surrealism, to which Ernst made major contributions after his move to Paris in 1922 (see Chapter 8).

The New Objectivity

After German Expressionism's and Berlin Dada's exhaustion in the early 1920s, many modern German artists returned to more traditional artistic means. They developed representational painting styles featuring clear contour lines, **naturalistic** color, sculptural **volumes**, and **perspectival** space—conventions that the Brücke, Blaue Reiter, and Dada artists had subverted or disregarded. Those who adopted these representational styles used them to depict the daily lives of modern Germans, especially in urban settings. These artists responded in various ways to the Weimar period's rapid social, cultural, and political transformations, from the volatile aftermath of the war to severe inflation in the early 1920s (rooted in Germany's war-time debts) and the succeeding so-called Golden Twenties (1924–29), a period of relative political stability and prosperity ended by the worldwide Great Depression, which set the stage for Hitler's rise to power. Labeled **Neue Sachlichkeit (New Objectivity)** at a 1925 exhibition at the Mannheim Kunsthalle, organized

by Gustav Friedrich Hartlaub, the return to artistic traditionalism never constituted a formal movement. Hartlaub recognized within Neue Sachlichkeit a split between more conservative artists who created classically tranquil images and those who aggressively pursued social criticism, often through caricature and exaggeration. George Grosz and Otto Dix, today the best-known Neue Sachlichkeit painters, represent the latter tendency. The term "Neue Sachlichkeit" was also applied to other art forms, including literature, film, and photography.

George Grosz (1893–1959)

George Grosz studied art in Dresden, Berlin, and Paris before World War I and developed a loose drawing style in which he depicted subjects from daily life and sensational popular literature. He volunteered for service in World War I and, through the traumatic experience, came to detest war and German militarism. He expressed his bitterness in a well-known satirical drawing, *Fit for Active Service (The Faith Healers)* (1916–17), showing a military doctor examining a moldering cadaver whom he declares fit for service in the presence of a group of complacent German officers. Also disgusted by what he perceived as German society's depravity and ugliness, Grosz summed up his pessimistic view of life in wartime Berlin in a large painting, *Dedication to Oskar Panizza* (1917–18). He named it for a psychiatrist and avant-garde author who suffered censorship and imprisonment under Kaiser Wilhelm II's reign. A hellish nocturnal urban scene of tilting buildings and a jostling mob, Grosz's picture shows what he called a "troupe of infernal figures . . . half-animal and half-human baggage, alcohol, syphilis, pestilence."[30] Triumphant Death rides on a black coffin at the center, swigging from a bottle.

Grosz's disenchantment with bourgeois values led him to join the German Communist Party in late 1918, as did his friends Wieland Herzfelde and John Heartfield. Collaborating with them in the Berlin Dada movement, Grosz made photomontages and caricatures that skewered military leaders and the rich and powerful. After his involvement with Dada, Grosz continued to convey social criticism through his satirical drawings and paintings. Between 1925 and 1927 he also painted several portraits in the meticulous, **illusionistic** style of the Neue Sachlichkeit (e.g., *The Poet Max Hermann-Neisse*, 1925). In early 1933, just prior to Hitler's seizure of power, Grosz immigrated with his family to the United States and five years later became an American citizen.

Otto Dix (1891–1969)

Trained in art in Gera and Dresden, Otto Dix developed an expressionist painting style before serving in the German

Army from 1914 to 1918. He later characterized his military experience as "something horrible, but nonetheless something powerful" that provided him fundamental knowledge about humanity.[31] Following the war, Dix made disturbing, caricatured images of gruesomely disfigured veterans, challenging his viewers to confront the reality of these men's shattered bodies and lives (e.g., *The Skat Players*, 1920). He exhibited some of these in the First International Dada Fair in Berlin in 1920.

Returning repeatedly to the theme of war, Dix published a portfolio of fifty etchings, *Der Krieg* (*The War*), in 1924, depicting the terrible conditions of trench warfare and soldiers' daily lives. In addition to grisly images of the dead and wounded, the series includes scenes of soldiers and prostitutes, rendered as decadent and hideous. Dix frequently drew and painted prostitutes in the 1920s, often in a caricatured fashion. His sarcastically titled painting *Girl before a Mirror* (1922), showing an aged prostitute standing before a mirror in a corset and bloomers with withered breasts and exposed genitals, brought charges of indecency against Dix. He successfully defended himself by explaining that the picture was meant to be a moral warning against prostitution's corrupting effects.

Like Grosz, Dix made his major contribution to Neue Sachlichkeit as a portraitist. Exemplary of his work in this genre, *The Journalist Sylvie von Harden* (1926, Figure 7.9) depicts a sitter whom Dix met in a Berlin café and insisted on portraying. Von Harden, who considered herself unattractive, asked Dix why he wanted to paint someone whose "dull eyes . . . long nose, thin mouth, long hands, short legs, and large feet would scare everybody off."[32] Dix responded that those were exactly the attributes that made her representative of their epoch. He likely saw von Harden as the embodiment of the Weimar-era Neue Frau (New Woman). Stereotypically, the Neue Frau was gainfully employed, sexually independent, and free to engage in masculine activities, like wearing a monocle and smoking in public, both of which von Harden does in Dix's portrait. Dix gives her an androgynous and mildly caricatured appearance. She has bobbed black hair and an elongated white face with darkly rouged lips parted to show buckteeth. Dix conceals her ungainly body behind exaggeratedly large hands and beneath a loose-fitting red and black checkered dress. He renders the background in various shades of red that play off against the white and blue-veined marble table. The table displays the accouterments of the liberated Neue Frau drinking and smoking alone in a café.

Appointed professor at the Dresden Academy in 1927, Dix lost his position in 1933 when Hitler came to power. His works, which the Nazis found morally offensive, were confiscated from German museums and included in the *Degenerate*

FIGURE 7.9 Otto Dix, *The Journalist Sylvie von Harden*, 1926. Oil and tempera on wood, 120 x 80 cm. Musée National d'Art Moderne, Centre Georges Pompidou, Paris.

Art exhibition of 1937. Dix remained in Germany but turned to painting landscapes and biblical themes in order to avoid censorship by the Nazis.

August Sander (1876–1964)

The most important photographer associated with Neue Sachlichkeit was August Sander, who established a portrait studio in a Cologne suburb in 1910. In the 1920s, Sander conceived of a grand project, *Menschen des 20. Jahrhunderts* (People of the Twentieth Century), intended to create a comprehensive portrait of German society. Employing a social scientist's systematic method, Sander made photographs of individuals from all different divisions of society, posed either against a neutral studio backdrop or in their daily environments. He did not record his subjects' names but presented them as typical representatives of their station in life. He planned to divide the portraits, totaling over five hundred, into seven sections that manifested his hierarchical and cyclical model of society. The first section was devoted to farmers, posited as the foundation of society, followed by skilled tradesmen, women,

professionals, artists, city dwellers, and "the last people"—the old, the sick, and the dying.

In his quasi-scientific quest to create sharp, detailed images of his sitters, Sander used an old-fashioned large-format tripod-mounted camera with glass plate negatives requiring an exposure time of several seconds. He believed that through "pure photography" he could "make portraits that show their subjects absolutely truthfully and in their whole psychology."[33] His riveting portrait of a *Pastry Cook* (1928, Figure 7.10) depicts its stocky male subject as an alert and dignified worker who gazes confidently at the camera with pride in his occupation. Sander cleverly composes the image so that the curves of the cook's bald head and arms are complemented by those of the round metal bowl he grasps. *Pastry*

FIGURE 7.10 August Sander, *Pastry Cook*, 1928. Gelatin silver print, 25.8 x 18.7 cm. The Museum of Modern Art, New York.

Cook was among the sixty images from the cycle published in *Antlitz der Zeit* (*Face of the Time*, 1929). The Nazis confiscated the book in 1936 because it represented social diversity rather than glorifying the Aryan master race of their ideology. Sander continued working on *Menschen des 20. Jahrhunderts* until his death; his son Gunther saw it through to posthumous publication in 1980.

Max Beckmann (1884–1950)

Although his paintings were included in the 1925 Neue Sachlichkeit exhibition, Max Beckmann's intensely personal and emotionally charged work is closer in spirit to Expressionism. He received academic training in Weimar (1900–3) and traveled to Paris and Florence before settling in Berlin in 1907. Informed by the old masters, nineteenth-century French **Romantic** painting, and German **Impressionism,** his prewar work was more conservative than that of the Brücke and Blaue Reiter artists. His huge painting dramatizing a subject from the headlines, *Sinking of the Titanic* (1912), synthesized influences from Michelangelo, Géricault, and Delacroix.

Beckmann served as a medical orderly in World War I and was discharged after suffering a mental breakdown. His wartime experience precipitated a profound change in his art. Now responding to the late Gothic art of German painters such as Matthias Grünewald and Lucas Cranach the Elder, Beckmann painted thin, angular figures pressed into cramped, airless spaces in a somber **palette**. His first major postwar painting, *Night* (1918–19), shows a gang of assassins brutally tormenting a hanged man and a partially nude bound woman in an attic space marked as contemporary by the figures' clothing and presence of a gramophone. Beckmann's painting reflects the violence of the period, which saw bloody riots and the murders of prominent public figures, including the leftist leaders Karl Liebknecht and Rosa Luxemburg in January 1919 following the failed Spartacist uprising. At the same time, the picture serves as a symbolic expression of the terrible persistence of cruelty, sadism, and murder throughout human history. Indeed, it seems to predict their horrific crescendo in the Nazi period.

Beckmann's art grew less morbid during the 1920s as the German economy and society became more stable. He painted portraits, **still lifes**, cityscapes, and scenes of urban leisure and entertainment. His work's mood was never cheerful, however, but always sober, even when he represented subjects of recreation. He used simply defined, heavy forms and a palette dominated by deep blacks and cold whites plus a few bold colors. Beckmann frequently rendered his own likeness, producing more than eighty self-portraits. In the striking *Self-Portrait in a Tuxedo* (1927), the artist presents himself as a cosmopolitan gentleman gazing sternly out at the viewer with his right arm

akimbo and a cigarette dangling casually from his left hand. Beckmann's prosperous appearance reflects his status as one of the Weimar Republic's most highly honored artists. When the Nazis came to power in 1933, however, Beckmann was declared "degenerate" and stripped of his teaching position at the Frankfurt Academy. In 1937, he left with his wife for Amsterdam, where they remained under difficult conditions during the wartime German occupation of the Netherlands. In 1947, Beckmann accepted a teaching position at Washington University in Saint Louis. He spent his last three years in the United States.

Beckmann's most celebrated works are the nine large-scale **triptychs** he painted during the last two decades of his life. The triptych format derives from medieval and Renaissance Christian altarpieces in which the central panel depicts the principal scene and figures, while two flanking wings of smaller dimensions show subordinate figures and events. Beckmann used the triptych format to invest his secular **subject matter** with the kind of spiritual and philosophical significance traditionally found in religious painting. Unlike Christian painters, however, Beckmann did not use **iconography** or symbolism with fixed meaning. Instead, he used allusive imagery that invites the viewer's personal interpretation—a key feature of much **modernist** art.

Beckmann started his first and best-known triptych, *Departure* (Figure 7.11), in Frankfurt in 1932 and finished it the next year in Berlin. The nightmarish side wings depict enigmatic figures and objects, along with bound and trussed people undergoing torture, all crowded into dark, shallow spaces. The central panel, by contrast, shows figures in a boat on calm blue water beneath clear blue sky: a king has an open fishing net, a mother holds a child, and a masked personage grasps a large fish. Beckmann reportedly told a friend, "the King and Queen have . . . freed themselves of the tortures of life—they have overcome them. The Queen carries the greatest treasure—Freedom—as her child in her lap. Freedom is the one thing that matters—it is the departure, the new start."[34] While it is tempting to read the triptych's wings as symbolizing Nazism's horrors and the central image as declaring Beckmann's decision to leave Germany in search of freedom, the artist did not intend such a literal biographical interpretation. He told his dealer in 1937 that the painting carried no particular meaning and "could well be applied to all times."[35]

FIGURE 7.11 Max Beckmann, *Departure*, 1932–33. Oil on canvas, three panels, side panels: 215.3 x 99.7 cm, center panel: 215.3 x 115.2 cm. The Museum of Modern Art, New York.

Surrealism

A revolutionary intellectual and artistic movement, Surrealism sought to unleash the creative energies of the unconscious mind. It grew out of the earlier Dada movement (see Chapter 7) but replaced Dada anarchism and negativity with an agenda for renewing art, society, culture, and politics. Like the Dadaists, the Surrealists reacted against the traditional European values of "reason" that had produced World War I's horrific devastation. They instead celebrated the irrational, ultimately seeking, in the words of Surrealism's founder and leader André Breton, a "resolution of . . . dream and reality, which are seemingly so contradictory, into a kind of absolute reality, a *surreality*."[1]

Initially a literary movement, Surrealism derived its name from the subtitle of Guillaume Apollinaire's farcical 1917 play *Les Mamelles de Tirésias (The Breasts of Tiresias)*, a *Drame surréaliste (Surrealist Drama)*. The term was adopted by the French poets Breton, Philippe Soupault, and Louis Aragon. A student of psychiatry, Breton was initially influenced by the work of the French psychologists Jean Charcot and Pierre Janet and subsequently by Sigmund Freud's psychoanalytic theories (see "Psychoanalysis" box) to view dreams and techniques such as automatic writing and free association as avenues of access to the unconscious. Yet Breton and the Surrealists explored the unconscious not to cure mental illness but to create art that would possess the quality of the *merveilleux* (marvelous) that causes wonder or astonishment. The Surrealists believed that the marvelous occurred naturally in areas free of reason's constraints: in childhood, madness, insomnia, and drug-induced hallucinations; in "primitive" societies, whose people supposedly lived more instinctively than "civilized" Europeans; and in dreams, the effects of which Surrealist artists attempted to reproduce both verbally and visually.[2]

Breton and Soupault published the first work of Surrealist literature, *Les Champs magnétiques (The Magnetic Fields)*, in 1920, consisting of poems produced through automatic writing, or automatism. Breton went on define Surrealism as follows in the movement's 1924 manifesto:

> **SURREALISM, n. Psychic automatism in its pure state, by which one proposes to express—verbally, by means of the written word, or in any other manner—the actual functioning of thought. Dictated by thought, in the absence of any control exercised by reason, exempt from any aesthetic or moral concern. . . .**
>
> **ENCYCLOPEDIA.** *Philosophy.* **Surrealism is based on the belief in the superior reality of certain forms of previously neglected associations, in the omnipotence of dream, in the disinterested play of thought. It tends to ruin once and for all all other psychic mechanisms and to substitute itself for them in solving all the principal problems of life.[3]**

At the end of 1924 Breton and his colleagues launched a new periodical, *La Révolution surréaliste* (The Surrealist Revolution), which became the movement's official organ until it was succeeded in 1930 by *Le Surréalisme au service de la révolution* (Surrealism in the Service of the Revolution),

whose title alluded to Breton's support for the communist revolution. Breton was among several Surrealists to join the French Communist Party in 1927, but he was expelled in 1935 due to his rejection of Stalinism—Soviet leader Joseph Stalin's totalitarian version of communism, to which the French Party adhered. Breton then gravitated to the socialism of Stalin's rival Leon Trotsky.

Throughout his leadership of Surrealism, Breton both welcomed new artists into the movement and expelled those who failed to follow his principles. Some artists and writers who fell out with him joined his intellectual opponent Georges Bataille, a dissident Surrealist who emphasized what he called "base materialism"—treating all phenomena, including art, as equal in their physicality—on the same level as substances like dust and saliva. Bataille's concept of the *l'informe*, or the formless, influenced avant-garde thinkers and artists of later generations.

Surrealist Visual Art

Although Breton's manifesto emphasized literary expression, he recognized several painters as Surrealists, from the fifteenth-century Italian Paolo Uccello to Gustave Moreau, Pablo Picasso, Paul Klee, Marcel Duchamp, Francis Picabia, Giorgio de Chirico, Max Ernst, Man Ray, and André Masson.[4] Only the last three formally joined the movement, though Duchamp collaborated with the Surrealists and much of Picasso's work of the interwar decades has affinities with **Surrealism** (see Chapter 9). The first exhibition of Surrealist painting, held in Paris in 1925, featured works by Jean Arp, Ernst, de Chirico, Klee, Joan Miró, Man Ray, Masson, Picasso, and Pierre Roy. Other artists Breton welcomed into Surrealism before 1930 were Yves Tanguy, René Magritte, and Salvador Dalí.

Surrealist painting falls into two broad stylistic tendencies—**abstract** and **illusionistic** (discussed below). Surrealism also found visual expression in photography, film, and sculpture. The most characteristic Surrealist technique in sculpture was the **assemblage** of **readymade** or **found objects** into unexpected and provocative combinations, such as Meret Oppenheim's famous fur-lined teacup and saucer, *Object*. Following its establishment in Paris, Surrealism spread quickly to Belgium and then other European countries, including Czechoslovakia and Britain. By the late 1930s, it was also influential in Japan, Egypt, and the Americas (see Chapters 10 and 11). The presence of Breton and several other Surrealists in New York during World War II stimulated the development of **Abstract Expressionism** in the United States, with the Surrealist technique of **automatism** forming the basis of Jackson Pollock's famous drip paintings (see Chapter 12).

Early Twentieth-Century Precursors of Surrealism: Henri Rousseau (1844–1910), Marc Chagall (1887–1985), and Giorgio de Chirico (1888–1978)

Three artists active before World War I whom the Surrealists admired for their exploration of the realms of fantasy and the irrational were the painters Henri Rousseau, Marc Chagall, and Giorgio de Chirico. The self-taught Parisian Rousseau, nicknamed "Le Douanier" (the customs agent) because he had worked as a toll collector, exhibited regularly at the Salon des Indépendants from 1886 onward. Rousseau strove to paint like the **academic** artists he revered, but he failed to achieve their polished illusionism due to his lack of formal training. He instead created a strange sense of unreality in brightly colored pictures with stiff figures, flattened space, and precise linear detail—**formal** characteristics typical of **naïve art**. **Modernists** including Picasso, Delaunay, Léger, and Kandinsky valued Rousseau's art for its "primitive" quality similar to that of the art of children, **folk artists,** and African and other non-Western cultures (see "Primitivism" box, Chapter 2). The modernists saw Rousseau's vision as uncorrupted by academic conventions of illusionism—the very ones he sought to emulate.

Rousseau's lush jungle pictures, his best known, grew out of his imagination nourished by a wide variety of visual sources and visits to the botanical garden and zoo. His most ambitious jungle painting, *The Dream* (1910, Figure 8.1), is a fantasy **composition** showing a nude light-skinned woman reclining on a red velvet couch in the midst of a dense jungle teeming with exotic plants and animals. **Stylized** lotus flowers stretch above her head. Two birds with colorful plumage and a trio of small brown monkeys perch in the trees. An elephant and two lions peer out through the foliage while a rosy-colored snake slithers away at the lower right. Behind the lions stands a dark-skinned musician, described by Rousseau as an "enchanter."[5] In a short poem, the artist explains that the painting reveals the woman's dream experiences. The picture's strange juxtaposition of domestic and wild motifs—the nude woman on a couch with the jungle flora and fauna—creates a surreal quality heightened by the vivid intensity of Rousseau's naïve **style.**

Marc Chagall was a more sophisticated painter whose images were filled with a joyful and childlike sense of fantasy. Chagall grew up in a large and devout Jewish family in Vitebsk, Belarus, and studied art in Saint Petersburg before

FIGURE 8.1 Henri Rousseau, *The Dream*, 1910. Oil on canvas, 204.5 x 298.5 cm. The Museum of Modern Art, New York.

moving in 1910 to Paris where he absorbed influences from **Fauvism**, **Cubism** and **Orphism**. Chagall's succeeding works featured imaginative subjects drawn from his childhood memories. They often include fanciful images such as upside-down figures and visually surprising jumps in scale. In *I and the Village* (1911, Figure 8.2) Chagall uses Cubist and Orphist visual devices, like fractured space and interpenetrating planes of transparent prismatic color, to render an enchanting image. Against the backdrop of a toy-like village rooted in the artist's recollection of Vitebsk, the profiled heads of a male Russian peasant and a cow gaze at each other affectionately. Irrational elements abound: the peasant has a green face and white lips; the cow's cheek harbors a diminutive milking scene; and in the distance, a woman and two houses float upside down.

Chagall returned to Russia in 1914 and was appointed Commissar for Arts in Vitebsk after the 1971 Russian Revolution. His continued commitment to the irrational and the poetic, however, proved incompatible with increasing demands in Russia for art to serve Communism (see Chapter 6). He left for Berlin in 1922 and settled in Paris the next year.

The Surrealists invited Chagall to join them, but he declined, wishing to create without concern for their doctrine of psychic automatism.

Highly consequential to Surrealism's development were the mysterious, melancholy paintings of Giorgio de Chirico, whose stated aim was "to imagine everything in the world as enigma. . . . To live in the world as in an immense museum of strange things."[6] The Greek-born Italian de Chirico studied art in Munich between 1906 and 1910, where he immersed himself in Friedrich Nietzsche's philosophy as he shared what Nietzsche called a "foreboding that underneath this reality in which we live and have our being, another and altogether different reality lies concealed."[7] After moving to Paris in 1911, de Chirico evoked that hidden reality through simply rendered but psychologically complex paintings of deserted city squares, steeped in his memories of Italian piazzas. Exemplary of these works, *The Soothsayer's Recompense* (1913, Figure 8.3) depicts a classical statue resting in a silent city square filled with long shadows that create a subtle sense of apprehension. The statue represents Ariadne, a mythological Greek princess

FIGURE 8.2 Marc Chagall, *I and the Village*, 1911. Oil on canvas, 192.1 x 151.4 cm. The Museum of Modern Art, New York.

whose lover Theseus abandoned her on the island of Naxos while she slept. The statue held personal meaning for de Chirico, who felt lonely and isolated in Paris. Rising like a stage flat behind the statue is the shadowy **arcaded façade** of a railway station. A brick wall extends to the right in front of a puffing steam locomotive. This motif was also personally significant to de Chirico: his father was a railroad engineer who died when the artist was sixteen.

Many of de Chirico's paintings of the early 1910s depict brightly lit **still-life** objects with no apparent logical relationship, displayed in the **foreground** of an urban setting. A well-known example, *The Song of Love* (1914), shows a red rubber glove hanging on a wall next to a plaster cast of the Apollo Belvedere's head and a green ball resting below. The meeting of these unrelated objects creates a strange, dreamlike effect. Such works inspired Surrealist artists including Ernst, Dalí, and Magritte to depict more blatantly irrational juxtapositions in their paintings.

Recalled to Italy in 1915 to serve in the army and discharged the next year, de Chirico in 1917 met the **Futurist** Carlo Carrà with whom he formed the short-lived Scuola Metafisica, or Metaphysical School. De Chirico used the term "metaphysical," which described all his work from 1911 to 1919, to refer to a mysterious reality hidden beneath the surface of everyday appearances. In the 1920s, de Chirico turned to a more traditional form of figurative painting inspired by **classical** statuary

FIGURE 8.3 Giorgio de Chirico, *The Soothsayer's Recompense*, 1913. Oil on canvas, 135.6 x 180 cm. Philadelphia Museum of Art.

and the Italian **Old Masters**, greatly disappointing the Surrealists who so highly valued his metaphysical works.

Abstract Surrealist Painting

Unlike the precisely rendered representational motifs seen in de Chirico's painting, abstract Surrealism (also known as organic or **biomorphic** Surrealism) employs free-form lines, shapes, and textures. These are often generated through automatist procedures, then modified deliberately to create simplified imagery within an abstract visual environment. This tendency's principal artists were André Masson, Joan Miró, Max Ernst (who also made illusionistic Surrealist pictures), and Matta. Also associated with Abstract Surrealism are Wifredo Lam's Cubist-influenced figurative paintings (see Chapter 10).

André Masson (1896–1987)

After studying painting in Brussels and Paris, the French artist André Masson was gravely wounded in World War I. His wartime experience led him to ponder the nature of human destiny in his mature art, which often treats themes of violence and metamorphosis. He joined the Surrealists in 1924 and made automatic pen-and-ink drawings that Breton published in *La Révolution surréaliste*. A close visual counterpart to the Surrealist poets' automatic writing, Masson's drawings

(e.g., *Furious Suns*, 1925) feature webs of slender lines interspersed with celestial, human, animal, plant, and other recognizable motifs. The drawings suggest a delirious stream of impulses and images flowing from the unconscious mind.

In 1926, Masson's observation of drifting sand on a southern French beach inspired him to develop a new automatic process, sand painting. He used this method to create *Battle of Fishes* (1926, Figure 8.4) by placing a **gesso**-covered canvas on the floor, randomly dribbling glue onto its surface, and spilling sand onto the glue. This yielded island-like shapes of bonded sand around which Masson rapidly sketched lines in pencil, charcoal, and **oil paint**. The painting's violent imagery of sharp-toothed wounded and bleeding fish transposes into the animal realm the brutal human conflict that Masson had experienced in war.

The individualistic Masson chafed at Breton's demands for the Surrealists to act as a unified group. This led to his expulsion from the movement in 1929. He then joined Bataille's circle before reconciling with Breton in 1937. Masson's paintings and drawings of the 1930s explore subjects of erotic violence and death, often mingled with themes from Greek mythology. He spent part of the World War II years in Connecticut and exhibited regularly in New York, where his biomorphic automatist paintings (e.g., *Pasiphae*, 1942) influenced young Americans, including Arshile Gorky and Jackson Pollock (see Chapter 12).

FIGURE 8.4 André Masson, *Battle of Fishes*, 1926. Sand, gesso, oil, pencil, and charcoal on canvas, 36.2 x 73 cm. The Museum of Modern Art, New York.

Joan Miró (1893–1983)

Described by Breton as "the most 'surrealist' of us all,"[8] Joan Miró never officially joined Surrealism but was closely associated with the group during the 1920s. Trained artistically in his native Barcelona, Miró moved to Paris in 1920 but returned to his family's farm in Montroig, Spain, each summer and remained deeply attached to the Catalan landscape throughout his life. His paintings of the late 1910s and early 1920s (e.g., *Standing Nude*, 1918) feature bold colors and precisely defined, faceted **forms,** merging influences from Fauvism and Cubism.

In Paris, Miró rented a studio next to that of Masson, who introduced him to Breton. Stimulated by Surrealist ideas, Miró began drawing and painting from his imagination rather than the observation of nature. His work became increasingly abstract and filled with a playful sense of fantasy. These qualities are seen in *Harlequin's Carnival* (1924–25), which depicts a room teeming with an unruly menagerie of hybrid creatures, brightly colored and crisply delineated as flat, biomorphic shapes. In the later 1920s, Miró simplified his painting compositions, defining landscapes through broad areas of color and populating them sparsely with schematic or cartoonlike motifs. For example, *Dog Barking at the Moon* (1926) shows a dog, ladder, moon, and bird in a spare, dark nocturnal setting inspired by the artist's memories of his native Catalonia. The ladder, rising to the top of the painting from its base, is a recurrent symbol in Miró's art that evokes the dream of escape or transcendence.

In spring 1933, Miró made an impressive series of eighteen large abstract paintings based on **collages** of illustrations of machines and other objects clipped from catalogs and periodicals. The illustrations inspired hard-edged biomorphic shapes or simplified figures that Miró suspended against **backgrounds** of atmospheric color. In *Painting* (1933, Figure 8.5), a quartet of inventively abstracted figures with simply delineated human faces float at the right and upper center. They are accompanied

FIGURE 8.5　Joan Miró, *Painting*, 1933. Oil on canvas, 130.5 x 162.9 cm. Wadsworth Atheneum Museum of Art, Hartford, Connecticut.

by five allusive but nonfigurative biomorphic configurations. While the imagery appears serenely detached from current events, *Painting*'s stark, reduced **palette** and somber background may evoke the financial difficulties of the Great Depression. Miró's awareness of the Second Spanish Republic's political instability also underlies this painting: the collage on which he based it includes an image from a newspaper cartoon about the Iberian Anarchist Federation's protests against what they considered the futility of the electoral process.[9]

During the mid-1930s, Miró drew and painted monstrous, tormented creatures in response to the worsening political unrest in Spain. Following the outbreak of the Spanish Civil War (1936–39), he painted an enormous mural, *The Reaper* (1937, now lost), showing a wildly abstracted Catalan peasant revolting against the atrocities perpetrated by General Francisco Franco's anti-democratic forces. Commissioned by the Republican government of Spain then resisting Franco, Miró's mural was exhibited alongside Picasso's *Guernica* (see Figure 9.8) and Alexander Calder's *Mercury Fountain* (see Figure 10.21) in the Spanish Pavilion of the 1937 Paris International Exposition.

During the early years of World War II, Miró made a highly innovative series of twenty-four *Constellations* (1939–41). Executed in **gouache** and oil wash on paper, most of them feature complex configurations of small precisely drawn biomorphic and geometric shapes and motifs—moons and suns, stars and comets, birds and insects, women and eyes (e.g., *The Beautiful Bird Revealing the Unknown to a Pair of Lovers*, 1941). Linked by thin black lines, these elements spread over the surface in an allover manner. These lively and intricate compositions drew inspiration from the music of Bach and Mozart, reflections on water, the migration of birds and butterflies, and the night sky's sparkling constellations to express Miró's "deep desire to escape" from the war's trauma.[10] Shown in 1945 at New York's Pierre Matisse Gallery, the *Constellations* were enthusiastically received by young American **avant-garde** artists and likely encouraged Pollock's employment of linear allover compositions in the poured paintings he began in 1947 (see Figure 12.4).

Max Ernst (1891–1976)

After his **Dada** activities in Cologne, Max Ernst moved to Paris in 1922. In the first half of the 1920s he made oil paintings that grew out of his Dada collages and "overpaintings" of the late 1910s (see Chapter 7). These oil paintings predict illusionistic Surrealism in their realistically rendered but strangely juxtaposed images that suggest the content of a disturbing dream. In *Two Children Are Threatened by a Nightingale* (1924), Ernst combined representational painting and Dada-inspired assemblage. In the painted composition, a small bird hovers above two sketchily rendered girls dressed in white—one running and brandishing a knife, the other fallen to the ground. A wall

to the right of the girls rapidly recedes to a distant **triumphal arch**. Further to the right, a figure in male garb with a shrouded face clutches a child and balances on a roof peak while reaching toward a knob attached to the picture frame, as if seeking to escape. The knob is one of three physical objects attached to the picture, along with the house **façade** supporting the fleeing figure and a hinged red gate at the left. The combination of these toy-like real elements and the enigmatic painted imagery suggests the Surrealist quest, articulated by Breton in his manifesto, for the "resolution of . . . dream and reality."

Writing in the third person, Ernst connected *Two Children Are Threatened by a Nightingale* to a childhood hallucination he experienced while suffering from the measles: "a fever-vision provoked by an imitation-mahogany panel opposite his bed, the grooves of the wood taking successively the aspect of an eye, a nose, a bird's head, a *menacing nightingale*, a spinning top and so on."[11] Later in life, Ernst sought to provoke similar hallucinations by staring at wood paneling, clouds, wallpaper, and rough walls—recalling Leonardo da Vinci's advice to gaze at stained walls and streaked stones to discover visual ideas for painting subjects and compositions.

In 1925, after joining the Surrealist movement, Ernst similarly stimulated his imagination through the technique of frottage (French for "rubbing"). He created his frottages by placing paper over various textured surfaces such as floorboards, leaves, and bark and rubbing pencil over the top of the paper. Because he did not consciously control the textures that appeared on the paper's surface, the technique was similar to automatic writing or drawing, which Breton advocated as a means of accessing the unconscious. However, Ernst consciously reworked the surfaces of his frottages by adding paint or more drawing to delineate strange images of birds, insects, plants, and other natural motifs. He gathered these drawings into a portfolio entitled *Histoire Naturelle* (*Natural History*).

Beginning in late 1926, Ernst adapted the frottage technique to oil painting through a method he called grattage (French for "scraping"). This involved covering a canvas with layers of oil paint, laying it over various surfaces and objects such as wood, string, and wire mesh, and scraping the paint away to reveal unexpected lines and patterns. As with his frottages, Ernst then reworked the painting's surface to form imagery and a coherent composition. Many of his grattage paintings (e.g., *The Forest*, 1927–28) depict dark, ruined forests: tree trunks packed together and rising like a wall, often harboring outlined images of spectral birds or other creatures. Such imagery is rooted in Ernst's childhood memories of visiting a forest near his home in the Rhineland, which he experienced with a mixture of enchantment and terror, recalling "the wonderful joy of breathing freely in an open space, yet at the same time the distress of being hemmed in on all sides by hostile trees."[12] In *The Horde* (1927, Figure 8.6), those hostile trees seem to have spawned a

FIGURE 8.6 Max Ernst, *The Horde*, 1927. Oil on canvas, 127.5 x 158.5 cm. Stedelijk Museum, Amsterdam.

nightmarish band of marauding monsters with wood-textured bodies who advance aggressively against an unseen opponent, evoking the violence of the previous decade's world war.

In the late 1930s, Ernst and other Surrealists adopted the automatic technique of decalcomania, in which a sheet of paper or glass is placed on a painted surface and then pulled away, producing unexpected patterns and textures. As with his grattage paintings, Ernst then used a brush to delineate recognizable images amidst the blot-like areas. An impressive use of decalcomania is seen in his large painting *Europe After the Rain II* (1940–42). Completed during his exile in New York, where he had fled to escape Nazi-occupied France, it shows a desolate and deformed landscape presided over by a bird-headed soldier—Ernst's requiem for the continent then being ravaged by World War II.

Matta (1911–2002)

Educated as an architect in his native Santiago, Chile, Matta (b. Roberto Matta Echaurren) traveled to Paris in 1935 and worked for two years in Le Corbusier's architectural office (see Chapter 17). In 1937, Matta met Dalí and Breton and exhibited his drawings in a Surrealist exhibition. The next year he began making oil paintings he called "psychological morphologies" or "inscapes" (e.g., *Psychological Morphology*, 1938), which he defined as "visual equivalences for various states of consciousness."[13] Executed through automatist techniques including the use of rags to spread spilled paint rapidly, these color-rich, nonobjective paintings feature organic forms that seem to mutate and melt within deep, liquid spaces, embodying a state of constant transformation. In 1939, to escape the war in Europe, Matta relocated to New York where he became a crucial link between the older Surrealists temporarily exiled there and the younger Americans.

Illusionistic Surrealist Painting

In contrast to abstract Surrealism, illusionistic Surrealism presents precisely rendered dreamlike imagery, following the precedent of de Chirico. Illusionistic Surrealists include Leonora Carrington, Salvador Dalí, Paul Delvaux, Max Ernst (in some of his works), Leonor Fini, Frida Kahlo (see Chapter 10), René Magritte, Kay Sage, Yves Tanguy, Dorothea Tanning, and Remedios Varo.

Yves Tanguy (1900–1955)

The Paris-born Yves Tanguy took up painting in 1923 after seeing a de Chirico picture in a gallery window. He joined the Surrealists in 1925 and soon developed his personal form of automatism, seen in paintings such as *The Sun in its Jewel Case* (1937). He laid down subtly gradated colors to evoke eerily still, infinitely receding terrains suggesting the barren ocean

floor or desert plains beneath vaporous skies. He populated these dreamlike vistas with strange forms variously resembling organic, geological, mechanical, and architectural structures. These forms arose spontaneously during the process of painting, but Tanguy rendered them with academic precision, heightening their illusionism through long cast shadows recalling those of de Chirico. Breton, who greatly admired Tanguy's work, wrote that his enigmatic forms "still await interpretation" and are "the words of a language which we cannot yet hear."[14]

Salvador Dalí (1904–1989)

The name Salvador Dalí is virtually synonymous with Surrealism thanks to his hallucinatory paintings of disturbing fantasies expressing his personal obsessions with such provocative subjects as voyeurism, masturbation, impotence, castration, putrefaction, and coprophilia. A native of Spain's Catalan region, Dalí received academic art training in Madrid and Barcelona. He experimented with various styles before committing, in 1929, to a precise, detailed style of illusionism inspired by the nineteenth-century French academic painter Ernest Meissonier. This deliberately anti-modernist aesthetic choice distinguished Dalí from his avant-garde contemporaries and was crucial to his compositions' dreamlike intensity. He described them as a product of "instantaneous color photography done by hand of . . . images of concrete irrationality"[15]—as if he were replicating color photographs of his dreams through painting.

Dalí was drawn to Surrealism in the late 1920s by de Chirico's and Tanguy's paintings and by Freud's writings on dreams and the unconscious, which helped Dalí understand his conflicts with his father and erotic obsessions that had tormented him since childhood. In 1929, Dalí collaborated with Spanish director Luis Buñuel to make the film *Un Chien andalou* (*An Andalusian Dog*), which strings together an illogical flow of disorienting images in the manner of Freudian free association. The film captured the attention of Breton, who welcomed the Spanish painter into the Surrealist movement.

Dalí's main theoretical contribution to Surrealism was the "paranoiac-critical method" he articulated in a 1930 essay. "I believe the moment is drawing near," wrote Dalí, "when, by a thought process of a paranoiac and active character, it would be possible (simultaneously with automatism and other passive states) to systematize confusion and thereby contribute to a total discrediting of the world of reality."[16] He understood paranoia—a mental illness characterized by delusions of persecution or grandeur—as a systematic misreading of the world in which everything is seen as potentially something else. Applying his paranoiac-critical method, Dalí made free associations in his drawings and paintings, resulting in unexpected transformations and distortions of figures and objects. He also produced double images, in which a grouping of drawn or painted forms resembles two different entities simultaneously. Following Freud's understanding of dreams as expressions of unconscious desire, in which one object may stand for another, Dalí revealed hidden meanings underlying the everyday reality he sought to discredit, while retaining conscious control of his delusions. "The only difference between me and a madman," said Dalí, "is that I am not mad."[17]

The most famous product of Dalí's paranoiac-critical method are the limp pocket watches depicted in his 1931 painting *The Persistence of Memory* (Figure 8.7). The artist said that the idea of the drooping watches came to him as he contemplated a plate of melting Camembert cheese one evening after dinner.[18] He inserted them into a painting of a deserted landscape on the Catalan coast with distant cliffs bathed in golden light. He shows one watch draped over the branch of a leafless olive tree, another over the edge of a blocky architectural form supporting the tree, and a third over an amorphous sleeping creature with long eyelashes (recognizable from earlier works as Dalí's self-portrait) from whose nostril emerges a tongue. Dalí explored his fascination with hard objects rendered soft in numerous works; in *The Persistence of Memory*, the flaccid watches may connote male sexual impotence, a condition he confessed to have experienced. A fourth timepiece, resting face down on the block, swarms with ants—Dalí's symbol of death and decay, here illogically associated with a hard, metallic object.

This bizarre gathering of surprisingly juxtaposed and mutated objects exemplifies Dalí's paranoiac-critical quest to discredit conventional notions of reality. Here, Dalí claimed even to have proposed a new understanding of space and time paralleling Albert Einstein's theory of relativity, referring to his melting watches as "the soft, extravagant, and solitary paranoiac-critical Camembert of space and time."[19] The limp watches, all stopped at different times, may symbolize the relativity of space and time and the sense of unstructured, nonlinear temporality one experiences in the dream state.

Dalí's increasingly naked pursuit of fame and fortune, combined with his refusal to denounce fascism, led to his 1939 expulsion from the Surrealist movement by Breton, who dubbed the painter "Avida Dollars"—a derisive anagram of his name that roughly means "greedy for dollars." Dalí and his wife, Gala, spent the World War II years in the United States, where he engaged in flamboyant self-promotion while painting society portraits and designing theatrical sets and store window displays. After returning to Spain in 1948, he declared his allegiance both to Franco and the Roman Catholic Church. Many of his later paintings depict Christian religious subjects rendered in the style of the Old Masters but transformed through his Surrealist imagination (e.g., *The Sacrament of the Last Supper*, 1955).

FIGURE 8.7 Salvador Dalí, *The Persistence of Memory*, 1931. Oil on canvas, 24.1 x 33 cm. The Museum of Modern Art, New York.

Psychoanalysis

Psychoanalysis is both a theory of the mind's functioning and a therapeutic method of treating mental disorders. The term was coined by Sigmund Freud, an Austrian neurologist whose theories evolved over five decades of clinical practice. His fundamental belief was that many mental problems are caused by the repression of unconscious thoughts, feelings, and memories rooted in traumatic childhood experiences, often of a sexual nature. Freud sought to cure his patients by employing free association as a therapeutic technique, thus making them consciously aware of their repressed impulses. He asked patients to speak or write down everything passing through their minds, spontaneously and without censorship, to reveal elements of the unconscious. Another of his techniques was dream analysis, whose precepts he introduced in *The Interpretation of Dreams* (1900). He understood dreams as the mind's way of working through unconscious conflicts or unfulfilled wishes, which dreams disguise by translating

them into symbols. The psychoanalyst sought to decode those symbols to make the patient aware of these conflicts and desires.

In the 1920s, Freud set out a structural model of the psyche comprising three parts:

- the id, the completely unconscious reservoir of instinctual drives and impulses;
- the ego, the conscious portion of the psyche that perceives and contends with external reality; and
- the superego, the ethical component of the personality whose moral standards govern the ego.

Freud hypothesized that conflicts among these structures could produce anxiety, against which psychic defense mechanisms formed by the patient could become pathological and require therapy to resolve.

While some of Freud's followers remained faithful to his principles, others such as Carl Jung broke with him and formed their own psychological theories. Jacques Lacan reinterpreted Freud's work in terms of linguistics, arguing that the unconscious is structured like a language. In the closing decades of the twentieth century, Freudian psychoanalysis came under criticism for being unscientific and for its bias toward masculine infantile psychic development as the model for both sexes. Nevertheless, Freud's theories remain influential in Western culture and modern neuroscience confirms his contention that most mental processes operate outside of conscious awareness.

René Magritte (1898–1967)

The Belgian René Magritte rendered straightforward, realistic images of everyday figures and objects surprisingly juxtaposed, dislocated, or transformed in physically impossible ways. Academically trained in Brussels, he experimented with **Impressionism**, Futurism, and Cubism in the late 1910s and early 1920s. After a decisive encounter with a reproduction of de Chirico's *The Song of Love* (1914), Magritte abandoned abstraction to adopt "an entirely banal, academic" style of painting in which he rendered "images of the visible world united in an order that evokes mystery," or "the unknowable."[20]

Between 1927 and 1930, Magritte lived near Paris, where he participated in the activities of the French Surrealists. Unlike them, he did not seek to plumb his unconscious through automatic techniques but consciously conceived and methodically executed his jarring compositions. During these years, he established much of the **iconography** he would employ throughout his career. Frequently recurring figures are the white, bowler-hatted man in a dark suit and the white female nude, her body often fragmented or bizarrely transformed. These latter images can be criticized on feminist grounds for objectifying and manipulating the female body to stimulate male heterosexual desires and fantasies.

During these years Magritte also made several paintings, inspired by children's textbooks, depicting common objects labeled with French words that conventionally denote other objects. In the most famous example, *The Treachery of Images* (1929), a smoothly rendered image of a pipe floats above the sentence "Ceci n'est pas une pipe" (This is not a pipe) written in schoolbook cursive. Magritte's painting reminds us of the difference between a physical object and its two-dimensional representation (a picture of a pipe is not actually a pipe). It also points to the arbitrary nature of linguistic signs—a concept introduced by Ferdinand de Saussure (see "Semiotics" box, Chapter 4).

By the mid-1930s, Magritte had devised a method for conceiving his painting compositions through the discovery of "a secret affinity between certain images, which applies equally to the objects these images represent."[21] He applied this method to *Time Transfixed* (see Figure I.8), whose genesis he later recalled: "I decided to paint the image of a locomotive. . . . In order for its mystery to be evoked, another *immediately* familiar image without mystery—the image of a dining room fireplace—was joined with the image of the locomotive."[22] The locomotive motif may have attracted Magritte due to its frequent appearance in de Chirico's paintings. The "secret affinity" he recognized between a locomotive and a stovepipe generated the surprising juxtaposition of disparate realities in *Time Transfixed*—its startling impact heightened through its precise, illusionistic style.

Leonora Carrington (1917–2011)

Born in England to a wealthy family, Leonora Carrington grew up on a country estate surrounded by animals and was introduced to Celtic folklore and legends by her Irish nanny. These experiences would influence her later art and writing. Rebelling against her disapproving parents, Carrington entered the circle of the Surrealists in 1937 when she moved to France to live with (the married) Max Ernst.

Carrington's dreamlike *Self-Portrait* (c. 1937–38, Figure 8.8), begun in London and completed in Paris, has been interpreted as her declaration of independence from her restrictive upbringing in a Catholic family.[23] The artist is perched on a chair with a wild mass of brown hair, gazing sternly at the viewer. She wears a riding outfit, suggestive of her upper-class background, and pointed lace-up boots, possibly signifying her new-found sexual freedom. She gestures toward a lactating hyena while a tailless rocking horse levitates behind her. Visible through a yellow-curtained window in the background, a white horse gallops in a tree-filled landscape.

Carrington visually links her self-image to those of living animals: her white jodhpurs match the color of the galloping horse while her brown tresses mimic a horse's mane and correspond in **hue** to the hyena's fur. She thus identifies herself with the hyena, a wild creature intruding into this domestic space, and the horse, her personal symbol of freedom (perhaps inspired by the Celtic goddess Epona, often depicted mounted on a white horse). The rocking horse represents the one she bought for the apartment she shared with Ernst, and which he straddled in photographs taken for a *Life* magazine story. The erotic connotations of his riding the horse lead to its possible signification of the sexual liberation Carrington found in her relationship with him.

FIGURE 8.8 Leonora Carrington, *Self-Portrait*, c. 1937–38. Oil on canvas, 65 x 81.3 cm. The Metropolitan Museum of Art, New York.

At the outbreak of World War II, when the French interned Ernst because of his German citizenship, Carrington fled for Spain, then to New York, and finally to Mexico, where she spent the rest of her life. There, she formed close friendships with the Spanish émigré painter Remedios Varo and the Hungarian-born photographer Kati Horna, all three of whom achieved professional success in their adopted country.

Dorothea Tanning (1910–2012)

Inclined to Surrealism's inherent psychological drama by the gothic novels she read in her youth, Illinois-born Dorothea Tanning was introduced to Surrealist art at MoMA's 1936–37 exhibition *Fantastic Art, Dada, and Surrealism*. In 1939 she sailed to Paris hoping to meet the Surrealists, only to discover that most of them had already fled as World War II approached. Back in New York, the largely self-taught Tanning developed a vivid, dreamlike painting style that gained the attention of the Surrealists in exile, including Max Ernst, whom she married in 1946 after his divorce from Peggy Guggenheim.

Among Tanning's best known early works is *Eine Kleine Nachtmusik* (1943, Figure 8.9), an enigmatic depiction of what appears to be a hotel corridor with numbered doors. The farthest door is ajar providing a glimpse into a light-filled space beyond—a metaphorical threshold to another world or the unconscious. An enormous sunflower lies on the blood-red carpet at the top of the stairs. Twisting pieces of its broken stem

FIGURE 8.9 Dorothea Tanning, *Eine Kleine Nachtmusik*, 1943. Oil on canvas, 40.7 x 61 cm. Tate, London.

lead the eye to two girls in white dresses at the left. One leans against a doorframe with eyes closed, her torso exposed and a sunflower petal in her left hand. The gap between her upper forehead and hairline suggests that she may be a doll rather than a living person. The other girl faces the sunflower with a clenched right fist and her long brown hair streaming upward as if propelled by a supernatural force. The girls' disheveled clothing and the sunflower's tattered state suggests the aftermath of a struggle. Tanning, who became fascinated by the sunflowers she planted at the Sedona, Arizona ranch where she and Ernst stayed in 1943, saw the sunflower as "a symbol of all the things that youth has to face and to deal with . . . representing the never-ending battle we wage with unknown forces, the forces that were there before our civilization."[24] She also said that *Eine Kleine Nachtmusik* "depicts a confrontation between the forces of grown-up logic and the bottomless psyche of a child"[25]—another instance of the Surrealist view of the child's natural access to the marvelous.

Surrealist Sculpture

Dream imagery and biomorphic abstraction acquired tangible, three-dimensional form in Surrealist sculpture. Alberto Giacometti's spindly constructions and Jean Arp's swelling *Concretions* represent sculptural analogues, respectively, to the illusionistic and abstract tendencies of Surrealist painting.

Alberto Giacometti (1901–1966)

Alberto Giacometti made important contributions to Surrealism in the early 1930s, creating sculptures that combined formal sophistication with charged psychological content. Born into an artistic family in Switzerland, he moved to Paris in 1922 and studied sculpture under Antoine Bourdelle, Rodin's former assistant. By the mid-1920s, Giacometti had abandoned realism to experiment with abstracted styles influenced by Cubism, Brancusi (see Chapter 9), and African sculpture. His 1.4-meter-tall bronze *Spoon Woman* (1926–27) was inspired by the large ceremonial spoons made by the Dan communities of West Africa's Guinea coast. These spoons often have handles in the form of a human neck and head; their bowls symbolize the female womb. Giacometti's standing figure possesses a wide, oval-shaped, curved central section (signifying the womb), rising from a leg-pedestal and topped by geometric blocks representing waist, torso, and head. Through its heavy, totemic presence, *Spoon Woman* evokes an archaic fertility figure.

Through Masson and the ethnographer Michel Leiris, Giacometti entered Bataille's circle in 1929. Aspects of Bataille's thinking are reflected in Giacometti's sculpture of the early 1930s. For example, the linkage of sexuality and violence finds

expression in Giacometti's *Disagreeable Object* (1931), a forty-nine-centimeter-long tapering form of smooth carved wood, with a knoblike handle and spiked pointed tip, giving it the appearance of a phallic weapon. Belonging to a series that the artist retrospectively characterized as "objects without a base and of no value, to be thrown out,"[26] *Disagreeable Object* also suggests Bataille's interest in the "low" or debased.

Many of Giacometti's sculptures of the early 1930s, including *Disagreeable Object*, were intended to be manipulated, transgressing the traditional physical separation between the viewer and the art object. One such work, *Suspended Ball* (1930), consists of an open rectangular metal frame with a crossbar at the top, from which a cleft sphere dangles by a string, inviting the viewer to set it in motion. The sphere hangs just above a curved wedge suggestive of a melon slice. The potential contact between the ball and wedge arouses a sensation of unconsummated desire that fascinated Breton and the Surrealists, whom Giacometti joined in 1930 after Breton discovered and purchased the sculpture.

In 1933, Giacometti claimed, "For years I have only made the sculptures that presented themselves to my mind in a finished state, merely reproducing them in space without changing any aspect of them or wondering what they could mean." Only after completing a sculpture did he "rediscover in it—transformed and displaced—images, impressions, facts which have deeply moved me (often without my knowing it), forms which I feel are very close to me, although I am often unable to identify them, which makes them more disturbing to me."[27] Giacometti articulates a Surrealist conception of art as arising from the unconscious—in his case in the form of mental visions he realized physically as sculpture.

According to Giacometti, the imagery of *The Palace at 4 a.m.* (1932, Figure 8.10) came to him "piece by piece" at the end of the summer of 1932, finally becoming so real that it took only one day to execute.[28] Within this fragile wood construction suggesting a haunted domestic interior, we find a hanging sheet of glass, skeletons of a bird and a spinal column suspended within frames, a tongue-like scoop in which nestles a ball, and a mannequin-like female figure standing before three vertical panels. Giacometti wrote poetically of this construction:

> It no doubt refers to the stage in my life that had concluded a year earlier, a period of six months spent hour after hour with a woman who, concentrating all life in herself, made every moment something marvelous for me. We used to construct a fantastic palace in the night . . . a very fragile palace of matchsticks: at the slightest false move a whole part of the minute construction would collapse: we would always begin it again.[29]

FIGURE 8.10 Alberto Giacometti, *The Palace at 4 a.m.*, 1932. Wood, glass, wire, and string, 63.5 x 71.8 x 40 cm. The Museum of Modern Art, New York.

Giacometti described the spinal column as the one "this woman sold me on one of the first nights I met her in the street" and the bird skeleton as one she saw on their last night together—"the skeleton birds fluttering away above the reservoir of clear green water in which the very delicate and very white skeletons of fishes were swimming, in the grand open-air hall amid the exclamations of astonishment at four o'clock in the morning."[30] He associated the statue of the woman with his mother in a long black dress that confused and frightened him as a child because it seemed to be a part of her body. He identified himself with the concave object at the composition's center, beneath a tower he described as either unfinished or broken. Possessing an insubstantial quality appropriate to its dreamlike character, Giacometti's spindly construction suggests a stage set for a melancholy drama infused with metaphors of mortality. In formal terms, its open, cage-like construction is radically innovative in denying the traditional sculptural principles of **mass** and **volume**, here replaced by linear elements forming a sort of drawing in space.

In 1934, Giacometti resumed making life studies from models rather than working only from his imagination, which led Breton to expel him from the Surrealist group early the next year. Giacometti remained committed to working from the live model for the rest of his life. After World War II he achieved his signature style in the attenuated, craggy-surfaced figures that brought him international recognition (see Figure 13.10).

Jean Arp (1886–1966)

The German-born sculptor Jean Arp moved to the Paris area in 1927 with his wife and fellow artist, Sophie Taeuber-Arp (see Chapter 7), after they obtained French citizenship. He was active in the Surrealist movement during its early years, using a biomorphic form language that alluded to nature without literally imitating it. He first developed this biomorphism in the automatic drawings and reliefs he made in Zurich as a participant in the Dada movement (see Figure 7.1). He continued to create biomorphic reliefs in the 1920s before turning

in 1930 to sculpture in the round. Arp made these sculptures by cutting and sanding a mass of hard plaster in an automatic fashion until he was satisfied with the overall form; he later had some cast in bronze or carved in stone. Arp described them as "concrete" rather than "abstract" to emphasize that they did not copy nature but emerged independently. "Concretion signifies the natural process of condensation, hardening, coagulating, thickening, growing together," he wrote. "Concretion designates solidification, the mass of the stone, the plant, the animal, the man. Concretion is something that has grown."[31]

Between 1933 and 1936 Arp made a series he called *Human Concretions*, including *Human Concretion on Bowl* (1933, Figure 8.11). He intended them to express a renewed unity between humanity and nature that he saw threatened by human greed, competitiveness, belligerence, and blind faith in technology.[32] The sculptures propose this healthy symbiosis through their swelling, curving forms that simultaneously suggest human body parts, fruits, buds, and eroded stones. The sculptures have no fixed orientation: Arp wanted them to be displayed in different positions so that they enjoy the same freedom of placement as objects in nature, such as leaves, stones, and shells. As the decade advanced, Arp's idealistic quest to reunify humanity and nature through "a basic, a sane and natural art that grows the stars of peace, love, and poetry in the head and heart,"[33] was given added urgency by the rising menace of fascism and the worsening political situation that culminated in World War II.

The Surrealist Object

Breton was fascinated with mundane objects, encountered by chance, that seemed magically to embody the unconscious desires of the person discovering them. He and other Surrealists prowled Parisian flea markets, hoping to find and acquire such objects. Dalí adapted this fascination to the creation of artworks that he designated "objects functioning symbolically." These were assemblages of found or readymade items brought into unexpected and provocative combinations like those experienced in dreams. In his *Lobster Telephone* (1938), a realistic plastic lobster rests atop a telephone's handset. Dalí associated both objects with sex—in this assemblage, the crustacean's tail, where its sexual organs are located, is situated directly over the mouthpiece.

Meret Oppenheim (1913–1985)

The most famous Surrealist object is Meret Oppenheim's *Object* (1936, Figure 8.12): a cup, spoon, and saucer surprisingly covered with animal fur. The German-born, Swiss-raised Oppenheim moved to Paris in 1932 and joined the Surrealist circle, modeling for the photographer Man Ray, having a

FIGURE 8.11 Jean Arp, *Human Concretion on Bowl*, 1933. French limestone, 56 x 81 x 54.5 cm. Kunsthaus Zurich, Switzerland.

FIGURE 8.12 Meret Oppenheim, *Object*, 1936. Fur-covered cup, saucer, and spoon, Cup 10.9 cm in diameter; saucer 23.7 cm in diameter; spoon 20.2 cm long, overall height 7.3 cm. The Museum of Modern Art, New York.

year-long affair with Ernst, and participating in Surrealist exhibitions. The inspiration for her iconic *Object* came from a 1936 café conversation with her friends Dora Maar and Pablo Picasso. Oppenheim was wearing a bracelet she had designed, a metal tube wrapped on the outside with fur. When Picasso quipped that anything could be covered with fur, she replied: "Even this cup and saucer."[34] She remembered this conversation when Breton invited her to contribute to that year's exhibition of Surrealist objects at the Galerie Charles Ratton. She promptly purchased a cup, saucer, and spoon at a department store and coated them with speckled brown fur.[35]

Breton named Oppenheim's work *Le Déjeuner en fourrure* (*The Luncheon in Fur*), linking it to Manet's *Le Déjeuner sur l'herbe* (*The Luncheon on the Grass*) (see Figure 1.13) and to Leopold Sacher-Masoch's novella *Venus in Furs* (1870), whose male protagonist's sexual enjoyment of pain gave rise to the term "masochism." While Breton's title implies meanings perhaps unintended by Oppenheim, her work certainly generates sexual analogies characteristic of Surrealist art. Freudian dream analysis interprets fur as symbolic of pubic hair, cups as vaginal, and spoons as phallic. Oppenheim's object can arouse pleasurable associations with coitus and cunnilingus, but also with the repellent experience of having hair in one's mouth.

Object caused a sensation at its Paris debut and later that year in New York at MoMA's landmark exhibition *Fantastic Art, Dada, Surrealism*. The publicity overwhelmed Oppenheim, who distanced herself from the Surrealists, returned to Switzerland, and sank into a depression that inhibited her creativity for almost twenty years. She began working again in the 1950s and in the 1970s was rediscovered by feminist scholars seeking to inscribe women artists' accomplishments into the history of art.

Surrealism and Photography

Due to its ability both to record and transform reality (through techniques such as multiple exposure, **combination printing, solarization,** and montage), photography contributed greatly to the Surrealist quest to resolve the seemingly contradictory states of dream and reality. Photographers made surreal images by photographing real-world subjects either in isolation or in unexpected combinations that evoke dreams or the uncanny—a Freudian term for something that is at once familiar and unfamiliar, hence disquieting. They also created surreal effects through a variety of darkroom procedures, engendering strange transformations and producing bizarre juxtapositions similar to those in the paintings of Dalí, Magritte, Carrington, and Tanning. The Surrealists also discovered uncanny dimensions in "found" photographs ranging from amateur to anthropological, medical, and police photographs that they detached from their original contexts and published in their journals as manifestations of the Surrealist "marvelous."

Eugène Atget (1857–1927)

Among the photographers embraced by the Surrealists but who had no formal affiliation with the movement was the

Frenchman Eugène Atget, little known in the art world before Man Ray discovered his work in the early 1920s and arranged for its publication in *La Révolution surréaliste*. Self-taught in photography, Atget used a tripod-mounted box camera and glass negatives to make some 10,000 photographs. From 1898 to 1914, he specialized in photographing the streets and architecture of Old Paris—its picturesque and historic aspects threatened by "progress." He considered this work documentation rather than art and sold most of his negatives to the French government in 1920. However, his precisely focused black-and-white images often transcend their factual status to express dreamlike melancholy and nostalgia for a rapidly vanishing world, the qualities that attracted the Surrealists.

Throughout his career, Atget also photographed modern Paris. His images of shop windows, with their visual interplay of elements seen through and reflected by the glass, held a particular fascination for the Surrealists. In *Magasin, avenue des Gobelins* (1925), fashionably dressed grinning dummies and a headless mannequin—uncanny due to their strange combination of the lifelike and the inanimate—are juxtaposed with the reflections of trees and buildings, transforming an ordinary scene into a disorienting and haunting vision.

Man Ray (1890–1976)

After participating in New York Dada (see Chapter 7), Man Ray moved to Paris in 1921 and adopted photography as his principal **medium**. In 1922, he began producing **photograms**— negative images created directly through the random placement of objects on photosensitive paper—that he called rayographs (e.g., *Rayograph*, 1923, MoMA). Created in the anarchic spirit of Dada but pointing toward Surrealism, the rayographs' arbitrary arrangements of unrelated objects produced dreamlike

free-associative effects like those Breton and Soupault realized in their automatic poetry. In the late 1920s, Man Ray perfected the **Sabattier effect**, which he called solarization—the partial reversal of dark and light tones in an image, made by briefly re-exposing the photographic emulsion to light during development. For example, a silvery aura seems to emanate from the objects and human figures in his solarized photographs (e.g., *The Primacy of Matter Over Thought*, 1929), giving them a ghostly presence. Man Ray developed the technique in collaboration with his American student, model, and lover, Lee Miller, who became a successful professional photographer in her own right.

Man Ray's arresting photograph *Minotaur* (1933, Figure 8.13) uses cropping and dramatic lighting to suggest the transformation of a woman's torso into the head of a bull: the shadowy concavity beneath her sternum becomes the mouth, her breasts become the eyes, and her upraised arms become the horns. The artist's imaginative re-envisioning of a torso as a face recalls Dalí's paranoiac-critical method while the collapsing of categories—female and male, human and animal—manifests Bataille's concept of formlessness. Additionally, the model's apparent headlessness suggests the rejection of reason and descent into base materialism that accompanies a loss of form.[36]

Through its title, Man Ray's photograph references the terrifying creature from Greek mythology. The Minotaur, a hybrid monster with a man's body and a bull's head, dwelt in a labyrinth on Crete and devoured the young men and women whom the Athenians annually sent to the island as sacrifices. In the 1930s, the Minotaur became a potent Surrealist symbol, with its labyrinth home evoking the unconscious mind's recesses and the rapacious monster embodying the primitive,

FIGURE 8.13 Man Ray, *Minotaur*, 1933. Gelatin silver print, 14.9 x 23.5 cm. The Museum of Modern Art, New York.

irrational, libido-driven impulses that the conscious mind represses. The Surrealists found the destructive Minotaur an appropriate emblem for the decade that witnessed the rise of fascism, the Spanish Civil War, and the outbreak of World War II. The creature was the namesake of the Surrealist-oriented journal *Minotaure* (1933–39), named by Bataille and coedited by Breton, on the cover of which Man Ray's photograph appeared in 1935.

Raoul Ubac (1910–1985)

Under Man Ray's influence, the Belgian-born Surrealist Raoul Ubac used solarization in combination with other techniques to create his late 1930s series, *Battle of the Amazons*. With compositions that recall ancient Greek carvings of warring Amazons, the series centers on Penthesilea, the mythic queen of the Amazons, who sided with the Trojans in their war against the Greeks. Imaginatively envisioning the powerful sexual and aggressive drives that seem to emerge from the archaic unconscious, the series captivated Breton, who used several of Ubac's images to illustrate one of his poetic texts in *Minotaure*.

In one of the series' prints (1937, Figure 8.14), Ubac represented the queen and her consort by taking several photographs

of his wife, Agathe, and a friend, which he then solarized to reverse **tonal** relationships. He also made solarized close-up photographs of Agathe's hair, sticks, and other props and then fragmented, montaged, and further solarized the resulting images to produce the final composition. In it, the fragmented nude female bodies appear to merge in a disorienting state evoking both violent disintegration and erotic ecstasy.

Dora Maar (1907–1997)

Dora Maar studied art and photography in her native Paris before establishing herself professionally as a fashion and advertising photographer in the early 1930s. She joined the Surrealist circle in the mid-1930s and made **photomontages** that featured enigmatic juxtapositions typical of much Surrealist art. Her most famous Surrealist image, however, is a straight (i.e., unmanipulated) close-up photograph of a fetal armadillo entitled *Père Ubu* (1936, Figure 8.15).

The photograph's title refers to Alfred Jarry's scandalous 1896 play, *Ubu Roi (King Ubu)*, whose vulgar, slothful and malicious protagonist appealed to the Surrealists as the embodiment of the unrestrained id (see "Psychoanalysis" box).[37] "If he resembles an animal," wrote Jarry of Ubu, "he

FIGURE 8.14 Raoul Ubac, *Battle of the Amazons*, 1937. Gelatin silver print, 39.53 x 29.85 cm. Nelson-Atkins Museum of Art, Kansas City, Missouri.

FIGURE 8.15 Dora Maar, *Père Ubu*, 1936. Gelatin silver print, 64.7 x 49.5 cm. The Metropolitan Museum of Art, New York.

particularly has a porcine face, a nose similar to the crocodile's upper jaw, and the totality of his cardboard caparison makes him overall brother to the most aesthetically horrible of all marine beasts, the sea louse."[38] Maar's image presents Ubu as an ambiguous creature, simultaneously menacing and pathetic, emerging from the darkness as if from the depths of the unconscious. The photograph enthralled Breton, who hung it at the entrance to the 1936 exhibition of Surrealist objects.

That same year, Maar began a relationship with Picasso, who painted her portrait repeatedly and encouraged her to take up painting in place of photography. After her break with Picasso in 1945, she continued to paint but largely withdrew from the art world. Her contributions to Surrealism, long overshadowed by biographers' interest in her relationship with Picasso, have gained increasing recognition since her death.

Claude Cahun (1894–1954)

Active within the Surrealist movement in the 1930s, the French artist Claude Cahun posed for photographs in a variety of guises—appearing either masculine, feminine, or androgynous—to question the normal distinctions between genders. "Masculine? Feminine? It depends on the situation," she wrote. "Neuter is the only gender that always suits me."[39] Born Lucy Schwob into an affluent Jewish family in Nantes, France, the artist changed her name in 1917, adopting her great uncle's surname and a unisex French first name. In 1920s Paris, Cahun lived in an open lesbian relationship with her stepsister Suzanne Malherbe, who assumed the name Marcel Moore.

Cahun made numerous photographs, possibly in collaboration with Moore, in which she took on various identities, such as Buddhist monk, aviator, dandy, or doll. In one photograph (1927, Figure 8.16), she poses as a comedic bodybuilder.[40] Her light-colored shirt with painted-on nipples parodies the look of a bare-chested male weightlifter. The text written on her chest, "I am in training, don't kiss me," clashes teasingly with her pursed lips, which seem to invite a smooch, and the hearts rouged on her cheeks, signifiers of love. Adding to the comedic effect, the names of the popular comic strip characters Totor and Popol decorate the globes of the barbell straddling her lap. The image not only mocks the hypermasculinity associated with bodybuilding, but also satirizes hyperfemininity through her exaggerated makeup. Cahun's self-conscious play with gender signifiers seems to argue for an understanding of gender as a performance shaped by social and cultural codes and expectations rather than something naturally or biologically given. This view became influential in the late twentieth century, through its articulation by **postmodern** theorists such as Judith Butler. Cahun is considered a precursor to contemporary artists such as Cindy Sherman (see Chapter 20), who

FIGURE 8.16 Claude Cahun, *I am in training don't kiss me*, 1927. Photograph, 11.7 x 8.9 cm. Jersey Heritage, United Kingdom.

also assumed various guises before the camera to destabilize notions of fixed identity.

André Kertész (1894–1985)

Affinities with Surrealism are seen in the work of many photographers active in the interwar decades who did not formally join or exhibit with the movement. They included the Budapest-born André Kertész, who worked as a freelance magazine photographer while also participating in exhibitions of art photography in Paris in the late 1920s. In 1936, he relocated to New York and from 1946 to 1962 did magazine photography for Condé Nast before devoting himself exclusively to his own creative work.

Unlike Man Ray and Ubac, Kertész eschewed darkroom manipulation and practiced straight photography. He trained his lens on a wide range of subjects, intuitively exploring his medium's possibilities without developing a signature style. He often produced studied, formally rigorous compositions such as *Chez Mondrian* (1926), an elegant image of Piet Mondrian's vestibule with a crisply lit vase of wooden flowers on a white table next to an open door offering a view onto a spiral staircase in the hallway. At the same time, Kertész was attracted to fleeting subjects he encountered while walking and snapped quickly with his 35mm Leica—a light, easy-to-handle roll-film camera he adopted in 1928 soon after it came on the market. Among the first photographs he shot with the

Leica, *Meudon, France* (1928, Figure 8.17), features the kind of unexpected, disquieting combinations that fascinated the Surrealists: a dark-suited man in the foreground walks toward the viewer, carrying a parcel against the backdrop of a construction site with a locomotive surging across a viaduct directly above. Exemplifying Breton's concept of the "marvelous," the dreamlike quality of this frozen vision of movement is all the more intense for having been encountered in waking life.

Kertész's works most often associated with Surrealism are his *Distortions* (1933, e.g., *Distortion Number 40, Paris*), some two hundred photographs of the stretched, twisted, fragmented, and multiplied funhouse-mirror reflections of the nude bodies of one or two white female models. The series grew out of a commission from the risqué men's magazine *Le Sourire* (*The Smile*), which published twelve of them. Simultaneously erotic and grotesque, the fantastic deformations of the women's bodies bear comparison to those realized in paint by Picasso and Dalí. Yet the *Distortions* remain true to Kertész's commitment to straight photography, since these fantastic effects were generated by mirrors rather than a manipulation of the photographic process.

FIGURE 8.17 André Kertész, *Meudon, France*, 1928. Gelatin silver print, 24.8 x 17.4 cm. The J. Paul Getty Museum, Los Angeles.

Brassaï (1899–1984)

Born Gyula Halász, Brassaï took his pseudonym from the name of his hometown, Brassó, Austria-Hungary (now Brasov, Romania). After studying art in Berlin (1921–22), he moved in 1924 to Paris, initially supporting himself as a journalist and painter. In 1926, he met Kertész, who encouraged him to take up photography. Brassaï published his evocative photographs of Paris after dark—foggy, deserted streets, shadowy buildings, squares and parks under glowing streetlamps, and bridges crossing the Seine—in the book *Paris de nuit* (*Paris by Night*, 1933), which brought him international recognition. He also took revealing photographs of Paris's café and dancehall nightlife and its nocturnal underworld of prostitutes and clients (e.g., *Brothel, Rue Quincampoix, Paris*, c. 1932), gays, vagrants, and opium dens. Despite their seeming spontaneity, Brassaï did not shoot these images quickly but with a tripod-mounted large-format camera that required considerable time to set up and his subjects' cooperation in having their pictures taken. Published much later in *The Secret Paris of the 30's* (1976), this is now Brassaï's best-known body of work.[41]

Between 1933 and 1939, Brassaï contributed photographs to *Minotaure*. His subjects included the studios of Picasso, Giacometti, and other artists; female nudes abstracted through cropping; and "involuntary sculptures"—small castoff objects gleaned from the streets, published with captions likely written in collaboration with Dalí (e.g., *Involuntary Sculpture: Rudimentary [Paper] Roll Obtained from a Mentally Disabled Person*, 1932).[42] Although the Surrealists admired Brassaï's work—especially his nocturnal images—he never considered himself part of the movement: "There was a misunderstanding. People thought my photographs were 'Surrealist' because they showed a ghostly, unreal Paris, shrouded in fog and darkness. And yet the surrealism of my pictures was only reality made more eerie by my way of seeing."[43]

Henri Cartier-Bresson (1908–2004)

A Surreal quality is often seen in the early photographs of the Frenchman Henri Cartier-Bresson, who studied Cubist painting in Paris in the late 1920s before turning to photography in the early 1930s. Wielding a 35mm Leica, Cartier-Bresson was alert to ambiguous and disjunctive arrangements of elements in the real world that he spontaneously recorded on film. His quest was to capture what he called "the decisive moment"—"the simultaneous recognition, in a fraction of a second, of the significance of an event as well as of a precise organization of forms which gave that event its proper expression."[44]

Many of the "decisive moments" Cartier-Bresson photographed in the 1930s possess a surreal quality. In *Bullring, Valencia, Spain* (1933, Figure 8.18), a mustachioed attendant

FIGURE 8.18 Henri Cartier-Bresson, *Bullring, Valencia, Spain,* 1933. Gelatin silver print, 24.13 x 36.35 cm. San Francisco Museum of Modern Art.

peers into the bullring through a rectangular opening in a door. Reflected light eerily transforms his eyeglasses' right lens into a white orb. At the left, the out-of-focus body of a boy in the background is visually linked to the severe-faced attendant through a painted half circle with the numeral 7 in its center, establishing a mysterious relationship between these two people, who seem like characters in an unsettling dream. The fragmented composition, with its startling shifts in scale and focus, suggests both the aesthetic of Cubism and the discontinuities of Surrealist photomontage, but its grounding in the photographer's experience of the real world heightens its uncanny expressive intensity.

From the mid-1930s onward, Cartier-Bresson traveled around the world as a photojournalist and, in 1947, cofounded the cooperative photo agency Magnum Photos. His steadfast commitment to capturing the "decisive moment" and his purist refusal of artificial lighting and cropping were ideals shared by many modernist photographers of the 1950s to 1970s.

Art in France and England between the World Wars

Dada, German New Objectivity, and Surrealism all arose in reaction to World War I—a conflict that revealed the bankruptcy of European civilization to these movements' participants. This chapter considers other modern artists, active in France and England between the 1920s and 1940s, or the interwar years, who produced a wide range of work. Some of this art responded to the war's impact and to contemporary events, while some of it was detached from social and political concerns.

World War I was a watershed event in early twentieth-century history. The deadliest and costliest war up to that time, its far-reaching political effects included the collapse of four empires (Russian, Ottoman, Austro-Hungarian, and German), the rise to power of the Bolsheviks in Russia (1917) and of the fascists in Italy (1922), and anti-colonial revolts in the Middle East and Southeast Asia. Following the war, many countries imposed new restrictions on trade, the flow of capital, and immigration, and suspicion of foreigners grew. The Great Depression began worldwide in 1929 and enabled Adolf Hitler's rise to power in Germany, ultimately leading to World War II.

France lost 1.4 million lives during World War I and suffered economic difficulties attending its staggering wartime debt. The country's postwar rebuilding effort included reconstructing the nation's culture. This generally involved a rejection of the avant-garde experimentation of the prewar years and an embrace of more traditional artistic forms and subjects, especially those rooted in classicism, which had been central to French painting from Poussin and Claude through David and Ingres (see Figures I.9 and I.11). This tendency became known as "the call to order," a name derived from the title of a 1926 book by Jean Cocteau. Painters who had practiced highly abstracted styles before World War I returned to more naturalistic modes in the postwar years, among them the former Fauves Matisse, Derain, and Vlaminck, and the former Futurist Severini. Braque, Picasso, and Gris continued to paint in a Cubist idiom but produced more stable compositions. Picasso also painted statuesque figures in a neoclassical vein in the early 1920s. Fernand Léger and the Purist painters Charles-Édouard Jeanneret (Le Corbusier) and Amédée Ozenfant combined inspiration from classicism and modern machinery for their precise, rational, and orderly aesthetic. The sculptor Constantin Brancusi likewise achieved aesthetic purity in his reductive abstract carvings based on human and animal forms.

World War I's human cost was lower for Britain than for France, but still staggering—about 750,000 British soldiers died—and Britain suffered economically in the postwar decade through higher unemployment, lower trade, and a greatly increased national debt. The war also shattered the sense of order and security many felt during the prewar Edwardian period. Some postwar English artists, such as the sculptors Henry Moore and Barbara Hepworth, responded by drawing inspiration from earlier art forms or the English landscape to create abstracted figures embodying longed-for values of stability and regeneration. Hepworth and painter Ben Nicholson also created purified geometric abstractions that evoked utopian values of social harmony. Still others, such as painters Stanley Spencer and Paul Nash, explored the uncertainties

of the postwar era through distorted or disquieting imagery—influenced in Nash's case by Surrealism.

Many British modern artists spent time in Paris, the cosmopolitan capital of modern art between 1900 and World War II and a magnet for foreign-born artists. Between the World Wars, a loosely affiliated group of artists of non-French origin, most of them Jewish, became known as the School of Paris—a phrase coined in 1925 by the critic André Warnod. The term encompassed the painters Marc Chagall (see Chapter 8) and Chaïm Soutine (Russia), Léonard Tsuguharu Foujita (Japan), Amedeo Modigliani (Italy), and Jules Pascin (Bulgaria). All of them worked in stylized figurative modes and lived in Montparnasse, the neighborhood that succeeded Montmartre as the center of Paris's bohemian cultural life during the 1910s. The term "School of Paris" was later applied to all foreign artists who had settled in the city since 1900, and then used even more broadly to identify the whole community of modern artists working in Paris during the first four decades of the twentieth century.

Les Maudits

The School of Paris painters Amedeo Modigliani, Jules Pascin, Chaïm Soutine, and their French-born colleague Maurice Utrillo became known as *peintres maudits* (cursed painters). The term derives from the nineteenth-century literary figure of the *poète maudit* (cursed poet), an outcast from modern society with an impoverished bohemian lifestyle often marked by substance abuse, alienation, suffering, and an early death.

Amedeo Modigliani (1884–1920)

The *maudit* label seems most appropriate to Modigliani, whose brief life—he died of tubercular meningitis at thirty-five—was one of poverty, sexual promiscuity, and illness exacerbated by drugs and alcohol. Born in Livorno, Italy, and academically trained in Florence and Venice, he moved to Paris in 1906. There, he met Picasso and befriended Constantin Brancusi, whose example encouraged Modigliani's devotion to sculpture between about 1909 and 1914. Like Brancusi, Modigliani practiced **direct carving**, creating a series of elongated stone heads with simplified features and long narrow noses (e.g., *Head*, c. 1911–12, Tate). Modigliani also drew stylistic inspiration from "primitive" sources such as the art of ancient Egypt and Cambodia and masks from the Ivory Coast and Gabon (see "Primitivism" box, Chapter 2).

After abandoning sculpture, Modigliani painted portraits of his friends, lovers, and colleagues. He typically rendered his sitters in a mannered, linear **style** with slightly tilted oval heads, **stylized** features, long necks, and sloping shoulders, as seen in the portrait of his lover Jeanne Hébuterne (1918,

Figure 9.1). He also produced a series of female nudes in seated and reclining poses (e.g., *Nude*, 1917, Guggenheim), the latter inspired by the recumbent nude tradition exemplified in the work of Giorgione, Titian, Velázquez, and Manet (see Figure 1.14). Despite their historical pedigree, Modigliani's nudes appeared contemporary in their sensuality and visible pubic hair. When some were included in his 1917 solo exhibition at the Galerie Berthe Weill, the police forced their removal from display on the grounds of obscenity.

Chaïm Soutine (1893–1943)

The leading School of Paris **expressionist**, Chaïm Soutine used thick, agitated **brushwork**, distorted **forms**, and strong colors to convey a sense of turbulent emotion in his **still lifes**, landscapes, and portraits. Born the son of a poor Jewish tailor in Belarus, he studied art in Vilna (now Vilnius), Lithuania, between 1910 and 1913, then moved to Paris, where he met Chagall, Jacques Lipchitz, and Modigliani. Painting between

FIGURE 9.1 Amedeo Modigliani, *Jeanne Hébuterne*, 1918. Oil on canvas, 101 x 65.7 cm. Norton Simon Museum, Pasadena, California.

1919 and 1922 in Céret in the French Pyrénées, his mature style emerged in wildly convulsive landscapes (e.g., *Landscape, Céret*, 1922, Philadelphia Museum of Art) that prefigure the work of **Abstract Expressionists** like Willem de Kooning (see Chapter 12). A great admirer of the **Old Masters**, Soutine painted a gruesomely beautiful series of beef carcasses in the mid-1920s. These were inspired by Rembrandt's *Slaughtered Ox* (1655, Louvre), but rendered from direct observation—Soutine's consistent artistic practice. He reportedly worked from a carcass whose stench brought complaints from the neighbors. In response, he treated the meat with formaldehyde and doused it with fresh blood to restore its color. Soutine also painted numerous portraits of uniformed young men (e.g., *The Pastry Chef [Baker Boy]*, c. 1919)—cooks, pageboys, waiters—with rubbery bodies and twisted features that verge on caricature but ultimately convey the artist's compassion for their hapless working-class existence.

Suzanne Valadon (1865–1938)

A generation older than the *peintres maudits*, Suzanne Valadon was associated with them as the mother of Maurice Utrillo (1883–1955), who specialized in painting simply and solidly rendered images of the quiet daytime streets of Montmartre and struggled with alcoholism throughout his life. Valadon grew up in working-class Montmartre and at fifteen began working as an artist's model—an occupation not considered "respectable" since female models were expected to be sexually available to the men for whom they posed. Valadon modeled for painters including Puvis de Chavannes (she posed for several of the figures in Figure 2.8), Renoir, and Toulouse-Lautrec. Having drawn since childhood, she also devoted herself increasingly to her own art, encouraged by male artists including Edgar Degas.

Valadon's 1896 marriage to a banker gave her the financial security to stop modeling and make art full time. She initially concentrated on drawing and printmaking, depicting nude women and children in domestic interiors, bathing or reclining, oblivious to the spectator (e.g., *Marie Bathing with a Sponge*, 1908). In 1909 Valadon met the painter André Utter, who became her second husband in 1914. He persuaded her to concentrate on **oil painting** and posed nude for many of her **compositions**.

Although she painted landscapes, still lifes, and portraits, Valadon's central subject remained the female nude. A striking example, *The Abandoned Doll* (1921, Figure 9.2), shows a young woman, naked save for a bracelet and pink bow, seated on a bed next to a mature woman, presumably her mother, who dries her with a towel. The cast-off doll at the lower right and the young woman's self-regard in a handheld mirror symbolize her passage from child to adult. The painting is characteristic of Valadon's mature style in its rich colors, simplified anatomical

FIGURE 9.2 Suzanne Valadon, *The Abandoned Doll*, 1921. Oil on canvas, 129.54 x 81.28 cm. National Museum of Women in the Arts, Washington, DC.

forms, and deliberately awkward poses defined through heavy outlines. Though elements of her style can be related to those of Gauguin and Matisse (see Chapters 2 and 3), her depiction of the nude in *The Abandoned Doll* stands apart from similar images by male **modernists**. Valadon presents the female body not as a static, timeless object displayed for the male gaze but in motion within a specific context. The nude woman exists in intimate relation with an older caregiver even as she is absorbed in her own psychological world.

The Later Work of Henri Matisse

A pioneer of **Fauvism** (see Chapter 3), Henri Matisse's paintings of the early 1910s featured simplified imagery, informal compositions, and rich, flat color, sometimes arranged into decorative patterns (e.g., *The Red Studio*, 1911). He painted them in defiance of **Analytic Cubism**'s fragmented geometric forms and space and reduced **palette**. During World War I,

however, Matisse responded to rather than reacted against Cubism, developing a more austere and formally structured style. *Piano Lesson* (1916, Figure 9.3), a large canvas painted in the dining room of his family's suburban Parisian home, exemplifies this phase of his work. Matisse's division of the highly compressed space into bands of flat color—green, gray, pink, orange, and pale blue—reflects Cubism's influence. The artist's son Pierre sits at the piano at the lower right. Above him hangs a schematically rendered version of Matisse's 1914 painting *Woman on a High Stool*, as if presiding sternly over the lesson. Another Matisse work, the 1908 bronze *Decorative Figure*, occupies the lower left corner. Above, an open window looks onto a lawn indicated minimally through a green wedge that complements the pink of the horizontal piano top. Also wittily complementary are the renditions of Matisse's own artworks: the stiffly seated clothed figure with a dull blue dress and her relaxed, nude dull brown counterpart in the opposite corner. Visual suggestions of music fill the composition's lower

zone. The candle and metronome atop the piano signal the passage and measuring of time. The black arabesques of the music rack and window grille flow across space like the unfolding sounds of a piano.

In late 1917, Matisse traveled to Nice in southern France to escape the wartime gloom and Paris winter. For the rest of his life, he would spend much of the year in Nice or its environs. Seduced by the Mediterranean light and glowing colors, Matisse traded the severe **abstraction** of *Piano Lesson* for a more relaxed, loosely brushed **naturalistic** style—a conservative aesthetic turn resonating with the postwar "call to order." Painting from observation, he rendered still lifes with fruit and flowers and tranquil interiors, often inhabited by women. His best-known pictures of this decade depict **odalisques**—a subject common in nineteenth-century **Orientalist** paintings (see Figure I.11) that had earlier inspired Matisse's 1907 *Blue Nude* (see Chapter 3). Matisse's odalisques (e.g., *Odalisque, Harmony in Red*, 1926–27) languidly recline, sit, or stand,

FIGURE 9.3 Henri Matisse, *Piano Lesson*, 1916. Oil on canvas, 245.1 x 212.7 cm. The Museum of Modern Art, New York.

partially or fully undressed, amidst the rich and colorful patterns of ornamented textiles, screens, and carpets. Unlike Orientalist paintings that seek to transport the viewer imaginatively to an exotic locale, Matisse's are self-consciously artificial modern images, posed by European models performing a masquerade.

In 1930, Matisse received a commission from Dr. Albert C. Barnes to paint murals for three contiguous lunettes in the main gallery of the Barnes Foundation, a school and museum near Philadelphia housing Barnes's great modern painting collection. Reprising the theme of the dance he had used in his 1910 painting for Sergei Shchukin's home (see Figure 3.4), Matisse represented nude women, three dancing in pairs on either side of two seated onlookers. Their simplified, flat, white bodies cropped by the lunettes' perimeters are set against a pink **background** traversed by wide diagonal bands of blue and black rising and falling in a rhythmic pattern.

After completing the Barnes murals, Matisse emphasized disciplined drawing, expressive distortion of the female figure,

and flat shapes of color in his painting—qualities seen in his *Large Reclining Nude* (1935, Figure 9.4), another odalisque image. The nude's curvilinear body with a disproportionally small head is locked into the blue-and-white grid of a chaise longue and melded to the canvas surface by the cropping of her feet and dangling left hand.

In composing the Barnes Foundation mural and *Large Reclining Nude*, Matisse pinned cut pieces of painted paper to the canvas to try out different configurations of shapes. This experience led him to adopt the paper cutout as his principal **medium** in his later years when his deteriorating physical condition left him unable to paint. "Cutting directly into vivid color" and "drawing with scissors,"[1] Matisse sliced painted sheets of paper into various shapes—animal, vegetal, figurative, and ornamental—that he arranged into exuberant compositions (e.g., *Beasts of the Sea*, 1950). He used this technique to design stained-glass windows and priest's vestments for the Chapel of the Rosary (1948–51) in Vence, near Nice, for which he also created white ceramic tile murals with black

FIGURE 9.4 Henri Matisse, *Large Reclining Nude*, 1935. Oil on canvas, 66.4 x 93.3 cm. Baltimore Museum of Art.

brush-drawn figures. A modest space intended for a small group of Dominican nuns' daily prayer, the chapel's white walls and floors glow with colors from the stained glass. Seeking to create "a spiritual space,"[2] Matisse used **hues** with Christian meaning: yellow for the sun and heavenly light; green for vegetation and the earth; and blue for the sky, the sea, and the Madonna. The chapel, which Matisse saw as summing up his life's work, is regarded as one of the twentieth century's greatest works of religious art.

The Later Work of Georges Braque

Braque and Picasso's collaboration in the Cubist adventure (see Chapter 4) ended with Braque's 1914 conscription into the French army. He suffered a serious head wound at the front, was cited for bravery, and received a medical discharge in 1916. Resuming painting, he transformed his prewar **Synthetic Cubist** idiom into a more relaxed and lyrical style. He employed a subdued palette and often mixed sand or other granular substances into his paint to achieve a textured surface. Like Picasso, Braque answered the 1920s "call to order" through a series of paintings on a **classical** theme: monumental, semidraped female basket-bearers (e.g., *Nude Woman with Basket of Fruit*, 1926), partly inspired by Renoir's late nudes. During this decade he largely focused, however, on still life, including several canvases depicting assorted objects piled atop a small round pedestal table (known in French as a *guéridon*).

The Round Table (Le Guéridon) (1929, Figure 9.5) features a centralized, top-heavy composition incorporating Cubism's shifting viewpoint: the table's legs and pedestal seem viewed from straight on, whereas its top tilts as if seen from an elevated angle. Braque also combines three-dimensional and two-dimensional effects. For example, the **modeled** knife and pipe appear to possess **volume** as does the bottom half of the neighboring guitar; the guitar's upper half, however, flattens into a black-and-white pattern. Colorful **abstract** planes behind the still-life block spatial recession and push the objects on the table forward toward the spectator.

Braque's inventive reordering of reality in *The Round Table* exemplifies his commitment to pure painting, serenely detached from social or political concerns. Still life remained his main subject for the rest of his career, which climaxed in a series of eight paintings, made between 1946 and 1956, on the theme of the artist's studio. Sculpted heads, palettes, easels, pitchers, compotes, and pedestal tables fill these dense, intricate, spatially ambiguous compositions (e.g., *Studio V*, 1949–50). Most also include the image of a flying bird—a manifestation of

FIGURE 9.5 Georges Braque, *The Round Table (Le Guéridon)*, 1929. Oil, sand, and charcoal on canvas, 145.7 x 113.7 cm. The Phillips Collection, Washington, DC.

movement through space, one of Braque's abiding concerns as a painter.[3]

The Later Work of Pablo Picasso

A citizen of neutral Spain, Picasso did not serve in World War I, but remained in Paris. In 1917, the poet Jean Cocteau persuaded Picasso to travel to Rome to design the costumes, sets, and curtains for an **avant-garde** ballet Cocteau was working on, *Parade*, staged by Sergei Diaghilev's Ballets Russes. The ballet's title refers to a sideshow performance meant to entice passersby into a theater or circus tent. Picasso's huge drop curtain shows a group of colorfully costumed performers on a stage prior to the show, painted in a legible style reminiscent of his Rose Period circus paintings (see Figure 4.2). By contrast, his set and his costumes for the characters of the three stage managers were elaborate Cubist compositions. The American manager's costume, over three meters tall, incorporates images of skyscrapers to express the jolting new experiences of the twentieth century. Erik Satie's score also did this

by featuring jazz and ragtime and the sounds of typewriters, sirens, and airplane propellers. At the May 1917 premiere in Paris, audience members found *Parade*'s Cubist aspects un-French and its popular references vulgar. Its *succès de scandale*, however, led to several more collaborations between Diaghilev and Picasso.

Picasso's experience of ancient art in Rome, Naples, and Pompeii inspired a new classicism in his painting, manifested in impassive, monumental figures placed in elemental settings. These neoclassical works (1917–23) were Picasso's answer to Cocteau's "call to order." They also express stability and contentment in Picasso's personal life: he married one of Diaghilev's ballerinas, Olga Kokhlova, in 1918 and she gave birth to their son Paolo in 1921. Picasso produced numerous images of maternity over the next two years, including the majestic *Mother and Child* (1921, Figure 9.6). It depicts a seated mother draped in a Grecian-style robe, gazing serenely at the squirming infant in her lap. The simple, still background of sand, sea, and sky accentuates her calm expression. The mother's colossal, powerfully modeled body with its self-contained pose—bearing comparison to Maillol's *Mediterranean* (see Figure 3.6)—provides a stable base for her active son. He tugs at his left foot, bends his head backward, and reaches toward her with his right hand—all movements that we can imagine Picasso carefully observing in Paolo.

Concurrent with his neoclassicism, Picasso continued to develop Synthetic Cubism, which he summed up in two large paintings entitled *Three Musicians* (1921; MoMA and Philadelphia Museum of Art). Each represents a trio of masked seated musicians in the costumes of Harlequin, Pierrot, and a Franciscan friar. The former two derive from the *commedia dell'arte*—the Italian popular theater tradition that had long fascinated Picasso (see again Figure 4.2). In both paintings, Picasso presents the figures side-by-side within a shallow boxlike space, their frontal bodies composed of flat, overlapping planes. Scholars generally agree that Picasso represents himself and his friends in the *Three Musicians*: the artist in the guise of Harlequin, and the poets Guillaume Apollinaire and Max Jacob as Pierrot and the monk, respectively. The Philadelphia composition, more complex and upbeat, may reflect Picasso's happy memories of his bohemian youth. The New York version, simpler and more solemn, may be an elegy to lost companionship: Apollinaire had died in 1918 and Jacob, a Jewish convert to Catholicism, left Paris in 1921 for Saint-Benoît-sur-Loire where he prayed daily at a Benedictine monastery.

In the mid-1920s, Picasso became friendly with the **Surrealists** (see Chapter 8) and André Breton recognized him as one of their own. Though Picasso did not officially join the group nor share their commitment to **automatism**, Surrealism encouraged him to produce violent and disquieting imagery

FIGURE 9.6 Pablo Picasso, *Mother and Child*, 1921. Oil on canvas, 142.9 x 172.7 cm. The Art Institute of Chicago.

of the kind not seen since *Les Demoiselles d'Avignon* (see Figure 4.3). *The Three Dancers* (1925), a large painting that Breton illustrated in *La Révolution surréaliste*, introduced this new expressiveness. The subject emerged from realistic studies of ballet dancers rehearsing, which Picasso transformed into tortured, emaciated figures with flattened, angular bodies. He identified the dancer on the right with his old friend from Barcelona, the painter Ramon Pichot, who died while Picasso was making the painting. The frenzied dancer on the left is Pichot's wife, Germaine Gargallo. She had spurned the advances of Picasso's friend Carles Casegemas, leading to his 1901 suicide—the tragic event that catalyzed Picasso's Blue Period (see Figure 4.1). The central dancer, arms outstretched as if crucified, may be suffering Casegemas's ghost. At the same time, *Three Dancers* reads as an aggressive parody of the classical ballet and may express Picasso's frustration in his marriage to Kokhlova, against whose conventional bourgeois values he increasingly strained.

As Picasso's relationship with Kokhlova deteriorated further, he produced paintings of women with monstrously distorted bodies (e.g., *Large Nude in a Red Armchair*, 1929) that many twenty-first-century viewers find misogynistic. In the late 1920s, he also returned to sculpture, creating several works in welded metal—a technique he learned from his friend Julio González. The most impressive of these, *Woman in the Garden* (1929–30), combines rods and thin sheets of white-painted iron to conjure the skeletal body of a woman with a triangular head and windswept hair. A bean-shaped plane suspended in her open torso represents her stomach; two curved bars on a disk below represent her genitals. Rising next to the woman, a pair of philodendron leaves connect her with fertile nature, but her monstrous appearance contradicts this positive association.

Picasso found refuge from his soured marriage in an affair with Marie-Thérèse Walter, who was seventeen when he met her in 1927. He expressed his passion for Walter through a flood of images in the 1930s that celebrate her sensual beauty in highly inventive ways. They include *Girl before a Mirror* (1932, Figure 9.7), which is based on the traditional theme of **vanitas** (vanity, derived from the Latin word for "emptiness"). **Renaissance** and **Baroque** artists visualized this theme through a young woman contemplating her reflection in a mirror—meant to remind the viewer of beauty's fleetingness and death's inevitability. In Picasso's painting, Walter—identified by her classic profile, blond hair, and curvaceous lilac body—stands before an oval mirror that she touches with an extended hand. Employing Cubism's mobile perspective, Picasso gives her a "double head" combining profile and frontal views. Her serene rosy lavender profile, surrounded by a white halo, is paired with a yellow frontal face, suggesting a moon partially eclipsing a blazing sun. The frontal face is also crudely brushed with colors that evoke rouge, lipstick, and green mascara. The double head

thus alludes both to the wedding of sun and moon and to the stereotypical Madonna-whore dichotomy. This stereotype, through which women are perceived as either chaste or seductive, creates a duality that reinforces patriarchy, according to feminist critics. Meanwhile, the ghostly reflection of Walter's face in the mirror—red, green, black, and gray, with an orange arc on the cheek, and the head surrounded by bands of lavender, blue, black, purple, and green—suggests she confronts a mysterious other, her soul or unconscious self.

Picasso's rendition of Walter's body with a curving lavender belly, round breasts, and a circular green womb emphasizes her fecund sexuality. Her reflected breasts and belly are likewise prominent in their bright white hue. Walter's body before the mirror also expresses male desire through the suggestion of testicles and an erect penis formed by her breasts and rising arm. Picasso similarly fused male and female anatomical references in other painted and sculpted portraits of Walter, conjuring the merger of bodies in erotic union. In *Girl before a Mirror*, Picasso's presence is also implied through the diamond-patterned wallpaper recalling the costume of Harlequin, his alter ego.

During the 1930s, Picasso's relationship with Walter nourished his efforts in printmaking, including the *Vollard Suite*—one hundred **etchings** he created between 1930 and 1937, published in 1939 by his dealer Ambroise Vollard. Neoclassical in style and theme, and replete with anonymous female nudes and portraits of Walter, the suite features numerous images of Picasso in the guise of a sculptor in his studio and as the Minotaur—the mythical monster of Greek mythology with the body of a man and head of a bull. This hybrid creature fascinated Picasso for the same reason as it did the Surrealists (see Figure 8.13): the Minotaur embodies reason's displacement by animal instinct.

The Minotaur features prominently in Picasso's ambitious etching, *Minotauromachy* (1935, not part of the *Vollard Suite*). In this dense composition, the Minotaur enters from the right, confronting a girl holding a candle and a bouquet. Between them, a wounded female picador with bared breasts is slumped over the back of a disemboweled horse—imagery derived from Picasso's long engagement with the subject of the bullfight. Above, two young women with doves, symbols of peace, peer from a window. A bearded man on a ladder at the left also looks down on the scene. Resisting definitive interpretation, *Minotauromachy* seems to harbor private meanings related to Picasso's relationship with Walter, whose features the candle-bearing girl bears and who was then pregnant with their daughter. Two years later, the artist would adapt some of its images for *Guernica*.

Picasso's most famous work, *Guernica* (1937, Figure 9.8), was created on commission from the Spanish government for its pavilion at the Paris International Exposition. A lifelong

FIGURE 9.7 Pablo Picasso, *Girl before a Mirror*, 1932. Oil on canvas, 162.3 x 130.2 cm. The Museum of Modern Art, New York.

Spanish citizen despite his French residence, Picasso took the side of the leftist Republican government in its fight against General Francisco Franco's right-wing Nationalist forces in the Spanish Civil War (1936–39). He chose for his mural's subject the bombing of the Basque town Guernica on April 26, 1937, by the German Luftwaffe (air force) at the behest of the Nationalists, allied with the Nazis. This assault destroyed most of the town and killed or wounded approximately one-third of its five thousand residents. Picasso channeled his outrage at this atrocity into an enormous composition that he executed in about a month, altering the position of its figures and animals in the process.

Guernica's black, white, and gray palette evokes the grainy **tones** of newspaper photographs documenting the bombing's aftermath. The images of people and animals with flattened and distorted Synthetic Cubist-style bodies strewn across a compressed, stage-like space constitute a nightmarish scene of suffering and carnage. Picasso created compositional stability through the **foreground** motifs' pyramidal arrangement: at the right, a pleading bare-breasted woman dragging a distended leg; at the center, a screaming horse, its body run through by a lance; at the left, the dismembered body of a fallen soldier whose right hand clutches a fragile flower and a broken sword. Above the soldier, a distraught woman weeps over her dead child beneath an anxious-looking bull. On the opposite side, at the upper right, a frantic woman trapped in a burning house thrusts her arms and chin heavenward. From a window at center right, another woman extends an elongated arm holding an oil lamp, juxtaposed with the harsh glow of an electric light above the horse's head.

The Later Work of Pablo Picasso **201**

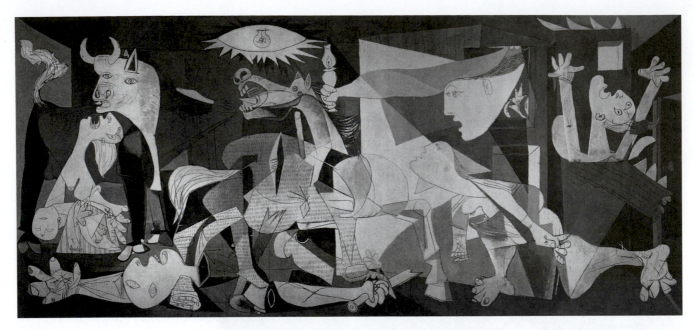

FIGURE 9.8 Pablo Picasso, *Guernica*, 1937. Oil on canvas, 349.3 x 776.6 cm. Museo Nacional Centro de Arte Reina Sofía, Madrid.

Guernica possesses the scale and dramatic sweep of a modern **history painting** like Goya's *Third of May, 1808* (see Figure I.12) or Delacroix's *Scenes from the Massacres at Chios* (see Figure I.13), but unlike those precedents, it does not depict the specific event that inspired it. Rather, it reads as an **allegory**, filled with symbols that the artist never explained beyond commenting that "the bull . . . represents brutality, the horse the people."[4] *Guernica* is perhaps best understood as a universal protest against war's destruction and inhumanity, in all times and places.

Picasso remained in Paris during World War II and in 1944 expressed his opposition to fascism by joining the Communist Party. After the war, he lived mostly in the South of France, where he made prodigious quantities of paintings, drawings, prints, sculptures, and ceramics. Among his best-known late works are freewheeling variations on famous compositions by Delacroix, Velázquez, and Manet. Through them, Picasso demonstrated his unflagging inventiveness and perhaps sought to declare his standing alongside these masters in the artistic pantheon.

School of Paris Sculpture

School of Paris sculptors such as Julio González, Jacques Lipchitz, and Constantin Brancusi developed innovative techniques and forms to explore new ways of abstracting human and animal bodies and to express political and spiritual themes.

Julio González (1876–1942)

Julio González's major contribution to modernism was the innovation of **direct-metal sculpture**, whereby the sculptor manipulates and welds together pieces of metal, adapting to art a method developed for utilitarian purposes. Born and raised in Barcelona, where he met Picasso, González moved to Paris in 1900 and supported himself by making decorative metalwork and jewelry. He learned welding in 1918 while working in a Renault car factory and made his first welded sculptures in 1929, composing simplified figures, busts, and masks out of flat pieces of sheet iron. González observed about metal:

> The age of iron began many centuries ago by producing very beautiful objects, unfortunately for a large part, arms. Today, it provides as well, bridges and railroads. It is time this metal ceased to be a murderer and the simple instrument of a super-mechanical science. Today the door is wide open for this material to be, at last, forged and hammered by the peaceful hands of an artist.[5]

Between 1928 and 1931, González gave Picasso technical assistance in realizing sculptures in iron. Some (e.g., *Figure: Project for a Monument to Guillaume Apollinaire*, 1928) were schematic figures composed of slender rods, replacing sculpture's traditional solid **masses** and closed **volumes** with open, linear structures. González used similar elements to "draw in space,"[6] as seen in *Maternity* (1934, Figure 9.9). This highly abstracted welded steel female figure rises from a horizontal ring and thick bar on a stone base. Four slim rods extending

FIGURE 9.9 Julio González, *Maternity*, 1934. Steel and stone, 130.5 × 40.6 × 23.5 cm. Tate, London.

from the ring form a "skirt" and converge on a cylinder representing an infant. A disk and ring signify breasts; the ring, a Cubist-style visual pun, may also signify the child's head. An open loop constitutes the mother's head, with strands of hair extending from both ends and two metal stalks forming eyes. The carved images of the Madonna and Child on Gothic cathedral portals may have inspired González's composition.[7] His modernist rendition of this time-honored subject is simultaneously elegant, bizarre, and whimsical.

González's abstract open-form sculptures were his most original accomplishments and greatly influenced later direct-metal sculptors such as David Smith (see Figure 12.17). His best-known work during his lifetime, however, was a more realistic, closed-form sculpture made of forged and welded sheet iron, *The Montserrat* (1935–37). Its title refers to a mountain range near Barcelona emblematic of Catalonia,

personified by González as a standing peasant woman carrying a bundled infant and wielding a scythe. Commissioned by the Spanish Republic for its pavilion at the Paris International Exposition, where it stood near Picasso's *Guernica*, Miró's mural *The Reaper*, and Alexander Calder's *Mercury Fountain* (see Figure 10.21), González's defiant mother symbolized Republican resistance to the Nationalists in the Spanish Civil War.

Jacques Lipchitz's Later Work

A major Cubist sculptor in the 1910s (see Chapter 4), Jacques Lipchitz continued to work in that mode after World War I. Starting in the late 1920s, he developed a robust style of massive, rounded volumes and began treating mythological and biblical **subject matter**. His dominant theme in the years leading up to World War II was the myth of Prometheus. Condemned by Zeus to eternal torment for stealing fire from the gods and giving it to humans, the immortal Prometheus was chained to a cliff where each day a giant eagle pecked out his liver, which regenerated nightly. Eventually freed by Herakles, Prometheus was hailed by the Greeks as a benefactor of humanity. With the rise of Nazism, the staunch anti-fascist Lipchitz adopted Prometheus as symbol of the victory of light over darkness, knowledge over ignorance, and good over evil. The left-wing French government commissioned him to create an enormous plaster sculpture for the 1937 Paris International Exposition, *Prometheus Strangling the Vulture*, as an allegory of democracy overcoming fascism. Lipchitz gave Prometheus a Phrygian cap, an ancient symbol of liberty, and replaced the eagle with a vulture, a scavenging bird signifying Hitler's anti-Semitic and expansionist agenda. Following Germany's invasion of France, Lipchitz and his wife immigrated to the United States. In his final decades, he produced numerous monumental public bronze sculptures, including another version of *Prometheus Strangling the Vulture* (1943), exploding with **baroque** energy.

Constantin Brancusi (1876–1957)

A friend of González and Lipchitz, sculptor Constantin Brancusi produced beautifully distilled abstractions based on human and animal bodies. He created smooth, simple, closed volumes through direct carving in stone and wood, and often translated his carved sculptures into polished cast bronze versions. He drew his subject matter primarily from nature, whose forms he reduced into elemental masses to reveal their Platonic essence. "What is real is not the external form but the essence of things," declared Brancusi. "Starting from this truth it is impossible for anyone to express anything essentially real by imitating its exterior surface."[8]

Born a peasant in rural Romania, Brancusi learned to carve wood as a shepherd in the Carpathian Mountains. He

went on to receive training at the School of Arts and Crafts in Craiova and the Bucharest School of Fine Arts. In 1903, he left for Paris, traveling mostly on foot, and arrived the next year. In 1905, he began academic study at the École des Beaux-Arts, but he quickly fell under the sway of Rodin, as the anatomical realism and expressive surfaces of Brancusi's modeled figures reveal. Brancusi worked briefly as Rodin's studio assistant in 1907 before leaving with the famous utterance, "Nothing can grow in the shadow of great trees."[9]

Brancusi then turned strongly against Rodin's style, encouraged by his discovery of African art (see "Primitivism" box, Chapter 2) with its emphasis on basic, simply carved forms, and inspired by his native Romania's folk traditions. From mid-1907, Brancusi adopted direct carving in stone and wood, concentrating on a few themes, including embracing lovers, heads, female portrait busts, and birds. He often produced multiple versions of the same subject over many years, progressively reducing and refining it to express its essence.

Brancusi carved several limestone renditions of *The Kiss*, depicting an embracing nude man and woman, their simplified bodies and faces pressed together. From the relatively realistic first version (1907) to the fourth (1916, visible in Figure 9.10), the lovers' bodies become increasingly schematic and compact, which conveys the inherent quality of the original block of stone. Brancusi enhances this compactness in three of these versions by truncating the bodies at mid-torso.

Brancusi also progressively abstracted his sculptures of a sleeping, disembodied head—self-sufficient and withdrawn from waking activity. Following Rodinesque versions of a man's head and baby's head (1908), he carved the marble *Sleeping Muse* (1909–10), a woman's head rendered as a simple ovoid incised with rough grooves of hair and refined facial features. Brancusi then cast six bronzes from a plaster mold of the marble, a practice he would continue with many subsequent carved sculptures. His distillation of the head culminated in *The Beginning of the World* (c. 1920) a pure marble egg symbolic of the origin of creation. He presented it on a mirror-like metal disk, making it seem to float in space. The disk rests on a limestone cube surmounting a taller cruciform limestone structure. Brancusi often presented his marble and bronze sculptures on multipartite bases made of stone or wood. The angular geometry of the bases sets in relief the purified organic marble and bronze forms that they elevate above the mundane world.

The female portrait bust was another theme Brancusi treated repeatedly. Drawings he made of the Hungarian painter Margit Pogány stimulated his *Mademoiselle Pogany*

series. The first, highly stylized marble version (1912) represents her with clasped hands resting on the side of an oval face dominated by enormous almond-shaped eyes separated by a slender nose above a tiny mouth. In later marble and polished bronze variations, Brancusi eliminated the mouth and reduced the eyes to arching ridges converging on a small, pointed nose, as seen in *Mademoiselle Pogany [III]*, 1931 (visible in Figure 9.10). The radically abstract marble *Princess X* (1915) was inspired by the notoriously vain Princess Marie Murat Bonaparte, who always carried a mirror in which she admired her reflection. Brancusi portrayed her gazing downward with a featureless face, long curving neck, and bulbous breast. The undeniably phallic composition, fusing the forms of the female bust with those of male genitalia, aroused great controversy: the police removed the bronze version (1916) from the 1920 Salon des Indépendants as an offense to public decency. Despite Brancusi's protest that he intended *Princess X* as "the very synthesis of Woman . . . reduced to her essence,"[10] he had an abiding interest in merging male and female sexual forms.[11] Another example, *Torso of a Young Man* (c. 1917–22), carved from the trunk and forking branches of a tree and subsequently translated into bronze, lacks male genitals but takes the overall form of an erect penis.

Birds obsessed Brancusi, who associated their flight with transcendent freedom. Around 1912 he made several marble and bronze versions of *Maiastra*, a magical bird from Romanian folklore. Standing on a plinth-like rectangular leg, the bird has a swelling breast, arching neck, and parted beak—an allusion to its song's miraculous powers. Brancusi subsequently elongated and streamlined the avian body in the *Golden Bird* (1919–20) series before reducing it further to the sleek ascending blade-like form he called *Bird in Space*. He rendered this subject sixteen times in marble and bronze (1923–40; two versions are visible in Figure 9.10). Rather than describing the appearance of a bird, Brancusi aspired to communicate the joyful sensation of soaring. "All my life I have sought the essence of flight," he exclaimed. "Flight! What bliss!"[12]

In contrast to his marble sculptures' smooth perfection, Brancusi's work in wood often has a primitive quality evoking African art and Romanian folk carvings. *King of Kings* (c. 1938), a three-meter-tall oak sculpture, has a rough-hewn vertically segmented composition suggesting both a totem and the stacked forms of Romanian veranda posts. The sculpture also reveals Brancusi's interest in Buddhism: its crowing element is a lotus—a Buddhist symbol of purity and creation—and it was originally entitled *Spirit of Buddha*. Brancusi intended it to stand in a private temple commissioned by

FIGURE 9.10 Constantin Brancusi installation at Philadelphia Museum of Art. Sculptures shown from left to right: *Bird in Space* (1924); *The Kiss* (1916); *Bird in Space (Yellow Bird)* (1923–24); *Mademoiselle Pogany [III]* (1931).

the maharajah of Indore that would also contain three *Birds in Space*.

The temple was never built, but Brancusi did realize a large-scale sculptural ensemble in 1938 in Târgu-Jiu, Romania—a tribute to those killed defending their town against a German invasion in World War I. Defining a 1.5-kilometer-long processional way, Brancusi's sequential abstracted monuments—the stone *Table of Silence*, stone *Gate of the Kiss*, and thirty-meter-tall cast-iron *Endless Column*—evoke the passage of life through their associations with domesticity, marriage and procreation, and eternity.[13] The *Endless Column* consists of fifteen repeated rhomboidal modules, with a half module at the bottom and at the top. Brancusi frequently used these serrated forms in his bases and in earlier, smaller versions of the work. Originally coated with bronze, the *Endless Column* glistened in the sun as a symbol of spiritual transcendence. In **formalist** terms, its structure of repeated nonrepresentational modules provided a model for the US Minimalists in the 1960s (see Chapter 16).

The Later Work of Fernand Léger

After making distinctive contributions to Cubism's development (see Chapter 4), Fernand Léger was drafted into the French army in 1914 and was exposed to "a blinding reality that was entirely new."[14] The war opened his eyes to mechanized weaponry's aesthetic potential: "I was suddenly stunned by the sight of the open breech of a .75 cannon in full sunlight, confronted with the play of light on white metal."[15] At the Battle of Verdun in September 1916, Léger was the victim of a poison gas attack. During his long convalescence he made a large painting, *La partie de cartes* (*The Card Party*, 1917), showing a trio of soldiers playing cards. Its subject pays homage to Cézanne's images of cardplayers, but Léger's admiration for military hardware inspired its depiction of the cardplayers as robot-like figures with shiny metal bodies and segmented limbs and appendages.

After the war, Léger embarked on his "mechanical period."[16] Embracing the machine and its products as embodiments of modern beauty, he painted machine-inspired themes in compositions dominated by Synthetic Cubist-style disks, semicircles, and rectangular planes of flat, uniform color. The spectacle of modern Paris with its bridges and subways, smoke, electric lights, shop windows, billboards, and bustling pedestrians also enthralled Léger. He brought these elements together, geometrically simplified, in his epic Cubist composition *The City* (1919).

In the early 1920s, Léger's paintings assumed a more static and balanced quality in keeping with the prevailing "call to order." During these years, he was associated with **Purism**. While the Purists represented mass-produced objects, Léger rendered the human figure as if manufactured. This is evident

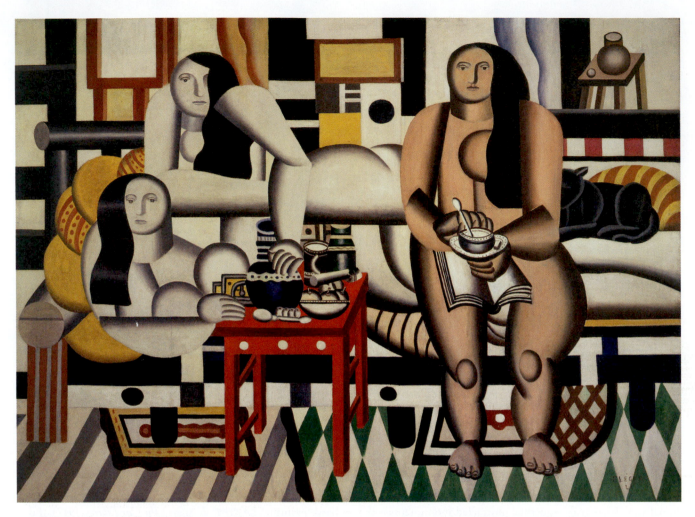

FIGURE 9.11 Fernand Léger, *Three Women*, 1921–22. Oil on canvas, 183.5 x 251.5 cm. The Museum of Modern Art, New York.

in his monumental painting *Three Women* (1921–22, Figure 9.11), which translates the traditional French subject of nudes in an interior into a machine-age idiom. Léger's nudes have nearly identical faces and bodies composed of precisely contoured and shaded geometric forms that appear as hard and interchangeable as mass-produced machine parts. Their environment is also ultra-modern: its flat geometric elements signal Léger's awareness of Mondrian's **Neo-plasticism** (see Figure 6.10); the still-life objects in the foreground and background recall those of the Purists. At the same time, *Three Women* possesses a classical quality similar to that of Picasso's contemporaneous neoclassical paintings. *Three Women*'s classicism consists in its balance of horizontals and verticals; its massive nude figures, which seem as much like statues as living machines; and their lack of emotion.

Léger's enthusiasm for the machine also found expression in the cinema: in 1924, he collaborated with Man Ray and Dudley Murphy to produce *Ballet mécanique*

(Mechanical Ballet)—a plotless film that conveys modern life's pulsing energy through shots of people, manufactured objects, machine parts, and geometric shapes, all in motion. In the same year, he opened an art school with the Purist painter Amédée Ozenfant and taught there until 1939. During World War II, Léger lived in the United States and painted divers, acrobats, cyclists, and musicians. After his return to France, he joined the French Communist Party and painted optimistic images of both work and leisure (e.g., *The Great Parade*, 1954) that he hoped would appeal to the proletariat.

Purism

The most programmatic artistic manifestation of the "call to order," Purism was launched in 1918 by the Frenchman Amédée Ozenfant (1886–1966) and the Swiss-born Charles-Édouard

Jeanneret (1887–1965, better known by his pseudonym, Le Corbusier, which he used for his architectural work, see Chapter 17). They announced the movement in a long manifesto, *Après le cubisme* (After Cubism, 1918) and developed its ideas in their journal *L'Esprit nouveau* (The New Spirit, 1920–25). Initially realized in painting and then extended to architecture, Purism advocated an art of "mathematical order"[17] embodied in a disciplined form of Cubism fusing the aesthetic values of classicism and the machine.

In *Après le cubisme*, Ozenfant and Jeanneret described pre–World War I Cubism as "a troubled art of a troubled era"[18] and "ornamental,"[19] or, superficially decorative. Defining the postwar spirit as one of organization and purification, they called for a new art, inspired by machinery's precise, impersonal beauty, which they compared to that of Classical architecture. Theirs would be a rigorous and reasoned art, replacing the personal, the fugitive and the ornamental (which they saw in **Romanticism**, **Impressionism**, and Cubism) with the general and the invariable.

Painting in very similar styles in their mature Purist work of the early 1920s, Ozenfant and Jeanneret created spatially compressed frontal compositions of soberly colored, crisply drawn, smoothly modeled, overlapping still-life objects. They depicted the same kinds of objects as the Cubists: glasses, pitchers, wine bottles, guitars, and pipes. Unlike Picasso,

Braque, and Gris, however, who saw these as picturesque café or studio items to be playfully fragmented or reshaped (see Figures 4.9, 4.10, and 4.14), Ozenfant and Jeanneret admired them as exemplars of mass-produced, streamlined functionality. They emphasized the objects' essential geometries, as in Jeanneret's *Still Life* (1920, Figure 9.12), which regularizes the Cubist principle of fusing different views of an object by showing the tipped-up mouths of the bottles and glass as perfect circles.

Modern Art in England between the Wars

After the decline of **Vorticism** (see Chapter 4), English art of the interwar period was generally more conservative than the progressive art made in France. Committed to native landscape and figurative traditions, most English artists responded hesitantly to challenging innovations from abroad. In the 1920s, painters of the Bloomsbury group, Vanessa Bell, Roger Fry (also an influential critic), and Duncan Grant, who had assimilated Fauvism in the 1910s, returned to more sober representational styles. The most adventuresome English representational painters of the period were Stanley Spencer and

FIGURE 9.12 Le Corbusier (Charles-Édouard Jeanneret), *Still Life*, 1920. Oil on canvas, 80.9 x 99.7 cm. The Museum of Modern Art, New York.

Paul Nash, both of whom gained renown within Britain. The English artists of the interwar years who achieved enduring international reputations were the sculptors Henry Moore and Barbara Hepworth and the painter Ben Nicholson.

Stanley Spencer (1891–1959)

Stanley Spencer's life and art were centered on his birthplace of Cookham, a Thames-side village thirty miles west of London. After studying art at London's Slade School and serving in World War I, Spencer painted enigmatic images of biblical events set in Cookham's streets, with precisely drawn, brightly lit, strongly modeled, simplified figures (e.g., *Christ's Entry into Jerusalem*, 1921). In these works, Spencer expressed his idealistic belief in the redeeming possibility of spirituality in war-traumatized England. Between 1927 and 1932, inspired by Giotto's **frescoes** in the Arena Chapel, Padua (c. 1305), Spencer painted a suite of nineteen oil-on-canvas murals for the Sandham Memorial Chapel in Burghclere, dedicated to war casualty Lieutenant Harry Sandham. Spencer filled the side walls with images of routine military life based on his experience as a medical orderly and infantryman. On the east wall, the visionary *Resurrection of the Soldiers* shows soldiers rising from their battlefield graveyard and resuming their daily activities, their white crosses heaped above the altar.

In the 1930s, Spencer often painted from life rather than imagination to confront raw reality. He produced tightly rendered, meticulously detailed landscapes and "naked portraits" of Patricia Preece, whom he married in 1937. In *Double Nude Portrait: The Artist and his Second Wife (The Leg of Mutton Nude)* (1937), the glasses-wearing but otherwise naked Spencer crouches above Preece's prone spread-legged body. An uncooked mutton leg in the foreground creates an analogy between what Spencer called "male, female and animal flesh."[20] The picture's unsparing confrontation with fleshy fact influenced Lucian Freud's later work (see Chapter 13).

Paul Nash (1889–1946)

London-born Paul Nash, briefly Spencer's fellow student at the Slade School in 1910, was largely self-taught in art. He served as an Official War Artist in World War I and received postwar commissions for large paintings from the British and Canadian governments. These canvases, such *The Menin Road* (1918–19), emphasize the war's terror, portraying devastated battlefields in somber palettes with bold, flat forms and emphatic diagonals influenced by Cubism and Vorticism. During the 1920s, when British artists generally turned away from extreme modernist experimentation, Nash concentrated more on formal problems than emotional expression in landscape paintings and **watercolors** informed by Cézanne's style.

Starting in the late 1920s, Nash worked to forge new connections between English artists and the continental avant-garde. Responding to Giorgio de Chirico's metaphysical painting (see Figure 8.3), he rendered isolated objects within still landscapes that seem to harbor hidden meanings (e.g., *Landscape at Iden*, 1929). In 1933, he formed the exhibiting group Unit One, which brought together British artists aligned with either abstraction or Surrealism, including Moore, Hepworth, and Nicholson. Nash's own inclination toward Surrealism led him to experiment with **found objects** such as flints, bones, and driftwood that he believed contained a life force and that he arranged into **assemblages** and photocollages featuring unexpected juxtapositions. In 1936, Nash helped to organize the International Surrealist Exhibition in London, whose other English participants included Moore, Eileen Agar, and Edward Burra.

During World War II, Nash again served as an Official War Artist. He painted *Totes Meer (Dead Sea)* (1940–41, Figure 9.13) after he was inspired by the heaps of crashed German aircraft he photographed at a salvage dump near Oxford. Nash drew on the Surrealist concept of metamorphosis to transform the twisted airplane bodies into the heaving waves of a gray-and-white metal sea. Seeming to crash against the earthy plain slicing diagonally across the composition's right side, this sea of wreckage is bathed in moonlight that intensifies its dreamlike character.

The Early Work of Henry Moore (1898–1986)

One of the twentieth century's most distinguished modern sculptors, Henry Moore's central subject was the human figure, endlessly and inventively abstracted, always with a powerful sense of three-dimensional form. A Yorkshire coalminer's son, Moore served in World War I and then studied for two years at the Leeds School of Art (1919–21). At Leeds he read Roger Fry's *Vision and Design* (1920), which led him to value direct carving over modeling, to respect the inherent nature of stone and wood, and to admire the formal and expressive vitality of African and other "primitive" art (see "Primitivism" box, Chapter 2). He then studied at the Royal College of Art in London (1921–24), where the academic discipline of drawing from life and regular visits to the British Museum shaped his development. In an effort to remove "the Greek spectacles from the eyes of the modern sculptor"[21]—a reference to Classical art's dominant influence on the European academic tradition—Moore studied the British Museum's collections of Cycladic, archaic Greek, Etruscan, ancient Mesopotamian, Egyptian, African, Oceanic, and Pre-Columbian sculpture.

The most important influence on Moore's early work was a Toltec-Maya *chacmool*, a stone sculpture from eleventh- or twelfth-century Mexico that he knew from a plaster cast. The *chacmool* is a male figure reclining on his back, with his knees bent, elbows resting on the ground to support his torso, his head

FIGURE 9.13 Paul Nash, *Totes Meer (Dead Sea)*, 1940–41. Oil on canvas, 102 x 152.4 cm. Tate, London.

rotated ninety degrees to face front, and his hands meeting at the pelvis to hold a disc, likely a receptacle for sacrificial offerings. The *chacmool* inspired Moore's *Reclining Figure* (1929, Figure 9.14), representing a slightly smaller than life-size nude woman with a massive, blocky body. Her pose and proportions conform to the edges of the rectangular block of brown Hornton stone—a limestone quarried in Oxfordshire—from which Moore cut her. The sculpture thus manifests his credo of "truth to materials"—his conviction that a body carved of stone should possess a quality of "stoniness."[22] At the same time, the *Reclining Figure* departs from the *chacmool*'s rigid deportment in her animated, asymmetrical pose: she rests on her right side and right elbow, raises her left arm to her head, and looks out with an alert expression.

FIGURE 9.14 Henry Moore, *Reclining Figure*, 1929. Brown Hornton stone, 54 x 82 x 37 cm. Leeds Museums and Galleries, United Kingdom.

In the 1930s, Moore's sculptures became increasingly abstract as he responded to Arp's **biomorphic** Surrealism and the distorted figures of Picasso and Giacometti. In *Four-Piece Composition: Reclining Figure* (1934), a small Cumberland alabaster carving, Moore dismembers the body into separate bone- or stone-like forms signifying the head, navel, and legs. The composition suggests a mutilated corpse, giving it a disturbing surreal quality. Also related to Surrealism are his "stringed figures" of the late 1930s (e.g., *Stringed Figure No. 1*, 1937)—extreme abstractions of the human body with taut strings threaded between their projecting elements. Inspired by mathematical models in the London Science Museum, the strings articulate the sculpture's internal spaces while creating an anxious, claustrophobic quality resonating with the period's troubled political atmosphere.

Among Moore's most admired works are his large, majestic reclining female figures of the late 1930s. His *Recumbent Figure* (1938, Figure 9.15), carved of green Hornton stone, was commissioned by the architect Serge Chermayeff for the terrace of his modernist country house in Sussex. Moore positioned the figure to look out over the rounded, grassy hills as a "mediator between the modern home and the ageless land."[23] Some parts of the figure are recognizably human, such as the head, breasts, supporting elbow, and upright knees. At same time, the body's masses flow together in undulant rhythms suggestive of a hilly landscape. Moore replaces the torso with an open cavity, emphasizing his sculptural concern with the relationship between solid and void. "The hole connects one side to the other, making it immediately more three-dimensional," Moore observed. "A hole can itself have as much shape-meaning as a solid mass."[24] He also noted "the mystery of the hole—the mysterious fascination of caves in hillsides and cliffs," identifying the landscape as an inspiration for his opening up of the human body.[25]

Moore's use of native English stones for *Recumbent Figure* and his other sculptures further emphasized his preoccupation with the English landscape construed as timeless, idyllic, and unspoiled by industrialization. This view of the rural landscape as a locus of national identity was deeply rooted in the English Romantic tradition and remained central to conservative English politics in the 1930s. In larger ideological terms, Moore's sculpture reinforces the traditional identification of the life-giving, nurturing female body with nature—an identification some feminists have criticized as serving to subordinate women to men, who are exalted as the producers of culture.[26] In his later work, much of it executed in bronze, Moore continued to represent reclining female figures as well as mothers and children, families, and upright personages (see Chapter 13).

The Early Work of Barbara Hepworth (1903–1975)

A friend and peer of Henry Moore, Barbara Hepworth, like Moore, was born in Yorkshire and studied sculpture at the Leeds School of Art (1919) and Royal College of Art in London (1920–24). Alongside her husband and fellow sculptor John

FIGURE 9.15 Henry Moore, *Recumbent Figure*, 1938. Green Hornton stone, 88.9 x 132.7 x 73.7 cm. Tate, London.

Skeaping, she learned the traditional Italian technique of marble carving in Rome in 1925. Through the early 1930s, Hepworth carved small, compact figures in wood and stone. They reflect her commitment to direct carving and her interest, shared with Moore, in African and ancient Egyptian, Sumerian, and Cycladic art. In the mid-1930s, Hepworth produced biomorphic abstractions on the theme of maternity (e.g., *Mother and Child*, 1934), a subject with personal significance: she had a son with Skeaping in 1929 and, after divorcing him, bore triplets in 1934, fathered by the painter Ben Nicholson, whom she would marry in 1938.

In the 1930s, Hepworth made several trips with Nicholson to France where she met Picasso, Braque, Brancusi, Arp, Taeuber-Arp, Calder, Kandinsky, and Mondrian. In 1933, she and Nicholson joined the Paris-based Abstraction-Création group, principally dedicated to geometric abstraction and **Constructivism**. The next year they joined Unit One. Hepworth moved away from figuration in the second half of the 1930s, carving simple compositions of smooth, precise, elegant geometric forms (e.g., *Three Forms*,1935), "absorbed in the relationships in space, in size and texture and weight, as well as the tensions between forms."[27]

In 1939, Hepworth and her family moved to Cornwall on England's southwest coast, where she would spend the rest of her life. There, in the mid-1940s, she created some her most innovative sculptures: smoothly finished, convex masses of carved wood with hollowed out and painted interiors, relating to the landscape around her home. *Pelagos* (1946, Figure 9.16), meaning "the open sea" in Greek, was inspired by the view

from her house overlooking St. Ives Bay. Hepworth cut out the interior of the wood to form two spiraling extensions evoking waves, seashells, and the arms of land embracing the bay. She painted the interior pale blue (later repainted white) and connected the arms' ends through seven taut lines of string. "I used color and strings in many of the carvings of this time," wrote the artist. "The color in the concavities plunged me into the depth of water, caves, or shadows deeper than the carved concavities themselves. The strings were the tension I felt between myself, the wind or the hills."[28]

Hepworth also recalled how the view of the enclosed bay inspired in her a sense of "containment and security"[29] and the interior space of *Pelagos* has been interpreted as inviting and womblike—a metaphor of comfort for a country recovering from the traumatic World War.

Ben Nicholson (1894–1982)

England's leading modernist painter of the interwar decades, Ben Nicholson was the son of the prominent portrait painter Sir William Nicholson. He studied briefly at the Slade School of Art (1910–11) but devoted himself seriously to painting only after his 1920 marriage to fellow artist Winifred Roberts. During the 1920s, he painted landscapes and still lifes characterized by simple drawing, loose paint handling, and delicate tonal relationships. The influence of Synthetic Cubism entered his work in the early 1930s, soon supplanted by that of Mondrian, whose Paris studio he visited in 1934. The Dutch artist's Neo-plasticism inspired Nicholson's most original and admired works: shallow wood **reliefs**, two or

FIGURE 9.16 Barbara Hepworth, *Pelagos*, 1946. Elm and strings on oak base, 43.0 x 46.0 x 38.5 cm. Tate, London.

three layers deep, composed of rectilinear planes with a few large circular or rectangular openings cut out of the top layer. He painted them a uniform white to achieve a quality of purity (e.g., *1935 [white relief]*, 1935). With their austere geometries and plain white surfaces, Nicholson's reliefs were considered ideal décor for the stripped-down interiors of **International Style** architecture (see Chapter 17). They were his main contribution to the international Constructivist movement of the 1930s, which sought to unify modernist painting, sculpture, architecture, and design, animated by the utopian vision of a world in which geometric abstraction would be a universal language promoting social harmony. A key document of this vision was the 1937 publication, *Circle: International Survey of Constructive Art*, co-edited by Nicholson, architect J. L. Martin, and Naum Gabo (see Chapter 6), resident in England between 1936 and 1946. After moving to Cornwall with Hepworth in 1939, Nicholson returned to landscape and still-life painting. His efforts in the latter genre (e.g., *1945 [still life]*, 1945), intricate, highly abstracted compositions with crisp drawing and a generally muted palette accented by hard-edged planes of bright color, are a distinctive contribution to late Cubism.

Modern Art in the United States, Canada, and Latin America, c. 1900–1945

This chapter surveys modern painting, sculpture, and photography in the United States, Canada, and Latin America from the early twentieth century to World War II, emphasizing artistic developments in the United States as it became a major world power. The United States expanded through imperialism in the 1890s, annexing Hawaii and acquiring the Philippines, Guam, and Puerto Rico by winning the Spanish-American War (1898). Immigration to the country, especially its urban areas, surged in the late nineteenth and early twentieth centuries. Though many of these immigrants provided labor for the growing industrial economy, they lived and toiled in poor conditions. The concentration of wealth in the hands of bankers and industrial monopolies led President Theodore Roosevelt and his successors to pursue reforms to rein in corporate power in the Progressive Era (c. 1890–1917).

During this era, US audiences were introduced to European modernism on a large scale at the 1913 Armory Show, officially titled the *International Exhibition of Modern Art*, shown first in New York City and in a reduced version in Chicago and Boston. Many visitors were baffled or scandalized by the abstraction seen in works by Matisse, Picasso, Braque, Picabia, Duchamp, Léger, Brancusi, and Kandinsky, which elicited derision from the popular press. However, the Armory Show excited some adventuresome American collectors and stimulated a new market for modern art in the United States. Alongside the participating Europeans, the Armory Show also featured work by modern New York artists who formed two distinct constellations, one around the urban realism of painter Robert Henri's Ashcan School and the other around the abstraction of photographer Alfred Stieglitz, owner of the 291 Gallery.

The United States entered World War I in 1917 and contributed crucially to the Allied victory the next year. Thereafter, the nation entered an isolationist period that continued until World War II. During the Roaring Twenties, Americans enjoyed great economic prosperity. This ended suddenly following the October 1929 stock market crash, which ushered in the Great Depression and its massive unemployment. President Franklin D. Roosevelt, elected in 1933, responded with a variety of New Deal programs designed to provide economic relief, including to artists: the Federal Art Project of the Works Progress Administration (FAP/WPA, 1935–43) gave full-time employment to about ten thousand artists whose creations became government property. The US economy only recovered following the country's 1941 entry into World War II.

In this interwar period, many US artists continued to work in both realist and abstract styles following the lead of the Ashcan School and the Armory Show's avant-garde pioneers. The Precisionists, like Charles Sheeler, found a middle ground between these two positions with their streamlined images of industrial and architectural subjects. Artists of the Harlem Renaissance, an explosion of African American creativity, depicted their everyday lives and responded to continued racial injustice and segregation, as in Aaron Douglas's work. The 1930s American Scene painting movement comprised both Midwestern Regionalists, like Thomas Hart Benton, who depicted rural life in largely positive terms, and the more critical Social Realists, like Ben Shahn, who largely focused on urban subjects and used their art to fight social and economic injustice.

Still there were those who worked in abstract or purely nonobjective styles in the interwar period, like Alexander Calder and Stuart Davis.

Concurrently, artists experimented with modernism in Canada and Latin America. Canadian artists sought to create a modern art that reflected their country's national identity rooted in its land. Latin American artists also aspired to express national pride, while exploring new aesthetic languages shaped by both European modernist and native sources. Examples of modern architecture in the United States and Latin America are considered in Chapter 17.

Modern Realism in New York: The Ashcan School

The capital of the early twentieth-century American art world, New York attracted ambitious young artists seeking formal training, to exhibit and sell their work in the city's commercial galleries, and to gain reviews in its newspapers and art magazines.

Painter Robert Henri and his colleagues formed the metropolis's first modern art movement, the **Ashcan School**—so called because they depicted New York's gritty realities. An influential teacher, Henri rebelled against the genteel constraints of official art world taste and urged artists to celebrate the vitality of everyday American life. He captured public attention in 1908 when he and seven colleagues exhibited together as "The Eight" at New York's Macbeth Gallery. The other artists were Arthur B. Davies, William Glackens, Ernest Lawson, George Luks, Maurice Prendergast, Everett Shinn, and John Sloan; Glackens, Henri, Luks, Shinn, and Sloan formed the nucleus of the Ashcan School. The exhibition challenged the authority of the conservative National Academy of Design, whose jury (of which Henri was a member) had rejected several canvases submitted by Henri's students and colleagues in 1907. Taking his cue from earlier groups such as the French **Impressionists**, Henri organized the Macbeth Gallery exhibition independently. This provided a venue for him and his peers to show their work without a jury's intervention and generated publicity, attendance, and sales.

Robert Henri (1865–1929)

Before moving to New York in 1900, Henri, a native Nebraskan, studied and taught in Philadelphia and took two trips to Europe. His exposure in Europe to the work of the seventeenth-century painters Frans Hals and Diego Velázquez and Édouard Manet's early work (see Figures 1.13 and 14) inspired Henri to develop a realist **style** modeled on theirs. Using a somber **palette** and quick, bold brushstrokes, Henri painted portraits showing their subjects directly conf[ronting] the viewer, brightly lit against dark **backgrounds**. H[e] made commissioned portraits but rather depicted frie[nds,] people he encountered in his daily life and travels—s[...] admiringly called "'my people,' whoever they may b[e,] ever they may exist, the people through whom dignit[y] is manifest."[1]

As an expression of his democratic ideals, Henri [painted] sitters of different ages, classes, races, and ethnicities. [...] the fresh-faced *Eva Green* (1907, Figure 10.1), the f[...] year-old African American daughter of his art-stu[dent's] tor. Painted at a time in US history when Black peo[ple were] both socially marginalized and granted little visi[bility in] art, this vivacious image affirms its subject's huma[n] potential.

George Bellows (1882–1925)

While Henri specialized in portraits, other Ashca[n] artists pictured the bustling metropolis's crowde[d] parks and docks, bars, restaurants, and entertainme[nt.] These artists, some of whom had worked as newspa[per illus-] trators, used rapid strokes to convey the sketch-like [...] an immediately recorded impression. Among the b[est-known] Ashcan School images are the boxing paintings, dra[wings]

FIGURE 10.1 Robert Henri, *Eva Green*, 1907. Oil on [canvas,] 51.44 cm. Wichita Art Museum, Kansas.

Skeaping, she learned the traditional Italian technique of marble carving in Rome in 1925. Through the early 1930s, Hepworth carved small, compact figures in wood and stone. They reflect her commitment to direct carving and her interest, shared with Moore, in African and ancient Egyptian, Sumerian, and Cycladic art. In the mid-1930s, Hepworth produced biomorphic abstractions on the theme of maternity (e.g., *Mother and Child*, 1934), a subject with personal significance: she had a son with Skeaping in 1929 and, after divorcing him, bore triplets in 1934, fathered by the painter Ben Nicholson, whom she would marry in 1938.

In the 1930s, Hepworth made several trips with Nicholson to France where she met Picasso, Braque, Brancusi, Arp, Taeuber-Arp, Calder, Kandinsky, and Mondrian. In 1933, she and Nicholson joined the Paris-based Abstraction-Création group, principally dedicated to geometric abstraction and **Constructivism**. The next year they joined Unit One. Hepworth moved away from figuration in the second half of the 1930s, carving simple compositions of smooth, precise, elegant geometric forms (e.g., *Three Forms*,1935), "absorbed in the relationships in space, in size and texture and weight, as well as the tensions between forms."[27]

In 1939, Hepworth and her family moved to Cornwall on England's southwest coast, where she would spend the rest of her life. There, in the mid-1940s, she created some her most innovative sculptures: smoothly finished, convex masses of carved wood with hollowed out and painted interiors, relating to the landscape around her home. *Pelagos* (1946, Figure 9.16), meaning "the open sea" in Greek, was inspired by the view

from her house overlooking St. Ives Bay. Hepworth cut out the interior of the wood to form two spiraling extensions evoking waves, seashells, and the arms of land embracing the bay. She painted the interior pale blue (later repainted white) and connected the arms' ends through seven taut lines of string. "I used color and strings in many of the carvings of this time," wrote the artist. "The color in the concavities plunged me into the depth of water, caves, or shadows deeper than the carved concavities themselves. The strings were the tension I felt between myself, the wind or the hills."[28]

Hepworth also recalled how the view of the enclosed bay inspired in her a sense of "containment and security"[29] and the interior space of *Pelagos* has been interpreted as inviting and womblike—a metaphor of comfort for a country recovering from the traumatic World War.

Ben Nicholson (1894–1982)

England's leading modernist painter of the interwar decades, Ben Nicholson was the son of the prominent portrait painter Sir William Nicholson. He studied briefly at the Slade School of Art (1910–11) but devoted himself seriously to painting only after his 1920 marriage to fellow artist Winifred Roberts. During the 1920s, he painted landscapes and still lifes characterized by simple drawing, loose paint handling, and delicate tonal relationships. The influence of Synthetic Cubism entered his work in the early 1930s, soon supplanted by that of Mondrian, whose Paris studio he visited in 1934. The Dutch artist's Neo-plasticism inspired Nicholson's most original and admired works: shallow wood **reliefs**, two or

FIGURE 9.16 Barbara Hepworth, *Pelagos*, 1946. Elm and strings on oak base, 43.0 x 46.0 x 38.5 cm. Tate, London.

three layers deep, composed of rectilinear planes with a few large circular or rectangular openings cut out of the top layer. He painted them a uniform white to achieve a quality of purity (e.g., *1935 [white relief]*, 1935). With their austere geometries and plain white surfaces, Nicholson's reliefs were considered ideal décor for the stripped-down interiors of **International Style** architecture (see Chapter 17). They were his main contribution to the international Constructivist movement of the 1930s, which sought to unify modernist painting, sculpture, architecture, and design, animated by the utopian vision of a world in which geometric abstraction would be a universal language promoting social harmony. A key document of this vision was the 1937 publication, *Circle: International Survey of Constructive Art*, co-edited by Nicholson, architect J. L. Martin, and Naum Gabo (see Chapter 6), resident in England between 1936 and 1946. After moving to Cornwall with Hepworth in 1939, Nicholson returned to landscape and still-life painting. His efforts in the latter genre (e.g., *1945 [still life]*, 1945), intricate, highly abstracted compositions with crisp drawing and a generally muted palette accented by hard-edged planes of bright color, are a distinctive contribution to late Cubism.

Modern Art in the United States, Canada, and Latin America, c. 1900–1945

This chapter surveys modern painting, sculpture, and photography in the United States, Canada, and Latin America from the early twentieth century to World War II, emphasizing artistic developments in the United States as it became a major world power. The United States expanded through imperialism in the 1890s, annexing Hawaii and acquiring the Philippines, Guam, and Puerto Rico by winning the Spanish-American War (1898). Immigration to the country, especially its urban areas, surged in the late nineteenth and early twentieth centuries. Though many of these immigrants provided labor for the growing industrial economy, they lived and toiled in poor conditions. The concentration of wealth in the hands of bankers and industrial monopolies led President Theodore Roosevelt and his successors to pursue reforms to rein in corporate power in the Progressive Era (c. 1890–1917).

During this era, US audiences were introduced to European modernism on a large scale at the 1913 Armory Show, officially titled the *International Exhibition of Modern Art*, shown first in New York City and in a reduced version in Chicago and Boston. Many visitors were baffled or scandalized by the abstraction seen in works by Matisse, Picasso, Braque, Picabia, Duchamp, Léger, Brancusi, and Kandinsky, which elicited derision from the popular press. However, the Armory Show excited some adventuresome American collectors and stimulated a new market for modern art in the United States. Alongside the participating Europeans, the Armory Show also featured work by modern New York artists who formed two distinct constellations, one around the urban realism of painter Robert Henri's Ashcan School and the other around the abstraction of photographer Alfred Stieglitz, owner of the 291 Gallery.

The United States entered World War I in 1917 and contributed crucially to the Allied victory the next year. Thereafter, the nation entered an isolationist period that continued until World War II. During the Roaring Twenties, Americans enjoyed great economic prosperity. This ended suddenly following the October 1929 stock market crash, which ushered in the Great Depression and its massive unemployment. President Franklin D. Roosevelt, elected in 1933, responded with a variety of New Deal programs designed to provide economic relief, including to artists: the Federal Art Project of the Works Progress Administration (FAP/WPA, 1935–43) gave full-time employment to about ten thousand artists whose creations became government property. The US economy only recovered following the country's 1941 entry into World War II.

In this interwar period, many US artists continued to work in both realist and abstract styles following the lead of the Ashcan School and the Armory Show's avant-garde pioneers. The Precisionists, like Charles Sheeler, found a middle ground between these two positions with their streamlined images of industrial and architectural subjects. Artists of the Harlem Renaissance, an explosion of African American creativity, depicted their everyday lives and responded to continued racial injustice and segregation, as in Aaron Douglas's work. The 1930s American Scene painting movement comprised both Midwestern Regionalists, like Thomas Hart Benton, who depicted rural life in largely positive terms, and the more critical Social Realists, like Ben Shahn, who largely focused on urban subjects and used their art to fight social and economic injustice.

Still there were those who worked in abstract or purely nonobjective styles in the interwar period, like Alexander Calder and Stuart Davis.

Concurrently, artists experimented with modernism in Canada and Latin America. Canadian artists sought to create a modern art that reflected their country's national identity rooted in its land. Latin American artists also aspired to express national pride, while exploring new aesthetic languages shaped by both European modernist and native sources. Examples of modern architecture in the United States and Latin America are considered in Chapter 17.

Modern Realism in New York: The Ashcan School

The capital of the early twentieth-century American art world, New York attracted ambitious young artists seeking formal training, to exhibit and sell their work in the city's commercial galleries, and to gain reviews in its newspapers and art magazines.

Painter Robert Henri and his colleagues formed the metropolis's first modern art movement, the **Ashcan School**—so called because they depicted New York's gritty realities. An influential teacher, Henri rebelled against the genteel constraints of official art world taste and urged artists to celebrate the vitality of everyday American life. He captured public attention in 1908 when he and seven colleagues exhibited together as "The Eight" at New York's Macbeth Gallery. The other artists were Arthur B. Davies, William Glackens, Ernest Lawson, George Luks, Maurice Prendergast, Everett Shinn, and John Sloan; Glackens, Henri, Luks, Shinn, and Sloan formed the nucleus of the Ashcan School. The exhibition challenged the authority of the conservative National Academy of Design, whose jury (of which Henri was a member) had rejected several canvases submitted by Henri's students and colleagues in 1907. Taking his cue from earlier groups such as the French **Impressionists**, Henri organized the Macbeth Gallery exhibition independently. This provided a venue for him and his peers to show their work without a jury's intervention and generated publicity, attendance, and sales.

Robert Henri (1865–1929)

Before moving to New York in 1900, Henri, a native Nebraskan, studied and taught in Philadelphia and took two trips to Europe. His exposure in Europe to the work of the seventeenth-century painters Frans Hals and Diego Velázquez and Édouard Manet's early work (see Figures 1.13 and 14) inspired Henri to develop a realist **style** modeled on theirs. Using a somber **palette** and quick, bold brushstrokes, Henri painted portraits showing their subjects directly confronting the viewer, brightly lit against dark **backgrounds**. He rarely made commissioned portraits but rather depicted friends and people he encountered in his daily life and travels—sitters he admiringly called "'my people,' whoever they may be, wherever they may exist, the people through whom dignity of life is manifest."[1]

As an expression of his democratic ideals, Henri painted sitters of different ages, classes, races, and ethnicities. One was the fresh-faced *Eva Green* (1907, Figure 10.1), the fourteen-year-old African American daughter of his art-studio janitor. Painted at a time in US history when Black people were both socially marginalized and granted little visibility in art, this vivacious image affirms its subject's humanity and potential.

George Bellows (1882–1925)

While Henri specialized in portraits, other Ashcan School artists pictured the bustling metropolis's crowded streets, parks and docks, bars, restaurants, and entertainment venues. These artists, some of whom had worked as newspaper illustrators, used rapid strokes to convey the sketch-like quality of an immediately recorded impression. Among the best-known Ashcan School images are the boxing paintings, drawings, and

FIGURE 10.1 Robert Henri, *Eva Green*, 1907. Oil on canvas, 61.28 x 51.44 cm. Wichita Art Museum, Kansas.

prints of George Bellows. This athletic Ohioan turned down an offer to play professional baseball for the Cincinnati Reds to instead study art in New York under Henri. In *Stag at Sharkey's* (1909, Figure 10.2), Bellows depicts two lean white boxers in head-to-head combat. The one on the left lunges into his opponent and delivers a right upper cut. The other boxer resists and swings his right arm back to respond with his own blow. A referee with blurred features closely monitors the fight while a crowd of spectators eagerly observes the brutal entertainment, which Bellows shockingly described as "two men trying to kill each other."[2]

While the painting seems to have been spontaneously executed, Bellows designed the **composition** carefully to create a sense of geometric order. In plotting his composition, he likely divided the surface of the painting into a grid, with four evenly spaced horizontal divisions and three evenly spaced vertical ones. The vertical through the left upper leg and torso of the right-hand boxer occupies this grid's midline, while the left boxer's back leg and the referee's left arm parallel diagonals drawn from the top center of the painting to either side of the grid's first horizontal line.

Based on personal experience—the baldheaded ringside observer below the referee's left elbow is likely Bellows himself—the painting depicts a bout at Sharkey's Athletic Club, a bar run by ex-boxer Tom Sharkey located across the street from Bellows's studio. Although prizefighting was illegal in New York, a loophole in the law permitted athletic clubs to hold contests between their members; to stage a match, a bar designated its backroom an "athletic club" for the evening and made the fighters club members. Combined with its violence, the illicit nature of Bellows's subject added to its fascination for contemporary viewers as a confrontation with real life's vulgar intensity heedless of polite aesthetic conventions.

FIGURE 10.2 George Bellows, *Stag at Sharkeys*, 1909. Oil on canvas, 92 x 122.6 cm. Cleveland Museum of Art, Ohio.

Art and Reform: Abastenia St. Leger Eberle (1878–1942) and Lewis Hine (1874–1940)

Like her Ashcan School contemporaries, sculptor Abastenia St. Leger Eberle represented everyday urban subjects in her small-scale bronzes. Arriving in New York from Ohio in 1899, she studied at the Art Students League and in 1906 was elected to the National Sculpture Society—a rare honor for a woman at the time. Eberle's best-known sculptures were innocuous depictions of playful street urchins or women engaged in domestic tasks (e.g., *Windy Doorstep*, 1910), but she also made works that confronted social problems, which the Ashcan School artists largely kept out of their paintings. The ideas of Jane Addams and her settlement house movement informed Eberle's commitment to social change. Characteristic of the Progressive Era, settlement houses were urban residential community centers that served poor, largely immigrant populations. Eberle herself lived for several years in a settlement house on New York's Lower East Side.

Eberle's artistic engagement with social ills found pointed expression in her sculptural group *The White Slave* (1913, Figure 10.3). The work indicted the abduction of young white girls for sale into prostitution, a problem that greatly concerned Addams and other social reformers. Eberle's composition juxtaposes a naked, downcast pubescent girl with a fully clothed male auctioneer who gestures to the unseen crowd of bidders. The captive girl's vulnerability is emphasized through her smooth skin, diminutive size, and closed pose, set in contrast to the roughly textured surfaces of the physically larger auctioneer who stands with spread arms and legs. Eberle's sculpture aroused controversy when it was exhibited in the Armory Show due to its sensational depiction of a social menace that some did not wish to see represented in art.

Eberle's contemporary Lewis Hine confronted social problems through documentary photography, declaring that he "wanted to show the things that had to be corrected."[3] Hine studied sociology before he became a photography teacher at New York's progressive Ethical Culture School. In 1908 he became the official photographer of the National Child Labor Committee (NCLC), an organization dedicated to abolishing child labor, a goal only achieved nationally with the Fair Labor Standards Act (1938). Often using subterfuge to gain access to workplaces—posing, for example, as a Bible salesman or fire inspector—Hine supported the NCLC cause by documenting the children who labored for up to twelve hours a day in the often hazardous conditions of textile mills, mines, farms, and factories. In his haunting image of an *Adolescent*

FIGURE 10.3 Abastenia St. Leger Eberle, *The White Slave*, 1913.

Girl, a Spinner, in a Carolina Cotton Mill (1908, Figure 10.4), the worker, who was only twelve years old, stares directly at the camera with an uncertain expression, her dirty right hand resting on a long row of bobbins representing the numbingly repetitive nature of her labor.[4]

Alfred Stieglitz (1864–1946) and the Rise of Abstraction

Alongside Ashcan School realism and its socially committed variety as practiced by Eberle and Hine, a second current in early twentieth-century American art emphasized **abstraction**: the assertion of purely **formal** values over the **illusionistic** depiction of nature that was a hallmark of European **modernism** during the same period (see Chapters 3, 4, and 6). A key promoter of this development was Alfred Stieglitz, a photographer, publisher, and art dealer who ran the 291 Gallery in New York between 1905 and 1917. At 291, Stieglitz mounted the first US exhibitions of European pioneers of modernism

FIGURE 10.4 Lewis Hine, *Adolescent Girl, a Spinner, in a Carolina Cotton Mill*, 1908. Gelatin silver print, 19.2 x 24.2 cm. Princeton University Art Museum, New Jersey.

including Rodin, Matisse, Cézanne, and Picasso, all before the 1913 Armory Show brought them wider attention in the United States. Stieglitz also exhibited the work of many young US modernists, laying the foundation for modernism's eventual cultural triumph won by the **Abstract Expressionists** at mid-century (see Chapter 12).

Born in Hoboken, New Jersey, to German Jewish immigrant parents, Stieglitz studied photography in Germany in the 1880s. After his return to the United States, he served as vice president of the Camera Club of New York and edited its periodical, *Camera Notes*. He tried to make it a vehicle for artistically ambitious photography, rather than the amateur version made possible by the new handheld, roll-film Kodak #1 camera. Frustrated in his efforts, Stieglitz cofounded the Photo-Secession in 1902, so named to ally it to anti-academic movements in Munich, Vienna and Berlin. In 1903, Stieglitz began publishing *Camera Work*, a journal promoting the Photo-Secession, and in 1905, with fellow photographer Edward Steichen, he opened the Little Galleries of the Photo-Secession at 291 Fifth Avenue, later known simply as 291.

Gertrude Käsebier (1852–1934)

The Photo-Secessionists generally worked in a style known as **Pictorialism**, exemplified by a romanticized 1902 portrait of Stieglitz (Figure 10.5) by Gertrude Käsebier, a cofounder of the Photo-Secession. Born Gertrude Stanton in Iowa, she grew up in Colorado before moving in 1864 with her family

to Brooklyn. She married businessman Eduard Käsebier and raised three children before turning to an art career over her husband's objections. After studying painting at the Pratt Institute and photography in Europe, she opened her own portrait studio in 1897 and became, according to Stieglitz, "the leading portrait photographer in the country."[5]

Aspiring to elevate photography to **fine art** status, Käsebier created photographs that emulated the look of paintings in their soft-focus atmospheric effects and narrow **tonal** range achieved through labor-intensive printing processes. Like other Pictorialists, she sometimes hand manipulated her negatives or prints to enhance their aesthetic qualities. In her portrait of Stieglitz, Käsebier added brushstrokes to the background and parts of the sitter's clothing to create **painterly** effects. She also employed a carefully calculated composition, treating Stieglitz's jacket as a dark wedge that points to the sitter's face and eyes, which fix us with the brooding intensity of a prophet—an image that Stieglitz cultivated.

Stieglitz as a Photographer

While Stieglitz often used Pictorialism's soft focus aesthetic in his early work, as in *The Hand of Man* (1902, see Figure I.4), within a few years of cofounding the Photo-Secession he embraced "straight" photography. This approach rejected the artificial manipulation of the photographic image in favor of an uncompromising acceptance of the scene in the world recorded in sharp focus by the camera lens. Stieglitz retrospectively

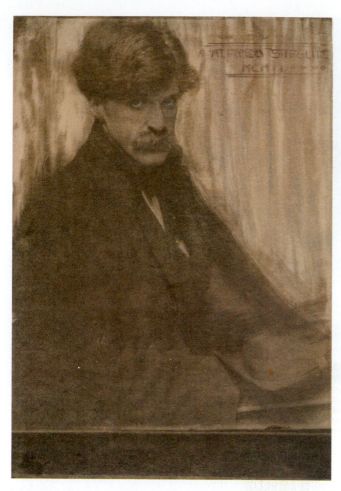

FIGURE 10.5 Gertrude Käsebier, *Alfred Stieglitz*, 1902. Gum platinum print, image: 34.3 x 26 cm. The Museum of Modern Art, New York.

FIGURE 10.6 Alfred Stieglitz, *The Steerage*, 1907. Photogravure, 33.4 x 26.4 cm. The J. Paul Getty Museum, Los Angeles.

identified *The Steerage* (1907, Figure 10.6), made while sailing to Europe, as his breakthrough to straight photography. He took this photograph standing on an upper deck he shared with the other first-class passengers, training his camera on the ship's lower levels occupied by the poorer passengers. While a documentary photographer like Lewis Hine would have been interested in this subject's sociological connotations, Stieglitz found himself fascinated by the scene's formal qualities:

> **A round straw hat, the funnel leaning leftt, the stairway leaning right, the white draw-bridge with its railings made of circular chains—white suspenders crossing on the back of a man in the steerage below, round shapes of iron machinery, a mast cutting into the sky, making a triangular shape. . . . I saw a picture of shapes and underlying that the feeling I had about life.[6]**

The last sentence conveys Stieglitz's essentially **Symbolist** understanding of his photography as both transcribing a subject in nature and expressing an inner emotional state. This view

is close to one Vasily Kandinsky articulated in *Concerning the Spiritual in Art* (see Chapter 3), excerpts of which Stieglitz published in *Camera Work* in 1912.

Stieglitz's Support of American Painters

Believing that painters and sculptors, unlike photographers, could legitimately use non-**naturalistic** means to express their feelings, Stieglitz increasingly featured their art at 291 and in *Camera Work*'s pages. He recognized that the most radical experiments with abstraction were occurring in Europe, and between 1908 and 1911, exhibited works on paper by Rodin, Matisse, Cézanne, and Picasso. At the same time, Stieglitz strongly encouraged American modernism's development by giving shows, and sometimes financial support, to young US artists experimenting with abstraction—not to create a movement, but to celebrate each artist as a uniquely creative individual.

Most of the American artists who showed at 291 had encountered the latest developments in Parisian modernism during stays in the French capital. They included Alfred Maurer, perhaps the first American to work in a **Fauvist** style, and Max Weber, one of the earliest US artists to experiment with **Cubism**. Other painters with European experience who showed at 291 were Arthur Dove, John Marin, and Marsden Hartley. These three along with Georgia O'Keeffe were the

painters to whom Stieglitz felt most personally connected. He continued to show the work of all four at his later New York galleries, The Intimate Gallery (1925–29), and An American Place (1929–46).

Arthur Dove (1880–1946) and John Marin (1870–1953)

Arthur Dove and John Marin both based their art on the observation of nature, which they abstracted for personally expressive ends. After a 1907–08 stay in Paris, painting **still lifes** revealing the impact of Cézanne and Matisse (e.g., *The Lobster*, 1908), Dove settled on a chicken farm in Westport, Connecticut. There he produced an innovative series of abstract **pastels** known as *The Ten Commandments*, exhibited at 291 in 1912. In them, Dove sought not to describe nature objectively but to evoke its vital essence. In Dove's *Nature Symbolized No. 2* (c. 1911), originally entitled *Wind on a Hillside*, repeated green sawtooth shapes resembling blades of grass enter from the lower left and upper right while darker comma-like shapes suggesting germinating seeds tumble amidst swelling light green masses. Small patches of light blue in the **background** conjure a distant sky. Dove continued to make nature-inspired abstractions for the rest of his career.

Marin made Whistler-inspired etchings and Cézanne-inspired **watercolors** in Paris between 1905 and 1909. Returning to his native New Jersey, he was enthralled by nearby Manhattan's bustling activity and took the Woolworth Building— the world's tallest upon its completion in 1913—as his symbol of the dynamic modern city. In his 1912 watercolor, *Woolworth Building, No. 31*, the pale, soaring skyscraper seems to shudder with excitement above the jumble of sketchily rendered buildings, trees, and traffic below. Brisk strokes of watercolor in the sky energize the scene. Marin's fragmentation of solid forms demonstrates his assimilation of Cubism, while his celebration of urban modernity resonates with the **Futurists**' aims. He responded to the natural world with equal excitement, rendering watercolor scenes of the Atlantic Coast that vibrate with the same kind of visual energy (e.g., *Sunset, Maine Coast*, 1919).

Marsden Hartley (1877–1943)

Marsden Hartley painted color-drenched landscapes of his native Maine in a robust **Neo-Impressionist** style (e.g., *Hall of the Mountain King*, 1908–09) before traveling to Paris in 1912 with Stieglitz's financial backing. He spent much of 1913–15 in Germany, meeting members of the Blaue Reiter group in Munich and living in Berlin, a cosmopolitan city where he felt comfortable due to its relative tolerance of homosexuality. Hartley relished the military pageantry of Kaiser Wilhelm II's imperial capital, which he celebrated in paintings featuring simplified, decoratively arranged images of cavalry soldiers and landscape and symbolic elements (e.g., *The Warriors*, 1913).

Hartley's delight turned to tragedy when World War I claimed the life of his close friend and possible lover, Lieutenant Karl von Freyburg, in October 1914. Hartley responded with his *War Motif* series, the most famous of which, *Portrait of a German Officer* (1914, Figure 10.7), symbolically portrays the fallen Freyburg. The painting's tightly knit, rigidly frontal arrangement of boldly colored shapes and patterns is filled with numerals, letters, and motifs referencing Freyburg. These include his initials (Kv.F), his age (24), his regiment number (4), epaulettes, helmet cockades, a spur, and the Iron Cross he was awarded the day before he died. The cursive *E* may refer to Hartley, whose given name was Edmund. Even the geometric patterns carry meaning: the blue and white diamonds come from the flag of Bavaria, the black and white stripes, from the flag of Prussia. The red, white, and black banner at lower center is the flag of

FIGURE 10.7 Marsden Hartley, *Portrait of a German Officer*, 1914. Oil on canvas, 173.4 x 105.1 cm. The Metropolitan Museum of Art, New York.

the German Empire, shown inverted. The chessboards evoke von Freyburg's favorite game.

In formal terms, Hartley's picture combines **Synthetic Cubism**'s flattened, overlapping planes with the coarse **brushwork** and brilliant palette of Kandinsky and German **Expressionism**. The black background surrounding the colors heightens their intensity while imparting a funereal undertone. By creating an abstract, symbolic portrait of Freyburg, Hartley hid his feelings for the man he loved at a time when homosexuality was criminalized in Germany and the United States.

Georgia O'Keeffe (1887–1986)

Alfred Stieglitz discovered Georgia O'Keeffe's innovative charcoal and watercolor abstractions in 1916 and exhibited them at 291 the next year. After O'Keeffe moved to New York in 1918, Stieglitz left his wife for her and they were married in 1924, passing their winters in New York City and their summers in upstate New York. From 1929 on, however, O'Keeffe spent most of her summers in New Mexico without Stieglitz, exemplifying the lifestyle of the liberated "New Woman" insistent on her independence and the importance of her career.

A Wisconsin native, O'Keeffe had studied art in Chicago, New York, and Charlottesville, Virginia. Her most influential teacher, Arthur Wesley Dow, embraced Japanese aesthetic principles and emphasized the formal elements of design over the imitation of nature. O'Keeffe recalled that Dow "had one dominating idea: to fill space in a beautiful way."[7] O'Keeffe realized this same goal in the famous images of enlarged flowers she began painting in 1924. These include the voluptuous *Red Canna* (1925–28, Figure 10.8), whose undulating, subtly **modeled** pink, red, orange, and yellow forms spread to the borders of the canvas and can be imagined to extend beyond it, suggesting irrepressible organic growth.

O'Keeffe magnified her flowers to grant them greater compositional presence and emotional force after realizing that their fragile beauty as rendered in traditional still lifes could go unnoticed amid the modern city's obsession with size, speed, and mechanical power. "Nobody sees a flower—really," wrote O'Keeffe in 1939, "it is so small—we haven't time—and to see takes time like to have a friend takes time. So I said to myself—I'll paint it big and they will be surprised into taking time to look at it—I will make even busy New Yorkers take time to see what I see of flowers."[8]

From the moment of their first exhibition in 1925, O'Keeffe's flower paintings have been read as metaphors for human sexuality, irritating the artist, who denied this intention despite the paintings' undeniable suggestions of vulval or phallic imagery. O'Keeffe instead wished these paintings to be appreciated as celebrating nature's primal life forces. Alongside flowers, she also painted New York skyscrapers in the 1920s, often seen from street level as in *The Shelton with Sunspots* (1926), in which

FIGURE 10.8 Georgia O'Keeffe, *Red Canna*, 1925–28. Oil on canvas mounted on masonite, 73.7 x 45.7 cm. University of Arizona Museum of Art, Tucson.

O'Keeffe abstracts the soaring building into an assembly of dark planar masses eaten away near the top by the glaring sun and surrounded by floating bright circular sunspots and wavy lines of smoke and steam, conjuring an ecstatic vision. From 1929 onward, O'Keeffe concentrated on New Mexico subjects, often depicting cow skulls as a symbol of the desert and of American identity (e.g., *Cow Skull: Red, White, and Blue*, 1931).

Modernist Photography in California: Edward Weston (1886–1958) and Group f.64

Parallels to O'Keeffe's enlarged images of flowers are found in the work of American modernist photographers of the same period who made aesthetically refined close-up studies of isolated objects, both natural and manufactured. Exemplary of such work is *Pepper No. 30* (1930, Figure 10.9) by Edward Weston, a California photographer who worked in a Pictorialist style before adopting straight photography in the early 1920s. Seeking to record his subjects "at the moment of deepest perception,"[9] Weston practiced what he called previsualization: using a large-format view camera, he envisioned the ideal

FIGURE 10.9 Edward Weston, *Pepper No. 30*, 1930. Gelatin silver print, 24 x 19 cm. The Museum of Modern Art, New York.

finished print on the ground glass (a pane of glass giving an image of the scene as focused by the lens) before exposing the negative.

Weston used a six-minute exposure for his photograph of the green pepper, which rests in a tin funnel, bathed in diffused light. Emerging in the print as a monumental and sensuous presence, the pepper's smooth surfaces register a full range of tonal gradations, from deep blacks to luminous highlights, while its sinuous curves and undulating **volumes** evoke those of the human body. Many viewers have detected sexual content in this and other Weston still-life photographs, but the photographer, like O'Keeffe, resisted such erotic readings. Weston insisted that *Pepper No. 30* was "abstract, in that it is completely outside subject matter. . . . This new pepper takes one beyond the world we know in the conscious mind."[10]

Weston was a charter member of Group f.64, a loosely knit group of modernist photographers who exhibited together in San Francisco in 1932. Dedicated to creating crisply detailed images, their name referred to a large-format view camera's smallest aperture setting, which provided the greatest depth of field and allowed both **foreground** and background to be in sharp focus. Other Group f.64 members included Ansel Adams, famous for his stunning images of Yosemite National Park (e.g., *Monolith, the Face of Half Dome, Yosemite National*

Park, California, 1927), and Imogen Cunningham, whose elegant close-up photographs of flowers (e.g., *Magnolia Blossom, Tower of Jewels*, 1925) have strong affinities with O'Keeffe's paintings of similar subjects.

The Machine Aesthetic and Precisionism

The core artists of the Stieglitz Circle in the 1920s and 1930s took their primary inspiration from nature, even if they occasionally represented the city. During these decades, Stieglitz adopted a cultural nationalist position, arguing that a vital American art would grow out of an organic connection between the artist and the land. Marin embraced the same ideology in declaring: "It is our legitimate hope that our soil will produce the artist."[11]

By contrast, other artists of the period saw modern American urban and industrial architecture, engineering, and machinery as dynamic expressions of the nation's identity and ideal subjects for their paintings, drawings, prints, and photographs. In this, they continued the association of the United States with technology made by European modernists who spent time in New York during World War I, including Duchamp and Picabia (see Chapter 7). The American artists' generally positive view of mechanization as a force that would produce a rational, orderly, and harmonious society also paralleled the attitude of the Russian **Constructivists** and French **Purists** (see Chapters 6, 9). Emulating the clean, precise, geometric aesthetics of the machine, these US painters of urban and industrial subjects employed a style of simplified forms, hard edges, clear colors, and smooth brushwork that critics labeled **Precisionism**.

Charles Demuth (1883–1935)

An icon of Precisionism is Charles Demuth's *My Egypt* (1927, Figure 10.10), a heroic image of the steel-and-concrete grain elevator of the John W. Eshelman & Sons' Feed Mills, built in 1919 in the artist's native Lancaster, Pennsylvania. Viewed frontally from a low vantage point, the building's twin silos, walls, windows, and curving smokestacks rise above roof sheds and stand against a blue-and-white sky. Intersecting diagonal shafts of atmospheric color, likely adapted from Futurist paintings' "force lines," rake across the composition. Most of these shafts descend from above like heavenly illumination, exalting the grain elevator and evoking the decade's metaphoric equation between industry and religion. This was most famously expressed by future US president Calvin Coolidge: "The man who builds a factory builds a temple. The man who works there worships there."[12]

FIGURE 10.10 Charles Demuth, *My Egypt*, 1927. Oil on canvas, 91.3 x 76.2 cm. Whitney Museum of American Art, New York.

Demuth's title—linking a modern American **vernacular** structure to ancient Egypt—is both witty and apt. In the same decade that Demuth painted *My Egypt*, the Swiss-French modernist architect Le Corbusier published photographs in *Toward an Architecture* (see Chapter 17) of American grain elevators, which he claimed embodied the same "great primary forms" as the Great Pyramids and Temple of Luxor.[13] A different association between the pyramids and grain elevators dates to the European Middle Ages, when many believed that the pyramids were hollow granaries erected by the Old Testament hero Joseph, the pharaoh's servant who stored up grain against a coming famine. Actually built as solid tombs intended to ensure the pharaohs' survival in the afterlife, the Egyptian pyramids symbolize immortality. This function and symbolism may have been the most meaningful to Demuth, who suffered from diabetes and was acutely aware of his own impending death. In calling the image of his hometown grain elevator *My Egypt*, Demuth appropriated that structure imaginatively as his own tomb and made his bid for artistic immortality.[14]

Charles Sheeler (1883–1965)

Charles Sheeler's 1927 series of black-and-white photographs of the Ford Motor Company's massive new River Rouge plant in Dearborn, Michigan, exemplifies the Precisionist aesthetic in photography. Trained as a painter in his native Philadelphia

before moving to New York, Sheeler supported himself largely through commercial photography from the early 1920s through the early 1930s, while continuing to make and exhibit paintings and drawings, which he often based on his photographs. The Ford commission, from an advertising agency, called on Sheeler to produce photographs to "appear in various magazines and . . . [to] serve as a creative interpreter of American Industry."[15] In *Criss-Crossed Conveyors, River Rouge Plant, Ford Motor Company* (1927, Figure 10.11), Sheeler fashioned a dramatic geometric composition by carefully cropping the view of the diagonally descending rectangular coke conveyors set against the rising cylinders of water tanks and the smokestacks of the background power plant. A stirring tribute to American industry's productive power, Sheeler's photograph was published in the February 1928 issue of *Vanity Fair* with the caption, "By Their Works Ye Shall Know Them"—a reference to a saying of Jesus ("by their fruits ye shall know them"; Matthew 7:20)—again positioning American industry as a new religion.

A few years after completing the Ford commission, Sheeler made several paintings based on his River Rouge plant photographs, executed in a crisp style emulating his camera's sharp focus. One of these paintings, an orderly, panoramic view of

FIGURE 10.11 Charles Sheeler, *Criss-Crossed Conveyors, River Rouge Plant, Ford Motor Company*, 1927. Gelatin silver print, 23.5 x 18.8 cm. The Metropolitan Museum of Art, New York.

the Rouge's boat slip and cement plant, Sheeler called *American Landscape* (1930). The deadpan title intimates that the factory has replaced the mountains and forests, glorified by nineteenth-century US landscape painters, as an emblem of national pride and identity.

The Harlem Renaissance

The 1920s and 1930s witnessed a blossoming of African American culture that encompassed literature, theater, the visual arts, and music, known as the Harlem Renaissance. While its epicenter was Harlem—the section of northern Manhattan with the country's largest urban African American population—Black creativity also flourished in other US cities, Paris, and the Caribbean. This cultural efflorescence occurred as the African American population of Northeastern and Midwestern cities swelled after World War I due to the Great Migration: the mass exodus of Black people fleeing discrimination and poor economic conditions in the largely agricultural South to seek greater social freedom and financial opportunity in the industrial North.

Their cause was promoted by the National Association for the Advancement of Colored People (NAACP, founded 1909), the National Urban League (founded 1911), and their respective journals, *The Crisis* and *Opportunity*. These organizations also supported the New Negro movement, which encouraged African American racial pride and political engagement. W. E. B. Du Bois, NAACP cofounder and editor of *The Crisis*, laid important foundations for the New Negro movement through his writings advocating social and political rights for African Americans. Alain Locke, a philosophy professor at Howard University, argued that African Americans' aesthetic achievements were equally important to advancing their cause. In March 1925, Locke edited a widely read issue of the literary journal *Survey Graphic* entitled *Harlem: Mecca of the New Negro*, focused on Harlem as the stage for a "dramatic flowering of a new race-spirit."[16] Promoting a distinctive racial sensibility in African American art, Locke's essay "The Legacy of the Ancestral Arts" called on Black artists to draw aesthetic inspiration from traditional African art rather than white European or US models.[17] Since white modernists like Picasso had already based their formal innovations on African art, Locke's charge offered Black artists the possibility of both reclaiming their racial inheritance and contributing to the mainstream of modernism.

Aaron Douglas (1899–1979)

The "New Negro" issue of *Survey Graphic* drew the painter Aaron Douglas from Kansas City, Missouri, to Harlem in 1925, where he quickly became friendly with Locke, Du Bois,

and other Black writers. Under the tutelage of Locke's friend Winold Reiss, a white graphic artist from Germany, Douglas developed a boldly abstracted style influenced by African art, Cubism, and **Art Deco**. Deluged with commissions for **graphic art**, he designed numerous playbill and magazine covers (for *The Crisis*, *Opportunity*, *Vanity Fair*, and others) and illustrations for books by New Negro authors Countee Cullen, Langston Hughes, James Weldon Johnson, and Claude McKay.

Douglas's painting style featured schematic, silhouetted figures shown in profile with the eye rendered frontally as in ancient Egyptian **reliefs** and **frescoes**. He limited his palette to a few **hues** varying in **value** from light to dark and he highlighted key compositional elements through concentric bands of color that suggest radiating sound or spiritual energy.

All these features are present in *Song of the Towers* (Figure 10.12), the last of four panels from the series *Aspects of Negro Life*, which Douglas painted in 1934 for the 135th Street Branch of the New York Public Library, sponsored by the Public Works of Art Project, a New Deal relief program. Meant to give his Black viewers a greater sense of their place in history and some perspective on their difficulties in the Depression, Douglas's series traced African American history from its origins in African tribal life through the eras of slavery, emancipation, and Reconstruction in the South. The culminating composition, *Song of the Towers*, is set in a **stylized**, contemporary New York City, filled with banks of soaring skyscrapers.

FIGURE 10.12 Aaron Douglas, *Song of the Towers*, from *Aspects of Negro Life*, 1934. Oil on canvas, 274.3 x 274.3 cm. Schomburg Center for Research in Black Culture, New York Public Library, New York.

At the center, a saxophone player stands atop a giant cog emblematic of the Machine Age. Embodying the quintessentially Black art form of jazz music, he raises his horn and gestures toward the Statue of Liberty—a symbol resonating with the African American quest for freedom. The optimism of the musician's heroic image is tempered, however, by two other symbolic figures: a fallen man at the lower left, embodying the despair of the Depression, and a running, valise-carrying man at the lower right, signifying the Great Migration. Both men are menaced by giant, skeletal white hands, indicating the persistent scourge of racism.

James Van Der Zee (1886–1983)

Photographer James Van Der Zee made his living as a portraitist of Harlem's middle- and upper-class African American residents, including many Harlem Renaissance celebrities such as poet Countee Cullen, dancer Bill "Bojangles" Robinson, and Marcus Garvey, the Black-nationalist leader of the Universal Negro Improvement Association (UNIA). Largely self-taught in photography, Van Der Zee moved to Harlem from Massachusetts in 1905, set up a portrait studio in the 1910s, and enjoyed his peak professional success during the Harlem Renaissance. His famous photograph, *Couple Wearing Raccoon Coats with a Cadillac, Taken on West 127th Street, Harlem, New York* (1932, Figure 10.13), depicts the ideal New Negro man and woman: prosperous, fashionable, and confident.

Augusta Savage (1892–1962)

A leading Harlem Renaissance sculptor, Augusta Savage moved to Harlem from her native Florida in 1921. She studied sculpture in Harlem and subsequently in Paris in the early 1930s on a fellowship from the Rosenwald Fund, a philanthropy established by the Sears, Roebuck and Company's white chairman, Julius Rosenwald. After her return, Savage opened the Harlem Art Workshop (1933) with financing from the Works Progress Administration. Three years later, also with WPA funding, Savage established the Harlem Community Art Center (1937), which provided art education to thousands of young African Americans.

Savage was the only African American artist given a commission for the 1939 New York World's Fair. The work she produced, *The Harp (Lift Every Voice and Sing)* (Figure 10.14), was inspired by the 1899 song identified in its subtitle, often called the "Black national anthem." Prominently displayed in the courtyard of the Contemporary Arts building, Savage's sculpture used naturalistically modeled anthropomorphic imagery to comprise a 16-foot-tall harp. Twelve singing heads atop columnar bodies formed the strings; the extended arm and open hand of God formed the sound board; and a kneeling male figure holding a plaque with musical notations formed the foot pedal. *The Harp* won the fair's silver medal, but unfortunately Savage lacked the funds to store or permanently cast the black-painted plaster and it was bulldozed at the close

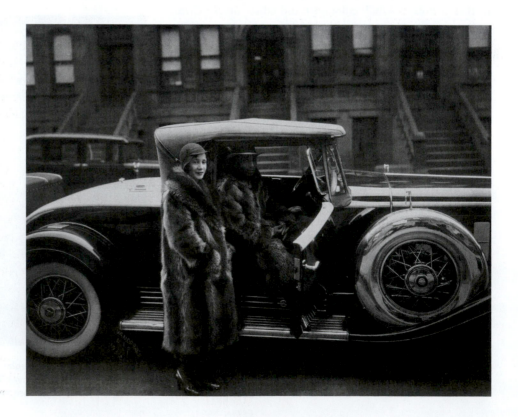

FIGURE 10.13 James Van Der Zee, *Couple Wearing Raccoon Coats with a Cadillac, Taken on West 127th Street, Harlem, New York*, 1932. Gelatin silver print, 19 x 23.7 cm. The Metropolitan Museum of Art, New York.

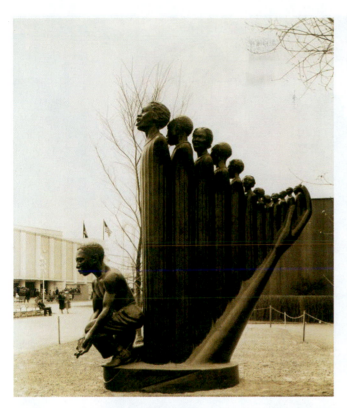

FIGURE 10.14 Augusta Savage, *The Harp (Lift Every Voice and Sing)*, 1939.

of the fair. Its imagery survived, however, in metal miniatures sold as souvenirs.

Jacob Lawrence (1917–2000)

Savage's student, and the most famous African American painter of his generation, Jacob Lawrence made his reputation in the late 1930s and early 1940s through several series of narrative paintings depicting Black history and its heroes. Seeking a vivid means of visual communication, he executed them in a bold abstracted style of bright colors and flat, simplified shapes reflecting the influence of Cubism as well as African American **folk art**.

With the support of a Rosenwald Fund fellowship, Lawrence created his best-known series, *The Migration of the Negro*, in 1940–41. Its sixty panels, each identical in size and accompanied by a short explanatory text Lawrence wrote in collaboration with his future wife, the artist Gwendolyn Knight, showed scenes from the post–World War I Great Migration of African Americans from the rural South to urban North. This subject was personally meaningful to Lawrence, whose father and mother had left South Carolina and Virginia for his birthplace of Atlantic City, New Jersey. In the first panel (Figure 10.15), a throng of southern Black people stream through portals marked "CHICAGO," "NEW YORK," and "ST. LOUIS" to board trains that will carry them north.

Subsequent panels show the adversities in the South—poverty, crop failures, discrimination, lynching—that had led African Americans to head to the North, where the series indicates they found generally better living and working conditions but still encountered prejudice and violence.

Picturing the American Scene

Images of modern Black life such as Van Der Zee's and Lawrence's show interwar US artists' strong interest in the daily activities of their fellow citizens. While Lawrence worked in an abstracted style, many such artists rendered realist images of American life, consciously spurning abstract modernist visual languages of European origin. They did so to communicate clearly with the public in a plainspoken idiom that many critics saw as forthrightly American. Their work can be considered under the broad umbrella term of the **American Scene**.

Many American Scene painters belonged to one of two camps: the **Regionalists**, who pictured rural life, especially in the Midwest; and the **Social Realists**, primarily based in New York City, who during the Great Depression depicted the dispossessed and downtrodden and used their art to promote social and political change. Many significant US figurative artists of the period, such as Reginald Marsh, Isabel Bishop, and Edward Hopper, fall outside these neat categories, however.

Edward Hopper (1882–1967)

New York-based Edward Hopper, who had studied under Henri from 1900 to 1906, supported himself primarily as an illustrator until the mid-1920s when his paintings began to achieve commercial and critical success. Reacting against the storytelling demands of illustration, Hopper represented isolated, uncommunicative individuals in urban environments, and lonely buildings in drab landscapes. Using restrained brushwork, he created simple, solid forms, tightly structured compositions, and strong contrasts of light and shadow.

In Hopper's *Automat* (1927, Figure 10.16), a young white woman in a green coat, yellow cloche hat, and lipstick sits alone at a round marble table with a downcast gaze, fingering the handle of a coffee cup. The setting is an automat, a cafeteria-style restaurant selling food from vending machines. Open twenty-four hours, New York City's automats were typically busy and crowded, but Hopper's is all but deserted. The artist tells us nothing about the thoughts or biography of the anonymous woman (modeled by his wife, Jo), but she clearly does not appear happy or fulfilled. The empty chair opposite her, the cold artificial illumination, and the blackness of the window—reflecting two rows of ceiling lights but denying

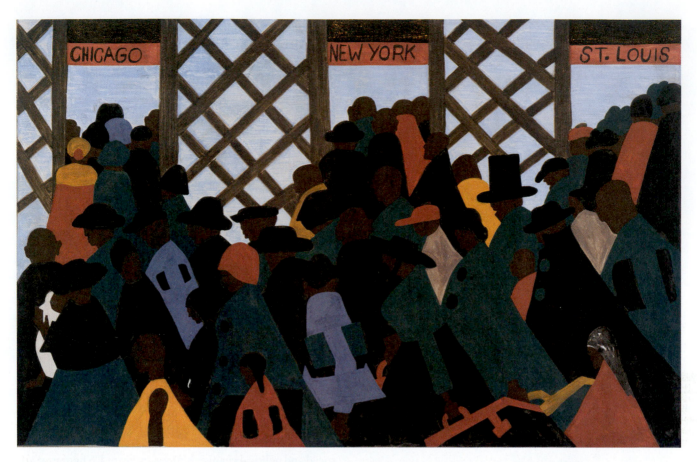

FIGURE 10.15 Jacob Lawrence, *The Migration of the Negro, Panel 1: During the World War there was a Great Migration North by Southern Negroes*, 1940–41. Tempera on masonite, 30.5 x 45.7 cm. The Phillips Collection, Washington, DC.

FIGURE 10.16 Edward Hopper, *Automat*, 1927. Oil on canvas, 71.4 x 88.9 cm. Des Moines Art Center, Iowa.

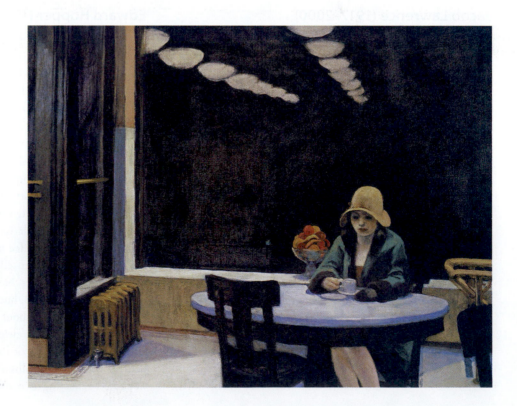

visual access to the city outside—only increase her isolation. As portrayed by Hopper, modern American existence is essentially lonely, static, and mundane.

Thomas Hart Benton (1889–1975)

Taking the opposite view from Hopper, another prominent American Scene painter, Thomas Hart Benton, depicted modern US life as energetic, productive, and filled with social dynamism. This can be seen throughout Benton's ambitious ten-panel mural series *America Today*, painted for the boardroom of New York's New School for Social Research in 1930–31. In addition to two panels representing many of Manhattan's popular entertainments and daily diversions, Benton's cycle offers a sweeping panorama of the nation's productive enterprises, such as cotton farming in the Deep South, logging and wheat harvesting in the Midwest, oil production in the West, and coal mining and steel production in the East.

Another panel, *City Building* (1930–31, Figure 10.17), shows the skyscrapers of Manhattan's southern tip as seen from New York Harbor, where a docked ship and train signal the arrival of building materials. Below them, a bespectacled architect studies a blueprint. In the center and left sections, the city rises through the efforts of powerful male laborers.[18] Prominent among them is an African American drill operator, shown working alongside whites. However, Benton's ideal vision of racial harmony was at odds with the de facto segregation of New York's construction industry in the 1930s.[19]

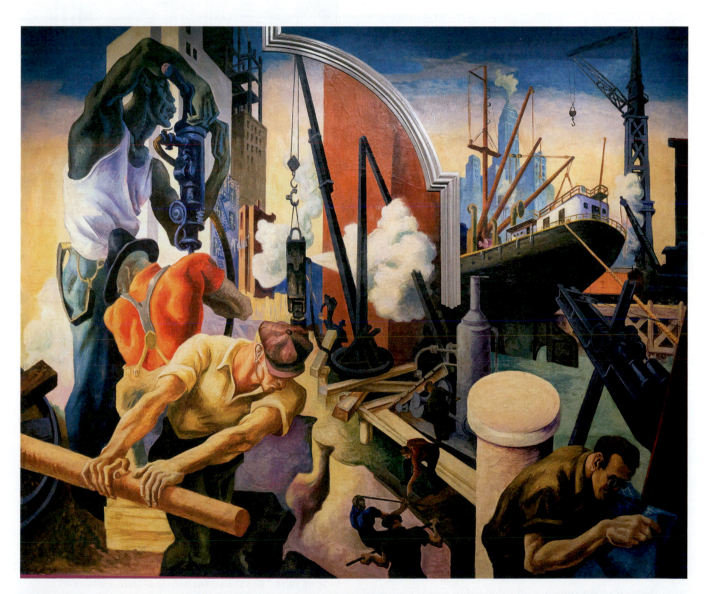

FIGURE 10.17 Thomas Hart Benton, *City Building*, from *America Today*, 1930–31. Egg tempera with oil glazing over Permalba on a gesso ground on linen mounted to wood panels with a honeycomb interior, 233.7 x 297.2 cm. The Metropolitan Museum of Art, New York.

City Building's muscular figures in vigorous poses and its crowded composition's undulating rhythms reveal sixteenth-century European Mannerist painting's influence on Benton's style. Additionally, the dramatic jumps between foreground and background scenes suggest both Cubist spatial fragmentation and the visual effect of cinematic montage. The Missouri-born Benton experimented with Cubist-inspired abstraction after a period of study in Paris (1908–11), when he moved to New York and was for a time associated with the Stieglitz Circle. Benton shifted his artistic focus to the American Scene in the 1920s and based many of *America Today*'s southern, Midwestern, and western images on sketches he made during travels to rural areas of the United States. By 1935, Benton had become disenchanted with the New York art world, which he called "too highly conditioned by borrowed ideas" and announced, "if there is going to be any art in this country . . . it is going to come from . . . regional groups in the Middle West."[20] Returning to his native state, Benton settled in Kansas City and became an outspoken leader of the Midwestern Regionalist movement.

John Steuart Curry (1897–1946) and Grant Wood (1891–1942)

Besides Benton, the two most successful Regionalist painters were the Kansas-born John Steuart Curry and the Iowa-born Grant Wood. Curry, who grew up in Kansas but spent his career in Connecticut and Wisconsin, pictured in a straightforward realist style the rural life and agrarian landscape of his native state. A well-known example is his painting *Baptism in Kansas* (1928), showing an evangelical Christian congregation gathered at a farm where the preacher performs a full-immersion baptism in a wooden livestock-watering trough. Wood gained fame for *American Gothic* (1930), a deadpan depiction of a stony-faced, pitchfork-holding farmer and his unmarried daughter (not a husband and wife, despite the popular understanding of the image), standing in front of their white Carpenter Gothic style Iowa house. Painted in a polished, highly detailed manner emulating that of the fifteenth-century Northern European painters Wood admired, *American Gothic* repudiates modernist aesthetics and culture to celebrate traditional Midwestern values. Although some have seen Wood's depiction of the farm couple as satirical, he intended it as an affectionate tribute to the conservative, hardworking, small-town Iowans with whom he had grown up.

Ben Shahn (1898–1969)

In contrast to the Regionalists' largely affirmative images of Midwestern rural life, the left-leaning Social Realists sought to expose and protest economic, social, and political injustice. They used their art to stir sympathy for those they saw as victims of oppression and to indict the oppressors. Ben Shahn did both in

The Passion of Sacco and Vanzetti (1931–32, Figure 10.18), which commemorates Nicola Sacco and Bartolomeo Vanzetti, two Italian immigrants convicted in 1921 and executed in 1927 for the murder of a shoe company paymaster and his guard in South Braintree, Massachusetts. Despite substantial incriminating evidence, many believed that Sacco and Vanzetti were innocent or had been denied a fair trial because Judge Webster Thayer was biased against them as immigrants, avowed anarchists, and draft evaders. Protests against the conviction in the United States, Europe, and Latin America moved Massachusetts Governor Alvan Fuller to appoint a committee to advise him on the trial's fairness. The committee's head, Harvard's president A. Lawrence Lowell, likely shared Thayer's bias against the defendants: Lowell was vice president of the

FIGURE 10.18 Ben Shahn, *The Passion of Sacco and Vanzetti*, 1931–32. Tempera and gouache on canvas mounted on composition board, 213.4 x 121.9 cm. Whitney Museum of American Art, New York.

Immigration Restriction League, which sought to limit immigration into the United States from Southern and Eastern Europe. Not surprisingly, Lowell and his colleagues, Judge Robert Grant and M.I.T. president Samuel W. Stratton, affirmed the verdict, sending Sacco and Vanzetti to the electric chair.

Among those who protested Sacco and Vanzetti's conviction and execution, Shahn must have identified with them as a left-wing Jewish Lithuanian immigrant who had experienced the discrimination often endured by those outside the White Anglo-Saxon Protestant establishment. Shahn adopted Sacco and Vanzetti's story as an artistic subject when he realized that their case was "something big, like The Crucifixion. Here was something to paint!"[21] Working from press photographs, he produced twenty-three small **gouache** paintings and two large **temperas**, including *The Passion of Sacco and Vanzetti*, whose title casts the executed Italian Americans, shown dead in their open coffins, as Christlike martyrs. The Lowell Committee looms above them, depicted in a quasi-caricatured fashion as insincere mourners. With bitter irony, Shahn gives the top-hatted Grant and Stratton lilies, Christian symbols of innocence and purity, also associated with Christ's resurrection. Above the Lowell Committee, an insubstantial courthouse **façade** bears a framed portrait of Judge Thayer with right hand raised, swearing to uphold the law—which the picture argues he failed to do.

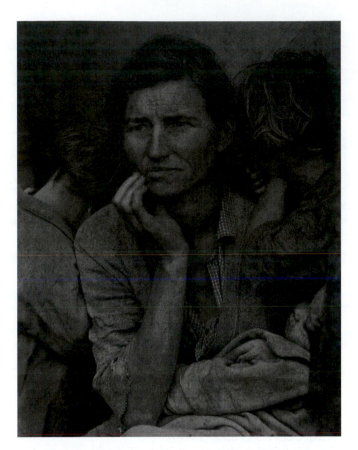

FIGURE 10.19 Dorothea Lange, *Migrant Mother*, 1936, printed 1949. Gelatin silver print, 28.3 x 21.8 cm. The Museum of Modern Art, New York.

Photographers of Rural Poverty: Dorothea Lange (1895–1965) and Walker Evans (1903–1975)

Many indelible images of the Depression's impact on the American people were created by photographers (including Ben Shahn) working for the Resettlement Administration (RA). Established in 1935, this New Deal agency resettled struggling rural families in government-planned communities and public housing; in 1937, it was absorbed into the Department of Agriculture and renamed the Farm Security Administration (FSA). California-based RA photographer Dorothea Lange created an icon of the era's suffering, *Migrant Mother* (1936, Figure 10.19). The title identifies the woman as a migrant agricultural laborer—perhaps one of the multitudes forced by the Dust Bowl in the Southern Plains to travel west seeking crop-picking work, a typical story fictionalized in John Steinbeck's novel *The Grapes of Wrath* (1939). In Lange's photograph, taken in a pea-picker's camp 175 miles north of Los Angeles, two children lean against their mother, their faces averted.

The mother holds a dirty-faced infant in her lap and looks out with a furrowed brow and worried expression accentuated by the hand she places near her mouth. Lange carefully orchestrated the image with her subjects' cooperation (the mother was identified decades later as thirty-two-year-old Florence Thompson, a widowed Cherokee mother of seven from Oklahoma). Lange intended her composition to elicit sympathy and support for official efforts to help people like this mother and her children. It worked: Lange took her photograph to the *San Francisco News*, which publicized the migrants' plight, spurring the federal government to send twenty thousand pounds of food relief for the hungry laborers.

Lange's Eastern colleague, the New York-based photographer Walker Evans, worked for the RA and the FSA from mid-1935 to early 1937. Traveling through the American South with an 8 x 10-inch plate camera, he created clinical, documentary-style images that seemed to distill the essence of American rural and small-town life found in ordinary subjects such as roadside architecture and shop windows. Evans made his best-known photographs in the summer of 1936 when, on hiatus from the RA, he and writer James Agee spent three weeks in Hale County, Alabama, working on an article

about three impoverished tenant farmer families for *Fortune* magazine. After *Fortune* rejected their work, they published it as an unconventional book, *Let Us Now Praise Famous Men* (1941), which features Agee's epic, lyrical, and intensely subjective text preceded by sixty-one of Evans's self-effacing, uncaptioned photographs. His portraits of the tenant farmers and their families posing in or before their humble homes (e.g., *Floyd Burroughs, Hale County, Alabama*, 1936) honor their independence and dignity in the face of hardship.

US Abstraction in the 1930s

While many US artists felt that realist styles were the most appropriate means to respond to the difficulties of the Great Depression, others continued to work in abstract modes. Many of them, including Burgoyne Diller, Ibram Lassaw, Alice Trumbull Mason, and George L. K. Morris, banded together in New York in 1936 as the American Abstract Artists, forging solidarity in the face of public hostility to abstraction, which became increasingly visible in New York with the opening of the Museum of Modern Art (1929) and Solomon R. Guggenheim's Museum of Non-Objective Painting (1939).

Stuart Davis (1892–1964)

A leading abstractionist, Stuart Davis attacked American Scene painting as retrograde and championed abstract art as "a progressive social force" that gave "concrete artistic formulation to the new lights, speeds, and spaces which are uniquely real in our time."[22] The Philadelphia-born Davis studied in New York under Henri between 1909 and 1912 and moved toward abstraction after discovering European modernism at the Armory Show. In the 1920s, he developed a Synthetic Cubist-influenced style that he applied to landscape and still-life subjects, including brand-name American consumer products (e.g., *Odol*, 1924), anticipating 1960s **Pop art**. During the Depression, Davis became politically active. He served as president of the Artists Union, an organization that advocated for artists' rights and the maintenance of federal support; and as an officer of the American Artists Congress, a left-wing group formed in 1936 to oppose the international spread of fascism. Davis also participated in the Federal Art Project (FAP).

The FAP commissioned Davis's ambitious *Swing Landscape* (1938, Figure 10.20), intended as a mural for the Williamsburg Housing Project in Brooklyn, but never installed there. The title refers to "swing" music, a form of jazz that inspired Davis's exuberant painting style. With its riot of bright colors and dense jumble of interwoven, flat shapes and thick lines, *Swing Landscape* induces a sensation of bouncing rhythms and ceaseless motion. Embedded within this matrix are representational elements derived from Davis's studies of the Gloucester, Massachusetts harbor. These are most discernible in the left third of the composition, which features a mast and rigging, a yellow house with a chimney belching red smoke, and two posts.

FIGURE 10.20 Stuart Davis, *Swing Landscape*, 1938. Oil on canvas, 224.8 x 443.9 x 8.9 cm. Eskenazi Museum of Art, Indiana University, Bloomington.

The surrounding blue field signifies water. Despite the absence of people, Davis's harbor is a vibrant precinct filled with life-affirming energy likely meant to counteract the dark mood of the Depression and the threat of fascism, soon to engulf the world in another war.

Alexander Calder (1898–1976)

Although less politically engaged than Davis, Alexander Calder supported the anti-fascist cause by contributing a work to the Spanish Pavilion at the 1937 International Exposition in Paris. The pavilion was sponsored by Spain's Republican government then engaged in a civil war against the Nationalist forces of General Francisco Franco. Installed in front of Pablo Picasso's *Guernica* (see Figure 9.8), Calder's *Mercury Fountain* (1937; Figure 10.21 illustrates a 1:3 scale model) honored the mercury mines in Almadén then being defended by the Republicans. The fountain pumped the liquid metal up from a large basin into a series of elliptical troughs through which it descended to strike a paddle that caused the name of the town, fashioned in brass wire, to vibrate.

The suspended, moving elements of Calder's *Mercury Fountain* exemplify his central contribution to the history of modern art, the **mobile**—a form of **kinetic art** that does not represent motion (as the Futurists sought to do) but actually creates it, freeing sculpture from its traditional stasis to make it dynamic and mutable. The Pennsylvania-born son and grandson of academic sculptors, Calder was trained in painting. He made his first mobiles in Paris, where he had moved in 1926 and made friends with Surrealists like Miró and abstractionists like Mondrian. After making wire sculptures of people and animals in the later 1920s, which he "drew" in three dimensions using wire, he shifted to abstraction following a 1930 visit to Mondrian's studio, where Calder saw rectangles of color tacked to a wall for compositional experimentation and told Mondrian he would like to make them oscillate. Some of Calder's earliest mobiles were hand- or motor-driven structures whose moving elements were painted metal disks or wooden spheres (e.g., *A Universe*, 1934). In the early 1930s, he suspended the moving elements to allow air currents to animate them, introducing chance as a factor in shaping the artwork's ever-changing configurations, and he also employed **biomorphic** shapes that visually resonate with those of Miró and Arp. In the *Mercury Fountain,* however, it is not air currents but variations in the flow of the cascading stream of liquid metal that make the work fascinatingly unpredictable.

Modern Art in Canada

Like the United States, the modern nation of Canada, made a member of the British Commonwealth in 1867, was established by the descendants of white Europeans, who in the seventeenth and eighteenth centuries colonized lands that had been home for millennia to Indigenous peoples. The establishment of the Royal Canadian Academy of Arts in 1880 encouraged the development of art as a profession in the new nation. White Canadian artists of the nineteenth century generally followed European aesthetic models and many studied in Paris in the century's closing decades. In 1907, several of the country's most progressive painters formed the Canadian Art Club, an exhibiting society based in Toronto, Ontario, counting Paris-based James Wilson Morrice as its most prominent member.

FIGURE 10.21 Alexander Calder, *Mercury Fountain* (1:3 scale model), 1937/43. Sheet metal, wood, wire, and paint, 88 x 105.5 x 106 cm. Museo Nacional Centro de Arte Reina Sofía, Madrid, long-term loan from the Calder Foundation, New York, 2008.

Tom Thomson (1877–1917) and the Group of Seven

Tom Thomson and his Toronto colleagues, the Group of Seven, specialized in paintings of the northern Canadian wilderness, which they understood as expressions of a distinctive Canadian national identity, despite their art's stylistic debt to European **Post-Impressionism** and **Art Nouveau**.

Raised on a Western Ontario farm and self-taught in art, Thomson began working in 1909 for a Toronto commercial design firm where he met several future members of the Group of Seven. An avid outdoorsman, Thomson from 1912 onward spent the warm months of each year in Algonquin Park, a large Ontario forest reserve, where he made boldly colorful, rapidly brushed oil sketches on small boards. Some of these sketches served as the basis for large landscape paintings executed in his studio during the winter.

Thomson's most celebrated painting, *The Jack Pine* (1916–17, Figure 10.22), derives from a sketch he made at Grand Lake in Algonquin Park. Dominating the foreground, the hardy tree with its drooping branches forms a vertical element silhouetted against the horizontal bands of the placid lake, glowing sky, and dark blue background hills. The hills' rounded peaks correspond to the curving masses of foliage and the shore's undulating outlines, rhythmically harmonizing foreground and background. The vermillion underpainting provides coloristic unity beneath the surface hues. The rich palette and thick, tactile brushwork align Thomson's painting with Post-Impressionism, while the composition's decorative quality reflects his graphic design experience and knowledge of Art Nouveau. Suffused with a reverential mood suggesting a divine presence in the northern wilderness, *The Jack Pine* is an icon of Canadian art and, for many, a symbol of the nation.

Three years after Thomson's tragic drowning death in an Algonquin Park lake, his colleagues Frank Carmichael, Lawren Harris, A. Y. Jackson, Frank Johnston, Arthur Lismer, J. E.H. MacDonald, and F. H. Varley formed the Group of Seven, an exhibiting society. These artists traveled across Canada in search of stirring wilderness subjects that they rendered in abstracted styles similar to Thomson's. Overcoming initial conservative opposition to their modernist aesthetics, the Group of Seven soon were recognized as the dominant school of Canadian painting.

FIGURE 10.22 Tom Thomson, *The Jack Pine*, 1916–17. Oil on canvas, 127.9 x 139.8 cm. National Gallery of Canada, Ottawa.

Lawren Harris (1885–1970)

The Group of Seven's unofficial leader, Lawren Harris received academic art training in Berlin between 1904 and 1907 before settling in Toronto. He achieved his signature landscape style of grand, open spaces, clear light, and austerely simplified forms after a 1921 trip to the North Shore of Lake Superior, to which he returned three more times in the 1920s.

Harris's *Morning Light, Lake Superior* (c. 1927, Figure 10.23) presents a bird's-eye view of the lake from which emerge two dark, massive islands. The stylized banks of firmly modeled gray and white clouds seem as solid as the rocky islands and shore below. The limpid sunlight illuminating the clouds and reflected by the water suggests spiritual radiance. The imagery's visionary intensity resonates with Harris's belief in Theosophy and his understanding of art as "a realm of life between our mundane world and the world of the spirit"[23] (see "Theosophy" box, Chapter 3). In his search for the universal, Harris ultimately abandoned representation to work in a completely non-objective style after 1934.

Emily Carr (1871–1945)

A Victoria, British Columbia-born painter, Emily Carr studied art in San Francisco and England in the 1890s and early 1900s and was an original member of the British Columbia Society of Art in Vancouver. During a 1907 trip to Alaska, Carr discovered the monumental carved poles of Northwest Coast Native Americans, inspiring her to make a visual record of the West Coast villages' Native art over the next few years. She made several difficult trips to remote Indigenous villages, some inhabited, some deserted, making drawings and watercolors. These served as the basis for paintings she executed in a vibrantly colorful Post-Impressionist style after a 1910–11 sojourn in Paris. A large 1913 Vancouver exhibition of her Native subjects failed commercially. Discouraged, Carr returned to Victoria where for the next fifteen years she ran a boarding house and made little art.

Carr was inspired to resume painting after meeting Harris and other members of the Group of Seven on a 1927 trip east to the National Gallery of Canada in Ottawa, Ontario, where her work was displayed in an exhibition of Native and modern Canadian West Coast art. Under Harris's influence, Carr developed the dark, sculptural style seen in *Big Raven* (1931, Figure 10.24). The painting was based on a 1912 watercolor she made in an abandoned Haida village in the Queen Charlotte Islands where she discovered a raven raised on a pole, the surviving member of a pair that had flanked a mortuary house doorway. Although described in her autobiography as "moss-grown. . . . old and rotting,"[24] the raven in the painting appears powerful and dignified. It rises majestically above a green sea

FIGURE 10.23 Lawren Harris, *Morning Light, Lake Superior,* c. 1927. Oil on canvas, 85.7 x 101.6 cm. University of Guelph Collection at the Art Gallery of Guelph, Canada.

FIGURE 10.24 Emily Carr, *Big Raven,* 1931. Oil on canvas, 87 x 114 cm. Vancouver Art Gallery.

of vegetation, silhouetted against a sky filled with Cubistic shafts of light descending from canopies of dark blue and green clouds. While working on the painting, Carr described in her journal the expressive quality she hoped to convey: "great loneliness . . . and a haunting broodiness, quiet and powerful."[25]

Modern Art in Latin America

Latin America refers to the countries of the Western hemisphere south of the United States in which Latin-based languages (Spanish, Portuguese, and French) are spoken. Europeans brought these languages across the Atlantic beginning in the fifteenth century as they established colonies, employed the colonized Indigenous people for labor, and imported Africans as slaves. The Spanish and Portuguese colonies, except Cuba and Puerto Rico, gained their independence between 1808 and 1826, but their ruling elites continued to follow European models of high culture. Accordingly, during the second half of the nineteenth century, most professional painters in Latin America worked in a European-derived style of academic realism that they applied to portraits, landscapes, and historical subjects. By the turn of the twentieth century, many Latin American artists had adopted styles influenced by **Impressionism**, Symbolism, and Art Nouveau.

Brazil

Latin American modernism driven by an **avant-garde** agenda first emerged in the 1920s. A key event catalyzing modernism's spread in the region was the Week of Modern Art held in São Paolo's municipal theater in 1922, the centenary of Brazil's independence from Portugal. Featuring concerts, lectures, and poetry readings in addition to an exhibition of the most stylistically adventuresome Brazilian art (showing influences from

Cubism, Futurism, and German Expressionism), the Week of Modern Art aimed to disrupt bourgeois complacency and assert Brazilian cultural nationalism.

The poet and critic Oswald de Andrade was particularly committed to building Brazilian cultural identity. His 1924 "Manifesto of Pau-Brasil [Brazilwood] Poetry" called for Brazilians to conceive of their poetry as a native product they could export like the brazilwood timber the Portuguese extracted during the colonial period. Reminding Brazilians of their dual heritage, "the forest and the school"[26] and invoking the population's mixture of European, African, and Indigenous ethnicities, Andrade celebrated Indigenous Brazilian culture's instinctive expressions: "Carnival in Rio is the religious event of our race. . . . [Richard] Wagner is submerged before the carnival lines of Botafogo. Barbarous and ours."[27] In his subsequent "Anthropophagic Manifesto" (1928), Andrade confronted the problem of Brazilian culture's relationship to that of Europe. He proposed that just as Brazilian cannibals had eaten Portuguese explorers, modern Brazilians should devour European culture, ingest it, and produce something strong and new.

Tarsila do Amaral (1886–1973)

The ideas in Andrade's manifestos resonated visually in the work of Tarsila do Amaral, his wife from 1926 to 1930 and the most important Brazilian modernist painter to emerge in the 1920s. The daughter of a wealthy rancher in the province of São Paolo, Tarsila (as she was known) studied in Paris in the early 1920s under the Cubists André Lhote, Albert Gleizes, and Fernand Léger (see Figure 9.11). Her *E.F.C.B. (Estrada de Ferro Central do Brasil [Central Railroad of Brazil]*, 1924, Figure I.6) depicts São Paolo's industrialized environs in a deliberately naïve style resonating with the "barbarous" quality Andrade praised in his "Pau-Brasil" manifesto. Tarsila's *Anthropophagy* (1929, Figure 10.25)—its title echoing that of Andrade's "Anthropophagic Manifesto"—depicts an intertwined pair of nude human figures, female on the left and male on the right, with tiny heads and enormously enlarged feet (emphasizing their contact with the earth), relaxing against a background of stylized cacti and a banana leaf under a lemon-slice sun. The painter follows Andrade's anthropophagic aesthetic philosophy by representing a tropical Brazilian subject in a style of digested French modernist sources: the assertive colors and smooth, cylindrical-limbed figures of Léger and Surrealism's anatomical distortions. The primitive simplicity of the figures and setting, however, is a product of Tarsila's own sensibility.

Mexico

The Mexican mural movement produced that country's first major form of modern art, beginning in the 1920s. Its three leading artists were Diego Rivera, David Alfaro Siqueiros, and

FIGURE 10.25 Tarsila do Amaral, *Anthropophagy*, 1929. Oil on canvas, 126 x 142 cm. Fundação José e Paulina Nemirovsky, São Paulo.

José Clemente Orozco, known as *los tres grandes* (the three great ones). Relatively realistic in style, addressed to a broad public audience, and supported by the government, their art generally focused on glorifying Mexican history and its people through narrative images decorating the walls of public buildings.

Diego Rivera (1886–1957)

Diego Rivera, the most famous and influential Mexican muralist, was a child prodigy who began taking classes in Mexico City's Academia de San Carlos at the age of ten. Between 1911 and 1919, he lived mainly in Paris, where he met Mondrian, Picasso, and Gris and mastered Cubism. Persuaded by José Vasconcelos, Mexico's minister of education, to return to his native country to help create a Mexican artistic renaissance, Rivera first spent several months in Italy (1920–21) studying the murals of the **Renaissance** masters. The murals he went on to paint in Mexico combined aesthetic lessons from the Italians with influences from Pre-Columbian art and a Cubist-informed approach to pictorial space. He painted them in fresco, applying water-based **pigments** to fresh plaster so that after the plaster dries the painting becomes a permanent part of the wall.

After executing murals for several public buildings in Mexico between 1921 and 1930, Rivera worked in the United States between 1930 and 1933, painting walls in San Francisco, Detroit, and New York. Both Orozco and Siqueiros also made murals in the United States in the years around 1930, helping to inspire the American mural movement of the 1930s whose participants included Aaron Douglas and Thomas Hart Benton.

All three of *los tres grandes* held radical left-wing political views that aroused controversy when expressed in their mural imagery. The most famous episode involved Rivera's fresco on the theme of "Man at the Crossroads Looking with Hope and High Vision to the Choosing of a New and Better Future," commissioned in 1932 by the wealthy Rockefeller family for the lobby of New York's RCA Building. After Rivera declared his communist beliefs by inserting a portrait of Vladimir Lenin into the composition and refused to remove it, the Rockefellers canceled his commission, paid him his fee, and had the unfinished mural destroyed in 1934.

Rivera denounced this "act of cultural vandalism"[28] and, with Mexican government support, recreated the mural in the Palacio de Bellas Artes in Mexico City, under the new title *Man, Controller of the Universe* (1934, Figure 10.26). The crowded composition centers on a young blond-haired figure in worker's overalls embodying Man (humanity), symbolically controlling the universe through technology—a force that Karl Marx believed could ultimately liberate workers. Bracketed by a pair of giant magnifying glasses, two large intersecting ellipses behind Man signify, respectively, the microcosm of life forms viewed through the microscope at his right hand and the macrocosm of outer space viewed through the large telescope above his head. Fruits and vegetables representing Man's agricultural productivity rise from the ground below.

Between the two ellipses to Man's left, Lenin clasps the hands of workers of many races. To Man's right, privileged capitalists—including John D. Rockefeller Jr.—turn their backs on workers and carouse in a nightclub, beneath disease-causing cells in the ellipse. Further to the left is a handless statue of Zeus wearing a Christian cross, below which an X-ray machine and the figure of Charles Darwin suggest science eclipsing traditional religions. Above and to the right,

FIGURE 10.26 Diego Rivera, *Man, Controller of the Universe*, 1934. Fresco, 485 x 1145 cm. Palacio de Bellas Artes, Mexico City.

marching soldiers and striking workers menaced by mounted police represent the capitalist world cursed by militarism and economic exploitation. By contrast, the mural's right third shows vigorous athletes and masses of workers embracing socialism, symbolically led by Marx and other prominent Communists beneath a headless statue of Caesar representing the destruction of fascism (the swastika on the fasces held by the statue refers specifically to Nazism). Rivera's sympathies clearly lie with those on this side of the composition.

Frida Kahlo (1907–1954)

While the muralists covered walls with messages aimed at the public, other Mexican artists explored private and subjective realms in the more intimate **medium** of easel painting. Among them was Frida Kahlo, whose central artistic subject was her own life, much of which revolved around two tumultuous marriages (1929–39; 1940–54) to Rivera. Born outside Mexico City to a German father and Mexican mother of mixed Spanish and Indigenous Mexican heritage, Kahlo was seriously injured at age eighteen when the bus she was riding hit a trolley. The accident caused Kahlo great pain for the rest of her life, but it also catalyzed her artistic vocation: she taught herself to paint during her convalescence. She worked in a simple, linear style influenced by nineteenth-century Mexican folk painting, intended to express her *mexicanidad* (Mexicanness).

Painted in late 1939 while her divorce to Rivera was being finalized, Kahlo's large, dreamlike *Two Fridas* (Figure 10.27) presents two impassive figures seated in a nondescript space against a low horizon and a gray cloud-swept sky. The different clothing styles in her doubled self-image signify her mixed heritage: the European Frida on the left wears a white Victorian dress while the Mexican Frida on the right wears a colorful Tehuana skirt and blouse. The artist said that the Mexican Frida was the one that Diego had loved and that the European Frida was the one he no longer loved.[29] The two Fridas are connected by their joined hands and by an artery. The artery originates in a miniature portrait of Rivera held in the Mexican Frida's lap and ends in the lap of the European Frida, who attempts unsuccessfully to stop the flow of blood from it with forceps. Both figures' hearts are exposed, and the European Frida's is cut open, suggesting it is broken.

Kahlo painted *The Two Fridas* for the International Surrealist Exhibition staged in Mexico City in 1940, co-organized by the Surrealist leader André Breton, who had met Rivera

FIGURE 10.27 Frida Kahlo, *The Two Fridas* (*Las dos Fridas*), 1939. Oil on canvas, 173 x 173 cm. Museo de Arte Moderno, Mexico City.

and Kahlo in Mexico City in 1938. Breton recognized Kahlo a natural Surrealist, which she later denied, saying, "I never painted dreams. I painted my own reality."[30] Nevertheless, she and Rivera willingly exhibited with the Surrealists, recognizing the professional advantages of being associated with the internationally recognized avant-garde movement.

Manuel Álvarez Bravo (1902–2002)

Mexico City native Manuel Álvarez Bravo was another artist who Breton met in 1938 and included in the 1940 International Surrealist Exhibition. Self-taught in photography, Álvarez Bravo's efforts in that medium were encouraged by several foreign photographers who came to Mexico in the 1920s and 1930s, including the Frenchman Henri Cartier-Bresson and the Americans Tina Modotti and Edward Weston. Like them, Álvarez Bravo practiced straight photography, which he used to picture the life, customs, and environment of Mexico's native peoples. He delighted in discovering unexpected juxtapositions of objects and images that generate an enigmatic visual poetry of the sort that Breton labeled Surrealist. A striking example is *Dos pares de piernas* (*Two Pairs of Legs*) (1928–29, Figure 10.28), in which a billboard advertising shoes through disembodied pairs of legs in masculine and feminine attire is

FIGURE 10.28 Manuel Álvarez Bravo, *Dos pares de piernas* (*Two Pairs of Legs*), 1928–29. Gelatin silver print, 23.3 x 18.1 cm. Ackland Art Museum, The University of North Carolina at Chapel Hill.

surmounted by two lamps and doubled windows. The uncanny arrangement of paired elements—legs, lamps, windows—and the bodies' seeming disappearance into the building create the compelling effect that Breton called the "marvelous": the sudden encounter in waking reality with the manifestation of unconscious desires normally communicated symbolically through dreams.

Cuba

In Cuba, nineteenth-century **academic art**'s lingering conventions were challenged by a group of young progressive artists who opened the *First Exhibition of New Art* in Havana in 1927 under the sponsorship the magazine *Revista de Avance*. The most prominent participant was Victor Manuel (1897–1969), who had mastered the academic style at Havana's Academia de San Alejandro before being exposed to French modern art on trips to Paris in the later 1920s. He was particularly drawn Paul Gauguin's primitivist style of simplified forms and colors, which Manuel adapted to Cuban subjects such as Havana street life, lush landscapes, and attractive, mixed-race peasants (e.g., *La Gitana Tropical*, 1929), intended as expressions of national cultural identity.

Amelia Peláez (1896–1968)

Another Havana academy graduate, Amelia Peláez also abandoned the academic mode while studying in Paris (1927–34), where her most influential teacher was the Russian Constructivist Alexandra Exter. After her return to Cuba, Peláez developed her signature **subject matter** and style. Inspired by traditional Cuban architectural interiors—a legacy of the Spanish colonial period—she painted domestic still lifes featuring centrally placed fruit, flowers, or fish surrounded by ornamental elements such as tablecloths, wicker chairs, wrought iron grilles, and stained-glass fanlights. She rendered these in a bold, kaleidoscopic style of **saturated** flat colors, simplified shapes, and decorative patterns defined by thick black lines—themselves inspired by the patterns of wicker, grilles, and stained-glass window leading. *Marpacifico* (*Hibiscus*) (1943, Figure 10.29), which celebrates Cuban identity through its focus on a red hibiscus common to the island, exuberantly exemplifies what one historian called Peláez's "tropical Cubism."[31]

Wifredo Lam (1902–1982)

While Kahlo, Rivera, and Álvarez Bravo participated in Surrealist exhibitions without officially joining the group, two Latin American artists who traveled to Paris in the 1930s, the Chilean Matta (see Chapter 8) and the Cuban Wifredo Lam, were formally welcomed into Surrealism and made important contributions to it. The Afro-Cuban son of a Chinese immigrant father and a Cuban mother of Black African and Spanish heritage, Lam studied art in Havana before traveling to Spain

FIGURE 10.29 Amelia Peláez, *Marpacifico* (*Hibiscus*), 1943. Oil on canvas, 115.6 x 88.9 cm. Art Museum of the Americas, Washington, DC.

in 1923 for further study. He fought on the Republican side in the Spanish Civil War in 1936 and 1937 and then went to Paris where he met Picasso, Breton, and the Surrealists. These colleagues introduced Lam to Oceanic and African art, to which he responded by painting in a style resembling Picasso's so-called 1907–08 African period. Fleeing Paris after the German invasion of 1940, Lam sailed for Martinique with Breton and the French anthropologist Claude Lévi-Strauss. There, Lam met the poet Aimé Césaire, an initiator of Négritude, a literary movement launched by Black African and Caribbean intellectuals in Paris in the 1930s that denounced French colonial rule and asserted Black racial and cultural pride. Upon his return to Cuba in 1942, Lam wed Négritude's ideas with those of the Afro-Cubanist movement to focus on recovering the island's African heritage, the legacy of 750,000 West African enslaved people—Lam's ancestors among them—brought to Cuba to cultivate sugar cane before the slave trade ended in 1886.

The degraded condition of Black life in Havana angered Lam. He found that Afro-Cubans were considered "picturesque" by tourists but endured racism and poverty, and that many mixed-race women were forced to earn their living as prostitutes. Lam resolved to express "the negro spirit, the

beauty of the plastic art of the blacks" to "act as a Trojan horse that would spew forth hallucinating figures with the power to surprise, to disturb the dreams of the exploiters."[32]

Lam conjured such "hallucinating figures" in *The Jungle* (1943, Figure 10.30). It depicts, in a moonlit palette of blues, greens, and whites, a fantastic quartet of slender human-animal monsters with mask-like faces, surrounded by sugar cane stalks within a dense jungle. The figures' metamorphic, hybrid character shows Lam's commitment to Surrealism, while their simplified, fragmented anatomies and the shallow, ambiguous pictorial space derive from Cubism. The sugar cane evokes the Cuban plantations and Black servitude, but the dense jungle setting refers to Africa (Cuba has no jungles) and to the sacred space used for Santería rituals. This syncretic religion developed in the nineteenth century by enslaved Black Cubans merges Catholicism with West African Yoruba beliefs. The rightmost figure in Lam's painting, a four-legged horse-human with prominent breasts and buttocks, may allude to the saying that a person possessed by a deity during a Santería ritual is "mounted" like a horse.[33] Lam, however, called her "as obscene as a whore," emphasizing his aim to protest the debased conditions of his fellow Afro-Cubans.[34] Another critical symbol is the open pair of scissors the figure holds. In a 1977 interview, Lam, a supporter of Fidel Castro's Cuban Revolution, said, "the scissors mean that a break with colonial culture was needed, that we had had enough of colonial domination."[35]

Uruguay: Joaquín Torres-García (1874–1949)

A counterpoint both to Mexican muralism and to the Surrealism of Lam and other Latin Americans was the Constructive Universalism of the Uruguayan Joaquín Torres-García. His best-known works are paintings structured by horizontal-vertical grids forming compartments that contain simply rendered iconic images and, sometimes, symbols, words, letters, and numerals. A characteristic example, *Composition* (1931, Figure 10.31), executed in **grisaille**, depicts a ship, arrow, house, man, anchor, fish, heart, key, ruler, clock, bottle, mask, pot, and ladder. Influenced by Platonic philosophy, Torres-García believed that such images possess universally understood human meanings, but that they also communicate on different levels. For example, the ship can connote travel from one place to another, the concept of exploration, or the metaphorical voyage of life.[36]

Torres-García developed Constructive Universalism during a six-year sojourn in Paris (1926–32). This followed his childhood in Uruguay, academic training in Barcelona, and two years (1920–22) in New York, where he tried unsuccessfully to build a business selling transformable wooden toys. In Paris, Torres-García became friendly with artists working in nonobjective geometric styles and in 1930 cofounded the short-lived group and journal Cercle et Carré (Circle and

FIGURE 10.30 Wifredo Lam, *The Jungle* (*La Jungla*), 1943. Gouache on paper mounted on canvas, 239.4 x 229.9 cm. The Museum of Modern Art, New York.

Square). Unlike his friends Theo van Doesburg and Piet Mondrian (see Chapter 6), however, who sought to express universal harmony through pure, impersonal geometry, Torres-García believed that art needed to balance rationality with intuition and geometric stability with human vitality. The simple hand-painted ideograms he devised to provide the latter quality were inspired by his study of ancient Mediterranean, medieval European, African, Oceanic, and Pre-Columbian art.

After returning with his family to his native Montevideo, Uruguay in 1934, Torres-García energetically promoted his aesthetic ideology of Constructive Universalism. He established the Asociacion de Arte Constructivo and later formed the Taller Torres-García, a workshop and school.

Argentina

Two events in 1924 marked the appearance of modernism in Buenos Aires, Argentina's cosmopolitan capital: the founding of *Martín Fierro*, a literary magazine that supported the avant-garde; and a solo exhibition by Emilio Pettoruti (1892–1971),

recently returned from an eleven-year stay in Europe. There, Pettoruti had developed a hard-edged Cubist style indebted to Juan Gris (see Figure 4.14), as seen in his still life *Sombra en la ventana* (1925). While conservative critics derided Pettoruti's modernist expression, it was applauded by his avant-garde colleagues, including his friend Xul Solar, who published an appreciation of Pettoruti's work in *Martín Fierro*.

Xul Solar (1887–1963)

The artist born Oscar Agustín Alejandro Schulz Solari took the name Xul Solar in order to identify himself with sunlight: Xul is an anagram of *lux*, the Latin word for light, and solar, in both Spanish and English, is an adjective referring to the sun. Xul adopted this name around 1917 during a twelve-year stay in Europe (1912–24), where he assimilated influences from a wide range of European avant-garde artists, including the Cubists, Futurists, **Dadaists**, and geometric Constructivists. Most consequential to his style of the 1920s was the example of Paul Klee (see Figure 6.14), whose work he saw in Munich.

FIGURE 10.31 Joaquín Torres-García, *Composition*, 1931. Oil on canvas, 91.7 × 61 cm. The Museum of Modern Art, New York.

Concrete Abstraction in Argentina

Later in Argentina, Torres-García's Constructive Universalist ideas reached Buenos Aires through his exhibitions, publications, and radio lectures. These inspired several young artists and poets to publish the journal *Arturo: Magazine of Abstract Art*, whose first and only issue in 1944 included an essay by Torres-García. Despite their respect for Torres-García, the younger Argentine painters rejected his use of imagery, his art's handmade quality, and the convention of the rectangular frame, which structures the painting as a "window" onto a separate world. They instead invented nonreferential geometric shapes, executed with precision (associated with technology) to signify their modernity, and they used irregularly shaped frames to give their paintings the quality of autonomous objects. Rather than calling their art "abstract," which suggests abstraction from reality, they called it "concrete," adopting the term first popularized by Theo van Doesburg to identify an art built from purely formal elements.

The artists associated with *Arturo* exhibited together in 1944 and 1945 in Buenos Aires then split into two rival groups, the Asociacion de Arte Concreto-Invencion (AACI), led by Tomás Maldonado, and Madí, led by Carmelo Arden Quin, Gyula Kosice, and Rhod Rothfuss. The AACI issued a manifesto opposed to "an art of representation" that traffics in fictions and "dims the cognitive energy" of the spectator, advocating instead a "presentation art" that "surround[s] humans with real things."[38] This insistence on the artwork's material reality aligned with the AACI artists' Marxist political leanings, and their use of eccentric formats emphasized it. For example, *Concreto* (1945, Figure 10.33), by Lidy Prati (1921–2008), comprises three polygonal planes—two white, one red—connected by two thin black-painted strips of wood set on diagonals. As in a painting by Mondrian—who inspired Prati—each element of the composition contributes equally to its overall sense of equilibrium.[39]

Even more experimental than the AACI, the artists of Madí (probably a nonsense word, like Dada) incorporated poetry, music, dance, and performance into their exhibitions. They made paintings and sculptures that were not only irregularly shaped but that also had movable parts, inviting the spectator to actively shape the work of art. A well-known example is the articulated wooden sculpture, *Röyi No. 2* (Figure 10.34; Röyi, like Madí, is a made-up word), by Gyula Kosice (1924–2016). Fascinated from childhood by Leonardo da Vinci's merger of art and science through his mechanical inventions, Kosice went on in 1946 to create the first sculptures made of neon lights. Both the Madí and AAIC artists continued to exhibit widely after the 1940s and helped to establish geometric art as a major current in Latin American modernism, also manifested in Brazilian **Concretism** of the 1950s (see Chapter 14).

Xul's delicate watercolors of the 1920s are reminiscent of Klee in conjuring fantasy worlds inhabited by puppet-like figures set within abstract landscapes or toy-like built environments filled with geometric shapes and symbols, letters, and numerals hinting at esoteric meanings. Xul's fascination with arcane knowledge was fed by his life-long study of belief systems such as Theosophy, the Jewish Kabbalah, the Chinese I Ching, alchemy, tarot cards, and astrology.

Xul's occult interests are evident in *Couple* (1923, Figure 10.32), depicting a torso and neck supporting a half-female, half-male compound head, near which floats the equation "2=B." Decorating the neck is an orange and red mandorla: a shape understood by alchemists as the intersection of two arcs, the left symbolizing female matter, the right symbolizing male spirit. At the upper right is another symbolic female-male combination: a blue moon (a female symbol) edged with a red crescent evoking the sun (a male symbol). Xul's **iconography** emphasizes the alchemical fusion of female and male principles that achieves a perfected state of being.[37]

FIGURE 10.32 Alejandro Xul Solar, *Couple* (*Pareja*), 1923. Watercolor on paper mounted on card, 25.9 x 32 cm. Museo de Arte Latinoamericano de Buenos Aires.

FIGURE 10.33 Lidy Prati, *Concreto*, 1945. Oil on plywood, 62 x 48 cm.

FIGURE 10.34 Gyula Kosice, *Röyi No. 2*, 1944. Wood, 70.5 x 81 x 15.5 cm. Museo de Arte Latinoamericano de Buenos Aires.

Modern Art in Asia: India, Japan, Korea, and China, c. 1900–1945

This chapter introduces some of the diverse forms of modern art that arose in Asia in the first decades of the twentieth century, focusing on India, Japan, Korea, and China. Whereas in the West the history of modernism is primarily understood as the history of the avant-garde with its emphasis on constant innovation, the modernisms of early twentieth-century Asia are better conceived as involving mutations within national cultural traditions, sometimes in response to foreign influences (both Western and intra-Asian).[1] These mutations generated forms of expression that were novel within their countries' histories of art and were recognized as modern. Not all Asian modernists assimilated Western modernism, but for those who did so, it was a double-edged process. It both allowed them to declare a modernist identity and encouraged them to reconsider their own countries' traditional art forms. In many cases, eclecticism rather than aggressive originality counted as a modernist strategy for Asian artists.

The early twentieth-century modern art of India, Japan, Korea, and China arose in specific historical contexts that are outlined in the following sections devoted to each of these countries. This chapter focuses on painting because most of the significant innovations in each country occurred in this medium. The chapter also uses Eastern order for the names of Japanese, Korean, and Chinese artists, with the family name given first and the personal name second.

India

The British colonial rule of India from the late eighteenth- to the mid-twentieth century transformed the country's art. In the mid-to-late nineteenth century, many Indians accepted Western cultural hegemony, viewing it as a means of self-improvement and losing faith in their own culture's value.[2] In this context, traditional Indian art forms and **styles** of pictorial art were displaced by Victorian **naturalism**, which was fostered by **academic** instruction in newly formed art schools, the patronage of art societies, and the exhibitions they sponsored. The leading Indian oil painter of this period, Raja Ravi Varma (1848–1906), gained great success with his commissioned portraits and depictions of subjects from Indian history and literature in a Victorian academic style. He created anatomically accurate, firmly modeled figures and rendered their attire with precise linear detail (e.g., *Maharashtrian Lady*, 1893.

By the time of Varma's death a national Indian culture was rising, and some considered his work inauthentic because of its European-derived style. One such critic was the Englishman Ernest Binfield Havell, head of the Calcutta School of Art from 1896 to 1906. Reforming the school's curriculum to give it an Indigenous rather than Western orientation, Havell directed students to emulate the miniature paintings of India's Muslim Mughal empire (sixteenth–eighteenth centuries), which were executed with fine lines, bright colors, and intricate details. He found allies in the distinguished Bengali poet Rabindranath Tagore (generally referred to as

Tagore) and Tagore's painter nephew, Abanindranath, whom he invited to teach at the school in 1905.

Abanindranath Tagore (1871–1951)

By the time of Havell's offer, Abanindranath had abandoned European-style **oil painting**, turning first to Mughal miniatures and then contemporary Japanese painting for inspiration. He was encouraged to explore the latter by his 1902 meeting with Japanese artist Okakura Kakuzō. The following year, two of Okakura's colleagues—Hishida Shunsō and Yokoyama Taikan—taught Abanindranath their ink-wash technique, which he adopted as his own.

Like Okakura, Abanindranath embraced Pan-Asianism, which encouraged unity among Asian people, promoted a contrast between supposed Western materialism and Asian spirituality, and signaled cultural resistance to European imperialism and colonialism. Abanindranath is credited with launching the Bengal School, the first self-consciously modern and nationalist Indian painting movement. The school sought to express Indian themes in a style derived from traditional Indian sources, including Mughal and Rajput painting (a miniature painting tradition of the Hindu courts contemporaneous with Mughal) and the ancient Buddhist murals in the caves of Ajanta. Bengal School painting also often incorporated the ink-wash technique.

A key expression of Abanindranath's cultural politics is his image of *Bharat Mater* (*Mother India*) (c. 1905, Figure 11.1), painted in the midst of the October 1905 partition of Bengal and the subsequent anti-British unrest. In solidarity with the Bengali opponents of partition, who demanded self-government and self-sufficiency, Abanindranath depicted Mother India as a beautiful, young, saffron-clad, four-armed Hindu deity. She holds gifts—a sheaf of rice, cloth, palm leaf manuscript, and Hindu prayer beads—that symbolize the nationalist objectives of food, clothing, education, and spiritual knowledge, respectively. In style, Abanindranath's work combines the linear refinement of Mughal painting with the delicate washes of Taikan's and Shunsō's style.

Gaganendranath Tagore (1867–1938)

The introduction of recent European modernist styles challenged the Bengal School's dominance in the 1920s. A key event was the December 1922 exhibition in Calcutta (Kolkata), which paired works by the school's artists with those by **Bauhaus** members, including Klee, Kandinsky, Feininger, and Itten (see Chapter 6). Among the Indian artists were Gaganendranath Tagore—Abanindranath's brother and Rabindranath's nephew—who was already working in a style informed by **Cubism**. In *Rabindranath Tagore in the Island of Birds* (1920s, Figure 11.2), the

FIGURE 11.1 Abanindranath Tagore, *Bharat Mata* (*Mother India*), c. 1905. Watercolor, 26.67 x 15.24 cm. Victoria Memorial Hall, Kolkata.

barely discernable figure of the painter's uncle occupies a kaleidoscopic fantasy landscape of soft **warm colors** filled with fluttering blue birds. While the painting's fragmented forms clearly derive from Cubism, its intricate decorative quality and small size recall Mughal miniatures, infusing it with an Indian flavor.

Rabindranath Tagore (1861–1941)

Tagore's nephew's choice to show him surrounded by birds seems appropriate given the prominence of avian motifs in his poetry as well as in the two thousand drawings and paintings on paper he began to create in his sixties. Lacking formal training, he worked in a highly personal and deliberately childlike style,

FIGURE 11.2 Gaganendranath Tagore, *Rabindranath Tagore in the Island of Birds*, 1920s. Wash and tempera on paper, 21.2 x 17 cm. National Gallery of Modern Art, New Delhi.

often with simple outlines enclosing fields of rich, mottled color. He depicted human and animal forms, fantastic hybrid creatures, and, in his final years, more conventionally realistic landscapes based on direct observation. Tagore's image of a peacock (c. 1933, Figure 11.3), a bird indigenous to India and celebrated in its myth and literature (including his poetry), is a striking example of his work.

Like Picasso and the German **Expressionists**, Tagore found inspiration in so-called primitive art, including that of Oceania and the Native Americans of the Pacific Northwest Coast (see "Primitivism" box, Chapter 2). He considered such art a universal expression of human creativity transcending modern national boundaries. Tagore's boldly simplified and loosely painted images were the most radical made in India before World War II and strongly inspired the younger generation of modernists.[3]

Amrita Sher-Gil (1913–1941)

In contrast to Tagore, whose imagery sprang largely from his imagination, Amrita Sher-Gil was inspired by her observation of rural Indian people. The first professional woman artist in India and one of its most talented pre–World War II modernists, Sher-Gil was born in Budapest to an aristocratic Sikh father and Hungarian mother; the family moved to the northern Indian city of Simla when she was eight. Between 1929 and 1934, she received academic training in Paris and mastered a **painterly** realist style. During this time, she painted mainly figurative subjects, including numerous self-portraits in which she explored her mixed cultural identity, sometimes wearing European clothes and at other times a sari.

Following her return to India, Sher-Gil dedicated herself to interpreting the lives of poor rural Indians. Inspired by the **frescoes** in the Ajanta Caves, which she visited in 1936, she developed a monumental style presenting large, simply drawn figures against monochrome **backgrounds** (e.g., *Brahamacharis*, 1937). The **compositions** of her final years were informed

FIGURE 11.3 Rabindranath Tagore, *Untitled (Peacock)*, c. 1933. Colored ink and poster color on paper, 15 x 23.7 cm. National Gallery of Modern Art, New Delhi.

FIGURE 11.4 Amrita Sher-Gil, *Woman Resting on a Charpoy,* 1940. Oil on canvas, 72.4 x 85 cm. National Gallery of Modern Art, New Delhi.

by Basholi painting—a style of Rajput miniature painting practiced in the Indian hill states in the late seventeenth and eighteenth centuries. These works grew less formal, more intimate, and intensely (even hotly) colored, as seen in *Woman Resting on a Charpoy* (1940, Figure 11.4). The picture shows a subject from Uttar Pradesh in eastern India, where women still lived in isolation on feudal estates. A dark-skinned servant holding a fan sits with an indolent girl "in red flowered clothes (the Punjabi dress, tight red trousers, shirt and veil) . . . reclining in a charpoy, its posts of an incandescent red rose round her like tongues of flame."[4] Sher-Gil called the picture "sensual, but not sensual in the effete rather repulsive manner of some of our good Bombay fine art exhibitors," distinguishing her modernist aesthetic from that of more conventional Indian painters.

Jamini Roy (1887–1972)

Older than Sher-Gil by a generation, the Kolkata-based Jamini Roy also sought a modern Indian identity in the country's rural life. However, unlike Sher-Gil and other twentieth-century artists who drew inspiration from India's high art traditions, he turned to **folk art**, specifically, the narrative picture scrolls (*pats*) made by untrained itinerant painters (*patua*) in his native region of Bankura in Bengal. A student of Abanindranath Tagore at the Calcutta School of Art, Roy enjoyed

early success as an oil painter making nostalgic images of rural Indian life, but he came to view these works as compromised by Western influence. During the 1920s, he began traveling in the countryside to collect *pats*, which led to the transformation of his art.

By the mid-1930s, Roy had adopted the *patua*'s materials and techniques and adapted their style into his own simplified version featuring bold contours, flat **shapes**, and strong colors (1941, Figure 11.5). He achieved a purified style similar to that of European modernist painters such as Léger (see Figure 9.11) but thoroughly Indian in its **subject matter**. Among Roy's frequent subjects was the *gopini* (also known as a *gopi*), a young and voluptuous female cow herder devoted to the Hindu god Krishna. Roy typically depicted the figure in the sinuous tri-bent pose (*tribhanga*) of traditional Indian sculpture and classical dance, with her body bent at the neck, waist, and knee.

The success of his *pat*-influenced paintings led Roy to further emulate folk-art practice. He opened a workshop in which apprentices, including his sons, made pictures based on his designs that were sold cheaply to the broad public. This embrace of communitarian values, rejection of originality, and acceptance of repetition have been interpreted as Roy's challenge to the colonial values of artistic individualism and artistic progress.[5] His commitment to expressing a distinctive

FIGURE 11.5 Jamini Roy, *Gopini*, c. 1941. Gouache on board, 44.8 x 26.5 cm. Art Gallery of New South Wales, Sydney.

modern Indian identity rooted in folk traditions inspired many younger modern artists after the country gained its independence from Britain in 1947 (see Chapter 18).

Japan

After a period of feudal rule by military leaders, imperial rule was restored in Japan and the Meiji period (1868–1912) began. The Meiji government promoted the assimilation of European culture as the basis for modernization. As part of this development, numerous Japanese painters, sculptors, and architects adopted current European concepts, styles, and techniques. In painting, a distinction developed between *Nihonga* (Japanese style painting) and *Yōga* (Western style painting). Nihonga artists employed time-honored Japanese painting materials, techniques, and formats. While they blended styles from earlier schools of their country's art, they also sometimes integrated visual features of modern Western art. Yōga artists painted in oil on canvas in styles strongly influenced by European models.

Ernest Fenollosa, Okakura Kakuzō, and Nihonga

A key figure in the development of Nihonga was the Harvard-educated philosopher and economist Ernest Fenollosa, who came to Japan in 1878 to teach at the newly established Tokyo Imperial University. Convinced that Japan needed to preserve its cultural heritage in the face of Westernization, he collaborated with his former student Okakura Kakuzō and others to establish the Kangakai (Painting Appreciation Society) in 1884. The organization's mission was to foster the study of traditional Japanese arts and stimulate a new approach to Japanese-style painting.

Fenollosa argued that this new style should merge aspects of Western art—such as **perspective** and **modeling** through light and shade—with the traditional Japanese elements of brushed, water-based ink and colors on silk or paper. He found such fusion in the work of contemporary artists of the Kanō school, a line of professional ink painters who had enjoyed the patronage of Japan's feudal leaders in the Tokugawa period (1615–1867). He and Okakura hired the Kanō school painter Hashimoto Gahō to teach at the Tōkyō Bijutsu Gakkō (Tokyo School of Fine Arts), which they founded in 1889. Nine years later, Okakura left the school to start the Nihon Bijutsu'in (Japan Fine Arts Academy), with Gahō as its principal painting instructor.

Yokoyama Taikan (1868–1958) and Hishida Shunsō (1874–1911)

Gahō trained leading Nihonga painters of the early twentieth century: Yokoyama Taikan and Hishida Shunsō. Beginning around 1899, both artists sought to modernize the approach by painting land- and seascapes that relied on washes of misty color rather than line to create a sense of atmosphere and spatial depth. Arguing for this inherently Japanese aspect of their work in a 1905 manifesto, they rejected the **calligraphy**-derived linear style of painting—an important feature of the Kanō school—as an import from China.[6] They contended that color could generate an essentially Japanese emotional quality. Conservative critics, however, saw the atmospheric effects in Taikan's and Shunsō's paintings (exemplified in Taikan's *Towing a Boat*, 1901) as too Western and derided their style as "murky" (*mōrō*).

Although Taikan retained the *mōrō* manner for the rest of his career, he began using more firmly outlined forms and a richer **palette** in 1909. This shift is seen in one of his best-known works, *Ryūtō* (*Floating Lanterns*) (1909, Figure 11.6).

FIGURE 11.6 Yokoyama Taikan, *Ryūtō* (*Floating Lanterns*), 1909. Japanese pigments on silk, 143 x 52 cm. The Museum of Modern Art, Ibaraki, Japan.

Based on the memory of his and Shunsō's 1903 trip to India (where, as previously mentioned, the artists met Abanindranath Tagore), the painting shows a trio of prosperous sari-clad women beneath the leaves of a bodhi tree on the banks of the Ganges River. The young woman on the right holds an earthenware oil lamp that she is about to float downstream as a ritual act.[7] Her two companions have already placed their lamps on the water and watch them calmly yet intently. While elements of *mōrō* linger in the mottled colors of the steps and the flowing hair of the woman at the left, the compositional focus on the three large, clearly defined figures—cropped at left and right within the shallow picture space—generates an expressive impact that differs greatly from Taikan's earlier atmospheric landscapes. In their pure, **idealized** beauty, the young women also share the sensual appeal of the images of beautiful women (*bijinga*) popular in Japanese **woodblock prints** from the seventeenth century onward, as well as in the work of other Nihonga painters.

Yōga: Kuroda Seiki (1866–1924)

Born into an aristocratic Tokyo family, Kuroda Seiki was sent to Paris in 1885 to study law. He took up art instead and, after returning to Japan eight years later, became the country's leading Yōga painter. Instructed by the academic painter Raphaël Collin, he learned to work *en plein air* using soft **brushwork** and the bright palette of **Impressionism** while retaining an academic commitment to firm modeling of the human figure. His *Morning Toilette* (1893), which shows a nude European woman arranging her hair before a mirror, won praise when exhibited at the Société Nationale des Beaux-Arts in Paris but caused a scandal at the 1895 National Industrial Exposition in Kyoto. Critics objected to the painting because the female nude, a respectable motif in European art since the

Renaissance, was not widely considered a morally proper subject in Japan.

More acceptable was *Kokage* (*In the Shade of a Tree*) (1898, Figure 11.7), Kuroda's depiction of a young Japanese woman reclining casually on the sun-dappled grass as she reaches up to pick berries from a silverberry tree. Her large straw hat sits beside her and supports two large lily blossoms (conventional symbols of purity). Along with such works, Kuroda continued to paint the female nude. When Japan officially banned the public exhibition of fully nude images in 1901, however, he and other artists began to render female nudes only from the waist up or with their lower bodies covered with waistcloths.

Kuroda also held some influential positions during his career. In 1896, he was hired to lead the new Western-style painting department at the Tokyo School of Fine Arts (established 1889), which had initially offered instruction only in Nihonga but became the main training ground for Yōga. That same year, he and several colleagues established the Hakubakai (White Horse Society), the principal organization for Yōga artists for the next several years. In 1907 Kuroda became a judge of the Western-style painting section of the Bunten, a new government-sponsored, juried exhibition modeled on the Paris Salon.[8]

The Fūzainkai and the Nikakai

Within a few years of the Bunten's establishment, the increasing conservativism of its Yōga section jurors led younger painters to rebel. During the early years of the Taishō Period (1912–26), they created rival exhibiting organizations that encouraged greater experimentation, much as the French Impressionists did in the 1870s (see Chapter 1). These groups included the Fūzainkai (Sketching Society, 1912–13) and the Nikakai (Second Division Society, formed in 1914).

Most of the artists in these groups were strongly interested in developments in modern European painting, including **Post-Impressionism**, **Fauvism**, Expressionism, Cubism, and **abstraction**. They learned about these movements from articles and reproductions in Japanese publications, such as the influential magazine *Shirakaba* (White Birch), or through direct experience in Europe. For example, Nikakai members Yasui Sōtarō and Umehara Ryūzaborō studied in France: Yasui between 1907 and 1914 and Umehara from 1909 to 1913 (as Renoir's pupil). After their return to Japan, they developed styles of modern Yōga featuring loose brushwork and bright colors that by the 1930s brought them considerable professional success.

Yorozu Tetsugorō (1885–1927)

A pioneering Japanese modernist who cofounded the Fūzainkai and later joined the Nikakai, Yorozu Tetsugorō studied Yōga

FIGURE 11.7 Kuroda Seiki, *Kokage* (*In the Shade of a Tree*), 1898. Oil on canvas, 78 x 93.7 cm. Woodone Museum of Art, Hatsukaichi, Japan.

at the Tokyo School of Fine Arts between 1907 and 1912. In an act of rebellion against his teachers, who included Kuroda Seiki, Yorozu painted a provocatively abstracted image for his graduation, *Nude Beauty* (*Ratai bijin*) (1912, Figure 11.8), a half-nude female figure reclining in a field.[9] The bold palette, thick brushstrokes delineating the grass, and the discordant pairing of the green foliage with the red cloth covering the woman's lower body recall the work of Van Gogh, while the simplified treatment of the woman's face and anatomy signal Matisse's influence.

More than a simple synthesis of modern European painting modes, however, *Nude Beauty* can be understood as a potent parody of Kuroda's refined plein-air style, which Yorozu saw as false and complacent. Instead of painting a beautiful image of a passive woman ensconced in nature and inhabiting **illusionistic** space—such as *In the Shade of a Tree*—Yorozo made something he knew his audience would find ugly, aggressive, dissonant, and artificial (in its denial of naturalism and spatial illusionism with the woman's body seeming to rise parallel to the **picture plane**). He did so to expose and call into question the academic conventions Kuroda and the Yōga establishment employed to create pictorial harmony. He also attacked the institutionalization of art and the state's power to censor it, as it had in the case of the nude—a topical reference clearly made by the red drapery covering the figure's lower half.

Mavo

Even more radical than Yorozu in its **avant-garde** challenge to institutional authority was the Mavo group, which was active in Tokyo from 1923 to 1925 and drew inspiration from **Dada**, **Futurism**, **Constructivism**, anarchism, and Marxism. A typically provocative Mavo action occurred in August 1923, when member Takamizawa Michinao protested the Nikakai jury's rejection of the group's submissions by throwing rocks through the glass ceiling of the exhibition hall. Mavo artists were not simply opposed to the artistic establishment; they actively sought to integrate art into daily life. Their efforts in this vein ranged from the publication of a magazine (with seven issues appearing between 1924 and 1925) to poster design, theatrical and dance performances, and the decoration of temporary barracks built after the devastating Great Kantō Earthquake of September 1, 1923.

Mavo artists also made **collages** and constructions from ready-made elements in the everyday world. For example, Murayama Tomoyoshi (1901–77), the group's leading artist, assembled *Construction* (1925, Figure 11.9) from pieces of wood, fabric, leather, and metal, which he set within a rectangular frame and embellished in various areas with paint. Occupying the work's upper right quadrant is a framed collage of printed photographs showing modern architectural, engineering, and mechanical

FIGURE 11.8 Yorozu Tetsugorō, *Nude Beauty* (*Ratai bijin*), 1912. Oil on canvas, 162 x 97 cm. National Museum of Modern Art, Tokyo.

structures; a scene of marching soldiers juxtaposed with glamorous shots of Euro-American women; and a logo for McCallum Silk Hosiery. The topsy-turvy ensemble evokes various aspects of the modern world as represented in the mass media—an interest Mavo shared with the Berlin Dadaists (see Chapter 7).

Surrealism

Both literary and visual **Surrealism** flourished in Japan during the early years of the Shōwa period (1926–89), and Surrealism was the dominant avant-garde movement in the decade leading up to the country's December 1941 attack on Pearl Harbor. Significant exchanges between the French Surrealists, led by André Breton, and the Japanese Surrealists, whose foremost theorist was Takiguchi Shūzō, occurred throughout the 1930s. During this time, exhibitions of European Surrealist paintings toured several Japanese cities; the painter Okamoto Tarō exhibited with the Surrealists in Paris; and, after living in Paris for several years, the painter Fukuzawa Ichirō brought a Surrealist style with him on his return to Japan. In 1931, Fukuzawa established the Dokuritsu Bijutsu Kyōkai (Independent Art Association) as a forum for the movement in Japan, attracting many young artists who had not been to Europe.

Among the most talented members of the Dokuritsu was the Hiroshima-born Ai-Mitsu (1907–46). His startling *Landscape with Eye* (1938, Figure 11.10)—perhaps the best-known example of Japanese Surrealism—depicts a strange, brooding, amorphous landscape with an outsize human eye staring out at the viewer. A versatile painter who worked in many styles, Ai-Mitsu died tragically young: after being conscripted into the Japanese army in 1944 and sent to the Chinese front, he succumbed to an illness in Shanghai in January 1946.

After 1941, Surrealism and other Japanese avant-garde tendencies were largely suppressed by the Japanese military government, which compelled many artists to produce propaganda imagery in support of the war effort. Following Japan's defeat and during its postwar reconstruction, Surrealism resurged and then gave way to radical new forms of abstraction and **performance art**, including those of the Gutai group (see Chapter 14).

Korea

Korea experienced a painful history during the first half of the twentieth century. It became a Japanese colony in 1910; its young men were forcibly conscripted into the Japanese army during the second Sino-Japanese War (1937–45); and many Korean young women were forced into sexual slavery in military brothels as "comfort women" for Japanese soldiers. Following Japan's defeat in World War II, Korea was divided between the Soviet-occupied north and US-occupied south, and in 1948, split into two separate republics. This division has persisted since the inconclusive Korean War (1950–53), started by North Korea's invasion of the south in an attempt to unify the country under communist rule.

Korean modern art emerged after the country's annexation by Japan, as Korean artists began to paint in oil—a **medium** associated with Western modernity and a departure from the centuries-old Korean tradition of ink painting following classical Chinese models. Korean artists were also affected by the breakdown of the former Chosŏn dynasty's rigid class system, in which painters were either upper class **literati** who practiced art for self-cultivation, or *chungin* (middle) class professionals employed by the court.[10] Now individuals from any social background could pursue an art career, though most came from wealthy families due to the difficulty of making a living as an artist. Among them were women, including the acclaimed

FIGURE 11.9 Murayama Tomoyoshi, *Construction*, 1925. National Museum of Modern Art, Tokyo.

FIGURE 11.10 Ai-Mitsu, *Landscape with Eye*, 1938. Oil on canvas, 102 x 193.5 cm. National Museum of Modern Art, Tokyo.

painters Na Hye-sŏk, Paik Nam-soon, and Park Re-hyeon, although they were greatly outnumbered by male colleagues.

Korean ink painting was affected by Western-style oil painting as well as the introduction of Nihonga, promoted by the Japanese to foster a sense of national belonging among their imperial citizens. A leading monochrome ink painter, Yi Sang-bŏm (1897–1972) continued to use traditional Chinese-style brushstrokes but introduced linear and atmospheric perspective and shading into his landscape paintings, adapting Western conventions of realism (e.g., *Early Winter Scene*, 1925). Kim Ŭn-ho (1892-1979) mastered Nihonga techniques through three years of study (1925–28)

in Tokyo and painted portraits and figures using fine linear strokes and delicate colors.

Ko Hŭi-dong (1886–1965)

During the colonial period, the Japanese government encouraged Koreans to pursue higher education in Japan in the belief that this would facilitate their assimilation into the Japanese Empire. Most Koreans seeking training in oil painting did so in Japan, many at the Tokyo School of Fine Arts where Kuroda Seiki led the oil painting department in the early 1910s. The first Korean to graduate from the Tokyo School of Fine Arts was Ko Hŭi-dong, widely known as Korea's first oil painter, who began his study in 1909. Ko followed his teacher Kuroda's example in merging solid draftsmanship and modeling with bright Impressionist color, as seen in his *Self-Portrait* (1915, Figure 11.11), which he painted shortly after his return to Korea.[11] Seated in a relaxed pose with a shelf of books and framed oil painting in the background, Ko holds a fan against his bent knee and wears an unbuttoned linen shirt, suggesting a hot summer day. The exposure of his chest signals his defiance of traditional Confucian codes of decorum. Rather than

representing himself as a working artist, Ko assumes the guise of a scholar surrounded by the paraphernalia of the literati— books and art—albeit one versed in Western artistic knowledge as indicated by the oil painting behind him. Coming from the *chungin* class, Ko would have been aware of *chungin* artists' low status in the Chosŏn dynasty, because they worked for money, as opposed to elite literati artists who painted for self-cultivation. The abolition of Korea's feudal class system freed Ko to imagine himself in the latter role, now modernized.

Kim Kwan-ho (1890–1959)

Kim Kwan-ho enrolled at the Tokyo School of Fine Arts in 1911 and graduated with highest honors in 1916. His graduation work, *Sunset* (1916), showing two standing nude women from the back drying themselves after bathing in the Taedong River that runs through Kim's native Pyongyang, received special recognition at the Bunten. The Korean daily newspaper *Maeil sinbo* reported on this but did not illustrate the painting because it depicted naked women—a subject still considered indecent in Korea two decades after the scandal caused by the exhibition of Kuroda's *Morning Toilette* in Kyoto. Following the Tokyo School of Fine Arts' precepts, Kim painted in a style combining academic and Impressionist elements: firmly drawn and modeled, anatomically accurate figures with loose strokes of blue and purple defining the **foreground** foliage and rocks. This would have made his picture seem modern to Korean viewers even though it includes no markers of modern life; the women seem frozen in a timeless state. While the praise Kim's painting received at the Bunten suggests he had been fully assimilated as a colonial subject, *Sunset* also conveyed nationalistic pride through its Korean setting.

The Chosŏn Art Exhibition, Local Colors, and Lee In-sung (1912–1950)

During the colonial period, the most important Korean venue for artists to show and gain recognition for their work was the annual Chosŏn Art Exhibition, established by the colonial government in 1922. Modeled on the French **Salon** and the Bunten, the Chosŏn Art Exhibition was controlled by a jury that selected works for display and awarded prizes. It was essentially a Japanese salon held in a Japanese colony: a large percentage of the participants were Japanese living in Korea, and almost all the jurors were Japanese.[12]

The Chosŏn Art Exhibition was initially divided into four sections encompassing "Eastern painting" (ink painting), "Western painting" (oil painting), calligraphy, and sculpture. Rather than images of modern Korean life, the judges of both the ink and oil painting sections favored depictions of what critics called "local colors." These were scenes of the pastoral countryside, farms, and Korean customs that

FIGURE 11.11 Ko Hŭi-dong, *Self-Portrait*, 1915. Oil on canvas, 61 x 46 cm. National Museum of Modern and Contemporary Art, Korea.

seemed quaint and exotic to the Japanese colonizers and reinforced their perception of Korea as a premodern Other to modern Japan.[13]

One of the most successful local colors artists was Lee In-sung, a Western-style painter from Taegu (Daegu) who studied in Tokyo (1931–34). His *Valley in Gyeongju* (1934, Figure 11.12), shown in the Chosŏn Art Exhibition in 1935, represents a shirt-less boy sitting on a rock at the right and another boy carrying a child on his back at the left, within a broad Korean landscape scattered with plants, trees, and rocks set against distant mountains under a blue sky with a few white clouds. Lee deliberately used blue in the sky and red in the earth because these were thought to be local Korean colors. The flattened forms, thick paint handling, and bright, anti-naturalistic colors (such as the red of the earth and yellow in the landscape behind the seated boy) suggest the influence of Gauguin, whose work Lee knew in reproduction. Lee's figures seem listless and aimless, as if waiting for something—or simply enduring their colonized existence. Rising at the upper left center are the ruins of Cheomseongdae, a seventh-century astronomical observatory built during the Silla

kingdom, evoking a period of Korean strength and prestige contrasting its contemporary subordination to Japan.

The New Woman

A significant societal development in Korea during the colonial period was the emergence of the "New Woman."[14] This term, popularized in the 1920s, denoted women who challenged the traditional patriarchal system through such means as gaining a modern education, pursuing careers, advocating for women's rights, and seeking sexual freedom. They often signaled their identity as New Women by cutting their hair short and wearing shorter versions of Korean women's jackets and skirts, or by adopting Western clothing.

Exemplary of the New Woman within the artistic profession was Na Hye-sŏk (1896–1948). The first Korean woman to study art in Tokyo (at the Tokyo Women's School of Fine Arts, 1913–18), to paint in the Western style, and to hold a solo exhibition in Korea (in 1921), she also championed women's liberation. In a poem she published in 1921 in *Maeil sinbo*, Na declared: "I was a human being/Even before being a husband's

FIGURE 11.12 Lee In-sung, *Valley in Gyeongju*, 1934. Oil on canvas, 130 x 194.7 cm. Leeum, Samsung Museum of Art, Seoul.

wife/and a mother of children./ First of all, I am a human being."[15] During a sojourn in Paris in the late 1920s, Na absorbed influences from Fauvism and Expressionism, as seen in her late work *Peonies of Hwayeongjeon Palace* (1935).

Although New Women were urban, male Korean artists depicted them in the 1920s and 1930s not on the city streets but in domestic interiors, reading or appreciating music—activities indicative of their education and cultivation. During the war years (1937–45), images of the New Woman largely gave way to those of the *hyonmo yangcho* (wise mother, good wife) or women supporting their husbands—virtuous roles in the ideological context of imperial Japanese demands for wartime propaganda images. A notable exception is Yi Yu-t'ae's (1916–99) arresting portrayal of a young woman in a science laboratory, *Inquiry* (also known as *Research*, 1944, Figure 11.13A). A student of Kim Ŭn-ho, Yi painted in the Nihonga style with fine linear detail and restrained colors. He shows the woman wearing a white lab coat over her *hanbok* (traditional Korean clothes) with shelves of glass flasks behind her. The table beside her holds a microscope and a battery-powered kymograph, which measures physiological responses in animals—in this case, the rabbits in wire mesh cages at the lower right—and is often used in pharmacological experiments monitoring the effects of drugs.[16] Although it is open to any number of readings, Yi's picture may be interpreted as reflecting the wartime need for images of strong yet feminine women serving on the home front.[17] Yi paired it with another painting of nearly the same dimensions, *Composing a Verse in Response* (Figure 11.13B), depicting a young bourgeois woman seated at a lace-doily topped round table before a pot of blooming peonies with her back to a grand piano. Yi's diptych (the paintings together are called *A Pair of Figures*) offers a contrast between types—the New Woman in a professional setting and the cultivated "wise mother, good wife" at home. The possibility that the two paintings represent the same woman suggests the societal pressure that some Korean women felt to perform both roles.[18]

Abstraction: Kim Whanki (1913–1974)

During the 1930s, several Korean painters interested in avant-garde styles such as Cubism, Futurism, and abstraction, lacking opportunities to show in Korea, exhibited instead in Japan with their likeminded Japanese colleagues of the Free Artists' Association formed in Tokyo in 1937. Among the Korean

FIGURES 11.13A & B Yi Yu-t'ae, *A Pair of Figures – Inquiry* (A) and *Composing a Verse in Response* (B), 1944. Watercolor on paper, 212 x 153 cm and 210 x 148.5 cm. National Museum of Modern and Contemporary Art, Korea.

FIGURE 11.14 Kim Whanki, *Rondo*, 1938. Oil on canvas, 61 x 71.5 cm. National Museum of Modern and Contemporary Art, Korea.

participants in the association's exhibitions was the Tokyo-educated Kim Whanki, celebrated as a pioneer of Korean abstract painting. Kim's best-known early work, *Rondo* (1938, Figure 11.14), features a puzzle-like composition of flat color planes with curved or straight edges. Although the picture is highly abstract, some shapes at the lower right suggest a trio of figures and the curved edges of the planes along the top evoke an open piano lid, in keeping with the painting's musical title. After the war, Kim expressed his cultural identity by incorporating Korean motifs such as the moon, cranes, and the shapes of Chosŏn ceramic vessels into his paintings.

China

From the mid-nineteenth century to the mid-twentieth, China experienced great political turmoil. The Qing dynasty, which had ruled the country since 1644, was weakened by several circumstances: China's defeat in the Opium Wars (1839–60) and the first Sino-Japanese War (1894–95); a poor economy; and a series of uprisings and rebellions. The Xinhai Revolution of 1911 finally overthrew the Qing dynasty and led to the establishment of the Republic of China a year later. Political fragmentation followed as warlords ruled different parts of the country from 1916 to 1927, when much of it was reunited

by General Chiang Kai-shek (Jiang Jieshi) and his National Revolutionary Army. Yet tensions remained high, as the Nationalists not only faced renewed aggression from Japan but also struggled to suppress the Chinese Communist Party. They failed: the Communists won the Chinese Civil War and established the People's Republic of China in 1949.

Against this backdrop, Chinese art thrived, animated by debates over how best to renew the national culture. Many reformers advocated embracing Western concepts of modernity, while others argued for the continuing validity of Chinese traditions.

The Shanghai School

The venerable Chinese traditions of ink painting and calligraphy flourished during the late Qing dynasty in the prosperous commercial center of Shanghai, which had been opened to the West in 1842 as a treaty port and grew rapidly over the rest of the century. Shanghai art collectors' demand for vivid, colorful, and easily comprehensible paintings was met by artists of the Shanghai School, including Ren Xiong, Ren Yi (Ren Bonian), and Wu Changshuo. These painters worked in the time-honored Chinese media of brushed ink and water-based colors on paper or silk, and depicted traditional subjects such as birds, flowers, figures, and landscapes. They drew inspiration from the individualist (as opposed to court) painters

of the Ming and early Qing dynasties and developed their own unique styles. Their efforts infused new vitality into the Chinese painting tradition, which came to be labeled *guohua* (literally national, or Chinese-style, painting) to distinguish it from *xihua* (Western-style painting).

Chen Hengke (1876–1923) and Qi Baishi (1864–1957)

In the more culturally conservative Beijing, the leading *guohua* painter of the early twentieth century was Chen Hengke. Although he had studied Western-style painting in Japan, he passionately promoted the Chinese tradition of literati painting (*wenrenhua*): the individualistic, self-expressive art of educated gentlemen (and, rarely, gentlewomen) painters that often emphasized abstract visual qualities, as seen in the unrestrained brushwork of Chen's *Orchids*.

Chen played an important role in mentoring Qi Baishi, widely recognized as the greatest twentieth-century *guohua* painter. From humble origins, Qi grew up in Hunan province, worked in the fields, and was trained as a craftsman. He learned to paint by studying with local professionals and emulating the work of past masters. He also gained knowledge of calligraphy, seal carving, and poetry—all traditional literati pursuits. Settling in Beijing in 1919, he was encouraged by Chen to develop the fresh, personal style of freely brushed ink painting that brought him acclaim.

A prolific artist who painted thousands of pictures, Qi Baishi is best known for his images of flowers and birds, grapes and gourds, crabs and frogs, and (above all) shrimp—subjects he was familiar with through his rural upbringing. His undated hanging scroll *Shrimps* (Figure 11.15) depicts six of the lively crustaceans gracefully descending through the vertical composition, singly in the top half and in pairs in the bottom half. Qi raised shrimp so that he could observe them closely and learn their anatomy, which he renders through expertly applied ink strokes of varying length, width, shape, and density. The inscription on another of Qi's paintings of shrimps characterizes this sure and fluent brushwork as a form of spontaneous expression: "If you can forget painting theory, you will not suffer from its deeply rooted bad effects. Then your brush will fly like the heavenly horse moving through the sky."[19]

Gao Jianfu (1879–1951) and the Lingnan School

As we have seen, the Meiji rulers of Japan encouraged modernization by promoting the assimilation of Western cultural influences, leading to the development of Nihonga and Yōga. Many Chinese artists who traveled to Japan absorbed these modernizing impulses and brought them back to China. Among the first to do so were three young painters—Gao Jianfu, his brother Gao Qifeng, and Chen Shuren—who studied in Japan in the first decade of the twentieth century. They absorbed Nihonga influences and assimilated Western techniques such as shading and perspective (also used by some Nihonga artists). After returning to China they founded the Lingnan School, named for its artistic base "south of the mountains" (*ling nan*) around Guangzhou, where the Gao brothers took up teaching positions in 1918.

Gao Jianfu proposed a "new national painting" (*xin guohua*) synthesizing Japanese and Western aesthetics to revolutionize Chinese art. *Eagle* (1929, Figure 11.16), a dramatic example of his mature style, is a patriotic picture that uses a ferocious bird of prey to symbolize the power of the revitalized Chinese Republic. The **foreshortening**, shading, and naturalistic details of the eagle's body, combined with the Chinese-style brushwork used to render the rocks below, show the successful fusion of Asian and Western aesthetics promoted by Gao.[20]

FIGURE 11.15 Qi Baishi, *Shrimps*, n.d. Hanging scroll, ink on paper, 103 x 35 cm.

Cai Yuanpei and the New Culture Movement

The nationalist sentiments of Gao's painting are consistent with the political commitments that he and his colleagues first made in Tokyo. As students, they had joined the Revolutionary League (Tongmenhui) of Sun Yatsen, an opponent of the Qing dynasty who briefly served as the first president of the Chinese Republic and cofounded the Nationalist Party (Guomindang) in 1912. Another member of the Revolutionary League, Cai Yuanpei, served as chancellor of Peking University from 1916 to 1926 and later held positions in the Nationalist government.

Cai was a leader of the New Culture Movement, which advocated for the reform of Chinese society through the adoption of Western ideals of democracy and science. In 1918, he established the Beijing Art School, China's first government-funded

institution of art education. The school offered instruction in both Chinese and Western painting, but Cai urged Chinese artists to abandon the "ink play" of the literati painters and to emulate the realism of Western art.[21]

Xu Beihong (1895–1953)

To encourage the adoption of Western artistic concepts, Cai established a government-supported scholarship for a few young artists to study in Europe. The first recipient was Xu Beihong, who received academic training in Paris and Berlin from 1919 to 1927. Xu developed an oil-painting style based on nineteenth-century academic realist standards rather than the innovations of the twentieth-century avant-garde, which he openly criticized after his return to China.

In 1928 Xu became head of the art department at the newly formed Central University in Nanjing (the Nationalist capital from 1927 to 1938). The same year, he began work on a large **history painting**, *Tian Heng and His Five Hundred Warriors* (1928–30, Figure 11.17), inspired by the monumental European history paintings, such as Jacques-Louis David's *Oath of the Horatii* (see Figure I.9), that he had studied at the Louvre. The hero of Xu's painting is Tian Heng, a nobleman of the 3rd c. BCE state of Qi who chose to commit suicide rather than submit to the first Han emperor. Xu shows the red-robed Tian Heng at the right, bidding farewell to his grief-stricken followers before setting out on the journey that would end in his death. On hearing of his suicide, his faithful followers all killed themselves with their own swords—an event foreshadowed by the bearded man in the left foreground grasping his weapon with both hands. Xu likely chose this subject to encourage his fellow citizens to emulate the uncompromising integrity of Tian Heng in confronting their nation's many challenges.

Like most Chinese artists trained in Western-style painting, Xu Beihong also worked in the traditional Chinese medium of brushed ink on paper. During the second Sino-Japanese War, he made numerous broadly brushed ink paintings of spirited horses, traditional symbols of Chinese military power (e.g., *Heavenly Horse*, 1942). Today, he is best known for these works.

Lin Fengmian (1900–1991)

Another young Chinese artist who studied in Europe was Lin Fengmian. In France and Germany between 1920 and 1925, he absorbed influences from Fauvism, Cubism, and German Expressionism (the latter evident in paintings such as Lin's *Pietà*, c. 1940). After returning to China, he became director of the new National Beijing College of Art, where he introduced his students to the work of Cézanne and Matisse and caused controversy by instituting the study of live nude models. In 1928, Cai Yuanpei appointed Lin to direct the new National

FIGURE 11.16 Gao Jianfu, *Eagle*, 1929. Hanging scroll; ink and color on paper, 167 x 83 cm. Chinese University of Hong Kong Art Museum.

Academy of Art in Hangzhou, where he mentored a new generation of innovative ink painters, including Li Keran and Wu Guangzhong.

The First National Exhibition of Art and the Xu Beihong–Xu Zhimo Debate

Lin Fengmian played a key role in organizing the First National Exhibition of Art in Shanghai in 1929—a showcase of traditional Chinese ink painting, calligraphy, and seal carving; Chinese, Japanese, and Western oil paintings; and

FIGURE 11.17 Xu Beihong, *Tian Heng and his Five Hundred Warriors*, 1928–30. Oil on canvas, 197 x 349 cm, Xu Beihong Memorial Museum, Beijing.

works of sculpture, architecture, design, and photography. The oil paintings sparked a debate over whether European-style academic realism or experimental modernism was the most appropriate visual language for modern China. Xu Beihong argued forcefully for the former position, attacking the works of Cézanne and Matisse as "shameless" and "despicable."[22] His critique implicitly indicted Chinese modernists such as Lin Fengmian and Liu Haisu, an influential educator and cofounder of the Shanghai Art School who painted oils in a Post-Impressionist style. In response, the Cambridge-educated modern poet Xu Zhimo published a defense of modernism and Cézanne in particular, praising his devotion to "pure art."[23]

Guan Zilan (1903–1986)

An example of the kind of modernist oil painting involved in this argument is *Portrait of Miss L.* by Guan Zilan (1929, Figure 11.18). One of the few women to enjoy professional success in the male-dominated art world of the Republican period, Guan studied Western-style painting in Shanghai and Tokyo, returning to Shanghai to teach in 1930.

Portrait of Miss L. features elements from Japan (where it was painted), China, and the West. With its bold colors, loose brushwork, and simplified forms, it reflects the strong influence of Fauvism, then popular among modernist Japanese painters. However, it depicts a fashionable Chinese subject: a well-to-do young woman with a stylish haircut dressed in a colorful *qipao* (sheath dress) and blue-green vest, cradling a cute lapdog (possibly a stuffed toy) bedecked in a red ribbon. The pet is a modern, Western-influenced element that would not be seen in a traditional Chinese portrait.[24]

FIGURE 11.18 Guan Zilan, *Portrait of Miss L.*, 1929. Oil on canvas, 90 x 75 cm. National Museum of Chinese Art, Beijing.

The Storm Society

Even more aggressively avant-garde than Guan Zilan were the painters of the Storm Society (*Juelanshe*, "great wave"). These artists, who banded together in Shanghai between 1931 and 1935, were determined to reform Chinese art by promoting the

modernist innovations they had encountered while studying in France and Japan. Led by Pang Xunqin and Ni Yide, the Storm Society issued a strident manifesto to accompany their first exhibition in 1932. Condemning the contemporary Chinese art world as "decadent and diseased," the group called for "new techniques to express the spirit of the new age." The manifesto praised "the passionate voice of the Fauves, the distorted forms of the Cubists, the shock of Dadaism [and] the dreamscapes of Surrealism" as models for the "new atmosphere" they sought to create.[25]

The Storm Society's works showed the influence of all of these European avant-garde currents. For example, Cubist, Dadaist, and Surrealist elements are seen in Pang Xunqin's (1906–85) **watercolor**, *Such is Paris* (1931). It is a street scene filled with large disembodied faces, fragments of lettering from commercial signs, playing cards, and, at the lower right, a urinal—a likely reference to Duchamp's *Fountain* (see Figure 7.3). Tragically, almost all of the Storm Society's paintings were destroyed in the second Sino-Japanese War or during the subsequent decades of Communist rule, when European-style modernism was denounced as bourgeois and counterrevolutionary. We now know these paintings only from reproductions.

Lu Xun and the Modern Woodcut Movement

While the Storm Society was active, a group of young printmakers who shared the painters' idealism formed the Modern Woodcut Movement (Xinxing banhua yundong). They diverged, however, from the Storm Society's art-for-art's-sake philosophy in viewing their prints as a vehicle for social and political activism. The movement's founder—the prominent writer, critic, and educator Lu Xun—was a leader of the New Culture Movement and spent the last decade of his life in Shanghai. A serious collector of both Japanese and European prints, he issued publications on and presented several small exhibitions of European **woodcuts** in the early 1930s, stimulating great interest in the medium among young artists. In collaboration with a Japanese printmaker friend, Lu also organized a woodcut training class in August 1931. It was attended by thirteen students, who formed the nucleus of the Modern Woodcut Movement and spread it to other parts of China over the next decade.

Perhaps the most dramatic product of the movement's early years is *To the Front!* (1932, Figure 11.19) by Hu Yichuan (1910–2000), who had studied oil painting in Hangzhou before taking up printmaking. His stark black-and-white image, reminiscent of the woodcuts of Käthe Kollwitz (see Chapter 3), was made to support Chinese resistance to the Japanese invasion of Manchuria. It shows a shouting male figure, pressed close to the picture plane and cropped by the vertical edges of the composition, exhorting his comrades to follow him to the front. While Hu's militant image could have functioned effectively as propaganda for the Nationalists, the left-wing political views that he and many of his colleagues held made them a target of suppression by the government, which arrested numerous Modern Woodcut artists active in Shanghai and Hangzhou, including Hu, in the 1930s.

Woodcuts remained an important medium in China during the second Sino-Japanese War. Hu Yichuan and other left-wing

FIGURE 11.19 Hu Yichuan, *To the Front!* 1932. Woodblock print, 20.5 x 27 cm. National Museum of Chinese Art, Beijing.

artists gathered in the Communist stronghold of Yan'an and produced images in the simple, flat style of Chinese New Year's prints. They used this folk art idiom to communicate clearly to the local populace, whose support the Communists sought. It was also at Yan'an that the Communist leader Mao Zedong delivered his famous talks on literature and art in 1942. Mao declared that art should serve the party and the masses of soldiers, workers, and peasants, reflecting their daily lives and encouraging their commitment to socialism. After the 1949 Communist Revolution, the government assumed complete control of the arts, banishing **formalist** modernism and enforcing the conception of art as a vehicle of Communist ideology.

Postwar Art in the United States: Abstract Expressionism and the New American Sculpture and Photography

The 1940s saw a remarkable transformation in the modern art of the United States. The representational painting modes of American Scene, Regionalism, and Social Realism, and the Cubist-based abstract styles of artists like Stuart Davis (see Chapter 10), were challenged by audaciously new forms of abstraction emphasizing raw, spontaneous gestures of roughly applied paint or large fields of pure color. Pioneered by artists working in New York City, these styles came to be known as Abstract Expressionism (because they did not represent nature and were understood to convey strong personal feelings); its practitioners were dubbed the New York School. By the 1960s, the signature works of the group's leading painters—Jackson Pollock's poured and dripped allover abstractions; Willem de Kooning's distorted, spontaneously painted *Women*; and Mark Rothko's luminous color fields—had become icons of twentieth-century modern art. And despite some European reluctance to acknowledge it, most understood that through Abstract Expressionism, New York had displaced Paris as the capital of the modern art world.

Abstract Expressionism received strong backing from MoMA and from a new generation of New York art dealers, beginning with Peggy Guggenheim, who gave Pollock his first solo exhibition in 1943, and continuing with Betty Parsons, Samuel Kootz, Charles Egan, Sidney Janis, Marian Willard, Martha Jackson, and others. Influential art critics such as Clement Greenberg and Harold Rosenberg (see box) also advocated for Abstract Expressionism.

In addition to the support that women dealers gave the Abstract Expressionists, many women painters participated in the movement. Foremost among them were Lee Krasner, Elaine de Kooning, Joan Mitchell, Grace Hartigan, and Helen Frankenthaler (discussed as the pioneer of Stained Canvas Color Field painting in Chapter 16). However, the postwar New York art world's sexism, which reflected that of the larger American society, and the popular understanding of Abstract Expressionism as a forceful, virile art form, impeded its women practitioners' professional success. "The galleries had quota systems, two women to a gallery, if they were lucky," recalled Mitchell in 1986. "[Kootz] didn't show women. Janis didn't show women."[1] African American men who painted in Abstract Expressionist styles, including Norman Lewis, Hale Woodruff, and Romare Bearden, likewise failed to achieve the same recognition as their white counterparts due to the period's racial bias.

Although they were highly individualistic and never formally considered themselves a movement, the New York School painters were unified in seeking deeply personal expression infused with powerful feeling. They also often reached for the sublime by working on very large canvases (continuing the trend of the pre–World War II mural movements in the United States and Mexico) that created physically imposing and engulfing pictorial environments. The Abstract Expressionists did not intend their works as nationalistic statements, but their daring and sometimes aggressive aesthetic came to be associated with growing American power in the early years of the Cold War (1945–89), which involved intense political competition between the United States-led democratic capitalist West and the Soviet Union-led totalitarian communist East.

The Cold War was also contested in the cultural sphere, with the US government enlisting Abstract Expressionism as a weapon. During the 1950s, the Congress for Cultural Freedom, secretly backed by the Central Intelligence Agency, sponsored several exhibitions featuring Abstract Expressionism that were sent to foreign countries, including MoMA's *The New American Painting*, which toured major European cities in 1958–59. These shows aimed to demonstrate the superiority of American values of individualism and free expression embodied in Abstract Expressionism, in opposition to the rigid conformity imposed on artists, and society, under communism.[2]

Ironically, many of the Abstract Expressionists themselves had been associated with left wing or anarchist politics before the war and afterward they remained alienated from US mainstream culture with its emphasis on consumerism and the power of the "military-industrial complex" (in President Dwight D. Eisenhower's famous term). Furthermore, many conservative American politicians considered abstraction "un-American" and even "communistic" (ignoring the fact that communist governments mandated highly legible representational art that would advance socialist ideology). Such contradictions were typical of the period's anti-communist hysteria.

While New York School painting emerged as the most celebrated modern American art form during this period of cultural unrest, this chapter also considers painters who remained committed to representational styles as well as related developments in sculpture and photography, either in dialogue with or independent of Abstract Expressionism's innovations.

Early Abstract Expressionism

The future **Abstract Expressionists** began to form a community in New York in the 1930s, where many worked for the Federal Art Project of the WPA (see Chapter 10). Some painted in **styles** related to the period's **American Scene** and **Social Realist** idioms while others explored forms of **Cubist**-derived geometric **abstraction**. By the decade's end, however, these young artists had come to see these modes of American painting as inadequate to the task of expressing the fears and hopes of a world wracked by a terrifying war and uncertain about humanity's future. In seeking new aesthetic means to convey profound emotions and content, the future Abstract Expressionists drew inspiration from European modern art's crucial innovations.

This art was shown in New York in Albert Gallatin's Gallery of Living Art (1927–43; renamed the Museum of Living Art in 1936), the Museum of Modern Art (MoMA, founded 1929), and Solomon R. Guggenheim's Museum of Non-Objective Painting (founded 1939). Also influential was the teaching of Hans Hofmann (1880–1966), a German expatriate artist who ran schools in New York City and Provincetown, Massachusetts. Hofmann's principle of "push-pull." synthesized Matisse's sensuous color with the displacements of form advanced by Cézanne and the Cubists to create pictorial space without recourse to **modeling** and **perspective**. This "push-pull" is best exemplified in his slab paintings of the 1950s and 1960s, such as *The Golden Wall* (1960). Particularly important to the future Abstract Expressionists was the example of abstract **Surrealism** with its commitment to **automatism** as a means of spontaneously creating unexpected visual forms, supposedly derived from the unconscious. Prominent Surrealists, including Breton, Ernst, Masson, and Matta, were among the many European modernists who sailed to New York seeking refuge from the Nazis and World War II.

Some future Abstract Expressionists, including Mark Rothko, Adolph Gottlieb, and Jackson Pollock, combined explorations of this Surrealist-inspired automatism with an interest in ancient myths. They believed that myths transcended individual cultures to express universal human concerns and feelings, including the violent impulses unleashed in modern war. They based this idea on the concept of the collective unconscious, developed by the Swiss psychoanalyst Carl Jung (see "Psychoanalysis" box, Chapter 8). Jung saw myths as primal stories populated by archetypes—symbolic images and ideas supposedly shared by all of humanity across time. Related to this idea of an unchanging, universal collective unconscious was the notion, now discredited, that so-called primitive peoples, such as tribal Africans and Native Americans, also lived in a timeless, mythic state (see "Primitivism" box, Chapter 2). They "have readier access to their unconscious mind than so-called civilized people,"[3] in the words of the Russian émigré artist John Graham, an important mentor to Pollock and other Abstract Expressionists.

Arshile Gorky (1904–1948)

Arshile Gorky, whom Matta befriended and Breton welcomed into the Surrealist fold, was especially close to the Surrealists in exile. Born Vosdanig Adoian in Armenia, then part of the Ottoman Empire, the artist adopted his pseudonym, translated as "bitter Achilles," in 1924, four years after immigrating to the United States. The new name signaled a bitterness rooted in Gorky's biography: he fled his homeland following the Ottoman Turks' campaign of deportations and massacres of Armenians during World War I, after witnessing his mother's death from starvation.

In the 1920s and 1930s, Gorky worked his way through the history of modern European painting, successively assimilating the styles of Monet, Cézanne, Picasso, Léger, Miró, Masson, and Matta. Matta urged Gorky to paint more

spontaneously with **oil paint** thinned with turpentine to allow it to flow more freely. The results are seen in Gorky's *Water of the Flowery Mill* (1944, Figure 12.1), which combines thinned areas of dripping paint alongside denser patches of lush color and fine linear elements applied with a slender brush. Areas of the white primed canvas ground show throughout. The complex overall effect recalls Kandinsky's pre-1914 abstractions (see Figure 3.15), another influence on Gorky. This abstracted landscape was among many inspired by Gorky's intense study of nature during summers spent in Connecticut and Virginia, which mingled in his mind with reminiscences of his childhood. *Water of the Flowery Mill* sprung from Gorky's observation of an old mill and bridge on the Housatonic River near his Connecticut home. It also includes a highly simplified image of a woman, possibly his mother, gesturing with her right hand from the other side of the dark bridge at the **composition**'s lower edge.[4] The title's punning words, a play on "flour mill," arose from verbal free association like that advocated by Breton for the production of Surrealist poetry.

The Early Work of Mark Rothko (1903–1970)

Russian-born Mark Rothko immigrated with his family to Oregon in 1910 and studied at the Art Students League in New York in the 1920s. During the 1930s, he painted urban scenes in a somber, **painterly** style. With the outbreak of World War II, Rothko felt the need to engage new subjects in a new style to acknowledge the era's horrible realities without illustrating them anecdotally. He found encouragement in Friedrich Nietzsche's treatise, *The Birth of Tragedy from the Spirit of Music* (1872), which argued that Greek tragedies and myths express universal human truths and that art can redeem humanity from the terror of existence.

During the early 1940s Rothko painted several pictures inspired by Greek tragedies, including *The Omen of the Eagle* (1942, Figure 12.2), derived from Aeschylus's play *Agamemnon*. Rothko's title refers to a scene in which two eagles attack and kill a pregnant hare, foretelling both Agamemnon's sacrifice of his innocent daughter Iphigenia to gain favorable winds to sail to Troy and the Greeks' victory over the Trojans. Rothko's loosely painted, layered composition is Surrealist in its irrational, dreamlike quality. It presents, from top to bottom, a row of Greek heads; abstracted eagles; overlapping architectural and **biomorphic** forms (some with sharp extensions suggesting eagle's talons); and a cluster of human feet. Rothko insisted that the picture did not deal with the anecdote referred to in its title "but rather with the Spirit of Myth, which is generic to all myths at all times. It involves a pantheism in which man, bird, beast and tree—the known as well as the knowable—merge into a single tragic idea."[5] In a similar vein, Rothko and Adolph Gottlieb asserted in 1943: "only that subject matter is valid which is tragic and timeless. That is why we profess kinship with primitive and archaic art."[6]

FIGURE 12.1 Arshile Gorky, *Water of the Flowery Mill*, 1944. Oil on canvas, 107.3 x 123.8 cm. The Metropolitan Museum of Art, New York.

FIGURE 12.2 Mark Rothko, *The Omen of the Eagle*, 1942. Oil and graphite on canvas, 65.4 x 45.1 cm. National Gallery of Art, Washington, DC.

The Early Work of Jackson Pollock (1912–1956)

Jackson Pollock's Abstract Expressionist paintings of the early 1940s reveal his awareness of Native American art and culture, to which Pollock, as a westerner, was particularly drawn. Born in Cody, Wyoming, and raised in Arizona and Southern California, Pollock moved at age seventeen to New York City to study under Thomas Hart Benton (see Chapter 10). By the mid-1930s, he had synthesized Benton's sweeping **baroque** compositional rhythms with the dark, visionary style of the late nineteenth-century American painter Albert Pinkham Ryder (e.g., *Going West*, c. 1934–35). In the late 1930s, Pollock embraced Surrealist automatism, which he believed gave him access to the primal creative energies of the unconscious, an idea encouraged by his friend John Graham and by the Jungian psychoanalysts who treated Pollock for alcoholism between 1939 and 1942.

Mythic and symbolic images suggestive of Jungian archetypes and sometimes influenced by Native American art regularly appear in Pollock's painting of the early 1940s, including *The She-Wolf* (1943, Figure 12.3). This composition evokes the legendary animal who suckled Romulus and Remus, ancient Rome's twin founders. Working impulsively, Pollock first laid down washes and color spatters, over which he painted the rough black contours of the leftward-facing wolf, subsequently reinforced with vigorous strokes of white. He covered the composition's top, right, and bottom edges with a gray-blue layer that throws the image of the wolf into relief. The red arrow traversing the she-wolf's midsection may derive from the **iconography** of Zuni Pueblo pottery; Pollock would have seen this type of decoration in MoMA's *Indian Art of the United*

FIGURE 12.3 Jackson Pollock, *The She-Wolf*, 1943. Oil, gouache, and plaster on canvas, 106.4 x 170.2 cm. The Museum of Modern Art, New York.

States exhibition (1941). Zuni potters depicted deer in black silhouette with the body opened around a red line and triangle representing the windpipe and heart, revealing the animal's inner life and spirit, which was likely Pollock's intention in using this motif.[7] Yet, even as he alluded to ancient myths and "primitive" beliefs, Pollock also indirectly acknowledged, through the picture's dark and agitated formal qualities, the violence of the World War then raging overseas. Followers of Jung understood this conflict as a modern unleashing of the human psyche's eternal primal forces.

Action Painting

The rough, impulsive paint handling seen throughout *The She-Wolf* epitomizes the style that Rosenberg called **action painting**. In theory, the action painters worked spontaneously, brushing or splashing paint without premeditation, to discover their compositions in the process of creating them—a risky, existentialist enterprise that could end in failure as easily as in success. This mode of art making is also called **gestural painting**, because the marks or strokes of paint record the artist's active gestures (physical movements) that laid them down.

Jackson Pollock's Drip Paintings

Pollock created the most famous and radically unconventional form of action painting in his series of "drip" paintings. He began making them in 1947, two years after he moved with his wife and fellow artist Lee Krasner to Long Island's eastern tip. Converting the barn behind their house into his studio, Pollock spread raw canvas on the floor and attacked it from all four sides, using sticks and hardened brushes to fling, drip, splash, and puddle liquid paint. In this way, he generated completely nonrepresentational paintings in which line no longer defines **shapes** or **forms** but achieves autonomy. Maintaining his commitment to automatism and belief in the unconscious as the source of his art, Pollock worked spontaneously: "When I am in my painting," he wrote, "I'm not aware of what I'm doing. It is only after a sort of 'get acquainted' period that I see what I have been about. I have no fears about making changes, destroying the image, etc., because the painting has a life of its own. I try to let it come through."[10]

Clement Greenberg and Harold Rosenberg: Champions of Abstract Expressionism

The chief critical proponents of Abstract Expressionism, Clement Greenberg and Harold Rosenberg, like many New York Jewish intellectuals, had both embraced Marxism in the 1930s and then rejected communism after the abuses of Stalinism were revealed. After the war, both critics saw Abstract Expressionism as a liberating alternative to debased mass culture in both its communist and capitalist forms—Stalinist **Socialist Realism** on the one hand and American popular entertainment on the other—but they understood Abstract Expressionism in different ways.

To Greenberg, a staunch formalist, Abstract Expressionism was a form of autonomous abstraction that emphasized its **medium's** purity. In the case of painting, this consisted of flat color spread across a rectangular canvas, denying narrative and spatial illusionism, which Greenberg argued were not inherent qualities of the medium. Greenberg championed Pollock in the 1940s and in the 1950s shifted his support to Rothko, Barnett Newman, and Clyfford Still. Disregarding these painters' interest in conveying spiritual or ethical values through abstraction, Greenberg assessed their compositions in purely formal terms. He claimed that their use of large areas of flat color represented the decade's most advanced style of abstract painting. The term "Color Field painting"—also applied to a younger group of painters Greenberg would promote in the later 1950s and 1960s (see Chapter 16)—came to refer to the mature styles of Rothko, Newman, Still, and others who created simple compositions of a few colors stretching across large expanses of canvas.

By contrast, Rosenberg, Greenberg's critical rival, valued the physical and psychological processes of art-making central to the work of most Abstract Expressionists. They approached their canvases without preconceived notions of what the finished painting would look like and discovered their compositions through the act of creating them—an attitude expressed by the term "action painting." "At a certain moment," wrote Rosenberg in his famous 1952 essay, "The American Action Painters":

> **the canvas began to appear to one American painter after another as an arena in which to act—rather than as a space in which to reproduce, re-design, analyze or "express" an object, actual or imagined. What was to go on the canvas was not a picture but an event.**[8]

Rosenberg saw the action painter not only as liberated from the demands of representation but also as engaged in defining their own identity through the act of painting. This idea was influenced by the existentialist philosophy of Jean-Paul Sartre (see "Existentialism" box, Chapter 13), who wrote in 1946: "There is no reality except in action. . . . Man is nothing else than . . . the ensemble of his acts."[9] For Sartre, authentic existence was not predetermined but realized through acts, undertaken in isolation, with complete freedom and with total responsibility. Rosenberg understood action painting in exactly these philosophical terms.

Pollock also explained his dynamic new painting method as a way of making an artistic statement appropriate to his time. "It seems to me that the modern painter cannot express this age, the airplane, the atom bomb, the radio, in the old forms of the Renaissance or of any past culture. Each age finds its own technique."[11]

In the monumental *Autumn Rhythm, Number 30* (1950, Figure 12.4), Pollock employed only four colors—black, white, brown, and scattered bursts of turquoise—to generate a complex linear web. This exemplifies what Greenberg called an "all-over" composition, decentralized and spreading evenly across the vast canvas.[12] While the **formalist** Greenberg admired Pollock's poured abstractions for their anti-**illusionistic** emphasis on the flatness of the **picture plane**, Pollock understood them in metaphorical and even metaphysical terms. He not only related them to powerful modern inventions like the airplane, the atom bomb, and the radio, but he also wrote that they embodied "organic intensity—energy and motion made visible."[13] Through titles such as *Autumn Rhythm*, he suggested that their energy partook of the vital forces of nature. Pollock also compared his technique to that of Navajo sand painters who carefully poured dry **pigments** onto the ground to create geometric images of holy figures on which a sick person would sit to be healed. Creating the poured paintings seems to have brought Pollock a sense of healing as well; during the last two years he made them, he abstained from alcohol. After he started drinking again, mythic images returned to his paintings (e.g., *Echo: Number 25, 1951*, 1951) and his psychological

problems deepened. He died at age forty-four in a drunk driving accident: he crashed into a tree, also killing a young woman passenger.

Lee Krasner (1908–1984)

Lee Krasner largely subordinated her career to Pollock's during their marriage. While he used the large barn for his studio, she used a small upstairs bedroom. Contemporaneous with Pollock's poured paintings of the late 1940s, she produced her own dripped, allover compositions (e.g., *Composition*, 1949, Philadelphia Museum of Art), featuring delicate lines forming grids of abstract signs evoking ancient and inscrutable hieroglyphs. After Pollock's death, Krasner took over his studio. As if seeking cathartic release from her tragic loss, she painted her exuberant *Earth Green* series, rich with swelling and bursting organic forms. In the largest of these canvases, *The Seasons* (1957, Figure 12.5), Krasner's bold painterly gestures, sweeping curves, and expansive passages of pink and green conjure abstract images suggesting both plant life and human body parts, merged to evoke nature's cycles of germination, growth, and ripeness.[14]

Willem de Kooning (1904–1997)

Suggestions of fragmented human anatomy also appear in many paintings by Willem de Kooning, another leading gestural Abstract Expressionist. His *Painting* (1948, Figure 12.6) features a jumble of large, overlapping black shapes outlined in white, hovering in a shallow, nameless environment. While

FIGURE 12.4 Jackson Pollock, *Autumn Rhythm, Number 30*, 1950. Enamel on canvas, 266.7 x 525.8 cm. The Metropolitan Museum of Art, New York.

FIGURE 12.5 Lee Krasner, *The Seasons*, 1957. Oil on canvas, 235.6 x 517.8 cm. Whitney Museum of American Art, New York.

FIGURE 12.6 Willem de Kooning, *Painting*, 1948. Enamel and oil on canvas, 108.3 x 142.5 cm. The Museum of Modern Art, New York.

some of these shapes evoke body parts such as buttocks and elbows, others hint at representation—an apple at the lower left, a fedora at the upper right—and still others read as nonreferential. This ambiguity is characteristic of de Kooning's painting, which often mixed abstraction and representation as he strove for an all-inclusive art encompassing a wide range of sensations and associations, ideas and emotions. Always remaining open to uncertainty and change, de Kooning never truly "finished" a painting in the sense of resolving and perfecting it. Instead,

he emphasized the active process of painting itself, and understood painting, in existential terms "as a way of living."[15]

Painting belongs to a series of black-and-white paintings de Kooning exhibited in his first New York solo show in 1948, having arrived in United States from his native Netherlands twenty-two years earlier as a stowaway. Trained in fine and **applied art** at the Rotterdam Academy of Fine Arts and Techniques, he initially supported himself as a commercial artist, carpenter, and house painter. His friendships in the 1930s with

Stuart Davis, John Graham, and Gorky kindled de Kooning's ambition to become a modern painter. He was particularly inspired by Cubism, as shown in the outlined shapes of *Painting* that descend from the flat planes of **Synthetic Cubism**.

After gaining critical recognition as a leading abstractionist, de Kooning surprised many by returning to a recognizable subject he had often depicted previously: women. The major canvas he began in 1950, *Woman I* (1950–52, Figure 12.7), absorbed some eighteen months of obsessive effort and frequent reworking. In the final version, a formidable broad-shouldered, large-breasted woman stares out at the viewer with enormous eyes and bared teeth. Her body and turbulent surrounding environment are rendered through bold, swift brushstrokes. The monstrous and menacing appearance of this and similar de Kooning women has prompted various interpretations. The *Women* have been viewed as modern incarnations of bloodthirsty goddesses; as autobiographical expressions of tensions between the painter and his wife, artist Elaine de Kooning, from whom he would soon separate; or as conveying long-repressed fears of his domineering mother. De Kooning himself said the pictures "had to do with the idea of the idol, the oracle, and above all the hilariousness of it."[16] He

acknowledged ancient Sumerian votive figures' influence on the *Women*'s broad shoulders and wide-staring eyes. However, he had an irreverent attitude toward the supposedly archetypal myths that Pollock and Rothko took seriously. Advertisements featuring pictures of conventionally beautiful, smiling young women also inspired him. *Woman I*'s toothy snarl originated in a cutout photograph of a woman's smile that de Kooning clipped from a magazine and attached to his canvas before transforming its imagery into his own expressively painted version.

After completing the *Women* series in 1955, de Kooning returned to nonrepresentational painting. Using housepainter's brushes to lay down wide swaths of paint that index his vigorous gestures, his dynamic and colorful compositions such as *Saturday Night* (1956) stimulated countless imitations by younger followers.

Franz Kline (1910–1962)

Willem de Kooning's close friend Franz Kline painted American Scene subjects in the 1940s before arriving at his signature Abstract Expressionist style in 1950. Working on large canvases, Kline created dramatic compositions such as *Mahoning* (1956, Figure 12.8) in which numerous broad, rugged intersecting swaths of black traverse fields of white. Many of the black bands reach the sides of the canvas. This melds the bands to the picture plane while also allowing their energy seemingly to continue beyond its borders. *Mahoning* appears to have been spontaneously realized but was actually derived from a small, swiftly brushed study that Kline executed on a telephone book page (*Untitled [Study for Mahoning]*, 1951) and used as a guide to making the large painting—his typical practice. While resolutely nonrepresentational, *Mahoning*'s architectonic composition, suggesting thrusting beams, evokes the industrial American landscape; its title names the Ohio county bordering Kline's native Pennsylvania that was a mid-twentieth-century center of coal and steel production.

Joan Mitchell (1925–1992)

Joan Mitchell belonged to the younger generation of American painters who adopted action painting in the 1950s under Willem de Kooning's influence. Mitchell's paintings of the mid-1950s featured vigorously and spontaneously applied thick strokes and arcing lines of pure color, loosely aligned with the canvas's horizontal and vertical edges and surrounded by fields of snowy white. Her compositions often evoked landscapes and waterscapes, as she sought to express in painting the powerful emotions she associated with remembered experiences of nature. The rhythmic, horizontal green swaths of *Hemlock* (1956, Figure 12.9) suggest a hemlock tree, though Mitchell denied the resemblance. She drew

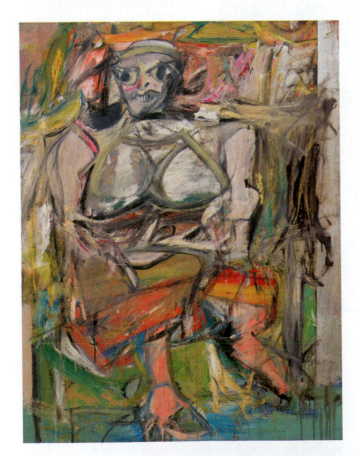

FIGURE 12.7 **Willem de Kooning, *Woman I*, 1950–52. Oil and metallic paint on canvas, 192.7 x 147.3 cm. The Museum of Modern Art, New York.**

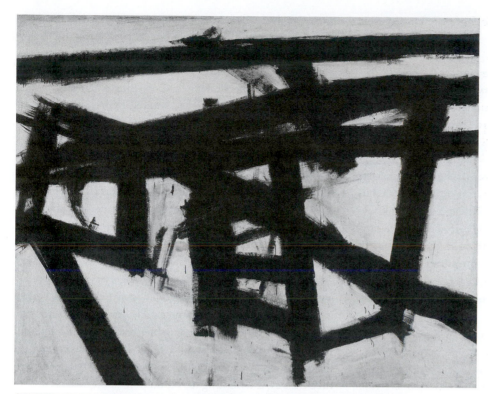

FIGURE 12.8 Franz Kline, *Mahoning*, 1956. Oil and paper on canvas, 204.2 x 255.3 cm. Whitney Museum of American Art, New York.

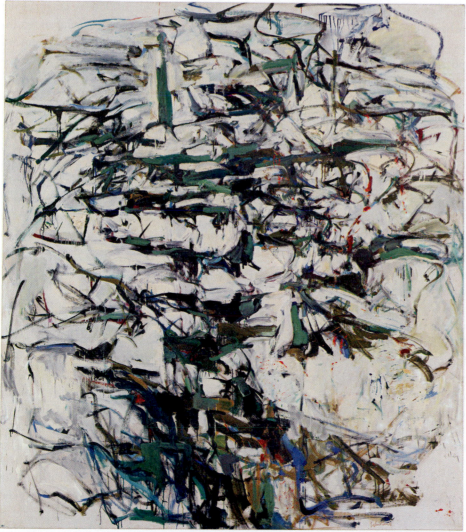

FIGURE 12.9 Joan Mitchell, *Hemlock*, 1956. Oil on canvas, 231.1 x 203.2 cm. Whitney Museum of American Art, New York.

its title from a 1916 poem by Wallace Stevens, "Domination of Black," which concludes:

Out of the window, / I saw how the planets gathered / Like the leaves themselves / Turning in the wind. / I saw how the night came, / Came striding like the color of the heavy hemlocks. / I felt afraid. / And I remembered the cry of the peacocks.[17]

The combination of sounds and images in Stevens's poem, in which the peacocks' cry expresses a fear of death, appealed to Mitchell, who while growing up in Chicago came to know many famous poets as the daughter of *Poetry* magazine editor Marion Strobel. Mitchell frequently likened her paintings to poems: a poem like Stevens's conveys meaning not through narrative but through creative use of language and metaphor. Mitchell believed her paintings communicated meaning purely through visual form.[18]

Color Field Painting

Beginning in the late 1940s, the major innovators of Abstract Expressionist **Color Field painting**—Clyfford Still, Mark Rothko, and Barnett Newman—largely suppressed gestural **brushwork**. Instead, they emphasized broad, simple expanses of intensely **saturated** color spreading across large canvases. They desired to achieve an effect of the **sublime**, which eighteenth-century philosopher Edmund Burke defined as an overwhelming emotion of astonishment or terror, such as might be experienced in the face of nature's immensity. While nineteenth-century **Romantic** landscape painters had evoked the sublime by depicting stirring natural scenes like soaring mountains or stormy seas (see Figure I.15), the Color-Field painters did so through completely nonrepresentational means, departing radically from earlier art's conventional subjects and styles. "We are reasserting man's natural desire for the exalted, for a concern with our relationships to the absolute emotions," announced Barnett Newman in 1948:

We are freeing ourselves of the impediments of memory, association, nostalgia, legend, myth . . . that have been the devices of Western European painting. Instead of making *cathedrals* out of Christ, man, or "life," we are making it [*sic*] out of ourselves, out of our own feelings. The image we produce is the self-evident one of revelation, real and concrete, that can be understood by anyone who will look at it without the nostalgic glasses of history.[19]

One attribute of the Burkean sublime was a sense of the infinite. Seeking this effect, Still, Rothko, and Newman painted open, evenly applied areas of color that extended to the edges of the canvas and did not seem bound by it. After 1950, they also worked on monumentally scaled canvases purposefully displayed in small rooms so that the paintings' expanses of color would fill the viewer's field of vision when seen from a close distance. Above all, they wanted their paintings to be experienced immediately and intimately as revelations that would move the viewer emotionally or even spiritually.

Clyfford Still (1904–1980)

Clyfford Still pioneered Color Field Abstract Expressionism during World War II. He achieved a highly personal style featuring ragged patches of harsh colors, thickly applied with a **palette knife**, that appear to climb or descend the canvas surface. The North Dakota-born Still lived in Washington State during the 1930s, where his artistic imagery evolved from expressionistic farm scenes to highly abstracted totemic figures in murky, nocturnal environments. He developed his nonrepresentational Color Field style while teaching in Richmond, Virginia between 1943 and 1945. In 1946, he exhibited his breakthrough works at Peggy Guggenheim's Art of the Century Gallery, establishing his reputation among the New York Abstract Expressionists. From 1946 to 1950, he taught at the California School of Fine Arts (now the San Francisco Art Institute), inspiring a Bay Area Abstract Expressionist movement.

From 1950 to 1961 Still lived in New York, where he created many of his most impressive works. The mural-sized *1957-J No. 1 (PH-142)* (1957, Figure 12.10) features rough-edged, abutting expanses of rusty red and dense black that open up to reveal tan oases of raw canvas, many encircling small islands of icy white paint. Scattered touches of brighter **hues**—orange, yellow, and blue—accent the otherwise stark **palette**. Aware of Still's origins in the American West, many critics have associated his craggy swaths of paint with the sublime vistas of the Grand Canyon and Yosemite. The artist, however, denied allusive readings of his work and insisted that the viewer accept it on its own terms. Still described his art as "an instrument of thought which would aid in cutting through all cultural opiates, past and present, so that a direct, immediate, and truly free vision could be achieved, and an idea be revealed with clarity."[20]

Rothko's Later Work

Rothko's quest to express the "Spirit of Myth" in universal terms led him to abandon abstracted figuration by 1947 to use exclusively loosely defined patches of luminous color. By 1950, he was organizing these patches into powerfully simple arrangements of a few large, stacked, soft-edged rectangles set against a ground of another color. Working with a full range of hues but usually employing only three or four in each composition (see Figure 12.11), Rothko applied thin paint with brushes, sponges, and rags to achieve an impalpable paint

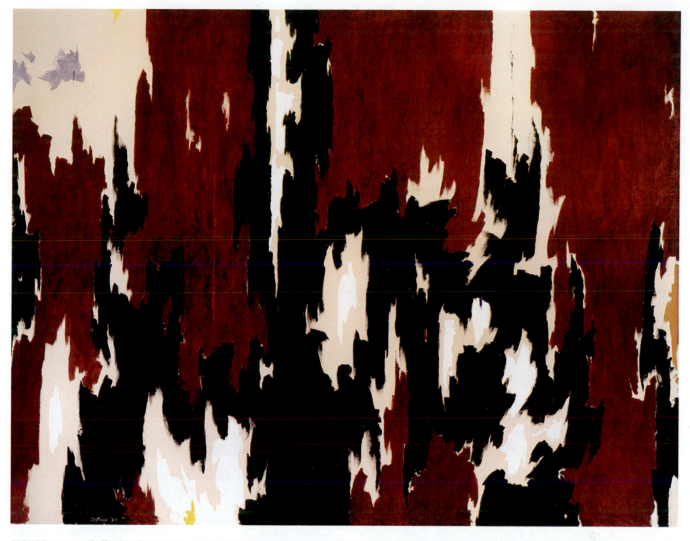

FIGURE 12.10 Clyfford Still, *1957-J No. 1 (PH-142)*, 1957. Oil on canvas, 287.97 x 373.06 cm. Anderson Collection at Stanford University, California.

surface and to generate subtly complex spatial dynamics. The blurred rectangles seem by turns to hover, radiate forward, and sink mysteriously into atmospheric depths, hinting at unstated meanings. These canvases invite an emotional response akin to that elicited by religious paintings of the past, which was Rothko's aim. Despite his mastery of color and composition, he denied any interest in formal concerns, saying:

> I'm interested only in expressing basic human emotions—tragedy, ecstasy, doom, and so on—and the fact that lots of people break down and cry when confronted with my pictures shows that I *communicate* those basic human emotions. . . . The people who weep before my pictures are having the same religious experience I had when I painted them.[21]

Rothko's attempts to stimulate religious feelings through nonrepresentational fields of color culminated in a series of paintings he was commissioned to create in 1964 by John and Dominique de Menil for a nondenominational chapel in Houston. The Rothko Chapel opened in 1971, a year after the painter's death by suicide. The chapel's fourteen enormous canvases, seven featuring hard-edged black rectangles on maroon grounds, seven painted in deep plum tones, invite quiet contemplation. For many visitors, they create a profoundly moving sense of the sacred.

Barnett Newman (1905–1970)

Barnett Newman shared Rothko's aspiration to elicit powerful emotions through purely abstract paintings. Newman first gained attention in the **avant-garde** art circles of his native New York City as an exhibition organizer and essayist in the mid-1940s. His paintings and drawings of these years (e.g., *Song of Orpheus*, 1944–45) featured abstract shapes, some biomorphic, others geometric. With titles referring to ancient myths and cultures, they evoked the primal origins of life and the cosmos and reflected Newman's determination to find a new beginning for art after the devastating war.

FIGURE 12.11 Paintings by Mark Rothko in the Rothko Room at The Phillips Collection, Washington DC. Left to right: *Green and Tangerine on Red*, 1956. Oil on canvas, 237.81 x 175.89 cm; *Ochre and Red on Red*, 1954. Oil on canvas, 235.27 x 161.93 cm; *Green and Maroon*, 1953. Oil on canvas, 231.46 x 139.38 cm.

Newman arrived at his signature style in 1948 when he bisected a small vertical canvas painted solid Indian red with a vertical stripe of masking tape that he smeared with light cadmium red. He called the picture *Onement*, an invented word suggesting unity as well as referring to the Jewish Day of Atonement (Yom Kippur). Understood metaphysically, this act of dividing the canvas through a line (that Newman called a "zip") symbolizes the biblical act of creation, God's separation of the light from the darkness. The vertical line itself conjures the upright presence of the first man, Adam.[22]

Working on canvases of increasingly large dimensions to create enveloping fields of color, Newman completed *Vir Heroicus Sublimis* (1950–51, Figure 12.12). It has a vast, 5.42-meter-wide surface of vivid, smoothly brushed cadmium red articulated by five unevenly spaced slender zips of different **value**. Earlier geometric abstractionists such as Mondrian (see Figure 6.10) created compositions segmented by both vertical and horizontal lines. Newman, however, used only vertical zips, which accent and energize the field of color rather than dividing it, so that it may be perceived holistically. His radically reductive formal means would prove influential for the American **Minimalists** of the 1960s (see Chapter 16).

Unlike them, Newman understood his paintings not as literal objects but as suffused with metaphysical content. In *Vir Heroicus Sublimis*, the zips serve as surrogates for the viewers Newman wanted to stand close to the painting, bathing in its color to experience the exaltation signaled by its title, Latin for "man, heroic and sublime."

Between Gesture and Field

Committed to free, individual expression, none of the Abstract Expressionist painters accepted the limitations of a stylistic label. Many of them combined aspects of both gestural and Color Field styles in their mature art. Ad Reinhardt's late monochrome paintings fit comfortably into neither category.

Adolph Gottlieb (1903–1974)

A native New Yorker and close friend of Rothko and Newman, Adolph Gottlieb's first distinctive body of paintings were the *Pictographs* (1941–53; e.g., *Pink and Indian Red*, 1946). Within the cells of loosely structured grids, they present biomorphic and symbolic motifs supposedly drawn from

FIGURE 12.12 Barnett Newman, *Vir Heroicus Sublimis*, 1950–51. Oil on canvas, 242.2 x 541.7 cm. The Museum of Modern Art, New York.

the artist's unconscious, aspiring to the universal validity of Jung's archetypes. Gottlieb's other major contribution to Abstract Expressionism was his long series of *Bursts* (e.g., *Blast I*, 1957), painted on large canvases similar in size to Rothko's. A typical *Burst* features a simple, bifurcated composition with a roughly painted explosive shape of a single color placed below a smoothly brushed or stained disk of another color, juxtaposing Abstract Expressionism's gesture and Color Field tendencies. While resolutely nonobjective, the *Bursts* generate associations ranging from nuclear mushroom clouds—an iconic Cold War motif—to basic dualities such as day and night, sun and earth, and male and female.

Robert Motherwell (1915–1991)

A native Californian, Robert Motherwell came to New York in 1940. Between 1948 and 1967 he created a series of paintings called *Elegies*, dedicated to the Spanish Republic, which had fallen after the terrible Spanish Civil War (1936–39). Motherwell's series symbolized the fundamental duality of life and death through the stark opposition of black and white. The *Elegies'* basic formal elements are broad vertical black bands alternating rhythmically with rough-edged black

ovoid shapes—evoking for many critics the severed penises and testicles of dead bulls after a Spanish bullfight. The black shapes are surrounded by fields of white and sometimes additional patches of other colors, as in *Elegy to the Spanish Republic No. 35* (1954–58, Figure 12.13). Motherwell first used the abutting bands and ovals seen in the series in a 1948 ink drawing made to accompany a poem by Harold Rosenberg. He came to associate this composition with a poem about the death of a Spanish bullfighter by Federico García Lorca. Lorca was murdered by the Nationalists during the Civil War. Motherwell called the *Elegies* a "private insistence that a terrible death happened that should not be forgot," as well as "general metaphors of the contrast between life and death, and their interrelation."[23]

Norman Lewis (1909–1979)

Born in Harlem to Afro-Bermudian parents, Norman Lewis studied art in Harlem under Augusta Savage in the 1930s and became friendly with other modern African American artists, including Aaron Douglas and Jacob Lawrence (see Chapter 10). He worked in a Social Realist style in the 1930s before turning to abstraction in the mid-1940s and exhibiting with the Abstract Expressionists in the 1950s. Lewis reduced his palette

FIGURE 12.13 Robert Motherwell, *Elegy to the Spanish Republic No. 35*, 1954–58. Oil and Magna on canvas, 203.8 x 254.6 cm. The Metropolitan Museum of Art, New York.

to black and white in the paintings he made in the 1960s, in response to the civil rights movement, which Lewis strongly supported. *Alabama* (1960, Figure 12.14) has dense black borders surrounding a central zone of vigorously applied black and white brushstrokes. It combines the Abstract Expressionist modes of Color Field and gestural painting to evoke the violence that often met Black people who struggled for freedom and equality in the American South. Lewis's title signals

Alabama's status as the epicenter of the civil rights movement, given impetus by the successful 1955 boycott of the segregated Montgomery bus system, led by the Rev. Martin Luther King Jr. The peaked white shapes in the painting's center suggest the hooded robes of the Ku Klux Klan. This white suprematist group terrorized southern African Americans during the civil rights era, often in the dark of night, conjured by the blackness filling the borders of Lewis's composition.

FIGURE 12.14 Norman Lewis, *Alabama*, 1960. Oil on canvas, 122.6 x 184.5 cm. The Cleveland Museum of Art, Ohio.

Ad Reinhardt (1913–1967)

Ad Reinhardt's painting escapes classification as either gestural or Color Field abstraction, but he was closely associated with the Abstract Expressionists and participated vigorously in their aesthetic debates. Dedicated to complete abstraction like his friends Newman, Rothko, and Still, Reinhardt rejected their belief that it could convey emotional, moral, or spiritual content. He instead insisted on "pure painting," with "no degree of illustration, distortion, illusion, allusion, or delusion."[24] Reinhardt painted Cubist-influenced geometric abstractions in the early 1940s and linear, atmospheric all-over compositions later in that decade. In the 1950s, he began painting flat rectangles on oblong canvases. By 1953, he was arranging these shapes symmetrically and using a monochrome red, blue, or black palette, with slight tonal variations between the rectangles. From 1960 to his death, Reinhardt exclusively made black paintings (e.g., *Abstract Painting*, 1960–61, MoMA). He executed each on a five-foot square canvas with its surface divided into a cruciform grid of squares comprising subtly different shades of matte black (mixed with other colors) evenly applied without visible brushwork. Resolutely anti-expressionist, these impersonal and self-contained paintings manifest Reinhardt's commitment to "art as art"—"a pure, abstract, non-objective, timeless, spaceless, changeless, relationless, disinterested painting—an object that is self-conscious (*no unconsciousness*), ideal, transcendent, aware of no thing but art."[25] The black paintings and Reinhardt's art-as-art philosophy helped open the path to 1960s Minimalism (Chapter 16).

Figurative Painting in the Age of Abstract Expressionism

While influential painters such as Rothko, Newman, and Still definitively abandoned figuration in the post–World War II years and the powerful critic Clement Greenberg declared abstraction's superiority to representational art, many Americans continued to make paintings containing recognizable imagery in a variety of styles.

East Coast Artists: Andrew Wyeth (1917–2009), Grace Hartigan (1922–2008), and Larry Rivers (1923–2002)

At one end of the spectrum was the meticulous realism of Andrew Wyeth. Wyeth exhibited in New York but depicted the rural life of his native Pennsylvania and coastal Maine, where he spent his summers. Wyeth's famous **tempera** painting *Christina's World* (1948) represents his paraplegic Maine neighbor Christina Olson at the bottom of a field looking back toward her old farmhouse on the horizon. The subject's turned back and the stillness of the intensely detailed setting create a disquieting, ambiguous mood that relates Wyeth's art to Surrealism and that also resonates with the anxious temper of the early Cold War.

At the other stylistic extreme, many emerging New York artists in the early 1950s worked in a painterly, gestural style inspired by Abstract Expressionist action painting and especially by Willem de Kooning's *Women*. One such younger painter was Grace Hartigan. Her *River Bathers* (1953), painted in response to Matisse's *Bathers by a River* (1916–17), represents its barely legible subject of nudes in a river landscape through broad, energetic brushstrokes and a bold palette dominated by cold blues and whites. In the mid-to-late 1950s Hartigan painted vibrant gestural abstractions inspired by her urban surroundings (e.g., *Broadway Restaurant*, 1957).

Larry Rivers was another New York artist working in a painterly figurative mode. For his *Washington Crossing the Delaware* (1953, Figure 12.15), he took Emanuel Leutze's monumental 1851 painting of the same title as the point of departure. Ambitious to create a painting that would spark controversy and bring him notoriety, Rivers reworked an image exemplary of grand-scale, nineteenth-century **academic history painting**—a tradition the New York avant-garde considered "dead and absurd."[26] Furthermore, Rivers chose an image emblematic of American patriotism at the height of Sen. Joseph McCarthy's anti-communist crusade. Combining fine charcoal drawing with roughly applied and rag-wiped paint, Rivers transformed Leutze's depiction of the confident Washington standing near the prow of a boat energetically rowed by Continental Army soldiers into an ambivalent image of the perplexed-looking general alone in a boat with his troops scattered across a fragmented brown and gray landscape. Courting ambiguity, Rivers managed to both acknowledge and subvert McCarthyist demands for resolutely patriotic expression.[27]

San Francisco Bay Area Artists: David Park (1911–1960) and Richard Diebenkorn (1922–1993)

Painters in the San Francisco region also applied Abstract Expressionist-style paint handling to figurative **subject matter** during the 1950s and early 1960s. David Park, the pioneer of Bay Area Figurative painting, had worked in an Abstract Expressionist style during the 1940s when he taught alongside Still and Rothko at the California School of Fine Arts (CSFA). After concluding that abstraction did not allow him to convey fully the human values he sought—"vitality, energy, profundity, warmth"[28]—Park abruptly turned to figuration in 1950, rendering everyday subjects in bold colors through thick strokes and slabs of paint (e.g., *Jazz Musicians*, 1954). Park's

FIGURE 12.15 Larry Rivers, *Washington Crossing the Delaware*, 1953. Oil, graphite, and charcoal on linen, 212.4 x 283.5 cm. The Museum of Modern Art, New York.

former CSFA colleagues Elmer Bischoff and Richard Diebenkorn soon followed him in abandoning Abstract Expressionism and embracing figuration. Diebenkorn's late 1950s paintings typically feature one or two motionless figures occupying a shallow, enclosed space with slices of landscape viewed through a window or beyond a rear wall. In *Woman on Porch* (1958, Figure 12.16), the simplified figure of a sun-drenched woman in a wicker chair is locked into the composition's lower left corner by the red-shadowed wedge to the right and by the deep blue wall stretching horizontally across the picture. The sensuous palette calls to mind the work of Matisse, while the anonymous and introspective woman recalls similar figures by Hopper (see Figure 10.16)—both painters greatly admired by Diebenkorn. The abstract compositional geometry of *Woman on Porch* also predicts Diebenkorn's return to nonobjectivity in his *Ocean Park* series. Begun in 1967 after his move to Santa Monica, these compositions enclose brushy fields of layered, luminous colors within scaffolds of horizontal, vertical, and diagonal lines (e.g., *Ocean Park #60*, 1973). They evoke Southern California's hazy light and open landscape through purely nonrepresentational means.

New York Sculpture at Mid-Century

A new sculptural tendency arose in New York in the 1940s and 1950s. It paralleled aspects of Abstract Expressionist painting by emphasizing aggressive forms and open compositions, and by exploring mythic and metaphysical themes that resonated in the atmosphere of historical crisis precipitated by World War II. Many Abstract Expressionist sculptors employed direct-metal processes, creating their work by welding together metal pieces—a method pioneered by Julio González in collaboration with Picasso in Paris in the late 1920s (see Chapter 9). Americans who used this technique included Ibram Lassaw, Seymour Lipton, Theodore Roszak, and David Smith.

David Smith (1906–1965)

The first American to take up **direct-metal sculpture**, David Smith as a teenager worked as a welder and riveter in an automobile assembly plant in his native Indiana before moving to New York City in 1926 to study painting. After seeing reproductions of Picasso's metal sculptures and an actual sculpture by González, Smith welded tool and machine parts together to create a series of abstract *Heads* in 1933. By the mid-1930s, he was, like González, "drawing in space," creating open-form sculptures possessing little solid **mass** or **volume**, their thin metal elements traversing but not enclosing space (e.g., *Aerial Construction*, 1936).

In 1940, Smith moved to rural Bolton Landing in upstate New York with his wife, the painter Dorothy Dehner. From 1942 to 1944, he worked welding tanks and locomotives at a defense plant in Schenectady. After the war, Smith built a new house and machine-shop style studio and increased the scale of his sculptures, which he placed in the surrounding fields. An early postwar work, *The Royal Bird* (1947–48, Figure 12.17), is based on the skeleton of a prehistoric diving bird. It projects a sense of predatory violence through its horizontally thrusting

FIGURE 12.16 Richard Diebenkorn, *Woman on Porch*, 1958. Oil on canvas, 182.88 x 182.88 cm. New Orleans Museum of Art, Louisiana.

FIGURE 12.17 David Smith, *The Royal Bird*, 1947–48. Steel, bronze, stainless steel, 56.2 x 151.92 x 21.59 cm. Walker Art Center, Minneapolis. Photograph taken by David Smith at Bolton Landing, New York.

composition and spiky forms at both ends suggesting sharp teeth and talons. Much like Pollock's *She-Wolf*, with which it shares formal qualities of aggressive horizontality and linearity, Smith's sculpture refers overtly to the ancient past's terrifying forces and metaphorically to World War II's violence, channeling his strong anti-war views. Underscoring *The Royal Bird*'s connection to modernity is its medium of welded steel, which Smith saw as possessing "little art history. What associations it possesses are those of this century: power, structure, movement, progress, suspension, brutality."[29]

In the 1950s, Smith produced several impressive sculptural series, including: the *Agricolas* (1951–59), incorporating metal parts scavenged from abandoned farm machinery; the *Tanktotems* (1952–60), assembled from steel beams and boiler-tank heads; and the *Sentinels* (1956–61), which ranged from stacked towers of painted steel to frontal arrangements of overlapping stainless steel planes. Many of these works were anthropomorphic—standing upright like human figures—and conceived as totemic presences. Smith had likely read Freud's *Totem and Taboo*, which described a totem, a sacred object emblematic of a social group in animistic religions, as something both desired and barred from possession. He therefore made his sculptures visually accessible yet unwelcome to the touch, crafted out of thin bars and planes of cold metal.[30]

Smith's final major series was the *Cubis*. These differed from most of his earlier sculptures in being composed of fully volumetric elements: hollow, rectangular boxes, cylinders, and cushions of stainless steel that the artist welded together into dynamic, unbalanced compositions. While some of the *Cubis* were anthropomorphic and others suggested architectural structures, the three illustrated in Figure 12.18, photographed by Smith at Bolton Landing, recall Cubist tabletop **still-life** compositions like Braque's *Round Table (Le Guéridon)* (see Figure 9.5). Intending the *Cubis* for outdoor placement, Smith burnished their stainless-steel surfaces with a grinder to create swirling patterns that catch and reflect natural light and color. These patterns give the sculptures' bulky volumes a sparkling, buoyant quality.

FIGURE 12.18 Sculptures by David Smith. Left to right: *Cubi XVIII*, 1964. Polished stainless steel, 294 x 152.4 x 55.2 cm. Museum of Fine Arts, Boston; *Cubi XVII*, 1963. Polished stainless steel, 273.69 x 163.51 x 96.84 cm. Dallas Museum of Art; *Cubi XIX*, 1964. Polished stainless steel, 286.4 x 148 x 101.6 cm. Tate, London. Photograph taken by David Smith at Bolton Landing, New York.

Isamu Noguchi (1904–1988)

While welded metal sculpture was predominant in New York during the 1940s and 1950s, other modern American sculptors used more traditional materials. One was Isamu Noguchi, whose commitment to simplified abstract forms carved directly in stone was inspired by the example of his mentor, Constantin Brancusi (see Chapter 9). Born in Los Angeles to a Japanese father and an Irish American mother, Noguchi spent his childhood in Japan and returned to the United States in 1918 to attend school. In 1925, he traveled to Paris where he worked briefly as Brancusi's assistant. During the 1930s, Noguchi began designing sets for the modernist dancer and choreographer Martha Graham and supported himself by producing realistic portrait busts.

After the United States entered World War II in December 1941, Noguchi showed solidarity with the Japanese Americans forcibly removed by the government to internment camps by voluntarily entering one himself in Poston, Arizona. Failing in his attempt to improve camp life by creating an arts and crafts program, he returned to New York six months later. He went on to create some of the most innovative sculptures of his career: a series of highly abstract upright figures composed of interlocking thin slabs of stone—an inexpensive material designed for use as a veneer in building. The largest of these, *Kouros* (1945, Figure 12.19), whose title is the term for an archaic Greek statue of a male youth, stands nearly three meters tall. *Kouros* blends influences from European modernism and Noguchi's Japanese heritage. Its amoeba-like pink Georgia marble forms recall the Surrealists' biomorphism, while its construction through notched and slotted stone slabs adapts the traditional Japanese carpentry method that connects pieces of wood through interlocking joints without the use of nails or screws. Because it can be rapidly assembled and disassembled, Noguchi's *Kouros* possesses a quality of mobility lacked by traditional statues—one resonating with the artist's own relocations in the 1930s and 1940s,

FIGURE 12.19 Isamu Noguchi, *Kouros*, **1945. Marble, 297.2 × 107 × 86.7 cm. The Metropolitan Museum of Art, New York.**

which included sojourns in Mexico City, San Francisco, Los Angeles, and the Arizona internment camp.[31] And though it towers majestically over the viewer, *Kouros*'s fragmentation lends it an air of fragility. "The structure of *Kouros* defies gravity, defies time in a sense," observed Noguchi. "The very fragility gives a thrill; the danger excites. It's like life—you can lose it at any moment."[32]

Louise Bourgeois (1911–2010)

Like Noguchi, Louise Bourgeois created highly abstracted figurative sculptures in the 1940s. Born in Paris, where she worked in her family's tapestry restoration workshop and studied art, Bourgeois immigrated to New York in 1938 after marrying the American art historian Robert Goldwater. Around 1946, she began carving and assembling elongated, life-size, anthropomorphic wood sculptures that she called "personages." She saw these sculptures as surrogates for herself, friends, and family members, including those she had left behind in Paris. In psychoanalytic terms (familiar to Bourgeois), the *Personages* standing for absent loved ones served as works of mourning. Sigmund Freud described mourning as a process whereby the ego must sever its bond with the lost object. Bourgeois perhaps achieved this sense of detachment through physically cutting the wood she used to make the *Personages*.[33] For her first solo sculpture exhibition at the Peridot Gallery in 1949, she arranged seventeen *Personages* on the gallery floor to create a sense of psychological interaction between them. This was an early example of **installation** art, in which the individual elements are meant to be experienced as part of a larger whole.

Decades later, in 1981, Bourgeois assembled five *Personages* on a single base and called the group *Quarantania, I* (Figure 12.20)—a title derived from the French *quarante* (forty), referring to the 1940s. Like most of Bourgeois's work, *Quarantania, I* is rich in autobiographical content. The figures' needle- and shuttle-like forms emerged from the artist's memories of using those tools in her family's business. The figure at the center, first exhibited separately as *Woman with Packages*, represents Bourgeois herself. The three pendulous "packages" at the figure's sides signal the woman's duty to shop and provide for her family. Bourgeois also called the packages "children" and associated them with her three sons.[34] "A woman who carries packages is responsible for what she carries and they are very fragile," the artist observed. "Yes, it is a fear of not being a good mother."[35]

Joseph Cornell (1903–1972)

The enigmatic qualities of Bourgeois's *Personages* suggest affinities with Surrealism, though she kept her distance from that movement's members. Joseph Cornell, another American sculptor, was friendly with several of the Surrealists and exhibited alongside them in New York in 1930s and 1940s. Although he did not share the Surrealists' theoretical interest in

FIGURE 12.20 Louise Bourgeois, *Quarantania, I*, 1947–53; reassembled by the artist 1981. Painted wood on base, 206.4 cm high, including base measuring 15.2 x 69.1 x 68.6 cm. The Museum of Modern Art, New York.

FIGURE 12.21 Joseph Cornell, *Medici Slot Machine (Object)*, 1942. Box construction: wood, glass, mirror, metal, marbles, jacks, coin, paint, and printed paper collage, 39.4 x 30.5 x 11 cm. Private collection.

the unconscious, Cornell adopted their method of juxtaposing apparently unrelated objects to produce dreamlike compositions. He did this through **assemblage**, creating unexpected and poetic combinations of objects, images, and texts—some quite recognizable, others obscure—collected from Manhattan's bookshops, antique stores, and flea markets, and displayed within glass-fronted boxes.

Cornell rarely ventured far from Manhattan or the Queens, New York, house he shared with his mother and a younger brother who lived with cerebral palsy, but he traveled widely in his imagination. His work often reflects a fascination with European history and culture. His well-known series of *Medici Slot Machines*, for example, features images of the Medici, the politically powerful family who ruled Florence, Italy, in the fifteenth and sixteenth centuries. *Medici Slot Machine (Object)* (1942, Figure 12.21) centers on a reproduction of Sophonisba Anguissola's mid-sixteenth-century portrait of a boy once believed to be a Medici prince.[36] Mirrored compartments at the base of the box contain jacks, balls, and toy blocks, while the boy's image is flanked by vertical rows of faces and other details from **Renaissance** paintings suggesting the frames of a motion picture. Coin-operated motion picture viewers and slot

machines were among the amusements in the penny arcades that Cornell enjoyed as a child. The direct model for *Medici Slot Machine (Object)*, however, was a chewing-gum machine in a subway station. It inspired Cornell to create something "that might be encountered in a penny arcade in a dream."[37] The artist might have seen the young Renaissance prince as a surrogate for his brother with a disability, imaginatively transported to the paradise of a candy machine, with movies and toys within easy reach.[38]

Postwar American Photography

The same historical events and conditions that gave rise to Abstract Expressionism—the Great Depression, the devastating World War, and the anxieties of the Cold War—shaped American photography of the 1940s and 1950s. While many photographers remained concerned with social and political life and sought to document the era's realities, others turned to abstraction, using their cameras to produce images that could be appreciated in purely formal terms or serve as vehicles for subjective feelings.

Photojournalism: Margaret Bourke-White (1904–1971) and Robert Capa (1913–1954)

Among the photographers most engaged with world affairs where those who worked as **photojournalists**, using handheld 35mm cameras (typically Leicas) that allowed them to quickly document newsworthy events for mass circulation newspapers and magazines. The most prominent of these publications, *Life* magazine (published from 1936 to 1972), was read by millions of Americans weekly. *Life*'s first cover (November 23, 1936), featured a dramatic, closely cropped photograph of the massive concrete forms of the Fort Peck Dam on the Missouri River in northeast Montana, a New Deal construction project shot by Margaret Bourke-White, one of the four photojournalists originally hired by *Life*. The twenty-one photojournalists that *Life* employed to cover World War II recorded many memorable images of the conflict and its aftermath, including Bourke-White's harrowing photographs of the victims and survivors of the Nazi death camps (e.g., *The Living Dead of Buchenwald*, 1945).

Many *Life* photographers wielded their cameras in combat zones, such as Hungarian-born American Robert Capa. His photographs of the Spanish Civil War gained him a lasting reputation as the greatest war photographer of his generation. Capa's iconic World War II photograph of the US D-Day invasion of the French coast in June 1944 (Figure 12.22) conveys a sense of dynamic action through its blurred imagery. This quality, likely produced by a shaking camera, offers a visual parallel to the aesthetics of Abstract Expressionist action painting. In 1947, Capa was one of the founders, along with Henri Cartier-Bresson (see Chapter 8) and several others, of Magnum Photos, the first cooperative photographic agency owned by its

members. Returning to combat photography in the first Indochina War, Capa was killed in Vietnam by a landmine.

Abstraction: Minor White (1908–1976), Harry Callahan (1912–1999), and Aaron Siskind (1903–1991)

Other American photographers turned their cameras away from modern life's turbulence and toward nature. There, they found inspiration, abstract formal qualities, and, in Minor White's case, symbolic significance. After World War II service in the US Army, White met Alfred Stieglitz in 1946. White was captivated by the older photographer's *Equivalents* (1922–34), a series of cloud studies in which Stieglitz attempted to find correspondences between his states of mind and the sky above (e.g., *Equivalent*, 1926, The Metropolitan Museum of Art). White adopted a similar metaphorical approach, photographing nature as a means of exploring his personal feelings. He taught at the California School of Fine Arts in the nation's first **fine-art** photography department. Made during his tenure there, *San Mateo County, California (Coast)* (1947, Figure 12.23), a photograph of sea foam that White turned on its side, embodies a feeling of disorientation, likely lingering from the photographer's wartime experience.[39] The rising spume also evokes male sexuality, signaling desires expressed more overtly in the many homoerotic photographs of male nudes that White made in the late 1940s but never published. The high degree of abstraction White achieved by rotating his photograph of the surf ninety degrees mirrors the nonrepresentational styles being developed simultaneously by the Abstract Expressionists, including Clyfford Still, White's colleague at the CSFA during the late 1940s.

FIGURE 12.22 Robert Capa, *Normandy Invasion, June 6, 1944*, 1944, printed 1964. Gelatin silver print, 22.8 x 34.1 cm. The J. Paul Getty Museum, Los Angeles.

FIGURE 12.23 Minor White, *San Mateo County, California (Coast)*, 1947. Gelatin silver print, 11.9 x 9.3 cm, Princeton University Art Museum, New Jersey.

Other American photographers of the postwar years who made photographs with abstract formal qualities included Harry Callahan and Aaron Siskind, who both taught at Chicago's Institute of Design at the Illinois Institute of Technology (Callahan from 1946 to 1961, Siskind from 1951 to 1961). The Detroit-born Callahan's commitment to photography as an artistic medium was sparked by a 1941 workshop he took with Ansel Adams, the prominent California landscape photographer. Adams, like Stieglitz and Edward Weston (see Chapter 10), championed the straight, purist approach to photography with his precise technique and devotion to nature as a source of formal richness and symbolic potential. In 1946, Callahan was invited to join the Institute of Design by its founder, László Moholy-Nagy (see Chapter 6). Moholy-Nagy was one of the pioneers of the New Vision, a 1920s modernist photography movement that employed novel approaches such as tight close-ups, disorienting perspectives, and negative or **solarized** images to achieve startlingly original visual effects. Callahan's mature work focused on three main subjects—his wife Eleanor's nude body, the world of nature, and the city—and drew technically on the examples of both Adams and Moholy-Nagy. He often practiced straight photography but also used experimental

techniques such as multiple exposures (e.g., *Multiple Exposure Tree, Chicago*, 1956).

Siskind, a native New Yorker, created tightly cropped, frontal, black-and-white images of weathered walls, torn posters, graffiti, and peeling paint, as in *[Jerome] Arizona* (1949, Figure 12.24). These photographs often share aesthetic qualities with the work of Abstract Expressionist painters such as Willem de Kooning, Franz Kline, and Robert Motherwell, whom Siskind counted as his friends, and arose from a similar sensibility. Like the New York School's abstractions, Siskind's photographs of mundane subject matter function as metaphors for human concerns. His fragmented imagery and unbalanced compositions communicate an existentialist view of life and meaning as uncertain and doubt-filled.[40]

Urban Life: Helen Levitt (1913–2009), Lisette Model (1901–1983), Gordon Parks (1912–2006), and Roy DeCarava (1919–2009)

Siskind turned to his abstract, metaphorical mode of photography after working in a social-documentary style in 1930s New York City as a member of the Photo League. This idealistic group of young urban photographers took pictures of

FIGURE 12.24 Aaron Siskind, *[Jerome] Arizona*, 1949. Gelatin silver print, 34.3 x 25.1 cm. The J. Paul Getty Museum, Los Angeles.

working-class street life to help advance labor, housing, and civil rights causes. Helen Levitt was a New York photographer whom the Photo League members admired, although she did not share their political engagement. Impressed by Cartier-Bresson's work and encouraged by her friend Walker Evans (see Chapter 10), Levitt took up street photography in the late 1930s. Her best-known images feature lower-class children, whom she photographed playing happily on the streets and sidewalks or, in the case of *New York* (c. 1940, Figure 12.25), posing expressively for her camera. Unlike the working children Lewis Hine photographed a generation earlier to expose their exploitation (see Figure 10.4), Levitt's carefree subjects brim with youthful joy and vitality.

Also committed to candid street photography was Austrian-born Lisette Model, who took up photography in Paris before moving to New York in 1938. Model's first significant body of work, shot in 1934, depicted wealthy vacationers lounging on the Promenade des Anglais in Nice—one month after large labor demonstrations occurred in that city. The left-wing journal *Regards* published some of these photographs in 1935 to illustrate an article criticizing the complacent bourgeoisie. In New York in the 1940s, Model worked as a freelance photographer for magazines and photographed on the sidewalks and in bars and nightclubs. Attracted to psychologically and sociologically complex subjects, she often trained her lens on memorable characters such as the *Singer at the Café Metropole, New York City* (1946)—a close-up, low-angled view of a fleshy, wild-eyed white woman, mouth open and hair flying as she belts into a microphone. From 1951 to her death, Model taught at the New School for Social Research, where her students included Diane Arbus (see Chapter 14).

Levitt, Model, Siskind, and other white photographers depicted African American subjects with great sympathy, but they did so from an outsider's perspective. By contrast, Gordon Parks and Roy DeCarava did so from within the Black community. Born and raised in poverty in segregated Fort Scott, Kansas, Parks was drawn to photography in the late 1930s when he saw images of destitute migrant workers by Farm Security Administration photographers in magazines (see Figure 10.19). This led him to recognize the camera's power as a weapon against social ills such as poverty and racism. After acquiring and learning to use a camera, Parks in 1942 became the first Black photographer to work for the FSA, with the support of a Rosenwald Fund fellowship. Seven years later, *Life* magazine hired him as its first Black staff photographer.

Parks's first project for *Life*, done as a freelancer, was a 1948 photo essay on the gang wars then plaguing Harlem—a significant step forward for the magazine whose pictures largely reflected its primary readers' white, middle-class lives. Parks pitched the story to *Life*, believing that if he could draw attention to the gang problem, it might be addressed through government programs or private intervention. He gained the trust of a seventeen-year-old gang leader, Leonard "Red" Jackson, and spent several weeks photographing him and fellow members. Parks's essay opens with an artfully composed bust-length portrait of Jackson in profile (Figure 12.26). His hair, face, and shoulder brightly lit against the surrounding darkness, the young man peers pensively through the broken window of an abandoned building to which he and his companions had retreated to avoid a fight with a rival gang. The majority of the twenty-one images *Life*'s editors chose to illustrate the essay emphasized violence, fear, or despair. However,

FIGURE 12.25 Helen Levitt, *New York*, c. 1940. Gelatin silver print, 16.67 x 24.45 cm. San Francisco Museum of Modern Art.

FIGURE 12.26 Gordon Parks, *Red Jackson, Harlem, New York*, 1948. Gelatin silver print, 48.5 x 39.6 cm. The Metropolitan Museum of Art, New York.

Parks also recorded numerous intimate scenes of Jackson at home and enjoying carefree Harlem street life that painted a fuller picture of his existence—no doubt meant to help *Life*'s predominantly white readers recognize Jackson's humanity.

Continuing to work for *Life* until 1972, the multitalented Parks also gained renown as a writer and the first African American to direct films for major Hollywood studios, including *The Learning Tree* (1969), based on his semiautobiographical 1963 novel, and the crime drama *Shaft* (1971).

Trained in painting and printmaking, the Harlem-born Roy DeCarava adopted photography in 1947. With the support of Edward Steichen, Stieglitz's one-time colleague who directed MoMA's photography department (1947–62), DeCarava became the first African American photographer to win a Guggenheim Foundation fellowship in 1952, which enabled him to devote a full year to his art. "I want to photograph Harlem through the Negro people," declared DeCarava in his fellowship application. "I do not want a documentary or sociological statement, I want a creative expression, the kind

of penetrating insight and understanding of Negroes which I believe only a Negro photographer can interpret."[41]

Among DeCarava's most memorable pictures are those he took in the home of Sam and Shirley Murphy and their two children, such as *Shirley Embracing Sam* (1952), a closely cropped composition that masterfully captures a deeply human moment of affection. It was among 140 of DeCarava's photographs published in the 1955 book *The Sweet Flypaper of Life*. The text, by poet Langston Hughes, told imaginary stories about the people in DeCarava's images in the voice of a fictional narrator, Sister Mary Bradley. This colorful and hopeful portrait of life in Harlem countered negative stereotypes of African Americans prevalent in the dominant white culture.

The Family of Man

In 1955, five of DeCarava's photographs (including *Shirley Embracing Sam*) were featured in MoMA's monumental exhibition *The Family of Man*, which also included Bourke-White's, Capa's, Levitt's, Model's, and Parks's work. Organized by Steichen and billed as "the greatest photographic exhibition of all time," *The Family of Man* comprised 503 images by 273 photographers from 68 countries. Steichen and his assistant reviewed some two million images before making their final selection. Their sources included thousands of photographs submitted in response to a worldwide appeal. They also combed the files of *Life*, various picture agencies, and government archives (including that of the FSA, from which they selected, among other images, Dorothea Lange's *Migrant Mother*, [see Figure 10.19]). Architect Paul Rudolph's exhibition design presented enlargements of the photographs attached to wood frames and often suspended from the ceiling. The visitor walking through the exhibition had an experience similar to leafing through the pages of *Life* magazine.

Steichen organized the untitled photographs into groupings illustrating such themes as love, birth, work, play, and death, accompanied by short, relevant texts from different cultural sources, including poetry, philosophy, the Bible, and the *Bhagavad Gita*. His intention was to emphasize human commonalities shared across the lines of geography, politics, class, race, ethnicity, and religion—what Steichen called "the essential oneness of mankind throughout the world"—as a way of counteracting the Cold War's tensions and divisions.[42] After its US showing, *The Family of Man* toured some forty countries and was seen by some nine million viewers. The tour's sponsor was the United States Information Agency, whose propaganda mission was to convince foreign audiences that US policies promoted freedom, peace, and prosperity throughout the world. The accompanying book became the best-selling photographic book of all time.

Robert Frank (1924–2019)

While the American public in large part responded warmly to *The Family of Man*, many photographers and critics objected to Steichen's subordination of the individual photographers' unique visions to the exhibition's unifying themes. Among these critics was Robert Frank, a Swiss-born photographer who moved to New York in 1947, and whose images were included in the show. Although he supported himself as a magazine and fashion photographer in the late 1940s and early 1950s, Frank's artistic goal was to make spontaneously observed pictures of everyday life with a handheld 35mm Leica camera. Successive Guggenheim Fellowships in 1955 and 1956 allowed him to travel widely across the United States shooting thousands of black-and-white pictures. He edited these to produce *The Americans* (French edition, 1958; United States edition, 1959), which became the most influential photographic book of the postwar era.

Training his lens on public spaces, Frank photographed roads, parks, city streets and cemeteries, bars, diners, drugstores, casinos, and drive-in movie theaters. His pictures show people gathered for parades, rodeos, and funerals, political conventions, movie premieres, and cocktail parties. They show people eating, driving, working, talking, and praying. Frank, however, did not celebrate the wholesome "good life" promoted by the American government and advertisers, nor embrace *The Family of Man*'s optimistic vision. Instead, he offered a bleak and melancholy view of American society. This grimness was amplified by the harsh and graceless style of his photographs,

often tilted, grainy, or unevenly focused—the result of Frank's "free" approach to photography that he compared to action painting.[43] Few of his pictures show genuine harmony or connection between human beings. Rather, Frank's Americans often appear weary, bored, lonely, or lost. Any of these adjectives might fit the young woman he photographed in *Elevator, Miami Beach* (1955, Figure 12.27), whose isolation is heightened visually by the blurred figures at left and right.

The rough style and critical content of Frank's photographs resonated with the anti-establishment attitude of the Beat writers of the late 1950s and early 1960s, among them William S. Burroughs, Allen Ginsberg, and Jack Kerouac. They rejected what they saw as middle-class American culture's suffocating conformism and mindless materialism. Based primarily in New York's Greenwich Village and in San Francisco, the Beats developed a counterculture that found literary expression in free-form poetry and prose with aesthetic qualities similar to those of improvised jazz and Abstract Expressionist action painting. Kerouac wrote the introduction to the American edition of *The Americans*, declaring that Frank had "sucked a sad poem right out of America onto film, taking rank among the tragic poets of the world."[44]

Many critics responded negatively to *The Americans*; one called it "an attack on the United States" demonstrating "contempt for any standards of quality or discipline in [photographic] technique."[45] Nonetheless, Frank's style and viewpoint proved enormously influential to the next decade's street photographers, including Garry Winogrand, Diane Arbus, and Lee Friedlander (see Chapter 14).

FIGURE 12.27 Robert Frank, *Elevator, Miami Beach*, 1955, printed ca. 1977. Gelatin silver print, 23.2 x 33.6 cm. The Metropolitan Museum of Art, New York.

Postwar Art in Europe

European artists of the later 1940s and 1950s worked in an atmosphere of doubt and despair. The devastating Second World War had claimed as many as sixty million lives worldwide— including nearly six million Jews killed by the Nazis in the genocidal Holocaust. The war ended with the atomic bombing of Hiroshima and Nagasaki by the United States, ushering in fears of humanity's potential annihilation as the planet's most powerful countries gained nuclear weapons. The ensuing Cold War pitted the Western capitalist democracies against the totalitarian communist countries of the East. This created profound tension on both sides of the political divide famously dubbed the "Iron Curtain" by British prime minister Winston Churchill.

The most innovative European artists of the postwar years avoided literally representing World War II's painful after-effects or the Cold War's topical realities. Instead, they sought new means of expression that resonated metaphorically and philosophically with the era's concerns. Many, including Wols and Georges Mathieu, adopted automatist styles of gestural abstraction that were intended to convey the period's intense feelings. Often seen as a European parallel to American Abstract Expressionism (see Chapter 12), the improvisational work of these gestural abstractionists was labeled *art informel* (unformed or formless art), to distinguish it from the highly structured geometric abstraction popular before the World War. It was also sometimes called *tachisme* (from the French "blot" or "stain") or lyrical abstraction (a term coined by Mathieu).

Powerfully expressive figurative art—drawn, painted, and sculpted—also flourished in Europe in the postwar years. Innovative painters such as Jean Dubuffet, Karel Appel, and Francis Bacon, and sculptors such as Alberto Giacometti and Germaine Richier, worked in rough and raw styles that seemed appropriate to a culture wounded by a cataclysmic war.

Rising from the ashes of war-torn Europe, both *art informel* and the new figurative art largely rejected past European traditions that seemed no longer capable of expressing contemporary feeling. These movements embodied a search for new beginnings—a fresh if anxious cultural start for the brave new postwar era (see "Existentialism" box). This was perhaps most evident in Dubuffet's and Appel's attraction to and emulation of the unhibited and spontanously expressive art of children, the ultmate cultural beginners. However, it is equally evident in Giacometti's quest to faithfully, if idiosyncratically, tranlsate into the medium of sculpture his visual perception of the world, heedless of prior artistic conventions.

Art Informel in France

The horrific experience of World War II shaped a generation of figurative and **abstract** artists in Europe. Movements like *art informel* attempted to convey the period's emotional trauma through violent visual qualities and impulsive or destructive techniques.

Jean Fautrier (1898–1964)

Although the term *art informel* is generally applied to nonrepresentational art, historians credit its origin to Jean Fautrier's series of small figurative paintings, *Hostages*. A French veteran of the First World War, Fautrier was briefly detained by the Gestapo (German secret police) on suspicion of Resistance activity during World War II. He responded to the war through the *Hostages* series. Each painting represents a simplified, anonymous human face or torso built up of thick layers of **impasto** to give it the appearance of a crushed mass of brutalized flesh. Fautrier drew a schematic mouth, nose, and pair of eyes on some of the faces, as in *Tête d'otage No. 1 (Head of a Hostage No. 1)* (1944, Figure 13.1), but left others featureless. The series was partly inspired by Fautrier's experience of living in a sanatorium on the outskirts of Paris after his release by the Gestapo. Surrounding the sanatorium was a forest that the Germans used for the secret torture and execution of prisoners. Fautrier evoked their suffering in his paintings, whose imagery hovers between form and formlessness as if straddling the boundary between life and death. He exhibited the *Hostages* in Paris in 1945 shortly after the nation's liberation from German rule. In the exhibition catalogue, novelist André Malraux called them

FIGURE 13.1 Jean Fautrier, *Tête d'otage No. 1 (Head of a Hostage No. 1)*, 1944. Mixed media on paper mounted on linen, 34.93 x 27.31 cm. The Museum of Contemporary Art, Los Angeles.

"the first attempt to dissect contemporary pain, down to its tragic ideograms, and force it into the world of eternity."[1]

In his 1952 book *Un art autre* (An other art), critic Michel Tapié recognized in the *Hostages*' amorphous materiality a radical freedom from artistic conventions that became the key feature of the new postwar art's "otherness." Tapié coined the term *art informel* to describe these works. His writing and curating established Fautrier as *art informel*'s pioneer, paving the way for such artists as Wols and Georges Mathieu.

Wols (1913–1951)

The German-born Wols (b. Alfred Otto Wolfgang Schulze) moved to Paris in 1933. He initially made **Surrealist**-influenced drawings and photographs, adopting his pseudonym in 1937 from a fragment of a telegram addressed to him. At the beginning of World War II he was interned as an enemy alien, but he gained his freedom and French citizenship by marrying his girlfriend Gréty Dabija in 1940. Living in poverty in the south of France during the war, Wols made abstracted, intricately linear ink and **watercolor** drawings inspired by cities, ships, and the natural world's processes of germination, growth, death, and decay (e.g., *Mollusks*, 1944). A 1945 exhibition of his watercolors in Paris was admired by the same group of French intellectuals who had praised Fautrier's *Hostages*. Gallery owner René Drouin provided Wols with **oil paint** and canvas, which he used to create intensely improvisational works such as *It's All Over* (1946–47, Figure 13.2). Critics recognized them as announcing a revolutionary new aesthetic Michel Tapié characterized as a "lyrical, explosive, anti-geometrical and unformal non-figuration."[2]

Spidery rivulets of thin, black paint extend from a black nucleus at the center of *It's All Over*, set against cloudy **glazes** of beige and brown bordered by thinly brushed dull blue. Wols tipped the canvas to direct the flow of paint creating the central curving lines. Accenting the **composition** are bright blue and red dots made by applying paint directly from the tube, and a pair of overlapping black rings likely transferred from the paint-covered bottom of a metal can. Wols's chaotic, energetic painting, with its central black burst evoking an exploding bomb, might be seen to respond to the recent war's devastation. But the artist, in failing health due to alcoholism during the last years of his short life (he died of food poisoning at thirty-eight), denied that his art carried negative messages, saying "in spite of misery, poverty and the fear of becoming blind one day, I love life."[3] The painting's downbeat title was not given by Wols, who never titled his works, but by the picture's owners, John and Dominique de Menil.[4]

Georges Mathieu (1921–2012)

Galvanized by Wols's radically freeform **abstractions**, Georges Mathieu declared, "After Wols, everything has to be done anew."[5]

FIGURE 13.2 Wols, *It's All Over*, 1946–47. Oil, grattage, and tube marks on canvas, 81 x 81 cm. The Menil Collection, Houston.

He often painted in public before audiences including journalists and filmmakers who recorded his remarkable performances.

Mathieu took only eighty minutes to create *Les Capétiens partout* (*Capetiens Everywhere*, 1954, Figure 13.3), live at the chateau of a gallery owner in St. Germain-en-Laye on October 10, 1954. The work's title refers to the Capetian dynasty (987–1328) of French kings, founded by Hugh Capet, a hero to the royalist Mathieu, who traced his ancestry back to the eleventh-century crusader Godfrey of Bouillon. While it can be appreciated purely for its vast size and crackling linear energy, *Les Capétians partout* incorporates symbolic colors and signs referencing Hugh Capet's coronation. Although difficult to decipher, the signs, according to Mathieu, include a globe topped by a cross and two crowns—one conjured through brushstrokes and another drawn in gold paint straight from the tube. The dusky violet **background** evokes the purple of the coronation robe.[7]

Highly educated in the liberal arts and self-taught in painting, he abandoned figuration in 1944 after reading Edward Crankshaw's study of Joseph Conrad's novels. Crankshaw argued that **style** rather than narrative could constitute a work's literary value—a philosophy Mathieu applied to painting. Settling in Paris in 1947, Mathieu discovered the work of Wols and another German-born French painter, Hans Hartung (1904–89). Hartung's improvisational abstractions featured rapidly brushed graphic lines and patches of color (e.g., *T-50 Painting 8*, 1950). They influenced Mathieu's mature style, which he dubbed "lyrical abstraction" to distinguish it from the geometric abstraction that had been dominant before the war.

"Speed, intuition, excitement: that is my method of creation," declared Mathieu.[6] During the 1950s, he made explosive compositions of sweeping strokes laid down with long-handled brushes and **calligraphic** lines squeezed directly from the tube, floating against monochrome grounds. Mathieu's paintings increased in size with his growing professional success. By the mid-1950s, he was painting on six-meter-wide canvases, which he completed in one brief, intense session of activity.

Pierre Soulages (1919–2022)

Very different in style and mood from Mathieu's impulsive **painterly** performances are the somber, rigorously structured compositions of Pierre Soulages. His signature style of the 1950s, developed in Paris, features broad bands of thick, lustrous black paint set against grounds of lighter colors. Growing up in Rodez in southern France, Soulages was captivated by the region's prehistoric dolmens (massive stone markers made of two or more upright posts capped by a horizontal **lintel**) as well as by the **Romanesque** architecture of the nearby pilgrimage church of Sainte Foy at Conques. Soulages's experience of the church's warm darkness, subtly suffused with light from its high, narrow windows, prompted him to become a painter. The monumental stone structures of both the dolmens and the church informed his interest in architectonic compositions. The assertive, overlapping vertical and horizontal black bands of *Painting, 195 × 130 cm, May 1953* (Figure 13.4) create a tightly integrated cruciform configuration tied together through a few diagonal bars of black. Areas of white and tan between the bands suggest

FIGURE 13.3 Georges Mathieu, *Les Capétians partout* (*Capetians Everywhere*), 1954. Oil on canvas, 295x 600 cm. Musée National d'Art Moderne, Centre Georges Pompidou, Paris.

light filtering through the upper windows of a dim church interior and enhance the solidity of the blacks.

Although grouped art historically with the *art informel* painters, Soulages always rejected the label. He was devoted to creating stately, monumental painterly effects at odds with the spontaneous "formlessness" of artists like Wols and Mathieu.

School of Paris Abstraction: Maria Helena Vieria da Silva (1908–1992)

An even greater contrast to *art informel*'s free-form gestural style was seen in the postwar work of French painters (often referred to as the School of Paris), including Roger Bissière, Alfred Manessier, Jean Bazaine, and Maria Helena Vieria da Silva. Their intricately wrought abstractions retained a sense of **Cubist** structure in their complex scaffolds of lines traversing or containing loosely geometric patches of color. Among the most distinctive are Vieria da Silva's paintings, such as *Le Promeneur Invisible* (*The Invisible Stroller*) (1951, Figure 13.5), which combines compartmentalized vignettes of fantastical spaces constructed through **linear perspective**. These spaces converge on different **vanishing points**, along with frontal checkerboard patterns that deny spatial recession. Born and raised in Lisbon, Portugal, Vieira da Silva studied painting in Paris between 1929 and 1932, where her teachers included

Fernand Léger (see Figure 9.11) and Bissière. She was strongly drawn to the art of Cézanne, whose use of multiple viewpoints in a single painting (see Figure 2.5) informed her creative obsession with **perspective**. After the war, Vieira da Silva quickly gained critical recognition. Critic Michel Seuphor praised her paintings for their "space without dimensions, simultaneously limited and limitless," and their "exalted marriage" of "rigor and freedom."[8]

Art Informel in Italy and Spain

Innovative postwar painters in Italy and Spain associated with *art informel* often used destructive techniques such as puncturing, cutting, or burning to incise or break through the picture surface. They incorporated real space into their paintings as opposed to the illusion of space created by painters like Vieira da Silva. These destructive acts, existing in a dialectical relationship with creation, generated paintings whose scarred or wrecked appearance metaphorically embodied the complexities of life in an anxious Cold War world shadowed by the threat of nuclear annihilation.[9]

Lucio Fontana (1899–1968)

A pioneer of these destructive-creative methods was Lucio Fontana, an Argentine-born Italian who spent the World War II

FIGURE 13.4 Pierre Soulages, *Painting, 195 x 130 cm, May 1953*, 1953. Oil on canvas, 196.5 x 130.2 cm. Solomon R. Guggenheim Museum, New York.

years in his native country. Returning to Italy in 1947, he discovered that Allied bombing had destroyed his Milan studio. Taking this obliteration of his prewar art as an opportunity to break completely with the past, Fontana announced his new theory of Spazializmo (Spatialism) in several manifestos issued between 1947 and 1952. Spatialism rejected the **illusionistic** space of traditional painting and called for a new art in real space that would synthesize color, sound, movement, time, and speed. This art would also take advantage of new technologies such as neon lights, which Fontana incorporated into an **environment** in Milan in 1951.

In 1949, Fontana inaugurated his series of *Concetti spaziali* (spatial concepts), which included the *Buchi* (holes) and *Tagli* (slashes), in which he opened his paintings' surfaces up to the surrounding environment. In the *Buchi*, begun in 1949, he used pens and brushes to puncture canvases with a multitude of small holes (e.g., *Spatial Concept,* 1949–50, Tate). In the *Tagli*, begun in 1958, he used a blade to make precise cuts in the surfaces of painted canvases; he then spread open the cuts gently with his hands and fixed them in place from the back with black gauze (e.g., *Concetto spaziale, Attese*, 1959, Guggenheim). Both the holes and the cuts register acts of violence and suggest wounds.

Alberto Burri (1915–1995)

Fontana's younger contemporary Alberto Burri created works called *Sacchi* (sacks) between 1950 and 1956, which he too opened up to the surrounding environment. He made the *Sacchi* out of tattered, stitched-together patches of burlap sacking, often painting a few sections in solid red, white, or black,

FIGURE 13.5 Maria Helena Vieira da Silva, *Le Promeneur Invisible* (*The Invisible Stroller*), 1951. Oil on canvas, 133.03 x 168.91 cm. San Francisco Museum of Modern Art.

as in *Sacco e bianco* (*Sack and White*) (1953, Figure 13.6). These works drew on Burri's wartime experience as a military physician in the Italian army who sutured the wounds of his fellow soldiers. The *Sacchi* were also informed by Burri's subsequent internment as prisoner of war in Texas, where he took up painting as a pastime. He used castoff burlap sacking as a painting **support** when he lacked canvas.

Burri said he employed "poor materials" such as ragged burlap "to prove that they could still be useful. The poorness of a medium is not a symbol: it is a device for painting."[10] Nevertheless, critics and historians have persistently read the *Sacchi* in metaphorical terms. The English critic Herbert Read saw "every patch in the sacking, every gaping wound-like hole," to "reveal the raw sensibility of an artist outraged by the hypocrisy of a society that presumes to speak of beauty, tradition, humanism, justice and other fine virtues, and at the same time is willing to contemplate the mass destruction of the human race." "Burri," Read continued, "seems to say: I will take the material which the technologist has used and rejected and out of his scrap-heap I will rescue beauty."[11]

After the *Sacchi,* Burri adopted materials associated with construction and industry (resonating with Italy's postwar economic recovery and rebuilding) and manipulated them creatively, often through destructive methods. In his *Combustione legni* (wood combustions), he scorched sheets of wood veneer that he affixed to a support and embellished with paint; in his *Ferri* (irons), he roughly welded together scarred sheets of metal; and in his *Combustione plastiche* (plastic combustions), he burned holes in sheet plastic stretched over rectangular frames. Burri's experiments with unconventional materials and techniques exerted a strong influence on younger artists, including Robert Rauschenberg, who visited his studio in 1953, and Yves Klein, who in 1961–62 made "fire paintings" using a flamethrower (see Chapter 14).

Antoni Tàpies (1923–2012)

In Spain, the leading artist associated with *art informel* was the Catalan Antoni Tàpies. He is best known for his somber-colored paintings begun in the mid-1950s that feature thickly textured surfaces (achieved by mixing granular materials such as sand and cement into the paint) and resemble weathered and pockmarked walls, often incised or brushed with graffiti-like strokes. Paintings like *Grey Relief Perforated with Black Sign. No. X* (1955, Figure 13.7) channeled Tàpies's memories of the terrible Spanish Civil War (1936–39) and experience of Francisco Franco's succeeding dictatorial rule. Franco brutally suppressed

FIGURE 13.6 Alberto Burri, *Sacco e bianco* (*Sack and White*), 1953. Burlap, fabric, thread and synthetic polymer paint on canvas, 149 x 249.5 cm. Musée National d'Art Moderne, Centre Georges Pompidou, Paris.

FIGURE 13.7 Antoni Tapiès, *Grey Relief Perforated with Black Sign. No. X,* 1955. Mixed media on canvas, 146.05 x 96.52 cm. The Museum of Contemporary Art, Los Angeles.

the Catalonians, banning the public use of their language. In 1969, Tàpies identified the war and city walls as factors shaping his artistic vision: "The suffering of the adults and all the cruel imaginings of my age, abandoned to its own impulses amid all the surrounding catastrophes, were drawn and etched all around me. All the walls . . . witnessed the martyrdom and the inhumane repression inflicted on our people." As early as 1945, said Tàpies, his works "had something to do with street graffiti and a universe of repressed protest, clandestine yet full of life, as one could find on the walls of my country."[12]

Postwar Figuration in France

Figurative artists expressed the postwar world's anxious mood by adopting a raw approach to representing human bodies. Fautrier's *Hostages* not only pointed in the direction of abstract *art informel,* but also toward developments in figurative art in

France that emphasized rough surfaces, assertive materiality, and often scarred and brutalized imagery.

Jean Dubuffet (1901–1985)

A highly original and controversial figurative painter who gained prominence in postwar Paris, Jean Dubuffet studied art as a teenager but took it up full time only at the age of forty-one after having previously worked in his family's wine-selling business. Inspired by urban graffiti and the art of children, people with mental illness, and other untrained creators—which he termed **art brut** (raw art) and of which he amassed a large collection—Dubuffet rejected all professional artistic conventions and worked in a deliberately spontaneous, primitive style that he considered the only valid form of expression. His first exhibition in Paris in 1944 featured scenes of urban and rural daily life with puppet-like figures executed in bright colors (e.g., *View of Paris with Furtive Pedestrians*, 1944). In 1946, he exhibited earth-colored figurative and landscape images coarsely incised into a dense, mud-like **medium** that Dubuffet called *haute pâte* (high paste)—thick oil paint often mixed with other substances including sand, gravel, coal dust, and plaster (e.g., *Jean Paulhan*, 1946). In using this technique, he was influenced by the thick textures of Fautrier's *Hostages* but achieved a new extreme of rough materiality. While conservative critics attacked Dubuffet's high-paste works as "excrement" and "filth,"[13] they won the **avant-garde**'s approval; Michel Tapié found them to possess the same "magical-incantatory charm" as prehistoric cave art.[14]

For his next exhibition held in 1947, Dubuffet made portraits that depicted his supportive avant-garde friends in wildly caricatured fashion, subverting expectations and arousing many negative responses. For example, in *Limbour as a Crustacean* (1947, Figure 13.8), Dubuffet portrays writer Georges Limbour, who had participated in Surrealism and in the underground literary resistance during the war, as a grotesque crab-like creature, with an enormous head, oval torso, and stiff, elongated arms. Limbour's flat, frontal, incised body fills most of the canvas, surrounded by a thickly textured field of paint and sand.

Dubuffet employed a similar style in his equally iconoclastic *Corps de dames* (bodies of ladies) series of 1950–51 (e.g., *Corps de dame, jardin fleuri* [*Lady's Body, Flower Garden*], 1950). These depict female nudes with small heads and enormous torsos flattened and splayed across the canvas, their breasts and genitals crudely carved into the terrain-like impasto. Although some viewers might find these images degrading and misogynistic, Dubuffet called the *Corps de dames* an "ardent celebration," embracing a broader conception of beauty than the "specious" one "inherited from the Greeks and cultivated by the magazine covers." Calling that aesthetic "miserable and most depressing," Dubuffet declared, "Surely I aim for a beauty, but not that one."[15]

FIGURE 13.8 Jean Dubuffet, *Limbour as a Crustacean*, 1947. Oil and sand on canvas, 116.2 x 88.9 cm. Hirshhorn Museum and Sculpture Garden, Washington, DC.

The Cobra Artists

Dubuffet influenced the younger artists who formed the international group Cobra in Paris in 1948. Persisting until 1951, the group's name derived from the initial letters of Copenhagen, Brussels, and Amsterdam, the home cities of its members, the most prominent of whom were the Dane Asger Jorn, the Belgian Pierre Alechinsky, and the Dutchmen Constant (see Chapter 17) and Karel Appel (1921–2006). Like many other young Europeans, they sought a fresh start for art in the World War's wake. The Cobra artists rejected geometric abstraction and **Constructivism** to emphasize spontaneous and impulsive expression, either in figurative or nonfigurative modes (as in Ernest Mancoba's gestural abstract paintings; see Chapter 18). Like Dubuffet, many Cobra artists found inspiration in children's art and graffiti, as well as in prehistoric and **folk art**, and the art of the Vikings and Eskimos. Denying rationality and **formalism**, and embracing instinct, the Cobra artists asserted, as Constant put it: "A painting is not a composition of color and line, but an animal, a night, a scream, a human being, or all of these at once."[16] Constant's ideas are reflected in Karel Appel's *People, Birds, and Sun* (1954, Figure 13.9), a ferociously energetic and freewheeling painting filled with scrawled lines and rough patches of strident color and childlike imagery. Appel settled

in Paris in 1950, and the next year was befriended by Tapié, who included Appel in his 1952 book *Un art autre*.

The Later Work of Alberto Giacometti

Albert Giacometti's later work represents a different, more restrained kind of expression in postwar figuration. Giacometti had gained recognition as a Surrealist sculptor in the early 1930s (see Chapter 8) but was expelled from the movement in 1935 after he started working again from the model—an activity the Surrealists rejected as reactionary. Frustrated in his efforts to render reality as he saw it, Giacometti returned by 1940 to working from memory, but found that his figures seemed "to have a bit of truth only when small."[17] In his native Switzerland between 1942 and 1945, Giacometti created figures so tiny that they fit into matchboxes. After his return to Paris, he began to enlarge them, but to his surprise, they "achieved a likeness only when tall and slender"[18]—as seen in the attenuated proportions of the approximately fifteen-centimeter-high figures in *Piazza* (*City Square*) (1947–48, Figure 13.10).

Solitary and uncommunicative, *Piazza*'s spindly, rough-surfaced figurines—four striding men and a motionless, standing woman—can be read as icons of modern urban anonymity and alienation as well as the existentialist conception of lonely human existence surrounded by the void. However, to Giacometti, this and his other postwar figurative works—some as tall as 1.8 meters (e.g., *Man Pointing*, 1947)—manifested his obsession with the act of perception, his attempt to represent not only bodies but also the space around them. Refusing close-up views that consumed him in the details of the model's body and physiognomy, Giacometti enforced a sense of distance between himself and his subjects in order to perceive them in their totality and within their environment (similar to viewing a person from across a room). He invested his sculpted figures with this quality of distance by attenuating them, stripping away their individuality, and leaving their surfaces rough and pitted; no matter how close one comes to them, they still seem far away. In *Piazza*, Giacometti heightened this effect of distance by making the figures tiny both relative to the viewer and to the large slab-like platform they occupy, which makes them seem even more remote.

Jean-Paul Sartre understood Giacometti's work in existentialist terms as representing the reality of a person as they exist for other people. Before Giacometti, Sartre argued, artists tried to sculpt "being, and that absolute melted away in an infinity of appearances." Giacometti, by contrast, sculpted

the situated appearance, and he has shown that in this way the absolute may be attained. . . . Each one of [Giacometti's figures] reveals man as one sees him to be, as he is for other men, as he appears in an intersubjective world . . . each shows us that man is not there first and to be seen afterwards, but that he is the being whose essence is to exist for others.[19]

FIGURE 13.9 Karel Appel, *People, Birds, and Sun*, 1954. Oil on canvas, 173 x 242.8 cm. Tate, London.

Other writers offered less philosophical interpretations of Giacometti's sculptures as symbols of the suffering and despair caused by the recently concluded war. One American critic found in Giacometti's "tall, mysterious, emaciated knotty forms . . . a sort of desperate struggle for survival."[20] Another called them "fugitives from Dachau"—the notorious Nazi-run concentration camp.[21]

Existentialism

The sense of freedom combined with anxiety pervading modern art in postwar Europe as well as some American Abstract Expressionism (see Chapter 12) found intellectual articulation in existentialism. Existentialism investigates the meaning of existence, or Being, as involving diverse possibilities from among which individuals must choose, within the limits of their concrete, historically determined situation. Its most prominent exponent in the 1940s and 1950s was the French philosopher Jean-Paul Sartre. Building on the ideas of the nineteenth-century philosophers Søren Kierkegaard and Friedrich Nietzsche and of his older contemporaries Martin Heidegger and Edmund Husserl, Sartre argued that humans are alone in the universe; there is no God to give their lives a higher purpose. Rather than a cause for despair, however, Sartre saw this situation as liberating, giving humans the freedom and responsibility to create their own lives and invest them with meaning. This quest, however, was anxious and never ending, a constant striving for an unattainable goal; to Sartre and other existentialists, the striving itself gave life meaning. Seriously interested in the visual arts, Sartre was a friend of both Wols and Giacometti, and wrote eloquently about their art.

The English painter Francis Bacon sounded an existentialist note in declaring "I think of life as meaningless; but we give it meaning during our own existence."[22] Giacometti's perpetual struggle to render his experience of reality resonated with Sartre's conception of life as a project that can never reach its goal but gains its nobility through this effort. More generally, existentalism's rejection of fixed patterns and beliefs encouraged adventuresome artists to make radically new work that both declared their artistic identity and created new values for a rebuilding culture.

FIGURE 13.10 Alberto Giacometti, *Piazza* (*City Square*), 1947–48. Bronze, 21 x 62.5 x 42.8 cm. Solomon R. Guggenheim Foundation, Peggy Guggenheim Collection, Venice.

Germaine Richier (1902–1959)

While Giacometti did not intend his work to symbolize postwar anxiety, other sculptors did respond metaphorically in their art to the era's difficult human situation. Germaine Richier, who had worked in a classically figurative style before World War II, created two life-size sculptures of standing nudes, *Storm Man* (1947–48) (Figure 13.11) and *Hurricane Woman* (1948–49) (Figure 13.12) in the early postwar years. Their rough, scarred surfaces give them the appearance of battered survivors of a cataclysmic storm. The figures recall Richier's experience of violent weather as a child in Provence in southern France and may also evoke the impact of the recent devastating war. *Storm Man* has the more degraded appearance, with facial features obliterated and areas of the body broken open to reveal the bronze's hollow interior. Richier likened such perforations to "flashes of lightning" into the material "which becomes organic and open . . . lit up and through the hollows." She also insisted that an artistic form "lives" when expressive, "and we decidedly cannot conceal human expression in the drama of our time."[23]

Postwar Figuration in Britain

Many British figurative artists also engaged artistically with the period's anxieties, as the country recovered from the devastating World War that had claimed nearly 450,000 British lives. Postwar Britons experienced economic hardship and rationing as well as the disquieting tensions of the Cold War. Artistic responses differed broadly depending on the generation of the artist. Henry Moore and Barbara Hepworth, established as leading modern British sculptors before the war (see Chapter 9), created benign and affirmative human images that provided

FIGURE 13.11 Germanie Richier, *Storm Man*, 1947–48. Bronze, 200 x 80 x 52 cm. Musée National d'Art Moderne, Centre Georges Pompidou, Paris.

FIGURE 13.12 Germaine Richier, *Hurricane Woman*, 1948–49. Bronze, 179 x 67 x 43 cm. Musée National d'Art Moderne, Centre Georges Pompidou, Paris.

reassuring hope for the future. By contrast, younger artists, such as the painters Francis Bacon and Lucian Freud, offered disquieting imagery that resonated with the era's unsettled mood.

The Later Work of Henry Moore and Barbara Hepworth

During the war, Henry Moore had responded artistically to his fellow citizens' tribulations by making drawings in the Underground (subway) of Londoners taking shelter from German nighttime aerial bombings (e.g., *Shelterers in the Tube*, 1941). After the war, Moore sculpted a series of *Family Groups* that expressed optimism for the renewal of human civilization. These works gave implicit support for the ideal of a secure family within a stable community promoted by the postwar British government. The groups also reflected Moore's own domestic happiness as a new father (his only child, Mary, was born in 1946). Each *Family Group* consists of a mother, father, and one or two children. Moore **modeled** these works in clay and

then cast them in bronze, forsaking his earlier commitment to **direct carving** in stone or wood. In the large *Family Group*, which Moore completed in 1949 (Figure 13.13), the seated parents—markedly **stylized** with broad shoulders, thin torsos, long limbs, and small heads bearing calm facial expressions—hold between them a small, chubby child. Moore described the focal point of this composition as "the arms of the mother and the father with the child forming a knot between them tying the three into a family unity."[24]

Barbara Hepworth expressed the ideal of harmonious human relations in more abstract terms in three *Groups* she carved in the early 1950s out of white Serravezza marble—**Classical** sculpture's primary medium and a material Hepworth associated with the Mediterranean sun.[25] Each *Group* features several highly simplified personages—one reclining, the others upright—casually arranged on a slab base. The tallest figure stands no more than twenty-five centimeters. In *Group I (Concourse), February 4, 1951* (Figure 13.14), several of the

FIGURE 13.13 Henry Moore, *Family Group*, 1948–49 (cast 1950). Bronze, 150.5 x 118 x 75.9 cm. The Museum of Modern Art, New York.

figures are pierced by holes, a device Hepworth had used since the early 1930s to create "an abstract form and space."[26] The inspiration for Hepworth's *Groups* came from a 1950 visit she made to Venice where she observed pedestrians in the Piazza San Marco. She recalled that people entering the Piazza, in response to the proportions of the architectural space, "walked differently, discovering their innate dignity. They grouped themselves in unconscious recognition of their importance to each other as human beings."[27]

Both Hepworth and Moore created many large public sculptures in bronze during the later decades of their careers. Hepworth's most significant public work, *Single Form* (1961–64), is a 6.4-meter-tall pierced, broad, bladelike sculpture. It was erected in the plaza fronting the United Nations Secretariat in New York as a memorial to the former UN secretary-general, Dag Hammarskjöld. Also in New York is one of Moore's most celebrated public sculptures, the 4.9-meter-tall *Lincoln Center Reclining Figure* (1963–65). Situated in a reflecting pool, the sculpture's two massive, roughly textured bronze segments are typically read as the vertical torso and horizontal legs of a woman (though Moore understood them to represent "a woman and rock rising from the water").[28] Moore likely derived the torso's shape from a flint stone; the lower arch-like section recalls the famous cliff-rock on the French coast at Étretat, painted several times by Monet. Through this imaginative merger of human and natural forms—a recurrent impulse in his sculpture—Moore sought to recognize people and their environment as healthily integrated in an organic whole.

Francis Bacon (1909–1992) and Lucian Freud (1922–2011)

In strong contrast to the reassuring tone of Hepworth's and Moore's work, Francis Bacon's paintings explored the dark side of the human condition through horrific imagery of anguished, mutilated, or menacing figures in claustrophobic environments. Born in Dublin, Ireland, to English parents, Bacon's angst-ridden worldview was influenced not only by the terrors of World War II but also by memories of his troubled childhood growing up in the midst of revolutionary violence (which resulted in the partition of Ireland in the early 1920s).

FIGURE 13.14 Barbara Hepworth, *Group I (Concourse) February 4, 1951*, 1951. Serravezza marble, 24.8 x 50.5 x 29.5 cm. Tate, London.

He experienced abuse as a boy and was expelled from home at sixteen because of his homosexuality, which was then illegal in the United Kingdom and Ireland. After a brief stay in Berlin, Bacon moved to Paris where he encountered Picasso's art and became interested in painting. Settling in London in 1929, he worked for a time as an interior decorator, and designed **Bauhaus**-influenced rugs and tubular metal furniture (see Chapter 6). After painting in the 1930s under the sway of Picasso's monstrous "bone" figures (e.g., *Seated Bather*, 1930), Bacon found his own style in the mid-1940s.

In *Painting* (1946, Figure 13.15), a key work of Bacon's early artistic maturity, an ominous black-suited figure with an open toothy mouth and blood-spattered upper lip presides under an umbrella over a nightmarish scene of slaughter loosely painted in a **palette** dominated by red, pink, black, and white. Above and behind the figure hangs a beef carcass beneath swags and against a backdrop of three drawn pink shades. Below, a tubular structure based on a chrome and glass coffee table Bacon designed in the late 1920s rests on an oriental rug and holds two slabs of meat pointing toward the figure. Sketchy vertical white forms on either side suggest microphones, giving the figure the aura of a politician speaking at a lectern.

Bacon claimed that *Painting* began as a picture of "a bird alighting on a field" and that the composition's incongruous images emerged through an **automatist** process of free-association he likened to "one continuous accident mounting on top of another."[29] Bacon's imagination was certainly stimulated, however, by photographs—a basis of his painting for the rest of his career. News photos of wartime leaders such as Joseph Goebbels, Heinrich Himmler,

FIGURE 13.15 Francis Bacon, *Painting*, 1946. Oil and pastel on linen, 197.8 x 132.1 cm. The Museum of Modern Art, New York.

Benito Mussolini, and Franklin Roosevelt likely inspired the sinister central figure of the politician. The umbrella was associated in the period with Neville Chamberlain, the British prime minister whose attempt to appease Hitler in the late 1930s failed to prevent World War II. The carcass recalls paintings of this subject by Rembrandt and Chaïm Soutine.

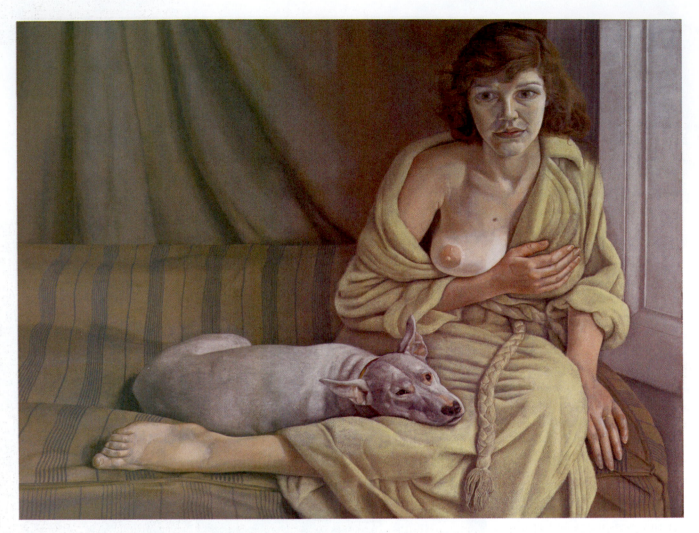

FIGURE 13.16 Lucian Freud, *Girl with a White Dog*, 1950–51. Oil on canvas, 76.2 x 101.6 cm. Tate, London.

Bacon professed to have been "very moved by pictures about slaughterhouses and meat." The artist, a confirmed atheist, associated these images with the Crucifixion, which he saw as "just an act of man's behavior, a way of behavior to another."[30] He subsequently cast doubt on religion's power in a series of paintings (1949–mid-1960s) inspired by Velázquez's *Portrait of Pope Innocent X* (1650); in them, Bacon showed the pontiff as a tortured, screaming figure—an embodiment of existential anxiety rather than confident faith (e.g., *Study After Velázquez's Portrait of Pope Innocent X*, 1953).

Equally indicative of the uneasy postwar mood in Europe but without the macabre and violent qualities of Bacon's art are his close friend Lucian Freud's early figure paintings. Critic Herbert Read called Freud the "Ingres of Existentialism" for his sharply focused, realist depictions of brooding subjects in spare interiors. A grandson of the psychoanalyst Sigmund Freud, the artist spent his childhood in Berlin before moving with his family to London in 1933. Critics have often compared his obsessively meticulous realism to that of the German **Neue Sachlichkeit** painters of the 1920s

(see Chapter 7). In *Girl with a White Dog* (1950–51, Figure 13.16), the artist's first wife, Kathleen "Kitty" Garman, sits tensely on a couch in a green dressing gown. Her pale, white right breast is provocatively exposed, as if on the order of her painter husband, whose intense scrutiny seems the likely cause of her apprehensive expression and slightly averted eyes. Even the bull terrier resting next to the young woman, its body aligned with her extended lower leg, seems somewhat nervous in the painter's presence.

By the late 1950s, Freud, influenced by Bacon's free **brushwork**, had begun to paint with thick, juicy brushstrokes that emphasized the fleshy mass of his nude models. Posing daily for months on end in long sessions in his drab apartment studio, Freud's subjects—always friends or relatives willing to reveal themselves to his gaze—appear fatigued and withdrawn, giving no evidence of a rapport between artist and model (e.g., *Naked Portrait*, 1972–73). Thus, Freud carried into the early twenty-first century the popular, albeit bleak, mid-century view of a solitary human existence to which art can only bear witness, not redeem.

14

Between Art and Life: International Trends of the 1950s and 1960s

"Painting relates to both art and life," said American artist Robert Rauschenberg in 1959. "Neither can be made. (I try to act in that gap between the two.) A pair of socks is no less suitable to make a painting with than wood, nails, turpentine, oil and fabric."[1] Rauschenberg's viewpoint, common among artists of his generation, represents a significant rejection of the Abstract Expressionist attitude. Jackson Pollock, Mark Rothko, Barnett Newman, and their colleagues embraced complete abstraction, using gestural brushstrokes, poured paint, and fields of pure color to convey their intense subjective feelings. Through abstraction, they repudiated the materialism of US culture in the 1950s—an economically prosperous decade in which consumerism, television, and the mass media grew rapidly. By contrast, many artists who emerged in the Abstract Expressionists' wake in the early 1950s and 1960s embraced quotidian images, objects, and events and incorporated them into their art. They likewise rejected the Abstract Expressionists' existentialist-tinged view of creativity as an anxious and heroic act and instead adopted a "cool," emotionally detached approach to art making. These values achieved their most widely recognized manifestation in American Pop art (see Chapter 15) of the 1960s. This chapter introduces several trends distinct from Pop that emerged in the 1950s and early 1960s—not only in the United States but also in Western Europe, and Japan, which experienced similar economic booms, as well as in still developing Brazil. Much of the art considered in this chapter falls within the broad and sometimes overlapping categories of assemblage, environments, and Happenings—art forms united by an impulse to blur or erase distinctions between art and everyday life. Artistic movements that sought to integrate art and life included Gutai (Japan), Nouveau Réalisme (France), Fluxus, and Neo-Concretism (Brazil).

Assemblage in the United States

A 1961 MoMA exhibition, *The Art of Assemblage*, brought attention to **assemblage** as a significant contemporary phenomenon. The exhibition surveyed modern art composed of preexisting objects and images, ranging from **Cubist collages** to **Dada readymades** and recent junk sculpture and "collage environments." Curator William C. Seitz explained that such works "are predominantly *assembled* rather than painted, drawn, modeled or carved" and that "entirely or in part, their constituent elements are preformed natural or manufactured materials, objects, or fragments not intended as art materials."[2] Despite its frequent inclusion of natural materials, Seitz characterized assemblage as a primarily urban art form—a manifestation of what English critic Lawrence Alloway called "junk culture":

Its source is obsolescence, the throwaway material of cities, as it collects in drawers, cupboards, attics, dustbins, gutters, waste lots, and city dumps. Objects have a history: first they are brand new goods; then they are possessions, accessible to few, subjected, often, to intimate and repeated use, then, as waste, they are scarred by use but available again. . . . Assemblages of such material come at the spectator as bits of life, bits of the environment.

The urban environment is present, then, as the source of objects, whether transfigured or left alone.[3]

Among the major US assemblage artists were Robert Rauschenberg and Jasper Johns, who combined painting with ready-made imagery and found objects; and the sculptors Louise Nevelson, John Chamberlain, Mark di Suvero, and Lee Bontecou, who constructed their works out of salvaged materials. Romare Bearden's collages, comprising photographic illustrations clipped from periodicals to create dynamic images of African American life, demonstrate a related impulse.

Robert Rauschenberg (1925–2008)

"I don't want a picture to look like something it isn't," said Robert Rauschenberg. "I want it to look like what it is. And I think a picture is more like the real world when it is made of the real world."[4] A native Texan, Rauschenberg served in the US Navy before studying at the Kansas City Art Institute, Académie Julian in Paris, and Black Mountain College, an innovative interdisciplinary arts school in Asheville, North Carolina, in the late 1940s and early 1950s. His most influential teacher at Black Mountain was Josef Albers, the former **Bauhaus** master (see Chapter 6), who encouraged students to explore the creative potential of a wide range of materials and objects, both individually and combined through collage and assemblage—strategies that became fundamental to Rauschenberg's art.

Rauschenberg's first significant works were a series of **photograms** he made in New York between 1949 and 1951 in collaboration with his wife and fellow artist Susan Weil; one would lie on a large sheet of photosensitive blueprint paper and the other would scan the paper with a portable sun lamp, revealing the ghostly white silhouette a human body. These were early examples of Rauschenberg's use of art to record rather than interpret the world around him.

Rauschenberg's dependence on the environment outside the artwork to provide its content became more radical in his *White Paintings* of the early 1950s. Devoid of signs of personal expression and predictive of **Minimalist** art (see Chapter 16), these were rectangular stretched canvases covered with flat white house paint applied with a roller. Rauschenberg's friend and mentor John Cage (see box) described them as "airports for the lights, shadows, and particles."[5] Their vacancy and sensitivity to the surrounding environment directly informed Cage's silent composition, *4'33"*.

After emptying his paintings out, Rauschenberg began to fill them up. He made *Black Paintings* (1952) by laying black **enamel** over crumpled newspapers and *Red Paintings* (1953–54) by smearing red **oil paint** over rough expanses of newspaper and various fabrics. He then pushed beyond the conventions of painting with his **Combines**—hybrid works energetically blending elements of painting and sculpture with all manner of discarded objects and materials. For an early example, *Bed* (1955, MoMA), the artist used his own quilt, sheet, and pillow as a painting surface, the upper half of which he slathered with **Abstract Expressionist**-style gestural brushstrokes, pencil scribbles, fingernail polish, and toothpaste. Although it hangs on the wall vertically, like a painting, *Bed* retains its association with the horizontal piece of furniture identified by its title, occupying the terrain that Rauschenberg called "the gap" between art and life. The smears and drips of paint suggesting stained bed sheets with connotations of sex and violence led many viewers to find *Bed* disturbing. Rauschenberg disagreed, calling *Bed* "one of the friendliest pictures I've ever painted. My fear has always been that someone would want to crawl into it."[6]

Rauschenberg welcomed all manner of objects, images, and materials into his Combines—none more outlandish than the stuffed Angora goat he purchased from a furniture store in 1955. He cleaned its dirty coat with rug shampoo, smeared paint over its damaged muzzle, and experimented with different ways of using it in a Combine before arriving at the solution that felt right: around the goat's midsection he placed a tire with white-painted treads—an everyday object balancing the animal's exotic appearance—and he stood the goat on a wooden platform, as if setting it out to pasture. He covered the platform with scattered Abstract Expressionist-style paint strokes and such odds and ends as a tennis ball, a section of a street barricade with signboard lettering, photographs from magazines and newspapers, the rubber heel from a man's shoe, and a series of four inked footprints—the latter two elements reinforcing the platform's horizontality. Rauschenberg entitled the work *Monogram* (1955–59, Figure 14.1) because he saw the goat and tire functioning like interlaced initials. Beyond such occasional references, Rauschenberg denied that his works contained fixed meanings, leaving them radically open to interpretation. Critic Robert Hughes, mindful of Rauschenberg's homosexuality (he divorced Susan Weil in 1953 and entered a relationship with Jasper Johns the next year) interpreted *Monogram* as a metaphor for anal sex. Hughes noted, "goats are the oldest metaphors of priapic energy" and called Rauschenberg's goat "one of the few great icons of male homosexual love in modern culture: the Satyr in the Sphincter, the counterpart to Meret Oppenheim's fur cup and spoon" (see Figure 8.12).[7] To many contemporary critics, however, the surprising juxtapositions of **found objects** and images in this and other Rauschenberg Combines simply revived the playful and absurd Dada spirit—a view encapsulated in the label **Neo-Dada**, applied also to the work of Johns.

In 1962, Rauschenberg replaced the Combines' found objects with photographic images culled from newspapers and magazines such as *Life*, *National Geographic*, and *Sports Illustrated* as well as his own snapshots. Following Andy Warhol's example (see Figure 15.7), he had these commercially converted to **photo-silkscreens**, so he could transfer them to his

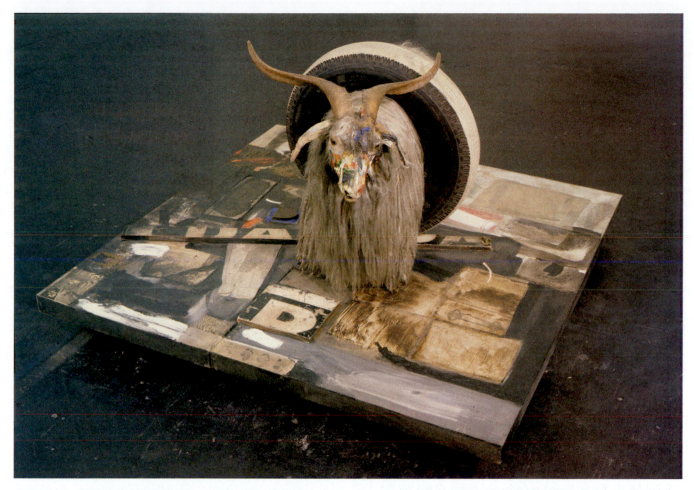

FIGURE 14.1 Robert Rauschenberg, *Monogram*, 1955–59. Oil on canvas, printed paper, textile, paper, metal sign, wood, rubber shoe heel, tennis ball, taxidermied angora goat with paint and painted rubber tire, 106.5 x 160.6 x 163.5 cm. Moderna Museet, Stockholm.

paintings in an improvisational fashion, producing **compositions** that he enlivened with gestural paint strokes. His process generated unexpected combinations; he found the transferred pictures to "constantly suggest different things when they're juxtaposed with other images."[8] The silkscreen paintings seem to bring together random samples from the stream of mass-media pictures cluttering the modern US urban environment. "I was bombarded with TV sets and magazines," Rauschenberg recalled, "by the refuse, by the excess of the world . . . I thought that if I could paint or make an honest work, it should incorporate all of these elements, which were and are a reality."[9]

While Rauschenberg did not intend the silkscreen paintings to convey stable meanings any more than the Combines did, their media-derived **iconography** refers to contemporary events. Many of them feature an image of the late President John F. Kennedy, whom Rauschenberg greatly admired. Dominating *Retroactive I* (1963, Figure 14.2) is Kennedy's blue likeness with a hand-painted emerald green tie and his right hand doubled to emphasize its pointing index finger, a gesture he often made

while speaking. To the left of Kennedy's head is a NASA photograph appropriated from *Life* magazine of a spacesuit equipped with a combination of a parachute and balloon for use by an astronaut ejecting out of a space capsule. It suggests Kennedy's commitment to the US space program—and Rauschenberg's fascination with it. To the right of Kennedy, screened in red, is another *Life* magazine image: Gjon Mili's time-lapse photograph of a nude female model walking down stairs—an homage to Duchamp's *Nude Descending a Staircase (No. 2)* (see Figure 4.18).[10] The nude's multiplied limbs suggested to Robert Hughes the famous figures of Adam and Eve expelled from Eden in Masaccio's fifteenth-century **fresco**.[11] This association in turn transforms the parachuting astronaut into a descending angel; the inverted box of apples below the astronaut becomes a reference to Eden's forbidden fruit; and Kennedy, who after his assassination approached apotheosis as the center of a sentimental cult, becomes a vengeful God. This is but one of many possible readings of Rauschenberg's painting, whose content remains open-ended and unpredictable—like life itself.

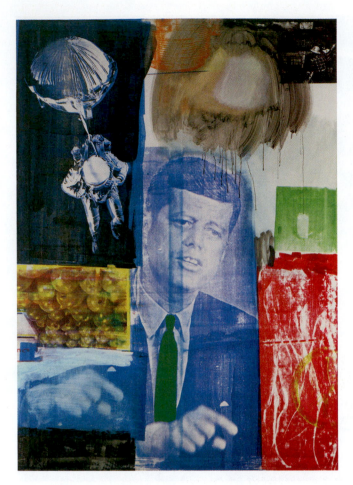

FIGURE 14.2 Robert Rauschenberg, *Retroactive I*, 1963. Oil and silkscreen ink on canvas, 213.4 x 152.4 cm. Wadsworth Atheneum Museum of Art, Hartford, Connecticut.

Uninterested in repeating himself, Rauschenberg stopped making the silkscreen paintings after winning the 1964 Venice Biennale's Grand Prize—recognition that cemented his

international reputation and, to many, signified New York's triumph over Paris for world leadership in the field of modern art. For the rest of the decade, he devoted much of his energy to interdisciplinary projects, having already served as the Merce Cunningham Dance Company's resident designer between 1954 and 1964. In 1966 Rauschenberg cofounded Experiments in Art and Technology (E.A.T.), with artist Robert Whitman and Bell Telephone Labs engineers Billy Klüver and Fred Waldhauer. This nonprofit organization brought together scientists, engineers, and artists in an effort to break down the divisions between these disciplines and expand art's creative possibilities through the incorporation of new technologies.

Jasper Johns (b. 1930)

Arriving in New York from his native South Carolina in 1954, self-taught artist Jasper Johns met and formed a close personal and working relationship with Rauschenberg that lasted until 1961. In contrast to Rauschenberg, who assembled his Combines spontaneously out of random objects and castoff materials, Johns chose subjects for his paintings deliberately and executed them painstakingly. In the spirit of Duchamp's readymades, he depicted familiar motifs, "things the mind already knows"[14]—targets, the American flag, letters, numerals, and the map of the continental United States. These commonplace subjects revealed nothing of Johns's emotions—a rejection of Abstract Expressionism—yet he gave them a sensual, handmade quality by carefully painting them in translucent layers of **encaustic**.

Johns's many depictions of the American flag—*Flag* (1954–55, MoMA) was among the earliest—preserved its flat, rectangular format. The flag's image conforms to the shape of the **support**, eliminating the traditional **figure-ground relationship** of representational painting and raising unanswerable questions about the object's status: is it a depiction of a flag,

John Cage and the Beauty of Life Itself

While assemblage artists deliberately incorporated fragments of life into art, composer John Cage found life itself to be an inexhaustible reservoir of unexpected beauty. An important mentor to younger visual artists including Rauschenberg, Allan Kaprow, and Nam June Paik, Cage was inspired by his friend Marcel Duchamp's readymades to see the everyday world as the source of art. After he discovered Zen Buddhism and Indian philosophy in the mid-1940s, Cage rejected the concept of art as an expression of personal emotion or ego, setting him at odds with the Abstract Expressionists. Instead, Cage embraced indeterminacy, which he saw as nature's operating principle. He used chance techniques to remove intention and personal taste from his compositions, treating all sonic phenomena—including those randomly occurring—as music. In his famous 1952 piece, *4'33"* (four minutes and thirty-three seconds), the performer sits

silently at the piano for the time designated by the title; the chance sounds of the environment constitute the music. Teaching a course on "Experimental Composition" at New York's New School for Social Research from 1956 to 1958, Cage introduced his students to the ideas of Duchamp, Zen Buddhism, and Antonin Artaud, who called for a total theater in which movements, sounds, scenery, and lighting would "break through language in order to touch life."[12] Cage's students included Kaprow, the founder of **Happenings**, and several future **Fluxus** artists. Cage's overriding purpose was to give his students a sense of freedom to experiment without worrying about success or failure. Many of the artists discussed in this chapter, whether directly influenced by Cage or not, shared what his student Dick Higgins called "the sense he gave that 'anything goes'"—and that anything could be art.[13]

an actual flag, or both? Beyond this conceptual ambiguity, the picture's stiff, deadpan quality provocatively subverts the highly charged patriotic symbolism of the American flag in the mid-1950s. In 1954, Congress approved the addition of the words "under God" to modify "nation" in the pledge of allegiance to the US flag—a Cold War response to "godless" communism. Sen. Joseph McCarthy's controversial investigation of the US government's supposed infiltration by communists peaked that same year. McCarthy also crusaded against government employees suspected of homosexuality, arguing they threatened national security because they could be blackmailed to reveal state secrets. As a gay man, Johns would have been particularly sensitive to this aspect of McCarthyism. His frozen *Flag* seems to register the ambivalence he likely felt regarding the banner's authority. In refusing to make an unequivocal patriotic statement, the painting raises doubts about the flag's sanctity—and the integrity of the nation it symbolizes.[15]

The MoMA *Flag* signals Johns's awareness of the contemporary political climate through the newspaper collage underneath the encaustic, suggesting concealed meanings. He used the same combination of materials for his early target paintings. Like the flags, they have a ready-made, two-dimensional subject—alternating concentric rings of blue and yellow on a red field—that corresponds to the shape of the support, allowing the painted targets to be read as both images and objects. Across the top of *Target with Four Faces* (1955, Figure 14.3), Johns placed a row of boxes with a hinged lid, each box containing a tinted plaster cast of the lower half of an expressionless masculine face. Targets attract the gaze, as do human faces and, especially, eyes. Johns's plaster faces, however, are eyeless. Juxtaposed with the target, they suggest blindfolded men before a firing squad. Reading *Target with Four Faces* in the context of Johns's biography raises the suggestion that the artist himself may have felt like a target in the homophobic atmosphere of the 1950s. The possibility of closing the lid to hide the faces hints at closeting, historically used by gay people to avoid scrutiny and persecution.

Perceived as an attack on Abstract Expressionism because of their banal **subject matter**, deadpan tone, and careful execution, Johns's paintings jolted the New York art world in 1958 at his first solo exhibition at the Leo Castelli Gallery. He and Rauschenberg, whom Castelli also represented, were initially labeled Neo-Dadaists and then became recognized in the 1960s as precursors of **Pop art**. However, neither embraced the subjects and techniques of commercial art and the mass media to the degree the Pop artists did. Johns made his closest approach to Pop art in his 1960 sculpture, *Painted Bronze*—a bronze rendition of two Ballantine Ale cans. It predicts Andy Warhol's use of consumer product logos and packaging as artistic subjects, but Johns painted the ale can labels freehand, giving them a handmade character at odds with Warhol's impersonal, machine-like style.

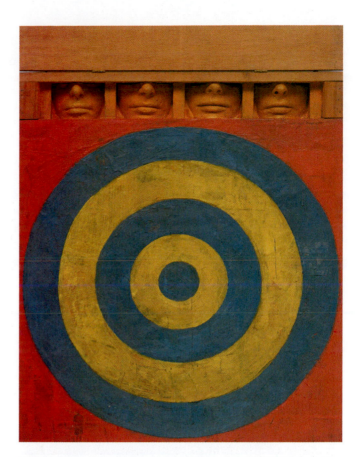

FIGURE 14.3 Jasper Johns, *Target with Four Faces*, 1955. Encaustic on newspaper and cloth over canvas surmounted by four tinted-plaster faces in wood box with hinged front, 85.3 x 66 x 7.6 cm. The Museum of Modern Art, New York.

Louise Nevelson (1899–1988)

Louise Nevelson gained prominence at the same moment as Johns and Rauschenberg when she exhibited her assembled wood sculptures in New York in 1958. Wood was a familiar material to Nevelson from childhood: she immigrated with her family at age six from Ukraine to Rockland, Maine, where her father ran a construction and lumber business. Her early 1930s studies with the **abstract** painter Hans Hofmann in Munich and New York introduced her to Cubism and collage. She began making free-standing assemblages out of scrap wood in the early 1940s but achieved her artistic breakthrough only in 1957. In that year, she started using wooden crates as containers for her assembled elements. She spray-painted the boxes and their contents matte black and stacked them to produce wall-scaled **relief** sculptures.

Exemplary of such works, *Sky Cathedral*'s (1958, Figure 14.4) approximately fifty crates of various shapes and sizes harbor a wide variety of found wood elements, including furniture parts, architectural ornaments, and rough oddments. Within the boxes, fragmented forms and complex interplays of flatness and depth, straight lines and curves have **formal** affinities with **Analytic Cubism** (see Figures 4.7 and 4.8), but the overall

Mark di Suvero (b. 1933)

Mark di Suvero, who arrived in New York from California in 1957, created sculptures using scavenged materials from demolished buildings. He assembled rough-hewn wooden beams and planks, steel rods, chains, and ropes into enormous asymmetrical structures set directly on the floor (e.g., *Hank-champion*, 1960). Thrusting aggressively into space, they were three-dimensional counterparts to the gestural **action paintings** of Willem de Kooning and Franz Kline (see Figure 12.8). In 1967, di Suvero began working with steel I-beams, which he hoisted into the air with a crane and bolted, riveted, and welded together into sprawling arrangements with strong diagonals (e.g., *Are Years What? [For Marianne Moore]*, 1967). He painted many of these towering sculptures bright red, giving them a cheerful personality in keeping with their open, buoyant compositions. Positioned outdoors, accessible to everyone, and extending heroically into free space, di Suvero's I-beam sculptures serve, in critic Barbara Rose's words, as "a metaphor for human liberty in thought and action."[17]

John Chamberlain (1927–2011)

John Chamberlain, like di Suvero, made junk sculptures that translate the aesthetics of Abstract Expressionist action painting into three dimensions. After study at the Art Institute of Chicago and Black Mountain College, Chamberlain moved to New York in 1957 and began making welded-metal assemblages out of crushed auto body parts. A characteristic work, *Delores James* (1962, Figure 14.5), in its large size, energetic sense of movement, forceful diagonals, bold colors, and strong light and dark contrasts bears comparison to Willem de Kooning's mid-1950s paintings (e.g., *Bolton Landing*, 1957). Chamberlain's work differs from de Kooning's however, in its bulky physicality and ready-made **palette**: he did not paint the metal pieces but chose them based on the colors they already bore. Chamberlain's artistic use of automobile carcasses inevitably evokes American car culture; his crumpled and jagged compositions suggest the aftermath of car crashes. Chamberlain resisted such metaphorical readings, however, insisting that he used car parts simply because they were readily available materials that he could employ creatively. He declared, "I wanted the sculpture to exist on its own terms coming through the process of myself."[18]

Lee Bontecou (1931–2002)

New York-based Lee Bontecou achieved international recognition in the 1960s for her dark, disquieting reliefs made of salvaged materials. She fashioned these painting-sculpture hybrids principally out of canvas fragments from bags and conveyer belts discarded by the laundry below her studio. She left these canvas pieces raw or blackened them with an oxy-acetylene torch, then stitched them together with wire over an eccentrically shaped welded steel armature projecting off the

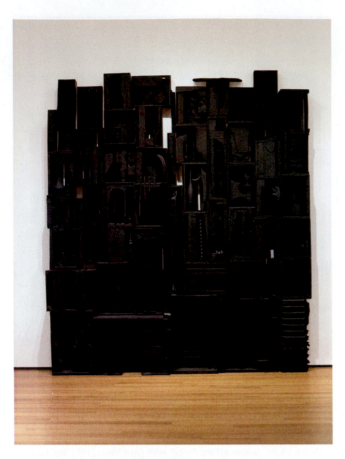

FIGURE 14.4 Louise Nevelson, *Sky Cathedral*, 1958. Painted wood, 343.9 x 305.4 x 45.7 cm. The Museum of Modern Art, New York.

work is more like an Abstract Expressionist painting in its large size, visual impact, and suggestiveness. Viewed from a distance, the intricate elements coalesce into a nonhierarchical overall composition like those of Pollock's poured **abstractions** (see Figure 12.4). The uniform black color transcends the castoff materials' cheapness to create a solemn aura of mystery similar to that of a dark Rothko painting. Nevelson shared Rothko's desire to convey a spiritual quality through abstraction, as indicated by her designation of the work as a cathedral. Her attitude toward assemblage was thus very different from Rauschenberg's: he accepted as facts the materials and objects that the world gave him, whereas she sought to transform them into something ineffable.

Nevelson considered black "the most aristocratic color of all" because it contained all other colors.[16] In 1959, she turned to its opposite, creating an all-white wooden assemblage **environment**, *Dawn's Wedding Feast*, for MoMA's *Sixteen Americans* exhibition. Its white **hue** symbolizing purity, the environment included free-standing and suspended columns signifying the wedding party members and wall reliefs signifying chapels (e.g., *Dawn's Wedding Chapel II*, 1959). The next year Nevelson began painting her sculptures gold, which she associated with royalty, before returning in the mid-1960s to black, which remained her signature color.

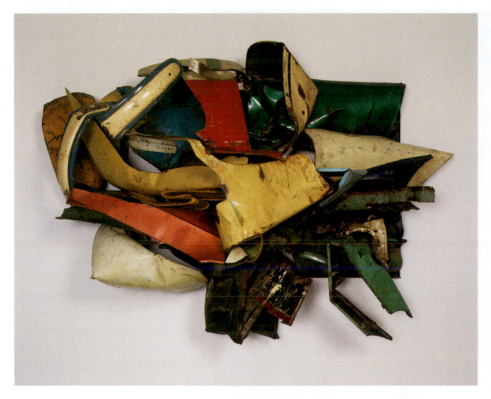

FIGURE 14.5 John Chamberlain, *Delores James*, 1962. Welded and painted steel, 184.2 x 257.8 x 117.5 cm. Solomon R. Guggenheim Museum, New York.

disturbing tableaux—his term for environments incorporating found objects and life-size cast or assembled figures—engage critically with the dark underside of American society. *The State Hospital* (1966, Figure 14.7), inspired by Kienholz's 1947 experience as an orderly in a mental hospital, indicts the dehumanization and abuse of patients in such institutions. The tableau is contained within a prison cell-like room with a padlocked door and barred window providing a view of the interior. Inside, two sickly yellow resin-coated plaster casts of emaciated, mummy-like figures lie in identical positions on filthy bunk beds. Their left wrists are shackled to the bed frame and their faces are replaced by Lucite bubbles, each containing two swimming black goldfish. A single bare lightbulb illuminates the bleak scene; a dirty bedpan sits on the floor. A cartoon speech balloon of neon tubing rises

wall. Bontecou opened the reliefs' surfaces into one or more circular or elliptical voids lined with black velvet or soot. The reliefs have structural analogies to the human body with its skin, bones, and orifices. Some of them include other found objects such as the rope and saw blades of *Untitled* (1961, Figure 14.6).

While she left her reliefs untitled so they remain open to multiple interpretations, Bontecou understood them as oblique responses to international politics and events. Excited by the Soviet Union's 1957 launch of Sputnik, the first satellite to orbit the earth, she associated the reliefs' deep recesses with outer space's vast blackness. At the same time, she related her use of this color to the troubles of the African continent.[19] Her works' ominous aspects, such as *Untitled*'s dangling rope, saw blades, and barred orifice suggesting a cage, express anxieties about the Cold War. Worrisome events in the year she created this work included the United States' failed Bay of Pigs invasion in Cuba and the rise of the Berlin Wall. Bontecou wrote in 1960, "My concern is to build things that express our relation to this country—to other countries—to this world—to other worlds—in terms of myself. To glimpse some of the fear, hope, ugliness, beauty and mystery that exists in us all and which hangs over all the young people today."[20]

Edward Kienholz (1927–1994)

Los Angeles-based Edward Kienholz was one of numerous California artists to create assemblages in the 1950s and 1960s. His

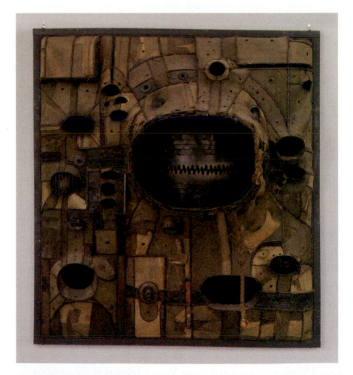

FIGURE 14.6 Lee Bontecou, *Untitled*, 1961. Welded steel, canvas, wire and rope, 184.2 x 167.6 x 62.9 cm. Whitney Museum of American Art, New York.

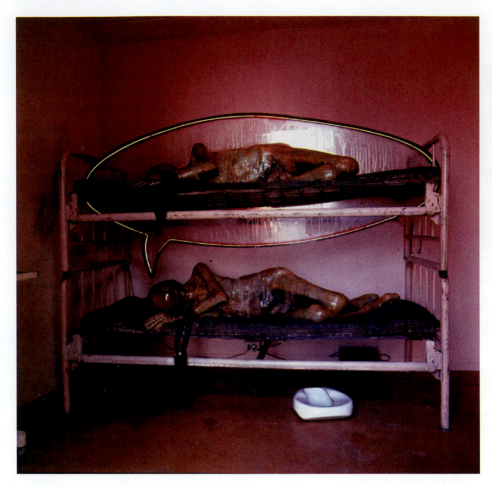

FIGURE 14.7 Edward Kienholz, *The State Hospital*, 1966. Various materials, 245 x 360 x 295 cm. Moderna Museet, Stockholm.

from the lower figure to encircle his double above, suggesting that he is talking to himself. "The man is naked," Kienholz wrote. "He hurts. He has been beaten on the stomach with a bar of soap wrapped in a towel (to hide telltale bruises)."[21] The figures' hollow heads read as metaphors of wasted minds; the fish swimming within them, as metaphors of confinement.[22]

Romare Bearden (1911–1988)

Collage—the **medium** from which assemblage derives—was the African American artist Romare Bearden's principal technique from 1963 to his death. He depicted aspects of Black life through highly inventive compositions of cut-and-pasted colored paper and photographic images clipped from magazines and newspapers, often embellished with pencil, ink, and paint. Bearden's collages treat subject matter from the rural South and urban North, reflecting his own life experience. Born in Charlotte, North Carolina, he moved as a young child with his family to New York City where he grew up in Harlem. He studied at the Art Students League (1936–37) and in the early 1940s painted **Social Realist** images of African

Americans (e.g., *Factory Workers*, 1942) in a simplified mode recalling Ben Shahn's (see Figure 10.18). After service in World War II, he rendered biblical and literary themes in a semi-Cubist style. From the mid-1950s to 1962, he made nonobjective Abstract Expressionist paintings with spattered paint and mottled textures, some incorporating collage elements.

Bearden's return to figuration was prompted by his involvement in Spiral. He cofounded this group in 1963 with Charles Alston, Norman Lewis (see Chapter 12), and Hale Woodruff—soon joined by other Black artists—to discuss their engagement in the civil rights movement, a few months before Rev. Martin Luther King Jr. led the March on Washington. Bearden's unrealized suggestion that the group collaborate on a collage addressing Black themes led him to adopt that medium. Bearden's *The Dove* (1964, Figure 14.8) is set in Harlem with its brick walls, limestone portals, and inviting stoops. The crowded, fragmented scene with its disjointed bodies and rapid shifts in scale conveys the bustle, noise, and vitality of Black urban street life. The dove perched on a **lintel** at the upper center suggests the blessing presence of the Holy Spirit. As the 1960s progressed, Bearden's **idealized** depictions of African American life came to seem conservative in comparison to the militancy of younger Black artists like David Hammons and Faith Ringgold (see Chapter 19), while his Cubist-based collage technique made his art acceptable to the white-dominated modern art establishment, confirmed by his 1971 MoMA retrospective.

Cy Twombly (1928–2011)

The American Cy Twombly—Rauschenberg's lover in the early 1950s and his lifelong friend—merged art and life by appropriating the scrawled look of graffiti to fill his paintings with nervous gestural marks that simultaneously evoked and undermined Abstract Expressionism's heroic rhetoric. Rather than inventing his own visual idiom driven by psychological or existentialist urgency, as did Jackson Pollock and Willem

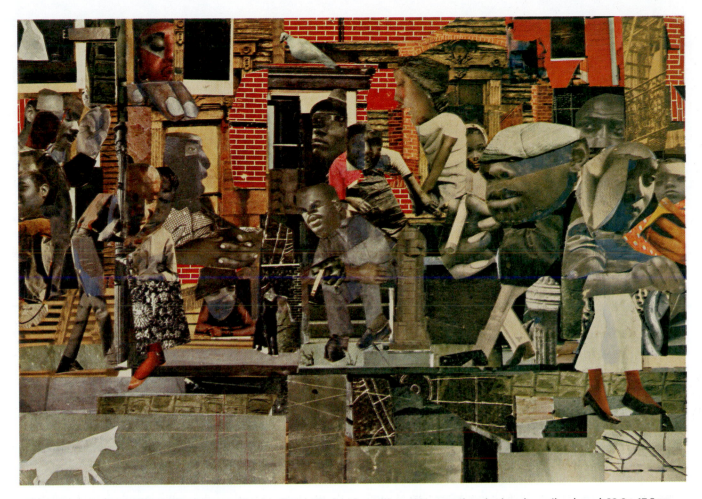

FIGURE 14.8 Romare Bearden, *The Dove,* 1964. Cut-and-pasted printed paper, gouache, pencil, and colored pencil on board, 33.8 x 47.5 cm. The Museum of Modern Art, New York.

de Kooning, Twombly found an aesthetic outside of himself that he modified for his own creative purposes. After moving to Rome in 1957, he also began to incorporate words, numerals, and schematic motifs such as hearts, windows, phalluses, and buttocks into his paintings, further relating them to graffiti (e.g., *The Italians,* 1961). Such pictures later inspired Jean-Michel Basquiat, whose paintings of the 1980s also channel the impulses of graffiti into the realm of art (see Figure 20.11).

The *New Documents* Photographers

Bearden's, Twombly's and the American assemblage artists' openness to the everyday world around them as a source of artistic material found a parallel in the work of several American photographers of the same generation. Three—Diane Arbus, Lee Friedlander, and Garry Winogrand—gained prominence through the 1967 MoMA exhibition *New Documents,* organized by John Szarkowski. Its title invoked the documentary tradition

of photographers such as Dorothea Lange (see Figure 10.19) who made pictures to serve social or political causes. By contrast, Arbus, Friedlander, and Winogrand "directed the documentary approach toward more personal ends," wrote Szarkowski. "Their aim has been not to reform life, but to know it. Their work betrays a sympathy—almost an affection—for the imperfections and the frailties of society. They like the real world, in spite of its terrors, as the source of all wonder and fascination and value."[23]

Diane Arbus (1923–1971)

A lifelong New Yorker, Diane Arbus started her career in the 1950s as a fashion photographer in collaboration with her husband Allan Arbus. By the late 1950s, however, she became dissatisfied with commercial work. Her study under Lisette Model (see Chapter 12) encouraged her to seek out socially marginal subjects, including female impersonators, circus performers, dwarfs, nudists, the elderly, and those with mental health disabilities. She also extensively photographed more typical members of society, whom she often caught appearing vacant or troubled. Like the German photographer August Sander

(see Figure 7.10), whose work she admired, Arbus aimed to create a collective portrait of the people of her time through straight-on images of idiosyncratic individuals. Recognizing the impossibility of photographing everyone in the world, Arbus credited Model with teaching her that "the more specific you are, the more general it will be."[24] Among Arbus's many iconic portraits is *Child with Toy Hand Grenade in Central Park* (1962). Following her usual practice, she engaged her subject to pose, made numerous exposures, then printed the most expressive image. The bony-kneed seven-year-old boy scowls in wide-eyed exasperation, gripping the toy grenade in his right hand and curling his empty left hand into a matching clawlike gesture. Disrupting the carefree innocence normally associated with images of children, Arbus's startling portrait became a metaphor for the angry and rebellious American youth of the late 1960s.

Lee Friedlander (b. 1934)

Influenced by Eugène Atget, Walker Evans, and Robert Frank, Lee Friedlander took emotionally detached photographs of what he called "the American social landscape," including shop windows, cars, television sets, and pedestrians on city streets.[25] Like Frank, Friedlander frequently violated the rules of a "good" photograph—a single unobstructed subject centered in the frame—in his quest for fresh and surprising ways of seeing. For example, *Colorado*'s (1967, Figure 14.9) brightly lit corner of a street-front window frame splits the composition vertically. This creates a jarring discrepancy: the receding space at the right, leading to entrance doors posted with handwritten signs, diverges from the compressed space at the left, in which superimposed images in the reflective plate-glass window

confuse inside and outside. At the window's upper center, a flat white rectangle—a sheet of paper—blocks the reflection of the photographer's head and shoulders, wittily replaced by a photographic portrait of the late President Kennedy rising behind the white plane. In its odd juxtapositions and patchwork quality—a rectangle filled with rectangles—Friedlander's photograph bears comparison to Rauschenberg's silkscreen painting *Retroactive I*, which also features Kennedy's image. The key difference is that Friedlander creates unity through his camera vision—his careful arrangement of all the visual elements seen through the viewfinder.[26]

Garry Winogrand (1928–1984)

"I photograph to find out what something will look like photographed," declared Garry Winogrand.[27] Ceaselessly observing the public life around him, Winogrand rapidly shot roll after roll of film with a handheld Leica. He then printed the images in which he found the banal transmuted into something interesting. Winogrand took many of his best-known pictures on the streets of his native city, including *World's Fair, New York City* (1964, Figure 14.10). The photograph's tilted horizon and abrupt cropping, typical of Winogrand's style, convey city life's restless unpredictability and diversity of human activities. The picture centers on six young white women seated on a park bench bookended by two men. The women's varied gestures, twisting bodies, and seemingly dancing legs and feet animate the composition; their actions and interactions fill it with anecdotal interest. The woman at the center cradles her exhausted companion's head while turning to hear her whispering friend to her other side. The two women at the right look over their shoulders toward something happening in the **background**, which the newspaper-reading older white man next to them ignores. At the left, a young Black man listens politely to the white woman next to him—an image of benign interracial relations at odds with that summer's "race riots," tumultuous protests by African Americans against police brutality in New York and several other American cities.

Nouveau Réalisme

Loosely organized and working in a variety of mediums, the Parisian artists known as the **Nouveaux Réalistes** (New Realists) were united in their opposition to the prevailing

FIGURE 14.9 Lee Friedlander, *Colorado*, 1967. Gelatin silver print, 17.2 x 24.8 cm. The Metropolitan Museum of Art, New York.

310 CHAPTER 14 Between Art and Life: International Trends of the 1950s and 1960s

FIGURE 14.10 Garry Winogrand, *World's Fair, New York City*, 1964. Gelatin silver print, 22.7 x 34.3 cm. The J. Paul Getty Museum, Los Angeles.

aesthetic of *art informel* (see Chapter 13). Original members, among them Arman, Yves Klein, Daniel Spoerri, and Jean Tinguely, formed the group in 1960 by signing a short manifesto written by the critic Pierre Restany. Seeking, in Restany's words, to get their "feet back on the ground,"[28] they rejected abstract art as out of touch with reality and **oil painting** as a depleted tradition. Except for Klein, they fashioned their art out of everyday materials from the urban environment, much like Rauschenberg and other assemblage artists. Restany wrote that they considered "the world a painting, the large, fundamental work from which they appropriate fragments of universal significance. They allow us to see the real in diverse aspects of its expressive totality. And through these specific images the entire sociological reality, the common good of human activity, the large republic of our social exchanges, of our commerce in society is summoned to appear."[29] Using found and readymade objects in the tradition of Duchamp, "They translate the right of direct expression belonging to an entire organic sector of modern activity, that of the city, the street, the factory, mass production."[30]

Nouveau Réalisme arose amidst profound historical changes in France. The Algerian War of Independence (1954–62) ended the French colonial empire, while US aid to Western European democracies via the Marshall Plan stimulated state-led modernization and a burgeoning consumer culture. Among that culture's products were street and subway advertising posters, which provided artistic material to the Nouveaux Réalistes François Dufrêne, Raymond Hains, Mimmo Rotella, and Jacques Villeglé. These *affichistes* (from *affiche*, "poster") appropriated posters whose accumulated layers had been ripped by passersby, exposing fragmented and dissociated **shapes**, images, and texts (e.g., Villeglé's *Jazzmen*, 1961). In some cases, the artists left the lacerated posters

as they found them; in others, they modified them through décollage, which involves tearing away layers of glued paper—the opposite of collage. Mounted on canvas and presented like paintings, the ripped posters' accidental patchworks of torn color-shapes suggest an ironic critique of *art informel* while offering similar aesthetic rewards.

Another common Nouveau Réaliste technique was the recontextualization of found objects. This artistic approach was rooted in Dada and **Surrealism**, but unlike the artists of those earlier movements, the Nouveaux Réalistes did not seek to create strange and irrational juxtapositions but presented their objects in a matter-of-fact way. Daniel Spoerri (b. 1930), for example, created assemblages he called *tableaux pièges* (snare pictures) by gluing down onto a board every item left on a table after a meal. He then rotated the composition ninety degrees and hung it on the wall as a literal, gravity-defying **still life** (e.g. *Kichka's Breakfast I*, 1960). César (1921–98) made sculptures called *Compressions* consisting of automobile bodies reduced to rectangular columns by a hydraulic crushing machine (e.g., *The Yellow Buick*, 1961). Christo, affiliated with but not a member of the Nouveaux Réalistes, wrapped everyday objects in rope-bound fabric or plastic, obscuring their identities. (His later work with his wife Jeanne-Claude is discussed in Chapter 19.)

Arman (1928–2005)

By making art out of detritus, the Nouveaux Réalistes, unlike some British and American Pop artists, did not celebrate capitalist consumerism so much as draw attention to its end product: waste. This was particularly true of Arman, who was born Armand Fernandez in Nice and changed his name in 1958 based on a printing error—an indication of his Dada-inspired willingness to embrace chance. In 1959, Arman introduced two series presenting discarded objects as art, the *Accumulations* and *Poubelles* (trash cans). For the *Accumulations*, he amassed numerous identical, second-hand manufactured items, such as gas masks, alarm clocks, and dolls' hands, dumped them into glass-fronted boxes and gave the works clever titles. For example, he dubbed an *Accumulation* of forks and spoons *Artériosclérose* (*Arteriosclerosis*, 1961), reminding the viewer that overeating can cause hardening of the arteries. The *Poubelles* were transparent containers filled with rubbish—its forms, colors, and textures creating an unexpected abstract beauty. The

containerized trash also provides evidence of the habits, tastes, and values of the household or person from which it came.

Arman realized his grandest *Poubelle* in 1960 when he filled the gallery of his Paris dealer Iris Clert with trash gathered from the streets, visible through the windows to passersby.[31] Titled *Le Plein* (*Full-Up*), the **installation** was Arman's rejoinder to his friend Yves Klein's metaphysical work, *Le Vide* (*The Void*, 1958), for which Klein emptied the same gallery and whitewashed its walls. Arman's focus on physical things provided the perfect complement to Klein's aspiration to the immaterial. Uniting these provocative exhibitions—one empty, the other full—was their challenge to the accepted art of their time. Both emphasized the importance of the gallery space itself in conferring the status of art on its contents—or lack thereof (see "The Institutional Theory of Art" box, Chapter 15).

Jean Tinguely (1925–1991)

Swiss-born Jean Tinguely's distinctive contributions to Nouveau Réalisme were the mechanized junk sculptures he began making a few years after moving to Paris in 1951. He coined the term "Meta-matics," meaning "beyond the machine," to describe his humorous **kinetic artworks,** which unlike the fine watches and other precision devices for which Switzerland is famous, performed erratically and with no practical function. The *Meta-matics* represented joy and freedom from the stifling routines of mechanized modern life. Simultaneously, they expressed an irreverent Neo-Dada spirit, as in his *Meta-matic* painting machines (e.g., *Méta-Matic No. 6*, 1959) that lampooned *art informel*'s gestural style by scribbling nonobjective compositions onto sheets of paper by means of a crayon or pen attached to a motor-driven arm. Tinguely declared that this kind of *Meta-matic* was "an anti-abstract machine, because it proves that anyone can make an abstract picture, even a machine."[32]

Tinguely transformed kinetic art into **performance art** with the public presentation of *Hommage à New York* (*Homage to New York*, 1960, Figure 14.11) in MoMA's sculpture garden. This ungainly 8.2-meter-high, white-painted contraption, which Tinguely assembled onsite in two weeks from locally sourced components, included fifteen motors, eighty bicycle, tricycle, and baby-carriage wheels, a piano, a child's bassinet, a washing-machine drum, an orange weather balloon, a radio, an electric fan, two *Meta-matic* painting machines, and bottles of foul-smelling chemicals. Designed to self-destruct before an invited black-tie audience on the evening of March 17, 1960, *Homage to New York* failed to operate as planned and required prodding from Tinguely and his collaborator, Billy Klüver. Once in motion, the giant machine quivered, shook, emitted a percussive din, and blew malodorous, yellow-colored smoke into the faces of the spectators. When a fire inside the piano, where a can of gasoline had been rigged to overturn on a burning candle, threatened to get out of control, two museum guards and a firefighter doused it with fire extinguishers. They then attacked the structure with axes to finish it off—to jeers from the audience expecting its auto-destruction—and to the delight of Tinguely, who relished the unexpected. While many reviewers considered the event a failed joke, critic John Canaday defended *Homage to New York* as "a legitimate work of art as social expression. . . . Mr. Tinguely makes fools of machines, while the rest of mankind supinely permits machines to make fools of them."[33]

Niki de Saint Phalle (1930–2002)

The Nouveaux Realistes' only woman member, Niki de Saint Phalle gained public attention in 1961 with her *Tirs* (shots) or *Shooting Paintings*, such as *Shooting Picture* (1961, Figure 14.12). These were thick reliefs of plaster and other materials containing numerous paint-filled bags or cans that Saint Phalle shot with a rifle or pistol, puncturing them so that their contents poured down the surface. Treating the painting as a target at which to fire rather than an "arena in which to act" (in Harold Rosenberg's description of action painting), these works with their spurts of color read as parodies of postwar gestural

FIGURE 14.11 Jean Tinguely, *Hommage à New York* (*Homage to New York*), March, 17, 1960. A "self-constructing and self-destroying work of art" exhibited in the Museum of Modern Art Sculpture Garden.

FIGURE 14.12 Niki de Saint Phalle, *Shooting Picture*, 1961. Plaster, paint, string, polythene, and wire on wood, 143 x 78 x 8.1 cm. Tate, London.

costumes and animated poses, these represent joyous fertility goddesses symbolizing a coming matriarchal epoch. In 1966, Saint Phalle constructed a huge *Nana* entitled *Hon: En katedral (She: A Cathedral)* in collaboration with Tinguely, her romantic and creative partner, and the Swedish painter Per Olof Ultveldt. Exhibited for three months at Stockholm's Moderna Museet and then destroyed, it was the huge, colorfully painted twenty-five-meter-long shell of a reclining woman, serving as an environment. Visitors entered through the figure's birth canal to wander through rooms and installations including a cinema showing Greta Garbo movies, an aquarium, a planetarium, and a milk bar inside one of the breasts. Hugely popular with the public, *Hon* was an early example of the immersive and interactive environments that have since become prominent attractions at biennials and art museums (e.g., Olafur Eliasson's *weather project*, see Figure 22.18).

Yves Klein (1928–1962)

Unlike his fellow Nouveaux Réalistes, Yves Klein, whose seven-year artistic career (1954–62) was cut short by his death from a heart attack at thirty-four, did not embrace materialism: he sought to transcend it and usher in a new epoch of immateriality. He did this through monochrome paintings as well as invisible and ephemeral artworks and public actions, anticipating **Conceptual** and performance art (see Chapter 19). Klein was a paradox: he professed sincere religious and philosophical beliefs that motivated his art but engaged in activities that many saw as hoaxes or publicity stunts. He also constructed an artistic persona based on a mixture of truth and myth. He considered his life to be his greatest work of art: "A painter must paint a single masterpiece, constantly: himself, and thus become a sort of atomic battery, a sort of constantly radiating generator that impregnates the atmosphere with his pictorial presence fixed in space after its passage."[36]

The Nice-born Klein had no formal artistic training. The foremost influence on his art was the mystical philosophy of Rosicrucianism, an esoteric Christian sect. Max Heindel's book *La Cosmogonie des Rose-Croix* taught Klein that the world was approaching the end of the Age of Matter, in which Spirit is trapped in solid bodies. Ahead was an age of Space, when Spirit will be liberated, solid bodies will levitate, and personalities will travel outside the body in ethereal form.[37] Another influence was judo, in which Klein attained the degree of fourth *dan* (level) black belt through study in Tokyo (1952–53) and which he described as the "discovery of the human body in a spiritual space."[38]

Klein adopted the monochrome—a painting covered edge to edge with a single evenly applied color—to express the freedom and unity of infinite space. He rejected "ordinary painting" as "a prison window whose lines, contours, forms and composition are all determined by bars." "Through color," he declared, "I experience total identification with space; I am truly free."[39]

abstraction. For Saint Phalle, however, "seeing the picture bleed and die"[34] also served to exorcize demons including the childhood trauma of sexual abuse by her father. She imagined aiming her gun at "Daddy . . . MYSELF, society with its IN-JUSTICES . . . my own violence and the VIOLENCE of the times. By shooting my own violence, I no longer had to carry it inside of me like a burden."[35] Saint Phalle often shot her paintings before audiences as performance events and sometimes invited others to participate, including Rauschenberg and Johns.

In the mid-1960s, Saint Phalle began creating the works for which she became best known, the *Nanas* (French for "broads" or "dames") (e.g., *Black Venus*, 1965–67). Monumental sculptures of rotund faceless women in bright multicolored

After showing monochromes in several different colors at a 1956 Paris exhibition, Klein developed, in collaboration with a chemist, a color he patented (in 1960) as International Klein Blue (IKB). It consisted of ultramarine blue powdered **pigment** suspended in a resin solution to preserve its brilliance and tactility. Klein applied IKB to his canvases (e.g., *IKB 79*, 1959) using a roller to eliminate any evidence of his hand, giving the color autonomy, and enhancing its traditional symbolic associations with the sea, sky, heaven, and the Holy Spirit.

Klein inaugurated his "Blue Epoch" in a 1957 exhibition in Milan that included eleven monochrome blue paintings. They all had the same dimensions and appearance, but Klein claimed that each possessed a distinctive "pictorial sensibility."[40] The next year, Klein offered that invisible "pictorial sensibility" as the sole content of his Paris exhibition *Le Vide* (*The Void*). To prepare for it, he cleaned out the Galerie Iris Clert, whitewashed its walls, and mailed out 3,500 invitations to the opening, during which so many people thronged the street outside the gallery that police and firefighters showed up to control them. While waiting in line, guests were served a cocktail containing methylene blue that stained their urine blue the next day. Many considered the exhibition a joke, but it profoundly moved others. Author Albert Camus wrote in the guest book, "With the void, full powers."

Following *Le Vide*, Klein ventured into Conceptual art by selling his invisible paintings as "Zones of Immaterial Pictorial Sensibility" for an amount of pure gold equal in material value to the immaterial zone. Some of these transfers took place in ritual performances on the banks of the Seine in early 1962, documented photographically. Klein received gold leaf from the collector and provided a receipt that the collector then burned while Klein threw half the gold into the river, integrating the buyer with immateriality (and leaving Klein with half the gold).

In 1958, Klein began using nude female models as "living brushes" to make paintings called *Anthropometries* (e.g., *Untitled Anthropometry [ANT 100]*, 1960). Under his direction, the models covered their torsos and thighs with blue paint and pressed them against large sheets of paper, leaving indexical imprints (see "Semiotics" box, Chapter 4). "The flesh itself applied the color to the surface," wrote the artist. "I could continue to maintain a precise distance from my creation and still dominate its execution. In this way I stayed clean. I no longer dirtied myself with color."[41] On March 9, 1960, Klein presented a public performance, *Anthropométries de l'Epoque bleue* (*Anthropometries of the Blue Period*, Figure 14.13) at the Galerie International d'Art Contemporain, Paris, before a hundred guests. The tuxedo-clad artist conducted three nude female models in the creation of *Anthropometries*, accompanied by a small orchestra playing his *Symphonie Monoton* (*Monotone Symphony*) —a single chord held for twenty minutes followed by twenty minutes of silence. In an ensuing discussion, Klein sought to mollify the shocked audience, some of whom found the work

obscene, by proposing a spiritual rather than sexual conception of the body.[42] Feminist critics have argued that by directing beautiful nude female models to create his works, Klein denies them agency: they remain eroticized objects of the heterosexual male gaze exploited for the expression of patriarchal authority.[43]

While continuing to make *Anthropometries*, Klein experimented with other approaches to painting, creating red and gold-leaf monochromes and using the elements of wind, water, and fire as mediums (e.g., attacking resin-pigmented cardboard with a flamethrower in *Fire Color Paintings*, 1962). In one of his grandest conceptual works, Klein appropriated November 27, 1960, for the presentation of his *Théâtre du vide* (*Theater of the Void*), in which life everywhere became, for one day, a manifestation of immateriality. For the event, he created and displayed on newspaper stands *Dimanche—Le journal d'un seul jour* (*Sunday—Journal of Single Day*), containing texts and pictures explaining his theories on color, emptiness, space, and immateriality. Reproduced on the cover was Harry Shunk's photograph *Leap into the Void* (1960) showing Klein launching himself from a high wall above an empty street. Intended to demonstrate that the artist could fly, the photo was manipulated through the combination of two negatives to eliminate Klein's judo colleagues holding the tarp that caught him as he fell. The contrived image brilliantly expressed Klein's unceasing devotion to the appropriation of all space—and forecast his dematerialization into the void.

Gutai

The use of everyday materials seen in American assemblage and Nouveau Réalisme was also a key facet of Gutai, Japan's most original postwar **avant-garde** art movement. Active between 1954 and 1972, the artists of Gutai (meaning "concreteness" or "embodiment") experimented with radically new ways of making art to emphasize life's vital freedom. Their values resonated with social and political changes in Japan. A new constitution promulgated during the US Occupation (1945–52) replaced the defeated imperial dictatorship with a democratic government, renounced the country's ability to wage war, and instituted women's suffrage. Gutai extended liberal American-style democracy into culture by making art out of the stuff of daily life, including old newspapers, masking tape, synthetic fabrics, sheet metal, inner tubes, light bulbs, plastic sheeting, water, mud, sand, light, and smoke. Gutai artists also employed unconventional means of painting, applying paint with their feet, by means of remote-controlled toy cars, or by smashing bottles of paint against the canvas.

The Gutai Art Association (Gutai Bijutsu Kyokai) was founded in Osaka in December 1954 by Yoshihara Jirō (1905–72), a well-respected artist and wealthy businessman who had worked in Surrealist and abstract geometric styles in the 1930s. After the war, he attracted to his studio several talented younger

FIGURE 14.13 Yves Klein, *Anthropométries de l'Epoque bleue* (*Anthropometries of the Blue Period*), Galerie International d'Art Contemporain, Paris, March 9, 1960.

artists who formed Gutai's initial membership. Yoshihara called for a new form of expression for a new era. He rejected the then-dominant trends of Reportage painting, which explored the difficulties of the postwar condition through blended elements of **social realism** and Surrealism; and of the Contemporary Art Discussion Group, which sought to modernize traditional Japanese art forms such as **calligraphy** and ink painting. He found an inspiring model of innovation in Pollock's and Mathieu's gestural abstractions (see Figures 12.4 and 13.3), admiring in them "the scream of the matter itself, cries of the paint and enamel."[44] Yoshihara's conception of Gutai emphasized materialism as a vehicle for human spiritual expression. He declared in the group's 1956 manifesto: "Gutai Art does not alter matter. Gutai Art imparts life to matter. . . . In Gutai Art, the human spirit and matter shake hands with each other while keeping their distance. Matter never compromises itself with the spirit; the spirit never dominates matter. . . . To make the fullest use of matter is to make use of the spirit."[45]

Gutai staged its first important exhibition outdoors in July 1955, in a pine grove park in Ashiya near Osaka. The exhibition featured various temporary installations made of both natural and industrial materials and responding to the environment. For example, Motonaga Sadamasa (1922–2011) hung plastic bags of colored water from trees; the bags shone like jewels in the sunlight. At the first indoor Gutai exhibition, held in October 1955 in Tokyo, the artists staged "action events" in which they spontaneously created artworks before an audience, engaging with their materials' basic properties. For a work called *Challenging Mud*, Shiraga Kazuo (1924–2008) stripped to his shorts and wrestled with a pile of thick mud to shape it with his body. Both his performance and the traces of his struggle with the material constituted the artwork. It was displayed alongside his nonrepresentational **gestural paintings**, which from 1954 onward he executed with his feet, either by standing on a large sheet of paper or canvas or swinging above it from a rope. Shiraga's painting made by the latter method, *Golden Wings Brushing the Clouds Incarnated from Earthly Wide Star* (*Chikatsusei Maunkinshi*) (1960, Figure 14.14), shows the dynamic and sensuously expressive effects he achieved through his unconventional painting process.

For his action at the October 1955 exhibition *At One Moment Openings Six Holes*, Murakami Saburo (1925–96) flung his body through three kraft paper screens six times to create works that were subsequently hung on the wall as paintings. The punctured screens evoked *shoji* and *fusama* paper-and-wood partitions of Japanese interiors, giving Murakami's work the connotation of breaking through conventional cultural limitations. Also violently asserting creative freedom were Shimamoto Shōzō's (1928–2013) performances (from 1956 onward) in which he hurled and smashed paint bottles against canvases to create explosive nonrepresentational paintings.

Yoshihara courted international recognition for Gutai, which it gained after French critic Michel Tapié, who visited Japan in 1957, hailed the movement as a Japanese manifestation of *art informel* and arranged Gutai exhibitions in New York, Paris, and Turin. In the 1960s, the American artist Allan Kaprow acknowledged Gutai "action events" as precursors of Happenings.

Tanaka Atsuko (1932–2005)

The most prominent woman member of Gutai, Osaka-born Tanaka Atsuko sought to expand the boundaries of painting. She conceived her contribution to the first Tokyo Gutai exhibition,

Work (Bell) (1955), as a "sound painting" that incorporated time, sound, and space. It was an interactive installation of twenty small electric bells positioned on the floor at two-meter intervals and connected by forty-six meters of cord. The visitor was invited to press a button that set off a chain reaction of the bells ringing sequentially for about two minutes, filling the space with an irritating racket that transgressed the usual hush of the gallery.

At the second Tokyo Gutai exhibition in 1956, Tanaka presented her *Electric Dress* (Figure 14.15). Inspired by a neon-illuminated Osaka advertising billboard, she created a massive, cable-suspended costume comprising nearly two hundred bulbs, mostly tubular, with colored or hand-painted glass in nine different shades of **primary** and **secondary colors**. Powered by an electric circuit, the bulbs radiated heat and flashed sequentially and ever more rapidly to reach "incessant and chaotic" levels.[46] Tanaka wore the dress as a performance, with only her face and hands visible, her body obscured beneath the blinking and blazing lights. Among many other possible interpretations, the work can be read as her resistant response to the display of sexualized female bodies in 1950s popular Japanese visual culture. *Electric Dress* offers an alluring surface of lights and colors that attract the gaze, but its heat and

FIGURE 14.14 Shiraga Kazuo, *Golden Wings Brushing the Clouds Incarnated from Earthly Wide Star* (*Chikatsusei Maunkinshi*), 1960. Oil on canvas, 130 x 195 cm. The Art Institute of Chicago.

FIGURE 14.15 Tanaka Atsuko, *Electric Dress*, 1956. Synthetic paint on incandescent lightbulbs, electric cords, and control, 165 x 80 x 80 cm. Photograph by Kiyoji Ōtsuji.

blinding luminosity keep the viewer at bay. The artist is both shielded by and absorbed within technology evoking Osaka's rapid postwar urban growth.

Happenings

A prime manifestation of the drive to merge art and life were the Happenings that flourished in New York in the late 1950s and early 1960s. Their originator, Allan Kaprow, described them as

> events which, put simply, happen. Though the best of them have a decided impact—that is, one feels, "here is something important"—they appear to go nowhere and do not make any particular literary point. In contrast to the arts of the past, they have no structured beginning, middle, or end. Their form is open-ended and fluid. . . . They exist for a single performance, or only a few more, and are gone forever, while new ones take their place.[47]

Rather than being presented in theaters, Happenings took place in art galleries, lofts, basements, vacant stores, the street, or in nature, before small audiences who commingled with the actors. Happenings' sets, props, and costumes were fashioned of cheap, everyday materials. Their actions, generated by rudimentary directions, involved improvisation and chance. In addition to Kaprow, artists who launched their New York careers through Happenings included Red Grooms, Jim Dine, Claes Oldenburg (see Chapter 15), and Robert Whitman.

Allan Kaprow (1927–2006)

Trained in both art (studying under Hans Hofmann) and art history (which he taught at Rutgers University from 1953 to 1961), Kaprow in the mid-1950s made "action collages" merging Hofmann-style gestural painting with quotidian materials such as newspaper, straw, and tinfoil. His move toward Happenings was influenced by John Cage, under whom he studied at the New School for Social Research in 1957–58.

Kaprow's 1958 essay "The Legacy of Jackson Pollock" resonates with Cage's promotion of an all-inclusive art. To Kaprow, Pollock's environmentally scaled poured abstractions pointed toward an art that would be continuous with life:

> Pollock, as I see him, left us at the point where we must become preoccupied with and even dazzled by the space and objects of our everyday life, either our bodies, clothes, rooms, or, if need be, the vastness of Forty-Second Street. Not satisfied with the *suggestion* through paint of our other senses, we shall utilize the specific substances of sight, sound, movements, people, odors, touch. Objects of every sort are materials for the new art: paint, chairs, food, electric and neon lights, smoke, water, old socks, a dog, movies, a thousand other things that will be discovered by the present generation of artists. Not only will these bold creators show us, as if for the first time, the world we have always had about us, but ignored, but they will disclose entirely unheard of happenings and events, found in garbage cans, police files, hotel lobbies, seen in store windows and on the streets, and sensed in dreams and horrible accidents.[48]

In the same year that he published this essay, Kaprow realized its principles by creating at New York's Hansa Gallery his first two environments—spaces filled with materials and objects that surround and immerse the visitor. The first featured different materials suspended from ceiling to floor, including sheets of plastic (some loosely painted with black or red strokes), sheets of crumpled aluminum foil and cellophane, and strings of white Christmas lights. Moving between the layers of materials, visitors experienced a collage of sensations and animated the work in unpredictable ways. Kaprow's interest in these aspects of the environment led him to develop Happenings.

Kaprow staged his first public Happening, *18 Happenings in 6 Parts*, over six evenings in 1959 at the Reuben Gallery in New York.[49] The ninety-minute piece played out in three rooms that Kaprow created through translucent plastic sheets. Following a carefully rehearsed script, Kaprow and his fellow performers executed different simple actions simultaneously in each room, such as reading from placards, playing records, performing on musical instruments, striking matches, squeezing oranges, and applying paint to a muslin panel. At various points, loudspeakers broadcast electronic sounds and jumbled speech, and a slide projector cast images and words on the wall between the third and second rooms. Each audience member was assigned to one room at the event's beginning and directed to move to another room after parts two and four. Due to the audience's movement and the diverse actions' simultaneity, everyone involved had a different experience of the Happening, which functioned as an assemblage of diverse sensory experiences approximating the flux and cacophony of the urban environment.

Kaprow went on to orchestrate Happenings in the 1960s that differed from the Reuben Gallery event's apparent pointlessness by incorporating conventional symbolism. For example, *Household* (1964), commissioned by Cornell University and staged at the Ithaca, New York, dump, employed sexual stereotypes to dramatize the theme of domestic strife between men and women played out like a children's war game.[50] It began with the men constructing a tower of junk and the women building a nest of saplings and string—symbolizing the phallus and womb, respectively. The men then slathered a junked car with strawberry jam that the women proceeded to lick off (Figure 14.16)—an act redolent with sexual connotations. Destructive conflict ensued: the men demolished the nest, the women pulled down the tower, and the men attacked the junked car with sledgehammers before setting it on fire. Neither side in this mock battle prevailed, suggesting Kaprow's awareness of the feminist movement's rising influence and the problematic nature of the Happening's sexual stereotypes. *Household*'s presentation in a dump may have implied that some of these stereotypes should be discarded.

Yayoi Kusama (b. 1929)

Yayoi Kusama, a Japanese artist who lived in New York between 1958 and 1973, staged some of the most highly publicized Happenings of the late 1960s. Kusama initially gained recognition for her intricately patterned monochromatic *Infinity Nets*, which the artist, who lives with mental illness and experiences hallucinations, said she painted out of "an obsessional compulsion."[51] She proceeded in the early 1960s to cover pieces of furniture and other objects with multitudes of stuffed white cloth sacs—phallic forms that expressed her fear of sex (e.g., *Accumulation No. 1*, 1962). In 1965, she created the first of her many *Infinity Mirror Rooms*—immersive environments in which the viewer's endlessly multiplied reflections manifest the theme of repetition driving Kusama's art.

Kusama turned to Happenings in 1967 as a vehicle for social and political protest and to celebrate sexual liberation—emphases of the late 1960s counterculture. Central to her Happenings was bodypainting: the artist, dressed in a costume of her own design, painted or sprayed polka dots on her models' partially or fully naked bodies. Kusama associated the polka dot with the sun and the moon—masculine and feminine symbols—and declared, "Polka dots suggest multiplication to infinity."[52]

Kusama staged two types of Happenings. Some were "Love Happening" or "Orgy" events in Manhattan studios, with nude, polka-dotted models engaging in erotic play. Others were outdoor naked demonstrations, in which Kusama would direct a small group of performers to disrobe and dance while she applied dots to their bodies. Kusama employed nudity as an expression of love and peace in the context of international protests by young people against the Vietnam War and the capitalist "Establishment." Emblematic of her anti-war, anti-capitalist Happenings was *Anatomic Explosion on Wall Street* (1968, Figure 14.17), a naked event Kusama staged outside the New York Stock Exchange on July 14, 1968. Kusama customarily published press releases to announce her Happenings,

FIGURE 14.16 Allan Kaprow, *Household*, May 3, 1964. Happening at the Ithaca City Dump, New York.

FIGURE 14.17 Yayoi Kusama, *Anatomic Explosion on Wall Street*, July 14, 1968. Happening outside the New York Stock Exchange. Photograph by ©Bob Sabin 1968.

which were designed for the press photographers' cameras and received extensive media coverage. In one such press release for a second *Anatomic Explosion on Wall Street*, she declared, "STOCK IS A FRAUD! STOCK MEANS NOTHING TO THE WORKING MAN. We want to stop this game. The money made with stock is enabling the war to continue. We protest this cruel, greedy instrument of the war establishment. . . . OBLITERATE WALL STREET MEN WITH POLKA DOTS ON THEIR NAKED BODIES. BE IN . . . BE NAKED, NAKED, NAKED."[53] Kusama saw publicity as critical to her work "because it offers the best way of communicating with a large number of people"; she proposed, "avant-garde artists should use mass communication as traditional painters use paint and brushes."[54]

Fluxus

Active from the early 1960s to the late 1970s, Fluxus was a loosely organized international network of artists seeking to unify art and life through quotidian actions, words, sounds, objects, and materials mobilized to heighten awareness of the wonder of the ordinary. Fluxus artists presented concerts, disseminated anthologies, and produced inexpensive editions of multiples. Their works overturned expectations of high artistic seriousness, often through disarming humor, and frequently required participation by the reader or viewer to be completed.

The name Fluxus, meaning "flowing," was coined in 1961 by the Lithuanian-born American artist George Maciunas (1931–78) as the title for a proposed series of anthologies highlighting the work of artists and composers engaged in experimental music, film, concrete poetry, and performance events. In a 1962 lecture, Maciunas characterized these as "Neo-Dada" efforts animated by concepts of concrete art or artistic nihilism. Concrete artists, wrote Maciunas, "prefer the world of concrete realities to that of artistic abstractions." Art nihilists produce "anti-art forms . . . primarily directed against art as a profession, against the artificial separation of producer or performer . . . or against the separation of art and life."[55]

An important crucible of Fluxus was John Cage's "Experimental Music" course at the New School of Social Research, attended not only by Kaprow but also by George Brecht, Al Hansen, Dick Higgins, and Jackson Mac Low, all of whom save Hansen would participate in Fluxus. Cage's students created proto-Fluxus performance scripts based on the principle of chance and eliminating the distinction between performer and audience. An example is Higgins's *A Winter Carol* (1959): "Any number of people may perform this composition. They do so by agreeing in advance on a duration for the composition, then by going out to listen to the falling snow."

The Cage-inspired composer La Monte Young, who moved from San Francisco to New York in fall 1960, gave added momentum to Fluxus's development. He proposed a new genre, "the theater of the single event,"[56] exemplified by *Composition #10* (1960): "Draw a straight line and follow it." Likeminded musicians, visual artists, dancers, and poets participated in a 1961 concert series Young organized in collaboration with Yoko Ono in her Chambers Street loft. His compilation of *An Anthology of Chance Operations* (1963), designed and printed by Maciunas, led to the latter's founding of Fluxus.

In September 1962, Maciunas organized the first of many Fluxconcerts, the International Fluxus Festival of the Newest Music, at the Museum Wiesbaden in Wiesbaden, West Germany (where he was working for the US Army). Fluxconcerts typically featured performers briefly enacting isolated, mundane activities or using unexpected sound sources to create music. After his 1964 return to New York, Maciunas continued to stage Fluxconcerts and collaborated with dozens of artists to design, produce, and disseminate hundreds of inexpensive multiples including scores, films, games, puzzles, and paper "events." Many artists associated with Fluxus operated independently from Maciunas, however, because they resented his pro-Soviet politics and dictatorial attempts to control the group.

Yoko Ono (b. 1933)

Born in Tokyo to a prominent banking family and a New York resident since the mid-1950s, Yoko Ono was a frequent contributor to Fluxus activities. Her art resonates with the Dadaist impulse to abolish the boundaries between art and everyday life and with Cage's idea that everything in the world can be experienced as art. Much of Ono's work relies on the reader's or viewer's imaginative or physical participation for its realization. By stimulating her audience's creativity and consciousness of the "wonderment" inherent in quotidian acts and experiences, Ono hopes to effect positive social change.[57]

In 1961, Ono exhibited her "Instruction Paintings" at AG Gallery in New York. Viewer participation was often integral to the completion of the works. For example, *Shadow Painting*, a bare linen rectangle hanging before a window, was completed by the viewers observing the fleeting shadows cast on its surface. The "Instruction Paintings" were pioneering examples of Conceptual art, in which the artwork consists of a repeatable idea rather than a unique object (see Chapter 19).

Ono also staged live art events based on simple directions given to the performers or the audience. In the most famous, *Cut Piece* (1964, Figure 14.18), which she performed several times in the 1960s, members of the audience were invited to come on stage and snip off pieces of Ono's clothing as she kneeled impassively. Ono explained *Cut Piece* in 1967 as "a form of giving, giving and taking. It was a kind of criticism against artists, who are always giving what they want to give. I wanted people to take whatever they wanted to, so it was very important to say you can cut wherever you want to."[58] Despite Ono's stipulation that *Cut Piece* could be performed by a man or a woman, it has since the 1990s been largely read in feminist terms, as drawing critical attention to the power dynamics of voyeurism, sexual aggression, and violence against women. Ever open to new understandings of her work, Ono, aged seventy, performed *Cut Piece* in Paris in 2003 "for world peace"— a cause for which she and her late husband John Lennon became famous in the late 1960s—and as a statement "against ageism, against racism, against sexism, and against violence."[59]

Nam June Paik (1932–2006)

Nam June Paik was responsible for some of the most memorable Fluxus "anti-art" actions. Like many Fluxus artists, his artistic roots were in music. Born in Seoul, Korea, he studied piano, composition, and music in West Germany in the mid-1950s. Paik's 1958 encounter with John Cage at a summer course for new music in Darmstadt was crucial to his artistic development. Cage advocated investing musical performances with theatrical elements to engage the audience, inspiring Paik's "action concerts." One was the notorious *Étude for Pianoforte* (1960), in which Paik, after playing the piano, rushed into the audience, cut off Cage's necktie with scissors, then

FIGURE 14.18 Yoko Ono, *Cut Piece*, 1964. Performed by Yoko Ono, Sōgetsu Art Center, Tokyo, August 11, 1964. © Yoko Ono.

doused him and composer David Tudor with shampoo. Other provocative performances ensued in the early 1960s during Paik's energetic participation in Fluxus. Some involved the destruction of musical instruments, such as *One for Violin Solo* (1962), in which Paik slowly lifted a violin over his head then smashed it on a table.

Paik's Cage-inspired interest in bridging the gap between art and life led him to experiment with television as an artistic medium. In his 1963 exhibition *Exposition of Music—Electronic Television* at a Wuppertal gallery, Paik presented television sets with mechanically distorted broadcast images. One, *Zen for TV* (1963), was an object of meditation: a television turned on its side displaying a single white vertical line. Another, *Participation TV* (1963), invited the visitor to generate graphic patterns through a microphone, turning the viewer from a passive consumer of TV imagery into its creator. After moving to New York in 1964, Paik made sculptures and installations out of working television sets, such as *Moon is the Oldest TV* (1965), a row of black-and-white monitors with their cathode ray tubes manipulated through magnets to show individual images suggesting phases of the moon.

In 1964, Paik began a close collaboration with Charlotte Moorman (1933–91), a classically trained cellist. Seeking to correct what Paik called "a lamentable historical blunder"[60]— the absence of sex from classical music—many of their performances involved Moorman playing Paik's compositions

in various states of undress. In *TV Bra for Living Sculpture* (1969, Figure 14.19), Moorman played the cello wearing a bra comprising two miniature television sets held by a vinyl strap. The screens displayed either a live television broadcast or live closed-circuit video of Moorman or her audience.[61] Through this combination of sex, classical music, performance art, and creative use of electronics, Paik and Moorman sought to humanize technology and counter its numbing effects.

In the 1970s, Paik created video works using an analog synthesizer to mix, distort, polarize, and colorize signals from multiple video and audio sources, as well as generate random and controlled video patterns. Through this technology he produced *Global Groove* (1973), a videotape whose soundtrack playfully mixes "oldies" rock, Korean ceremonial drumming, tap-dance music, and electronic compositions by Cage and Karlheinz Stockhausen. Its imagery includes shots of a topless dancer, snippets of Japanese TV commercials, Moorman playing a video cello, the electronically distorted face of US President Richard M. Nixon, and an interview with Cage calling for worldwide free exchanges of culture. Through its

FIGURE 14.19 Charlotte Moorman (left, with Nam June Paik, right) performing Paik's *TV Bra for Living Sculpture*, 1969. Video tubes, televisions, rheostat, foot switches, plexiglass boxes, vinyl straps, cables, copper wire, dimensions variable. Photograph by David Gahr.

multicultural mélange of sounds and images, *Global Groove* is an early expression of the theme of globalization in contemporary art (see Chapter 22 and "Globalization" box).

Joseph Beuys (1921–1986)

The most internationally prominent German artist of his generation, Joseph Beuys participated in Fluxus concerts between 1962 and 1964. He then broke with the group due to conflicts with George Maciunas. Whereas the anti-individualist Maciunas envisioned art's disappearance as a special mode of subjective expression, Beuys sought to expand, not eliminate, the category of art, and he exalted the artist's role in reshaping society. He pursued a mission "to change the social order"[62] through activities ranging from creating drawings, sculptures, multiples, and installations to performance art, teaching, lecturing, and political activism.

Growing up in northwest Germany, Beuys dreamed of being a doctor. He later understood much of his art as a magical form of healing—a view springing from personal experience. While serving in the Luftwaffe (German air force) in World War II, Beuys survived a plane crash in Crimea in 1944. He later claimed that nomadic Tatars rescued him by wrapping his body in fat and felt for warmth, and nursed him back to health in a felt-lined tent smelling of cheese, fat, and milk.[63] While Beuys did live through a plane crash, he fabricated the story about the Tatars.[64] However, it served as the mythic basis of his persona: an artist reborn to repair the trauma Germany experienced under the Nazis and to extend that healing energy to social transformation, using fat and felt as symbolically charged sculptural materials. Beuys's 1969 work *The Pack* refers to the theme of rescue central to his personal legend. It consists of a Volkswagen bus with an open back gate out of which spill twenty sleds, each carrying its own "survival kit": a flashlight (for orientation), a roll of felt (for protection) and a wedge of fat (for food).[65]

The writings of philosopher and mystic Rudolf Steiner strongly influenced Beuys's aesthetics. Countering what he saw as modern society's excessive materialism and rationalism, Steiner proposed a path to human freedom through spiritual awakening stimulated by imagination, inspiration, and intuition—qualities that Beuys embraced in his art. Steiner's *Nine Lectures on Bees* (1923) inspired Beuys's "Theory of Sculpture." Steiner's attention to the bee colony's production of wax, a malleable fatty material that hardens into the honeycomb's crystalline structure, informed Beuys's description of the passage of everything physical or psychological from a chaotic (warm) to an ordered (cold) state.[66] Beuys associated warmth with "unchanneled will power." His *Chair with Fat* (*Stuhl mit Fett*, 1963) is an old wooden chair with a wedge of fat on its seat. Beuys noted that the fat "keeps something of its chaotic character" and that the chair "represents a kind of human anatomy, the area of the digestive and

excretive warmth processes, sexual organs and interesting chemical change, relating psychologically to will power."[67]

Beuys first did performances, which he called "Actions," during his participation in Fluxus, and they became central to his art. For the opening of a 1965 exhibition in Düsseldorf, Beuys performed *How to Explain Pictures to a Dead Hare* (Figure 14.20), which the audience could only witness through the gallery door or window. With his head covered in honey and gold leaf, and an iron sole (representing hard reason) tied to his right foot (a felt sole, representing spiritual warmth, rested on the floor), Beuys spent three hours mouthing silent explanations of his pictures to a dead hare cradled in his arm. Animals had special significance to Beuys as creatures that "pass freely from one level of existence to another."[68] The honey on his head was a metaphor for thinking: "Human ability is not to produce honey, but to think, to produce ideas. In this way, the deathlike character of thinking becomes lifelike again, for honey is undoubtedly a living substance." The

combination of honey and gold indicated "a transformation of the head . . . the brain and our understanding of thought, consciousness, and all the other levels necessary to explain pictures to a hare." Beuys felt that the work expressed "the problem of explaining things, particularly where art and creative work are concerned" and "that explaining to an animal conveys a sense of the secrecy of the world and of existence that appeals to the imagination. Then, as I said, even a dead animal preserves more powers of intuition than some human beings with their stubborn rationality." Beuys, following Steiner, emphasized that understanding has many levels "which cannot be restricted to rational analysis" but also include "imagination, inspiration, intuition and longing."[69]

In the later 1960s, Beuys responded to the growing intensity of West German students' anti-capitalist, anti-authoritarian protests by turning to political activism. In 1967, he founded the German Student Party, calling for universal disarmament, an end to Europe's communist-capitalist political division, and the transformation of social, economic, and political life through autonomous self-government.[70] He went on to co-found the Organization for Direct Democracy through Referendum (1971) and the Free International University (FIU, 1973)—the latter following his dismissal from his teaching post at the Düsseldorf Academy of Art due to his refusal to limit entry to his classes. The FIU offered an interdisciplinary curriculum reflecting Beuys's concept of "social sculpture," which regarded society as a total work of art to which each person can contribute creatively—a view encapsulated in his motto, "EVERY HUMAN BEING IS AN ARTIST."[71] Among the progressive causes Beuys embraced in his final years was environmentalism. In 1982, he inaugurated *7,000 Oaks* for the *Documenta 7* exhibition in Kassel, Germany. This "regenerative activity" involved planting seven thousand oak trees throughout the city, each accompanied by a 1.2-meter-tall basalt column.[72] Completed in 1987 after Beuys's death by his son Wenzel, the project was intended by Beuys to continue around the globe—"making the world a big forest."[73]

FIGURE 14.20 Joseph Beuys, *How to Explain Pictures to a Dead Hare*, November 26, 1965. Action at the Schelma Gallery, Düsseldorf. Photo: Ute Klophaus, vintage print on bartye paper, 29.5 x 18.5 cm.

Brazilian Neo-Concretism

Banding together in Rio de Janeiro in 1959, the **Neo-Concretists** were Brazilian artists who sought to integrate art and life. Their movement emerged from **Concretism**, a version of geometric abstraction that originated in São Paolo in the early 1950s. Concrete art's exponents emphasized reason, objectivity, and universalism through paintings and sculptures employing flat, hard-edged geometric forms and restrained colors. These formal qualities resonated with Brazil's intense postwar industrialization and modernization, powerfully symbolized by the rapid construction of its new capital city, Brasília (see

Figure 17.18), between 1956 and 1960. Rio artists who adopted Concretism, including Lygia Clark, Lygia Pape, and Hélio Oiticica, later rejected its supposed rationalism and objectivity. After breaking with the São Paolo group and establishing Neo-Concretism through a manifesto written by poet Ferreira Gullar, Clark, Pape, and Oiticica made artworks that invited physical interaction, transforming the viewer into a participant.

Lygia Clark (1920–1988)

After making Concrete paintings and collages in the late 1950s using black and white geometric shapes, Lygia Clark created transformable metal sculptures known as *Bichos* (critters) from 1959 to the mid-1960s (e.g., *Creature-Maquette*, 1964). Each consists of multiple geometric metal shapes hinged together so that the viewer may manipulate them into several different configurations. Clark described the *Bicho* as "a living organism, a work essentially active." Through interaction with it, "A full integration, existential, is established between it and us. . . . What happens is a body-to-body between two living entities."[74]

Clark's desire to turn the viewer into a participant led her to create *Objetos sensoriais* (sensorial objects) intended to be worn. Her *Máscaras sensoriais* (*Sensorial Masks*, 1967) were hoods with distinct interior textures, tinted or blind eye openings, and various scents (such as lavender or cloves) held in sachets in the nosepiece. By obscuring or reducing visual stimuli, the masks heightened users' alertness to touch and smell, and fostered awareness of the entire body's role in shaping perception. This idea was informed by philosopher Maurice Merleau-Ponty's phenomenology (see box, Chapter 16), important also to Oiticica. Clark lived in Paris between 1968 and 1975, where she taught at the Sorbonne and studied psychoanalysis. After her return to Rio, she became a therapist, and placed what she called *objetos relacionais* (relational objects), such as stones, seashells, and plastic bags filled with air or water on or around her patients' bodies to facilitate healing.

Lygia Pape (1927–2004)

A restlessly experimental artist, Lygia Pape worked in multiple mediums including painting, printmaking, dance, poetry, film, and performance. Her early Neo-Concrete works included unbound books that spectators

were invited to manipulate, thereby participating in the creative process. For example, *O Livro da Criação* (*The Book of Creation*, 1959–60), consists of sixteen **gouache**-painted cardboard squares, many with movable geometric elements. Each page represents a phase of the biblical creation story or of the development of civilization, such as the discovery of fire.

After a 1964 military coup that overthrew President João Goulart and led to increasing restrictions on freedom of expression, Pape conveyed opposition to the dictatorship obliquely through her art. *Caixa das formigas* (*Box of Ants*) and *Caixa das baratas* (*Box of Cockroaches*)—her contributions to the 1967 *New Brazilian Objectivity* group show at Rio de Janeiro's Museum of Modern Art—were acrylic boxes presenting, respectively, live ants swarming over a piece of raw meat and dead cockroaches mounted in a grid formation over a mirrored surface. The former work evoked the dictatorship's voracity while the latter suggested the claustrophobic conditions it imposed. *Caixa das baratas* also implicitly criticized art museums for transforming works of art into dead specimens.

In the same year, Pape went to a *favela* (shantytown) on the outskirts of Rio where she presented a group of children with *Divisor* (*Divider*)—a thirty-by-thirty-meter sheet of white fabric with equidistant slits cut into its surface. The children activated the work by poking their heads through the openings and playfully moving together like a giant organism. Pape then restaged *Divisor* several times in 1968 in Rio's more prosperous areas, where it functioned as a metaphor for the emancipatory power of united effort in the face of the dictatorship. Restaged in Rio in 1990 (Figure 14.21)

FIGURE 14.21 Lygia Pape, *Divisor* (*Divider*), 1967. Performance at Museu de Arte Moderna, Rio de Janeiro, 1990.

and in numerous other cities since Pape's death, *Divisor* takes on different meanings in different contexts, but it is fundamentally about bringing people together to engage in collective action.

Hélio Oiticica (1937–1980)

Hélio Oiticica sought to liberate painting and color from the wall. His *Bilaterals* (1959) and *Spatial Reliefs* (1960) were variously configured wooden panels painted on both sides and suspended from the ceiling, requiring the viewer to walk around them to experience them fully. These led to the *Nuclei* (1960–63): maze-like configurations of rectangular panels covered in solid colors and hung from the ceiling at 90-degree angles. A viewer enters the *Nuclei* to discover ever-changing relationships between hues and negative and positive spaces. Seeking further to stimulate the senses through color and invite viewer interaction with the artwork, Oiticica began making *Bolides* (fireballs) in 1963. These include *Box Bolides*, simple plywood boxes with brightly painted sides and moveable elements, such as drawers containing powdered pigment and other materials.

Oiticica moved boldly to integrate art into life in 1964 when he introduced his *Parangolés* (Figure 14.22), brilliantly colorful multilayered capes made from a variety of materials. He intended them to be worn or carried while dancing to the samba, a popular form of Brazilian music that originated among West Africans enslaved and brought to the country in the nineteenth century. *Parangolé* is a slang term with many meanings, including a sudden confusion. Oiticica first encountered it in the northern Rio *favela* of Mangueira Hill. A white artist, Oiticica frequently visited the shantytown, occupied primarily by poor Black Brazilians, and attended its samba school. He viewed samba as an ecstatic form of direct expression "born out of the interior rhythm of the collective," capable of bringing people of all social classes together in "a total act of life."[75] He saw the *Parangolés* not as independent artworks, but as vehicles for incorporating the body in the work and the work in the body. Oiticica made some of the *Parangolés* for specific Mangueira friends. He inscribed these *Parangolés* with messages relevant to their wearers' lives, such as "Of adversity we live," "We are hungry," or "I embody revolt." The latter phrase had political meaning in the context of the repressive military dictatorship that took over Brazil in 1964.

Oiticica went on to create environments that visitors were invited to enter. The first, *Tropicália* (*Tropicalism*, 1967), suggested a shantytown through its two wooden-framed booths draped with colorful fabrics and a floor of dirt, sand, and

FIGURE 14.22 Hélio Oiticica, *Parangolé P4 Cape I*, 1964. Worn by Nildo de Mangueira. Mixed media.

pebble pathways. It incorporated signifiers of Brazil including tropical plants, live macaws in a cage, and a tent in which visitors could watch local entertainment on a television set. An inscription above one of the partitions read, "purity is a myth," indicating Oiticica's ironic intent in presenting exaggerated national stereotypes to counter the inflated patriotism promoted by the military dictatorship. Oiticica also sought to evoke an authentic Brazilian experience: "The created environment was obviously tropical, evoking a small plot of land; but more importantly, you would have the feeling of actually walking on the earth. This was the same sensation I had felt earlier walking among the hills, of entering and leaving the *favelas*. Turning along the informal structures of *Tropicália* brings back memories of those hills."[76]

Pop Art

Pop art's emergence on both sides of the Atlantic in the early 1960s was a revolutionary cultural development. In Pop, for the first time, modern artists frankly derived their subject matter and, often, style from everyday capitalist visual culture—the realms of advertising, mass media, and popular entertainment. While earlier modern artists, such as the Cubists and Dadaists, had used visual and textual elements from commercially printed sources in collages or photomontages (see Figure 7.6). These artworks subsumed elements appropriated from "low" culture into the "high" cultural context of challenging modernist art. The same is true of Jasper Johns's and Robert Rauschenberg's 1950s works (see Chapter 14): they used familiar popular imagery and found objects but invested their artworks with a handmade, high-art quality at odds with the slick perfection of consumer products and advertisements. In Pop art, by contrast, the low cultural content equals or surpasses the high: the immediately legible image of, say, Marilyn Monroe, a Coca-Cola bottle, or a comic-strip panel seems at least as important as the way in which it is rendered.

Pop art in its most radical, two-dimensional form, exemplified by the paintings and prints of Andy Warhol, Roy Lichtenstein, and James Rosenquist, uses not only subject matter but also techniques derived from mass media and commercial art, rendering imagery through comic-book or billboard-illustration styles, or stencils and photo-silkscreens. (Not coincidentally, Warhol, Rosenquist, and other Pop artists did commercial work before turning to fine art.) Warhol and his peers consciously rejected Abstract Expressionism's nonrepresentational forms and improvisatory methods, which had dominated New York's avant-garde in the 1950s. In place of Abstract Expressionism's heated subjectivity, supposed to reveal the artist's inner drives and emotions through impassioned brushwork and expanses of raw color, the Pop artists adopted a "cool," unemotional and objective attitude toward art making. Instead of discovering their images spontaneously through the process of painting them, Pop artists chose ready-made subjects from the daily outpouring of comic strips, magazine advertisements, news photographs, brand-name consumer products, movie posters, and similar visual material saturating the modern capitalist environment. Significantly, all of these subjects had already been processed by the mass media. The Pop artists did not work from nature, as had earlier representational artists, but from culture and its systems of communication. As Lawrence Alloway, the British critic usually credited for the term "Pop art," observed: "[Pop] is essentially, an art about signs and sign-systems"[1] (see "Semiotics" box, Chapter 4).

Alloway referred to "Pop art" amidst discussions of popular culture held at London's Institute of Contemporary Art (ICA) by the Independent Group. Alloway originally used the term to describe the products of the mass media and popular culture. In the face of postwar austerity, the Independent Group's young artists, writers, and architects were enthralled by American "pop art" phenomena such as Hollywood movies, Madison Avenue advertising, Detroit automobile styling, science fiction, and pop music. The material abundance represented in American advertising was particularly appealing to them as some products were rationed until 1958 in the United Kingdom.

Meanwhile, the US economy boomed in the 1950s and 1960s, generating tremendous private wealth for some and encouraging the development of a consumer culture. During the 1960s, US government policies and corporate growth emphasized consumption, which came to define the personal lifestyles of Americans inundated by advertisements and diverted by popular entertainment. American Pop art developed within and reflected this context, both economic and visual.[2]

This chapter considers the origins and development of Pop art in Britain, its explosion in the United States in the early 1960s, and its rapid adoption thereafter by artists in Germany, Argentina, Brazil, and Japan.

The Independent Group

The Independent Group, who met at the ICA in London between 1952 and 1955, rebelled against what they perceived as the elitism of **modernist abstraction** and argued that modern art should reflect postwar life's democratic and inclusive values. They saw those values expressed in mass media products and popular culture, the original referent of Alloway's term "pop art."[3] The Independent Group hosted lectures and disseminated their ideas through publications and exhibitions its members either organized or participated in, including *Parallel of Life and Art* (1953), *Man, Machine and Motion* (1955), and *This Is Tomorrow* (1956). The group's artist members included Eduardo Paolozzi and Richard Hamilton, both of whom produced works anticipating British **Pop art**.

Eduardo Paolozzi (1925–2005)

Influenced by **Dada** and **Surrealism** in the late 1940s, Eduardo Paolozzi made **collages** out of images clipped from American magazines and other printed material he acquired from former US military members while living in Paris. These collages, such as *Dr. Pepper* (1948), incorporate erotically charged advertising imagery designed to stimulate desire for new consumer products. To Paolozzi, "The American magazine represented a catalogue of an exotic society . . . bountiful and generous, where the event of selling tinned pears was transformed into multi-coloured dreams, where sensuality and virility combined to form . . . an art form more subtle and fulfilling than the orthodox choice of either the Tate Gallery or the Royal Academy."[4] At the first event of the Independent Group's ICA program in 1952, Paolozzi gave a lecture in which he rapidly projected images of his collages, as well as others culled from printed sources. Their **subject matter** ranged from science fiction to aviation, technology, comics, pin-up pictures, and advertisements for food, domestic appliances, and cars. The lecture manifested the dizzying profusion of images and messages circulating through the modern capitalist urban environment and predicted the **iconography** of Pop art.

Trained as a sculptor, Paolozzi in the 1950s assembled rough, fragmented figures out machine parts and other scrap metal that he then cast into bronze. He turned to a cool Pop-inflected machine **style** in the 1960s, producing brightly painted welded aluminum sculptures with crisp blocky rectilinear **forms** (e.g., *The City of the Circle and the Square,* 1963 and 1966) that seem simultaneously to glorify and parody the automated modern age.

Richard Hamilton (1922–2011)

Richard Hamilton's **fine arts** training (at the Royal Academy Schools and Slade School of Fine Art) and experience working as a commercial artist at the record company EMI prepared him to embrace the Independent Group's commitment to eliminating the boundaries between "high" and "low" art. Hamilton emphasized the "low" iconography of advertising in *Just What Is It That Makes Today's Homes So Different, So Appealing?* (1956; Figure 15.1 illustrates a 2004 print after the original), a small collage he made as a catalogue and poster illustration for the Whitechapel Gallery exhibition *This Is Tomorrow.* The collage illustrates a list of interests Hamilton sought to explore in the exhibition: "Man, Woman, Humanity, History, Food, Newspapers, Cinema, TV, Telephone, Comics (picture information), Words (textual information), Tape recording (aural information), Cars, Domestic appliances, Space."[5]

Hamilton shows a domestic interior occupied by an eroticized couple equipped with humorous accessories: a white male bodybuilder holding a lollipop rather than a barbell—its wrapper emblazoned with the word "POP"—and a buxom nude white woman seated on a sofa wearing pasties on her nipples and a lampshade on her head. The objects surrounding the couple ("Man" and "Woman")—a newspaper, reel-to-reel tape recorder, canned ham, books, television set showing a woman talking on a telephone, framed romance comic book panel, Ford logo, and vacuum cleaner—signify specific interests on Hamilton's list. "Humanity" appears in the rug—its seemingly abstract pattern made from a grainy black-and-white photograph of a crowd on a Coney Island beach (by the American photographer Weegee). "Cinema" is present in the movie theater façade seen through the window, its marquee advertising *The Jazz Singer* (1927), one of the earliest films with synchronized sound. "Space" replaces the ceiling—a satellite photograph of Earth. "History" is embodied in the portrait of the nineteenth-century critic John Ruskin. He seems to look down with moralizing disapproval on this amusing scene filled with modern items providing convenience, pleasure, and entertainment. This is a consumer fantasy world "different" and "appealing" to its British audience still emerging from postwar austerity.

FIGURE 15.1 Richard Hamilton, *Just What Is It That Makes Today's Homes So Different, So Appealing?* 1956, Upgrade 2004. Piezo pigment inkjet print, 41.9 x 29.8 cm. The Metropolitan Museum of Art, New York.

who studied at the RCA in the early to mid-1950s. A second generation, at the RCA in the years around 1960 included Derek Boshier, Pauline Boty, Patrick Caulfield, David Hockney, Allen Jones, and Peter Phillips. These artists worked in diverse styles but shared an interest in subjects drawn from popular culture.

Peter Blake (b. 1932)

Elements from popular culture first appeared in Peter Blake's student paintings such as *On the Balcony* (1955–57), which, like Hamilton's *Just What Is It?*, presents a compendium of widely available consumer products, including Lucky Strike cigarettes, *Life* magazine, and Kellogg's Corn Flakes. Hand-rendered in careful detail, the items in *On the Balcony* rest on tables or float against the green grass of a park occupied by five youthful figures painted in a simplified style indebted to **folk art**. Surrounding these young people are numerous framed pictures of figures on balconies, all hand-painted from photographic sources, including a copy of Manet's *On the Balcony* (1868) and a 1930s-era image of the Royal Family. Three of the young people wear badges, signifying their popular cultural enthusiasms, and one wears a tie with a cartoon-style image of Marilyn Monroe. Blake's mixture of images from high and low American and British culture suggests Pop's erasure of distinctions between fine art and mass consumerism.

Blake achieved his mature Pop style in the collage paintings he began making in 1959. These paired appropriated photographic and printed imagery and **found objects** with flat, brightly colored geometric patterns inspired by Johns's paintings of flags and archery targets (see Figure 14.3). Aiming to make pictures that "can be enjoyed by young people who like pop music,"[8] Blake devoted many of these paintings to rock'n'roll and pop musicians. *Got a Girl* (1960–61, Figure 15.2) takes its title from the Four Preps' hit song, incorporated into the work as a 45rpm vinyl record at the upper left. The lyrics convey a teenage boy's lament about competing for his girlfriend's

Advertising imagery inspired Hamilton's paintings of the late 1950s and early 1960s executed in a **Cubist**-based style. *$he* (1958–61) presents the disassembled figure of an eroticized female model—reduced to a white skirt, bare pink breast/shoulder, and collaged winking plastic eye—juxtaposed with an open refrigerator and combination toaster-vacuum cleaner. Hamilton claimed that he did not intend this exploration of the "relationship of woman and appliance" as "a sardonic comment on our society."[6] The title's inclusion of a dollar sign, however, suggests a skeptical view of American advertisers' calculated use of feminine sex appeal to stimulate consumerist desire.[7]

British Pop

The first group of artists consistently described as Pop emerged from London's Royal College of Art (RCA). The initial generation comprised Peter Blake, Richard Smith, and Joe Tilson,

FIGURE 15.2 Peter Blake, *Got a Girl*, 1960–61. Oil paint, wood, photo-collage and record on hardboard, 94 x 154.9 x 4.2 cm. The Whitworth Art Gallery, The University of Manchester, United Kingdom.

affections with the pop idols she dreams of—Fabian, Frankie Avalon, Ricky Nelson, Bobby Rydell, and Elvis Presley—represented in that order through photographs along the painting's top (with Presley shown twice). The bold red, white, and blue design below the portraits evokes both the American and UK flags and suggests US pop music's suffusion of the British airwaves. Within a few years, the tide reversed as the Beatles led the British rock'n'roll invasion of the United States. Blake contributed to this phenomenon by designing the cover of the Beatles' album, *Sgt Pepper's Lonely Hearts Club Band* (1967), in collaboration with his wife, Jann Haworth.

Pauline Boty (1938–1966)

Pauline Boty gained recognition in 1962 as an up-and-coming Pop artist featured in the BBC documentary *Pop Goes the Easel*, alongside her fellow RCA alumni Blake, Derek Boshier, and Peter Phillips. Described in a magazine profile as "a brainy actress who is also a painter and a blonde"[9]—a condescending line typical of early 1960s British culture's patriarchal values—Boty was not only a talented painter but also an actor with numerous television and movie credits. She may

have identified with another blond actor, Marilyn Monroe, the Hollywood star whom Boty, like Warhol and many other Pop artists, depicted posthumously. In *The Only Blonde in the World* (1963, Figure 15.3), Boty frames a loosely painted image of a joyful, running Monroe—based on a still from *Some Like it Hot* (1959) published in *Life* magazine—with lush fields of green accented with simple abstract red and purple shapes. The image celebrates Monroe's vitality, but the **composition** hems her in visually. This might suggest her entrapment by oppressive forces, such as the Hollywood studio system that exploited her as a sex symbol, or the depression that led to her suicide. Tragically, Boty also died young, succumbing to leukemia at age twenty-eight.

David Hockney (b. 1937)

The most successful artist associated with British Pop, David Hockney as a student at the RCA (1959–62) made paintings focused on the theme of homosexual love with scrawled texts

FIGURE 15.3 Pauline Boty, *The Only Blonde in the World*, 1963. Oil paint on canvas, 122.4 x 153 x 2.5 cm. Tate, London.

language of crisp, **stylized** forms and bright, flat **acrylic** colors. He often depicted the pool as a site of homosexual desire. *Peter Getting Out of Nick's Pool* (1966, Figure 15.4), for example, offers an enticing view of the round buttocks of Hockney's boyfriend, Peter Schlesinger, as he emerges from the pool of Hockney's dealer Nicholas Wilder. Schlesinger's **modeled** body, which Hockney based on a photograph, contrasts with the image's overall flatness, with loops of white paint and repeated diagonal white lines creating ornamental patterns on the water and windows. Hockney frames the composition with an unprimed canvas border to declare its status as a representation—one giving seductive, sun-drenched visibility to same-sex desire as part of Los Angeles's surface image.[10]

FIGURE 15.4 David Hockney, *Peter Getting Out of Nick's Pool*, 1966. Acrylic on board, 152 x 152 cm. Walker Art Gallery, Liverpool, United Kingdom.

and coarsely rendered figures suggestive of children's art and Dubuffet's faux naïve style (see Figure 13.8). He made his closest approach to Pop art in *Tea Painting in an Illusionistic Style* (1961), a 2.32-meter-tall shaped canvas he built to resemble a Ty-Phoo Tea box with an open lid, viewed in **perspective**. He covered its surface with crudely hand-painted logos and brewing instructions copied from an actual box. Seen through the front logo is a seated nude male figure "inside" the box. This imaginatively transforms the box into a "tea room," a gay slang term for a public toilet—a favorite site for cruising and anonymous sexual encounters between men.

Hockney became the face of British Pop more because of his media-oriented persona than the look of his art: he returned from his first visit to New York in 1961 sporting bleached-blond hair, large round glasses, and a gold lamé jacket—a fashion item associated with rock stars like Elvis Presley. In 1963, Hockney moved to Los Angeles, imagining it as a promised land of warm sunshine, tropical colors, and easily available erotic pleasures, or everything England was not. In Los Angeles, Hockney took as his signature subject the private suburban backyard swimming pool, which he rendered in a visual

New York Pop

Pop burst onto the New York art scene in the October 1962 *New Realists* show at the Sidney Janis Gallery. The exhibition, which Janis organized with Pierre Restany, featured many of the European Nouveaux Réalistes (see Chapter 14) alongside the Americans Jim Dine, Robert Indiana, Roy Lichtenstein, Claes Oldenburg, James Rosenquist, George Segal, Wayne Thiebaud, Andy Warhol, and Tom Wesselmann. The Americans' unvarnished presentation of commercial subject matter aroused the attention of not only art professionals, but also of the popular press and public, who had been baffled by **Abstract Expressionism** but could easily understand paintings and sculptures of cars, hot dogs, soup cans, and movie stars. As Janis, Leo Castelli, and other dealers aggressively promoted Pop and a new generation of collectors eagerly acquired it, a few critics praised Pop as a fresh and bold art with the power, in G. R. Swenson's words, to "revitalize our sense of the contemporary world."[11] Many more critics condemned it, however, as a betrayal of high modernism and a descent into tastelessness and triviality. To them, Pop art failed to transcend the debased commercial culture that inspired it and was little better than kitsch, which Clement Greenberg had famously denounced in his 1939 essay "Avant-Garde and Kitsch."[12] In Max Kozloff's

judgment, the Pop artists were "New Vulgarians" rubbing the spectator's nose "into the whole pointless cajolery of our hard-sell, sign-dominated culture. . . . The truth is, the art galleries are being invaded by the pin-headed and contemptible style of gum chewers, bobby soxers, and worse, delinquents."[13]

Lichtenstein responded to such accusations by saying, "There are certain things that are usable, forceful, and vital about commercial art. We are using these things, but we're not really advocating stupidity, international teenagerism and terrorism [war]."[14] Pop's cool, deadpan style made it difficult to discern what its artists did think about the signs of commercialism they employed. Most critics in the 1960s understood American Pop art to celebrate or, at least, uncritically accept consumerism—a position seemingly affirmed by Warhol's statement that Pop is about "liking things."[15] Some art historians in recent decades have seen American Pop as subtly subversive and either critical of or ambivalent about consumer culture. In fact, the American Pop artists did not share a common attitude toward popular culture, making it impossible to generalize about whether they were for or against it.[16] Alloway's semiotic reading argues that Pop art images have no fixed meanings but rather concern "meaning in process, an experience based on the proliferation and interpenetration of our sign- and symbol-packed culture."[17] In this view, the meaning of any Pop artwork is always unstable and subject to multiple interpretations.

Claes Oldenburg (1929–2022)

A major contributor to American Pop art's development, Claes Oldenburg is best known for his sculptures of common objects surprisingly rendered larger than life in soft materials or made colossal and placed outdoors as irreverent monuments. Living on Manhattan's Lower East Side in the late 1950s, Oldenburg was captivated by the shabby scenery he encountered on the street—cluttered store window displays, women with shopping bags, Bowery derelicts, garbage piles, and bundled debris. These experiences inspired *The Street*, a 1960 **environment** he created in the Judson Gallery, an alternative space in the basement of a Greenwich Village church. The environment featured scruffy silhouetted images of cars, human figures, handguns, a traffic barricade, and illegible signs made of cardboard, paper, newsprint, wood scraps, and black paint. Its chaos evoked slum life's dirt and desperation, while its crude aesthetic reflected the influence of what Dubuffet called **art brut**. Within *The Street*, Oldenburg and his soon-to-be wife Patricia Muschinski (later Patty Mucha) staged a **Happening**, *Snapshots from the City*, in which they portrayed writhing, abject characters in shabby costumes matching their trash-strewn surroundings.

Oldenburg installed his next environment, *The Store*, in a rented East Second Street storefront in December 1961. Presented under the auspices of the Ray Gun Manufacturing Company—Oldenburg's science-fiction comics-inspired name

for his studio—*The Store* was stocked floor to ceiling with his sculptures of household items, clothing, food, and advertising signs, emulating the crowded interiors of his neighborhood's cut-rate shops (e.g., *Pepsi Cola Sign*, 1961). He fashioned the lumpy, ragged-edged sculptures out of plaster-dipped muslin formed over chicken wire armatures and slathered their surfaces in brightly colored **enamel** paint. He allowed the paint to drip, as a parody of Abstract Expressionism and to convey the vitality of his friendly enterprise in which everything was for sale—even the cash register. After the exhibition closed, Oldenburg renamed the space the Ray Gun Theater to host a series of ten plotless theatrical events in which he, his wife, and their friends performed. The themes of these "plays dealing with the US consciousness"[18] ranged from slum life to cathartic ritual and lyrical rebirth.

In September 1962, Oldenburg reincarnated *The Store* at the Green Gallery on Fifty-Seventh Street in the heart of New York's upscale art world. For this exhibition, Oldenburg enlarged some objects so that they filled the gallery as impressively as did cars and grand pianos in Manhattan showrooms. He presented giant food items—a 3.45-meter-long ice cream cone, a 2.9-meter-long cake slice, and a 2.13-meter-diameter hamburger—made of stuffed, painted canvas sewn by Patty Oldenburg. Placed directly on the floor, these familiar American foods assumed a surreal presence, not only through their enormous size but also because of their softness and malleability—a rejection of sculpture's conventional rigidity.

The next year, Oldenburg began creating soft sculptures of everyday objects—a pay telephone, a typewriter, light switches—out of stuffed vinyl, giving them a glossy Pop appearance. Oldenburg's transformation of hard, manufactured things into strange, sagging entities recalls Dalí's surreal image of melting watches (see Figure 8.7). In addition to each subject's vinyl rendition, Oldenburg would typically produce a "hard" version in rigid cardboard and a "ghost" version in unpainted cloth. These baggy objects often possess an anthropomorphic quality: the *Soft Toilet* (1966, Figure 15.5), for example, droops pathetically like an aged human body while its bowl and raised lid resemble a mouth and face.

Imagining a public art more relevant to contemporary life than traditional sculptural and architectural monuments, Oldenburg in the mid-1960s made drawings and collages in which he envisioned quotidian objects on a colossal scale in urban settings. He proposed, for example, replacing the Pan Am (now Met Life) Building on Park Avenue with a melting ice cream bar, and the Washington Monument with a giant pair of scissors. Oldenburg installed his first realized large outdoor project, *Lipstick (Ascending) on Caterpillar Tracks* (1969) on his alma mater Yale University's campus. The industrially fabricated 7.16-meter-tall sculpture of a lipstick tube rising from tank tracks exalted a feminine-coded cosmetic product

FIGURE 15.5 Claes Oldenburg, *Soft Toilet*, 1966. Wood, vinyl, kapok, wire, plexiglass on metal stand and painted wood base, 142.6 x 79.5 x 76.5 cm. Whitney Museum of American Art, New York.

to celebrate Yale College's decision to admit women for the first time in 1969. The juxtaposition also suggested the message "make love, not war," used by student and hippie protestors against US military involvement in Vietnam, reflecting Oldenburg's anti-war stance. Oldenburg's numerous later large-scale projects, realized in collaboration with his second wife Coosje van Bruggen (1942–2009), were apolitical. Among the most striking is *Shuttlecocks* (1994), comprising four 5.5-meter-tall sculptures of shuttlecocks strewn across the north and south lawns of Kansas City's Nelson-Atkins Museum of Art, whose **classical**-style building the artists imagined as a badminton net.

Roy Lichtenstein (1923–1997)

After gaining fine arts training and commercial art experience, and experimenting with Willem de Kooning-style gestural abstraction in the late 1950s, Roy Lichtenstein made his breakthrough to Pop art in the early 1960s. His painting of Donald Duck and Mickey Mouse, *Look Mickey* (1961), features a composition he transposed from a Disney children's book. This hand-painted enlargement of a lowbrow illustration, bold in its immediate legibility, broke definitively with Abstract Expressionism and opened Lichtenstein's eyes to the fresh artistic potential of mass-produced commercial imagery. For the next

few years, he appropriated his subjects from advertisements, reproductions of Picasso and Mondrian paintings, and, most famously, panels from comic books. His paintings used simplified forms defined through heavy black outlines, flat, **primary colors**, and stenciled **Benday dots** (employed in commercial printing to create shading, **tone**, or **secondary colors**)—the impersonal conventions of comic-book illustration that Lichtenstein paradoxically claimed as his signature style.

For his comic-book paintings, Lichtenstein drew from such sources as *All-American Men of War* and *Secret Hearts*, aimed at teenage boys and girls, respectively. These comics' plots reinforced stereotypical gender roles that Lichtenstein exaggerated by representing tense or climactic scenes in the comics' narratives. His war paintings emphasize masculine values of action and aggression, often through images of discharging weapons as in *Whaam!* (1963), showing a US fighter jet blasting an enemy aircraft out of the sky. By contrast, his romance paintings depict passive young women in emotional distress, as in *Drowning Girl* (1963, Figure 15.6), whose wave-engulfed heroine, her closed eyes streaming with tears, seems overwhelmed by her sorrow as much as by the threatening waters.[19] Lichtenstein's hyperbolic expressions of comic-book gender roles can be read as parodies designed to reveal these roles' artificiality. However, he professed no critical intention, claiming that emotionally charged comic-book narratives attracted him because he "wanted the subject matter to be opposite to the removed and deliberate painting techniques."[20]

Lichtenstein did not slavishly copy comic-book panels but carefully reworked them to create more forceful and unified compositions. This is clear in comparing *Drowning Girl* to its source, which includes the heroine's boyfriend clinging to their overturned boat in the **background** beneath the story title, "Run for Love!"[21] Lichtenstein cropped out the original panel's upper half, moved the thought bubble closer to the girl's head and shortened its text, and eliminated linear details in the girl's face, hand, hair, and the surrounding water. These alterations, combined with the painting's large size, create a more concentrated **formal** impact, and emphasize flatness, aligning Lichtenstein's art with contemporaneous **Hard Edge** and **Minimalist** abstraction (see Chapter 16). To Lichtenstein's critical supporters, these aesthetic qualities qualified his paintings as high modernist works that transcended their low cultural sources.

In 1965, Lichtenstein transitioned from comic-book imagery to modern painting styles as his subject matter. He made a series of brushstroke paintings and prints (e.g., *Little Big Painting*, 1965) that translate the thick, energetic gestural strokes of action painters like Willem de Kooning into flat, frozen, comic-book style representations, isolated against fields of Benday dots. Lichtenstein's brushstroke images ironically replace Abstract Expressionism's heated, personal emotion with Pop art's cool, impersonal sensibility. In the 1970s,

FIGURE 15.6 Roy Lichtenstein, *Drowning Girl*, 1963. Oil and acrylic on canvas, 171.6 x 169.5 cm. The Museum of Modern Art, New York.

and films and me, and there I am. There's nothing behind it."[23] Warhol and his art served as blank screens onto which viewers could project their own beliefs.

Warhol studied pictorial design in his native Pittsburgh at the Carnegie Institute of Technology (1945–49) before moving to New York, where he became an award-winning commercial artist and illustrator. He also made and exhibited homoerotic drawings; their poor reception by the mainstream New York art world led Warhol to abandon overt expression of gay content in his later Pop work. Desiring recognition as a fine rather than commercial artist, Warhol followed the examples of Johns and Rauschenberg to draw on the everyday visual world for his subject matter. He made his first Pop paintings in 1961 by projecting banal advertisements from the back pages of newspapers and magazines onto canvas and copying their imagery, occasionally allowing his paint to drip and adding scrawled lines or paint strokes in the composition's margins (e.g., *$199 Television*, 1961). He also made paintings based on comics (e.g., *Dick Tracy*, c. 1961), but stopped doing so after discovering Lichtenstein's work in this vein.

The next year, Warhol eliminated abstract and gestural elements to present his imagery in a stark, unmodulated manner. He selected subjects from the supermarket shelf—Coca-Cola bottles and Campbell's soup cans—and appropriated them as personal emblems. To Warhol, these products represented American democracy. "You can be watching TV and see Coca-Cola," he wrote, "and you can know that the President drinks Coke, Liz Taylor drinks Coke, and just think, you can drink Coke, too."[24] He claimed that he painted Campbell's soup, "Because I used to drink it. I used to have the same lunch every day for twenty years . . . the same thing over and over again."[25] His numerous Campbell's soup depictions included thirty-two twenty-by-sixteen inch hand-painted canvases (*Campbell's Soup Cans*, 1962), each representing one of the thirty-two varieties of the product. Now in the MoMA collection, they were shown in his first solo exhibition in Los Angeles in 1962 lined up on shelves like products displayed in a supermarket.

Lichtenstein painted new compositions incorporating appropriated or paraphrased motifs from Matisse, Léger, and other past masters (e.g., *Artist's Studio: The Dance*, 1974) in a bid to reconcile his comic-book idiom with the modernist canon and assert his place within it.

Andy Warhol (1928–1987)

Andy Warhol's name and his iconic depictions of Campbell's Soup cans, Brillo boxes, and Marilyn Monroe are virtually synonymous with Pop art. He held up a mirror to the United States in the 1960s by reproducing illustrations, commercial product packages, and photographs from mass media sources, representing familiar imagery embodying the core values of a consumer-driven, celebrity-obsessed, media-absorbed capitalist society. He did so in a deadpan manner that revealed nothing of his personal feelings. He complemented these dispassionate images with a detached, emotionless public persona, famously saying in 1963, "I want to be a machine."[22] He claimed to have no hidden message: "If you want to know all about Andy Warhol, just look at the surface of my paintings

Unabashedly eager for financial success, Warhol frankly conceived of his artworks as commodities. During the first half of 1962 he increasingly used mechanical methods, including rubber stamps, stencils, and **silkscreens**, that enabled him to turn much of the art-making over to assistants, improving his enterprise's efficiency and profitability. He also routinely repeated the same motif, both in series and within a single work, emulating assembly-line production and the proliferation of consumer items and mass media images in American society.

After summer 1962, the mechanical means Warhol most often employed was **photo-silkscreen**. Fascinated by celebrity and seeking it himself, he and his assistants produced a silkscreen painting series of Hollywood movie stars—Marilyn Monroe, Elizabeth Taylor, Elvis Presley, Marlon Brando, and others—who function as human products, packaged, promoted, and consumed like Coca-Cola and Campbell's soup. (By portraying attractive young male stars like Presley and Brando, Warhol was able to indulge his same-sex desire without highlighting his queerness because he also depicted Taylor and Monroe.) Warhol made hundreds of Monroe paintings using a silkscreen derived from a publicity photograph for her

1953 movie *Niagara*, cropped to isolate her heavily made-up smiling face beneath her bleached blond hair. Repeated images of Monroe in a five-by-five grid fill both sides of Warhol's *Marilyn Diptych* (1962, Figure 15.7). In the left panel, her photographic image is screened in black over hand-painted shapes of bright color. The right panel lacks color, and the silkscreen ink varies in density from image to image. In the upper section of the second row, the heavy ink nearly obliterates Monroe's features, while its light application in the final row gives her a faded, ghostly appearance. The color-drenched depictions of Monroe evoke her glossy and artificial Hollywood persona while the disembodied black images suggest emptiness beneath the glamorous façade.

Warhol made his first images of Monroe shortly after her death by probable suicide in August 1962. This event helped catalyze his concern with themes of death and disaster over the next three years—acknowledging the darker side of American existence obsessively covered by the news media. Appropriating published and unpublished photographic images, Warhol made silkscreen paintings and prints of suicide victims and wrecked automobiles, of white police officers siccing their dogs

FIGURE 15.7 Andy Warhol, *Marilyn Diptych*, 1962. Silkscreen ink and acrylic paint on 2 canvases, 205.4 x 144.8 x 2 cm each. Tate, London.

on peaceful Black civil rights demonstrators in Birmingham, Alabama, and of nuclear mushroom clouds and the electric chair. As with his celebrity paintings, Warhol often screened the same disaster-themed image multiple times on one canvas, commenting, "When you see a gruesome picture over and over again, it really doesn't have any effect."[26] His electric chair paintings, such as *Orange Disaster #5* (1963, Figure 15.8), reproduce a photo of the chair in Sing Sing prison used in 1953 to execute the alleged atomic spies Ethel and Julius Rosenberg. Although made in a period of intense public activism against the death penalty in the United States, Warhol's painting characteristically refuses to comment on the issue beyond emphasizing the chilling presence of the empty chair awaiting its next victim, isolated in a room with a wall sign reading "SILENCE."

Warhol and his assistants also used silkscreens to transfer logos to the surfaces of painted plywood sculptures mimicking shipping boxes for Brillo soap pads, Mott's apple juice, Kellogg's cornflakes, Del Monte peaches, Campbell's tomato juice, and Heinz ketchup. He exhibited them in 1964 at New York's Stable Gallery, in stacks evoking a crowded grocery distribution center. Because Warhol's box sculptures were nearly indistinguishable visually from the cardboard cartons they imitated, philosopher Arthur Danto proposed that they were seen as art because they were presented within the context of the art world—an idea central to the Institutional Theory of Art (see box).

In the mid-1960s, Warhol began making experimental films that often depict a single prolonged activity, such as *Sleep*

FIGURE 15.8 Andy Warhol, *Orange Disaster #5*, 1963. Acrylic, silkscreen ink, and graphite on canvas, 269.2 x 207 cm. Solomon R. Guggenheim Museum, New York.

The Institutional Theory of Art

Andy Warhol's *Brillo Boxes* catalyzed an influential theory holding that what makes an object a work of art is its presentation to an art world public. Propounded by the philosopher George Dickie, this theory arose from philosopher Arthur Danto's 1964 essay "The Artworld." Danto asked why Warhol's *Brillo Boxes* were works of art even though they looked just like Brillo shipping boxes in a grocer's stockroom. His answer was, "To see something as art requires something the eye cannot [see]—an atmosphere of artistic theory, a knowledge of the history of art: an artworld."[27] Danto claimed that both Warhol's painted, silkscreened plywood facsimiles of cardboard Brillo shipping cartons and the cartons themselves would be art if displayed in an art gallery—an argument applicable to Duchamp's **readymades** (see Chapter 7). Danto thus abandoned traditional aesthetic definitions of art as well as those defining art according to its function—imitative, symbolic, or expressive. He proposed that something could be art not due to its inherent properties but because of its relation to a larger context, "the artworld." Dickie offered his fully developed institutional theory of art in *The Art Circle: A Theory of Art* (1984): "A work of art is an artifact of a kind created to be presented to an artworld public," "An artist is a person who participates with understanding in the making of a work of art," "A public is a set of persons the members of which are prepared in some degree to understand an object which is presented to them," "The artworld is the totality of all artworld systems," and "An artworld is a framework for the presentation of a work of art by an artist to an artworld public."[28] Dickie admitted that his definition was circular but argued that it was informative (not a logically fallacious vicious circle) and that his five central notions were interdependent, supporting one another. The art world comprises individuals such as artists, dealers, critics, collectors, curators and art historians and institutions such as galleries, auction houses, and museums. According to the institutional theory of art, anything presented within the art world system—from a person wearing a dress made out of light bulbs (see Figure 14.14) to a pair of fifty-feet-deep by thirty-feet-wide trenches cut from either side of the top of a mesa (Michael Heizer's *Double Negative*, see Chapter 19) to a pile of candy (as presented by Felix Gonzalez-Torres, see Chapter 22)—is a work of art. As such, even a pile of candy can invite any of the responses and approaches traditionally applied to art, such as aesthetic appreciation, critical evaluation, interpretation, and contextualization.

(1963), a 321-minute silent black-and-white film of his lover John Giorno sleeping. Warhol's silver-walled studio, The Factory, became a gathering place for artists, writers, socialites, drug addicts, and cross-dressers, and the site of concerts by the Velvet Underground and Nico, a rock band whose first album Warhol produced. After surviving an assassination attempt by Valerie Solanas in 1968, Warhol dedicated himself to "business art," cranking out commissioned Polaroid-based silkscreen portraits of rich and famous clients. His later works also included the *Oxidation Paintings* (1978), strangely beautiful parodies of Pollock's drip paintings made by urinating on a surface of wet copper paint, and *Shadows* (1978–79), screen printed in various colors from a greatly enlarged photograph of a shadow and installed edge-to-edge around the gallery walls to create "disco décor."[29]

James Rosenquist (1933–2017)

Like Lichtenstein and Warhol, James Rosenquist built his Pop paintings out of images derived from commercial media sources. However, he painted by hand in a bland illustrational mode rather than using a comic-book style or photo silkscreening. Furthermore, instead of presenting his motifs whole, he pictured them as fragments on a large scale, juxtaposed in unexpected combinations. These features of Rosenquist's art derived from his experience as a billboard painter in New York in the late 1950s, a profession he pursued after his fine arts study at the University of Minnesota. Covering vast canvases rivaling those of the Abstract Expressionists in size, Rosenquist transposed to high art the commercial sign painter's technique of hand rendering huge faces, bodies, and consumer products meant to be legible from a distance. He based his compositions on collages of images mostly clipped from advertisements of the late 1940s and early 1950s, a period remote enough to be viewed dispassionately but recent enough to prevent nostalgia.

Rosenquist typically used anonymous images combined with no logical relationship, as in *Silver Skies* (1962). This billboard-sized (502.3-cm wide) canvas features differently scaled depictions of a turkey's head, car tires, a red rose blossom, a bicycle rider's knees, the upper part of a feminine face, car windows, the top of an open bottle, and a masculine-styled lower pant leg and shoe. This creates an effect of discontinuity similar to those of the Surrealists. However, Rosenquist did not seek to evoke the irrational and the unconscious but the experience of the modern urban dweller bombarded by random images on billboards and television screens and in newspapers and magazines. "I'm interested in contemporary vision—the flicker of chrome, reflections, rapid associations, quick flashes of light. Bing-bang! Bing-bang! I don't do anecdotes, I accumulate experiences."[30]

Rosenquist's most famous work, *F-111* (1964–65, Figure 15.9), is unusual in delivering a political message. He intended it as a critique of the American military-industrial complex,

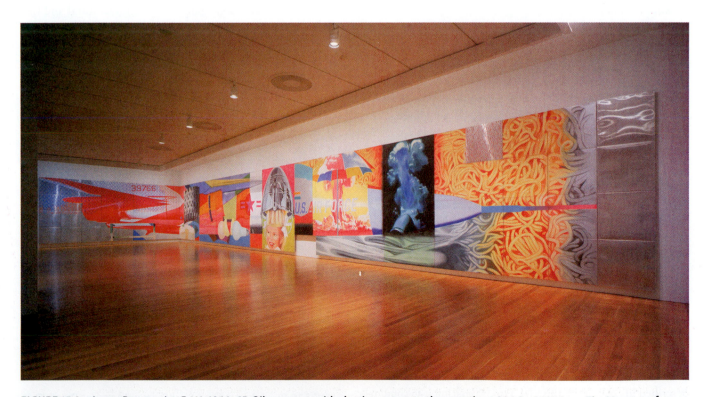

FIGURE 15.9 James Rosenquist, *F-111*, 1964–65. Oil on canvas with aluminum, twenty-three sections, 304.8 x 2621.3 cm. The Museum of Modern Art, New York.

the system whereby the government channels tax money to private weapons and military equipment manufacturers in response to supposed external threats, such as communism's spread during the Cold War. Named for a fighter-bomber then under development by General Dynamics Corporation for the US military, *F-111* is a 3 × 26.2-meter painting comprising fifty-one interlocking panels. Rosenquist designed it to wrap around the Leo Castelli Gallery's four walls to envelop the viewer with phosphorescent colors and rapidly shifting imagery. The aircraft's fuselage extends the length of painting. Over its tail is superimposed a red floral wallpaper pattern, laid down with a roller, succeeded by images of an angel food cake and a Firestone tire; three light bulbs (one broken like an egg); a smiling blond girl beneath a hair dryer; a beach umbrella overlying an atomic mushroom cloud; bubbles rising from an undersea diver's helmet; and an orange field of canned spaghetti. Rosenquist employed commercial images to reveal how government military spending creates employment and drives consumption, explaining:

A man has a contract from the company making the bomber, and he plans his third automobile and his fifth child because he is a technician and has work for the next couple of years. Then the original idea is expanded, another thing is invented; and the plane already seems obsolete. The prime force of this thing has been to keep people working, an economic tool; but behind it, this is a war machine.[31]

Underscoring this critical theme, the girl under the "bomb-shaped hair dryer" stands for "the middle-class families prospering from the building of this death-dealing machine," and occupies the pilot's position, "just as middle-class society was really the momentum behind the plane."[32] The painting also conveys Rosenquist's concerns about nuclear holocaust: the floral wallpaper evokes nuclear fallout, the bubbles above the diver allude to "the big gulp of air that a nuclear explosion consumes"[33] and the adjoining mushroom cloud overtly pictures such a blast. Over time, *F-111* also became understood as a protest against the US involvement in the Vietnam War—a meaning that Rosenquist accepted.

Robert Indiana (1928–2018)

Road signs, pinball machines, jukeboxes, and advertisements inspired the Pop art of Robert Indiana, who changed his surname from Clark to that of his native state in 1958, four years after his move to New York City. Indiana employed sign-painting techniques to crisply delineate eye-popping compositions of words, numerals, symbols, and fields of flat color. He described his style as "hard-edge Pop,"[34] relating it to contemporary Hard Edge abstraction (see Chapter 16).

Indiana used this commercially derived idiom subversively to address social and political problems, as in *Black Diamond American Dream #2* (1962, Figure 15.10) from his *American Dream* series. Described by Indiana as "generous, optimistic, and naïve,"[35] this dream envisions the United States as a land of freedom and opportunity where everyone can achieve prosperity. However, Indiana recognized that oppressive forces including racism, sexism, homophobia, and economic inequality keep millions of Americans from realizing their dreams. His painting evokes the American road through star-surrounded words boldly advertising diners ("EAT"), jukeboxes ("JUKE"), and money (through the slang term "JACK"). Its punchy graphics and amped-up **palette** belie the depressing atmosphere of the "grubby bars and roadside cafés, alternate spiritual homes of the American"[36] that for Indiana perverted "the 'Dream' . . . into a very cheap, tawdry experience."[37]

Much simpler visually and verbally than the *Black Diamond American Dream #2* is Indiana's most famous creation: the representation of the word "LOVE" in a square layout with a tilted *O*. The vivid red letters set against areas of green and blue create an "optical, near-electric quality."[38] Indiana first realized *LOVE* in 1965 as a Christmas card design for MoMA. He went on to produce many variations in multiple **mediums**, including outdoor sculptures. By distilling an enormously rich and complex subject into a "one-word poem,"[39] Indiana invited viewers to project onto the artwork their own emotional, erotic, spiritual, or other associations with the concept of love.[40] His image soon became a symbol of the countercultural and free

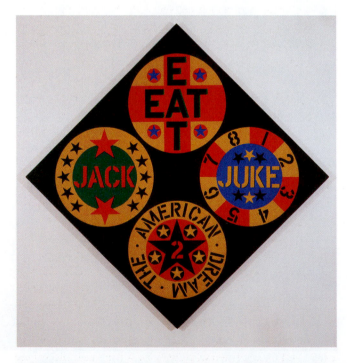

FIGURE 15.10 Robert Indiana, *Black Diamond American Dream #2*, 1962. Oil on canvas, 152.5 x 152.5 cm. Museu Coleção Berardo, Lisbon.

love movements of the late 1960s. Since he did not copyright it, it was also subject to countless commercial knockoffs—Pop art reclaimed by the consumer culture that inspired it.

Tom Wesselmann (1931–2004)

Tom Wesselmann's principal contribution to Pop art was his *Great American Nudes* series of the early 1960s. Depicting sinuous, silhouetted, depersonalized female nudes in domestic settings, these visually bold, formally rigorous mixed-media works (e.g., *Great American Nude #4*, 1961) updated the Western tradition of the reclining female nude. Wesselmann often surrounded the nudes with reproductions of paintings by artists such as Leonardo da Vinci, Gilbert Stuart, and Matisse, as well as photographic or plastic representations of American consumer products, suggesting Pop art's leveling of cultural hierarchies. Juxtaposing nude women with supermarket items also implied that their bodies were offered up for consumption by the heterosexual male viewer. The *Great American Nudes* resonated with liberalization of American attitudes toward sexuality in the late 1950s and early 1960s. This period saw the relaxation of obscenity laws, the ongoing impact of the Kinsey Reports on human sexual behavior, the success of *Playboy* magazine, and the introduction of the birth control pill.[41] While Wesselmann's works were well received in the early 1960s, later feminist critics deplored their objectification of women's bodies.

Jim Dine (b. 1935)

Jim Dine's paintings and **assemblages** featuring everyday objects earned him recognition as a Pop artist in the early 1960s, although he was never comfortable with the label. Dine began his career as a creator of **Happenings**, five of which he presented in New York in 1960, including *The Smiling Workman*, a performance in which he scrawled the words "I love what I'm doing" on a huge canvas, drank paint from a can, and jumped through the canvas. Dine went on to create hybrid combinations of painting and real objects, such as *Five Feet of Colorful Tools* (1962). In this work, thirty-two tools spray-painted in bright colors hang from a board across the top of a bare canvas. Behind them are the tools' ghostly spray-paint defined silhouettes. Dine rearranged the actual tools so that they no longer align with these outlines, heightening awareness of the gap between the tools' physical presence and the traces of their previous positions. Tools were a highly personal subject for Dine, whose grandfather ran a hardware store in Cincinnati. Another personal subject was the bathrobe, an image of which he copied from a newspaper advertisement and used as a surrogate self-portrait in paintings and prints from mid-1960s onward (e.g., *Bathrobe*, 1964). Dine feels that his art's autobiographical quality distinguishes it from Pop: "Pop is concerned with exteriors. I'm concerned with *interiors*. When I use objects I see them as a vocabulary of feelings."[42]

George Segal (1924–2000)

Often considered a Pop sculptor, George Segal represented ordinary contemporary Americans as plaster-molded figures surrounded by real objects and architectural elements from domestic, urban, or roadside settings. His figures differ from standard Pop imagery in their solemnity and loneliness. Segal made his sculptures by covering his models with plaster-soaked bandages and assembling the hollow pieces after they had dried. The sculptures' rough white surfaces record his gestural manipulation of the liquid plaster, but the frozen mummy-like figures, with closed eyes and blank expressions, are impassive and inscrutable. Segal frequently placed them in environments extracted from actual structures, including a diner, a gas station, and an airport. By situating lifelike yet ghostly figures within literal yet constructed settings, he generated fascinating tensions between absence and presence, art and life.

In *The Diner* (1964–66, Figure 15.11), the plaster figure of a male customer sits at the counter on a leatherette stool. Opposite, a female server fills a coffee cup from a metal urn under the cold light of an overhead fluorescent fixture. The red panel behind the urn injects vivid color into the otherwise

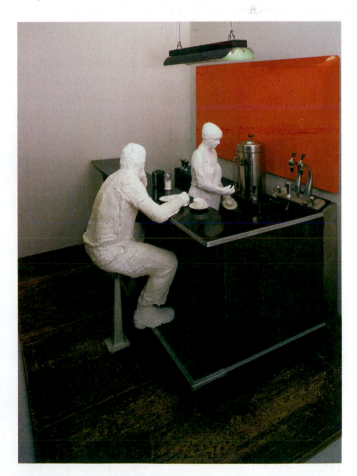

FIGURE 15.11 George Segal, *The Diner*, 1964–66. Plaster, wood, chrome, laminated plastic, Masonite, fluorescent lamp, glass, paper, 238.13 x 365.76 x 243.84 cm. Walker Art Center, Minneapolis.

stark palette of black, dark green, white, and stainless steel. Described by Segal as "the essence of every New Jersey diner," the work was inspired by his late-night coffee stops at diners on drives back from Manhattan to his New Jersey home.[43] He aimed to suggest a sense of psychic distance between the customer and server, paradoxically heightened by their physical closeness. In its subject matter and mood, Segal's tableau prompts comparison to Edward Hopper's famous painting *Nighthawks* (1942), which also shows lonely customers seated at the counter of all-night diner under fluorescent lights.

Marisol (1930–2016)

The Venezuelan American sculptor Marisol made distinctive figurative sculptures in the 1960s out of carved and assembled wood, embellished with drawing and paint, cast body parts, found objects, and articles of clothing. Her depiction of everyday American scenes, celebrities and political leaders, her use of real objects, and her friendship with Andy Warhol led her to be associated with Pop art.

Marisol's tableau of a white upper-middle-class family out for a stroll, *The Family* (1963, Figure 15.12), exemplifies her inventive combination of mediums, whimsical humor, and sharp social observation.[44] She created the stroller by placing a carved and painted wood baby basket on an actual chassis. Playful details proliferate: the babies have adult-size cast plaster feet; one carriage wheel is made of wood; the red-clad girl has three legs; and the father is clad below the knee in real trousers and shoes. Marisol signifies the family's class through the expensive baby carriage; the hats, gloves, and Mary Janes; the mother's fashionable polka-dot patterned dress; and the father's stylish sport coat and red tie. The humorous elements suggest a satire of the stable and happy nuclear family, promoted in the period's popular culture and women's magazines, in which the woman finds fulfillment as a housewife and mother (note how Marisol surrounds the smiling mother with her children while the husband stands stiffly to the side). In *The Feminine Mystique* (1963), dating to the same year as Marisol's sculpture, Betty Friedan revealed that many suburban American women felt confined by their domestic roles; she advocated that they pursue education and careers outside the home. Significantly, Marisol herself never married or had children but devoted herself fully to her artistic profession. We can imagine her rejecting the mother's position in *The Family*, hemmed in by four children and with her identity obscured by the hat pulled over her eyes.

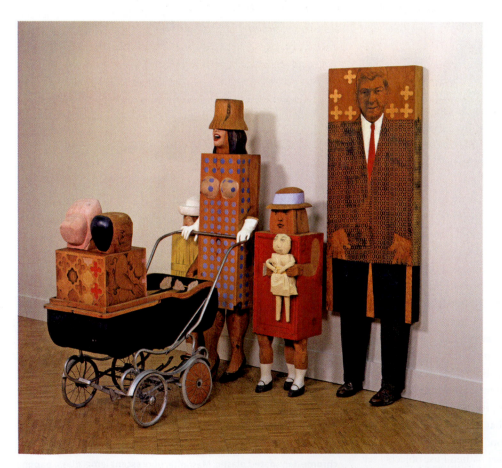

FIGURE 15.12 Marisol, *The Family*, 1963. Wood, metal, graphite, textiles, paint, plaster and other accessories, 202 x 160 x 185 cm. Currier Museum of Art, Manchester, New Hampshire.

California Pop

Regional variants of Pop art emerged in the early 1960s in the San Francisco Bay Area and in Los Angeles. Pop was particularly visible in the latter city, where Andy Warhol had his first solo exhibition at the Ferus Gallery in July 1962, showing his thirty-two *Campbell's Soup Cans*. In September 1962, the first museum exhibition of American Pop art, *New Painting of Common Objects*, opened at the Pasadena Art Museum, curated by Walter Hopps. Along with Dine, Lichtenstein, and Warhol, it included Ed Ruscha and Wayne Thiebaud, who became recognized as the most important California Pop artists.

Ed Ruscha (b. 1937)

Ed Ruscha moved from Oklahoma to Los Angeles in 1956 to study at the Chouinard Art Institute (now CalArts) and supported himself as a graphic designer following graduation. Magazine

reproductions of Johns and Rauschenberg works that Ruscha saw in the late 1950s prompted him to reject the Abstract Expressionist aesthetic then prevailing at Chouinard and to make art responding to the everyday world. He did so in a series of documentary photobooks and paintings of words and roadside commercial signs and buildings.

Ruscha's first photobook, *Twentysix* [*sic*] *Gasoline Stations*, presents unremarkable black-and-white photographs of twenty-six filling stations taken on Route 66 between Los Angeles and his parents' home in Oklahoma City. The text consists only of captions identifying each station by its name and location. The deadpan take on quotidian subject matter—roadside architecture dominated by advertising signage—is characteristic of Pop art. *Twentysix Gasoline Stations* and subsequent photobooks, such as *Every Building on the Sunset Strip* (1966), also prefigure **Conceptual art** because they are generated by a simple idea realized through mundane, serial imagery. Ruscha's banal, artless photographs manifested his provocative opinion that "photography is dead as a fine art; its only place is in the commercial world, for technical or information purposes."[45] Ruscha declared, "My pictures are not that interesting, nor the subject matter. They are simply a collection of 'facts'; my book is more like a collection of 'readymades.'"[46] Ruscha's reference to readymades identifies a kinship with Duchamp, whose first-ever retrospective was held in 1963 at the Pasadena Art Museum.

Ruscha based his painting *Standard Station, Amarillo, Texas* (1963, Figure 15.13) on a photograph in *Twentysix Gasoline Stations*, but he transformed the commonplace building into a sleek, monumental presence on a three-meterwide canvas. Employing his graphic design skills, Ruscha renders the filling station as a streamlined structure slicing diagonally across the canvas as it recedes in **two-point perspective**. The brightly lit station is dramatically silhouetted against a black sky raked at the left by yellow bands of searchlights, used to

FIGURE 15.13 Ed Ruscha, *Standard Station, Amarillo, Texas*, 1963. Oil on canvas, 164.9 × 309.4 cm. Hood Museum of Art, Dartmouth College, Hanover, New Hampshire.

advertise special events such as movie premieres and grand openings. With no hint of irony, Ruscha's painting exalts the gasoline station as a glamorous icon of the American way of life centered on the automobile, roads, and highways.

Wayne Thiebaud (1920–2021)

Using a **painterly** realist style influenced by Willem de Kooning and the Bay Area Figurative artists (see Chapter 12), the Northern California artist Wayne Thiebaud painted orderly arrangements of cakes, cake and pie slices, hot dogs, and other typically American foods in the early 1960s. Thiebaud's paintings, like 1961's *Pies, Pies, Pies* (Figure 15.14), were based on his experience

FIGURE 15.14 Wayne Thiebaud, *Pies, Pies, Pies*, 1961. Oil on canvas, 50.8 x 76.2 cm. Crocker Art Museum, Sacramento, California.

of working in restaurants and his memories of bakery counters and window displays of food. These pictures earned him recognition as a Pop artist when shown in New York in 1962, despite the aesthetic differences between his work and that of his East Coast peers. Thiebaud's repeated images of mass-produced food items displayed for sale resonated with Warhol's serial images of consumer products. However, instead of creating flat, unexpressive surfaces, Thiebaud laid on his paint in thick, luscious layers that imitated both the appearance and texture of substances like cake icing and meringue. He also increased his compositions' visual allure by outlining their brightly lit forms with thin bands of prismatic color and by rendering blue shadows that throw the foodstuffs' warm **hues** into relief. Finally, he sought to invest his images of tantalizing abundance with a sense of "yearning" very different from New York Pop's deadpan quality.[47]

German Capitalist Realism

Gerhard Richter, Sigmar Polke, and Konrad Lueg (later the art dealer Konrad Fischer), who met at the Düsseldorf Art Academy in 1961, made the principal German contribution to Pop art under the label Capitalist Realism. The name acknowledged **Socialist Realism**, the only approved style in East Germany (from which Richter and Polke had emigrated), and the capitalism of West Germany. American Pop art inspired Richter, Polke, and Lueg to reject their teachers' *art informel* orientation and engage artistically with banal subject matter from everyday life and mass media. In 1963, Lueg and Richter staged an exhibition in a Düsseldorf furniture store, *Life with Pop: A Demonstration for Capitalist Realism*, in which the artists appeared in business attire as "living sculptures" seated on furniture on pedestals on either side of a television set tuned to the news. Although partly inspired by Oldenburg's *The Store*, Lueg and Richter's exhibition responded to conditions in Germany, which had experienced an "economic miracle" of rapid growth in industrial production and employment in the 1950s and an increase in mass media. Wrote Richter in 1963, "Pop art is not an American invention, and we do not regard it as an import. . . . This art is pursuing its own organic and autonomous growth in this country; the analogy with American Pop Art stems from those well-defined psychological, cultural and economic factors that are the same here as they are in America."[48] Richter's and Polke's later work is discussed in Chapter 20.

Gerhard Richter (b. 1932)

Gerhard Richter developed outstanding skills as a traditional representational artist through training at the Dresden Art Academy before his 1961 move to Düsseldorf. There, he encountered the latest trends in international **avant-garde** art, including **Fluxus**, whose anarchistic attitude freed him to break from his conservative East German education and the conventions of Western modernism. He did so by making paintings based on black-and-white photographs that he projected onto his canvases and replicated by hand. He remarked that the photograph offered him "a new view, free of all the conventional criteria I had always associated with art. It had no style, no composition, no judgment. It freed me from personal experience. . . . there was nothing to it: it was pure picture."[49] While he appropriated some of his source photos from the mass media, as did Warhol and other American Pop artists, Richter took many from family albums or shot them himself. Unlike Warhol, he largely avoided images of well-known people or events. He instead chose photographs whose subjects most viewers would not recognize, making them seem generic. He also obscured his subjects' identity by blurring his compositions through swipes of a dry paintbrush over wet paint. This blurring creates effects of ambiguity and ephemerality and heightens the viewer's awareness that the hand-painted, photo-based images are twice removed from their referents in the real world. The photo-based paintings ultimately express Richter's belief that reality is elusive. "I can make no statement about reality clearer than my own relationship to reality; and this has a great deal to do with imprecision, uncertainty, transience, incompleteness."[50]

In some cases, the photo-based paintings' gray, deadpan quality contradicts their charged subject matter. For example, *Uncle Rudi (Onkel Rudi)* (1965, Figure 15.15), the streaked image of a Nazi officer, is a troubling reminder of Germany's recent imperialist aggression and genocide. The image of the uniformed man proudly smiling for the camera resonates with philosopher Hannah Arendt's argument about the "banality of evil": ordinary people, not fanatics, perpetrated great historical crimes like the Holocaust because they accepted those crimes' normalization by the state. The fact that this Nazi officer was Richter's uncle, who died in Normandy in 1944, gives the image personal as well as historical meaning.

Sigmar Polke (1941–2010)

Like his close friend Richter, Sigmar Polke made paintings based on photographs published in the mass media. Polke's *Rasterbilder* (raster paintings) focused on the mechanisms used to reproduce images for broad distribution. "Raster" is a term that describes the screen or grid guiding the electron beam that generates an image on a television screen or computer monitor. In commercial printing, the rastering process divides the original photograph's tones into individual Benday dots that merge into a seamless image when seen from a distance. Polke, in his raster paintings, accentuated the dots so that they interfere with the image's legibility and take on a life of their own. In this, they differ from the Benday dots in Lichtenstein's paintings, which simply create tone.

Polke's *Bunnies* (1966, Figure 15.16) depicts a quartet of Playboy Bunnies in a Playboy Club, one of *Playboy* magazine publisher Hugh Hefner's worldwide chain of nightclubs in which

FIGURE 15.15 Gerhard Richter, *Uncle Rudi (Onkel Rudi),* 1965. Oil on canvas, 87 x 49.5 x 2.5 cm. Lidice Memorial, Prague.

FIGURE 15.16 Sigmar Polke, *Bunnies,* 1966. Synthetic polymer on linen, 149.2 x 99.3 cm. Hirshhorn Museum and Sculpture Garden, Washington, DC.

the attractive young waitresses wore one-piece costumes with cuffs, bow ties, and bunny tails and ears. Using three different systems of large dots to create off-register effects, Polke disrupts the allure of the Playboy Bunny image, designed and marketed to arouse heterosexual male desire. By rendering it imperfect, he suggests that it is a false and decadent construct. Polke's tendency to undermine the capitalist-driven craving for commodities in his raster paintings sets him apart from most other Pop artists.

Pop Art in Argentina

Rising consumerism and the efflorescence of popular culture and mass media in 1960s Argentina inclined many of its young artists to embrace Pop art. In Buenos Aires, the work of Argentine Pop artists, including Alfredo Rodríguez Arias, Delia Cancela, Edgardo Giménez, Pablo Mesejean, Marta Minujín, Dalila Puzzovio, Susana Salgado, Rubén Santantonín, Carlos Squirru, and Juan Stoppani, was seen on the streets, in private galleries, and in prestigious venues such as the Centro de Artes Visuales (CAV) of the Instituto Torcuato di Tella (ITDT). In addition to creating paintings, sculptures, **graphic art, installations**, environments, and Happenings, many Argentine Pop artists from the mid-1960s used the mediums of mass communication and marketing as their artistic means. For example, Puzzovio, Squirru, and Giménez rented a billboard presenting a photograph of the smiling artists holding their artworks surmounted by the question, "Por qué son tan geniales?" (Why are they so brilliant?). This work challenged traditional notions of art's separation from daily life by using an advertising format to address the urban public—predicting the work of Jenny Holzer and other postmodern media artists of the 1980s (see Chapter 20). Argentine Pop artists in the late 1960s also designed apartment interiors, movie sets and wardrobes, jewelry, and fashion, further merging art with everyday life and popular culture.

Delia Cancela (b. 1940)

Delia Cancela made collages incorporating men's and women's clothing and magazine photos, placing her early 1960s work at the leading edge of the Buenos Aires Pop movement. Interested in women's social and cultural experiences, Cancela addressed *Broken Heart* (1964, Figure 15.17) to the cliché of heartbreak conventionally associated with feminine sentimentality. The mixed-media work features the flat painted image of a red heart whose lower left side is eaten away. Six **biomorphic**, red-painted wood shapes, one collaged with the photograph of a young white woman, dangle below from silk ribbons. These shapes suggest the heart's missing pieces as well as the body's internal organs. Cancela called the heart "a symbol of womanhood, as in popular women's magazines. . . . a symbol emerged from the mass media, a kind of naive image of women."[51] Her work challenges the heart's naïve and sentimental symbolism through the attached objects that evoke the fleshy body.[52] The dangling shapes also invite viewers to imagine reassembling the broken heart, turning them from passive consumers into active participants.

In 1965, Cancela started collaborating with her life partner Pablo Mesejean (1937–91). For their first show, *Love and Life*, the duo decorated a Buenos Aires gallery with flowers and figures of astronauts; visitors were greeted by hostesses in vinyl dresses who gave them sunglasses and appliqué flowers, transforming the exhibition into a kind of Happening. In 1966, Cancela and

FIGURE 15.17 Delia Cancela, *Broken Heart*, 1964. Oil paint on canvas, lace and painted wood panels, 150 x 100 cm. Collection of Mauro Herlitzka.

Mesejean issued a manifesto, "Nosotros amamos" (We love), in which they declared their love for pop culture ranging from the Rolling Stones to Sonny and Cher to Yves Saint-Laurent. In the late 1960s they began designing clothing and in 1970 moved to London, where they launched their own fashion label.

Marta Minujín (b. 1943)

Marta Minujín encouraged the viewer's physical and sensory involvement in her Pop works. In 1964, she won the national Di Tella Award for *¡Revuélquese y viva!* (*Roll around and live!*), a "livable structure" made of mattress-like stuffed fabric painted in colorful stripes. Visitors could enter it to the accompaniment of music. The title's prompting of the audience to "roll around and live" in a bed-like environment resonated with the 1960s atmosphere of sexual liberation. The next year, Minujín collaborated with Rubén Santantonín and other artists to create a multiroom, multilevel environment in the Centro de Artes Visuales, *La Menesunda* (slang for "chaos" or "confusion"). Inspired by the city's energetic disorder, the labyrinthine environment led visitors through a series of spaces, starting with a tunnel lit by neon signs and infused with the smell of frying oil, evoking a busy Buenos Aires street.[53] Next came a tunnel filled with blaring TV sets tuned to local stations and two TVs connected to closed-circuit cameras recording the visitors themselves. The latter technological feature was an exciting, groundbreaking concept in 1965 that today prompts associations with mass surveillance. The next two rooms harbored live performers. In the first, a man and woman in pajamas lay in bed chatting and listening to the Beatles—a risqué reference to free love in a Catholic country dominated by strict views on morality. In the next room, shaped like a woman's head and decorated with cosmetics, a beautician and a masseuse offered their services (Minujín intended the room as a critique of housewives whom she believed spent most of their time buying and applying makeup). Visitors then navigated other spaces providing diverse sensory experiences, such as a passage filled with pink-painted polyethylene tubing resembling intestines and a corridor completely lined with foam. The journey ended in an octagonal mirrored room featuring ultraviolet lights and confetti blown around by fans. The enormously popular fifteen-day exhibition attracted an estimated thirty thousand people, many of whom queued for hours waiting to enter. Minujín hoped that experiencing *La Menesunda*'s multisensory stimuli would liberate visitors from their passive acceptance of a Christian society and bourgeois consumerism.[54]

Pop Art and Politics in Brazil

A trend known as New Figuration with similarities to US Pop flourished in Brazil between the 1964 military coup that overthrew President João Goulart and the 1968 proclamation of Institutional Act No. 5 that hardened authoritarian rule. New Figuration reacted against the geometric abstraction of the **Concrete** and **Neo-Concrete** movements of the 1950s and

early 1960s (see Chapter 14). Like US Pop, it drew on imagery from popular and commercial culture and rejected the elitism of "high" art while embracing everyday life. New Figuration was also similar to US Pop in employing styles and techniques derived from graphic design and commercial art. What distinguished New Figuration from much US Pop was its intense involvement with social and political issues. Brazilian artists who addressed charged topical themes through Pop-inflected works in the 1960s included Antônio Henrique Amaral, Antonio Dias, Rubens Gerchman, Nelson Leirner, Anna Maria Maiolino, Antonio Manuel, Marcello Nitsche, Wanda Pimentel, Teresinha Soares, Cláudio Tozzi, and Cybèle Varela.

Antonio Dias (1944–2018)

Critic Mário Pedrosa identified Rio de Janeiro artist Antonio Dias as one of the "'popists' of underdevelopment," contrasting the work of artists from underdeveloped regions with that made in affluent countries.[55] Pedrosa alluded to Dias's origins in Brazil's drought-stricken state of Paraíba and stressed his art's passion and violence in opposition to the detached, "journalistic" approach of US Pop. Dias's striking mixed media work, *Nota sobre a Morte Imprevista (Note on the Unforeseen Death)* (1965, Figure 15.18), features a large wooden diamond

recalling a traffic sign, subdivided into smaller diamonds containing images of skulls, bones, toxic gas and gas masks, a mushroom cloud, and a clawed animal paw. These are rendered in red, black, yellow, and white in a simple graphic style influenced by Brazilian comic books. Below, a cloverleaf-shaped cushion-like form surrounds a plexiglass-fronted case displaying a red object resembling human flesh. A black vinyl form oozes from the base of the case to the floor, its shapeless, abject quality strongly contrasting that of the tightly rendered images above. The cheery Pop-style imagery exists in tension with the disturbing references to violence, dismemberment, war, and death. These resonate with the ominous title alluding to the repressive atmosphere created by the military dictatorship.

Wanda Pimentel (1943–2019)

One of the few Brazilian artists to address women's issues in the 1960s, Rio de Janeiro-based Wanda Pimentel used a graphic-design influenced hard-edge Pop style to depict intimate domestic scenes in her *Envolvimento* (Involvement) series, begun in 1968. She inserted the flat white forms of her own legs and feet into these compositions to indicate a feminine presence. In the work illustrated here (Figure 15.19), large geometric planes

FIGURE 15.18 Antonio Dias, *Nota sobre a Morte Imprevista* (*Note on the Unforeseen Death*), 1965. Acrylic, oil, vinyl, plexiglass on fabric, and wood, 195 x 176 x 63 cm.

FIGURE 15.19 Wanda Pimentel, *Involvement Series*, 1968. Vinyl on canvas, 130 x 98 cm. The Art Institute of Chicago.

of blue, purple, and white create a claustrophobic interior with a red ironing board cropped at the right by a diagonal row of hanging blouses. The artist's toes dangle from behind the ironing board. The absence of the woman's body suggests her entrapment within this domestic space. Critic Frederico Morais observed that "Everything in [Pimentel's] work—themes, images, coloring, space connection, and graphic structure—is used in order to increase a feeling of oppression and confinement."[56] Pimentel's painting reads as a quiet protest against middle-class urban white women's lack of independence outside the domestic sphere—a protest that became much louder with the emergence of the women's movement in Brazil in the mid-1970s.

Japanese Pop

American popular culture flooded into Japan during the US Occupation (1945–52), creating fertile ground for the development of American-style Pop art. Japanese Pop artists took up strategies from American Pop: they adopted motifs from popular culture and used commercial art techniques and styles. However, they produced a distinct Japanese expression by appropriating imagery from their own country's rich tradition of popular visual culture, both premodern and modern. Exemplary of the premodern tradition are the *ukiyo-e* **woodblock prints** of the late Edo Period (1603–1868) that depicted actors,

famous courtesans, and scenic locales, providing inexpensive pictorial entertainment to people of all classes. These prints' strong graphic style featuring flattened space and decorative patterns was readily adaptable to the hard-edge aesthetic of 1960s Pop. The principal Japanese Pop artists were Ushio Shinohara, Tiger (Kōichi) Tateishi, Keiichi Tanaami, and Tadanori Yokoo.

Ushio Shinohara (b. 1932)

The pivotal figure in Japanese Pop, Ushio Shinohara was a leading member of the Tokyo-based Neo Dada group in the years around 1960. He gained notoriety through his *Boxing Paintings*—gestural abstractions he created by means of punching paper or canvas with paint-soaked sponges attached to boxing gloves. Shinohara's 1963 discovery of American Pop through magazine reproductions prompted his *Imitation* series, crude works based on compositions by Johns and Rauschenberg. These imitations function as parodies, commenting on their models' lack of originality by using the same motifs (the American flag and Coca-Cola bottles) that Johns and Rauschenberg appropriated from American culture (Rauschenberg incorporated Coca-Cola bottles into some of his Combines).

Shinohara next turned to his own country's historic popular culture—*ukiyo-e* woodblock prints—for his subject matter. *Doll Festival* (1966, Figure 15.20) depicts *ukiyo-e* figures in a slick Pop style achieved through fluorescent paint applied

FIGURE 15.20 Ushio Shinohara, *Doll Festival*, 1966. Fluorescent paint, oil paint, plastic board on plywood, 196.1 x 399.7 cm. Hyogo Prefectural Museum of Art (The Yamamura Collection), Kobe, Japan.

with an airbrush to wood panel and sections of custom-cut acrylic sheets.[57] The title refers to the annual festival dedicated to prayers for the future prosperity of daughters of well-to-do families. Rather than depicting the dolls of the emperor, empress, and court ladies typically displayed in this festival, however, Shinohara's painting brings together characters adapted from different *ukiyo-e* prints, depersonalized through the blank white shapes signifying their faces, arms, and hands. From the left, they are a parade leader, a townswoman, a bowler-hatted man, a male prostitute (*wakashū*), and a high-class courtesan (*oiran*) with elaborate hairpins. Shinohara culled the central man's image from an early Meiji Period (1868–1912) print. The print demonstrates Tokyo's transformation through rapid Westernization, showing some people clad in European-style clothing and others wearing Japanese kimono. This "sense of mismatch"[58] resonated with Shinohara's experience of Japan's Americanization during and after the Occupation. Such incongruity characterizes the artwork as a whole, with its translation of nineteenth-century motifs into a contemporary Pop idiom generating a clash between past and present. Shinohara moved to New York in 1969 and continued his engagement with popular culture by making lumpy painted cardboard sculptures of oversized motorcycles.

Tadanori Yokoo (b. 1936)

Tanadori Yokoo, who began his career in Tokyo in 1960 as a stage designer, created posters infused with a Pop sensibility. An early screenprint, *Tadanori Yokoo (Matsuya)* (1965), declares his Pop style's main characteristics: bright, flat, crisply outlined colors; bold typography; the use of familiar, even clichéd motifs; and **photomontage**. The print features English texts: "Made in Japan/ Tadanori Yokoo/Having Reached/a Climax at the Age of 29,/I was Dead." Its hackneyed iconography includes images of Mount Fuji in the upper corners and a stylized rising sun (adapted from the banned Japanese imperial military symbol) against which is suspended a hanged male figure (presumably the artist). A photograph of Yokoo as an infant appears at the lower left and a class photo of boys and girls in school uniforms appears at the lower right, overlain by the graphic image of a feminine hand making an obscene gesture. Despite the print's darkly humorous prediction of an early death, Yokoo went on to an illustrious career, receiving commissions for posters advertising consumer products and significant cultural events, such as the 1968 *Word and Image* exhibition at MoMA, which gave him a solo exhibition 1972. During the 1970s, Yokoo designed album covers for international recording artists such as Santana and Miles Davis, becoming the best-known Japanese graphic designer of his generation.

Abstraction in North America and Europe in the 1960s

This chapter surveys abstract art of the 1960s in North America and Europe, including Post-Painterly Abstraction, Op and kinetic art, Minimalism, and Light and Space art. In general, this art turned away from the postwar, human-centered values of Abstract Expressionism, *art informel*, and existentialist-oriented forms of figuration (see Chapters 12, 13) to conceive of the artwork as an impersonal object that revealed nothing about its maker's psyche or subjective concerns. The decade's younger abstract painters rejected Abstract Expressionist action painting and *art informel*'s gestural brushwork, tactile surfaces, and emotionalism. The new abstract painting was instead characterized by neutral forms of paint handling (smoothly brushed, poured, rolled, or sprayed), flat surfaces, and an objective attitude that emphasized formal and material qualities rather than the artist's personal feelings. The decade's abstract sculpture and work in new mediums manifest a similar trend.

The tendency to replace self-revelation with a revelation of phenomena external to the artist is one the abstractionists shared with their contemporaries, the Pop artists. Whereas the latter welcomed images and objects from the everyday world into their art, however, the abstractionists sought to purge their work of everything extraneous to art itself: they made paintings, sculptures, and works in new mediums possessing their own undeniable reality. As the critic and historian Irving Sandler observed, artists of the 1960s looked "at things for what they actually were and not as metaphors of human feelings. . . .Thus there was a shift—from psychology to physicality, from interpretation to presentation . . . to seeing things as they literally are and 'saying it like it is,' a catchphrase of the sixties."[1]

Sandler contextualized this "sensibility of the sixties" within a larger intellectual discourse.[2] Artist Marcel Duchamp and composer-philosopher John Cage both rejected the concept of art as an expression of the artist's ego; Cage proposed that everyday objects and experiences, like Duchamp's readymades, could be art, blurring the distinction between art and life (see box, Chapter 14). Although diametrically opposed to Cage's merger of art and life, painter Ad Reinhardt's "art-as-art" philosophy (see Chapter 12) likewise rejected self-expression to emphasize the work's purity and autonomy. Clement Greenberg similarly maintained that the artwork should refer to nothing outside of itself and be self-sufficient. In her influential essay "Against Interpretation," Susan Sontag argued that art's most liberating value is "experiencing the luminousness of the thing in itself," and that criticism should carefully describe the artwork's form rather than seek to reveal its meaning.[3] Ludwig Wittgenstein's positivist philosophy, which gained new attention in the 1960s, held that description should replace explanation—a position akin to Sontag's. Finally, theorist Marshall McLuhan also stood against interpretation in arguing that new communications technologies like the telephone, radio, television, and computer transformed human consciousness not through their content but through their alteration of people's sensory patterns, as summed up in his aphorism, "the medium is the message."[4]

Post-Painterly Abstraction

The dominant form of nonrepresentational painting in North America in the years around 1960 was **Post-Painterly Abstraction**, a term Greenberg coined in 1964.[5] He presented Post-Painterly Abstraction as the latest advance in what he theorized as **modernist** painting's progressive drive, from **Impressionism** onward, toward purity. This involved painting ridding itself of all conventions not belonging to the **medium** itself, such as narrative, figuration, and spatial depth, in order to concentrate on its inherent properties: pure flat color spreading across a two-dimensional surface.[6] By the late 1950s Greenberg had turned against "painterly painting," exemplified by Willem de Kooning's work (see Figures 12.6, 12.7), because, even if it contained no recognizable **subject matter**, its tactile **brushwork** and **value** contrasts created **illusionistic** space that contradicted pictorial flatness. Greenberg instead favored the **Color Field paintings** of Clyfford Still, Mark Rothko, and Barnett Newman (see Figures 12.10, 12.11, and 12.12), who created "a new kind of flatness" in large canvases whose surfaces, "broken by relatively few incidents of drawing or design . . . exhale color with an enveloping effect that is enhanced by size itself."[7]

The younger Post-Painterly Abstractionists made paintings tending toward "a physical openness of design, or towards linear clarity, or towards both."[8] Post-Painterly Abstraction encompasses **Stained Canvas Color Field** painters who applied diluted paint onto raw canvas to infuse it with flat color, such as Helen Frankenthaler, Morris Louis, Kenneth Noland, Jules Olitski, and Jack Bush, and the related Color Field works of Alma Thomas, who painted with a brush. It also encompasses **Hard Edge** painters such as Ellsworth Kelly, Carmen Herrera, Jack Youngerman, Leon Polk Smith, Al Held, and Al Loving whose **compositions** comprise large, flat, sharply defined **shapes**. Two other Post-Painterly Abstractionists, Agnes Martin and Frank Stella, paved the way for **Minimalism** through their use of monochrome **palettes** and modules organized according to a preconceived system.

Stained Canvas Color Field Painting

Stained Canvas Color Field painting is a mode of nonrepresentational art in which the artist applies diluted paint onto unprimed canvas so that the color bleeds into the two-dimensional surface, producing the effect of dyed cloth. Stained canvas paintings of the late 1950s and 1960s are often very large. Greenberg, who championed this form of **abstraction**, argued that it required a large format so that the painting fills the viewer's field of vision to lose its character as a "discrete tactile object" to become "a strictly visual entity."[9]

Helen Frankenthaler (1928–2011)

The New York-born Helen Frankenthaler pioneered Stained Canvas Color Field painting after Greenberg took her to Jackson Pollock's studio, where she saw how Pollock puddled **enamel** paint directly onto unprimed canvas laid out on the floor. Adopting a similar practice, she created a large painting, *Mountains and Sea* (1952), by pouring thinned-out **oil paint** onto her raw canvas. This produced streams and pools of translucent blues, greens, and reds, contained in some areas within looping gestural lines she had drawn in charcoal to guide her pouring. Described by the artist as an "abstract memory"[10] of Nova Scotia's coastal landscape that she had depicted in **watercolor**, *Mountains and Sea* is important more for its technique than its subject matter. Frankenthaler's thin oil paint soaked into the canvas to create textureless expanses of liquid color resting within the canvas weave.

Frankenthaler often used whip-like gestural lines in her paintings of the later 1950s and early 1960s (e.g., *Round Trip*, 1957) before transitioning to make broad shapes of lush, poured color, whose irregular edges she sometimes defined with a brush. Prompting this stylistic change was her shift from oil to **acrylic** paint, which she favored for its fluidity, durability, and quick-drying nature. Exemplary of Frankenthaler's work in this vein is *The Bay* (1963, Figure 16.1), its composition dominated by a billowing **abstract** shape of varied blues floating above green and gray zones. Like all her pictures, this one arose from an unpremeditated painting process, much like improvised music, yet Frankenthaler's experience of the world also affected the painting's appearance. She executed it in her bayside Provincetown studio and titled it after laying down the large blue area, which made her think of "the bay—of weather, but in terms of abstract shapes."[11] Frankenthaler spoke in general of her paintings as "full of climates, abstract climates and not nature per se, but . . . the feeling of an order that is associated with nature. . . . I think art itself is order out of chaos, and nature is always fighting that same battle."[12]

Morris Louis (1912–1962)

The Washington, DC-based painter Morris Louis adopted Stained Canvas Color Field painting after a 1953 visit in the company of Greenberg and Kenneth Noland to Frankenthaler's New York studio, where they saw her recently completed *Mountains and Sea*. To make two series of pictures (1954 and 1958–59), Louis tacked unprimed canvas onto a large stretcher and poured successive paint layers over the surface, tilting the stretcher to control the streams of color. Rather than oil, he used Magna, an oil-miscible acrylic resin paint that he could thin to the consistency of watercolor. Magna dried quickly, allowing the application of several colors in a single painting session without muddying the hues. The resulting fanlike

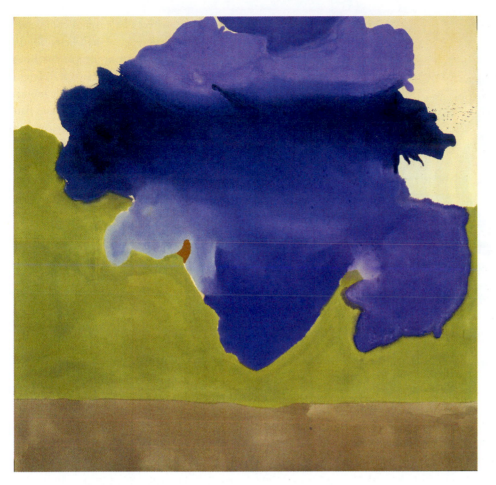

FIGURE 16.1 Helen Frankenthaler, *The Bay,* 1963. Acrylic on canvas, 204.2 x 208.6 cm. Detroit Institute of Arts.

Kenneth Noland (1924–2010)

Louis's fellow Washington, DC–based painter Kenneth Noland also adopted the stained canvas painting technique after seeing Frankenthaler's *Mountains and Sea*. Like Frankenthaler, Noland frequently painted on unprimed canvas spread across the floor. This allowed him to approach his work from every side and encouraged him to develop the centrally oriented, symmetrical composition of nested circles that became his signature format in 1958. Noland began these pictures by staining a crisp circle into the center of a nearly square canvas and then surrounding it with concentric rings. This simple arrangement freed him to concentrate on variables such as the width, number, spacing, edge definition and color of the circular areas. *Whirl* (1960, Figure 16.3) has a central orange circle orange surrounded by bands of white, green, black, and aqua blue, demonstrating Noland's

patterns of subtly blended, close-valued hues led these paintings to be called *Veils* (e.g., *Tet*, 1958). Greenberg hailed their "purely optical" quality of disembodied color devoid of tactile associations.[13]

In a subsequent series, the *Unfurleds* (1960–61), exemplified by *Beta Kappa* (1961, Figure 16.2), Louis achieved radical simplicity by pouring separate, irregular rivulets of **saturated** color diagonally inward from either side of a huge, bare canvas, leaving the middle empty. The V-shaped off-white central expanse reads simultaneously as yawning void and light-filled presence. Free of imagery, illusionistic space, or implied symbolism, the *Unfurleds* offer nothing other than the distilled **formal** beauty of full-bodied color, flowing line, and flat surface on an epic scale.

refreshingly intuitive approach to selecting and juxtaposing colors. Equally engaging is the contrast between the hard-edged inner rings and rough-edged outer band, which seems

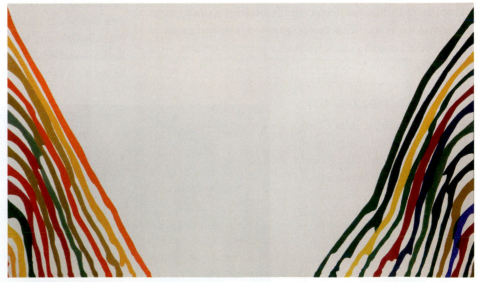

FIGURE 16.2 Morris Louis, *Beta Kappa*, 1961. Acrylic on canvas, 262.3 x 439.4 cm. National Gallery of Art, Washington, DC.

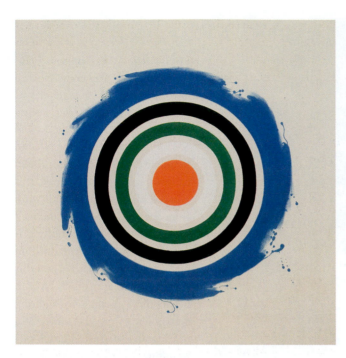

FIGURE 16.3 Kenneth Noland, *Whirl*, 1960. Acrylic on canvas, 179.9 x 177.2 cm. Des Moines Art Center, Iowa.

to spin rapidly in a counterclockwise direction. A similar contrast in another circle painting moved one early viewer to say, "It draws you into the center like a target and then throws you out to the edge like a pinwheel."[14]

By 1961, Noland had eliminated the rough edges from his paintings. He continued to explore the purely aesthetic possibilities of flat colors arranged into geometrically ordered compositions in a series of paintings using a chevron motif (e.g., *Trans Shift*, 1964), many of them in a diamond format. His succeeding stripe paintings (e.g., *New Day*, 1967) feature tiered parallel stained color bands of different widths laterally spanning large horizontal canvases. With color, structure, and surface completely locked together, these paintings possess a unified, vivid immediacy.[15]

Jules Olitski (1922–2007)

The American artist Jules Olitski made Color Field paintings in the early 1960s by rolling liquid acrylic onto large bare canvases to create simple compositions of large tautly balanced organic shapes (e.g., *Cleopatra Flesh*, 1962). Seeking to realize the effect of "a cloud of color that remains there transfixed,"[16] he began in 1965 using a spray gun to apply thinned acrylic paint to vast canvases, whose surfaces he covered completely to generate a misty all-over field (e.g., *Pink Alert*, 1966). Spraying broke the **pigments** up into tiny drops; the **hues** maintained their purity even as Olitski spread several different colors to produce atmospheric effects of one hue subtly modulating into another. To acknowledge the field's shape and flatness, Olitski brushed a few long, rough, thick strokes of rich colors along one or more edges of the canvas. This created a contrast between sprayed evanescence and **painterly** materiality as if to wed Mark Rothko's disembodied colorism with Willem de Kooning's gestural vitality—while also achieving arresting originality.

Jack Bush (1909–1977)

One of the first Canadian artists to achieve international recognition, Jack Bush experimented with gestural abstraction in the 1950s before developing his own variety of Stained Canvas Color Field painting, encouraged by Greenberg, who visited his Toronto studio in 1958. Beginning in 1963 Bush executed several overlapping series, including the *Sashes*, *Ladders*, *Columns*, and *Fringes*, composed of a limited number of large, hand-painted, loosely geometric shapes of joyous color in either symmetrical or asymmetrical configurations. Spanning three-and-a-half meters, the breathtaking *Blue Studio* (1968, Figure 16.4), from the *Fringe* series, features six stacked, horizontal bands of color (the "fringe")—lime green, rose pink, yellow, persimmon, tan, and plum—climbing the canvas's right quarter, set beside an enormous horizontal rectangle of blue, fainter along the bottom edge and deeper above. The color bands vary in size and shape and the bottom green one is unfinished, giving the picture an engaging quality of imperfection that keeps it from appearing mechanical or static. Inspired not only by his American colleagues' Color Field paintings but also by Matisse, Bush gave *Blue Studio* a title that nods to the former's *Red Studio* (1911). *Blue Studio*'s vast blue field distills into pure abstraction the **background** sky of Matisse's *Dance (II)* (see Figure 3.4), underlining Bush's aspiration to "hit Matisse's ball out of the park."[17]

FIGURE 16.4 Jack Bush, *Blue Studio*, 1968. Acrylic on canvas, 134.6 x 650.5 cm. Museum of Fine Arts, Boston.

Alma Thomas (1891–1978)

A friend of her fellow Washington, DC-based nonrepresentational painters Morris Louis, Kenneth Noland, Gene Davis, and Sam Gilliam (see Chapter 19), Alma Thomas developed a distinctive **style** blending elements of gestural abstraction and Color Field painting. She did not stain raw canvases but painted in acrylic over **gesso**-covered surfaces. She laid down small, flat, irregular patches of exuberant color in repeated vertical, horizontal, or concentric circular bands to produce dense, mosaiclike compositions that are both visually dazzling and rigorously structured. Although completely abstract, Thomas's paintings, like Frankenthaler's, were often inspired by nature, as reflected in the title of *Iris, Tulips, Jonquils, and Crocuses* (1969, Figure 16.5). This painting demonstrates her skill in organizing color, with its single or clustered stripes of various hues—blues, reds, greens, and yellows—creating complex rhythmic effects. The eye flits across the canvas to take in the colors, an experience similar to seeing flowers in a garden.[18]

The first person to graduate (in 1924) from Howard University's newly founded art department, Thomas achieved her signature style in her seventies after retiring from a thirty-five-year career as a junior high school art teacher. In 1972, she was the first African American woman given a solo exhibition at the Whitney Museum of American Art. Unlike many of her younger contemporaries in the **Black Arts Movement** (see Chapter 19), however, Thomas did not use her art to assert her racial identity or protest injustice but to create joy. "Through color," she said, "I have sought to concentrate on beauty and happiness, rather than on man's inhumanity to man."[19]

Hard Edge Painting

The critic and curator Lawrence Alloway employed the term Hard Edge painting to define a new tendency arising in the 1950s and flourishing in the 1960s, "which combined economy of form and neatness of surface with fullness of color, without continually raising memories of earlier geometric art."[20] Hard Edge paintings employ a limited number of shapes and colors—often just black and white—and have smooth surfaces giving little or no evidence of the artist's hand. Unlike earlier geometric abstract paintings, such as Malevich's and Mondrian's (see Figures 6.3 and 6.10), with compositions built from individual parts that sometimes create **figure-ground relationships**, in Hard Edge painting, as Alloway explained, "the whole picture becomes the unit," so that "the spatial effect of figures on a field is avoided."[21] Alloway identified Ad Reinhardt (see Chapter 12), Leon Polk Smith, and Ellsworth Kelly as this style's key American initiators in the 1950s. More recently, art historians have added Carmen Herrera to that list. A Hard Edge aesthetic was developed independently in the 1950s by Brazilian **Concrete** and **Neo-Concrete** artists such as Willys de Castro, Lygia Clark, Lygia Pape, and Hélio Oiticica (see Chapter 14).

Ellsworth Kelly (1923–2015)

Ellsworth Kelly adopted abstraction in Paris in the early 1950s, where he met and drew inspiration from Jean Arp and Constantin Brancusi. After settling in New York City in 1954, Kelly painted bracingly simple abstract compositions of flat, crisply bounded shapes of uninflected color. His paintings never contained recognizable imagery but were stimulated by his perceptions of details of the everyday environment, such as the shape of a shadow or a vaulted ceiling, or the negative space between objects—isolated as "a fragment of the visual world with the third dimension removed."[22] He worked mostly in black and white during the mid-1950s and then introduced the **primary colors** and green into his palette near the decade's end.

Blue, Green, Red (1963, Figure 16.6) manifests Kelly's penchant for strong, basic colors and simple, flat shapes. By stretching the curved blue shape across the width of the canvas, he avoids creating a figure-ground relationship between it and the green field. This encourages the perception that the color-shapes lie side by side on the painting's surface. At the same time, the cool blue seems to recede in relation to the warmer green surrounding it, while the red rectangle at the bottom advances strongly visually, in optical tension with the effect of flatness. The painting manifests Kelly's intention to create an autonomous, sensuously rewarding object. As the artist put it, "the form of my painting is its content."[23]

FIGURE 16.5 Alma Thomas, *Iris, Tulips, Jonquils, and Crocuses*, 1969. Acrylic on canvas, 152.4 x 127 cm. National Museum of Women in the Arts, Washington, DC.

FIGURE 16.6 Ellsworth Kelly, *Blue, Green, Red*, 1963. Oil on canvas, 231.1 x 208.3 cm. The Metropolitan Museum of Art, New York.

Carmen Herrera (1915–2022)

Born and raised in Havana, Cuba, Carmen Herrera moved to New York in 1939 where she studied at the Art Students League. She lived in Paris between 1948 and 1954, where she experimented with geometric abstraction. After returning to New York

in 1954, she developed an accomplished Hard Edge style, with the encouragement of her friends Barnett Newman and Leon Polk Smith. However, the New York art world's prejudice against her as a Cuban woman prevented Herrera from gaining a significant audience during Hard Edge's heyday in the 1960s. She did not achieve widespread recognition until she was in her eighties.

Among Herrera's key bodies of work is her *Blanco y Verde* (white and green) series of paintings (1959–71). Each features a different combination of a few narrow dark green triangles slicing across a rectangular field of white—a color pairing the artist described as "like saying yes and no."[24] In *Blanco y Verde* (1960, Figure 16.7), executed on two abutting square canvases, two green wedges at the composition's base meet at the centerline to form a broad low pyramid. This pyramid, similar to the other green shapes, alternately reads as a negative space receding behind the **picture plane** and as a flat plane on the canvas surface. A slender triangle along the lower right vertical side leads to a larger triangle extending laterally to the left, its sharp tip terminating at the centerline. The top of this triangle is parallel to the top of the canvas, while its lower side parallels the slope of the triangle at the canvas base. Through such calculated correspondences, Herrera creates a satisfying stability that balances the dynamism of the slanting and thrusting triangles.

Precursors of Minimalism: Agnes Martin (1912–2004) and Frank Stella (b. 1936)

Distinct from both the Stained Canvas Color Field and Hard Edge painters, Agnes Martin and Frank Stella produced rigorously structured nonrepresentational paintings that predicted

FIGURE 16.7 Carmen Herrera, *Blanco y Verde (White and Green)*, 1960. Acrylic on canvas, 121.9 x 243.8 cm. Smithsonian American Art Museum, Washington, DC.

Minimalism. Martin's grids and Stella's symmetrical arrangements of parallel bands both created allover designs that Stella called "nonrelational," avoiding a hierarchical composition with unequal parts or a central focus. Stella and Martin brought different attitudes to their painting, however. Stella rejected **expressionism** and insisted that his paintings were self-sufficient, nonreferential objects, whereas Martin sought to express emotion and transcendent reality through abstraction.

Following the path opened by Stella, Martin, and other artists such as Ad Reinhardt and Barnett Newman, numerous American painters of the 1960s used reduced or monochrome palettes and sometimes employed simple grids or geometric shapes to draw attention to the shape of the **support** and emphasize the painting's status an object. Among the major practitioners of what became known as Minimal painting were Jo Baer, Brice Marden, Robert Mangold, and Robert Ryman.

The Canadian-born Agnes Martin lived in New York City between 1957 and 1967, where she developed an abstract style based on repetitive linear marks arranged in tight grids on six-foot-square canvases. From the mid-1960s, she drew her lines in graphite or colored pencil over lightly tinted canvas backgrounds, collapsing distinctions between drawing and painting. Exemplary of her work is *Morning* (1965, Figure 16.8), whose light gray ground is covered by a grid of dark graphite squares, each square vertically traversed by four delicate red pencil lines, creating a holistic, nonhierarchical field.

Martin chose to render the grid because it is a mathematical system of perfect order existing in an ideal realm.[25] The grid represents the "perfection"[26] and "transcendent reality"[27] to which she dedicated her art. She recognized that her paintings were not perfect—her hand-drawn lines, though guided by straightedges or taut strings, vary in strength, weight, and length—but, she explained, "the work is *about* perfection as we are aware of it in our minds."[28] Inspired by diverse spiritual traditions, including Christianity, Zen Buddhism, and Taoism, Martin sought to achieve an egoless state of emptiness in which she carefully and quietly executed her paintings. She intended each canvas to serve as a focus for meditation that might lead the viewer to experience "beauty and happiness"[29]—expressions of the sublime perfection of reality. "When I painted *Morning*," wrote Martin, "I was painting about happiness and bliss. . . . a wonderful dawn, soft, and fresh—before daily care takes hold. It is about how we feel."[30] In seeking to evoke "abstract emotions,"[31] Martin was closer to **Abstract Expressionists** such as Rothko and Newman than she was to Stella and the Minimalists, who employed abstract geometry for its purity and autonomy rather than for transcendental purposes.

Stella gained prominence in the New York art world when MoMA displayed his *Black Paintings* (as they became known) in its 1959 *Sixteen Americans* exhibition. Executed with "the house painter's technique and tools"[32] (Stella had formal art training but supported himself painting houses), the *Black Paintings* are composed of repeated bands of flat black enamel paint laid down on large unprimed canvases in predetermined symmetrical arrangements. The bands run either parallel or diagonally to the picture's edges. Stella drew inspiration for these works from Jasper Johns's *Flag* paintings, whose stripes conformed to the canvas' rectangular shape and affirmed the picture plane. The *Black Paintings* reacted against the intuitive

FIGURE 16.8 Agnes Martin, *Morning*, 1965. Acrylic paint and graphite on canvas, 182.6 x 181.9 cm. Tate, London.

compositions, gestural brushwork, spatial depth, and emotionalism of Willem de Kooning-style **action painting** (see Figure 12.7). Stella also rejected the "relational painting" of European geometric abstractionists like Mondrian (see Figure 6.10), who balanced unequal parts to create pictorial equilibrium. He countered with a "nonrelational" approach, using a symmetrical, allover composition that "forces illusionistic space out of the painting at a constant rate by using a regulated pattern."[33]

Resolutely nonobjective, the *Black Paintings* declare themselves as material facts, revealing only the mode of their organization and execution—what Stella's friend Carl Andre called "the necessities of painting."[34] While Andre claimed the paintings are "not symbolic," their titles evoke what Stella called "downbeat" or "depressed political"[35] situations resonating with the

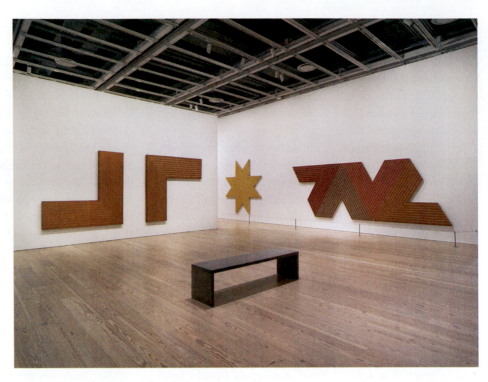

FIGURE 16.9 Installation view of *Frank Stella: A Retrospective*, Whitney Museum of American Art, 2015. Left to right: *Crede I*, 1961. Copper oil paint on canvas, 210.2 x 210.2 cm. Private collection; *Crede II*, 1961. Copper oil paint on canvas, 210.2 x 210.2 cm. Private collection; *Plant City*, 1963. Zinc chromate on canvas, 260 × 260 cm. Philadelphia Museum of Art; *Empress of India*, 1965. Metallic powder in polymer emulsion on canvas, 195.6 x 569 cm. The Museum of Modern Art, New York.

various meanings of the adjective "black." Some titles make Nazi references (e.g., *Die Fahne Hoch!* "Hold high the banner!" from a Nazi marching song); others refer to Black New York nightclubs (e.g., *Zambezi*); others to tenement housing in depressed Brooklyn neighborhoods (e.g., *Arundel Castle*). Contemporary critics were not concerned with the *Black Paintings'* titles, however, but with their radical negation of the values of Abstract Expressionist gesture painting. To that movement's supporters, the *Black Paintings* seemed boring or even nihilistic. Many younger artists and critics, however, found their matter-of-fact visual and physical qualities to open up exciting new artistic possibilities.

To further stress his paintings' literal objectness, Stella began in 1960 to work with opaque metallic paints on shaped canvases whose framing edges echoed the configuration of their internal stripes, and vice versa. For the *Aluminum Paintings* (1960), he cut notches in the edges and centers of standard rectangular formats. He executed the *Copper Paintings* (1960–61) on canvases with rectilinear shapes such as a Greek cross, L, T, U, and H; the *Purple Paintings* (1963) on polygonal canvases with empty centers; and the *Running V Paintings* (1964–65) on canvases structured by horizontal and V-shaped bands (see Figure 16.9 for examples of the *Copper* and *Running V* paintings). In their rigorous, impersonal abstraction, these series manifest Stella's commitment to **formalism**. He insisted, "My painting is based on the fact that only what can be seen *is* there. It really is an

object. . . . All I want anyone to get out of my paintings, and all I ever get out of them, is the fact that you can see the whole idea without any confusion. . . . What you see is what you see."[36] This was an attitude shared by the Minimalists, whose use of repeated geometric units Stella's stripe paintings predicted.

In the later 1960s, Stella moved toward greater coloristic and structural complexity. He composed his *Irregular Polygons* (1965–67, e.g., *Sanbornville III*, 1966) using large geometric planes of bright color abutting each other but not consistently relating to the shaped canvas' framing edge. For the Day-Glo colored *Protractor Paintings* (1967–71, e.g., *Hatra I*, 1967), he delineated protractor-shaped arcs that conformed to large canvases' curved edges while intersecting and overlapping one another on the interior. In subsequent series, such as the *Exotic Birds* (1976–80) and *Circuits* (1980–84, e.g., *Zeltweg*, 1981), he incorporated real space into his paintings by building them out from the wall as dynamic relief constructions made of industrially fabricated metal components with freewheeling shapes derived from drafting templates. Stella covered their surfaces with bold strokes of high-keyed color and **calligraphic** scribbles, applied with a gestural bravado worthy of the action painters against whom he had reacted so strongly in the late 1950s. The progenitor of Minimalism was now a maximalist, infusing abstract painting with coloristic exuberance, structural complexity, and sculptural presence.

Abstract Sculpture in Britain: Anthony Caro (1924–2013) and the New Generation

British artists of the 1960s extended Post-Painterly Abstraction's aesthetic innovations into sculpture. Rejecting both figuration and traditional stone and bronze, they created completely abstract, vibrantly colored compositions using new materials such as steel, aluminum, plastics, and fiberglass.

Anthony Caro, the pioneer of this trend, worked as an assistant to Henry Moore (1951–53) and went on to teach sculpture at St Martin's School in London (1953–79). In the mid-late 1950s, Caro produced **modeled** bronze figures with distorted, massive bodies; awkward, animated poses; and rough, expressive surfaces.

His work changed radically after a 1959 visit to the United States, where he met David Smith and became friends with Greenberg and Noland. Having gained a new sense of freedom to depart radically from art-historical tradition, Caro adopted Smith's method of **direct-metal sculpture** (see Chapter 12). Using a geometric formal syntax derived from **Cubism**, he welded or bolted together metal pieces—principally steel beams, plates and channel stock and aluminum tubing—into improvised, completely abstract open-form arrangements, which he unified by painting the metal, usually a single bright color. Caro generally gave his sculptures low-lying, horizontal compositions and always placed them on the floor to invite the viewer into a direct physical relationship with them. Although composed of heavy metal parts, Caro's 1960s sculptures have an almost weightless appearance due to their open, lateral compositions and buoyant colored exteriors.

Early One Morning (1962, Figure 16.10), Caro's best-known work, features a complex arrangement of linear and planar

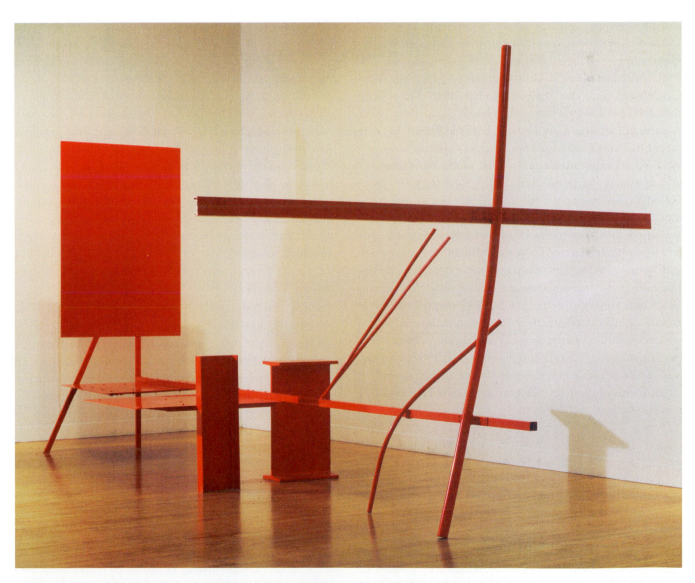

FIGURE 16.10 Anthony Caro, *Early One Morning*, 1962. Painted steel and aluminum, 289.6 x 619.8 x 335.3 cm. Tate, London.

elements—some parallel to the floor, some vertically oriented, some straight, some curved—disposed along a six-meter-long horizontal axis. These elements create varying rhythms and relationships as the viewer walks around the vivid, red-painted sculpture. This suggests an analogy to music, which Caro offered himself:

> I have been trying to eliminate references and make truly abstract sculpture, composing the parts of the pieces like notes in music. Just as a succession of these make up a melody or sonata, so I take anonymous units and try to make them cohere in an open way into a sculptural whole. Like music, I would like my sculpture to be the expression of feeling in terms of the material, and like music, I don't want the entirety of the experience to be given all at once.[37]

Many viewers sense in *Early One Morning* a light, cheerful, and confident feeling—associations reinforced by the title, which is not descriptive but seems appropriate to the sculpture's expressive character.

Some young sculptors who had been Caro's students—David Annesley, Michael Bolus, Phillip King, Tim Scott, William Tucker, and Isaac Witkin—became known as the "New Generation" when they showed together in the *New Generation: 1965* exhibition at London's Whitechapel Gallery. While sometimes following Caro in using steel and aluminum, they more often employed plastic and fiberglass—materials associated with manufactured objects—and produced **volumetric**, as well as flat and linear, forms. They further evoked product design and manufacture through their use of strong and sometimes unconventional colors. Like Caro, they placed their sculptures directly on the floor to share the viewer's space. Their sculptures are wittier and more playful than Caro's, however: they approach a **Pop art** sensibility and suggest everyday objects even as they remain abstract. Characteristic New Generation works are William Tucker's (b. 1935) painted steel *Meru I-III* sculptures (1964), each a variation on a stepped bridge with a rectilinear central opening and curving external contours; and Phillip King's (1934-2021) *Rosebud* (1962), a smooth pink 1.48-meter-tall fiberglass cone whose surface opens in a sinuous vertical slit to reveal a dark green layer beneath, like a flower's petals.

Op Art

Op art, an abbreviation for "optical art," refers to abstract art in various mediums that creates optical illusions through precise, calculated arrangements of lines, shapes, and colors. Op gained international attention when it was featured in the 1965 MoMA exhibition *The Responsive Eye*, curated by William C. Seitz. The principal Op artists were Victor Vasarely, Bridget Riley, Jesús Rafael Soto, Yaacov Agam, Carlos Cruz-Diez, Julio Le Parc, François Morellet, and Richard Anuszkiewicz.

Op's art-historical lineage reaches back to the **Neo-Impressionists'** interests in color interaction, which the **Futurists** carried forward. More recent progenitors were **Bauhaus** artists who explored nonobjective illusionism—visual effects of depth and movement on a two-dimensional surface—by applying scientific and psychological theories to practical experiments. The best known of these were Josef Albers's linear black and white compositions that produced illusions of spatial depth or movement, and his famous *Homage to the Square* series (see Chapter 6), focusing on chromatic interactions.

Op works differed from Albers's in their visual aggressiveness. Manipulating repetitive elements such as parallel lines, checkerboard patterns, and concentric circles, or producing chromatic tension by juxtaposing equally **intense complementary colors**, Op artists created optical effects such as pulsations, vibrations, flickering **moiré patterns**, and ghostly after-images. Op works often induce a sensation of movement, preventing the viewer's eye from lingering on any single part of the composition.

Hailed by the American popular media as the successor to Pop art, Op appealed to the public because its dazzling visual effects required no special artistic knowledge to enjoy. Around the time of the MoMA exhibition, Op patterns were adapted to consumer products, such as clothing, shoes, textiles, and jewelry. This commercialization did not endear Op to American critics, many of whom dismissed it as perceptual gimmickry with no more artistic value than a psychology textbook illustration. Op's practitioners, however, were seriously committed to creating an art of pure sensation. Some even saw Op as a democratic force for positive social change because of its universal comprehensibility.

Victor Vasarely (1906–1997)

Op art's pioneer was the Hungarian-born Victor Vasarely, who absorbed Bauhaus principles through his study (1929–30) at Sándor Bortnyik's Mühely Academy, known as the "Budapest Bauhaus." Vasarely moved to Paris in 1930 and supported himself as a commercial **graphic artist** while experimenting with various optical effects in images of zebras, checkerboards, and harlequins. He also created illusions by overlaying sheets of transparent cellophane bearing black-and-white patterns that shifted as the sheets moved—a technique he would use in his later "kinetic depth" paintings of layered glass or plexiglass.

In the early 1950s, Vasarely devoted himself to rigorously controlled geometric abstraction focused on visual experience. For much of that decade he limited his palette to black and white, employing strong contrasts to create optical illusions, as in his painting *Supernovae* (1959–61, Figure 16.11). Its composition features a forty-three by twenty-seven grid of white lines enclosing rows of black squares. The lines thin or thicken in the

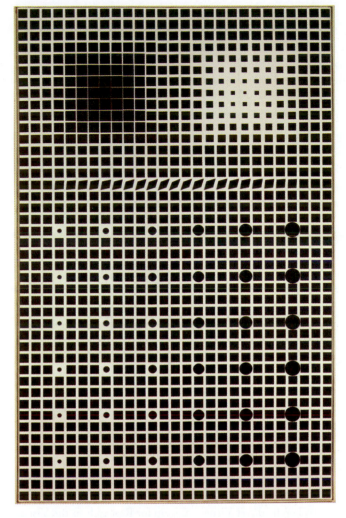

create an all-encompassing aesthetic environment. After 1965, he employed assistants to execute paintings, prints, and multiples based on his designs. The use of assistants and impersonal production methods reflected Vasarely's anti-elitist view of art as a "collective treasure," rather than the creation of a solitary genius.[40] His studio's profuse output diminished Vasarely's reputation, however, among critics who found his work mechanical and overly commercialized.

Bridget Riley (b. 1931)

After working as a figurative and landscape painter in the 1950s, the English artist Bridget Riley adopted abstraction in 1960 in order to convey what she considered essential in nature: "the dynamism of visual forces—an event rather than an appearance."[41] Between 1961 and 1965, Riley created black and white compositions of repeated units—squares, triangles, circles, stripes, and wavy lines—that she distorted or manipulated to generate rhythms that move restlessly around the painting's surface. Many of these paintings bombard the eye with unnerving visual energy, as is the case with *Current* (1964, Figure 16.12). Its composition consists of scores of repeated, closely spaced, parallel curving vertical lines that gather momentum near the center to form vibrating horizontal bands of crests and troughs that create a dizzying effect. In 1966, Riley abandoned the sharp division between black and white to introduce **tonal** variations and the next year began to use pure color laid down in vertical stripes (e.g., *Late Morning*, 1967–68). As did Vasarely, Riley employs assistants to execute her paintings based on her designs. The absence of her personal brushstroke

FIGURE 16.11 Victor Vasarely, *Supernovae*, 1959–61. Oil paint on canvas, 241.9 x 152.4 cm. Tate, London.

top section to form radiating dark and bright areas, respectively. In a row below, the squares tilt inward to become lozenges. In the lower section, circles replace some of the squares and grow in size from left to right, moving from brightness to darkness. The juxtapositions of these various elements induce pulsating visual effects, while the opposition between light and dark signifies positive and negative elements—matter and anti-matter, proton and electron—permeating the universe.[38] This symbolism conveys Vasarely's fascination with modern science's discoveries, which he felt representational images failed to convey. He sought through his art to "express the cosmic age of atoms and stars."[39]

In the 1960s, Vasarely created paintings employing his "Plastic Alphabet"—a standard repertory of geometric shapes superimposed on squares of different basic colors forming "plastic units" that can be combined in infinite variations. By this means, Vasarely sought to democratize art, carrying forward Bauhaus and **De Stijl** ideas with a simple, universally applicable system that could be extended to an architectural scale to

FIGURE 16.12 Bridget Riley, *Current*, 1964. Synthetic polymer paint on board, 148.1 x 149.3 cm. The Museum of Modern Art, New York.

allows both the artist and viewer to focus on the disciplined orchestration of line, shape, and color and to engage intensely in the act of seeing.

Jesús Rafael Soto (1923–2005)

Jesús Rafael Soto's work straddles the categories of Op and **kinetic art**; while it sometimes contains mobile elements, it more often generates an impression of movement as the spectator passes before it. Arriving in Paris from his native Venezuela in 1950 with the ambition to "make Mondrian move,"[42] Soto created a series of *Superimpositions*, applying a regular grid of small uniform dots to a plexiglass square that he set at an angle over a second dotted grid. By placing the squares eight centimeters apart, he created a kinetic quality—the composition appears to change as the viewer moves. In his *Vibrations* series (e.g., *Cardinal*, 1965), Soto suspended swaying rods in front of striated rectangular panels to generate a moiré effect. In the late 1960s, he began to create his most ambitious optical-kinetic works, the *Penetrables* (e.g., *Houston Penetrable*, 2004–14)—**environments** of densely hung colored rods, tubes, or nylon strands, which viewers enter to become participants rather than observers. Immersed in the *Penetrables*, said Soto, "We swim in the space-time-matter trinity as a fish swims in water."[43]

Kinetic Art

Kinetic art of the 1950s and 1960s relates closely to and sometimes overlaps with Op art. Whereas Op works create optical illusions of movement, kinetic works incorporate actual mobility, generated mechanically or through touch or air currents. Duchamp pioneered kinetic art with his *Bicycle Wheel* of 1913 (see Chapter 7) and in 1920 devised a mechanized *Rotorelief*—a machine that rapidly spins four staggered transparent glass panels painted with curving black and white lines to form the illusion of a complete circle. Also in 1920, the Russian **Constructivists** Naum Gabo and Anton Pevsner in their "Realistic Manifesto" called for a new element in pictorial and plastic art, "the kinetic rhythms as the basic forms of our perception of real time."[44] Gabo demonstrated this principle in his *Kinetic Construction (Standing Wave)* (1919–20), a motor-driven vertical steel rod that oscillates to create the illusion of a volumetric form. Several modern artists advanced research into actual motion in the interwar decades, including László Moholy-Nagy, in his *Light Prop* (see Figure 6.15), and Alexander Calder in his **mobiles** (see Figure 10.23). Post–World War II kinetic art's international efflorescence came into focus in the 1955 exhibition *Le Mouvement* at the Galerie Denise René in Paris. This show included works by Duchamp, Calder, Soto, Vasarely, Yaacov Agam, Jean Tinguely, and Pol Bury. The René gallery remained a center for kinetic and Op art into the 1970s.

The major kinetic artists of the 1950s and 1960s worked within either the **Dada**-Surrealist or Constructivist traditions. Tinguely's wacky mechanized junk contraptions (see Figure 14.11) belong to the Dada tradition. A **Surrealist** quality infuses Bury's (1922–2005) kinetic sculptures of wooden spheres, cubes, rods, and hairlike tendrils set in slow, random, sometimes imperceptible motion by hidden motors, as if endowed with life (e.g., *16 Balls, 16 Cubes in 8 Rows*, 1966). Heirs of Constructivism included the Englishman Kenneth Martin (1905–84), who fashioned mobiles of horizontal metal bars that spiral around a vertical spine (e.g., *Small Screw Mobile*, 1953), and the American George Rickey (1907–2002), author of meticulously engineered sculptures of tapering stainless steel blades that pivot gracefully on knifelike spars like tall grass swaying the breeze (e.g., *Peristyle—Three Lines*, 1963–64). Also in the Constructivist vein are the "spatiodynamic" sculptures of the Hungarian-French Nicolas Schöffer (1912–92), such as *Cysp I* (1956): fitted with an electronic brain, this mobile tower and its rotating multicolored discs and plates move in response to external stimuli of light, color, and sound, like a living organism.

Schöffer's work belongs to a general European trend of the period know as la Nouvelle Tendance (the New Tendency). It comprised artists who rejected romantic individualism and adapted methods of science, technology, and industry to the creation of new art forms dynamically involving space, time, motion, and light, and encouraging audience participation. The Nouvelle Tendance encompassed several different artists' collectives, including Zero in Düsseldorf and GRAV (Groupe de Recherche d'Art Visuel, "Group for Research in the Visual Arts") in Paris. The most prominent artist associated with the Nouvelle Tendance was the Argentine-born GRAV member Julio Le Parc (b. 1928), who made Vasarely-influenced Op paintings in the late 1950s and went on to create installations in the 1960s using projected, moving, and reflected light (e.g., *Continuous Light Mobile*, 1968). Believing in the political potential of aesthetic experience, Le Parc intended these destabilizing sensations of light and movement to shake viewers out of their passivity and raise awareness of their ability to effect social change.[45]

Minimalism

Minimalism describes a stripped-down style centered in New York City in the 1960s typified by three-dimensional artworks comprising simple, geometric forms presented as unitary objects or arranged in symmetrical or gridded configurations. Placed directly on the floor or wall to emphasize their literal physical presence, Minimalist forms are often ready-made or fabricated of industrial or building materials. Their uninflected

surfaces and their colors are typically those inherent to their materials or are applied with no trace of the artist's hand. Aesthetician Richard Wollheim introduced the term "Minimalism" to the art-critical vocabulary in a 1965 article addressing works such as Ad Reinhardt's monochrome paintings and Duchamp's **readymades** that have "a minimal art-content":[46] they have simple forms or resemble manufactured objects and they lack the expressive quality normally regarded as important in art. The first large-scale exhibition of Minimalist sculpture, *Primary Structures*, was held at the Jewish Museum in spring 1966.

The principal artists working in three dimensions identified as Minimalists were Carl Andre, Dan Flavin, Donald Judd, Sol LeWitt, and Robert Morris. None of them liked being called a Minimalist, because it implied that their art was reductive or negative, but the label stuck. (LeWitt is also considered a **Conceptual** artist and is discussed in Chapter 19.) Some of them likewise refused the term "sculpture" to describe their three-dimensional works—Flavin called his "proposals" and Judd called his "specific objects." This emphasized the differences between their art and traditional carved, modeled, cast, or assembled sculpture.

The Minimalist sculptors intended their works to be seen as things-in-themselves. As critic Barbara Rose wrote, Judd's and Morris's "elementary, geometrical forms" offer "no more than a literal and emphatic assertion of their existence. . . . The thing . . . is not supposed to be suggestive of anything other than itself."[47] In this, they followed the example of Stella's *Black*, *Aluminum*, and *Copper Paintings*. Judd admired these, but he felt that even nonrepresentational painting retained vestiges of illusionism, because "anything on a surface has space behind it."[48] The three-dimensional works he called Specific Objects used "actual materials, actual color, and actual space."[49] Those materials are often ones employed in manufacturing such as steel, aluminum, chrome, fluorescent lights, plastic, fiberglass, and plexiglass. Despite the Minimalists' insistence on their purely aesthetic interests, their use of industrial materials and fabrication processes aligned their art with capitalist production, linking it to Pop art.

Judd contrasted traditional sculpture made "part by part, by addition, composed"[50] with the new three-dimensional work in which "the thing as a whole, its quality as a whole, is what is interesting."[51] He repudiated sculpture like Caro's, with its Cubist-derived balancing of unequal parts. So, too, did Morris, who argued for the use of simple regular and irregular polyhedrons that "create strong gestalt sensations"[52]—they are perceived as wholes rather than objects with separate parts. Morris was also concerned with the work's physical situation and its external relationships. "The better new work," he wrote, "takes relationships out of the work and makes them a function of space, light, and the viewer's field of vision."[53]

The critics Clement Greenberg and Michael Fried attacked Minimalism due to its lack of intuitively discovered, complex compositional relationships, which they believed were essential to successful modernist sculpture such as Caro's. Fried accepted Morris's observation that Minimalist objects heightened the viewer's awareness of the work's physical situation—and he found this to be Minimalism's fatal flaw. Fried contrasted modernist art's "presentness"—an instantaneous quality of existing in a "continuous and perpetual *present*,"[54] with Minimalism's "presence," a durational "theatrical" quality that he likened to "*stage* presence."[55] Fried contended that Minimalist art "*depends* on the beholder, is *incomplete* without him"[56]—it lacks the autonomy of modernist art. Despite Fried's widely read critique, Minimalism's "theatricality" was a major stimulus to subsequent developments in **site-specific**, **installation**, and **performance art** (see Chapter 19) that engaged spectators' embodied awareness of space and temporality.

Criticizing Minimalism from a very different, feminist perspective a generation after Fried, art historian Anna Chave argued that "by manufacturing objects with common industrial and commercial materials in a restricted vocabulary of geometric shapes," the Minimalist artists not only "availed themselves of the cultural authority of the markers of industry and technology," but also asserted a domineering aesthetic that reinforced the era's predominantly male authority—that of corporate and government institutions and the military.[57] Chave thus challenged the claim of Judd and other Minimalists that their art was aloof from society.

Donald Judd (1928–1994)

Donald Judd began his career as a painter, but his dissatisfaction with the spatial illusionism he considered inherent to painting led him to turn to three-dimensional construction in 1962. Using wood and metal pipe, he built boxes, ramps, and open frames (e.g., *Untitled*, 1963) that he placed directly on the floor to emphasize their physical presence as objects. He painted the wood a uniform light cadmium red to define the forms clearly. In 1964, Judd began having his works fabricated in galvanized iron, seeking a "thinner, more shell-like surface, so that the volume inside would be clear" and because he "wanted to get out of painting pieces"[58] (though he would subsequently apply enamel or lacquer paint to some of his metal sculptures). In addition to galvanized iron, he used aluminum, stainless steel, hot- or cold-rolled steel, brass, and copper for later works. He also adopted plexiglass sheets—their color "embedded in the material"[59]—which he used to create chromatic richness and to reveal his hollow boxes' interior volumes.

By 1966, Judd's sculptures consisted of either a single box placed on the floor; a set of uniform, evenly spaced rectangular frames or boxes lined up on the floor or the wall; or a horizontal wall-mounted object featuring a sequence of projecting

volumes arranged according to a mathematical progression (e.g., *Untitled [Progression]*, 1965). His best-known works are vertical stacks of thin-sided metal boxes **cantilevered** out from the wall. He favored this configuration because "it's not a column and not resting on its base,"[60] and generated no references to the human figure. In *Large Stack* (1968, Figure 16.13), the stainless steel boxes are fitted with translucent amber-colored plexiglass tops and bottoms that create a warm internal glow playing off against the cold metal. The boxes are identical and the spaces between them are equal in height to the boxes. Thus, the sculpture is not composed in the traditional sense—it avoids a balancing of major and minor parts into a hierarchical structure. Like a Stella stripe painting, Judd's stack has a nonrelational structure comprising "one thing after another."[61] Without a center or internal dynamic tension, it is meant to be experienced as a whole. Devoid of hidden meaning or symbolism, it creates an immediate aesthetic impact through its crisp purity of forms and materials and its elegantly clear arrangement.

FIGURE 16.13 Donald Judd, *Large Stack*, 1968. Stainless steel and amber Plexiglas (10 units), 469.9 x 101.6 x 78.74 cm. Nelson-Atkins Museum of Art, Kansas City, Missouri.

Robert Morris (1931–2018)

Robert Morris brought to Minimalism interests developed through his involvement in experimental dance and theater. He made his first work with a Minimalist appearance for a **Fluxus**-style theatrical performance in January 1962. *Column* was an eight-foot-high, two-foot-square hollow, gray-painted plywood column that served as the "actor." It stood upright for three and a half minutes and then was toppled by a cord and lay prone for the same amount of time. The object's perceived character changed due to the shift in its spatial relation to the viewer. Morris would further explore this phenomenon in *Untitled (L-Beams)* (1965): three large identical L-shaped gray-painted plywood sculptures (later refabricated in steel) placed in different positions to give them the appearance of different objects.

Column was a precursor to the seven geometric volumes of gray-painted plywood that Morris installed in the Green Gallery in December 1964 (Figure 16.14). Each was meant to be seen as a self-contained whole, but each also related directly to the gallery's physical space. For example, the slab-like *Untitled (Cloud)* was suspended from the ceiling, the triangular-faced *Untitled (Corner Piece)* fit into a corner, and *Untitled (Corner Beam)* spanned a gap between perpendicular walls. These placements encouraged spectators' heightened awareness of the sculptures' shapes, sizes, surfaces, lighting, and relationship to their own bodies. Morris's concern with the relation between the object and the situation in which it is experienced was motivated in part by his reading of Maurice Merleau-Ponty's phenomenology (see "Phenomenology" box).

Morris was also interested in Gestalt psychology, which explores how humans perceive separate elements as meaningful configurations different from and greater than the sum of their parts. He demonstrated his sculptural advocacy of "the simpler forms that create strong Gestalt sensations"[62] in *Untitled* (1965/71), a set of four mirrored waist-high cubes placed on the floor. The reflective cubes form a gestalt, generating fluctuating visual interactions with the mobile spectator and the surrounding environment, even as they retain their individual identities.

Dan Flavin (1933–1996)

Dan Flavin adopted fluorescent tubes, fixtures, and light as his artistic materials in 1963. Like Duchamp with his readymades, Flavin applied commercially available manufactured objects to an artistic purpose. He referred to his works not as sculptures but as "proposals"—manifestations of his ongoing project of artistic inquiry. He used the fixtures and tubes in Minimalist fashion as modules that he placed either singly or in multipart configurations onto walls and floors in horizontal, vertical, diagonal, or rectilinear arrangements. Flavin's proposals were neither sculpture nor painting but had qualities of both: the fixtures and tubes are tangible objects (like sculpture) while their ethereal glow gives literal presence to color (as do painter's pigments) and light (which paint can only evoke).

FIGURE 16.14 Robert Morris, installation view, Green Gallery, New York, 1964. Left to right: *Untitled (Table)*, *Untitled (Corner Beam)*, *Untitled (Floor Beam)*, *Untitled (Corner Piece)*, *Untitled (Cloud)*.

daylight fluorescent tubes spaced evenly across the gallery wall in a one-two-three progression—a manifestation of seriality common in Minimalist art. The work honors the fourteenth-century English Scholastic philosopher famous for his maxim, "No more entities should be posited than necessary." Known as "Ockham's Razor," this dictum holds that the simplest explanation is likely to be the correct one. In *the nominal three*, Flavin adapts this principle by using the minimum number of fluorescent fixtures needed to establish a series.

Carl Andre (b. 1935)

For his first major body of work, the *Pyramid* series, Carl Andre stacked notched, interlocking beams into stepped configurations with four identical faces, symmetrical along their vertical and horizontal axes (e.g., *Cedar Piece*, 1959/1964). These works' serrated contours and internal symmetries relate to Stella's chevron-patterned *Black Paintings*, while their modular structure implies the potential of continuation, as in Brancusi's *Endless Column*.[63]

While Flavin did not intend his artworks as metaphors or symbols, he dedicated many of them to friends or historical figures he admired. An early example, *the nominal three (to William of Ockham)* (1963, Figure 16.15), consists of six vertical eight-foot

Phenomenology

A mode of philosophical inquiry originating in Edmund Husserl's early twentieth-century writings, phenomenology seeks to describe things as they appear (phenomena)—that is, things as we consciously experience them. For Husserl, phenomenology's task is to return "to the things themselves": to study the objects of consciousness while suspending or "bracketing" one's preconceptions about or knowledge of their independent existence. Husserl claimed that every act of consciousness is intentional—it is "about" something (the intended object)—and always involves an experiencing human subject. In the "natural" or nonphilosophical attitude, the beholder is absorbed in the intended object in a practical way, conceiving of it has having a separate existence and oblivious to how consciousness makes it present. The phenomenologist overcomes the natural attitude to reflect on the intentional relationship between the object and the consciousness to which it is given, and between the mind and the intended object. Husserl's ideas influenced many subsequent philosophers including Maurice Merleau-Ponty. In *The Phenomenology of Perception* (1945), Merleau-Ponty insisted on the primacy of perception in constituting our knowledge of the world. He emphasized perception's embodied nature and the lived body's centrality to consciousness. (Merleau-Ponty distinguished between the fleshy body as a functional organism and the lived body as our means of participating in and perceiving the world.) Rejecting the mind-body dualism associated with the philosophy of René Descartes, Merleau-Ponty viewed consciousness as a matter of the lived body in "communion" with the world. Merleau-Ponty's ideas about visual perception offered a radical alternative to conventional formal analysis and were much discussed in the 1960s American art world after their translation into English. Unlike Clement Greenberg, Merleau-Ponty conceived of viewing not as the activity of a disembodied eye but as rooted in the body and tied to its situation within the physical environment. This view had close affinities with the Minimalists' rethinking of sculpture as a presence in the spatial arena shared by the spectator rather than an isolated, self-contained object. It also predicted the work of the Light and Space artists who dematerialized the object to emphasize the embodied act of perception itself.

FIGURE 16.15 Dan Flavin, *the nominal three (to William of Ockham)*, 1963. Daylight fluorescent light, 183 cm high, overall width variable. Solomon R. Guggenheim Museum, New York.

used elemental metals (aluminum, copper, lead, magnesium, tin, and zinc), initially one metal per sculpture. In Minimalist fashion, he chose these metals for their inherent color; he called the periodic table of elements "a kind of palette."[66] In several 1969 works, Andre arranged the plates into checkerboard patterns with alternating one-foot squares of two different metals (e.g., *Steel Zinc Plain*, 1969). He favored this configuration because it was nonhierarchical and immediately comprehensible from any direction. Andre invited spectators to walk on his metal floor pieces. In this way, he literally created a "sculpture of place" that visitors experienced through their bodies.

Anne Truitt (1921–2004)

The Washington, DC-based sculptor Anne Truitt was associated with Minimalism through her inclusion in the *Primary Structures* exhibition and the formal simplicity of her signature works: slender, rectangular wood columns often over six feet tall and painted with flat color. However, she denied she was a Minimalist, "because minimal art is characterized by nonreferentiality . . . [My work] is totally referential. I've struggled all my life to get maximum meaning in the simplest possible form."[67] Unlike the Minimalists, Truitt gave her works evocative titles and sought to infuse them with personal meanings rooted in her experiences, emotions, and memories. She had her sculptures fabricated to her specifications, as did the Minimalists, but she rejected their hands-off attitude by lavishing great care in painting the wood with multiple layers of acrylic that she sanded down between applications to build up smooth luminous color planes. She often applied multiple hard-edged bands of different hues to her columns, creating rich internal chromatic relationships of the kind the Minimalist sculptors generally avoided. She aspired to create the effect of "color in three dimensions, color set free, to a point where, theoretically, the support should dissolve into pure color."[68] She enhanced this quality by elevating her columns on recessed bases that make them appear to ascend toward weightless "pure color." Exemplary of Truitt's art is *Summer Dryad* (1971, Figure 16.16). Although completely nonrepresentational, the work refers through its title to a wood nymph in Greek mythology. It evokes the nymph's spirit through vertical bands of varied greens conjuring grasses, plants, and leaves.

Two experiences shaped the development of Andre's mature Minimalist sculpture. One was his work as a railroad freight conductor and brakeman in Newark, New Jersey (1960–64). The task of coupling and uncoupling freight cars confirmed his commitment to making sculpture out of standard, interchangeable units and suppressed his desire to create relational compositions. The second experience came in summer 1965: while canoeing on a New Hampshire lake, Andre realized he wanted to make his sculpture as level as water.

Andre then turned from stacking materials to laying them down horizontally and relating them to their site to engage with the concept of "sculpture as place."[64] His first work in this mode was *Lever* (1966) shown in the *Primary Structures* exhibition: a straight row of 137 firebricks running from the wall to a doorway. Andre described it as "Brancusi's *Endless Column* on the ground."[65] In the same year, he showed *Equivalents*—eight rectangular slabs of sand-lime bricks set on the floor in alignment with the gallery walls. Each sculpture was made of 120 bricks in two layers of 60 (e.g., *Equivalent III*, 1966). They were thus equivalent in **mass** and volume, but they had different shapes. These were determined by four of the possible factorial combinations of sixty, each yielding two different shapes dependent on the bricks' orientation.

Starting in 1967, Andre took his sculpture even lower by making it out of thin metal plates that he placed on the floor in simple rectilinear arrangements. Besides steel (an iron alloy), he

FIGURE 16.16 Anne Truitt, *Summer Dryad*, 1971. Acrylic on wood, 193.04 x 33.02 x 20.32 cm. National Museum of Women in the Arts, Washington, DC.

Light and Space Art

Paralleling New York Minimalism's development, an even more minimal approach to making art emerged among a small group of loosely affiliated artists in Southern California. Unlike their New York peers who emphasized the physical reality of objects, the California artists downplayed or eliminated the object and took light and space as their primary materials. Known as Light and Space artists, their work involved directing natural light or incorporating artificial light into objects or architectural spaces, or manipulating light by means of transparent,

translucent, or reflective materials. They shared a preoccupation with stimulating heightened sensory awareness, often through minimal means that serve to sharpen the viewer's attention and engagement. Their work has been described as phenomenal—known through the senses rather than through thought or intuition. Many of them were interested in Merleau-Ponty's phenomenological emphasis on the primacy of perception as the foundation of knowledge (see "Phenomenology" box). The two most prominent Light and Space artists are Robert Irwin and James Turrell. Other key practitioners include Larry Bell, Maria Nordman, Helen Pashgian, Eric Orr, and Doug Wheeler.

Robert Irwin (b. 1928)

Robert Irwin has devoted his career to raising questions and posing theories about the nature of art. In the 1960s, this involved an inquiry into the nature of painting. Between the late 1950s and mid-1960s, his work evolved from gestural Abstract Expressionism to monochrome canvases traversed by a few thin horizontal lines, then to convexly bowed square canvases covered with thousands of evenly spaced red and green dots (e.g., *Untitled*, 1963–65, Hirshhorn). From a distance, the dot paintings appear to glow and vibrate; a misty greenish square seems to advance from the center while the edges fade imperceptibly into a pink halo.

Irwin's growing concern with visual perception and the relationship between the painting's center and edge led him to adopt convex, spray-painted discs. He had his first series of discs (1966–67) fabricated of aluminum and his second series (1968–69) cast in acrylic resin, as in *Untitled* (Figure 16.17). Bisecting the acrylic discs' mid-sections is a horizontal band that is painted opaque gray at the center and fades to actual

FIGURE 16.17 Robert Irwin, *Untitled*, 1969. Acrylic paint on cast acrylic, 37 cm in diameter. The Art Institute of Chicago.

transparency at the edges, creating confusion between illusionistic and real space visible through the disc. The discs project out from the wall on 45.7-cm tubes. When illuminated from above and below by a quartet of floodlights, they create a cloverleaf pattern of interlaced shadows. Viewed from the front, the disc seems to dematerialize, while the shadows assume an unexpected palpability. Disc, shadow, and wall merge into a single aesthetic continuum. For Irwin, "the discs resolved that one simple question—how to paint a painting that doesn't begin or end at the edge—by more or less transcending painting. . . . After the discs, there was no reason for me to go on being a painter."[69]

Since 1970, Irwin has concentrated on creating "site determined" or "site conditioned"

FIGURE 16.18 James Turrell, *Afrum I (White)*, 1967. Projected light, dimensions variable. Solomon R. Guggenheim Museum, New York.

works of art that subtly transform the qualities of spaces and heighten and alter visitors' perceptions of them.[70] He has made numerous temporary installations in galleries and museums using simple materials such as string, tape, and panels of white nylon scrim that read as opaque or translucent depending on how light falls on them. He also has designed many permanent public artworks and landscape projects, including the Getty Center's *Central Garden* (1997), a living artwork Irwin describes as "Always changing, never twice the same."[71] Through his "phenomenal art," Irwin "seeks to discover and value the potential for experiencing beauty in everything."[72]

James Turrell (b. 1943)

James Turrell aims to make viewers "feel the presence of light inhabiting a space."[73] His art defines spaces through ambient or artificial light and engages the perception of colored light. "What is really important to me," says Turrell, "is to create an experience of wordless thought, to make the quality of sensation of light itself something really quite tactile. . . . Light is not so much something that reveals, as it is itself the revelation."[74]

Turrell's undergraduate study of experimental psychology informed his interest in perception, while his affinity for light is rooted in his Quaker faith: he says that Quakers pray to "greet the light"[75] (a metaphor for the divine). Also influential is his experience as a pilot: in flying, he says, "you experience light purely and in a different way from being on the ground with all kinds of distractions."[76]

Turrell initially used xenon projectors to shine white or colored light onto white walls in dark rooms. The *Cross Corner Projection Pieces* (e.g., *Afrum I [White]*, 1967, Figure 16.18) formed illusions of three-dimensional geometric forms suspended in the corners of rooms. The *Single Wall Projection Pieces* (e.g., *Fargo Blue*, 1968) cast luminous geometric shapes that seem to dematerialize the wall surface. Turrell then created actual openings in the wall in his *Space Division Constructions* (e.g., *Acton*, 1976). These are rooms divided into a "viewing space," occupied by spectators, and a "sensing space" filled with diffused light, perceived initially as a flat surface that gradually becomes transparent. He has also produced scores of *Skyspaces*, cutting away a room's ceiling to "create a space that is completely open to the sky, yet seems enclosed."[77] The *Skyspaces* offer viewers an absorbing experience of constantly shifting light and color conditioned by changes in weather and sunlight.

Facilitating observation of the sky is the key purpose of Turrell's magnum opus, the *Roden Crater* (begun in 1977). He has transformed this dormant volcanic cinder cone in the northern Arizona desert into a monumental, controlled environment of tunnels and chambers that capture light from the sun, moon, stars, and planets. Heightening visitors' sense of their connection to the cosmos through contemplation of the heavens, the *Roden Crater* project is Turrell's most ambitious expression of spirituality rooted in his Quaker faith, which advocates slow, quiet reflection as a means of experiencing the divine.

Mid-Century Modern Architecture, c. 1920–1970

No single narrative can encapsulate modern architecture's complex and multifaceted history from the 1920s through the 1960s. Many critics and historians of the period, however, recognized one architectural current as the most innovative and appropriate for the age: the International Style (see box) or, simply, the Modern Movement. Emerging in Europe in the 1920s, this form of architecture was characterized by the use of modern construction materials (principally, reinforced concrete, steel, and glass); the refusal of applied ornament; emphasis on space rather than mass; simple, abstract geometry in design; and freedom in the composition of plans and elevations. Celebrated pioneers, like Walter Gropius, Le Corbusier, and Ludwig Mies van der Rohe, viewed it as a thoroughly modern yet also timelessly valid style. Each realized a building that achieved canonical status in histories of the movement: Gropius's Bauhaus Building (see Figure 6.13), Le Corbusier's Villa Savoye, and Mies's Barcelona Pavilion.

Though critics, curators, and historians endorsed the International Style in the 1930s, it largely failed to win over the public, resulting in few commissions for its practitioners. The Great Depression and totalitarian European governments' reaction against modernism also impeded its success. The rise of Nazism caused many modern architects to flee Germany, including Gropius and Mies; both continued their teaching careers in the United States, which fostered the International Style's widespread adoption in the United States after 1945.

Mies's stripped-down, boxy style became a common, global architectural idiom in the 1950s and 1960s. Many ambitious young architects sought to distinguish themselves from this mainstream by developing alternative styles. Some, such as Eero Saarinen and Jørn Utzon, reached back for inspiration to the dramatic and emotive forms of architectural Expressionism. Others took their cues from the Le Corbusier's later work, which traded his early machine-inspired Purist aesthetic for massive, sculptural forms in raw concrete. Still others, such as Alvar Aalto, Oscar Niemeyer, and Kenzō Tange, blended influences from first-generation International Style masters with their own countries' regional traditions. Standing proudly apart was Louis Kahn, whose late works earned him a place in the pantheon of twentieth-century architecture. Finally, later mid-century architects took modernism's utopian ideals to their logical conclusions by proposing futuristic megastructures to replace conventional cities.

The First Wave of the International Style

Modern European architecture's development following World War I involved the same search for fresh beginnings that spurred **Dada**, **Purism**, **Constructivism**, **De Stijl**, and the **Bauhaus** (see Chapters 6 and 7). Postwar modern architects like Gropius, Le Corbusier, Eileen Gray, and Mies wanted to create a new architecture for a new era, vociferously opposing **historicism** and drawing inspiration from engineering and technology as expressions of the modern machine

age spirit. They generally embraced the related concepts of rationalism and **functionalism** to pursue their utopian ideals.[1] Rationalism applies reason to the solution of design problems, while functionalism holds that the function of a building or architectural ensemble (e.g., a city) should determine its form. Some key Modern Movement principles proceeded from these positions. First, reason-based architecture, design, and urban planning could foster the improvement of society. Second, economical building methods using prefabricated elements could create efficient, standardized dwellings. Third, demolition of the existing urban fabric was justified to clear space for new housing estates. Fourth, functional, constructional, economic, social, and political factors rather than the architect's personal inclinations should, in theory, generate architectural form. In practice, however, aesthetic considerations were always important; the architects often employed spatial and design elements adapted from **Cubism**, De Stijl, and Constructivism. Post-World War I Modern Movement architects pursued their utopian aims with zeal, and, sometimes, arrogance. Despite their professed commitment to functionalism, many of their buildings were not comfortable to occupy. For example, the flat roofs they favored were notoriously prone to leaking and the dissolution of walls into huge expanses of glass turned living spaces into hothouses in the summer and freezers in the winter.

The Early Architecture of Le Corbusier (1887–1965)

Charles-Édouard Jeanneret, cofounder of the Purist painting movement (see Chapter 9), adopted the pseudonym Le Corbusier for his architectural work in 1920 and emerged as one of the **International Style**'s leading figures.[2] Two intertwined goals guided his architectural efforts: the provision of functional efficiency and the creation of beauty through refined arrangements of **abstract** formal elements and spaces. He expressed the first goal through his famous dictum, "the house is a machine for living in."[3] He conveyed the second by defining architecture as "the masterful, correct and magnificent play of volumes brought together in light."[4] In the early 1900s, the Swiss-born Jeanneret worked under architect Auguste Perret in Paris, where he gained a stronger understanding of reinforced concrete, and under Peter Behrens in Berlin, where he absorbed the **Deutscher Werkbund**'s commitment to improving design through the merger of art, craft, and industry (see Chapter 5). He then took a sketching trip through the Balkans, Turkey, Greece, and Italy, where his study of **Classical** architecture informed his evolving aesthetic.

After settling in Paris in the late 1910s, Jeanneret issued his influential book *Vers une architecture* (*Toward an Architecture*, 1923) under the name Le Corbusier and produced drawings and models for houses and cities—housing being a crucial need in the postwar rebuilding period. His *Citrohan* house proposal (1920–22) established his characteristic domestic design: an abstract, box-like **volume** with a well-lit double-height living room and a roof deck. Its name, playing on that of the Citroën automobile, signaled Le Corbusier's intention that it be mass-produced. His geometrically rigorous design for "A Contemporary City for Three Million Inhabitants" (1922), fully developed as the *Ville Radieuse* (Radiant City) (1935) was his antidote to the dirty, crowded, and chaotic traditional city. Le Corbusier's project featured twenty-four sixty-story cruciform steel-and-glass office towers ranged around a central transportation terminal. Lower residential blocks surrounded the central skyscrapers, separated from them by lawns, parks, and gardens. Utopian in its vision of the city as clean, airy, orderly, and efficient, Le Corbusier's Ville Radieuse concept strongly influenced mid-twentieth-century urban planning and the development of high-density housing solutions, some realized by Le Corbusier himself. However, later in the century his principles were criticized as totalitarian and dehumanizing, imposing uniformity and subordinating the individual.

Beginning in 1922, Le Corbusier built a series of houses demonstrating his "Five Points of a New Architecture."[5] These were: 1) The support of the building on evenly spaced *pilotis* (piers) that rise through the interior, lifting the first floor off the ground; 2) the incorporation of a flat roof, serving as a roof garden; 3) a free interior **plan**, with rooms formed by non–load-bearing partitions; 4) the use of long horizontal or ribbon windows opening interiors to light; and 5) the free composition of the **curtain walls**. Functionally, these principles permitted the creation of a house with living spaces lifted above the dark, humid ground story, filled with healthy light and air, and efficiently exploiting space, including the roof.[6] In aesthetic terms, they permitted the realization of the abstract **modernist** architectural ideal: a pure, unadorned membrane of reinforced concrete and glass stretched over a geometric structural frame—open, airy, and elevated above nature.[7]

These principles are famously expressed in Le Corbusier's Villa Savoye (1929–31, Figure 17.1), an icon of the International Style. Built in suburban Poissy as a weekend retreat for a wealthy Parisian family, the villa originally looked out from a half-circle of trees across a gently rolling landscape. Its ground floor's curving contour was determined by the turning radius of the cars that conveyed the owners from Paris—functionally accommodating and symbolically acknowledging this machine-age means of transportation. The driveway continues under the house to a three-car garage; the ground floor also contains servants' quarters. Inside, both a sculptural spiral staircase and a straight ramp lead to the main floor, where Le Corbusier maximizes the integration of interior and exterior

FIGURE 17.1 Le Corbusier, Villa Savoye, 1929–31. Poissy, France.

space. The living room and adjacent roof garden, separated by a sliding glass door, offer views of the surrounding landscape through continuous ribbon windows. A ramp from the roof garden leads to an upper sundeck partially enclosed by undulating windscreen walls.

From the outside, the Villa Savoye appears as an elegantly simple embodiment of the Purist aesthetic, "a box raised above the ground."[8] Square in plan, its external **elevations** are nearly identical, with a horizontal strip of windows wrapping around all four sides of white planar walls elevated on a regular grid of *pilotis*. Secondary to this rectilinear uniformity are the curved recessed wall of the ground floor and the tubular windscreens of the sundeck. The more complex interior contains stirring oppositions between structure and space, inside and outside, rest and movement. The villa's long central ramp, connecting all three levels, forms an "architectural promenade"[9] providing ever-shifting viewpoints that play against the external appearance of Platonic stability. Contemplating nature "through the four sides of the long windows," wrote Le Corbusier of the owners, "their home life will be set in a Virgilian dream."[10] This reference to the Roman lyric poet Virgil evokes the Classical roots of Le Corbusier's pastoral ideal and its **Renaissance** architectural manifestation in Palladio's Villa Rotonda with its views of the countryside from its four identical porches. Aspiring at once to timelessness and contemporaneity, the Villa Savoye adapts classical values to the modern functionality of a "machine for living in." The practical results, unfortunately, were less than fully functional: Mme. Savoye complained that the flat roof and terrace leaked terribly; this, combined with heat loss through the windows and problems with the heating system, rendered the living spaces cold and damp.[11]

Eileen Gray (1878–1976)

Architecture has been and remains a male-dominated field worldwide, due to historical factors like women's limited access to architectural training and continuing bias within the profession.[12] Among the few women architects active within the International Style's first wave was Eileen Gray, who was associated with and influenced by Le Corbusier but developed a more personal form of modernism. Her designs responded to the specific nature of the site, program, and needs of the

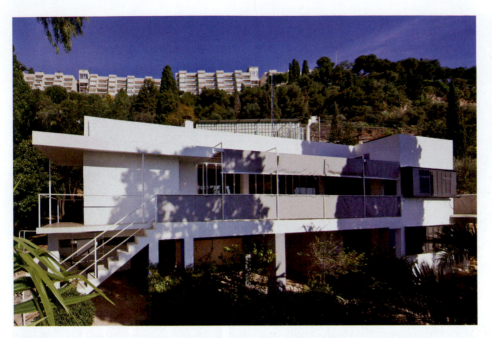

FIGURE 17.2　Eileen Gray, E-1027, 1929. Roquebrune-Cap-Martin, France.

occupants rather than proceeding, as did Le Corbusier's, from principles intended to be universally applicable.

Born in Ireland and educated in painting in London, Gray moved to Paris in 1902 where she specialized in the design of **lacquer**-covered furniture, selling it in her own shop in the 1920s alongside other creations. She also developed architectural projects, designing and building a vacation home, the villa E-1027, overlooking the Mediterranean at Roquebrune-Cap-Martin in southern France (1929, Figure 17.2). The white-painted reinforced concrete house incorporates several of Le Corbusier's principles, including the use of *pilotis*, strip

The International Style

Pioneered in the 1920s by architects in France, Germany, and the Netherlands, the International Style was a shared formal language that dominated modernist architecture from the 1930s to the 1960s. Henry-Russell Hitchcock and Philip Johnson's 1932 MoMA exhibition and their accompanying book, *The International Style: Architecture since 1922*, gave the term currency. Hitchcock and Johnson defined three principles of the International Style. The first was "a new conception of architecture as volume rather than as mass."[15] Supported by a steel structural skeleton and without load-bearing walls, the building would essentially consist of space enclosed by planes. The second principle was "regularity rather than axial symmetry [serving] as the chief means of ordering design."[16] The even distribution of structural supports and repetition of vertical and horizontal elements produced regularity and allowed for flexible asymmetry in design, rather than the bilateral symmetry of Classical and Renaissance architecture. The third principle was the elimination of "arbitrary applied decoration."[17] Now aesthetic quality would be achieved through technical perfection in materials such as metal, wood, glass, and concrete; the fine proportions of units such as doors and windows; and the relationships between those units' proportions and the overall design.[18]

The International Style's first concentrated manifestation came at the Deutscher Werkbund's 1927 exhibition in Stuttgart, the Weissenhofsiedlung (Weissenhof model housing estate),

directed by Mies. For this project, seventeen leading European modernist architects, including Peter Behrens, Gropius, Mies, Le Corbusier, and J. J. P. Oud, designed and built modestly scaled housing units as prototypes for mass production. The buildings emphasized functionalism in their economical use of modern construction materials and their unadorned geometric designs. Almost all were painted white—a hallmark of much global International Style architecture of the 1930s and 1940s.

International Style principles dominated post–World War II modernist urban planning through the powerful influence of the "Athens Charter"—formulated in 1933 by the Congrès Internationaux d'Architecture Moderne (CIAM, International Congress of Modern Architecture) and published in 1943 by Le Corbusier. This doctrine emphasized rigid zoning and high-rise housing structures separated by green spaces—concepts realized most completely in Brasília, the new capital of Brazil designed by Lúcio Costa and Oscar Niemeyer. The International Style reached its peak in Mies's post–World War II work and that of his followers. Its most characteristic buildings were sleek, rectilinear, steel-and-glass skyscrapers, such as Mies and Johnson's Seagram Building, which became symbols of corporate power. In the 1970s, many architects and critics began to reject the late International Style "glass boxes" that they found formulaic and soulless. In reaction, a variety of new architectural expressions emerged under the label of **Postmodernism** (see Chapter 21).

windows, free façades, and a roof terrace. Unlike Le Corbusier, Gray did not use an open plan, but created defined, private interior spaces, each with its own access to the exterior. More attentive than Le Corbusier to temperature control, she affixed sliding shutters to the strip windows, allowing ventilation while limiting solar penetration. She also integrated useful furniture of her own design, such as built-in bedside tables, which could be swung out of the way on pivoting arms and had adjustable easels to facilitate reading in bed. Rejecting Le Corbusier's dictum, Gray declared, "A house is not a machine to live in"[13] and "not just the expression of abstract relationships; it must also encapsulate the most tangible relations, the most intimate needs of subjective life."[14] Balancing aesthetic and functional considerations, she produced a dwelling that is both modern and accommodating.

The Early Architecture of Ludwig Mies van der Rohe (1886–1969)

The last director of the Bauhaus (see Chapter 6), Ludwig Mies van der Rohe's famous aphorism, "less is more," expresses his architectural philosophy of achieving excellence through simplicity. Mies's father was a master stonemason who taught him to respect the craft and materials of building. After moving from his native Aachen to Berlin, Mies started working for Behrens in 1908, where he met Gropius and Le Corbusier. Behrens introduced Mies to the Werkbund ideal of a marriage between art and technology, as well as the austere **Neoclassical** aesthetics of the nineteenth-century German architect Karl Friedrich Schinkel, which influenced Mies's pre–World War I work.

In the early 1920s, Mies made prophetic designs for soaring steel-framed skyscrapers completely sheathed in glass (e.g., Friedrichstrasse Skyscraper Project, Berlin-Mitte, Germany, 1921) and for a seven-story office building with floors formed by **cantilevered** concrete slabs. He also proposed a brick country house with an asymmetrical, open plan and walls extending into the landscape as vertical planes. The design synthesized influences from Frank Lloyd Wright's spatial fluidity and De Stijl's abstract geometry and predicted Mies's German Pavilion (Figure 17.3).

This building was a result of Mies's 1928 appointment to direct the German government's exhibits at an international trade fair in Barcelona. For this event, he designed a pavilion for ceremonial functions, including a formal reception for the Spanish king and queen, and open to the elements, since it was only to be used in the summer of 1929. Raised on a podium, a Neoclassical element derived from Schinkel, its floor was a fifty-three by seventeen-meter platform of Roman travertine bordered on two sides by rectangular reflecting pools, the smaller of which was enhanced by Georg Kolbe's life-sized sculpture of a female nude. A roof slab resting on a grid of eight slender cruciform chromium-plated steel **columns** covered the main ceremonial space. Mies divided this space through walls of golden onyx, green Tinian marble, and tinted, frosted, and clear glass—opulent materials creating aesthetic richness. He did not connect the walls to form rooms, however, but allowed space to flow freely through the interior and into the structure's open-air portions. For the interior, Mies designed elegant chairs and stools with frames of flat chromium-plated steel bars and white leather cushions. Intended for the Spanish royal couple (who actually never used them), Mies's Barcelona chair and stool quickly became classics of modern design and are still manufactured today.

A masterpiece of refinement in structure, proportions, space, and materials, the German pavilion exemplifies Mies's distinctive aesthetic. Dismantled at the fair's conclusion, it gained fame through photographs and was rebuilt in 1986 to celebrate the artist's centenary. Mies's later work, discussed below, was crucial to International Style modernism's development in the middle decades of the twentieth century.

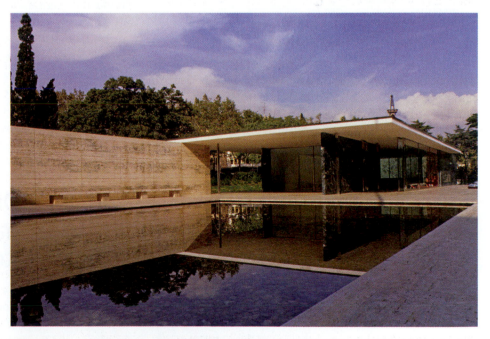

FIGURE 17.3 Ludwig Mies van der Rohe, German Pavilion, 1929. Barcelona. Reconstructed 1984–86.

Expressionist Architecture in Germany

Expressionism, prevalent in Germany in the 1910s and early 1920s, was a countercurrent to the early International Style. Expressionist architects ignored rationalism and functionalism to pursue subjective visions conveyed through dynamic and irregular forms. Drawing on Nietzsche's and Bergson's ideas, many Expressionist architects saw themselves as mediums who channeled the vital forces and spirit of their times into utopian architectural visions intended to improve human life.[19] The disaster of World War I and ensuing dire material and political conditions in Germany only intensified their utopian aspirations.

A prophet of architectural Expressionism was Paul Scheerbart (1863-1915), whose book *Glasarchitektur* (*Glass Architecture*, 1914) envisioned a crystalline, light-filled built environment of clear and colored glass that would generate a new culture. Inspired by Scheerbart, Bruno Taut (1880-1938) created a Glass Pavilion for the 1914 Werkbund exhibition in Cologne and in 1919 proposed a town plan centered on a "city crown"—"a crystal house constructed of glass" that "reigns above the entire city like a sparkling diamond" to serve a new collective religion in a postwar utopian socialist world without national boundaries.[20] Mies van der Rohe's 1919–21 projects for glass-walled skyscrapers—one with a star-shaped plan to reflect light like a crystal—participate in this Expressionist dream of a radiant and redemptive architecture.

Erich Mendelsohn (1887–1953)

Most Expressionist architectural proposals remained unrealized, but the movement did produce a few significant buildings. The best known is Erich Mendelsohn's Einstein Tower (1917–21, Figure 17.4), in Potsdam, Germany, an astronomical observatory designed for experiments seeking to prove Albert Einstein's theories about the relationship between energy and matter. Trained in architecture in Munich, Mendelsohn, like Vasily Kandinsky and other Blaue Reiter Expressionists (see Chapter 3) with whom he was associated, sought to communicate ideas and emotions through **abstraction**. The Einstein Tower's organic forms originated in rapid sketches he made in the trenches during World War I. Mendelsohn intended the tower's animated, curving elements to represent the energy inherent within mass posited by Einstein's special theory of relativity.[21] Unlike other manifestations of Expressionism, this was not a mystical vision but Mendelsohn's attempt to translate a scientific concept into architectural form. Mendelsohn planned to build the tower out of reinforced concrete, but technical difficulties and economic necessity forced him to use

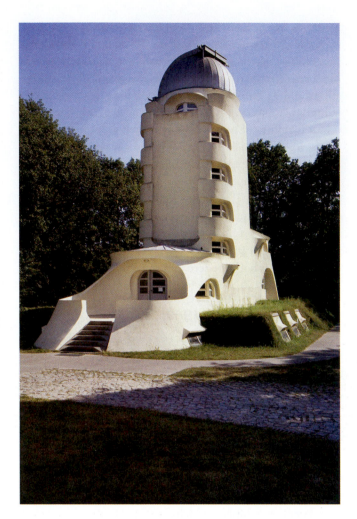

FIGURE 17.4 Erich Mendelsohn, Einstein Tower, 1917–21. Potsdam, Germany.

stucco-covered brick for most of it instead. Despite this compromise, the Einstein Tower remains a powerful architectural symbol embodying ever-advancing modern science's revolutionary excitement. Its expressionist idiom differs markedly from the austere rectilinear aesthetic of the emerging International Style.

The Early Diffusion of the International Style to the United States

European immigrants brought the International Style to the United States, beginning with the Austrian-born Rudolph Schindler (1887–1953), who established a practice in Los Angeles in 1922 after working for Frank Lloyd Wright. He designed his most famous building, the Lovell Beach House (1926) in Newport Beach, for Philip Lovell, a naturopathic

doctor who promoted healthy living. Five parallel reinforced concrete frames support the severely geometric house. The two-story living room has a floor-to-ceiling glass wall and balcony on the south end, overlooking the ocean, with sleeping lofts tucked above in a horizontal tray along the west side. The building blends aspects of Wright's organic design philosophy with the reductive style of contemporary progressive European work.

In 1927 Lovell commissioned a second house from Richard Neutra (1892–1970), another Austrian-born architect, who had worked for Mendelsohn's Berlin office before moving to the United States. Neutra designed the Lovell Health House (1929, Figure 17.5) to facilitate the patron's fitness-promoting ideas. Built on a steep hillside in Griffith Park, Los Angeles, the three-level dwelling has a rectilinear, machine-age aesthetic comparable to Le Corbusier's, with a light steel frame, white-painted concrete walls, cantilevered balconies, and strip windows and curtains of glass providing ample light and air. It features open-air porches for sleeping and sunbathing and an outdoor swimming pool, partly covered by the house's west end rising over the pool on *pilotis*. Hitchcock and Johnson included the Lovell Health House in their 1932 MoMA exhibition, cementing its status as an icon of the early International Style in the United States.

Also included in the MoMA exhibition was the Philadelphia Savings Fund Society (PSFS) Building, the world's first International Style skyscraper (Figure 17.6), designed by George Howe (1886–1955) and William Lescaze

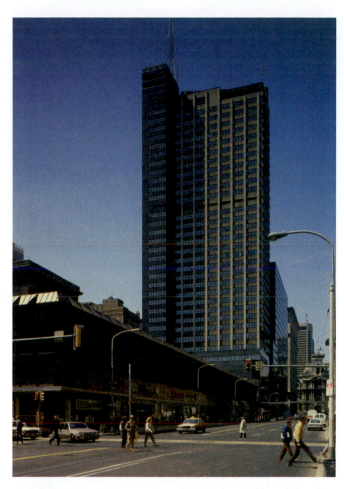

FIGURE 17.6 George Howe and William Lescaze, Philadelphia Savings Fund Society (PSFS) Building, 1926–32. Philadelphia.

(1896–1969). The thirty-two-story building's design reflects its different functions. The sleek, curving base, cantilevered out from the skyscraper shaft above, accommodates street-level shops, a second-floor banking hall, and three floors of banking offices. The banking hall's horizontal band of thirty-two-foot-tall windows wraps around the corner—a dissolution of solid walls made possible by the steel skeleton supporting the building. The tower above contains identical floors of ribbon-window lit offices, capped by an executive suite. An attached service spine holding elevators, stairs, and restrooms, gives the tower a T-shaped plan. On the office wing's long sides, evenly spaced columns rising from the sixth floor to the top emphasize the building's verticality. Each building section is clad in a different material: polished charcoal-colored granite on the first three

FIGURE 17.5 Richard Neutra, Lovell Health House, 1929. Los Angeles.

stories; sand-colored limestone on the top two bank office floors and office-tower columns; gray brick on the office-tower spandrels; and black brick on the service spine. The overall design manifests the International Style's characteristic rationality and efficiency.

In its abstract rectilinear style and lack of applied ornament, the PSFS building differed markedly from other US skyscrapers of the same period. John Mead Howells and Raymond Hood gave the Chicago Tribune Tower (1922–25) a Gothic-style tower, complete with flying buttresses. Two New York skyscrapers, the Chrysler Building (1930) by William Van Alen and the Empire State Building (1931) by Shreve, Lamb, and Harmon, were more fashionably up to date. Both had **setbacks**—step-like recessions in their elevations dictated by Manhattan's building codes—and **Art Deco** spires, giving them a more ornamental appearance than the crisply geometric PSFS building.

The Later Work of Frank Lloyd Wright

The abstract geometries and spatial freedom of Wright's early work (see Chapter 5) influenced many European pioneers of the International Style, who studied his designs in a deluxe portfolio published in Germany in 1911. Wright, however, disdained the International Style as a "miscarriage of a machine age" that attempted "to strip hide and horns from the living breathing organism that is modern architecture."[22] Throughout his career, Wright remained committed to the organic ideal of unity between the building, its furnishings, and its site.

In the early 1920s, Wright built several houses in Southern California using concrete blocks, smooth or cast with geometric patterns inspired by Mayan architecture, tied together with steel rods (e.g., The Ennis House, 1924). Although he designed these homes for wealthy clients, Wright saw this modular "textile block" system as an economical modern construction method that anyone could use—an affirmation of his democratic principles. During this decade, he also created unrealized designs for tall office and apartment buildings with reinforced concrete floors cantilevered out from a central spine. This structure's likeness to the trunk and branches of a tree manifested Wright's philosophy of organic architecture. He eventually built towers with this design for the S. C. Johnson Company (Racine, Wisconsin, 1943) and the H. C. Price Company (Bartlesville, Oklahoma, 1952–56).

Wright channeled his interest in democracy into his plan for Broadacre City (1934–35), his utopian solution to the social, economic, environmental, and political problems he perceived capitalism to have created. Disparaging modern cities as "unwholesome," overcrowded, "ultra-capitalistic centers,"[23] Wright proposed to resettle the entire US population onto individual homesteads, with each family owning at least an acre of land and a car for transportation, within a larger city including all essential elements of modern society, from farms to factories to places of worship. Broadacre City's decentralized, agrarian character, meant to encourage individual liberty, was Wright's counter to Le Corbusier's centralized, high-density Ville Radieuse concept.

As a complement to Broadacre City, Wright developed the Usonian[24] house: an inexpensive single-story dwelling set on a concrete slab foundation with radiant floor heating; walls of wood, brick, or textile block; a flat overhanging roof; and a cantilevered carport (a term Wright coined). Like the earlier Prairie Style houses (see Figure 5.15), the Usonians had open plans, a horizontal orientation relating them to the earth, and banks of windows and glass doors creating visual flow between interior and exterior. Beginning with the Herbert Jacobs House (1936–37), Wright realized over 140 Usonian homes. Commercial builders of suburban US houses soon adopted aspects of their formula, such as carports, merged kitchen and living areas, and the elimination of the formal dining room.

In the midst of his work on Broadacre City, Wright received the commission that generated his masterpiece, Fallingwater (Figure 17.7), a summer home for the family of Edgar and Liliane Kaufmann in a wooded ravine in the Appalachians southeast of Pittsburgh. Wright situated the building directly above a waterfall on the stream known as the Bear Run, accessible by a stairway descending from the living room, enabling the Kaufmanns to "live with the waterfall . . . as an integral part of [their] lives."[25] The building's horizontal layers—cantilevered reinforced concrete trays anchored to the native rock—hover dramatically over the stream. The elevation's major vertical element is the chimney, fashioned of rough-cut gray sandstone providing a textural and coloristic contrast to the smoothly finished, ochre-painted concrete balconies. Wright largely eliminated walls in favor of expanses of glass that open the house up to the surrounding woods and water. He gave the cave-like interiors low ceilings to direct the eye horizontally through the windows. The large open ground-floor living and dining space has a polished flagstone floor mimicking the wet streambed rocks. This floor's focal point is the hearth, the symbolic center of family life. A large boulder on which the Kaufmann family used to sunbathe forms the hearthstone, rooting the house to its site. A remarkable fusion of dwelling place with nature, Fallingwater is the supreme expression of Wright's philosophy of organic architecture. Despite its inclusion of formal elements seen in the International Style, such as ribbon windows and horizontal reinforced concrete balconies, it is very different from a house like Le Corbusier's Villa

reported greatly increased productivity and a superior retention rate among employees in the main workspace.[27]

The climax of Wright's late career was the Guggenheim Museum (1943–59, Figure 17.8), which he began designing in 1943, though it was finished sixteen years later, six months after his death. Its main, cast concrete volume, described by Wright as an inverted ziggurat, widest at the top and tapering as it descends, is closed off from the surrounding environment and lit from above, like the Johnson Wax Building. It contains a vast 29.2-meter-high rotunda, capped by a graceful skylight spanning 17.7 meters. A spiraling, descending reinforced concrete ramp encircles the rotunda. The ramp's outer walls are segmented into bays originally designed to show Solomon R. Guggenheim's collection of nonobjective paintings by artists such as Kandinsky, assembled with the guidance of Guggenheim's curator, painter Hilla Rebay, who engaged Wright to design the museum. Rejecting the conventional museum plan of a series of rectangular galleries, Wright's continuous ramp

FIGURE 17.7 Frank Lloyd Wright, Fallingwater, 1934–37. Bear Run, Pennsylvania.

Savoye, which stands aloof from the surrounding landscape rather than being embedded in it.

In contrast to Fallingwater, Wright's next major commission, the Johnson Wax Company Administration Building (Racine, Wisconsin, 1936–39), has no windows because it is located in an unattractive industrial area. Instead, as he had done in the Larkin Building (see Figure 5.16), Wright turned the building in on itself. He gave its double-height workspace an atmosphere of nature through a grid of slender white steel-mesh reinforced concrete columns that support 5.48-meter-diameter discs resembling lily pads. Light pours down from the ceiling and through a **clerestory** encircling the upper perimeter of the red brick-walled workspace. The light is filtered through layered tubes of Pyrex glass—a material designed for laboratory equipment. Adhering to his organic principles, Wright designed all the office furniture in a streamlined style of curved wood and metal harmonizing with the overall aesthetic. In the Johnson Wax Building, Wright claimed to have created "as inspiring a place to work in as any cathedral ever was in which to worship."[26] In later years, the company

FIGURE 17.8 Frank Lloyd Wright, Guggenheim Museum, 1943–59. New York.

fosters fluid movement through the building as the visitor progresses from one artwork to the next and it allows for views across the central space. However, the soaring rotunda and its unspooling ramps constantly compete for attention with the displayed artworks. Many have praised the Guggenheim as a grand work of pure architecture, irrespective of its function. Philip Johnson called it "one of the greatest rooms of the 20th century."[28] Critic Hilton Kramer, however, indicted it as a "disaster inflicted upon art. . . . an architecture totally irrelevant to its purposes, an architecture which succeeds in having only one 'organic' function: to call attention to itself."[29]

FIGURE 17.9 Alvar Aalto, Town Hall, 1949–52. Säynätsalo, Finland.

The Organic Architecture of Alvar Aalto (1898–1976)

Finnish architect Alvar Aalto's work, like Wright's, is often described as organic. Aalto sought to integrate the parts of the building and integrate the building with its surroundings, aspiring to the unity of life within nature. An attention to human needs and comfort also distinguishes Aalto's designs; he described architecture as a "great synthetic process of combining thousands of definite human functions" in order "to bring the material world into harmony with human life."[30]

Aalto's first major project was a tuberculosis sanatorium in Paimio, Finland (1929–33) built in the International Style idiom, with smooth white walls, flat roofs, ribbon windows, and cantilevered balconies. The balconies and large roof terrace of the highly functional design facilitated patients' exposure to fresh air and sunshine as part of their treatment. Aalto collaborated with his wife and fellow architect Aino Aalto (1894–1949) in designing the sanatorium's furniture and fittings to fulfill functional requirements elegantly. The Paimio Chair (1931–32), still in production today, has a curving frame of laminated wood and a sinuous seat of bent plywood with its back angled to help the sitter breathe more easily.

After World War II, Aalto departed from the International Style and adopted a more poetic mode. He employed a greater variety of materials, forms, and textures, and references to older building traditions. His most admired later work is the town hall for the small community of Säynätsalo,

Finland (1949–52, Figure 17.9). Its buildings are simple geometric volumes of red brick with details in wood and copper—all traditional materials of Finland. The ensemble comprises a rectangular library and a U-shaped government building facing an elevated central courtyard reached by stairs from either of the southern corners. The dominant element is the council chamber, covered by a single pitch roof with a seventeen-meter-high peak supported on the interior by impressive fan-shaped timber trusses. The hill towns of medieval Italy likely inspired Aalto to elevate the courtyard using earth excavated for the town hall's construction. He used the enclosed courtyard because "in parliament buildings and courthouses the court has preserved its inherited value from the time of ancient Crete, Greece and Rome to the Medieval and Renaissance periods."[31] Aalto infuses this civic space with a natural atmosphere: vines climb trellises surrounding the courtyard, mostly covered by grass, and the western stairs consist of grass-covered earth retained by wood risers. In the Säynätsalo Town Hall, Aalto masterfully blends modern refinement with rustic simplicity, sensory richness, and symbolic and historical resonance to create a meaningful place.

The Later Work of Le Corbusier

During the 1930s, Le Corbusier influenced the architectural profession through his domination of CIAM (see "The International Style" box). This group's "Athens Charter" (1933) promoted urban planning tenets for the "functional city" inspired

by Le Corbusier's Ville Radieuse concept. The charter identified four functions of the city—dwelling, recreation, work, and transportation—to be separated through strict zoning. It considered the dwelling "the prime center of all urban planning, to which all other functions are attached."[32]

Between the World Wars, Le Corbusier made numerous proposals for high-density apartment buildings within his urban planning schemes. In 1945, the French government commissioned him to build one in the southern port city of Marseilles, in response to the postwar housing shortage. The result was the Unité d'Habitation (roughly, Housing Unit, 1945–52, Figure 17.10), one of Le Corbusier's most celebrated and influential works. Designed as a self-contained vertical city of 1,600 residents, the titanic 56 x 137 x 24-meter block is lifted off the ground by colossal splayed *pilotis*. Its seventeen stories hold 337 apartments of twenty-three different types. Most are L-shaped in section with double-height living rooms. The apartments interlock around internal corridors running the building's length at every third level and they open onto balconies on the east and west sides. The balconies provide cross-ventilation and have brise-soleils (sunscreens) to deflect the intense Mediterranean light. The seventh and eighth levels

contain services, like a shopping center, a hotel, and a restaurant, while the rooftop holds a kindergarten/nursery and recreation facilities. With its freestanding structures, swimming pool, and sculptural ventilation stack, the rooftop resembles the deck of an ocean liner—a model, to Le Corbusier, of elegant functionality achieved through advanced engineering.

The Unité d'Habitation announced a new style quite different from Le Corbusier's Purist aesthetic that helped to define the International Style. Rather than the Villa Savoye's seemingly weightless volumes enclosed by smooth thin white painted walls and sheets of glass, the Unité d'Habitation is massive and sculptural, with rugged concrete surfaces bearing the imprint of the wood boards used to form them. Le Corbusier would use *béton brut*—raw concrete—as his primary building material for the rest of his career. His example spawned the architectural movement known as Brutalism, widespread in the 1950s and 1960s, characterized by hulking concrete forms.

Raw concrete is also prevalent in Le Corbusier's Chapel of Nôtre Dame du Haut in Ronchamp, France (1950–55, Figure 17.11), perhaps the most famous church of the twentieth century. Departing radically from the predominantly rectilinear

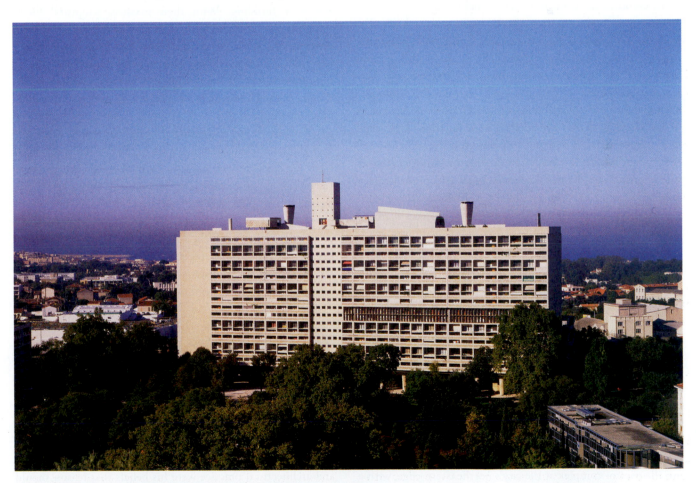

FIGURE 17.10 Le Corbusier, Unité d'Habitation, 1945–52. Marseilles, France.

character of his earlier buildings including the Unite d'Habitation, its curving, powerfully sculptural forms create stirring expressive effects. The chapel, commissioned by the local Catholic diocese to replace one destroyed in World War II, stands on a hill in eastern France near the Swiss border, the destination of an annual pilgrimage honoring the Virgin Mary. Le Corbusier gave the building arcing outlines that respond to the neighboring profiles of the mountain ranges to the site's north and south. The chapel's most dramatic external feature is an asymmetrical curved roof, inspired by a crab shell. Seen from the southeast, the roof resembles an upswept wing or a ship's prow. It appears massive but is actually light, comprising two thin concrete shells supported by steel columns set in the rough-surfaced, whitewashed walls. The walls are constructed of plastered brick and rubble from the destroyed church, or, in the case of the southern wall, sprayed concrete. The roof projects over the eastern end where it shelters an outdoor pulpit and altar used for open-air Masses. An irregular array of splayed rectangular windows deeply set in the southern wall illuminate the serene interior. Additional light comes through a glazed strip between the walls and the ceiling, and through windows in three semicylindrical towers surmounting side chapels. Recognizing the exceptional nature of his creation, Le Corbusier described the Ronchamp chapel as "a totally free architecture. No programme other than the celebration of the Mass—one of the oldest of human institutions. One respectable personality was always present—the landscape, the four horizons. They were the ones in command . . . A pilgrimage place on specific days, but also a place of pilgrimage for individuals coming from the four horizons."[33]

Despite his career-long devotion to city planning, Le Corbusier only once had the opportunity to design an actual city—a commission from the government of India for a new capital of the northern state of Punjab in Chandigarh. Le Corbusier began work on the plan for Chandigarh in 1951 with his cousin Pierre Jeanneret and the British couple Jane Drew and Maxwell Fry. They divided the city into sectors with differing functions, laid the streets out in a grid, and provided ample greenspace. Le Corbusier devoted most of his energy to designing the capitol complex at the city's northeastern edge, with a view of the Himalayan foothills. It consists of the Governor's

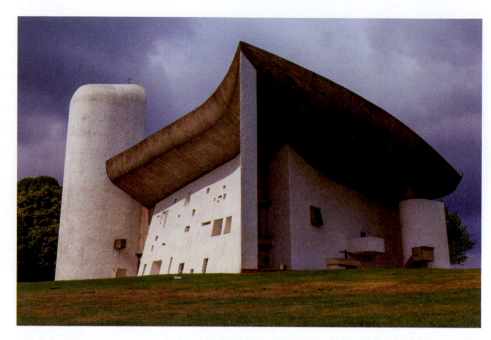

FIGURE 17.11 Le Corbusier, Chapel of Nôtre Dame du Haut,1950–55. Ronchamp, France.

Palace (not built), the High Court, the Secretariat, and the Assembly Building. With their massive, sculptural forms of raw concrete, these buildings possess the grand, solemn presence of temples. The focal point, the Assembly Building (Figure 17.12), faces a large square with an artificial lake. A huge upward curving roof supported by eight **pylons** perpendicular to the **façade** forms its portico. Its cavernous column-filled interior harbors a large Assembly chamber in the form of a hyperbolic funnel extending through the roof as a massive skylight tower. Grids of offices with recessed windows screened from the harsh Indian sunlight by brise-soleils stretch along the building's outer sides. The monumental abstract power of the capitol complex represents the grand climax of Le Corbusier's career. At Chandigarh, he answered Indian Prime Minister Jawaharlal Nehru's call for a modern city that would declare his country's postcolonial identity—"a new town, symbolic of the freedom of India, unfettered by the traditions of the past, an expression of the nation's faith in the future."[34]

The Later Work of Mies van der Rohe

After leaving Nazi Germany for the United States, Mies settled in Chicago in 1938 as head of the architecture department at the Armour Institute of Technology, which in 1940 became the Illinois Institute of Technology (IIT). Guiding his teaching and architectural practice were his beliefs that reason should guide human work; that architecture should express the spirit

FIGURE 17.12 Le Corbusier, Assembly Building, 1951–62. Chandigarh, India.

7.3 x 7.3-meter squares and aligned the buildings, courtyards, and walkways with the grid's axes. A focal point of the campus is Crown Hall (1956), which houses the School of Architecture. Symmetrical along its short axis and raised on a high basement holding workshops, offices, restrooms, and mechanical equipment, the one-story building has an exposed steel skeleton. The roof hangs from four evenly spaced plate girders, leaving the glass-walled interior clear of columns to serve as an "open room" adaptable to multiple uses.[36]

Through his connection with Chicago developer Herbert Greenwald, Mies gained the opportunity to design several high-rise apartment buildings, beginning with the Lake Shore Drive Apartments (1949–51). These led to other commissions, none more famous than the Seagram Building (1958, Figure 17.13) in New York City, which Mies designed

of its age; and that architecture should be elevated to a higher plane through an understanding of *Baukunst*—German for the "building art." In his American period, Mies distilled his building art to an essential "skin and bone construction"[35] — glass or brickwork (skin) set in a rectilinear structural frame (the bones). For the latter, Mies favored steel, emblematic of the modern industrial age. His buildings were refined variations of either a single story, low-rise, or high-rise skeleton frame with open plans adaptable to a variety of functions.

Mies's most famous one-story building from this phase of his career is the house he designed for Dr. Edith Farnsworth along the Fox River in Plano, Illinois. Conceived in 1945 and completed in 1951, the Farnsworth House is the very essence of skin-and-bones construction: eight vertical steel I-beams support a flat roof and floor slab raised 1.6 meters off the river meadow to clear the floodwaters. The frame's eastern three-fifths enclose a glass-walled living space; the western two-fifths shelter a patio. Two suspended flights of stairs forming a cross-axis to the dwelling entrance lead to a rectangular terrace further to the west and from the terrace to the ground. All of the structural elements are painted white, creating the impression of an immaculate steel-and-glass temple hovering above the landscape. The Farnsworth House is unparalleled as an elegant realization of the International Style ideal of an apparently weightless, transparent, abstract geometric volume. As a practical dwelling, it leaves much to be desired: Dr. Farnsworth felt exposed living within its glass walls and sweltered in it during the summer because it lacked air conditioning.

Mies produced a master plan for the IIT campus manifesting his commitment to orderly rectilinear geometry. He subdivided the rectangular site into a modular grid of

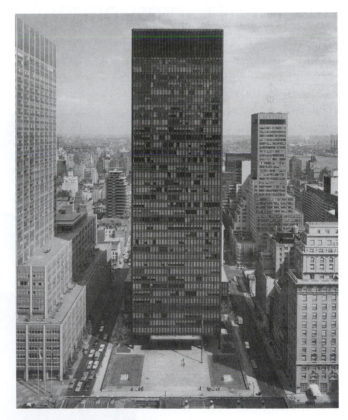

FIGURE 17.13 Ludwig Mies van der Rohe and Philip Johnson, Seagram Building, 1958. New York.

in collaboration with Philip Johnson as the Canadian liquor company's US headquarters. Desiring to project a modern, dignified, and luxurious image, Seagram authorized the use of expensive materials to enrich the thirty-eight-story building. These include marble, tinted pink-gray glass, bronze **spandrel panels**, and custom fabricated bronze I-beams that run the vertical length of the façades. These beams serve no structural function but express the internal steel frame, which is encased in concrete for fireproofing. Also lavish is the pink-gray granite plaza occupying 60 percent of the prime Park Avenue building site—Mies's solution to a zoning requirement meant to ensure that air and sunlight reached street level between skyscrapers, which previous New York skyscraper architects usually met through setback designs. The plaza with its twin fountained pools and long marble benches creates an inviting public space in the middle of crowded Manhattan. It also affords a ceremonial approach to the building's main entrance via a glass-walled lobby nestled within a grid of bronze-sheathed columns that seem to lift the office slab effortlessly off the ground. The Seagram Building provided a model for sleek steel-and-glass corporate office towers fronting open plazas built in major cities for the next two decades, though few came near the quality of the Miesian prototype.

Resurgent Expressionism

The International Style spread widely after World War II in the form of reductive, Miesian steel-and-glass structures, but the curving sculptural styles of Le Corbusier's Notre Dame du Haut at Ronchamp and Wright's Guggenheim Museum offered an expressive alternative. Numerous younger architects in the 1950s also employed an organic formal language to produce individualistic designs that revived the spirit of early twentieth-century Expressionism. Their distinctive architectural forms required complex custom construction, denying the economic logic of prefabrication underlying Mies's design systems.

Eero Saarinen (1910–1961)

One of the most versatile mid-century American modernist architects, Eero Saarinen produced both International Style designs for corporate clients and unique, highly expressive buildings. The

Finnish-born, Yale-educated son of the prominent architect Eliel Saarinen, Eero Saarinen established his national reputation in 1948 by winning the architectural competition for the Jefferson National Expansion Memorial in Saint Louis. Its signature element, the Gateway Arch (completed in 1965), is a 192-meter-tall stainless-steel-faced arch in the shape of an inverted catenary curve. It is a monument not only to US nineteenth-century westward expansion but also to the triumph of twentieth-century abstract form and advanced engineering technology.

Saarinen went on to create two airport terminals that are among his most dramatic designs: the Trans World Airlines (TWA) Terminal at Idlewild (now John F. Kennedy) Airport in New York (1956–62) and Dulles International Airport in Chantilly, Virginia (1958–62) outside Washington, DC. The TWA Terminal (Figure 17.14) is an exuberant building intended to evoke the excitement of air travel. Symmetrical in plan, its four segmented concrete-shell vaults rise from twisting Y-shaped buttresses to resemble the wings of a flying bird. Curving bridges, staircases, counters, and display boards fill the undulating interior, conveying a sense of fluid motion. Despite its futuristic aesthetic, the TWA Terminal could not keep pace with the future it celebrated: it proved too small to accommodate the ever-increasing numbers of passengers moving through JFK and closed in 2001. A protected architectural landmark, it was renovated and reopened in 2019 as the entryway and lounge for an airport hotel. By contrast, Saarinen's Dulles terminal, a vast hall covered by a concave concrete roof hanging gracefully from outward leaning piers, was designed for expansion, and doubled to thirty bays in the 1990s.

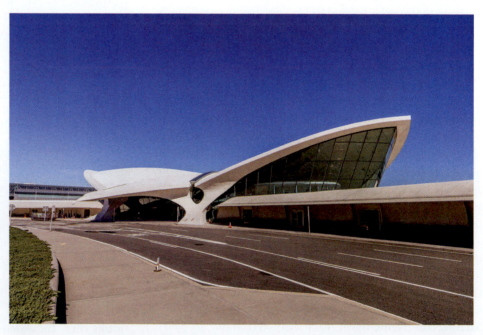

FIGURE 17.14 Eero Saarinen, TWA Terminal, John F. Kennedy Airport, 1956–62. Queens, New York.

Jørn Utzon (1918–2008)

Perhaps the most remarkable mid-century expressionist monument is the Sydney (Australia) Opera House (1957–73) by the Danish architect Jørn Utzon, a former assistant to Aalto. Utzon's winning entry for the 1957 competition to design the opera house proposed to cover its two auditoriums with rows of enormous shell-like roof structures evoking sails or ship's hulls in reference to its location on a promontory in Sydney Harbor. The London-based structural engineer Ave Orup helped Utzon to realize the dramatic design, using ribbed precast concrete shells to form the roofs as segments of a sphere, their surfaces clad with white **glazed** ceramic tiles. Huge cost overruns during construction led Utzon to resign from the project under pressure in 1966. Government-appointed architects completed the building and altered his plans for the interiors. Utzon nevertheless retains credit for creating a breathtaking building that became a symbol of modern Australia.

Louis Kahn (1901–1974)

Louis Kahn's work provides an alternative to Saarinen's and Utzon's flamboyant expressionism. Kahn used simple geometry and sober monumentality to create meaningful symbolic forms for human institutions. Born in Estonia, raised in Philadelphia, and trained in architecture at the University of Pennsylvania (1920–24), Kahn devoted substantial attention to urban housing designs in the 1930s and 1940s. From 1947 to 1957, he taught at the Yale School of Architecture, then at the University of Pennsylvania until his death.

Kahn's work blossomed into maturity after a fellowship at the American Academy in Rome (1950–51) that opened his eyes to the power of massive historic architectural forms, such as ancient Roman ruins and medieval Italian hill towns. While retaining the modernist commitment to abstract form, Kahn embraced architectural mass and structure achieved through heavy materials like concrete and brick rather than the lightness and transparency of steel and glass characteristic of the International Style. He likewise rejected its concept

of the free plan with undifferentiated spaces flowing into one another; he instead defined architecture as "the making of a room; an assembly of rooms."[37] In organizing those rooms, he distinguished between the "served" primary spaces for human activity and the "servant" spaces housing mechanical or supporting functions.

Kahn masterfully employed these principles in his design for the Salk Institute for Biological Sciences in La Jolla, California (1959–65, Figure 17.15). The institute, situated on a bluff, consists of two long reinforced concrete wings that mirror each other across a travertine-paved courtyard facing the Pacific Ocean. The served spaces are loftlike labs running the length of the wings and individual wood-paneled scientists' studies projecting over the courtyard. The servant spaces are perimeter towers holding stairs and bathrooms, and mezzanines above the laboratories containing ducts and mechanical equipment. The center's commissioner, Dr. Jonas Salk (famous for devising the first safe and effective polio vaccine), wanted it to provide spaces for both privacy and community—a vision inspired his visit to a Franciscan monastery in Italy. The studies, with windows overlooking the ocean, are private spaces conducive to reflection, while the labs foster collaboration and the courtyard welcomes communal gathering. A shallow channel of water running the courtyard's longitudinal axis draws the visitor's eye to the ocean and sky framed by the austerely beautiful buildings to create a sublime composition. The ensemble possesses a serene equilibrium characteristic of Kahn's architecture and manifests his definition of monumentality: "a spiritual quality inherent in a structure which conveys feeling of its eternity."[38]

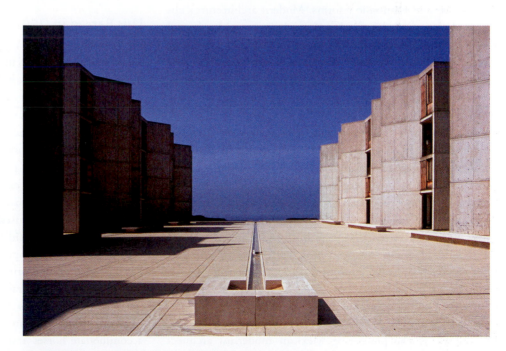

FIGURE 17.15 Louis Kahn, Salk Institute for Biological Sciences, 1959–65. La Jolla, California.

The philosophically inclined Kahn wrote poetically of his art as existing between "Silence and Light," where silence represented the "desire to express" and light was "the giver of all presences."[39] Kahn's Kimbell Art Museum in Fort Worth, Texas (1966–72), widely considered his masterpiece, has been described as his "offering to Light."[40] He designed the Kimbell to display historic artworks under natural light—the kind in which they were originally made and experienced. It features a sequence of long, open, parallel galleries (accepting in this instance the free-plan concept) covered by vault-like cycloidal roofs that open into skylights at the top. Curved aluminum baffles below the skylights filter and reflect light off the concrete ceilings. The travertine-faced walls and oak floors endow the Kimbell's silent luminous spaces with subtle richness to create an ideal environment for the contemplation of art.

Mid-Century Modern Architecture in Latin America

Modern architecture flourished in Latin America during the middle decades of the twentieth century. It displaced the Beaux-Arts styles that had dominated the region's urban architecture at the turn of the twentieth century as legacies of European colonialism. Modern Latin American architecture developed in the context of national modernization projects fostering technological and industrial advances and progressive social and economic reforms. Modern architecture's abstract style provided Latin American designers with a formal resource to transcend the provincialism of the colonial past while also incorporating indigenous references conveying pride in their national traditions.

Mexico

Mexico was the first Latin American country to embrace modern architecture in the wake of its Revolution of 1910–20, which broke the power of aristocratic landowners—power rooted in the colonial past—and generated a new sense of national purpose. Mexican artists, led by muralists such as Diego Rivera (see Chapter 10), contributed by developing new expressive forms that were both modern and imbued with *mexicanidad*, or Mexican-ness. In architecture, this process involved the adaptation of European modernist models to Mexican cultural aims.

Juan O'Gorman (1905–1982)

The work of the pioneering Mexican modernist architect Juan O'Gorman was shaped by his study at the Universidad Nacional de México (1921–25) under anti-traditionalist teachers who advocated rationalism, and by Le Corbusier's writings. The twin houses and studios O'Gorman built in a Mexico City suburb for his close friends Diego Rivera and Frida Kahlo (1929–32) incorporate Le Corbusier's Five Points of Architecture. They also feature elements drawn from the Mexican **vernacular**: clay-brick ceilings, brightly painted exterior walls—red on Rivera's house and blue on Kahlo's—and a cactus fence enclosing the compound, infusing the International Style machine aesthetic with *mexicanidad*.

In the 1950s, O'Gorman was one of many architects and engineers involved in building the new Ciudad Universitaria (University City) in a Mexico City suburb—an ambitious project emblematic of the national commitment to progress. The campus synthesized modernist architecture and mural art depicting Mexican subjects. O'Gorman's mosaic murals cover all four sides of the central library's tall, largely windowless upper block (Figure 17.16). Made of millions of tesserae gathered from throughout Mexico, O'Gorman's murals represent aspects of the country's culture from pre-Hispanic to modern times through geometrically structured compositions filled with narrative images and symbols. The south wall depicts the colonial period. It features two large discs representing the astronomical systems of Ptolemy and Copernicus, corresponding to O'Gorman's conception of the good (the Catholic faith) and the bad (science) brought to Mexico by the Spanish. At the lower center, O'Gorman superimposes the façade of a Catholic church over an Aztec pyramid surmounted by a Greek temple, suggesting the endurance of pre-Christian, polytheistic religions in Mexican history.[41]

Luis Barragán (1902–1988)

Like O'Gorman, Luis Barragán merged International Style abstraction with Mexican cultural references. On trips to Europe in the 1920s and 1930s, he was enthralled by the high-walled courtyards and gardens of the Hispano-Moorish palace complex, the Alhambra—as well as by Le Corbusier's Purist architecture, which influenced Barragán's early designs. His mature architecture remained abstract, but was connected to nature and harbored intimate, private spaces. These were features of the Alhambra as well as of traditional Mexican houses with secluded interiors and high-walled patios functioning as outdoor rooms—both elements used by Barragán. He often covered his buildings' walls with solid colors inspired by Mexican **folk art** and contemporary European and Mexican paintings.

Barragán worked primarily for affluent clients for whom he created tranquil retreats and beautiful minimalist open-air spaces like those of Las Arboledas (1958–61), an upper-class residential subdivision in northern Mexico City. Designed to accommodate horses and riders, the subdivision included a riding school, for which Barragán created a sequence of walled

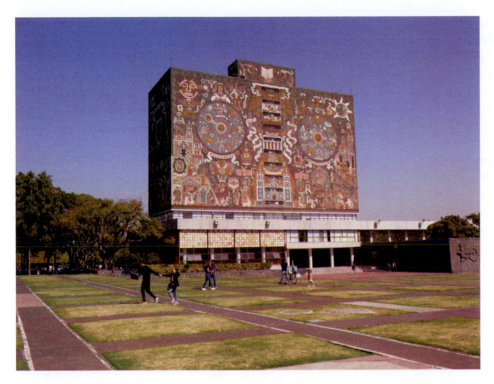

FIGURE 17.16 Juan O'Gorman, Gustavo Saavedra, and Juan Martínez de Velasco, Biblioteca Central (Central Library), Ciudad Universitaria, 1948–56; exterior mosaic murals by Juan O'Gorman. Mexico City.

beds on the roof of the two-story wing below the office slab, designed by the landscape architect Roberto Burle Marx, and the decoration of the exterior ground-floor walls with *azulejo* (blue and white ceramic tile) designs by painter Candido Portinari, gave the Ministry a Brazilian character.

Oscar Niemeyer (1907–2012)

Oscar Niemeyer studied under Costa at the Escola Nacional de Belas Artes in Rio de Janeiro (1929–34) and was his chief collaborator in designing the Ministry of Education and Health Building. Niemeyer went on to become Brazil's most prominent modern architect, celebrated for inventing strikingly expressive new forms. He worked principally in reinforced

enclosures, watering troughs, fountains, and pools organized around an avenue of eucalyptus trees. The avenue culminates in the Plaza y Fuente del Bebedero (Plaza and Fountain of the Trough, Figure 17.17), in which the shadows and reflections of the trees interacting with the abstract planes of the freestanding white wall, background blue wall, and horizontal water trough create an environment that is both surreal and serene.

Brazil

The Brazilian government adopted modern architecture after the Revolution of 1930 that brought the dictator Getúlio Vargas to power. Vargas promoted modernization through centralization and industrialization and initiated a public works program.

The Ministry of Education and Health

Vargas's government established a new Ministry of Education and Health and commissioned a building (1937–43) to house it in Rio de Janeiro. The commission went to Lúcio Costa (1902–98), who designed the building with a team of collaborators and invited Le Corbusier to Brazil in 1936 as a consultant. The fifteen-story structure shows Le Corbusier's imprint in its elevation on *pilotis*, incorporation of roof gardens, and use of brise-soleils on the sun-facing façade, a device Le Corbusier would later incorporate into the Unité d'Habitation. The garden of indigenous plants set in **biomorphically** shaped

FIGURE 17.17 Luis Barragán, Plaza y Fuente del Bebedero (Plaza and Fountain of the Trough), Las Arboledas, 1958–61. Mexico City.

Mid-Century Modern Architecture in Latin America **381**

concrete, which he used to create sensuous curves, inspired by such sources as the sinuous lines of Brazilian **Baroque** architecture, the free-flowing contours of Brazil's mountains and rivers, and women's bodies.[42] In the early 1940s, Niemeyer designed a group of buildings for Pampulha, a new luxury suburb of Belo Horizonte. Four concrete parabolic vaults—a form used for airplane hangars—constitute the interior spaces of Niemeyer's Church of Saint Francis of Assisi (1943) at Pampulha, with the longest and tallest vault serving as the nave. Niemeyer's frequent collaborator Portinari contributed a blue and white ceramic tile mural on the rear exterior wall and a **fresco** behind the altar representing episodes from Saint Francis's life. This highly unorthodox design proved so controversial that local ecclesiastical authorities refused to consecrate the church until 1959.

Costa and Niemeyer's Brasília

In 1956, Niemeyer was appointed Chief Architect of Brasília, the new national capital constructed on the orders of President Juscelino Kubitschek. Costa provided the bow-and-arrow-shaped master plan for the city of 500,000 residents built on an undeveloped plateau in Brazil's geographic center—the most ambitious urban project of the twentieth century. Costa followed the modern planning ideals advocated by the CIAM and derived from Le Corbusier's Ville Radieuse, dividing the city into separate zones devoted to housing, work, leisure, and transportation. Residential blocks stretch along the curved north-south axis. Government buildings line the east-west axis, culminating at the east in the Praça dos Três Poderes (Plaza of the Three Powers: legislative, judicial, and executive). For this site, Niemeyer designed the spectacular Congresso Nacional (National Congress) complex (1958–60, Figure 17.18). It consists of the Administration Building's twin high-rise slabs towering behind a low horizontal building housing the Senate and Chamber of Deputies, covered respectively by a shallow dome and inverted dome (bowl). Other distinctive buildings Niemeyer created for Brasília are the Palácio da Alvorada (Palace of the Dawn, the presidential residence), its glazed façade recessed within a porch resting on graceful marble-faced columns with parabolic contours; and the Cathedral, a circular glass-walled structure supported by sixteen concrete ribs rising in an hourglass shape that forms a symbolic crown.

Embodying President Kubitschek's vision for a pioneering, progressive, and dynamic Brazil, Brasília was constructed in an astonishingly short three years and five months. Despite Costa and Niemeyer's socialist aspirations for the city to provide housing for the entire population regardless of income, the

FIGURE 17.18 Oscar Niemeyer, Congresso Nacional (National Congress), 1958–60. Brasília, Brazil.

working class could not afford to reside in Brasília and ended up in crowded satellite towns. Furthermore, critics have long attacked Brasília's vast open spaces and high-density apartment blocks as a dismal example of modernist urban planning's failure to accommodate vibrant street life—a characteristic of traditional Brazilian cities. Despite these problems, the remarkable buildings Niemeyer created for Brasília stand among high modernism's great monuments, achieving his aim of creating "surprise and enchantment."[43]

Lina Bo Bardi (1914–1992)

Conceived at the same time as Brasília, Lina Bo Bardi's Museu de Arte de São Paolo (MASP, São Paulo Museum of Art, Figure 17.19) is one of Brazil's major cultural institutions and an icon of innovative museum design. The Italian-born Bo Bardi, who had practiced architecture in Milan, moved to Brazil in 1946 with her husband Pietro Maria Bardi, who had been invited to establish the Art Museum of São Paulo. After the museum outgrew its original home, Bo Bardi was commissioned in 1957 to create its new building along the busy Avenida Paulista opposite a park, with the stipulation that she preserve the site's vista onto the city's lower-lying parts. Bo Bardi met this requirement by lifting the main structure eight meters off the ground, creating a sheltered space below that serves as a **belvedere** and public square. She did this in dramatic fashion by suspending the seventy-meter-long steel-and-glass box from an enormous, red-painted reinforced concrete exoskeleton: two beams supported by piers like a table on four legs. A three-level semisubterranean block below the plaza holds additional galleries, auditoriums, a restaurant, and research center. The picture gallery on the elevated block's upper floor is a completely transparent open volume. Within it, Bo Bardi created a novel system for displaying paintings on freestanding glass panels supported by concrete cubes, so that the paintings appear to float freely within the space. Bo Bardi's politics of democracy and inclusion motivated this exhibition design, which emphasized the nature of the paintings as material objects, eliminated hierarchies between them, and freed visitors to follow their own path among them.

FIGURE 17.19 Lina Bo Bardi, Museu de Arte de São Paulo (MASP), 1957–68. São Paulo.

Mid-Century Modern Architecture in Japan

Japan's progressive architects, like its other artists (see Chapter 11), sought to define a new Japanese modern style by cross breeding Western styles with native traditions in the late-nineteenth and early twentieth centuries. Western modern architects such as Frank Lloyd Wright had themselves been influenced by Japanese aesthetics. Wright designed fourteen buildings for Japan, including the Imperial Hotel in Tokyo (1912–23). His assistant Antonin Raymond established a practice in Tokyo in 1920 and synthesized East and West in buildings whose concrete frames resembled Japanese timber construction. Meanwhile, Japanese architects traveled to Europe in the 1920s and 1930s, including Kunio Maekawa and Junzō Sakakura, both of whom studied under Le Corbusier and brought his principles back to Japan.

Kenzō Tange (1913–2005)

Kenzō Tange, who studied architecture at the University of Tokyo and worked briefly as Maekawa's assistant, was the first modern Japanese architect to achieve international recognition. In 1949, Tange won the commission for the Peace Memorial Park in Hiroshima, the first city destroyed by an atomic bomb. This major project expressed Japan's postwar image as a peaceful democracy following the 1945 defeat of the Japanese Empire. Tange's design centered on an axis leading from

FIGURE 17.20 Kenzo Tange, Yoyogi National Indoor Stadiums, 1961–64. Tokyo.

the Atomic Bomb Dome (a ruined building left standing after the bombing) to the Peace Memorial Museum. The museum, a long, horizontal flat-roofed structure of reinforced concrete raised on *pilotis* with its windows shaded by delicate sunscreens, demonstrates Le Corbusier's strong influence. Tange also identified a Japanese design source, however: the building on *pilotis* resembles a traditional wooden storehouse with an elevated floor.[44]

Tange contributed to Japan's growing sense of national self-confidence during its economic boom from the mid-1950s to the early 1970s through more massive and monumental buildings. They include his famous Yoyogi National Indoor Stadiums (1961–64, Figure 17.20) built for the 1964 Tokyo Olympics. The stadiums, a smaller circular one and larger elliptical one, have reinforced concrete walls and vast tentlike steel roofs hung from steel cables. The elliptical stadium had the world's largest suspended roof at the time of its completion. Evoking giant seashells or scaled dragons, the buildings possess an organic quality achieved through advanced structural engineering. Their dramatic sweeping curves and soaring interior spaces astonished spectators in 1964 and remain awe-inspiring.

Megastructures

Between the late 1950s and mid-1970s, certain architects concerned with the social and environmental problems of cities developed urban planning proposals employing the concept of the **megastructure**, a large frame housing all or part of the city's functions. In a megastructure, permanent elements constitute the city's infrastructure with attached modular units subject to rearrangement or periodic replacement. One example is Kenzō Tange's Plan for Tokyo (1960), a proposal to address urban overcrowding by building a city of ten million people over the water in Tokyo Bay, organized around a transport spine of highways from which secondary housing spines extend at right angles. The plan resembled that of Le Corbusier's Ville Radieuse but differed in envisioning the city not as a fixed form, but one that would grow and mutate.

The Metabolists

A group of younger Japanese architects and designers associated with Tange who shared this view of the city banded together in 1960 as the Metabolists—a name emphasizing their metaphorical conception of the city as a constantly changing organism. The group's members included Kiyonori Kikutake, Kishō Kurokawa, and Fumihiko Maki. Exemplary of Metabolism are Kikutake's proposals for floating cities comprising huge vertical cylinders to which individual dwelling units would be connected. These marine cities would not only accommodate Japan's swelling population but also be safe from the floods and earthquakes that plague the country.

Archigram

In England, the megastructure concept was popularized by Archigram, a group named for the **avant-garde** architectural journal founded in 1961 by Peter Cook (b. 1936). Archigram's other core members were Warren Chalk, Dennis Crompton, David Greene, Ron Herron, and Michael Webb. Considering established modernist architectural practice irrelevant to the conditions of the 1960s, and infused with that decade's optimism about technology's power to create a better future, Archigram drew inspiration from space comics, popular science fiction, the US space program, and the visionary American engineer and inventor Buckminster Fuller. Fuller's use of identical lightweight elements to create self-supporting structures—most famously, his geodesic dome—informed Archigram's approach to design. Cook's *Plug-in City*, first published in *Archigram* 4 (1964), represents the city as an extendable weblike megastructure of interconnected housing units. Owners could remove and replace these units with updated models, just as they would buy a new appliance or automobile.

The Situationist International

The Situationist International (SI, 1957–72) was a Paris-based neo-Marxist group of artists and writers who aimed to overturn capitalism by revolutionizing everyday life. The Situationists' name derives from existentialist philosopher Jean-Paul Sartre's insistence that human existence is always situated in a specific, lived context. The Situationists resisted what their leader, Guy Debord, termed "the society of the spectacle" (the title of his influential 1967 book): a capitalist society that renders individuals passive consumers of its pervasive "spectacle" of marketing, media, and mass culture. The group proposed two critical strategies to counter capitalism's dictates. One was the *dérive* (drifting), an aimless stroll through the city. Inspired by the **Surrealists'** wanderings seeking chance encounters that might stimulate the unconscious, the *dérive* had a more political aim: to subvert the alienating routines of everyday life and achieve a sense of personal liberty, as envisioned in the free nomadic movement and play in Constant's New Babylon. The other Situationist technique, *détournement* (diversion), involved the creative reworking of existing artworks and other cultural products to negate their ideological status as commodities and spark awareness of the possibility of radical political change. Exemplary of *détournement* is *Fin de Copenhague* (1957), a limited-edition book by Debord and SI cofounder Asger Jorn that features scattered texts, illustrations, and clipped advertising images printed onto pages decorated with Pollock-like ink drips and spatters. The surprising and unexplained relationships between texts and images force viewers out of the passive role of media consumer and into the active role of creative interpreter.

Constant (1920–2005)

The Dutch artist Constant, a former Cobra member (see Chapter 13), envisioned the renewal of society through a futuristic worldwide city called New Babylon, proposals for which he developed between 1956 and 1974 through drawings, **collages**, **photomontages** (Figure 17.21), models, and writings. New Babylon would consist of a network of multilevel interior spaces spreading across the planet, rising on tall columns, with vehicular traffic flowing beneath them and airplanes landing on their roofs. All of the megastructure's practical functions would be automated, freeing its residents from the need to work and allowing them to travel and create freely, embodying the ideal of *homo ludens* (man at play). New Babylon's nomadic inhabitants would drift by foot through the labyrinthine interiors and continuously reconstruct their environment. They would no longer need to make art, since they would be creative in their daily life. Constant argued that the integration of art and life "cannot be realized with traditional means. First, a radical change should take place in our existence and our thinking. The construction of new situations is our first and most necessary task."[45] Constant's interest in dissolving the distinction between art and life and his reference to "situations" reveals his allegiance to the ideas of the Situationist International (see box), of which he was a member from 1958 to 1960.

FIGURE 17.21 Constant, *View of New Babylonian Sectors*, 1971. Watercolor and pencil on photomontage, 134.9 x 228.8 cm. Kunstmuseum Den Haag, The Hague, The Netherlands.

Modern Art in India, Africa, and the Middle East, Mid-Twentieth Century

Despite their many differences and diverse and complex histories, India, Africa, and the Middle East are bound by past colonial domination (see "Colonialism and Postcolonialism" box). India was part of the British Empire from 1858 to 1947; almost the entire African continent was controlled by European powers from the late nineteenth century until the 1960s; and parts of the Middle East were administered by either France or Britain after World War I until they emerged as independent countries in the 1930s and 1940s. During the Cold War, most of the newly liberated countries in these regions refused to align politically with either the democratic-capitalist United States, United Kingdom, and their allies (the "First World"), or the communist bloc led by the Soviet Union and China (the "Second World"). Instead, they, along with most of Latin America, comprised the "Third World."

As this chapter will demonstrate, the modern art that developed in India, Africa, and the Middle East in the mid-twentieth century was often strongly influenced by European models. Many artists from these regions sought European training, and some lived and worked either in Europe or the United States for extended periods. At the same time, much mid-twentieth-century Indian, African, and Middle Eastern art incorporated Indigenous visual and cultural references. The result was often a rich hybrid of imported and native elements that declared a new artistic identity for emerging modern nations.

India

India gained its freedom from Great Britain on August 15, 1947, thus realizing the aims of Mohandas K. Gandhi's anti-colonial movement. In a famous speech, Jawaharlal Nehru, the first prime minister of independent India, announced the country's goals to end "poverty, ignorance, disease and inequality of opportunity," and pledged its cooperation with the world's nations to further "peace, freedom and democracy."[1] However, this new independence was marred by extreme violence precipitated by British India's division into two separate nations, Hindu-majority India and Muslim-majority Pakistan, the latter split geographically into West and East Pakistan (which became Bangladesh in 1971). This partition along religious lines prompted a mass migration of Muslims to Pakistan and Hindus and Sikhs to India. Horrific sectarian violence accompanied the migration, claiming hundreds of thousands of lives.

The Progressive Artists' Group

This tragic situation was only obliquely acknowledged in the work of this period's major modern Indian artists, who banded together in Bombay (now Mumbai) in 1947 as the Progressive Artists' Group (PAG). These young men were left-leaning politically, opposed to **academic** realism, and appreciative of both European **modernism** and Indian traditions such as **folk art** and classical Indian art from the Gupta and Mughal periods (early fourth–late

sixth century and early sixteenth–mid-nineteenth century, respectively). Building on the efforts of progressive artists such as Gaganendranath Tagore, Amrita Sher-Gil, and Jamini Roy (see Chapter 11), the PAG aspired to create a new art for the independent nation that would be both Indian and modern. The PAG's leading founder-members, M. F. Husain, F. N. Souza, and S. H. Raza, became the most celebrated modern Indian artists of their generation. The group later expanded to include other painters who forged distinguished careers, such as Ram Kumar, Tyeb Mehta, and V.S. Gaitonde.

M. F. Husain (1915–2011)

M. F. (Maqbool Fida) Husain, who grew up in a Muslim family in the provincial city of Indore, received some formal training at the Indore School of Art and, briefly, at the Sir J. J. School of Art in Bombay. He settled in the latter city at age nineteen, initially supporting himself by painting cinema billboards. After being welcomed into the PAG by Souza, he was introduced to Austrian and German **Expressionism** (see Chapter 3) by supporters of the PAG, Jewish émigrés who had fled Europe for Bombay during the rise of the Nazis. Husain admired the Expressionists' commitment to artistic freedom, which resonated with his experience of India's liberation from British colonial rule, and he assimilated their expressive use of line, color, and brushstroke. Husain was also deeply impressed by the masterpieces of

Indian art he saw at an exhibition in Delhi in 1948, including figurative sculpture of the Gupta period and seventeenth- and eighteenth-century Pahari painting from the Himalayan hill kingdoms of North India.

Husain developed a personal **style** integrating influences from both modern Western and traditional Indian art, as seen in his ambitious *Man* (1951, Figure 18.1). With a **palette** dominated by black bordered by patchy planes of crimson, olive-green, ochers, and white, the painting manifests a **Cubist** influence in its cut out style figures occupying a fragmented and ambiguous pictorial space. The **composition** centers on a seated black male figure, his pose adapted from Auguste Rodin's *Thinker*. The man holds a tablet depicting fragmented female figures in the voluptuous style of the Gupta period, suggesting that he, like Husain, is a creative artist. A similar tablet sits upside down beside him. At the extreme right, a goddess figure holds up a white hand, as if to confront an odd, slouching nude green figure facing her. At the extreme left, an inverted male figure rests on the back of a bull, an animal seen throughout rural India and associated with the Hindu god Shiva. Although the artist never specified its meaning, *Man*'s complex **iconography** suggests an **allegory** of modernity. The central man calmly observes with his frontal green eye the topsy-turvy imagery surrounding him. That imagery evokes such contradictory forces as the ancient and modern, Eastern and Western, sacred and secular, peaceful and chaotic, powerful and vulnerable—all characteristic of

FIGURE 18.1 M. F. Husain, *Man*, 1951. Oil on fiberboard, 126.4 x 248.9 cm. Peabody Essex Museum, Salem, Massachusetts.

the conditions of postindependence life so acutely experienced by artist-intellectuals such as Husain.[2]

F. N. Souza (1924–2002)

Born in the Portuguese colony of Goa on India's west coast and raised as a Roman Catholic, F. N. (Francis Newton) Souza studied at the Sir J. J. School of Art in Bombay (1940–45) but was expelled for participating in the anti-British Quit India movement launched by Gandhi in 1942. He then briefly joined the Indian Communist Party and painted in a **social realist** mode—an idiom he abandoned for a European expressionist-influenced style by the time he cofounded the PAG in 1947. Two years later Souza moved to London, where he eked out a living as a journalist before gaining recognition in the mid-1950s for his starkly expressive paintings. Their **subject matter** ranged from **still lifes** and landscapes to erotically charged female nudes and images of the Last Supper and the Crucifixion.

Souza's tortured 1959 depiction of the Crucifixion (Figure 18.2) presents Christ and two disciples as stiff, jagged, grotesque black figures with masklike faces. This imagery rejects conventional depictions of the "blond operatic Christs and flaxen-haired shy Virgins" Souza said he was expected to admire at the Jesuit high school he attended in Bombay; it instead conveys "the impaled image of a Man supposed to be the Son of God, scourged and dripping, with matted hair tangled in plaited thorns" he saw on crucifixes in Catholic churches.[3] Souza's agonized depiction may be compared with similarly brutal renditions of the Crucifixion painted in the 1940s by the English modernist Graham Sutherland, which referred to the gruesome image of the dead Christ in German painter Matthias Grünewald's *Isenheim Altarpiece* (1515). Grünewald's famous work also likely inspired Souza in its emphasis on Christ's physical suffering rather than his spiritual triumph over death.

S. H. Raza (1922–2016)

Like Souza, S. H. (Sayed Haider) Raza was an alumnus of the Sir J. J. School of Art (where he studied from 1943 to 1947) and moved to Europe shortly after the PAG's establishment. Drawn to Paris in 1950 by his desire to study Cézanne's work, Raza's painting evolved from Cézannesque townscapes of the 1950s, to **abstract** compositions in the 1960s and 1970s, featuring patches of pure color. He frequently enclosed his composition's central elements with a rectangular border of solid color—a device adapted from Rajput court painting of the seventeenth and eighteenth centuries. Frequent trips back to India in the 1970s led Raza to develop the nonrepresentational geometric style of his last decades. This style centered on the motif of the *bindu* (Sanskrit for "point" or "dot"), a perfect circle representing the starting point of creation in Hindu

FIGURE 18.2 F. N. Souza, *Crucifixion*, 1959. Oil paint on board, 183.1 x 122 cm. Tate, London.

philosophy and symbolizing, for Raza, "a point of departure; a unity of tremendous force, power, energy."[4] Thus Raza saw his geometric abstract paintings (e.g., *Universe*, 1993), as infused with metaphysical significance, setting them apart from the purely **formalist** works of his younger American contemporaries such as Frank Stella (see Figure 16.19), whose work the Indian painter knew and respected.

K. G. Subramanyan (1924–2016)

The influential artist, teacher, and theoretician K. G. (Kalpathi Ganpathi) Subramanyan drew artistic inspiration from Indigenous Indian craft traditions, offering an alternative to the PAG's orientation to European modernism as a prime source for Indian modern art. Raised in Mahe, a French colonial possession in what is now the state of Kerala, Subramanyan's artistic philosophy was shaped by the education he received between 1944 and 1947 at the private Visva-Bharati University, established in 1921

Colonialism and Postcolonialism

Colonialism refers to the subjugation of one people by another. Historically, it has involved powerful nations exercising control over dependent territories by exploiting their resources, labor, and markets; displacing and dispossessing their Indigenous peoples; and imposing social, cultural, political, economic, and religious structures on them. (A related term, "imperialism," emphasizes the dominant nation's assertion of power over the colony.) In response, colonized people have resisted their subjugation, both violently and nonviolently throughout history. Colonial powers justified their conquests on the basis of now-discredited anthropological theories portraying non-European Indigenous peoples as inferior, primitive, incapable of governing themselves, and in need of "civilizing" by their colonial masters. Underlying these theories was the unfounded racist belief that white Europeans were more evolved and biologically superior to others.

European colonialism began in the fifteenth century as Portugal and Spain occupied lands in the Americas, Africa, India, and East Asia. By the seventeenth century, England, France, and the Netherlands had also established empires overseas. Most European colonies in the Western Hemisphere gained independence in the eighteenth and nineteenth centuries. Britain, France, and the Netherlands then intensified the colonization of South Africa, India, and Southeast Asia. Between the 1880s and 1914, European powers raced to colonize sub-Saharan Africa (the "Scramble for Africa"). Meanwhile, Japan built an empire in East Asia, starting with its 1910 colonization of Korea. After World War I, the colonial possessions of the losing nations were distributed among the victors. A period of worldwide decolonization ensued, with most territories achieving independence following World War II.

Colonial rule brought some benefits, such as the development of modern public services and infrastructure. However, the difficulties that beset many nations after achieving independence—including repression, corruption, poverty, violence, environmental degradation, and ethnic rivalries—are in many cases the dark legacy of colonialism, which always enriched the colonizers at the expense of those they exploited.

Postcolonialism refers both to the period after colonialism and to the critical investigation of colonial rule's impact around the world. The Martinique-born French psychiatrist and philosopher Frantz Fanon argued in *The Wretched of the Earth* (1961) that violence defined colonialism and that violence could be legitimately used against the colonizer as a force for decolonization. The Palestinian American scholar Edward Said, who inaugurated postcolonial studies with his *Orientalism* (1978), claimed that literary characterizations of the Middle East as exotic, backward, and uncivilized were misrepresentations that justified European colonial domination of its inferior Other. In contrast to this binary opposition of colonizer/colonized, the Indian-born theorist Homi Bhabha argued that both sides were locked in a dialectical relationship that produced hybridity—a mixture of two cultures that subverts the colonizer's authority and that the colonized can use to challenge their domination. This concept finds expression in the work of postcolonial artists such as Yinka Shonibare (see Chapter 22).

by the renowned poet and artist Rabindranath Tagore (see Chapter 11) in the West Bengal village of Santiniketan. At Santiniketan (as the university is commonly known), the anti-colonial pedagogy of painter Nandalal Bose and his colleagues incorporated training by Indian craftsmen, collaborative creative work, and the study of several different **vernacular** mediums and techniques. Subramanyan embraced these principles and applied them in his own teaching at Maharaja Sayajirao University in Baroda (now Vadodara), where he taught from 1951 until returning to Santiniketan as a professor in 1980.

Among the many **mediums** Subramanyan mastered was **terracotta**, used in India from the time of the Bronze Age Harrapan civilization (c. 3300–1300 BCE) onward for figurines, votive tablets, and **relief** tiles decorating temples. In 1971, he created a series of small (approximately twenty-one inches square) terracotta reliefs inspired by disturbing current events, including the Vietnam and Bangladesh Liberation Wars. In *Generals and Trophies* (1971, Figure 18.3), three grinning, medal-bedecked military leaders, crudely rendered as ghoulish caricatures through slabs of clay, occupy the upper three panels of the square nine-panel composition. Below the central general dangle the pathetic corpses of three small children, two of them emerging from slits in torso-like forms, suggesting infants cruelly cut from their mothers' wombs. Subramanyan's gridded composition—perhaps adapted from the work of the **Minimalists** he encountered in New York on a Rockefeller Fellowship (1966–67)—enforces a spatial separation between the generals and their victims. In the artist's words, the work points to "the idiotic chase in which a man makes his fellow-man his quarry, where in the face of suffering he causes, he gloats in his victories and rattles his medals."[5]

Nasreen Mohamedi (1937–1990)

Most Indian artists who came of age following the PAG's heyday were committed to **stylized** representational art that often conveyed or suggested a narrative based on the artist's personal experience. An exception was Nasreen Mohamedi, who in the 1970s and 1980s produced a

remarkable body of nonrepresentational drawings featuring intricate linear geometric patterns meticulously executed in pencil and ink using drafting tools, as in the work *Untitled* (c.1980, Figure 18.4).

Born in Karachi, British India (now Pakistan), Mohamedi studied at St Martin's School of Art, London (1954–57), then lived for several years in Bombay before joining the Fine Arts faculty of Maharaja Sayajirao University in Baroda in 1973. The drawings she made there were nourished by visual sources ranging from Kazimir Malevich's **Suprematism** (see Chapter 6) to geometric patterns in Islamic architecture and Mohamedi's own black-and-white photographs isolating linear patterns discovered in the natural and manmade worlds—for example, ripples on the ocean's surface or parallel threads on a weaver's loom.

Like Malevich and other European modernists she admired such as Mondrian, Klee, and Kandinsky, Mohamedi understood her abstraction in spiritual terms. Her Muslim upbringing taught her to conceive of God as a formless and unseen reality underlying the visible universe, which led her to reject representational drawing.[6] Through study of Zen Buddhism she embraced the concept of emptiness, paradoxically understood as fullness—the ground of all being. Emptying her drawings of everything but pure, controlled, repeated linear marks, Mohamedi ultimately sought to transcend the physical and invoke the infinite.

Modern African Art

Characterized by a diverse range of visual expressions, modern African art blossomed fully in the postindependence period of the 1960s.[7] Its manifestations in earlier decades were prompted by Indigenous Africans' negotiations with modernity from the late nineteenth century, when several European powers (Belgium, Britain, France, Italy, Germany, Portugal, and Spain) colonized the continent, seeking to exploit its natural resources and to open new markets for European products and investment.

In cultural terms, most Europeans erroneously viewed African people as living in a "primitive" state, without the technical or intellectual sophistication to create or appreciate

FIGURE 18.4 Nasreen Mohamedi, *Untitled*, c. 1980. Ink and graphite on paper, 46.99 x 68.58 cm. Private collection.

"high" art. Such Europeans saw the absence of realistic figural representation in traditional African art forms, such as masks and wood sculpture, as evidence of the Indigenous peoples' cultural backwardness. This viewpoint was supported by the period's scientific racism that classified Black Africans as less advanced than white Europeans on the evolutionary scale.

At the same time, African masks and sculpture asserted a strong influence on the formal development of Expressionism and Cubism (see Chapters 3 and 4). Artists such as Picasso, Braque, Derain, Matisse, Brancusi, and the members of Die Brücke, who encountered African and Oceanic artifacts in European ethnographic museums, recognized their striking stylized forms as a primal expression of human creativity uncorrupted by European academic conventions. This art provided the European modernists with compelling visual models for their own radical anti-academic innovations (see "Primitivism" box, Chapter 2).

By contrast, the first generation of modern African artists of the early twentieth century, such as the Nigerian portrait painter Aina Onabolu, sought European academic training and worked in realist representational styles. They also promoted the establishment of art schools in African cities to provide academic instruction as opposed to the traditional crafts training offered in colonial government schools. In breaking from the abstract formal language and largely religious functions of traditional African masks and carved statues, realistic easel paintings by academically trained Africans such as Onabolu were just as "modern" and progressive in their context as the African-inspired abstract styles of the Europeans.

The post–World War II struggle for independence from colonial rule, which most African countries achieved in the 1960s, prompted the development of a modern African art that communicated symbolically the values of progress, political autonomy, and cultural pride. Underwriting these values in sub-Saharan Africa were the ideologies of Négritude and Pan-Africanism. Initially developed by expatriate African artists and intellectuals in Paris in the 1930s, Négritude was an anti-colonialist literary and philosophical movement that emphasized pride in Black African history and cultural

achievement. Pan-Africanism advocated African unity through political integration of the continent. With roots in the eighteenth century, this concept flourished in the 1950s and 1960s, during the period of decolonization. These ideologies led many modern African artists of the time to express their cultural identity and patriotism by incorporating formal and iconographic elements from Indigenous traditions and histories into their art, often combining these elements with materials, techniques, and styles derived from European modern art.

The following sections offer a highly selective survey of modern art in sub-Saharan West Africa, East Africa, and Southern Africa during the decades of decolonization. North Africa, largely Arab and Muslim, is considered in the section on postindependence art in North Africa and the Middle East.

West Africa

Stretching from the Sahara Desert to the Gulf of Guinea on the Atlantic Coast, the West African subregion as defined by the United Nations comprises sixteen countries. They include Nigeria, which was colonized by the British, and Senegal and Mali, which were colonized by the French. All three became independent in 1960.

Nigeria

Africa's most populous and ethnically diverse country, Nigeria has produced some of the continent's most highly regarded modern artists, including Aina Onabolu (1882–1963), the first West African artist to make Western-style **oil paintings**. Believing that realistic oil painting should be the basis of a modern African art, he taught himself to paint before studying academically in London and Paris between 1920 and 1922. He created dignified portraits of the Nigerian elite during the colonial period (e.g., *Portrait of an African Man*, 1955) as a way of asserting both his and his countrymen's modernity and national pride. Onabolu's advocacy of European-style academic training and professionalization put him at odds with white Europeans working in Nigeria such as Kenneth Murray, the country's first government-appointed art teacher. Murray encouraged continuing the supposedly more authentic native craft and artistic traditions unadulterated by modern European influences.

Ben Enwonwu (1917–1994)

One of Murray's students, Ben Enwonwu became the first modern Nigerian artist to gain international renown. Eager to transcend his teacher's nativist conception of African art, Enwonwu traveled to London for academic training at the Slade School of Fine Art, graduating in 1947. The next year he

returned to Nigeria and was appointed official art adviser to the colonial government.

Adept in both painting and sculpture, Enwonwu's artistic development was strongly influenced by Négritude, which encouraged him to draw artistic inspiration from his Igbo heritage as well as other Nigerian traditions. This impulse is seen in his most famous work, *Anyanwu* (1954–55, Figure 18.5), a sculpture he created for the new National Museum in Lagos, founded by Murray to preserve the nation's antiquities. The sculpture depicts an elegant, forward-bending female figure with an unnaturally slender and elongated body that tapers to a point at its base. (Enwonwu rejected the inevitable comparison to the work of Giacometti [see Figure 13.10], insisting that his style and symbolism derived from his native heritage rather than European influences.)

The figure's head with its distinctive "chicken beak" headdress is based on a famous bronze portrait of a Queen Mother from Edo, capital of the Kingdom of Benin in what is now southern Nigeria. The sculpture's title, *Anyanwu*, means "the sun" in the Igbo language and evokes the Igbo

FIGURE 18.5 Ben Enwonwu, *Anyanwu*, 1954–55. Bronze, 210 cm high. National Museum, Lagos.

practice of venerating the Great Spirit by saluting the rising sun. The sculpture thereby conveys Enwonwu's aspirations for his rising nation, soon to gain independence from Britain. (In 1966 the Nigerian government commissioned a second version of *Anyanwu*, which it presented to the United Nations.) The sculpture also served as a symbolic guardian of the country's cultural patrimony held in the National Museum by evoking Ani, the Igbo earth goddess and protector of culture and morality, given nobility in Enwonwu's image through the iconographic reference to an Edo royal portrait.[8]

The Zaria Art Society and Uche Okeke (1933–2016)

In 1958, several art students at the Nigerian College of Arts, Sciences and Technology in Zaria—led by Uche Okeke, Demas Nwoko, and Bruce Onobrakpeya—rebelled against that institution's British-style curriculum and formed the Zaria Art Society. Two years later, when Nigeria won its independence, Okeke issued a manifesto calling for a "natural synthesis" of "old and new"—Indigenous Nigerian art forms and the modernist **avant-garde** sensibility—as the basis for the new nation's art.[9]

In the early 1960s, Okeke turned for inspiration to his own Igbo heritage and the symbolic linear designs known as *uli*. Traditionally made by Igbo women, including Okeke's mother, *uli* were drawn with temporary dye on women's bodies in preparation for important village events and painted on the walls of dwellings. Okeke adapted the style for his striking oil painting *Ana Mmuo* (*Land of the Dead*) (1961, Figure 18.6), which features the highly abstracted black linear figures of masked spirit dancers who appear at funerals, set against a **background** of flat, irregularly shaped planes of white, orange, red, and yellow. In its merger of Igbo cultural symbolism and modernist-style abstraction, the painting embodies Okeke's philosophy of "natural synthesis."

The Mbari Mbayo Club and Prince Twins Seven-Seven (1944–2011)

Hosting both theatrical productions and art workshops, the Mbari Mbayo Club offered an alternative to the academic instruction of Nigerian university art departments. The club was established in Oshogbo, an urban center of traditional Yoruba life, in 1962 by Duro Lapido, a Yoruba musician, and Ulli Beier, a white, German-born literary scholar and educator. The latter's wife, the white, London-born Georgina Beier, was an influential teacher at the club's summer school. She encouraged her students to develop their individual artistic visions rather than conform to academic rules.

The most successful artist to emerge from the Oshogbo summer school was Prince Twins Seven-Seven. The grandson of an Ibadan king, the artist changed his name from Taiwo Olaniyi Oyewale to indicate his status as the only survivor of seven sets of twins. He was a talented dancer and musician as well as a versatile visual artist who worked in multiple mediums, including drawing, printmaking, painting, textiles, and metals. Twins Seven-Seven often drew his artistic subject matter from Yoruba religion and folktales, rendered in a visionary style featuring strongly outlined figures and intricate abstract patterns filling most of the pictorial space.

This style is seen in Twins Seven-Seven's painting on carved wood, *Healing of Abiku Children* (1973, Figure 18.7). According to Yoruba belief, *abiku* are the spirits of children who die and are reborn repeatedly to the same mother. The mother who fears she has an *abiku* child will visit a *babalawo* or divination priest who prescribes a sacrifice on the mother's part to keep the *abiku* alive past childhood. In the painting's

FIGURE 18.6 Uche Okeke, *Ana Mmuo* (*Land of the Dead*), 1961. Oil on board, 92 × 122 cm. National Museum of African Art, Smithsonian Institution, Washington, DC.

FIGURE 18.7 Twins Seven-Seven, *Healing of Abiku Children*, 1973. Pigment on wood, carved, 130 x 130 cm. Indianapolis Museum of Art at Newfields, Indiana.

foreground, a mother sits with a child on her lap and another clinging to her back, awaiting guidance from the *babalawo* framed in the doorway. A multitude of figures engaged in various tasks surround the mother and the priest. The subject matter was personal to the artist, who shared his parents' belief that he was an *abiku* child reborn six times as a twin. Twins Seven-Seven claimed he remained alive in his seventh incarnation because his mother made sacrifices to the water goddess Oshun (whom he had worshipped in a former life) at a local lake and gave him water from that lake to drink.[10]

Senegal

A national modern art developed in independent Senegal under the patronage of Léopold Sédar Senghor, the country's president from 1960 to 1980. A poet and intellectual as well as a political leader, Senghor was a pioneer of Négritude. As Senegal's president, he promoted this ideology as the theoretical basis of a national aesthetic rooted in African ancestral traditions yet infused with formal values assimilated from European modernist abstraction.

Senghor's government established numerous national cultural institutions, including the École Nationale des Beaux-Arts (National School of Fine Arts), which opened in the capital, Dakar, in 1960. Senghor invited two Senegal-born, Paris-trained painters, Iba N'Diaye (1928–2008) and Papa Ibra Tall (1935–2015), to teach at the school; they became their generation's most prominent modern Senegalese artists. N'Diaye, skeptical of the ideas of a racially based African aesthetic and a uniquely national art, emphasized artistic individuality and sought to equip his students with a technical command of the elements of Western art. Tall, more in line with Négritude, formed a department known as the Atelier de Récherches Plastiques Nègres (Workshop for Research in Black Visual Arts), which emphasized the artistic exploration of Black African cultural heritage. Tall and his students produced highly stylized, brightly colored two-dimensional art, which typically combined figurative imagery derived from traditional African masks and sculpture with rhythmic, decorative patterns. Tall and other artists working in this visual mode came to be identified as the École de Dakar (School of Dakar).

The École de Dakar style is brilliantly exemplified by Tall's *Royal Couple* (1965, Figure 18.8), made at the Manufactures Nationales des Tapisseries (National Tapestry Manufactory), a state-sponsored school and workshop that Tall established in 1965 in the town of Thiès. Although presenting African imagery and intended to evoke traditional African weaving, the tapestries produced under Tall's direction were made on looms imported from France with wool imported from the Netherlands and Belgium. The tapestries served the agenda of Senghor's national cultural program by decorating government offices and serving as official gifts to foreign visitors.

Mali: Seydou Keïta (c. 1921–2001)

The bold patterns favored by Tall and other École de Dakar artists are also seen in many of the black-and-white portrait photographs of Seydou Keïta, who worked in his

FIGURE 18.8 Papa Ibra Tall, *Royal Couple*, 1965. Tapestry, 220 x 150 cm.

FIGURE 18.9 Seydou Keïta, *Two Women*, 1958, printed 1997. Gelatin silver print, 60.9 x 50.8 cm. Museum of Fine Arts, Boston.

native Bamako, Mali's capital. Now recognized as one of the greatest photographers of the twentieth century, the self-taught Keïta ran a successful portrait studio from 1948 until 1962, when he became the official photographer to Mali's new socialist government. His portrait clients, who included both elite and middle-class individuals, couples, and families, valued Keïta's masterful ability to create attractive and dignified images that visually declared their modern social identities.

Keïta favored shooting in natural light using a large format camera that enabled him to achieve crisp resolution and to make contact prints without the aid of an enlarger. He often photographed his clients against patterned cloth backdrops that impart visual energy, flatten the picture space, and highlight the sitters' faces. For example, the pattern of stylized leaves in the backdrop of *Two Women* (1958, Figure 18.9) blends visually with the repeated ostrich motifs decorating the subjects' matching dresses. Keïta did not record his portrait subjects' names, but it is known that these confident-looking women were honored leaders of neighborhood associations in Bamako.[11]

East Africa

The UN subregion of East Africa comprises twenty countries stretching along the continent's east side from the Horn of Africa to Tanzania. This subregion's northernmost country, Ethiopia, was the only African country to resist European colonization. Below it are Uganda and Kenya, both colonized by the British before achieving independence in 1962 and 1963, respectively.

Ethiopia

Ethiopia has been an outpost of Orthodox Christianity since the fourth century CE. Its rich tradition of Christian art and architecture was given modern expression in the twentieth century by Afewerk Tekle (1932–2012), who studied at London's Slade School of Fine Arts, where he developed a realist style featuring firm outlines, bold colors, and strong **modeling**. After returning to Ethiopia, Afewerk[12] gained commissions for numerous murals, mosaics, and stained-glass windows in both religious and government buildings. His best-known work is

Total Liberation of Africa (1961), a monumental stained-glass-window **triptych** in the Africa Hall of the United Nations Economic Commission for Africa in Addis Ababa.

Afewerk's contemporaries, Gebre Kristos Desta (1932–81) and Alexander "Skunder" Boghossian (1937–2003), represented more avant-garde directions. Both studied in Europe—Gebre Kristos in Germany and Skunder in London and Paris—and returned to Ethiopia to teach at the School of Fine Arts in Addis Ababa (established in 1957). Gebre Kristos made figurative and nonrepresentational paintings in a gestural style influenced by German Expressionism and American **Abstract Expressionism**. While some Ethiopian critics criticized Gebre Kristos for abandoning Ethiopian traditions, he was supported by Emperor Haile Selassie, who embraced the avant-garde as a progressive force in his country's modernization.

The emperor also gave his approval to Skunder, who taught for three years (1966–69) in Addis Ababa before moving to the United States, where he became a professor at Howard University in Washington, DC. As a student in Paris, Skunder had embraced Négritude and Pan-Africanism. His work of the 1960s and early 1970s synthesized influences from French **Surrealism**, various Indigenous African artistic and spiritual traditions, and Ethiopian Christianity. It was also impelled by his anti-colonialist political commitments and his support for the civil rights and anti-Vietnam War movements in the United States.

Skunder's political concerns find symbolic expression in his visually energetic painting *Devil Descending* (1972, Figure 18.10). It depicts a convulsive landscape filled with brightly colored graphic marks, geometric **shapes**, and schematically drawn images of African masks. A totemic figure at the right stands beneath an orange-red sun while a diabolical masked avian creature, surmounted by a lunar crescent, looms above. The jumbled forms at the center represent the oppressed masses, whether in Vietnam, Africa, or the United States. Resistance and salvation are symbolized by the banded arm and hand reaching up in opposition to the descending devil.[13]

Uganda

Modern art in Anglophone East Africa was fostered by the art program at Makerere University in Kampala, Uganda, established by the British government. The white British artist Margaret Trowell began offering formal art instruction there in 1937. Like Kenneth Murray, she sought to preserve what she saw as the "fresh and delightful" vision of her Black African students.[14] She discouraged the emulation of European

FIGURE 18.10　Alexander "Skunder" Boghossian, *Devil Descending*, 1972. Oil and mixed media on canvas, 152.7 x 122.4 cm. National Museum of African Art, Smithsonian Institution, Washington, DC.

styles and advocated the acquisition of new technical knowledge that would enhance native cultural traditions. Trowell encouraged her painting students to depict genre scenes of rural African life as well as Christian religious imagery (Christianity being the country's dominant religion). Rural African **genre** scenes painted in a boldly colored, unsophisticated style were the specialty of Trowell's outstanding pupil Sam Ntiro, from Tanzania, the first East African to exhibit internationally.

Another early student of Trowell was the Kenyan sculptor Gregory Maloba (1922–2007), who taught at Makerere from 1942 to 1966. Maloba's most famous work is the *Independence Monument* (1962, Figure 18.11), erected in Kampala the year Uganda gained its independence from Britain. In a blunt, simplified style, this concrete sculpture depicts a standing mother holding aloft her naked male child. The mother's legs pull apart bands of cloth, representing the loosening bonds of colonialism. The child, his arms stretched diagonally upward in a gesture of victory, symbolizes the country's liberation.

Cecil Todd, a white South African who was head of the Makerere School of Fine Arts from 1958 to 1971, rejected Trowell's pedagogical emphasis on Indigenous African culture. Todd and his faculty exposed their students to Western art, including European modernism, and encouraged them to develop vigorous and original styles. One student who benefited from such teaching was Theresa Musoke (born c. 1944), a Kampala native who emerged as one of the most successful women artists in East Africa. While still a student, she was commissioned to paint a large mural for a dining hall at Makarere University. Entitled *Symbols of Birth and New Life* (1964), it presents a rhythmically arranged series of simplified images of living creatures, including human beings, framed by patterns of plant forms. Musoke went on to teach at Makarere before moving in 1976 to Nairobi, Kenya, to escape Idi Amin's brutal dictatorial rule of Uganda. Her later work often features semiabstract imagery of African wildlife.

Southern Africa

The UN subregion of Southern Africa comprises nine countries in the southernmost part of the continent. They include Zimbabwe (formerly the British colony of Southern Rhodesia) and South Africa, both of which were ruled by white minority governments for much of the twentieth century (Zimbabwe until 1980, South Africa until 1994).

Zimbabwe: The Shona School

A modern African art movement that received international attention was nurtured in Salisbury, Southern Rhodesia (now Harare, Zimbabwe) by Frank McEwen, a white Briton who became the first director of the country's National Gallery of Art in 1956. Seeking to foster local talent, McEwen established a workshop school at the museum. He provided its African employees with art supplies but no direct instruction, believing (like many other white Europeans) that Black Africans possessed an "innate African aesthetic."[15] One of the workshop school's earliest attendees, Thomas Mukarobgwa (1924–99), created highly expressive landscape paintings featuring thick brushstrokes, bold colors, and strong **value** contrasts (e.g, *View You See in the Middle of a Tree*, 1962). MoMA acquired four of his paintings in 1963.

After 1962, Mukarobgwa and the other artists mentored by McEwen turned to sculpture, carving simple, abstracted figures and animals out of stone. McEwen encouraged them to draw their subject matter from the beliefs and folklore of the Shona people (a Zimbabwean ethnic group famous for their mastery of stone construction and carving). His

FIGURE 18.11 Gregory Maloba, *Independence Monument*, 1962. 6 m high. Kampala, Uganda.

protégés and carvers working at other sites became known as the Shona sculptors (even though some belonged to other ethnic groups) and gained international recognition through exhibitions of their work at MoMA (1968) and the Musée Rodin, Paris (1971). Besides Mukarobgwa, well-known Shona sculptors include Joram Mariga and Nicholas Mukomberanwa.

South Africa

Modern art in the country now known as the Republic of South Africa was pioneered by white artists who were either European immigrants or descendants of the country's European colonizers—the Dutch beginning in the mid-seventeenth century and the British in the early nineteenth century. South African artists painting landscapes *en plein air* established Cape Impressionism, an adaptation of the European style, in the late nineteenth and early twentieth centuries. Leading artists of this tendency included Hugo Naudé, Pieter Wenning, and Strat Caldecott. Two important South African modern artists of the next generation drew inspiration from German Expressionism, which they absorbed directly in Germany. They were Irma Stern, who was mentored in Berlin in the late 1910s by Max Pechstein, a former member of Die Brücke (see Chapter 3), and Maggie Laubser, who met Pechstein and other former Brücke artists in Berlin in the early 1920s.

Irma Stern (1894–1966)

The daughter of a wealthy German-Jewish immigrant farmer in the Transvaal, Irma Stern spent the 1910s in Berlin, where she studied art and cofounded the November-gruppe (November Group), a progressive artists' organization. After returning to South Africa in 1920, she settled in Cape Town, where her boldly colorful, vigorously brushed expressionist-style paintings shocked conservative viewers and even led the police to investigate her first exhibition on charges of immorality. Highly prolific, Stern had over a hundred solo exhibitions during her career both in South Africa and abroad. She also traveled widely, including trips to Zanzibar and the

Belgian Congo (now the Democratic Republic of the Congo) in the 1940s.

On these trips Stern drew and painted portraits of local people, including the striking *Congolese Woman* (1942, Figure 18.12). The bust-length composition shows the solemn young woman in a three-quarter view, wearing a colorfully patterned blouse and holding a dark green mango. The wall behind her bears a decoration featuring concentric circular bands of red and white framing a series of black and white sawtooth motifs, its design likely adapted from Bwa and Nuna wood masks from Burkina Faso.[16] Two bright red shapes at the center connect visually to the woman's head and draw attention to the patches of red that highlight her complexion. Her face also bears small scarification marks carrying symbolic meaning in her traditional society.

The white Stern clearly viewed the dark-skinned Congolese woman as an Other but did not turn her into an exotic spectacle. As Joseph Sachs argued in his 1942 book on the artist, Stern "achieved a human identification with the native: she has tried to penetrate into his soul as a human being, to obtain a

FIGURE 18.12 Irma Stern, *Congolese Woman*, 1942. Oil on canvas, 56 x 56.5 cm. Irma Stern Museum, Cape Town, South Africa.

feeling of common humanity without which an inward portrayal is impossible. . . . In all her work Irma Stern seeks the inner meaning as well as the outer form."[17]

The New Group and Walter Battiss (1906–1982)

While Stern forged an independent path through the art world, several of her mostly younger white contemporaries banded together in Cape Town in 1937 as the New Group, at the instigation of painters Gregoire Boonzaire and Terence McCaw. Between 1938 and 1953, the New Group (with a membership that changed over the years) organized collective exhibitions in various South African cities. Most members painted in styles derived from **Post-Impressionism**, German Expressionism, and Cubism, absorbed through European study.

One exception was Walter Battiss, a white South African painter whose modern style was nurtured not only by Post-Impressionism but also by ancient San rock painting, an indigenous art form that he studied seriously, carefully copying its imagery and publishing two books on it. Exemplary of Battiss's fusion of **Fauve**-inspired color and San rock-painting-derived imagery is his 1950 painting *Yellow Afternoon*, which presents flat, schematic depictions of lemon-yellow hued antelopes within an abstract environment of patches of **saturated** color.

Black Artists in Segregated South Africa

The white minority government of the Union of South Africa (formed in 1910 through the union of four British colonies) imposed strict racial segregation through such measures as the Natives Lands Act of 1913, which reserved less than 10 percent of the country's land for Black residents. This policy led many Black South Africans to settle in crowded and underdeveloped townships on the edges of large white-populated cities such as Johannesburg and Cape Town. Segregation was legally strengthened after the National Party took power in 1948. It imposed apartheid, which compelled South Africans of color—officially categorized as Bantu (Black), colored (mixed race), or Asian (Indian or Pakistani)—to live in separate areas from whites and to use separate public facilities. Despite resistance to this discriminatory system by both South Africans of color and progressive white South Africans, it was not abolished until 1994, after increasing international pressure.

Gerard Sekoto (1913–1993)

While whites in segregated South Africa had access to formal art education, schools for people of color, largely run by Christian missionaries until mid-century, usually provided only vocational or craft training. Black South Africans who aspired to become artists therefore either taught themselves, sought white mentors, or left the country for European training. The pioneering Black South African modern artist Gerard Sekoto, who studied at the Grace Dieu Diocesan Training College (an Anglican teachers' college near Pietersburg) but was largely self-taught in art, began his artistic career as a "township artist," painting scenes of daily life in Sophiatown outside Johannesburg. His unsophisticated realist style with its fresh color and simplified forms appealed to white South Africans curious about the townships, into which they rarely ventured.

Sekoto's *Yellow Houses—A Street in Sophiatown* (1939–40, Figure 18.13) depicts a sunlit view of an unpaved road receding diagonally into the distance. The road is lined with yellow house walls and traversed by a few small figures—the majority of the residents being at work in menial jobs in the city during the daytime. Acquired in 1940 by the Johannesburg Art Gallery, *Yellow Houses* was the first work of art by a Black South African to enter an institutional collection. But since only white people were permitted to visit the gallery, Sekoto was advised to seek a janitorial job there in order to see his painting hanging on the wall. In 1947 he left for Paris, where he continued to paint scenes of township life from memory but supported himself as a jazz pianist. He never returned to South Africa.

FIGURE 18.13 Gerard Sekoto, *Yellow Houses—A Street in Sophiatown*, 1939–40. Oil on canvas, 50.5 x 74.5 cm. Johannesburg Art Gallery, South Africa.

Ernest Mancoba (1904–2002)

Black South African Ernest Mancoba left South Africa for Paris in 1938, where he enrolled at the École des Arts Décoratifs (School of Decorative Arts). Like his friend Sekoto, Mancoba had studied at the Grace Dieu Diocesan Training College, where he learned to carve Christian religious figures out of wood—a useful craft skill in the missionaries' eyes. In Paris, he adopted the Western mediums of **watercolor** and oil painting and began to execute abstractions spontaneously under the influence of Surrealist **automatism**.

Interned by the occupying Germans during World War II, Mancoba and Sonja Ferlov, his wife and fellow artist, moved to Denmark in 1947, where they were among the founding members of Cobra (see Chapter 13). They returned permanently to Paris in 1952 and Mancoba became a naturalized French citizen nine years later. His style of the 1950s, exemplified by two paintings in the Tate collection (both *Untitled*, 1957) composed of separate, quickly and roughly applied brushstrokes of various colors set at angles to one another, fits comfortably within the international tendency of ***art informel***.

The Polly Street Center: Cecil Skotnes (1926–2009) and Sydney Kumalo (1935–1988)

During the early years of apartheid, the Polly Street Center in Johannesburg, which the government had established as an adult education and recreation center, provided an exceptional opportunity for South Africans of color to gain formal instruction in art. The white artist Cecil Skotnes, the center's head from 1952 until its closure in 1960, led this instruction. Skotnes made black-and-white woodcut prints depicting abstract, totem-like figures in a **Synthetic Cubist** style (e.g., *Woodcut No. 7, Figure Composition*, 1958). He introduced his students to European modern art influenced by African art, especially Cubism, but he encouraged them to develop personal styles. Among his most successful pupils was Sydney Kumalo, a Sophiatown native, who gravitated to clay modeling and became Skotnes's assistant in 1958. That same year, Kumalo began to receive instruction from Eduardo Villa, a white abstract sculptor from Italy who introduced the young Black African to the sculpture of Henry Moore and the Italian Marino Marini.

Kumalo's mature style blended European modernist influences with African references, as seen in his small bronze sculpture, *Killed Horse* (1962, Figure 18.14). The pitted surfaces and expressive stylization of the horse's body recall the work of Marini and other mid-century European sculptors, while the abject animal corpse with its splayed limbs and bloated belly may be a metaphor for the deprived and decaying townships, where dead animals could be seen rotting on roadsides.[18]

Dumile Feni (1942–1991)

Even more expressionistic than Kumalo's sculpture are the drawings of Dumile Feni, a largely self-taught Black South African associated with the Polly Street Center artists in the 1960s. Dumile's art of that decade gave intensely emotional expression to the brutal and desperate conditions of Black township life under apartheid. His debased and ungainly figures, drawn with powerfully sculptural modeling in black and white, sometimes appear as hybrid human-animal creatures. In *Man with Lamb* (1965, Figure 18.15), for example, the man with his blunt snout and toothy mouth seems more bestial than the struggling animal he awkwardly carries off to slaughter. Dumile's animalistic figure has been interpreted as emblematic of the colonized condition of Black Africans under apartheid, economically exploited as cheap labor and

FIGURE 18.14 Sydney Kumalo, *Killed Horse*, 1962. Bronze on wooden base, 33 cm high. University of the Witwatersrand Art Galleries, Johannesburg, South Africa.

FIGURE 18.15 Dumile Feni, *Man with Lamb*, 1965. Charcoal on paper, 72 x 52 cm. Campbell Smith Collection, South Africa.

treated as beasts of burden by their white "masters."[19] Considered a political dissident by the apartheid regime, Dumile went into voluntary exile in 1968, living first in London and later in the United States, where he supported himself largely by designing record covers and doing illustration work.

North Africa

While Africa is a single continent geographically, its northernmost countries—Morocco, Algeria, Tunisia, Libya, Egypt, and Sudan—are culturally distinct from those south of the Sahara Desert. In the seventh and eighth centuries, these northern territories fell under the control of Arabs, who imposed Islam and the Arabic language on the native peoples. In the later nineteenth and twentieth centuries, these countries, like most of the African continent, experienced European colonial domination before gaining their full independence in the 1950s and 1960s.

Under colonialism in the early twentieth century, the styles and subjects of painting and sculpture in North Africa were largely defined by European artists who operated art schools, clubs, and French-style salons. They catered to elite clients who demonstrated their high social status by patronizing European artists. Indigenous artists who worked in European-derived mediums either taught themselves to paint or sculpt or acquired European-style training in colonial institutions or in Europe, where some remained to pursue their careers.

Morocco: Ahmed Cherkaoui (1934–1967)

Modern art in Morocco emerged after the country gained its independence from France and Spain in 1956. The pioneering Moroccan modernist artist was Ahmed Cherkaoui, who was trained in Arabic **calligraphy** in Casablanca before leaving for Paris in 1956. There he studied at the École des Métiers d'Art (School of Crafts) (1956–59) and École Nationale Supérieure des Beaux-Arts (National School of Fine Arts) (1960) before spending a year at the Academy of Fine Arts in Warsaw (1961). On his return to Paris, Cherkaoui received a research grant from UNESCO to study Arabic calligraphy and signs and symbols in Berber visual culture—his heritage from the maternal side of his family. This research informed his distinctive style, which also drew on influences from European modern art—especially Paul Klee and the French abstract painter Roger Bissière.

Cherkaoui often painted on jute, which gave his pictures an underlying grainy texture. In works such as *Linda* (1965, Figure 18.16), he brushed simple, bold motifs made of straight and curving bands, surrounded by thinner areas of atmospheric color. Inspired by design elements in Berber tattoos, ceramics, jewelry, rugs, and leatherwork, his graphic motifs suggest symbolic meanings but are ultimately abstract, creating a purely formal beauty.

Sudan: Osman Waqialla (1925–2007) and Ibrahim El-Salahi (b. 1930)

In Sudan, a British colony from 1898 to 1956, no formal art instruction in easel painting was offered until 1950, when the Khartoum Technical Institute was founded. A few years earlier, the colonial Department of Education sent several Sudanese artists to London for training to become art teachers. Most of them adopted European modernist styles, which they used to depict local subject matter upon their return to Sudan. However, Osman Waqialla created paintings that explored the purely expressive possibilities of Arabic calligraphy, liberating it from its traditional function of conveying the sacred words of the Qu'ran and applying it to secular texts. He was the first North African artist to propose Arabic calligraphy as a form of modernist expression and is considered an exponent of *Hurufiyya*.

In 1960, three younger painters associated with Waqialla—Ahmed Shibrain, Kamala Ishaq, and Ibrahim El-Salahi—formed what became known as the Khartoum School, seeking to forge a modern art expressive of Sudan's complex cultural identity, which merges Black African, Arab, and Islamic traditions.

FIGURE 18.16 Ahmed Cherkaoui, *Linda*, 1965. Oil on jute, 73.2 x 92.5 cm. Mathaf: Arab Museum of Modern Art, Doha, Qatar.

FIGURE 18.17 Ibrahim El-Salahi, *The Mosque*, 1964. Oil on canvas, 30.7 x 46 cm. The Museum of Modern Art, New York.

The group's most prominent member, El-Salahi, studied modern Western art at the Slade School of Fine Arts on a government scholarship (1954–57) before returning to Khartoum to teach. By the early 1960s, he had abandoned the representational style he had mastered in London and was filling his semiabstract pictures with simple motifs drawn from Sudanese and other African sources and with lines and shapes derived from Arab calligraphy. The latter was rooted in the childhood training he received from his father, an Islamic scholar who ran a Qu'ranic school in the family home. El-Salahi also largely limited his palette to black, white, gray, and earth tones, inspired by the colors of the Sudanese landscape.

This reduced palette is seen in *The Mosque* (1964, Figure 18.17). Amidst the intricately composed painting's lyrical array of flat black and brown shapes and lively calligraphic fragments, the viewer recognizes a pair of silhouetted minarets at the left center and the large head and shoulders of a figure with mask-like features at the right. These images conjure the coexistence of Islamic and Black African culture characteristic of Sudan and central to El-Salahi's aesthetic.

Egypt

Egypt was home to the first Western-style art institution in the Arab world, the School of Fine Arts, founded in Cairo in 1908 by Prince Yusuf Kamal. Staffed exclusively by European instructors during its early years, the school formed Egypt's first generation of modern artists, including Mahmoud Mukhtar, Raghib Ayad, Youssef Kamel, and Mohammed Naghi. Mukhtar (1891–1934), a sculptor who studied in Paris at the École des Beaux-Arts after his initial training at the Cairo school, initiated the movement known as neo-Pharaonism, which visually communicated the values of Egyptian nationalism by reviving subjects and symbolism from ancient Egyptian art.

Mukhtar's most famous sculpture, *Egypt Awakened* (1919–28), depicts a colossal crouching sphinx and a standing woman lifting her veil. The latter symbolizes the rising

nation and refers to the Egyptian feminist movement led by Mukhtar's friend Huda Sha'arawi, who stopped wearing her veil in public in 1922. That same year, Britain granted Egypt limited independence—a cause for which Sha'arawi had also fought by organizing an anti-British demonstration in 1919.

The Art and Freedom Group and the Contemporary Art Group

While Mukhtar worked in an academic style informed by his Parisian training, many younger Egyptian artists embraced Surrealism in the 1930s and 1940s. Several were members of the Art and Freedom Group, formed in Cairo in 1938 to advocate free expression and to oppose fascism's rise in Europe. However, the stylistic debt that several of its members, such as Ramses Younan, owed to European Surrealism put them at odds with the values of the Contemporary Art Group, a rival organization founded in Cairo in 1946 by the artist and teacher Hussein Youssef Amin. Critical of Western-style art education, Amin and his followers, including Abdel Hadi al-Gazzar, sought to forge a distinctively Egyptian modern art by drawing on the country's pharaonic, Coptic, Arab, and folk art traditions. They also conveyed a socially reformist vision by depicting the daily lives of poor, oppressed rural Egyptians.

The Group of Modern Art: Gazbia Sirry (1925–2021)

The Group of Modern Art, formed in 1947 in Cairo, shared the Contemporary Art Group's sympathy with the rural poor and its rejection of the European avant-garde as a model for modern Egyptian art. Led by Gamal al-Sigini, Hamed Oweis, and Gazbia Sirry, the Group of Modern Art supported the revolutionary nationalism that arose in Egypt following the 1952 military coup that overthrew the monarchy and brought army colonel Gamal Abdel Nasser to power. As prime minister, Nasser established Egypt as a socialist Arab state and promoted a modernizing, progressive, and secular Egyptian nationalism as well as Pan-Arabism, the ideological belief that all Arabs should be politically and culturally united. In the early 1950s, members of the Group of Modern Art created images that resonated with Nasser's political agenda, drawing inspiration from social realism, pharaonic and Egyptian folk imagery, and Coptic figuration.

However, the increasing authoritarianism of Nasser's military government from the mid-1950s onward led many Egyptian intellectuals and artists who had initially supported the prime minister to become disenchanted. One was Sirry, a 1950 graduate of Cairo's Higher Institute for Arts Education for Women who furthered her education in Paris, Rome, and London before returning to Cairo in 1953. Her paintings of the early 1950s depicted powerful female figures wearing boldly patterned garments, their flattened bodies outlined in black in a graphic style influenced by children's coloring books. These images have been interpreted as expressing support for the social advancement of Egyptian women, who were granted the right to vote in 1956.[20]

By the later 1950s, however, Sirry's painting style had changed; she often used expressionistically distorted forms and applied paint thickly with a **palette knife** in addition to using a brush. Her more emotionally charged style responded to the repressive political situation in Egypt, which affected her personally. In 1959, the government imprisoned Sirry for a week and her husband for thirty-three months for their alleged communist activity. Painted during her husband's incarceration, *The Kite* (1960, Figure 18.18)—a surprisingly strained

FIGURE 18.18 Gazbia Sirry, *The Kite*, 1960. Oil on canvas, 95.9 x 51.4 cm. The Metropolitan Museum of Art, New York.

and depressing image of youthful play—may be interpreted as the artist's oblique response to this painful situation.

The Middle East

The Middle East denotes the lands around the southern and eastern shores of the Mediterranean Sea, the Arabian Peninsula, and Iraq and Iran to the west. The North African countries of Egypt, Lybia, and Sudan are also part of the Middle East. With the exceptions of Turkey, Israel, and Iran, the countries of the Middle East are Arab-speaking.

Iraq

The modern state of Iraq was formed in 1920 as a British Mandate after the post–World War I breakup of the Ottoman Empire, which had ruled the region from 1534 to 1918. The British-installed King Faisal I's government supported the development of Iraqi art in the 1920s and 1930s by providing scholarships to promising young artists for study in Europe.[21] From the early 1940s the all-Iraqi staff of Baghdad's recently established Institute of Fine Arts provided formal training in art, with the Paris-trained Faiq Hassan (1914–92) leading the painting department and the Rome-trained Jewad Selim heading the sculpture section. In the Institute's early years, its students learned to represent landscapes, portraits, and still lifes in academic, **naturalistic** styles. Their efforts were understood as modern and progressive in comparison to the Ottoman traditions that had been previously imposed on the country.

During World War II, several Polish artists stationed in Baghdad as Allied soldiers encouraged their Iraqi colleagues to adopt more abstract and self-expressive artistic styles inspired by Cubism and Expressionism. This new approach was particularly appealing to Hassan and Selim, who emerged as pioneers of modern Iraqi art. In 1950 Hassan formed the Société Primitive, later renamed Al-Ruwad (The Pioneers), which was committed to painting the Iraqi landscape and daily life in a variety of modern European styles. Hassan's painting moved through Impressionist, Cubist, Expressionist, and abstract phases. He is best known for his Cubist-style scenes of desert Bedouin life (e.g., *Bedouin Tent*, 1950).

Jewad Selim (1921–1961)

An original member of the Pioneers, Jewad Selim left the group in 1951 to form the Baghdad Group of Modern Art along with several other artists, including his British-born wife, Lorna Selim. Conscious of Western imperialism's destructive impact on Iraq and the Middle East generally, Selim argued for the development of a contemporary Iraqi art that would incorporate modern Western art's innovations while proudly acknowledging his region's great contributions to the history of world art. These ranged from the sculptures and reliefs of ancient Sumer, Babylonia, and Assyria to the brilliant miniature paintings made by Yahya al-Wasiti in the thirteenth century. Selim also saw traditional Iraqi folk art as a source for the country's contemporary art.

Iraqi defiance of Western imperialism culminated in the July 14, 1958, revolution that overthrew the British-backed monarchy and empowered the socialist government of General Abdul Kerim Qassim. To celebrate this achievement, the new regime commissioned Selim and the architect Rifat Chadirji to create the *Monument of Freedom* (1959–61, Figure 18.19), unveiled in Baghdad in a partially finished state on the two-year anniversary of the monarchy's fall. For the monument, Selim created a **frieze** of massive bronze figures in low relief, cast in Italy. It centers on a heroic male soldier smashing open iron gates, a potent symbol of freedom. Comprising an additional twenty-four human figures plus a bull and a horse, Selim's composition was intended to be read as a narrative of the revolution and to evoke a line of Arabic poetry. Embodying the kind of cultural synthesis he advocated for contemporary Iraqi art, his stylized figures drew inspiration from Sumerian and Babylonian sculptures as well as the abstracted styles of Picasso and Moore. Sadly, Selim died of a heart attack before

FIGURE 18.19 Jewad Selim (sculptor) and Rifat Chadirji (architect), *Monument of Freedom*, 1959–61. Bronze, 10 x 50 m (frieze). Tahrir Square, Baghdad.

the frieze was fully installed; his widow oversaw the work's completion.

Hurufiyya

The likeness of Selim's frieze to a line of Arabic poetry resonates with the incorporation of actual Arabic script and words into painting, **graphic art**, and other mediums, which became a major impulse in modern Iraqi and Middle Eastern art generally from the 1960s onward. It was identified by the term *Hurufiyya* (from the Arabic word *harf*, meaning "letter"), loosely translated as "letterism."

Arabic has long been central to the Muslim culture of the Middle East and North Africa because it is the original language of the Holy Qu'ran. Calligraphy, used to render the verses of the Qu'ran and other texts in an aesthetically pleasing manner, is likewise considered the highest form of visual expression in Islam, which generally prohibits the representation of humans and animals in religious art. While many artists of the Hurufiyya movement continued this use of Arabic to write both sacred and secular texts in novel and creative ways, others creatively explored the aesthetic possibilities of Arabic letters and script without concern for conveying legible content.

Madiha Umar (1908–2005) and Shakir Hassan al-Said (1925–2004)

The Syrian-born Iraqi Madiha Umar is recognized as the first artist to incorporate Arabic letters into her paintings; she did this while studying art in Washington, DC, in the 1940s. Umar developed an abstract painting style in which Arabic letters lose their function as the building blocks of words and instead serve as dynamic, curvilinear formal elements, while sometimes also conveying symbolic meaning. In an untitled watercolor of 1978, Umar builds her composition out of sweeping, overlapping crescent shapes that evoke the gestural movements of writing and could derive from any number of different Arabic letters but do not form a complete letter.[22]

Another exponent of Hurufiyya and a leading Iraqi modern artist of the later twentieth century was Shakir Hassan al-Said. A cofounder of the Baghdad Group of Modern Art, he studied art in Paris between 1955 and 1959 before returning to Baghdad. In the 1960s, he immersed himself in the study of Sufism, a mystical strain of Islam, and developed his theory of one-dimension—also the name of a short-lived artistic group he formed in 1971, whose members included Umar and Jamil Hammoudi, another Iraqi pioneer of Hurufiyya. For Al-Said, the written letter, composed of a line of a single dimension, could reveal mystic truth beyond linguistic meaning. In his view, the alphabet's one-dimensional letters represent a positive force that can unite humanity with God in infinity, counteracting the negative force of the human ego.[23]

Unlike many Hurufiyya artists, Al-Said rejected traditional Arabic calligraphic scripts as regressive and confining. He instead emulated the spontaneous scribbling of children and graffitists, which he saw as expressing the human soul's instinctive nature.[24] Like his Catalan Spanish contemporary Antoni Tàpies (see Figure 13.7), whom Al-Said admired, the Iraqi artist drew inspiration from the scarred urban walls on which graffiti appears. He imitated their appearance in paintings such as *Al-Hasud la yasud (The envious shall not prevail)* (1979, Figure 18.20). The titular phrase, spray painted along the upper portion of the composition, is a popular Arab proverb that warns against the sin of envy. While rooted in Baghdad's local culture, Al-Said's painting also shares visual qualities with the international tendencies of **Graffiti art** and **Neo-Expressionism** then emerging in Western Europe and the United States (see Chapter 20).

Iran

In Iran, known as Persia until 1935, Western-influenced modern art emerged in the 1940s, in concert with the country's modernization along Western lines promoted by its autocratic ruler, the UK- and US-backed Shah Mohammed Reza Pahlavi. Modern Iranian art reacted against the popular European academic-style **illusionism** of the painter Kamal al-Mulk, who had taught at Tehran's Academy of Fine Arts. The pioneer of modern Iranian painting was Jalil Ziapour (1920–99), who after his 1945 graduation from Tehran University's School of Fine Arts was sent to Paris by the Ministry of Culture for graduate study at the École des Beaux-Arts. The year after his 1948 return to Tehran, he and several like-minded artists, musicians, and writers formed the Fighting Cock, an artistic and literary society that also published a magazine. In keeping with the aggressive nature of its symbol, the society fought against traditions it deemed outmoded and detached from contemporary reality, such as Al-Mulk's academic illusionist manner of painting. Ziapour designed the magazine's cover image of a strutting rooster in a Cubist style that remained the basis of his subsequent work.

The Saqqakhaneh Artists: Charles Hossein Zenderoudi (b. 1937) and Parviz Tanavoli (b. 1937)

Ziapour justified Cubism as an appropriate artistic mode for expressing Iranian themes because of the traditional use of geometric patterns in Persian-Islamic **decorative arts**, such as ceramic tiles. By contrast, many younger Iranian artists who emerged in the early 1960s rooted their art more directly in Indigenous Iranian culture rather than employing a European style to depict Iranian themes. They came to be known as *saqqakhaneh* artists—a name referring to public water fountains in Iranian towns that commemorate the Shi'ite martyrs of the seventh-century Battle of Karbala. The most prominent

FIGURE 18.20 Shakir Hassan al-Said, *Al-Hasud la yasud* (*The envious shall not prevail*), 1979. Acrylic on wood, 84.5 x 123 cm. Collection Salma Samar Damluji.

artists associated with this tendency are Charles Hossein Zenderoudi and Parviz Tanavoli.

Zenderoudi's intricate drawings of the early 1960s were stimulated by profusely decorated folk objects such as talismans and zodiac signs he discovered in Tehran's bazaars, as well as by Shi'ite Islamic calligraphy and printed prayers. A sense of hermetic, mystical significance infuses his drawings, exemplified by *K+L+32+H+4. Mon père et moi (My Father and I)* (1962)—its title's string of letters and numerals suggesting a private code. The composition features abstracted representations of its subjects with rectangular bodies. At the left is the artist, with arms raised and head lowered; at the right is his father, with seven feet and two hands, crowned by a constellation of discs bearing schematic facial features. Presented against a densely patterned background, the imagery's flatness harmonizes with that of Western abstract art but is rooted in Persian visual traditions.

Tanavoli, a sculptor, drew artistic inspiration from handmade functional objects he collected in bazaars, such as faucets, doorknobs, grilles, and padlocks. He incorporated their forms into bronze sculptures like *Heech Tablet* (1973, Figure 18.21). Recalling the famous Babylonian Stele of Hammurabi, *Heech Tablet*'s surface is incised with repeated rectangular indentations suggesting cuneiform inscriptions as well as the grille protecting a *saqqakhaneh* or shrine. The three padlocks projecting from the tablet resemble those that worshipers attach to these grilles as prayer offerings. The Persian word *heech* in the sculpture's title means "nothing," but is not intended here to convey emptiness or despair. The artist invokes its meaning in Persian Sufism: "God created the world out of nothing and so nothingness is everywhere, in every part of the universe and within all of us."[25] Significantly, the sculpture itself contains the word *heech*: the tablet's undecorated areas trace the basic lines of the written word, composed of the Farsi letters *he*, *ye*, and *če*. In calligraphy, *heech* evokes a living creature, with a head and two eyes, a sinuous body, and an upturned tail—the latter rendered in *Heech Tablet* as a protruding wedge. The sculpture's three padlocks not only reference *saqqakhaneh* but also the three dots composing part of the letter *če*.

FIGURE 18.21 Parviz Tanavoli, *Heech Tablet*, 1973. Bronze on travertine base, 181.61 x 46.99 x 30.16 cm. Grey Art Gallery, New York University Art Collection.

Monir Shahroudy Farmanfarmaian (1922–2019)

Earlier Iranian art forms also inspired the modernist works of Zenderoudi's older contemporary Monir Shahroudy Farmanfarmaian. Born and raised in Iran, Monir (as the artist was known) moved to the United States in 1945 and studied fashion at New York's Parsons School of Design. After graduation she worked as a fashion illustrator and befriended numerous

American artists, including Joan Mitchell and Andy Warhol, before returning to Iran in 1957. There she became enthralled by traditional Iranian visual culture and folk art, such as reverse paintings on glass (a technique in which the image is painted on the backside of a sheet of glass and viewed through the front plane). Monir painted on glass herself and was also attracted to the mirror mosaics that adorned the opulent interiors of Iranian palaces and shrines.

Monir had a transformative experience in 1975 when she visited a Shi'ite pilgrimage site, the Shah Cheragh (King of Light) Shrine in Zhiraz, Iran, where she sat for hours in the high-domed hall, its walls entirely covered "in a mosaic of tiny mirrors cut into hexagons, squares, and triangles. . . . The very space seemed on fire, the lamps blazing in hundreds of thousands of reflections."[26] Monir subsequently explored the infinite possibilities of small mirrors and pieces of reverse-painted glass, precisely cut into geometric shapes and orchestrated into orderly but optically dazzling configurations, as in *Geometry of Hope* (1976, Figure 18.22). Her mirror-and-glass compositions were informed by her study of Sufi cosmology and the metaphysical idea of universal structures represented by geometric patterns, but her ultimate interest was in absolute freedom of expression within her distinctive material and visual idiom.[27]

Israel

The ancient home of the Jewish people, modern Israel was born out of a plan approved by the United Nations in 1947 to divide British-controlled Palestine into Jewish and Arab states. Israel declared its independence in May 1948, despite the Arabs' rejection of the partition plan. Several wars between Arab states and Israel ensued and the country has been plagued by repeated violent clashes between Israelis and Palestinians.

Zionism—a religious and political movement originating in late nineteenth-century Europe that sought to reestablish a Jewish homeland in Palestine—impelled modern Israel's founding. Zionism encouraged hundreds of thousands of Jews to immigrate to Palestine between the 1880s and 1930s. They first established villages of independent farmers, then collective farms known as kibbutzim, and finally developed industry and built cities, the largest being Tel Aviv. During these decades, Jewish artists in Palestine, many of them immigrants from Europe, used European-derived techniques and styles—from academic realist to Post-Impressionist, Expressionist, **primitivist**, and Cubist idioms—to depict the local landscape, Jewish people, and Near Eastern and Hebrew biblical subjects, seeking to express their historical connection to the land.

Anna Ticho (1894–1980)

Outstanding among such artists was Anna Ticho, who devoted her life to drawing the city of Jerusalem and the surrounding countryside. Ticho grew up in Vienna, where she

FIGURE 18.22 Monir Shahroudy Farmanfarmaian, *Geometry of Hope*, 1976. Mirror, oil painting behind glass, stainless steel and plaster on wood, 128 x 128 x 5 cm. Private collection, London. Courtesy Rose Issa Projects, London.

Israel's communal labor movement and in some cases Marxist in politics, were committed to social realism; among them were Yohanan Simon, Moshe Gat, and Naphtali Bezem. Their politically engaged work criticized social and economic injustice, promoted workers' rights, and idealized the productivity and social harmony of the kibbutzim. By contrast, other artists who conceived of themselves as internationalists adopted European-modernist-inspired styles of abstraction. Unlike the social realists, these abstractionists saw their work as detached from social and political concerns and as a vehicle for subjective, personal expression. This "art for art's sake" position was represented by the New Horizons group, formed in 1948, which came to dominate modern Israeli art in the 1950s. Its most prominent members included Avigdor Stematsky, Yehezkiel Streichman, and Yosef Zaritsky.

The leader of the New Horizons group, Zaritsky immigrated in 1923 to Palestine from his native Ukraine, where he had studied art in Kyiv before World War I. Additional study in Paris in the late 1920s fired his enthusiasm for European modernism. During the 1930s and 1940s, he painted freely brushed, brightly hued watercolors of Tel Aviv from his rooftop. In some of these compositions, Zaritsky depicted himself wielding a paintbrush before a canvas depicting the cityscape; these are paintings about the act of painting, emphasizing the autonomy of the creative act in modernist terms.

In the late 1940s, Zaritsky began painting more in oils and his work became increasingly abstract. The trend climaxed in his *Yehiam* series, based on his experience of teaching art for three summers (1949–51) at Kibbutz Yehiam in Western Galilee. Memories of the watercolors he made there, featuring flat, schematic images of humans and animals and the painter with his palette, underlay the oil paintings he subsequently executed in his Tel Aviv studio, such as *Yehiam (Life on the Kibbutz)* (1951, Figure 18.24). The highly abstracted figure of the painter holding his palette and pointing skyward with his right index finger may be

studied art. Settling in Jerusalem in 1912, she was deeply impressed by "the grandeur of the scenery, the bare hills, the large, ancient olive trees, and the cleft slopes . . . the sense of solitude and eternity."[28] Through the 1940s, she depicted the Jerusalem cityscape and surrounding hills and foliage with academic precision rooted in her Viennese training.

After she moved in the 1950s to the Judean Mountains on the outskirts of Jerusalem, Ticho stopped working from direct observation and made drawings in her studio. More freely executed on larger sheets of paper than her earlier works, these late drawings, such as *Jerusalem* (1969, Figure 18.23), offer sweeping and exhilarating vistas of the mountainous terrain, composed of vigorous strokes of charcoal animated by the artist's deep feeling for her subject.

New Horizons: Yosef Zaritsky (1891–1985)

Two competing views of art vied for supremacy in Israel in the years around its independence. Some artists, aligned with

FIGURE 18.23 Anna Ticho, *Jerusalem*, 1969. Charcoal on paper, 70.1 x 100.3 cm. The Museum of Modern Art, New York.

discerned to the right of center. The overall emphasis, however, is on pure painting, with rough, sometimes overlapping patches of grays, muted greens, browns, and off-whites formed by gestural strokes of a loaded brush.

One critic has likened the elemental, primitive quality of Zaritsky's Yehiam abstractions to prehistoric cave art, appropriate both to the theme of the birth of a new Israeli society as encountered by the artist in the kibbutz, and to the artist's immersion in the adventure of devising a new visual language.[29] In formal terms, Zaritsky's painting of this moment holds its own with that of his Western modernist contemporaries, the New York **action painters** and the European exponents of *art informel*.

Ten Plus

By the time of the last New Horizons exhibition in 1963, a reaction against the group's insistence on autonomous abstraction had set in among younger artists whose interests were aligned with those of the French **Nouveaux Réalistes** and American progenitors of **Pop art** such as Larry Rivers and Robert Rauschenberg. These Israeli artists—several of whom banded together in 1965 in Tel Aviv as Ten Plus (the name signified the group's ten charter members and their wish to attract more)—often worked in the modes of **collage** and **assemblage**, combining everyday objects and materials with conventional artistic mediums. They also frequently infused their work with humor, irony, and references to popular culture.

FIGURE 18.24 Yosef Zaritsky, *Yehiam (Life on the Kibbutz)*, 1951. Oil on burlap mounted on canvas, 208 x 228 cm. Tel Aviv Museum of Art, Israel.

Among the most prominent members of Ten Plus was Raffi Lavie (1937–2007), whose work of the later 1960s blends influences from Rauschenberg and Cy Twombly (see Chapter 14). A characteristic example, *Untitled* (1969, The Israel Museum, Jerusalem) features at the upper left a collaged poster advertising a pop music concert in Hebrew. Loosely brushed white paint partially covers the poster and fills the rest of the composition, overlain by gestural loops and scribbles of pencil and **acrylic** and scrawled graffiti-like inscriptions. Lavie's incorporation of a bit of urban reality (the poster) and evocation of the markings on city walls sets his work against the pure abstraction of the New Horizons artists, which Lavie and his colleagues considered escapist.

Pluralism: Trends of the Late 1960s to Mid-1970s

This chapter surveys artistic trends of the late 1960s through the mid-1970s, primarily in the United States with some attention paid to artists working in Europe, Brazil, and Japan. This was a period of pluralism in the visual arts, with multiple movements flourishing simultaneously in different contexts. These movements were united in questioning or rejecting dominant values—aesthetic, social, political, or philosophical—in the pursuit of new forms of expression. These new forms often resonated with agendas of the period's countercultural and liberation movements, which arose amidst tremendous social and political upheaval worldwide. The escalation of the Vietnam War, a US attempt to stop communism's spread from North to South Vietnam, sparked a vigorous anti-war movement in the United States and internationally. The 1968 assassinations of civil rights leader Dr. Martin Luther King Jr. and presidential candidate Sen. Robert F. Kennedy, both critics of the Vietnam War, rocked the United States, as did the Watergate scandal that forced President Richard Nixon's resignation in 1974. Many young people who protested the war participated in a global youth movement, forming a counterculture that rejected what they saw as the conformist and materialist values of their parents' generation. Alongside anti-war protests, civil rights activism intensified in the United States, carried out by the Black Power, women's liberation, gay liberation, Chicano, and Red Power (Native American) movements. The period also saw demonstrations against right-wing governments in Argentina, Brazil, and Mexico and against communist governments in Czechoslovakia, Poland, and Yugoslavia; promoting students' and workers' rights in Italy and France; and against nuclear proliferation in Australia and Western Europe.

In American art, Minimalism (see Chapter 16) gave way in the later 1960s to Post-minimalism, an umbrella term coined by critic Robert Pincus-Witten that encompasses Process art, Conceptual art, Land art, and Body and Performance art. Post-minimal artists accepted Minimalism's direct, reductive character but allowed references to ideas and concerns beyond the strictly physical and visual, which Minimalists had refused. Process artists emphasized the materials and procedures used to fashion the artwork. Conceptual artists downplayed or eliminated the physical object to emphasize ideas, while Body and Performance artists used the body as their medium to convey ideas. Land and Site artists transported natural materials into the gallery or museum or worked directly in the landscape or an urban site rather than creating objects in the studio.

Many Post-minimal works were ephemeral or immaterial, known only through verbal or photographic documentation, or were site-specific, requiring the viewer to travel to experience them. In these senses, they shared in the countercultural critique of art as an exchangeable capitalist luxury good. Post-minimal artists did typically produce saleable objects, such as photographs, videos, and films, or nonrepresentational sculptures made of unconventional materials. However, such works lacked the traditional aesthetic qualities of representational painting and sculpture, which also remained vital art forms in the United States during this period despite their renunciation by the Post-minimalists. Sharing in that renunciation were the Arte Povera

artists in Italy and the Mono-ha artists in Japan, whose works have strong affinities with US Post-minimalism. On the other hand, artists aligned with the period's civil rights and liberation movements often used representational modes to affirm their identities as Blacks, women, Native Americans, or Chicana/os.

Process Art

A **Post-minimal** mode that retained **Minimalism's** use of undisguised materials and nonrepresentational forms, **Process art** refers to art in which the procedures and materials used to make the work are given prominence in the finished product. Process art thus harbors narrative content—not storytelling, but relating to the temporal sequence of events or forces that brought the work into being.

Robert Morris (1931–2018)

Robert Morris articulated Process art's central ideas in his 1968 article "Anti Form."[1] He advocated moving beyond Minimalism's fixed, rectilinear forms to investigate flexible materials, shaped by chance and gravity to yield "forms that were not projected in advance" and that reveal the process of their making.[2] Morris identified Jackson Pollock's and Morris Louis's exploitation of "the physical, fluid properties of paint"[3] to create **abstractions** and Claes Oldenburg's use of soft materials as important precedents for these proposed investigations.

After making rigid Minimalist painted plywood sculptures in the mid-1960s (see Figure 16.14), Morris turned to a soft **medium**: heavy, dark gray industrial felt. He used it for anti-form works such as *Untitled (Tangle)* (1967, Figure 19.1)—a large felt sheet incised to create long rectangular strips that fall to the floor in a tangled pile when hung from a peg on the wall. Lacking a fixed structure and revealing the process of its making through its components' response to gravity, this sculpture appears different each time it is installed.

Morris pushed anti-form into "scatter pieces"—temporary works comprising materials randomly dispersed on the floor—a mode employed by numerous Post-minimal artists. He created an **environment**, *Continuous Project Altered Daily* (1969), in the Leo Castelli Gallery warehouse by scattering, shoveling, and repositioning diverse materials and objects—earth, water, paper, grease, plastic, wood, felt, electric lights, photographs, tape, and a tape recorder—on the floor, tabletops, and walls. He changed the installation every day for a month but produced nothing permanent or saleable. *Continuous Project Altered Daily* thus challenged **modernist formalism** and the art object's commodity status, resonating with countercultural calls for art's liberation from the repressive confines of the gallery, museum, and market.[4]

Eva Hesse (1936–1970)

Eva Hesse's dedication to labor-intensive methods such as wrapping forms with cloth or string and hand casting fiberglass, as well as her use of flexible materials that sag in response to gravity qualify her as a process artist. One of her generation's most original and influential American sculptors, she created her mature work between 1965 and 1970 before dying of a brain tumor at age thirty-four. Creating **abstract** art infused with awkwardness, vulnerability, humor, and pathos, Hesse identified her work's content as "the total absurdity of life"—a quality she sought to evoke through formal contradictions and oppositions.[5]

FIGURE 19.1 Robert Morris, *Untitled (Tangle)*, 1967. Felt, 296.7 x 269.3 x 147.4 cm. The Museum of Modern Art, New York.

Hesse gained attention in the New York art world through her participation in *Eccentric Abstraction*, a 1966 exhibition organized by critic Lucy Lippard. This exhibition helped to establish the grounds of Post-minimalism by presenting objects possessing Minimalism's **formal** clarity but offering "emotive or 'eccentric' or erotic alternatives" to its solemn lack of expressiveness."[6] Exemplary of such eccentricity is Hesse's *Hang-Up* (1966). A hybrid object combining aspects of painting and sculpture, it consists of two connected parts: an open six-by-seven-foot cloth-wrapped wood frame hanging on the wall and a large, cord-wrapped steel rod that loops out six-and-a-half feet from the frame's top and bottom to touch the floor. Hesse painted the wrapped frame with subtly gradated **tones** shifting from pale to ash gray. She called it "the most ridiculous structure I have ever made," possessing "a kind of depth and soul and absurdity and life and meaning or feeling or intellect that I want to get."[7] Hesse's words reveal her drive to invest her work with subjective qualities at odds with Minimalism's impersonal literalism.

In early 1968, Hesse began working with latex rubber and with fiberglass and polyester resin—materials she could easily shape into organic forms. She created works in these mediums that transformed Minimalism's repetition of identical machine-fabricated geometric units into repeated handmade forms that

are similar but unique. She used repetition for expressive purposes: "If something is absurd, it's much more greatly exaggerated, absurd, if it's repeated."[8] Hesse's *Repetition Nineteen III* (1968) consists of nineteen hollow, bucket-like fiberglass and resin forms, each about twenty inches high, disposed across the floor in a random configuration, which differs each time the work is installed. She also employed repetition in *Contingent* (1969, Figure 19.2), which, like many of her works, she suspended from the ceiling, allowing it to sag in response to gravity. *Contingent* comprises eight loosely rectangular planes of rubberized cheesecloth embedded in roughly worked translucent fiberglass panels. Although it occupies space like sculpture, its elements are flat and incorporate expanses of cloth, like painting. The panels hang in an orderly row like the units of a Donald Judd sculpture (see Figure 16.13), but each has a different size and appearance. Rather than hard Minimalist perfection, they project human qualities of fragility and fallibility, heightened by the tallest panel's droop onto the floor. They are also perishable; Hesse knew that the latex rubber would oxidize, turn brittle, and discolor over time. Acutely conscious of her own mortality—she completed *Contingent* between periods of hospitalization for treatment of her brain tumor—Hesse also saw her art as transitory, musing, "Life doesn't last; art doesn't last. It doesn't matter."[9]

FIGURE 19.2 Eva Hesse, *Contingent*, 1969. Cheesecloth, latex, fibreglass, overall 630 x 350 x 109 cm. National Gallery of Australia, Canberra.

Richard Serra (b. 1939)

Arriving in New York in 1966 as a young artist, Richard Serra was encouraged by Morris, Judd, and Carl Andre to work in real, three-dimensional space with simple, nonrepresentational forms and raw industrial materials. Simultaneously, he became interested in asserting the process that produces the work of art, a concern he shared with such friends as Hesse and Robert Smithson. In 1966–67, Serra made numerous sculptures out of strips of vulcanized (hardened) rubber, which he hung from the wall or scattered across the floor, allowing chance and gravity to determine the work's ultimate form. In 1968–69, he created a series of splashing pieces by flinging molten lead against the right-angle juncture of the wall and floor—an act recalling Pollock's paint-slinging technique. For a work called *Casting*, Serra allowed

the flung lead to cool and harden, then pulled it away from the wall and repeated the process until he had created a row of ragged-edged metal strips. This **site-specific** work of Process art revealed the nature of both the splashing procedure and of the physical space that gave the strips their form.

In other late 1960s works, Serra propped massive lead plates, pipes, and rolled lead sheets against one another or against gallery walls, producing simple configurations that gravity simultaneously held together and threatened with collapse. *One Ton Prop (House of Cards)* (1969) consists of four forty-eight-inch-square, 500-pound lead antimony plates balanced against each other in an open cube—a Post-minimalist variation on a Judd box. Since weight and the force of gravity keep it standing, *One Ton Prop* communicates the sensation of sculptural process by constantly recreating its own making, the outcome of which remains precarious.

In the 1970s, Serra began working with hot-rolled steel on a greatly enlarged scale. He leaned huge steel plates against one another in both interior and outdoor locations to define sculptural spaces that demand bodily involvement. By 1980 he was also fabricating curved steel walls that carved space into convex and concave sections, such as the controversial *Tilted Arc* (1981), discussed in Chapter 20 (see Figure 20.17).

Sam Gilliam (1933–2022) and Lynda Benglis (b. 1941)

Working independently, Washington, DC-based Sam Gilliam and New York-based Lynda Benglis fused elements of painting and sculpture in objects whose final appearance was determined by processes outside of the artist's complete control. Gilliam won acclaim for his "drape paintings" of the late 1960s and early 1970s (e.g., *Carousel State*, 1968). These are large unprimed canvases onto which he dripped, splashed, and brushed **acrylic** paint in a variety of colors, leaving some areas of the canvas bare. He then transfigured the brilliantly colored surface into a sculptural form by pleating and suspending the canvas so that gravity shapes it. Benglis adapted Pollock's and Helen Frankenthaler's pouring techniques by spilling various Day Glo-pigmented latex colors onto the floor, allowing the work to "dictate its own form."[10] The results (e.g., *Contraband*, 1969) integrate material, process, and sumptuous color into what the artist called "fallen paintings." They can likewise be considered flat, floor-bound sculptures whose irregular contours were determined by the flow of liquid latex.

Conceptual Art

In **Conceptual art**, ideas or concepts constitute the artwork, which need not take physical form. Conceptual artists of the 1960s and 1970s conveyed ideas through paintings and sculptures, but more often through **readymades** and **found objects**, written proposals and instructions, diagrams, charts, maps, books, photographs, film, video, neon, their bodies, and many other materials, with language itself being the most characteristic medium. Regardless of its form, or lack thereof, Conceptual art existed most fully in artist's mind and required a new kind of mental participation from the viewer.[11] Resisting embodiment in a unique, precious, and aesthetically complex object, and often existing outside of conventional exhibition spaces, Conceptual art sought an alternative both to the confines of the art gallery and commodification by the art market.[12] Conceptual art's radically anti-commercial nature resonated with the counterculture's rejection of materialism.

Duchamp's readymades (see Figure 7.3) laid the foundations for Conceptual art by demonstrating that art did not need to be made by hand nor concerned with aesthetic form but was fundamentally defined by the artist's intentions. **Fluxus** artist Henry Flynt defined "Concept Art" in a 1963 essay as "art of which the material is 'concepts,'"[13] but the term first gained widespread currency with Sol LeWitt's 1967 essay "Paragraphs on Conceptual Art." LeWitt wrote that "Conceptual Art is made to engage the mind of the viewer rather than his eye or his emotions," and he announced, "the idea itself, even if not made visual, is as much a work of art as any finished product."[14]

Conceptual art at its most radical resulted in what Lucy Lippard called "the dematerialization of the art object"—its reduction to the statement or documentation of an idea.[15] An early manifestation of this trend was the ten-page proposal for an "Air Show" (1966) (exploring the idea of nominating a quantity of air as "art") by the English artists Terry Atkinson and Michael Baldwin. They went on in 1968 to cofound the group Art & Language, which emphasized critical and theoretical writing over the production of conventional art objects. Also committed to dematerialization were the Americans Robert Barry, Lawrence Weiner, and Douglas Huebler. Barry's *Telepathic Piece* (1969) consisted of this statement: "During the exhibition I will try to communicate telepathically a work of art, the nature of which is a series of thoughts that are not applicable to language or image."[16] Weiner published terse descriptions of possible objects (e.g., "One standard dye marker thrown into the sea"), leaving it up to the "receiver" to determine if the piece would be realized.[17] Huebler's contribution to a 1969 exhibition catalogue encapsulated Conceptual art's anti-materialist orientation: "The world is full of objects, more or less interesting; I do not wish to add any more. I prefer, simply, to state the existence of things in terms of time and/ or place."[18]

In addition to those named above and discussed below, prominent Conceptual artists included the Americans John Baldessari, Mel Bochner, and Adrian Piper (see Figure 20.13); Luis Camnitzer (Uruguay); Hanne Darboven (Germany); Jan Dibbets

(the Netherlands); Yutaka Matsuzawa (Japan); Komar and Melamid (USSR, see Chapter 20); and Roman Opalka (Poland).

Sol LeWitt (1928–2007)

Sol LeWitt's white-painted, open modular cube structures earned him recognition as a Minimalist, but he was primarily interested in the concepts and systems that generated his works, rather than in their appearance. He employed the cube because "it is relatively uninteresting. . . . the best form to use as a basic unit for any more elaborate function, the grammatical device from which the work may proceed."[19] Using an arbitrarily chosen ratio of 1:8.5 between the width of the cube's structural elements and the spaces between them, he composed wood or metal structures consisting of a single large cube comprised of multiple smaller ones (e.g., *Open Modular Cube*, 1966); or stepped arrangements of modular cubes based on simple arithmetic progressions (*Untitled*, 1971, Figure 19.3). These structures were built by LeWitt's assistants following his plans, manifesting his definition of Conceptual art as "usually free from the dependence on the skill of the artist as a craftsman" (which links it to Minimalism).[20] Starting in 1968, LeWitt also wrote simple instructions for wall drawings (e.g.,

FIGURE 19.3 Sol LeWitt, *Untitled*, 1971. Painted wood, 61.5 x 62 x 61.5 cm. Mart (Museo di Arte Moderna e Contemporanea di Trento e Rovereto), Rovereto, Italy.

Wall Drawing # 146. All two-part combinations of blue arcs from corners and sides, and blue straight, not straight, and broken lines, 1972). As with his structures, he left the wall drawings' execution to others and accepted that they would be painted over after exhibitions. He did not consider the drawings precious and unique, but perishable and repeatable; what endures are the instructions—each embodying an idea, which "becomes a machine that makes the art."[21]

Joseph Kosuth (b. 1945)

In his early work, Joseph Kosuth was concerned with "the effect of language on one's perception of the world and organization of reality."[22] His *One and Three Chairs* (1965) presents a wooden folding chair set against a wall, flanked by a full-scale black-and-white photograph of the chair and a photographic enlargement of the printed dictionary definition of "chair." These juxtapositions invite consideration of the different types of "chairness" manifested by the object and its visual and verbal representations. In his subsequent *First Investigations* series, subtitled *Art as Idea as Idea* (1966–68), Kosuth focused exclusively on dictionary definitions of adjectives and nouns (e.g., *"Titled (Art as Idea as Idea)" [Water]*, 1966). These took the form of square board-mounted Photostats with white lettering against a black ground, hung like paintings. Kosuth explained that the subtitle's repetition of "as idea" signaled that he was not just using "ideas or concepts as the work itself," but "changing the idea of art itself."[23] Ultimately, he argued that Conceptual art is "based on an inquiry into the nature of art. Thus, it is . . . a working out, a thinking out, of all the implications of all aspects of the concept 'art.'"[24] For Kosuth, language was the ideal medium for carrying out this inquiry.

On Kawara (1932–2014)

Japanese-born On Kawara settled in New York in 1964 and on January 4, 1966, began his *Date Paintings* (part of the *Today* series)—a Conceptual art project he continued for the rest of his life. Following strict protocols, Kawara would use a horizontal rectangular canvas in one of eight different sizes to which he applied a monochrome ground (red, blue, or dark gray) in four layers of acrylic. Over this, centered on the canvas, he would meticulously render in several coats of white paint the day's alphanumeric date (e.g., *OCT. 31, 1978*). If Kawara did not complete the painting by midnight, he would discard it. He encased many of the finished *Date Paintings* in specially made cardboard boxes lined with clippings from that day's newspaper in the city where he was working (he traveled frequently). While the newspaper excerpts provide information about certain current events, the paintings' emptiness allows them to be associated with anything that happened on that date, anywhere. At the same time, the paintings provide evidence of how Kawara spent that day, taking up to seven hours

to execute a painting as a kind of meditative practice. Much of Kawara's art, including postcards sent to friends documenting the time he got up that day (*I Got Up*, 1968–79), simply affirmed his existence and his passage through time.

Cildo Meireles (b. 1948)

In Brazil, Cildo Meireles applied Conceptual art to political ends. He designed *Insertions into Ideological Circuits: Coca-Cola Project* (1970, Figure 19.4) to offer furtive resistance to his country's oppressive military dictatorship. Coca-Cola, an American product, was an emblem of US capitalism and political imperialism (the US government supported the Brazilian military dictatorship). Meireles temporarily removed over one thousand recyclable Coca-Cola bottles from circulation and screen-printed critical political messages or information on them, such as "Yankees Go Home!" or instructions for making a Molotov cocktail. Meireles's white inscriptions were nearly invisible on the empty bottles but became legible against the dark brown liquid after the bottles were refilled. For a second project, he stamped banknotes with subversive texts, such as calls for democracy and free elections. Meireles used readymades not to transfer manufactured objects into the realm of art (as did Duchamp) but as a means of distributing messages anonymously through society, avoiding government censorship. He said that his works "concentrated on isolating

and defining the concept of the circuit, by taking advantage of a pre-existing system of circulation. In this sense, the texts on the Coca-Cola bottles and on the banknotes functioned as a kind of mobile graffiti."[25]

Conceptual Art as Institutional Critique: Daniel Buren (b. 1938), Marcel Broodthaers (1924–1976), and Hans Haacke (b. 1936)

A current within Conceptual art, Institutional Critique focuses on the institutional frameworks that define and give art its meaning or value. Such art investigates or disrupts the operations of galleries, museums, private collections, and other art institutions to expose their ideologies and power structures. Prominent exponents of this approach in the late 1960s and 1970s were the Frenchman Daniel Buren, the Belgian Marcel Broodthaers, and the German American Hans Haacke.

In 1965, Buren adopted a standard visual language of alternating 8.7-cm-wide colored and white vertical stripes, printed on paper, cloth, or another material, based on a striped awning canvas he discovered in a Parisian market. Using this impersonal, repetitive, machine-produced design, Buren challenged expectations regarding the art object's uniqueness and expressivity. Engaged with Situationism's left-wing politics (see box, Chapter 17) and a participant in the 1968 student uprisings, Buren attacked the notion of the artwork as a precious commodity decorating bourgeois apartments. In April 1968, he pasted two hundred striped posters over billboards and other advertising spaces in Paris without authorization. These *affichages sauvages* (feral posterings) were his creative act of *détournement*—the Situationist tactic of taking over an existing form and subversively reusing it. Buren appropriated the spaces of advertising both to protest its proliferation and, in accordance with his critique of traditional art institutions, to demonstrate art's boundlessness when released from the confines of a private collection, gallery, or museum.[26]

Between 1968 and 1972, Marcel Broodthaers "curated" an ironic, itinerant museum in order to investigate the art museum's ideological power to confer social, cultural, economic,

FIGURE 19.4 Cildo Meireles, *Insertions into Ideological Circuits: Coca-Cola Project*, 1970. 3 glass bottles, 3 metal caps, liquid and adhesive labels with text, each 25 x 6 x 6 cm. Tate, London.

and political value upon its contents. He first installed the *Museum of Modern Art, Department of Eagles, Section of the Nineteenth Century* on the ground floor of his Brussels home. This museum displayed empty packing crates for works of art and postcards of famous nineteenth-century French paintings, expressing Duchampian indifference toward uniqueness and originality. In 1972, at the Kunsthalle, Düsseldorf, Broodthaers presented his museum's "Figures Section," displaying over three hundred artifacts loaned by museums and private collectors. The objects, all representing eagles, came from different cultures and historical periods and ran the gamut from paintings, sculptures, and metalwork to consumer packaging and advertisements. Broodthaers submitted them to no discernible ordering system, treating them all as if they were equal in aesthetic, historical, or functional importance, thereby demonstrating the museum's power to confer a deceptive unity on a group of objects sourced from radically different contexts. Each object was accompanied by a plaque reading, "This is not a work of art," conflating Duchamp's tactic of designating something as art and René Magritte's "This is not a pipe." This paradoxical statement raised questions: did the artist, by means of language alone, have the power to determine whether an object is a work of art? And, if objects customarily acknowledged to be art were actually not art, by what criteria were they placed in this "museum of modern art"? Such questions manifested Broodthaers's aim "to provoke critical thought about how art is presented in public."[27]

After moving to New York in 1965, German-born Hans Haacke devoted his art to the presentation of real-time physical systems, such as ice forming on a refrigerated pole (*Ice Stick*, 1966) or grass growing in a plexiglass container (*Grass Cube*, 1967). In the late 1960s, he began to explore human social systems through questionnaires and polls conducted in art venues. His contribution to MoMA's 1970 *Information* exhibition was a poll asking: "Would the fact that Governor Nelson Rockefeller has not denounced President Nixon's Indochina policy be a reason for you not to vote for him in November?" Visitors responded by inserting paper ballots through electronic counting devices into transparent plexiglass boxes (Figure 19.5). Haacke's question referred to Nixon's escalation of the Vietnam War by invading officially neutral Cambodia. This invasion led to large anti-war demonstrations across the United States, including at Kent State University, where Ohio National Guardsmen shot and killed four students two months before *Information* opened. Over two-thirds of Haacke's MoMA poll respondents answered "Yes" to express opposition to Nelson Rockefeller's tacit support of Nixon. Since Rockefeller was a prominent MoMA trustee, Haacke's poll implicated the museum in this political question.

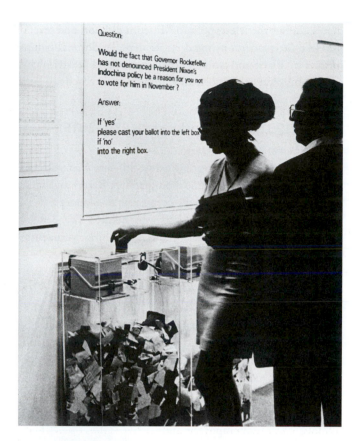

FIGURE 19.5 Hans Haacke, *MoMA Poll*, 1970. Installation view in the *Information* exhibition, The Museum of Modern Art, New York.

The Art Workers' Coalition and the New York Art Strike

Institutional Critique turned into activism in January 1969 when several New York critics and artists, including Haacke, formed the Art Workers' Coalition (AWC), initially to protest the degree of control that museums, galleries, and private collectors exercised over living artists' work. Targeting MoMA, the group issued demands including that the museum be open to the public free of charge and that it establish a wing for Black art. The AWC soon took up the anti-Vietnam war cause. In January 1970, its members rallied in front of Picasso's antiwar mural *Guernica* (see Figure 9.8) at MoMA and held up posters featuring Ronald Haeberle's photograph showing victims of the US massacre of 347 unarmed civilians in the South Vietnamese village of My Lai. Superimposed on the image was the text, "Q. And babies? A. And babies." The words came from reporter Mike Wallace's interview with a participant in the My Lai massacre, Paul Meadlo. An offshoot of the AWC led by Robert Morris organized the New York Art Strike, asking all New York art institutions to close on May 22, 1970, "as an expression of shame and outrage at our government's policies of racism, war and oppression." Several museums and galleries

did close, but the Metropolitan Museum did not, and several hundred artists demonstrated on its steps. Additional groups formed by Black and women artists to demand greater inclusion in museum exhibitions and collections are discussed later in this chapter.

Bernd (1931–2007) and Hilla (1934–2015) Becher

Achieving international prominence in the years around 1970s, the married German photographers Bernd and Hilla Becher created work that was compared to Conceptual art because of its systematic, rule-driven nature. The Bechers dedicated their joint career to photographing **vernacular** structures, such as **half-timbered** houses, and industrial ones, such as water towers, cooling towers, gas tanks, winding towers, and blast furnaces. Starting in 1959, they worked in Bernd Becher's native Siegerland region before expanding their reach to other areas of Germany, Europe, and North America. The Bechers photographed both contemporary and historical structures. Although many of the latter faced demolition with the decline of mining and metals industries, the Bechers insisted: "We do not intend to turn old industrial buildings into relics, but we do want to create a more-or-less complete chain of the phenomena, embracing all the different forms."[28] Aiming to document their subjects objectively, the Bechers used a large-format camera and black-and-white film; shot under overcast skies to achieve even lighting; and centered the subject in the frame. They organized their photographs into typologies (grouped together by structure type) and displayed them in Minimalist-style grids of equally sized prints (e.g., *Water Towers*, 1968–80, Figure 19.6), allowing discernment of individual variations between functionally identical structures. The Bechers' dispassionate approach and typological method drew on the example of the interwar **Neue Sachlichkeit** (New Objectivity) photographers such as August Sander (see Figure 7.10). The Bechers left their mark on many young artists who studied under Bernd Becher at the Düsseldorf Academy in the 1970s and 1980s; his students Andreas Gursky (see Figure 22.15), Candida Höfer, Thomas Ruff, and Thomas Struth all became renowned photographers.

Arte Povera

The Genoese critic Germano Celant grouped together fourteen Italian artists, including Giovanni Anselmo (b. 1934),

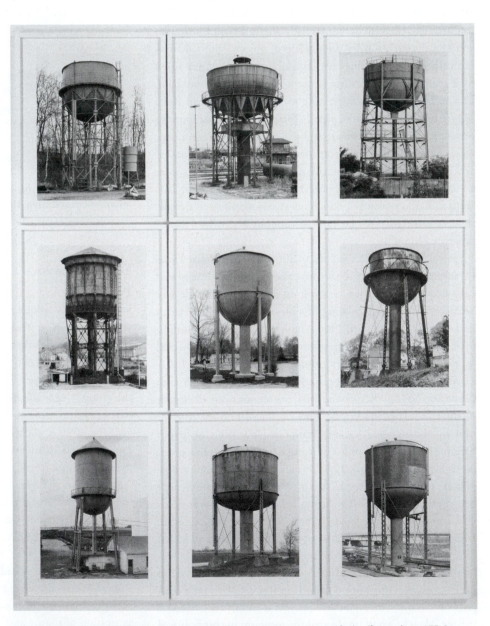

FIGURE 19.6 Bernd and Hilla Becher, *Water Towers*, 1968–80. Nine gelatin silver prints, 155.6 x 125.1 cm. Solomon R. Guggenheim Museum, New York.

Jannis Kounellis (1936–2017), Mario Merz (1925–2003), and Michelangelo Pistoletto (b. 1933), under the label **Arte Povera** (poor art) in 1967, and published a book of that title in 1969. In the context of a surging Italian economy accompanied by university students' demonstrations against an authoritarian educational system, Arte Povera's artists opposed rationalism, technocracy, consumerism, and repressive social and institutional hierarchies. Rejecting **oil paint**, marble, and bronze for their associations with elite high culture, they used "poor" materials, often found in nature or the everyday world. Like many 1960s artists, they sought to break down barriers between art and life. "The artist mixes himself with the environment," wrote Celant. "He draws from the substance of the natural event—that of the growth of a plant, the chemical reaction of a mineral, the movement of a river . . . the fall of a weight—he identifies with them in order to live the marvelous organization of living things."[29]

Arte Povera works often juxtaposed motifs evoking Italy's rich cultural heritage with discarded materials suggesting contemporary social and economic inequality. For example, Pistoletto's *Venus of the Rags* (1967; he made several later versions) features a modern reproduction of an ancient statue of the Roman goddess with its back turned to the viewer, placed against a multicolored mound of rags (Figure 19.7). Celant interpreted the latter as representing "disparate communities of social rejects . . . the 'rags of society.'"[30] Dichotomies embodied in *Venus of the Rags*—hard/soft, unchanging/movable—recur in Anselmo's *Untitled (Structure that Eats Salad)* (1968). It comprises a sixty-five-centimeter-tall rectangular block of polished granite to which a much smaller granite block is lashed by means of a copper wire. Tightly wedged between them is a fresh head of lettuce. As the lettuce wilts, the wire slackens and the smaller block slides down—a manifestation of the effects of decay, time, and gravity possessing affinities with American Process art.

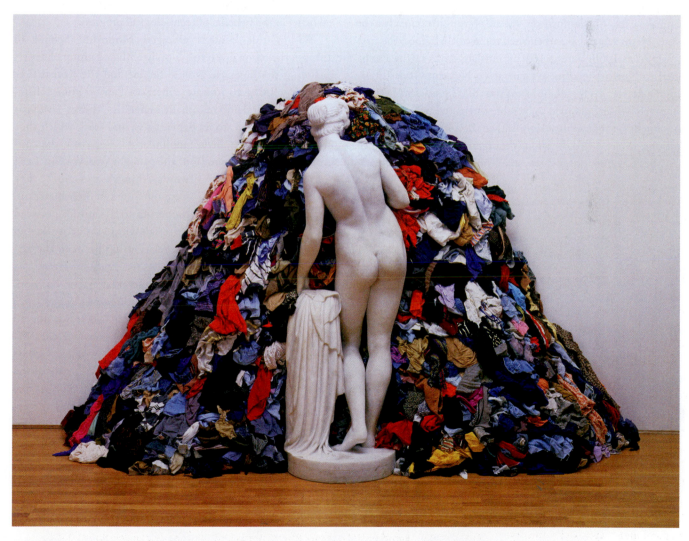

FIGURE 19.7 Michelangelo Pistoletto, *Venus of the Rags*, 1967/1974. Marble and textiles, 212 x 340 x 110 cm. Tate, London.

The Greek-born Kounellis combined inorganic forms and organic presences to generate a dialectical interplay between "structure" and "sensibility."[31] In a 1967 **installation**, he presented three sensibility/structure pairs: a live parrot perched in front of a rectangular steel sheet; a bale of white cotton overflowing a boxlike steel container; and cacti growing in earth within eight steel bins. Kounellis's most radical use of organic presences was a 1969 installation of twelve live horses tethered to the walls of Rome's Galleria L'Attico, a converted garage space (Figure 19.8). The work existed for only three days and the horses were not for sale; in this way, the leftist Kounellis challenged the art gallery's bourgeois economic interests. Like Pistoletto's Venus statue, Kounellis's horses evoked a Greco-Roman heritage, specifically the **classical** tradition of equestrian art, but also radiated elemental strength and a calming presence, intensified by their gallery setting.

Mario Merz was best known for his igloos, large hemispherical structures supported by metal frameworks and incorporating "poor" materials such as earth, clay, twigs, fruit, canvas, wax, or clamped-on sheets of roughly cut glass or slate. Neon texts also embellished some of the igloos: the first (*Giap Igloo*, 1968) bore an Italian translation of a saying attributed to North Vietnamese General Vo Ngyuen Giap: "If the enemy masses his forces, he loses ground; if he scatters, he loses strength." (Merz claimed to be more interested in this circular statement's philosophical significance than its political implications.) Merz called the igloo "the organic form par excellence . . . both the world and the small house."[32] He often made his igloos out of materials found in the places where he constructed them, in accordance with his view that art should be transitory and always changing but connected to the earth.[33] Merz also believed that the artist, like the igloo dweller, should be a nomad, always in motion, at home everywhere, in contact with both nature and culture.[34]

Mono-ha: Nobuo Sekine (1942–2020) and Lee Ufan (b. 1936)

Japan, like most industrialized countries, experienced both a booming economy and social upheaval in the 1960s. In 1968 and 1969, Japanese university students protested the impending renewal of the US–Japan Mutual Cooperation and Security Treaty and the war in Vietnam. More generally, many young Japanese questioned Western modernity and its uncritical belief in the benefits of technological progress.

Within this context emerged **Mono-ha** (School of Things), the name given to a loosely affiliated group of artists including the Japanese Nobuo Sekine and the Korean Lee Ufan. Declining to imitate American Pop or Minimalism, they used natural and manmade materials ("things"), such as earth, stone, wood, rope, paper, glass, and steel, which they presented with very little manipulation. Rejecting the concept of art as representation, they sought to reveal, in Lee's words, "things as they are."[35] They were interested in their materials' properties, relationships between materials within the artwork, and the relationship between the artwork, its site, and the viewer.

The seminal Mono-ha work was Sekine's *Phase—Mother Earth* (1968), which he created for an outdoor exhibition in Kobe. Assisted by two fellow artists, Sekine dug a cylindrical 2.7-meter-deep, 2.2-meter-diameter pit in the ground. He then molded the excavated earth with cement into a 2.2-meter-diameter cylinder he placed aboveground a short distance from the hole. Beyond simply demonstrating the interplay between a concave negative

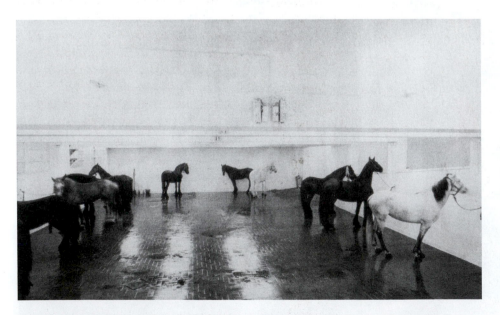

FIGURE 19.8 Jannis Kounellis, *Untitled (12 Horses)*, 1969. Installation view at Galleria L'Attico, Rome.

space and a complementary convex form, the sheer physical presence of the "thing" Sekine had constructed amazed the artist and his colleagues. Lee wrote that Sekine "merely rendered the earth as the earth; that is, he presented the earth within the being of the world."[36]

After moving from Seoul to Tokyo in 1956, Lee studied philosophy at Nihon University (1958–61). Absorbing ideas from Martin Heidegger, Maurice Merleau-Ponty, Emmanuel Levinas, and Nishida Kitarō, he rejected Western rationalism's subject-object division and sought to create art that, rather than emphasizing the artist's agency, opens up an "encounter" with the world—an unmediated phenomenological experience of matter and existence (see "Phenomenology" box, Chapter 16).[37] Lee made his first Mono-ha work, *Phenomena and Perception B* (1968/69, retitled *Relatum* in 1972), by dropping a large stone block onto a pane of glass atop a steel sheet, cracking the glass. His simple act highlighted the different properties of the three materials, which he otherwise did not alter, allowing these "things" to establish their own interrelationships, and the viewer to encounter their "otherness."[38] In the mid-1970s, steel plates and stones became Lee's signature sculptural materials, which he carefully juxtaposed in works uniformly titled *Relatum*. This philosophical term denotes entities existing in a relationship, such as a naturally formed, irregularly shaped mottled stone, and an industrially produced, uniformly dark steel plate (Figure 19.9). Lee was also a key figure in the nonrepresentational Korean *Dansaekhwa* (monochrome painting) school

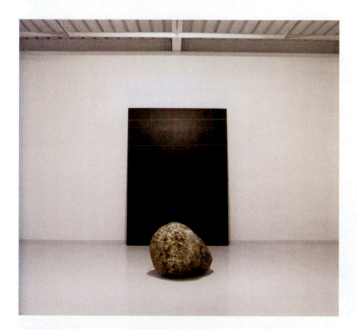

FIGURE 19.9 Lee Ufan, *Relatum – Silence*, 1979. The Museum of Modern Art, Kamakura & Hayama, Japan.

of the 1970s, in which repeated gestural marks or veils of pure color register the artist's tactile engagement with materials and process.

Land Art and Site-Specific Works

In **Land art**, also known as Earthworks, Earth art, or Environmental art, the artist interacts directly with the land and natural environment to produce a permanent or temporary site-specific artwork. Alternatively, the artist may relocate materials from the land into the gallery. As a Post-minimal trend, Land art shares Minimalism's commitment to declaring the reality of the materials from which the work is fashioned. The pioneering examples of Land art in the years around 1970s also typically employed a Minimalist-inspired simple geometric formal vocabulary. Many of the best-known works of Land art were made in isolated locations far from population centers and are known to most people through photographs, maps, texts, and other documentation.

Land art arose in the context of the counterculture's back-to-nature ideals and a growing interest in ecology. However, the movement's American pioneers showed little concern for the natural environment when they imposed abstract, geometric shapes on the land. While some of them expressed countercultural contempt for the art market, they still operated within its system even when they avoided making portable objects that could be displayed in a gallery, collector's home, or museum. The vast works made in the American Southwest by the leading American Land artists, Michael Heizer, Robert Smithson, and Walter De Maria, were all underwritten by wealthy patrons such as Robert Scull, gallerist Virginia Dwan, and the Dia Art Foundation.

Other pioneering Land artists were the Americans Dennis Oppenheim and Alan Sonfist and the Englishman Richard Long. Related to Land art are site-specific works of a quasi-architectural character, installed in a natural or urban location. Prominent creators of such works in the United States include De Maria, Heizer, Nancy Holt, Christo and Jeanne-Claude, Alice Aycock, Mary Miss, and Gordon Matta-Clark.

Robert Smithson (1938–1973)

Robert Smithson first used geological materials in his 1968 *Non-sites*, which he called "indoor earthworks." These featured rocks or rubble from outdoor locations contained within metal bins resembling Minimalist sculptures, often accompanied by maps and explanatory texts. Smithson organized them around a "dialectic of site and non-site." The site—the physical location from which the geological material was gathered—was

characterized by "open limits" and "scattered information." The non-site—the work in the gallery and the gallery itself—was characterized by "closed limits" and "contained information."[39] Several of the *Non-sites* incorporated materials from degraded metropolitan fringe areas of Smithson's native New Jersey. *Non-site (Palisades-Edgewater, N.J.)* (1968), for example, features rock from an abandoned trolley system. These sites attracted Smithson because of his fascination with entropy, a term in physics that describes a system's devolution into disorder and undifferentiated sameness.

Smithson built his most famous earthwork, the *Spiral Jetty* (1970, Figure 19.10), on the northeastern shore of Utah's Great Salt Lake, a location he chose for its algae-colored pinkish-red water. With Virginia Dwan's financial backing, he hired a contractor who used earthmoving equipment to construct a fifteen-feet-wide rock and dirt path extending 1,500 feet into the shallow water and coiling into a counterclockwise spiral. Smithson chose this motif for its macroscopic, microscopic, and mythological associations: it evokes spiral nebulae in outer space, the spiral structure of salt crystals on the jetty's basalt boulders, and a local eighteenth-nineteenth-century legend

of a whirlpool at the lake's center connecting it to the ocean through an underground tunnel. The reddish water surrounding the jetty suggests blood and the liquid origins of life. In a film he made about the *Spiral Jetty*, Smithson ruminated on the site's prehistory, comparing the earthmovers that built the jetty to the dinosaurs that once roamed Utah. Like much Land art, *Spiral Jetty* is affected by changes in the environment it occupies. Two years after its completion, it disappeared under the rising water and only reappeared in 2002. Unless preserved, it will eventually cease to exist, subject to the effects of entropy that enthralled its creator, who died in an airplane crash while surveying a planned Land art site in Texas.

Michael Heizer (b. 1944)

Michael Heizer began making Land art in 1967 by creating negative spaces through excavation, reversing the traditional conception of sculpture as a solid **mass** surrounded by space. In the summer of 1968, Heizer dug *Nine Nevada Depressions* of various abstract linear configurations in separate sites stretching across 520 miles. For his most famous earthwork, *Double Negative* (1969–70), he used dynamite and bulldozers to cut

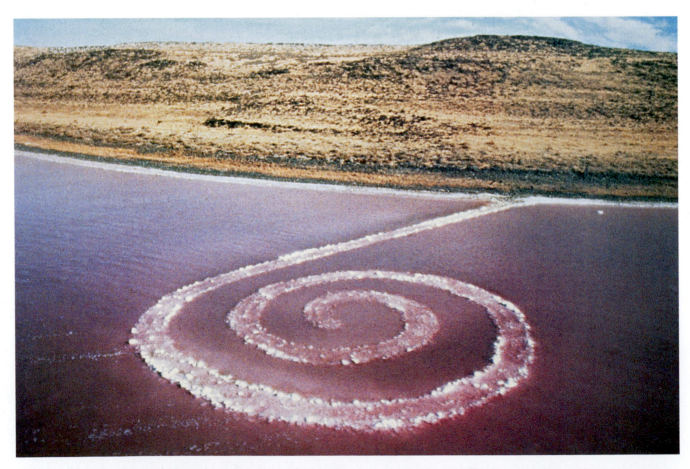

FIGURE 19.10 Robert Smithson, *Spiral Jetty*, 1970. Mud, precipitated salt crystals, rocks, water, 457.2 m long and 4.6 m wide. Great Salt Lake, Utah. Dia Art Foundation.

two fifty-feet-deep, thirty-feet-wide trenches into facing slopes of the Mormon Mesa in the southern Nevada desert, creating a 1,500-foot-long negative space (including the void between the slopes)—a simple, Minimalist-style excision. Visitors walk down ramps into the trenches to experience the work's impressive size, spaces, structure, and surfaces. *Double Negative* exemplifies Robert Morris's observation that the Land artists took Barnett Newman's concept of the **sublime** "back to nature where it originated in nineteenth-century American landscape painting." Heizer's monumental straight line cut into the earth fuses "Abstract Expressionism's impulse for grandeur . . . to Minimalism's emblematic forms."[40] A less sympathetic, ecologically conscious critic remarked in 1971 that Heizer "proceeds by marring the very land, which is what we have just learned to stop doing."[41]

Richard Long (b. 1945)

Richard Long's first work of Land art, *A Line Made by Walking* (1967), was radically simple. He walked back and forth in a straight line across an English field until he had worn a visible path in the grass. Long subsequently trekked across England and locations all over the world, making ephemeral marks on the earth. He also arranged materials he found on site, such as rocks or sticks, into simple geometric configurations (e.g., *A Line in the Himalayas*, 1975). Long recorded his walks and displacements of natural materials with photographs, maps, and concise texts that allow the viewer to imagine the artist's real-world experience. Long also brought stones or sticks into the gallery and organized them into lines, circles, or other geometric shapes (e.g., *Stone Line*, 1980). Like Smithson's *Nonsites*, Long's indoor works establish a dialectical relationship between the gallery and the natural location from which the materials were gathered. Long explains his work as "a simple metaphor for life. . . . It is an affirmation of my human scale and senses: how far I walk, what stones I pick up, my particular experiences. . . . I am content with the vocabulary of universal and common means; walking, placing, stones, sticks, water, circles, lines, days, nights, roads."[42] Long's light touching of the earth stands in contrast to the permanent alterations his American contemporaries made to it, especially Heizer's *Double Negative*—a line made by bulldozing.

Walter De Maria (1935–2013)

In 1968, Walter De Maria made his first *Earth Room*, temporarily filling a Munich gallery with forty-five cubic meters of black soil rising to about 60 centimeters. A glass plate of corresponding height at the gallery door allowed visitors to view the soil but prevented them from entering, keeping the earth pure. De Maria's installation offered a dramatic formal contrast between the black earth and the white-walled gallery and highlighted the latter's function in conferring art status on anything occupying it (see "The Institutional Theory of Art" box, Chapter 15). The *Earth Room* also became a sanctuary within the busy urban environment: visitors could smell the soil's rich aroma and contemplate the relationship between art and nature. In 1977, De Maria created a permanent *Earth Room* in New York, owned and maintained by the Dia Art Foundation.

The Dia Foundation also commissioned De Maria's iconic site-specific work, *The Lightning Field* (1977, Figure 19.11). Set on a desert plateau in western New Mexico, it consists of a 1 mile-by-1 kilometer grid of 400 stainless steel poles set sixty-seven meters (220 feet) apart. The poles vary in height from 4.6 to 8.2 meters according to the terrain's contours, but their tips form a level plane. The poles rest in concrete foundations, protected by grounding cable and rods that divert electrical current into the earth. De Maria's work courts the awesome power of lightning from summer thunderstorms. However, he insisted, "the light is as important as the lightning."[43] Visitors must book through the Dia Foundation and spend twenty-four hours at the *Lightning Field* (accommodated overnight in a small cabin) in order to experience it under different lighting conditions. The poles are most visible at dawn and dusk and almost disappear in the midday sun.

Nancy Holt (1938–2014)

Nancy Holt made her first trip to the desert with her husband Robert Smithson and Michael Heizer in 1968. She felt immediately connected to the region in which the rocks seem "ageless" and "'time' takes on a physical presence."[44] She was also greatly interested in time as measured by the earth's yearly revolution around the sun. After helping to complete Smithson's last earthwork, *Amarillo Ramp* (1973), Holt created her own site-specific work, *Sun Tunnels* (1973–76, Figure 19.12) in the northwestern Utah desert. It consists of four eighteen-feet-long, nine-feet-diameter reinforced concrete tunnels laid out in an open X configuration, eighty-six feet long on the diagonal. The tunnels align with the sun's extreme positions on the horizon at the summer and winter solstices. Holes cut into the tunnels' upper walls represent the stars of four different constellations; sunlight and moonlight shine through the holes casting moving luminous circles and ellipses on the tunnel interiors. The *Sun Tunnels* not only sharpen the visitor's awareness of the earth's rotation and its orbit around the sun, but also frame views of the landscape, achieving Holt's aim "to bring the vast space of the desert back to human scale."[45]

Christo (1935–2020) and Jeanne-Claude (1935–2009)

Christo and Jeanne-Claude's site-specific works evolved from Christo's early 1960s "packages"—ordinary objects that he wrapped to "make a new form, a very abstract one" that still

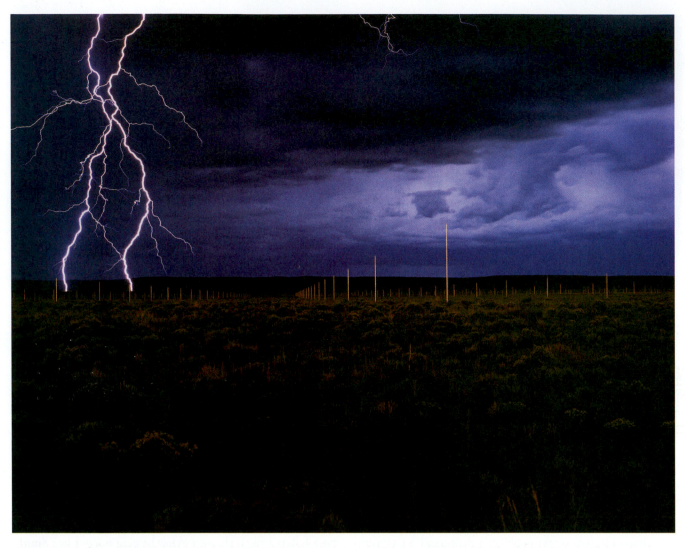

FIGURE 19.11 Walter De Maria, *The Lightning Field*, 1977. Stainless steel, one mile by one kilometer. Quemado, New Mexico. Dia Art Foundation.

provided a sense of "what is behind the package."⁴⁶ The couple moved from Paris to New York in 1964 where Christo proposed wrapping tall Manhattan buildings. For their contribution to a 1968 exhibition of environmental art at the Kunsthalle in Bern, Switzerland, they wrapped the museum under 2,430 square meters of translucent white polyethylene. The next year, they draped a 2.4-kilometer stretch of a cliff-lined Australian shore with 92,900 square meters of straw-colored erosion-control fabric tied with 56.3 kilometers of red polypropylene rope. Their most celebrated 1970s project was *Running Fence* (1972–76), a 39.4-kilometer-long, 5.5-meter-high white nylon fabric fence suspended from 2,050 steel poles, snaking across the hills of Sonoma and Marin Counties, California and descending into the Pacific Ocean. To its admirers, *Running Fence* was a graceful presence that enhanced appreciation of the surrounding land, sky, and water, fulfilling the artists' aim to create "joy and beauty."⁴⁷

To maintain their artistic independence, Christo and Jeanne-Claude funded such projects through the sale of Christo's preparatory drawings, **collages**, and other works. (*Running Fence* cost $3.25 million.) Each project required extensive planning, permits, and complex installation logistics involving engineers and work crews. Christo and Jeanne-Claude had to win the assent of landowners, local residents, government officials, judges, and environmental groups—often a long and difficult process. The artists considered all of the planning and negotiations to be part of their art, whose physical manifestation was always temporary; *Running Fence*, for example, was in place for only two weeks. This transience was essential to the art's meaning; as Jeanne-Claude explained, "Limiting the duration is a way of endowing our work those feelings of love and tenderness for things that do not last—like childhood or like our own lives."⁴⁸ For Christo, transience had political connotations: "Nobody can own the work, and nobody can charge

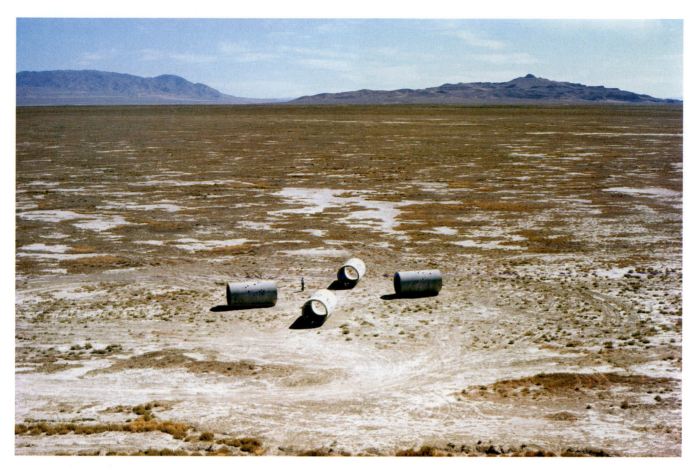

FIGURE 19.12 Nancy Holt, *Sun Tunnels*, 1973–76, Great Desert Basin, Utah. Concrete, steel, and earth, overall dimensions: 2.8 x 26.2 x 16.2 m; length on the diagonal: 26.2 m. Dia Art Foundation.

tickets for the work. . . . The projects . . . are beyond the ownership of the artists because freedom is the enemy of possession, that's why these projects do not stay. They are absolutely related to artistic and aesthetic freedom."[49]

Gordon Matta-Clark (1943–1978)

Gordon Matta-Clark made ephemeral site-specific works in urban and suburban locations by cutting through abandoned buildings with a chainsaw. He called this "Anarchitecture," a combination of "anarchy" and "architecture." The son of the Surrealist painter Matta (see Chapter 8), Matta-Clark studied architecture at Cornell University, moved to New York in 1969, and made his first building cut three years later. For *Splitting* (1974, Figure 19.13), Matta-Clark bisected a suburban New Jersey house (slated for demolition and provided by his dealer Holly Solomon's husband). He excised the house's top four corners as objects to display in a gallery and made photo-collages to convey the disorienting spatial effects of the lacerated architecture. Matta-Clark also took his chainsaw to derelict tenements in New York's lower-class Black neighborhoods. His work had a critical intent.

"By undoing a building there are many aspects of the social conditions against which I am gesturing: first, to open a state of enclosure which had been preconditioned not only by physical necessity but by the industry that profligates suburban and urban boxes as a context for insuring a passive, isolated consumer."[50] Regarding his tenement cuts, Matta-Clark said, "I would not make a total distinction between the imprisonment of the poor and the remarkably subtle self-containerization of higher socio-economic neighborhoods. The question is a reaction to an ever less viable state of privacy, private property, and isolation."[51]

Body and Performance Art

Body art and **performance art** are overlapping terms with different connotations. Body artists use their own or others' bodies as their artistic medium. Performance art is live art, often enacted before an audience. Rather than expressing themselves through the creation of objects, performance artists communicate directly through their presence and actions.

FIGURE 19.13 Gordon Matta-Clark, *Splitting 9* (Documentation of the action *Splitting* made in 1974 in New Jersey), 1974, printed 1977. Gelatin silver print, 25.4 x 20.3 cm. Whitney Museum of American Art, New York.

Lucy Lippard characterized performance art as "the most immediate art form. . . . getting down to the bare bones of aesthetic communication—artist/self confronting audience/society."[52]

Body and Performance art flourished internationally in the later 1960s and 1970s alongside Conceptual art with its dematerialization of the art object. Like Conceptual artworks, Body and Performance works of this period were often documented through photographs, films, videos, and texts. Many also qualify as Conceptual art: the artists executed simple acts based on minimal instructions rather than following elaborate scripts. These acts could generate a wide range of emotions, from boredom or alienation to laughter or shock. Through bodies and performance, artists explored themes ranging from identity to spirituality, politics, sexuality, gender, violence, and death, often resonating with the period's topical issues. (Feminist examples of Body and Performance art are addressed later in the chapter.)

Bruce Nauman (b. 1941)

Facing the question of what to do alone in his San Francisco studio after earning his MFA in 1966, Bruce Nauman decided that since he was an artist, anything he did in his studio was art. Inspired by Ludwig Wittgenstein's philosophical ideas about ordinary language, Nauman photographed himself performing simple acts based on common phrases. In one photograph, *Self-Portrait as a Fountain* (1966–67), the bare-chested artist raises his open-palmed hands to shoulder height and spurts water out of his mouth, enacting the title. The work pays homage to Duchamp's *Fountain* (see Figure 7.3) and the concept of the readymade, which here is Nauman's own body. Nauman also made sculptures relating directly to his body, such as *Neon Templates of the Left Half of My Body Taken at Ten-Inch Intervals* (1966) and he filmed himself performing simple activities, such as *Playing a Note on the Violin While I Walk Around the Studio* (1967–68). In the early 1970s, Nauman exhibited narrow, tall-walled corridors that invited viewers to enter them, to become aware of their own bodies in relation to the object and perhaps experience claustrophobia. By inducing discomfort, Nauman hoped viewers might gain insight into their place in the world and their reasons for resisting unfamiliar situations.

Gilbert (b. 1943) and George (b. 1942)

After graduating from London's St [*sic*] Martin's School of Art in 1968, the British duo, Gilbert (Prousch) and George (Passmore) declared themselves "living sculptures." Adopting unfailingly polite manners and conservative wool suits, they fashioned their entire existence into art. Gilbert and George performed frequently between 1969 and 1973 as *The Singing Sculpture* (Figure 19.14), sometimes for as long as eight hours a day. With their faces and hands covered in bronze-colored makeup, they stood on a table with a glove and walking stick as props and moved robotically as they sang along to a tape recording of "Underneath the Arches," a 1930s English music hall standard. They chose this song, about two tramps sleeping under a railroad bridge, because, said George, "We were very close to being down-and-out ourselves."[53] Each time the song ended, one of the artists would descend from the table, rewind the tape, and press play again, creating an effect of absurdity through repetition. In the later 1970s, the duo abandoned live performance for wall-sized, multipaneled "photo-pieces" (e.g., *Here*, 1987). The artists themselves often appear in these works as subjects or witnesses to contemporary themes ranging from homosexuality and AIDS to urban blight, social class, racism, religion, war, nature, youth, and death.

Vito Acconci (1940–2017)

Vito Acconci started his career as a poet before stepping off the page and into the world as his field of action. For an early performance, *Following Piece* (1969), Acconci spent each day following a person picked at random on the streets of Manhattan until that person entered a private space. In this work, Acconci did not consider himself a stalker but someone "whose space and time are being controlled. . . . I'm being dragged along."[54] He next turned in on himself and performed acts with sadomasochistic overtones. For example, in *Trademarks* (1970), Acconci sat naked on the floor, bit every part of his body he could reach, and made prints from the bites. In his best-known work, *Seedbed* (1972), Acconci sought to "be with an audience"[55] in a gallery: he concealed himself under a ramp and masturbated while vocalizing fantasies through a loudspeaker about the visitors walking above him. *Seedbed* was notorious not only because it involved Acconci performing a normally private sexual act in a public space, but also because it made the visitor complicit. Inspired by psychologist Kurt Lewin's notion that individuals radiate a "power field" that influences other people in a space, Acconci through his vocalizations exerted control over visitors, who became accomplices in the artist's fantasies and in the production of the work.[56]

Chris Burden (1946–2015) and Marina Abramović (b. 1946)

Working independently in California and Yugoslavia, Performance artists Chris Burden and Marina Abramović endured danger, pain, or deprivation to address charged social and political issues metaphorically. For his graduate thesis at the University of California—Irvine in 1971, Burden spent five days in a two-by-three-foot locker, drinking from a five-gallon water bottle in the locker above and urinating into a five-gallon bottle in the locker below. *Five Day Locker Piece* served as institutional critique, pointing out the isolation UCI's graduate students felt because their program did not provide them with studio spaces.[57] Later that year, in *Shoot* (1971), Burden had a friend shoot him in the arm with a .22 caliber rifle from fifteen feet away in front of small audience in an art gallery. "You see people getting shot on T.V. every day," said the artist, "so I wanted to find out how it would be to receive a bullet in my body."[58] *Shoot* alluded to soldiers in Vietnam, student protestors at Kent State, Black Panthers targeted by the police, and other shooting victims, but unlike them, Burden had the privilege of seeking out the violence, controlling its terms, and gaining art world recognition for it.

In her *Rhythm* series of solo performances (1973–75), Abramović put herself in risky situations that highlighted the issue of control, figuratively resisting or questioning the government's imposition of control on its citizens in her native

FIGURE 19.14 Gilbert and George performing *The Singing Sculpture* **at Nigel Greenwood Gallery, London, 1970.**

Yugoslavia. In *Rhythm 5* (1974, Figure 19.15), Abramović laid out strips of wood in the shape of a large five-pointed star, the symbol of the regime, filled it with wood shavings and petrol, lit it, threw her cut hair and nails into the flames, then lay down in the star's center with outstretched arms. Her act symbolized the younger generation burning in the flames of the older generation's socialist ideals.[59] The fire depleted the oxygen, causing Abramović to lose consciousness, and two of her colleagues carried her out of the star to safety. Between 1976 and 1988, Abramović did collaborative performances with the German artist Ulay (1943–2020), many of which locked the artists into an unsustainable interdependence. For example, in *Breathing In/Breathing Out* (1977), Abramović and Ulay blocked their nostrils with cigarette filters, joined mouths, and breathed only each other's exhaled air for as long as they could (nineteen minutes). They enacted the fantasy of breathing as one being, negating their individual subjectivities, while also acknowledging that such a merger could ultimately be suffocating.

FIGURE 19.15 Marina Abramović, *Rhythm 5*, 1974. Gelatin silver print, 57.2 x 81.9 cm. Solomon R. Guggenheim Museum, New York.

Representational Painting and Sculpture in the United States

Representational painting and sculpture remained vital practices in the United States in the late 1960s and 1970s despite their rejection by Post-minimal artists. Many painters continued the realist tradition of painting from direct observation. For example, Alice Neel (1900–84) made starkly honest portraits of friends and acquaintances in a vivid, **painterly** style (e.g., *Linda Nochlin and Daisy*, 1973), while Philip Pearlstein (b. 1924) rendered brightly lit nude studio models with clinical precision, usually with their bodies cropped by the canvas edges (e.g., *Two Female Models on Hammock and Floor*, 1974).

Rather than painting from life, **Photorealists** such as Richard Estes (b. 1932), Chuck Close (1940–2021), and Audrey Flack (b. 1931) based their paintings on photographs, acknowledging photography's role in conditioning our perception of the contemporary world. Estes made sharply focused cityscapes based on multiple color photographs, often featuring the complicated play of reflections in plate glass windows (e.g., *Central Savings*, 1975). Close painted giant, frontal mug-shot style portraits of his friends and himself using an airbrush to transfer visual information systematically from the gridded photographic source to the canvas (e.g., *Big Self-Portrait*, 1967–68). Flack shot color slides of **still lifes**, projected them onto large canvases, and airbrushed the colors. Her work is distinctive for its symbolic richness. For example, *Marilyn (Vanitas)* (1977, Figure 19.16) incorporates Flack's rendition of a black-and-white photograph of the fresh-faced Marilyn Monroe before her breakthrough into stardom and reflects on Monroe's brief and tragic life through the conventions of seventeenth-century *vanitas* painting. The **composition** includes objects symbolizing time's passage and the fleetingness of youth and beauty: a burning candle, pocket watch, hourglass, rose blossom, fruit, jewelry, mirrors, cosmetics, perfume, and a calendar page for August, the month of Monroe's death.

FIGURE 19.16 Audrey Flack, *Marilyn (Vanitas)*, 1977. Oil over acrylic on canvas, 243.84 x 243.84 cm. University of Arizona Museum of Art, Tucson.

The progenitor of New Image Painting was Philip Guston (1913–80), who began making crudely rendered cartoonlike images in the late 1960s, abandoning the Abstract Expressionist style that he had come to consider irrelevant to the period's social and political upheavals. Revisiting a subject he had treated realistically in anti-racist works of the 1930s, Guston depicted figures in Ku Klux Klan hoods, now as clownish characters. In some images, they puff on cigars while they drive around the city (e.g., *City Limits*, 1969). Although the pictures are open to multiple interpretations, the white Jewish Guston described the figures as "self-portraits," acknowledging his own implication in the ideology of white supremacy championed by the KKK.[61]

The Feminist Art Movement

The US-centered **Feminist Art Movement** sprang from the broader women's liberation movement of the late 1960s. Betty Friedan's bestselling book *The Feminine Mystique* (1963), which analyzed the plight of married white middle-class American women unhappily confined to the domestic sphere by traditional gender roles and longing for their own careers, gave the initial impetus to feminist activism. In 1966, Friedan and others established the National Organization for Women (NOW) to fight for an end to legal discrimination against women in employment, education, and reproductive rights. Soon thereafter, younger women radicalized by the civil rights, anti-war, and student movements formed feminist groups and pushed for a mass women's liberation movement. Radical feminists disseminated revolutionary ideas through writing and public speaking and engaged in consciousness-raising, meeting in small groups to share their experiences of gender-based exploitation and gain understanding of their subjugation.

Duane Hanson (1925–96) produced a sculptural counterpart to Photorealist paintings in his startlingly lifelike figures cast directly from models in polyester resin and fiberglass, painted in oil, and fitted with wigs, glass eyes, and real clothing. Delivering quiet social commentary, Hanson represented lower- and middle-class American types (e.g., *Woman with a Laundry Basket*, 1974) with static poses and bored expressions conveying "the resignation, emptiness and loneliness of their existence."[60]

New Image painters such as Jennifer Bartlett, Neil Jenney, Robert Moskowitz, and Susan Rothenberg—their name derived from the 1978 *New Image Painting* exhibition at the Whitney Museum of American Art—rejected Photorealist **illusionism** and technical refinement for painterly or schematic representations of rudimentary subjects. Characteristic of this trend are Rothenberg's (1945–2020) paintings of silhouetted horses (e.g., *Cabin Fever*, 1976), simply outlined without internal detail and placed against loosely brushed grounds of a single or a few geometrically divided colors, an outgrowth of Minimalist monochrome painting.

Artists, critics, and art historians carried the energies of women's liberation into the art world. Women Artists in Revolution (W.A.R.), a splinter group of the Art Workers' Coalition, formed in 1969 to agitate for greater representation of

women in New York museum exhibitions and collections. The Ad Hoc Women's Art Committee, founded in 1970 by critic Lucy Lippard, successfully pressured the Whitney Museum of American art to increase the percentage of women in its Annual exhibition (from 5 percent in 1969 to 22 percent in 1970—still short of the committee's demand of 50 percent). The Los Angeles Council of Women Artists similarly protested the absence of women from LACMA's 1971 *Art and Technology* exhibition. Art historian Linda Nochlin's 1971 article "Why Have There Been No Great Women Artists?" answered the question by identifying patriarchal social biases that had prevented women from achieving professional artistic accomplishment equaling men's.[62] The major exhibition *Women Artists: 1550–1950* (1976), curated by Nochlin and Anne Sutherland Harris, brought attention to historically neglected women artists. New journals such as the *Feminist Art Journal*, *Chrysalis*, *Heresies*, and the *Woman's Art Journal* provided forums for art-historical research and critical debates. Women artists formed their own cooperative galleries and collectives, including A.I.R. in New York, Artemisia in Chicago, and the Woman's Building in Los Angeles. Women artists of color, marginalized by the white-dominated mainstream feminist movement, also organized: African American women formed Where We At (WWA) in New York and Chicanas formed Las Mujeres Muralistas in San Francisco.

First-generation feminist artists aimed, in critic Moira Roth's words, "to make art about women from the woman's point of view" and "to teach others about the conditions of women in a way that would lead to changing those conditions."[63] Embracing the slogan "the personal is political," feminist artists rejected impersonal formalist and Minimalist aesthetics and created art based on their own experiences, turning formalist criticism of their work as too "feminine" into a source of pride. Their art investigated political issues central to women's liberation activism, including gender stereotypes, domesticity, and female sexual imagery. Feminist artists also incorporated the methods and materials of traditional women's crafts such as sewing, weaving, knitting, quilting, appliqué, and china painting to rehabilitate women's creative heritage and challenge the hierarchical and patriarchal distinction between "low" crafts and "high" painting and sculpture.

Womanhouse

Judy Chicago organized the first feminist art course at Fresno State College in 1970. The following year she and Miriam Schapiro established the Feminist Art Program at the California Institute of the Arts (CalArts) in Valencia. The program's mission was to help students make art from their experiences as women and to rethink art and social history from a feminist perspective. In 1971–72, Chicago, Schapiro, and their students collaborated on *Womanhouse*, transforming an abandoned Los Angeles mansion into an environment based on middle-class women's domestic lives. Many of *Womanhouse*'s rooms visualized ideas explored in *The Feminine Mystique*. For example, Sandra Orgel's *Linen Closet* featured a nude female mannequin wedged between shelves of clean folded sheets, entrapped by housework. The ceiling of the *Nurturant Kitchen* (Figure 19.17), a room entirely painted pink, was covered with plastic fried eggs that transformed into breasts as they descended the walls, comically literalizing the stereotypical connection between women's "natural" roles as nurturing mothers and cooks. During the month it was open, *Womanhouse* also hosted student performances centered on women's experiences such as scrubbing floors, waiting, and giving birth.

Women's Work: Harmony Hammond (b. 1944), Mierle Laderman Ukeles (b. 1939), Mary Kelly (b. 1941), and Martha Rosler (b. 1943)

In the wake of *Womanhouse*, numerous feminist artists addressed themes of domestic labor and motherhood that previous modern art had largely excluded, exploring the

FIGURE 19.17 Susan Frazier, Vicki Hodgetts, and Robin Weltsch, *Nurturant Kitchen* (detail), *Womanhouse*, 1972.

psychological and political dimensions of women's confinement to narrowly defined gender roles under patriarchy. Harmony Hammond created artworks resembling rag rugs traditionally made by women: her circular *Floorpieces* (1973, Figure 19.18) were made of recycled knit fabric that she braided, coiled, stitched together, and selectively painted with acrylics. Produced the year Hammond came out as a lesbian, the *Floorpieces* express a queer identity: they rest on the floor like domestic craft objects but function as sculpture and look like paintings, challenging all three categories.[64] Also in 1973, Mierle Laderman Ukeles did *Maintenance Performances* at the Wadsworth Atheneum in Hartford, Connecticut, which included her scrubbing and mopping the museum's floors for four hours while it was open to the public. She intended her performances to bring visibility and honor to maintenance work, primarily done by housewives and minimum wage workers and devalued by American society. In her six-section, 135-part *Post-Partum Document* (1973–79), Mary Kelly charted and analyzed her son's development and socialization and the mother-child relationship using framed diagrams, texts, and items such as his soiled diapers. Informed by feminist psychoanalytic theory, Kelly's work explored gender formation, the concept of the child as a fetish, and the unequal division of childcare under patriarchy. Martha Rosler

expressed the frustrations of women constrained by their domestic roles with deadpan humor in her video *Semiotics of the Kitchen* (1975). In it, the apron-clad artist methodically names and demonstrates the use of kitchen tools in descending alphabetical order, often wielding them violently to suggest barely suppressed rage.

Judy Chicago (b. 1939): *The Dinner Party*

After leaving CalArts in 1973, Judy Chicago spent six years creating the decade's most iconic feminist artwork, *The Dinner Party* (1974–79, Figure 19.19). Symbolizing "the history of women in Western civilization,"[65] the work was realized through the efforts of hundreds of women and a few men under Chicago's direction. It comprises an open triangular table with thirty-nine place settings dedicated to women ranging from ancient goddesses to historical figures such as Hatshepsut, Eleanor of Aquitaine, Sacajawea, Sojouner Truth, Susan B. Anthony, and Virginia Woolf, and concluding with Georgia O'Keeffe. Supporting the table is the white porcelain Heritage Floor inscribed in gold with the names of another 999 women of accomplishment. The thirteen place settings per side reflected Chicago's initial conception of the *Dinner Party* as a reinterpretation of the all-male Last Supper "from the point of view of women, who, throughout history, had prepared the meals

FIGURE 19.18 Harmony Hammond, *Floorpiece VI*, 1973. Cloth and acrylic, 165.10 cm in diameter.

FIGURE 19.19 Judy Chicago, *The Dinner Party,* 1974–79. Mixed media, 91.4 x 1463 x 1463 cm. Brooklyn Museum, New York.

and set the table" but would now "be the honored guests."[66] The equilateral triangle, an ancient symbol of the female, expressed feminism's goal of "an equalized world."[67] Each place setting has a fourteen-inch-diameter painted ceramic plate and a runner embroidered with the honored woman's name and imagery or decoration appropriate to her biography or time. Chicago's incorporation of china painting and embroidery into the *Dinner Party* celebrated crafts traditionally practiced by women. All but two of the plates feature **stylized** designs based on the human vulva—imagery Chicago used to reclaim the female body from male domination, turning the vagina, the mark of woman's otherness, into a vehicle asserting "the truth and beauty of her identity."[68]

The Dinner Party was an enormous popular success: over 100,000 people saw its inaugural exhibition in San Francisco, and it attracted large audiences as it toured the United States and five other countries over the next decade. Its critical reception, however, was mixed. April Kingsley spoke for many in hailing the *Dinner Party*'s potential to bring about social change because it is "so beautiful and profound that it leaps beyond art to life."[69] Male modernist critics like Hilton Kramer dismissed it as populist kitsch and its vulval imagery as vulgar. Some feminists also found this imagery problematically "essentialist" for its apparent reduction of women's identity to their anatomy. Others have questioned the *Dinner Party*'s privileging of Western white, heterosexual women among the thirty-nine honored guests. Notwithstanding such criticisms, the *Dinner Party* was indisputably successful in raising awareness of women's many contributions to history.

Miriam Schapiro (1923–2015) and the Pattern and Decoration Movement

After returning to New York from California in 1976, Miriam Schapiro made large, striking paintings in the shapes of fans, hearts, and houses incorporating fabric collage arranged into decorative patterns (e.g., *Barcelona Fan*, 1979). She selected

these shapes for their references to sentimentality and domesticity and she used fabric—often women-made artifacts like embroidered handkerchiefs and samplers, aprons, and quilts—for its associations with women's lives and experiences. Schapiro and her collaborator Melissa Meyer coined the term *femmage* to refer to the female creative traditions such as sewing, piecing, hooking, quilting, and appliquéing that preceded collage.[70] Schapiro honored these traditions in her paintings, which she made large to insist on the importance of women's culture.

Schapiro became a leader of the Pattern and Decoration (P&D) movement, whose other prominent members included Valerie Jaudon, Joyce Kozloff, Robert Kushner, Kim MacConnel, and Robert Zackanitch. These painters willfully rejected formalist modernism's taboo against decoration and Minimalism's reductive aesthetics by using sensuous color and extravagant patterning. They also embraced multiculturalism by using ornamental motifs derived from non-Western cultures, including Pre-Columbian, Islamic, and Asian. Although not all of the P&D artists identified as feminists, their employment of decorative styles, materials, themes, and imagery long regarded as "feminine" effectively challenged the masculinist mainstream.

Feminist Body and Performance Art

A key feminist issue in the 1970s was the role that images of the female body, especially in advertising, the mass media, and popular entertainment, played in shaping women's identity. According to theorists of the gaze—a term for visual perception that brings pleasure and exerts power over the perceived object—visual representations of the body are designed to appeal to viewers of a specific gender, sexual orientation, race, and class. Feminist critics argued in the 1970s that historically in the West, most images of women have addressed a gaze defined as male, heterosexual, white, and economically privileged. In her influential article "Visual Pleasure and Narrative Cinema," Laura Mulvey posited that mainstream films display women as passive objects for the active male gaze, "with their appearance coded for strong visual and erotic impact."[71] Feminist artists aimed to reclaim the female body as a *subject* and assert women's right to control and enjoy their bodies and sexuality. One way they did this was by using their own bodies as their medium.

Hannah Wilke (1940–1993)

For her *S.O.S. Starification Object Series* (1974–82), Hannah Wilke did live performances and posed for pin-up style black-and-white photographs with her face and nude torso decorated by pieces of chewing gum twisted into vulva-like shapes. Wilke said gum is "the perfect metaphor for the American woman—chew her up, get what you want out of her, throw her out and

pop in a new piece."[72] She intended the gum to mimic scars, which she linked to the numbers tattooed on Jews in the concentration camps, evoking vulnerability and death. In these ambiguous images, Wilke both solicits and disrupts the male gaze. She performs as a "star" flaunting her good looks through farcical "sexy" poses, and she mars her body through the chewing gum forms. These images challenge the viewer to resolve the tension between the pleasure that Wilke's beauty provides and the disturbing sight of her "scars," which suggest the harm caused by women's objectification.

Carolee Schneemann (1939–2019)

Painter, filmmaker, and Performance artist Carolee Schneemann was one of the first Americans of her generation to explore feminist issues. In an early work, *Eye Body* (1963), she applied paint, grease, and chalk to her naked body and allowed snakes to slither over it. She later identified snakes as symbols of "the cosmic energy of the female womb" and artistic attributes of the ancient "Goddess"—an instance of feminist interest in a woman-centered alternative to patriarchal religions.[73] Embracing the female body's creative potential, Schneemann declared: "The life of the body is more *variously* expressive than a sex-negative society can admit. . . . In some sense I made a gift of my body to other women: *giving our bodies back to ourselves.*"[74]

In her 1975 work *Interior Scroll* (Figure 19.20), performed before an audience of mostly women artists, Schneemann, wrapped in a white sheet, read from her book *Cezanne, She Was a Great Painter*, then disrobed, painted her naked body with large strokes defining its contours, assumed a series of life-model poses, and finally, extracted a forty-one-inch-long scroll from her vagina and read from it. Her text concerned a male "structuralist filmmaker" (actually the film critic Annette Michelson) who denigrated Schneemann's films for their "personal clutter" and "persistence of feelings" and criticized her inability to "appreciate the system/the grid/the numerical rational procedures."[75] This text conveyed the disdain Schneemann encountered from an art world oriented to traditionally "masculine" values of order and rationality, against which she insisted on expressing "primary knowledge" rooted in the womb and vagina, from which she unspooled the serpent-like scroll.[76]

Ana Mendieta (1948–1985)

Combining aspects of Land and Body art, Cuban-born Ana Mendieta made over two hundred *Siluetas* (silhouettes) in the 1970s: outdoor "earth/body" sculptures composed of natural materials such as earth, water, rocks, twigs, flowers and, more dramatically, gunpowder and fire. All of them featured the outline of the artist's body, often with arms upraised (e.g., *Silueta de Arena*, 1978, Figure 19.21), imprinted or sculpted into

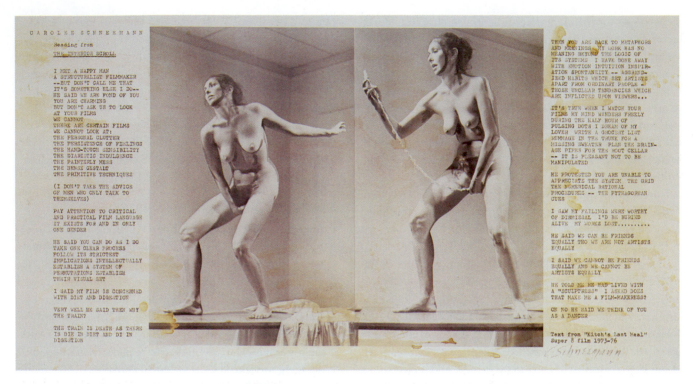

FIGURE 19.20 Carolee Schneemann, *Interior Scroll*, 1975. Screenprint with handwriting in beet juice, coffee, and urine on paper, 90.5 x 183.0 cm. Tate, London.

FIGURE 19.21 Ana Mendieta, *Silueta de Arena*, 1978. Black and white photograph, 40.6 x 50.8 cm. © The Estate of Ana Mendieta Collection LLC; Courtesy Galerie Lelong & Co.; Licensed by the Artist Rights Society.

the ground or placed against a wall, sometimes with the silhouette filled with organic materials. Mendieta documented these ephemeral, site-specific works through photographs and films. She executed many of them in Iowa, where she and her sister were placed after her parents sent them to Miami in 1961 following the imprisonment of her father as a counterrevolutionary by Fidel Castro's government; Mendieta later studied art at the University of Iowa. She wrote that her "dialogue between

the landscape and the female body" was motivated by "having been torn from my homeland (Cuba) during my adolescence" and being "overwhelmed by the feeling of having been cast from the womb (nature)."[77] She described her art as "the way I re-establish the bonds that unite me to the universe. It is a return to the maternal source."[78] Informing Mendieta's *Silueta* works, as it did the paintings of her older compatriot Wifredo Lam (see Figure 10.30), was her interest in Santería, an Afro-Caribbean religion that fuses West African Yoruba beliefs with Catholicism, and whose gods and goddesses embody the forces of nature; Mendieta said, "I believe in water, air, and earth. They are all deities."[79]

The Black Arts Movement

The **Black Arts Movement** arose in the later 1960s in the context of African Americans' struggles for social, political, and economic equality. At this time, younger African Americans abandoned the appellation "Negro" and embraced the word "Black" to express racial pride and empowerment—goals the Black Arts Movement shared with the militant Black Panther Party (founded 1966). The Black Panthers rejected the civil rights movement's moderate strategies of nonviolent protest, civil disobedience, and integration as insufficient to achieve social and political change, and instead advocated armed resistance, separatism, and political revolution. Within the art world, Black artists organized to challenge their exclusion from white-dominated museums, formed their own collectives and museums, and generated their own exhibitions.

In New York, the Studio Museum in Harlem was founded in 1968 to support Black art and artists through exhibitions and an artist-in-residence program. The next year, Benny Andrews and other artists formed the Black Emergency Cultural Coalition (BECC) to protest the exclusion of Black art and artists from New York's white-dominated museums and those institutions' failure to seek input from the Black community or employ Black curators for exhibitions such as the Metropolitan Museum of Art's *Harlem on My Mind* (1969).

In Chicago, OBAC (Organization of Black American Culture, established 1967) artists painted a collaborative mural on an abandoned South Chicago building, the *Wall of Respect* (1967), which portrayed some fifty "Black heroes." OBAC artist William Walker went on to complete more than thirty sociopolitical-themed murals in working-class Chicago neighborhoods, contributing to a nationwide community mural movement. OBAC evolved into AfriCOBRA (African Commune of Bad Relevant Artists), whose members, including Jeffrey Donaldson, Wadsworth Jarrell, Jae Jarrell, Barbara Jones-Hogu, Nelson Stevens, and Gerald Williams, made figurative art that emphasized Black history and the fight for equal rights.

Visual artists of the Black Arts Movement worked in a wide variety of mediums and styles, including abstraction. For example, Melvin Edwards's (b. 1937) *Lynch Fragments* (begun 1963, e.g., *Afro-Phoenix No. 1*, 1963), head-sized wall-mounted welded **assemblages** of such elements as tools, hooks, chains, and knife blades, convey the violence of enslavement and lynching. Barbara Chase-Riboud's (b. 1939) *Malcolm X* series (begun 1969, e.g., *Malcolm X #3*, 1969), inspired by African headdresses, are vertical sculptures combining folded, curving bronze sheets ("heads") with cascades of knotted and braided silk, wool, or cotton cords ("skirts") to honor the slain civil rights leader through a dynamic melding of materials and forms.

Wadsworth Jarrell (b. 1929)

AfriCOBRA cofounder Wadsworth Jarrell's *Revolutionary (Angela Davis)* (1971, Figure 19.22) is a dazzlingly colorful portrait of the militant Black activist composed of letters, words, and phrases highlighting her power as an orator. Davis speaks into a microphone as words such as RESIST, REVOLUTION, BLACK, and BEAUTIFUL radiate from her head. Running down her left arm and chest is her statement "I have given my life to the struggle. If I have to lose my life in the struggle, that's the way it will have to be." Davis is shown wearing a jacket with a bandolier holding painted wood dowels collaged onto the canvas, inspired by the *Revolutionary Suit* that Jae Jarrell (b. 1935) designed in 1969. The dowels could represent either bullets or crayons or **pastels**—ammunition for revolution or creation.

David Hammons (b. 1943)

Exemplary of the Black Art Movement's protest art is David Hammons's *Injustice Case* (1970, Figure 19.23), which depicts a bound and gagged seated male figure straining against his bondage. The Los Angeles-based Hammons created the imagery by smearing his hair, body, clothes, and a chair with margarine, pressing them onto a sheet of paper, dusting the grease with powdered **pigment**, and applying a fixative. His technique recalls Yves Klein's use of models as "living paintbrushes" (see Figure 14.13), but Hammons used his own body to communicate his personal identification with the subject. The work refers to Black Panther cofounder Bobby Seale, gagged and chained to a chair in a Chicago courtroom on the orders of a white judge after Seale vocally protested being denied the right to choose his own counsel in his trial for conspiring to incite riots at the 1968 Democratic National Convention. Hammons collaged the print to an American flag to indict what he saw as the American judicial system's unjust treatment of African Americans. Hammons's later work is discussed in Chapter 20.

FIGURE 19.22 Wadsworth Jarrell, *Revolutionary (Angela Davis)*, 1971. Acrylic and mixed media on canvas, 162.6 x 129.5 cm. Brooklyn Museum, New York.

Black Feminist Art

Black women committed both to feminism and to Black Power faced a dilemma. They were marginalized within the Feminist Art Movement, which was dominated by white middle-class women with little interest in art-world racism. They were also marginalized within the patriarchal Black Arts Movement. They therefore created their own professional support groups, such as WSABAL (Women, Students and Artists for Black Art Liberation), formed in 1970 by Faith Ringgold, her daughters Michelle and Barbara Wallace, and Tom Lloyd. WSABAL fought for the inclusion of women in Black art exhibitions and protested exhibitions that excluded Blacks and women.

WSABAL's group exhibition, *"Where We At"—Black Women Artists, 1971*, at Acts of Art Gallery in Greenwich Village, led to the formation of a cooperative, Where We At, Inc. (WWA). Led by Kay Brown, WWA organized community-based projects such as art workshops in prisons.

Faith Ringgold (b. 1930)

The Harlem-born Ringgold's stylized figurative paintings of the later 1960s confronted uneasy race relations in the United States (e.g., *American People Series #20: Die*, 1967). In the early 1970s, she created political posters using the red, black, and green of the Pan-African flag, symbolic of Black liberation. Her poster, *Woman Freedom Now* (1971),

FIGURE 19.23 David Hammons, *Injustice Case*, 1970. Body print and American flag, 160.02 x 102.87 cm. Los Angeles County Museum of Art.

synthesizes feminism and Black Power in block-lettered words set within chevrons, inspired by Congo Bakuba textile patterns. Ringgold also used chevrons to separate the eight vignettes comprising *For the Women's House* (1971, Figure 19.24), which she painted for the Riker's Island Women's House of Detention. The mural shows women of different races in roles they rarely or never attained in the 1970s, including doctor, bus driver, police officer, construction worker, professional basketball player, and US president. Ringgold designed this inspiring imagery to provide hope to the women in the prison after asking them what they would like to see in the mural. The next year, Ringgold began painting on unstretched canvases she framed in brocaded textiles inspired by the borders of thangkas—Buddhist paintings from Tibet. These led in the 1980s to her celebrated "story quilts" (e.g., *Flag Story Quilt*, 1985), which asserted the high art status of

quilting—traditionally associated with women's communal work and African American craft (including Ringgold's mother's and grandmother's).

Betye Saar (b. 1926)

Inspired by Joseph Cornell's shadow boxes (see Figure 12.21), Los Angeles-based Betye Saar began assembling found objects in glass-fronted boxes in 1966. In addition to addressing Black history, her personal ancestry, and African heritage and ritual practices, Saar created politically charged works incorporating derogatory commercial images of African Americans. Her purpose was "to remind us about the struggle of African Americans and to reclaim the humiliating images of how these workers were once portrayed."[80] In *The Liberation of Aunt Jemima* (1972, Figure 19.25) Saar appropriates and transforms the demeaning stereotype of the cheerfully servile "mammy" into an icon of militant Black feminist power. Set against a Warhol-style **background** (see Figure 15.7) of repeated Aunt Jemima advertising images—used to market pancake mix and syrup—stands a caricatured mammy figurine that functioned as a notepad holder. In addition to holding a broom (whose handle is the pencil for the notepad), she is armed with a toy pistol and rifle, added by Saar. In the notepad's place is an illustration of a jolly mammy holding a crying child identified by Saar as a mulatto, or person of mixed black and white ancestry—an allusion to the offspring of enslaved Black women raped by white owners. In front of this pair is the clenched Black fist that symbolizes Black Power, backed by a strip of kente cloth, symbolizing the African diaspora. Saar's armed Aunt Jemima is empowered not only to liberate herself from racial oppression but also from traditional gender roles that relegated African American women to subservient occupations such as domestic servant or mammy.

Fritz Scholder (1937–2005) and T. C. Cannon (1946–1978): Critical Native American Painters

The critical agendas of feminist and Black art of the late 1960s and 1970s resonated with artists from other marginalized groups also seeking to affirm their identities in the modern United States. They included Native Americans, whose struggle for recognition of their sovereignty by the US government was led by the American Indian Movement,

FIGURE 19.24 Faith Ringgold, *For the Women's House*, 1971. Oil on canvas, 243.8 x 234.8 cm. Rose M. Singer Center, Rikers Island Correctional Center, New York on extended loan to the Brooklyn Museum, New York.

an activist group formed in 1968. Painters Fritz Scholder (Luiseño) and T.C. Cannon (Caddo and Kiowa) adopted mainstream modern art styles to make images that subverted clichéd representations of authentic "Indianness" familiar from nineteenth-century paintings by George Catlin and Karl Bodmer, the photographs of Edward Curtis, and Hollywood movies. Scholder used a painterly style influenced by Francis Bacon (see Figure 13.15) to create his *Indian* series (1967–80), which confronted harsh realities experienced by Natives such as poverty, alcoholism, and the harmful effects of stereotypes. His *Indian with Beer Can* (1969) is a distorted representation of a Native man seated at a table in a western shirt and black cowboy hat, his eyes hidden by dark sunglasses and his teeth bared in a Bacon-style grimace. At his elbow sits a beer can with a legible Coors logo, a Pop insertion into the otherwise expressionist aesthetic. This scary looking beer drinker reflects Scholder's observation that "people don't really like Indians. Oh, they like their own conceptions of the Indian—usually the Plains Indian, romantic and noble and handsome and somehow the embodiment of wisdom and patience. But Indians in America are usually poor, sometimes derelicts outside the value system, living in

uncomfortable surroundings. We have really been viewed as something other than human beings by the larger society. The Indian of reality is a paradox—a monster to himself and a non-person to society."[81]

T. C. Cannon, who studied under Scholder at the Institute of American Indian Arts in Santa Fe in the mid-1960s, developed a boldly colorful style blending influences from Van Gogh, Matisse, **Pop art**, and Japanese **woodblock prints**. He often based his paintings on historic photographs of Native Americans in order to highlight the gap between outmoded perceptions of "Indianness" and the actualities of contemporary Native life. The figure at the center of *Collector #5 (Man in a Wicker Chair)* (1975, Figure 19.26) is adapted from an 1857–58 photograph of Pawnee Chief Peta-La-Sha-Ra by James E. McClees. While the white photographer "collected" the chief as an ethnographic portrait subject, in Cannon's painting, the chief is the collector—of a Navajo rug beneath his chair and a print of van Gogh's *Wheat Field with a Lark* (1887) on the wall behind him. Cannon's painting thus wittily overturns the expected subjugation of the Indian to the colonizing gaze and gives him his own agency.

FIGURE 19.25 Betye Saar, *The Liberation of Aunt Jemima*, 1972. Mixed media, 29.85 x 20.32 x 6.99 cm. University of California, Berkeley Art Museum and Pacific Film Archive.

The Chicano Art Movement

In the later 1960s, many young Mexican Americans embraced the label Chicano or Chicana, originally pejorative terms, to align themselves with the Chicano movement, or El Movimiento, an alliance of farmers, workers, and students fighting for Mexican American civil rights. Artists of the **Chicano Art Movement** advanced El Movimiento's objectives through public art forms such as posters, prints, and outdoor and indoor murals addressing social and political themes in figurative styles. Chicana/o artists also made paintings, sculptures, assemblages, and installations, and some worked in new mediums such as performance and video.

Antonio Bernal (b. 1937) painted what is perhaps the earliest Chicano mural in 1968 on the exterior of the Del Ray, California headquarters of El Teatro Campesino, a theater troupe associated with the United Farm Workers (UFW), a labor activist group. Among the figures Bernal depicted were heroes of

the 1910–20 Mexican Revolution Pancho Villa and Emiliano Zapata, UFW leader Cesar Chavez, Reies Lopez Tijerina (a champion of Chicanos' land-rights claims in New Mexico), a rifle-toting Black Panther Party member, and Martin Luther King Jr. This **iconography** associated the Chicana/o struggle with both the Mexican Revolution and Black civil rights and Black Power movements.

Inspired by Mexican muralists like Diego Rivera (see Chapter 10), Chicana muralist Judith F. Baca (b. 1946) founded the Citywide Mural Project, Los Angeles's first public mural program, in 1974. Two years later she cofounded the nonprofit Social and Public Art Resource Center (SPARC), which she directs. SPARC funds community-based participatory public art projects designed to empower communities facing marginalization or discrimination. Under SPARC's auspices, Baca led the creation of *The Great Wall of Los Angeles* (1976–84), a mural covering 839 m of the Tujunga Flood Control Channel in North Hollywood. Painted over five summers, the project employed over four hundred youths of different ethnic backgrounds, mostly from low-income families. Its imagery, devised with community input and in consultation with scholars, oral historians, and cultural ethnographers, narrates the history of California from 20,000 BCE to the 1960s, with an emphasis on the contributions and difficult experiences of women, immigrants, and racial and ethnic minorities. One mural section (Figure 19.27) shows the division of Chicana/o communities by freeway construction and their uprooting from the Chavez Ravine neighborhood by the building of Dodger Stadium—shown descending like a UFO—on land once designated for public housing. At the right, a white policeman tackles a Chicana raising her fists in futile protest against her peoples' forced eviction to make way for the stadium.

In contrast to the earnest tone of Bernal's and Baca's murals, the Los Angeles collective Asco (Spanish for "nausea")—its core members were Harry Gamboa Jr. (b. 1951), Gronk (b. 1954), Willie Herrón (b. 1951), and Patssi Valdez (b. 1951)—took an irreverent approach to public art. Impatient with what they saw as Chicana/o murals' predictable, romanticized expressions of cultural identity, they sought to convey the uncertainty of contemporary Chicana/o life by "transforming muralism from a static to a performance medium."[82] In *Instant Mural* (1974), Gronk strapped Valdez and Humberto Sandoval to the wall of an East Los Angeles liquor store with masking tape, making a mural out of actual Chicana/o bodies. In *Walking Mural* (1972), Asco members walked along a busy East Los Angeles boulevard dressed in costumes referencing the Virgin of Guadalupe (a standard image in Chicana/o art), a Christmas tree, and a section of a Chicana/o mural so disenchanted with its environment that it breaks free from the wall. As Gronk later commented, "A lot of Latino artists went

FIGURE 19.26 T. C. Cannon, *Collector #5 (Man in a Wicker Chair)*, 1975. Oil and acrylic on canvas, 182.88 x 152.4 cm. Collection of Nancy and Richard Bloch, Santa Fe, New Mexico.

back in history for imagery because they needed an identity, a starting place. We didn't want to go back, we wanted to stay in the present and find our imagery as urban artists and produce a body of work out of our sense of displacement."[83]

Other notable Chicano Art Movement artists include Rupert García (b. 1941), Luis Jiménez (1940–2006), and Amalia Mesa-Bains (b. 1943). García made his reputation through posters supporting left-wing political causes and opposing the Vietnam War in a flat Pop-influenced style (e.g., *¡Fuera de Indochina!*, 1970). Jiménez depicted working-class Southwestern subjects in stylized, glossy, vibrantly colored fiberglass figurative sculptures evoking the aesthetic of

lowrider cars popular in Mexican American barrios (e.g., *Vaquero*, 1980). Mesa-Bains is known for her temporary installations based on *ofrendas* (Mexican home altars with offerings to deceased loved ones, set up for Day of the Dead ceremonies). Works such as Mesa-Bains's *An Ofrenda for Delores del Rio*, (1984, revised 1991), dedicated to the first major Mexican movie star to achieve Hollywood fame, are filled with photographs and various found objects embodying the Chicana/o aesthetic of *rasquachismo*, defined by critic Tomás Ybarra-Frausto as a resourceful, improvisational "making do with what's at hand" rooted in Mexican vernacular traditions.[84]

FIGURE 19.27 Judith F. Baca, *Division of the Barrios and Chavez Ravine* from *The Great Wall of Los Angeles*, 1983. Los Angeles.

Postmodernism: Art in Europe and the United States, Late 1970s to Late 1980s

The late 1970s to the late 1980s were the heyday of postmodern art in the United States and Europe. Critics initially applied the term "postmodernism" in the mid-1970s to describe architecture that rejected the abstract, machine-age aesthetic of International Style modernism by employing historical architectural styles and vernacular references (see Chapter 21). By the 1980s, other visual arts that reacted against the formal purity of modernism as defined by critics such as Clement Greenberg and as manifested in Minimalism were routinely described as postmodern.

Postmodernism is not an artistic style but a constellation of ideas about society and culture strongly influenced by the writings of French poststructuralist theorists including Roland Barthes, Jean Baudrillard, Jacques Derrida, Michel Foucault, Julia Kristeva, Jacques Lacan, and Jean-François Lyotard (see "Postmodern Theory" box). Poststructuralism is characterized by a skepticism toward such concepts as universal truths, institutional authority, and transparent reality, and an emphasis on relativism, difference, and diversity. Because of its radically anti-authoritarian values, poststructuralism gained favor in the 1970s and 1980s among many leftist European and American intellectuals disillusioned by the failure of the late 1960s student rebellions to bring about political revolution.

Derrida's dictum that everything is a text, and that there is nothing outside the text, and Baudrillard's conception of culture as a limitless proliferation of signs sum up the basic postmodern claims about art. In the postmodern view, any cultural expression can be considered a text composed of signs (signifers and signified, see "Semiotics" box, Chapter 4), whose meaning is not found in the relationship between signifiers and their referents in the real world, but in the relationship between the signifiers themselves, lacking secure signifieds. Therefore, the author does not control the meaning of a text; it is always open to multiple readings, because of the instability of language itself. Postmodernism also rejects the humanist conception of the stable, centered, individual human subject. It instead sees the subject as fragmented and decentered—as argued by such theorists as Fredric Jameson—and subjectivity as constructed by social and cultural discourses rather than being essential or self-determined. Postmodernism overturns the modernist paradigm of the artist as a creative genius expressing an authentic personal vision or statement in an original, individual style. Instead, the postmodern artist manipulates established signs and cultural codes, employing strategies of appropriation (reusing an existing image or object) and pastiche (imitating or mixing existing styles) to produce a visual text that is open to manifold interpretations.

Postmodernism's relativistic attitude can be seen as a form of deregulation in the cultural sphere that paralleled widespread economic deregulation in the 1980s. The conservative governments of US president Ronald Reagan and UK British prime minister Margaret Thatcher led this economic trend, known as neoliberalism. Reagan's economic policies, dubbed "Reaganomics," resulted in widespread tax cuts, decreased social spending, increased military spending, and the deregulation of domestic markets. Thatcher likewise reduced social spending and state

intervention in markets and emphasized the privatization of nationally owned enterprises. Globally over the course of the 1980s, China liberalized its economy, Soviet communism collapsed, the Iron Curtain fell, and democracy spread in Eastern Europe, Latin America, and elsewhere.

Neoliberalism and a surging stock market fostered an upward redistribution of wealth that fed a booming art market in the United States and other Western countries during the 1980s. Art forms of the 1970s that were difficult or impossible to collect, such as Conceptual, Land, and Performance art, gave way to collectible manifestations of postmodernism such as Neo-Expressionist and Graffiti-based painting, photo-based appropriation art, and Neo-Geo, which newly rich collectors eagerly acquired. This chapter introduces these postmodern movements, emphasizing developments in the United States, while also briefly considering the work of Late Modernist artists who continued to work within the modernist paradigm. The chapter also attends to related topics in US art of the 1980s: African American artists who confronted racism; controversies over public art and public funding for the arts; and American artists' responses to AIDS, a global health crisis that grew during the decade.

Neo-Expressionism

"The artists' studios are full of paint pots again," wrote curator Christos Joachimides in 1981, introducing the exhibition *A New Spirit in Painting* that he co-organized with Norman Rosenthal and Nicholas Serota at the Royal Academy in London.[1] This exhibition, followed in 1982 by Joachimides and Rosenthal's *Zeitgeist* in Berlin and *Documenta 7* in Kassel, Germany, heralded the advent of **Neo-Expressionism**. This term described a return by European and American artists to large-scale, gesturally executed representational painting containing narrative, historical, symbolic, or mythic **subject matter** after the dominance of **Conceptual**, **Performance**, and video art and photography in the 1970s. One of Neo-Expressionism's chief promoters, the Italian critic Achille Bonito Oliva, declared, "the dematerialization of the work and the impersonality of execution that characterize the art of the seventies along the lines of a strictly Duchampian development are superseded by a revival of manual skill and of joy in execution that reintroduces the tradition of painting into art."[2]

Neo-Expressionism's brightest stars were the Americans Julian Schnabel, David Salle, and Eric Fischl; the Italians Sandro Chia, Francesco Clemente, and Ezno Cucchi; and the Germans Georg Baselitz, Jörg Immendorff, Anselm Kiefer, Markus Lüpertz, and A. R. Penck. The Neo-Expressionist label connected these artists' work to that of early twentieth-century German and Austrian Expressionists (see Chapter 3) and the mid-twentieth-century American **Abstract Expressionists** (see Chapter 12). The Neo-Expressionists reanimated these earlier traditions in a self-conscious, postmodern manner. They employed **expressionist formal** qualities as ready-made visual devices and they appropriated and mixed materials, **styles**, and images from a variety of cultural sources, both high and low, resulting in a leveling of hierarchies characteristic of **postmodernism**.

American Neo-Expressionism

Neo-Expressionist painting flourished in the United States in the late 1970s and early 1980s and received considerable attention both in the art-world and popular press, conferring celebrity on many of its practitioners.

Julian Schnabel (b. 1951)

The first American artist hailed as a Neo-Expressionist was Julian Schnabel, whose second New York exhibition in 1979 brought him instant art-world fame. Schnabel made enormous paintings on bulky wood **supports** whose surfaces he covered with broken plates and overpainted with thick, vigorously brushed colors and crudely rendered images. Schnabel got the idea for painting on plates on a 1978 visit to Barcelona, where he saw the broken glazed tiles architect Antoni Gaudí had incorporated into his park benches. Smashed crockery gave Schnabel a chunky, disrupted painting surface and infused his works with connotations of violence and chaos. Such qualities also exist in much of his imagery, such as the mutilated torso in the central panel of *The Death of Fashion* (1978, Figure 20.1). Next to the torso is an elongated vertical brown shape emblazoned with a naples yellow cross. Schnabel associated the former with a poplar trunk and thought of it as a surrogate for a human figure; he saw the cross as alluding to the history of Western painting, replete with Christian imagery.[3] The painting's title came from a radio report about a fashion model's death, but its imagery makes no obvious reference to the story, nor do its discontinuous and ambiguous motifs cohere to produce legible meaning. Such disunity did not trouble Schnabel's critical champions, who praised his work's physical energy and ambition and compared him to Jackson Pollock. While continuing to paint, Schnabel turned to filmmaking in the 1990s, directing a filmic portrait of his late friend Jean-Michel Basquiat (*Basquiat*, 1996), and several subsequent critically acclaimed films.

David Salle (b. 1952)

David Salle composed his paintings from preexisting images, sourced from popular culture, high art, and his own photographs of nude or seminude female models. He combined these intuitively in complex **compositions** that often layer transparent images over opaque ones, a device he borrowed from Sigmar Polke and Francis Picabia (Polke's own source). Salle said his images were "not logically

FIGURE 20.1 Julian Schnabel, *The Death of Fashion*, 1978. Oil and crockery on canvas and wood, 241.9 x 304.8 x 33 cm. Des Moines Art Center, Iowa.

or hierarchically organized, but . . . like cross-referencing without an index."[4] A characteristic work, *His Brain* (1984, Figure 20.2), is divided vertically into two sections. The left consists of printed fabric with a loud, colorful pattern, overlaid by a slender oblong excremental brown shape. On the right, a depersonalized, bent-over female nude blandly rendered in sickly yellow and green presents her buttocks. Atop her body float a sketchy red drawing of female figure's head and upper torso; four transparent Lincoln's-head profiles derived from the US penny; and an image of Monet's studio boat copied from his 1874 painting. As in Schnabel's *The Death of Fashion*, these motifs fail to form a legible storyline, and Salle insisted that his paintings had none. To postmodern writers, his pastiches visually paralleled Barthes's characterization of the literary text as "a tissue of quotations drawn from the innumerable centers of culture." Some feminists attacked Salle's sexualized representations of nude women as objectifying and misogynistic; most

critics found them to lack erotic appeal. Many agreed that his work's underlying sensibility was disillusionment. In this sense, the Neo-Expressionist label fits Salle poorly, but it persists.

Eric Fischl (b. 1948)

Like Salle, Eric Fischl worked in an improvisational manner and relied on fragmented photographic sources—in printed publications or his own snapshots—but unlike Salle, Fischl integrated these fragments into spatially cohesive narrative scenes in a loose, **painterly** realist style. Fischl depicted ordinary bedrooms, patios, swimming pools, and beaches populated by upper-middle-class, white American suburbanites, usually naked, unselfconsciously engaged in activities suggesting boredom, alienation, decadence, or perversion. His intention was to show "how people act when they think they are alone and not observed."[5] In his best-known picture, *Bad Boy* (1981), an adolescent boy simultaneously contemplates the

FIGURE 20.2 David Salle, *His Brain*, 1984. Oil and acrylic on canvas, fabric, 297.18 x 268.61 cm.

figures in a harsh, illustrational mode and often used a Pompeiian red **background** to push them forward into the viewer's space. He laid the paint on thickly then dissolved it and scraped it off with a meat cleaver. The eroded colors and raw surfaces increase the discomfort viewers may experience confronted by imagery that revels how repressive power operates in many parts of the world, sometimes with support from the US government. For example, in El Salvador (the subtitle of Golub's *White Squad IV*), the Salvadoran army, supplied with training and weapons by the United States, organized death squads to terrorize the rural population in a civil war in the 1980s.

Sue Coe (b. 1951)

English-born Sue Coe, who moved to New York in 1972, makes art that confronts contemporary injustices with expressionist urgency. Among the problems she addressed in her work of the 1980s were poverty, homelessness, drug abuse, sexism, rape, vivisection, racism, apartheid, political repression, and nuclear proliferation; animal rights became a particular passion in her

vagina of a splayed-legged naked woman (possibly his mother) while he steals from her purse. Viewers of Fischl's paintings become voyeurs of banal yet taboo-breaking scenarios that reveal secret desires and shame-inducing behaviors beneath the wholesome veneer of the suburban American lifestyle.

Leon Golub (1922–2004)

The politically engaged figurative painter Leon Golub gained recognition as a Neo-Expressionist in the 1980s for his *Mercenaries, Interrogations,* and *White Squad* series (e.g., *White Squad V*, 1984). These enormous paintings depict mercenaries, secret police, and death squads who enforce the will of repressive governments through clandestine violence, torture, and execution. Golub based the paintings on news photos and reports of such brutality in Latin America and South Africa. Most of his pictures do not refer to specific countries, however, but are generic indictments of the murderous abuse of power. Working in **acrylic** on unstretched canvases, Golub painted twice life-size

subsequent work. Driven by leftist and feminist convictions, Coe seeks to make the realities of inequality, oppression, and degradation evident to a wide audience beyond the elite art world. She does this by not only making paintings and drawings sold in art galleries, but also by disseminating her imagery through inexpensive prints and illustrations for books, magazines, and newspapers. For example, her painting *Let Them Eat Cake* (1985, Figure 20.3) was also reproduced as a color print sold for $12 through *Mother Jones* magazine. Coe's composition concentrates on a desperate and distorted **foreground** figure occupying a nightmarish nocturnal world of abject urban poverty. An animal head stamped with dollar signs devours this person's left arm while they extend their bony right hand toward a newspaper announcing, "Ronald Reagan's $1000 A Plate Bash." The painting's title, a famous phrase commonly attributed to France's eighteenth-century queen Marie Antoinette, compares the queen's disregard for the starving peasants to Reagan's perceived lack of concern for the poor.

The Italian Transavanguardia

Beginning in 1979, Italian critic Achille Bonito Oliva promoted the painting of Sandro Chia, Francesco Clemente, Enzo Cucchi, Nicola de Maria, and Mimmo Paladino under the label *Transavanguardia* (Transavantgarde). Meaning "beyond the **avant-garde**," the term indicated that these artists no longer accepted **modernism**'s avant-garde mission of continuous innovation to push art and society forward. That idealistic agenda no longer seemed credible to many Italian artists in the turbulent social and political atmosphere of the 1970s and early 1980s, dominated by far-left and far-right terrorism and assassinations. Rejecting the imperative to create new forms, the Transavantgarde artists revived and combined past artistic languages. They did so, as Bonito Oliva wrote, "with the awareness that, in a society of transition towards an undefinable stabilization, it is only possible to adopt a nomadic and transitory frame of mind."[6] What united them was a commitment to figurative and narrative painting infused with a powerful sense of the artist's subjectivity.

Francesco Clemente (b. 1952)

Francesco Clemente, the most celebrated Transavantgarde painter, embodied Bonito Oliva's conception of the artist as a nomad in terms of geography, painting **mediums**, styles, and his art's cultural references. Born in Naples, Clemente spent part of every year in Rome, New York, and India. He worked in **fresco**, **encaustic**, **watercolor**, **gouache**, **tempera**, and **oil paint** on canvas in modes ranging from linear elegance to liquid sensuality to gestural aggressiveness. He responded to local cultural traditions in each place he worked, creating miniatures in India (collaborating with painters trained in the sixteenth-century Mughal idiom), frescoes in Italy, and oil paintings in New York. He filled his work with references to historical art (Egyptian, Greek, Roman, **Renaissance**, Hindu, **Surrealist**,

FIGURE 20.3 Sue Coe, *Let Them Eat Cake*, 1985. Oil on canvas, 179.1 x 140 cm. The Eli and Edythe L. Broad Collection, Los Angeles.

Expressionist) and diverse metaphysical traditions (Christianity, alchemy, astrology, Tantrism, the Tarot).

Clemente's primary artistic subject in the early 1980s was his own ever-changing face and body—whole, doubled, fragmented, or transmuting between male and female or human and animal. Many of these pictures emphasize bodily orifices serving as channels between the inner and outer worlds. The gesturally brushed *Name* (1983, Figure 20.4) depicts the artist's head against a background window and wall. Six smaller self-portraits peer out of his eyes, nostrils, mouth, and ear. This image suggests the postmodern self—multiple and fragmented rather than unified and centered. It also represents the self not

FIGURE 20.4 Francesco Clemente, *Name*, 1983. Oil on canvas, 198 x 236 cm.

as an ego projecting itself to the outside world but as porous and open to what is around it—a metaphor for Clemente's receptivity to diverse cultures and historical traditions.

German Neo-Expressionism

German Neo-Expressionism arose in the Cold War environment of the 1960s and 1970s in democratic, capitalist West Germany, divided from communist East Germany. Many German Neo-Expressionists looked to pre–World War I German Expressionism as a model in their effort to revive a national cultural lineage ruptured by Nazism and subsequently by German artists' adoption of international *art informel* (see Chapter 13). The German Neo-Expressionists also engaged with themes from German history, including its darkest chapter—the horrors of Nazism and the Holocaust. They believed that this darkness had to be confronted before the nation could recover its moral standing and recuperate its culture.

Georg Baselitz (b. 1938)

Pioneering examples of German Neo-Expressionism, Georg Baselitz's mid-1960s paintings of "heroes" show crudely rendered, hulking, distorted male figures embodying existential isolation and uncertainty (e.g., *The Great Friends*, 1965). These images subvert propagandistic expressions of heroism in both Nazi art and the **Socialist Realism** of East Germany, where Baselitz grew up before moving to West Berlin in 1956.

Baselitz went on to depict hunters, woodsmen, and animals sliced or broken into ragged fragments (e.g., *Woodman [Waldarbeiter]*, 1969), suggesting his generation's traumatic experience living in a war-torn and divided nation. In 1969, Baselitz began depicting his subjects upside down. He claimed he did this to emphasize the painting's formal qualities over its representational content. The inverted images also suggest a world turned upside down, in which chaos replaces order. During the 1970s, Baselitz's paint handling became increasingly vigorous and his **palette** increasingly dramatic, culminating in works such as *Supper in Dresden* (1983, Figure 20.5) Here, in a scene reminiscent of the Last Supper, Baselitz portrays members of Die Brücke—the German Expressionist group formed in Dresden in 1905 (see Chapter 3)—as inverted, angst-ridden figures gathered around a table. Despite its visual intensity, Baselitz's painting seems to simulate rather than authentically convey the emotional urgency of prewar German Expressionism, making it postmodern.

Anselm Kiefer (b. 1945)

Anselm Kiefer's paintings of the 1980s greatly impressed international audiences through their sheer physical power. Many are colossal, covering entire walls, their surfaces clotted with paint as well as such materials as straw, shellac, emulsion, ashes, clay, photographs, scraps of paper, and lead sheets shaped into books, wings, or palettes. Kiefer also made an impression through his ambitious exploration of subjects from German cultural and political history, including Nazism and the Holocaust. His art invoked grandiose Nordic, **Neoclassical**, and Wagnerian themes, resurrecting German **Romantic** content contaminated by the Nazis' political use of it. Like Joseph Beuys (see Chapter 14), with whom Kiefer was in contact in the early 1970s, he made these references to remind his compatriots of their terrible history and to force them to deal with its implications. Many German critics accused Kiefer of secretly identifying with the Nazis and warned that his art could reinforce resurgent German fascism. By contrast, many critics in the United States, England, and Israel praised Kiefer's journey into the German past as a courageous effort to work through its trauma. His art's dark, heavy atmosphere supports

FIGURE 20.5 Georg Baselitz, *Supper in Dresden*, 1983. Oil on canvas, 280 x 480 cm. Kunsthaus Zurich, Switzerland.

reading it as mournful rather than neo-fascist: his paintings do not trumpet a revived German nationalism but roam the dark and ancient forests, fields, and chambers haunted by its ghosts.

Nürnberg (Nuremberg) (1982, Figure 20.6) is one of numerous Kiefer paintings that depict historically significant German locales as scarred and desolate in the aftermath of destruction. Nuremberg was a flourishing center of art and learning in the fifteenth and sixteenth centuries but later was the site of Nazi rallies and the postwar trials of Nazi war criminals. A vast straw-clogged charred field with furrows converging to a **vanishing point** at the left on the high horizon dominates Kiefer's composition. Silhouetted buildings at the upper right situate the location as the Nazi party rally grounds southeast of Nuremberg. Kiefer has inscribed the words *Nürnberg—Fest-spiele—Wiese* (Nuremberg—Festival—Meadow) above the buildings. A scrap of paper below bears the name "Eva." These elements refer to Richard Wagner's opera *The Mastersingers of Nuremberg* (1867); Eva is its main female character and its final scene takes place in a meadow. This opera was performed at the Bayreuth Festival (a showcase for Wagner's operas) when it reopened in 1924 after its closure during World War I. The Nazis appropriated Wagner's music for propagandistic purposes and staged *The Mastersingers of Nuremberg* at the 1935 Nazi party rally where the anti-Semitic Nuremberg Laws were promulgated. The furrows of Kiefer's field evoke the ordered ranks of Nazi soldiers gathered on the rally grounds. The ashen earth suggests the burning of crops by an invading army but also the agricultural practice of burning fields to regenerate the soil. Fire figures in alchemy, the medieval pseudoscience that sought to transmute base metals into gold. The straw that seems to grow from *Nuremberg*'s burned fields recalls the German folk tale of Rumpelstiltskin who spun straw into gold. Such multiple, layered references are characteristic of Kiefer's art, which acknowledges history's weight and complications through its own dense complexity.

Jörg Immendorff (1945–2007)

Jörg Immendorff's *Café Deutschland* series of paintings (e.g., *Café Deutschland 38. Parteitag*, 1983) depict crowded West German nightclubs. Painted in an expressive realist style blending influences from pre–World War I German Expressionism and interwar **Neue Sachlichkeit**, these theatrical pictures combine qualities of political cartooning, **history painting**, and autobiography. The artist himself frequently appears in them, alongside a changing cast of characters from Hitler, Stalin, and Mao to Immendorff's fellow artist A. R. Penck and contemporary political leaders—East Germany's Erich Honecker and West Germany's Helmut Schmidt. Recurrent politically charged motifs

FIGURE 20.6 Anselm Kiefer, *Nürnberg* (*Nuremberg*), 1982. Oil, acrylic, emulsion, and straw on canvas, 280 x 380 cm. The Eli and Edythe L. Broad Collection, Los Angeles.

Postmodern Theory

Postmodern theory is often expressed in difficult jargon, but its essential ideas can nevertheless be summarized. It is based in poststructuralism, an intellectual movement that grew out of structuralism. Structuralism derives from the linguistic theories of Ferdinand de Saussure, who conceived of language as a structure composed of signs, in which each sign's meaning depends on its difference from other signs (see "Semiotics" box, Chapter 4). The anthropologist Claude Lévi-Strauss applied structuralism to the analysis of kinship, myths, and other cultural phenomena, which he saw as rooted in structures inherent in the human mind and transcending historical and cultural differences. Lévi-Strauss argued that every culture's mythology was structured around "binary oppositions," such as raw/cooked, or healthy/sick, which humans use to make sense of the world. Poststructuralists also understand cultural practices as structures but deny that these structures

are timeless and universal truths, seeing them instead as fictions created in specific contexts to serve specific social and political ends.

Jean-François Lyotard took an anti-universalist position in describing the postmodern condition as a loss of belief in "grand narratives," such as narratives of progress dominating Enlightenment-based Western philosophies of history (e.g., Hegelianism, Marxism), which claimed universal truth but led to totalitarianism. Michel Foucault likewise conceived of history not as a march of progress but a discontinuous process of gaps and ruptures, and he analyzed how power operated in European history, permeating every social institution. Roland Barthes applied a poststructuralist approach to the analysis of literature. In his influential essay "The Death of the Author," he argued that the text is not as an original expression of the author's intended meaning but "a tissue of quotations drawn from the innumerable

centers of culture."⁷ To Barthes, the text's meaning depended on the reader's interpretation rather than the author's intentions. A related concept articulated by Barthes, Julia Kristeva, and others is intertextuality: all texts (including all cultural expressions) exist in relation to other texts and are intersections of texts. Jacques Derrida similarly argued that everything is a text, and that there is "nothing outside the text," meaning that reality is never self-evident but is always a product of interpretation. Derrida conceived of language as an endless play of signifiers whose meanings are perpetually deferred. He advocated the practice of "deconstruction," probing a text for its hidden contradictions to reveal its repressed meanings, which may be the opposite of those intended by the author.

Deconstruction undermined the stability of the binary oppositions that Lévi-Strauss and other structuralists posited by inverting their terms to elevate the subordinate one. A prime example is the binary "original/copy." Modernism valued the original over the copy, but deconstruction reversed this binary to privilege copying, as in Jean Baudrillard's concept of the simulacrum (pl. simulacra). Baudrillard claimed that images circulated by the mass media, popular entertainment, and advertising function as simulacra: they are copies without originals, or signifiers without real-world signifieds. Because Baudrillard's ideas dealt specifically with images rather than texts, they were especially influential in writing about postmodern art in the 1980s.

in the paintings include the swastika, the German eagle, and the Brandenburg Gate in Berlin, the prime symbol of the division between East and West Germany. A student of Beuys who shared his teacher's belief in art's power to foster social change, Immendorff through the *Café Deutschland* series highlighted his country's past and present political tensions and urged attention to the goal of German reunification, finally achieved in 1990.

and painted them on unorthodox supports, such as printed fabrics, creating a cacophonous, layered effect (and influencing David Salle). *Watchtower with Geese* (1987/88, Figure 20.7), for example, sets the ghostly silhouette of a watchtower next to a white-outlined gaggle of geese and a kitschy pattern of

Sigmar Polke and Gerhard Richter

Sigmar Polke and Gerhard Richter, who launched their careers as "Capitalist Realists" in Düsseldorf in the early 1960s (see Chapter 15), stood apart from their Neo-Expressionist compatriots by questioning painting's nature and purpose rather than accepting its conventions. Both resisted developing a "signature style" and instead worked in a variety of modes. This led some critics to see them as lacking a stable or authentic artistic identity and to label them postmodern. This descriptor accurately fits Polke, who starting in the 1970s mixed diverse images appropriated from both high and low cultural sources

FIGURE 20.7 Sigmar Polke, *Watchtower with Geese*, 1987/88. Resin and acrylic paint on various fabrics, 290 x 290 cm. The Art Institute of Chicago.

white sunglasses, umbrellas, and folding chairs printed on black fabric. The elevated hut generates sinister associations ranging from the raised chair used by German fowl hunters (reinforced by the geese) to a lookout tower on the East–West German border to a concentration camp watchtower. At the same time, the tower's juxtaposition with the fabric decorated with beach motifs conjures the more reassuring image of an elevated lifeguard chair. Polke's jumbled motifs recall the disjunctive qualities of certain **Dada** and Surrealist compositions (see Figures I.8 and 7.6) while suggesting the postmodern play of signifiers unmoored from stable signifieds and never settling on a fixed meaning.

During the 1970s, Richter continued to paint blurred images based on photographs, both in **grisaille** and color. In the late 1970s, he also made paintings that meticulously replicated blurry photographic enlargements of details of his own small gestural **abstractions**; the large paintings (e.g., *Abstract Painting No. 439*, 1978) were effectively representations of abstraction. Richter went on to paint large abstractions without the mediation of photography, combining and layering different

techniques and visual effects in one composition. *Merlin* (1982, Figure 20.8), for example, features an atmospheric red, yellow, and white background suggesting an opening onto deep space, overlaid at the left with an angular geometric plane modulated from dark red to purple to blue to a white highlighted edge. Superimposed over these are meandering gestural brushstrokes of varying colors, width, and density. Along the right are smeared flat yellow passages created by a large spatula or squeegee. Although the strident colors and gestural brushstrokes evoke Willem de Kooning-style **action painting**, their dissonant coexistence with carefully or mechanically rendered elements such as the geometric plane and the dragged yellow creates a self-conscious, anti-expressionist quality that can be considered postmodern.

While continuing to experiment with abstraction, Richter made a series of fifteen gray, blurred, photo-based paintings, *October 18, 1977* (1988), named for the date when three members of the Red Army Faction (RAF), a radical left-wing West German terrorist group, were found dead in their prison cells in Stuttgart, probably by suicide. Using portrait, press, and police photographs showing RAF members both alive and dead as his sources, Richter produced a form of contemporary history painting that acknowledges the power of photography and the mass media in constructing our knowledge of history. He claimed he was not concerned with the RAF's specific politics but struck by their "ideological motivation . . . the terrifying power that an idea has, which goes as far as death."[8] He called the paintings expressions of "compassion and grief" for young people who were victims not of a specific ideology but "of the ideological posture as such."[9] Having grown up under Nazism and then East German communism, Richter mistrusted all totalizing ideologies, whether political or artistic, but he professed to believe in art itself, sounding more like a modernist than a postmodernist: "Art is the pure realization of religious feeling, capacity for faith, longing for God…. The ability to believe is our outstanding quality, and only art adequately translates it into reality. But when we assuage our need for faith with an ideology we court disaster."[10]

FIGURE 20.8 Gerhard Richter, *Merlin*, 1982. Oil on canvas, 250 x 250 cm. Fonds regional d'art contemporain de Bourgogne, Dijon, France.

Nonconformist Soviet Art: Komar (b. 1943) and Melamid (b. 1945), and Ilya Kabakov (b. 1933)

During the Cold War, Socialist Realism, imposed by Joseph Stalin in 1934, was the Soviet Union's official aesthetic. Socialist Realism was the dominant form of modern art under state socialism—itself a modernizing social, economic, and political system that paralleled liberal-democratic capitalism for much of the twentieth century.[11] Socialist Realism was not, however, modernist: it demanded clearly legible representations and easily understood narratives that served as propaganda for the Communist Party and its policies. Until the 1980s, the Soviet Union prohibited **abstract**, erotic, and religious art, or art critical of the party or the state. To secure studio space, exhibit publicly, accept commissions, or teach officially, artists had to belong to a union, and union membership was restricted to those who conformed to party principles. In resistance to these constraints, a small unofficial art community developed in Moscow in the 1960s and 1970s; these artists staged exhibitions in their private apartments, engendering the term "apartment art." The government suppressed the effort of some of these artists to exhibit in public, sending bulldozers to destroy an unofficial outdoor painting exhibition outside Moscow in September 1974.

Among the participants in this "Bulldozer Exhibition" were the duo Vitaly Komar and Alexander Melamid, who initiated Sots art. This term refers simultaneously to Socialist Realism and **Pop art** through the near rhyme of "Sots," the first syllable of *Sotsialisticheskiy realizm* (Socialist Realism) with "pop." Sots art reflected the Soviet propaganda images "that surrounded all of us from childhood," said Komar. "Unlike Western pop art, which responded to the overproduction of advertising and commercial consumption, Sots-art instead was a comment on the pervasion of Soviet ideology and its propaganda."[12] In the early 1970s, Komar and Melamid made paintings resembling Communist Party banners with white-lettered slogans on red backgrounds; some paintings ironically replicated actual slogans (e.g., "Our Goal is Communism") while others replaced the letters with white rectangles, suggesting the propaganda was meaningless.

After relocating to the United States in 1978, Komar and Melamid made a series of paintings mocking Stalin's glorification in Socialist Realist art by using a neo-**Baroque** representational style that would have pleased Stalin himself. In *The Origin of Socialist Realism* (1982–83, Figure 20.9), a female muse traces the outline of the shadow of Stalin's profile by lamplight in a **classical** setting. This **iconography** invokes

FIGURE 20.9 Komar and Melamid, *The Origins of Socialist Realism,* 1982–83. Tempera and oil on canvas, 183.5 x 122 cm. Zimmerli Art Museum, Rutgers University, New Brunswick, New Jersey.

the Roman author Pliny's story about a Corinthian maiden tracing the shadow of her lover while he slept before he departed for battle—a mythic origin story of representational art. A postmodern pastiche, the painting employs a bombastic, premodern **academic** style to identify Stalin as Socialist Realist art's quasi-divine origin. In this way, Komar and Melamid satirize the pretensions of Communist mythmaking that elevated Stalin to heroic status and ignored his crimes against humanity (between the 1930s and his 1953 death, he had more than a million Soviet citizens executed).

Alongside Sots art, the other major trend of 1970s and 1980s nonconformist Soviet art was Moscow Conceptualism. It was generally concerned with language, communication, and the construction of meaning, and generated ironic and critical deconstructions of Soviet bureaucratic and ideological discourses. Its principal exponent, Ilya Kabakov, described it as "a collection of observations of a cultural nature of various aspects of Soviet life, Soviet consciousness, and so-called art."[13] Known publicly as an

illustrator of children's books for state publishing houses, Kabakov's private work in the early 1970s included *Ten Characters*, a set of albums narrating ambiguous fables of everyday Soviet citizens with absurd dreams and obsessions—psychological attempts to escape Soviet life's dispiriting banality. Between 1981 and 1988, Kabakov created a series of **installations**, also called *Ten Characters*. Each was a life-size representation of an imaginary inhabitant's room in a communal apartment. Forced to live under their neighbors' scrutiny and sharing kitchens and bathrooms, many tenants of these apartments felt alienated and retreated into extremes of personal oddity or fantasy to maintain their individual identity. Among the eccentric characters imagined by Kabakov is *The Man Who Flew into Space from His Apartment* (1985, Figure 20.10). This installation shows the room of a man inspired by the Soviet space program to construct a catapult that has apparently launched him through the ceiling to realize his "dream of a lonely flight into space."[14] Beneath the hole in the ceiling (created, per Kabakov's fanciful account, by explosives set to go off just before the launch), the room's walls are covered with political and industrial posters. They also bear sheets of paper with sketches of the catapult and flight plans and calculations. In the corner is a model of the city with a metal strip extending upward to indicate the flight's path. (The sketches and model are not visible in Figure 20.10.) In 1988, Kabakov was himself propelled out of the Soviet Union, immigrating to New York. Since then, he has collaborated on installations with his wife and fellow artist, Emilia Kabakov.

FIGURE 20.10 Ilya Kabakov, *The Man Who Flew into Space from His Apartment*, 1985. Wood, rubber, ropes, paper, electric lamp, crockery, model, rubble, and plaster dust, 280 x 242 x 613 cm. Musée National d'Art Moderne, Centre Georges Pompidou, Paris.

Graffiti Art and Its Influence

Postmodernism's emphasis on difference and diversity encouraged interest in the marginalized Other, which brought attention to **Graffiti art** within the white-dominated New York art world in the early 1980s. A visual expression of personal identity linked to hip-hop and breakdancing culture, Graffiti art was practiced largely by young men of color from Brooklyn and the Bronx, employing pseudonyms such as Daze, Futura 2000, Rammellzee, and Toxic. They illegally "bombed" (spray-painted) walls and subway cars by covering them with skillfully executed, multicolored, highly **stylized** writing. This illicit, underground art form entered the legitimate, aboveground art world in 1980 when the South Bronx storefront gallery, Fashion Moda, staged a Graffiti art show including Crash, Lady Pink, Lee, and Zephyr. Graffiti art was also featured in the new galleries that sprung up in the early 1980s on Manhattan's gritty Lower East Side, known as the East Village.

Attracted by the cheap rents in this derelict, lower-class neighborhood, young artists, writers, musicians, and other creative types—mostly white and college-educated—flooded into the East Village starting in the late 1970s. A bohemian scene developed around galleries such as Fun, Gracie Mansion, Nature Morte, and PPOW, and nightclubs such as CBGB, the Mudd Club, and Club 57, which featured punk rock and new wave music. The *Times Square Show* (1980), organized by the East Village artist's collective Colab in an abandoned massage parlor in the sex-shop district, took the East Village's scruffy energy uptown. Open twenty-four hours a day during all of June, this "irreverent, raw, rebellious, messy,"[15] show featured graffiti, experimental painting and sculpture, music, performance, video, and fashion. Among the participants were Keith Haring, Kenny Scharf, and Jean-Michel Basquiat, who would quickly gain tremendous success through their graffiti-based art.

Keith Haring (1958–1990)

The white Keith Haring made art "in transit" in New York subway stations. Beginning in 1980, he drew thousands of white chalk drawings (e.g., *Untitled [Subway Drawing]*, 1984) on the black paper that covered expired advertisements. He used a distinctive vocabulary of simply outlined cartoon-style motifs, including the "radiant child" (an infant emitting light rays), barking dog, flying saucer, TV sets, and dancing and praying men. Like Daniel Buren, who covered Parisian billboards in 1968 with his signature striped posters (see Chapter 19), Haring appropriated space devoted to advertising for artistic expression, though Haring's act was less subversive than Buren's since he did not draw over existing advertisements. He worked in the subway to provide free art and provoke viewers "to think and use their own imagination" in interpreting his images, which had no fixed meanings.[16] While Haring also created paintings and drawings that sold for high prices in art galleries, he made his art accessible to a broad audience as merchandise such as buttons and t-shirts that he sold through his Pop Shop (established in 1986). A political activist, Haring made art, posters, and public murals advocating causes like children's literacy and the end of South African apartheid. The openly gay artist also made images promoting AIDS awareness and safe sex before succumbing to the disease himself at age thirty-one.

Jean-Michel Basquiat (1960–1988)

Haring's friend Jean-Michel Basquiat, the Brooklyn-born son of a Haitian father and a Black mother of Puerto Rican descent, quit high school and left home at seventeen to become a street artist. For three years, he and Al Diaz covered Lower Manhattan walls with short, witty texts signed SAMO© (short for "same old shit"). Basquiat's participation in the *Times Square Show* and other Graffiti art exhibitions brought him to the attention of the white-dominated art world. In 1981, dealer Annina Nosei provided him a studio space and art supplies and he began to paint prolifically. Basquiat synthesized influences from Rauschenberg's **Combines**, Dubuffet, late Picasso, and Cy Twombly (see Chapter 14) to create aggressively "primitivist" paintings executed with childlike impulsiveness and filled with totemic figures, symbols, words, and numbers. White collectors avidly acquired them, and Basquiat became an art world superstar before dying of a heroin overdose at age twenty-seven.

Basquiat insistently painted Black subject matter to counter its absence from mainstream modern art. He frequently represented famous African American boxers and musicians, with whom he identified as figures of resistance and creative innovation, respectively. His triptych *Horn Players* (1983, Figure 20.11) features cartoonish portraits of bebop jazz legends Charlie Parker (at the upper left) and Dizzy Gillespie (center right). Basquiat names both men through white lettering in the upper center, but he crosses through and paints over Parker's name. "I cross out words so you will see them more," said the artist; "the fact that they are obscured makes you want to read them."[17] Basquiat includes other words relating to Parker: "Chan" and "Pree," the names of his wife and daughter, respectively, and "Ornithology," the title of a Parker composition. The central skull-like head, a recurrent motif in Basquiat's art, suggests a self-portrait. The scrawled lettering and energetic paint handling seem authentically expressionist, communicating the painter's emotional connection to his subject: Basquiat collected jazz records, listened to jazz while painting, and considered Parker a personal hero.

Tim Rollins (1955–2017) + K.O.S.

The Graffiti art movement influenced the work of Tim Rollins + K.O.S. (Kids of Survival), a collaborative group that the white Rollins formed with mostly Black and Latina/o youth in the impoverished South Bronx in the early 1980s. K.O.S. emerged from Rollins's work teaching art in a junior high school, which he extended to an after-school program that combined art-making with literacy improvement. Rollins guided the students' reading of classic texts by authors ranging from Shakespeare to George Orwell to Malcolm X. Through a long process of study and sketching, they would distill the book's narrative into a single motif, variations of which individual students would paint atop the book's pages laid down in a grid over a canvas. In this way, the Kids not only consumed culture but also created it and developed their own voices. Rollins's pedagogy followed Paolo Freire's

FIGURE 20.11 Jean-Michel Basquiat, *Horn Players*, 1983. Acrylic and oilstick on three canvas panels mounted on wood supports, 243.8 x 190.5 cm. The Eli and Edythe L. Broad Collection, Los Angeles.

Black Artists Countering Racism: David Hammons (b. 1943) and Adrian Piper (b. 1948)

Jean-Michel Basquiat confronted racism by painting Black people so that his predominantly white audience could not ignore them. David Hammons, who initially also represented Black subjects in his body prints (see Figure 19.23), took a different approach after his 1974 move from Los Angeles to Harlem: he expressed Black identity through sculptures and installations made of **found objects** and substances associated with everyday African American life. For example, he assembled sculptures out of greasy paper bags and chewed rib bones, Black hair, and empty bottles of Night Train (a cheap fortified wine). Hammons used these dirty or castoff materials to challenge his art's potential commodification by the white-dominant system of dealers, collectors, and museum professionals, whom he denounced as "frauds."[18] He also often presented his work on the street rather than in art galleries. *Higher Goals* (1986), temporarily installed in Brooklyn, consisted of five basketball hoops and backboards elevated on telephone poles decorated in various patterns with bottle caps and ranging in height from twenty to thirty feet. "It's an anti-basketball sculpture," explained Hammons. "Basketball has become a problem in the black community because the kids aren't getting an education. They're pawns in someone else's game. That's why it's called 'Higher Goals.' It means you should have higher goals in life than basketball."[19]

Another outdoor work, sited in a parking lot facing the National Portrait Gallery in Washington, DC, was a billboard-size

educational philosophy, which advocated a problem-solving approach in which students actively participate in knowledge production, empowering them to change society. K.O.S.'s best-known works are a series of large paintings that respond to Franz Kafka's *Amerika* (e.g., *Amerika VIII*, 1986–87). They feature allover compositions of fantastical golden horns inspired by the trumpets blown by angels in the book's final chapter. Rollins arranged exhibitions of K.O.S.'s paintings in mainstream art galleries and the group achieved remarkable critical and market success, with sales funding stipends and college scholarships for some of the Kids.

bust-length portrait of the Reverend Jesse Jackson, the unsuccessful African American candidate for the Democratic Party's 1988 presidential nomination. Hammons represented Jackson with pink skin, blue eyes, and blond hair, with the question "How Ya Like Me Now?," the title of a song by rapper Kool Moe Dee, spray-painted across his upper torso (Figure 20.12). During the work's installation, young Black men who interpreted it as a racist insult against Jackson attacked it with sledgehammers. They misunderstood Hammons's intention, which was to expose the white electorate's racism by suggesting that it rejected Jackson as a presidential candidate due to his skin color. (Hammons also thumbed his nose at the National Portrait Gallery, which at the time displayed no portraits of Black Americans.) Hammons took the assault in stride by subsequently displaying *How Ya Like Me Now?* indoors fronted by several sledgehammers, sardonically incorporating the defacers' tools and misreading into the work.[20]

Adrian Piper used her personal experience as a light-skinned African American who can pass for white to make art that forces viewers to confront their racial biases and anxieties. In 1986, she devised a calling card for use in social situations where someone made or agreed with a racist comment in her presence; the card informs the recipient that Piper is Black. In *Cornered* (1988, Figure 20.13), Piper looks out from a video monitor placed in the corner of the room behind an upended table and before a set of chairs. Hanging on either side of the monitor are her father's two birth certificates—one identifying him as white, the other as octoroon (one-eighth Black). (Piper has explained that after her light-skinned father's birth, the doctor perceived him as white and issued the document certifying his whiteness; the doctor issued the second certificate at the request of Piper's grandmother.[21]) Dressed demurely in a plain blue top with pearls, Piper calmly announces to the viewer, "I'm black. Now, let's deal with this social fact,

FIGURE 20.12 David Hammons, *How Ya Like Me Now?* 1988. Tin, plywood, sledgehammers, Lucky Strike cigarette wrapper, and American flag, 401 x 564 x 122 cm. Glenstone Museum, Potomac, Maryland.

FIGURE 20.13 Adrian Piper, *Cornered*, 1988. Video installation with birth certificates, color video, monitor, table, and chairs, dimensions variable. Museum of Contemporary Art, Chicago.

and the fact of my stating it, together."[22] Piper describes herself as "cornered. If I tell you who I am, you become nervous and uncomfortable, or antagonized. But if I don't tell you who I am, I have to pass for white. And why should I have to do that?"[23] She goes on to inform her "white" viewers that they are also likely Black. She bases this on research estimating that "almost all purportedly white Americans have between 5% and 20% black ancestry" and she reminds her viewers of "entrenched conventions" classifying a person as Black if they have any Black ancestry.[24] "If I choose to identify myself as black whereas you do not," says Piper, "that's not just a special, personal fact about me. It's a fact about us. It's our problem to solve."[25] The video concludes with the words "Welcome to the Struggle." For Piper, the struggle to resolve racism requires us "to overcome the divisive illusion of otherness, the illusion that each of us is defined not just by our individual uniqueness but by our racial uniqueness."[26]

Photo-Based Postmodern Appropriation Art in the United States

Numerous American artists critically investigated the nature of photographic representation in the late 1970s and 1980s. Animating their investigations was the postmodern idea that images rather than direct experience had come to define many people's understanding of the world. Critic Douglas Crimp wrote in the catalogue for *Pictures*, a 1977 New York exhibition that included some of the artists associated with this view: "To an ever greater extent our experience is governed by pictures, pictures in newspapers and magazines, on television and in the cinema. Next to these pictures firsthand experience begins to retreat, to seem more and more trivial. While it once seemed that pictures had the function of interpreting reality, it now seems that they have usurped it."[27]

These artists employed **appropriation** as their critical strategy, using photography to copy images or styles from various sources, including those named by Crimp, as well as historical artworks. By reproducing preexisting images and styles in new contexts, these artists drew attention to photography's role in mediating reality. They also raised questions about authorship and originality, and about the ideological role of advertisements, the media, popular entertainment, and art institutions in shaping beliefs, arousing desires, and asserting value. They recognized, as critic Craig Owens wrote, that "representation … is not—nor can it be—neutral; it is an act—indeed the founding act—of power in our culture."[28]

Richard Prince (b. 1949)

Richard Prince practiced an extreme form of appropriation by re-photographing images from printed sources and presenting the copies as his own work. Prince got the idea to re-photograph magazine advertisements while working in the tear-sheet department of Time Life, clipping articles and noticing how the adjacent advertisements used similar visual devices to sell comparable products, such as jewelry or furniture. Prince began re-photographing such advertising images and presenting them in sets (e.g., *Untitled [Three Women Looking in the Same Direction]*, 1980). In this way, he intensified the advertising images' artificiality and unveiled them as fictions intended to seduce consumers. Beginning in 1980, Prince re-photographed pictures of cowboys from Marlboro cigarette advertisements, excising the logo and text (e.g., *Untitled [Cowboy]*, 1989). Isolating the cowboy as a mythic American archetype of virility and rugged individualism, Prince opened this myth up to deconstruction through the viewer's awareness

of its appropriation by Marlboro to sell an addictive and deadly product. Prince's cowboy photographs also resonated with the mythology of the Reagan era. A former Hollywood actor who starred in westerns, Ronald Reagan as president continued to play the role of cowboy for photographers on his California ranch, exploiting the nation's nostalgia for a simpler, vanished time and offering a romanticized persona of morally upright yet approachable masculine authority.[29]

Sherrie Levine (b. 1947)

Sherrie Levine similarly appropriated preexisting images, gaining prominence in the early 1980s through her photographic copies of photographs by Edward Weston (from 1925) and Walker Evans (from 1936). Levine titled them *After Edward Weston* and *After Walker Evans*, acknowledging their lack of originality. She also raised questions about the originality of her sources. She did not re-photograph vintage Weston and Evans prints but photomechanical reproductions of their images on a poster and in an exhibition catalogue, respectively. Even "original" Weston and Evans prints are copies, potentially infinitely reproducible from a single negative. This point about photography was reinforced by German philosopher Walter Benjamin's 1936 essay "The Work of Art in the Age of Mechanical Reproduction," which influenced many photographers and critics in the 1980s. Furthermore, Weston and Evans used formal and stylistic conventions derived from other works of art; in this sense, they were themselves copyists. As Douglas Crimp put it, "underneath each picture there is always another picture."[30] Levine did not mean to attack Weston and Evans specifically, but to critique originality as a modernist myth. She also had a feminist intent in copying pictures by male artists, commenting that her work was largely about "realizing the difficulties of situating myself in the art world as a woman, because the art world is so much an arena for the celebration of male desire."[31] By appropriating Weston's and Evans's images, Levine managed paradoxically both to question their authority and subversively assert her own.

Barbara Kruger (b. 1945)

Beginning in the early 1980s, Barbara Kruger made large photographs using appropriated black-and-white photographic images, mostly from mid-twentieth-century mass media sources, overlaid with her own pithy texts in Futura Bold Italic typeface, and framed in bright red strips. Drawing on her long experience as a graphic designer for *Mademoiselle* and other magazines, Kruger gave her works the visually arresting look of advertisements. Unlike advertisements, however, Kruger's works are not designed to stimulate consumerist desire but to challenge stereotypes and expose power, especially it affects women under patriarchy. For example, *Untitled (Your Gaze Hits the Side of My Face)* (1981, Figure 20.14) suggests the heterosexual male gaze's objectification of the female body

FIGURE 20.14 Barbara Kruger, *Untitled (Your Gaze Hits the Side of My Face)*, 1981. Photostat, red painted wood frame, 140 x 104 cm. Glenstone Museum, Potomac, Maryland.

through the image of a classical-style feminine bust (appropriated from a 1950s-era photo annual). Kruger's texts typically use pronouns such as "you," "your," "I," "my" and "we," while never explicitly identifying the speaker or addressee, inviting the viewer to imagine shifting positions. "I'm involved in a series of attempts to displace things," said the artist, "to change people's minds, to make them think a little bit."[32] In addition to showing in art spaces, Kruger produces public works to address a broad audience, such as the poster she designed for the April 1989 March for Women's Lives in Washington, DC in support of abortion rights. Kruger's poster features a vertically bisected positive-negative photograph of a white woman's face overlaid with the text *Your Body is a Battleground*.

Guerrilla Girls

Like Kruger, the Guerilla Girls appropriated the visual conventions of advertising for their art, which took the form of posters, billboards, and ads exposing art world sexism and racism. Formed in 1985 as an anonymous group of feminist women artists whose members wear gorilla masks during public performances, the Guerilla Girls' artworks provide statistics and name museums, dealers, curators, critics, and artists they find

responsible for or complicit in excluding women and people of color from exhibitions and publications. For their 1989 poster *Do Women Have to Be Naked to Get into the Met. Museum?*, the Guerilla Girls used a black-and-white reproduction of the reclining female nude from the Met's grisaille version of Jean-Auguste-Dominique Ingres's painting *La Grande Odalisque* (see Figure I.11), covering her head with a gorilla mask and providing the facts: "Less than 5% of the artists in the Modern Art sections are women, but 85% of the nudes are female." Since the 1980s, the Guerilla Girls have expanded their focus to target discrimination not only in the art world but also in politics and popular entertainment.

Cindy Sherman (b. 1954)

Distinct from Prince, Levine, Kruger and the Guerilla Girls, Cindy Sherman poses for the camera herself and appropriates stylistic devices from film, television, advertising, fashion, and popular culture rather than quoting specific preexisting images (with a few exceptions). From the late 1970s to the present, Sherman has adopted a tremendous variety of roles and guises, continually transforming her appearance through makeup, wigs, costumes, prosthetic devices, and, more recently, digital manipulation. Her subject is not herself but the ways in which the self—the female self in particular—is constructed in visual culture.

In her breakthrough series of *Untitled Film Stills* (1977–80), Sherman impersonated young women acting in classic Hollywood and foreign films, films noirs, and B-movies from the 1940s to the 1960s. She also appropriated the format of actual film stills—the 8 × 10-inch, black-and-white photographic prints that studios produced to publicize their movies. She never imitated a specific film character, however, but devised costumes, poses, and settings that evoked roles and narrative situations withheld from the viewer, who can only imagine them. Many of the subjects in the *Untitled Film Stills* appear vulnerable or anxious, like the professionally dressed young woman in *Untitled Film Still No. 21* (1978, Figure 20.15), who is visually hemmed in by the tall buildings looming behind her in the low-angle shot. Sherman remarked of the series, "I suppose unconsciously . . . I was wrestling with some sort of turmoil of my own about understanding of women. These characters . . . were women struggling with something. . . . questioning something."[33]

Sherman's continually shifting self-presentation in a variety of patently artificial feminine roles made the *Untitled Film Stills* models of the postmodern feminist conception of gender as a performance—a manipulation of social and cultural codes rather than something natural or essential (a view advanced by philosopher Judith Butler). Following the *Untitled Film Stills*, Sherman during the 1980s explored constructions of the feminine subject in other visual discourses, ranging from pornography to fashion, fairy tales, horror movies, and **Old Master** paintings (also impersonating male characters in some of these latter works, e.g., *Untitled #201*, 1989). She now worked in color and made large, visually dramatic prints rivaling paintings in their impact—a trend seen generally in **fine art** photography during that decade.

FIGURE 20.15 Cindy Sherman, *Untitled Film Still No. 21*, 1978. Gelatin silver print, 18.7 x 23.9 cm. The Metropolitan Museum of Art, New York.

Public Art and Politics in the United States in the 1980s

Creating public art gives artists the opportunity to address a broad audience but exposes their work to criticism from members of the public who find their taste and interests challenged by the artwork. In a sense, every work of public art is a political statement—even if it makes no overt social or political commentary—because it conveys certain values that compete with others for dominance in society. This explains why public artworks, especially sited in prominent locations, or supported by public funding, often

become lightning rods for controversy. Abstraction, which has never achieved widespread acceptance among the American public, can be a factor in such controversies, as was the case with Maya Lin's *Vietnam Veterans Memorial* (1982, Figure 20.16), and *Tilted Arc* (1981) by Richard Serra, whose earlier work is discussed in Chapter 19.

Maya Lin (b. 1959): The *Vietnam Veterans Memorial*

Maya Lin was a twenty-year-old undergraduate architecture student at Yale when her proposal for a privately funded, Congress-authorized memorial to the US veterans of the Vietnam War on the National Mall in Washington, DC, was selected from among 1,412 entries in a public competition in 1981. Because Americans were bitterly divided about the war, which ended inconclusively, the design competition criteria stipulated that the memorial should be "reflective and contemplative" in character but make no political statement. Lin's design replaced the conventional classical architectural aesthetic of war memorials with modernist abstraction: it was a simple V-shaped polished black granite wall sunken into the ground, employing the vocabularies of **Land art** and **Minimalism**. The wall was to be engraved with the names of the Americans killed or missing in action in Vietnam, listed in chronological order (from the highest point at the center to the right corner of the V's right arm, and continuing from the left corner to the lowest point of the V's left arm). Visitors would read the names as they descended and ascended the walkways in front of the wall. Lin described the wall "not as an unchanging monument, but as a moving composition to be understood as we move into and out of it."[34]

When Lin's design was unveiled, its minimal aesthetic and lack of patriotic symbolism, its black color, and its sunken position offended some Vietnam veterans, conservative politicians, and commentators. One veteran decried it as "insulting to the sacrifices made for their country by all Vietnam veterans…. a black gash of shame and sorrow."[35] Opponents sought to change the wall's color to white and place a realistic sculpture of soldiers in front of it and an American flag at its apex. Lin protested that these modifications would violate her design's integrity. Through a compromise, the wall remained black and the bronze statue (by Frederick Hart) of three male servicemen and flag were installed nearby in 1984. A second bronze figurative group by Glenna Goodacre honoring American women who served (in noncombat roles) in Vietnam was added in 1993.

FIGURE 20.16　Maya Lin, *Vietnam Veterans Memorial*, 1982. National Mall, Washington, DC.

Lin's solemn memorial achieved widespread acceptance after its completion. The wall draws viewers in as they walk along it, immersed in the overwhelming sense of loss invoked by over 58,000 inscribed names while seeing themselves reflected in the polished granite—a symbolic encounter between the living and the dead. Through its reticence and evocation of absence rather than assertion of its own presence, Lin's memorial inverted the standard monumental strategy and provided a space for memory, mourning, and contemplation.

Richard Serra (b. 1939): *Tilted Arc*

Richard Serra's *Tilted Arc* (1981, Figure 20.17) was a 12-foot-high, 120-foot-long curving Cor-Ten steel wall leaning one foot off its vertical axis, installed on the Federal Plaza in New York City in 1981. A committee of art professionals selected Serra to receive the commission for the work, which was funded by the General Service Administration's (GSA) Art-in-Architecture Program. Serra described the sculpture as "a very slow arc that will encompass the people who walk on the plaza in its volume. . . . After the piece is created, the space will be understood primarily as a function of the sculpture."[36]

The employees who worked in the Federal Plaza buildings were not consulted before *Tilted Arc* was installed. Many of them detested the sculpture and petitioned for its removal, leading the GSA regional administrator to call a hearing in 1985 on the issue of relocating *Tilted Arc*. At the hearing, the sculpture's opponents attacked it as an oppressive eyesore that attracted urine and graffiti, blocked views, and prevented the plaza's use for concerts and other events. Serra and his art world supporters defended *Tilted Arc* by arguing that innovative art is often challenging

and that the work had been designed specifically for the Federal Plaza site, so that to relocate it would be to destroy it. The GSA panel decided against Serra, who sued the government to prevent *Tilted Arc*'s removal, and lost; *Tilted Arc* was dismantled in 1989. Serra denounced this outcome as government censorship, but to others, the *Tilted Arc* case raised the question of whether an artist should have the right to impose their taste and values on a resistant public. In the wake of the *Titled Arc* debacle, the GSA changed its procedures to require greater community involvement in the commissioning and design of public artworks.

Jenny Holzer (b. 1950)

In contrast to Lin and Serra who create large abstract public sculptures intended to be permanent, Jenny Holzer makes temporary public artworks employing language as their medium. Holzer's first series of texts, *Truisms* (1977–79), consists of alphabetical lists of statements resembling popular sayings, often with a critical, sinister, or cynical cast, for example: "ABUSE OF POWER COMES AS NO SURPRISE"; "ENJOY YOURSELF BECAUSE YOU CAN'T CHANGE ANYTHING ANYWAY"; "MONEY CREATES TASTE." Holzer initially disseminated the *Truisms* through printed posters she pasted on walls and windows in Lower Manhattan. She later circulated them on t-shirts, baseball caps, billboards, and electronic signboards. In 1982, selections from the *Truisms* flashed periodically on the giant Spectacolor board on Times Square (Figure 20.18), interrupting its usual display of advertisements.

Although Holzer invented them, the *Truisms* sound like well-known aphorisms. They exemplify a postmodern use of language that seems quoted rather than original—a verbal analogue to Cindy Sherman's *Untitled Film Stills*. Holzer's aphoristic style and anonymous voice create the illusion that each statement is commonly accepted as true. She undermined that effect, however, by riddling the *Truisms* with contradictions (e.g., "EVERYONE'S WORK IS EQUALLY IMPORTANT" and "EXCEPTIONAL PEOPLE DESERVE SPECIAL CONCESSIONS") and by pushing many of them beyond the edge of general acceptability (e.g., "STUPID PEOPLE SHOULDN'T BREED.").[37] In this way, Holzer, without taking a specific political position, sought to jolt viewers out of passive consumption of public pronouncements and advertisements and to think critically about their coercive power.

FIGURE 20.17 Richard Serra, *Tilted Arc*, 1981. Federal Plaza, New York.

Edgar Heap of Birds (b. 1954)

Like Jenny Holzer, Edgar Heap of Birds makes public artworks that employ language presented in a form mimicking signage—a postmodern appropriation of a format usually used for advertising or official communications. A Cheyenne and Arapaho artist, Heap of Birds's work confronts silenced or unacknowledged histories of genocide and dispossession of Native Americans by European settler colonists. It also seeks to remind non-Native viewers that Indigenous people have not vanished but continue to live alongside them. Heap of Birds's long-running series *Native Hosts* (begun 1988) consists of official-looking aluminum panels printed with texts bearing a greeting to a US state or territory or Canadian province from one of the tribes that lived or still lives there. One reads, "ARKANSAS/TODAY YOUR HOST/IS/OSAGE," with "ARKANSAS" printed backward, as if viewed in a mirror (Figure 20.19). The backward printing of the settler colonist-imposed name disrupts its legibility and throws its legitimacy into doubt. Prompting critical awareness that the United States and Canada were built on land stolen from Native peoples, Heap of Birds's panels symbolically reclaim the land for its original inhabitants.

Krzysztof Wodiczko (b. 1943)

Polish-born Krzysztof Wodiczko, who settled in New York in 1983, gained recognition in the 1980s for his politically charged video projections onto building **façades**, statues, and monuments. The projections transformed these structures

FIGURE 20.19 Edgar Heap of Birds, *Native Hosts* (one of seven aluminum panels), 2018. Crystal Bridges Museum of American Art, Bentonville, Arkansas.

into canvases for imagery that asks audiences to consider how public sites convey or hide contemporary truths relating to power and social and economic justice. For example, in his *Astor Building/New Museum* (1984), Wodiczko projected padlocked chains onto the dark floors surmounting the New Museum of Contemporary Art. These floors, renovated into apartments, were soon to welcome wealthy tenants while in the same neighborhood homeless people lived on the street. Wodiczko was acutely aware of the explosion of homelessness in New York in the 1980s, largely caused by widening income inequality and a lack of affordable housing for middle- and lower-class residents. In the late 1980s, he designed *Homeless Vehicles* in consultation with homeless people. The vehicles have the appearance of shopping carts that unfold to provide their homeless owners with compartments for sleeping, washing up, and storing their belongings and recyclables. While these vehicles served their users' needs, they were also intended to draw the attention of better-off city dwellers to the homeless, too often ignored, and urge those in power to take serious steps to solve the homelessness crisis.

Neo-Geo

Neo-Geo, shorthand for New Geometry or Neo-Geometric Conceptualism, was a label applied to a diverse group of artists who emerged in New York in the mid-1980s, including Ashley Bickerton, Ross Bleckner, Peter Halley, Jeff Koons, Allan McCollum, Haim Steinbach, Philip Taaffe, and Meyer Vaisman. Two distinct tendencies are seen within Neo-Geo. Some Neo-Geo artists made simulations of modernist geometric abstraction. Others appropriated objects, advertising imagery, and logos from contemporary consumer culture, following the example of Andy Warhol and other Pop artists. As a term, Neo-Geo best describes the visual qualities of the first kind of art. Commodity art is a more accurate descriptor for the second tendency.

A broader conceptual label applied to both tendencies is Simulationism, drawn from French poststructuralist philosopher Jean Baudrillard's use of the term "simulation." Baudrillard argued that in postindustrial, capitalist consumer society, images—disseminated through advertising, popular entertainment, and the mass media—have come to seem more real than reality itself, achieving "hyperreality." Such images are simulacra—simulations of the real, which is no longer directly accessible but is subsumed by signs. Applied to art, this theory replaces the modernist conception of the artist as a heroic creator of new, original realities with the postmodern conception of the artist as an appropriator and manipulator of ready-made artifacts and signifiers. Appropriation was the Neo-Geo artists' strategy. They seemed to accept that they could not escape

consumer society and could make art only by "shopping" for existing objects and images, which they turned into high-end products marketed to wealthy art collectors. While this approach could be construed as critical—an ironic embrace of consumerism intended to reveal its soullessness—it can also be seen as complicit with capitalism.

Allan McCollum (b. 1944) and Peter Halley (b. 1953)

The Neo-Geo artists McCollum and Halley adopted abstract modernist geometric painting's hard-edged shapes but drained them of the transcendental associations given to them by artists like Kazimir Malevich, Piet Mondrian, Barnett Newman, and Agnes Martin. McCollum in the early 1980s produced thousands of *Plaster Surrogates*—small, generic, rectangular cast plaster paintings, consisting of a black center, white mat, and painted frame (e.g., *Collection of Forty Plaster Surrogates*, 1982/84). Never identical but always hung in groups to emphasize their interchangeability, the *Plaster Surrogates* function as signs for paintings rather than paintings themselves. In their profusion, they evoke both mass production and the wealth and privilege that make the accumulation and display of art possible.

Peter Halley's 1980s paintings, such as *Two Cells with Conduit* (1987, Figure 20.20) feature squares or rectangles within fields of solid color and connected to or placed above thick lines. Halley's described the paintings as "diagrammatic" representations of cells (either physical or electronic) and conduits, such as circuits, telephone wires, or pipes for air and water. He laid down the cells with Roll-a-Tex, a synthetic stucco, and he painted with Day-Glo colors to produce "a kind of light that was technological ... and not natural."[38] Halley explained his use of geometry in postmodern terms. He rejected the mystical view of geometry held by artists like Mondrian and Newman, and the Minimalists' view of geometry as neutral. He argued that they all used geometry in their art to reconcile themselves to the "great geometric orderings of industrial society.... geometric structures in cities, factories, and schools, in housing, transportation, and hospitals," that controlled people to maximize their obedience and productivity—ideas Halley derived from Foucault's *Discipline and Punish*.[39] For artists of his generation, wrote Halley, Foucauldian "confinement" had been transformed into "Baudrillardian deterrence, in which the hard geometries of hospital, prison, and factory have given way to the soft geometries of interstate highways, computers, and electronic entertainment."[40] Halley's paintings employed the "digital space" of the simulacrum—a space "akin to the simulated space of the videogame, of the microchip, of the office tower."[41] Halley's vision was pessimistic; he simulated modernist abstraction but denied its utopian belief in art's power to transform society.

FIGURE 20.20 Peter Halley, *Two Cells with Conduit*, 1987. Day-Glo, acrylic, and Roll-a-Tex on canvas, two panels, 198.1 x 393.1 cm. Solomon R. Guggenheim Museum, New York.

Commodity Art: Haim Steinbach (b. 1944) and Jeff Koons (b. 1955)

The principal Commodity artists, Haim Steinbach and Jeff Koons, made sculptures that incorporated manufactured items in the tradition of the Duchampian **readymade**, sometimes including logos or brand names in the spirit of Pop art. Steinbach's mid-1980s works consisted of wedge-shaped, plastic laminate-covered wood shelves holding sets of objects he purchased himself and presented as art. Steinbach's shelves with their sleek geometric forms referred simultaneously to commercial display, streamlined home décor, and Donald Judd's Minimalist wall sculptures (see Figure 16.13). Steinbach chose the objects he placed on the shelves for their design, colors, and function, and he coordinated their colors with those of the shelves. For example, *supremely black* (1985), features two glossy black ceramic pitchers juxtaposed with three red boxes of Bold detergent (with black-lettered logos), set atop a shelf divided visually into red and black sections. *ultra red #2* (1986, Figure 20.21), features six digital alarm clocks displaying red numerals against black backgrounds; a tower of nine red enameled cast iron cooking pots; and four lava lamps filled with red colored oil, set on shelves covered with different shades of red plastic laminate. This creates a seductive overall aesthetic unity while inviting the viewer to imagine narrative relationships between the dissimilar consumer items. Steinbach's combinations of shelves and merchandise blurred distinctions between art-object-as-commodity and

commodity-as-art-object, leading to critical debates over whether he ironically criticized or celebrated consumer society.[42] The artist professed to feel both "fascination and revulsion" in relation to capitalism.[43] He mainly aimed to immerse himself in its culture and "do with objects ... what anyone can do ... which is to ... communicate through a socially shared ritual of moving, placing and arranging them."[44]

In the 1980s, Jeff Koons carefully selected categories of manufactured objects and used their forms as sculpture and their function and social meanings as subject matter.[45] Koons's sculpture series, *The New* (1980–86), consists of brand new vacuum cleaners and rug shampooers—isolated, stacked, or paired side by side within Plexiglas cases and lit by fluorescent tubes (e.g., *New Shelton Wet/Dry Double Decker*, 1981). The tiered plexiglass boxes and fluorescent fixtures evoke the Minimalism of Judd and Dan Flavin (see Figures 16.13 and 16.15), respectively. Separated from the everyday world and glamorously illuminated, the appliances seem to possess an almost holy aura, suggesting how brand-new commodities become fetishes in consumer culture. Koons explained this series as exploring "a psychological state tied to newness and immortality": the perpetually new appliances, though inanimate, were "in a position to be immortal."[46] He chose the vacuum cleaner "because of its anthropomorphic qualities. It is a breathing machine. It also displays both male and female sexuality. It has orifices and phallic attachments."[47] Vacuum cleaners function to suck up

FIGURE 20.21 Haim Steinbach, *ultra red #2*, 1986. Plastic laminated wood shelf; six plastic and metal digital clocks; nine enameled cast iron pots; four glass, metal, and oil Lava Lamps, 165.1 x 193 x 48.3 cm. Solomon R. Guggenheim Museum, New York.

dirt, but Koons preserves them in a clean and orderly state that he associated with "economic security."[48]

Koons's next series, *Equilibrium*, featured sculptures comprised of new Spalding and Wilson basketballs (one, two, or three) floating in aquarium-like vitrines half or completely filled with water (e.g., *Three Ball 50/50 Tank (Two Dr. J Silver Series, One Wilson Supershot)*, 1985, Figure 20.22). The series also included sculptures of floatation devices such as an inflatable lifeboat and aqualung, meticulously cast in bronze, and framed posters advertising Nike basketball shoes starring NBA players, mostly Black. Koons said that the series dealt with "states of being that really don't exist, like the fish tank with a ball hovering in equilibrium, half in and half out of the water. This ultimate or desired state is not sustainable: Eventually the ball will sink to the bottom of the tank."[49] The bronzes also suggested unattainable equilibrium; they would not save users

from drowning but would drag them under. Koons called the Nike posters "the Sirens—the great deceivers, saying 'Go for it! I have achieved it. You can achieve it, too!'"[50] He saw the basketball stars "as representing the artists of the moment, and the idea that we were using art for social mobility the way other ethnic groups have used sports. We were middle-class white kids using art to move up into another social class."[51]

Koons engaged with issues of class and taste in his 1988 sculpture series, *Banality*. He had cute, gift-shop style animals and figures—sometimes combined with images appropriated from popular visual culture or high art—enlarged and remade in porcelain or **polychromed** wood in limited editions by master European craftspeople. One wood sculpture, *Ushering in Banality* (1988), depicts a large pig with a green ribbon around its neck, accompanied by two blond cherubs in yellow and blue robes and being pushed from behind by white boy in red and

black ski clothing—Koons's surrogate self-portrait. Koons monumentalized imagery associated with middle-class taste that many in the elite art world considered kitsch. He claimed to do this not ironically but in a spirit of generosity, seeking to liberate his audience from any sense of guilt about enjoying sentimentality. "I wanted to make works that just embraced everybody's own cultural history and made everybody feel that their history was perfect just the way it was," said Koons.[52] He sounded very much like Andy Warhol, who declared that Pop art was about "liking things." So, too, were Koons's sculptures that celebrated banality.

Rosemarie Trockel (b. 1952)

Like the American Neo-Geo artists, German artist Rosemarie Trockel produced geometric compositions that simulate modernist abstraction in the mid-to-late 1980s. Trockel's works took the form of framed rectangular "pictures" comprised of patterns of appropriated texts, logos, symbols, or abstract shapes, fashioned of knitted wool. Trockel had a feminist intent in using a medium and technique traditionally devalued in the male-dominated Western art world because of their association with women's domestic craft. She sought to take these "signifiers of the feminine, culturally inferior materials and skills such as wool and knitting" and see "whether it is possible to overcome the negative cliché by eliminating the handicraft aspect from the whole complex."[53] She did this by having her pictures knit by a computer-programmed machine, linking them to industrial capitalism. This connection is overtly expressed in *Untitled (Made in Western Germany)* (1987, Figure 20.23), which from a distance appears to be a dark monochrome painting but upon close viewing reveals the words "MADE IN WESTERN GERMANY" repeated in a pattern filling its entire surface. Trockel reinforced her knitted pictures' association with capitalism by using patterns of commercial logos or icons such as the Playboy bunny and the Marlboro cowboy in some of them. In others, she employed political symbols including the swastika and the

FIGURE 20.22 Jeff Koons, *Three Ball 50/50 Tank (Two Dr. J Silver Series, One Wilson Supershot)*, 1985. Glass, painted steel, distilled water, plastic, and three basketballs, 154 x 123.9 x 33.6 cm. The Museum of Modern Art, New York.

hammer and sickle. Her professed attitude toward these logos, icons and symbols was one of "depreciation":[54] by deploying them as decorative patterns in simulated abstractions, she subverted their value as propaganda for consumer products and political ideologies.

Late Modernist Painting and Sculpture

Despite the widespread pronouncements of the death of modernism by postmodern artists and critics, many European and American artists working in the late 1970s and 1980s retained the modernist belief in the possibility of personal expression through formal innovation. Their work is sometimes labeled Late Modernist to indicate that it was

FIGURE 20.23 Rosemarie Trockel, *Untitled (Made in Western Germany)*, 1987. Wool, 250 x 180 cm. The Museum of Modern Art, New York.

emphasizing painting as an active creative process—a legacy of Abstract Expressionism.

Among the most original American abstract painters of the 1980s was Elizabeth Murray (1940–2007). She stretched her canvases over massive eccentrically shaped three-dimensional plywood supports and covered their surfaces with vibrantly colorful, playfully abstracted figures and familiar objects. She drew formal inspiration from both "high" modernist art and "low" popular culture: **Cubist**-style fragmentation, **Fauvist** color, Surrealist **biomorphism**, and gestural Abstract Expressionist paint handling, on the one hand, and cartoons and animated films, on the other. Murray's depicted objects often seem alive, like the lemon yellow table set against a deep blue background in *Things to Come* (1988, Figure 20.24). The table appears to morph into a windblown dress along the bottom edge of the curved, twisting canvas, assuming an anthropomorphic quality. Cartoon-style liquid drops squirt from the snaking segmented table legs and from an oval opening in its lower center, evoking tears or urine. Murray's use of organic shapes, sensuous forms, and cut-open interiors led some critics to suggest that she was concerned with exploring women's bodily experience, but the artist saw her work as androgynous. "Art is about the male and female components in all of us. Art is sexy, but it doesn't have sex."[56]

Late Modernist figurative sculptors who achieved international prominence in the 1980s include Magdalena Abakanowicz (1930–2017) and Antony Gormley (b. 1950). Abakanowicz created headless, half-hollow seated and standing figures cast in burlap and resin (e.g., *Androgyne III*, 1985). Presented singly or in regimented groups, they often suggest dehumanized victims of imposed conformity such as Abakanowicz herself experienced in Poland under the Nazis and Communists. She rejected narrow political readings of her work, however, insisting, "Everything I do is about the human condition."[57] The Englishman Gormley aimed for a similar interpretative open-endedness in sculptures he created using his naked body as a matrix for plaster molds, reinforced with fiberglass and encased in smoothly hammered shells of soldered lead to project a mummy-like presence (e.g., *Untitled [for Francis]*, 1985). His goal was to make figures that corresponded to his individual experience while also inviting the viewer to project their own thoughts and feelings onto them.

Martin Puryear (b. 1941) and Anish Kapoor (b. 1954) gained renown in the 1980s for their elegant, allusive abstract sculptures. The British Kapoor used such materials as wood, plaster, cement, and polystyrene to fashion forms inspired by geometry, architecture, nature, and the human body (e.g., *As if to Celebrate, I Discovered a Mountain Blooming with Red Flowers*, 1981). He gave his forms a sensuous, tactile quality by covering them with brilliant powdered **pigments**, mostly the **primary colors**, used in rituals in his native India. He

made after modernism's mid-twentieth-century heyday but perpetuates its values.

Exemplary of Late Modernism are the large abstract paintings of the Irish-born, US-based Sean Scully (b. 1945) and the American Terry Winters (b. 1949). Scully in the 1980s composed his paintings out of roughly applied, thickly layered broad bands of rich color organized into alternating vertically and horizontally oriented blocks (e.g., *Round and Round*, 1985). Scully shared with Mark Rothko, one of his chief inspirations, the modernist view of abstraction as a vehicle of spiritual expression; he described abstraction as "a non-denominational religious art the spiritual art of our time."[55] Winters's paintings of the 1980s feature abstracted images of cell clusters, seeds, pods, leaves, shells, and anatomical cross-section illustrations, floating against loosely brushed grounds (e.g., *Theophrastus' Garden*, 1982). His motifs evoke organic life and nature's cycle of birth, growth, and decay. He employed multiple techniques, including slathering, scumbling, erasing, and firm drawing,

placed his sculptures on the floor in small groups to suggest symbolic relationships between them, but their meanings remain enigmatic. (Kapoor's later work is discussed in Chapter 22.) Puryear, an African American artist inspired by traditional African carpentry and versed in Scandinavian word-working techniques, worked primarily in wood in the late 1970s and early 1980s. He joined pieces of wood together either to produce monolithic closed forms, like the black-stained and painted *Self* (1978), or open structures like *Bower* (1980, Figure 20.25), a graceful construction of fanning bentwood slats. Typical of Puryear's sculptures, *Bower*'s eloquent abstract form evokes a range of associations, including the section of a nautilus shell, an aircraft wing skeleton, or a pleasant place to shelter under trees or climbing plants (the definition of "bower"). Its shape also suggests a recurring reference in Puryear's art: the Phrygian cap, an emblem of liberty in the American and French Revolutions and a signifier of abolitionism in the nineteenth century.

FIGURE 20.24 Elizabeth Murray, *Things to Come*, 1988. Oil on canvas, 292.1 x 287.02 x 68.58 cm. San Francisco Museum of Modern Art.

American Art and the AIDS Crisis

AIDS (acquired immune deficiency syndrome) is a disease caused by a virus, HIV (human immunodeficiency virus), transmitted through blood, semen, breast milk, and other bodily fluids. Researchers first identified AIDS in the United States in 1981 among homosexual men and among intravenous drug-users who shared contaminated needles; it disproportionally affects gay and bisexual men. Conservative groups during the 1980s and 1990s associated AIDS with drug addiction or sexual behavior they considered immoral. The Reagan administration responded slowly and ineffectually to the pandemic, which claimed over 89,000 American lives between 1981 and 1989. AIDS took a devastating toll on the American art world, killing such talented artists as Scott Burton, Felix Gonzalez-Torres, Keith Haring, Peter Hujar, Robert Mapplethorpe, Paul Thek, and David Wojnarowicz.

Beginning in the mid-1980s, American artists responded to the AIDS crisis through artworks whose emotional tenor spanned the spectrum from sorrow to rage. Ross Bleckner made paintings of spectral candelabras, vases, and chandeliers floating against dark backgrounds—elegies for friends and colleagues lost to AIDS. Robert Gober sculpted **enamel**-painted plaster sinks with faucet and drain openings but no fixtures or running water—dysfunctional emblems of helplessness against the epidemic. Nan Goldin took intimate photographs of friends affected by HIV while photographer Nicholas Nixon, in his series *People with AIDS*, documented the progressive decline of fifteen men

FIGURE 20.25 Martin Puryear, *Bower*, 1980. Sitka spruce, pine, and copper tacks, 163.3 x 240.2 x 66.0 cm. Smithsonian American Art Museum, Washington, DC.

"SILENCE = DEATH." Gran Fury, a group allied with ACT UP, addressed fear and misinformation about AIDS through public artworks employing the visual conventions of advertising—a political strategy also used by other 1980s artists such as Jenny Holzer and Barbara Kruger. Gran Fury's best-known work, displayed on New York City buses under the sponsorship of Creative Time, appropriated the style of a Benneton clothing ad to show three interracial same- and opposite-sex couples kissing beneath the caption, "Kissing Doesn't Kill: Greed and Indifference Do" (Figure 20.26). AIDS activism helped to speed research that in 1996 yielded an antiretroviral therapy that greatly lengthened the lifespan of people with AIDS.

The most ambitious artistic response to the epidemic is the NAMES Project AIDS Memorial Quilt. Begun in San Francisco in 1985, the quilt consists of three-by-six-foot panels (the size of a grave), each naming and commemorating its subject through imagery or personal items like photographs and articles of clothing. When first publicly displayed on the National Mall in Washington, DC, in 1987, the AIDS Memorial Quilt comprised 1,920 panels. As of 2022, it numbered over 50,000. The National AIDS Memorial now administers the quilt, as part of its work to preserve the memory of lives lost to AIDS, and to "inspire new generations of activists in the fight against stigma, denial, and hate, for a just future."[58]

suffering from the disease. Keith Haring and Masami Teraoka authored artworks that advocated safe sex to prevent the spread of HIV: Haring made cartoon-style images of men masturbating each other while Teraoka appropriated the style of *ukiyo-e* prints for witty watercolors showing geishas opening condom packages. David Wojnarowicz made bitterly angry text-and-image works indicting conservative politicians, healthcare officials, and the religious right for "murder" of people with AIDS.

Artists also participated in collective activism urging faster governmental and pharmaceutical industry action in finding effective AIDS treatments, and protesting the Catholic Church's opposition to condoms. The activist group ACT UP (AIDS Coalition to Unleash Power) raised consciousness through its logo, a pink triangle surmounting the text

The Culture Wars in the United States

The late 1980s and early 1990s witnessed intense battles over freedom of expression and public funding for the arts in the United States—episodes in the ongoing "culture wars" pitting

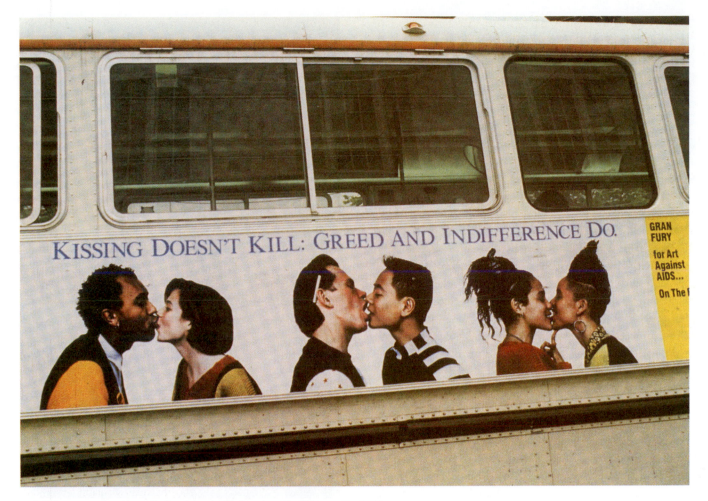

FIGURE 20.26 Gran Fury, *Kissing Doesn't Kill: Greed and Indifference Do*, 1989.

conservative against liberal forces. These battles centered on the National Endowment for the Arts (NEA), established in 1965 to support and fund the arts in the United States. NEA financial support of the work of two photographers—Andres Serrano (b. 1950) and Robert Mapplethorpe (1946–89)—outraged conservatives who protested the expenditure of taxpayer money on art they found offensive.

Serrano received a $15,000 award from the Southeastern Center for Contemporary Art (SECCA), an institution partially funded by the NEA. His color photograph, *Piss Christ* (1987, Figure 20.27), showing a dramatically lit plastic crucifix submerged in the artist's urine, was included by SECCA in a 1988–89 traveling exhibition. Serrano was raised Catholic and did not intend *Piss Christ* to be blasphemous but as a protest against the commercialization of sacred imagery.[59] However, Rev. Donald Wildmon, president of the American Family Association, denounced the photograph as "hate-filled, bigoted, anti-Christian, and obscene."[60] At Wildmon's urging, his followers flooded Congress with letters of complaint, and Republican politicians quickly joined the fight. In May 1989, Sen. Alfonse D'Amato tore up the exhibition

catalogue containing *Piss Christ* on the Senate floor, declaring, "This is an outrage, and our people's tax dollars should not support this trash."[61]

Congressional conservatives simultaneously targeted *Robert Mapplethorpe: The Perfect Moment*, a traveling exhibition originated by Philadelphia's Institute of Contemporary Art partially funded by a $30,000 NEA grant, because the show included homoerotic and sadomasochistic images and a few pictures of children with exposed genitals (commissioned by their parents). Mapplethorpe's elegantly composed and gorgeously printed black-and-white erotic photographs were intended to represent sexual desire from a gay perspective, but Sen. Jesse Helms called them "pornography" and "sick."[62] In June 1989, Christina Orr-Cahall, the director of the Corcoran Gallery of Art in Washington, DC, sought to remove her institution from the political fight over the NEA by canceling its showing of the Mapplethorpe exhibition—a move widely condemned by the contemporary art and LGBTQ communities. In April 1990, after *The Perfect Moment* opened at the Cincinnati Contemporary Arts Center (CAC), prosecutors charged the museum

and its director, Dennis Barrie, with pandering obscenity. A jury acquitted Barrie and the museum, affirming that Mapplethorpe's photographs were artistic expression protected by the First Amendment.

In July 1989, Congress punished the NEA by cutting its $171 million budget by $45,000—the amount awarded to Serrano and to the Mapplethorpe exhibition. The next year, Congress amended the NEA's guidelines to require it to take into consideration "general standards of decency and respect for the diverse beliefs and values of the American public" in awarding grants. This "decency clause" was quickly challenged in federal court on First Amendment grounds by Karen Finley, John Fleck, Holly Hughes, and Tim Miller, performance artists who were denied grants for their provocative work dealing with queer sexuality or violence against women. Although the lower courts sided with the "NEA Four," the US Supreme Court in 1998 upheld the decency clause's constitutionality because it was "advisory" and not direct governmental regulation of speech. During the years of this legal battle, pressure from the Republican-controlled House of Representatives led to restructuring of the NEA and a 40 percent cut to its budget in 1996. Grants to individual artists in all areas except literature, jazz, and folk music were also abolished, making it impossible for controversial visual and performance artists to receive direct government funding. Continuing conservative opposition to public funding for the arts found expression in President Donald Trump's annual budget proposals calling for the elimination of the NEA; Congress preserved the agency and approved modest increases to its budget, which remains a tiny fraction of overall government spending.

FIGURE 20.27 Andres Serrano, *Piss Christ*, 1987. Cibachrome print, 152.4 x 101.6 cm.

Recent Architecture: From Postmodernism to Green Design

This chapter tracks major shifts in late modern and contemporary architecture from Postmodernism to sustainability in design. The 1960s saw the emergence of a new approach to architecture that reacted to the perceived failures of the International Style (see Chapter 17), the dominant modernist architectural mode since the 1930s. This reaction, known as Postmodernism, originated in the United States and quickly spread across the industrialized world. The International Style rejected references to historical architecture and promoted an abstract, machine-age aesthetic of smooth planes and geometric volumes of unadorned concrete, steel, and glass. Conversely, Postmodernist architecture revived elements of historical styles and often mixed them playfully with vernacular forms, using strategies of appropriation and pastiche like those seen in other forms of postmodern visual art (see Chapter 20) to produce disjunctions and ambiguities. Many Postmodernists designed buildings that responded to and incorporated references to their site's history and the specific needs of the building's users instead of aspiring to the International Style goal of a rationally planned architectural environment supposed to improve society through standardized, universal designs.

While Postmodern architects viewed International Style modernism as just another historical code that they could cite in their designs, others who emerged contemporaneously, such as Richard Meier, revived and extended International Style aesthetics to produce a form of Neomodernism. In South Asia, Balkrishna Doshi, Charles Correa, and Geoffrey Bawa created a Tropical Modernism, designing buildings that merged Western modernism and historic building traditions of their own countries without the Postmodernists' ironic distance. Other architectural trends appearing alongside or in the wake of Postmodernism were High Tech and Deconstructivism. The former exposes advanced structural engineering and mechanical systems to produce a strongly technological image. The latter draws on early twentieth-century avant-garde sources, such as Futurism, Suprematism, and Constructivism, to generate effects of disunity and disorientation. Alongside these trends, architects have become more concerned with creating sustainable designs that do not further degrade the environment, waste precious natural resources, or contribute to global warming. This chapter concludes by considering examples of sustainable or "green" architecture addressing the challenges humanity has created for itself in the age known as the Anthropocene.

Postmodern Architecture

Young members of CIAM (or the International Congress of Modern Architecture, a bastion of the **International Style**) planted the seeds of **Postmodernism** when they questioned the group's principles at the Congress's 1959 meeting, resulting in the organization's dissolution. These young architects, who called themselves Team Ten, included England's Ralph Erskine and Alison and Peter Smithson, and Aldo van Eyck from the Netherlands. They worked in different

styles but all opposed **modernist** designs based on rationalism rather than human users' needs. For example, Erskine's design for Byker Wall Housing (1969–75) in Newcastle-upon-Tyne responded to suggestions solicited from its future residents: he gave the housing block's north side, facing a proposed highway, a fortress-like **façade** and its south side, opening onto greenery, multicolored wood-lattice balconies.

By the mid-1960s in the United States, a backlash set in against the stripped-down International Style boxes of concrete, steel, and glass that many saw as monotonous, indifferent to their physical surroundings, and even inhumane. Exemplary of this, the Pruitt-Igoe housing complex in Saint Louis, Missouri, came to symbolize International Style public housing's failures. Designed in 1950 by the Japanese American modernist Minoru Yamasaki (subsequently responsible for New York's World Trade Center), this ensemble of thirty-three eleven-story high-rise apartment buildings surrounded by greenspace followed Le Corbusier's utopian Ville Radieuse (Radiant City) concept (see Chapter 17). However, the federal agency that commissioned Pruitt-Igoe used cheap construction materials and fixtures, resulting in shoddy quality. Furthermore, when Pruitt-Igoe's white residents abandoned the complex (designed as segregated housing), the remaining lower-income Black occupants endured increasingly squalid conditions as building maintenance was neglected and crime and vandalism surged. The city's decision to clear out the remaining residents and demolish Pruitt-Igoe by dynamite in 1972 created a potent image of modernism's failed utopian dreams.

In the decade before Pruitt-Igoe's destruction, numerous books criticizing the Modern Movement expressed changing attitudes that would shape subsequent architectural developments. Jane Jacobs's *The Death and Life of Great American Cities* (1961) attacked Le Corbusier's modernist urban renewal principles that replaced vibrant and diverse neighborhoods with spiritless high-rise blocks. Hasan Fathy, who used traditional earthen construction techniques, argued in *Gourna: A Tale of Two Villages* (1969) that Western modernism did not offer viable solutions for housing needs in developing countries like Egypt. Aldo Rossi, in *The Architecture of the City* (1966), argued that cities were organic collections of building types rooted in specific histories and embodying collective memories and proposed that new buildings should continue local traditions, not break with them in modernist fashion.

Most consequential for the formation of American Postmodern architecture was Robert Venturi's *Complexity and Contradiction in Architecture* (1966). Enthralled by the sophistication of historic architecture, which he studied during two years at the American Academy in Rome, Venturi opposed orthodox modernism's idealization of simplicity over diversity. Countering Mies's dictum, "less is more," Venturi declared, "less is a bore."[1]

I like elements which are hybrid rather than "pure," compromising rather than "clean," distorted rather than "straightforward," ambiguous rather than "articulated" … conventional rather than "designed," accommodating rather than excluding … inconsistent and equivocal rather than direct and clear. I am for messy vitality over obvious unity. I include the non sequitur and proclaim the duality…. I prefer "both-and" to "either-or."[2]

Venturi illustrated his book with buildings by **Renaissance**, Mannerist, and **Baroque** architects who used **classical forms** with cleverness and ambiguity, as well as images of the work of Le Corbusier, Aalto, and Kahn to demonstrate these qualities even within modernism. Venturi also embraced the contemporary urban vernacular environment's "messy vitality," celebrating the vulgarity of the US commercial strip and advertising signage in *Learning from Las Vegas: The Forgotten Symbolism of Architectural Form* (1972), coauthored with Denise Scott Brown and Steve Izenour.

Against purified International Style **abstraction**, Venturi proposed a hybrid, playful architecture built through modern construction techniques while incorporating references to both historical styles and the contemporary **vernacular** environment. In semiotic terms (see "Semiotics" box, Chapter 4), such "both-and" buildings employed multiple signifiers to signify on multiple levels to different audiences. Architectural professionals could discern the buildings' sophistication and wit while the public could appreciate their familiar aspects drawn from history and popular culture. This "both-and" semiotic quality is reflected in critic Charles Jencks's definition of Postmodernism in architecture as "double coding: the combination of Modern techniques with something else (usually traditional building) in order for architecture to communicate with the public and a concerned minority, usually other architects."[3]

Robert Venturi (1925–2018) and Venturi, Rauch, and Scott Brown

Robert Venturi designed a house for his mother in his native Philadelphia embodying the qualities of complexity and contradiction promoted in his 1966 book. The Vanna Venturi House (1959–64, Figure 21.1) is a sophisticated parody of a conventional suburban US home. The seeming symmetry of its **gabled** and stuccoed façade is contradicted by the different window patterns on either side of the recessed entrance porch. The ribbon window at the right is a winking reference to that element's prevalence in the International Style (see Figure 17.1). A split in the gable alludes to a broken pediment—a feature of Mannerist and Baroque architecture—and reveals a window in what initially appeared to be a massive chimney, whose actual width is shown by its extension above this false chimney wall. The "inconsistent and equivocal" qualities extend to the

FIGURE 21.1 Robert Venturi, Vanna Venturi House, 1959–64. Philadelphia.

house's sides and rear, each with a different design, and to the compact interior. Among the interior's oddities are a staircase that widens and then narrows as it passes behind the chimneystack to a second-floor bedroom, and another staircase that leads nowhere. The ordinary imagery and deadpan humor of the Vanna Venturi House, similar in spirit to Warhol's and Lichtenstein's contemporaneous **Pop** paintings, were as shocking to the modernists as was Le Corbusier's Villa Savoye to the academic architects of his day.

In 1967, Venturi welcomed his new wife Denise Scott Brown (b. 1931), a former student of Louis Kahn, to the firm he had formed with John Rauch. Scott Brown became Venturi's equal creative partner and felt slighted by the male-dominated architectural establishment when Venturi alone received the Pritzker Prize, the profession's highest honor, in 1991. She did win several prestigious awards later, many independent of Venturi. After architectural Postmodernism became fashionable in the 1970s, Venturi, Rauch, and Scott Brown (VRSB) received major commissions, including for the Sainsbury Wing of the National Gallery in London (1985–91, Figure 21.2). Set on the northwest corner of Trafalgar Square, the wing's principal façade plays off the nineteenth-century **Neoclassical** design of the adjoining main building: the Sainsbury façade is faced with the same pale Portland limestone, continues the **cornice** line at the same height, and uses the same order of Corinthian

pilasters. The pilasters' progression, however, differs as they are bunched accordionlike in the east corner, then spaced more broadly as they move west, terminating in a single engaged fluted **column** that imitates the monument to Lord Nelson in the square. The façade then shifts on a diagonal and opens into a grid of modern-looking windows.

The other façades continue the theme of inconsistency with brick facing on the west and a glass-and-steel wall on the east illuminating a grand staircase leading to the Renaissance paintings galleries. Taking their cue from the fifteenth-century Florentine architect Filippo Brunelleschi, VRSB gave these galleries oak floors, light gray plaster walls, and Tuscan sandstone **moldings** to create a serene environment bathed in a mechanically controlled mixture of artificial and natural light descending from **clerestories**. Critics hostile to Postmodernism lambasted the Sainsbury Wing's exterior—one called it "a camp joke, pretentious architectural rubbish and an insult to London"[4]—but its dignified galleries are generally deemed highly successful.

Charles Moore (1925–1993)

The playful Postmodern use of classical allusions seen in the Sainsbury Wing is more flamboyant in Charles Moore's Piazza d'Italia in downtown New Orleans, Louisiana (Figure 21.3, 1975–79). In a provocative 1965 essay, Moore identified Disneyland as

FIGURE 21.2 Venturi, Rauch, and Scott Brown (VRSB), Sainsbury Wing of the National Gallery, 1985–91. London.

California's most exciting and memorable public space, and Disneyland's patently artificial but genuinely festive spirit pervades the Piazza d'Italia.[5] Moore designed it in collaboration with Perez and Associates as a gathering place for the city's Italian American community, especially on the feast day of Saint Joseph.

The piazza surrounds the visitor with symbolism and classical motifs meant to evoke its principal audience's Italian roots and collective memories. The circular piazza is open on the west and enclosed at the east by a series of curving **trabeated** screens, each painted in Pompeiian reds, yellows, and blues and incorporating columns in the Classical orders, some with stainless steel **capitals**. Extending from the east is Saint Joseph's Fountain, whose waters surround an image of Italy's "boot" rising in steps from the pavement, with Sicily, ancestral home of most of New Orleans's Italian American families, at the piazza's center. Colored neon lights illuminate the central **triumphal arch**, creating a gaudy, commercial effect at night. Whimsical touches abound, including two masks of Moore's smiling face serving as waterspouts. While some critics denounced Moore's design as a kitschy stage set, the architect defended it as a sincerely joyful expression of Italian cultural pride. Even as a Postmodern construct, the Piazza d'Italia possesses a distinctive sense of place that refreshingly counters the monotony of corporate modernism.

Philip Johnson (1906–2005)

No one did more to make Postmodernism respectable among corporate clients than Philip Johnson, who, with his partner John Burgee (b. 1933), won the commission to build a new Postmodern skyscraper headquarters for the American Telegraph and Telephone Company (AT&T) in Manhattan (1978–84, Figure 21.4). Johnson started his career in the 1930s as the MoMA architecture curator. After study at Harvard in the early 1940s he produced designs strongly influenced by Mies van der Rohe, with whom he collaborated on the Seagram Building (see Figure 17.13). Johnson's work remained largely **abstract** until the AT&T Building, whose design caused a sensation when it was unveiled in a 1978 model and drawings. The pink granite-clad building's main street-level

FIGURE 21.3 Charles Moore, Piazza d'Italia, 1975–79. New Orleans.

façade has an arched opening and flanking loggia inspired by Brunelleschi's Pazzi Chapel, emphasizing the ground floor as a public space. With a broken pediment crowning the soaring 197-meter shaft, the overall **composition** drew comparisons to an eighteenth-century Chippendale tall clock or high chest of drawers. Johnson denied intending the Chippendale reference,[6] but it endures in writings about the building and in the public imagination as an emblem of architectural Postmodernism.

Michael Graves (1934–2015)

The first major US public building erected in the Postmodern style was Michael Graves's Portland Public Services Building (1978–82, Figure 21.5), in Portland, Oregon. Graves worked in an abstract Le Corbusier-influenced Neo-modernist style until the late 1970s when he began admitting traditional architectural features such as columns, arches, doors, and windows into his buildings. In Postmodern fashion, he represented these elements as simplified forms that function

FIGURE 21.5 Michael Graves, Portland Public Service Building, 1978–82, before 2015–20 renovation. Portland, Oregon.

FIGURE 21.4 Philip Johnson and John Burgee, AT&T Building, 1978–84. New York.

as signs (see "Semiotics" box, Chapter 4). Graves applied such signs to the exterior of the cubic, fifteen-story Portland Building, which resembles a giant toy assembled from colorful building blocks. He gave the principal façade cream-colored sides punctuated by grids of small square, blue-tinted windows and a colossal earthen red "keystone" overlaying the top four stories. Below the "keystone" are two maroon "pilasters" whose "fluting" was formed by vertical strips of blue mirror glass. The pilasters are capped by chunky maroon "impost blocks" possessing actual **volume** in contrast to the two-dimensionality of the rest of the façade. Similar "pilasters" on the sides of the building are surmounted by flattened and stylized green "garland swags." Exemplary of Postmodern "double-coding," these simplified forms were meant to appeal to the public as colorful geometric decoration while being recognized by professionals as clever quotations of classical motifs. Although friendly critics hailed the Portland Building as a refreshing triumph, tenants disliked it due to poor interior air quality; gloomy, cramped offices; and water leaks. A $195 million renovation completed in 2020 included new air circulation systems, replacement of tinted with clear glass to improve internal lighting, and overcladding the cream-painted concrete exterior in cream-painted aluminum

to solve leaking problems. These changes made the building more functional and ensured its continuing viability.

James Stirling (1926–1992)

The British architect James Stirling, one of numerous Europeans who worked in historicizing Postmodern modes in the 1970s, created an iconic building in that style with his Neue Staatsgalerie (New State Art Gallery) in Stuttgart, Germany (1977–84, Figure 21.6). Stirling made his reputation as a modernist using dramatically composed hard-edged industrial forms in brick, tile, metal, glass, and exposed concrete, as in his Engineering Laboratories at Leicester University (1959–63). Commissioned to create an extension to the old Staatsgalerie, a handsome nineteenth-century Neoclassical building, Stirling, in partnership with Michael Wilford, sought to harmonize the new wing with the old by incorporating classical elements but added other historical references in free-wheeling Postmodern fashion.

Working on a sloping site hemmed in by a highway below and a street above, Stirling gave the Neue Staatsgalerie a ramped, terraced composition reminiscent of the ancient Egyptian funerary temple of Queen Hatshepsut and the Sanctuary of Fortuna Primigenia outside Rome. However, he clad the building in alternating sandstone and travertine bands that evoke **polychrome** medieval Italian buildings. The exhibition spaces have a U-shaped **plan** repeating that of the original building and wrap around a central open-air sculpture court, the negative image

of the domed rotunda of Karl Friedrich Schinkel's Neoclassical Altes Museum in Berlin. The lower façade balances these historical allusions with undulating glass walls framed in bright green metal and tubular blue and magenta metal railings that nod to the Pompidou Center's colorful **High Tech**. The ramps leading from the lower sidewalk to the upper terraces and spiraling around the rotunda to the street above evoke the famous ramped "architectural promenade" of Le Corbusier's Villa Savoye (see Figure 17.1). Stirling's masterful integration of these diverse elements created what one critic called a "visual tour de force" that is "in every way more spectacular" than the adjoining old Staatsgalerie, "while still demonstrating respect for it."[7]

Arata Isozaki (b. 1931)

Critics have described Japanese architect Arata Isozaki as a Postmodernist due to the heterogeneity of his work, which dissolves high modernism's aesthetic purity into an assembly of diverse historical and cultural references, both Japanese and Western. A student of Kenzō Tange and loosely affiliated with the Metabolists (see Chapter 17), Isozaki proposed new housing for overcrowded Tokyo in the form of Clusters in the Air (1960–62): a **megastructural** forest of cylindrical service towers ("trunks") supporting **cantilevered** "branches" to which modular units ("leaves") would be attached, permitting expansion and reorganization. The design was futuristic but also evoked the Japanese past: the towers and their extensions recall the wooden posts and *sashihijiki* (bracket arm structures) of Buddhist temples such as Todai-Ji in Nara.

In the later 1960s and early 1970s, Isozaki used an open, gridded treatment of **mass** and space in buildings culminating in the Gunma Prefectural Museum of Fine Arts (1971–74), based on a modular cubic framework potentially capable of infinite expansion, like a Sol LeWitt open cube (see Figure 19.3). He then turned to explore the barrel vault, the most prominent feature of his Fujimi Country Clubhouse (1973–74, Figure 21.7). Seen from the air it resembles a question mark, as if to embody the common inquiry, "Why do the Japanese love golf so much?" In addition to serving a sport imported to Japan by British expatriates in the early twentieth century, the building draws on Western architectural sources:

FIGURE 21.6 James Stirling, Neue Staatsgalerie, 1977–84. Stuttgart, Germany.

FIGURE 21.7 Arata Isozaki, Fujimi Country Clubhouse, 1973–74. Oita, Japan.

the ancient Romans first used the barrel vault extensively, and Isozaki adapted the **porte-cochère**'s elevation from Palladio's Villa Poiana. The design, however, also has a Japanese basis. Isozaki said its question mark shape arose spontaneously as he drew pen studies for the building, relating its fluid curves to the Japanese art of **calligraphy**.[8] Furthermore, the copper-clad barrel vault's domination of the exterior is characteristic not of Western architecture but of the prominence given to roofs in traditional Japanese buildings.[9]

Late Modernism

In contrast to their Postmodern contemporaries, Late Modernist architects have continued to employ the Modern Movement's abstract aesthetic to achieve distinctive forms of expression, often drawing inspiration from such earlier masters as Wright, Le Corbusier, and Kahn.

Tadao Andō (b. 1941)

One of the most successful contemporary Japanese architects, Osaka-based Tadao Andō educated himself in architecture through extensive travel studying buildings in Japan, Europe, the United States, and Africa. Inspired by Le Corbusier's and Kahn's late work, he developed a refined, introspective minimalist style using smooth reinforced concrete walls cast directly from the formboards. His other main material is light, admitted through windows and openings between walls. The sanctuary of Andō's remarkable Church of the Light (1989), built in the Osaka suburb of Ibaraki for the United Church of Christ in Japan, is a simple concrete box whose east wall is cut open in a **glazed** cruciform shape through which the sun shines to create a cross. Devoid of other religious symbols, the church's empty space assumes meaning in relation to the Buddhist concept nothingness (*mu*), which can be equated with the divine foundation of the universe. "If you give people nothingness," said Andō, "they can ponder about what can be achieved from that nothingness."[10] Andō achieved a similarly serene, contemplative quality on a much larger scale is his Modern Art Museum of Fort Worth (2002), comprising a parallel series of five elegant glass-walled rectangular pavilions, the rear three fronting a reflecting pool.

Richard Meier (b. 1934)

Richard Meier produced fresh versions of Le Corbusier's pioneering International Style aesthetic to create his personal Late Modernist idiom, sometimes called Neo-modernism due its self-conscious revivalist nature. Meier's houses of the 1960s and 1970s (e.g., the Saltzman House, 1969) evoke Le Corbusier's Purist villas such as the Villa Savoye (see Figure 17.1), sharing their use of abstract geometry, free façades, ribbon windows, and white horizontal and vertical planes enclosing and slicing through open volumes, as well as details such as *pilotis*, ramps, and metal railings. Meier's structures, however, are more intricate and sophisticated than Le Corbusier's and have been described as Mannerist.

In the 1970s, Meier began to gain larger public commissions and became a leading contributor to the museum building boom of the late twentieth and early twenty-first centuries that has seen thousands of museums erected or expanded. In cities around the globe, a brand-new museum or museum wing designed by a celebrated architect (a "starchitect") has become a source of civic pride and cultural prestige—and a hoped-for tourist attraction to boost the local economy. Meier designed the High Museum of Art in Atlanta (1980–83, Figure 21.8) in his signature style of geometric steel-framed volumes clad in gleaming white square porcelain-enamel panels. The building is laid out in an L-configuration forming the sides of a glass-enclosed four-story quarter-circle-shaped atrium. An extended ramp draws visitors from the sidewalk into the atrium rimmed by ramps providing vertical circulation. Frank Lloyd Wright's

FIGURE 21.8 Richard Meier, High Museum of Art, 1980–83. Atlanta.

Guggenheim Museum (see Figure 17.8) inspired Meier's atrium, but whereas Wright's is closed off from the surrounding city and its ramp doubles as gallery space, Meier provided rectangular galleries surrounding the High Museum atrium and wrapped it with windows, opening it up to natural light and views of Atlanta.

Meier's largest and most spectacular project is the Getty Center in Los Angeles (1984–97), which includes pavilions displaying the Getty art collections, a conservation center, a research institute, and gardens designed by Robert Irwin (see Chapter 16). Here, Meier drew inspiration from Italian sources: Hadrian's Villa and the Villa Farnese above Caprarola, "for their sequences, their spaces, their thick-walled presence, their sense of order, the way in which building and landscape belong to each other."[11] He gave most of the buildings simple geometric forms based on blocks or cylinders and arranged them around two axes deduced from the San Diego Freeway's inflection as it angles northward at the Getty site. Rather than using his trademark white, Meier clad some of the buildings in ivory-colored enamel panels and others in rough faced honey-hued Italian travertine. This stone, the principal building material of the Roman Colosseum, imparts a dignified classical veneer to Meier's Neo-modernist aesthetic.

Tropical Modernism in South Asia

Concurrent with Postmodernism's rise in the United States and Europe, progressive architects in formerly colonized South Asian countries developed what has been called Tropical Modernism. They designed buildings suitable to the region's tropical climate melding influences from the West with local building traditions and cultural references. Prominent among these architects were Balkrishna Doshi and Charles Correa in India, and Geoffrey Bawa in Sri Lanka.

Balkrishna Doshi (b. 1927)

Balkrishna Doshi started his career in Le Corbusier's studio in the 1950s, assisting with Le Corbusier's projects for Chandigarh (see Chapter 17) and the western Indian city of Ahmedabad. After establishing his own practice in the

FIGURE 21.9 Balkrishna Doshi, Sangath Architect's Studio, 1980. Ahmedabad, India.

manifesting Doshi's ideal of harmony between the individual, the community, and nature.

Through his Vastu Shilpa (Design for the Environment) Foundation, Doshi developed low-cost housing projects and urban plans to accommodate the impoverished Indians who left their villages to create squatter settlements in and around large cities. His Aranya Low Cost Housing scheme for Indore (1989) gave 6,500 families chosen through a government lottery a thirty-meter square plot with a plumbing and electrical service core and the opportunity to build their own house adapted from any of sixty prototypes. Doshi declared, "in mass housing it is possible to have house form variations for personalization and a sense of belonging, without losing overall coherence."[12] Giving Aranya residents the responsibility of building their own homes provided them a sense of agency and generated community pride and social cohesion—often lacking in standardized public housing in the Western modernist mold.

latter city, Doshi was instrumental in arranging the 1962 commission for Louis Kahn to design the Institute of Indian Management, for which Doshi became the associate architect. Influences from Le Corbusier and Kahn are evident in Doshi's School of Architecture (1968) in Ahmedabad with its strong, simple structures of concrete floor slabs and concrete and brick walls.

Doshi realized a more personal expression in his office and studio and complex, Sangath, which means "moving together through participation," on the outskirts of Ahmedabad (1980, Figure 21.9). As much a landscape as a building, Sangath's double- and triple-height interiors, surmounted by barrel vaults, are sunken into the ground to insulate them from the heat and surrounded by platforms through which channels of water flow during the rainy season. The complex's west side opens onto a grassy stepped amphitheater, a communal space for relaxation and informal meetings. The vaults are shell structures built of two thin layers of concrete with hollow **terracotta** tubes between the layers to provide insulation. The vaults are covered with fragments of white glazed pottery that reflect the sun to reduce heat gain. Doshi drew inspiration for Sangath from indigenous sources such as the intricate plans of southern Indian temple cities, earthen rural vernacular architecture, and vaulted Buddhist prayer halls. Sangath also suggests a debt to Le Corbusier's vaulted spaces in the nearby Sarabhai House and to Kahn's use of parallel vaults in the Kimbell Museum. Sangath achieves its own poetry and sense of place, however,

Charles Correa (1930–2015)

Trained in architecture at the University of Michigan and M.I.T., Charles Correa shared with Doshi an admiration for Le Corbusier and Kahn, whose influences are seen in his early work, and a strong interest in town planning and mass housing. Correa's incremental housing project at Belapur (1983–86) in Navi Mumbai (New Bombay) provided residences for families of varying incomes. Each family was provided with a plot ranging in size from forty-five to seventy square meters on which to build a simple single or two-story house that could be expanded with their income and needs. The houses were arranged in squares of seven units around open courtyards in the manner of traditional Indian settlements. These squares in theory could be endlessly multiplied to form an entire city also containing larger open public spaces.

In contrast to Belapur's horizontal orientation, Correa's Kanchanjunga Apartments (1970–83, Figure 21.10) in Mumbai is a vertical tower of thirty-seven interlocking luxury units. Square in plan, the tower's corners are cut out to create double-height verandahs on its east and west sides providing cross-ventilation and shelter from both the sun and the

FIGURE 21.10 Charles Correa, Kanchanjunga Apartments, 1970–83. Mumbai, India.

monsoon rains. While the tower's minimalist design conforms with Western modernist aesthetics, the verandahs derive from Indian bungalows and allude to the country's historic architecture. Correa often spoke of the contrast between the fully enclosed spaces and freestanding forms typical of Western architecture and the Indian tradition, especially in Mughal architecture of the sixteenth and seventeenth centuries, to create "rooms" that are either roofless or unwalled like the *chhatri*, a domed canopy supported on columns.[13] Correa's preference for the square planning module, seen both in Belapur and the Kanchanjunga Apartments, also derives from an Indian source: the mandala, a sacred symbol often represented as a circle enclosed within a square.

Geoffrey Bawa (1919–2003)

Born in Colombo, Ceylon (now Sri Lanka), at that time a British colony, Geoffrey Bawa absorbed modernist principles as a student at the Architectural Association in London in the mid-1950s. Returning to Ceylon in 1957, Bawa developed a Tropical Modernism that drew on the rich cultural mixture of Sri Lankan vernacular architecture, which includes native Sinhalese and Kandyan traditions, as well as colonial Portuguese, Dutch, and British elements. He designed numerous private residences and luxury hotels featuring hipped roofs, linked interior courtyards and verandahs—features derived from the traditional Sri Lankan manor house and appropriate to the tropical climate.

In 1979, Bawa received the prestigious commission for the National Parliament Building of Sri Lanka (1979–82, Figure 21.11), built outside Colombo at Sri Jayawardenepura

FIGURE 21.11 Geoffrey Bawa, National Parliament, 1979–82. Sri Jayawardenepura Kotte, Sri Lanka.

Kotte. Bawa had the marshy site flooded to form an artificial lake and situated the government buildings on an island ceremonially approached by a long causeway. This processional axis leads to the parliament chamber in the main, three-story, verandah-encircled pavilion; other pavilions orbit around the central building. All are covered by double-pitched copper-covered roofs supported by simple posts and beams. While the roofs recall those of precolonial Kandy's monastic and royal buildings, the island's layout resembles that of south Indian Hindu and Sri Lankan Buddhist temple complexes. Through such multivalent references, Bawa sought in the National Parliament Building to create a symbol of democratic unity in a country long riven by strife between the Sinhalese Buddhist majority and minority Hindu and Muslim Tamils.[14]

High Tech

Rivaling Postmodernism in the later 1970s and 1980s was High Tech, an architectural style that emphasized the expressive use of modern technology, structural and mechanical systems, and industrial materials. This style continued and amplified the faith in technology that had spurred modern architecture's development from the mid-nineteenth century onward and generated influential engineered structures ranging from the Eiffel Tower (see Figure 5.2) to Buckminster Fuller's geodesic domes. High Tech countered calls by some architectural thinkers of the 1960s and early 1970s for "low tech" designs that would respond to concerns over the environment and the needs of underdeveloped regions. In the words of one detractor, High Tech expressed an "attitude that assumes that architecture has no further task other than to perfect its own technology."[15] To its proponents, High Tech communicated futuristic optimism and glorified all that advanced technology made possible, such as the 1969 moon landing.

Renzo Piano (b. 1937) and Richard Rogers (1933–2021)

The paradigmatic High Tech monument is the Centre Georges Pompidou in Paris (1970–77, Figure 21.12), named for the French president who called for its construction to reassert his country's cultural leadership in Europe. The Italian Renzo Piano and the Englishman Richard Rogers won the international competition in 1970 for this unique new cultural center. Challenged with designing a huge building to house multiple institutions—the national museum of modern art, a library, a center for industrial design, and an institute for contemporary music—Piano and Rogers chose to provide flexible interior spaces, similar to, but much larger than, those created by Mies van der Rohe. They also left the site's west side open as a public plaza to integrate the building with city life. To create the open internal spaces, Piano and Rogers externalized the Centre Pompidou's supporting structure, circulation, and mechanical systems. The building's six steel-and-glass, **curtain-walled** floors hang from an exoskeleton of steel columns and girders. A plexiglass-enclosed escalator snaking up the west façade provides access to all floors as well as spectacular views of Paris. Brightening the building's factorylike aspect are color-coded external service elements: blue air ducts, green water pipes, yellow electric conduits, and red escalator and elevator shafts.

FIGURE 21.12 Renzo Piano and Richard Rogers, Centre Georges Pompidou, 1970–77. Paris.

In its flexible spaces, colorful elements, and assertive Lego-like assembly, the Centre Pompidou reveals the influence of Archigram's *Plug-in City* concept for a megastructure (see Chapter 17). It also realizes its young architects' radical beliefs that "culture should be fun" and that museums should no longer be "dusty, boring, and inaccessible."[16] While some critics found the Centre Pompidou's High Tech aesthetic ugly and inappropriate to its historic urban context, it was and remains a hit with both tourists and Parisians, visited by millions annually.

Norman Foster (b. 1939)

Another major High Tech monument is the Hong Kong and Shanghai Bank (HKSB, 1979–86, Figure 21.13) by the English architect Norman Foster. Foster's early High Tech designs grew from his concept of the building as a "serviced shed"—a lightweight prefabricated space frame integrating services and providing a flexible interior—a concept he massively amplified in the HKSB. Here, Foster abandoned the conventional office tower design: a stack of floors supported by an internal steel frame with a central service core (as in the contemporaneous AT&T Building). Instead, Foster created an open atrium spanning the third to eleventh stories and adaptable office spaces in the higher levels. He did this, as had Piano and Rogers in the Centre Pompidou, by pushing the building's structural skeleton and mechanical services to its exterior.

The HKSB consists of five parallel setback slabs supported by pairs of ladderlike masts cross-braced with struts from which intermediate floors are suspended. Elevators, stairs, and restrooms are located at the building's sides to maximize flexible interior floor space. A computer-controlled mirrored "sunscoop" system channels daylight from the top of the building all the way down to the atrium, which is reached by escalators from a sheltered street-level plaza. At its completion, Foster's HKSB was believed to be the most expensive building ever constructed. Its spectacular technological image conveyed the Hong Kong and Shanghai Banking Corporation (HSBC)'s desire for "the best bank building in the world."[17] Erected when Hong Kong, a British crown colony, was preparing for its return to the People's Republic of China in 1997, the building was meant to convey HSBC's confidence in its future at an uncertain time.

Santiago Calatrava (b. 1950)

Spanish architect and engineer Santiago Calatrava's buildings and bridges display an affinity with High Tech in their assertion of structure but are distinguished through their sculptural expressiveness. Often drawing inspiration from the articulated forms of animals and plants, Calatrava creates

FIGURE 21.13 Norman Foster, Hong Kong and Shanghai Bank (HKSB), 1979–86. Hong Kong.

designs resembling bodies in tension, with leaning, straining, and spanning elements. His Alamillo Bridge (1992) in Seville is suspended at one end by thirteen pairs of cables from a 142-meter high **pylon** inclined at a 58-degree angle, strong enough to support the roadway without back stays. Calatrava's buildings often feature canopies and roofs shaped like blades, shells or wings, and their seemingly animated forms are in some cases actually kinetic. His gleaming white Quadracci Pavilion (1994–2001) at the Milwaukee Art Museum has a glazed

atrium covered by sets of curved steel ribs that open and close like the wings of a giant bird. When extended, they function as a *brise-soleil*, blocking the sun to help keep the atrium cool.

Deconstructivism

A 1988 MoMA exhibition announced a new architectural trend, **Deconstructivism**, through projects by seven international architects or architectural collectives—Coop Himmelb(l)au, Peter Eisenman, Frank Gehry, Zaha Hadid, Rem Koolhaas/OMA, Daniel Libeskind, and Bernard Tschumi. Curators Philip Johnson and Mark Wigley, a Princeton architect and lecturer, presented Deconstructivist architecture not as a cohesive movement but as a formal approach that many architects adopted independently during the 1980s. In contrast to the International Style's pure geometric forms, Deconstructivist architects favored what Johnson called "'warped' images."[18] Wigley related Deconstructivism to Jacques Derrida's philosophy of deconstruction (see "Postmodern Theory" box, Chapter 20): just as Derrida argued that all texts undermine themselves by containing traces of meanings opposite to what they intend to communicate, Deconstructivism challenged architectural "harmony, unity and stability" to locate the inherent "flaws" and "dilemmas" within buildings.[19] The Deconstructivists employed formal strategies developed by early twentieth-century Russian **avant-garde** artists such as Malevich and Tatlin (see Chapter 6), whose "'impure' skewed, geometric compositions"[20] led, following the Russian Revolution, to unrealized proposals for contorted architectural structures that would advance Communism. The Deconstructivists revived the Russian avant-garde's "anxiously conflicting forms" to "irritate modernism from within, distorting it with its own genealogy."[21] Deconstructivist architecture disquiets and alienates through disturbances within the building's structure and, often, a disruption of the expected relationship between the building and its context.

Peter Eisenman (b. 1932)

Nearing completion at the time of the MoMA exhibition, Peter Eisenman's Wexner Center for the Arts at the Ohio State University in Columbus (1983-89, Figure 21.14) was the first large-scale Deconstructivist building, reflecting its designer's highly intellectual approach to architecture. Drawing on a term used by Derrida, Eisenman understood the Wexner Center site as a palimpsest—a sheet of parchment on which traces of erased writing remain visible beneath the surface text. Eisenman's design revealed an historic contradiction between the town-plan grid and that of the Ohio State University campus, which deviated 12.5 degrees from the Columbus street grid. Eisenman achieved Deconstructivist disjunction by orienting the new arts center to the city grid and positioning it between and around two existing auditoriums on the campus grid. He accentuated this collision by slicing a walkway through the middle of the complex, partly enclosed in a white scaffolding of open, gridded frames. Further emphasizing these discordant geometries, the inner walls of the arts center, encompassing exhibition and performance spaces, a lecture hall, and a library, are set on either the city grid or the campus grid. Castle-like brick towers at the corner elicit the memory of a nineteenth-century armory, destroyed by fire in 1958, that once stood there. Superficially akin to the comforting historical elements used by Eisenman's Postmodernist contemporaries, these towers are signifiers of the site's erased history. They clash stylistically with the surrounding white grids and one splits open to reveal a modernist-style glass curtain wall within—a Deconstructivist disruption of unity and stability.

FIGURE 21.14 Peter Eisenman, Wexner Center for the Arts, The Ohio State University, 1983–89. Columbus, Ohio.

Frank Gehry (b. 1929)

The most celebrated architect associated with Deconstructivism, despite his disavowal of the label, Toronto-born, California-based Frank Gehry generated Deconstructivist disjunction in the idiosyncratic 1977–78 remodeling of his own family home in Santa Monica. He extended the original 1920s bungalow through a seemingly helter-skelter assemblage of cheap corrugated iron, plywood, and chain-link fencing, creating the appearance of an active construction site rather than an occupied dwelling. Gehry's remodeled residence manifested "messy vitality" even more radically than had Robert Venturi's house built for his mother some fifteen years earlier.

By employing skewed and fragmented forms in larger public buildings, Gehry achieved his signature style of monumental curving, metal-sheathed volumes in the 1990s, most famously realized in the Guggenheim Museum Bilbao, in Spain (1991–97, Figure 21.15). The result of a collaboration between the Solomon R. Guggenheim Foundation and the Basque government, the new museum, located on the Nervión River at the site of a former shipyard, was intended to help revive the region's depressed postindustrial economy by attracting tourists, which it succeeded spectacularly in doing. Challenged by Guggenheim director Thomas Krens to create a better building than Frank Lloyd Wright's New York Guggenheim (see Figure 17.8), Gehry responded with a startlingly original design that is both exhilarating and functional. The dynamic, asymmetrical plan features two rectangular limestone-clad volumes set roughly perpendicular to each other and surrounded by enormous curvilinear spaces of various shapes and sizes, covered in a lustrous skin of thin titanium shingles that ripple in the breeze and change color as they reflect the sky. The spaces converge on a glass curtain-walled atrium that surpasses Wright's Guggenheim rotunda both in its soaring height (fifty versus twenty-eight meters) and visual excitement, as it swirls upward through curving bridges and transparent elevator cages toward skylights. Conventional orthogonal galleries display the museum's permanent collections while temporary installations spread through the vast, curvaceous, column-free "boat gallery" facing the river.

Appearing different from every angle, the building's warped and billowing forms generate associations ranging from a ship to a titanic scaly fish and a giant "flower" (Gehry's term) where they cluster around the atrium. Gehry developed these forms traditionally through sketches, drafting, and models, but CATIA software enabled their technical realization. Initially used in the

FIGURE 21.15 Frank Gehry, Guggenheim Museum Bilbao, 1991–97. Bilbao, Spain.

aerospace industry and adapted by Gehry and his associate Jim Glymph to their purposes, this software used digitized scans of drawings and models to render three-dimensional computer images, which in turn guided computer-robotic fabrication of the building's components. Architects in Gehry's wake have used the computer not just to facilitate design and construction but also to generate form—a common practice in the twenty-first century.

Daniel Libeskind (b. 1946)

Daniel Libeskind won the competition for his first major building, the Jewish Museum Berlin, in 1989, the year after his work was featured in MoMA's *Deconstructivist Architecture* exhibition. A serious student of music, literature, and philosophy, the Polish-born, US-based Libeskind developed a sophisticated intellectual approach to architecture moving beyond modernism's conventions to seek the "deeper order rooted not only in visible forms, but in the invisible and hidden sources which nourish culture itself, in its thought, art, literature, song and movement."[22] Denying that form follows function, Libeskind insisted, "a building's form follows an idea."[23]

Libeskind devised a complex symbolic program for the Jewish Museum Berlin (1989–2001, Figure 21.16), which he conceived of as a building "Between the Lines." One line, straight but fragmented, runs through the museum, defining a Void representing the Holocaust's absent Jewish victims — many of Libeskind's family members among them. The other line, an unruly zigzag, shapes the building's plan, deriving from a distended Star of David—a symbol the Nazis forced Jews to wear on their clothing. Narrow rectangular windows cutting through the building's zinc exterior at various angles also refer to the Star of David. Three "roads" extend from the museum's underground entrance. One road, symbolizing Jewish Berlin's continuing history, leads to the main stair and the exhibition spaces displaying objects of Jewish art and culture. The second road leads to the outdoor Garden of Exile, a grid of forty-nine concrete pillars from which emerge flowering oleaster trees, symbolizing the emigration and exile of German Jews. (Forty-eight of the pillars, filled with the soil of Berlin, represent the 1948 establishment of Israel; the forty-ninth pillar is filled with soil from Israel.) The third road leads to the Holocaust Tower—a claustrophobic, dead-end concrete-walled chamber

FIGURE 21.16 Daniel Libeskind, Jewish Museum Berlin, 1989–2001.

lit by a single narrow slit in the roof. While the museum's many aggressive and disorienting Deconstructivist architectural features express the trauma of a painful history, the building also embodies optimism as a locus of revived Jewish life in Berlin, serving as "an emblem of Hope."[24]

Zaha Hadid (1950–2016)

Baghdad-born, London-educated Zaha Hadid, the only woman included in the *Deconstructivist Architecture* exhibition, was one of the most internationally successful architects in her male-dominated profession, becoming the first woman to win the Pritzker Prize in 2004. MoMA's exhibition featured Hadid's unrealized designs for The Peak, a luxury club in the hills above Hong Kong, where she envisioned excavating the site into a fragmented artificial landscape of geometric polished granite cliffs. Inserted into each cliff would be beam-like horizontal buildings set at conflicting angles to each other. Luxurious features, such as entrance decks, exercise platforms, a swimming pool, library, and penthouses, would detach themselves from the upper two beams to float freely like dynamic elements in Malevich's **Suprematist** paintings (see Figure 6.3). Hadid also realized a Suprematist quality in her first significant building, the Vitra Fire Station, in Weil am Rhein, Germany (1989–93), a jagged composition of leaning, intersecting concrete, metal, and glass planes that cut through space.

As Hadid gained increasing recognition and more substantial commissions, her compositions became less explosive but no less dramatic. Among her most complex, ambitious, and thrilling buildings is the Guangzhou Opera House (2003–10, Figure 21.17). Occupying a tiered site between the Pearl River

and the city's financial district, it consists of two volumes—one containing an 1,804-seat auditorium, the other a 443-seat theater—likened by the architect to "pebbles in a stream smoothed by erosion."[25] Hadid and her collaborator Patrik Schumacher employed three-dimensional computer modeling technology to generate the building forms. Each multilevel structure is enclosed within a giant steel lattice resembling a spider's web. The lattice supports large triangular windows and triangular granite tiles (black on the larger building and white on the smaller) forming roofs and walls. Inside are vast, sculpted lobbies with cantilevered terraces and twisting staircases that create dramatic spaces for circulation and socializing. The asymmetrical auditorium has undulating gold balconies molded in fiberglass-reinforced gypsum that emerge seamlessly from the walls and provide excellent acoustics. In the ceilings, four thousand LED lights glow like stars in the night sky. Hailed by one critic as "the world's most spectacular opera house,"[26] Hadid's takes its place alongside Garnier's in Paris (see Figure 5.1) and Utzon's in Sydney (see Chapter 17) as a defining monument in this building type's evolution.

Rem Koolhaas (b. 1944) and OMA

The Dutch architect Rem Koolhaas established his reputation as a provocative urban theorist with the publication of his book *Delirious New York* (1978). In it, Koolhaas argued that Manhattan, unplanned beyond its 1811 street grid, was created through a combination of new technologies (principally the steel frame and the elevator) and commercial logic dictating the construction of tall, high-density, flexible-use buildings. Koolhaas exalted the resulting messy but vital "culture of congestion" over the rigid modernist urban planning principles of CIAM. Furthermore, like Venturi, Scott Brown, and Izenour's praise of Las Vegas, Koolhaas deemed popular New York places such as Coney Island and Radio City Music Hall more enduring and successful than the modernists' high-minded utopian designs.

Through his architectural practice, the Office for Metropolitan Architecture (OMA), Koolhaas has produced innovative projects on every scale, from the domestic to the urban, that manifest his acceptance of complexity and unpredictability while also responding to the practical needs of modern life. OMA's Kunsthal (Art Hall, 1988–92), in Koolhaas's native Rotterdam, accommodates exhibition galleries, an auditorium, and a restaurant within a flat-roofed box. Unexpectedly, however, its main entrance on a busy avenue leads not to a foyer but to a public ramp descending straight through the building to a park on the other side. Inside, additional ramps, corridors, and stairs create a continuous circuit linking the Kunsthal's programmatically different spaces. Each façade is different, and each space is defined through different materials, ranging from galvanized steel grates to bare concrete, translucent polycarbonate panels, and rough tree trunks.

Ramps are also a key feature of OMA's innovative Seattle Central Library (1999–2004). At the building's heart is the Books Spiral, a continuous, square ramp of shelving, four levels high, holding the library's collections. The Books Spiral is one of five "platforms" serving different purposes based on OMA's rigorous analysis of the library's multitude of functions. The building's exterior—a faceted composition of tilting planes comprising diamond-shaped panes of glass held in a steel lattice—provides an envelope for the overhanging platforms. The glass walls flood the ground floor atrium with light, creating an inviting civic space—a "living room" for both Seattleites and tourists.

OMA's audacious and visionary China Central Television (CCTV) Headquarters in Beijing (2002–12, Figure 21.18) rises 234 meters and encloses 473,000 square meters of floor space, providing facilities for the entire TV-making process within a continuous loop. Production studios occupy a platform from which rise two towers, one dedicated to news and broadcasting, one to editing and other functions. The towers lean toward each other and join in a seemingly

FIGURE 21.17 Zaha Hadid, Guangzhou Opera House, 2003–10. Guangzhou, China.

FIGURE 21.18 OMA, China Central Television (CCTV) Building, 2002–12. Beijing.

gravity-defying, seventy-five-meter cantilever known as the Overhang, housing the administrative offices. Meant to foster collaboration and a sense of solidarity between CCTV's ten thousand employees, this unprecedented looped structure represents a revolutionary alternative to the skyscraper typology of vertically stacked floors that Koolhaas considers exhausted and inimical to creativity. With its distinctive, Moebius-strip-like form and silver-gray sun-shading glass curtain walls articulated through a web of steel tubes that vary in density according to the stresses in the underlying structure, the CCTV Headquarters is a singular, futuristic presence in the Beijing skyline. A recognized masterpiece of innovative contemporary architecture, it, like Hadid's Guangzhou Opera House, is a prime architectural symbol of China's emergence as a major world power through its rapid economic expansion, technological development, and explosive urban growth from the 1990s onward.

Green Design

Since the early 1970s, architects and urban planners have become increasingly committed to "green" or environmentally responsible design. This dedication arose from the global environmental movement of the 1960s and 1970s, which sought to address air and water pollution. Significant milestones in the United States were the publication of Rachel Carson's *Silent Spring* (1962), warning of the dangers of the chemical pesticide DDT, and the 1970 establishment of both the Environmental Protection Agency and the first annual Earth Day. The mid-1970s energy crisis, precipitated by the oil embargo imposed in 1973 by oil-producing Arab countries on the United States and other nations in retaliation for their support of Israel in the Yom Kippur War, raised international awareness of the need to conserve fossil fuels and develop renewable energy sources. Furthermore, the burning of fossil fuels releases carbon dioxide, a greenhouse gas, which became a serious environmental concern in the 1980s as scientists raised alarms about global warming resulting from massive carbon dioxide buildup in the earth's atmosphere.

Scientific evidence demonstrates unequivocally that ever-rising carbon dioxide emissions attributable primarily to the burning of fossil fuels cause climate change. This has led some to call our epoch the Anthropocene, a geological period characterized by human activity's significant impact on the Earth's climate and ecosystems. Evidence of rapid climate change over the last few decades includes a steady global rise in temperatures; warming oceans; shrinking ice sheets and glaciers; rising sea levels; ocean acidification; and the surge in extreme weather events, such as droughts and wildfires. Unfortunately, United Nations–coordinated international treaties—the 1997 Kyoto Protocols and 2015 Paris Climate Agreement—failed to slow global carbon dioxide emissions.

Because buildings are the largest consumers of energy—accounting for some 41 percent of the world's energy use according to the US Green Building Council (USGBC)—architects can contribute to the planet's health by producing more sustainable designs. Sustainability involves creating and maintaining conditions that permit humans and nature to live in harmony without compromising future generations' ability to meet their own needs. The LEED (Leadership in Energy and Environmental Design) program, developed by the USGBC, encourages sustainability by accrediting architects and certifying buildings according to a four-tier rating system (Certified, Silver, Gold, and Platinum) that evaluates the building's performance over its life cycle. LEED certification is based on credits awarded for use of sustainable sites, energy and water efficiency, materials and resource use, indoor environmental quality, emissions, and operation and maintenance, with extra points for innovative design and considerations specific to the building's regional location.

Contemporary architects employ numerous techniques to create sustainable buildings. These include the use of

renewable or recycled building materials; passive (nonpowered) ventilation, heating, cooling, and lighting; wind turbines and photovoltaic cells for power generation; **green roofs** and the integration of plants into the building; and the capture of stormwater runoff for irrigation or other uses. Other than wind and photovoltaic power systems, many of these features are seen in preindustrial-era building traditions—a source of inspiration to many contemporary green architects.

Complementing the design of more sustainable buildings is green urban planning, which aims to counter the low-density urban sprawl that paves over farmland, destroys natural ecosystems, and clogs roads with fossil-fuel burning private vehicles. Instead, green urban planning promotes high-density housing close to places of employment, commercial centers, schools, and mass transit; and incorporates ample green space, car-free zones in city centers, and walking and biking paths to encourage those modes of transit. Exemplary of green planning in Europe is Vauban, Germany, a virtually car-free middle-class suburb of Freiburg whose residents routinely travel by bike or tram to the city center.[27] Most of Vauban's well-insulated houses (with triple-glazed windows and 35cm-thick walls) are powered by solar panels and wood chip-fueled cogenerator engines; most generate a surplus of electricity that they sell back to the power company.[28]

In the United States, the New Urbanism movement combats urban sprawl through the development of mixed-use, walkable neighborhoods. A pioneering New Urbanist project is Seaside (1981–85), a Florida town planned by the husband-and-wife architects Andrés Duany (b. 1949) and Elizabeth Plater-Zybek (b. 1950). Seaside's compact plan is modeled on that of a traditional town with a clearly defined system of streets, walking paths, and parks and a central square facing a Gulf Coast beach. The environmentally responsible landscaping consists of native plants rather than grass lawns, eliminating the need for chemical applications, irrigation systems, and lawn mowers. The design of the houses—none more than a five-minute walk from downtown—is governed by a code that allows for variety within a strict set of guidelines emphasizing picturesque Southern US vernacular elements such as porches and balconies, wooden board-and-batten siding, and white picket fences. Despite its planners' goal of creating a genuine community, Seaside eventually became an upscale resort with most of the houses rented out to vacationers.

Glenn Murcutt (b. 1936)

The Australian architect Glenn Murcutt is deeply committed to environmentally responsible design. He once declared, "I cannot pursue my architecture without considering the minimization of energy consumption, simple and direct technologies, a respect for site, climate, place and culture.

Together, these disciplines represent for me a fantastic platform for experimentation and expression."[29] Murcutt's outlook on architecture was deeply influenced by his father, a developer-builder who introduced him to Mies van der Rohe's work and to Henry David Thoreau's philosophy of simple living in harmony with nature. After designing steel-and-glass boxes in Mies's minimalist idiom, Murcutt turned for inspiration to local vernacular building traditions in the mid-1970s as he sought to adapt his designs more sensitively to the Australian landscape and climate.

Following the Aboriginal proverb to "touch the earth lightly," Murcutt employs low-cost materials such as the corrugated sheet iron used in Australian ranch buildings, and he designs his buildings to consume as little energy as possible. His Magney House (1982–84/1999, Figure 21.19), at Bingie Point on the New South Wales coast, is a long, simple structure surmounted by a graceful, corrugated iron butterfly roof. Murcutt designed it as a vacation home for clients who had previously camped on the site and wanted a house as lightweight as a tent, open to the ocean view, and in close contact with nature.[30] The fully glazed north façade, with glass sliding doors shaded by external aluminum blinds and a central verandah, overlooks the Pacific Ocean. The lower south front is buffered from cold southerly winds by an insulated, corrugated iron-clad **masonry** wall. The curving roof overhangs the north side, supported by angled struts, to admit raking winter sunlight into the interior while blocking the midday summer sun. The house has no air conditioning but is cooled by cross ventilation through vents along the top of the south wall. Underground

FIGURE 21.19 Glenn Murcutt. Magney House, 1982–84/1999. Bingie, Australia.

storage tanks collect rainwater through downpipes on the east and west sides fed by a central gutter. Divided into two wings on either side of the verandah, the simple plan locates bathrooms and kitchens along the south wall and living areas to the north. The Magney House is an elegant modernist "machine for living in" finely attuned to its windswept environment.

Diébédo Francis Kéré (b. 1965)

The need to conserve resources and protect the environment is acutely felt in less developed nations, where centuries-old local building methods often generate more sustainable results than do imported modern architectural techniques and materials. Exemplary of such sustainability is the Primary School in Gando, Burkina Faso by Diébédo Francis Kéré (2001, Figure 21.20), who studied in Berlin and established an architectural practice there (which he maintains) before returning to work in his home village. Adapting traditional clay building techniques, Kéré constructed the school's three rectangular classrooms with clay-cement brick walls providing insulation against the region's intense heat. Passive ventilation cools the building: tall narrow windows with adjustable louvers draw cool air in and perforated clay brick ceilings permit the upward release of warm air, which escapes through the gap between the ceiling and curved metal roof elevated on a space frame. Following the rural Burkina Faso custom of community members working together to build homes, Kéré involved the village in the school's construction: children gathered stones for its foundation and women brought water for the manufacture of its bricks. Since the primary school's opening, Kéré has continued to work with the Gando community to build additional educational and cultural facilities, funded by a nonprofit foundation he established. These projects have won numerous international awards and become a model for broader sustainable development in West Africa. In 2022, Kéré became the first African architect to win the Pritzker Prize.

From High Tech to Eco-Tech

In contrast to Murcutt's and Kéré's low-tech approaches to sustainability, architects associated with the High Tech movement have used advanced technology combined with natural means such as passive ventilation and integrated greenery to create energy-efficient buildings. Labeled "Eco-Tech" (the title of Catherine Slessor's 1997 book), this trend is exemplified by Norman Foster's 30 St Mary Axe Building in London (2004). Nicknamed the Gherkin because it resembles a pickle, the circular-plan skyscraper widens in profile as it rises and then tapers toward the top. An exterior curtain wall of clear diamond-shaped double-glazed panels and an interior curtain wall of rectangular glass panels cover most of each office floor's circumference. Heat in the airspace between the two curtain walls is exhausted to the outside by vents. Six atria without interior curtain walls spiral up the building, all featuring tinted windows to reduce solar heat gain. A computerized system can open some of these windows selectively to circulate air through the building using pressure differentials at atria thirty degrees apart around the façade. Foster claimed that this system would enable the building to consume half as much energy as a conventionally air-conditioned tower.[31]

Another example of Eco-Tech is Renzo Piano's California Academy of Sciences in San Francisco (2008). This LEED Platinum-certified building has an undulating "living roof" covered with 1.7 million native plants and rimmed with photovoltaic cells. Skylights in two of the roof mounds illuminate the spaces below and are automated to open and close for ventilation. The green roof provides excellent insulation to keep the un-air-conditioned ground-floor public areas of the museum cool in the summer. The green roof also captures storm water, provides a habitat for insects and birds, and, through photosynthesis, transforms carbon dioxide into oxygen.

Ken Yeang (b. 1948)

A leader in contemporary green architecture is the Malaysian-born, UK-educated Ken Yeang, known for his many books, including *Designing with Nature: The Ecological Basis for Architectural Design* (1995), and his concept of the "bioclimatic skyscraper"—a passively performing, low-energy-consuming

FIGURE 21.20 Diébédo Francis Kéré, Primary School, 2001. Gando, Burkina Faso.

structure designed to respond to the local climate. An early realization of this concept attuned to Malaysia's hot, humid conditions, the Menara Mesiniaga (IBM) Tower (1992) in Sengalor, Malaysia, is a circular fifteen-story building supported by exposed metal-clad columns in the High Tech manner. Its body opens into deep-set garden sky-courts spiraling around the exterior and fronting glass curtain walls on the north- and south-facing façades. Bands of windows flush with the tower's circumference are screened from the sun by louvers to prevent heat buildup. A planned rooftop photovoltaic system was never installed.

Yeang insists that a building should be responsive to its surrounding ecosystem and also function as a healthy living ecosystem itself. This philosophy is well illustrated in his Solaris (2008–10, Figure 21.21), located in the Fusionopolis research and development complex in Singapore.[32] The fifteen-story building's curving, asymmetrical plan gives it an organic quality. Its public spaces, offices, and laboratories surround a central, naturally ventilated atrium equipped with glass louvers that open to allow airflow in fair weather but close when it rains. Energy-saving passive illumination is provided by an angled light shaft that channels sunlight deep into the building and by sunshades that deflect daylight into the interiors. Solaris's most prominent ecological feature is the 1.5km-long vegetated ramp that spirals around the exterior. Terraces at the building's corners accommodate larger trees and the roofs are also planted with gardens. The plants shade, cool, and insulate the building, afford a park-like amenity, and they enhance biodiversity. Rainwater tanks in the basement collect water used to irrigate the plants. A truly green building, Solaris contains one thousand trees and harbors 13 percent more vegetation than could have been planted on the empty building site.

Driven by the belief that "saving our environment has to be the most vital task facing humankind today," Yeang promotes a comprehensive ecodesign system extending from individual buildings to entire city plans, based on five strategies.[33] The first strategy is the integration of four color-coded ecoinfrastructures: *green* being nature's own utilities, *blue* being water management, *gray* being sustainable cleantech engineering systems and utilities, and *red* being human built systems, including laws and regulations.

The second strategy is biointegration—the benign integration of the artificial (human made) with the natural environment. The third strategy is ecomimesis—designing the built environment to imitate ecosystems that eliminate waste through recycling and use only the sun's energy. The fourth strategy is the rehabilitation of the existing built environment and restoration of damaged ecosystems. The fifth strategy is environmental monitoring to maintain global ecological stability. Through these strategies and the inspiring example of buildings such as Solaris, Yeang offers an optimistic path toward a sustainable future through green design.

FIGURE 21.21 Ken Yeang, Solaris, 2008–10. Singapore.

The Global Contemporary: Themes in Art Since c. 1989

This chapter considers art made since circa 1989, a period of unprecedented innovation, disruption, and complexity—qualities reflected in its art. The year 1989 witnessed the fall of the Berlin Wall, marking the end of the Cold War. That same year, the Chinese government's bloody crackdown on pro-democracy demonstrations in Beijing's Tiananmen Square consolidated authoritarianism in that country, which embraced capitalism to become an economic power second only to the United States. The end of apartheid in the early 1990s brought peace and democracy to South Africa, but elsewhere, ethnic and religious conflicts took a terrible human toll, as in the civil war that broke apart Yugoslavia (1991–99), the Rwandan genocide (1994), and the Syrian Civil War (begun 2011). Rising religious fundamentalism sparked horrific violence including the deadly September 11, 2001, attacks against the United States by Sunni Islamist terrorists. Chaos in Iraq following the US-led war on that country spawned the rise of ISIS, a Sunni Islamist terror group that controlled parts of Iraq and Syria before its 2019 defeat by a global coalition.

Globalization (see box) and neoliberal economic policies increased corporate wealth and raised living standards for hundreds of millions of people in such nations as China, India, and Brazil. However, globalization also exacerbated income inequality within many countries. Poor nations face challenges including food and freshwater shortages, pollution, and the lack of quality healthcare, education, and infrastructure. Global warming threatens all of humanity, as do deadly infectious diseases like COVID-19. Ever-expanding scientific knowledge gained through such initiatives as the Hubble Space telescope (launched 1990) and the Human Genome Project (1990–2003) has been complemented by the World Wide Web (introduced 1990), which radically transformed communication, commerce, and access to information (though billions of people, mostly in developing countries, lack internet access).

The art world—the network of prominent artists, dealers, collectors, curators, critics, galleries, auction houses, and museums—has expanded rapidly since 1989 and become more global. Artists from outside Western Europe and North America have gained increasing international recognition—a trend initiated by the 1989 Paris exhibition *Magiciens de la Terre*, which presented works by 104 artists from 50 countries, half of them outside the West. Recurrent international survey exhibitions of contemporary art have also proliferated: in addition to the long-established Venice Biennale, Carnegie International (Pittsburgh), São Paolo Bienal, and Documenta (Kassel, Germany), scores of such exhibitions are now held regularly in cities worldwide. A parallel trend has been the proliferation of commercial art fairs, such as Art Basel (Basel, Miami, and Hong Kong), Frieze Art Fair (London, New York, and Los Angeles), and the Armory Show (New York). The prices paid for works by prominent contemporary artists have also exploded as art collecting has become a status symbol for the ultra-wealthy.

As the contemporary art world has expanded, so too has the variety of styles and mediums artists employ, along with the range of subjects they explore. While traditional mediums remain

important, newer modes including video, audio, performance, installation, and Land art have become increasingly salient. Many artists have also adopted digital tools and techniques, and have used computer programs, the internet, and social media as mediums. Others have emphasized social engagement, language, or sensory stimulation over the creation of objects. Contemporary artists stretch the creative possibilities of established mediums, invent new ones, and often work in multiple modes rather than developing a signature style in one medium. Such diversity is seen also in the subjects and issues contemporary artists address. They continue to develop the possibilities of abstraction and established representational genres while also investigating every sphere of human activity, from popular culture to politics, science, and religion. Additionally, many artists, critics, and scholars of contemporary art are deeply interested in critical theories, ranging from those of postmodernism (see box, Chapter 20) to semiotics (see box, Chapter 4); feminism, queer, and transgender theory; psychoanalysis (see box, Chapter 8), Marxism; postcolonialism (see box, Chapter 18); and eco-criticism.

Contemporary art's astonishing diversity of forms, practices, and ideas has led many to conclude that its development since the 1980s cannot be described convincingly as a sequence of styles and movements—the model typically used to narrate Western art's history from the Renaissance to the late twentieth century. Accordingly, rather than surveying recent art chronologically, this chapter takes a thematic approach. It groups artists from many different countries around selected themes representing prevalent concerns in contemporary life—themes that have elicited compelling creative responses indicative of contemporary art's richness and complexity.

The Body

Numerous contemporary artists use the human body as a subject and sometimes as a **medium**, as in **performance art**. Of course, there is no such thing as *the* body, but only bodies in the plural.[1] Each person's body is unique, carrying signifiers of age, race, sex, and gender. Bodies are the seats of subjectivity, sites of pleasure and pain, and vehicles for self-expression. They are both private and public, and feel the pressures of the social order, law, politics, and religion. Contemporary artists treat the body both as a lived, corporeal entity and a cultural signifier. Some seek to deconstruct the mind-body dualism of Western philosophy—the privileging of minds over bodies. Feminists have criticized this dualism for positing white heterosexual men as able to transcend embodiment by conceiving of their bodies as containers for pure consciousness, while others—women, people of color, LGBTQ people, people

with disabilities, children, the elderly—are seen as limited to or confined by their bodies. Many contemporary artists and critics also follow Michel Foucault's analysis of how society's regulating mechanisms (such as time) and institutions (such as prisons, schools, and hospitals) discipline the body and its behavior. Contemporary artists' images of ambiguous, unruly, excessive, grotesque, hybrid, and abject bodies symbolically disrupt such disciplinary control and can serve as vehicles of social and political resistance.

The theorist Julia Kristeva defines abjection as a force that "disturbs identity, system, order. What does not respect borders, positions, rules."[2] Corporeal wastes such as excrement and vomit are abject: they induce revulsion because they are produced but cast off by the body, destabilizing the distinction between subject and object. Kristeva associated the abject with the feminine as opposed to the rule-bound patriarchal order. A similar association is seen in American artist Kiki Smith's (b. 1954) life-sized wax-modeled sculptures of naked Caucasian female figures leaking bodily fluids such as urine or menstrual blood (rendered through cascading yellow or red glass beads) from their vaginas (e.g., *Pee Body*, 1992; *Train*, 1993).

While Smith represented fluids from the body's interior, Palestinian-British artist Mona Hatoum (b. 1952) showed the interior of her own body in *Corps Étranger* (*Foreign Body*, 1994, Figure 22.1), a cylindrical architectural structure with a circular video projected on its floor. The video, shot with an endoscopic camera, enters Hatoum's orifices to explore hairy nasal passages, the vaginal canal, the bowels, and other inner spaces, accompanied by the rhythmic sounds of her breath and heartbeat. Hatoum said that *Corps Étranger* is "about the body probed, invaded, violated, deconstructed, by the scientific eye," but also about "the fearsome body of the woman as constructed by society."[3] Observing the image projected on the floor, "You feel like you are at the edge of an abyss that threatens to engulf you. It activates . . . fears and insecurities about the devouring womb, the *vagina dentata*, the castration complex."[4] Psychoanalytic theory attributes these fears to men, suggesting a feminist agenda impelling Hatoum's work. Refusing to represent the female body as a seductive object for the heterosexual male gaze, she instead renders it as foreign, unnerving, and abject.

American Robert Gober's (b. 1954) wax sculptures of Caucasian men's legs or the lower halves of their bodies, implanted with human hair and fitted with actual clothing to make them lifelike, are literally abject in their cast down state: jutting out from the wall along the floor to evoke mortality. In one disturbing example (*Untitled*, 1991–93), Gober sunk nine plastic drains into the truncated body, rendering it a humiliated receptacle for waste and disease—a chilling metaphor

FIGURE 22.1 Mona Hatoum, *Corps Étranger (Foreign Body)*, 1994. Video installation of 1 cylindrical structure, 1 video projector, 4 speakers, 1 videotape, PAL, color, stereo sound. Duration: 11 min 51 sec. Musée National d'Art Moderne, Centre Georges Pompidou, Paris., Paris.

for the ravages of AIDS. Also responding to that epidemic are works that the Cuban-born American artist Felix Gonzalez-Torres (1957–96) made out of **readymade** objects that refer to the human body without representing it. For example, some of his candy "spills," consisting of thousands of colorfully wrapped candies piled up in the corner of a gallery, function as portraits. *Untitled (Ross in L.A.)* (1991) signifies the body of Gonzalez-Torres's lover Ross Laycock, then dying of AIDS. The spill has an "ideal weight" of 175 pounds, matching Laycock's when he was healthy. Viewers are invited to take a piece of candy, unwrap it, and eat it, as if in an act of communion. Depletion of the pile through the candy's consumption poignantly symbolizes and implicates the viewer in Laycock's wasting away from his illness. However, the work also communicates hope and regeneration through its "endless supply" of candy; the spill is meant to be replenished daily.

The Bahamian-born American Janine Antoni (b. 1964) uses her own body as her primary art-making instrument. For *Gnaw* (1992), she laboriously created 600-pound cubes of chocolate and lard, then carved them by gnawing away at

their edges. The work blends elements of **Minimalism**, **Process art**, and performance art, respectively, in the geometric form of the chocolate and lard blocks, the visual evidence they give of Antoni's process of sculpting them, and her employment of her body to do so. *Gnaw* also has a feminist dimension. Antoni did not swallow the chocolate or lard but spat them out, evoking bulimia—an eating disorder involving binging and purging that mostly affects young women in developed countries. Bulimia is often caused by the psychological pressure that these women feel to conform to an ideal beauty standard of thinness, so that they can find love. Antoni referred to this motivation by casting the expectorated chocolate into heart-shaped candy packages and casting the spit-out lard, combined with beeswax and dyed red, into lipsticks—symbols of romance and seduction. She displayed these items in mirrored vitrines adjacent to the chewed chocolate and lard cubes, relating her work to the that of Commodity artists like Jeff Koons (see Chapter 20).

American artist Matthew Barney (b. 1967) used the body **allegorically** to investigate themes of gender and sexuality in his *Cremaster* cycle (1994–2002). This series of five enigmatic, largely dialogue-free films and related sculptures, photographs, and drawings is named for the muscle that raises and lowers the testicles in response to external stimuli. References to the reproductive organs' position during the embryonic process of sexual differentiation recur throughout the cycle. *Cremaster 1* represents the most "ascended" (undifferentiated) state; *Cremaster 5,* the most "descended" (differentiated). The cycle returns frequently to the early stage of development when sex is indeterminate—for Barney, a state of pure potentiality. Throughout the cycle, Barney (who stars in every film except *Cremaster 1*) employs gooey substances such as Vaseline and wax, whose transition between solid and liquid serves as a metaphor for transformation. The films' plots feature complex symbolism rooted in a dizzying array of sources, ranging from Barney's autobiography to biology, geology, history, popular culture, mythology, and esoteric lore and rituals.

Barney shot the films out of sequence, completing the longest and most elaborate, *Cremaster 3* (2002) last. Its convoluted plot revolves around the construction of the Chrysler Building in New York City (completed 1930) and a struggle between two men working on it: the Architect (a Master Mason, played by sculptor Richard Serra), and the Entered Apprentice (a first-degree Freemason, played by Barney). They reenact the myth of Hiram Abiff, the legendary architect of the Temple of Solomon, murdered by junior masons for his refusal to reveal his Master Mason's secret knowledge, and then resurrected by Solomon. In a sequence called "The Order," an allegory for the *Cremaster* cycle's five chapters,

the athletic Barney (a former high school football star) scales the ramps of the Solomon R. Guggenheim Museum (see Figure 17.8)—another Solomon's temple—like a mountaineer, confronting a different challenge on each level. On Level Three he meets his feminine alter ego, the Entered Novitiate, played by Aimee Mullins, a double-amputee Paralympic track star and fashion model. She appears initially as a white-gown-clad couture model with crystal legs. In a gender-crossing transformation, the Entered Apprentice also assumes feminine garb to embrace his double and achieve oneness (Figure 22.2). She then whispers into his ear the words of divine knowledge, "Maha byn," spoken by the resurrected Hiram Abiff to Solomon, and transmutes into a hybrid cheetah-woman. The Entered Apprentice fights and kills her ceremonially with mason's tools to achieve the level of Master Mason. Such hermetic **iconography** is typical of the *Cremaster* cycle. The cycle's power ultimately depends less on legible meanings than on the wondrously bizarre and impressively realized scope of its creator's imagination.

Some contemporary artists employ others' bodies in performance art to highlight social, cultural, and political issues. Italian-born, US-based Vanessa Beecroft (b. 1969) is known

FIGURE 22.2 Matthew Barney, *Cremaster 3: Maha Byn*, 2002. Color photograph, 76 x 50 cm.

for arranging naked or scantily young women with thin, well-toned bodies into formations in exhibition spaces where they display themselves like living statues, simultaneously inviting voyeurism and critical reflection on Western culture's artificially narrow ideal of female beauty (e.g., *VB35*, 1998). Spanish-born, Mexico City-based artist Santiago Sierra (b. 1966) draws attention to the exploitation of human labor by hiring impoverished and marginalized people to perform degrading or pointless tasks or even to permanently alter their bodies. For example, for *160 cm Line Tattooed on Four People* (2000), Sierra gave four female prostitutes addicted to heroin the price of a hit in return for getting their backs tattooed with a horizontal line. Although done with their subjects' consent, such works raise ethical questions by enacting the very exploitation and dehumanization they are intended to critique.

Many contemporary artists address topical issues by representing fragmented and mutated figures. Kenyan-born, New York-based Wangechi Mutu (b. 1972) creates such figures—Black and female—to challenge colonialism, racism, sexism, and militarism. She composes her figures of out of illustrations clipped from disparate sources including medical texts, *National Geographic*, and news, fashion, and pornographic magazines, and she embellishes her **compositions** with ink, paint, and other materials to create seductive aesthetic effects. At once monstrous and alluring, Mutu's figures are fantastic hybrids often incorporating human, plant, animal, and machine parts. *Misguided Little Unforgivable Hierarchies* (2005, Figure 22.3) shows a female figure squatting on a mottled earth mound amidst tall blades of grass.[5] Her posture signifies women's primal bodily functions: birth, sex, and elimination. Multiple black phallic and breast-like shapes projecting from her front and back also suggest reproductive and nurturing forces. Photographs of motorcycles comprise her feet, evoking the futuristic concept of the cyborg—a human body with integrated electromechanical devices. Photographs of naked women's body parts make up her face. A smaller figure in a high-heeled shoe stands on the larger figure's back and bends over so that their faces nearly meet. A still smaller hybrid woman-motorcycle-animal figure rides on the bending figure's abdomen. This structure of stacked bodies speaks to the problematic nature of presumed hierarchies signaled by the work's title. These include hierarchies between human and animal, and those of racist evolutionary theories that posited white supremacy and justified European colonization of Africa and other parts of the global South. The red blotches in the **background**, evoking blood splatters, express colonization's violence. They also suggest explosions and the artist's anti-war sentiments. Mutu made this work in anger over the United States' recent invasion of Iraq, which many critics considered unjustified.[6]

FIGURE 22.3 Wangechi Mutu, *Misguided Little Unforgivable Hierarchies*, 2005. Ink, acrylic, collage, and contact paper on Mylar, 205.74 x 132.08 cm. San Francisco Museum of Modern Art.

Identity

As traditionally defined, identity implies the unity or sameness of an entity that distinguishes it from other entities.[7] The Enlightenment understanding of personal identity conceives of the individual as fully centered and coherent. Collective identity is similarly conceived: groups such as societies, religions, and nations are posited as unified communities. Such views are often considered essentialist in assuming that a person's or group's distinctiveness expresses some innate, enduring essence. An anti-essentialist view arose in the 1970s, emphasizing the socially constructed nature of all identities. In this perspective, identities are not fixed and unified but are mutable, multiple, and contingent upon ever-changing contexts. They are defined through their difference from other identities—identity is always relational rather than essential.

Globalization has further affected understandings of identity, with transnational flows of images and information and global markets' homogenizing effects challenging the national and cultural frameworks in which individuals have traditionally formed their identities. This has led to reassertions of ethnic, cultural, and religious identities by right-wing and populist nationalist movements and religious fundamentalist groups. On the other hand, some feel liberated by the destabilization of restrictive identities and embrace the **postmodern** possibility of building identities around multiple bases. These range from national, ethnic, religious, or class allegiances to lifestyles, age, race, gender, sexuality, disability, or involvement in social or political movements. Many now understand identity as involving choice, accommodating diversity, and embracing transformation. Some recognize identity as a performance—a fiction that can be applied to critical or constructive purposes.

Identity politics—the politics of an identity group promoting the group's interests—animated much identity-themed art in the United States in the 1980s and 1990s.

Globalization

Globalization denotes the worldwide interconnection of economic, political, social, and cultural processes. Travel and trade have forged such interconnections for millennia. The Silk Road, an ancient trade route between China and the Mediterranean, was an early vehicle of globalization. The Age of Exploration (late fifteenth–eighteenth century) fostered increasing economic and cultural exchange between Europe, Asia, Africa, Australia, and the Americas, while also initiating the slave trade and colonialism. Technological innovations of the Industrial Age (mid-eighteenth–mid-twentieth century) such as factories, steamships, railroads, automobiles, airplanes, the telegraph, telephone, radio, and television, expedited the worldwide flows of goods, people, and information. Globalization has accelerated exponentially in the current Information Age (1970s–present), with information becoming a commodity widely and rapidly transmitted through computer technology.[8] Electronic communication has facilitated the mobility of finance capital and the interconnection of world markets.

These developments were abetted by the neoliberal economic policies of advanced capitalist countries such as the United States and United Kingdom that promoted free trade, deregulation, and privatization. Their governments renegotiated regional and global trade agreements and enhanced the power of international regulatory agencies (e.g., the World Trade Organization) and transnational economic institutions (e.g., the World Bank and the International Monetary Fund). These moves facilitated the ascendancy of multinational corporations and transformed the labor market, with many manufacturing jobs outsourced to developing countries offering cheap labor. Neoliberal globalization signifies the triumph of an integrated global capitalist market that functions efficiently through free international trade. In cultural terms, globalization has fostered the worldwide diffusion of popular cultural products and consumer brands, largely issuing from the United States (e.g., Hollywood movies, McDonald's). This has raised fears that globalized culture will render human experience uniform everywhere. However, local cultures do not simply succumb but adapt to globalizing forces, producing hybrid forms through "glocalization"—a combination of globalization and localization.

Globalization also involves the migration of people around the world, often from formerly colonized countries to the countries that colonized them. For those with access to the new communications technologies, globalization can produce a greater consciousness of the world as a whole and the sense of inhabiting what Marshall McLuhan in the 1960s called the "global village." In this condition, the intensified awareness of other people, places, and cultures may induce greater tolerance for diversity and difference. Despite this hopeful possibility, globalization has many critics. Its right-wing opponents see it threatening national economies and identities; they argue for national control of the economy and restrictions on immigration to safeguard national identity.[9] Globalization's left-wing opponents argue that its capitalist logic produces asymmetrical power relations, both domestically and worldwide, and negatively affects labor, the environment, national self-governance, and daily existence—treating every aspect of life as a commodity.

Artists from groups who have experienced marginalization and injustice—such as African Americans, Asian Americans, Latina/os, Native Americans, women, and LGBTQ people—used their work to assert pride in their identity, oppose discrimination, and advance social justice. Many African American artists, such as Lorna Simpson (b. 1960), emphasized skin color as the source of bias against them. Simpson's *Guarded Conditions* (1989) presents eighteen large color Polaroid prints arranged to form six portraits of a standing Black woman in a simple white shift, facing away from the viewer with her arms folded behind her back. Black plastic letters spelling out "GUARDED CONDITIONS" surmount the photographs; multiple plaques alternately reading "SEX ATTACKS" and "SKIN ATTACKS" span the wall below them. The woman's isolation, shapeless white garb, and repeated body evoke surveillance and institutional control; the surrounding words suggest that she is under guard and subject to violence because of her sex and skin color. The term "intersectionality," coined in 1989 by legal scholar Kimberlé Crenshaw, describes the combination of overlapping forms of discrimination such as racism and sexism, often experienced by marginalized individuals like the one in Simpson's photographs. At the same time, this woman resists scrutiny and victimization by turning her back and folding her arms defensively.

Kerry James Marshall (b. 1955) paints figures with pitch black skin to emphasize their racial identity, as in his *Garden Series* (1994–95): large paintings depicting life in Chicago public housing projects with "Garden" in their names. Built as affordable housing by the federal government after World War II, the projects were initially successful but ultimately declined into what Marshall called "warehouses for the poor . . . riddled with gang violence"[10]—the opposite of what their pastoral names promised. Marshall insists, however, that their inhabitants lead rich and complex lives. He communicates hope and possibility in pictures like *Better Homes, Better Gardens* (1994, Figure 22.4), using an opulently colorful children's-storybook-like representational **style** to show calm, youthful Black figures enjoying outdoor leisure under blue skies amidst birds and flowers, against the backdrop of low-rise housing units. Marshall's visual model for the *Garden Series* was the **pastoral**

FIGURE 22.4 Kerry James Marshall, *Better Homes, Better Gardens*, 1994. Acrylic paint and paper collage on canvas, 254 x 360.68 cm. Denver Art Museum, Colorado.

painting genre stretching from the **Renaissance** to Manet's *Dejeuner sur l'herbe* (see Figure 1.13). Marshall places his art in dialogue with the history of European painting, in which Black bodies are marginalized or absent, in order to "move the black figure from the periphery to the center."[11]

The same motive impels Kehinde Wiley (b. 1977), who since the early 2000s has painted large **photorealist** portraits of young Black men (and, since 2012, women) in the poses of white aristocrats, saints, and heroes in European **Old Master** paintings (e.g., *Napoleon Leading the Army over the Alps*, 2005). Presented against ornately patterned backgrounds and dressed in contemporary garb, Wiley's figures project the same confident authority as their white prototypes, giving Black people an inspiring image of themselves as empowered rather than downtrodden.

Numerous contemporary artists from marginalized groups in the United States appropriate stereotypical racist imagery in order to challenge it, much as Betye Saar did in *The Liberation of Aunt Jemima* (see Figure 19.25). Jaune Quick-to-See Smith (b. 1940), an enrolled Salish member of the Confederated

Salish and Kootenai Nation of Montana, topped her mixed media painting *Trade (Gifts for Trading Land with White People)* (1992, Figure 22.5) with a chain from which dangle Native American themed toys, dolls, and sports souvenirs of such teams as the Cleveland Indians and Washington Redskins, which many Native Americans consider demeaning. Appropriating the style of Rauschenberg's **Combines** (see Figure 14.1), Smith filled the three panels below with a **collage** of articles from her tribal newspaper, patterned fabric, and clippings from magazines, advertisements, and other printed sources. The collaged materials include nineteenth-century Indian imagery and news of the depressing realities of contemporary reservation life plagued by alcoholism, pollution, poverty, and AIDS. Passages of **Abstract Expressionist**-style **brushwork** animate the collaged surfaces, with dripping red paint evoking blood, rage, and Native American racial identity. The image of a canoe, symbolizing trade, stretches across the composition's lower center. As signaled by its title, Smith's painting proposes with bitter irony to reverse the colonizers' historic trading of trinkets to Native Americans for land

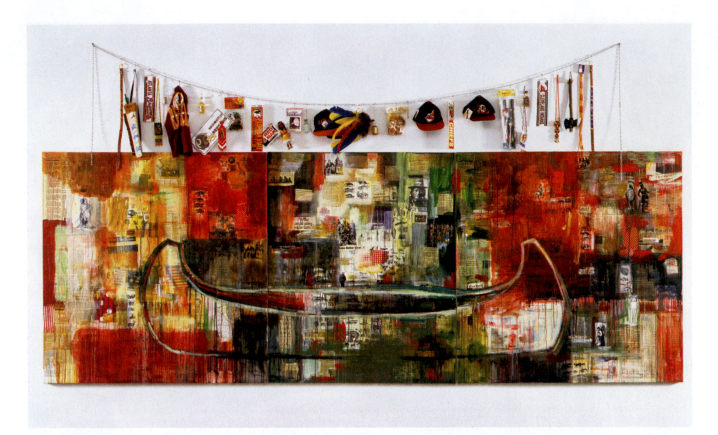

FIGURE 22.5 Jaune Quick-to-See Smith, *Trade (Gifts for Trading Land with White People)*, 1992. Oil and mixed media on canvas, 218.4 x 431.8 cm. Chrysler Museum of Art, Norfolk, Virginia.

by offering the suspended "silly trinkets that so honor us" to whites in exchange for the land's return.[12]

Trade belongs to a series of paintings Smith made in critical response to the 500th anniversary of Christopher Columbus's arrival in the Americas, which led to European colonization and dispossession of the hemisphere's Native peoples. Also reacting to that anniversary, the Cuban American interdisciplinary artist and writer Coco Fusco (b. 1960) and Chicano performance artist and writer Guillermo Gómez-Peña (b. 1955) devised a collaborative performance, *Two Undiscovered Amerindians Visit the West*, presented at several different venues in the United States and internationally in 1992 and 1993 (Figure 22.6). Playing natives of Guatinaui, a fictitious, uncolonized island in the Gulf of Mexico, the artists were displayed in a cage before audiences. This format recalled the once-popular practice of exhibiting Indigenous people from Africa, Asia, and the Americas in European and North American zoos, museums, and other venues, including the 1893 World's Columbian Exposition in Chicago, which dehumanized them as exotic, "primitive" specimens.

Wearing stereotypical "native" garb—a grass skirt (Fusco) and a feathered headdress (Gómez-Peña)—combined incongruously with Western accoutrements including sunglasses, cowboy boots, and Converse sneakers, the caged "Guatinauis"

performed their "traditional tasks" such as sewing voodoo dolls, lifting weights, watching television, and typing on a laptop computer.[13] For a small fee, they would pose for photographs with visitors, Fusco would dance to rap music, and Gómez-Peña would recite "authentic" Amerindian stories (in a nonsensical language). The artists intended the performance as a "satirical commentary on Western concepts of the exotic, primitive Other,"[14] but many visitors believed they were seeing actual "undiscovered Amerindians." "The cage," wrote Fusco, "became a blank screen onto which audiences projected their fantasies of who and what we are. As we assumed the stereotypical role of the domesticated savage, many audience members felt entitled to assume the role of colonizer, only to find themselves uncomfortable with the implications of the game."[15]

Los Angeles-based photographer Catherine Opie's (b. 1961) striking color portraits give visibility to queer sexual identities. *Being and Having* (1991) is a series of close-up head shots of Opie and her lesbian friends posing in their masculine personae, wearing fake mustaches or goatees. The series' title plays on Jacques Lacan's psychoanalytic theory holding that man "has" the phallus, while woman, who embodies male desire, is presumed to "be" the phallus. By performing their masculinity, the photographed women *have* the phallus; by

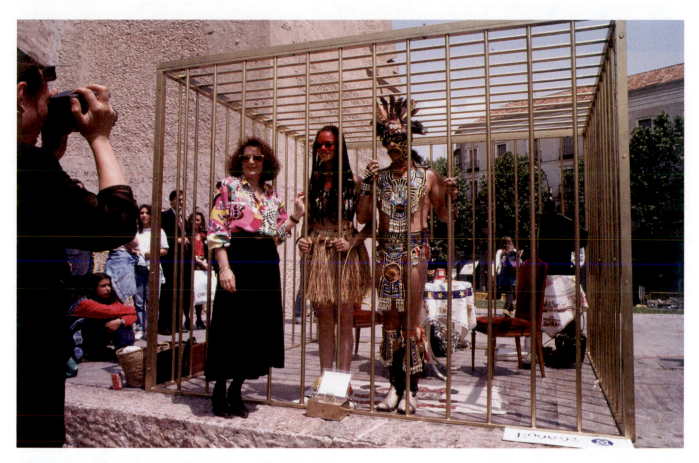

FIGURE 22.6 Coco Fusco and Guillermo Gómez-Peña, *Two Undiscovered Amerindians Visit Madrid*, 1992. Performance, Plaza de Colón, Madrid.

representing the desire of another—now a female—they *are* the phallus. These photographs challenge heteronormativity—the belief that heterosexuality is human sexuality's only normal form. Practices like cross-dressing and stylized butch/femme identities can resist this belief.

Opie's subsequent *Portraits* series (1993–97) depicts her gay, lesbian, and transgender friends in the San Francisco S/M (sadism and masochism) community.[16] Using an aestheticized style inspired by Northern Renaissance portrait paintings, Opie posed her pierced and tattooed subjects against simple, vibrantly colored backgrounds, often looking straight at the camera. The sitters' gender is often difficult to determine, which destabilizes the concept of gender itself. *Mike and Sky* (1993, Figure 22.7) depicts two lesbians undergoing gender reassignment, taking hormones to transition to men. Opie's formal composition gives the sitters a sense of dignity often denied to them by "mainstream" society and honors their courageous crafting of their own identities in the face of restrictive social norms.

Language is a fundamental means of cultural expression and marker of identity that numerous contemporary artists

have explored in their work. **Calligraphic** writing in Farsi (modern Persian) is a key feature of Iranian-born Shirin Neshat's (b. 1957) *Women of Allah* series of black-and-white photographs (1993–97). Based in the United States since 1975, Neshat created this series after her 1990 visit to Iran—her first since the 1979 Islamic revolution—where she was shocked by the requirement that women wear the chador (a full-body veil) in public. In the *Women of Allah* series (e.g., *Rebellious Silence*, 1994), chador-clad female models, including Neshat herself, sometimes brandish rifles to create a confrontational quality. On each photograph's surface, the artist wrote lines of prose or poetry in Farsi script over the woman's exposed body parts. The texts, mostly by contemporary Iranian women authors, present conflicting ideological views, ranging from feminist resentment of Islamic-enforced patriarchy to devout support for the revolution. Neshat claimed to have no position, just curiosity: "I put myself in a place of only asking questions but never answering them."[17]

In her two-channel black-and-white video **installation**, *Turbulent* (1998), Neshat used the contrast between intelligible

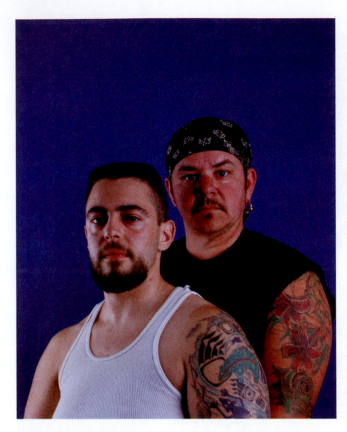

FIGURE 22.7 Catherine Opie, *Mike and Sky*, 1993. Chromogenic print, 50.8 x 40.64 cm.

sung language and incomprehensible vocalization to dramatize the male-female social dichotomy in Islamic-ruled Iran. On one screen, a male singer performs a passionate song of divine love with lyrics by the Sufi poet Rumi on stage before an all-male audience. As he sings, the screen on the opposite wall shows a chador-clad woman standing with her back to the camera on the same stage before an empty auditorium. After the male singer finishes, the woman performs an emotionally intense song of strident, melodious, and rhythmic nonspeech sounds as the camera tracks around to record her expressive face and gestures. She thus rebels against the Iranian prohibition of women performing in public, surprising the male singer who stares at her intently. The viewer, unable to watch both screens simultaneously, is caught between dueling male and female performances—one conventional, one highly personal—and the different identities they express.

Chinese artists Xu Bing (b. 1955) and Wenda Gu (also known as Gu Wenda, b. 1955) investigate language's role in constituting cultural identity by using fake or creatively transformed language in their art. For *Book from the Sky* (1987–91), Xu invented some four thousand meaningless Chinese characters that he carved and printed on scrolls and in books using traditional methods and arranged into immersive installations. The impressive display of verbiage honors writing as a Chinese cultural treasure while its meaninglessness challenges

language's authority. Xu related *Book from the Sky* to the Zen Buddhist teaching that "words are unreliable."[18] After moving to the United States in 1990, he developed Square Word Calligraphy, a method of writing English words using the traditional strokes and structure of Chinese characters. This new style heightens both English- and Chinese-literate peoples' awareness of the centrality of writing and reading to their sense of cultural identity.

Wenda Gu incorporates miswritten languages into his on-going series of *united nations* series of installations (e.g., *united nations—china monument: temple of heaven*, 1998), whose principal medium is human hair fashioned into bricks, braids, and suspended panels. The hair in the panels is often shaped into unreadable texts based on English, Hindi, Arabic, and Chinese seal script. These texts symbolize the different linguistic and cultural identities that divide humanity, while the blended human hair, often gathered from multiple nations, signifies the utopian possibility of human unification through biological merger. Gu's works also often feature pseudo-characters synthesized from elements of Chinese seal script and English letters, reflecting his experience of moving back and forth frequently between China and the United States.

Gu's pseudo-characters and Xu's Square Word Calligraphy exemplify the cultural mixture, or hybridization, fostered by such processes as colonization, immigration, and globalization. Numerous contemporary artists explore similar concepts of hybridity. One is Yasumasa Morimura (b. 1951), a Japanese artist who uses wigs, makeup, costumes, props, and digital technology to restage famous paintings by such artists as Rembrandt, Manet, Van Gogh, and Frida Kahlo as large color photographs in which he plays all the parts. In *Portrait (Futago [Twin])* (1988, Figure 22.8), a reprise of Manet's *Olympia* (see Figure 1.14), Morimura blurs the boundaries of race, ethnicity, and gender by impersonating both the white Olympia and her Black African maid, even as he emphasizes his personas' artificiality: his "Olympia" sports a blonde wig and displays a flat masculine chest and his maid has red rather than black skin. Morimura also adds Japanese elements: his "Olympia" reclines on a beautiful kimono and the hissing black cat in Manet's painting is replaced by a black ceramic "beckoning cat," displayed near the entrances of Japanese businesses to attract customers. Morimura's work reflects Western art and culture's strong influence on contemporary Japan while his crossing-over from male to female appearance evokes traditions of Western drag and Japanese Kabuki theater, in which male actors play female roles. Morimura is often compared to Cindy Sherman, who also takes on multiple guises in her art (see Figure 20.15). The key difference is that Sherman operates within her own Euro American cultural tradition, whereas Morimura inserts himself into that tradition from his outsider position as an East Asian, creating an effect of hybridity.

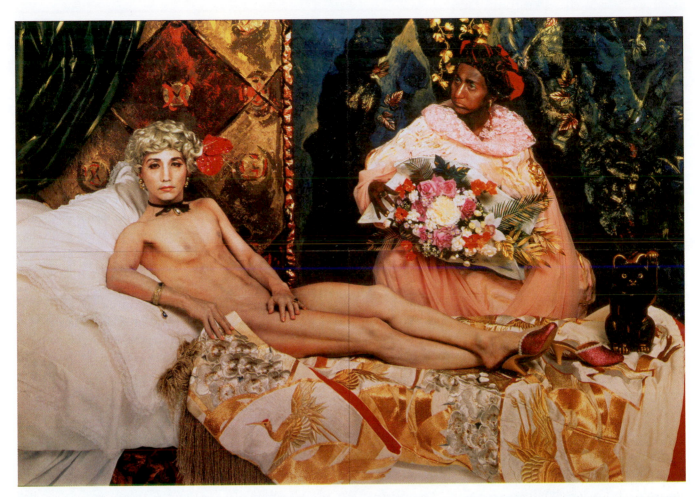

FIGURE 22.8 Yasumasa Morimura, *Portrait (Futago [Twin])*, 1988. Color photograph, Edition of 5: 209.6 x 299.7 cm, Edition of 3: 240.03 x 342.9 cm. © Yasumasa Morimura; Courtesy of the artist and Luhring Augustine, New York.

The London-born Yinka Shonibare (b. 1962), who grew up in Lagos, Nigeria (a former British colony) and returned to London in the mid-1980s, creates an effect of hybridity in sculptural tableaux of headless, life-sized mannequins wearing upper-class eighteenth- or nineteenth-century European-style clothing fashioned of brightly colorful patterned "African" fabric. This fabric actually originated outside Africa, however. Known as "Dutch wax," it was developed in the 1850s in the Netherlands as a mass-produced imitation of the batik dyeing process used in Indonesia, then a Dutch colony. Dutch, British, and Swiss manufacturers began exporting it to West Africa in the late nineteenth century, where it became, ironically, a symbol of African identity despite its European origin. For Shonibare, this fabric with its tangled transcontinental history is a metaphor for interdependence. His use of it to create clothing in the fashion of the British Empire's heyday, in works such as *Three Graces* (2001), evokes postcolonial theorists' conception of hybridity as the blending of different cultures arising in colonial situations that destabilizes the identities of both the colonizer and the colonized. In his *Age of Enlightenment* series (2008), Shonibare presented sculptural tableaux of five eighteenth-century European thinkers as representatives of the Enlightenment ideas that justified nineteenth-century colonialism's "civilizing mission." Shonibare depicted each figure with a physical disability. For example, French mathematician Jean le Rond d'Alembert has a prosthetic leg and crutches. These alterations evoke the artist's own disability—Shonibare contracted a virus in his late teens that left him partially paralyzed—but also serve, in his words, as "a device for showing how these figures, who were partly responsible for defining otherness in the context of the Enlightenment, could be also 'othered' in the context of disability."[19]

Memory and History

The related themes of memory and history have engaged numerous contemporary artists. Memory, a faculty of the mind that stores and retrieves information and past experiences, is subjective; individual memories are partial and unreliable—subject

to repression, distortion, or falsification. By contrast, history, in its professionalized form developed in the nineteenth century, aimed at objectivity—the true retelling of past events. Late twentieth-century postmodernists proposed a new conception of history emphasizing its constructed and ideological nature. In this view, history consists of representations of the past that serve the interests of those who construct them. Contemporary artists often address memory and history in their work through references to the past as it is known through its surviving traces. These include photographs, film and video footage, artifacts, illustrations, news reports, and documents, as well as participants' and witnesses' first-hand accounts of remembered experiences. Representations of the past in contemporary art generally announce their status not as objective records but as imaginative fictions, creative interpretations, critical commentaries, memorials, or some combination of these.

Historical traumas, such as the transcontinental enslavement of Africans and the Holocaust, and more recent traumas, such as Latin American political violence and South African apartheid, have elicited compelling responses from

contemporary artists. Fred Wilson (b. 1954), an American artist of African and Carib Indian ancestry, addressed slavery in a project that critically examined how museum collection displays are shaped ideologically to tell certain stories about the past while excluding others. In *Mining the Museum*, his 1992–93 installation at the Maryland Historical Society (MHS) in Baltimore, Wilson used objects from the MHS collection to create an unconventional exhibition revealing racist aspects of Maryland's history not acknowledged in the museum's permanent displays. In a case labeled "Metalwork, 1793–1880," he displayed a pair of iron slave shackles next to exquisitely crafted Baltimore silver repoussé vessels—provocatively juxtaposing normally segregated artifacts to suggest slavery's foundational role in generating Maryland elites' wealth (signified by the silver).

Beginning in the mid-1990s, another African American artist, Kara Walker (b. 1969), addressed the subject of slavery using black paper cutouts executed in the elegant style of eighteenth- and early nineteenth-century silhouette portraits. She installed these cutouts on white gallery walls to represent

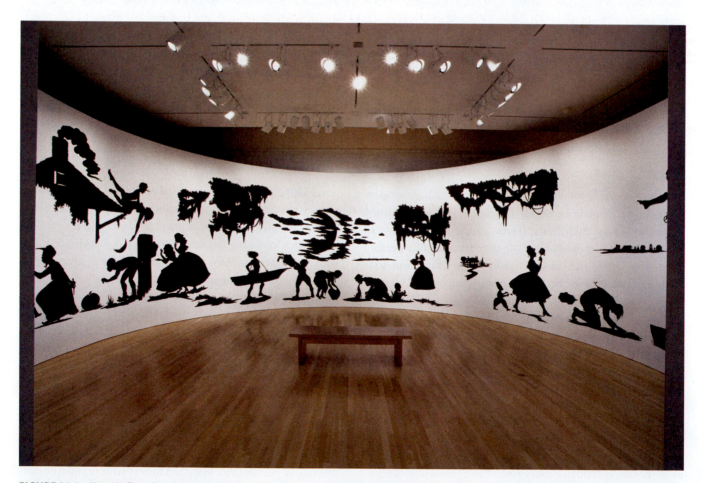

FIGURE 22.9 Kara Walker, detail of *Slavery! Slavery! Presenting a GRAND and LIFELIKE Panoramic Journey into Picturesque Southern Slavery or "Life at 'Ol' Virginny's Hole' (sketches from Plantation Life)" See the Peculiar Institution as never before! All cut from black paper by the able hand of Kara Elizabeth Walker, an Emancipated Negress and leader in her Cause,* 1997. Cut paper and adhesive on wall, 3.7 x 25.9 m overall. Installation view: *Kara Walker: My Complement, My Enemy, My Oppressor, My Love,* Hammer Museum, Los Angeles, 2008.

narratives from the antebellum American South filled with shocking scenes of abjection, violence, and sexual depravity involving stock characters from romantic stories of Southern plantation life (Figure 22.9). Walker gave her African American figures demeaning stereotypical features such as low brows, large lips, and "pickaninny" hair, historically employed in racist visual culture. She sees a structural equivalent between her style and imagery: "The silhouette says a lot with very little information, but that's also what the stereotype does."[20] Some older Black artists, including Betye Saar, accused Walker of recirculating harmful racist stereotypes to amuse the white art establishment. Walker, however, contends that stereotypes and racism can only be overcome by confronting their continuing presence in the American psyche. Her tableaux's mostly life-sized figures function like shadows thrown by the viewers, who are implicated in the nightmarish scenes of degradation and compelled to reflect on slavery's unresolved history and persistent effects.[21]

Numerous works in Christian Boltanski's (1944–2021) series of *Monuments*, begun in 1985, refer to the Holocaust. This was a subject of personal significance to the Paris-born artist, whose mother was Catholic and father was Jewish; the latter hid under the floorboards from the Nazis during the German occupation of France. The *Monuments* incorporate framed, enlarged, blurry black-and-white photographs of children Boltanski re-photographed from printed sources. He mounted the photographs to the wall in geometric configurations and illuminated them with incandescent lightbulbs or lamps, leaving the black electrical cords dangling. Boltanski often juxtaposed the photographs with rusted tin biscuit boxes. The old photographs of children evoke the transience of life; the lights suggest votive candles in a memorial to the dead, or when shining on the photo from a lamp, a police interrogation; and the biscuit tins evoke containers for personal effects or metal urns holding ashes. A work like *Monument (Odessa)* (1989–2003), featuring photographs Boltanski appropriated from a snapshot of Jewish students celebrating Purim in France in 1939, inevitably evokes the Holocaust. Beyond thinking of any specific historical trauma, however, Boltanksi wanted his viewers to relate his works to their own feelings about childhood, loss, death, and remembrance. "I want to make people cry," said the artist; "I am for an art that is sentimental."[22]

Many contemporary artists and architects have created Holocaust memorials and museums. The 1996 commission for Vienna's Holocaust memorial went to English sculptor Rachel Whiteread (b. 1963), who makes casts in plaster, resin, rubber, and concrete of the interiors of furniture pieces, rooms, and entire buildings, turning voids into positive sculptural forms that evoke memory, absence, and loss. The memorial's construction in Vienna's historic Judenplatz was delayed for four years by political and religious controversies, including the question of whether Jewish law permitted it to be built over an excavated medieval synagogue, ultimately preserved as an underground museum. Whiteread was no stranger to controversy: she gained notoriety in Britain for her temporary **site-specific** sculpture *House* (1993). It was the sprayed-concrete cast of the interior of a three-story Victorian row house in East London, the last in a terrace being demolished to clear space for a park. *House* became a lightning rod for outspoken public opinion concerning its aesthetic merits, the perceived elitism of the art world and philistinism of many community residents, and frustration with the state of housing in London. Whiteread's *Holocaust Memorial* (1995–2000, Figure 22.10), dedicated to the 65,000 Austrian Jews murdered by the Nazis, is a gray concrete minimalist block standing on a base inscribed with the names of the Nazi death camps. Intended to resemble an inside-out-library—a reference to the Jews as "People of the Book"—its walls are covered with incisions that simulate rows of books on shelves with their spines facing inward and fore edges facing outward. On one side, a pair of double doors remains permanently sealed. A room that cannot be entered containing books that cannot be read, the memorial symbolizes

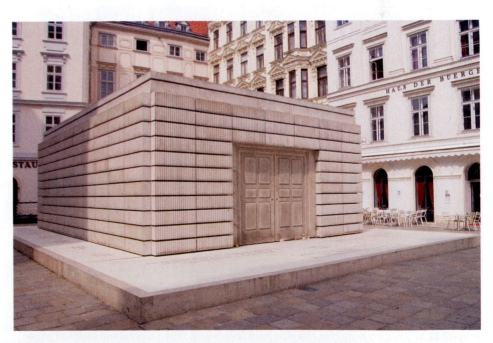

FIGURE 22.10 Rachel Whiteread, *Holocaust Memorial*, 1995–2000. Judenplatz, Vienna.

lives forever lost. As one critic noted, its "emphatic muteness and silence is the appropriate response to the enormity of its subject."[23]

Doris Salcedo's (b. 1958) art is conceptually related to Boltanski's and Whiteread's in evoking loss and memory's workings but is more politically charged in confronting contemporary mass violence. In the later 1980s and 1990s, she made work dealing with the horrific realities of her native Colombia, in which strife between political factions, paramilitary squads, guerilla bands, and drug traffickers claimed thousands of lives annually.[24] The countless victims of abduction, torture, and assassination were known as *desaparecidos,* those who have been "made to disappear." Learning that shoes were often used to identify victims' remains, Salcedo in her *Atrabiliarios* series (1992–2004) focused on the female casualties of violence by displaying women's shoes, donated by the families of the disappeared, in sunken niches covered with stretched cow bladder sutured into the wall. Viewed through translucent membranes as if through the filter of memory, the shoes function as mournful relics. Salcedo also commemorated murdered Colombians by filling pieces of domestic furniture such as chairs and wardrobes with cement, rendering them dysfunctional (e.g., *Untitled*, 1998, Tate). Sometimes incorporating clothing into the cement, these objects stand in for the bodies of those who once used them, but they are now sealed and silenced, evoking death and entombment.

White guilt over the racist system of South African apartheid is the unifying theme of William Kentridge's (b. 1955) series of films made between 1989 and 2003. He composed these nine films, known as *Drawings for Projection*, by photographing, one frame at a time, a roughly sketched charcoal drawing that he modified through erasures and/or and additions between each exposure. The result is the dreamlike illusion of a drawing in continuous flux, with ghostly vestiges of previous images lingering as partially effaced traces. Kentridge made several drawings for each film to produce different scenes. Two recurring white male characters populate the films: Soho Eckstein, a rapacious, pinstripe-suit wearing industrialist, and Felix Teitelbaum, a melancholy, romantic artist and observer, shown naked. They are alter egos of one another and of Kentridge himself. In *Felix in Exile* (1994), the title character occupies a sparsely furnished hotel room whose walls become increasingly covered with drawings—his own and those of a Black woman, Nandi, who sketches the landscape with the aid of surveyor's instruments. These characters converge when Felix's mirror image is replaced by Nandi's visage and the two meet eye to eye through a double-ended telescope (Figure 22.11). Through a series of drawings, Felix experiences sexual fantasies about the naked Nandi bathing in a pond. She is his racial and sexual Other and an object of forbidden desires; Kentridge describes her as "perhaps . . . a displaced self-portrait."[25] The focus then shifts to sequences of Black Africans' bleeding corpses on the barren ground of the East Rand outside Johannesburg. Fluttering newspapers cover their bodies, which disappear into the earth. In the narrative climax, Felix witnesses the bare-breasted Nandi felled by a gunshot. Her body transforms first into a mound of earth and then a small blue pond, to which Felix is transported from his hotel room—also filled with blue water, symbolizing tears of grief—to stand with his back to the viewer. Made shortly before the first democratic elections in postapartheid South Africa, *Felix in Exile* meditates poetically on that system's brutal legacy. Kentridge said the film questions "the way in which the people who had died on the journey to this new dispensation would be remembered—using the landscape as a metaphor for the process of remembering or forgetting."[26]

Memorialization is the central concern of *Remembering* (2009, Figure 22.12), a temporary installation by the Chinese artist Ai Weiwei (b. 1957) dedicated to the more than five thousand children who perished in the May 2008 earthquake in Sichuan Province.

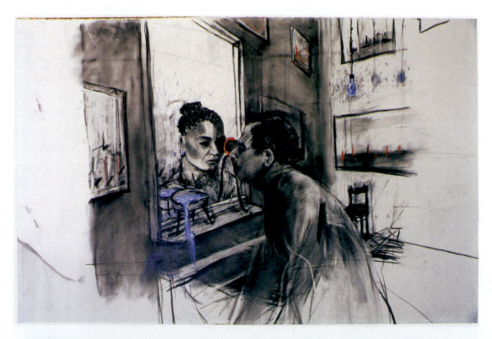

FIGURE 22.11 William Kentridge, Drawing from *Felix in Exile*, 1994. Charcoal and pastel on paper, 120 x 150 cm.

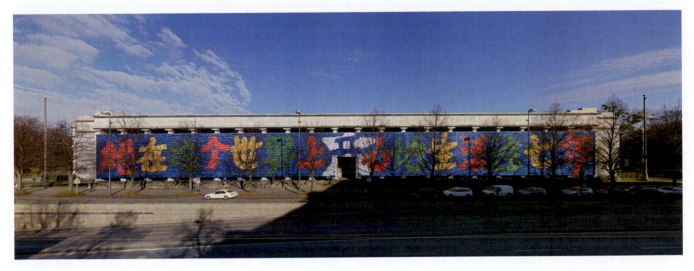

FIGURE 22.12 Ai Weiwei, *Remembering*, 2009. Installation of 9,000 children's backpacks on the façade of the Haus der Kunst, Munich.

They died when their schools collapsed due to their shoddy construction, a result of corrupt collusion between local officials and construction companies. After the earthquake, Ai, an unrelenting critic of China's authoritarian regime, launched a "citizens' investigation" team of seventy-three volunteers, thirty-eight of whom joined him in Sichuan to collect the children's names, birthdates, and death locations. His goal was to "remember the departed, to show concern for life," and to force the government and construction companies to take responsibility.[27] The Chinese authorities resisted Ai's efforts, shutting down his blog and arresting members of his team. Ai himself was severely beaten by police in Chengdu who prevented him from testifying at the trial of another activist charged with subversion for investigating the schoolchildren's deaths. The most poignant of several artworks Ai made bringing the deaths to public attention, *Remembering* consisted of nine thousand children's backpacks of different colors spelling out in Chinese, "She lived happily for seven years in this world," a sentence uttered by a quake victim's mother. *Remembering*'s monumental size, use of readymade objects associated with childhood innocence, and the contrast between its cheery colors and its heart-rending words produced a powerful emotional impact. This heightened the work's effectiveness in memorializing the children while drawing attention to Ai's mission to hold the Chinese government accountable for their deaths.

In addition to creating memorials in various mediums, many contemporary artists have creatively explored the past by employing the conventions of historical reenactments. Especially prevalent in England and the United States, these reenactments, most often restaging famous battles, incorporate historically accurate details to simulate history come to life, but they often fail to encourage critical thinking about how the understanding of the past is shaped by its interpreters' interests. Conscious that history is always subject to rewriting from different perspectives, English artist Jeremy Deller (b. 1966) presented *The Battle of Orgreave* on June 18, 2001, in the South Yorkshire village of Orgreave, employing some one thousand reenactors to restage a clash between striking coal miners and mounted police that had occurred there seventeen years earlier. It was a dramatic event in the nationwide 1984–85 strike by the National Union of Mineworkers in opposition to the planned closure of coalmines by conservative prime minister Margaret Thatcher's government—a struggle the miners lost. Deller's research revealed that media coverage of the Orgreave incident was biased against the miners, whom Thatcher demonized as perpetrators of "mob violence" and called "the enemy within."[28] Seeking "to find out exactly what happened on that day,"[29] Deller interviewed the miners and police who were involved and enlisted many of them in the reenactment, orchestrated by Howard Giles, a reenactment expert, and documented in a film by Mike Figgis. For many of the participating miners, *The Battle of Orgreave* offered a cathartic opportunity to assert their truth of what happened in 1984 and to dispel the media's negative stereotypes of them. The work also provided a forum for considering the difficult legacy of the mines' closure, which devastated the former mining communities economically and socially.

Mobility

Contemporary artists address various kinds of mobility—social, geographical, and physical, and the movement of capital, information, and commodities—all accelerated by globalization (see box). Mobility is often seen as a positive value

within such realms as law and commerce and is widely desired as an individual right. However, mobility for migrants and those seeking to escape poverty, natural disasters, war, or political oppression is often difficult and restricted by borders and anti-immigration policies. Mobility is also a challenge for many people with disabilities who have increasingly advocated for improvements in accessibility to facilitate their full participation in society. Matthew Barney's casting of Paralympic athlete Aimee Mullins in *Cremaster 3* highlights the capacity of a person with a disability to achieve impressive mobility through the use of prosthetics.

Prominent contemporary artists are usually highly mobile, sometimes relocating from their native lands to other countries and frequently traveling around the world. Among them is South Korean artist Kimsooja (b. 1957), who uses *bottari*, based on traditional Korean cloth-wrapped bundles of household possessions, as an emblem of mobility in her art. For her performance and video work, *Cities on the Move—2727 kilometers Bottari Truck* (1997), made right before she relocated from Seoul to New York, Kimsooja took an eleven-day journey through Korea sitting atop a pile of *bottari* on the back of a truck visiting villages from her childhood, when her family often moved. Besides mobility, this work evokes the importance of textiles in everyday life: the *bottari* were wrapped in used bed covers like those that Kimsooja formerly sewed with

her mother—objects that intimately accompany the cycle of human existence from birth to death.

Another Korean-born artist, Do Ho Suh (b. 1962), who moved to the United States in the 1990s and subsequently to London, reflects on his itinerant existence by creating portable fabric sculptures that represent, to scale, his former and current residences. The first of these, made in 1999 in collaboration with a master Korean seamstress, was a diaphanous green silk replica of the walls and roof of a structure that comprised part of Suh's childhood home. He displayed it at the Korean Cultural Center in Los Angeles as *Seoul Home/ L.A. Home*, suspended tent-like from the ceiling. With each subsequent installation in another venue, the work's title expanded to record its exhibition history; as of 2002, it was *Seoul Home/L.A. Home/New York Home/Baltimore Home/ London Home/Seattle Home* (Figure 22.13). Suh's feelings of displacement and longing, and his wish to transport his childhood home with him to the United States, inspired this sculpture. He visualized it as "the space of personal memory and history" but believed that any viewer could potentially identify with it.[30]

Bharti Kher (b. 1969), who moved from her native England to New Delhi in the early 1990s, also addresses themes of dislocation resonating with her transnational experience. *Not All Who Wander Are Lost* (2015), Kher's temporary installation on the **façade** of Boston's Isabella Stewart Gardner Museum, conveys her interest in mapping, colonization, and migration across Africa, the Middle East, and Europe though its reproduction of a map from the *Larousse International Political and Economical Atlas* (1950). Kher overlaid the map with her signature motif of multicolored bindis—dots traditionally worn on the forehead by Indian and other South Asian women to enhance the power of the Ajna (third-eye) chakra that gives access to inner wisdom. Kher places bindis on maps to "mark presence . . . people, movement" in the twenty-first century in which "mapping, migration, issues of borders . . . require greater urgency for the world to see."[31] The bindi, a "marker of seeing," metaphorically facilitates this discernment.[32] The 1950 map she uses in *Not All Who Wander Art Lost* reminds us of colonialism's history and lingering impact

FIGURE 22.13 Do Ho Suh, *Seoul Home/L.A. Home/New York Home/Baltimore Home/London Home/ Seattle Home*, 1999. Silk and metal armatures, 378.5 x 609.6 x 609.6 cm. Installation view, Korean Cultural Center, Los Angeles, 1999. Collection of The Museum of Contemporary Art, Los Angeles.

on migration, especially to Europe from postcolonial Africa, which was still almost wholly under European control when this map was published.

Many people in the world cannot travel freely across the borders marked on maps—a point poignantly made by Emily Jacir (b. 1970) in her work *Where We Come From* (2001–03). Jacir is a Bethlehem-born artist holding a US passport that permitted her unrestricted entry into Palestine and movement between Palestine and Israel—rights that Israel denies many Palestinians. She posed a question to Palestinians living inside their homeland and abroad: "If I could do anything for you, anywhere in Palestine, what would it be?" Some requests were mundane, for example: "Go to the Israeli post office in Jerusalem and pay my phone bill"; others were more sentimental or symbolic, such as: "Go to my mother's grave in Jerusalem on her birthday and place flowers and pray." Jacir did her best to carry out each entreaty. An example of **Conceptual art**, driven by an idea that the artist executes, *Where We Come From* is documented through framed texts in English and Arabic presenting the requests, paired with photographic or video records of Jacir's efforts to fulfil them (e.g., *Munir*, 2001–03). The work implicitly criticizes Israeli policies that restrict Palestinians' free movement, but it avoids polemics, simply making visible the impact of those policies on ordinary people's lives in a straightforward, intimate, and emotionally affecting way.

Maps are among the many visual sources that nourish the Ethiopian-born American painter Julie Mehretu's (b. 1970) immense **abstract** paintings filled with the illusion of frenzied, whirling movement. Using multiple layers of drawing and painting, Mehretu in the first decade of the twenty-first century depicted imaginary spaces incorporating graphic features from maps, architectural renderings, topographical symbols, advertising, and news photos, among other sources. She overlaid and interspersed these elements with swarms of abstract marks, whiplash lines, and floating geometric planes, collapsing art-historical references to **Futurism**, **Suprematism**, and Abstract Expressionist gesture painting. Mehretu's restless and fragmented style serves as a visual metaphor for the hypercomplex networked forces of globalization. Her paintings also refer to politically charged subjects such as war, violence, protest, and migration. In *Black City* (2007, Figure 22.14), Mehretu layered drawings of fortifications ranging from those of ancient Mesopotamia to American Civil War forts and Nazi-built Atlantic Wall bunkers—historical manifestations of a "fortress mentality" she related to reactionary fears of terrorism and immigrant labor circulating in the West after the 9/11 attacks.[33] Over *Black City*'s architectural layers, Mehretu drew

FIGURE 22.14 Julie Mehretu, *Black City*, 2007. Ink and acrylic on canvas, 304.8 x 487.7 cm. Pinault Collection, Paris.

clusters of small marks intended to function as characters invested with agency, mobility, and the capacity for resistance.

Contemporary artists convey aspects of the global movement of commodities, capital, information, and people through works in every conceivable medium. The German Andreas Gursky (b. 1955) does so through huge color photographs of emblematic spaces of global capitalism: high-tech factories, ports and shipping facilities, stock exchanges, international hotels, luxury boutiques, discount stores, and crowded sporting events and concerts. Gursky uses distanced, elevated viewpoints, deep space, and panoramic sweep to create a detached effect, and bright light, rich color, and sharp, uniform focus to invest his subjects with glamor. He enhances his images' hyperreal quality through digital manipulation, combining multiple shots of the same subject, eliminating details, and heightening colors. In *Chicago Board of Trade II* (1999, Figure 22.15), Gursky depicts the frenetic activity of buying and selling by a multitude of brokers in brightly colored jackets clustered around computer monitors, seated at desks, or standing on the paper-littered floor. Numerous blurred figures and double exposures amplify the sense of movement. Viewed from a distance, the imagery dissolves into an allover composition reminiscent of an Abstract Expressionist painting like Pollock's *Autumn Rhythm* (see Figure 12.4).

Ghanaian-born, Nigeria-based El Anatsui (b. 1944) creates shimmering cloth-like sculptures that embody the theme of mobility through their medium. Many of his works, including *Dusasa I* (2007, Figure 22.16), feature thousands of flattened recycled aluminum liquor-bottle tops stitched together with copper wire—discards of consumer culture mobilized for aesthetic ends. The bottle tops also evoke liquor's role in the historic transatlantic movement of commodities and enslaved Africans known as the triangular trade. In one such triangle, rum shipped from New England to West Africa was exchanged for slaves; they were then transported to the West Indies to work on sugar plantations; and molasses from the sugar was shipped to New England to make rum. While alcohol is entangled in slavery's dark history, it also has other resonances for Anatsui. He notes that "liquor in many cultures (especially African) has this association with the spiritual, with healing. Just think about the many ways a hand must open metal caps to pour out schnapps for prayers or libations."[34] Anatsui's tapestry-like sculptures also manifest mobility in their flexible structure, which enables them to be folded easily for transport (like Suh's fabric sculptures) and to take on different shapes each time they are hung. "I've always looked for an art form that reflects that dynamic freedom," says the artist, "Because life is not a fixed thing, is it?"[35]

FIGURE 22.15 Andreas Gursky, *Chicago Board of Trade II*, 1999. Chromogenic print on paper, 157.4 x 284 cm. Tate, London.

FIGURE 22.16 El Anatsui, *Dususa I*, 2007. Found aluminum and copper wire, 792.5 x 1005.8 cm. Nelson-Atkins Museum of Art, Kansas City, Missouri.

Participation

Drawing on the lineage of 1960s movements such as **Happenings** and **Neo-Concretism** (see Chapter 14), many contemporary artists encourage audience members to participate in—rather than passively experience—their art. Participatory art may invite physical engagement with an art object or installation. It may also involve social interaction, and take the form of a discussion, event, workshop, or performance. Current participatory art's overlapping aims include: to create active subjects empowered to determine their own social and political reality; to cede authorship, in part or completely, to the work's participants, promoting a nonhierarchical social model; and

to foster collective elaboration of meaning, countering competitive individualism and restoring the social bond.[36] Much recent participatory art is encompassed by the term "**relational art**," coined in the 1990s by French critic and curator Nicolas Bourriaud. It refers to "a set of artistic practices which take as their theoretical and practical point of departure the whole of human relations and their social context, rather than an independent and private space."[37] Relational artists create public situations that facilitate convivial exchange between people. To Bourriaud, relational art is democratic and promotes social cohesion.

A key practitioner of relational art, the Thai artist Rirkrit Tiravanija (b. 1961) stages exhibitions consisting of free

meals and the social interaction between those who gather to enjoy the food. For *Untitled (Free)* (1992), Tiravanija set up a makeshift kitchen in the back office of New York's 303 Gallery where he cooked Thai vegetable curry, served without charge to all visitors. He recreated the same exhibition several times, including at MoMA in 2011–12, and has done other cooking-and-eating-as-art projects. Tiravanija has also produced installations designed for visitors to use freely, including a recording studio in a museum and a replica of his East Village apartment in an art gallery that was open twenty-four hours a day.

A nomadic artist with residences in New York, Berlin, and Thailand, Tiravanija offers Thai food to visitors all over the world, fostering cross-cultural encounters. Chinese artist Cai Guo-Qiang (b. 1957) pursued a similar aim in *Cultural Melting Bath* (1997, Figure 22.17), a relational work of art that invites people from different cultures to bathe together in a hot tub filled with Chinese medicinal herb-infused water promoting skin health and relaxation. For the work's 1997 installation at the Queens Museum of Art, Cai recreated the format of a Chinese scholar's garden: he surrounded the hot tub with dramatically shaped

FIGURE 22.17 Cai Guo-Qiang, *Cultural Melting Bath: Project for the 20th Century*, 1997. Collection of Musée d'art contemporain de Lyon. Installation view at Queens Museum of Art, New York, 1997.

limestone Taihu (Lake Tai) rocks, a common feature of such gardens, placed according to Feng Shui principles to enhance the flow of qi (energy) through the space. Live birds were perched on banyan tree roots suspended above, further connecting the installation to nature. Playing on the metaphor of New York as a melting pot for the fusion of different nationalities, ethnicities, and cultures, Cai—a Chinese-raised immigrant to New York—sought to nurture communion between diverse visitors soaking together in the warm healing waters.

Contemporary participatory artworks often take the form of large multisensory installations. The Brazilian Ernesto Neto (b. 1964) has made sprawling room-sized sculptures of flexible translucent fabric stretched into membranes or suspended in elongated sacs filled with Styrofoam pellets or aromatic spices like cloves, cumin, and ginger, appealing to the olfactory as well as tactile senses. Some of his sculptures incorporate large pillow-like forms on which people may lounge and interact with others in "a place of sensations, a place of exchange and continuity between people."[38] More recently, Neto has made colorful ceiling-hung, crocheted sculptures of polypropylene and polyester cord with snake-like, plastic-ball filled floors that visitors traverse in a spirit of playground adventure (e.g., *SunForceOceanLife*, 2020). The German sculptor Carsten Höller (b. 1961) amplifies that spirit in temporary museum installations of large, twisting and turning tunnel slides that visitors are invited to ride. One, *Test Site* (2006), featured five slides descending from different levels of the vast Turbine Hall in London's Tate Modern. People who choose to ride Höller's slides are temporarily integrated into the artwork and may gain an altered perspective on the world through an experience that is at once exhilarating and unnerving.

The Turbine Hall was also the site of Danish Icelandic artist Olafur Eliasson's (b. 1967) spectacular relational artwork, *The weather project* (2003–04, Figure 22.18). Committed to investigating perception, Eliasson generates captivating optical phenomena by using simple devices such as mirrors, kaleidoscopes, and electric lights. His installations posit looking as a social experience, arousing viewers' awareness of sharing an act of perceiving with their fellow visitors. For *The weather project*, Eliasson suspended mirror foil from the Turbine Hall's thirty-five-meter-high ceiling and, at the far end of the hall, installed two hundred yellow lights behind a semicircular plastic screen, paired with their reflection to form a disc. He pumped in mist to create the effect of a sunset seen through the fog. More than two million visitors came to the hugely popular show over six months to bask in the fake sun's rays and to gaze up at their reflections while standing, sitting, or lying on the concrete floor. Underscoring his interest in participatory art, Eliasson said, "I would like to think that . . .

FIGURE 22.18 Olafur Eliasson, *The weather project*, 2003–04. Turbine Hall, Tate Modern, London.

Eschewing the kind of advanced technology that Lozano-Hemmer employs, Swiss artist Thomas Hirschhorn (b. 1957) creates participatory artworks in public places using quotidian materials such as lumber, plywood, tarpaulins, and shiny packing tape. These materials' "poor" nature and Hirschhorn's ramshackle aesthetic comport with his slogan: "Energy, Yes! Quality, No!" His best-known public works are four temporary "monuments" to his favorite philosophers: Baruch Spinoza (Amsterdam, 1999), Gilles Deleuze (Avignon, France, 2000), Georges Bataille (Kassel, Germany, 2002), and Antonio Gramsci (The Bronx, New York, 2013). Hirschhorn sited the latter three in housing projects occupied by poor and working-class tenants, with their agreement, and he hired some of these residents to help build them. The *Gramsci Monument* (Figure 22.19), sponsored by the Dia Art Foundation, occupied a lawn surrounded by the brick apartment towers of Forest Houses. It was open to the public for seventy-seven days, with Hirschhorn ever present alongside a paid staff of Forest Houses tenants. The monument's makeshift pavilions included a stage for daily lectures and performances, an office that produced a free daily newspaper, a radio station, an internet center, a workshop, a snack bar, a children's wading pool, and a library with books by and about Gramsci. An Italian Communist, Gramsci's political philosophy focused on hegemony, the dominance of one group over another. He argued that under capitalism both the bourgeois and the proletariat internalized hegemony, but that "counter hegemonies" developed by subordinated groups could challenge it. Hirschhorn's monument made Gramsci's ideas available to the Forest Houses residents, though he insisted its purpose was not to serve their community, but "to serve art."[40] "My goal . . . is not so much about changing the situation of the people who help me, but about showing the power of art to make people think about issues they otherwise wouldn't have thought about."[41]

the project twisted the Tate so the people who came to visit were what the art was about."[39]

The same can be said for Mexican Canadian artist Rafael Lozano-Hemmer's (b. 1967) *Pulse* series of technologically sophisticated immersive **environments** (e.g., *Pulse Topology*, 2021). These use fingerprint scanners, heart-rate sensors, and computer software to translate visitors' biometric data into kinetic visual displays such as patterned sequences of flashing lights or ripples in illuminated water tanks. Each contributor of biometric data generates a transient visual "portrait" of themselves that moves through the artwork, following and followed sequentially by those of other participants. In an era when biometry is increasingly used for identification and control, Lozano-Hemmer applies it creatively to visualize relationships between the individual and the collective, anonymity and community.

FIGURE 22.19 Thomas Hirschhorn, *Gramsci Monument*, 2013. Forest Houses, Bronx, New York.

Nature and Ecology

Nature has been defined in the West since the sixteenth century as the living and nonliving material world that surrounds humans and exists independently of their activities. By considering themselves separate from nature, humans have felt free to exploit its resources and to use it as a receptacle for waste. Humans have been altering nature for millennia through such practices as agriculture and deforestation, while recent scientific advances have permitted humans to modify organic life in unprecedented ways through genetic engineering. Industrialization has increasingly damaged the natural world, polluting the air, water, and soil, destroying habitats, and causing the extinction of many species. The worldwide environmental movement has sought since the 1960s to address these problems, with ever-more urgent attention paid in recent decades to the threat of global warming, mainly caused by the burning of fossil fuels. Contemporary artists have attended to these developments, exploring the results of bioengineering on plants and animals, raising awareness of human-caused environmental damage, proposing creative solutions to environmental problems, or simply reminding viewers of the healthy virtues of living in harmony with nature.

Exemplary of the last position, English sculptor Andy Goldsworthy (b. 1956) works directly in nature by digging snaking lines into the earth or arranging ice, stones, sticks, leaves, or flower petals into visually pleasing configurations. He documents these creations in color photographs but does not preserve them physically. Goldsworthy sees nature as constantly moving and changing, growing, and decaying; his art's transience reflects this experience. He also builds permanent, site-specific stone structures such as cairns, arches, and serpentine walls that draw attention to the ever-changing character of their natural surroundings (e.g., *Storm King Wall*, 1997–98).

Artists Patricia Piccinini (b. 1965) and Eduardo Kac (b. 1962) explore the implications of the rapidly expanding use of recombinant DNA technology to create transgenic, or genetically modified organisms. The Australian Piccinini makes hyperrealistic silicon-based sculptures of creatures that appear to be hybrids of humans and other animals, destabilizing anthropocentrism—the belief that humans are the most significant entities in the world—and questioning human-animal distinctions. For example, *The Young Family* (2002, Figure 22.20) shows a hybrid human-pig mother with her babies; Piccinini imagines that the mother has been bred for organs to be transplanted into humans, "yet she has children of her own that she nurtures and loves," posing an ethical dilemma for anyone who would consider harvesting her organs.[42]

The Brazilian American Kac actually creates transgenic organisms as living works of art. For *GFP Bunny* (2000), Kac collaborated with scientists at a research institute in Paris who inserted a green fluorescent protein (GFP) jellyfish gene into the fertilized egg of an albino rabbit. The rabbit that was born, named Alba, had skin and eyes that fluoresced bright green under ultraviolet light. Kac intended to live together with Alba in an Avignon art gallery and then take her to live with his

FIGURE 22.20 Patricia Piccinini, *The Young Family*, 2002. Silicone, fiberglass, leather, human hair, plywood, 85.1 x 149.9 x 120 cm.

family in Chicago. He aimed to stimulate public debate on genetic engineering's "cultural and ethical implications" and to explore "interspecies communication between humans and a transgenic mammal."[43] His plans were thwarted, however, when the research institute refused to release Alba due to protests from animal rights activists and concerns about her transport and security. In a subsequent project, the artist collaborated with a plant biologist to integrate a gene from Kac's blood into the chromosome of a petunia, creating an "Edunia"—a transgenic flower or "plantimal" with red veins that express the artist's DNA.

While Piccinini's and Kac's works prompt consideration of the ethics of experimenting on living organisms, other artists use their work to heighten awareness of threats to the environment. American Chris Jordan's (b. 1963) series *Intolerable Beauty: Portraits of American Mass Consumption* (2003–05) comprises large color photographs of massive accumulations of discarded consumer products such as cell phones, circuit boards, crushed cars, and glass bottles. Rendered as seductive allover abstract compositions, their beauty exists in tension with the recycling process's consumption of resources and the environmental damage caused by waste. In a similar spirit to Jordan's photographs, Indian artist Subodh Gupta (b. 1964) offers a visual metaphor for the excesses of consumerism and squandering of resources in *When Soak Becomes Spill* (2015), a six-meter-tall sculpture of a stainless steel bucket overflowing with hundreds of gleaming stainless steel cooking pots, pans and utensils—mass-produced objects from everyday Indian life that Gupta uses as his signature medium.

Whereas Gupta's work alludes to water through its title and imagery, Berlin-based Danish artist Tue Greenfort's (b. 1973) *Diffuse Einträge (Diffuse Deposits)* (2007, Figure 22.21) used water itself to comment on its pollution by industrialized agriculture and meat production. Presented at *Sculpture Projects Münster* on the shore of the artificial Lake Aa, Greenfort's work was a liquid manure spreader modified to pump in water from the lake, treat it with iron (III) chloride, and spray it back into the lake. Iron (III) chloride is used to control the growth of blue-green algae caused by phosphates from fertilizers that drain from factory farm fields into the lake via the Aa River. Greenfort's work highlights the essentially cosmetic use of chemicals to suppress algae growth; in his view, the better solution would be to tackle the problem's cause, by more strictly regulating the agriculture industry.

FIGURE 22.21 Tue Greenfort, *Diffuse Einträge (Diffuse Deposits)*, 2007. *Skulptur Projekte Münster, Germany.*

Artists are also attuned to the problems of ocean warming due to climate change, which melts ice sheets, raising the sea level, and causes coral bleaching and the loss of marine animal breeding grounds. Olafur Eliasson drew attention to the first problem through *Ice Watch* (2014), transporting twelve large chunks of ice cast off from the Greenland ice sheet to Copenhagen's City Hall Square where he installed them in a clock-like circle to confront an urban audience with the tangible reality of melting arctic ice. Communicating climate change's effect on corals is a goal of the *Crochet Coral Reef*, a project by Australian-born twin sisters Margaret Wertheim and Christine Wertheim (b. 1958) and their Los Angeles-based Institute for Figuring. Fusing art, science, handicraft, and environmentalism, the work uses crochet techniques to mimic the crenelated forms of reef organisms and to illustrate how they manifest "hyperbolic" geometry. Simultaneously beautiful and blighted, the *Crochet Coral Reef* features sections of colorful yarn simulating healthy organisms while other segments use white yarn to represent bleached coral and incorporate plastic trash to highlight its devastating impact on marine life. Numerous individuals have contributed to the ever-growing *Crochet Coral Reef*, curated by the Wertheim sisters and displayed worldwide. The project also features a community-art program in which more than ten thousand people around the world have participated to produce over forty locally based *Satellite Reefs*, symbolizing collective action's power to address global problems.

Some contemporary artists not only point out environmental problems but also offer creative solutions to them.

Pioneers in this vein of eco-art were the California-based husband-and-wife team Newton (1932–2022) and Helen Mayer Harrison (1927–2018), who from the 1970s worked internationally. The Harrisons were typically invited to an area by an arts organization to identify an environmental problem and consult with local experts. They then presented a public display that visualized the circumstances that caused the problem, proposed a "visual metaphor" suggesting a viable solution, and prompted discussion of how the solution might actually be realized.[44] The Harrisons' *Peninsula Europe I* (2000–04) ignored national borders to envision the landmass as a single geophysical network of drain basins that, with restored forests, meadows, and grasslands in its high grounds, could purify the region's waters and enhance biodiversity. The Harrisons' ideas, demonstrated through maps and information displays about water flows, land use, and nonpolluting industries such as green farming, were disseminated throughout Europe in a traveling exhibition funded by several institutions including the European Union's Culture Section.

The Harrisons' large-scale proposals like *Peninsula Europe I* function primarily to instigate ecological, economic, and political debates that might lead to incremental change, but many eco artists have realized works that actually improve the environment. For example, the American Mel Chin's (b. 1951) *Revival Fields*, which he designed in collaboration with agronomist Dr. Rufus Chaney, restore contaminated soil through the action of hyperaccumulating plants that absorb heavy metals. Chin created his first *Revival Field* in 1991 in the Pig's Eye Landfill near Saint Paul, Minnesota, using chain-link fencing to form a circle within a square (representing heaven and earth in Chinese iconography). He seeded the circle's inside with hyperaccumulating plants and the outside with nonaccumulating plants as a control. Scientific analysis confirmed that the hyperaccumulating plants removed metals from the soil, demonstrating "green remediation's" potential as a low-tech alternative to costlier and less satisfactory methods.[45]

In addition to the hyperaccumulating plants used by Chin, trees also take up pollutants from groundwater and benefit the environment by absorbing and storing carbon dioxide—a

greenhouse gas—and releasing oxygen through photosynthesis. Joseph Beuys planted trees as an environmentally conscious artistic action in his *7,000 Oaks* (1982–87) (see Chapter 14). Conceived in the same year as Beuys's project, Hungarian American artist Agnes Denes's (b. 1931) *Tree Mountain—A Living Time Capsule—11,000 Trees, 11,000 People, 400 Years* (1992–96, Figure 22.22) is an artificial, elliptical-shaped, twenty-eight-meter-tall forested mound rising from a former gravel pit in Ylöjärvi, Finland that provides a natural habitat for living creatures and filters the ground water. Commissioned by the Finnish government and announced on World Environment Day in 1992, *Tree Mountain* was planted with 11,000 trees by 11,000 people from all over the world. The trees—a variety of pine that can live for four hundred years—grow in a swirling pattern the artist derived mathematically from a combination of the Golden Section and the curvature of sunflower and pineapple patterns. Denes intended the project to affirm "humanity's commitment to the future well-being of ecological, social and cultural life on the planet" and "unite the human intellect with the majesty of nature."[46]

Death, Religion, and Spirituality

Throughout history and around the world, art has dealt with death, served religion, and expressed spirituality. Spirituality may be defined as the yearning to transcend the self, to explore the source of life and the nature of death, and to acknowledge the intangible, ineffable forces pervading the universe.[47] Religions such as Judaism, Hinduism, Buddhism, Christianity, and Islam give spirituality formal structure, uniting their adherents through rituals and doctrines meant to facilitate communion with higher powers (a deity or deities). Many contemporary artists address spiritual and religious themes, prompting reflection on the meaning of life and death, expressing or questioning faith, or seeking to evoke states of transcendence.

Death is a prominent subject in contemporary art, sometimes treated in relation to spiritual and religious beliefs about the soul's postmortem survival, sometimes represented as a material fact without reference to the concept of an afterlife. *The Physical Impossibility of Death in the Mind of Someone Living* (1991), by the English artist Damien Hirst (b. 1965), manifests morality through the preserved carcass of a fierce-looking, open-mouthed tiger shark suspended in a giant formaldehyde-filled tank. The work's title evokes the viewer's inability to imagine ceasing to exist even as confrontation with the shark's sharply jagged teeth and black gullet prompts the fear of annihilation. In contrast to the visceral presence of Hirst's shark, *En el aire (In the air)* (2003), by Mexican multimedia artist Teresa Margolles (b. 1963), offers a disembodied meditation on death in the form of soap bubbles wafting through an empty gallery. A traditional **vanitas** symbol due to their fragile, fleeting nature, Margolles's soap bubbles carry literal traces of death: they are generated by bubble machines with water that was used to wash bodies in a morgue. These bubbles are simultaneously beautiful and threatening: if one bursts on a visitor's skin, that person absorbs a

FIGURE 22.22 Agnes Denes, *Tree Mountain – A Living Time Capsule – 11,000 Trees, 11,000 People, 400 Years*, 1992–96. 28 x 420 x 270 m. Ylöjärvi, Finland.

corpse's residue and loses the separation from death most of us seek vigilantly to maintain.

That separation remains intact in representations of death that do not incorporate its material traces and allow the viewer to contemplate it with detachment. An ambitious example of such representational art is Canadian photographer Jeff Wall's (b. 1946) *Dead Troops Talk (A vision after an ambush of a Red Army patrol, near Moqor, Afghanistan, winter 1986)* (1992, Figure 22.23), a "hallucination" in which Soviet soldiers killed in the Afghan war awake to discuss their fate.[48] Typical of his practice, Wall created the work over a few months in his studio, photographing actors playing soldiers in several different sessions, digitally assembling a seamless composition, and presenting the photograph as a mural-sized transparency set into a lightbox, giving it the luminous aura of an advertising sign. *Dead Troops Talk* engages in a visual dialogue with **history painting**, paraphrasing sections of Géricault's *Raft of the Medusa*. At the same time, it suggests a zombie movie by depicting ashen, bloody reanimated corpses chatting and joking with one another.

In contrast to Wall's representation of reanimated bodies without spiritual connotations, Bill Viola's (b. 1951) large-scale silent color video, *Emergence* (2002), evokes Christ's death and resurrection. Influenced by Zen Buddhism and Christian and Islamic mysticism, Viola explores the metaphysical significance of universal human experiences such as birth, death, and

extreme emotion. *Emergence* is nearly twelve minutes long, filmed at seven times normal speed to enable extreme slow-motion playback inducing heightened sensory awareness and contemplation. Its imagery was inspired by Masolino da Panicale's *Pietà* (1492), a **fresco** of the dead Christ standing in his tomb mourned by two women. The video shows two white women witnessing the miracle of a pale, slender, young white man emerging naked from a cistern as water overtops it and spills onto the floor. After his emergence, the young man falls lifeless, and the women lay him out and cover him with a cloth; one woman cradles his head and breaks down into tears. In addition to suggesting the Resurrection and the Lamentation (reversing their order in the Christian narrative), *Emergence* alludes through its gushing water to drowning and birth.

Many contemporary artists besides Viola employ Christian imagery, sometimes in provocative ways that generate controversy, as did Andres Serrano's *Piss Christ* (see Figure 20.26). Some Catholics protested Robert Gober's installation *Untitled* (1997) centered on a statue of the Virgin Mary pierced by six-foot cast-bronze culvert pipe—an expression of the gay artist's conflicted relationship with the religion in which he was raised and which deems same-sex sexual activity immoral. In 1999, a storm of controversy erupted over the Brooklyn Museum's display of Chris Ofili's (b. 1968) *Holy Virgin Mary* (1996)—the Afro-British artist's dazzling painting of a flat, **stylized** Black Madonna. She stands in a light blue robe against a yellow

FIGURE 22.23 Jeff Wall, *Dead Troops Talk (A vision after an ambush of a Red Army patrol, near Moqor, Afghanistan, winter 1986)*, 1992. Transparency in lightbox, 229 x 417 cm. The Eli and Edythe L. Broad Collection, Los Angeles.

background surrounded by collaged photographs of women's buttocks and genitalia from pornographic magazines and with an exposed breast made of a map-pin-decorated, resin-sealed ball of elephant dung. Ofili said he used elephant dung to symbolize cultural regeneration and his African heritage. He used the pornographic cutouts to acknowledge Mary's sexuality. Raised Catholic, Ofili professed to have been confused as an altar boy by the contradiction of a virgin mother. "Now when I go to the National Gallery and see paintings of the Virgin Mary, I see how sexually charged they are. Mine is simply a hip-hop version."[49] To critics such as then-New York mayor Rudolph Giuliani, it was simply sacrilegious.

Buddhism is another major religion that inspires many contemporary artists. In the 1990s, Chinese artist Zhang Huan (b. 1966), a practicing Buddhist, did naked performances in which he endured difficult experiences, seeking to transcend physical pain and achieve a meditative state. In *12 Square Meters* (1994), Zhang sat upright motionless for an hour in a sweltering, filthy public toilet in his neighborhood outside Beijing, his body covered with honey and fish oil to attract flies—a commentary on the wretched living conditions of the Chinese poor, including Zhang himself. After 2006, Zhang shifted from performance art to painting and sculpture that he frequently invests with Buddhist references, for example, by using ash from incense burned in temples as a painting medium.

Japanese artists Mariko Mori (b. 1967) and Takashi Murakami (b. 1962) merge Buddhist iconography with popular entertainment-based aesthetics, making the imagery accessible to contemporary audiences. Mori's 3-D video *Pure Land* (1996–97) and a large-scale digitally composed photograph derived from it (Figure 22.24) feature the artist floating in a sumptuous kimono above the placid Dead Sea, in the guise of the Japanese Buddhist deity Kichijōten, goddess of good fortune and happiness.[50] Accompanying Mori's Kichijōten is a computer-generated retinue of cartoonlike candy-colored cyborg-alien musicians, each perched on a small puffy cloud. At one point in the video, the aliens, observed through 3-D glasses, zoom forth from the landscape in bubble-like spacecraft and penetrate the viewer's space. Their high-pitched melodies complement the artist's chant invoking the spiritual journey to nirvana. *Pure Land*'s luscious color and fluid space achieved through advanced technology, and its fusion of cartoonish space-age imagery with Buddhist spirituality produce a transfixing experience manifesting Mori's wish for "an eternal harmony of human spirit."[51]

Murakami's 100-meter-long painting *500 Arhats* (2012) depicts enlightened disciples of the Buddha who spread his teachings. Murakami's painting style fuses **Nihonga**'s (Japanese-style painting) flattened space with influences from American and Japanese popular culture, including anime and manga. He coined the term "Superflat" to describe the visual flatness and cultural leveling of art, graphic design, animation, and pop culture in Japan, as well as the shallowness of Japan's consumer culture. Emulating sixteenth-century Japanese master Kanō Eitoku's workshop system, Murakami directed a team of over two hundred assistants who meticulously executed *500 Arhats* based on his designs. Divided into four panels, each featuring a sacred

FIGURE 22.24 Mariko Mori, *Pure Land*, 1996–97. Glass with photo interlayer, 305 x 610 x 2.2 cm.

animal—Blue Dragon, White Tiger, Black Tortoise, and Vermilion Bird—it features brilliant colors and a firmly structured, intricately detailed composition, replete with mesmerizing patterns.[52] The arhats are surrounded by images of surging waves, raging fires, and swirling galaxies. These seemingly signify nature's mercilessness in contrast to the arhats' benevolence—perhaps a reference to the 2011 Japan earthquake and tsunami.

In contrast to these examples of art employing religious imagery, many contemporary artists aspire to convey spiritual transcendence through **abstraction**, as did earlier artists such as Piet Mondrian, Mark Rothko, and Agnes Martin (see Figures 6.10, 12.11, and 16.8). Fusing influences from Buddhism, Hinduism, and Minimalism, German artist Wolfgang Laib (b. 1950) seeks spirituality through a ritual-like process of creating geometric forms with natural materials. For example, he slowly pours milk onto the slightly indented surface of a polished marble slab to make a *Milk Stone* (e.g., *Milk Stone*, 1978), or he sifts pollen, which he gathers annually, into a yellow rectangle on the gallery floor—fashioning life-giving substances into serenely beautiful ephemeral presences. Iranian-born, London-based Shirazeh Houshiary (b. 1955) creates abstract art inspired by Sufism, a mystical form of Islam that seeks a direct personal experience of God. Houshiary makes paintings by repeatedly inscribing Sufi phrases in Arabic in delicate layers over **acrylic** grounds on canvas, subsuming the text's legibility into an immaterial surface she identifies with the vital life force of breath (e.g., *Presence*, 2006–07).

Indian-born British sculptor Anish Kapoor, whose early work is discussed in Chapter 20, has since the 1980s sought to evoke the Buddhist concept of emptiness or the void—an absolute, undifferentiated state out of which all apparent entities and distinctions arise. "You cannot enter the void," says Kapoor, "but viewing gives prospect to the wholeness it contains."[53] The void finds expression in Kapoor's *Cloud Gate* (2004, Figure 22.25): an elliptically shaped 110-ton polished stainless steel sculpture whose curved mirrored surfaces create distorted reflections of its surroundings in Chicago's Millennium Park. *Cloud Gate* shows viewers their outward appearance—transitory and constantly changing, like the clouds—while also serving, says Kapoor, as a "gateway to eternity," reaching beyond the self to contain infinite space and time.[54]

Time

A word with many different meanings, *time* is defined primarily as "a finite extent or stretch of continued existence, as the interval separating two successive events or actions, or the period during which an action, condition, or state continues; a finite portion of time (in its infinite sense); a period."[55] Time can be conceived of in terms of numerical units of measurement or as an intrinsic phenomenological feature of human experience; as a dynamic process of change or a continuous process of endurance on timescales far exceeding a human life.[56] Contemporary artists engage with time in a variety of ways. Many used time-based media, such as video and performance art, which unfold in real time, making the viewer aware time's passage. Some create works that respond to the mechanistic time of clocks and calendars—simply registering it, as On Kawara did in his *Today* series (see Chapter 19)—or subverting it by proposing alternative ways of measuring time. Some artists explore the experience of duration, considering time as a feature of human consciousness—what Henri Bergson called *durée*, a mobile, ongoing temporality that cannot be divided into measurable units. Still others seek to destabilize experiences of time and space, suggesting affinities with Einstein's special theory of relativity, which denies that time and space have fixed dimensions and posits a relative, malleable "spacetime."

Time is a key factor in the medium of photography in terms of *when* the photograph was taken (the moment in time it records) and *how long* the camera lens was open in front of the scene (the exposure time). Photographers often take pictures of the same subject at different moments to reveal how the subject's

FIGURE 22.25 Anish Kapoor, *Cloud Gate*, 2004. Stainless steel, 10 x 13 x 20 m. Millennium Park, Chicago.

appearance changes in different conditions and with time's passage. Examples include Joel Meyerowitz's (b. 1938) series of color photographs, *Looking South: New York City Landscapes, 1981–2001*, all showing the same studio-window view of the Lower Manhattan skyline, each image dramatically different due to shifts in light and color affected by weather and the time of day or night; and Nicholas Nixon's (b.1947) ongoing series of black-and-white photographs, *The Brown Sisters*, annual group portraits of the artist's wife and her three sisters (always posed in the same order) that document their progressive aging and evoke mortality's inevitability.

In contrast to Meyerowitz's and Nixon's conventional use of the camera to record an instant in the ongoing flow of time, Japanese photographer Hiroshi Sugimoto (b. 1948) makes black-and-white photographs in which different times seem to coexist. He has photographed natural history museum dioramas of prehistoric life and waxwork portraits of historical figures such as Henry VIII: subjects taken out of time and placed in ours as simulations whose falsity exists in tension with Sugimoto's crisp documentary style with its connotations of truthfulness. Sugimoto also makes photographs in darkened movie theaters, leaving the shutter open for the entire screening of a film to record all of its light, registered as a glowing white rectangle in the photographic print that functions as a visual document of duration (e.g., *El Capitan, Hollywood*, 1993).

While Sugimoto's photographs collapse the running time of a film into a single static image, other artists use film or video to record time as it unfolds in actuality—or to speed it up or slow it down. English artist Tacita Dean (b. 1965) does the first in *Fernsehturm* (2001), a single, forty-four-minute static shot looking across the interior and out the windows of a revolving circular restaurant atop the Cold War–era Berlin TV Tower. Filmed in the late afternoon as day turns to night, Dean's meditative work records the slowly changing light and activity stirring as diners appear and music begins to play. *Fernsehturm*'s viewers watch time go by at the same pace we experience it in daily life. By contrast, English artist Sam Taylor-Johnson (formerly Taylor-Wood, b. 1967) accelerates time in her time-lapse digital video *Still Life* (2001). An update of the *vanitas* tradition, *Still Life* shows an elegant bowl of fruit that in the span of under four minutes decays before our eyes into a moldy mass buzzing with flies. In contrast to this sped-up experience,

Scottish artist Douglas Gordon's (b. 1966) large-screen projection *24-Hour Psycho* (1993) replays Alfred Hitchcock's 1960 thriller at one-thirteenth of its original speed without sound, subverting the film's narrative coherence and absorbing the viewer in each shot's visual details.

Gordon is one of numerous contemporary artists who appropriate and creatively rework existing films to alter their temporal structure. An ambitious example of such projects, Christian Marclay's (b. 1955) *The Clock* (2010, Figure 22.26) takes time itself as its subject. *The Clock* is a twenty-four-hour single channel video composed of thousands of clips that feature verbal references to the time of day or images of timepieces of all sorts, including sundials, hourglasses, grandfather clocks, wristwatches, and digital clocks. The video also functions as a timepiece: when screened, it is synchronized so that the time displayed in its scenes corresponds to the actual time in the screening location. The product of three years' labor by the Swiss American Marclay and six assistants, *The Clock* splices together appropriated snippets from a century's worth of movies (and a few TV shows) from around the world. It samples various genres including thrillers, westerns, science fiction, and comedies, many featuring famous actors; it thus takes a non-linear journey through cinematic history highlighting the role of time in filmed narratives. Actors, settings, moods, pacing, and narrative content shift from clip to clip, creating a kaleidoscopic plot impelled by the flow of time. Sound—important to Marclay, also a musician and DJ—helps to hold *The Clock* together: transitions are smoothed through masterful audio editing that sometimes carries dialogue or music from one scene into the next. Fixated on time's inexorable passage, *The Clock*

FIGURE 22.26 Christian Marclay, *The Clock*, 2010. Video projection (color, stereo sound), duration: 24 hours.

is, in Marclay's words, "very much about death in a way. It is a memento mori. The narrative gets interrupted constantly and you're constantly reminded of what time it is. So you know exactly how much time you spent in front of *The Clock*."[57]

While the actors' filmed performances in works like Marclay's are fragmented through editing, video art often features performances unfolding continuously in real time, sometimes of long duration, as in the seventy-seven-minute-long *Death is Elsewhere* (2019), by the Icelandic artist Ragnar Kjartansson (b. 1976). This seven-channel video installation is shown on seven screens arranged in a circle. On the screens, two male-female pairs of white musicians projected at life size, the twin American guitarists Aaron and Bryce Dessner of the National, and the twin Icelandic singers Gyða and Kristín Anna Valtýsdóttir, formerly of Múm, perform the melancholy title song over and over as they slowly walk in a circle in an austerely beautiful grassy Icelandic landscape. Choreographed so that the musician-pairs always appear on opposite sides of the circle, *Death is Elsewhere* literally surrounds the viewer. It offers what one curator calls "an immersive meditation on the tension between nature and death—the loveliness of one amidst the omnipresence of the other."[58]

Whereas *Death is Elsewhere* records a performance staged for cameras and microphones in Iceland, live performance art takes place in the same space and time as that occupied by the viewer. Marina Abramović, a leading practitioner of such art since the 1970s (see Figure 19.15), emphasized duration in her iconic performance, *The Artist is Present* (2010), for which she sat silent in a long flowing gown (dark blue, red, or white) on a chair in the MoMA's atrium every day of her retrospective's three-month run at the museum—some 736 hours. Opposite the artist was another chair that visitors were invited to occupy, becoming participants in the work. People waited in line for hours for the chance to sit opposite Abramović for as long as they desired—the average was over twenty minutes. Many were brought to tears by this open-ended sharing of time with the artist, who described herself as being "like a mirror" for the people looking into her eyes.[59] Abramović explained that the work "is about being in the present time. We always project into the future or reflect in the past but we are so little in the present."[60] Though she endured great pain sitting up to ten hours at a stretch, Abramović also felt her heart open to those who sat across from her, experiencing "unconditional love for the total stranger."[61]

In contrast to Abramović's emphasis on experiencing time in the present, French artist Camille Henrot's (b. 1978) acclaimed single-channel video, *Grosse Fatigue* (2013, Figure 22.27), meditates on the unfathomably vast timespan of the history of the universe. She made the video as a resident artist at the Smithsonian Institution, where she filmed objects in its scientific and natural history collections. She combined these images with clips shot elsewhere or found online to forge a narrative that blends scientific knowledge with creation stories from diverse religious, esoteric, and oral

FIGURE 22.27 Camille Henrot, *Grosse Fatigue* (still), 2013. Video (color, sound), 13 min. The Museum of Modern Art, New York.

traditions. These traditions are referenced in *Grosse Fatigue*'s soundtrack: a spoken-word poem by Henrot and poet Jacob Bromberg, voiced by Akwetey Orraca Tetteh and propelled by Joakim Bouaziz's percussive music. The video's imagery ranges from astronomical and ethnographic photographs to shots of moving and preserved animals; naked human bodies, both sculpted and living; Wikipedia pages; and Smithsonian curators in their offices and laboratories. Periodically, white feminine hands with painted nails appear, drawing a Zen circle symbolizing emptiness and fullness, turning book pages, or manipulating objects such as marbles, batteries, an orange, and an egg.

Structured to reflect how images are consumed on computers, *Grosse Fatigue*'s full-screen shots are often overlaid by additional images in open browser windows that pile one on top of another. Its title, French for "great exhaustion," conveys Henrot's sense of fatigue when confronted by the Smithsonian's accumulated mass of knowledge and that induced by the internet's seemingly infinite supply of data and imagery. "The more information you have access to, the more unhappy you're likely to be," says the artist.[62] At the same time, *Grosse Fatigue* creates magic through its chains of intuitively linked images and, in the words of one critic, it "restores a sense of wonder and discovery, the epiphany of holding a mysterious specimen in your hands."[63]

Glossary

The terms below are defined as they are used in this book; many of these terms have alternate or additional definitions.

abstract—in pictorial or sculptural art, departing from the realistic imitation of nature to create simplified, distorted, or otherwise **stylized** imagery; or lacking recognizable **subject matter** (**nonobjective**); in architecture, the rejection of historical **styles** and emphasis on purely **formal** qualities

Abstract Expressionism—an American art movement of the 1940s and 1950s characterized by **abstract** painting styles emphasizing spontaneous gestures of roughly applied paint or large fields of pure color intended to convey the artist's personal feelings

abstraction—the practice of, or process that creates **abstract** art

academic art—art made following the aesthetic doctrines of an academy, an artist-run organization, often state-sponsored, that trains artists and holds public exhibitions, such as the French Académie des Beaux-Arts

acrylic—a fast-drying, synthetic, water-soluble paint composed of **pigments** suspended in acrylic resin

action painting—a form of **Abstract Expressionism** in which the painter spontaneously brushes or splashes paint, emphasizing the painting process over its outcome; see also: **gestural painting**

Aesthetic Movement, Aestheticism—a movement in British and American fine and **decorative arts**, c. 1870–1900, that emphasized the creation of pure beauty and, in painting, the

autonomy of art ("art for art's sake")

albumen print—a photographic print made on a sheet of paper given a smooth glossy surface through an egg-white (albumen) coating sensitized by silver nitrate to yield an image when a glass negative is placed on the paper and exposed to light

allegory—in art, an image or images symbolizing an abstract concept or idea, often moral, religious, or political

American Scene—a term describing US art of the 1920s, 1930s, and 1940s that represented subjects from everyday American life in realist styles

Analytic Cubism—a form of **Cubist** painting in which the **subject matter** appears to have been broken down into geometric fragments as if viewed simultaneously from multiple perspectives and opened up to the surrounding environment

applied arts—art forms designed for utilitarian use, such as furniture, textiles, metalwork, ceramics, and glassware

Appropriation art—a **postmodern** art form in which artists adopt or replicate preexisting images, objects, formats, or artworks and incorporate them into, or present them unaltered, as a new artwork

arcade—a series of connected arches, either freestanding on **columns** or **piers** or attached to a wall

art brut—French for "raw art," Jean Dubuffet's term for art made by people

outside the established art world, such as children, the incarcerated, and people with mental illness

Art Deco—a fashionable, **Cubist**-influenced design style of the 1920s and 1930s seen in pictorial and decorative arts, furniture, and architecture, characterized by streamlined and geometric forms evocative of the machine age

art informel—French for "unformed art" or "formless art," a term describing the improvisatory, often gesturally executed abstractions of post–World War II European and American painters; sometimes also called *tachisme*

Art Nouveau—an international late nineteenth–early twentieth-century style in Europe and North America, principally in architecture and the **decorative** and **graphic arts**, characterized by sinuous lines based on organic forms, but also by abstract geometric patterns, both a reaction against nineteenth-century **historicism**

Arte Povera—Italian for "poor art," a term describing Italian **avant-garde** art of the later 1960s and 1970s that used "poor" materials, often found in nature or the everyday world

Arts and Crafts Movement—an informal movement in **decorative arts** and architecture originating in mid-nineteenth-century Britain that opposed industrial manufacture and championed individual

handcraftsmanship using quality materials and construction

Ashcan School—the name given to a group of New York-based early twentieth-century realist artists, informally led by Robert Henri, who defied genteel and academic conventions to depict everyday urban subjects

assemblage—the technique of assembling an artwork out of disparate new or **found objects** and materials; also, an artwork made through this technique

automatism—a process or technique of artistic creation without conscious direction or control, supposed to reveal the contents of the unconscious according to psychoanalytic theory; employed by many **Surrealist** and **Abstract Expressionist** artists

avant-garde—a term describing innovative artworks as well as artists, artists' groups, and movements opposed to aesthetic orthodoxies, sometimes alienated from mainstream society, and committed to exploring radically new creative possibilities

axonometric projection—in architecture, a graphic technique for representing a building by rotating it around one or more of its axes to reveal multiple sides

background—in two-dimensional art, the area of the picture space farthest from the viewer

balustrade—a row of balusters (vertical posts) topped by a rail

Barbizon School—a group of mid-nineteenth-century painters who worked in and around the village of Barbizon on the edge of forest of Fontainebleau, southeast of Paris, painting landscapes and humble scenes of rural life in realist styles

Baroque, baroque—when capitalized, a term describing late sixteenth–mid eighteenth-century art and architecture in Western Europe and Latin America, manifested in diverse styles generally characterized by the careful study of nature and pursuit of **illusionism** in painting and sculpture, and by a concern for appealing to the emotions through exuberance, sensuous richness, grandeur, and a sense of drama; when lower cased, describes later artworks possessing characteristic Baroque expressive qualities of exuberance, etc.

Bauhaus—a school of art, design, and architecture founded in 1919 in Weimar, Germany and subsequently based in Dessau (1925–32) and Berlin (1932–33), which provided practical workshop training and emphasized the integration of art and technology in designs that embodied the machine age's modern beauty

belvedere—Italian for "beautiful view," a structure built in an elevated position to command a scenic view

Benday dots—variously spaced small colored dots (typically cyan, magenta, yellow, and black) employed in commercial printing to create shading, **tone**, or **secondary colors**

biomorphic—resembling or suggesting the **forms** of living organisms such as plants or animals

Black Arts Movement—a politically engaged African American artistic, literary, and cultural movement of the later 1960s and 1970s that sought to promote Black empowerment and racial pride

body art—art made using the human body as a **medium**; when capitalized, refers to this kind of art as a major **avant-garde** mode in the 1960s and 1970s

brushwork—the particular way in which an artist applies paint

calligraphy—beautiful, elegant, or decorative handwriting, and the art of producing such writing

calotype—a photographic technique invented by William Henry Fox Talbot in the 1830s in which a negative image is fixed on paper coated with light-sensitive chemicals, which can yield positive images by putting light-sensitized paper in contact with the negative and exposing it again to light; see **negative-positive printing method**

camera obscura—a room or box with a small aperture in one wall, sometimes fitted with a lens, through which light enters to project an inverted image on the opposite wall

cantilever—a rigid structural element, such as a beam or girder, anchored at only one end and extending horizontally

capital—the decorative top of a **column**

chiaroscuro—from the Italian *chiaro* ("clear") and *oscuro* ("obscure"), in two-dimensional art, **modeling** through light and shade to create the illusion of **mass** and **volume**

Chicano Art Movement—a politically engaged art movement of the later 1960s and 1970s that sought to promote Mexican American civil rights and cultural pride

chronophotography—a method of recording successive phases of an object's or body's motion in a single photograph or series of photographs

classical—when capitalized, a term referring to the art and culture of ancient Greece and Rome; when lower cased, a term describing any aspect of later art or architecture imitating ancient Greek or Roman examples, or more generally embodying qualities of rationality, restraint, balance, and order, or belonging to a well-respected and authoritative tradition

clerestory—the upper section of a wall containing a series of windows

cloisonné—a decorative technique in which metal strips are soldered to a metal surface to create cellular areas (*cloisons*, French for "partitions") that are filled with **enamel**

collage—from the French *coller*, "to glue," a technique in which cutout pieces of paper, cloth, or other materials are glued to a **support**; also, an artwork made through this technique

colonnade—a row of evenly spaced **columns**

Color Field painting—a term describing a form of **Abstract Expressionist** painting as well as **Post-painterly Abstraction** employing broad expanses of **saturated** color spreading across large canvases

column—an upright, supporting architectural element, consisting of a rounded or polygonal shaft, sometimes rising from a base and topped with a **capital**

combination printing—a photographic technique that uses two or more negatives to produce a final print

Combine—Robert Rauschenberg's term for his mixed media works that combined aspects of painting and sculpture while belonging fully to neither category

complementary colors—the **primary** and **secondary colors** opposite each other on the color wheel (red and green, blue and orange, yellow and purple)

composition—the arrangement of individual elements in a work of art

Conceptual art—a term that emerged in the 1960s to describe art that emphasizes ideas over the creation of objects or a concern with traditional aesthetic qualities

Concrete art, Concretism—terms describing nonobjective paintings and sculptures made in late 1940s Argentina and 1950s Brazil composed of precisely executed nonreferential geometric **shapes** and **forms** emphasizing qualities of objectivity and rationality

Constructivism—an **avant-garde** tendency originated by Russian artists in 1921 who rejected the **composition** of aesthetically pleasing **fine art** objects in favor of a machine- and science-inspired mode of construction, sometimes to support Russian Communism; also refers generally to **abstract** art "constructed" from geometric elements and

characterized by qualities of precision, impersonality, clear **formal** order, and the use of modern materials

conté crayon—a drawing **medium** in the form of a stick made of a mixture of compressed graphite or charcoal and wax, sometimes also with **pigment**

cool colors—blue, green, and purple, which tend to recede visually when used in two-dimensional art

cornice—a projecting horizontal **molding** along the top of a building or wall

Cubism—a **modernist** artistic style in which recognizable **subject matter** is fragmented, simplified, and abstracted through a geometric formal vocabulary of lines, angles, and planes

Cubo-Futurism—a Russian **avant-garde** painting style of the early-mid 1910s synthesizing **Cubism**'s fragmented forms with **Futurism**'s representation of dynamic motion

curtain wall—a thin, non–load-bearing external wall attached to a building's structural frame

Dada—an international artistic and literary movement formed in Zurich in 1916 in reaction to the horrors of World War I; its adherents rebelled against logic and traditional artistic values to embrace absurdity, chance, and irreverence

daguerreotype—a unique photograph consisting of a positive image fixed on a silver-iodide coated copper plate, named for its inventor Louis-Jacques Mandé Daguerre

Deconstructivism—an architectural trend emerging in the 1980s whose practitioners employed radically free and distorted forms to create disturbances and complexities within a building's structure, and often to disrupt the expected relationship between the building and its context

decorative arts—**applied art** forms that are intended to be both functional and aesthetically pleasing, including furniture, textiles, metalwork, ceramics, and glassware

De Stijl—Dutch for "The Style," an international group of artists and architects formed in the Netherlands in 1917 whose collective aim was to integrate and life through an abstract geometric aesthetic

Deutscher Werkbund—(German Labor League) an association founded in Munich in 1907 that promoted fine designs free of **historicism** and suitable for mass industrial production

direct carving—a **modernist** sculpture technique involving cutting wood or stone, typically without assistance or preliminary models, often to yield forms that reveal the carved material's inherent qualities

direct-metal sculpture—a **modernist** sculpture technique involving welding together pieces of metal, either **found objects** or metal components shaped by the artist

Divisionism—in painting, the technique of laying down separate strokes of pure color, as practiced by the **Neo-Impressionists**; also, the name of an Italian Neo-Impressionist movement of the 1890s and 1900s

elevation—an exterior or interior vertical face of a building, or an architectural drawing of such a face

enamel—glass bonded to a metal surface through intense heat to create a glossy decorative effect; also, a paint that dries to an opaque, durable, usually glossy finish

encaustic—paint made from **pigments** mixed with hot liquid wax

engraving—an **intaglio** printmaking technique in which lines are incised into a wood block or metal plate; the recessed lines are then inked, the block or plate surface is wiped clean, and a print is made by pressing paper or another **support** against the block or plate to transfer the ink; also, a print made through this technique

entablature—in architecture, a horizontal **lintel** consisting of different bands of **molding**, supported by the **columns** in **Classical** buildings or similar supports in non-Classical buildings

environment—an artwork filling an entire space or location that the viewer enters; see also **installation art**

etching—an **intaglio** printmaking technique in which a metal plate is coated with an acid-resistant resin into which lines are incised to expose portions of the plate; the plate is then immersed in acid which eats into (etches) the exposed metal; the resin is removed and the etched plate is inked, wiped, and printed by pressing paper or another **support** against the plate to transfer the ink held in the etched lines; also, a print made through this technique

expressionism—a term describing various **abstracted** or completely nonobjective **styles** intended to communicate intense subjective feelings, psychological states, or spiritual concerns, often through impulsive techniques and jarring or aggressive **formal** qualities; capitalized when used in the name of movements such as German Expressionism and **Abstract Expressionism**

façade—any exterior face of a building, usually the front

Fauvism—a movement in French painting of c. 1904 to 1907, characterized by bold, anti-naturalistic colors, applied in thick, discrete strokes or as broader planes to emphasize communication of the artist's feelings over realistic representation

Feminist Art Movement—a US-centered 1970s art movement that emphasized political issues central to women's liberation activism to empower women and validate their experiences

fenestration—the arrangement of, or pattern formed by windows in a building wall

figure-ground relationship—the relationship between a depicted **form** or **shape** and its **background** or the space surrounding it

fine art—creative visual art made and intended to be appreciated primarily for its aesthetic, intellectual, expressive, or symbolic value, and not to serve a utilitarian purpose

finial—an ornament, usually knoblike, crowning the upper extremity of a building or piece of furniture

Fluxus—a loosely organized international network of artists active in the 1960s and 1970s who used quotidian actions, words, sounds, objects and materials to unify art and life

folk art—art, often decorative or utilitarian and simple and direct in **form**, made by artists without formal training and within a communal tradition

foreground—in two-dimensional art, the area of the picture space closest to the viewer, immediately behind the **picture plane**

foreshortening—in two-dimensional art, the technique of depicting an object or body so that it appears to recede sharply into space

form—an object possessing or appearing to have three dimensions (as opposed to a flat **shape**); or a visual or physical element of an artwork

formal analysis—a mode of analysis that identifies, describes, and interprets the expressive effects of an artwork's **formal** qualities (rather than its **subject matter** or its meaning)

formalism—an approach to understanding and appreciating an artwork solely based on its **formal** qualities

found object—a natural or human made object, discovered rather than created by the artist, and incorporated into or presented as an artwork; unlike a **readymade**, a human-made found object is usually secondhand rather than new

fresco—a wall painting technique in which water-based **pigments** are applied to and absorbed by wet plaster so that the painting

becomes an integral to the wall after the plaster dries; also, a painting made through this technique

frieze—a long, horizontal band of sculpted or painted decoration on a wall, piece of furniture, etc.

functionalism—the belief that an object's or building's practical use should determine its design

Futurism—an Italian **avant-garde** art movement, founded in 1909, that celebrated the energy and dynamism of the mechanized modern world

gable—an external building wall between the sloping sides of a roof

genre painting—a painting representing a scene from everyday life, such as people at work or at leisure

Gesamtkunstwerk—German for "total work of art," an artwork synthesizing various art forms (such as painting, sculpture, and architecture) into an aesthetic unity

gesso—a paint made of white **pigment**, a filler (such as chalk), and a binder, applied to a canvas, wood panel, or other **support** to provide a smooth painting surface

gestural painting—a form of painting in which lines or brushstrokes visibly record the artist's physical movements that laid them down; see also: **action painting**

glaze, glazing—in painting, a thin layer of translucent paint applied over a more opaque layer; in architecture, to furnish with glass; in ceramics, an impervious vitreous coating fused to pottery through firing

gouache—an opaque, water-based matte paint, or

a painting made with gouache

Graffiti art—expressive images or texts painted onto public walls, signs, train cars, etc., usually illicitly; also, art made for display in galleries using graffiti techniques and styles

graphic art—two-dimensional visual art forms primarily based on the use of line and **tone**, such as drawing and printmaking; also refers to such applied art forms as illustration, animation, and poster design

green roof—a waterproofed, soil and vegetation-covered roof that provides insulation and reduces stormwater runoff

grisaille—monochromatic painting in shades of gray

half-timbering—a construction method in which a wooden frame is left exposed and filled in with brick or plaster

Happening—a term coined by Allan Kaprow in the late 1950s to describe a live art event with sets, props, and costumes made of cheap, everyday materials, and performers engaging in actions based on rudimentary directions, chance, and improvisation

Hard Edge painting—a non-representational painting style of the 1950s and 1960s featuring large, flat, sharply defined, smoothly brushed **shapes** in black and white or a few colors

hierarchy of genres—an **academic** system codified in seventeenth-century France that ranked types of painting (genres) in descending order based on their perceived nobility and difficulty of execution, from **history painting**, to

portraiture, **genre painting**, landscape, and **still life**

High Tech—an architectural style of the 1970s and 1980s that exposes advanced structural engineering and mechanical systems to produce a strongly technological aesthetic

Hinterglasmalerei—German for "reverse glass painting," a form of painting in which the imagery is painted on the reverse side of a glass sheet then viewed through the front side of the glass

historicism—in architecture, the emulation of past styles, particularly during the nineteenth century

history painting—a painting depicting a subject from history, mythology, literature, or the Bible, considered the noblest form of art in the European **hierarchy of genres**

horizon line—in two-dimensional representational art, an implied or depicted horizontal line where the earth and sky meet

hue—the attribute of a color that permits it to be classified as red, blue, green, etc., regardless of its **saturation** or its **value**

Hurufiyya—loosely, "lettrism," from the Arabic word *harf* ("letter"), a term describing the incorporation of Arabic script and words into painting, **graphic art**, and other mediums in modern Middle Eastern art from the 1960s onward

iconography—the imagery of a work of art or shared by a group of artworks, especially imagery carrying culturally specific meaning or conventional symbolism

idealization—the depiction of a subject to make it appear

more attractive than in reality, or flawless, according to culturally specific standards of beauty and perfection

illusionism—in two-dimensional art, the use of techniques such as precise drawing, **modeling**, and **linear perspective** to create the convincing illusion of three-dimensional reality

impasto—paint thickly applied to a canvas, panel, or other **support** to create a palpable surface texture

Impressionism—a painting movement originating in France in the late 1860s committed to depicting subjects from modern life without regard for **academic** conventions and in pursuit of a sense of freshly observed truth, often achieved through the use of informal **compositions**, broken **brushwork** and bright colors that convey transitory effects of light and atmosphere

installation—a work of art made of multiple parts assembled or arranged within a specific space or location to create a totality that the viewer may either observe from without or enter as an **environment**

intaglio—in printmaking, any technique through which lines or other marks are cut into the plate and subsequently receive ink that is transferred to the print; includes **engraving** and **etching**

intensity—a synonym for **saturation**: a color's quality of brightness or dullness

International Style—a widespread style of modernist architecture from the 1930s to the 1960s characterized by rectilinear geometric **forms**, open **plans**, an

emphasis on **volume** over **mass**, modern materials such as steel, glass, and reinforced concrete, and the refusal of applied decoration

Japonisme—a term describing the influence of Japanese art on late nineteenth-century European and American art

Jugendstil—German for "young style," the term for **Art Nouveau** in German-speaking countries

kinetic art—art that incorporates actual motion, either generated mechanically, through touch, or by natural means such as air currents or gravity

lacquer—a liquid coating substance, usually resin dissolved in a solvent or drying oil, which dries to a hard, durable finish

Land art—a term describing **site-specific** art made directly in the natural landscape, or made of materials relocated from the land into a gallery

linear perspective—a system for representing three-dimensional space on a two-dimensional surface by establishing a **horizon line** and multiple **orthogonal lines** that converge on one, two, or three **vanishing points**

lintel—a horizontal spanning element above a door, window, or other opening

literati—in East Asian cultures, educated and cultivated intellectuals, typified by Chinese scholar-officials who practiced calligraphy, poetry, and painting for self-expression rather than professionally

lithograph—a print made through the process of lithography, in which a design is drawn on a flat

stone block or metal plate using a greasy crayon; ink applied to the wet block or plate adheres only to the greasy portions and is transferred to the **support** when printed

maquette—a small model or three-dimensional study for a sculpture or architectural project

masonry—construction using brick, stone, or concrete blocks laid and bound together with mortar

mass—dense, solid material filling space, especially in sculpture and architecture

massing—the overall, three-dimensional configuration of a building

mechanopmorphic—a term describing the representation of an organic subject, such as human figure or plant, as mechanized or machinelike

medium—a type of art (such as painting or sculpture), or the material or materials from which an artwork is made

megastructure—a massive complex of buildings with a unitary style and coordinated program of diverse functions; also, an architectural concept for a city as a single massive building or series of interconnected structures

middle ground—in two-dimensional art, the area of the picture space between the **foreground** and the **background**

Minimalism—a style of nonrepresentational art centered in New York City in the 1960s typified by three-dimensional artworks comprising simple, geometric **forms**, often readymade or fabricated of industrial or building materials,

presented as unitary objects or arranged in symmetrical or gridded configurations, and placed directly on the floor or wall

mobile—a sculpture made of suspended elements that move in response to air currents or motor power, a **medium** originated by Alexander Calder

model, modeling—in two-dimensional arts, to create the illusion of three-dimensional **mass** and **volume** through light and shade (using a range of **values** to create a transition from the most brightly lit part of an object to its darker, shadowed side); in sculpture, the process of building and shaping a **form** from a malleable material such as wax, clay, or plaster

modernism—in art, the impulse to break with the past, reject conventions, and pursue innovations that achieve more vital, challenging, and original forms of expression

moiré pattern—a wavy pattern formed by the superimposition of two similar patterns of lines or **shapes** placed at an angle to one another

molding—in architecture and the **decorative arts**, a contoured strip used to cover a transition or outline an edge in an aesthetically pleasing way

Mono-ha—Japanese for "School of Things," a loosely affiliated group of artists in 1960s Japan who used natural and manmade materials ("things"), such as earth, stone, wood, rope, paper, glass, and steel, presented with very little manipulation

mullion—a slender vertical bar that divides a window into smaller units

Nabis—from the Hebrew for "prophets," a group of late nineteenth-century painters in France, inspired by Paul Gauguin's **Synthetism** to emphasize decorative qualities of simplified drawing, flat patches of color and bold contours in their two-dimensional art

naïve art—a term applied to the work of nonprofessional, self-taught artists lacking conventional technical skills but strongly committed to individual personal expression

naturalism—a style of depiction aiming to record the physical appearance of nature (including human beings) in an accurate and detailed manner

negative-positive printing method—a method of printing photographs whereby a negative photographic image, which reproduces the bright parts of the photographed subject as dark, and vice versa, is used to produce a positive photographic print (with the dark and light tones reversed) by placing the negative in contact with or projecting its image onto light-sensitive paper

Neoclassicism—a style of art and architecture originating in mid eighteenth-century Europe, inspired by **Classical** art and architecture and characterized by aesthetic values of clarity, order, and restraint

Neo-Concretism—a movement launched in Rio de Janeiro in 1959 in reaction against Brazilian **Concretism**'s supposed rationality and objectivity; Neo-Concretists made artworks that invited physical interaction, seeking to integrate art and life

Neo-Dada—a term describing American and European art of the 1950s and early 1960s that employed **found objects** and found images in ways reminiscent of **Dada**

Neo-Expressionism—a movement in European and US art of the 1970s and 1980s characterized by large-scale, gesturally executed representational paintings containing narrative, historical, symbolic, or mythic **subject matter**

Neo-Geo—shorthand for New Geometry or Neo-Geometric Conceptualism, a label applied to a diverse group of artists in New York City in the 1980s who made simulations of **modernist** geometric **abstraction** or appropriated objects, advertising imagery, and logos from contemporary consumer culture

Neo-Impressionism—a **Post-Impressionist** painting style of the late nineteenth century that renounced **Impressionist** spontaneity for a more disciplined and rigorous method informed by scientific studies of light and color, employing the techniques of **Divisionism** or **Pointillism**

Neo-plasticism—a nonrepresentational painting style originated in 1920 by Piet Mondrian, based on horizontal and vertical lines, the **primary colors**, and neutral colors (black, white, and gray), intended to express a transcendent reality independent of nature

Neo-primitivism—a Russian **avant-garde** painting style of the early 1910s inspired by traditional Russian popular art forms, such as icons, peasant arts and crafts, and *lubki*, cheap, brightly colored prints with narrative imagery

Neue Sachlichkeit (New Objectivity)—a term describing representational art in 1920s Germany, especially painting, either cool and calm in execution and imagery, or with caricatured and exaggerated imagery conveying social criticism

Nihonga—a term introduced in late nineteenth-century Japan for Japanese-style painting using materials, techniques, and formats in the Japanese tradition, as distinguished from *Yōga* (Western style painting)

Nouveau Réalisme—a Parisian **avant-garde** movement of the early 1960s whose adherents mostly fashioned their art out of everyday materials from the urban environment

odalisque—an enslaved woman or concubine in a harem (the space in a Muslim house reserved for women), a popular subject in nineteenth-century European art

oil paint—a slow-drying paint made from **pigments** suspended in a drying oil

Old Masters—a term describing distinguished European painters from the fourteenth through the early eighteenth centuries

Op art—an abbreviation of "optical art," a term originating in the 1960s to refer to geometric nonrepresentational art that creates optical illusions through precise, calculated arrangements of lines, **shapes**, and colors

Orientalism—an art-historical term applied to depictions of Middle Eastern subjects by European and American artists, particularly in the nineteenth century

Orphism—a term coined by Guillaume Apollinaire to refer to the work of several painters in Paris who used joyous color and semi- or fully **abstract forms** rooted in **Cubism**

orthogonal lines—in **linear perspective**, parallel lines within the picture space that converge on a **vanishing point** to create the illusion of recession into depth

painterly—a term describing a painting style that emphasizes the material quality of the paint itself (such as its thickness and texture), and the manner of its application (e.g., through loose or emphatic **brushwork**)

palette—a thin oval or rectangular board or other support used for holding and mixing paint, or the range of colors in an artwork

palette knife—a tool with a thin, flexible metal blade attached to a handle, used for mixing, applying, or scraping paint

papier collé—French for "pasted paper," a **Cubist collage** made from pieces of cut paper

passage—a painting technique originated by Paul Cézanne in which unbounded planes of color flow into adjacent planes of different colors

so that surfaces appear to bleed together

pastel—a drawing stick made of pure powdered **pigments** combined with a nongreasy binder, or a drawing made in this medium

pastoral—a term describing an artwork depicting peaceful life in the countryside, often in an **idealized** manner

patina—a thin coating, usually green, that forms on bronze through oxidation after prolonged exposure to the air, or burial, or is imparted artificially through chemical treatment; also, any surface appearance of an object resulting from age, use, corrosion, etc.

pendant—one of two paintings meant to hang together as a pair

performance art—live art, often enacted before an audience, and sometimes incorporating elements of theater, dance, music, poetry, or other visual arts; when capitalized, refers to this kind of art as a major **avant-garde** mode in the 1960s and 1970s

perspective—a technique or system for representing three-dimensional objects and space on a two-dimensional surface

photogram—a photograph made without the use of a camera by placing objects between light-sensitive paper or film and a light source

photogravure—an **intaglio** ink-printing process for reproducing photographic images by means of a copper plate etched with the image; also, a print made through this process

photojournalism—a form of journalism that uses photographs, frequently supplemented with text, to report a news story

photomontage—a **collage** constructed from cutout photographs, or a photographic composition made from numerous smaller photographs

Photorealism—a painting style originating in the 1960s that uses photographs as the source of its imagery and imitates the appearance of photographs

photo-silkscreen—a **silkscreen** printing process using a photographic image as the stencil; the photographic image is transferred to the screen through the application of a light-sensitive emulsion to the screen and its exposure to a film positive

Pictorialism—a late-nineteenth and early twentieth-century European and American movement that sought to elevate photography to a **fine art** by emulating the look of paintings, prints, and drawings, usually through soft-focus atmospheric effects and a narrow **tonal** range

picture plane—in two-dimensional artworks, the imaginary vertical plane dividing the internal, fictive space of the picture from the viewer's real space

pigment—a substance that gives color to paint, ink, or another material

plan—an architectural diagram showing the complete layout of one level of a building as if viewed from directly overhead, including the walls, windows, doors, stairs, fittings, and sometimes also furniture

plein air—a term describing the practice of painting in outdoor daylight, from the French phrase *en plein air* (in the open air)

Pointillism—in painting, the technique of laying down individual colors in dots, as practiced by the **Neo-Impressionists**

polychrome—having many various colors

Pop art—an international movement of the 1960s that drew its artistic subject matter and, often, style from popular and commercial sources such as advertising, mass media, and popular entertainment

porte-cochère—a roofed structure built over a driveway at the entrance to a building

Post-Impressionism—a term used broadly to characterize all modern late nineteenth-century art that reacted against the **Impressionists'** attempts to record appearances objectively and used more **abstract** styles to convey personal or symbolic content

Post-minimalism—an umbrella term for late 1960s American art forms including **Process art**, **Conceptual art**, **Land art**, and **Body** and **Performance art**.

postmodernism—when capitalized, refers to a prominent architectural trend of the 1970s and 1980s rejecting the **abstract International Style** aesthetic in favor of designs incorporating historical and, sometimes, **vernacular** stylistic elements; in art and culture more broadly, postmodernism denotes a late twentieth-century reaction against **modernism** characterized by skepticism toward the concepts of universal truth, institutional authority, and transparent reality, and an emphasis on relativism, difference, and diversity

Post-Painterly Abstraction—a term coined by Clement Greenberg in 1964 for non-representational painting lacking tactile **brushwork** and emphasizing surface flatness through expanses of pure color on large canvases; includes both **Stained Canvas Color Field painting** and **Hard Edge painting**

Precisionism—a term describing US painting, photography, and **graphic art** of the 1920s and 1930s depicting urban and industrial **subject matter** in a clean, hard-edged style emulating machine aesthetics

Pre-Raphaelite Brotherhood (PRB)—a secret society formed in London in 1848 by young painters who rejected **academic** conventions and drew inspiration from fourteenth- and fifteenth-century Italian and Northern European art for their sharp-focus style in which they depicted sacred or literary subjects and scenes from contemporary British life conveying moral messages

primary colors—the three basic colors (red, yellow, and blue) that can be mixed together to produce other colors

primitivism—a term describing late nineteenth and

twentieth-century modern Western artists' use of artefacts from preindustrial societies as sources of innovation; in broader terms, the romanticized Western view of preindustrial societies as supposedly pure, simple, and untouched by modernity

Process art—a term originating in the late 1960s describing nonrepresentational art that emphasizes the materials, actions, and procedures used to fashion it

Productivism—the movement promoted by the Communist government after the 1917 Russian Revolution to abolish the bourgeois distinction between art and industry and to consider art as another aspect of manufacturing activity, leading artists to design useful items such as furniture and clothing; a major tendency within Russian **Constructivism**

Purism—a painting movement established in Paris in 1918 by Amédée Ozenfant and Charles-Édouard Jeanneret (Le Corbusier), later extended to architecture, manifested in a disciplined form of **Cubism** fusing the harmonious aesthetic values of **classical** art with the precise, impersonal beauty of the machine

pylon—the monumental truncated pyramidal **masonry** towers flanking the gateway to an ancient Egyptian temple, or, in modern construction, a supporting structure or tower

Rayism/Rayonism—an **abstract** painting style employed by Mikhail Larionov and Natalia Goncharova

in Russia between 1912 and 1915 employing forms evoking rays of energy reflected from an object's surface

readymade—a term coined by Marcel Duchamp to describe a manufactured object chosen by an artist, removed from its usual context and function, and presented as a work of art

Realism—when capitalized, the mid- to late-nineteenth-century European and North American art movement whose adherents were committed to empirical observation and representation of subjects in the everyday world, rendered in a seemingly truthful manner

Regionalism—an American art movement during the 1930s and early 1940s that focused on local subject matter rendered in accessible realist styles, especially rural Midwestern scenes

relational art—a term coined by Nicolas Bourriaud in the 1990s referring to contemporary participatory art in the form of public situations that facilitate social exchange between people

relief—a form of sculpture in which the three-dimensional elements project from a supporting background, usually flat

Renaissance—French for "rebirth," a cultural period in Europe from the late fourteenth to the mid-sixteenth century characterized by art and architecture based on the creative imitation of **Classical** models and values

Rococo—a light, sensuous, and highly ornamental eighteenth-century European style in **fine**

and **decorative arts** and architecture

Romanesque—a style of eleventh- and twelfth-century medieval European architecture characterized by round arches and vaults and heavy **masonry** walls

Romanticism—a late eighteenth–mid nineteenth-century European cultural movement that emphasized emotion, imagination, and passion over rationality, objectivity, and restraint

Sabattier effect—the partial or complete reversal of light and dark tones in a photographic image, produced when an exposed photographic emulsion is briefly re-exposed to white light during development; often incorrectly referred to as **solarization**

Salon—a large official exhibition of contemporary art held in Paris between 1667 and 1880, sporadically before 1737 and usually annually or biennially thereafter

sash window—a window consisting of one or more movable glazed panels (sashes) that slide vertically or horizontally

saturation, saturated—a color's quality of brightness or dullness, also known as **intensity**

secondary colors—the colors obtained by mixing two **primary colors** in equal quantities: orange (a mixture of red and yellow); purple (a mixture of red and blue); and green (a mixture of yellow and blue)

setback—in architecture, a steplike recession in a high rise building's **elevation**,

usually dictated by building codes to allow light and air to reach the street level

shape—an enclosed, two-dimensional area or configuration

silkscreen—a printmaking process using ink forced through a fine-mesh screen (of silk or another material) to which a stencil made of paper (or another thin material) is adhered

Simultanism—An abstract painting style developed in 1912–13 by Robert Delaunay and Sonia Delaunay-Terk that sought to generate a visual sensation of brilliance and movement through the precise juxtaposition of contrasting colors

site-specific—a term describing an artwork designed for and integrated into a specific location or environment

social realism—art in realist styles depicting contemporary subjects of social, economic, or political concern, intended to protest injustice and promote social or political change; when capitalized, refers to the US movement of the 1930s that produced art of this kind

Socialist Realism—art promoted by socialist governments such as those of the Soviet Union or People's Republic of China, characterized by realistic, optimistic, and heroic imagery glorifying socialist leaders and ideals

soft-ground etching—an **etching** method that produces soft lines or a grainy texture in prints, using a softer and stickier ground (a waxy, acid-resistant

material applied to an etching plate) than in normal etching, over which an artist may apply a sheet of paper on which pencil lines are drawn that lift the wax beneath and expose areas of the metal that are subsequently etched with acid and receive ink for printing; other techniques may also be used with soft ground

solarization—the light and dark tone reversal of a negative or printed photographic image caused by tremendous overexposure to light; see also **Sabattier effect**

spandrel panel—in a multistory building, a panel filling the space between the top of the window in one story and the windowsill in the story above

Stained Canvas Color Field painting—a form of nonrepresentational painting originating in the United States in the 1950s in which the artist applies diluted paint onto raw canvas to infuse it with flat color

still life—an artwork representing inanimate objects, such as fruit, flowers, food, and kitchenware

stringcourse—a continuous horizontal decorative band of brick, stone, or **molding** set in or projecting from a wall

style—the distinctive visual appearance of a work of art, or the distinctive treatment of **form** and manner of expression characteristic of an individual artist, school, or movement

stylized—represented in an artificial, non-**naturalistic** manner; **abstracted**

subject matter—the representational content of a work of art; what it depicts

sublime—an experience of elation or terror produced by the vast, the infinite, or the mysterious, which many **Romantic** painters sought to evoke through dramatic landscape and seascape imagery

support—in two-dimensional art, a surface or material on which an artist draws, paints, prints, etc.

Suprematism—an innovative form of nonobjective painting introduced in Russia by Kazimir Malevich in 1915 that employed flat geometric **shapes** of pure color, usually oriented diagonally, set against a white ground; the name implied this new art's supremacy over the art of the past

Surrealism—an international cultural movement, founded by André Breton in Paris in 1924, which sought to unleash the creative energies of the unconscious mind and celebrated the irrational

Symbolism—when capitalized, a literary and artistic movement in Europe and the United States, c. 1885–1910, which rejected materialism and sought to express a deeper, intuitively sensed reality through suggestion rather than description

synaesthesia—a neurological condition in which the stimulation of one sense simultaneously stimulates another sense

Synthetic Cubism—a form of **Cubist** painting and **collage** in which the subject matter appears to have been built up or synthesized out of flat **shapes**

Synthetism—a term applied to the art of Paul Gauguin and his circle in the late 1880s-early 1890s, conceived of as synthesizing three features: the representation of nature's outward appearance, the artist's feelings about the subject, and purely **formal** considerations

tempera—a water-soluble paint made from **pigments** usually mixed with egg yolk as the binder

terracotta—Italian for "cooked earth," a type of porous clay that when fired, becomes durable and assumes a color, most often red-brown, and may be painted or **glazed**

tone, tonal—another word for **value**, or a color's lightness or darkness, independent of its *hue*; *tonal* describes two-dimensional art that limits or excludes the linear definition of **form** to use gradations of value that emphasize light and shadow or produce atmospheric effects

trabeated construction—a structural system using **columns** or posts that support horizontal beams or **lintels**, also known as the post and lintel system

Transavanguardia (Transavantgarde)—critic Achille Bonito Oliva's name for an Italian figurative painting movement associated with **Neo-Expressionism**

transom—a horizontal bar dividing a window, or a crosspiece over a door

triptych—an artwork consisting of three parts, such as painted or sculpted panels, usually displayed side by side

triumphal arch—originated by the ancient Romans, a monumental gateway with one or three arched openings, intended to commemorate a military or other victory

two-point perspective—a form of **linear perspective** using two **vanishing points** on the **horizon line**; one or both vanishing points may be placed outside the picture space on the horizon line as it is imagined extending beyond the frame

tympanum—the area above a door between a **lintel** and an arch or a similar crowning element

value—a color's degree of lightness or darkness

vanishing point—in **linear perspective**, a point at which **orthogonal lines** converge

vanitas—Latin for "vanity," an artwork representing objects symbolizing the transience of life, beauty, and pleasure, especially in a **still-life** composition

vernacular—in architecture, a term describing local or regional construction using locally sourced materials and traditional methods to create buildings that accommodate a particular community's needs and values

volume—a three-dimensional space having height, width, and depth; a volume may be either hollow or possess **mass**

Vorticism—a British literary and artistic movement established in 1914 by Wyndham Lewis that drew inspiration from machines and the urban environment

warm colors—red, orange, and yellow, which tend to

advance visually when used in two-dimensional art

warp—vertical threads tightly strung lengthwise over the loom in textile weaving

watercolor—a transparent paint made of **pigments** in a water-soluble binder

weft—horizontal threads woven over and under the **warp**

threads in textile weaving to form cloth

wet collodion process—a photographic process using a negative formed on a glass plate coated with a syrupy solution of collodion (nitrocellulose, alcohol, and ether) and potassium iodide, sensitized with

silver nitrate, exposed in the camera while still wet, then immediately developed and fixed

woodblock print—a **woodcut** print in Japanese art

woodcut—a print made by means of a wood block cut so that the areas not

to be printed are carved away, leaving the lines and **shapes** that will be inked and printed raised in relief

Yōga—Japanese term for Western-style painting, which became popular starting in the late nineteenth century

Notes

Introduction

1. Ian Kennedy and Julian Treuherz, *The Railway: Art in the Age of Steam* (Liverpool: Walker Art Gallery; Kansas City, MO: Nelson-Atkins Museum of Art in association with Yale University Press, 2008), 105.

2. Kennedy and Treuherz, *The Railway*, 105.

3. Pam Meecham and Paul Wood make this point in similarly comparing William Frith's *Paddington Station* (1862) and Monet's *Interior of the Gare Saint-Lazare* (1877). See Meecham and Wood, "Modernism and Modernity: An Introductory Survey," in *Investigating Modern Art*, ed. Liz Dawtrey, Toby Jackson, Mary Masterton, Pam Meecham, and Paul Wood (New Haven, CT: Yale University Press in association with Open University, 1996), 11.

4. Léon de Laura, *Le Gaulois*, April 10, 1877, quoted in *The New Painting: Impressionism 1874–1886* (San Francisco: Fine Arts Museums of San Francisco, 1986), 224.

5. Georges Rivière, *L'Impressioniste*, April 6, 1877, quoted in *The New Painting*, 223.

6. Kennedy and Treuherz, *The Railway*, 146.

7. Kennedy and Treuherz, *The Railway*, 152.

8. Alfred Stieglitz, "The Pictures in This Number," *Camera Work* 1 (January 1903): 63.

9. Oswald de Andrade, "Manifesto of Pau-Brasil Poetry," trans. Stella M. de Sá Rego, *Latin American Literary Review* 14, no. 27 (January–June 1986): 187.

10. Andrade, "Manifesto," 187.

11. Kennedy and Treuherz, *The Railway*, 242.

12. Charles Baudelaire, *The Salon of 1846*, in *Art in Paris 1845–1862: Salons and Other Exhibitions—Reviewed by Charles Baudelaire*, trans. and ed. Jonathan Mayne (London: Phaidon, 1965), 46.

13. David Blayney Brown, *Romanticism* (London: Phaidon, 2001), 285.

14. Brown, *Romanticism*, 287.

15. William Vaughan, *Romantic Art* (London: Thames & Hudson, 1978), 132.

16. John Constable, letter to John Fisher, October 23, 1821, quoted in C. R. Leslie, *Memoirs of the Life of John Constable, Esq., R. A.* (London: J. M. Dent; New York: E. P. Dutton, 1911), 75.

17. Constable, Lecture at the Royal Institution of Great Britain, London, June 16, 1836, quoted in Leslie, *Memoirs*, 285.

18. Vaughan, *Romantic Art*, 203.

Chapter 1

1. The depicted burial is likely that of Courbet's great-uncle by marriage, Claude-Etienne Teste, the first person interred in a new cemetery established in Ornans in September 1848. See Claudette B. Mainzer, "Who Is Buried at Ornans?," in Sarah Faunce and Linda Nochlin, *Courbet Reconsidered* (Brooklyn, NY: Brooklyn Museum, 1988), 77–81.

2. A.-J. Dupays, "Salon de 1850," *L'Illustration* 17 (January 31–February 7, 1851), and Gustave Geffroy, "Le Salon de 1850," *Revue des deux mondes*, nouv. pér., t. 9 (January–March 1851), quoted in Albert Boime, *Art in an Age of Civil Struggle, 1848–1871* (Chicago: University of Chicago Press, 2007), 179.

3. Champfleury, "In Defense of the Funeral at Ornans," *Messager de l'assemblée*, February 25–26, 1851, reprinted with slight changes in Champfleury, *Grandes figures d'hier et d'aujourd'hui* (Paris: Poulet-Malassis et de Broise, 1861), the latter version translated and reprinted in *Courbet in Perspective*, ed. Petra ten-Doesschate Chu (Englewood Cliffs, NJ: Prentice-Hall, 1977), 69.

4. Courbet, letter to the editor of *Le Messager de l'assemblée*, November 19, 1851, in *Letters of Gustave Courbet*, ed. and trans. Petra ten-Doesschate Chu (Chicago: University of Chicago Press, 1992), 103.

5. Gustave Courbet, "Manifest du réalisme," preface to *Exhibition et vente de 40 tableaux et 4 dessins de l'oeuvre de M. Gustave Courbet* (Paris: Simon Raçon, 1855), n.p., trans. Claude Cernuschi and Jeffrey Howe, in *Courbet: Mapping Realism: Paintings from the Royal Museums of Fine Arts of Belgium and American Collections*, ed. Jeffrey Howe (Chestnut Hill, MA: McMullen Museum of Art, Boston College, 2013), 7.

6. Boime, *Art in an Age of Civil Struggle*, 121.

7. Robert Rosenblum and H. W. Janson, *19th-Century Art*, rev. ed. (Upper Saddle River, NJ: Pearson Prentice Hall, 2005), 233.

8. Lorenz Eitner, *19th Century European Painting, David to Cézanne*, rev. ed. (Boulder, CO: Westview Press, 2002), 254.

9. See Albert Boime, "The Case of Rosa Bonheur: Why Should a Woman Want to be more like a Man?," *Art History* 4, no. 4 (December 1981): 384–409; and James M. Saslow, "'Disagreeably Hidden': Construction and Constriction of the Lesbian Body in Rosa Bonheur's *Horse Fair*," in *The Expanding Discourse: Feminism and Art History*, ed. Norma Broude and Mary D. Garrard (New York: HarperCollins, 1992), 187–205.

10. John Ruskin, "Pre-Raphaelitism," review, *Economist* 9, no. 417 (August 23, 1851), reprinted in *The Works of John Ruskin*, ed. E. T. Cook and Alexander Wedderburn (London: George Allen, 1904), 12: 339. Ruskin's 1851 review quotes his own words from *Modern Painters, Volume 1* (1843), pt. II, sec. VI, ch. III, § 21.

11. Charles Dickens, "Old Lamps for New Ones," *Household Words*, June 15, 1850, reprinted in Dickens, *Old Lamps for New Ones: And Other Sketches and Essays, Hitherto Uncollected* (New York: New Amsterdam, 1897), 5.

12. Carlyle made this argument in *Past and Present* (1843).

13. My discussion of *Work*'s iconography follows Julian Treuherz, *Ford Madox Brown: Pre-Raphaelite Pioneer* (London: Philip Wilson Publishers in association with Manchester Art Gallery, 2011), 188–93.

14. James McNeill Whistler, Cross-examination in the Trial of Ruskin for Libel (1878), in *Art in Theory 1815–1900*, ed. Charles Harrison and Paul Wood with Jason Gaiger (Oxford: Blackwell, 1998), 835.

15. John Ruskin, "Letter the Seventy-ninth," *Fors Clavigera*, July 2, 1877, quoted in Don C. Seitz, *Writings by and about James McNeill Whistler: A Bibliography* (Edinburgh: Otto Schulze, 1910), 56.

16. This was the title of a book illustrated with Talbot's photographs—an innovation in the history of publishing—issued in six parts between 1844 and 1846.

17. Delaroche's supposed statement is likely apocryphal. See Martin Gasser, "Between 'From Today, Painting is Dead' and 'How the Sun Became a Painter': A Close Look at Reactions to Photography in Paris 1839–1853," *Image* 33, nos. 3–4 (Winter 1990–91): 15.

18. Charles Baudelaire, "The Modern Public and Photography" extract from his "Salon de 1859," *Revue Française* (Paris), June 10–July 20, 1859, in Harrison, Wood, and Gaiger, *Art in Theory*, 667–68.

19. Gustave Le Gray, *Photographie: traité nouveau théorique et pratique, des procédés et manipulations: sur papier, sec, humide: sur verre, au collodion, à l'albumine*, rev. ed. (Paris: Lerebours et Secretan, 1854), 68.

20. Nadar, testimony in an 1856 lawsuit, in *Revendication de la propriété exclusive du pseudonyme Nadar (Félix Tournachon-Nadar contre A. Tournachon jeune et Compagnie)* (Paris, 1857), pt. 2, p. o, trans. and quoted in James H. Rubin, *Nadar* (London: Phaidon, 2001), 3.

21. From a letter to John Herschel, December 31, 1864, reprinted in Helmut Gernsheim, *Julia Margaret Cameron: Her Life and Photographic Work* (Millerton, NY: Aperture, 1975), 14.

22. Alexander Gardner, *Gardner's Photographic Sketch Book of the War* (Washington, DC: Philp and Solomons, 1866), 1:36.

23. Boime, *Art in an Age of Civil Struggle*, 662. Baudelaire published "The Painter of Modern Life" in two parts in *Le Figaro*, November 28 and December 3, 1863.

24. Charles Baudelaire, "The Painter of Modern Life," in Harrison, Wood, and Gaiger, *Art in Theory*, 497.

25. Quoted in Margherita d'Ayala Valva, *The Musée d'Orsay* (New York: Barnes and Noble, 2007), 60.

26. See Robert L. Herbert, *Impressionism: Art, Leisure, and Parisian Society* (New Haven, CT: Yale University Press, 1988), 61; and Boime, *Art in an Age of Civil Struggle*, 677.

27. On Laure's role in Manet's art see Denise Murrell, "*Olympia* in Context: Manet, the Impressionists, and Black Paris," chap. 1 in *Posing Modernity: The Black Model from Manet and Matisse to Today* (New Haven, CT: Yale University Press in association with Miriam and Ira D. Wallach Art Gallery, Columbia University, 2018).

28. Courbet quoted in Theodore Reff, *Manet: Olympia* (London: Allen Lane, 1976), 30.

29. Émile Zola, "Une nouvelle manière en peinture. M. Édouard Manet," *Revue du XIXe Siècle*, January 1, 1867, quoted in Hajo Düchting, *Edouard Manet: Images of Parisian Life* (Munich: Prestel, 1995), 46.

30. Petra ten-Doesschate Chu, *Nineteenth-Century European Art*, 3rd ed. (Boston: Prentice Hall, 2012), 395.

31. Claude Monet quoted in Lilla Cabot Perry, "Reminiscences of Claude Monet from 1889 to 1909," *American Magazine of Art* 19, no. 3 (March 1927): 120.

32. My discussion of this painting follows Herbert, *Impressionism*, 119, 121.

33. See Kirk Varnedoe, "The Artifice of Candor: Impressionism and Photography Reconsidered," *Art in America* 68, no. 1 (January 1980): 66–78.

34. Degas reportedly said this to George Moore, quoted in François Mathey, *The Impressionists*, trans. Jean Steinberg (New York: Frederick A. Praeger, 1961), 187.

35. [Octave Maus], "Les vingtistes parisiens," *L'Art Moderne* (Brussels), June 27, 1886, quoted in Martha Ward, "The Rhetoric of Independence and Innovation," in *The New Painting: Impressionism 1874–1886* (San Francisco: Fine Arts Museums of San Francisco, 1986), 433.

36. See Eunice Lipton, "The Bathers: Modernity and Prostitution," chap. 4 in *Looking Into Degas: Uneasy Images of Women and Modern Life* (Berkeley: University of California Press, 1986).

Chapter 2

1. Friedrich Nietzsche, *The Will to Power*, §821, in *The Complete Works of Friedrich Nietzsche*, ed. Oscar Levy (Edinburgh: T. N. Foulis, 1910), 15: 264.

2. Seurat's *Esthétique*, draft of an 1890 letter to Maurice Beaubourg, in Robert L. Herbert, Françoise Cachin, Anne Distel, Susan Alyson Stein, and Gary Tinterow, *Georges Seurat, 1859–1891* (New York: Metropolitan Museum of Art, 1991), 382.

3. Referring to a sculptural frieze by Phidias on the Athenian Parthenon, Seurat told the poet Gustave Kahn, "The Panathenaeans of Phidias formed a procession. I want to make modern people, in their essential traits, move about as they do on those friezes, and place them on canvases organized by harmonies of color, by directions of the tones in harmony with the lines, and by the directions of

the lines." Gustave Kahn, "Exposition Puvis de Chavannes," *La revue indépendante* 6 (1888): 142, quoted in Herbert et al., *Georges Seurat*, 106.

4. See Robert L. Herbert's summaries of interpretations of *La Grande Jatte* in Herbert et al., *Georges Seurat*, 173–79; and in Robert L. Herbert and Neil Harris, *Seurat and the Making of* La Grande Jatte (Chicago: Art Institute of Chicago in association with University of California Press, 2004), 162–75.

5. Cézanne's young admirer Maurice Denis recorded this remark. Denis, "Cézanne," in Denis, *Théories, 1890–1910: du Symbolisme et de Gauguin vers un nouvel ordre classique*, 4th ed. (Paris: L. Rouart and J. Wakelin, 1920), 250.

6. Paul Cézanne, letter to Joachim Gasquet, September 26, 1897, in *Paul Cézanne Letters*, 4th ed., ed. John Rewald, trans. Marguerite Kay (New York: Hacker Art Books, 1976), 261.

7. Cézanne to Maurice Denis, in *Conversations with Cézanne*, ed. Michael Doran, trans. Julie Lawrence Cochran (Berkeley: University of California Press, 2001), 176.

8. Stéphane Mallarmé, "Réponse à une Enquête," 1891, reprinted in Guy Michaud, *La Doctrine Symboliste* (Paris: Librarie Nizet, 1947), 74. Italics in the original.

9. Charles Baudelaire, *The Salon of 1846*, in *Art in Paris 1845–1862: Salons and Other Exhibitions—Reviewed by Charles Baudelaire*, trans. and ed.

Jonathan Mayne (London: Phaidon, 1965), 47.

10. Gustave Kahn, "Response of the Symbolists" (1886), in *Art in Theory 1815–1900: An Anthology of Changing Ideas*, ed. Charles Harrison and Paul Wood with Jason Gaiger (Oxford: Blackwell, 1998), 1017. Italics in the original.

11. Odilon Redon, "Suggestive Art" (c. 1898), in Harrison, Wood, and Gaiger, *Art in Theory 1815–1900*, 1065.

12. For this and the following see Barbara Larson, *The Dark Side of Nature: Science, Society, and the Fantastic in the Work of Odilon Redon* (University Park: Pennsylvania State University Press, 2005), 114–15.

13. Paul Gauguin, letter to Émile Schuffenecker, August 14, 1888, in *Gauguin by Himself*, ed. Belinda Thomson (Boston: Little, Brown, 1993), 89.

14. The critic G.-Albert Aurier singled out *Vision After the Sermon* for attention in his important article "Symbolism in Painting: Paul Gauguin," *Mercure de France*, March 1891, reprinted in *Gauguin: A Retrospective*, ed. Marla Prather and Charles F. Stuckey (New York: Hugh Lauter Levin Associates, 1987), 150–56.

15. Paul Gauguin to Mette Gauguin, February 1890, in *Paul Gauguin: Letters to his Wife and Friends*, ed. Maurice Malingue, trans. Henry J. Stenning (London: Saturn Press, 1946), 137.

16. Paul Gauguin, letter to Charles Morice, July 1901, quoted in Henri Dorra, *The Symbolism of Paul Gauguin: Erotica, Exotica, and the Great Dilemmas of*

Humanity (Berkeley: University of California Press, 2007), 253.

17. Gauguin, letter to Daniel Monfried, February 1898, quoted in Dorra, *Symbolism of Paul Gauguin*, 253.

18. Gauguin, letter to Monfried, in Dorra, *Symbolism of Paul Gauguin*, 253.

19. Gauguin, letter to Monfried, in Dorra, *Symbolism of Paul Gauguin*, 253.

20. Gauguin, letter to Morice, in Dorra, *Symbolism of Paul Gauguin*, 253.

21. Gauguin, letter to Monfried, in Dorra, *Symbolism of Paul Gauguin*, 254.

22. Willem A. Nolen, Erwin van Meekeren, Piet Voskuil and Willem van Tilburg, "New Vision on the Mental Problems of Vincent van Gogh; Results from a Bottom-up Approach using (Semi-) structured Diagnostic Interviews," *International Journal of Bipolar Disorders* 8, no. 30 (2020), https://doi.org/10.1186/s40345-020-00196-z.

23. See Martin Bailey, "Did Van Gogh Cut off his Whole Ear, or Only a Part?," *The Art Newspaper*, April 17, 2020, https://www.theartnewspaper.com/2020/04/17/did-van-gogh-cut-off-his-whole-ear-or-only-a-part. For the theory that Gauguin was responsible for mutilating van Gogh's ear, see Hans Kaufmann and Rita Wildegans, *Van Goghs Ohr—Paul Gauguin und der Pakt des Schweigens* (Berlin: Osburg, 2008). The authors offer an English summary of their findings and argument on their website, https://vangoghsear.com/.

24. Van Gogh scholars have discounted the theory that someone else shot Van Gogh, as proposed in Steven Naifeh and Gregory White Smith's 2011 biography, *Van Gogh*, and dramatized in the films *Loving Vincent* (2017) and *At Eternity's Gate* (2018). See Martin Bailey, "Van Gogh's Suicide: Ten Reasons Why the Murder Story is a Myth," *The Art Newspaper*, September 6, 2019, https://www.theartnewspaper.com/2019/09/06/van-goghs-suicide-ten-reasons-why-the-murder-story-is-a-myth.

25. Vincent van Gogh, letter to Theo van Gogh, September 10, 1889, "Vincent van Gogh: The Letters," Van Gogh Museum, http://vangoghletters.org/vg/letters/let801/letter.html.

26. Vincent van Gogh, letter to Theo van Gogh, August 18, 1888, http://vangoghletters.org/vg/letters/let663/letter.html.

27. Vincent van Gogh, letter to Theo van Gogh, September 8, 1888, http://vangoghletters.org/vg/letters/let676/letter.html.

28. Vincent van Gogh, letter to Theo van Gogh, September 9, 1888, http://vangoghletters.org/vg/letters/let677/letter.html.

29. See Albert Boime, "Van Gogh's *Starry Night*: A History of Matter and a Matter of History," *Arts Magazine* 59, no. 4 (December 1984): 86–103.

30. Richard Thomson, *Vincent Van Gogh: The Starry Night* (New York: Museum of Modern Art, 2008), 28. The quotation is from

Vincent van Gogh, letter to Theo van Gogh, August 18, 1888, http://van-goghletters.org/vg/letters/let663/letter.html.

31. Munch first described this episode in a diary entry of January 22, 1892. The text given here is an English translation of the Norwegian inscription that Munch wrote c. 1895 on the reverse of a lithograph of *The Scream*, reprinted in Reinhold Heller, *Edvard Munch: The Scream* (New York: Viking, 1973), 107. Munch could have witnessed a blood-red sky in Norway in late 1883 or early 1884 as sunsets and sunrises around the world were turned red by dust and gasses emitted into the atmosphere by the August 27, 1883 eruption of the volcanic island of Krakatoa in Indonesia. See Sky and Telescope, "Astronomical Sleuths Link Krakatoa to Edvard Munch's Painting *The Scream*," press release, December 9, 2003, https://skyandtelescope.org/press-releases/astronomical-sleuths-link-krakatoa-to-edvard-munchs-painting-the-scream/.

32. Patricia G. Berman, *James Ensor: Christ's Entry into Brussels in 1889* (Los Angeles: Getty Publications, 2002), 52.

33. This reading of the *Gates of Hell* follows Albert Elsen, *Rodin* (New York: Museum of Modern Art, 1963), 43–48.

34. *Rodin on Art*, translated from the French of Paul Gsell by Romilly Fedden (New York: Horizon, 1971), 88, 89.

35. Rodin in an article signed by "X," *Journal* (Paris),

May 12, 1898, quoted in Elsen, *Rodin*, 103.

36. Denis, "Définition du néo-traditionnisme," *Art et Critique*, August 1890, reprinted in Denis, *Théories*, 4th ed., 1.

Chapter 3

1. Henri Matisse, "Notes of a Painter" (1908), in Jack D. Flam, *Matisse on Art*, rev. ed. (Berkeley: University of California Press, 1995), 38.

2. Louis Vauxcelles, "Salon d'Automne," *Gil Blas*, October 17, 1905, quoted in John Elderfield, *The "Wild Beasts": Fauvism and Its Affinities* (New York: Museum of Modern Art, 1976), 43.

3. André Derain quoted in Denys Sutton, *André Derain* (London: Phaidon, 1959), 20–21.

4. This painting was originally exhibited as *Le Bonheur de vivre* (the happiness of living) but Matisse subsequently often called it *La Joie de vivre* (the joy of living) and it is routinely referred to in English as *The Joy of Life*. See Jack Flam, "Henri Matisse: *Le Bonheur de vivre (The Joy of Life)*," in *Great French Paintings from the Barnes Foundation: Impressionist, Post-Impressionist, and Early Modern* (New York: Alfred A. Knopf in association with Lincoln University Press, 1993), 306-7n1.

5. Paul Signac, letter to Charles Angrand, January 14, 1906, quoted in Flam, "Henri Matisse: *Le Bonheur de vivre*," 233.

6. Henri Matisse, unpublished 1941 interview by Pierre Courthion, quoted in Jack D. Flam,

"Matisse and the Fauves," in *"Primitivism" in 20th Century Art: Affinity of the Tribal and the Modern*, ed. William Rubin (New York: Museum of Modern Art, 1984), 1: 216.

7. Matisse, "Notes of a Painter," in Flam, *Matisse on Art*, rev. ed., 42.

8. Henri Matisse, "Statement to Tériade: On Fauvism and Color" (1929), in Flam, *Matisse on Art*, rev. ed., 85.

9. Gill Perry, *Women Artists and the Parisian Avant-Garde: Modernism and "Feminine" Art, 1900 to the Late 1920s* (Manchester, UK: Manchester University Press, 1995), 55.

10. André Gide, "Promenade au Salon d'Automne," *Gazette des Beaux-Arts* 34 (December 1, 1905): 476.

11. Wendy Slatkin, *Women Artists in History: From Antiquity to the Present*, 4th ed. (Upper Saddle River, NJ: Prentice Hall, 2001), 180.

12. Käthe Kollwitz, *Die Tagebücher*, ed. Jutta Bohnke-Kollwitz (Berlin, 1989), quoted in Elizabeth Prelinger, "Kollwitz Reconsidered," in Prelinger, *Käthe Kollwitz* (Washington, DC: National Gallery of Art in association with Yale University Press, 1992), 76.

13. This overview of the Brücke artists' group follows Reinhold Heller, "Brücke in Dresden and Berlin, 1905–1913," in *Brücke: The Birth of Expressionism in Dresden and Berlin, 1905–1913* (New York: Neue Galerie, Museum for German and Austrian Art; Ostfildern, Germany: Hatje Cantz, 2009), 12–57.

14. Nietzsche, *Thus Spoke Zarathustra*, part I, section 3, quoted in Heller, "Brücke in Dresden and Berlin," 14.

15. *Brücke Program*, quoted in Heller, "Brücke in Dresden and Berlin," 15.

16. Deborah Wye, *Kirchner and the Berlin Street* (New York: Museum of Modern Art, 2008), 76.

17. This reading follows Heller, "Brücke in Dresden and Berlin," 37.

18. Ernst Barlach quoted in Alfred Werner, *Ernst Barlach* (New York: McGraw-Hill, 1966), 13.

19. Barlach quoted in Stephanie Barron's introduction to *German Expressionist Sculpture* (Los Angeles: Los Angeles County Museum of Art in association with University of Chicago Press, 1984), 19.

20. Wassily Kandinsky, "Whither the 'New' Art?" (1911), in *Kandinsky: Complete Writings on Art, Volume One (1901–1921)*, ed. Kenneth C. Lindsay and Peter Vergo (Boston: G. K. Hall, 1982), 103.

21. Wassily Kandinsky and Franz Marc, typescript preface to "Almanac: *Der Blaue Reiter*" (1911), in *The Blaue Reiter Almanac*, ed. Kandinsky and Marc, new documentary edition, ed. Klaus Lankheit (New York: Viking, 1974), 250.

22. Kandinsky, *On the Spiritual in Art, and Painting in Particular*, 2nd ed. (Munich: R. Piper, 1912), in *Kandinsky: Complete Writings on Art, Volume One*, 218.

23. My discussion follows Barnaby Wright's catalogue entry in *Gabriele Münter: The Search for Expression*

1906–1917 (London: Courtauld Institute of Art Gallery in association with Paul Holberton Publishing, 2005), 90–91.

24. Franz Marc, letter to August Macke, December 1910, quoted in Armin Zweite and Annegret Hoberg, *The Blue Rider in the Lenbachhaus, Munich* (Munich: Prestel, 1989), 66. Italics in the original.

25. Paul Klee, *The Diaries of Paul Klee 1898–1918*, ed. Felix Klee (Berkeley: University of California Press, 1964), no. 873, p. 244.

26. Oskar Kokoschka, *My Life* (London: Thames & Hudson, 1974), 33.

27. Albert Ehrenstein, 1925, quoted in Beatrice von Bormann, "'Expressionism, on the Other Hand Depicts Life as People Experience It': Kokoschka as Rebel and Humanist," in *Oskar Kokoschka: Portraits of People and Animals* (Rotterdam: Museum Boijmans van Beuningen, 2013), 16.

Chapter 4

1. Patricia Leighten, *The Liberation of Painting: Modernism and Anarchism in Avant-Guerre Paris* (Chicago: University of Chicago Press, 2013), 13.

2. Picasso from a 1937 conversation with André Malraux, in Malraux, *La Tête d'obsidienne* (Paris: Gallimard, 1974), reprinted in *Primitivism and Twentieth Century Art: A Documentary History*, ed. Jack Flam and Miriam Deutch (Berkeley: University of California Press, 2003), 33.

3. See Daniel-Henry Kahnweiler, *The Rise of Cubism* (New York: Wittenborn, Schultz, 1949), 7. This is the first English translation of *Der Weg zum Kubismus* (Munich, 1920), written in 1915.

4. William Rubin, *Picasso in the Collection of the Museum of Modern Art* (New York: Museum of Modern Art, 1972), 42.

5. As reported by Kahnweiler, *Rise of Cubism*, 7.

6. Louis Vauxcelles, "Exposition Braque. Chez Kahnweiler, 28 rue Vignon," *Gil Blas*, November 14, 1908, trans. and reprinted in *A Cubism Reader: Documents and Criticism, 1906–1914*, ed. Mark Antliff and Patricia Leighten (Chicago: University of Chicago Press, 2008), 48. Vauxcelles evidently picked up the reference to cubes from Matisse, a member of the Salon d'Automne jury who in rejecting Braque's submitted paintings referred to them as containing "little cubes."

7. Jacques Lassaigne, "Un entretien avec Georges Braque," *XXe Siecle*, December 1973 (interview conducted in 1961), quoted in Karen Wilkin, *Georges Braque* (New York: Abbeville Press, 1991), 34.

8. Dora Vallier, "Braque, la peinture et nous. Propos de l'artiste recueillis," *Cahiers d'art* 29, no. 1 (October 1954): 14.

9. According to art historian Neil Cox, the application of "analytic" and "synthetic" to different forms of Cubism derives from Immanuel Kant's use of those terms in his *Critique of Pure Reason* (1781). Critic Roger Allard was among the first to use "analytic" and "synthetic" in discussing Cubism in 1910. The terms were systematized in Daniel-Henry Kahnweiler's and Juan Gris's writings between 1915 and 1921 and became entrenched in art history through their use by Alfred Barr in his 1936 MoMA exhibition and catalogue, *Cubism and Abstract Art*. Neil Cox, *Cubism* (London: Phaidon, 2000), 426.

10. Braque in Vallier, "Braque, la peinture et nous," 16.

11. Braque in Vallier, "Braque, la peinture et nous," 16. Italics in the original.

12. See Bernice B. Rose, *Picasso, Braque and Early Film in Cubism* (New York: Pace Wildenstein, 2007).

13. Robert Rosenblum, *Cubism and Twentieth-Century Art,* rev. ed. (New York: Harry N. Abrams, 1976), 65.

14. Yve-Alain Bois, "The Semiology of Cubism," in *Picasso and Braque: A Symposium*, ed. Lynn Zelevansky (New York: Museum of Modern Art, 1992), 188.

15. My discussion of this work follows Rosenblum, *Cubism and Twentieth-Century Art*, 68.

16. Raymond Duchamp-Villon in a letter to Walter Pach, quoted in Pach, *Queer Thing, Painting: Forty Years in the World of Art* (New York: Harper & Brothers, 1938), 145.

17. My discussion of Laurencin's painting follows Elizabeth Otto, "Memories of Bilitis: Marie Laurencin beyond the Cubist Context," *Genders*, August 1, 2002, https://www.colorado.edu/gendersarchive1998-2013/2002/08/01/memories-bilitis-marie-laurencin-beyond-cubist-context.

18. Mark Rosenthal, *Juan Gris* (Berkeley: University Art Museum, University of California, Berkeley; New York: Abbeville, 1983), 70.

19. Rosenblum, *Cubism and Twentieth-Century Art*, 133.

20. Paul Cézanne, letter to Emile Bernard, April 15, 1904, in John Rewald, ed., *Paul Cézanne Letters*, 4th ed., trans. Marguerite Kay (New York: Hacker Art Books, 1976), 301.

21. Fernand Léger, "The Origins of Painting and its Representational Value" (1913), in Léger, *Functions of Painting*, trans. Alexa Anderson, ed. Edward F. Fry (New York: Viking, 1973), 7.

22. Léger, "Contemporary Achievements in Painting" (1914), in *Functions of Painting*, 12.

23. F. T. Marinetti, "Manifesto of Futurism," *Le Figaro*, February 20, 1909.

24. Marinetti, "Manifesto of Futurism."

25. Lucia Re, "Futurism and Feminism," *Annali d'Italianistica* 7 (1989): 254.

26. Umberto Boccioni, Carlo Carrà, Luigi Russolo, Giacomo Balla, and Gino Severini, "Futurist Painting: Technical Manifesto" (1910), in *Futurist Manifestos*, ed. Umbro Apollonio (London: Thames & Hudson, 1973), 27–28.

27. Boccioni et al., "Futurist Painting," 28.

28. Umberto Boccioni, Carlo Carrà, Luigi Russolo, Giacomo Balla, and Gino Severini, "The Exhibitors to the Public" (1912), in Apollonio, *Futurist Manifestos*, 46.

29. Boccioni et al., "Exhibitors to the Public," 46.

30. Anton Giulio Bragaglia, "Futurist Photodynamism" (1911), in Apollonio, *Futurist Manifestos*, 45.

31. Anne Coffin Hanson, *Severini Futurista: 1912–1917* (New Haven, CT: Yale University Art Gallery, 1995), 72.

32. Umberto Boccioni, "Technical Manifesto of Futurist Sculpture" (1912), in Apollonio, *Futurist Manifestos*, 62.

33. Boccioni, "Technical Manifesto of Futurist Sculpture," 63. These words are printed all in capitals in the original text.

34. Boccioni, "Technical Manifesto of Futurist Sculpture," 65.

35. Antonio Sant'Elia, "Manifesto of Futurist Architecture" (1914), in Apollonio, *Futurist Manifestos*, 170.

36. Sant'Elia, "Manifesto of Futurist Architecture," 170.

37. Richard Humphreys, *Futurism* (Cambridge: Cambridge University Press, 1999), 48.

38. Richard Aldington, Malcolm Arbuthnot, Lawrence Atkinson, Henri Gaudier-Brzeska, Jessica Dismorr, Cuthbert Hamilton, Ezra Pound, William Roberts, Helen Saunders, Edward Wadsworth, and Wyndham Lewis, "Manifesto," *Blast* 1 (June 14, 1914): 39.

39. Aldington et al., "Manifesto," 40.

40. Wyndham Lewis, "A Review of Contemporary Art," *Blast* 2 (July 1915): 42.

41. Lewis, "Review of Contemporary Art," 43.

Chapter 5

1. *Le Temps*, February 14, 1887, quoted in Roger Célestin and Eliane DalMolin, *France from 1851 to the Present: Universalism in Crisis* (New York: Palgrave Macmillan, 2007), 113.

2. William Morris, "The Beauty of Life," in *Hopes and Fears for Art: Five Lectures Delivered in Birmingham, London, and Nottingham, 1878–1881*, 5th ed. (London: Longmans, Green, 1898), 113. Italics in the original.

3. Marvin Trachtenberg and Isabelle Hyman, *Architecture: From Prehistory to Postmodernity*, 2nd ed. (Upper Saddle River, NJ: Prentice-Hall; New York: Harry N. Abrams, 2002), 469.

4. Michael Fazio, Marian Moffett, and Lawrence Wodehouse, *Buildings across Time: An Introduction to World Architecture*, 4th ed. (Boston: McGraw-Hill Education, 2014), 425.

5. Otto Wagner, *Moderne Architektur* (Vienna, 1896), 37, quoted in Nikolaus Pevsner, *Pioneers of Modern Design: From William Morris to Walter Gropius*, 4th ed. (New Haven, CT: Yale University Press, 2005), 21.

6. Wagner, *Moderne Architektur*, 41, quoted in Pevsner, *Pioneers*, 21.

7. Wagner, *Die Baukunst Unserer Zeit* (*Moderne Architektur*, 4th ed.) (Vienna: Schroll, 1914), 136, quoted in Iain Boyd White, "The Architecture of Futurism," in *International Futurism in Arts and Literature*, ed. Günter Berghaus (Berlin: Walter de Gruyter, 2000), 364.

8. Joseph Maria Olbrich, "Das Haus der Secession," *Der Architekt* V (1899): 5, quoted in Ian Latham, *Joseph Maria Olbrich* (New York: Rizzoli, 1980), 18.

9. Josef Hoffmann and Koloman Moser, "Das Arbeitsprogramm der Wiener Werkstätte," *Hohe Warte* 1 (1904–05): 263, quoted in Francesco Borsi and Ezio Godoli, *Vienna 1900: Architecture and Design*, trans. Marie-Hélène Agüeros (New York: Rizzoli, 1986), 136.

10. Panayotis Tournikiotis, *Adolf Loos* (New York: Princeton Architectural Press, 1994), 78.

11. H. H. Richardson quoted in *Chicago Tribune*, October 25, 1885, quoted in James F. O'Gorman, "The Marshall Field Wholesale Store: Materials toward a Monograph," *Journal of the Society of Architectural Historians* 37, no. 3 (October 1978): 178.

12. Louis H. Sullivan, "Kindergarten Chats," in *Kindergarten Chats (revised 1918) and Other Writings* (New York: Wittenborn, Schultz, 1947), 30.

13. Sullivan, "The Tall Office Building Artistically Considered" (1896), in *Kindergarten Chats*, 205.

14. Sullivan "The Tall Office Building," 203.

15. Sullivan, "The Tall Office Building," 206.

16. Michael Mostoller, "Louis Sullivan's Ornament," *Artforum* 16, no. 2 (October 1977): 44.

17. Louis H. Sullivan, *The Autobiography of an Idea* (New York: Dover, 1956 [1924]), 325.

18. Sullivan, *Autobiography of an Idea*, 325.

19. Spiro Kostof, *A History of Architecture: Settings and Rituals* (New York: Oxford University Press, 1985), 685.

20. Frank Lloyd Wright, "In the Cause of Architecture" (1908), in *The Essential Frank Lloyd Wright: Critical Writings on Architecture*, ed. Bruce Brooks Pfeiffer (Princeton, NJ: Princeton University Press, 2008), 35.

21. For Wright's characterization of the traditional room as a "box," see Frank Lloyd Wright, *An Autobiography* (New York: Duell, Sloan and Pearce, 1943), 141–42.

22. Fazio, Moffett, and Wodehouse, *Buildings Across Time*, 4th ed., 463.

23. Frank Lloyd Wright, "The New Larkin Administration Building" (1906), quoted in Neil Levine, *The Architecture of Frank Lloyd Wright* (Princeton, NJ: Princeton University Press, 1996), 38.

24. Richard Ingersoll, *World Architecture: A Cross-Cultural History*, 2nd ed. (New York: Oxford University Press, 2019), 758.

25. Frank Lloyd Wright, "Recollections: United States, 1893–1920," *Architects' Journal* 84 (July 30, 1936): 142, quoted in Levine, *Architecture of Frank Lloyd Wright*, 40.

Chapter 6

1. Mikhail Larionov, "Rayist Painting" (1913), in *Russian Art of the Avant-Garde: Theory and Criticism*, new ed., ed. and trans. John E. Bowlt (New York: Thames & Hudson, 2017), 93.

2. Larionov, "Rayist Painting," 96.

3. Jane A. Sharp, "Natalia Goncharova," in *Amazons*

of the Avant-Garde: Alexandra Exter, Natalia Goncharova, Liubov Popova, Olga Rozanova, Varvara Stepanova, and Nadezhda Udaltsova*, ed. John E. Bowlt and Matthew Drutt (New York: Guggenheim Museum Publications, 2000), 162.

4. I am grateful to my colleagues Maria Carlson and Vitaly Chernetsky for their identification and translations of the fragments of Russian words in Popova's painting.

5. Aleksei Kruchenykh, "New Ways of the Word" (1913), quoted in Christina Lodder, "The Transrational in Painting: Kazimir Malevich, Alogism, and *Zaum*," *Forum for Modern Language Studies* 32, no. 2 (April 1996): 121.

6. Kazimir Malevich, "From Cubism and Futurism to Suprematism: The New Painterly Realism" (1915), in Bowlt, *Russian Art of the Avant-Garde*, new ed., 133.

7. Malevich, "From Cubism and Futurism to Suprematism," 134.

8. Malevich, *The Non-Objective World* (Chicago: Paul Theobald, 1959), 67. This is the first English edition of Malevich's book, originally written in Russian and published in a German translation in 1927.

9. Malevich, *Non-Objective World*, 76.

10. Although given as "void" in the 1959 English edition, the 1927 German edition of Malevich's text uses the word "Nichts," better translated as "nothingness." See Denise McColgan, "Kazimir Malevich," in Mark Rosenthal, *Abstraction in the Twentieth Century: Total Risk, Freedom, Discipline* (New York: Guggenheim Museum Publications, 1996), 269.

11. Malevich, letter to Mikhail Matiushin, before June 23, 1916, in *Kazimir Malevich: Letters, Documents, Memoirs, Criticism*, ed. and comp. Irina A. Vakar and Tatiana N. Mikhienko (London: Tate Publishing, 2015): 1:89.

12. Alison Hilton, *Kazimir Malevich* (New York: Rizzoli, 1992), n.p.

13. Several different possible origins have been proposed for Proun. It could be a contraction of the Russian "proekt unovisa," meaning "architectonic design of Unovis"; the "pro" in Proun could be the Latin "for," yielding "for Un[ovis]"; or Proun could stand for "proekt utverzhdenya novogo," meaning "design for the confirmation of the new." Henk Puts, "El Lissitzky (1890–1941), His Life and Work," in *El Lissitzky 1890–1941: Architect, Painter, Photographer, Typographer* (Eindhoven, Netherlands: Municipal Van Abbemuseum, 1990), 17.

14. El Lissitzky and Hans Arp, *Die Kunstismen* (1925), quoted in George Heard Hamilton, *Painting and Sculpture in Europe 1880–1940*, 6th ed. (New Haven, CT: Yale University Press, 1993), 317.

15. See Isabel Tejada Martín, "El Lissitzky and his German Exhibition Projects," in *El Lissitzky: The Experience of Totality* (Madrid: La Fábrica, 2014), 141–51.

16. Tatlin's drawings show these volumes as a cube at the base, surmounted by a right-angled pyramid, a cylinder, and a hemisphere. In the physical model, a cylinder replaced the cube.

17. "Program of the Constructivist Working Group of INKhUK" (1921), in *Art into Life: Russian Constructivism 1914–1932* (Seattle: Henry Art Gallery, University of Washington, 1990), 67.

18. Hal Foster, Rosalind Krauss, Yve-Alain Bois, Benjamin H. D. Buchloh, and David Joselit, *Art Since 1900: Modernism, Anti-Modernism, Post-Modernism*, 3rd ed. (New York: Thames & Hudson, 2016), 1:202.

19. Varst (Varvara Stepanova), "Present Day Dress—Production Clothing" (1923), in Radu Stern, *Against Fashion: Clothing in Art, 1850–1930* (Cambridge, MA: MIT Press, 2004), 173.

20. Naum Gabo and Anton Pevsner, "The Realistic Manifesto" (1920), in Bowlt, *Russian Art of the Avant-Garde*, new ed., 208–14.

21. Gabo and Pevsner, "Realistic Manifesto," 212.

22. Gabo and Pevsner, "Realistic Manifesto," 212.

23. Gabo and Pevsner, "Realistic Manifesto," 213.

24. Martin Hammer and Christina Lodder, *Constructing Modernity: The Art and Career of Naum Gabo* (New Haven, CT: Yale University Press, 2001), 95.

25. Naum Gabo, "Russia and Constructivism" (1956), interview with Gabo by Ibram Lassaw and Ilya Bolotowsky, quoted in Hammer and Lodder, *Constructing Modernity*, 96.

26. Paul Overy, *De Stijl* (New York: Thames & Hudson, 1991), 8.

27. Piet Mondrian, "Pure Art and Pure Plastic Art" (1936), in *The New Art—The New Life: The Collected Writings of Piet Mondrian*, ed. and trans. Harry Holtzman and Martin S. James (Boston: G. K. Hall, 1986), 299.

28. Mondrian, "Pure Art and Pure Plastic Art," 299.

29. Mondrian, "Pure Art and Pure Plastic Art," 300.

30. Mondrian, "Toward the True Vision of Reality" (1941), in *Collected Writings*, 338.

31. Mondrian, "Neo-Plasticism: The General Principle of Plastic Equivalence" (1920), in *Collected Writings*, 137.

32. See Mondrian, "The True Value of Oppositions in Life and Art" (1934), in *Collected Writings*, 283–85.

33. Theo van Doesburg, "Notes on Monumental Art with Reference to Two Fragments of a Building (Hall in Holiday Center at Noordwijkerhout)" (1918), in Hans L. C. Jaffé, *De Stijl* (London: Thames & Hudson, 1970), 99.

34. Walter Gropius, "From the First Proclamation of the Weimar Bauhaus" (1919), in *Bauhaus 1919–1929*, ed. Herbert Bayer, Walter Gropius, and Ise Gropius (New York: Museum of Modern Art, 1938), 18.

35. Paul Klee quoted in Werner Haftmann, *The Mind and Work of Paul Klee* (New York: Praeger, 1954), 115.

36. Paul Klee, *The Thinking Eye: The Notebooks*

of *Paul Klee*, ed. Jürg Spiller (London: Lund Humphries; New York, George Wittenborn, 1961), 1: 264.

37. Wassily Kandinsky, *Point and Line to Plane*, ed. Hilla Rebay (New York: Solomon R. Guggenheim Foundation, 1947), 92.

38. Anna Rowland, *Bauhaus Source Book* (New York: Van Nostrand Reinhold, 1990), 36.

39. My discussion follows T'ai Smith, "Gunta Stölzl: 5 Choirs. 1928," in Berry Bergdoll and Leah Dickerman, *Bauhaus 1919–1933: Workshops for Modernity* (New York: Museum of Modern Art, 2009), 206–09.

Chapter 7

1. Leah Dickerman, "Introduction," in Dickerman *Dada: Zurich, Berlin, Hannover, Cologne, New York, Paris* (Washington, DC: National Gallery of Art and D.A.P./Distributed Art Publishers, New York, 2005), 7–8.

2. Dickerman, "Introduction," 8.

3. John Keegan, *The First World War* (New York: Alfred A. Knopf, 1999), 3.

4. Paul Valéry, "The Crisis of the Mind" (1919), in Valéry, *History and Politics*, trans. Denise Folliot and Jackson Mathews (New York: Bollingen, 1962), 26.

5. Hugo Ball, "Dada Manifesto" (1916), reprinted in *Flight Out of Time: A Dada Diary*, ed. John Elderfield, trans. Ann Raimes (Berkeley: University of California Press, 1996), 220.

6. Richard Huelsenbeck, *En Avant Dada: A History of Dadaism* (1920), trans.

Ralph Manheim, in *The Dada Painters and Poets: An Anthology*, rev. ed., ed. Robert Motherwell (Boston: G. K. Hall, 1981), 24.

7. Ball, *Flight Out of Time*, 63.

8. Tristan Tzara, "Dada Manifesto" (1918), in Motherwell, *Dada Painters and Poets*, 77.

9. This is how Ball describes the costume in *Flight Out of Time*, 70.

10. Richard Huelsenbeck, "Dada Lives!" (1936), in Motherwell, *Dada Painters and Poets*, 280.

11. Ball, *Flight Out of Time*, 71.

12. Jean Arp, "Dadaland" (c. 1938), in Arp, *Arp on Arp: Poems, Essays, Memories*, ed. Marcel Jean, trans. Joachim Neugroschel (New York: Viking Press, 1972), 232.

13. He was born Hans Arp in Alsace-Lorrain, which was then part of Germany, having been ceded to that country by France after the 1870–71 Franco-Prussian War. Germany returned Alsace-Lorrain to France in 1919. Arp was fluent in German and French and alternately went by Hans and Jean depending on which language he was using. He officially changed his name to Jean in 1939.

14. Arp, "And So the Circle Closed" (c. 1946), in *Arp on Arp*, 246.

15. Arp, "I Became More and More Removed from Aesthetics" (c. 1947), in *Arp on Arp*, 238.

16. Arp, "Signposts" (1950), in *Arp on Arp*, 271.

17. Dickerman, "Zurich," in Dickerman, *Dada*, 39.

18. Marcel Duchamp, "Painting … at the service of the mind" (1946), from an interview with James Johnson Sweeney, in "Eleven Europeans in America," *Bulletin of the Museum of Modern Art*, 13, nos. 4–5 (1946): 19–21, reprinted in Herschel B. Chipp, *Theories of Modern Art: A Sourcebook by Artists and Critics* (Berkeley: University of California Press, 1968), 394.

19. Marcel Duchamp, note of 1913 in *À L'infinitif (The White Box)* (New York: Cordier and Ekstrom, 1966), reprinted in *The Essential Writings of Marcel Duchamp*, ed. Michael Sanouillet and Elmer Peterson (London: Thames & Hudson, 1975), 74.

20. "The Richard Mutt Case," *The Blind Man*, no. 2 (May 1917), reprinted in Calvin Tomkins, *Duchamp: A Biography* (New York: Henry Holt, 1996), 185. Of uncertain authorship, this text may have been collaboratively written by the magazine's editors, Duchamp, Henri-Pierre Roché, and Beatrice Wood.

21. See David M. Lubin, "Opening the Floodgates," chap. 5 in *Grand Illusions: American Art and the First World War* (New York: Oxford University Press, 2016).

22. Duchamp, note of 1913 in *The Bride Stripped Bare by Her Bachelors, Even (The Green Box)* (Paris: Editions Rrose Sélavy, 1934), reprinted in *Essential Writings of Marcel Duchamp*, 68.

23. Francis Picabia quoted in "French Artists Spur on American Art," *New York Tribune*, October 24, 1915, quoted in William A. Camfield, "The Machinist Style of Francis Picabia," *Art Bulletin* 48, nos. 3–4 (September-December 1966): 309.

24. Huelsenbeck, *En Avant Dada*, quoting from his "Dadaist Manifesto" (1918), in Motherwell, *Dada Painters and Poets*, 40.

25. Raoul Hausmann, French text first published in *Rétrospective Raoul Hausmann* (Stockholm: Moderna Museet, 1967), quoted in *Raoul Hausmann, autour de L'Esprit de notre temps* (Paris: Musée National d'Art Moderne, 1974), n.p.

26. Kurt Schwitters, "Daten aus meinem Leben" (1926), quoted in John Elderfield, *Kurt Schwitters* (London: Thames & Hudson, 1985), 12.

27. Schwitters, "Die Merzmalerei" (Merz painting), *Der Sturm*, July 1919, quoted in Elderfield, *Kurt Schwitters*, 50.

28. Max Ernst, "An Informal Life of M. E. (As Told by Himself to a Young Friend)," in *Max Ernst*, ed. William S. Lieberman (New York: Museum of Modern Art, 1961), 11.

29. André Breton, "Max Ernst" (1920), in Ernst, *Beyond Painting* (New York: Wittenborn, Schulz, 1948), 177.

30. George Grosz, notes made in 1930, quoted in Ralph Jentsch, *George Grosz: Berlin-New York* (Milan: Skira, 2008), 83.

31. Otto Dix quoted in Hans Kinkel, "Der Unerbittliche: Zum siebzigsten Geburtstag des Malers Otto Dix," *Stuttgarter Zeitung*, December 1,

1961, quoted in Reinhold Heller, "Dix, (Wilhelm Heinrich) Otto," *Grove Art Online*, 2003, https://www-oxfordartonline-com.www2.lib.ku.edu/groveart/view/10.1093/gao/9781884446054.001.0001/oao-9781884446054-e-7000022978.

32. Sylvia von Harden, "Erinnerungen an Otto Dix," *Frankfurter Rundschau*, March 25, 1959, quoted in Sabine Rewald, *Glitter and Doom: German Portraits from the 1920s* (New York: Metropolitan Museum of Art; New Haven, CT: Yale University Press, 2007), 134. My discussion of Dix's painting follows Rewald, 134–37.

33. August Sander, statement of 1925, quoted in *August Sander*, ed. Manfred Heiting (Cologne: Taschen, 1999), 51.

34. Max Beckmann quoted in Lothar-Günther Buchheim, *Max Beckmann* (Feldafing, West Germany: Buchheim, 1959), quoted in Peter Selz, *Max Beckmann* (New York: Abbeville, 1996), 52.

35. Beckmann, letter to Curt Valentin, February 11, 1938, quoted in Selz, *Max Beckmann*, 53.

Chapter 8

1. André Breton, "Manifesto of Surrealism" (1924), in Breton, *Manifestoes of Surrealism*, trans. Richard Seaver and Helen R. Lane (Ann Arbor: University of Michigan Press, 1972), 14.

2. Fiona Bradley, *Surrealism* (Cambridge: Cambridge University Press; Tate Gallery Publishing, 1997), 9.

3. Breton, "Manifesto of Surrealism," 26.

4. Breton, "Manifesto of Surrealism," 27.

5. Henri Rousseau, letter of April 1, 1910 to André Dupont, published in *Les Soirées de Paris*, January 15, 1914, quoted in *Henri Rousseau* (New York: Museum of Modern Art, 1984), 250.

6. Giorgio de Chirico, "Manoscritti Eluard," in *Giorgio de Chirico Scritti/I: Romanzi e Scritti critici e teorici 1911–1945*, ed. Andrea Cortellessa (Milan: Classici Bompiani, 2008), 612.

7. Friedrich Nietzsche, *The Birth of Tragedy from the Spirit of Music* (1872), *Writings of Nietzsche*, ed. Anthony Uyl (Woodstock, ON: Devoted, 2016), 2:21.

8. André Breton, *Surrealism and Painting* (1928), trans. Simon Watson Taylor (New York: Icon Editions, Harper & Row, 1972), 36.

9. Marko Daniel and Matthew Gale, "The Tipping Point: 1934–9," in *Joan Miró: The Ladder of Escape*, ed. Daniel and Gale (London: Tate Publishing, 2011), 74.

10. Joan Miró, interview with Georges Duthuit, 1936, in Herschel B. Chipp, *Theories of Modern Art: A Source Book by Artists and Critics* (Berkeley: University of California Press, 1968), 434.

11. Max Ernst, *Beyond Painting* (New York: Wittenborn, Schultz, 1948), 28. Italics in the original.

12. Ernst quoted in *Max Ernst: A Retrospective* (New York: Solomon R. Guggenheim Museum, 1975), 44.

13. Matta quoted in Germana Ferrari, *Entretiens Morphologiques, Notebook No. 1, 1936–1944* (London: Sistan, 1987), 72, quoted in Elizabeth A. T. Smith and Colette Dartnall, "Crushed Jewels, Air, Even Laughter: Matta in the 1940s," in *Matta in America: Paintings and Drawings of the 1940s* (Chicago: Museum of Contemporary Art, Chicago; Los Angeles: Museum of Contemporary Art, Los Angeles, 2001), 13.

14. André Breton, "The Most Recent Tendencies in Surrealist Painting" (1939), in Breton, *Surrealism and Painting*, 147–48.

15. Salvador Dalí, "The Conquest of the Irrational" (1935), in *The Collected Writings of Salvador Dalí*, ed. and trans. Haim Finkelstein (Cambridge: Cambridge University Press, 1998), 265. Numerous popular sources quote Dalí as referring to his images as "hand painted dream photographs," but I have not found this phrase in the primary Dalí literature.

16. Dalí, "The Rotting Donkey (L'Âne pourri)" (1930), in *Collected Writings*, 223.

17. Dalí quoted in Simon Wilson, "Salvador Dalí," in *Salvador Dalí* (London: Tate Gallery, 1980), 11. Per Wilson, Dalí made this remark at the opening of his 1934 exhibition at the Wadsworth Atheneum in Hartford, Connecticut.

18. Dalí, *The Secret Life of Salvador Dalí*, trans. Haakon M. Chevalier (New York: Dial Press, 1942), 317.

19. Dalí, "Conquest of the Irrational," in *Collected Writings of Salvador Dalí*, 272.

20. René Magritte, interview with Pierre Du Bois, 1966, in Magritte, *Écrits Complets*, ed. André Blavier ([Paris]: Flammarion, 2001), 652.

21. Magritte, notes for a lecture given in London, 1937, in *Écrits Complets*, 97.

22. Magritte, letter of May 8, 1959, to Monsieur Hornik, in Harry Torczyner, *Magritte: Ideas and Images*, trans. Richard Miller (New York: Harry N. Abrams, 1977), 81. Italics in the original.

23. My reading of this painting follows Susan L. Aberth, *Leonora Carrington: Surrealism, Alchemy and Art* (Aldershot, UK: Lund Humphries, 2004), 30–35.

24. Dorothea Tanning, Tate catalogue file, quoted in Jennifer Mundy, "Dorothea Tanning, *Eine Kleine Nachtmusik*, 1943," Tate, 2001, https://www.tate.org.uk/art/artworks/tanning-eine-kleine-nachtmusik-t07346.

25. Tanning, interview with Victoria Caruthers, New York, 2005, quoted in Mundy, "Dorothea Tanning, *Eine Kleine Nachtmusik*."

26. Alberto Giacometti, letter to Pierre Matisse, 1947, in Angel González, *Alberto Giacometti: Works, Writings, Interviews* (Barcelona: Ediciones Polígrafa, 2006), 133.

27. Giacometti, "I Can Only Speak *Indirectly* of My Sculptures," *Minotaure*, nos. 3–4 (December 12, 1933): 46, in González, *Alberto Giacometti: Works, Writings, Interviews*, 131.

28. Giacometti, "I Can Only Speak *Indirectly*," 131.

29. Giacometti, "I Can Only Speak *Indirectly*," 131.

30. Giacometti, "I Can Only Speak *Indirectly*," 131.

31. Jean Arp, "Looking," in *Arp*, ed. James Thrall Soby (New York: Museum of Modern Art, 1958), 15.

32. Margherita Andreotti, "A New Unity of Man and Nature: Jean Arp's *Growth* of 1938," *Art Institute of Chicago Museum Studies* 16, no. 2 (1990): 134.

33. Arp, "Concrete Art" (1944), in *Arp on Arp: Poems, Essays, Memories*, ed. Marcel Jean, trans. Joachim Neugroschel (New York: Viking Press, 1972), 140.

34. Bice Curiger, "Defiance in the Face of Freedom," in Curiger, *Meret Oppenheim: Defiance in the Face of Freedom* (Zurich: Parkett Publishers; Cambridge, MA: MIT Press, 1989), 39.

35. Oppenheim claimed she used the fur of a Chinese gazelle. However, tests by the MoMA conservation department have determined that the fur is not from a Chinese gazelle but have not identified its source. Carolyn Lanchner, *Oppenheim: Object* (New York: Museum of Modern Art, 2017), 43n6.

36. Hal Foster, Rosalind Krauss, Yve-Alain Bois, Benjamin H.D. Buchloh, and David Joselit, *Art Since 1900: Modernism, Antimodernism, Postmodernism*, 3rd ed. (New York: Thames & Hudson, 2016), 1: 290.

37. Ian Walker, "Ubu in London: Between Surrealism and Documentary," in *Dora Maar*, ed. Damarice Amao, Amanda Maddox, and Karolina Ziebinska-Lewandowska (Los Angeles: J. Paul Getty Museum; London: Tate Publishing, 2020), 127.

38. Breton, quoting Jarry in, *Les Pas perdus* (The Lost Steps) (1924), quoted in Walker, "Ubu in London,"127.

39. Claude Cahun, *Aveux nos avenus* (Paris: Éditions du Carrefour, 1930), quoted in Dawn Ades, "Claude Cahun's 'Self-Portraits," in Sarah Howgate, *Gillian Wearing and Claude Cahun: Behind the Mask, Another Mask* (Princeton, NJ: Princeton University Press, 2017), 184.

40. My reading follows that of Jennifer L. Shaw, *Exist Otherwise: The Life and Works of Claude Cahun* (London: Reaktion, 2017), 85.

41. Brassaï, *The Secret Paris of the 30's* (London: Thames & Hudson, 1976).

42. Brassaï, "Involuntary Sculptures," *Minotaure* 3–4 (1933).

43. Brassaï, interview with France Bequette, *Culture et Communication*, no. 27 (May 1980), quoted in Annick Lionel-Marie, "Letting the Eye be Light," in *Brassai: The Monograph*, ed. Alain Sayag and Annick Lionel-Marie (Boston: Bullfinch Press/ Little, Brown, 2000), 160.

44. Henri Cartier-Bresson, *The Decisive Moment* (New York: Simon & Schuster, 1952), n.p.

Chapter 9

1. Henri Matisse, *Jazz* (Paris: Tériade, 1947), in Jack D. Flam, *Matisse on Art*, rev. ed. (Berkeley: University of California Press, 1995), 172.

2. Matisse, "Testimonial" (1951), Flam, *Matisse on Art*, rev. ed., 207.

3. Alex Danchev, *Georges Braque: A Life* (New York: Arcade, 2005), 249.

4. Pablo Picasso, conversation on *Guernica* as recorded by Jerome Seckler, "Picasso Explains," *New Masses* 54, no. 11 (March 13, 1945): 4–7, excerpt reprinted in Herschel B. Chipp, *Theories of Modern Art: A Source Book by Artists and Critics* (Berkeley: University of California Press, 1968), 487.

5. Julio González, untitled, undated statement in *Julio Gonzalez*, intro. Andrew Carnduff Ritchie (New York: Museum of Modern Art in collaboration with Minneapolis Institute of Art, 1956), 42. The statement is adapted from González's unpublished manuscript, "Picasso sculpteur et les cathedrales" (1932), translated and transcribed in Josephine Withers, *Julio Gonzalez: Sculpture in Iron* (New York: New York University Press, 1978), Appendix I, 131–45.

6. González, untitled statement in *Julio Gonzalez*, 42.

7. Withers, *Julio Gonzalez: Sculpture in Iron*, 64.

8. Constantin Brancusi quoted in Paul Morand, "Brancusi," *Brancusi* (New York: Brummer Gallery, 1926), n.p.

9. Brancusi quoted in Sidney Geist, *Brancusi: A Study of the Sculpture*, rev. ed. (New York: Hacker Art Books, 1983), 2.

10. Brancusi quoted in Roger Devigne, "L'homme qui rabote les femmes," *L'Ère Nouvelle* (January 28, 1920), 6, quoted in Friedrich Teja Bach, Margit Rowell, and Ann Temkin,

Constantin Brancusi 1876–1957 (Philadelphia: Philadelphia Museum of Art, 1995), 138.

11. For an intensive analysis of Brancusi's sexually ambiguous imagery, see Anna C. Chave, "Princess X/Prince's Sex," chap. 3 in *Constantin Brancusi: Shifting the Bases of Art* (New Haven, CT: Yale University Press, 1993).

12. Brancusi quoted in Carola Giedion-Welcker, *Constantin Brancusi* (New York: George Braziller, 1959), 220.

13. Eric Shanes, *Constantin Brancusi* (New York: Abbeville, 1989), 97.

14. Fernand Léger in "Que signifie: être témoin de son temps?" *Arts* (Paris), no. 205 (March 11, 1949): 1, quoted in Carolyn Lanchner, *Fernand Léger* (New York: Museum of Modern Art, 1998), 174.

15. Léger, "Que signifie: être témoin de son temps?," in Lanchner, *Fernand Léger*, 174.

16. Léger, in an interview with Dora Vallier, "La Vie fait l'oeuvre de Fernand Léger" (1954), quoted in Lanchner, *Fernand Léger*, 18.

17. Amédée Ozenfant and Charles-Édouard Jeanneret, "Le Purisme," *L'Esprit nouveau*, no. 4 (January 15, 1921): 370.

18. Ozenfant and Jeanneret, *Après le cubisme* (Paris: éditions des Commentaires, 1918); English translation, *After Cubism*, in Carol S. Eliel, *L'Esprit Nouveau: Purism in Paris, 1918–1925* (Los Angeles: Los Angeles County Museum of Art in association with Harry N. Abrams, 2001), 133.

19. Ozenfant and Jeanneret, *After Cubism*, in Eliel, *L'Esprit Nouveau*, 138.

20. Stanley Spencer papers, 1955, quoted in Fiona McCarthy, *Stanley Spencer: An English Vision* (New Haven, CT: Yale University Press in association with British Council and Hirshhorn Museum and Sculpture Garden, 1997), cat. 33, n.p.

21. Henry Moore, "The Nature of Sculpture" (1930), in *Henry Moore on Sculpture*, ed. Philip James (New York: Viking Press, 1967), 57.

22. Moore, "Primitive Art" (1941), in *Henry Moore on Sculpture*, 159.

23. Moore, "Sculpture in the Open Air" (1955), in *Henry Moore on Sculpture*, 99.

24. Moore, "The Sculptor Speaks" (1937), in *Henry Moore on Sculpture*, 66.

25. Moore, "The Sculptor Speaks," 66.

26. See Sherry B. Ortner, "Is Female to Male as Nature is to Culture?" (1972) in *Woman, Culture, and Society*, ed. Michelle Zimbalist Rosaldo and Louise Lamphere (Stanford, CA: Stanford University Press, 1974), 68–87.

27. Barbara Hepworth, *Barbara Hepworth: Carvings and Drawings* (London: Lund Humphries, 1952), sect. 3, n.p.

28. Hepworth, *Barbara Hepworth*, sect. 4, n.p.

29. Hepworth quoted in Edouard Roditi, *Dialogues on Art* (New York: Horizon Press, 1961), 93.

Chapter 10

1. Robert Henri, "My People," *The Craftsman* 27, no. 5 (February 1915): 459.

2. George Bellows quoted in Charles H. Morgan, *George Bellows: Painter of America* (New York: Reynal, 1965), 77.

3. Lewis Hine quoted in Robert W. Marks, "Portrait of Lewis Hine," *Coronet*, February 1939, 157.

4. Alexander Nemerov, *Soulmaker: The Times of Lewis Hine* (Princeton, NJ: Princeton University Press, 2016), 3.

5. A. S. [Alfred Stieglitz], "Our Illustrations," *Camera Notes* 3 (July 1899): 24.

6. Alfred Stieglitz, "How *The Steerage* Happened," *Twice A Year* 8-9 (Spring/Summer-Fall/Winter 1942): 128.

7. Georgia O'Keeffe quoted in Lloyd Goodrich and Doris Bry, *Georgia O'Keeffe* (New York: Praeger in association with Whitney Museum of American Art, 1970), 8.

8. O'Keeffe, "About Myself," in *Georgia O'Keeffe: Exhibition of Oils and Pastels*, exhibition checklist (New York: An American Place, 1939), n. p.

9. Edward Weston, "What is Photographic Beauty?," *American Photography* 45, no. 12 (December 1951): 740.

10. Edward Weston, *The Daybooks of Edward Weston*, ed. Nancy Newhall (Millerton, NY: Aperture, 1973), 2: 181.

11. John Marin, "Guest Editorial," *Palisadian*, November 15, 1940, reprinted in Marin, *The Selected Writings of John Marin*, ed. Dorothy Norman (New York: Pellegrini and Cudahy, 1949), 196.

12. Calvin Coolidge quoted in Robert Sobel, "Coolidge and American Business" (1988), Calvin Coolidge Presidential Foundation, https://coolidgefoundation.org/resources/essays-papers-addresses-35/. This quote comes from a speech Coolidge made in 1916 as lieutenant governor of Massachusetts.

13. Le Corbusier, *Toward an Architecture*, trans. John Goodman (Los Angeles: Getty Research Institute, 2007), 105.

14. My reading of Demuth's painting follows Karal Ann Marling, "Charles Demuth, *My Egypt*, 1927," in *Frames of Reference: Looking at American Art, 1900–1950*, ed. Beth Venn and Adam D. Weinberg (New York: Whitney Museum of American Art, 1999), 159–61.

15. Quoted in Charles Brock, *Charles Sheeler: Across Media* (Washington, DC: National Gallery of Art in association with University of California Press, 2006), 169.

16. *Survey Graphic* 6, no. 6 (March 1925), 627. This special issue was soon expanded and published as a book: *The New Negro: An Interpretation*, ed. Alain Locke (New York: A. and C. Boni, 1925).

17. Locke, "The Legacy of Ancestral Arts," in *The New Negro*, 254–67.

18. This reading of the iconography of *City Building* follows that of Stephanie L. Herdrich in Randall R. Griffey, Elizabeth Mankin Kornhauser, and Stephanie L. Herdrich, "Thomas Hart Benton's *America Today*," *The Metropolitan Museum of Art Bulletin* 72, no. 3 (2015): 36.

19. Erika Doss, *Benton, Pollock and the Politics of Modernism: From Regionalism to Abstract Expressionism* (Chicago: University of Chicago Press, 1991), 86.

20. Thomas Hart Benton quoted in "Radical Art Trend Seen in Midwest: Benton, Mural Painter, Finds Rejection of Communist Symbolism, However," *New York Times*, February 8, 1935.

21. Ben Shahn quoted in John D. Morse, "Ben Shahn: An Interview," *Magazine of Art* 37, no. 4 (April 1944): 137.

22. Stuart Davis, "Abstract Painting Today" (1939), in *Art for the Millions: Essays from the 1930s by Artists and Administrators of the WPA Federal Art Project*, ed. Francis V. O'Connor (Greenwich, CT: New York Graphic Society, 1973), 126.

23. Lawren Harris quoted in Peter Mellen, *Landmarks of Canadian Art* (Toronto: McClellan and Stewart, 1978), 176.

24. Emily Carr, *Klee Wyck* (Vancouver: Douglas & McIntyre, 2003), 53.

25. Emily Carr, journal entry, February 5, 1931, in *Hundreds and Thousands: The Journals of Emily Carr* (Vancouver: Douglas & McIntyre, 2006), 52.

26. Oswald de Andrade, "Manifesto of Pau-Brasil Poetry," trans. Stella M. de Sá Rego, *Latin American Literary Review* 14, no. 27 (January—June 1986): 187.

27. Andrade, "Manifesto of Pau-Brasil Poetry,"184.

28. Diego Rivera quoted in "Rivera RCA Mural is

Cut from Wall," *New York Times*, February 13, 1934.

29. Hayden Herrera, *Frida: A Biography of Frida Kahlo* (New York: Harper & Row, 1983), 278.

30. Frida Kahlo quoted in "Art: Mexican Autobiography," *Time*, August 27, 1953, 91.

31. Giulio Blanc, "Cuba (1900–1950)," in *Latin American Art in the Twentieth Century*, ed. Edward J. Sullivan (London: Phaidon, 1996), 85.

32. Wifredo Lam quoted in Max-Pol Fouchet, *Wifredo Lam* (New York: Rizzoli, 1976), 188–89.

33. David Craven, *Art and Revolution in Latin America 1910–1990* (New Haven, CT: Yale University Press, 2002), 109. Craven credits Jasmine Alinder with this insight.

34. Lam quoted in Fouchet, *Wifredo Lam*, 199.

35. Lam quoted in Gerardo Mosquera, "Entrevista con Wifredo Lam," *Explorations en la plástica Cubana* (Havana, 1983), 184, quoted in Craven, *Art and Revolution*, 109.

36. Valerie Fletcher, *Crosscurrents of Modernism: Four Latin American Pioneers— Diego Rivera, Joaquin Torres- Garcia, Wifredo Lam, Matta* (Washington, DC: Hirshhorn Museum and Sculpture Garden in association with Smithsonian Institution Press, 1992), 115.

37. This reading of Xul Solar's *Couple* draws on Mario H. Gradowczyk, *Alejandro Xul Solar* (Buenos Aires: Ediciones ALBA, 1994), 98, 100; and Jacqueline Barnitz and Patrick Frank, *Twentieth-Century Art of Latin America*, rev. ed. (Austin: University of Texas Press, 2015), 71.

38. "Manifiesto Invencionista" (Inventionist Manifesto, 1947), quoted in Alexander Alberro, "To Find, to Create, to Reveal: Torres-García and the Modes of Invention in Mid-1940s Río de la Plata," in Luis Pérez-Oramas, *Joaquín Torres-García: The Arcadian Modern* (New York: Museum of Modern Art, 2015), 117.

39. Alberro, "To Find, to Create, to Reveal," 118.

Chapter 11

1. This paragraph draws on R. Siva Kumar, "Modern Indian Art: A Brief Overview," *Art Journal* 58, no. 3 (Fall 1999): 14.

2. Kumar, "Modern Indian Art," 14.

3. Partha Mitter, *Indian Art* (Oxford: Oxford University Press, 2001), 194.

4. Amrita Sher-Gil, letter to Karl Khandalavala, from Simla, August 14, 1940, reprinted in *Amrita Sher-Gil: Essays*, ed. Vivan Sundaram (Bombay: Marg, 1972), 133, quoted in Sonal Khullar, *Worldly Affiliations: Artistic Practice, National Identity, and Modernism in India, 1930–1990* (Oakland: University of California Press, 2015), 80.

5. Partha Mitter, *The Triumph of Modernism: India's Artists and the Avant-Garde 1922–1947* (London: Reaktion, 2007), 120.

6. Miriam Wattles, "The 1909 *Ryūtō* and the Aesthetics of Affectivity," *Art Journal* 55, no. 3 (Autumn 1996): 51.

7. In his memoirs, published in 1951, Taikan claimed that these were unmarried women performing a divination ritual; if a lamp continued to burn for as long as it remained within the woman's sight while floating away, the woman would enjoy good fortune, presumably in marriage. See Wattles, "The 1909 *Ryūtō*," 55.

8. Bunten was an abbreviation of *Monbushō Bijutsu Tenrankai*, or Ministry of Education Arts Exhibition. In 1927, the Bunten was renamed Teiten, an abbreviation of *Teikoku Bijutsu Tenrankai*, or Imperial Academy of Arts Exhibition.

9. My reading of the painting follows Alicia Volk, "*Nude Beauty*: A Modernist Critique," chap. 2 in *In Pursuit of Universalism: Yorozu Tetsugorō and Japanese Modern Art* (Berkeley: University of California Press, 2010).

10. For this and the following, see Charlotte Horlyck, *Korean Art: From the 19th Century to the Present* (London: Reaktion, 2017), 41.

11. My reading of this painting follows Horlyck, *Korean Art*, 57.

12. Youngna Kim, "Yi In-song's 'Local Colours': Nationalism or Colonialism?," *Oriental Art* 46, no. 4 (Winter 2000): 20.

13. Kim, "Yi In-song's 'Local Colours,'" 20.

14. This section draws on Youngna Kim, "Modernity in Debate: Representing the 'New Woman' and 'Modern Girl,'" in Kim, *20th Century Korean Art* (London: Laurence King, 2005), 64–87.

15. Na Hye-sŏk, *Maeil sinbo*, April 3, 1921, quoted in Kim, "Modernity in Debate," 64.

16. Joan Kee, "Modern Art in Late Colonial Korea: A Research Experiment," *Modernism/Modernity*, 3, Cycle 2, April 18, 2018, https://modernismmodernity.org/articles/research-experiment.

17. Horlyck, *Korean Art*, 37.

18. Kee, "Modern Art in Late Colonial Korea."

19. Quoted in Robert Hatfield Ellsworth, *Later Chinese Painting and Calligraphy, 1800–1950* (New York: Random House, 1987), 1:157.

20. Julia F. Andrews and Kuiyi Shen, *The Art of Modern China* (Berkeley: University of California Press, 2012), 35.

21. Andrews and Shen, *Art of Modern China*, 39.

22. Xu Beihong, "I Am Bewildered," *Art Exhibition Newsletter* (Shanghai), no. 5, April 22, 1929, trans. Michael Fei, in *Shanghai Modern 1919–1945*, ed. Jo-Anne Birnie Danzker, Ken Lum, and Zheng Shengtian (Ostfildern-Ruit, Germany: Hatje Cantz, 2004), 373–74.

23. Xu Zhimo, "I Am 'Bewildered' Too—A Letter to Xu Beihong," *Art Exhibition Newsletter*, no. 5, April 22, 1929, trans. Michael Fei, in *Shanghai Modern*, 377.

24. Andrews and Shen, *Art of Modern China*, 70.

25. "Storm Society Manifesto," *Yishu xunkan* 1, no. 5 (October 11, 1932): 8, quoted in Andrews and Shen, *Art of Modern China*, 77–78.

Chapter 12

1. Oral history interview with Joan Mitchell, April 16, 1986, conducted by Linda Nochlin for the Archives of American Art, Smithsonian Institution, https://www.aaa.si.edu/collections/interviews/oral-history-interview-joan-mitchell-12183#transcript.

2. See Frances Stonor Saunders, *The Cultural Cold War: The CIA and the World of Arts and Letters* (New York: New Press, 1999).

3. John D. Graham, "Primitive Art and Picasso," *Magazine of Art* 30, no. 4 (April 1937): 237.

4. See Harry Rand, *Arshile Gorky: The Implications of Symbols* (Berkeley: University of California Press, 1991), 106–08.

5. Mark Rothko quoted in Sidney Janis, *Abstract and Surrealist Art in America* (New York: Reynal and Hitchcock, 1944), 118.

6. Mark Rothko and Adolph Gottlieb, letter to the *New York Times*, printed in Edward Alden Jewell, "The Realm of Art: A New Platform and Other Matters: 'Globalism' Pops into View," *New York Times*, June 13, 1943. Barnett Newman gave Rothko and Gottlieb editorial assistance in writing the letter but did not sign it.

7. Stephen Polcari, *Abstract Expressionism and the Modern Experience* (Cambridge: Cambridge University Press, 1991), 248.

8. Harold Rosenberg, "The American Action Painters," *Art News* 51, no. 8 (December 1952): 22.

9. Jean-Paul Sartre, "The Humanism of Existentialism" (1945/46) in Sartre, *Essays in Existentialism*, ed. Wade Baskin (Secaucus, NJ: Citadel Press, 1965), 47.

10. Jackson Pollock, "My Painting," *Possibilities* 1 (Winter 1947/48): 79, quoted in Herschel B. Chipp, *Theories of Modern Art: A Source Book by Artists and Critics* (Berkeley: University of California Press, 1968), 548.

11. Pollock quoted in William Wright, "An Interview with Jackson Pollock" (1950), in *American Artists on Art from 1940 to 1980*, ed. Ellen H. Johnson (New York: Harper & Row, 1982), 7.

12. Clement Greenberg, "The Crisis of the Easel Picture" (1948), in Greenberg, *The Collected Essays and Criticism, Volume 2: Arrogant Purpose, 1945–1949*, ed. John O'Brian (Chicago: University of Chicago Press, 1986), 222.

13. Pollock, undated note, quoted in Ellen G. Landau, *Jackson Pollock* (New York: Harry N. Abrams, 1989), 182.

14. Robert Hobbs, *Lee Krasner* (New York: Abbeville Press, 1993), 67.

15. Willem de Kooning, "What Abstract Art Means to Me," *Bulletin of the Museum of Modern Art* 18, no. 3 (Spring 1951), in Chipp, *Theories of Modern Art*, 560.

16. Willem de Kooning, "Content Is a Glimpse," excerpts from an interview with David Sylvester, *Location* 1, no. 1 (Spring 1963), reprinted in Thomas B. Hess, *Willem de Kooning* (New York: Museum of Modern Art, 1968), 149.

17. Quoted in Judith E. Bernstock, *Joan Mitchell* (New York: Hudson Hills Press, 1988), 40.

18. Bernstock, *Joan Mitchell*, 41.

19. Barnett Newman, "The Sublime is Now," *Tiger's Eye* 6 (December 15, 1948), in Chipp, *Theories of Modern Art*, 553.

20. Clyfford Still, letter of January 1, 1959 to Gordon Smith, Director, Albright Art Gallery, in *Paintings by Clyfford Still* (Buffalo: Buffalo Fine Arts Academy 1959), n. p.

21. Mark Rothko quoted in Selden Rodman, *Conversations with Artists* (New York: Devin-Adair, 1957), 93–94. Italics in the original.

22. Thomas B. Hess, *Barnett Newman* (New York: Museum of Modern Art, 1971), 55–56.

23. Robert Motherwell, "A Conversation at Lunch," Smith College, 1963, quoted in Frank O'Hara, *Robert Motherwell* (New York: Museum of Modern Art, 1965), 54.

24. Ad Reinhardt, statement in the catalogue of his exhibition at the Betty Parsons Gallery, October 18–November 6, 1948, n.p., quoted in Irving Sandler, *The Triumph of American Painting: A History of Abstract Expressionism* (New York: Praeger, 1970), 221.

25. Ad Reinhardt, "Autocritique de Reinhardt" (1963), reprinted in *Art as Art: The Selected Writings of Ad Reinhardt*, ed. Barbara Rose (New York: Viking Press, 1975), 83. Italics in the original.

26. Larry Rivers with Arnold Weinstein, *What Did I Do? The Unauthorized Autobiography* (New York: HarperCollins, 1992), 314.

27. My reading of Rivers's painting follows that of Sidra Stich, *Made in U.S.A.: An Americanization in Modern Art, The '50s and '60s* (Berkeley: University of California Press, 1987), 14–17.

28. David Park, statement for his 1953 exhibition at the King Ubu Gallery, San Francisco, quoted in Nancy Boas, *David Park: A Painter's Life* (Berkeley: University of California Press, 2012), 158.

29. David Smith, "The New Sculpture" (1952), in *David Smith*, ed. Garnett McCoy (New York: Praeger, 1973), 84.

30. See Rosalind E. Krauss, "*Tanktotem*: Welded Images," chap. 5 in *Passages in Modern Sculpture* (Cambridge, MA: MIT Press, 1977).

31. Amy Lyford, "Noguchi, Sculptural Abstraction, and the Politics of Japanese American Internment," *Art Bulletin* 85, no. 1 (March 2003): 137.

32. Isamu Noguchi quoted in Katharine Kuh, "An Interview with Isamu Noguchi," *Horizon* 2, no. 4 (March 1960): 108.

33. Mignon Nixon, "Psychoanalysis—Louise Bourgeois: Reconstructing the Past," in *Louise Bourgeois*, ed. Frances Morris (New York: Rizzoli, 2008), 229–30.

34. Bourgeois said the packages are "children, of course." Bourgeois quoted in Deborah Emont Scott, *Louise Bourgeois: Sculpture and Drawings*, exhibition brochure (Kansas

City, MO: Nelson-Atkins Museum of Art, 1994), n.p.

35. Bourgeois quoted in Alain Kirili, "The Passion for Sculpture: A Conversation with Louise Bourgeois," *Arts Magazine* 63, no. 7 (March 1989): 71.

36. At the time Cornell used this image by Sophonisba Anguissola, it was believed to portray a child of Cosimo I de' Medici, Grand Duke of Tuscany, possibly his youngest son, Piero de' Medici. See Federico Zeri, *Italian Paintings in the Walters Art Gallery* (Baltimore: Walters Art Gallery, 1976), 2:427. Later scholarship established that the subject is Massimiliano Stampa, third marquess of Soncin, painted in 1557 by Anguissola.

37. Cornell, undated note filed in his "Night Voyage" folder, Archives of American Art, Smithsonian Institution, roll 1066, quoted in Deborah Solomon, *Utopia Parkway: The Life and Work of Joseph Cornell* (New York: Farrar, Straus and Giroux, 1997), 139.

38. Solomon, *Utopia Parkway*, 140.

39. Colin Westerbeck, "Beyond the Photographic Frame," in Sarah Greenough, Joel Snyder, David Travis, and Colin Westerbeck, *On the Art of Fixing a Shadow: One Hundred and Fifty Years of Photography* (Washington, DC: National Gallery of Art; Chicago: Art Institute of Chicago, 1989), 346.

40. Keith F. Davis, *An American Century of Photography: From Dry-Plate to Digital—The Hallmark Photographic Collection* (Kansas City, MO: Hallmark in association with Harry N. Abrams, 1995), 206–07.

41. Roy DeCarava quoted in Peter Galassi, *Roy DeCarava: A Retrospective* (New York: Museum of Modern Art, 1996), 19.

42. Edward Steichen, *The Family of Man* (New York: Published for the Museum of Modern Art by Maco Magazine Corp., 1955), 4.

43. Frank said: "I was very free with the camera. I didn't think of what would be the correct thing to do; I did what I felt good doing. I was like an action painter." Frank quoted in William S. Johnson, "History – His Story," in "The Pictures are a Necessity: Robert Frank in Rochester, NY, November 1988," ed. Johnson, *Rochester Film & Photo Consortium Occasional Papers No. 2*, January 1989 (Rochester, NY: University Educational Services, International Museum of Photography at George Eastman House, 1989), 30.

44. Jack Kerouac, introduction to Robert Frank, *The Americans* (Millerton, NY: Aperture, 1978), 9.

45. "An Off-Beat View of the U.S.A.," *Popular Photography* 46, no. 5 (May 1960): 104–06, quoted in Davis, *An American Century of Photography*, 224.

Chapter 13

1. André Malraux, "Les Otages," in *Les Otages, peintures et sculptures de Jean Fautrier* (Paris: Galerie René Drouin, 1945), quoted in Frances Morris, *Paris Post War: Art and Existentialism 1945–55* (London: Tate Gallery, 1993), 89.

2. Michel Tapié, "Espaces et Expressions" (1952), *Premier bilan de l'art actuel, 1937–1953*, 102, quoted in Morris, *Paris Post War*, 181.

3. Ione Robinson, "Talks with Wols," in *Modern Art Yesterday and Tomorrow: An Anthology of Writings on Modern Art from* L'Oeil, *The European Art Magazine*, ed. Georges Bernier and Rosamund Bernier (New York: Reynal, 1960), 113, quoted in Toby Kamps, "Seeing Wols," in *Wols Retrospective* (Munich: Hirmer in association with Kunsthalle Bremen and Menil Collection, Houston, 2013), 64.

4. Kamps, "Seeing Wols," 67n41.

5. Georges Mathieu, *Au-delà du Tachisme* (Paris: R. Julliard, 1963), 35, quoted in Morris, *Paris Post War*, 182.

6. Mathieu quoted in "Art: In the End, Nothing," *Time*, September 16, 1957.

7. Georges Mathieu, text of April 27, 1987, published September 11, 1987 in *Dynastie*, per https://georges-mathieu.fr/en/artworks/les-capetiens-partout-capetians-everywhere/. Original French quoted in *Georges Mathieu* (Milan: Silvana, 2003), 264.

8. Michel Seuphor, "Style and Cry," preface to the catalogue of the Maria Helena Vieria da Silva exhibition at the Galerie Pierre, Paris, 1949, reprinted in Jacques Lassaigne and Guy Weelen, *Vieira da Silva*, trans. John Shepley (New York: Rizzoli, 1979), 184.

9. See Paul Schimmel, "Painting the Void," in *Destroy the Picture: Painting the Void, 1949–1962* (New York: Skira Rizzoli in association with Museum of Contemporary Art, Los Angeles, 2013), 188–203.

10. Alberto Burri quoted in Marco Valsecchi, "Alberto Burri dal 1959 ad oggi," *Il Giorno* (Milan), March 5, 1974, quoted in Gerald Nordland, *Alberto Burri: A Retrospective View 1948–77* (Los Angeles: Frederick S. Wright Art Gallery, University of California, Los Angeles, 1977), 72.

11. Herbert Read, "Alberto Burri," *The Observer* (London), October 30, 1960, quoted in *Burri: 1915–1995 Retrospektive* (Milan: Electa, 1997), 283.

12. Antoni Tàpies, "A Report on the Wall" (1969), in *Collected Essays. Complete Writings, Volume II*, trans. Josep Miguel Sobrer (Barcelona: Fundació Antoni Tàpies in association with Indiana University Press, 2011), 108.

13. Henri Jeanson, *Le Canard enchainé*, May 15, 1946, and Jean Texcier, *Gavroche*, May 30, 1946, quoted in Morris, *Paris Post War*, 79.

14. Michel Tapié, *Mirolobus, Macadam et Cie.* (Paris: Galerie René Drouin, 1946), quoted in *Towards an Alternate Reality*, essay by Mildred Glimcher; writings by Jean Dubuffet (New York: Pace Gallery; Abbeville Press, 1987), 9.

15. Jean Dubuffet, "Landscaped Tables, Landscapes of the Mind, Stones of Philosophy," in Peter Selz, *The Work of Jean Dubuffet* (New York: Museum of Modern Art, 1962), 64.

16. Constant Niewenhuys, "Manifesto," *Reflex* I (Amsterdam), September—October 1948, trans. Leonard Bright, reprinted in Willemijn Stokvis, *Cobra: An International Movement in Art after the Second World War* (New York: Rizzoli, 1988), 30.

17. Alberto Giacometti, letter to Pierre Matisse, 1947, reprinted in Herschel B. Chipp, *Theories of Modern Art: A Source Book by Artists and Critics* (Berkeley: University of California Press, 1968), 601.

18. Giacometti, letter to Pierre Matisse, in Chipp, *Theories of Modern Art*, 601.

19. Jean-Paul Sartre, "The Search for the Absolute" (1948), excerpts reprinted in *Art in Theory 1900–2000: An Anthology of Changing Ideas*, ed. Charles Harrison and Paul Wood (Malden, MA: Blackwell, 2002), 615.

20. Allan S. Weller, "Coast-to-Coast: Chicago," *Art Digest* 28, no. 4 (November 15, 1953): 15.

21. Jo Gibbs, "Attenuated Beauty," *Art Digest* 22, no. 9 (February 1, 1948): 13.

22. Francis Bacon, interview by Hugh Davies, March 17, 1973, London, quoted in Hugh Davies and Sally Yard, *Francis Bacon* (New York: Abbeville, 1986), 8.

23. Germaine Richier, untitled statement (1959) in Peter Selz, *New Images of Man* (New York: Museum of Modern Art, 1959), 130.

24. Henry Moore and John Hedgecoe, *Henry Spencer Moore*, ed. John Hedgecoe (London: Thomas Nelson and Sons, 1968), 177.

25. J. P. Hodin, "Barbara Hepworth and the Mediterranean Spirit," *Marmo* (Milan) 3 (December 1964): 59.

26. Barbara Hepworth, *Barbara Hepworth: Carvings and Drawings*, with an introduction by Herbert Read (London: Lund Humphries, 1952), sect. 2, n.p.

27. Hepworth, *Barbara Hepworth*, sect. 6, n.p.

28. Henry Moore quoted in Albert Elsen, "Henry Moore's Reflections on Sculpture," *Art Journal* 26, no. 4 (Summer 1967): 354.

29. Francis Bacon, October 1962, in David Sylvester, *Interviews with Francis Bacon* (London: Thames & Hudson, 1975), 11.

30. Bacon, Sylvester interview, 23.

Chapter 14

1. Robert Rauschenberg, statement in *Sixteen Americans*, ed. Dorothy C. Miller (New York: Museum of Modern Art, 1959), 58.

2. William C. Seitz, *The Art of Assemblage* (New York: Museum of Modern Art, 1961), 6.

3. Lawrence Alloway, "Junk Culture," *Architectural Design* (London) 31, no. 3 (March 1961): 122, quoted in Seitz, *Art of Assemblage*, 73.

4. Rauschenberg quoted in Calvin Tomkins, *Off the Wall: Robert Rauschenberg and the Art World of Our Time* (Garden City, NY: Doubleday, 1980), 87.

5. John Cage, "On Robert Rauschenberg, Artist, and his Work," *Metro* (Milan) 2 (1961): 43.

6. Rauschenberg quoted in Calvin Tomkins, *The Bride and the Bachelors: The Heretical Courtship in Modern Art* (New York: Viking, 1965), 216.

7. Robert Hughes, *The Shock of the New*, rev. ed. (New York: Alfred A. Knopf, 1991), 335.

8. Rauschenberg quoted in Calvin Tomkins, "The Sistine on Broadway," in Roni Feinstein, *Robert Rauschenberg: The Silkscreen Paintings 1962–64* (New York: Whitney Museum of American Art in association with Bulfinch Press, Little, Brown, Boston, 1990), 16.

9. Rauschenberg quoted in Hughes, *Shock of the New*, 345.

10. "The Incomparable Workings of the Human Body," *Life*, October 26, 1962, 76.

11. Hughes, *Shock of the New*, 346.

12. Antonin Artaud, *The Theatre and Its Double*, trans. Mary Caroline Richards (New York: Grove Press, 1958), 13.

13. Dick Higgins quoted in Geoffrey Hilsabeck, "John Cage in the Classroom," *Chronicle of Higher Education*, May 8, 2016, https://www.chronicle.com/article/john-cage-in-the-classroom/.

14. Jasper Johns quoted in Leo Steinberg, "Jasper Johns: The First Seven Years of his Art" (1962), in Steinberg, *Other Criteria: Confrontations with Twentieth-Century Art* (New York: Oxford University Press, 1972), 31.

15. Sidra Stich, *Made in USA.: An Americanization in Modern Art, the '50s and '60s* (Berkeley: University of California Press, 1987), 19.

16. Louise Nevelson, *Dawns and Dusks*, taped conversations with Diana MacKown (New York: Charles Scribner's Sons, 1976), 126.

17. Barbara Rose, "On Mark di Suvero: Sculpture outside Walls," *Art Journal* 35, no. 2 (Winter 1975–76): 120.

18. John Chamberlain quoted in Diane Waldman, *John Chamberlain: A Retrospective* (New York: Solomon R. Guggenheim Museum, 1971), 17.

19. Mona Hadler, "Lee Bontecou's 'Warnings,'" *Art Journal* 53, no. 4 (Winter 1994): 58. Bontecou mentioned being "angry" in the 1950s and 1960s both about the traumas of World War II she remembered from her childhood and about contemporary problems; she commented, "Africa was in trouble and we were so negative." Bontecou quoted in Eleanor Munro, *Originals: American Women Artists* (New York: Simon & Schuster, 1979), 384.

20. Lee Bontecou, from a letter of 1960, in *Americans 1963*, ed. Dorothy C. Miller (New York: Museum of Modern Art, 1963), 12.

21. Edward Kienholz and Walter Hopps, "Concept Tableaux," *Grand Street* 55 (Winter 1996): 87.

22. Robert L. Pincus, *On a Scale that Competes with the World: The Art of Edward and Nancy Reddin Kienholz* (Berkeley: University of California Press, 1990), 66.

23. John Szarkowski's introduction to *New Documents: Diane Arbus, Lee*

Friedlander, Garry Wino-grand, brochure for the cir-culating exhibition (New York: Museum of Modern Art, 1967), reprinted in Sarah Hermanson Meister, *Arbus, Friedlander, Wino-grand: New Documents, 1967* (New York: Museum of Modern Art, 2017), 161.

24. Diane Arbus, Westbeth class transcript, 1971, quoted in Arthur Lubow, *Diane Arbus: Portrait of a Photographer* (New York: HarperCollins, 2016), 168.

25. Lee Friedlander quoted in an untitled note by Lee Lockwood introducing Friedlander's portfolio in *Contemporary Photographer* 4, no. 4 (Fall 1963): 13, quoted in Peter Galassi, "You Have to Change to Stay the Same," in Galassi, *Friedlander* (New York: Museum of Modern Art, 2005), 37.

26. Galassi, "You Have to Change to Stay the Same," 38.

27. Barbarlee Diamonstein quoting Garry Winogrand in Diamonstein, *Visions and Images: American Pho-tographers on Photography* (New York: Rizzoli, 1981, 1982), 185.

28. Pierre Restany, "Forty De-grees above Dada" (1961), in *Theories and Documents of Contemporary Art: A Sourcebook of Artists' Writ-ings*, ed. Kristine Stiles and Peter Selz (Berkeley: Uni-versity of California Press, 1996), 308.

29. Restany, "Forty Degrees above Dada," 308.

30. Restany, "Forty Degrees above Dada," 308.

31. My discussion of this work is indebted to Bruce Alt-shuler, "Pop Triumphant:

A New Realism," chap. 11 in *The Avant-Garde in Exhibition: New Art in the 20th Century* (New York: Harry N. Abrams, 1994).

32. Jean Tinguely quoted in Tomkins, *The Bride and the Bachelors*, 164.

33. John Canaday, "Machine Tries to Die for Its Art: Device Saws, Melts, and Beats Itself at Museum," *New York Times*, March 18, 1960.

34. Niki de Saint Phalle, *Niki de Saint Phalle: Bilder, Figuren, phantastische Gärten* (Munich: Prestel, 1987), quoted in Laurence Bertrand Dorléac, "Living to Live: The Conditions for Another Politics," in *Niki de Saint Phalle 1930–2002* (Bilbao: Guggenheim Bilbao and La Fábrica, Madrid, 2015), 103.

35. Niki de Saint Phalle, letter to Pontus Hulten, in Hulten, *Niki de Saint Phalle* (Bonn: Kunst- und Ausstellungshalle der Bundesrepublik Deutsch-land and Verlag Gert Hadje, 1992), 161–62.

36. Yves Klein, "Some Ex-cerpts from my Journal of 1957," in *Overcoming the Problematics of Art: The Writings of Yves Klein*, trans. Klaus Ottmann (New York: Spring Publi-cations, 2007), 14.

37. This summary of Heindel's ideas comes from Thomas McEvilley, "Conquistador of the Void," in *Yves Klein 1928–1962: A Retrospec-tive* (Houston: Institute for the Arts, Rice University in association with The Arts Publisher, New York, 1982), 24.

38. Klein, "On Judo" (1954), in *Overcoming the Prob-lematics of Art*, 4.

39. Klein, "My Position on the Battle between Line and Color" (1958), in *Over-coming the Problematics of Art*, 19.

40. Klein, "Mon Livre," sec-tion published in *Yves Klein* (Paris: Musée Na-tional d'Art Moderne, Centre Georges Pompi-dou, 1983), 173, quoted in Sidra Stich, *Yves Klein* (Stuttgart: Hatje Cantz, 1994), 86–87.

41. Klein, "Truth Becomes Reality" (1960), in *Yves Klein 1928–1962: A Retro-spective*, 230.

42. "Biography," in *Yves Klein*, ed. Olivier Berggruen, Max Hollein, and Ingrid Pfeiffer (Ostfildern-Ruit, Germany: Hatje Cantz, 2004), 222.

43. See the comments by Julia Steinmetz in Steinmetz, Heather Cassils, and Clover Leary, "Behind Enemy Lines: Toxic Tit-ties Infiltrate Vanessa Beecroft," *Signs: Journal of Women in Culture and Society* 31, no. 3 (March 2006): 758–60.

44. Yoshihara Jirō, "Gutai bijutsu sengen" (Gutai Art Manifesto), *Gaijutsu Shinchō* 7, no. 12 (Decem-ber 1956), 202–04, trans. Reiko Tomii, in Ming Tiampo and Alexandra Munroe, *Gutai: Splendid Playground* (New York: Guggenheim Museum Publications, 2013), 18.

45. Yoshihara, "Gutai bijutsu sengen," 18.

46. Tanaka Atsuko, "Sakuhin 11: Butai-fuku" (On *Work 11: Stage Dress*), *Gutai* 7 (July 1957): 13, quoted in Namiko Kunimoto, "Tanaka Atsuko's *Electric Dress* and the Circuits of Subjectivity," *Art

Bulletin* 95, no. 3 (Septem-ber 2013): 467.

47. Allan Kaprow, "'Hap-penings' in the New York Scene," *Art News* 60, no. 3 (May 1961): 39, 58.

48. Allan Kaprow, "The Legacy of Jackson Pol-lock," *Art News* 57, no. 6 (October 1958): 56–57. Italics in the original.

49. My discussion follows Jeff Kelley, "Eighteen Happen-ings in Six Parts," chap. 3 in *Childsplay: The Art of Allan Kaprow* (Berkeley: University of California Press, 2004).

50. My discussion follows Kelley, *Childsplay*, 100–3.

51. Yayoi Kusama quoted in Alexandra Munroe, "Obsession, Fantasy and Outrage: The Art of Yayoi Kusama," in *Yayoi Kusama: A Retrospective* (New York: Center for International Contemporary Arts, 1989), 18.

52. Kusama quoted in John Gruen, "The Under-ground: Anatomic Ex-plosions, Polka Dots for Love," *Vogue*, October 1, 1968, 148.

53. Kusama, "Press Release for Naked Protest at Wall Street, New York, 10:30 A.M., Sunday 15 October 1968," in Akira Tatehata, Laura Hoptman, Udo Kul-termann, and Catherine Taft, *Yayoi Kusama*, 2nd ed. (London: Phaidon, 2017), 105.

54. Kusama quoted in Munroe, "Obsession, Fan-tasy and Outrage," 30.

55. George Maciunas, "Neo-Dada in the United States" (1962), trans. from the German by Peter Herbo, in Jon Hendricks, *Fluxus Codex* (Detroit: Gilbert and Lila Silverman Fluxus

Collection in association with Harry N. Abrams, New York, 1988), 23.

56. La Monte Young quoted in Barbara Haskell, *BLAM! The Explosion of Pop, Minimalism, and Performance 1958–1964* (New York: Whitney Museum of American Art in association with W. W. Norton, 1984), 53.

57. Yoko Ono quoted in Alexandra Munroe, "Why War? Yoko Ono at the Serpentine Gallery," in *Yoko Ono: To the Light* (London: Koenig Books; Serpentine Gallery, 2012), 11.

58. Yoko Ono quoted in Roger Perry and Tony Elliott, "Yoko Ono," *Unit* (Keele, UK) 9 (December 1967): 26–27, quoted in Kevin Concannon, "Yoko Ono's *Cut Piece*: From Text to Performance and Back Again," *PAJ—A Journal of Performance and Art* 30, no. 3 (September 2008): 88.

59. Ono quoted in Concannon, "Yoko Ono's *Cut Piece*," 83.

60. Nam June Paik, "Charlotte Moorman: Chance and Necessity" (undated, unpublished typescript [1992], Emily Harvey Foundation Archives, New York, p. 1), quoted in Joan Rothfuss, "The Ballad of Nam June and Charlotte: A Revisionist History," in *Nam June Paik*, ed. Sook-Kyung Lee and Susanne Rennert (London: Tate Publishing, 2010), 146.

61. Eve Keller, "Biographical Notes," in *Nam June Paik: Video Time, Video Space*, ed. Toni Stooss and Thomas Kellein (New York: Harry N. Abrams, 1993), 134.

62. Joseph Beuys quoted in "I Put Me on This Train!, Interview with Art Papier" (1979), in *Energy Plan for the Western Man: Joseph Beuys in America—Writings by and Interviews with the Artist*, comp. Carin Kuoni (New York: Four Walls Eight Windows, 1990), 39.

63. Caroline Tisdall, *Joseph Beuys* ([London]: Thames & Hudson; Solomon R. Guggenheim Foundation, 1979), 16–17.

64. The story was debunked after Beuys's death. See Ulrike Knöfel, "Joseph Beuys: New Letter Debunks More Wartime Myths," trans. Ella Ornstein, *Spiegel International*, July 12, 2013, https://www.spiegel.de/international/germany/new-letter-debunks-myths-about-german-artist-joseph-beuys-a-910642.html.

65. Beuys quoted in Tisdall, *Joseph Beuys*, 190.

66. Tisdall, *Joseph Beuys*, 72.

67. Beuys quoted in Tisdall, *Joseph Beuys*, 72.

68. Beuys quoted in *Joseph Beuys: The Secret Block for a Secret Person in Ireland* (Oxford: Museum of Modern Art Oxford, 1974), n.p.

69. Beuys quoted in Tisdall, *Joseph Beuys*, 105.

70. Allan Antliff, *Joseph Beuys* (London: Phaidon, 2014), 66.

71. Beuys, "I am Searching for Field Character" (1973), in *Energy Plan for the Western Man,* 22.

72. Beuys quoted in Richard Demarco, "Conversations with Artists, Richard Demarco interviews Joseph Beuys, London

(March 1982)," *Studio International* 195, no. 996 (September 1982): 46.

73. Beuys, Demarco interview, 46.

74. Lygia Clark, "The Bichos" (1960), in Cornelia Butler and Luis Pérez-Oramas, *Lygia Clark: The Abandonment of Art, 1948–1988* (New York: Museum of Modern Art, 2014), 160.

75. Hélio Oiticica, "Dance in My Experience (Diary Entries), 1965–66," trans. Michael Asbury, in *Participation*, ed. Claire Bishop (London: Whitechapel; Cambridge, MA: MIT Press, 2006), 105, 106.

76. Hélio Oiticica, "Tropicália e parangolés—Entrevista a Mário Barata, 1967," in César Oiticica Filho, Sergio Cohn, and Ingrid Vieira, *Hélio Oiticica* (Rio de Janeiro: Beco do Azougue Editorial, 2009), 50, quoted in Guilherme Wisnik, "Tropicália/Tropicalismo: The Power of Multiplicity," in Lynn Zelevansky, Elizabeth Sussman, James Rondeau, and Donna De Salvo with Anna Katherine Brodbeck *Hélio Oiticica: To Organize Delirium* (Pittsburgh: Carnegie Museum of Art; Munich: Delmonico Books/Prestel, 2016), 57–58.

Chapter 15

1. Lawrence Alloway, *American Pop Art* (New York: Macmillan in association with Whitney Museum of American Art, 1974), 7.

2. See Christin J. Mamiya, *Pop Art and Consumer Culture: American Super Market* (Austin: University of Texas Press, 1992).

3. Alloway initially used the term "mass popular art" in "The Arts and the Mass Media," *Architectural Design* 28 (February 1958): 84–85.

4. Eduardo Paolozzi, untitled retrospective statement, in *The Independent Group: Postwar Britain and the Aesthetics of Plenty*, ed. David Robbins (Cambridge, MA: MIT Press, 1990), 192.

5. Richard Hamilton, *Collected Words, 1953–1982* (London: Thames & Hudson, 1982), 24.

6. Hamilton, *Collected Words*, 36, 37.

7. Marco Livingstone, *Pop Art: A Continuing History*, 2nd ed. (London: Thames & Hudson, 2000), 37.

8. Peter Blake quoted in Mervyn Levy, "Peter Blake, Pop Art for Admass: The Artist at Work: 23," *Studio International* 166 (November 1963): 187.

9. Quoted in Karen Rosenberg, "Overlooked No More: Pauline Boty, Rebellious Pop Artist," *New York Times*, November 20, 2019, https://www.nytimes.com/2019/11/20/obituaries/pauline-boty-overlooked.html.

10. Cécile Whiting, *Pop L.A.: Art and the City in the 1960s* (Berkeley: University of California Press, 2006), 128. Whiting makes this point generally about Hockney's Los Angeles pool paintings.

11. G. R. Swenson, "The New American 'Sign Painters,'" *Art News* 61, no. 5 (September 1962): 62.

12. Clement Greenberg, "Avant-Garde and Kitsch" (1939), in Greenberg, *The Collected Essays and Criticism, Volume I:*

Perceptions and Judgments, 1939–1944, ed. John O'Brian (Chicago: University of Chicago Press, 1986), 5–22.

13. Max Kozloff, "'Pop Culture,' Metaphysical Disgust, and the New Vulgarians," *Art International* 6, no. 2 (March 1962): 35, 36.

14. Lichtenstein quoted in G. R. Swenson, "What Is Pop Art? Answers from Eight Painters, Part I: Jim Dine, Robert Indiana, Roy Lichtenstein, Andy Warhol," *Art News* 62, no. 7 (November 1963): 25.

15. Andy Warhol quoted in Swenson, "What is Pop Art? Part I," 26.

16. Bradford R. Collins, *Pop Art* (London: Phaidon, 2012), 12.

17. Alloway, *American Pop Art*, 47.

18. Claes Oldenburg, untitled statement (1962), in *Claes Oldenburg: An Anthology* (New York: Solomon R. Guggenheim Foundation, 1995), 130.

19. Cécile Whiting, *A Taste for Pop: Pop Art, Gender and Consumer Culture* (Cambridge: Cambridge University Press, 1997), 110.

20. Lichtenstein quoted in John Coplans, "Talking with Roy Lichtenstein," *Artforum* 5, no. 9 (May 1967): 36.

21. See the panel from "Run for Love!" in *Secret Hearts*, 83 (November 1962), with art by Tony Abruzzo and lettering by Ira Schnapp, reproduced in Kirk Varnedoe and Adam Gopnik, *High and Low: Modern Art and Popular Culture* (New York: Museum of Modern Art, 1990), 199.

22. Andy Warhol quoted in Swenson, "What Is Pop Art? Part I," 26.

23. Warhol quoted in Gretchen Berg, "Andy Warhol: My True Story," *East Village Other* 1, no. 23 (November 1, 1966).

24. Andy Warhol, *The Philosophy of Andy Warhol: From A to B and Back Again* (New York: Harcourt, Brace, Jovanovich, 1975), 100–1.

25. Warhol quoted in Swenson, "What Is Pop Art? Part I," 26.

26. Warhol quoted in Swenson, "What Is Pop Art? Part I," 60.

27. Arthur Danto, "The Artworld," *Journal of Philosophy* 61, No. 19 (October 15, 1964): 580. The original wording is "something the eye cannot decry"—the intended word being "descry."

28. George Dickie, *The Art Circle: A Theory of Art* (New York: Haven, 1984), 80–82.

29. Andy Warhol, "Painter Hangs Own Paintings," *New York*, February 5, 1979, 10.

30. James Rosenquist quoted in "Art: Pop: Bing-Bang Landscapes," *Time*, May 28, 1965, 80.

31. Rosenquist quoted in G. R. Swenson, "The F-111: An Interview with James Rosenquist," *Partisan Review* 32, no. 4 (Fall 1965): 589–90.

32. James Rosenquist with David Dalton, *Painting below Zero: Notes on a Life in Art* (New York: Alfred A. Knopf, 2009), 160.

33. Rosenquist with Dalton, *Painting below Zero*, 159.

34. Robert Indiana quoted in Swenson, "What Is Pop Art? Part I," 27.

35. Indiana quoted in Swenson, "What Is Pop Art? Part I," 27.

36. Indiana quoted in John W. McCoubrey's introduction to *Robert Indiana* (Philadelphia: Institute of Contemporary Art, University of Pennsylvania, 1968), 23.

37. Indiana quoted in "Conversations with Robert Indiana" (excerpts from conversations between Robert Indiana and Donald B. Goodall), in *Robert Indiana* (Austin: University Art Museum, University of Texas at Austin, 1977), 29.

38. Indiana quoted in McCoubrey, *Robert Indiana*, 29.

39. Indiana quoted in Frances Koslow Miller, "Robert Indiana," *Tema Celeste* 20, no. 95 (January/February 2003): 73.

40. Barbara Haskell, "Robert Indiana: The American Dream," in Haskell, *Robert Indiana: Beyond Love* (New York: Whitney Museum of American Art, 2013), 104.

41. David McCarthy, "Tom Wesselmann and the Americanization of the Nude, 1961–63," *American Art* 4, nos. 3–4 (Summer-Autumn 1990): 103.

42. Jim Dine quoted in John Gruen, "Jim Dine and the Life of Objects," *ARTnews* 76, no. 7 (September 1977): 38.

43. George Segal, "The Diner, 1964–66," in Martin Friedman and Graham W. J. Beale, *George Segal: Sculptures*, with commentaries by George Segal (Minneapolis: Walker Art Center, 1978), 37.

44. My discussion of *The Family* follows Marina Pacini, "Marisol's Families," in Pacini, *Marisol: Sculptures and Works on Paper* (Memphis: Memphis Brooks Museum of Art in association with Yale University Press, 2014), 82–85.

45. Ed Ruscha quoted in John Coplans, "Concerning 'Various Small Fires': Edward Ruscha Discusses His Perplexing Publications," *Artforum* 3, no. 5 (February 1965): 25.

46. Ruscha quoted in Coplans, "Concerning 'Various Small Fires,'" 25.

47. Wayne Thiebaud quoted in Adam Gopnik, "An American Painter," in Steven A. Nash with Adam Gopnik, *Wayne Thiebaud: A Paintings Retrospective* (San Francisco: Fine Arts Museums of San Francisco; New York: Thames & Hudson, 2000), 55.

48. Gerhard Richter, letter to a newsreel company, April 29, 1963, in *Gerhard Richter: The Daily Practice of Painting—Writings and Interviews 1962–1993*, trans. David Britt, ed. Hans-Ulrich Obrist (Cambridge, MA: MIT Press; London: Anthony d'Offay Gallery, 1995), 16. Richter wrote the letter on behalf of himself, Lueg, Polke, and Manfred Küttner.

49. Gerhard Richter, Interview with Rolf Schön (1972), in *Gerhard Richter: The Daily Practice of Painting*, 73.

50. Richter, Schön interview, 74.

51. "Artist Interview: Delia Cancela," September 2015, Tate, https://www.tate.org.uk/whats-on/tate-modern/exhibition/ey-exhibition-world-goes-pop/artist-interview/delia-cancela.

52. Mercedes Trelles-Hernández, "Pop Art in

Argentina," in *The World Goes Pop*, ed. Jessica Morgan and Flavia Frigeri (New Haven, CT: Yale University Press, 2015), 105.

53. This description follows Zanna Gilbert, "Mediating Menesundas: Marta Minujín from Informalismo to Media Art," in *Marta Minujín: Menesunda Reloaded*, ed. Helga Christoffersen and Massimiliano Gioni (New York: New Museum, 2019), 15–16.

54. Gilbert, "Mediating Menesundas," 14.

55. Mário Pedrosa, "Do Pop Americano ao Sertanejo Dias" (From American Pop to the Backcountry Days), *Correio da Manhã*, October 29, 1967, quoted in Claudia Calirman, "Pop and Politics in Brazilian Art," in Darsie Alexander with Bartholomew Ryan, *International Pop* (Minneapolis: Walker Art Center, 2015), 122.

56. Frederico Morais, "Wanda Pimentel e a Estética da Solidão," in *Wanda Pimentel: Coleção Artistas Brasileiros: monografias de bolso*, ed. Daniela Labra (Rio de Janeiro: Museu de Arte Contemporânea de Niterói, 2010), n.p., quoted in Calirman, "Pop and Politics in Brazil," 124.

57. My discussion of Shinohara's *Doll Festival* follows Reiko Tomii, "Oiran Goes Pop: Contemporary Japanese Artists Reinventing Icons," in *The World Goes Pop*, 98–99. I am grateful to Hiroko Ikegami for explaining to me the details of Shinohara's technique in creating this work.

58. Ushio Shinohara interviewed by Reiko Tomii,

October 27, 2014, quoted in Tomii, "Oiran Goes Pop," 99.

Chapter 16

1. Irving Sandler, *American Art of the 1960s* (New York: Icon Editions, Harper & Row, 1988), 61.

2. See Sandler, "The Sensibility of the Sixties," chap. 3 in *American Art of the 1960s*.

3. Susan Sontag, "Against Interpretation" (1964), in *Against Interpretation and Other Essays* (New York: Farrar, Straus and Giroux, 1966), 13.

4. "The Medium is the Message" is the title of chapter 1 in Marshall McLuhan, *Understanding Media: The Extensions of Man* (New York: McGraw-Hill, 1964).

5. See Clement Greenberg, "Post-Painterly Abstraction" (1964), in *The Collected Essays and Criticism, Volume 4: Modernism with a Vengeance, 1957–1969*, ed. John O'Brian (Chicago: University of Chicago Press, 1993), 192–96.

6. See Greenberg, "Modernist Painting" (1961), in *Collected Essays and Criticism, Volume 4*, 85–93.

7. Greenberg, "'American-Type' Painting" (1955, revised 1961) in Greenberg, *Art and Culture: Critical Essays* (Boston: Beacon Press, 1961), 226.

8. Greenberg, "Post-Painterly Abstraction," 195.

9. Greenberg, "Louis and Noland" (1960), in *Collected Essays and Criticism, Volume 4*, 97.

10. Helen Frankenthaler quoted in Gene Baro, "The Achievement of Helen Frankenthaler," *Art*

International 2, no. 7 (September 1967): 36.

11. Frankenthaler quoted in E. A. Carmean Jr., *Helen Frankenthaler: A Paintings Retrospective* (New York: Harry N. Abrams in association with Modern Art Museum of Fort Worth, 1989), 36.

12. Frankenthaler, voiceover in Perry Miller Adato, *Frankenthaler—Toward a New Climate*, 1978, *The Originals: Women in Art* series, WNET/Channel 13, DVD, quoted in Alexandra Schwartz, "As in Nature: On Frankenthaler's Painting," in Schwartz, *As in Nature: Helen Frankenthaler Paintings* (Williamstown, MA: Clark Art Institute, 2017), 32.

13. Greenberg, "Louis and Noland," in *Collected Essays and Criticism, Volume 4*, 97.

14. Unidentified viewer quoted in Thomas Wolfe, "Artist's New Technique Goes All Over," *Washington Post*, January 5, 1960.

15. Daniel Wheeler, *Art since Mid-Century: 1945 to the Present* (Englewood Cliffs, NJ: Prentice Hall; New York: Vendome Press, 1991), 194.

16. Jules Olitski, lecture at Hartford Art School, University of Hartford, Connecticut, symposium "Caro, Noland, Olitski," April 1994, unpublished typescript, 25, quoted in Karen Wilkin, "Strange, New, Wonderful," in *Revelation: Major Paintings by Jules Olitski* (Kansas City, MO: Kemper Museum of Contemporary Art, 2011), 117.

17. Jack Bush quoted in Karen Wilkin, "Jack Bush: Not

What It Seems," in Marc Mayer and Sarah Stanners, *Jack Bush* (Ottawa: National Gallery of Canada, 2014), 86.

18. Ian Berry and Lauren Haynes, "Alma Thomas," in *Alma Thomas* (New York: Studio Museum in Harlem; Frances Young Tang Teaching Museum and Art Gallery at Skidmore College; DelMonico Books/Prestel, 2016), 61.

19. Alma Thomas quoted in H. E. Mahal, "Interviews: Four Afro-American Artists: Approaches to Inhumanity," *Art Gallery* 13, no. 7 (April 1970): 37.

20. Lawrence Alloway, introduction to *Systemic Painting* (New York: Solomon R. Guggenheim Museum, 1966), 14. Alloway credited critic Jules Langsner with coining the term Hard Edge for a 1959 exhibition of Southern California geometric abstract art.

21. Alloway, *Systemic Painting*, 14.

22. Ellsworth Kelly quoted in Elizabeth C. Baker, *Ellsworth Kelly: Recent Paintings and Sculptures* (New York: Metropolitan Museum of Art, 1979), 7.

23. Kelly, "Notes of 1969," in *Theories and Documents of Contemporary Art: A Sourcebook of Artists' Writings*, ed. Kristine Stiles and Peter Selz (Berkeley: University of California Press, 1996), 92.

24. Carmen Herrera in conversation with Dana Miller, February 18, 2014, quoted in Miller, "Carmen Herrera: Sometimes I Win," in Miller, *Carmen Herrera: Lines of Sight* (New York: Whitney Museum of American Art, 2016), 28.

25. Leesa K. Fanning, "Engaging the Spiritual in Contemporary Art," in Fanning, *Encountering the Spiritual in Contemporary Art* (Kansas City, MO: Nelson-Atkins Museum of Art, 2018), 94.

26. Agnes Martin, "On the Perfection Underlying Life," in Martin, *Writings*, ed. Dieter Schwarz (Ostfildern, Germany: Cantz, 1991), 67–74.

27. Martin, "What is Real?" *Writings*, 95.

28. Martin, "Notes," *Writings*, 15.

29. Martin, "The Current of the River of Life Moves Us," *Writings*, 135.

30. Martin, letter of May 19, 1975, quoted in Ronald Alley, *Catalogue of the Tate Gallery's Collection of Modern Art other than Works by British Artists* (London: Tate Gallery and Sotheby Parke-Bernet, 1981), 488.

31. Martin quoted in "Agnes Martin Interviewed by Irving Sandler," *Art Monthly* 169 (September 1993): 3.

32. Frank Stella, "The Pratt Lecture" (1960), in Brenda Richardson with Mary Martha Ward, *Frank Stella: The Black Paintings* (Baltimore: Baltimore Museum of Art, 1976), 78.

33. Stella, "Pratt Lecture," 78.

34. Carl Andre, "Preface to Stripe Painting," in *Sixteen Americans*, ed. Dorothy C. Miller (New York: Museum of Modern Art, 1959), 76.

35. Stella quoted in William S. Rubin, *Frank Stella* (New York: Museum of Modern Art, 1970), 44.

36. Stella quoted in "Questions to Stella and Judd" (1964), interview by Bruce Glaser, edited by Lucy Lippard, *ARTnews* 65, no. 5 (September 1966): 55–61, reprinted in *Minimal Art: A Critical Anthology*, ed. Gregory Battcock (New York: E. P. Dutton, 1968), 158. Italics in the original.

37. Anthony Caro quoted in William Rubin, *Anthony Caro* (New York: Museum of Modern Art, 1975), 99.

38. Cyril Barrett, *An Introduction to Optical Art* (London: Studio Vista, 1971), 28.

39. Victor Vasarely quoted in Barrett, *Introduction to Optical Art*, 28.

40. Vasarely, untitled statement (1969), in *Vasarely*, trans. I. Mark Paris (New York: Alpine Fine Arts Collection, 1979), n.p.

41. Bridget Riley, "Working with Nature" (1977), in *The Eye's Mind: Bridget Riley Collected Writings 1965–2009*, ed. Robert Kudielka (London: Ridinghouse, 2009), 110.

42. Jesús Rafael Soto quoted in Barrett, *Introduction to Optical Art*, 62.

43. Soto quoted in *World Artists 1980–1990*, ed. Claude Marks (New York: H. W. Wilson, 1991), 367.

44. Naum Gabo and Anton Pevsner, "The Realistic Manifesto" (1920), in *Russian Art of the Avant-Garde: Theory and Criticism*, new ed., ed. and trans. John E. Bowlt (New York: Thames & Hudson, 2017), 214.

45. See Estrellita B. Brodsky, "Julio Le Parc: Form into Action," in Brodsky, *Julio Le Parc: Form into Action* (Miami: Pérez Art Museum Miami and Delmonico Books/Prestel, 2016), 11–29.

46. Richard Wollheim, "Minimal Art," *Arts Magazine* 39, no. 4 (January 1965): 26–32, reprinted in Battcock, *Minimal Art*, 387.

47. Barbara Rose, "ABC Art," *Art in America* 53, no. 5 (October-November 1965): 57–69, reprinted in Battcock, *Minimal Art*, 291.

48. Donald Judd, "Specific Objects," *Arts Yearbook* 8 (1965): 74–82, reprinted in Judd, *Complete Writings, 1959–1975: Gallery Reviews, Book Reviews, Articles, Letters to the Editor, Reports, Statements, Complaints* (Halifax: Press of the Nova Scotia College of Art and Design, 1975), 182.

49. Judd, "In the Galleries: Kenneth Noland," *Arts Magazine* 37, no. 10 (September 1963): 53–54, reprinted in Judd, *Complete Writings*, 93.

50. Judd, "Specific Objects," *Complete Writings*, 183.

51. Judd, "Specific Objects," 187.

52. Robert Morris, "Notes on Sculpture, Part I," *Artforum* 4, no. 6 (February 1966): 42–44, reprinted in Battcock, *Minimal Art*, 226.

53. Morris, "Notes on Sculpture, Part II," *Artforum* 5, no. 2 (October 1966): 20–23, reprinted in Battcock, *Minimal Art*, 232.

54. Michael Fried, "Art and Objecthood," *Artforum* 5, no. 10 (June 1967): 12–23, revised version in Battcock, *Minimal Art*, 146. Italics in the original.

55. Fried, "Art and Objecthood," 127. Italics in the original.

56. Fried, "Art and Objecthood," 140. Italics in the original.

57. Anna C. Chave, "Minimalism and the Rhetoric of Power," *Arts Magazine* 64, no. 5 (January 1990): 44.

58. Donald Judd quoted in John Coplans, "An Interview with Don Judd," *Artforum* 9, no. 10 (June 1971): 44.

59. Judd, Coplans interview, 45.

60. Judd, Coplans interview, 45.

61. Judd, "Specific Objects," *Complete Writings*, 184.

62. Morris, "Notes on Sculpture, Part I," in Battcock, *Minimal Art*, 226.

63. David Bourdon, "A Redefinition of Sculpture," in *Carl Andre: Sculpture 1959–1977* (New York: Jaap Rietman, 1978), 21.

64. Carl Andre quoted in David Bourdon, "The Razed Sites of Carl Andre," *Artforum* 5, no. 2 (October 1966): 15.

65. Andre quoted in Bourdon, "Razed Sites of Carl Andre," 15.

66. Andre quoted in Philip Leider, "To Introduce a New Kind of Truth," *New York Times*, May 25, 1969.

67. Anne Truitt quoted in Victoria Dawson, "Anne Truitt and the Color of Truth," *Washington Post*, March 14, 1987.

68. Truitt quoted in Eleanor Munro, *Originals: American Women Artists* (New York: Simon & Schuster, 1979), 324.

69. Robert Irwin quoted in Lawrence Weschler, *Seeing Is Forgetting the Name of the Thing One Sees* (Berkeley: University of California Press, 1982), 107.

70. Irwin's definitions of "working categories for public/site art" are "site dominant," "site adjusted," "site specific," and "site conditioned/determined." See Robert Irwin, "Introduction: *Change, Inquiry, Qualities, Conditional*," in *Being and Circumstance: Notes Toward a Conditional Art* (Larkspur Landing, CA: Lapis Press, 1985), 26–27.

71. Irwin quoted in "Gardens," Getty, https://www.getty.edu/visit/center/top-things-to-do/gardens/.

72. Irwin, "Introduction," *Being and Circumstance*, 29.

73. James Turrell quoted in Julia Brown, "Interview with James Turrell," in *Occluded Front: James Turrell*, ed. Brown (Los Angeles: Fellows of Contemporary Art and Lapis Press, 1985), 22.

74. Turrell, Brown interview, 43.

75. Turrell quoted in Richard Whittaker, "Greeting the Light: An Interview with James Turrell," *Works & Conversations*, March 22, 1999, www.conversations.org/story.php?sid=32.

76. Turrell quoted in Julie L. Belcove, "Incredible Lightness: Pace Artist James Turrell Prepares for Superstardom," *Harper's Bazaar*, April 19, 2013, www.harpersbazaar.com/culture/features/g2667/james-turrell-interview-0513/?slide=1.

77. Turrell, "Structural Cuts & Skyspaces," in *James Turrell: Light & Space* (New York: Whitney Museum of American Art, 1980), 33.

Chapter 17

1. This discussion is indebted to the entry on "Rationalism," in James Stevens Curl and Susan Wilson, *A Dictionary of Architecture and Landscape Architecture*, 3rd ed. (Oxford: Oxford University Press, 2015).

2. Le Corbusier adapted the pseudonym from his maternal grandfather's surname, Lecorbésier. He may have intended it to evoke *le corbeau*, French for "the crow."

3. Le Corbusier, *Toward an Architecture*, trans. John Goodman (Los Angeles: Getty Research Institute, 2007), 87.

4. Le Corbusier, *Toward an Architecture*, 102.

5. Le Corbusier and Pierre Jeanneret, "Five Points towards a New Architecture," *Almanach de l'Architecture moderne* (Paris, 1926), in *Programmes and Manifestoes on 20th-Century Architecture*, ed. Ulrich Conrads, trans. Michael Bullock (Cambridge, MA: MIT Press, 1970), 99–101.

6. Marvin Trachtenberg and Isabelle Hyman, *Architecture: From Prehistory to Postmodernity*, 2nd ed. (New York: Harry N. Abrams; Upper Saddle River, NJ: Prentice-Hall, 2002), 502.

7. Trachtenberg and Hyman, *Architecture*, 2nd ed., 502.

8. Le Corbusier, "The Plan of the Modern House" (1929), in *Precisions on the Present State of Architecture and City Planning* (Cambridge, MA: MIT Press, 1991), 136.

9. Le Corbusier and Pierre Jeanneret, *Oeuvre Complète Volume 2, 1929–1934* (Zurich: Les Éditions d'Architecture, 1946), 24.

10. Le Corbusier, "The Plan of the Modern House," 139.

11. Nicole Sully, "Modern Architecture and Complaints about the Weather, or, 'Dear Monsieur Le Corbusier, It is still raining in our garage. …'" *M/C Journal: A Journal of Media and Culture* 12, no. 4 (2009), http://journal.media-culture.org.au/index.php/mcjournal/article/view/172.

12. See Despina Stratigakos, *Where Are the Women Architects?* (Princeton, NJ: Princeton University Press, 2016).

13. Eileen Gray quoted in Peter Adam, *Eileen Gray: Architect/Designer—A Biography*, rev. ed. (New York: Harry N. Abrams, 2000), 309.

14. Eileen Gray and Jean Badovici, "Maison en bord de mer" (House by the Sea), *L'Architecture Vivante* (Winter 1929), trans. and reprinted in Caroline Constant, *Eileen Gray* (London: Phaidon, 2000), 239.

15. Henry-Russell Hitchcock and Philip Johnson, *The International Style*, 3rd ed. (New York: W. W. Norton, 1995), 36. This is the third edition of a book originally published as *The International Style: Architecture since 1922* (New York: W. W. Norton, 1932).

16. Hitchcock and Johnson, *The International Style*, 3rd ed., 36.

17. Hitchcock and Johnson, *The International Style*, 3rd ed., 36.

18. Alfred H. Barr Jr., "Foreword," *Modern Architecture: International Exhibition, New York Feb. 10 to March 23, 1932* (New York: Museum of Modern Art, 1932), 15.

19. Trachtenberg and Hyman, *Architecture*, 2nd ed., 489.

20. Bruno Taut, "The City Crown" (1919), trans. Ulrike Altenmüller and Matthew Mindrup, *Journal of Architectural Education* 63, no. 1 (2009): 131, 132.

21. See Kathleen James, "Expressionism, Relativity, and the Einstein Tower," *Journal of the Society of Architectural Historians* 53, no. 4 (December 1994): 392–413.

22. Frank Lloyd Wright, "Of Thee I Sing," *Shelter* 2 (April 1932): 10–12, quoted in Neil Levine, "Abstraction and Representation: The International Style of Frank Lloyd Wright," *AA Files* 11 (Spring 1986): 3.

23. Frank Lloyd Wright, "Broadacre City: A New Community Plan," *Architectural Record* 77 (April 1935), reprinted in *The City Reader*, 5th ed., ed. Richard T. LeGates and Frederick Stout (London: Routledge, 2011), 350.

24. First used in the late nineteenth century, "Usonian" refers to a citizen of the United States of North America, or Usona. The term acknowledges that using "America" to denote only the hemisphere's dominant country excludes all the other nations of North and South America.

25. Frank Lloyd Wright quoted by Byron Keeler Mosher in a letter to Donald Hoffmann, January 20, 1974, quoted in Hoffmann, *Frank Lloyd*

Wright's *Fallingwater: The House and Its History* (New York: Dover, 1978), 17.

26. Frank Lloyd Wright, *An Autobiography* (New York: Duell, Sloan and Pearce, 1943), 472.

27. Robert McCarter, *Frank Lloyd Wright* (London: Reaktion, 2006), 139.

28. Philip Johnson quoted in "Last Monument," *Time*, November 2, 1959, 67.

29. Hilton Kramer, "Month in Review," *Arts* 34, no. 3 (December 1959): 48.

30. Alvar Aalto, "The Humanizing of Architecture" (1940), in *Alvar Aalto in His Own Words*, ed. Göran Schildt (New York: Rizzoli, 1998), 103.

31. Text in the Alvar Aalto Archive, c. 1949, quoted in Richard Weston, *Alvar Aalto* (London: Phaidon, 1995), 137.

32. IV International Congress for Modern Architecture, Charter of Athens (1933), Cultural Heritage Policy Documents, Getty Research Institute, https:// www.getty.edu/conservation/publications_resources/research_resources/ charters/charter04.html.

33. Le Corbusier, *Textes et Dessins pour Ronchamp* (Paris: Editions Forces Vives, 1965), quoted in *Le Corbusier: Architect of the Century* (London: Arts Council of Great Britain, 1987), 249.

34. Jawaharlal Nehru, on his visit to the Chandigarh project on April 2, 1952, quoted in *History, Religion and Culture of India*, ed. S. Gajrani (Delhi: Isha Books, 2004), 4:3.

35. Mies van der Rohe, "The Office Building" (1923), in Philip C. Johnson, *Mies van der Rohe* (New York: Museum of Modern Art, 1947), 183.

36. Mies van der Rohe, "The H. House, Magdeburg," *Die Schildgenossen* 14, no. 6 (1935), quoted in Ransoo Kim, "The Tectonically Defining Space of Mies van der Rohe," *arq: Architectural Research Quarterly* 13, no.3/4 (2009): 251.

37. This statement appears in a drawing by Louis Kahn accompanying his lecture "Architecture: Silence and Light" (1969), illustrated in Robert McCarter, *Louis I. Kahn* (London: Phaidon, 2005), 478.

38. Louis Kahn, "Monumentality" (1944), in McCarter, *Louis I. Kahn*, 455.

39. Kahn, "Architecture: Silence and Light" (1969), in McCarter, *Louis I, Kahn*, 472.

40. John Lobell, *Between Silence and Light: Spirit in the Architecture of Louis I. Kahn*, 2nd ed. (Boston: Shambhala, 2008), 94.

41. Margaret M. Grubiak, *Monumental Jesus: Landscapes of Faith and Doubt in Modern America* (Charlottesville: University of Virginia Press, 2020), 36.

42. "I am not attracted to straight angles or to the straight line, hard and inflexible, created by man. I am attracted to freeflowing, sensual curves. The curves that I find in the mountains of my country, in the sinuousness of its rivers, in the waves of the ocean, and on the body of the beloved woman. Curves make up the entire Universe, the curved Universe of Einstein," Oscar Niemeyer, *The Curves of Time: The Memoirs of Oscar Niemeyer* (London: Phaidon, 2000), n.p.

43. Oscar Niemeyer quoted in Michael Kimmelman, "The Last of the Moderns," *New York Times Magazine*, May 15, 2005, https://www.nytimes.com/2005/05/15/ magazine/the-last-of-the-moderns.html.

44. Hyunjung Cho, "Hiroshima Peace Memorial Park and the Making of Japanese Postwar Architecture," *Journal of Architectural Education* 66, no. 1 (2012): 78.

45. Constant quoted in Catherine de Zegher's introduction to *The Activist Drawing: Retracing Situationist Architectures from Constant's New Babylon to Beyond*, ed. de Zegher and Mark Wigley (New York: Drawing Center; Cambridge, MA: MIT Press, 2001), 9.

Chapter 18

1. Jawaharlal Nehru, "A Tryst with Destiny," August 14, 1947, The Guardian, https://www.theguardian.com/theguardian/2007/ may/01/greatspeeches.

2. This is Susan S. Bean's reading of *Man*, in *Midnight to the Boom: Painting in India after Independence from the Peabody Essex Museum's Herwitz Collection* (New York: Thames & Hudson in association with Peabody Essex Museum, 2013), 86.

3. F. N. Souza, *Words and Lines*, 2nd ed. (New Delhi: Nitin Bhayana, 1997), 8, 10.

4. Sayed Haider Raza and Ashok Vajpeyi, *Passion: The Art and Life of Raza* (New Delhi: Rajkamal Books, 2005), 61, quoted in Bean, *Midnight to the Boom*, 105.

5. K. G. Subramanyam, *Moving Focus: Essays on Indian Art* (New Delhi: Lalit Kala Akademi, 2006), 110, quoted in Devika Singh, "Indian Art and the Bangladesh War," *Third Text* 31, no. 2–3 (2017): 468.

6. Roobina Karode, "Waiting Is a Part of Intense Living," in *Nasreen Mohamedi: Waiting Is a Part of Intense Living* (Madrid: Museo Nacional Centro de Arte Reina Sofia, 2015), 18.

7. This overview is indebted to Chika Okeke-Agulu, "Africa: Modern African Art," *Grove Art Online*, 2003, https://wwwoxfordartonline-com. www2.lib.ku.edu/ groveart/view/10.1093/ gao/9781884446054. 001.0001/oao-9781884446054-e-60000100082.

8. My reading of *Anyanwu* follows that of Sylvester Okwunodu Ogbechie, *Ben Enwonwu: The Making of an African Modernist* (Rochester, NY: University of Rochester Press, 2008), 128–31.

9. See Uche Okeke, "Natural Synthesis" (1960), in *Seven Stories about Modern Art in Africa*, ed. Clémentine Deliss (London: Whitechapel Art Gallery, 1995), 208–09.

10. See Henry Glassie, "An Abiku Child," chap. 4 in *Prince Twins Seven-Seven: His Art, His Life in Nigeria, His Exile in America* (Bloomington: Indiana University Press, 2010), see esp. 63–70.

11. Caption by Youssouf Tata Cissé in *Seydou Keïta*, ed.

André Magnin (Zurich: Scalo, 1997), 273.

12. References to Ethiopian names follow the country's practice of using only the personal name. In Ethiopia, people's names consist of a personal name followed by their father's personal name; there are no surnames.

13. Tritobia H. Benjamin, "Skunder Boghossian: A Different Magnificence," *African Arts* 5, no. 2 (Summer 1972): 23.

14. Mrs. K. M. [Margaret] Trowell, "Modern African Art in East Africa," *Man* 47 (January 1947): 5.

15. Frank McEwen quoted in Sidney Littlefield Kasfir, *Contemporary African Art* (London: Thames & Hudson, 1999), 69.

16. I am grateful to my colleague Jessica Gerschultz for this suggestion regarding the traditional African source of the decorative pattern painted by Stern.

17. Joseph Sachs, *Irma Stern and the Spirit of Africa* (Pretoria, South Africa: J. L. Van Schalk, 1942), 51, 55, quoted in Claudia B. Braude, "Beyond Black and White: Rethinking Irma Stern," *Focus: Journal of the Helen Suzman Foundation*, 61 (June 2011): 57–58.

18. John Peffer, *Art and the End of Apartheid* (Minneapolis: University of Minnesota Press, 2009), 42.

19. Peffer, *Art and the End of Apartheid*, 48.

20. Chika Okeke-Agulu, "Politics by Other Means: Two Egyptian Artists, Gazbia Sirry and Ghada Amer," *Nka:*

Journal of Contemporary African Art 25 (Winter 2009): 14.

21. My discussion of twentieth-century Iraqi art is indebted to Ulrike al-Khamis, "An Historical Overview 1900s-1990s," in *Strokes of Genius: Contemporary Iraqi Art*, ed. Maysaloun Faraj (London: Saqi Books, 2001), 21–32.

22. Suheylah Takesh, "Introduction: 'No Longer a Horizon, but Infinity,'" in *Taking Shape: Abstraction from the Arab World, 1950s-1980s*, ed. Sukeyla Takesh and Lynn Gumpert (New York: Grey Art Gallery, New York University; Munich: Hirmer, 2020), 22.

23. Wijdan Ali, *Modern Islamic Art: Development and Continuity* (Gainesville: University Press of Florida, 1997), 168–69.

24. Ali, *Modern Islamic Art*, 169.

25. Parviz Tanavoli quoted in Sholeh Johnston, "Heech, Poems in Three Dimensions: Parviz Tanavoli's Sculptures of Nothingness," *Sufi* 82 (Winter 2012): 34–35.

26. Monir Shahroudy Farmanfarmaian and Zara Houshmand, *A Mirror Garden: A Memoir* (New York: Anchor Books, 2007), 186.

27. Suzanne Cotter, "Begin, Begin Again. Progressions of an Artist," in *Monir Shahroudy Farmanfarmaian—Infinite Possibility: Mirror Works and Drawings 1974–2015*, ed. Cotter (Porto, Portugal: Museu de Arte Contemporânea de Serralves, 2014), 20.

28. Anna Ticho, letter to a friend, quoted in Irit Salmon, "Anna Ticho," *Shalvi/Hyman Encyclopedia of Jewish Women*, December 31, 1999. Jewish Women's Archive, https://jwa.org/encyclopedia/article/ticho-anna.

29. Yigal Zalmona, *A Century of Israeli Art* (Farnham, UK: Lund Humphries in association with Israel Museum, Jerusalem, 2013), 175.

Chapter 19

1. Robert Morris, "Anti Form," *Artforum* 6, no. 8 (April 1968): 33–35.

2. Morris, "Anti Form," 35.

3. Morris, "Anti Form," 35.

4. Maurice Berger, *Labyrinths: Robert Morris, Minimalism, and the 1960s* (New York: Harper & Row, 1989), 74.

5. Eva Hesse quoted in Cindy Nemser, "A Conversation with Eva Hesse" (1970), in *Eva Hesse*, ed. Mignon Nixon (Cambridge, MA: MIT Press, 2002), 7.

6. Lucy Lippard, *Eva Hesse* (New York: New York University Press, 1976), 83.

7. Hesse, Nemser interview, 7.

8. Hesse, Nemser interview, 11.

9. Hesse, Nemser interview, 18.

10. Lynda Benglis, interview by Ned Rifkin, in Lynn Gumpert, Ned Rifkin, and Marcia Tucker, *Early Work* (New York: New Museum, 1982), 11.

11. Roberta Smith, "Conceptual Art," in *Concepts of Modern Art: From Fauvism to Postmodernism*, ed. Nikos Stangos (London:

Thames & Hudson, 1994), 256.

12. Smith, "Conceptual Art," 256.

13. Henry Flynt, "Concept Art," in La Monte Young, comp., *An Anthology of Chance Operations* (New York: La Monte Young and Jackson Mac Low, 1963) n.p.

14. Sol LeWitt, "Paragraphs on Conceptual Art," *Artforum* 5, no. 10 (Summer 1967): 83.

15. See Lucy Lippard, *Six Years: The Dematerialization of the Art Object from 1966 to 1972* (New York: Praeger, 1973).

16. Quoted in Lippard, *Six Years*, 98.

17. Quoted in Lippard, *Six Years*, 37.

18. Douglas Huebler, catalogue statement, *January 5–31, 1969* (New York: Seth Siegelaub, 1969), quoted in Lippard, *Six Years*, 74.

19. LeWitt, "The Cube," in *Sol LeWitt*, ed. Alicia Legg (New York: Museum of Modern Art, 1978), 172. The MoMA catalogue indicates incorrectly that LeWitt's statement was published in *Art in America* (Summer 1966). Instead, it appears to be a variant of his untitled statement about the square and the cube published in Lucy R. Lippard, "Homage to the Square," *Art in America* 55, no. 4 (July-August 1967): 54.

20. LeWitt, "Paragraphs on Conceptual Art," 80.

21. LeWitt, "Paragraphs on Conceptual Art," 80

22. Joseph Kosuth quoted in Ronald Alley, *Catalogue of the Tate Gallery Collection*

of *Modern Art Other than Works by British Artists* (London: Tate Gallery in association with Sotheby Parke Bernet, 1981), 400.

23. Joseph Kosuth, "Art as Idea as Idea: An Interview with Jeanne Siegel" (1970), in Kosuth, *Art after Philosophy and After: Collected Writings, 1966–1990* (Cambridge, MA: MIT Press, 1991) 47.

24. Kosuth, "Introduction to *Art-Language* by the American Editor" (1970), in *Art after Philosophy and After*, 39.

25. Cildo Meireles, interview by Gerardo Mosquera, in Paulo Herkenhoff, Gerardo Mosquera, and Dan Cameron, *Cildo Meireles* (London: Phaidon, 1999), 13.

26. Charissa N. Terranova, "Performing the Frame: Daniel Buren, Degree Zero Painting and a Politics of Beauty," Stretcher, n.d., https://www.stretcher.org/projects/symposia/performingtheframe.html.

27. Marcel Broodthaers, "Section des Figures," in *Der Adler vom Oligozän bis heute* (Düsseldorf: Städtische Kunsthalle, 1972), II: 18, quoted in Anne Rorimer, *New Art in the 60s and 70s: Redefining Reality* (London: Thames & Hudson, 2001), 241.

28. Bernd and Hilla Becher, "Anonyme Skulpturen," *Kunst-Zeitung*, no. 2, ed. Hans Kirschbaum and Eugen Michel (Düsseldorf: Verlag Michelpresse, 1969), n.p, quoted in Armin Zweite, "Bernd and Hilla Becher's 'Suggestion for a Way of Seeing': Ten Key Ideas,"

in *Bernd and Hilla Becher: Typologies*, ed. Zweite (Cambridge, MA: MIT Press, 2004), 10.

29. Germano Celant, *Art Povera* (New York: Praeger, 1969), 225.

30. Germano Celant, *Michelangelo Pistoletto* (New York: Rizzoli, 1988), 26.

31. Thomas McEvilley, "Mute Prophecies: The Art of Jannis Kounellis," in Mary Jane Jacob, *Jannis Kounellis* (Chicago: Museum of Contemporary Art, 1986), 52.

32. Mario Merz, quoted in interview with Jean-Christophe Amman and Suzanne Pagé, in *Mario Merz* (Paris: ARC/Musée d'Art Moderne de la Ville de Paris; Basle: Kunsthalle, 1981), n.p.

33. Nancy Spector, "Biography," in Germano Celant, *Mario Merz* (New York: Solomon R. Guggenheim Museum; Milan: Electa, 1989), 252.

34. Spector, "Biography," 252.

35. Lee Ufan, "World and Structure—Collapse of the Object (Thoughts on Contemporary Art)" (1969), trans. Stanley N. Anderson, in Alexandra Munroe, *Lee Ufan: Marking Infinity* (New York: Guggenheim Museum Publications, 2011), 110.

36. Lee Ufan, "Beyond Being and Nothingness: On Sekine Nobuo [excerpts]" 1970, in Munroe, *Lee Ufan*, 112.

37. Alexandra Munroe, "Stand Still a Moment," *Lee Ufan*, 22.

38. Lee Ufan, "In Search of Encounter: The Sources of Contemporary Art" (1970), in Munroe. *Lee Ufan*, 113.

39. Robert Smithson, "The Spiral Jetty" (1972), in *Robert Smithson: The Collected Writings*, ed. Jack Flam (Berkeley: University of California Press, 1996), 152–53.

40. Robert Morris, "American Quartet," *Art in America* 62, no. 12 (December 1981): 96.

41. Joseph Masheck, "The Panama Canal and Some Other Works of Work," *Artforum* 4, no. 9 (May 1971): 41.

42. Richard Long, "Words After the Fact" (1982), in Richard Long, *Selected Statements and Interviews*, ed. Ben Tufnell (London: Haunch of Venison, 2007), 27.

43. Walter De Maria, "The Lightning Field," *Artforum* 18, no. 8 (April 1980): 52.

44. Nancy Holt, "Sun Tunnels," *Artforum* 15, no. 8 (April 1977): 34.

45. Holt, "Sun Tunnels," 35.

46. Christo, excerpt from "Dialogue," an unpublished interview conducted by Ching-Yu Chang with Cesar Pelli and Christo, 1979, in *American Artists on Art: From 1940 to 1980*, ed. Ellen H. Johnson (New York: Harper & Row, 1982), 197.

47. Jeanne-Claude, interview with Christo and Jeanne-Claude in New York conducted by Alan Hilliker (Egon Zehnder International, New York) and Ulrike Mertens, for *The Focus* 12, no. 2 (n.d.): 32, https://www.egonzehnder.com/insight/interview-with-artists-christo-and-jeanne-claude.

48. Jaune-Claude, Hilliker and Mertens interview.

49. Christo quoted in Howard Kaplan, "Christo and Jeanne-Claude: On the Making of the Running Fence," *Eye Level* (blog), Smithsonian American Art Museum, April 1, 2010, https://americanart.si.edu/blog/eye-level/2010/01/936/christo-and-jeanne-claude-making-running-fence.

50. Gordon Matta-Clark quoted in Donald Wall, "Gordon Matta-Clark's Building Dissections," *Arts Magazine* 50, no. 9 (May 1976): 76.

51. Matta-Clark in Wall, "Gordon Matta-Clark's Building Dissections," 76.

52. Lucy Lippard, "The Angry Month of March," *Village Voice*, March 25, 1981, 91, quoted in Robert Nickas's introduction to *The Art of Performance: A Critical Anthology*, ed. Gregory Battcock and Robert Nickas (New York: E. P. Dutton, 1984), xiii.

53. George quoted in Daniel Farson, *With Gilbert and George in Moscow* (London: Bloomsbury, 1991), 33.

54. Vito Acconci quoted in "Tapes with Liza Béar: The *Avalanche* Interview" (1972), in Frazer Ward, Mark C. Taylor, and Jennifer Bloomer, *Vito Acconci* (London: Phaidon, 2002), 95.

55. Acconci, *Avalanche* interview, *Vito Acconci*, 98.

56. Kate Linker, *Vito Acconci* (New York: Rizzoli, 1994), 44.

57. Matthew Teti, "Occupying UCI: Chris Burden's Five Day Locker Piece as Institutional Critique," *RACAR: Revue d'art canadienne/Canadian Art*

Review 43, no. 1 (2018): 39–52.

58. Chris Burden quoted in Måns Wrange, "A Conversation with Chris Burden," in *Chris Burden* (Stockholm: Magasin 3 Stockholm Konsthall, 1999), n.p.

59. Mary Richards, *Marina Abramović* (London: Routledge, 2010), 86.

60. Duane Hanson quoted in Colin Naylor and Genesis P-Orridge, *Contemporary Artists* (London: Saint James' Press, 1977), 384.

61. Philip Guston, "Talk at 'Art/Not Art?' Conference" (1978) in *Philip Guston: Collected Writings, Lectures, and Conversations*, ed. Clark Coolidge (Berkeley: University of California Press, 2011), 282.

62. Linda Nochlin, "Why Have There Been No Great Women Artists?" *ARTnews* 69, no. 9 (January 1971): 22–39, 67–71.

63. Moira Roth, "Visions and Revisions: Rosa Luxemburg and the Artist's Mother," *Artforum* 19, no. 3 (November 1980): 38.

64. See Julia Bryan-Wilson, "Queerly Made: Harmony Hammond's Floorpieces," *Journal of Modern Craft* 2, no. 1 (2009): 59–79.

65. Judy Chicago, *The Dinner Party: A Symbol of Our Heritage* (Garden City, NY: Anchor/Doubleday, 1979), 12.

66. Chicago, *The Dinner Party*, 11.

67. Chicago, *The Dinner Party*, 12.

68. Judy Chicago and Miriam Schapiro, "Female Imagery," *Womanspace Journal* 1 (Summer 1973): 14.

69. April Kingsley, "The I-Hate-To-Cook 'Dinner Party,'" *Ms.*, June 1979, 31, quoted in Gail Levin, *Becoming Judy Chicago: A Biography of the Artist* (New York: Harmony, 2007), 311.

70. Miriam Schapiro and Melissa Meyer, "Waste Not Want Not: An Inquiry into What Women Saved and Assembled—FEMMAGE," *Heresies* 1, no. 4 (Winter 1977–78): 66–69, reprinted in *Theories and Documents of Contemporary Art: A Sourcebook of Artists' Writings*, ed. Kristine Stiles and Peter Selz (Berkeley: University of California Press, 1996), 151–54.

71. Laura Mulvey, "Visual Pleasure and Narrative Cinema" (1975), in Mulvey, *Visual and Other Pleasures* (Bloomington: Indiana University Press, 1989), 19.

72. Hannah Wilke quoted in Avis Berman, "A Decade of Progress, But Could a Female Chardin Make a Living?" *ARTnews* 79, no. 8 (October 1980): 77.

73. Carolee Schneemann, *More Than Meat Joy: Complete Performance Works and Selected Writings*, ed. Bruce McPherson (New Paltz, NY: Documentext, 1979), 234.

74. Carolee Schneemann, *Cezanne, She Was a Great Painter* (New Paltz, NY: Tresspuss Press, 1975), 24. Italics in the original.

75. Schneemann, *More Than Meat Joy*, 238–39.

76. Schneemann, *More Than Meat Joy*, 234.

77. Ana Mendieta, unpublished statement, 1981, quoted in *Ana Mendieta: A Retrospective*, Petra Barreras del Rio and John Perreault, curators (New York: New Museum of Contemporary Art, 1987), 10.

78. Mendieta, unpublished statement, *Ana Mendieta*, 10.

79. Ana Mendieta, interview by Linda M. Montano, in Montano, comp., *Performance Artists Talking in the Eighties* (Berkeley: University of California Press, 2000), 396.

80. *Betye Saar: In Service, a Version of Survival* (New York: Michael Rosenfeld Gallery, 2000), 3, quoted in *Betye Saar: Extending the Frozen Moment* (Ann Arbor: University of Michigan Museum of Art in association with University of California Press, 2005), 86.

81. Fritz Scholder quoted in Lynne Bundesen Waugh, "The Artistry of the Indian," *Chicago Tribune*, February 25, 1973.

82. Harry Gamboa Jr., "In the City of Angels, Chameleons, and Phantoms: Asco, a Case Study of Chicano Art in Urban Tones (or, Asco Was a Four-Member Word)" (1991) in *Urban Exile: Collected Writings of Harry Gamboa, Jr.*, ed. Chon A. Noriega (Minneapolis: University of Minnesota Press, 1998), 124.

83. Gronk quoted in Steven Durland and Linda Burnham, "Gronk," *High Performance* 35, vol. 9, no. 3 (1986): 57.

84. Tomás Ybarra-Frausto, "Rasquachismo: A Chicano Sensibility," in *Chicano Art: Resistance and Affirmation, 1965–1985*, ed. Richard Griswold del Castillo, Teresa McKenna, and Yvonne Yarbro-Bejarano (Los Angeles: Wight Art Gallery, University of California, Los Angeles, 1991), 157.

Chapter 20

1. Christos M. Joachimides, "A New Spirit in Painting," in *A New Spirit in Painting*, ed. Christos M. Joachimides, Norman Rosenthal, and Nicholas Serota (London: Royal Academy of Arts, 1981), 14.

2. Achille Bonito Oliva, *Avanguardia Transavanguardia* (Milan: Electa, 1982), 149.

3. Julian Schnabel, telephone conversations with the author, October 18 and 19, 2022.

4. David Salle quoted in Peter Schjeldahl, "David Salle Interview," *LAICA Journal*, no. 30 (September-October 1981): 22, quoted in Irving Sandler, *Art of the Postmodern Era: From the Late 1960s to the Early 1990s* (New York: HarperCollins, 1996), 236.

5. Eric Fischl quoted in Avis Berman, "Artist's Dialogue: Eric Fischl, Trouble in Paradise," *Architectural Digest* 42, no. 12 (December 1985): 76.

6. Bonito Oliva, *Avanguardia Transavanguardia*, 149.

7. Roland Barthes, "The Death of the Author" (1968), in Barthes, *Image-Music-Text*, trans. Stephen Heath (New York: Hill and Wang, 1977), 146.

8. Gerhard Richter quoted in "Conversation with Jan Thorn Prikker Concerning the Cycle *18 October 1977*" (1989) in Richter,

The Daily Practice of Painting: Writings and Interviews 1962–1993, ed. Hans-Ulrich Obrist, trans. David Britt (Cambridge, MA: MIT Press; London: Anthony d'Offay Gallery, 1995), 193.

9. Richter, conversation with Thorn Prikker, *Daily Practice of Painting*, 194.

10. Richter, Notes (1988), in *Daily Practice of Painting*, 170.

11. Terry Smith, *Contemporary Art: World Currents* (Upper Saddle River, NJ: Prentice Hall, 2011), 85.

12. "Artist Interview: Vitaly Komar and Alexander Melamid," September 2015, Tate, https://www.tate.org.uk/whats-on/tate-modern/world-goes-pop/artist-interview/vitaly-komar-and-alexander-melamid.

13. Ilya Kabakov, "Foreword," in *Primary Documents: A Sourcebook for Eastern and Central European Art since the 1950s*, ed. Laura Hoptman and Tomáš Pospiszyl (New York: Museum of Modern Art, 2002), 8.

14. Kabakov, text accompanying *The Man Who Flew into Space from His Apartment*, quoted in Amei Wallach, *Ilya Kabakov: The Man Who Never Threw Anything Away* (New York: Harry N. Abrams, 1996), 196.

15. Kim Levin, "The Times Square Show," *Arts Magazine* 55, no. 1 (September 1980): 87.

16. Keith Haring, *Art in Transit: Subway Drawings by Keith Haring* (New York: Harmony Books, 1984), n.p.

17. Jean-Michel Basquiat in conversation with Robert Farris Thompson, early March 1987, quoted in Thompson, "Royalty, Heroism, and the Streets: The Art of Jean-Michel Basquiat," in Richard Marshall, *Jean-Michel Basquiat* (New York: Whitney Museum of American Art, 1992), 32.

18. David Hammons quoted in Maurice Berger, "Interview with David Hammons," *Art in America* 78, no. 9 (September 1990): 80.

19. Hammons quoted in Douglas C. McGill, "Art People," *New York Times*, July 18, 1986.

20. Greg Tate, "Dark Angels of Dust: David Hammons and the Art of Streetwise Transcendentalism," *Art in the Streets*, organized by Jeffrey Deitch (New York: Skira Rizzoli in association with Museum of Contemporary Art, Los Angeles, 2011), 114.

21. John P. Bowles, "Adrian Piper as African American Artist," *American Art* 20, no. 3 (Fall 2006): 113.

22. Adrian Piper, "Cornered: A Video Installation Project" (1992), in *Theory in Contemporary Art since 1985*, ed. Zoya Kocur and Simon Leung (Malden, MA: Blackwell, 2005), 182.

23. Piper, "Cornered," 183.

24. Piper, "Cornered," 184.

25. Piper, "Cornered," 186.

26. Piper quoted in Maurice Berger, "Interview with Adrian Piper," in *Art, Activism, and Oppositionality: Essays from Afterimage*, ed. Grant H. Kester (Durham, NC: Duke University Press, 1998), 217.

27. Douglas Crimp, "Pictures," exhibition catalogue essay, Artists Space, New York, 1977, reprinted in *X-TRA* 8, no. 1 (Fall 2005): 17.

28. Craig Owens, "Representation, Appropriation & Power," *Art in America* 70, no. 5 (May 1982): 10.

29. Nancy Spector, "Nowhere Man," in Spector, *Richard Prince: Spiritual America* (New York: Guggenheim Museum Publications, 2007), 34.

30. Douglas Crimp, "Pictures," *October* 8 (Spring 1979): 87.

31. Sherrie Levine quoted in Jeanne Siegel, "After Sherrie Levine," *Arts Magazine* 59, no. 10 (June 1985): 142.

32. Barbara Kruger, interview with Sarah Rogers-Lafferty, in *Breakthroughs: Avant-Garde Artists in Europe and America, 1950–1990* (New York: Rizzoli in association with Wexner Center for the Arts, Ohio State University, 1991), 228.

33. Cindy Sherman, "The Making of Untitled," in *The Complete Untitled Film Stills: Cindy Sherman* (New York: Museum of Modern Art, 2003), 9.

34. Maya Lin's original proposal, 1981, Vietnam Veterans Memorial Fund, https://www.vvmf.org/About-The-Wall/history-of-the-vietnam-veterans-memorial/Maya-Lin/.

35. Tom Carhart, "Insulting Vietnam Vets," *New York Times*, October 24, 1981.

36. Richard Serra quoted in Douglas Crimp, "Richard Serra's Urban Sculpture: An Interview," *Arts Magazine* 55, no. 3 (November 1980): 118.

37. Angela L. Miller, Janet C. Berlo, Bryan J. Wolf, and Jennifer L. Roberts, *American Encounters: Art, History, and Cultural Identity* (Upper Saddle River, NJ: Pearson, 2008), 628.

38. Peter Halley quoted in Giancarlo Politi, "Peter Halley," *Flash Art*, no. 150 (January–February 1990): 84.

39. Peter Halley, "The Crisis in Geometry," *Arts Magazine* 58, no. 10 (June 1984): 111.

40. Halley, "Crisis in Geometry," 113.

41. Halley, "Crisis in Geometry," 114.

42. Irving Sandler, *Art of the Postmodern Era*, 492.

43. Haim Steinbach, "Joy of Tapping Our Feet," *Parkett* 14 (1987): 17.

44. Steinbach quoted in Tricia Collins and Richard Milazzo, "Double Talk: McDonald's in Moscow and the Shadow of Batman's Cape. Haim Steinbach," *Tema Celeste* 25 (April–June 1990): 36.

45. Roberta Smith, "Rituals of Consumption," *Art in America* 76, no. 5 (May 1988): 164.

46. Jeff Koons, *The Jeff Koons Handbook* (New York: Rizzoli, 1992), 48.

47. Koons, *Jeff Koons Handbook*, 44.

48. Koons, *Jeff Koons Handbook*, 50.

49. Koons quoted in "Jeff Koons Talks to Katy Siegel," *Artforum* 41, no. 7 (March 2003): 253.

50. Koons quoted in "Interview: Jeff Koons—Anthony Haden-Guest," in *Jeff Koons*, ed. Angelika Muthesius (Cologne: Taschen, 1992), 19.

51. Koons, "Jeff Koons Talks to Katy Siegel," 253.

52. Koons, interview with Rem Koolhaas and Hans Ulrich Obrist, New York, March 13–14, 2004, in *Jeff Koons Retrospective*, ed. Marit Woltmann (Oslo: Astrup Fearnley Museet for Moderne Kunst, 2004), 67.

53. Rosemarie Trockel quoted in Doris von Drathen, "Rosemarie Trockel, Endlich ahnen, nicht nur wissen," *Kunstforum International*, no. 93 (February–March 1988): 212–13, quoted in Hans Ulrich Obrist, "1987: Rosemarie Trockel, Untitled (Made in Western Germany)," in *Defining Contemporary Art—25 Years in 200 Pivotal Works* (London: Phaidon, 2011), 29.

54. Trockel quoted in Jutta Koether, "Interview with Rosemarie Trockel," *Flash Art*, no. 34 (May 1987): 41.

55. Sean Scully quoted in Judith Higgins, "Sean Scully and the Metamorphosis of the Stripes," *ARTnews* 84 no.9 (November 1985): 106.

56. Elizabeth Murray quoted in Paul Gardner, "Elizabeth Murray Shapes Up," *ARTnews* 83, no. 7 (September 1984): 55.

57. Magdalena Abakanowicz quoted in Hunter Drohojowska, "Magical Mystery Tours," *ARTnews* 84, no. 7 (September 1985): 112.

58. "About the National AIDS Memorial," National AIDS Memorial, n.d., https://www.aidsmemorial.org/about.

59. William H. Honan, "Congressional Anger Threatens Arts Endowment's Budget," *New York Times*, June 20, 1989.

60. Donald Wildmon quoted in Bruce Selcraig, "Reverend Wildmon's War on the Arts," *New York Times Magazine*, September 2, 1990.

61. Congressional Record—Senate, May 18, 1989, p. 9788.

62. Congressional Record—Senate, July 26, 1989, p. 16277.

Chapter 21

1. Robert Venturi, *Complexity and Contradiction in Architecture* (New York: Museum of Modern Art in association with Graham Foundation for Advanced Studies in the Fine Arts, Chicago, 1966), 25.

2. Venturi, *Complexity and Contradiction*, 22.

3. Charles Jencks, *What is Post-Modernism?* (London: Academy Editions, 1986), 14.

4. Gavin Stamp quoted in William Tuohy, "New Flair for Two Old Museums: London: Architects and Critics are Blasting the Staid New Wing of the National Gallery, But the Queen Loves It. And So Does Her Son," *Los Angeles Times*, July 10, 1991, https://www.latimes.com/archives/la-xpm-1991-07-10-ca-2019-story.html.

5. Charles W. Moore, "You Have to Pay for the Public Life," *Perspecta* 9/10 (1965): 57–106.

6. Johnson said the top "did not come from a Chippendale clock." Philip Johnson, AIA Gold Medal Acceptance Speech, 1978, quoted in Christian Bjone, *Philip Johnson and His Mischief: Appropriation in Art and Architecture* (Mulgrave, Australia: Images, 2014), 32.

7. Paul Goldberger, "Architecture View: James Stirling Made an Art Form of Bold Gestures," *New York Times*, July 19, 1992, https://www.nytimes.com/1992/07/19/arts/architecture-view-james-stirling-made-an-art-form-of-bold-gestures.html.

8. Marvin Trachtenberg and Isabelle Hyman, *Architecture: From Prehistory to Postmodernity*, 2nd ed. (Upper Saddle River, NJ: Prentice-Hall; New York: Harry N. Abrams, 2002), 548.

9. Trachtenberg and Hyman, *Architecture*, 2nd ed., 548.

10. Tadao Andō quoted in Robert Ivy, "Tadao Ando Speaks for the RECORD," *Architectural Record*, 190, no. 5 (May 2002): 172.

11. Richard Meier, letter of October 12, 1984 to Bill Lacy, in *Building the Getty* (New York: Alfred A. Knopf, 1997), 39.

12. Balkrishna Doshi quoted in Andrew Higgott, *Key Modern Architects: 50 Short Histories of Modern Architecture* (London: Bloomsbury, 2018), 223.

13. Colin Davies, *A New History of Modern Architecture* (London: Laurence King, 2017), 311.

14. See Lawrence Vale, "Sri Lanka's Island Parliament," chap. 7 in *Architecture, Power, and National Identity* (New Haven, CT: Yale University Press, 1992).

15. Alan Colquhoun, "Plateau Beaubourg," *Architectural Digest* 47, no. 2 (1977), reprinted in Colquhoun, *Essays in Architectural Criticism: Modern Architecture and Historical Change* (Cambridge, MA: MIT Press, 1981), 114.

16. Richard Rogers and Renzo Piano quoted in Rowan Moore, "Pompidou Centre: A 70s French Radical that's Never Gone Out of Fashion," *Guardian*, January 8, 2017, https://www.theguardian.com/artanddesign/2017/jan/08/pompidou-centre-40-years-old-review-richard-rogers-renzo-piano.

17. "Hong Kong and Shanghai Bank Headquarters," Foster + Partners, n.d., https://www.fosterandpartners.com/projects/hongkong-and-shanghai-bank-headquarters/.

18. Philip Johnson, preface to Johnson and Mark Wigley, *Deconstructivist Architecture* (New York: Museum of Modern Art, 1988), 7.

19. Mark Wigley, "Deconstructivist Architecture," *Deconstructivist Architecture*, 11.

20. Wigley, "Deconstructivist Architecture," 11.

21. Wigley, "Deconstructivist Architecture," 16.

22. Daniel Libeskind, "Symbol and Interpretation," in *Between Zero and Infinity: Selected Projects in Architecture* (New York: Rizzoli, 1981), 29.

23. Libeskind quoted in "'The Brain has Corridors, Surpassing Material Place': Conversation with Daniel Libeskind," in *Daniel Libeskind: Jewish Museum Berlin, Berlin* (Barcelona: Ediciones Polígrafa, 2011), 21.

24. Libeskind, "Project Memory," in *Daniel Libeskind: Jewish Museum Berlin*, 73.

25. Zaha Hadid quoted in Michael Kimmelman, "Zaha Hadid, Groundbreaking Architect, Dies at 65," *New York Times*, March 31, 2016, https://www.nytimes.com/2016/04/01/arts/design/zaha-hadid-architect-dies.html.

26. Jonathan Glancey, "Move Over, Sydney: Zaha Hadid's Guangzhou Opera House," *Guardian*, February 28, 2011, https://www.theguardian.com/artanddesign/2011/feb/28/guangzhou-opera-house-zaha-hadid.

27. Tony Patterson, "Autoban: German Town Goes Car-Free," *Independent*, June 26, 2009, https://www.independent.co.uk/news/world/europe/autoban-german-town-goes-car-free-1720021.html.

28. Patterson, "Auto-ban."

29. Glenn Murcutt, Acceptance Speech, The Pritzker Architecture Prize, 2002, https://www.pritzkerprize.com/sites/default/files/file_fields/field_files_inline/2002_Acceptance_Speech_0.pdf.

30. My discussion of the Magney House follows Françoise Fromonot, *Glenn Murcutt: Buildings + Projects 1962–2003* (London: Thames & Hudson, 2003), 146, 148.

31. For a critical analysis of this claim, see Jonathan Massey, "Risk Design," *Aggregate* 1 (October 2013), http://we-aggregate.org/piece/risk-design.

32. My discussion of Solaris follows Sara Hart, *EcoArchitecture: The Work of Ken Yeang*, ed. David Littlefield (Chichester, UK: Wiley, 2011), 202–04.

33. Ken Yeang, "Essay," in Hart, *EcoArchitecture*, 258. The summary of Yeang's five strategies is drawn from this essay, 258–63.

Chapter 22

1. This paragraph draws on Robyn Longhurst, "The Body," in *Cultural Geography: A Critical Dictionary of Key Concepts*, ed. David Atkinson, Peter Jackson, David Sibley, and Neil Washbourne (London: I.B. Tauris, 2005), 91–96; and Maureen McNeil, "Body," in *New Keywords: A Revised Vocabulary of Culture and Society*, ed. Tony Bennett, Lawrence Grossberg, and Meaghan Morris (Malden, MA: Blackwell, 2005), 15–17.

2. Julia Kristeva, *Powers of Horror: An Essay on Abjection*, trans. Leon S. Roudiez (New York: Columbia University Press, 1982), 4.

3. Mona Hatoum quoted in Janine Antoni, "Mona Hatoum" (interview), *Bomb* 63, April 1, 1998, https://bombmagazine.org/articles/mona-hatoum/.

4. Hatoum, Antoni interview.

5. My reading follows Trevor Schoonmaker, "A Fantastic Journey," in *Wangechi Mutu: A Fantastic Journey*, ed. Schoonmaker (Durham, NC: Nasher Museum of Art at Duke University, 2013), 26, 29.

6. See Benjy Hansen-Bundy, "A Fantastic Journey into the Mind of Collage Artist Wangechi Mutu," *Mother Jones*, October 12, 2013, https://www.motherjones.com/media/2013/10/interview-collage-artist-wangechi-mutu-fantastic-journey/

7. My discussion of identity follows Kevin Robins, "Identity," in *New Keywords*, 172–74.

8. My treatment of contemporary globalization is indebted to Lawrence Grossberg, "Globalization," in *New Keywords*, 146–50.

9. For this and the following, see Christian Fuchs, "anti-globalization," *Encyclopedia Britannica*, December 10, 2015, https://www.britannica.com/event/antiglobalization.

10. Kerry James Marshall, "Notes on Career and Work," in Kerry James Marshall, Terrie Sultan, and Arthur Jafa, *Kerry James Marshall* (New York: Harry N. Abrams, 2000), 120.

11. Marshall quoted in "An Argument for Something Else: Dieter Roelstraete in Conversation with Kerry James Marshall, Chicago 2012," in *Kerry James Marshall: Painting and Other Stuff* (Brussels: Ludion; Antwerp: M HKA; Copenhagen: Kunsthal Charlottenburg; Barcelona: Fundació Antoni Tàpies; Madrid: Museo Nacional Centro de Arte Reina Sofia, 2013), 26, 27.

12. Jaune Quick-to-See Smith quoted in Arlene Hirschfelder, *Artists and Craftspeople* (New York: Facts On File, 1994), 115.

13. For this and the following see Coco Fusco, "The Other History of Intercultural Performance," *TDR* 38, no. 1 (Spring 1994): 145.

14. Fusco, "The Other History of Intercultural Performance," 143.

15. Fusco, "The Other History of Intercultural Performance," 152.

16. My discussion is based on Nat Trotman's introduction to the *Portraits* series in *Catherine Opie: American Photographer* (New York: Guggenheim Museum Publications, 2008), 52–53.

17. Shirin Neshat quoted in Lina Bertucci, "Shirin Neshat: Eastern Values," *Flash Art* 30, no. 197 (November/December 1997): 84.

18. Glenn Harper, "Exterior Form—Interior Substance: A Conversation with Xu Bing," *Sculpture*, January 1, 2003, https://sculpturemagazine.art/exterior-form-interior-substance-a-conversation-with-xu-bing/.

19. "The Age of Enlightenment – Adam Smith," Yinka Shonibare MBE, November 10, 2009—March 7, 2010, National Museum of African Art, Smithsonian Institution, 2009, https://africa.si.edu/exhibits/shonibare/smith.html.

20. Kara Walker quoted in "Kara Walker: Interview with Alexander Alberro," *Index* 1, no. 1 (February 1996), http://www.indexmagazine.com/interviews/kara_walker.shtml.

21. Angela L. Miller, Janet C. Berlo, Bryan J. Wolf, and Jennifer L. Roberts, *American Encounters: Art, History, and Cultural Identity* (Upper Saddle River, NJ: Pearson Prentice Hall, 2008), 646.

22. Christian Boltanski quoted in Georgia Marsh, "The White and the Black: An

Interview with Christian Boltanski," *Parkett* 22 (1989): 38, 39.

23. Adrian Searle, "Austere, Silent and Nameless—Whiteread's Concrete Tribute to Victims of Nazism," *Guardian*, October 25, 2000, https://www.theguardian.com/culture/2000/oct/26/artsfeatures6.

24. Olga M. Viso, "Doris Salcedo: The Dynamic of Violence," in Neal Benezra and Olga M. Viso, *Distemper: Dissonant Themes in Art of the 1990s* (Washington, DC: Hirshhorn Museum and Sculpture Garden, Smithsonian Institution in association with D.A.P./Distributed Art Publishers, 1996), 86.

25. William Kentridge quoted in Carolyn Christov-Bakargiev, *William Kentridge* (Brussels: Société des Expositions du Palais des Beaux-Arts, 1998), 12.

26. Kentridge quoted in Christov-Bakargiev, *William Kentridge*, 90.

27. Ai Weiwei, blog post, March 20, 2009, quoted in Matthew Israel, *The Big Picture: Contemporary Art in 10 Works by 10 Artists* (Munich: Prestel, 2017), 98.

28. Margaret Thatcher, *The Downing Street Years* (London: HarperCollins, 1993), 348, and speech to the meeting of the Conservative 1922 Committee, July 19, 1984; both quoted in Alice Correia, "Interpreting Jeremy Deller's *The Battle of Orgreave*," in *Killer Images: Documentary Film, Memory and the Performance of Violence*, ed. Joram Ten Brink and Joshua Oppenheimer

(New York: Wallflower Press of Columbia University Press, 2013), 95.

29. Jeremy Deller, "Foreword," in Deller, *The English Civil War Part II: Personal Accounts of the 1984–85 Miners' Strike* (London: Artangel, 2002), 7.

30. Do Ho Suh, 2008 interview with Paul Laster for *Artkrush*, quoted in Laster, "Do Ho Suh: From Sculpture to Film," *Whitehot Magazine*, November 2019, https://whitehotmagazine.com/articles/ho-suh-from-sculpture-film/4436.

31. Bharti Kher in Isabella Stewart Gardner Museum, "Bharti Kher: Not All Who Wander Are Lost," 2015, https://www.youtube.com/watch?v=PZ31ShlT2D4.

32. Kher in Gardner Museum, "Bharti Kher."

33. Hilarie M. Sheets, "Industrial Strength in the Motor City," *New York Times*, November 11, 2007, https://www.nytimes.com/2007/11/11/arts/design/11shee.html.

34. El Anatsui quoted in Polly Savage, *El Anatsui* (New York: David Krut Publishing in association with October Gallery, 2006), n.p., quoted in Leesa Fanning, "El Anatsui," in Jan Schall and Robert Storr, *Sparks! The William T. Kemper Collecting Initiative at the Nelson-Atkins Museum of Art* (Kansas City, MO: Nelson-Atkins Museum of Art, 2008), 62.

35. Anatsui quoted in Murray Whyte, "El Anatsui: Finding the Meaning of Junk," *Toronto Star*, October 1, 2010, https://www.thestar.com/entertainment/2010/10/01/

el_anatsui_finding_the_meaning_of_junk.html.

36. Claire Bishop, introduction to *Participation*, ed. Bishop (London: Whitechapel; Cambridge, MA: MIT Press, 2006), 12.

37. Nicolas Bourriaud, *Relational Aesthetics*, trans. Simon Pleasance, Fronza Woods with participation of Mathieu Copeland (Paris: Les presses du réel, 1998 [2002 for the English translation]), 113.

38. Ernesto Neto quoted in *The Venice Biennale: 49th International Exhibition: Plateau of Humankind*, ed. Harald Szeemann and Cecilia Liveriero Lavelli (Milan: Electa, 2001), 1:180.

39. Olafur Eliasson quoted in Michael Kimmelman, "The Sun Sets at the Tate Modern," *New York Times*, March 21, 2004, https://www.nytimes.com/2004/03/21/arts/art-the-sun-sets-at-the-tate-modern.html.

40. Thomas Hirschhorn quoted in Randy Kennedy, "Bringing Art and Change to Bronx," *New York Times*, June 27, 2013, https://www.nytimes.com/2013/06/30/arts/design/thomas-hirschhorn-picks-bronx-development-as-art-site.html.

41. Hirschhorn quoted in Kennedy, "Bringing Art and Change to Bronx."

42. Patricia Piccinini, "The Young Family" (2002), https://www.patriciapiccinini.net/writing/51.

43. Eduardo Kac, "GFP Bunny" (2000), https://www.ekac.org/gfpbunny.html#gfpbunnyanchor.

44. Terry Smith, *Contemporary Art: World Currents* (Upper

Saddle River, NJ: Pearson Education, 2011), 282.

45. Mel Chin, "Revival Field," https://melchin.org/oeuvre/revival-field/.

46. Agnes Denes, "Tree Mountain - A Living Time Capsule-11,000 Trees, 11,000 People, 400 Years, 1992–96, (420 x 270 x 28 meters) Ylojarvi, Finland," http://www.agnesdenesstudio.com/works4 html.

47. I draw this definition of spirituality from Jean Robertson and Craig McDaniel, *Themes of Contemporary Art: Visual Art After 1980*, 4th ed. (New York: Oxford University Press, 2017), 366.

48. Jeff Wall, interview with Craig Burnett, in Burnett, *Jeff Wall* (London: Tate Publishing, 2005), 59.

49. Chris Ofili quoted in Michael Ellison, "New York Seeks to Ban Britart Sensation," *Guardian*, September 23, 1999, https://www.theguardian.com/uk/1999/sep/24/michaelellison.

50. My discussion follows Linda Weintraub, "Envisioning Nirvana: Mariko Mori," *In the Making: Creative Options for Contemporary Art* (New York: D.A.P./Distributed Art Publishers, 2003), 320.

51. Mariko Mori quoted in Neville Wakefield, "Momentous Mori," *Interview*, June 1999, 109.

52. My discussion follows Hiroko Ikegami, "Takashi Murakami: Mori Art Museum," *Artforum* 54, no. 6 (February 2016): 232–33.

53. Anish Kapoor quoted in Mary Jane Jacob, "Being with Cloud Gate," in *Anish Kapoor: Past, Present,*

Future, ed. Nicholas Baume (Boston: Institute of Contemporary Art; Cambridge, MA: MIT Press, 2008), 131.

54. Kapoor quoted in Jacob, "Being with Cloud Gate," 131.

55. "time, n., int., and conj." OED Online, March 2022, Oxford University Press, https://www.oed.com/viewdictionaryentry/Entry/202100.

56. Kate Brettkelly-Chalmers, *Time, Duration and Change in Contemporary Art: Beyond the Clock* (Bristol, UK: Intellect, 2019), 153. My summary of contemporary artists' ways of engaging with time is indebted to Brettkelly-Chalmers's study.

57. Christian Marclay, "On Time: Discussing the Clock," *Out of Sync—Art in Focus*, June 17, 2017, https://www.youtube.com/watch?v=EQ_wKD6XQTM.

58. Adelina Vlas quoted in Art Gallery of Ontario, "A Mesmerizing Panorama, Ragnar Kjartansson's Installation *Death is Elsewhere* Opens at the AGO on Nov. 7," press release, November 3, 2020, https://ago.ca/press-release/mesmerizing-panorama-ragnar-kjartanssons-installation-death-elsewhere-opens-ago-nov.

59. Marina Abramović quoted in Rachel Dodes, "Artist Marina Abramović Sits for an Interview," *Wall Street Journal*, June 1, 2010, https://www.wsj.com/articles/BL-SEB-36493.

60. Abramović, Dodes interview.

61. Abramović, Dodes interview.

62. Camille Henrot quoted in "Camille Henrot in Conversation with Stephanie Bailey, Germany, 5 February 2015," *Ocula Magazine*, https://ocula.com/magazine/conversations/camille-henrot/.

63. Kyle Chayka, "'Grosse Fatigue' Tells the Story of Life on Earth," *New Yorker*, July 10, 2020, https://www.newyorker.com/recommends/watch/grosse-fatigue-tells-the-story-of-life-on-earth.

Credits

Introduction

Fig. I.2 © Harvard Art Museums/Bequest from the Collection of Maurice Wertheim, Class 1906/Bridgeman Images; Fig. I.4 Bridgeman Images; Fig. I.5 Bridgeman Images; Fig I.6 Index Fototeca/Bridgeman Images; Fig. I.7 Photo © Fine Art Images/Bridgeman Images; Fig. I.8 © 2022 C. Herscovici/Artists Rights Society (ARS), New York, The Art Institute of Chicago/Art Resource, NY; Fig. I.9 © RMN-Grand Palais/Art Resource, NY; Fig. I.10 © RMN-Grand Palais/Art Resource, NY; Fig. I.11 © RMN-Grand Palais / Art Resource, NY; Fig. I.12 Bridgeman Images; Fig. I.13 © RMN-Grand Palais/Art Resource, NY; Fig. I.14 Bridgeman Images; Fig. I.15 Photograph © 2022 Museum of Fine Arts, Boston. All rights reserved./Henry Lillie Pierce Fund/Bridgeman Images

Chapter 1

Fig. 1.1 Image courtesy of Musée d'Orsay, Paris; Fig. 1.2 Scala/Art Resource, NY; Fig. 1.3 © RMN-Grand Palais/Art Resource, NY; Fig. 1.4 © Tate, London/Art Resource, NY; Fig. 1.5 © DeA Picture Library/Art Resource, NY; Fig. 1.6 © Tate, London/Art Resource, NY; Fig. 1.7 Brooklyn Museum, New York, NY/Gift of Anna Ferris; Fig. 1.8 © Royal Photographic Society Collection/Victoria & Albert Museum, London/Art Resource, NY; Fig. 1.9 Photo courtesy of Nelson-Atkins Media Services; Fig. 1.10 World History Archive/Alamy Stock Photo; Fig. 1.11 Gift of William Rubel, 2013; Fig. 1.13 © RMN-Grand Palais/Art Resource, NY; Fig. 1.14 © RMN-Grand Palais/Art Resource, NY; Fig. 1.15 © Courtauld Institute/Art UK; Fig. 1.16 Collection of Mr. and Mrs. Paul Mellon; Fig. 1.17 © RMN-Grand Palais/Art Resource, NY; Fig. 1.18 © RMN-Grand Palais/Art Resource, NY; Fig. 1.19 © CSG CIC Glasgow Museums Collection; Fig. 1.20 HIP/Art Resource, NY; Fig. 1.21 The Butler Institute of American Art, Youngstown, Ohio; Fig. 1.22 Philadelphia Museum of Art: Gift of the Alumni Association to Jefferson Medical College in 1878 and purchased by the Pennsylvania Academy of the Fine Arts and the Philadelphia Museum of Art in 2007 with the generous support of more than 3,600 donors, 2007, 2007-1-1

Chapter 2

Fig. 2.1 The Art Institute of Chicago/Art Resource, NY; Fig. 2.2 The Art Institute of Chicago/Art Resource, NY; Fig. 2.3 Image copyright © The Metropolitan Museum of Art. Image source: Art Resource, NY; Fig. 2.4 Erich Lessing/Art Resource, NY; Fig. 2.5 The Art Institute of Chicago/Art Resource, NY; Fig. 2.6 Philadelphia Museum of Art: Purchased with the W. P. Wilstach Fund, 1937, W1937-1-1; Fig. 2.7 © RMN-Grand Palais/Art Resource, NY; Fig. 2.8 The Art Institute of Chicago/Art Resource, NY; Fig. 2.9 Digital Image © The Museum of Modern Art/Licensed by SCALA/Art Resource, NY; Fig. 2.10 © National Galleries of Scotland/Bridgeman Images, Purchased 1925; Fig. 2.11 Photograph © 2022 Museum of Fine Arts, Boston. All rights reserved./Tompkins Collection/Bridgeman Images, Tompkins Collection–Arthur Gordon Tompkins Fund; Fig. 2.12 Photo credit: Yale University Art Gallery; Fig. 2.13 Digital Image © The Museum of Modern Art/Licensed by SCALA/Art Resource, NY; Fig. 2.14 Photo credit: Høstland, Børre; Fig. 2.16 © RMN-Grand Palais/Art Resource, NY; Fig. 2.17 Bridgeman Images; Fig. 2.18 Cathy Carver. Hirshhorn Museum and Sculpture Garden; Fig. 2.19 © RMN-Grand Palais/Art Resource, NY; Fig. 2.20 © CSG CIC Glasgow Museums Collection

Chapter 3

Fig. 3.1 Collection of Mr. and Mrs. John Hay Whitney; Fig. 3.2 ©2021 Succession H. Matisse/Artists Rights Society (ARS), New York; Fig. 3.3 The Cone Collection, formed by Dr. Claribel Cone and Miss Etta Cone of Baltimore, Maryland; Fig. 3.4 The State Hermitage Museum, St. Petersburg, Photograph © The State Hermitage Museum/photo by Vladimir Terebenin; Fig. 3.5 John Hay Whitney Collection; Fig. 3.6 © 2022 Artists Rights Society (ARS), New York, Digital Image © The Museum of Modern Art/Licensed by SCALA/Art Resource, NY; Fig. 3.7 Bildagentur/Staatliche Museen zu Berlin–Preussischer Kulturbesitz Nationalgalerie/Art Resource, NY; Fig. 3.8 © The Trustees of the British Museum; Fig. 3.9 Von der Heydt-Museum, Wuppertal; Fig. 3.10 Digital Image © The Museum of Modern Art/Licensed by SCALA/Art Resource, NY; Fig. 3.11 © 2022 Artists Rights Society (ARS), New York/VG Bild-Kunst, Bonn, Digital Image © The Museum of Modern Art/Licensed by SCALA/Art Resource, NY; Fig. 3.12 © Nolde Stiftung Seebüll; Album/Alamy Stock Photo; Fig. 3.13 © Tate, London/Art Resource, NY; Fig. 3.14 Andrew W. Mellon Fund; Fig. 3.16 © VG Bild-Kunst, Bonn 2018. Städtische Galerie im Lenbachhaus und Kunstbau München, Gabriele Münter Stiftung 1957; Fig. 3.17 Collection Walker Art Center, Minneapolis, Gift of the T. B. Walker Foundation, Gilbert M. Walker Fund, 1942; Fig. 3.18 © 2022 Artists Rights Society (ARS), New York; Image copyright © The Metropolitan Museum of Art. Image source: Art Resource, NY; Fig. 3.19 © ProLitteris; Fig. 3.20 The Metropolitan Museum of Art, Bequest of Scofield Thayer, 1982

Chapter 4

Fig. 4.1 © Cleveland Museum of Art/© Succession Picasso/DACS, London 2021/Bridgeman Images; Fig. 4.2 Chester Dale Collection; Peter Barritt/Alamy Stock Photo; Fig. 4.3 Digital Image © The Museum of Modern Art/Licensed by SCALA/Art Resource, NY; Fig. 4.4 © CNAC/MNAM, Dist. RMN-Grand Palais/Art Resource, NY; Fig. 4.5 Artepics/Alamy Stock Photo; Fig. 4.6 The Solomon R. Guggenheim Foundation/Art Resource, NY; Fig. 4.7 Gift of Mrs. Gilbert W. Chapman in memory of Charles B. Goodspeed; artillustratn/Alamy Stock Photo; Fig. 4.8 Georges Braque, The Portuguese (The Emigrant), 1911. Oil on canvas, 116.7 x 81.5 cm. Öffentliche Kunstsammlung, Kunstmuseum Basel, Basel, Switzerland. Image Courtesy of Öffentliche Kunstsammlung, Kunstmuseum Basel, Basel, Switzerland. © Georges Braque; Fig. 4.9 Album/Alamy Stock Photo; Fig. 4.10 © Estate of Pablo Picasso/Artists Rights Society (ARS), New York; Fig. 4.11 Digital Image

© The Museum of Modern Art/Licensed by SCALA/Art Resource, NY; Fig. 4.12 Digital Image © The Museum of Modern Art/Licensed by SCALA/Art Resource, NY; Fig. 4.13 Courtesy Moderna Museet; Fig. 4.14 Chester Dale Fund; Fig. 4.15 Digital Image © CNAC/MNAM, Dist. RMN-Grand Palais/Art Resource, NY; Fig. 4.16 The Picture Art Collection/Alamy Stock Photo; Fig. 4.17 Scala/Art Resource, NY; Fig. 4.18 © Association Marcel Duchamp/ADAGP, Paris/Artists Rights Society (ARS), New York 2022, © Philadelphia Museum of Art/The Louise and Walter Arensberg Collection, 1950/Bridgeman Images; Fig. 4.19 ©Mark Edward Smith/Bridgeman Images; Fig. 4.20 © 2022 Artists Rights Society (ARS), New York/SIAE, Rome, Image copyright © The Metropolitan Museum of Art. Image source: Art Resource, NY; Fig. 4.21 © 2022 Artists Rights Society (ARS), New York/ADAGP, Paris, Digital Image © The Museum of Modern Art/Licensed by SCALA/Art Resource, NY; Fig. 4.22 Digital Image © The Museum of Modern Art/Licensed by SCALA/Art Resource, NY; Fig. 4.23 © Tate, London/Art Resource, NY

Chapter 5

Fig. 5.1 © Imagebroker/Alamy Stock Photo; Fig. 5.2 By WDG Photo; Fig. 5.3 RIBA Collections; Fig. 5.4 Luisa Ricciarini/Bridgeman Images; Fig. 5.5 Heritage Image Partnership Ltd/Alamy Stock Photo; Fig. 5.6 JOHN KELLERMAN/Alamy Stock Photo; Fig. 5.7 Jacek Sopotnicki/Alamy Stock Photo; Fig. 5.8 robertharding/Alamy Stock Photo; Fig. 5.9 Photographer: Boris Breytman; Fig. 5.10 © Wim Robberechts; Fig. 5.11 Album/Alamy Stock Photo; Fig. 5.12 Viennaslide/Alamy Stock Photo; Fig. 5.13 Courtesy of Chicago History Museum; Fig. 5.14 Library of Congress, Prints and Photographs Division, Washington DC; Fig. 5.16 ©The Frank Lloyd Wright Fdn, AZ/Art Resource, NY; Fig. 5.18 Bildarchiv Monheim GmbH/Alamy Stock Photo

Chapter 6

Fig. 6.1 © N.Goncharova/UPRAVIS 2022, ARS, NY, The Solomon R. Guggenheim Foundation/Art Resource, NY; Fig. 6.2 Norton Simon Art Foundation; Fig. 6.3 Heritage Images/Contributor/Getty Images; Fig. 6.4 Sovfoto/Contributor/Getty Images; Fig.

6.6 Buyenlarge/Contributor/Getty Images; Fig. 6.7 Digital Image © The Museum of Modern Art/Licensed by SCALA/Art Resource, NY; Fig. 6.8 Buyenlarge/Contributor/Getty Images; Fig. 6.9 The Solomon R. Guggenheim Foundation/Art Resource, NY; Fig. 6.10 © 2021 Mondrian/Holtzman Trust; Fig. 6.11 Digital Image © The Museum of Modern Art/Licensed by SCALA/Art Resource, NY; Fig. 6.12 © Centraal Museum, Utrecht/Kim Zwarts 2005/Pictoright, Amsterdam, Rietveld Schröder House, Designed by Gerrit Thomas Rietveld (1888–1964), 1924, © Centraal Museum Utrecht/Kim Zwarts/Pictoright, Amsterdam; Fig. 6.13 Sturman/Deposit Images; Fig. 6.14 © 2022 Artists Rights Society (ARS), New York, Digital Image © The Museum of Modern Art/Licensed by SCALA/Art Resource, NY; Fig. 6.15 The J. Paul Getty Museum, Los Angeles © 2014 Estate of László Moholy-Nagy/Artists Rights Society (ARS), New York; Fig. 6.16 Digital Image © CNAC/MNAM, Dist. RMN-Grand Palais/Art Resource, NY; © St. Annen-Museum Lübeck/Fotoarchiv Fig. 6.18 © The Josef and Anni Albers Foundation/Artists Rights Society (ARS), New York, 2022, The Art Institute of Chicago/Art Resource, NY

Chapter 7

Fig. 7.1 Kunsthaus Zürich, Donated by the Georges and Jenny Bloch Foundation, 1984; Fig. 7.2 Digital Image © CNAC/MNAM, Dist. RMN-Grand Palais/Art Resource, NY; Fig. 7.3 Image courtesy of collection of the International Dada Archive, Special Collections and Archives, University of Iowa Libraries; Fig. 7.4 © Association Marcel Duchamp/ADAGP, Paris/Artists Rights Society (ARS), New York 2022, The Philadelphia Museum of Art/Art Resource, NY; Fig. 7.5 © 2010 Artists Rights Society (ARS), New York/ADAGP, Paris, National Portrait Gallery, Smithsonian Institution; gift of Katharine Graham; Fig. 7.6 © 2022 Artists Rights Society (ARS), New York/VG Bild-Kunst, Bonn, bpk Bildagentur/Art Resource, NY; Fig. 7.7 © 2022 Artists Rights Society (ARS), New York, bpk Bildagentur/Art Resource, NY; Fig. 7.8 © 2022 Artists Rights Society (ARS), New York/ADAGP, Paris, Digital Image © The Museum of Modern Art/Licensed by SCALA/Art Resource, NY; Fig. 7.9 © 2022 Artists Rights

Society (ARS), New York/VG Bild-Kunst, Bonn, © CNAC/MNAM, Dist. RMN-Grand Palais/Art Resource, NY; Fig. 7.10 Digital Image © The Museum of Modern Art/Licensed by SCALA/Art Resource, NY; Fig. 7.11 © 2022 Artists Rights Society (ARS), New York, Digital Image © The Museum of Modern Art/Licensed by SCALA/Art Resource, NY

Chapter 8

Fig. 8.1 Digital Image © The Museum of Modern Art/Licensed by SCALA/Art Resource, NY; Fig. 8.2 Digital Image © The Museum of Modern Art/Licensed by SCALA/Art Resource, NY; Fig. 8.3 © 2022 Artists Rights Society (ARS), New York/SIAE, Rome, The Philadelphia Museum of Art/Art Resource, NY; Fig. 8.4 JJs/Alamy Stock Photo; Fig. 8.5 Allen Phillips/Wadsworth Atheneum; Fig. 8.6 © NPL–DeA Picture Library/Bridgeman Images; Fig. 8.7 The Ella Gallup Sumner and Mary Catlin Sumner Collection Fund, 1934.40; Fig. 8.8 © 2022 Estate of Leonora Carrington/Artists Rights Society (ARS), New York, Image copyright © The Metropolitan Museum of Art. Image source: Art Resource, NY; Fig. 8.9 © Tate, London/Art Resource, NY; Fig. 8.10 Digital Image © The Museum of Modern Art/Licensed by SCALA/Art Resource, NY; Fig. 8.11 Kunsthaus Zürich, Donated by Dr. Emil Friedrich, 1935; Fig. 8.12 © 2022 Artists Rights Society (ARS), New York/ProLitteris, Zurich, Digital Image © The Museum of Modern Art/Licensed by SCALA/Art Resource, NY; Fig. 8.13 © Man Ray 2015 Trust/Artists Rights Society (ARS), NY/ADAGP, Paris 2022, Digital Image © The Museum of Modern Art/Licensed by SCALA/Art Resource, NY; Fig. 8.14 Photo: Gabe Hopkins; Fig. 8.15 © 2022 Artists Rights Society (ARS), New York/ADAGP, Paris, Image copyright © The Metropolitan Museum of Art. Image source: Art Resource, NY; Fig. 8.16 Courtesy of Jersey Heritage Collections; Fig. 8.17 The J. Paul Getty Museum, Los Angeles, © Estate of André Kertész; Fig. 8.18 © Henri Cartier-Bresson/Saif, Paris/Licensed by VAGA at ARS, New York photograph: Don Ross, Gift of Mr. and Mrs. Frank Spadarella

Chapter 9

Fig. 9.1 Bridgeman Images; Fig. 9.2 Gift of Wallace and Wilhelmina Holladay; Fig. 9.3

Digital Image © The Museum of Modern Art/ Licensed by SCALA/Art Resource, NY; Fig. 9.4 The Baltimore Museum of Art: The Cone Collection, formed by Dr. Claribel Cone and Miss Etta Cone of Baltimore, Maryland, BMA 1950.429, Photography By: Mitro Hood; Fig. 9.5 Acquired 1934; © 2015 Artists Rights Society (ARS), New York/ADAGP, Paris; Fig. 9.6 The Art Institute of Chicago/Art Resource, NY; Fig. 9.7 Digital Image © The Museum of Modern Art/Licensed by SCALA/ Art Resource, NY; Fig. 9.8 Art Resource, NY; Fig. 9.9 © 2022 Artists Rights Society (ARS), New York, © Tate, London/Art Resource, NY; Fig. 9.10 Photo: Adam Friedberg; Fig. 9.11 © 2022 Artists Rights Society (ARS), New York/ ADAGP, Paris, Digital Image © The Museum of Modern Art/Licensed by SCALA/Art Resource, NY; Fig. 9.12 Digital Image © The Museum of Modern Art/Licensed by SCALA/Art Resource, NY; Fig. 9.13 © Tate, London/Art Resource, NY; Fig. 9.14 Reproduced by permission of The Henry Moore Foundation, Photograph courtesy of Leeds Museums and Galleries; Leeds Museums and Galleries, UK/© The Henry Moore Foundation. All Rights Reserved, DACS 2022/www. henry-moore.org/Bridgeman Images; Fig. 9.15 © Tate, London/Art Resource, NY; Fig. 9.16 Barbara Hepworth © Bowness

Chapter 10

Fig. 10.1 Roland P. Murdock Collection, Wichita Art Museum, Wichita, Kansas; Fig. 10.2 Hinman B. Hurlbut Collection/Bridgeman Images; Fig. 10.3 Library of Congress; Hagelstein Bros., photographer; Fig. 10.4 Princeton University Art Museum/Art Resource, NY; Fig. 10.5 Digital Image © The Museum of Modern Art/Licensed by SCALA/ Art Resource, NY; Fig. 10.6 sold to the J. Paul Getty Museum, 1984; Fig. 10.7 Image copyright © The Metropolitan Museum of Art. Image source: Art Resource, NY; Fig. 10.8 Collection of The University of Arizona Museum of Art, Tucson; gift of Oliver James; Fig. 10.9 © 2022 Center for Creative Photography, Arizona Board of Regents/Artists Rights Society (ARS), New York, Digital Image © The Museum of Modern Art/ Licensed by SCALA/Art Resource, NY; Fig. 10.10 Digital image © Whitney Museum of American Art/Licensed by Scala/Art Resource, NY; Fig. 10.11 © The Lane Collection, Courtesy Museum of Fine Arts,

Boston, Image copyright © The Metropolitan Museum of Art. Image source: Art Resource, NY; Fig. 10.12 From The New York Public Library; Fig. 10.13 © 2021 Estate of James Van Der Zee; Fig. 10.14 © Augusta Savage;

Fig. 10.15 © 2016 The Jacob and Gwendolyn Knight Lawrence Foundation, Seattle/ Artists Rights Society (ARS), New York; Fig. 10.16 © NPL—DeA Picture Library/Bridgeman Images; Fig. 10.17 Peter Barritt/Alamy Stock Photo; Fig. 10.18 © 2022 Estate of Ben Shahn/Licensed by VAGA at Artists Rights Society (ARS), NY, Digital image © Whitney Museum of American Art/Licensed by Scala/ Art Resource, NY; Fig. 10.19 Digital Image © The Museum of Modern Art/Licensed by SCALA/Art Resource, NY; Fig. 10.20 © Estate of Stuart Davis/Licensed by VAGA, New York, NY, Allocated by the U.S. Government, Commissioned through the New Deal Art Projects, Eskenazi Museum of Art, Indiana University; Fig. 10.21 © 2022 Calder Foundation, New York/Artists Rights Society (ARS), New York; Photo courtesy of Calder Foundation, New York/Art Resource, New York; Fig. 10.22 Niday Picture Library/Alamy Stock Photo; Fig. 10.23 UG1988.002 Lawren Harris, *Morning Light, Lake Superior* Circa 1927, Oil on canvas, Canvas: 33 3/4 x 40 in. | Frame: 38 1/4 x 44 1/2 in., Gift of Frieda Helen Fraser, in memory of her friend Dr. Edith Bickerton, Williams, OVC '41, 1988, University of Guelph Collection at the Art Gallery of Guelph; Fig. 10.24 Collection of the Vancouver Art Gallery, Emily Carr Trust, VAG 42.3.11, Photo: Vancouver Gallery; Fig. 10.25 Album/Alamy Stock Photo; Fig. 10.26 © 2022 Banco de México Diego Rivera Frida Kahlo Museums Trust, Mexico, D.F./Artists Rights Society (ARS), New York, Schalkwijk/Art Resource, NY; Fig. 10.27 © 2022 Banco de México Diego Rivera Frida Kahlo Museums Trust, Mexico, D.F./Artists Rights Society (ARS), New York Schalkwijk/ Art Resource, NY; Fig. 10.28 Ackland Art Museum, The University of North Carolina at Chapel Hill I Art Resource, NY; Fig. 10.29 OAS AMA | ART MUSEUM OF THE AMERICAS COLLECTION; GIFT OF IBM © AMELIA PELÁEZ FOUNDATION; Fig. 10.30 Digital Image © The Museum of Modern Art/Licensed by SCALA/Art Resource, NY; Fig. 10.31 Digital Image © The Museum of Modern Art/ Licensed by SCALA/Art Resource, NY; Fig.

10.32 Eduardo F. Costantini, Buenos Aires; Fig. 10.33 Photo credit: José Cristelli; Fig. 10.34 Gyula Kosice, Röyi No. 2, 1944–1993. Wood, dimensions variable, 70.5 x 81 x 15.5 cm. Museo de Arte Latinamericano de Buenos Aires. MALBA 2001.101. © Courtesy of Fundación Kosice, Buenos Aires

Chapter 11

Fig. 11.1 Niday Picture Library/Alamy Stock Photo; Fig. 11.2 National Gallery of Modern Art, New Delhi; Fig. 11.3 National Gallery of Modern Art, New Delhi; Fig. 11.4 National Gallery of Modern Art, New Delhi; Fig. 11.5 Gift of Oscar Edwards 1958, Image © AGNSW, 9670; Fig. 11.6 The Museum of Modern Art, Ibaraki; Fig. 11.7 History and Art Collection/Alamy Stock Photo; Fig. 11.8 Historic Collection/Alamy Stock Photo; Fig. 11.9 MOMAT/DNPartcom, Photo: UENO Norihiro; Fig. 11.10 Photo: MOMAT/DN-Partcom; Fig. 11.11 Courtesy William Ko, National Museum of Modern and Contemporary Art, Korea; Fig. 11.12 Pictures from History/Bridgeman Images; Fig. 11.13 © Piljong Lee and National Museum of Modern and Contemporary Art, Korea; Fig. 11.14 Kim Whanki, Rondo, 1938. Oil on canvas, 61 x 71.5 cm © Whanki Foundation·Whanki Museum; Fig. 11.15 Photo © Christie's Images/Bridgeman Images; Fig. 11.16 Collection of Art Museum, The Chinese University of Hong Kong. Gift of Mr. Ho Iu-kwong, Mr. Huo Pao-tsai, Chong Yun & Sons Estates Limited, The S.H. Ho Foundation Limited, Sir Quo-wei Lee, Mr. Brian McElney, Mr. Quincy Chuang Kwei-lun, Sir Sidney Gordon, Mr. Ko Fook-son, Mr. Lai Tak, Mr. Lin Po-shou, Mr. T.Y. Chao, Mr. Liu Han-tang, Mr. Yeung Wing-tak, Mr. Yung Hung-ching, Mr. Stanley Kuo Cheng-dai, Dr. Lee Jung-sen, Mr. K.K. Tse, and Mr. Shum Choi-sang; Fig. 11.17 Historic Collection/Alamy Stock Photo; Fig. 11.19 Courtesy Hu Yichuan Institute of the Guangzhou Academy of Fine Arts

Chapter 12

Fig. 12.1 © 2022 The Arshile Gorky Foundation/Artists Rights Society (ARS), New York, Image copyright © The Metropolitan Museum of Art. Image source: Art Resource, NY; Fig. 12.2 Copyright © 1998 Kate Rothko Prizel and Christopher Rothko; Fig. 12.3 Digital Image © The Museum of Modern Art/Licensed by SCALA/Art

Resource, NY; Fig. 12.4 Image copyright © The Metropolitan Museum of Art. Image source: Art Resource, NY; Fig. 12.5 Digital image © Whitney Museum of American Art/Licensed by Scala/Art Resource, NY; Fig. 12.6 © 2022 The Willem de Kooning Foundation/Artists Rights Society (ARS), New York Digital Image © The Museum of Modern Art/Licensed by SCALA/Art Resource, NY; Fig. 12.7 © 2022 The Willem de Kooning Foundation/Artists Rights Society (ARS), New York; Fig. 12.8 © 2022 The Franz Kline Estate/Artists Rights Society (ARS), New York, Digital image © Whitney Museum of American Art/Licensed by Scala/Art Resource, NY; Fig. 12.9 Image courtesy of Joan Mitchell Foundation. Whitney Museum of American Art, New York; purchase, with funds from the Friends of the Whitney Museum of American Art; Fig. 12.10 Clyfford Still, 1957-J No. 1 (PH-142), 1957, oil on canvas, 113 3/8 x 146 7/8 in., Anderson Collection at Stanford University, Gift of Harry W. and Mary Margaret Anderson, and Mary Patricia Anderson Pence, 2014.1.038. Photo: Ian Reeves.; Fig. 12.11 The Rothko Room at The Phillips Collection, Washington, D.C. Photo © Robert Lautman; Fig. 12.12 © 2021 Barnett Newman Foundation/Artists Rights Society (ARS), New York; Fig. 12.13 Image copyright © The Metropolitan Museum of Art. Image source: Art Resource, NY; Fig. 12.14 © Estate of Norman Lewis, Courtesy of Michael Rosenfeld Gallery LLC, New York, NY; Fig. 12.15 © 2022 Estate of Larry Rivers/Licensed by VAGA at Artists Rights Society (ARS), NY, Digital Image © The Museum of Modern Art/Licensed by SCALA/Art Resource, NY; Fig. 12.16 Richard Diebenkorn, Woman on a Porch, The New Orleans Museum of Art: Museum Purchase through the National Endowment for the Arts Matching Grant, 77.64. Museum purchase through the National Endowment for the Arts Matching Grant; Fig. 12.17 Courtesy of David Smith Estate; Fig. 12.18 Courtesy of David Smith Estate; Fig. 12.19 © 2022 The Isamu Noguchi Foundation and Garden Museum, New York/Artists Rights Society (ARS), New York, Image copyright © The Metropolitan Museum of Art. Image source: Art Resource, NY; Fig. 12.20 Digital Image © The Museum of Modern Art/Licensed by SCALA/Art Resource, NY; Fig. 12.21 © 2022 The Joseph

and Robert Cornell Memorial Foundation/Licensed by VAGA at Artists Rights Society (ARS), NY, © Edward Owen/Art Resource, NY; Fig. 12.22 © Robert Capa © International Center of Photography/Magnum Photos; Fig. 12.23 © Trustees of Princeton University; Minor White, 1908–1976; born Minneapolis, MN; died Boston, MA; active Portland, OR, Rochester, NY, San Mateo County, California, November 4, 1947, Gelatin silver print, 11.9 × 9.3 cm, The Minor White Archive, Princeton University Art Museum, bequest of Minor White (x1980-813); Fig. 12.24 The J. Paul Getty Museum, Los Angeles, © Aaron Siskind Foundation; Fig. 12.25 © Estate of Helen Levitt/Laurence Miller Gallery, New York, photograph: Don Ross; © Film Documents LLC, courtesy Galerie Thomas Zander, Cologne; Fig. 12.26 Credit: Photograph by Gordon Parks. Copyright: Courtesy of and copyright The Gordon Parks Foundation; Fig. 12.27 © Andrea Frank Foundation, Image copyright © The Metropolitan Museum of Art. Image source: Art Resource, NY

Chapter 13

Fig. 13.1 The Museum of Contemporary Art, Los Angeles, The Panza Collection; Fig. 13.2 © Artists Rights Society (ARS), New York/ADAGP, Paris; Fig. 13.3 © CNAC/MNAM, Dist. RMN-Grand Palais/Art Resource, NY; Fig. 13.4 © 2022 Artists Rights Society (ARS), New York/ADAGP, Paris, The Solomon R. Guggenheim Foundation/Art Resource, NY; Fig. 13.5 © Estate of Maria Elena Vieira da Silva/Artists Rights Society (ARS), New York photograph: Katherine Du Tiel, Gift of Mr. and Mrs. Wellington S. Henderson; Fig. 13.6 © 2022 Artists Rights Society (ARS), New York/SIAE, Rome, © CNAC/MNAM, Dist. RMN-Grand Palais/Art Resource, NY; Fig. 13.7 The Museum of Contemporary Art, Los Angeles, The Panza Collection; Fig. 13.8 Lee Stalsworth. Hirshhorn Museum and Sculpture Garden; Fig. 13.9 © Karel Appel Foundation; Fig. 13.10 The Solomon R. Guggenheim Foundation Peggy Guggenheim Collection, Venice, 1976; © Alberto Giacometti Estate/by SIAE in Italy; Fig. 13.11 Digital Image © CNAC/MNAM, Dist. RMN-Grand Palais/Art Resource; Fig. 13.12 Digital Image © CNAC/MNAM, Dist. RMN-Grand Palais/Art Resource; Fig. 13.13 © The Henry Moore Foundation. All Rights Reserved,

DACS 2022/www.henry-moore.org, Digital Image © The Museum of Modern Art/Licensed by SCALA/Art Resource, NY; Fig. 13.14 Barbara Hepworth © Bowness; Fig. 13.15 Digital Image © The Museum of Modern Art/Licensed by SCALA/Art Resource, NY; Fig. 13.16 © Tate

Chapter 14

Fig. 14.1 Purchase 1965 with contribution from The Friends of Moderna Museet (The Museum of Our Wishes); Fig. 14.2 Allen Phillips/Wadsworth Atheneum ; Fig. 14.3 © 2022 Jasper Johns/Licensed by VAGA at Artists Rights Society (ARS), NY, Digital Image © The Museum of Modern Art/Licensed by SCALA/Art Resource, NY; Fig. 14.4 Digital Image © The Museum of Modern Art/Licensed by SCALA/Art Resource, NY; Fig. 14.5 Solomon R. Guggenheim Museum, New York, © 2018 John Chamberlain/Artists Rights Society (ARS), New York; Fig. 14.6 Whitney Museum of American Art, New York; purchase, © Lee Bontecou; Courtesy Michael Rosenfeld Gallery, N.Y.; Fig. 14.7 Purchase 1971; © Estate of Nancy Reddin Kienholz. Courtesy of L.A. Louver, Venice, CA; Fig. 14.8 © 2022 Romare Bearden Foundation/Licensed by VAGA at Artists Rights Society (ARS), NY, Digital Image © The Museum of Modern Art/Licensed by SCALA/Art Resource, NY; Fig. 14.9 Purchase, Joyce and Robert Menschel Gift, 1993, © Lee Friedlander, courtesy Fraenkel Gallery, San Francisco and Luhring Augustine, New York; Fig. 14.10 The J. Paul Getty Museum, Los Angeles, © 1984 The Estate of Garry Winogrand; Fig. 14.11 Digital Image © The Museum of Modern Art/Licensed by SCALA/Art Resource, NY; Fig. 14.12 © The estate of Niki de Saint Phalle; Fig. 14.13 Album/Alamy Stock Photo; Fig. 14.14 © Art Institute of Chicago/Through prior purchase from the Mary and Leigh Block Fund, restricted gift of Barbara Bluhm-Kaul and Don Kaul/Bridgeman Images;Fig. 14.15 © Kiyoji Otsuji, Photograph in Tate Gallery, London, UK collection, Purchased with funds provided by the Asia-Pacific Acquisitions Committee 2019; Fig. 14.16 © Estate of Sol Goldberg, © Allan Kaprow Estate. Courtesy Hauser & Wirth, Getty Research Institute, Los Angeles; Fig. 14.17 © Yayoi Kusama, Photograph by Robert L. Sabin; Fig. 14.18 Copyright © Yoko Ono 1964, Photo by Mioru HIRATA, Used by Permission/All Rights Reserved; Fig. 14.19

Chapter 19

Chapter 20

Rights Society (ARS), New York, photograph: Katherine Du Tiel; Fig. 20.25 © 1980, Martin Puryear, Smithsonian American Art Museum; Fig. 20.26 Gran Fury, Manuscripts and Archives Division, The New York Public Library ©NYPL; Fig. 20.27 Image courtesy of Andres Serrano and Galerie Nathalie Obadia, Paris/Brussels

Chapter 21

Fig. 21.1 Library of Congress; Highsmith, Carol M., 1946–, photographer; Fig. 21.2 Photograph by Richard George, licensed under CC BY-SA 3.0; Fig. 21.3 © Charles Moore Foundation; Fig. 21.4 Laurence Mackman/Alamy Stock Photo; Fig. 21.5 Photo courtesy of Brian Libby; Fig. 21.6 Arcaid Images/Alamy Stock Photo; Fig. 21.8 John Muggenborg/Alamy Stock Photo; Fig. 21.9 Edmund Sumner-VIEW/Alamy Stock Photo; Fig. 21.10 © All rights reserved by Peter Serenyi; Fig. 21.11 Arcaid Images/Alamy Stock Photo; Fig. 21.12 Charles Leonard/Shutterstock; Fig. 21.13 Arcaid Images/Alamy Stock Photo; Fig. 21.14 aceshot1/Shutterstock; Fig. 21.15 Photo © Luc Boegly/Artedia/Bridgeman Images; Fig. 21.16 imageBROKER/Alamy Stock Photo; Fig. 21.17 Imaginechina Limited/Alamy Stock Photo; Fig. 21.18 Prasit Rodphan/Alamy Stock Photo; Fig. 21.19 Photo: Anthony Browell, courtesy Architecture Foundation Australia; Fig. 21.20 Courtesy Kéré Architecture, Photograph by Siméon Duchoud; Fig. 21.21 ©

T.R. Hamzah & Yeang Sdn. Bhd., Photo by UbiSing, licensed under CC BY-SA 3.0

Chapter 22

Fig. 22.1 Photo Credit: Digital Image © CNAC/MNAM, Dist. RMN-Grand Palais/Art Resource, NY; Fig. 22.2 Copyright Matthew Barney, Courtesy of the artist and Gladstone Gallery; Fig. 22.3 Courtesy of the artist and Susanne Vielmetter Los Angeles Projects, San Francisco Museum of Modern Art, Purchase through a gift of The Buddy Taub Foundation, Jill and Dennis Roach, Directors, © Wangechi Mutu, Photograph: Ben Blackwell; Fig. 22.4 © Kerry James Marshall, Courtesy of the artist and Jack Shainman Gallery, New York; Fig. 22.5 Museum purchase in memory of Trinkett Clark, Curator of American and Contemporary Art, 1989–96, © Jaune Quick-to-See Smith; Fig. 22.6 © Coco Fusco and Guillermo Gómez-Peña, courtesy of the artists; Fig. 22.7 © Catherine Opie, Courtesy Regen Projects, Los Angeles and Lehmann Maupin, New York, Hong Kong, London, and Seoul; Fig. 22.8 © Yasumasa Morimura; Courtesy of the artist and Luhring Augustine, New York; Fig. 22.9 Artwork © Kara Walker, courtesy of Sikkema Jenkins & Co., New York; Sprüth Magers, Berlin. Photo: Joshua White; Fig. 22.10 PjrTravel/Alamy Stock Photo; Fig. 22.11 Courtesy of the artist and Marian Goodman Gallery, © William Kentridge; Fig. 22.12 Photo

Credit Courtesy of Ai Weiwei Studio; Fig. 22.13 Do Ho Suh, Seoul Home/L.A. Home/New York Home/Baltimore Home/London Home/Seattle Home/L.A. Home, 1999. Silk and metal armatures, 149 x 240 x 240 in. (378.5 x 609.6 x 609.6 cm). The Museum of Contemporary Art, Los Angeles, Purchase with funds provided by an anonymous donor and a gift of the artist; Fig. 22.14 © Julie Mehretu; Fig. 22.15 © Courtesy Monika Sprueth Galerie, Koeln/VG Bild-Kunst, Bonn and DACS, London 2020; Fig. 22.16 © El Anatsui, Courtesy of the artist and Jack Shainman Gallery, New York; Fig. 22.17 Photo by Hiro Ihara, courtesy Cai Studio; Fig. 22.18 © Olafur Eliasson. Photo © Tate; Fig. 22.19 Courtesy Dia Art Foundation, Photo: Romain Lopez; Fig. 22.20 Courtesy the artist, Tolarno Galleries and Roslyn Oxley9 Gallery; Fig. 22.21 Courtesy of the artist & KÖNIG GALERIE Berlin | London | Seoul | Vienna; Fig. 22.22 © Agnes Denes, Courtesy Leslie Tonkonow Artworks + Projects; Fig. 22.23 The Broad Art Foundation. Image courtesy of the artist.; Fig. 22.24 © Mariko Mori, Courtesy: Sean Kelly, New York; Fig. 22.25 Photographer/Artist: Marilyn Nieves; Fig. 22.26 © Christian Marclay. Courtesy Paula Cooper Gallery, New York and White Cube, London. Photo: Todd-White Photography; Fig. 22.27 Photo Credit: Digital Image © The Museum of Modern Art/Licensed by SCALA/Art Resource, NY

Index

Le Gray, Gustave, 27, 29; *Brig upon the Water*, **27**
Le Mouvement (exhibition), 358
Le Parc, Julio, 3
Leadbetter, Charles, 83
Leck, Bart van der, 143
Lee, 456
Lee In-sung, *Valley in Gyeongju*, **253**
Lee Ufan, 422, 423; *Phenomena and Perception B*, 423; *Relatum – Silence*, **423**
Léger, Fernand, 8, 104, 106–7, 136, 172, 193, 205–6, 213, 235, 246, 262, 290, 332; *Ballet mécanique* (with Man Ray and Murphy), 206; *The City*, 206; *Contrast of Forms* series, 107; *La partie de cartes (The Card Party)*, 205; *Nudes in a Forest*, 106–7; *Three Women*, **206**
Lehmbruck, Wilhelm, 81; *Seated Youth*, **81**
Leibl, Wilhelm, 74
Leirner, Nelson, 343
Lenin, Vladimir, 134, 163, 236
Leroy, Louis, 33
Les Maudits (*peintres maudits*, "cursed painters"), 194–95
Lescaze, William, Philadelphia Savings Fund Society (PSFS) Building, Philadelphia (with Howe), 371–72, **371**
L'Esprit nouveau (journal), 207
Les XX (*Les Vingt*, "the twenty"), 59–60
Leutze, Emanuel, *Washington Crossing the Delaware*, 275
Levine, Sherrie, 461, 462; *After Edward Weston*, 461; *After Walker Evans*, 461
Lévi-Strauss, Claude, 239, 452, 453
Levitt, Helen, 283, 284; *New York*, **283**
Lewis, Norman, 261, 273–274, 308; *Alabama*, **274**
Lewis, Wyndham, 114; *Workshop*, **114**
LeWitt, Sol, 359, 417, 480, 559n19 (chap. 19); "Paragraphs on Conceptual Art," 416; *Untitled*, **417**
Lhote, André, 235
Li Keran, 257
Libeskind, Daniel, 487; Jewish Museum Berlin, **489**

Lichtenstein, Roy, 325, 329, 330, 331–32, 335, 338; *Drowning Girl*, 331, **332**; *Look Mickey*, 331; *Whaam!*, 331
Liebermann, Max, 74, 80
Life (magazine), 181, 281, 283–84, 303, 327, 328
Life with Pop: A Demonstration for Capitalist Realism (exhibition), 340
Light and Space art, 347, 361, 363–64
Limbour, Georges, 293
Lin Fengmian, 257, 258
Lin, Maya, *Vietnam Veterans Memorial*, 463–64, **463**
Lingnan School, 256
Lipchitz, Jacques, 103–4, 106, 194, 202, 203; *Man with a Guitar*, 103–4, **103**; *Prometheus Strangling the Vulture*, 203
Lippard, Lucy, 415, 416, 428, 432
Lipton, Seymour, 276
Lismer, Arthur, 232
Lissitzky, El, 138, 142, 150, 543n13; *Beat the Whites with the Red Wedge*, 138; *Room for Constructive Art*, 138
Little Galleries of the Photo-Secession. *See* 287
Liu Haisu, 258
Lloyd, Tom, 438
Locke, Alain, 223; "The Legacy of the Ancestral Arts," 223
Long, Richard, 423, 425; *A Line Made by Walking*, 425
Loos, Adolf, 87, 88, 113, 115, 119, 122, 124; "Ornament and Crime," 124; Steiner House, 124, **125**
Los Angeles Council of Women Artists, 432
Louis XIV, 116
Louis XVI, 10, 11
Louis, Morris, 348–49, 351, 414; *Veils*, 349; *Unfurleds*, 349; *Beta Kappa*, **349**
Louis-Philippe I, 18
Loving, Al, 348
Lozano-Hemmer, Rafael, *Pulse* series, 515
Lu Xun, 259
Lueg, Konrad, 340
Luks, George, 214

Lüpertz, Markus, 446
Lyotard, Jean-François, 445, 452

Maar, Dora, 186, 188–89; *Père Ubu*, 188–89, **188**
Mac Low, Jackson, 319
MacConnel, Kim, 435
MacDonald, J. E. H., 232
Macdonald, Margaret, 118, 119
Maciunas, George, 319, 321
Macke, August, 81, 85, 86, 87
Mackintosh, Charles Rennie, 118–19; Glasgow School of Art, 118–19, Library, **119**
MacNair, Frances Macdonald, 118
MacNair, Herbert, 118
Madí, 241
Magritte, René, 9–10, 172, 174, 178, 181, 186; *Time Transfixed*, 9–10, **9**, 181; *The Treachery of Images*, 181, 419
Mahler, Alma, 88–89
Maillol, Aristide, 73; *The Mediterranean*, 73, **74**, 199
Maiolino, Anna Maria, 343
Maki, Fumihiko, 384
Maldonado, Tomás, 241
Malevich, Kazimir, 135–38, 139, 142, 149, 351, 391, 466, 487, 489; *Black Square*, **137**; *The Knife Grinder or Principle of Glittering*, 136–37
Mallarmé, Stéphane, 51
Maloba, Gregory, *Independence Monument*, **398**
Malraux, André, 288
Man Ray, 158, 161, 162, 172, 185, 187–88, 189; *Ballet mécanique* (with Léger and Murphy), 206; *Cadeau (Gift)*, 162; *Minotaur*, 187–88, **187**
Mancoba, Ernest, 294, 401
Manessier, Alfred, 290
Manet, Édouard, 17, 19, 25, 29–33, 37, 40, 194, 202, 214, 504; *A Bar at the Folies-Bergère*, 33, **34**; *Le Déjeuner sur l'herbe (Luncheon on the Grass)*, 30–32, **31**, 35, 186, 501; *Olympia*, 32–33, **32**, 55, 504; *On the Balcony*, 327
Mangold, Robert, 353
Manguin, Charles-Henri, 68

Manuel, Antonio, 343
Manuel, Victor, 238
Mao Zedong, 260
Mapplethorpe, Robert, 471, 473–74
Marc, Franz, 68, 81, 82, 84–86; *Large Blue Horses*, 85–86, **86**
Marcks, Gerhard, 146
Marclay, Christian, *The Clock*, 523–324, **523**
Marconi, Guglielmo, 91
Marden, Brice, 353
Marées, Hans von, 74
Marevna, 104
Marey, Étienne-Jules, 109, 111
Margolles, Teresa, *En el aire (In the air)*, 519–20
Marie Antoinette, 11–12, 448
Mariga, Joram, 399
Marin, John, 218; 219; *Woolworth Building, No. 31*, 219
Marinetti, Filippo Tomasso, 109–10, 111, 113; "Manifesto of Futurism," 110
Marini, Marino, 401
Marisol, 338; *The Family*, **338**
Marque, Albert, 68
Marquet, Albert, 68
Marsh, Reginald, 225
Marshall, Kerry James, *Better Homes, Better Gardens*, 500–1, **501**; *Garden Series*, 500–1
Martín Fierro (journal), 240
Martin, Agnes, 348, 352–53, 466, 522; *Morning*, **353**
Martin, J. L., 212
Martin, Kenneth, 358
Marx, Karl, *Communist Manifesto* (with Engels), 5, 17
Masaccio, 303
Masolino da Panicale, *Pietà*, 520
Mason, Alice Trumbull, 230
Masson, André, 172, 175, 176, 183, 262; *Battle of Fishes*, **175**
Mathieu, Georges, 287, 288–89, 290, 315; *Les Capétiens partout (Capetiens Everywhere)*, 289, **290**
Matisse, Henri, 51, 67, 68–71, 73, 77, 78, 82, 85, 95, 134, 193, 195–198, 213, 217, 218, 219, 249, 257, 258, 262, 276, 332, 337, 350, 392, 440, 541n6; *Bathers by a*

River, 275; *Blue Nude: Souvenir of Biskra*, 70, 71, 196; Chapel of the Rosary, Vence, France, decorations for, 197–198; *The Dance* (mural), 197; *Dance (II)*, 70, 71, **72**, 350; *Decorative Figure*, 196; *Harmony in Red*, 71; *Large Reclining Nude*, **197**; *Le Bonheur de vivre ("The Joy of Life")*, 69–70, **69**, 71, 94, 540n4; *Luxe, calme, et volupté (Luxury, Calm, and Voluptuousness)*, 68; *Music*, 71; "Notes of a Painter," 71; *Open Window, Collioure*, 68–69, **68**, 71; *Piano Lesson*, **196**; *Red Studio*, 195, 350; *Reclining Nude I (Nu couché I, Aurore)*, 70–71, **70**; *Woman on a High Stool*, 196
Matisse, Pierre, 196; Gallery, 177
Matsuzawa, Yutaka, 417
Matta, 175, 178, 238, 262
Matta-Clark, Gordon, 423, 427; *Splitting*, 427, **428**
Maurer, Alfred, 218
Maurice, Frederick Denison, 23
Mavo, 249–50
Mbari Mbayo Club, 394
McCarthy, Joseph, 275, 305
McCaw, Terence, 400
McCollum, Allan, 466; *Plaster Surrogates*, 466
McEwen, Frank, 398–99
McKim, Charles, 128
McLuhan, Marshall, 347, 500
Mead, William, 128
Medunetsky, Konstantin, 139
megastructures, 384–85, 486
Mehretu, Julie, 511; *Black City*, 511–12, **511**
Mehta, Tyeb, 388
Meier, Richard, 475, 481; Getty Center, Los Angeles, 482; High Museum of Art, Atlanta, 481–82, **482**
Meireles, Cildo, 418; *Insertions into Ideological Circuits: Coca-Cola Project*, **418**
Meissonier, Ernest, 179
Melamid, Alexander. *See* Komar and Melamid
Mendelsohn, Erich, 371; Einstein Tower, Potsdam, Germany, **370**

Mendieta, Anna, *Silueta* series, 435–37; *Silueta de Arena*, **436**
Menil, de, John and Dominique, 271, 288
Merleau-Ponty, Maurice, 323, 360, 361, 363, 423; *The Phenomenology of Perception*, 361
Merz, Mario, 421, 422; *Giap Igloo*, 422
Mesa-Bains, Amalia, 442
Mesejean, Pablo, 341, 342
Metabolists, 384, 480
Metzinger, Jean, 104, 109, 134, 135; *On Cubism* (with Gleizes), 104
Metzner, Fritz, 124
Meyer, Adolf, Fagus Factory, Alfeld-an-der-Leine, Germany (with Gropius), 130, **131**
Meyer, Hannes, 147, 153
Meyer, Melissa, 435
Meyerowitz, Joel, *Looking South: New York City Landscapes, 1981–2001* series, 523
Michelangelo, 61, 168; *Dying Slave*, 61
Mies van Rohe, Ludwig, 119, 145, 147, 365, 368, 369, 370, 376–78, 476, 485, 492; Barcelona Pavilion, 365, **369**; Crown Hall, Illinois Institute of Technology, Chicago, 377; Farnsworth House, Plano, IL, 377; Seagram Building, New York (with Johnson), 368, 377–88, **377**, 478
Mili, Gjon, 303
Millais, John Everett, 21, 22, 25; *Christ in the House of His Parents (The Carpenter's Shop)*, 21–22, **22**
Miller, Lee, 187
Miller, Tim, 474
Millet, Jean-François, 17, 19, 40, 57; *The Gleaners*, 19–20, **20**
Minimalism, 205, 272, 275, 331, 347, 348, 352, 353, 354, 358–62, 363, 390, 417, 420, 422, 431, 432, 435, 445, 463, 466, 467, 497, 522; Land art and, 423, 425; Post-minimalism and, 413, 414, 415, 416
Minotaure (journal), 188, 190
Minujín, Marta, 341, 342; *La Menesunda*, 342; *¡Revuélquese y viva! (Roll around and live!)*, 342
Miró, Joan, 172, 175, 176–77, 231, 262; *Constellations* series, 177;